COROT

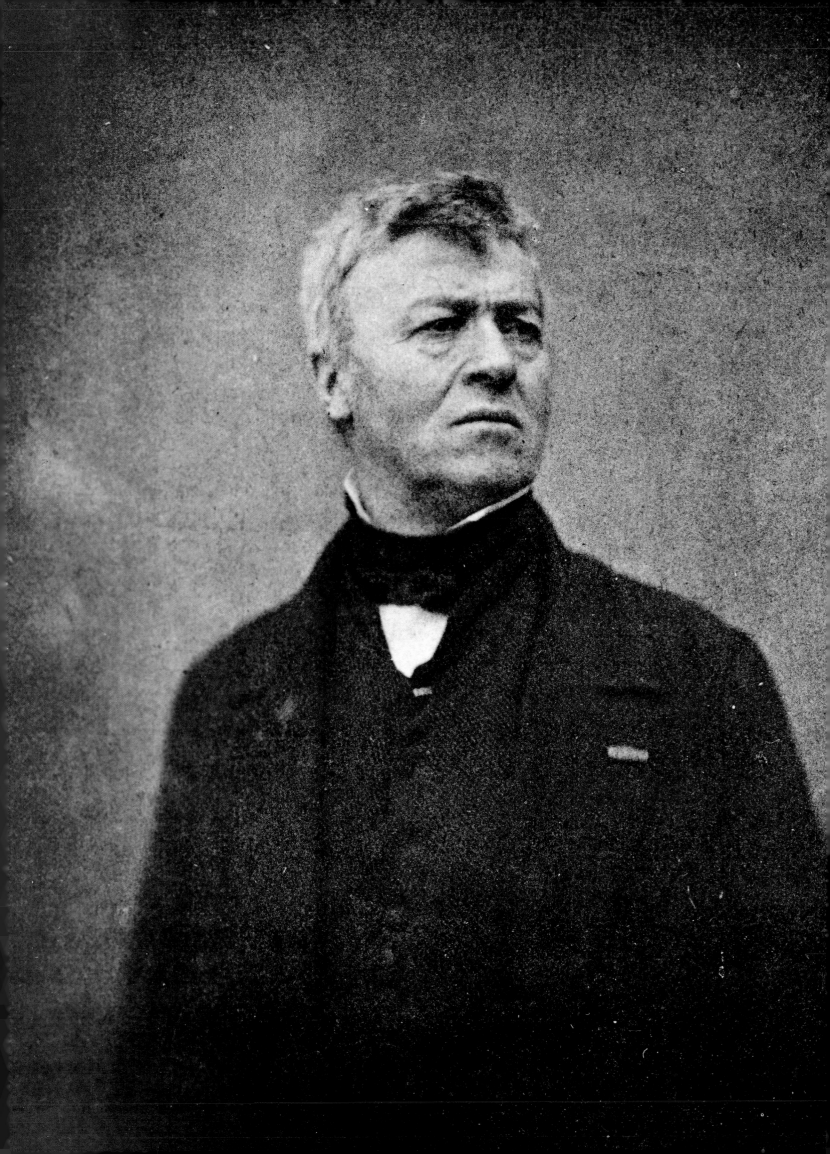

COROT

Gary Tinterow

Michael Pantazzi

Vincent Pomarède

The Metropolitan Museum of Art, New York

Distributed by Harry N. Abrams Inc., New York

This catalogue is published in conjunction with the exhibition "Corot," held at the Galeries Nationales du Grand Palais, Paris, February 27–May 27, 1996, at the National Gallery of Canada, Ottawa, June 21–September 22, 1996, and at the Metropolitan Museum of Art, New York, October 29, 1996–January 19, 1997.

The exhibition was organized by The Metropolitan Museum of Art, the National Gallery of Canada, and the Réunion des Musées Nationaux.

Published by The Metropolitan Museum of Art, New York

John P. O'Neill, Editor in Chief
Ruth Lurie Kozodoy, Editor
Bruce Campbell, Designer
Gwen Roginsky, Production, with Matthew Pimm and Jay Reingold
Robert Weisberg, Computer Specialist

"The Making of an Artist," the chronology, entries 1, 3–5, 7–17, 20, 21, 23–27, 29, 32, 34–41, 43–49, 51, 53–55, 57–59, 67, 68, 94, and quotations in entries 115–63 and in "The Greatest Landscape Painter of Our Time" translated from the French by Lory Frankel. "Corot Forgeries," entries 2, 6, 18, 19, 22, 28, 30, 31, 42, 50, 56, and quotations in entries 61–114 and in "Corot and His Collectors" translated from the French by Mark Polizzotti. Quotations in "Le Père Corot" translated from the French by Ruth Kozodoy. Bibliography edited by Jayne Kuchna.

Typeset in Centaur by North Market Street Graphics, Lancaster, Pennsylvania
Printed by Julio Soto Impresor, S.A., Madrid
Bound by Encuadernación Ramos, S.A., Madrid

LIBRARY OF CONGRESS CATALOGUING-IN-PUBLICATION DATA
Tinterow, Gary.
 Corot / Gary Tinterow, Michael Pantazzi, Vincent Pomarède.
 p. cm.
 Published in conjunction with the exhibition "Corot", held at the Grand Palais, Paris, Feb. 27 to May 27, 1996; at the National Gallery of Canada, Ottawa, June 21 to September 22, 1996; and at the Metropolitan Museum of Art, from October 29, 1996, to January 19, 1997.
 Includes bibliographical references and index.
 ISBN 0-87099-769-6 (hc).—ISBN 0-87099-771-8 (pbk. : alk. paper).—0-8109-6501-1 (Abrams)
 I. Corot, Jean Baptiste Camille, 1796–1875—Exhibitions.
I. Pantazzi, Michael. II. Pomarède, Vincent. III. Galeries nationales du Grand Palais (France) IV. National Gallery of Canada. V. Metropolitan Museum of Art (New York, N.Y.) VI. Title
ND553.C8A4 1996 759.4—dc20 96-6768 CIP

Frontispiece: Victor Laisné. *Corot*, 1853. Salted-paper print. Published in Robaut 1905, vol. 4, p. 305

Contents

Curators of the Exhibition

MICHAEL PANTAZZI
Curator, National Gallery of Canada

VINCENT POMARÈDE
Conservateur, Départment des Peintures, Musée du Louvre
assisted by Gérard de Wallens

GARY TINTEROW
Engelhard Curator of European Paintings, The Metropolitan
Museum of Art
assisted by Anne M. P. Norton and Rebecca A. Rabinow

Lenders to the Exhibition

PUBLIC INSTITUTIONS

Austria

Vienna, Österreichische Galerie im Belvedere, 74, 84

Belgium

Brussels, Musées Royaux des Beaux-Arts de Belgique, 2

Ghent, Museum voor Schone Kunsten, 68

Canada

Montreal, The Montreal Museum of Fine Arts, 128

Ottawa, National Gallery of Canada, 27

Denmark

Copenhagen, Ordrupgaardsamlingen, 69, 158

France

Arras, Musée des Beaux-Arts, 100

Bordeaux, Musée des Beaux-Arts, 105

Boulogne, Château-Musée de Boulogne-sur-Mer, 123

Caen, Musée des Beaux-Arts, 132

Dunkirk, Musée des Beaux-Arts, 113

Lyons, Musée des Beaux-Arts, 138

Marseilles, Musée des Beaux-Arts, 94

Metz, La Cour d'Or, Musées de Metz, 76

Montpellier, Musée Fabre, 95

Nantes, Musée des Beaux-Arts, 78

Paris, Church of Saint-Nicolas-du-Chardonnet, 89

Paris, Musée du Louvre, 6, 8, 9, 13, 21, 26, 28, 37, 42, 48, 50, 54, 55, 83, 87, 92, 98, 99, 107, 108, 112, 126, 137, 140, 156, 159, 160, 162; on deposit elsewhere, 46, 100, 132, 134

Paris, Musée d'Orsay, 103, 124, 129, 130, 134, 149

Paris, Musée du Petit Palais, 85

Quimper, Musée des Beaux-Arts, 66

Reims, Musée des Beaux-Arts, 18, 145, 146

Rouen, Musée des Beaux-Arts, 46, 147

Saint-Lô, Musée des Beaux-Arts, 90

Semur-en-Auxois, Musée Municipal, 88

Senlis, Musée d'Art, 34

Strasbourg, Musée des Beaux-Arts, 38

Toulouse, Musée des Augustins, 125

Ville-d'Avray, Church of Saint-Nicolas-Saint-Marc, 62

Germany

Hamburg, Kunsthalle, 163

Munich, Bayerische Staatsgemäldesammlungen, Neue Pinakotek, 59

Great Britain

Cambridge, The Fitzwilliam Museum, 20

Edinburgh, National Galleries of Scotland, 4, 52

Glasgow, Art Gallery and Museum, Kelvingrove, 150, 152

London, The Trustees of the National Gallery, 67

Oxford, The Visitors of the Ashmolean Museum, 3, 25

Italy

Florence, Galleria degli Uffizi, 51

Venice, Galleria Internazionale d'Arte Moderna di Ca'Pesaro, 1

The Netherlands

Amsterdam, Rijksmuseum, 154

Otterlo, Rijksmuseum Kröller-Müller, 41

Switzerland

Geneva, Musée d'Art et d'Histoire, 12, 81, 97, 106

Saint Gall, Kunstmuseum, 58

Zurich, Kunsthaus, 29

Zurich, Fondation Rau pour le Tiers-Monde, 143

Foreword

To commemorate the two-hundredth anniversary of the birth of Jean-Baptiste-Camille Corot—the most protean and poetic landscape painter of nineteenth-century France— the Réunion des Musées Nationaux, the National Gallery of Canada, and The Metropolitan Museum of Art have jointly organized this retrospective of the artist's paintings. Celebrated during his lifetime as a god of sylvan painting, Corot subsequently achieved that strange status that Degas wished for himself: to be both illustrious and unknown. For while Corot's renown is great, his work in its entirety remains unfamiliar to all but specialists. His views of Ville-d'Avray veiled in silvery mists are universally admired, but the limpid Italian landscapes of his youth and the grand history paintings of his maturity are rare in North America, and few European collections contain examples of the many fine figure paintings he made in the last decade of his life.

The curators of the exhibition, Michael Pantazzi, Vincent Pomarède, and Gary Tinterow, have seized this opportunity to demonstrate the great range of Corot's work and to celebrate the poetic vision that was uniquely his. From nearly three thousand paintings they have chosen one hundred sixty-three: informal sketches and large, finished canvases destined for the annual Salons, paintings done from nature and others that emerged entirely from the artist's fecund imagination. Drawing on the two most important collections of Corot's paintings, the first belonging to the French state and housed at the Musée du Louvre and the Musée d'Orsay in Paris, the second at The Metropolitan Museum of Art in New York, they have sought additional works from another sixty-seven museums as well as two churches and some fifteen private collectors—testimony to the widespread appreciation of Corot's painting by collectors and curators during the last one hundred years. Indeed, so dispersed was Corot's work by the beginning of this century that the remarkable collector and connoisseur Étienne Moreau-Nélaton, the cataloguer, along with Alfred Robaut, of Corot's oeuvre, believed that it would be impossible to organize a representative exhibition worthy of the artist. Important exhibitions were mounted in Zurich in 1934, Paris in 1936, Philadelphia in 1946, Bern and Chicago in 1960, and Paris in 1962 and again in 1975. However, not since the commemorative display organized after Corot's death in 1875 have so many of the artist's paintings been gathered as are presently brought together. Thanks to the extraordinary cooperation of museums and collectors around the world, the exhibition that Moreau-Nélaton considered unfeasible in 1905 has now been realized.

Happily, Corot's achievement is very much in evidence in this, his bicentennial year. His drawings, prints, and photographs are the subject of a concurrent exhibition at the Bibliothèque Nationale de France. And, in addition to the present retrospective, three very different exhibitions will feature his work: one devoted to plein air painting of the Neoclassical epoch (in Washington, Saint Louis, and Brooklyn), another to painters of the Barbizon school (in Kobe, Munich, and The Hague), and still another to the art of Romanticism (in Nantes, Paris, and Plaisance). As it did during his lifetime, Corot's work continues to elude simple classification, all the while giving great pleasure through its extraordinary beauty.

Philippe de Montebello
Director, The Metropolitan Museum of Art, New York

Françoise Cachin
Director, Musées de France
President, Réunion des Musées Nationaux, Paris

Shirley L. Thomson
Director, National Gallery of Canada, Ottawa

Acknowledgments

We would like first to express our profound gratitude to the lenders to the exhibition, both the owners of the works and their custodians: museum directors, curators, registrars, and curatorial assistants—all of whom rank as co-organizers by virtue of the extraordinary level of their participation. We particularly thank the officers of the Museum of Fine Arts, Boston, the Art Institute of Chicago, the Musée d'Art et d'Histoire, Geneva, the Musée d'Orsay, Paris, and the Philadelphia Museum of Art for the generous scope of their loans.

We thank those individuals who liberally offered their time and expertise to suggest, locate, and document works for this exhibition. Hélène Toussaint, organizer of the 1975 "Hommage à Corot," paved the way with her extensive examination of works by Corot in France. Martin Dieterle, the latest representative of a long line of connoisseurs specializing in the study of Corot's work, opened his vast archives and shared his great knowledge with us. Philip Conisbee and Sarah Faunce, two organizers of the concurrent exhibition, "In the Light of Italy: Corot and Early Open-Air Painting," kindly shared their plans with us, making it possible to coordinate the two endeavors. Michael Clarke and John Leighton were quick to lend works from their respective collections in Edinburgh and London and to inform us of important works in private hands. Jacques Foucart generously placed the riches of the Documentation du Département des Peintures of the Musée du Louvre at our disposal, and Yveline Cantarel-Besson and Isabelle Le Masne de Chermont did the same with the Bibliothèque and Archives of the Musées Nationaux.

We also acknowledge our great debt to the current generation of young Corot scholars and especially to Peter Galassi and Fronia Wissman, as well as to the previous generations, whose ranks include many luminaries of the study of French painting: Jean Leymarie, Germain Bazin, Lionello Venturi, Julius Meier-Graefe, and, most important for the study of Corot, Étienne Moreau-Nélaton and Corot's friend Alfred Robaut.

In Paris, Pierre Rosenberg and Irène Bizot gave their full support to this project, and Jean-Pierre Cuzin, after his arrival as curator in charge of the Département des Peintures, provided constant assistance. Catherine Chagneau organized the exhibition for the Réunion des Musées Nationaux with her characteristic efficiency and precision. We are very grateful for her flawless collaboration. Bernadette Caille performed the nearly impossible task of assembling the French manuscript in record time. We thank her and Anne de Margerie for their kindness and dedication. We appreciate the assistance provided by Philippe Couton and Elizabeth Molle.

Gerard de Wallens coordinated many aspects of the exhibition in Paris and facilitated its entire organization. His efficiency, kindness, and careful work improved both the catalogue and the exhibition, and we express our sincere gratitude to him. The personnel of the Laboratoire de Recherche des Musées de France contributed greatly to our understanding of Corot's technique. We are grateful to Jean-Pierre Mohen, Elizabeth Martin, Anne Roquebert, Danièle Giraudy, Maurice Solier, and Jean-Paul Rioux. Thanks to the efforts of Nathalie Volle, France Dijoud, Christiane Naffah, and Annick Lautraite of the Services de Restauration, a number of works from the Musée du Louvre, the Musée d'Orsay, and other museums in northern France were conserved prior to their exhibition at the Grand Palais.

In Ottawa, Graham Larkin provided precious assistance at the beginning of the project, conducting bibliographic research and preparing a detailed chronology. After his departure Magda Le Donné continued the research with ingenious and smiling energy. Bonnie Bates, Peter Trépanier, and Maija Vilcins facilitated our access to scholarly resources. In innumerable ways, Colin Bailey, Catherine Johnston, Shirley Proulx, and Brydon Smith helped us in the course of our work. We are very grateful to Shirley L. Thomson and Daniel Amadei for their warm cooperation, and most particularly to Catherine Jensen, who assured the administration of the exhibition with enthusiasm and efficiency. The constant assistance and combined efforts of Delphine Bishop, Marie Currie, Cheryl Gagnon, Kate Laing, Helen Murphy, Jacques Naud, Barbara Ramsey-Jolicoeur, Serge Thériault, Ursula Thiboutot, and Alan Todd permitted the realization of the project in Canada.

In New York, Anne M. P. Norton administered the exhibition with her characteristic grace and efficiency until February 1996. She also supervised research, which was

conducted by Andrew Shelton and Rebecca Rabinow, with the aid of Robert McDonald Parker in Paris. Isabelle de la Bruyère cheerfully performed any number of tasks. Rebecca Rabinow assisted in organizing the exhibition, bringing her intelligent and experienced eye to endless hours of proofing and fact-checking, and she took on the practical organization of the exhibition after Anne Norton left the Metropolitan, shepherding the project over many administrative hurtles. As always, the Department of European Paintings was assisted by the Office of the Director, and we especially thank Philippe de Montebello, Mahrukh Tarapor, and Jennifer Russell for their practical and moral support. We also express our thanks to Everett Fahy, Susan Alyson Stein, Dorothy Kellett, Della Sperling, Samantha Sizemore, and Suzanne McDermott for their gracious assistance. We are grateful to Charlotte Hale for contributing many insights about Corot's working technique. We appreciate the unflagging help provided by Diana Kaplan.

Ruth Kozodoy is warmly thanked for her tireless work on the English edition of this book. For nearly one year she has shaped the manuscript and improved it in every conceivable manner. Kathleen Howard and Margaret Aspinwall also made valuable editorial contributions. Jayne Kuchna verified all of the bibliographic and exhibition references, and we are deeply indebted to her for her careful work. Lory Frankel and Mark Polizzotti were the hardworking translators, and Peter Rooney ably compiled the index.

We are very grateful to John P. O'Neill for his constant support. We thank Bruce Campbell for the handsome design he created, Gwen Roginsky and Matthew Pimm for skillfully producing the book, and Katherine Penn for collecting the transparencies.

Finally, we extend our most sincere thanks to the following individuals: Véronique Allemany-Dessaint; Lynn Ambrosini; Jeanne Amoore; Joseph Baillio; Blanche Bauchau; Elizabeth Belarbi; Catherine Belanger; Madame Bellomo; André Berthelot; Robert Boardingham; Gilles Biaille de Langibaudière; Violaine Bouvet-Lanselle; Claude Buret; Hans Buys; Jean Cadogan; Xavier Cappelare; Antoine Castanier; Patrick Le Chanu; Bénédicte Chantelard; Père Charpagne; Marie-Claude Chaudonneret; Valentine de Chillaz; Cynthia Clark; Micheline Colin; Desmond L. Corcoran; Yves Dagenais; Jacques Desjardins; Martine David; Malcolm Daniel; Madame Dawans; Fabienne De Sadeleer; Martine Delval; Madame Dieu; Benjamin Dollar; Père Dominique; Deirdre Donohue; Douglas Philippe Duret; Sylvie Duvigneau; Elizabeth Easton; Sarah Faunce; Richard L. Feigen; Marianne Feilchenfeldt; Walter Feilchenfeldt; Manfred Fisher; S. Formentin; Aline François; Jean Galard; Gilles Grandjean; Denis Gravel; Martine Guichard; Fabienne Grolière; Gloria Groom; Charlotte Hale; Vivian Hamilton; Nancy Harrison; Lauren B. Hewes; Ay-Whang Hsia; Robert Hozee; Roseline Hurel; Anne Hurley; Simon Jervis; David Johnson; Sona Johnston; William R. Johnston; Laurence Kanter; Mr. and Mrs. Hubert Kemlin; Steven Kern; Isabelle Klinka; Harold Koda; Bertille Lanne; Sylvain Laveissière; Frederick Leen; John Leighton; Timothy Lennon; Neil MacGregor; Mary Jo McLaughlin; Jean Marsac; Philippe Lorentz; Henri Loyrette; Laurier Marion; Gilles Mechani; Melissa de Medeiros; Olivier Meslay; Charles S. Moffett; Christophe Monin; Patricia Mounier; Moniek Nagels; Mr. Nardin; Gisèle Ollinger; William O'Reilly; David Ogawa; Geoffrey Parton; Marie Pessiot; E. Persoons; Stuart W. Pyhrr; André Quariou; Marie-France Ramspacher; Jay Reingold; Christopher Riopelle; Joseph Rishel; Claude Ritschard; Anne Roquebert; Daniel Rosenfeld; Anne Ruggles; Marie-Catherine Sahut; Renzo Sarti; Polly J. Sartori; George Shackelford; Martin Summers; Geroen de Scheemaker; Chiara Stefani; Nathalie Texier; R. Tielmans; Emily Tolot; Roger van Schoute; Hélène Verougstraete; Lise Villeneuve; Anne de Wallens; John Walsh; Francine Wapler; Mathias Wascheck; Margit Weinberg; Rolf Weinberg; J. J. Whitely; Wheelock Whitney; Daniel Wildenstein; Mikael Wivel; and Eric M. Zafran.

M. P. V. P. G. T.

Introduction

"There is only one master here—Corot. We are nothing compared to him, nothing." *Claude Monet, 1897*[1]

"He is still the strongest, he anticipated everything. . . ." *Edgar Degas, 1883*[2]

Today it is rather surprising to read the unqualified praise for Corot voiced over and over again by the generation of painters who were maturing just when he died. It seems peculiar that these artists so greatly esteemed *le père Corot*, since Corot pretended to be out of touch with artistic developments at the end of his life and disapproved of the confrontational nature of the work produced by Monet and the other *Intransigeants* seeking to commandeer the walls of the annual Paris Salon. The very notion of modernity that infuses much of Monet's art, the knowing urbanity of Degas's, the ceaseless experimentation that characterizes both these oeuvres seem completely at odds with Corot's contemplative vision of a timeless, unchanging Arcadia—or what some call his monotonous views of Ville-d'Avray. Reading further, one learns that in the late 1920s and early 1930s both the painter Jacques-Émile Blanche and the historian Alfred Barr, founder of New York's Museum of Modern Art, believed that Corot's impact on twentieth-century art would rival Cézanne's.[3] These views are so far from the present-day conception of Corot's importance to the history of painting that a thorough reappraisal of his art is clearly long overdue.

Since the 1930s historians have attempted to establish Corot as the precursor of Impressionism, the inventor of sunlit landscapes untroubled by anecdote or meaningful incident. Struck by his marvelous studies painted in the open air in Italy, the writers Germain Bazin and Kenneth Clark saw Corot as the perfectly optical painter with a perfectly innocent eye—in short, the unthinking man's painter—so long as he was only sketching from nature. Comparing the on-the-spot study of the bridge at Narni (cat. no. 26) with the finished Salon painting of the same view (cat. no. 27), Bazin called the former "a marvel of spontaneity in which there is already the germ of Impressionism, [while] the Salon picture, even though it is painted in beautiful thick

paint and with great delicacy, is nonetheless a rather artificial Neoclassical composition."[4] In Clark's opinion, the same study "is as free as the most vigorous Constable; the finished picture in Ottawa is tamer than the tamest imitation of Claude."[5]

Since the 1980s, when Peter Galassi directed attention to the outdoor painting of Corot's near contemporaries Michallon, Bertin, Granet, and Caruelle d'Aligny, art historians have linked Corot to the generation of painters who preceded him as opposed to those who followed him. As those and other painters in Corot's Italian circle became better known, Corot was more and more seen as the obedient disciple of Pierre-Henri Valenciennes, the codifier of Neoclassical landscape painting; as the last in a line of painters continuing to work an aesthetic forged in the eighteenth century.

Yet while both views contain much truth, neither characterization of Corot—as the last Neoclassicist or as the first Impressionist—is sufficient to encompass the totality of his achievement. For example, neither explanation satisfactorily accommodates the extraordinary history paintings, among them *Hagar in the Wilderness, Diana Surprised in Her Bath, Democritus and the Abderites, Homer and the Shepherds* (cat. nos. 61, 63, 78, 90), that actually made Corot's reputation in the 1840s: the kind of painting that prompted Baudelaire to write, "at the head of the modern school of landscape stands M. Corot."[6] These are the works that continue to disturb modern critics.[7]

Nor does either theory adequately account for Corot as a painter of figures. When pressed by an interlocutor, Degas proclaimed Corot an even greater figure painter than a landscapist.[8] It was largely the figure paintings that Degas recommended to his collector friends, such as Henri Rouart, who owned *Lady in Blue* (cat no. 162). Degas's colleague Mary Cassatt actively counseled American collectors—the Havemeyers, the Palmers, Colonel Payne, and others—to buy figure paintings rather than landscapes.[9] It was Corot the figure painter who impressed Van Gogh, Gauguin, and Cézanne; as Edward Lucie-Smith has observed, paintings such as Corot's *Dance of the Nymphs* (cat. no. 103) may be the key to Cézanne's late paintings of bathers.[10] In the 1910s, Juan Gris and Picasso copied figures by Corot. The exhibition

of his figure paintings organized at Paul Rosenberg & Cie. in 1928 profoundly affected the work of André Derain and André Lhote, and it prompted Blanche and Barr to reevaluate Corot's impact on the art of the present century.

Yet today Corot continues to elude art historians and critics, which is why we believed it important to mount a retrospective in which every aspect of his painted oeuvre would be fully represented. A different kind of exhibition might have shown Corot only at his most ravishing, but it would be deceptive: a fundamental aspect of Corot's work is that his drawing is sometimes awkward, his compositions sometimes formulaic. An exhibition tightly focused by theme or period might have shown Corot as a more coherent and consistent artist than he appears here; but his oeuvre does in fact reflect the seemingly contradictory tenets of Neo-classicism, Romanticism, Realism, and Naturalism. Nonetheless, artists from Delacroix to Courbet to Renoir to Picasso, who knew Corot's work well, stubbornly held it in the highest possible regard. We hope that this exhibition will enable a new generation of viewers to know Corot's art well and to discover for themselves all that his paintings have to offer.

1. "Il n'y en a a qu'un ici, c'est Corot; nous, nous ne sommes rien, rien, près de lui!" Claude Monet, remark quoted in Koechlin 1927, p. 47.

2. "Il est toujours le plus fort, il a tout prévu. . . ." Edgar Degas, remark recorded by Alfred Robaut and quoted by Jean Dieterle in Paris 1971, preface, p. 15.

3. "It is proclaimed, however, that Corot is perhaps the nineteenth-century master whose hold is the strongest, whose influence will be the most lasting on artists of the twentieth century." ("On proclame cependant que Corot est peut-être le maître du XIXe siècle dont la prise est la plus forte, dont l'influence sera la plus durable sur les artistes du XXe siècle.") Blanche 1931, pp. 18–19. "Corot's influence on subsequent painting has been more far reaching probably than any other master with the exception of Cézanne....Today even more than Cézanne Corot appears to be a dominant force among living French painters." Alfred Barr in New York 1930c, p. 16.

4. "Tandis que l'étude est une merveille de spontanéité, où l'impressionnisme est déjà en germe, l'envoi du Salon, s'il est peint dans une belle matière dense et pleine de délicatesse, est d'une composition néo-classique, quelque peu artifi-cielle." Bazin 1973, p. 30.

5. Clark 1979, p. 158.

6. "À la tête de l'école moderne du paysage, se place M. Corot." Baudelaire, "Salon de 1845," in Baudelaire 1923, p. 55.

7. See for example Robert Hughes, "Bringing Nature Home," *Time*, March 25, 1996, pp. 71–72.

8. "I think he is even finer in his figures." ("Même je l'estime encore supérieur dans ses figures.") Edgar Degas, remark quoted in Robaut 1905, vol. 1, p. 336.

9. Figure paintings purchased by those three collectors include cat. nos. 133, 142, 144, 151, 152, 153.

10. Edward Lucie-Smith, "Journey of a Restless Master," *Spectator*, March 9, 1996, pp. 37–38.

Note to the Reader

The catalogue raisonné of Corot's works, *L'Oeuvre de Corot*, published in 1905, was the collaborative effort of Alfred Robaut and Étienne Moreau-Nélaton. Robaut drafted a manuscript and amassed a large number of documents but because of his age was unable to complete the project. Moreau-Nélaton edited and added to Robaut's notes, contributed a biographical essay, and published the completed work under Robaut's name; thus it is abbreviated Robaut 1905.

In the present volume, a work by Corot is identified by its number in the catalogue raisonné, abbreviated as R, or by a number in one of several supplements to the catalogue raisonné. The title given for the work is generally the one assigned in the catalogue raisonné; however, if the title that was used by Corot is known, as are those that were published in the catalogues of the annual Paris Salons, it is given here as the primary title.

Dates given for works in this volume were assigned by the three authors. Information about media, dimensions, and inscriptions was supplied by the owners of the works. Information on the previous owners and locations of the catalogued works is largely based on the work of Robaut and Moreau-Nélaton, but has been amplified and occasionally corrected by the present authors. Exhibition histories and reference lists were compiled by the authors. The order of the catalogue entries is roughly chronological, although exceptions have been made for certain thematic groupings.

References are cited in the notes in an abbreviated form. The corresponding full citations will be found in the bibliography that begins on page 419.

Corot's *carnets*, which served as both sketchbooks and notebooks, are housed in various institutions, primarily at the Musée du Louvre, Paris. Eighty-five *carnets* are catalogued in Robaut 1905, vol. 4, pp. 87–88, nos. R 3938–R 3122.

Robaut's unpublished papers contain much important information not found in the catalogue raisonné. The papers now belong to the Bibliothèque Nationale de France, Paris, and are classified in several categories. Those most frequently cited here are Robaut *cartons* (these albums are presently housed in the Département des Peintures, Musée du Louvre) and Robaut *documents* (in the Bibliothèque Nationale de France). A useful directory of this archival material appears in Galassi 1991b, p. 244.

COROT

1821-34

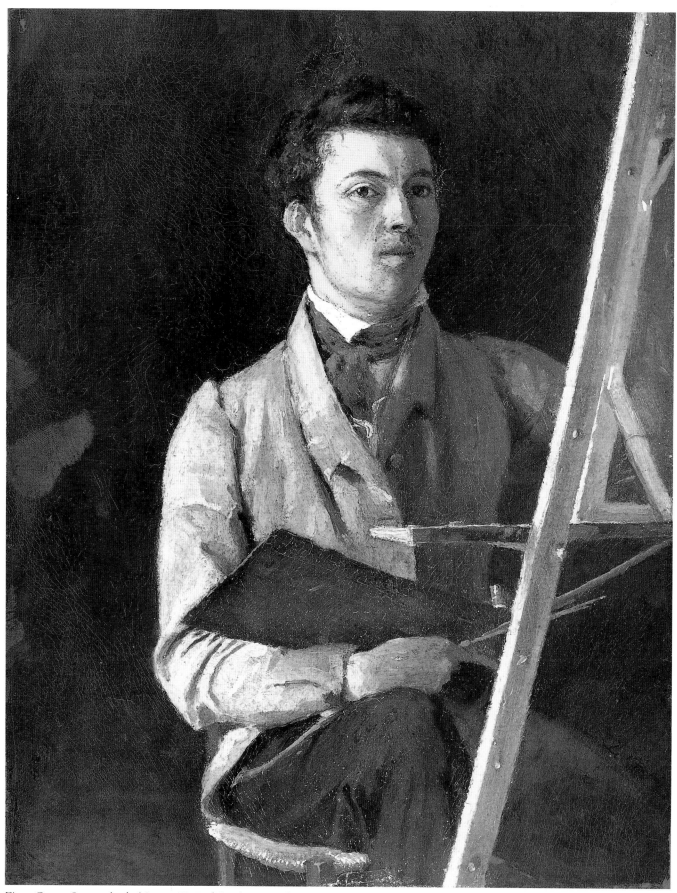

Fig. 1. Corot. *Corot au chevalet* (*Corot at His Easel*; R 41), 1825. Oil on canvas, 11¾ × 9½ in. (30 × 24 cm). Musée du Louvre, Paris (R.F. 1608)

The Making of an Artist

VINCENT POMARÈDE

"NO MAN SHOULD BECOME AN ARTIST WHO IS NOT PASSIONATE ABOUT NATURE."[1]

"His father was a salaried worker, his mother a seller of hats,"[2] is how Corot's first biographer, Théophile Silvestre, defined the artist's origins. Étienne Moreau-Nélaton offered a somewhat more complete introduction: "His father, Louis-Jacques Corot, was a Parisian, the son of a wigmaker in the rue des Grands-Degrés, but his family was originally from a small village in Burgundy on the outskirts of Semur called Mussy-la-Fosse. Mme Corot's maiden name was Marie-Françoise Oberson; her parents came from Switzerland."[3]

Louis-Jacques Corot (1771–1847) was twenty-one years old and Marie-Françoise Oberson, or Auberson (1768–1851), was twenty-four when they were married on May 6, 1793.[4] Louis-Jacques brought to the union his father's shop, given to him by his mother's third husband, one Pierre Amenc—also a wigmaker[5]—who had continued to run the family business. The young couple, both children of fairly prosperous merchants, listed their respective possessions in the marriage contract, a customary practice if those involved had some property. The future husband came with "1,500 livres' worth of clothes and linens as well as ready cash, all from his earnings and savings, and . . . the sum of 600 livres representing the value of the wigmaker's shop that M. Amenc relinquishes and hands over as a gift in favor of the aforementioned household."[6] His wife, older than her husband by three years, seems also to have been the better dowered of the two: her goods consisted "1. in various properties located in the Swiss canton of Fribourg and several transferable obligations in Versailles, all acquired from inheritance from her father and mother. . . . 2. in the sum of 10,000 livres worth of clothes and linens as well as ready cash, of which the future husband has been given an account, which he acknowledges." The couple "agreed *inter vivos* on a settlement to the survivor, mutual, equal, and reciprocal . . . of all the movable goods and real estate, common property, and acquired property."[7]

The newlyweds thus began their life together with a comfortable amount of money, which, while not a fortune, enabled them to make some investments. It seems likely, although it is not documented, that their first important transaction was the purchase of Mme Corot's shop. Apparently, Marie-Françoise Corot bought "an atelier for women's headwear in the fashion house where [she] had been employed before her marriage." Louis-Jacques gave up his wigmaker's shop in 1798 in order to manage his wife's establishment.[8] And in 1801 the couple opened a second-floor millinery shop on the rue du Bac, across from the Pont Royal, which soon achieved considerable renown. They shared the activities of

1. "Un homme ne doit embrasser la profession d'artiste qu'après avoir reconnu en lui une vive passion pour la nature." Jean-Baptiste-Camille Corot, *carnets*, 1825–35.

2. "Son père était un employé, sa mère une marchande de modes." Silvestre 1853, p. 74.

3. "Son père, Louis-Jacques Corot était parisien; il était le fils d'un perruquier de la rue des Grands-Degrés. Mais le pays d'origine de la famille était un petit village de Bourgogne, des environs de Semur, nommé Mussy-la-Fosse. Quant à Mme Corot, elle portait le nom de Marie-Françoise Oberson, et ses parents provenaient de Suisse." Moreau-Nélaton 1924, vol. 1, p. 6.

4. See note 118 for a quotation at length from their certificate of marriage. Some questions remain about this marriage. According to the birth certificate of the couple's first daughter, Annette-Octavie, they were married in 1792 at the church of Saint-Thomas-d'Aquin (see Robaut 1905, vol. 4, p. 396). That would indicate a gap of several months between the religious marriage ceremony and the civil marriage. In any case, it seems that Mme Corot was already pregnant when the civil ceremony was performed, since her daughter was born the following August.

5. Suzanne Gutwirth mischievously points out the unusually large proportion of wigmakers among the relatives of Neoclassical painters, including Jean-Victor Bertin's father and uncle and the fathers of Louis-Gabriel Moreau and Pierre-Henri de Valenciennes. Gutwirth 1974, pp. 337–58.

6. "1 500 livres tant en habit, linge et hardes à son usage qu'en deniers comptants, le tout provenant de ses gains et épargne, plus . . . la somme de 600 livres à laquelle il évalue le fonds de boutique de perruquier que le sieur Amenc pour à présent et intervenant lui cède, délaisse et abandonne à titre de don en faveur du dit ménage." From the certificate of marriage; see n. 4. But Corot's biographers differ on the origins of this wigmaker's shop. Some think that Louis-Jacques Corot had it handed down from his father, others that it came to him through an uncle, still others that he himself was a wigmaker. The store was soon neglected, and it appears that Corot's father never practiced wigmaking there.

7. "1. dans différents immeubles situés en Suisse canton de Fribourg et plusieurs créances mobilières dues à Versailles le tout provenant des successions de ses père et mère. . . . 2. dans la somme de 10,000 livres, tant en habit, linge et hardes à son usage, qu'en deniers comptants dont il a été justifié au futur époux qui le reconnaît"; "se sont fait l'un à l'autre ce au survivant d'eux

Fig. 2. Paul Gavarni (Sulpice-Guillaume Chevalier, 1804–1866). *Modes de Mme Corot (Fashions by Mme Corot)*, ca. 1830. Published in Robaut 1905, vol. 1, p. 20

donation entre vifs, mutuelle égale et réciproque . . . les biens meubles et immeubles, acquêts, conquêts propres." It seems that the young woman's assets in Switzerland were not managed strictly, as she never realized them or received corresponding amounts from the assets of her family that remained in Switzerland. In the marriage contract she stated that she did not know the value of these assets.

8. "un atelier de coiffures féminines dans la maison de modes où [elle] avait été employée avant son mariage." Jouin 1887, p. 84, cited in Moreau-Nélaton 1924, vol. 1, p. 6.

9. "Mme Corot rivalisait de goût et de coquette ingéniosité avec la célèbre Mme Herbault, qui coiffa Joséphine et sa cour. . . . Sous la Restauration, la maison Corot a encore la vogue. . . . Dix ans plus tard, ses créations sont encore goûtées. Une gravure de modes dessinée par Gavarni vers 1830 nous montre une dame coiffée d'une 'capote de crêpe et des marabouts, de Mme Corot, rue du Bac.'" Moreau-Nélaton 1924, vol. 1, pp. 5–6.

10. In 1809 Corot's parents bought their primary residence at 39, rue Neuve-des-Petits-Champs, Paris. In 1812 they bought a house at 23, rue des Moulins, apparently as an investment, and in 1817 they bought the property at Ville-d'Avray, of which more will be said later. During this time they continued to rent the building that housed their shop.

11. The birth certificate of Corot's sister Annette-Octavie Corot is cited in Robaut 1905, vol. 4, p. 396.

12. Archives de Paris, V2E 869. In fact, there is great confusion about Corot's date of birth. Théophile Silvestre gave it as July 29, 1796 (Silvestre 1853, p. 75); André Michel declined to commit himself (Michel 1896a, p. 2); Émile Michel gave the date as July 26 (Michel 1905, p. 5); Étienne Moreau-Nélaton first offered July 17 (Robaut 1905, vol. 1, p. 20), then July 16 (Moreau-Nélaton 1924, vol. 1, p. 6). The entire issue is summarized in Selz 1988, pp. 10–12.

the enterprise, Mme Corot handling the creative side, her husband the business side. Moreau-Nélaton makes clear how famous the shop was among worldly Parisians of the Empire and the Restoration: "Mme Corot rivaled in taste and stylish inventiveness the famous Mme Herbault, who made hats for Josephine and her attendants. . . . The Corot establishment remained in vogue under the Restoration. . . . Ten years later, its creations were still in demand. A fashion engraving done by Gavarni about 1830 shows us a woman wearing a 'hood made of crêpe and marabou by Mme Corot, rue du Bac'" (fig. 2).[9] The shop's success enabled Corot's parents to make their fortune quickly—and all the more because it seems that his father added on to the store a flourishing trade in cloth and also invested in real estate.[10]

The young household was soon enlarged by three children. Annette-Octavie (1793–1874), the older sister to whom Corot remained so close, was born on August 17, 1793.[11] Three years later, on July 16, 1796, Mme Corot bore a son, Jean-Baptiste-Camille, at about one-thirty in the morning.[12] The following year a second daughter, Victoire-Anne (1797–1821), rounded out the family.[13] Nothing is known of the children's upbringing beyond the strong affection that seems to have bound together all the members of this family and the solid moral instruction that they must have received from their parents: "It was one of those back-of-the-shop households of formal, dignified merchants, people who made their own fortune, in which Paris under the Restoration abounded," wrote Paul Cornu in 1911.[14] Corot's parents, then living above their shop at 1, rue du Bac, were so busy with their work that they left young Jean-Baptiste in the care of a nurse until he was four years old.

According to Moreau-Nélaton, "At seven or eight he was sent to a boarding school on the rue de Vaugirard kept by a teacher named Letellier, where he stayed until the age of eleven."[15] That year, 1807, his father succeeded in obtaining a scholarship for him so he could complete his studies at a secondary school in Rouen. Despite evidence of scholastic setbacks,[16] Corot's sojourn there proved pivotal. In the five years he spent in Rouen he formed strong emotional ties to Normandy, a region he would love and paint throughout his life. The friendly relationship he developed with a gentleman named Sennegon, a friend of his father who acted as his guardian, and the long walks the adolescent took in his company were also factors in his choice of a career. The close link between the two families was further reinforced when Corot's older sister, Annette-Octavie, married Laurent-Denis Sennegon, the son of his father's friend, in August 1813.[17]

Despite all the good will in the world, the young Corot seemed destined for nothing much. As Émile Michel wrote, he "was not a brilliant student, and throughout his entire school career he did not get a single nomination for a prize, not even for the drawing classes."[18] In the time before 1815 he gave no indication of any artistic ambition, and art does not appear to have interested him much during his adolescence.

Our picture of Corot's personality at that time remains completely blank. The only known description of his character and physical appearance is the later one by Alfred Robaut, as reported by Moreau-Nélaton: "At nineteen Corot was a big child, shy and awkward. He blushed when spoken to. Before the beautiful ladies who frequented his mother's salon, he was embarrassed and fled like a

Fig. 3. Detail of Corot, *Ville-d'Avray. Entrée du bois avec une vachère (Ville-d'Avray: Edge of the Woods, with a Woman Cowherd)*, cat. no. 4

Corot's birth certificate, in the collection of the Archives de Paris, gives precise information not available to Corot's historians before 1924 but remains confusing about the date of birth. See note 118 for the text of the certificate.

13. Victoire-Anne later married a man named Froment, with whom she had a daughter, who died at the age of six months on August 15, 1821. Victoire-Anne died at the age of twenty-four on September 8, 1821.

14. "C'était une de ces arrière-boutiques de commerçants formalistes et dignes, artisans de leur propre fortune, comme le Paris de la Restauration en comptait beaucoup." Cornu 1911, p. 10.

15. "It was there that he became fast friends with Marcotte, who, as Corot's oldest friend, headed the committee formed in 1874 to present him with a medal of honor." ("Vers sept ou huit ans, on le met en pension rue de Vaugirard, chez un maître nommé Letellier, où il reste jusqu'à onze ans. C'est là qu'il eut pour camarade ce Marcotte qui, en qualité de doyen de ses amis, présida le comité formé, en 1874, pour lui offrir une médaille d'honneur.") Moreau-Nélaton 1924, vol. 1, p. 7. Throughout his life, Marcotte remained close to Corot. He was president of the societies of friends of the arts of Marseilles and Strasbourg and was active in the purchase of *Vue prise à Riva* (cat. no. 94) by the Musée des Beaux-Arts of Marseilles. He was present during Corot's last days and later organized the unveiling of the monument to Corot opposite the ponds of Ville-d'Avray. He owned many of his friend's paintings (R 319, 1175, 1279, 2084, 2439).

16. "Until the fourth form, the student maintained a good enough average. But his teacher in the fourth, a man named Quidit, conceived a dislike for him and rebuffed him. That was it, he had to leave the school. His father made that decision in 1812, putting an end to his second year; and to complete his studies he put him in a boarding school in Poissy, where he stayed two years, began his second all over again, and more or less made it to the next to highest level." ("Jusqu'à la quatrième, l'élève se maintient dans une assez bonne moyenne. Mais son professeur de quatrième, un certain Quidit, le prend à rebours et le rebute. C'en est fini, il faut le retirer du collège. Son père s'y décide en 1812, quand il a terminé son année de seconde; et il le met, pour achever ses études, dans une pension à Poissy, où il resta deux ans, recommença sa seconde et fit, selon son expression, 'une espèce de rhétorique.' ") Moreau-Nélaton 1924, vol. 1, p. 8.

17. Marriage contract recorded in Robaut 1905, vol. 4, p. 396. See note 118 below, where the text is given.

18. "n'était pas un élève brillant, et, pendant toute la durée de ses classes, il n'obtint pas une seule nomination aux distributions de prix de cet établissement, même pour les cours de dessin." Michel 1905, p. 1.

19. "À 19 ans, Corot est un grand enfant, timide et gauche. Il rougit quand on lui adresse la parole. Devant les belles dames qui hantent le salon maternel, il est emprunté et s'enfuit comme un sauvage. . . . Au physique, le jeune artiste est un gars vigoureux, grand, bien bâti et solide au travail. . . . Au moral, c'est un fils tendre et docile, qui adore sa mère et tremble quand le père parle. On trouve ses manières empruntées et sa toilette négligée. Qu'importe?" Moreau-Nélaton 1924, vol. 1, pp. 8, 11–12.

wild thing. . . . Physically, the young artist was a strong fellow, tall, well built, a sturdy worker. . . . Emotionally, he was an affectionate and well-behaved son, who adored his mother and trembled when his father spoke. His manners were thought gauche and his appearance untidy. What did that matter?"[19] While this portrait is not grounded in direct observation, it is clearly believable, although it seems to project the adult's personality onto the adolescent a little too much.

On March 4, 1817, Corot's parents purchased the property at Ville-d'Avray that would become so important to the painter. Research conducted about 1915 by Louis Guinon,[20] owner of the property at one time, established that the house Corot's parents bought for 25,000 francs was in existence in 1783. Situated near two ponds that had belonged to the private domain of Queen Marie-Antoinette, the house was modest, with a kitchen, dining room, and drawing room on the ground floor and probably one or two dormer-windowed bedrooms upstairs. Construction done about 1800 on the house and especially in the garden created a sort of miniature trianon, still standing in Corot's day. The house was enlarged at the same time by opening dormer windows on a third story. After 1808 a rather pretentious porch was added, which still adorns the entry to the house. When his family bought this house in 1817, Corot, then twenty-one, immediately took over one of the dormer-windowed rooms on the third floor, at the western end of the house. Although small (8 by 9½ feet), the room had two pretty windows that overlooked the closer of the ponds. In this room, which Corot occupied until his death, he set up a makeshift studio where he could paint from nature. Thus, at the time when his artistic instinct was just beginning to emerge, Ville-d'Avray played an important part in the development of his intimate relationship with nature.[21]

Meanwhile, Corot's father was looking to give his son the same opportunity to rise in life that he and his wife had enjoyed. "A job with a cloth merchant was found for him. He began as a salesman at Ratier's on the rue de Richelieu."[22] After some time he took another position, with Delalain on the rue Saint-Honoré. His experience in the draper's trade clearly contributed to the formation of his aesthetic sensibility and taste, since it meant eight years spent in the world of fashion, where the textures and exact colors of fabrics matter a great deal. Surely it is at the root of Corot's observation, quoted by Silvestre: " 'An artist can't control whether he is born a genius with a natural ability to paint,' he said, 'but anyone without disabilities can become aware of the relationship of forms and of colors. The women who sell hats rarely make a mistake when combining materials. My sister has a gardener at Ville-d'Avray who makes beautiful bouquets; she could teach our famous artists the laws of harmony.' "[23]

It was while Corot was at Delalain's, all signs indicate, that he decided to become a painter and that during his free time he first tried using oil paints.[24] In a letter to his friend Abel Osmond of August 1821, Corot wrote that he was "still enjoying [himself] painting landscapes,"[25] which seems to mean that he had been attempting them for a little while. According to his earliest biographer, during this period Corot began to study drawing at the Académie Suisse: "Trade bored him; he slipped away to draw the model from life in the Suisse studio without daring to say a word to his father about his attraction to the arts. That straitlaced man would have seen it as leading inevitably to the poorhouse."[26] His parents' actual reaction is unknown; legend has it that they long opposed their

Fig. 4. Detail of Corot, *Mme Corot, mère de l'artiste (Mme Corot, the Artist's Mother)*, cat. no. 52

Fig. 5. Corot. *Le Père de Corot (Corot's Father)*, 1832. Graphite on paper, p. 22 of sketchbook. Kunsthalle, Bremen (63/219)

son's decision. But it was apparently freely and unconditionally that, early in 1822, just after the death of their younger daughter, Victoire-Anne, they decided "to give Camille the fifteen hundred francs that they had allowed the deceased. It seems clear that the young man, once he was economically independent, would be able to choose his own profession, even if his parents did not much care for his choice. That didn't matter to him, and he immediately moved into a studio on the quai Voltaire."[27]

Corot lived near his parents until he was fifty-six, when, in 1851, his mother died. That entire time he received the yearly allowance of 1,500 francs that was begun in 1822; it financed his artistic career, including his materials and often his travels. But he had no property of his own.

"I Am Studying like a Little Devil."[28]

Corot adored music and opera, and his interest in lyric drama might well have led him toward history painting. But his love of nature, kindled by his long walks with M. Sennegon in the countryside around Rouen and by solitary Sundays at the ponds of Ville-d'Avray, seems to have been the stronger impulse, and without even a period of experimentation he moved straight into landscape painting. Landscape was then a flourishing genre, having been fully revived by Neoclassicism.

In the early years of the nineteenth century, the art of the great eighteenth-century landscape painters was still very much alive. Joseph Vernet (1714–1789), whose impact on landscape painting before the French Revolution was immense, had been dead for some thirty years, but it was only about fifteen years since the deaths of Hubert Robert (1733–1808) and Louis-Gabriel Moreau (1740–1806), artists who moved landscape toward a greater fidelity to nature and to the actual topography of a place, and of Pierre-Antoine de Machy (1723–1807) and Jean

20. Guinon 1925 (text dated May 15, 1915).

21. After the death of Corot's father on November 28, 1847, and then of Mme Corot on February 27, 1851, Corot's sister Annette-Octavie Sennegon and her family lived in the house. After she was widowed in 1865 she lived there alone, visited often by her children and her brother. During the war of 1870–71 the house was occupied by Prussian troops, and Mme Sennegon sought refuge in Marseilles. Corot's last stay at Ville-d'Avray was in May 1874, although he went back for two days when his sister died that year on October 12. After Corot's death the property was sold.

22. "On lui a trouvé une place chez un marchand de drap. Il entre comme vendeur, rue de Richelieu, chez Ratier." Moreau-Nélaton 1924, vol. 1, p. 8.

23. "S'il ne dépend pas de l'artiste, dit-il, de naître homme de génie et de devenir un grand exécutant, le premier venu peut arriver, à moins d'infirmité, à se rendre compte de la proportion des formes et de la relation des couleurs. Les marchandes de modes ne se trompent guère dans leurs assortiments. Il y a chez ma soeur, à Ville-d'Avray, une jardinière qui fait très bien les bouquets; elle enseignerait les lois de l'harmonie à plusieurs de nos peintres célèbres." Silvestre 1853, p. 81.

24. Three lithographs known about only from documents gathered by Robaut are generally dated to this period before 1822. They were entitled *La Garde meurt et ne se rend pas (The Guard Dies and Does Not Surrender)*, *La Peste de Barcelone (The Plague of Barcelona)*, and *Une Fête villageoise (A Village Celebration)*. On this subject see Melot 1978 and Galassi 1991a, pp. 56–57.

25. "[s]'amuse toujours de peindre des paysages." Corot, letter (a.l.s.) to Abel Osmond, Paris, August 21, 1821, Département des Arts Graphiques, Musée du Louvre, Paris, Moreau-Nélaton Bequest in 1927, A.R. 8 L 1. See n. 77.

26. "Le commerce l'ennuyait; il allait à la dérobée dessiner le modèle vivant dans l'atelier de Suisse sans oser dire un mot à son père de sa vocation

Fig. 6. Detail of Corot, *Vue prise des jardins Farnèse (le matin) (View from the Farnese Gardens: Morning)*, cat. no. 7

Pillement (1728–1808), champions of the decorative landscape as it was envisaged in the eighteenth century. Indeed, the landscape artists who most influenced Corot when he was beginning his career were men of the eighteenth century.

Pierre-Henri de Valenciennes (1750–1819), a skilled painter, rigorous and sometimes visionary theoretician, and excellent teacher, had joined the Académie Royale de Peinture et de Sculpture in 1787. He survived the political and social upheavals of the Revolution and kept his position as professor at the École des Beaux-Arts until his death. In 1800 Valenciennes published a monumental treatise on landscape;[29] it remained the authoritative work on the techniques and aesthetics of the genre until 1860, and Corot—no exception to the rule—surely studied it closely. Jean-Joseph-Xavier Bidauld (1758–1846), a student of Vernet's, dominated the landscape genre under the Empire. By the 1830s he would be doing battle against the realist approach of Théodore Rousseau and his fellow Romantics. Alexandre-Hyacinthe Dunouy (1757–1841), Nicolas-Didier Boguet (1755–1839), Jean-Antoine Constantin (1756–1844), and Jean-Victor Bertin (1775–1842), who became teachers to the entire younger generation of landscapists, had themselves been formed under the monarchy and the Revolution.

At the beginning of the nineteenth century, two different approaches to landscape were present in French art. The classical tradition, modeled after the great Italian landscapists like Carracci and Rosa and the "Italianate" French painters like Poussin, Claude Lorrain, and Gaspard Dughet, was experiencing a renaissance. Urged on by the theories of Valenciennes, painters sought to uphold the idealized historical landscape as the major landscape genre while renewing it by introducing a more realistic depiction of nature. This movement has been labeled, accurately or not, the Neoclassical school of landscape. Ranged with Valenciennes and Bidauld were Bertin, Achille-Etna Michallon, Pierre-Athanase Chauvin (1774–1832), and François-Marius Granet (1775–1849), all of them marked by the experience of traveling in Italy and by a passion for the great French and Italian masters of the seventeenth century, and all painters of historical landscapes, humanistic in approach, that were recomposed in the studio. Neoclassical landscape painting is much criticized, but its assets, which included the practice of painting outdoors, should not be overlooked. During his early years, Corot was strongly attracted to this school.

In contrast to the imaginary, idealized landscape of the Neoclassicists, another approach to landscape painting was realistic, intimate, and faithful to the topography of actual sites, drawing on the example of Flemish and Dutch painters of the seventeenth and eighteenth centuries. Jean-Louis Demarne (1752–1829), Georges Michel (1763–1843), and Jean-François-Joseph Swebach-Desfontaines (1769–1823) especially admired the northern painters' precise realism, feeling for light, and materiality; they strove to develop a contemporary equivalent.

Art historians have generally described these two tendencies as opposites, making the former the partisan of a rigid academicism and the latter a brilliant precursor to the Barbizon school, with the Neoclassical current attempting to stifle the painting of the Romantic landscapists in the 1830s. But this Manichaean reading ignores the complexities of the situation. The extent to which Lancelot-Théodore Turpin de Crissé (1781–1859) or Nicolas-Antoine Taunay (1755–1830) or even Dunouy or Michallon assimilated a variety of influences is surprising; admiration for Poussin proved perfectly compatible with that for Ruisdael, the

pour les arts. Le prud'homme n'aurait vu là qu'une prédestination à l'hôpital." Silvestre 1853, p. 76. There is no evidence of Corot's attendance at the Académie Suisse, and Silvestre offers no substantiation. It was at 4, quai des Orfèvres and was among the oldest academies in nineteenth-century Paris, having been founded by a former model of David's named Charles Suisse. Courbet, Delacroix, Manet, Pissarro, Cézanne, and Monet worked from the model there.

27. "donner à Camille les quinze cents livres qu'on servait à la défunte. Il semble évident que le jeune homme, une fois acquise l'indépendance matérielle, avait pu choisir seul sa profession, même si ses parents ne s'enthousiasmèrent pas de ce choix. Il n'en fut rien et il emménagea immédiatement dans un atelier sur le quai Voltaire." In fact, Corot's parents gave him the choice of taking his entire inheritance, about 100,000 francs, in order to start a dry goods store, or receiving the annual income from his sister's dowry. He obviously decided on the latter. Robaut reported this anecdote in Robaut *documents*, vol. 3, fols. 3, 4.

28. "J'étudie comme un petit brigand." Corot, letter. Private archives.

29. Valenciennes 1800.

careful emulation of Claude with the study of Hobbema. In fact, the two currents shared two essential characteristics. The first was a search for greater realism in depicting nature, and thus an increased emphasis on painting out of doors with oils (which allowed the artist to work in color). The second was the preservation of the rule that governed the genre of *paysage composé*, or imaginary landscape: that even when painting a view of an actual site, the painter still makes his final version in the studio, "from memory" *(de ressouvenir)*, based on his studies done from nature. Painters on both sides of the divide cultivated this subtle relationship between the plein air study and studio work, which would form the heart of Corot's method. The double heritage—classicism from the Italianate painters and realism from the northern painters—was the foundation on which the art of the French landscape built in the first half of the nineteenth century. (Interest in the genre was heightened by events like the creation in 1817 of the Grand Prix de Rome for historical landscape and the commission given leading landscapists in 1818 to decorate the Gallery of Diana in the Château de Fontainebleau with historical landscapes celebrating the kings of France.)[30]

French artists also discovered the realism of late-eighteenth-century English landscapists. The ultimate revelation was the work of John Constable (1776–1837). He and other English landscapists, including Joseph Mallord William Turner (1775–1851),[31] set forth a new vision, realist and above all expressive, that would mark Corot's generation and Corot himself. When Corot began to paint in 1822, his countryman Paul Huet (1803–1869) had been working out of doors for six years in the environs of Paris, strongly influenced by the English painters, especially his friend Richard Parkes Bonington (1801–1828). Théodore Rousseau (1812–1867) had not yet begun his career, nor had Narcisse Diaz de la Peña (1807–1876), Jules Dupré (1811–1889), or Charles-François Daubigny (1817–1878).

When he arrived at Michallon's studio in the spring of 1822, Corot threw himself into the study of landscape technique with the passion of a man who knows what he wants to do. Achille-Etna Michallon (1796–1822), although the same age as Corot, was already well known as a landscape painter; he had begun his artistic career about 1810, had been introduced to society by some influential patrons, and had won the first Grand Prix de Rome for historical landscape in 1817.[32] While the two men had evolved in very different social and cultural milieus, Corot had met Michallon before, either in 1817 or early in 1822, and we do not know whether Michallon influenced Corot's decision to devote himself to landscape.[33] On his return from Italy, the young Michallon, experiencing financial problems, had opened a studio on the rue des Fossés-Monsieur-le-Prince, which he furnished with several plaster models of antique sculptures given him by his grandfather. So it was surrounded by some thirty-odd plaster casts of statues, including "heads of Minerva, Pallas Athena, Diana, Mercury, Caracalla, Demosthenes, Venus, the antique torso Laocoön, an Egyptian head, two dogs, a clay camel . . . ,"[34] that Corot made his first attempts at copying three-dimensional forms. Michallon also encouraged his students to paint outdoors every day, something he had acquired a passion for during his stay in Italy.

Michallon had many other students: Augustin-François Lemaître and André-Léopold Pic, engravers, and Antoine-Marie Perrot, Joseph-Louis Leborne, Antoine Guindrand (1801–1843),[35] and Léon Fleury (1804–1858), who later accompanied

30. On the commission of landscapes for the Gallery of Diana at Fontainebleau, see Chaudonneret 1980, pp. 39–41; Blandine Lesage and Vincent Pomarède, "Les Envois de Rome," in Paris 1994, pp. 146–49.

31. Others included Richard Wilson (1714–1782), Thomas Girtin (1775–1802), and Thomas Jones (1743–1803).

32. On Michallon's introduction to society, see Vincent Pomarède and Blandine Lesage in Paris 1994 and files of the Département des Peintures and the Département des Arts Graphiques, Musée du Louvre, Paris. On his receiving the Prix de Rome, see Paris 1994, n. 83.

33. For the relationship between Michallon and Corot and Corot's entry into his studio, see Vincent Pomarède, "Les Relations de Michallon et de Corot: L'Enseignement du paysage historique et le partage du plein air," in Paris 1994, pp. 156–61.

34. "têtes de Minerve, Pallas, Diane, Mercure, Carracala [*sic*], Démosthène, Vénus, Laocoon le tors [*sic*] antique, une tête égyptienne, deux chiens, un chameau en terre. . . ." Inventory taken after Michallon's death. Archives Nationales, Paris, ET/XLIV/865.

35. Guindrand became one of the principal representatives of the Romantic school of landscape of Lyons.

Fig. 7. Achille-Etna Michallon (1796–1822). *Démocrite et les Abdéritains (Democritus and the Abderites)*, 1817. Oil on canvas. École Nationale Supérieure des Beaux-Arts, Paris. Michallon won the Grand Prix de Rome for this painting

Corot during his first trip to Italy.[36] But Corot's studies in this atelier were brief; Michallon caught pneumonia and died on September 24, 1822.

Corot's relationship with Michallon, an artist with a similar sensibility and passion for nature, merits a moment's attention. A Neoclassical artist who nonetheless exhibited some Romantic paintings (*La Mort de Roland*, Musée du Louvre, Paris) and some more realistic ones (*Paysage inspiré d'une vue de Frascati*, fig. 8), he drew a fair measure of strong criticism: "Michallon was one of those teachers who preached respect for the truth while distorting it in his pedantic works— the academic landscapists prune the trees and weed out the mosses in the forest of Fontainebleau, finding virgin nature too ordinary for the *grand style*."[37] But Moreau-Nélaton maintained that Michallon, "while caught up in the conventional formulas of the school," as a teacher "relieved the arbitrariness of the historical genre as much as he could through a careful study of nature."[38] Michallon's teachings benefited Corot in several ways.[39]

First, Michallon not only taught drawing from the model but also encouraged copying from his own works, some of which he had mounted for his students: "On rainy days, Corot carefully copied Michallon's studies, of which the simplest had been chosen: views of roofs and chimneys in Montmartre, plants, and factories."[40] The sale of Corot's work after his death included ten sheets of studies of trees, plants, and architecture that the artist had religiously held onto since 1822.[41] And Michallon's students surely copied with interest the plein air studies he brought back from Italy, which are seen in the background in views of his studio (some are now in the Louvre). Corot thus had the opportunity to analyze the pictorial effects Michallon obtained in his studies, training his eye and his hand through the works of one of the greatest landscapists of his time. Corot imitated Michallon's style directly in his assigned studies of a tree trunk outdoors; two of these oil studies painted during the period (fig. 15)[42] recall

36. Fleury also studied with Bertin. He exhibited regularly in the Salon from 1831 to 1855, becoming one of the major proponents of directing the Neoclassical landscape toward the Romantic sensibility.

37. "Michallon était un de ces professeurs qui prêchent le respect dû à la vérité tout en la défigurant dans des ouvrages pédants. Ainsi les paysagistes académiques émondent les arbres, arrachent les mousses de la forêt de Fontainebleau, trouvant dans la nature vierge des vulgarités incompatibles avec *le grand style*." Silvestre 1853, p. 75.

38. "Tout en demeurant embarrassé dans les formules conventionnelles de l'école, il relevait autant que possible l'arbitraire du genre historique par une étude attentive de la nature." Moreau-Nélaton 1924, vol. 1, p. 10.

39. See Vincent Pomarède, "Les Relations de Michallon et de Corot," in Paris 1994, pp. 156–61.

40. "Les jours de pluie, Corot copiait avec une extrême conscience des études de Michallon choisies parmi les plus simples: des vues de toits et de cheminées prises à Montmartre, des plantes et des fabriques." Michel 1905, p. 10.

41. Part 2 of the sale, no. 505.

42. R 5, R 8.

Fig. 8. Achille-Etna Michallon (1796–1822). *Paysage inspiré d'une vue de Frascati (Landscape Inspired by a View of Frascati)*, 1822. Oil on canvas, 50 × 67 3/8 in. (127 × 171 cm). Musée du Louvre, Paris (inv. 6633)

the one by Michallon in the Louvre.[43] About 1830, again at the Louvre, Corot copied the last painting his teacher had exhibited (Salon of 1822),[44] *Paysage inspiré d'une vue de Frascati* (fig. 8), evidence that Michallon's influence remained important for Corot after he had traveled in Italy.

Corot himself later recognized another artistic debt he owed to Michallon, according to Silvestre: "'I made,' he said, 'my first landscape from nature at Arcueil under the eye of this painter, whose only advice was to render with the greatest scrupulousness everything I saw before me. The lesson worked; since then I have always treasured precision.'"[45] Scholars elaborated the relationship between the two men on the basis of this direct account, and in 1896 André Michel introduced a new idea—that of Corot's "naïveté"—which gradually obliterated the original version and became the accepted wisdom: "From his earliest attempts Michallon deemed him capable of venturing out in the field, and he outfitted him with the advice 'to look hard at nature and reproduce it naively with the greatest scrupulousness.'"[46] Subsequent art historians all took up this idea.[47] In 1822 Michallon worked outdoors especially in the environs of Neuilly,[48] where Corot reported that they painted together.

Finally, Michallon passed on to Corot his feeling for the classical landscape tradition and his conviction that the *paysage composé* was the summit of the landscape painter's art.[49] Through Michallon, Corot found the basis for his own art, that close and constant balance between the uncompromising realism of plein air work and the assiduous attention to imagination and memory in the studio.

After Michallon's death Corot studied for three years with Jean-Victor Bertin, who had been Michallon's teacher. Historians of art have been particularly harsh to Bertin, whom Corot called "a painter who began his pictures well and finished them badly." (Corot was criticizing his teacher's inability to impart basic drawing techniques, not his Neoclassical theories.)[50] In choosing Bertin, Corot was placing himself with the best-known landscape teacher in Paris then

43. See Blandine Lesage, "Catalogue de l'oeuvre peint d'Achille-Etna Michallon," in Paris 1994, p. 183, no. 90; Musée du Louvre, Paris, R.F. 2873.

44. Corot's copy is R 198, now in a private collection.

45. "J'ai fait, dit-il, mon premier paysage d'après nature à Arcueil sous l'oeil de ce peintre, qui me donna pour unique conseil de rendre avec le plus grand scrupule tout ce que je verrais devant moi. La leçon m'a servi; j'ai toujours eu depuis l'amour de l'exactitude." Silvestre 1853, p. 75.

46. "Michallon, dès ses premiers essais, le jugea capable d'aller sur le terrain et lui donna pour tout viatique le conseil 'de bien regarder la nature et de la reproduire naïvement avec le plus grand scrupule.'" Michel 1896a, p. 11.

47. Cornu 1911, p. 14, given as a citation from Silvestre's book; Moreau-Nélaton 1924, vol. 1, p. 10.

48. See *Le Bac de Neuilly-sur-Seine (The Ferryboat at Neuilly)*, painted after Michallon's return from Italy. Blandine Lesage, "Catalogue de l'oeuvre peint d'Achille-Etna Michallon," in Paris 1994, p. 182, no. 71.

49. Dimier 1914, p. 9.

50. "un peintre qui ébauchait bien et finissait mal ses tableaux." Silvestre 1853, pp. 75, 77.

alive. The instruction he received from Bertin was complementary to that from Michallon and undoubtedly decisive for Corot. Despite his criticism, he respected his teacher's memory devotedly, keeping his portrait on his studio wall.[51] While Corot's known works of this period, mostly studies from nature, reveal little of his teacher's influence, his notebooks show that he followed Bertin's suggestions faithfully. "Draw every night. . . . Gather subjects for historical figures. Make close copies for my records. Keep a collection of costumes from various centuries," he wrote in one of his notebooks from 1825.[52] In his atelier Bertin had Corot copy engravings of plants, trees, and botanical studies taken from Alphonse-Nicolas Mandevare's pedagogic collection[53] or from the suite of lithographs he himself had been publishing since 1816[54] in order to learn the precise form of each specimen.

In addition to this Neoclassical instruction, Corot investigated northern artistic currents. In one of his notebooks[55] he writes that he must copy or trace animals by Berghem and Potter and horses and dogs by Van der Meulen. Certain contemporary artists interested him as well. He mentions the figures of Auguste-Xavier Leprince (1799–1826), a young landscapist and an admirer of the northern painters who had just exhibited the *Embarquement de bestiaux sur le* Passager *dans le port d'Honfleur* at the Salon of 1824 (fig. 51). André Michel tells us that he took notice of Bonington's watercolors.[56] This variety of visual experiences gave him a solid basis for comparing his own technical ideas with those taught by Bertin, as reflected in a notebook of 1822–23: "The method for objects in shadow seems to be borne out by nature. For greenery, I would prefer using bitumen afterward in the sketch, instead of just ivory black. Sketch in the closest possible tone and go back and glaze with clarified poppy seed oil. Put the paint on over this glaze, after drawing in all the masses."[57]

The lessons learned from Michallon and Bertin gave Corot enough confidence to tackle nature on his own and take on the problems of light and space it presents to the artist. In his earliest studies from nature,[58] Corot seems especially to have remembered Valenciennes's suggestion to paint on site "quick rough sketches, to seize Nature in action";[59] he made no attempt to work on the studies at length, first outdoors and then with revisions in the studio, as he would do when painting in Italy. During this period Corot did most of his work in four specific locales, finding in each simple motifs that lent themselves to studies of light and materials. Paris first, and the banks of the Seine, served as the subject of numerous studies and one of his first masterpieces of simplicity and pictorial effectiveness, *Paris. Le Vieux Pont Saint-Michel* (fig. 9). Next, his adopted region around Ville-d'Avray inspired many plein air studies.[60] He was in Normandy in the summer of 1822, perhaps with Michallon, and he returned there several times until 1825, painting views of Dieppe (cat. no. 2, R 11), Honfleur (cat. no. 5), and, of course, the countryside around Rouen (cat. no. 1). But the area of his principal work during this period was unquestionably the forest of Fontainebleau; probably on Michallon's advice, he was among the first artists to work there regularly. He painted close-up studies of a fallen tree trunk, farmyards portrayed with thoroughgoing realism, and studies of trees and rocks in the forest.[61] His drawing notebooks show his experimentation with graphic techniques in plein air during the same period.[62]

51. Robaut 1875.
52. "Dessiner tous les soirs. . . . Me donner des sujets de figures historiques.—Faire des calques dans les Annales.—Avoir une suite de costumes de différents siècles." *Carnet* 66, quoted in Robaut 1905, vol. 4, pp. 96–97, no. 3103.
53. Mandevare 1804.
54. Bertin 1816–24.
55. *Carnet* 66, quoted in Robaut 1905, vol. 4, pp. 96–97, no. 3103.
56. Michel 1896a, p. 26.
57. "La méthode pour les objets dans l'ombre me paraît d'accord avec la nature. Pour la végétation, je préférerais que l'on employât de suite dans l'ébauche le bitume, au lieu de n'employer que le noir d'ivoire. Ébaucher le plus près du ton possible et revenir en glaçant avec de l'huile d'oeillette clarifiée. Dessus ce glacis, peindre dans la pâte après avoir dessiné toutes les masses." *Carnet* 26, quoted in Robaut 1905, vol. 4, p. 91, no. 3063.
58. R 1–R 40.
59. "des maquettes faites à la hâte, pour saisir la Nature sur le fait." Valenciennes 1800, p. 404.
60. R 4, 9, 14, 17, 19, 23, 36, 37, 294.
61. R 5–8, 20–22, 25, 29, 30.
62. *Carnet* 7, in Robaut 1905, vol. 4, p. 88, no. 3044; carnet 35, ibid., p. 92, no. 3072.

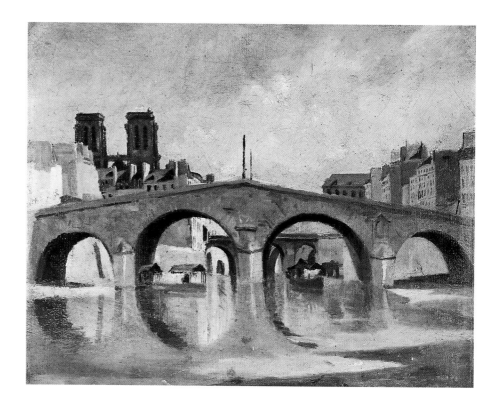

Fig. 9. Corot. *Paris. Le Vieux Pont Saint-Michel* (*Paris: The Old Saint Michel Bridge;* R 15), ca. 1823–24. 9⅞ × 11¾ in. (25 × 30 cm). Musée Départemental de l'Oise, Beauvais

It would be wrong to suppose that these studies from nature had diverted Corot from the ultimate goal promoted by his teachers: the *paysage composé* with a historical subject. While he did not yet feel confident enough to exhibit ambitious historical compositions at the Salon, he was already putting down ideas in his notebook for a historical landscape inspired by scenes from the *Voyage du jeune Anacharsis en Grèce*[63] and another project featuring Cain and Abel. He also tried his hand at a mythological landscape, done in oil on a canvas larger than usual. This *Orphée charme les humains* (*Orpheus Charms the Mortals;* R 195, private collection), still awkward and reflecting Bertin's influence, shows Corot's real ambitions. Thus in 1825, when he made plans to follow the advice of Bertin and his friends and make the crucial trip to Italy, his own view of painting seemed clear enough. A notebook of the period contains observations that demonstrate the maturation not only of his technique but also of his aesthetic ideas: "I have noticed that all the work done on the first attempt is more honest, more pleasing in form, and that it was obvious then how to take advantage of contingencies; whereas in going back to it, that harmonious original touch often gets lost.... I also see how necessary it is to be strict in copying nature and not be satisfied with a quickly made sketch. How many times have I regretted, when looking over my drawings, that I did not have the fortitude to remain another half hour!... Nothing should be left imprecise."[64]

63. *Carnet 26,* ibid., p. 91, no. 3063. Jean-Jacques Barthélemy's *Voyage du jeune Anacharsis en Grèce,* written in 1788, became an important source for the Neoclassical generation.

64. "J'ai remarqué que tout ce qui était fait du premier coup était plus franc, plus joli de forme et que l'on savait profiter beaucoup de hasards; tandis que lorsqu'on revient, on perd souvent cette teinte harmonieuse primitive.... Je vois aussi combien il faut être sévère d'après nature et ne pas se contenter d'un croquis fait à la hâte. Combien de fois j'ai regretté, en regardant mes dessins, de n'avoir pas eu le courage d'y passer une demi-heure de plus!... Il ne faut laisser d'indécision dans aucune chose." Corot, *carnet,* 1825.

In 1896 André Michel wrote, "If one could place on one side of a gallery the 'official' compositions that Corot painted in his first years—following the rules and for submission to the Salon to be judged by his masters and the public— and on the other side the small studies that he made on his own . . . one would be struck by the deep differences between them. He seems as constrained and forced in the one group as he is spontaneous, original, and charming in the other." [66] In the present exhibition, just such a juxtaposition occurs. But when Corot's various works are compared, it should be kept in mind that he did not intend his plein air studies to be exhibited and did not consider them an end in themselves. Of his studies done in Italy, which include more than 150 known paintings and numerous drawings, Corot put only one before the public during his lifetime. [67] And only at the end of his life did he begin to think of these open-air studies as being sufficiently important for the history of art to enter the Louvre. [68] He seems to have viewed them as one stage in his training or as preparatory works for future studio paintings, although he had a fondness for them, often lent them to colleagues or students, and kept them on display in his studio until his death. Thus, a double-sided question needs to be asked about the contribution Corot's first trip to Italy made to his career and its art-historical significance. During that journey, was Corot a student following a program that had been defined by a teacher, or was he already a creator beginning to stake out his own aesthetic territory? Or, as articulated in 1892 by David Croal Thomson: "Would Corot have been as able to paint the pictures which have made him famous, if he had not thoroughly gone through the training manifested in these early works?" [69]

It is clear in any case that the journey to Italy proved indispensable to Corot, who considered it the culmination of his training. And he shared the attraction to the Mediterranean that marked an entire generation of artists. Valenciennes had strongly advised painters to travel as part of their education, already an old practice: "We now send [the student] from our studio, and even away from Paris . . . to go out and observe, with taste and judgment, the differences of climate and the varied productions of Nature and art." [70] After exhaustively listing the merits of Egypt, Palestine, Syria, Cyprus, all of Asia Minor, and Greece, Valenciennes suddenly becomes impassioned while evoking the pedagogic virtues of Italy: "Italy! Italy! That is the goal of all Artists who begin to sense the beauties of their art and who have the enthusiasm of talent." [71] Thus, the young artist, especially if he had not had the luck to win the Grand Prix de Rome, had to come up with the money to go to Italy if he wanted his training to be complete. This custom, which had been widespread since the Renaissance, when Italy became a cultural center of intense creativity, had been reinforced by Neoclassical teaching. Valenciennes's disciples were of course adjured to spend their time in Italy copying the masterpieces of the Italian Renaissance, but above all they were urged to experience the culture of antiquity, to see and draw Roman monuments—which could later become the settings for large *paysages composés.* But in his treatise on landscape Valenciennes also recommended making studies from nature in this country of particularly varied and light-filled sites.

65. "La nature est une éternelle beauté." Corot, *carnet.*
66. "Si l'on pouvait disposer dans une même galerie, d'un côté les 'compositions' officielles que Corot peignit en ses premières années d'active production, d'après les préceptes et pour être soumis, aux Salons, au jugement de ses maîtres et du public,—de l'autre, les petites études qu'il exécutait seul, . . . —on serait frappé de contradictions singulières. Autant il paraît embarrassé et contraint dans les unes, autant il est spontané, original et charmant dans les autres." Michel 1896a, p. 14.
67. At the Salon of 1849. See cat. no. 10, *Le Forum vu des jardins Farnèse.*
68. On his death Corot left to the Louvre two of his Roman studies, *Le Forum vu des jardins Farnèse* and *Étude du Colisée à Rome* (cat. nos. 9, 8).
69. Thomson 1892, p. 19.
70. "Nous allons actuellement [l'élève] faire sortir de notre atelier, et même l'éloigner de Paris . . . d'aller observer, avec goût et avec jugement, les différences des climat, les productions variées de la Nature et de l'art." Valenciennes 1800, pp. 519–20.
71. "L'Italie! L'Italie! tel est le voeu de tous les Artistes qui commencent à sentir les beautés de leur art, et que possède l'enthousiasme du talent." Ibid., p. 563.

Corot does not seem to have had an especially hard time convincing his parents to finance his journey. Parents who had put their son into an eight-year apprenticeship in the cloth trade well understood that learning a profession entailed a lengthy training and saw the trip to Italy as a serious way to begin a career and attain recognition. Tradition has it that they placed only one condition on his going away: they wanted a self-portrait of their son (see fig. 1). Although not themselves from a highly cultivated milieu, Corot's parents dealt with a refined clientele, and they knew that not only for artists but for people of fashion as well, Italy was an essential cultural reference point.[72]

Corot's first stay in Italy, between 1825 and 1828, is one of the most thoroughly documented periods of his career. Alfred Robaut and Étienne Moreau-Nélaton painstakingly catalogued the 154 paintings from this time,[73] which Robaut uncovered in the course of tracking down Corot's work. Peter Galassi gives the current locations of many of them in his recent book.[74] Robaut's attributions, which Moreau-Nélaton reviewed, remain generally accepted, and the problem of forgeries hardly affects the beginning of Corot's career. The chief difficulty is that a great many copies were made of his Italian studies, for he lent them out freely after he returned to France.[75] It is also true that a very similar technique was used by Corot and by some of his colleagues, such as Caruelle d'Aligny, Fleury, and Édouard Bertin, who often worked at the same sites. In any case, the known and localized works constitute the primary documents for the art historian. By analyzing them one can trace Corot's stylistic evolution during his journey and find the sites he studied, thus establishing an embryonic chronology that the classification of the drawings and notebooks[76] can further refine.

There is also an important correspondence, seventeen letters that Corot wrote to his childhood friend Abel Osmond.[77] Osmond came to Paris from Saint-Lô about 1812. An engineer by profession, he became deputy head clerk at the Ministry of the Interior and held the position until his premature death in 1840. How he and Corot met is not known, but the letters exchanged between 1821 and 1834 show that he was not only a friend but a true confidant. It may be, as Rodolphe Walter maintains,[78] that the relationship begun in 1822 between Corot and Parfaite-Anastasie Osmond, Abel's aunt, which seems to have gone beyond simple friendship, led to the closeness between the two men that was quickly extended to the entire family.[79] His friendship with the Osmond family explains Corot's special ties to the towns of Mantes[80] (cat. no. 145), Saint-Lô (cat. no. 42), and Rosny-sur-Seine.

The correspondence between the two men is informative on many levels. It is, first of all, valuable for dating, since Corot noted the date and place on each of the ten letters he wrote to Osmond from Italy. One of these letters tells us the precise circumstances of Corot's visit to Papigno in August 1826.[81]

The exchange of confidences in the letters also offers some sense of Corot's personality, which up to this point has been difficult to fathom. Here Corot opens up without reservation, whether expressing grief over his younger sister's being carried off by illness[82] or relating his "amorous exploits" in Italy.[83] The two friends plainly shared a passion for music and, especially, for women, and here a little-known aspect of Corot is revealed: "You ask for news of the Romans. They still have the most beautiful women in the world that I have met. I enjoy

72. See Galassi 1991a, p. 89.

73. R 41–R 194.

74. Galassi 1991b.

75. In *carnet* 66 (R 3103), dated about 1825 by Robaut but actually extending from 1825 to 1855, Corot made a list of studies lent to his friends, including Poirot, Français, Scheffer, Aligny, Lavieille, Etex, Fleury, Leleux, Prévost, Oudinot, Dutilleux, and Robaut.

76. Several notebooks from this Italian journey, *carnets* 2, 24, 43, and 64, are published in Robaut 1905, vol. 4, nos. 3039, 3061, 3080, 3101.

77. In 1927 Moreau-Nélaton bequeathed the autograph letters to the Louvre (A.R. 8 L 1–17, Cabinet des Dessins, Département des Arts Graphiques). He had published them in Moreau-Nélaton 1914b and in Moreau-Nélaton 1924.

78. Walter 1975, pp. 30–37, 84.

79. Abel Osmond's uncle André was curator of the Bibliothèque Mazarine as well as the library of the duchesse de Berry at the Château de Rosny-sur-Seine. In Rosny-sur-Seine he met the young Parfaite-Anastasie Tollay, and despite the difference in their ages—she was twenty-seven, he fifty-five—they were married in 1822. A strong attachment developed between Corot and Mme Osmond, although the actual nature of their relationship has never emerged. After André Osmond died in 1837, they remained close, and Corot spent several months of the year in the vicinity of the Osmonds. Robaut and Moreau-Nélaton deliberately downplayed this episode so crucial to the artist's emotional life, which was brought back into the light by Rodolphe Walter. I thank J.-C. Nardin of the Bibliothèque Mazarine for vital information on André Osmond, whose descendants still own a portrait of him that has always been attributed to Corot.

80. François-Parfait Robert, a magistrate and nephew of Mme Osmond, lived at Mantes. It was for his house that Corot painted the bathroom decoration now in the Louvre.

81. Letter (a.l.s.), Département des Arts Graphiques, Musée du Louvre, Paris, A.R. 8 L 6.

82. Letter (a.l.s.), Paris, August 21, 1821, Département des Arts Graphiques, Musée du Louvre, Paris, A.R. 8 L 1.

83. "exploits amoureux." Letter (a.l.s.), Rome, December 2, 1825, Département des Arts Graphiques, Musée du Louvre, Paris, A.R. 8 L 2.

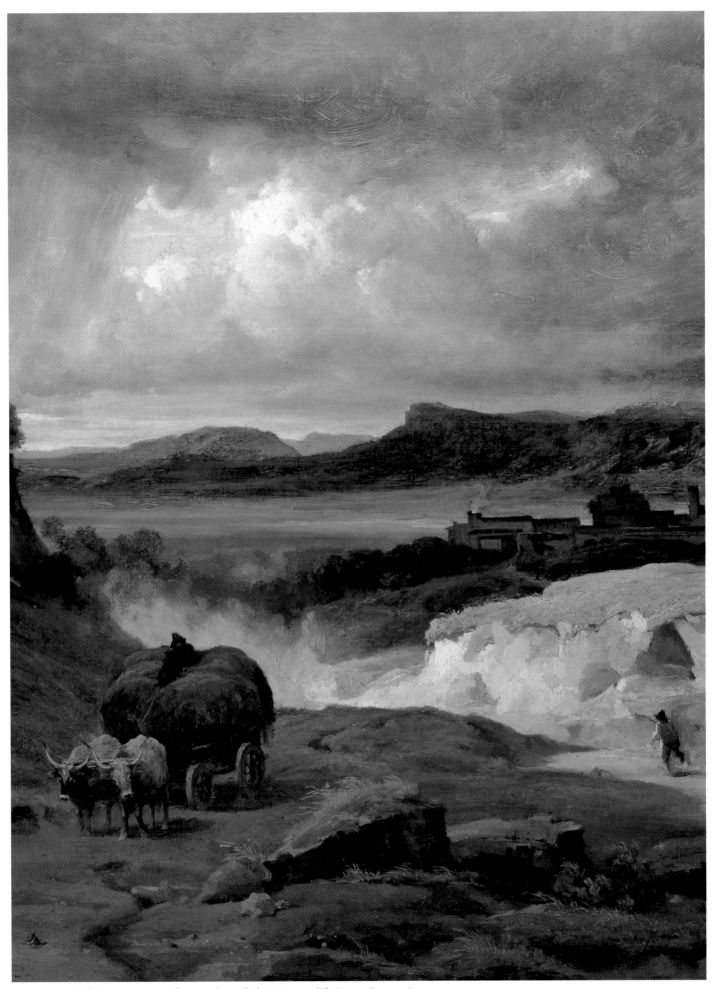

Fig. 10. Detail of Corot, *Campagne de Rome*, also called *La Cervara (The Roman Campagna)*, cat. no. 29

Fig. 11. Corot. *Ischia. Vue prise au pied du Mont Epomeo (Ischia: View at the Base of Mount Epomeo;* R 188), 1828. 9⅞ × 15¼ in. (25 × 40 cm). Musée du Louvre, Paris (R.F. 2231)

84. "Tu me demandes des nouvelles des Romaines. Ce sont toujours les plus belles femmes du monde que je connais. J'en possède de temps en temps; mais cela coûte. Toutes ne sont pas voluptueuses. . . . Cela me rappelait la rue du Pélican. Malgré cela, les yeux, les épaules, les mains et les culs sont superbes. En cela, elles l'emportent sur nos dames; mais en revanche, elles leur cèdent en grâce, en amabilité. Quelle différence! Vois qui tu préférerais. Moi, comme peintre, j'aime mieux l'Italienne; mais pour faire le sentiment, je me penche sur la Française." Letter (a.l.s.), Rome, March 10, 1827, Département des Arts Graphiques, Musée du Louvre, Paris, A.R. 8 L 7.

85. "Ce soleil répand une lumière désespérante pour moi. Je sens toute l'impuissance de ma palette. Apporte des consolations à ton pauvre ami, qui est tout tourmenté de voir sa peinture si misérable, si triste auprès de cette éclatante nature qu'il a sous les yeux." Letter (a.l.s.), Rome, March 1826, Département des Arts Graphiques, Musée du Louvre, Paris, A.R. 8 L 3.

86. "Pour la démoralisation, je vais t'expliquer. Notre sacrée peinture est terrible pour cela. Aujourd'hui nous nous flattons, nous nous regardons comme des génies supérieurs. Demain, nous rougissons de nos ouvrages, nous ne sommes capables de rien. Il ne faut pas s'affoler de cela: nous sommes des fous, on le sait." Letter (a.l.s.), Rome, August 23, 1827, Département des Arts Graphiques, Musée du Louvre, Paris, A.R. 8 L 8.

87. The reference is to Anna Saint-Laurent, whom Corot reportedly loved very much—as he did her sister Adèle—whom he expected to put in a landscape, and who got married during his journey in Italy.

one of them from time to time, but that's expensive. Not all of them are voluptuous. . . . It reminded me of the rue du Pélican. Even so, their eyes, their shoulders, their hands, and their asses are spectacular. In that, they surpass our women, but, on the other hand, they are not their equals in grace and kindness. What a difference! Let's see which you prefer. Myself, as a painter I prefer the Italian woman, but I lean toward the French woman when it comes to emotion."[84]

More seriously, these letters acquaint us with the agonies of creation that Corot experienced at the time, such as the real problems he had rendering the intense light of Italy: "This sun gives off a light that makes me despair. It makes me feel the utter powerlessness of my palette. Offer some consolation to your poor friend, who is absolutely tormented to see his painting so wretched, so dreary, next to the brilliant nature he has before his eyes."[85] In another letter Corot mentions in a more general way the almost existential anxieties of his calling, which ricochet the artist between the most ebullient passions and the deepest despair: "As for demoralization, I'll explain it to you. Our sacred painting is terrible for that. Today we puff ourselves up, we see ourselves as geniuses. Tomorrow we blush for our creations, we can do nothing. We mustn't let it drive us crazy: we already know that we are mad."[86]

One of these letters contains Corot's fullest explanation of why he remained unmarried, a question that greatly intrigued his biographers, who could not understand why a man with strong family feeling and such love for women did not find one to whom he could dedicate his emotional life. "But, after all, my friend, Mlle A. pleased me greatly and still does;[87] but I have only one goal in life that I want to pursue faithfully: to make landscapes. This firm resolution keeps me from a serious attachment. That is to say, in marriage. . . . I still love this young woman; but my independent nature and my great need for serious study make me take the matter lightly."[88] He was thirty and had just defined his future way of life: it would clearly be dedicated to painting, although women would always be part of his life, sometimes platonically, often more carnally.

It was during his stay in Rome, the letters to Osmond suggest, that the study of painting became a communal activity for Corot. While from the beginning he

had always worked alone, in Italy he had fruitful exchanges with his colleagues and subsequently acquired the habit of painting in the company of friends at the sites he chose. (He kept his passion for working in a group, later gathering friends or students to accompany him on painting expeditions and treasuring his jaunts to visit painter friends—Daubigny at Auvers-sur-Oise, the Dutilleux family in Arras or Douai.) In Rome he devoted himself entirely to his studies, rarely attending social events,[89] and he energetically mixed with others in the circle of painters who came from all over Europe to live and work there between 1825 and 1830. He had left for Italy with a friend from Bertin's studio, Johann Karl Baehr (1801–1869), a painter from Latvia; in Rome he shared painting experiences with the many other painters he met more than with his travel companion. He quickly encountered Léon Fleury, an old comrade from both Michallon's and Bertin's studios who shared his classical values, and he became friends with Auguste Lapito (1803–1874), Guillaume Bodinier (1795–1872), Édouard Bertin (1797–1871), Théodore Caruelle d'Aligny (1798–1871), and the German Ernst Fries (1801–1833), who were often his companions when he worked from nature in Rome or the surrounding countryside. Corot had equally sympathetic work sessions with the two painters awarded the Grand Prix de Rome for historical landscape in 1825, André Giroux (1801–1879), winner of the first prize, and Jacques-Raymond Brascassat (1804–1867), who had won the second. He made the acquaintance of other artists as well, including Prosper Barbot (1798–1878) and Julien Boilly (1796–1874), with whom he kept in touch after returning to Paris.

It was in Italy that Corot met two men who later became his friends, the architect Poirot and the future director of the Beauvais factory, Badin. He enjoyed discussing art with the more experimental painters, such as Victor Schnetz (1787–1870), who lived in Italy, and Léopold Robert (1794–1835), an acquaintance from Michallon's studio who painted amusing figures in regional costumes, which Corot surely looked at carefully when he was making his own figure studies.

During this period Corot unquestionably preferred the companionship of Édouard Bertin when working from nature. "'It's thanks to him,' he said, 'that I am kept on the road to the Beautiful! When the three of us would go looking for a subject in the Roman Campagna, Édouard was always the first to start working and in the best spot!'"[90] His other favorite work companion was Aligny, who, as Robaut told it, was the first to point out Corot's talents to the small community of artists that gathered every evening after a day spent working. "One morning . . . Aligny, struck by what he saw, let a cry of admiration escape . . . and that evening at the café, when jokes started up again about that naive application of paint that was much ridiculed, he silenced the laughter by saying, 'My friends, Corot is our master.'"[91]

All these friendships, woven together in Rome during long work sessions and animated evenings at the Ristorante della Lepre or the Caffè Greco, were greatly reinforced on the trips to the Roman countryside that began in early spring and continued until the start of winter. During his first stay in Rome, Corot moved about frequently and followed different itineraries to take in the sites recommended by landscape treatises like Valenciennes's, by guidebooks, and by studio tradition. Galassi describes three routes habitually followed by painters during their work tours in the Roman countryside.[92] One went north

88. "Mais, après tout, mon ami, Mlle A. me plaisait beaucoup et me plaît encore; mais je n'ai qu'un but dans la vie que je veux poursuivre avec constance: c'est de faire des paysages. Cette ferme résolution m'empêchera de m'attacher sérieusement. Je veux dire en mariage. . . . Je l'aime toujours cette jeune personne; mais, mon caractère indépendant et l'étude sérieuse, dont je m'aperçois avoir un grand besoin, me font prendre la chose en plaisantant." Letter (a.l.s.), Papigno, August 8, 1826, Département des Arts Graphiques, Musée du Louvre, Paris, A.R. 8 L 5.

89. Letter (a.l.s.), Département des Arts Graphiques, Musée du Louvre, Paris, A.R. 8 L 10.

90. "C'est à lui, disait-il, que je dois d'être resté dans la voie du Beau! Quand nous allions tous trois cherchant un motif dans la campagne de Rome, Édouard était toujours le premier à l'ouvrage et à la bonne place!" Michel 1905, p. 15.

91. "Un matin . . . Aligny, frappé par ce qu'il voit, laisse échapper un cri d'admiration . . . et quand, le soir, au café, les plaisanteries recommencent sur cette naïve application qu'on tourne en ridicule, il impose silence aux rieurs en disant: 'Mes amis, Corot est notre maître.'" Moreau-Nélaton 1924, vol. 1, p. 16.

92. Galassi 1991a, pp. 121–22.

from Rome to Civita Castellana, a route that could be taken from the Alps to Rome or from Rome to the French frontier. The second followed the road from Rome to Naples, then branched off toward Frascati, Albano, Marino, Ariccia, and Genzano. The last route essential for the landscapist headed east out of Rome in the direction of Tivoli and Subiaco. Corot traveled these three circuits many times during his stay, extending the first to Narni, Terni, and Papigno and the second, in 1828, as far as Naples and Ischia.[93]

Corot alternated his travels outside of Rome with long sessions in the city studying antique or Renaissance monuments. He generally spent the winter in the studio, painting more ambitious compositions: the first two canvases he sent to the Salon of 1827 (cat. nos. 27, 29) and those he was preparing for the Salon of 1831 (cat. no. 30). He also gave some time to retouching and improving his plein air studies. He seems to have been particularly dissatisfied with his studio work, to him his most important activity: "It is all too true that the more you progress, the more problems you encounter. There are certain aspects of painting that I would like to deal with but that seem to me impenetrable. It's gotten to the point where I haven't the nerve to tackle the paintings that I made sketches for at the beginning of winter. The weather has stayed fine and I would rather go out. I can't keep myself in the studio."[94] This remark by Corot on his state of mind during the winter of 1827 has generally been interpreted as evidence of his spontaneous, irresistible attraction to open-air work and his distaste for painting in the studio, but that interpretation is erroneous. It was precisely Corot's confusion in the face of his difficulty painting imaginary landscapes that drove him to leave the studio, putting off the moment when he had to confront his blocked inspiration. For the Neoclassical artist, painting from nature required only coordination of the eye and the hand, as Valenciennes had emphasized, while the true moment of creation came in the studio. Corot did not yet feel ready to face that moment.

Since Corot did not consider them truly independent works, all these studies of Italy done from life, sometimes in extended sessions spread over several days, sometimes painted in an hour or two, are especially hard to classify either thematically or chronologically. Corot made more than one journey to some sites, making precise dating even more difficult. Galassi resolutely undertook to establish a classification by subject: figure studies, landscapes of Rome and its surroundings, landscapes of rural sites, landscapes of Naples and Venice.[95] This enabled him to better discern Corot's working method, since the artist adapted his technique to the type of site.

Another classification should be employed as well, one that creates a typology of the didactic works made by Corot, who, after all, was in Italy to complete his training and who chose the subjects of his studies for their pedagogic value. In addition to figure studies,[96] the first stage in an aesthetic consideration of the human form that would be needed later for large historical landscapes, four other categories echo obligatory exercises for the Neoclassical painter: the architectural study—Italy was the training ground for artists partly because it offers so many antique monuments; the study of trees and rocks, something the young landscapist had to practice regularly, first by copying paintings and engravings, then in plein air; the study of reflections and the effects of light created by moving or still water; and the study of panoramic views, to master the play of light in space.

93. May 1826: departs following the Tiber River in the direction of the Sabine Mountains. June–July 1826: Civita Castellana, Nepi, Viterbo, Castel Sant'Elia. August–September 1826: Papigno, Terni, Piediluco, Narni. November 1826: Albano, Nemi, Rocca di Papa, Ariccia, Frascati, Marino. December 1826: visits the Villa d'Este, Tivoli. March 1827: still in Rome. Sends two paintings to the Salon of 1827. April 1827: Olevano, Civitella. May 1827: Genzano, Marino. July 1827: Lake Albano, Ariccia, Olevano. August 1827: Civitella and Subiaco. September 1827: Civita Castellana, Castel Sant'Elia. October 1827: Castel Sant'Elia and Ariccia. Spring 1828: Naples, Vesuvius, Capri, and Ischia. September: returns [to France] by way of Venice and then Switzerland. Galassi 1991b, p. 241, n. 9.

94. "L'on a bien raison de dire que plus on avance, plus on trouve de difficultés. Il y a certaines parties de la peinture, comme je voudrais les traiter, qui me paraissent inattaquables. C'est au point que je n'ose pas aborder les tableaux que j'avais ébauchés au commencement de l'hiver. Le temps a été continuellement beau et je préférais sortir. Je ne pouvais tenir à l'atelier." Corot, letter (a.l.s.) to Théodore Duverney, Rome, March 27, 1828, quoted in Robaut 1905, vol. 1, pp. 46, 47, and vol. 4, p. 331, no. 9.

95. Galassi 1991a, p. 143.

96. See cat. nos. 16–19, and, for example, R 64 (Musée Picasso, Paris), R 87 (private collection), and R 109 (Musée du Louvre, Paris, Moreau-Nélaton Bequest).

Fig. 12. Corot. *L'Italienne Maria di Sorre assise* (*An Italian Woman, Maria di Sorre, Seated;* R 64), 1826–27. 10¼ × 7⅛ in. (26 × 18 cm). Musée Picasso, Paris (R.F. 1973–66)

Fig. 13. Ernst Fries (1801–1833). *Corot at Civita Castellana*, 1826. Graphite on paper, 9½ × 7¼ in. (24 × 18.5 cm). Dresden, Staatliche Kunstsammlungen

Corot did architectural studies[97] mainly in Rome during his first stay in Italy (although on his second trip, in 1834, he found superb subjects in Genoa, Florence, and Venice [cat. nos. 53, 55, 56]). The subject was rarely a single isolated monument. These urban studies were of two types: those of ancient monuments, which Corot treated less poetically and philosophically than Giovanni Pannini and Robert and less "archaeologically" than Valenciennes and Michallon, preferring to concentrate on rendering the light and the material; and those of Renaissance monuments or the modern city, in which he added to his technical preoccupations a clear desire to communicate the poetic atmosphere of the place.

Corot made studies of trees and rocks,[98] long recommended as an exercise indispensable to the landscapist, chiefly around Civita Castellana, although he also made such studies in Papigno, Narni, Olevano, Marino, and in the region of Rocca di Papa. Here he is most explicitly the dutiful student. On his return to France, he continued these studies in the forest of Fontainebleau.

The study of effects caused by light on water[99] especially lent itself to poetic researches. When Michallon was in Italy he had painted numerous studies of waterfalls and streams coursing down a mountain, which Corot surely scrutinized in his studio.[100] From these studies he gained an understanding of the play of water vapor in air or on rocks and how to represent a transparent liquid.

Finally, the panoramic view,[101] which proved so successful for Valenciennes and Bidauld[102] and which called for an already well developed technique, is the type of study that Corot continued to practice longest after returning to France, painting sites at Soissons, Rouen, Pierrefonds, Avignon, and Saint-Lô (cat. nos. 41, 43, 66, 67, 42). One can see him attempting to master aerial perspective—the treatment of space distorted by distance and light—and he succeeded unequivocally, demonstrating how far he had progressed in the three years during which

97. See cat. nos. 6–14, and, for example, R 72 (Museum Boymans-van Beuningen, Rotterdam), R 75, 81, 98, 187 (all in private collections).
98. See, for example, R 114 (private collection), R 151, R 156 (J. B. Speed Art Museum, Louisville), R 174 (Neue Pinakothek, Munich).
99. See, for example, R 132 (private collection).
100. *La Cascade de Terni*, Musée des Beaux-Arts, Orléans; *La Cascade* (*Tivoli*), *Le Torrent* (*Tivoli*), *Vagues au pied de rochers, Paysage de montagne traversé par un torrent*, all, Musée du Louvre, Paris.
101. See, for example, R 43 (private collection), R 45 (Musée du Louvre, Paris, Moreau-Nélaton Bequest), R 98 bis (National Gallery, London), R 160 (The Metropolitan Museum of Art, New York), R 103 (private collection), and R 164 (Musée des Beaux-Arts, Reims).
102. As in Bidauld's *Vue de Subiaco* and *Vue d'Avezzano*, Musée du Louvre, Paris.

Fig. 14. Corot. *Le Lac d'Albano et Castel-Gandolfo* (*Lake Albano and Castel Gandolfo*; R160), 1826–27. Oil on paper mounted on wood, 9 × 15½ in. (22.9 × 39.4 cm). Purchase, Dikran G. Kelekian Gift, 1922, The Metropolitan Museum of Art, New York (22.27.2)

he systematically made studies from nature, beginning with his first attempts at Chaville and Saint-Cloud.

This classification lets us understand to what extent Corot chose his sites and viewpoints in line with a certain classicizing taste and the tradition imposed for a half century by the "vedutists" on their "grand tour" of Italy. During his three years in Italy, Corot was chiefly preoccupied with strictly technical considerations, learning to modulate colors according to the light, to imitate all the different kinds of substances that nature offered—water, vapor, bark, leaf, stone—and, most important, to paint the sky. So when Silvestre wrote in 1853 that "Corot went to live in Rome, not to receive an official education there but to revel in the good weather and work almost the entire year outdoors, as was impossible under the changeable sky of Paris," he was half wrong.[103] True, the young man went to Italy to paint from nature, but there he executed the traditional pictorial exercises of a Neoclassical artist. Moreau-Nélaton too forgot to refer to this training,[104] but Galassi recognized the importance of this journey as "an extension of the artist's education."[105]

Once back in France, Corot could take satisfaction in his Italian stay: he had amassed numerous studies, with which he embellished the walls of his studio; he had acquired a technique excellent for depicting nature; and he had grappled with the ultimate stage, composing large studio landscapes, one of which had been accepted by the Salon jury. For establishing his career, the journey had been a distinct success.

It was many years before historians of art fully grasped the power and expressiveness of these landscape studies. "The view that Corot's early Italian landscapes and late figure pieces represent his highest achievement, and that these private or personal works are far superior to his public Salon paintings . . . began to take hold in the early decades of this century," wrote Galassi.[106] Until the turn of the century, the public remained partial to his paintings of the 1860s, with their beautiful effects of morning mist, lyrical countrysides, and silvery evening views. It was only in the early years of the twentieth century that some writers grew enthusiastic about Corot's Italian journey. Then the idea was increasingly

103. "Corot alla demeurer à Rome, non pas pour y recevoir l'éducation officielle, mais pour y jouir du beau temps et y travailler presque toute l'année en plein air, chose impossible sous le ciel variable de Paris." Silvestre 1853, p. 77.
104. Moreau-Nélaton 1924, vol. 1, p. 13.
105. Galassi 1991b, p. 2.
106. Ibid., p. 5.

advanced that these works from Italy were harbingers of a new art, primarily because Corot worked outdoors, taking special pains over the color and the light; that in 1826, "all by himself, without any program, entirely naturally, Corot leapt over fifty years of painting, moving from the Neoclassical style to the Impressionist style."[107] Galassi punctured this overblown notion of Corot as the precursor of Impressionism in 1991, making more explicit what Germain Bazin, René Huyghe, and Hélène Toussaint had already implied: "The appropriate context for Corot's Italian landscapes is not what came after but what came before."[108] Thus he recalled the Neoclassical origins of Corot's art, while also coming to the more traditional conclusion of Henri Focillon and Élie Faure that Corot was the spiritual link between Poussin and Sisley, Claude and Monet, that the "perception of equilibrium in Corot's Italian landscapes between classicism and naturalism, between tradition and modernity, between order and freedom, has become a salient theme."[109]

"I Return Again and Again, without Being Stopped by Anything and without Any System."[110]

Alfred Robaut assembled valuable information on Corot's technique during this Italian period which also sheds light on the artist's way of working after his return to Paris.[111] Robaut found many drawings that correspond to the painted studies[112] and concluded that Corot used drawings to save time and as an aid to his memory, to facilitate progress on a study which he then finished on the spot in a few sessions. Thus, four stages can be perceived in Corot's study of a site. He began outdoors, blocking in the subject fairly completely, usually in pencil but sometimes in oil; then in the studio, using oils, he repainted from memory, making the drawing and the effects of light and shadow more precise; next he returned to the site to analyze in detail various elements of the landscape; finally he retouched the painting in the studio, sometimes over a period of years, until he considered it perfect: "Nothing should be left imprecise." Of course, these stages were not sharply defined, and the process could take hours, months, or years.

From a consideration of this working method one might reasonably conclude that Corot, overwhelmed by the beauty of Italy, was—perhaps unconsciously—painting nature more and more for its own sake, for the pure pleasure of it, forgetting the didactic framework and the connection to his future Salon paintings. However, it would be a mistake to go further and deduce that he consciously regarded his studies as independent works worthy of being exhibited. Even though our contemporary eyes find the youthful Italian studies more moving than the lyrical paintings of the 1860s; even though our modern taste favors an unfinished work that reflects the artist's first response over a finished work, which can be stiff because of social or professional considerations, we still must recognize that the true motivation for Corot's studies was his studio painting, or else we will be false to his pictorial conception.

For Corot, the study was only an artistic potential that preceded and inevitably led to the studio landscape. When working in the studio he could dispense with the study itself, relying instead on his memory: "'This memory,'

107. "Tout seul, sans programme, de la façon la plus naturelle possible, Corot sautait cinquante ans de peinture, et passait du goût néoclassique au goût impressionniste." Venturi 1941, p. 141.
108. Galassi 1991b, p. 9.
109. Ibid., p. 8.
110. "Je reviens sans cesse, sans être arrêté par rien et sans système." Corot, carnet 68, ca. 1840–45, quoted in Robaut 1905, vol. 4, p. 97, no. 3105.
111. Robaut documents, vol. 1, fol. 36.
112. The painted studies were generally on paper, which was the most commonly used support for outdoor work. Later Corot had most of them mounted on canvas.

Fig. 15. Corot. *Fontainebleau. Détail de troncs d'arbres en forêt (Fontainebleau: Detail of Tree Trunks in the Forest;* R 5), 1822. 9½ × 12½ in. (24 × 32 cm). Salander-O'Reilly Galleries, Inc., New York

he said, 'has served me better at times than nature itself could.... I would base a painting on that study; but, in a pinch, I could do without having it in front of me. When someone requests a copy of one of my subjects, I can make it easily without referring to the original; I keep a copy of all my works in my heart and in my eyes.'" [113] Italy served to nourish that visual memory; the passion he later developed for making *souvenirs* had begun to take shape at that time. When he worked in the studio Corot did not systematically use his studies as a source of inspiration for a *paysage composé,* as some have asserted, and he could go directly to the painting without the preliminary stage of making a study from nature. The study from nature thus could become a work in the abstract, with the actual pictorial object obtained after each session of plein air painting mattering less than the memory it implanted in the mind of the landscapist.

When he returned from Italy, Corot concentrated on ways to exploit the experience he had gained and the pictorial and graphic material he had amassed during those three years without "losing his touch" before nature. Between the years 1828 and 1834 he found himself working in three directions: continuing the open-air sessions; learning to paint the portrait, a genre closely related to landscape by virtue of the realism they share; and realizing paintings that were more ambitious both in size and in narrative content.

We know little about the period between Corot's return from Italy in 1828 and his second trip there in 1834, but it seems that he traveled frequently, looking all over France for areas that inspired him. When he found such sites he painted them often, almost obsessively. After the rich period in Italy, Corot sought variety, finding different qualities in different regions: it was serene and hazy in Ville-d'Avray, wild and rugged in the forest of Fontainebleau, thick and luxuriant in the Morvan, transparent and luminous in Normandy. The views he painted entirely or partially from nature on his return from Italy are among his most beautiful and most accomplished. With the mastery of perspective, light, and construction that they reveal, it seems hardly appropriate to speak of naïveté in

113. "Cette mémoire m'a, dit-il, mieux servi par moments que ne l'eût fait la nature elle-même.... Je tirerai, me disait Corot, un tableau de cette étude; mais, à la rigueur, je pourrais à présent me passer de l'avoir devant moi. Lorsqu'un amateur désire la répétition d'un de mes sujets, il m'est facile de la lui donner sans revoir l'original; je garde dans le coeur et dans les yeux la copie de tous mes ouvrages." Silvestre 1853, pp. 82–83.

discussing these works, as some authors have done. Corot's approach was further enlarged during this period by his attention to the realism of seventeenth-century Dutch and Flemish landscapists and to the expressive qualities of contemporary English painters. Despite his frequent work in the forest of Fontainebleau and his development of his own conception of plein air painting, he did not join Rousseau and Huet in their challenge to the classical landscape, which was beginning in the 1830s.

Corot said that he "very much likes figures animating his landscapes; he wants to have company in the woods, in the valleys, along rivers, to see animals and people rambling around the countryside, where he could not live absolutely alone."[114] Beginning in 1830, he tried his hand at a genre he had not up to then attempted (except for his own image), the portrait, finding subjects mostly among his own family and friends (cat. nos. 47–50). After he returned to France he painted the portraits of his two closest friends, Abel Osmond and Auguste Faulte du Puyparlier (fig. 16), quickly arriving at his characteristic style for this genre: the figure presented half length, careful attention to the rendering of the face, and a dark background that sets off the figure, in the manner of portraits by David and Ingres.[115] Portrait painting, which he developed over the next twenty years, helped give him confidence when it came to treating the human figure in a large landscape. But the aesthetic sensibility that drove Corot's interest in the Realist portrait was different from the sensibility of his imaginary landscapes. It is clear that emotional and psychological elements played an important role in the portraits painted before 1840.

Having absorbed his Neoclassical training, Corot at last pursued his continuing, all-important work in the studio, preparing large landscapes for the Salon.[116] He did not paint historical landscapes, to his eyes a landscape painter's greatest work, before the celebrated *Agar dans le désert* of 1835 (cat. no. 61), preferring to create rustic landscapes *(paysages champêtres)*. He adhered faithfully to Roger de Piles's definition, renewed by Valenciennes, of an everyday, intimate, realistic representation of nature. Except for the superb *Une Marine* (cat. no. 46), exhibited in 1834, the paintings that he showed at the Salon during this period had only two themes: there were views based on his studies and memories of Italy and views of the forest of Fontainebleau. Ville-d'Avray was too ordinary to be the subject of any of these paintings intended to launch his career; the classical notion of grandeur still weighed heavily on his work, despite the influence of Constable, which was very evident in the two views of the forest of Fontainebleau that he exhibited at the Salons of 1831 and 1833.

Unquestionably, studio work provided some of the most intense moments in Corot's artistic career. In his memory he relived the sensations he had experienced during his outdoor sessions; his education and his theoretical conceptions seem at these times to have been forgotten. "After my outings I invite Nature to come spend several days with me; that is when my madness begins. Brush in hand, I look for hazelnuts among the trees in my studio; I hear birds singing there, trees trembling in the wind; I see rushing streams and rivers laden with a thousand reflections of sky and earth; the sun sets and rises in my studio."[117] Thanks to his solid training and the crucial journey to Italy, Corot had learned to forget technique and go beyond his education to find the pure poetry that would give life to all his works to come.[118]

114. "aimait beaucoup les figures animant le paysage, il veut être en compagnie dans les bois, dans les vallées, au bord des rivières, voir bêtes et gens courir la campagne où il ne pourrait vivre absolument seul." Ibid., p. 77.

115. In the same period, at the Salon of 1833, Ingres exhibited *Monsieur Bertin* (Musée du Louvre, Paris), whose realism and skillful construction made a deep impression on Corot.

116. At the Salon of 1831 he exhibited four paintings: *Vue de Furia; Couvent sur les bords de l'Adriatique*, R 201; *La Cervara* (cat. no. 29); and *Vue prise dans la forêt de Fontainebleau*, R 255, National Gallery of Art, Washington, D.C. In 1833 he submitted only a single painting, *Le Gué*, R 257, and received a second-class medal. In 1834 he showed three paintings: *Une Forêt, Une Marine* (cat. no. 46), and *Site d'Italie*, R 361.

117. "Après mes excursions, j'invite la Nature à venir passer quelques jours chez moi; c'est alors que commence ma folie: le pinceau à la main, je cherche des noisettes dans les bois de mon atelier; j'y entends chanter les oiseaux, les arbres frissonner sous le vent, j'y vois couler ruisseaux et rivières chargés de mille reflets du ciel et de la terre; le soleil se couche et se lève chez moi." Silvestre 1853, p. 78.

118. Text of the marriage certificate of Corot's parents, cited in note 4: "'Certificate of marriage between Jacques-Louis [*sic*] Corot, twenty-one years of age, born October 11, 1771, in Paris, parish of Saint-Étienne Dumont, wigmaker, son of Claude Corot and Jeanne-Françoise Guyot, both deceased.

'And Marie-Françoise Auberson, twenty-four years of age, born December 15, 1768, in Versailles, daughter of Claude-Antoine Auberson and

Fig. 16. Corot. *Le Capitaine Faulte de Puyparlier* (R 206), 1829. Oil on canvas, 25½ × 21½ in. (64.8 × 54.6 cm). Gift of Emilie L. Heine in memory of Mr. and Mrs. John Hauck, Cincinnati Art Museum (1956.227)

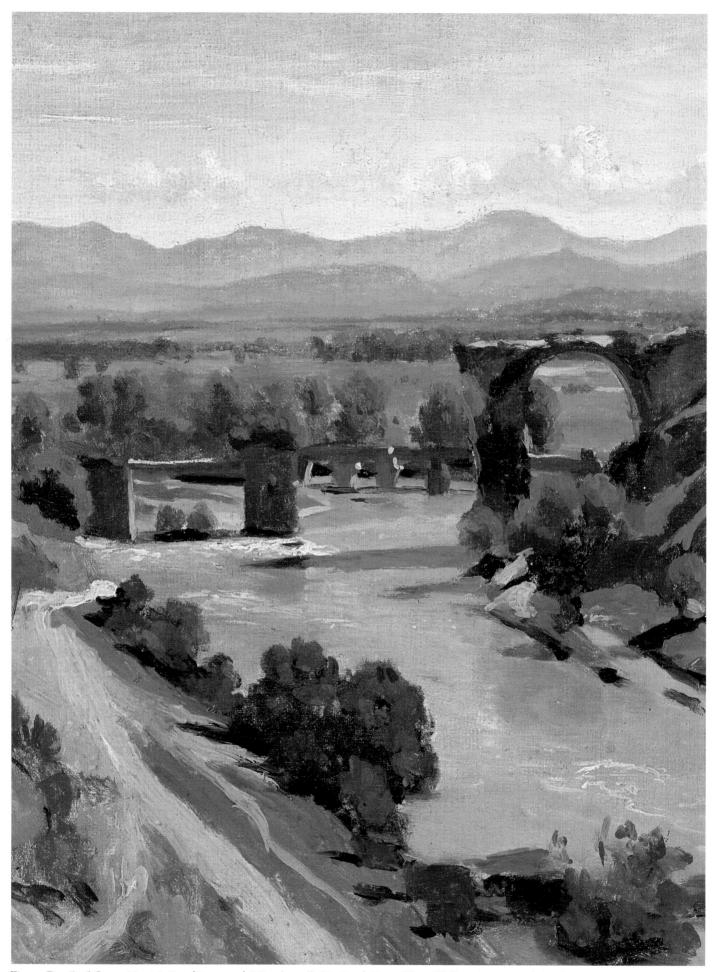

Fig. 17. Detail of Corot, *Narni. Le Pont d'Auguste su la Néra,* also called *Le Pont de Narni* (*Narni: The Ponte Augusto over the Néra*), cat. no. 26

Marie-Julie Serre. Both deceased [penciled in the margin a note that the husband's profession has been effaced].' (Marriage of Corot and Auberson, Extract from the Register of marriage certificates for May 6, 1793, the first year of the Republic, Archives de Paris, V2E 8156, Marriage, Certificate no. 204)." (" 'Acte de Mariage de Louis-Jacques Corot âgé de vingt et un ans né à Paris, paroisse Saint-Étienne Dumont le 11 octobre 1771 perruquier fils de Claude Corot et de Jeanne Françoise Guyot, tous deux décédés.

'Et Marie-Françoise Auberson âgée de vingt-quatre ans, née à Versailles le 15 décembre 1768 fille de Claude Antoine Auberson et de Marie Julie Serre. Tout deux décédés.' [Mariage de Corot et d'Auberson, Extrait du Registre des actes de mariages du 6 mai 1793 l'an premier de la République [sic], Archives de Paris, V2E 8156, Mariage, Acte no. 204].") Archives Nationales, Paris, May 5, 1793, minute R, fol. 409, MC/ET/LVII/583.

Text of Corot's birth certificate, cited in note 12: "In the year four, 27 Messidor ['27' crossed out in pencil and '28' written in], was born in Paris in the 10th arrondissement, rue du Bacq, no. 129, Corot, Jean Baptiste Camille, male son of Louis Jacques Corot and Marie Françoise

Oberson, his wife, living at Paris rue du Bac no. 125." ("L'an quatre le 27 messidor est né à Paris sur le 10 arrondissement, rue du Bacq n° 129 Corot Jean Baptiste Camille du sexe masculin fils Louis Jacques Corot et de Marie Françoise Oberson son épouse demeurant à Paris rue du Bac n° 125.")

The civil record reads: "Tenth arrondissement. Ward of la Fontaine de Grenelle. On the twenty-eighth of Messidor in the year 4 of the Republic, birth of J.B.C., male, born this day at one-thirty in the morning. Place: rue du Bacq no. 125, son of Louis Jacques Corot and Marie Françoise Oberson, married May 6, 1793." ("Dixième arrondissement. Section de la Fontaine de Grenelle. Du vingt huit messidor de l'an 4 de la République, naissance de J.B.C. du sexe masculin, né ce jour d'huy, à une heure trente du matin. Lieu: rue du Bacq n° 125, fils de Louis Jacques Corot et de Marie Françoise Oberson marié le six mai 1793.") Archives de Paris, V2E 869.

Text of Annette-Octavie's marriage certificate, cited in note 17: "The contract came before the lawyer Ozanne on March 21, 1813. Louis-Jacques Corot, merchant, and M.-F. Oberson, his wife, parents of the bride, were living at no. 1, rue du Bacq. The parents of the groom (M. and Mme

Sennegon, of Rouen) gave as their address a town house on the rue de Grenelle. A.-O. Corot's dowry consisted partly of a share in their business valued at 15,000 francs that would start paying interest on August 1, 1816 [and 30,000 francs]. M. Sennegon was granted permission to add a trade in silk fabrics to his in-laws' establishment, its profits to go entirely to him. Among the witnesses were Camille Corot and his second sister, both living with their parents at 1, rue du Bacq." ("Le contrat est passé devant Maître Ozanne, le 21 mars 1813. Louis-Jacques Corot, négociant, et M.-F. Oberson, son épouse, parents de la future, sont domiciliés rue du Bacq n° 1. Les parents du futur [M. et Mme Sennegon, de Rouen] sont indiqués comme demeurant présentement dans un hôtel de la rue de Grenelle. La dot d'A.-O. Corot se compose en partie du fonds de commerce de ses parents, dont ils lui cèdent la jouissance à partir du 1er août 1816. [Mais la dot est constituée aussi de 30 000 francs.] M. Sennegon est autorisé à joindre à l'établissement de ses beaux-parents un commerce de soieries, dont les bénéfices lui seront propres. Le fonds de commerce Corot est évalué 15.000 francs. Parmi les témoins sont: Camille Corot et sa seconde soeur, l'un et l'autre domiciliés chez leurs parents, rue du Bacq, n° 1.")

I

Bois-Guillaume, près de Rouen. Une Porte flanquée de deux piliers (Bois-Guillaume, near Rouen: A Gate Flanked by Two Posts)

1822
Oil on paper mounted on canvas
9½ × 12⅝ in. (24 × 32 cm)
Stamped lower right: VENTE COROT
Wax seal of the Corot sale on back
Galleria Internazionale d'Arte Moderna, Ca' Pesaro, Venice 1890
Paris only

R 2

As a youth Corot lived with the Sennegon family between 1807 and 1812, while he attended secondary school in Rouen. The elder Sennegon was a friend of Corot's father and served as a substitute father during the young man's years at school, imparting to him his love of the outdoors: "He was a man . . . who ran from people but delighted in nature. He took his young boarder with him on his walks, preferably through solitary countryside far from the noise of the town. They would sit on a peaceful riverbank and watch in silence as twilight descended and the day came to a close."[1] Later, one of Corot's sisters, Annette-Octavie, married the son of his walking companion, Laurent-Denis Sennegon, which brought the two families even closer together.[2]

These attachments and the memories of those quiet walks no doubt explain how at the outset of his artistic career Corot came to settle on land owned by the Sennegon family. There, in the tiny village of Bois-Guillaume set in the hills surrounding Rouen, he made his first paintings after nature.

In August 1822, taking a break from his studies in the atelier of Achille-Etna Michallon[3] to work out of doors on his own, Corot chose not the more usual subject of the cathedral's lofty spires but that of the simple, tranquil countryside round about, painting "with equal ardor and equal application the posts of a gate or a thatched roof."[4]

Among the earliest known works by Corot are four oil studies painted before his first trip to Italy in the area around Bois-Guillaume. Alfred Robaut and Étienne Moreau-Nélaton dated two of these (R 1, R 2) to the tour of the countryside he made in August 1822 and the other two (R 12, R 13) to subsequent stays at Bois-Guillaume before 1825. The date of 1822 seems correct for this small painting, with its naive freshness and awkward technique. That it was made outdoors is suggested by the spontaneous and fluid facture and confirmed by its execution on paper, the support traditionally used for plein air works.

The influence of the Neoclassical theories of Pierre-Henri de Valenciennes and of Corot's training with Michallon is discernible in this study, which calls to mind works by Louis-Gabriel Moreau or Jean-Victor Bertin. Bertin's tightly focused studies called *Entrée du parc de Saint-Cloud*, painted about 1810,

show a similar composition, although from farther back, with marked contrasts of light and shadow (fig. 18).[5] Corot had also seen in some of Michallon's Italian studies how an effect of contrast is obtained from a strongly lit landscape glimpsed through a doorway or arch, with the foreground in shadow (see, for example, Michallon's *Vue de la villa Médicis*, Musée des Beaux-Arts, Orléans).

The overall simplicity of this composition recalls the teaching of Valenciennes, who advised artists to work outdoors and "at first, limit yourself to copying, as well as you can, the principal tones of Nature," starting with the sky, "which sets the tones of the background."[6] The careful treatment of the sky in this study suggests that Corot followed his advice.

Reportedly, this work was among the youthful efforts that Corot most valued "as a reminder of his beginning years."[7] It seems that he later retouched it very little or not at all, contrary to his usual practice. The light and the sky, clear and rather transparent, are beautifully handled, as are the well-controlled effects of certain material objects—such as the impasto on

Fig. 18. Jean-Victor Bertin (1767–1842). *Entrée du parc de Saint-Cloud (Entrance to the Park of Saint-Cloud)*, ca. 1810. 13 × 11 in. (33 × 28 cm). Musée de l'Île-de-France, Sceaux

the post on the right. On the other hand, his treatment of the bush on the left, in which he attempts to imitate the thin washes of color in Valenciennes's studies of Italy, and the landscape seen through the gate still show many struggles with technique and some difficulty with perspective.

Throughout his career, Corot remained very much attached to reminders of his early days as a painter and to this lovely countryside: "In springtime when I smell the hazels, my mind races back to Bois-Guillaume near Rouen, where I spent my childhood, and plunges into the scented woods where long ago I went on Sundays to gather morels."[8] He kept this study to the end of his life. Bought at the posthumous sale of his work, it disappeared until 1951, when it turned up in London several months before being acquired by the Galleria Internazionale d'Arte Moderna in Venice.

1. "C'était un homme . . . qui fuyait le monde, mais goûtait la nature. Il prenait le jeune pensionnaire pour compagnon de ses promenades et l'emmenait de préférence dans des campagnes solitaires, loin du bruit de la ville; on s'asseyait au bord d'une rive tranquille et l'on assistait, dans le silence, au déclin de la lumière et à la fin du jour." Moreau-Nélaton 1924, vol. 1, p. 7, from a firsthand account recorded by Alfred Robaut.
2. They were married in 1813 and had seven children, most of whom were portrayed by Corot.
3. The date is given in Moreau-Nélaton 1924, vol. 1, p. 11. Michallon died a month later, on September 24, 1822.
4. "avec la même amour et la même conscience les piliers d'une porte ou le chaume d'une toiture." Ibid.
5. Two pictures by Bertin of this subject are known, in the Musée de l'Île-de-France at the Château de Sceaux in Sceaux and in the Bibliothèque Marmottan in Boulogne-Billancourt. Corot also painted an *Entrée du parc de Saint-Cloud* (private collection, France), a work very similar to Bertin's paintings that was undoubtedly done after he entered Bertin's studio at the end of 1822. He would soon return to the motif of a landscape viewed through a gateway in another work surely painted at Bois-Guillaume, *Porte flanquée de deux gros piliers* (R 38, present location unknown).
6. "Il faut d'abord se borner à ne copier, le mieux possible, que les tons principaux de la Nature"; "qui donne les tons de fond." Valenciennes 1800, p. 407. For a fuller quotation of the passage, see cat. no. 20.
7. "comme souvenir de ses années de début"; according to Robaut in Robaut 1905, vol. 2, p. 8, no. 2.
8. "Lorsqu'au printemps je sens l'odeur des noisetiers, mon imagination s'enfuit à Bois-Guillaume près de Rouen, où s'est passée mon enfance et s'enfonce dans les fourrés odorants où, jadis, j'allais le dimanche, cueillir des morilles." Quoted in Lafargue 1925, p. 31.

PROVENANCE: The artist; his posthumous sale, Hôtel Drouot, Paris, pt. 2, May 31–June 4, 1875, no. 230; purchased at that sale by Lebas for 210 francs; Marlborough Fine Art, Ltd., London, 1951; acquired by the Galleria Internazionale d'Arte Moderna, Venice, at the Venice Biennale in 1952 for 1,200,000 lire

EXHIBITIONS: London 1951, no. 4; Venice 1952, no. 1

REFERENCES: Michel 1896a, p. 10; Robaut 1905, vol. 2, pp. 8–9, no. 2, ill., and vol. 4, p. 221, no. 230; Fouchet 1975, pp. 26–27; Leymarie 1979, p. 10, ill.

2

Dieppe. Bout de jetée et la mer
(Dieppe: End of a Pier and the Sea)

1822
Oil on paper mounted on canvas
9¼ × 12¼ in. (23.5 × 31 cm)
Stamped lower left: VENTE COROT
Musées Royaux des Beaux-Arts de Belgique, Brussels 3646

R 3

Achille-Etna Michallon had discovered the seacoast of Dieppe about 1816, when he was working on the engraved illustrations of various sites that had been commissioned from him by the publisher Ostervald.[1] Charmed by the luminosity of the region, he must have advised his students, among them Corot, to go to Dieppe and there try to capture the transparency of the sky and the reflections on the waves. Probably on the basis of Corot's own remarks, Robaut and Moreau-Nélaton stated that this study was painted in 1822, and it was undoubtedly during the summer or fall of 1822 that Corot went to Dieppe, after spending several days in Bois-Guillaume with the Sennegons.

Still awkward in its technique, which has not yet found the proper balance between paint used thickly and glazing, this study is nonetheless beautifully luminescent, and the depth of space, like the placement of the clouds and waves, seems to be perfectly mastered.

Corot saw this seacoast first and foremost as the occasion for an exercise in pure technique, and that is how he painted it, with none of the lyrical or romantic longing that Eugène Delacroix would express in his journal thirty years later on coming to the same site: "It was beautifully calm, one of the most beautiful [seas] I've seen. I couldn't tear myself away from it. I stayed on the beach and didn't go up on the pier all day. The soul becomes passionately attached to the things one is about to leave. I painted a study of that sea from memory."[2]

No doubt Corot, already a great lover of nature, experienced similar feelings before this spectacular setting, but at the time he seems to have been so much absorbed by his own artistic development and the pursuit of visual and pictorial experience that he failed to convey his more profound impressions. This small study from nature was his first seascape—a genre in which, whether in Normandy, La Rochelle, or Brittany, he would always find his own particular touches with which to render the light (see cat. no. 96).

1. See cat. no. 5, first paragraph.
2. "Elle était du plus beau calme et une des plus belles que j'ai vues. Je ne pouvais m'en arracher. J'étais sur la plage et n'ai point été sur la jetée de toute la journée. L'âme s'attache avec passion aux objets que l'on va quitter. C'est d'après cette mer que j'ai fait une étude de mémoire." Delacroix 1932, vol. 1, pp. 487–88. Delacroix's paintings of the subject are *La Mer vue des hauteurs de Dieppe,* 1852, oil on canvas, Musée du Louvre, Paris, and *La Mer à Dieppe,* watercolor, private collection.

PROVENANCE: The artist; his posthumous sale, Hôtel Drouot, Paris, pt. 1, May 26–28, 1875, no. 1; purchased at that sale by Charles Deschamps for 810 francs; Edmond Huybrechts, Antwerp; his sale, Hôtel Marie-Thérèse, Antwerp, May 15, 1902, no. 389; purchased at that sale by the Musées Royaux des Beaux-Arts de Belgique, Brussels, for 1,550 francs

EXHIBITIONS: Brussels 1960

REFERENCES: Robaut 1905, vol. 2, pp. 8–9, no. 3, ill., and vol. 4, p. 193, no. 1; Brussels, Musées Royaux des Beaux-Arts de Belgique 1984, p. 134, ill.

3

Le Petit Chaville
(Little Chaville)

Ca. 1825
Oil on paper mounted on canvas
9½ × 13 in. (24 × 33 cm)
Stamped lower right: VENTE COROT
The Visitors of the Ashmolean Museum, Oxford A642
New York and Ottawa only

R 16

Fig. 19. Corot. *Ville-d'Avray. Les Maisons Cabassud (Ville-d'Avray: The Cabassud Houses*; R 284). Oil on canvas, 10⅝ × 15⅜ in. (27 × 39 cm). Musée du Louvre, Paris (R.F. 2640)

To the west of Paris near Ville-d'Avray, nestled in the hills, is the small village of Chaville. Like Sèvres, Saint-Cloud, and Meudon, it was once surrounded by picturesque forests in which artists often worked—since they were easily accessible, even by foot, in just a few hours. Midway between Paris and Versailles, Chaville provided landscape motifs for Corot before his trip to Italy[1] and throughout his career.[2]

Robaut and Moreau-Nélaton dated this painting to 1823–25, but a comparison with the small study of Bois-Guillaume (cat. no. 1) points to a dating toward the end of this period, about 1825. Despite certain persisting awkwardnesses—the figures on the road are smaller in scale than the overall view—this work, painted on paper and certainly out of doors, already displays an accomplished technique. Hélène Toussaint correctly

emphasized its relation to *Ville-d'Avray. Les Maisons Cabassud* (fig. 19), given to the Louvre by Moreau-Nélaton in 1907, which shows some hesitancies and a certain dryness of style but also a perfect mastery of the effects of light and the treatment of trees.[3]

Peter Galassi, comparing this painting with certain works by Jean-Victor Bertin, correctly demonstrated that it is rooted in classic landscape instruction.[4] A beginner learned landscape painting through stylistic exercises in which he concentrated on the treatment of the sky, of trees, or of roads, relying not

only on working from nature but also on published collections of prints by Bertin or Mandevare intended for the use of students.[5] Corot was following this pedagogical method when he carefully copied the tree that takes up the entire right side of his study.

Despite such indications of his apprentice status, Corot already reveals here his own ambitions. Thus, the still Neoclassical construction he employs in this landscape will become systematic in his later work: the right side filled by foliage, the left side open to the horizon. This is the composition of the mature *Souvenir de Mortefontaine* (cat. no. 126). Corot's personality, that of a man devoted to the description of modest, everyday reality, is already evident in this seductive scene, as is his passion for the beautiful effects of light, heightened by the solidity of material things.

Robaut and Moreau-Nélaton identify a copy in a larger format that Corot made of this painting about 1855 and that he kept in his studio.[6]

1. Robaut and Moreau-Nélaton cite two paintings from this youthful period (R 16, R 34) and one painted after the trip to Italy (R 352).
2. A drawing in a sketchbook (R 3045) has been so identified, as well as two more paintings: *Blanchisseries de Chaville* (*Washhouses of Chaville*, R 797) and *Chaville le matin au printemps* (*Chaville, Morning, Springtime*, R 1473). Clearly, many landscapes that today are unidentified were also painted at Chaville.
3. Hélène Toussaint in Paris 1975, no. 3.
4. Galassi 1991a, pp. 77–80.
5. Mandevare 1804; Bertin 1816–24, 41 lithographs.
6. Robaut 1905, vol. 2, p. 10, no. 16. This copy was bought at the Bascle sale in April 1883 by Altmayer for 5,900 francs. Its present location is unknown.

PROVENANCE: Sold or given away by Corot at an unknown date and bought back by him in 1874 (according to Robaut); Corot's posthumous sale, Hôtel Drouot, Paris, pt. 1, May 26–28, 1875, no. 2; purchased at that sale by Marion, Paris, for 570 francs; Gustave Tempelaere, Paris (dealer), 1904 (according to Robaut); Hindley Smith; his bequest to the Ashmolean Museum, Oxford, 1939

EXHIBITIONS: Edinburgh, London 1965, no. 1; Manchester, Norwich 1991, no. 5

REFERENCES: Robaut 1905, vol. 2, pp. 10–11, no. 16, ill., and vol. 4, p. 193, no. 2; Fouchet 1975, p. 27; Leymarie 1979, pp. 11–12, ill.; Selz 1988, p. 21, ill. p. 28; Galassi 1991a, pp. 77–78, ill.; Galassi 1991b, p. 78, pl. 89

4

Ville-d'Avray. Entrée du bois avec une vachère (Ville d'Avray: Edge of the Woods, with a Woman Cowherd)

Ca. 1825
Oil on canvas
18⅛ × 13¾ in. (46 × 34.9 cm)
Signed lower right, undoubtedly at a later date: COROT
National Galleries of Scotland, Edinburgh NG 1681

R 33

The dating of this painting is rendered problematic by retouches Corot added to the right side after 1850 and above all by changes made by his friend Narcisse Diaz de la Peña, the Spanish painter. The drawing Robaut and Moreau-Nélaton reproduced in their catalogue raisonné (fig. 20) was based on a copy that differs from the original,[1] showing how the work appeared before retouching: a woman stood at the right of the picture, tending a cow beside the road that runs down toward the ponds of Ville-d'Avray.

Alfred Sensier, who owned the work until 1877, witnessed its transformation in Corot's studio.[2] Diaz had criticized the cow's execution (the composition was then as it is represented in the copy), and Corot, rather curtly, asked him to redo it himself. Diaz ignored his friend's offensive tone and set to work on the problem, removing the animal and replacing it with the figure of a seated woman, which can be seen in the painting in its present state. According to Robaut, Sensier added that on the same occasion he watched Corot change other details on the left side of the canvas. Most of these retouches are apparent to the eye.

Fig. 20. Drawing made by Alfred Robaut (1830–1909) after a copy of Corot's *Ville-d'Avray. Entrée du bois avec une vachère*. Robaut *cartons*. Département des Peintures, Musée du Louvre, Paris

Fig. 21. Corot. *La Route de Ville-d'Avray* (*The Road to Ville-d'Avray*), 1874. Museu Calouste Gulbenkian, Lisbon

The sky and the large tree, which were essentially left alone, suggest that the painting was done about 1825, in a style resembling that of *Le Petit Chaville* (cat. no. 3) and *Ville-d'Avray. Les Maisons Cabassud* (fig. 19), given to the Louvre by Moreau-Nélaton. As in *Le Petit Chaville*, Corot paid special attention to the treatment of the tree, the central element of the painting, and we are reminded that for him these studies were so many stages in his formation as a painter and were not necessarily meant to be exhibited.

This is one of the earliest works painted at Ville-d'Avray, where Corot's parents had owned a small country house since 1817. The road in those hills would figure in many other works, among them the first painting Corot made on returning from Italy (cat. no. 32) and *La Route de Ville-d'Avray* (fig. 21), painted in 1874. Corot often forsook the coolness of the ponds to work along the many small roads that radiated out beyond his parents' property.

1. "My sketch was made after a copy that had gone through the hands of many dealers." ("Mon croquis a été fait d'après une copie qui a passé par les mains de plusiers marchands.") Robaut *carton* 1. The copy is owned by the Göteborg Konstmuseum, Sweden.
2. Robaut 1905, vol. 2, p. 14, no. 33. Corot was especially close to Alfred Sensier after 1855, which puts this episode in the second half of his career.

PROVENANCE: Alfred Sensier, Paris (according to Robaut); purchased by the dealer Georges Petit, Paris, for his personal collection after Sensier's death in 1877; sale, Galerie Georges Petit, Paris, March 5, 1921, no. 65; P. E. Cremetti; purchased from him by the National Gallery of Scotland, Edinburgh, 1927, with the assistance of A. E. Anderson

EXHIBITIONS: London 1974, no. 27; Manchester, Norwich 1991, no. 4

REFERENCES: Robaut 1905, vol. 2, pp. 14–15, no. 33, ill.

5

Honfleur. Le Vieux Bassin (Honfleur: The Old Wharf)

Ca. 1824–25
Oil on canvas
11¾ × 16¾ in. (29.8 × 42.5 cm)
Signed lower left:[1] Corot Inscribed lower left: Honfleur
Museum of Art, Rhode Island School of Design,
Providence 43.007

R 35

The port of Honfleur gained renown through the artists of the Impressionist generation after Baudelaire's legendary visit of 1859, when he discovered, with astonishment, the art of Eugène Boudin. But artists had been coming since the end of the eighteenth century to this small, picturesque village, whose expansive lookouts lent themselves to the making of seascapes. Before 1830, Bonington, Turner, Paul Huet, Eugène Isabey, and of course Corot were all guests at the celebrated inn at the Saint-Siméon farm, run by Mère Toutain and her daughter, who later played host to Courbet, Jongkind, Boudin, and the young Monet. In going out to paint at Honfleur, Corot was not trailblazing but rather following once again in the footsteps of his teacher Michallon, who had worked in the ports along the Normandy coast while preparing a series of prints for the *Nouveau Voyage pittoresque de la France.* This collection

of "picturesque views of France" was brought out in 1817 by the publisher Ostervald, who commissioned illustrations from a variety of contemporary landscapists.

Uncertainty remains about the exact dates of Corot's trips to Normandy, and more specifically Honfleur, before 1825. Robaut and Moreau-Nélaton cite two pictures painted at Dieppe in 1822 and 1823,[2] but they mention only one work—the present painting—executed at Honfleur during that time, and they date it between 1822 and 1825. It is no easy task to

Fig. 22. Corot. *Dunkerque. Bateaux de pêche amarrés à quai* (*Dunkirk: Fishing Boats Tied to the Wharf;* R 213), 1829–30. Oil on canvas, 9¼ × 14¼ in. (23.6 × 36.1 cm). Sterling and Francine Clark Art Institute, Williamstown, Massachusetts

narrow down the date, since there are no known pictures representing kindred subjects painted in a similar technique.

Some fifteen paintings featuring the landscape around Honfleur done later in Corot's career are documented by Robaut and Moreau-Nélaton. It seems clear that, except for the Saint-Siméon farm (R 404), which Corot painted in homage to his hostesses as tradition dictated, and the Côte de Grâce, which recurs often in his early studies,[3] what attracted Corot about Honfleur was its port—the play of light on the water, the rigging of the ships, and the fishermen's houses.[4]

In this work, painted with pure colors and lit by an exceptionally transparent sky, Corot sought to render the effects of light on the buildings realistically and without any concessions to the picturesque. The fluidity and honesty of his palette, characteristic of his mature landscapes, are already evident here. This is the first in a lengthy series of works representing French ports, including La Rochelle, Le Havre, Dunkirk (fig. 22), and Saint-Malo.

1. Very likely at a later date, according to Robaut.
2. *Dieppe. Bout de jetée et la mer* (cat. no. 2), and *Dieppe. Vue panoramique prise aux environs* (*Dieppe: Panoramic View from the Outskirts*; R 11, private collection).
3. See cat. no. 45 and R 224, R 402, R 1355.
4. See cat. no. 44 and R 223, R 234, R 405, R 406, and a drawing, R 2716.

PROVENANCE: Alfred Forgeron, 1890, purchased for 8 francs (according to Robaut); Édouard-Napoléon-César-Edmond Mortier, the duc de Trévise, Paris; sale, Sotheby's, London, July 9, 1938, no. 98; M. Knoedler & Co., New York, 1942; purchased from them by the Museum of Art, Rhode Island School of Design, Providence, Works of Art Fund, January 8, 1943

EXHIBITIONS: Providence 1942, no. 15; New York 1956, no. 1; New York 1972, no. 13; Providence 1972, no. 15; Memphis, Oberlin, Louisville 1987–88, no. 36; New York 1988; Tokyo, Osaka, Yokohama 1989–90, no. 1

REFERENCES: Robaut 1905, vol. 2, pp. 14–15, no. 35, ill.; Anon. 1943, n.p., ill.; *Corot* 1952, n.p., no. 3, ill.; Leymarie 1966, p. 21; Bazin 1973, p. 275, ill. p. 124; Fouchet 1975, p. 34; Leymarie 1979, p. 12, ill.; Woodward and Robinson 1985, p. 189, ill.; Rosenfeld 1991, no. 15, ill.

6

Rome. Le Colisée vu à travers les arcades de la basilique de Constantin (Rome: The Coliseum Seen through Arches of the Basilica of Constantine)

December 1825
Oil on paper mounted on canvas
9⅛ × 13¾ in (23.2 × 34.8 cm)
Dated lower right: Xbre 1825 Stamped lower left: VENTE COROT
Musée du Louvre, Paris
Bequest of Étienne Moreau-Nélaton, 1906 R.F. 1696
Paris only

R 44

Although his arrival in Rome was greeted by days of steady downpour,[1] Corot immediately set to work, and the month of December 1825 proved rich in landscape studies.[2] After painting Rome's rooftops from the window of his room,[3] he worked before the Coliseum[4] and then undertook two panoramic views, expanding his field of investigation to include sky and light effects.[5] Finally, he fulfilled his desire to revive the spirit of Nicolas Poussin by painting *Les Fabriques du Poussin* (*The Buildings of Poussin*; R 48, private collection) on the banks of the Tiber. The present picture, one of these canvases dating from early in his stay, reveals the scope of his ambitions. Here he was grappling with a subject often treated by his teachers and colleagues: the contrast between shadow and light and the construction of space, as they are heightened by viewing a landscape through open archways.

To be sure, Corot had already studied similar effects as early as 1822 during his apprenticeship in Paris and the Île-de-France.

There was his painting of the gate to the Sennegons' property in Rouen (cat. no. 1); *Paris. Le Vieux Pont Saint-Michel* (fig. 9), which shows the banks of the Seine, the moored barges, and the Petit Pont seen through the arches of the Pont Saint-Michel;[6] and *Moret (Seine-et-Marne). Arches de pont*, which, like this view of the Coliseum, is narrowly focused on the arches.[7]

But when he set himself up before the Roman ruins, Corot could take particular inspiration from many studies by his predecessors depicting the city's ancient monuments. Peter Galassi has rightly stressed those antecedents of Corot's compositions; the Coliseum and the Basilica of Constantine were traditional subjects for landscape artists working in Rome.[8] He cites oil studies and drawings of the basilica seen through the arcades from farther back, facing away from the Coliseum, by the German artist Ernst Fries[9] and by Corot himself,[10] as well as drawings by Achille-Etna Michallon[11] and Théodore Caruelle d'Aligny,[12] closer still to the present painting, which show the

Fig. 23. Pierre-Henri de Valenciennes (1750–1819). *Ruines romaines (Roman Ruins)*. Oil on paper mounted on card, 16½ × 10¼ in. (42 × 26 cm). Musée du Louvre, Paris (R.F. 2928)

ruins of the basilica, the arcades on either side, and the Coliseum in the distance.

In adopting this compositional device, which highlights the nobility of the ancient architecture, these Neoclassical artists were rediscovering an approach to landscape used by numerous painters of the eighteenth century. An older antecedent is Poussin's masterly, luminous landscape seen through the windows of a dark room in *Le Mariage*, from the series *Les Sacrements*,[13] but there are also Hubert Robert's *Intérieur du Colisée*[14] and *Le Vieux Pont*[15] as well as Pierre-Henri de Valenciennes's Italian oil studies, such as *À la villa Farnèse, l'escalier* and *Ruines romaines* (fig. 23).[16] All these works use a landscape seen through an architectural opening as the basis for a pictorial tour de force that combines contrasts of shadow and light with an intriguing visual surprise.

Both of Corot's teachers had employed this compositional artifice. Michallon used it in *Les Voûtes du Colisée au soleil couchant (The Arches of the Coliseum in the Setting Sun)*, in which the Arch of Constantine is visible through the arcades of the Coliseum,[17] as well as in his superb series of studies in pencil, wash, and oil, La *Villa Médicis vue à travers une arcade* (fig. 24)[18] and another series of broader views, *Ruines du théâtre de Taormine*.[19] Corot had surely been able to see and perhaps to copy these studies, which were then in his teacher's studio, just as he must have known those by Jean-Victor Bertin, who in 1819 had painted an ambitious studio composition, *Paysage avec une grande arche*, that demonstrated similar concerns.[20]

Still, it was without intellectualism or any apparent reference to other works and with utter lucidity that Corot painted the present study, in which he borrowed Michallon's pictorial approach, squared and solid for the architecture, fluid for the sky. The arcades of the Basilica of Constantine fill the entire surface of the work, and the Coliseum's noble architecture is counterbalanced by the bare, ravaged wall of the basilica at the left. The extremely limited palette, mostly browns, light grays, and dark greens, evokes a bleak winter's morning.

Some art historians have understood what was so innovative about this view of the Coliseum, among them Lionello Venturi: "This small painting is truly a masterpiece. . . . Think of Pannini and Hubert Robert, both painters of Roman ruins, and of their superficiality and artifice. . . . In Corot's small paintings, what has disappeared is precisely the 'view.' Corot painted many 'views' of Roman sites, and perhaps even repeated too often those *Castel Sant'Angelos* and *Roman Forums* in which he could demonstrate his refinement of composition and his sensitive treatment of light. But this little panel is different. The subject is the Roman ruins, but the motif is the painter's own humility, his tenderness, his affection for the refuge that he has found."[21]

Later Corot would recall this arrangement in some of his compositions, such as *Les Ruines du temple de Jupiter Stator à Rome* (R 129) or even *Narni. Le Pont d'Auguste sur la Néra* (cat. no. 26),

Fig. 24. Achille-Etna Michallon (1796–1822). *La Villa Médicis vue à travers une arcade (The Villa Medici Seen through an Arch)*. Musée des Beaux-Arts, Orléans (643)

Fig. 25. Corot. *Le Château de Maintenon* (Schoeller and Dieterle 1948, no. 24), ca. 1850. Private collection

6

and then take it up again in its entirety in a study done about 1850 of the château of Maintenon, near Paris, seen through the arches of its aqueduct (fig. 25).

1. Letter (a.l.s.), Corot to his friend Abel Osmond, Rome, December 2, 1825 (Département des Arts Graphiques, Musée du Louvre, Paris, Moreau-Nélaton Bequest, 1927, A.R. 8 L 2).
2. Robaut and Moreau-Nélaton cite six oil studies, which show the cloudy gray skies of early winter, painted during this month (R 43–R 48), and mention that Corot painted or drew in figures in his studio on rainy days.
3. *Rome. Vue prise de la fenêtre de Corot*, R 43, private collection.
4. *Rome. Le Colisée*, R 46, location unknown, and the present painting.
5. *Monte Testaccio*, R 45, Musée du Louvre, Paris, Moreau-Nélaton Bequest; *Rome. De la Tour Saint-Clément au Colisée*, R 47, location unknown.
6. R 15, Musée Départemental de l'Oise, Beauvais.
7. Painted in October 1822; R 28, private collection.
8. Galassi 1991a, p. 138.
9. Fries, *La Basilique de Constantin*, black and white chalk, Staatliche Graphische Sammlung, Munich.
10. Corot, *La Basilique de Constantin*, R 80, private collection.
11. Michallon, *La Basilique de Constantin*, graphite on paper, Département des Arts Graphiques, Musée du Louvre, Paris.
12. Aligny, *La Basilique de Constantin*, graphite on paper, Museo di Roma.
13. Nicolas Poussin, *Les Sacrements*, collection of the Duke of Sutherland, housed at the National Gallery of Scotland, Edinburgh.
14. Musée du Louvre, Paris, R.F. 2959.
15. National Gallery of Art, Washington, D.C.
16. Musée du Louvre, Paris, R.F. 2988, 2928.
17. Musée des Beaux-Arts, Orléans, no. 1083.
18. A small oil study, Musée des Beaux-Arts, Orléans, no. 643, and two drawings in private collections.
19. Two studies are in the Musée du Louvre, Paris: an oil study, R.F. 2874, and a wash study in the Département des Arts Graphiques, R.F. 14,276. A studio painting based on these studies is in Baltimore, and another went to the collection of the duc d'Orléans, son of Louis-Philippe.

20. Now in the Musée du Louvre, Paris. Other relevant works are Christopher Wilhelm Eckersberg's study *Vue de Rome prise à travers les arcades du Colisée* of about 1815 (Statens Museum for Kunst, Copenhagen), which is very similar in composition to Corot's picture, and *La Loge Aldobrandini à Frascati* by Nicolas Didier Boguet (Musée Granet, Aix-en-Provence), painted one year before Corot's arrival in Rome in 1824, which shows a concern with construction and light identical to his.
21. "Ce petit tableau est vraiment un chef-d'oeuvre. . . . Songez à Pannini et à Hubert Robert, tous deux peintres de ruines romaines, à leur superficialité, à leur artifice. . . . Dans les petites peintures de Corot, ce qui a disparu, c'est précisément la 'vue'. Corot a peint beaucoup de 'vues' romaines: il n'a même que trop répété ces *Château Saint-Ange* et ces *Forum romain* où il a pu montrer son raffinement dans la composition et sa sensibilité dans la lumière. Mais dans ce petit panneau le motif est autre. Le sujet, ce sont des ruines romaines, mais le motif c'est l'humilité du peintre, sa tendresse, son affectueux attachement au refuge qu'il a trouvé." Venturi 1941, pp. 139–40.

PROVENANCE: The artist; his posthumous sale, Hôtel Drouot, Paris, pt. 1, May 26–28, 1875, no. 258 (painted on wood, according to Robaut); purchased at that sale by Aimé-François-Désiré Diot, Paris, for 180 francs; Doria collection, Paris; Doria sale, Galerie Georges Petit, Paris, May 5, 1899, no. 111; purchased at that sale by the painter Jean-Charles Cazin, Paris, for 3,000 francs; Étienne Moreau-Nélaton, Paris; bequeathed by him to the Musée du Louvre, Paris, 1906; displayed at the Musée des Arts Décoratifs, Paris, from 1907; entered the Louvre, 1934

EXHIBITIONS: Paris 1907, no. 7; Paris 1991, no. 41

REFERENCES: Robaut 1905, vol. 1, pp. 30–31, vol. 2, pp. 18–19, no. 44, ill., vol. 4, p. 224, no. 258; Brière 1924, no. M 7; Moreau-Nélaton 1924, vol. 1, p. 14, ill.; Venturi 1941, pp. 138–41, ill.; Sterling and Adhémar 1958, no. 350, ill.; Paris, Musée du Louvre 1972, p. 92; Leymarie 1979, p. 19, ill.; New York, Omaha, Los Angeles, Chicago 1981–82, fig. 16; Compin and Roquebert 1986, p. 152; Galassi 1991a, pp. 137–40, ill.; Galassi 1991b, pp. 137–40, pl. 161

Three views of Rome

7. Vue prise des jardins Farnèse (le matin)
(View from the Farnese Gardens: Morning)

8. Étude du Colisée, also called *Vue prise des jardins Farnèse (le midi)*
(Study of the Coliseum, also called *View from the Farnese Gardens: Noon)*

9. Le Forum vu des jardins Farnèse (le soir)
(The Forum Seen from the Farnese Gardens: Evening)

Fig. 26. Pierre-Henri de Valenciennes (1750–1819). *Vue du Colisée (View of the Coliseum).* Oil on paper mounted on card, 10 × 15 in. (25.5 × 38.1 cm). Musée du Louvre, Paris (R.F. 2945)

"Fifteen days in a row he came back and sat himself down at the same time, in the same place, and, on a small square of canvas three times the size of a hand, painstakingly detailed the splendors of the site he had chosen as his subject. Opposite him, the Coliseum, looming up from the heart of the ancient city, dominated the blue horizon of the mountains with its warm, ruddy mass. If the light began to change too much for this study he replaced it with another, and, without leaving the terrace of the Farnese Gardens but merely shifting his point of view, he steadfastly pursued his task."[1]

Étienne Moreau-Nélaton's description of the making of a series of three studies painted from the Farnese Gardens in Rome comes from accounts by Alfred Robaut and Théophile Silvestre, who were reporting Corot's own recollections. We know that the three pictures were executed in the open air, and we know their topographical orientations; but how the artist completed the works, the extent of his retouching in the studio, and what motivated him to paint these studies as a group remain unclear.

The Farnese Gardens, which were laid out covering the ancient palace of Tiberius in the sixteenth century, offer the best vantage point for viewing the extraordinary Roman Forum and the ancient ruins that surround it. From these heights, a few steps from the Palatine, the Arch of Constantine, and the Coliseum, "the city par excellence" is displayed, its ruins revealing that "modern Rome is but a shadow of ancient Rome."[2] The painter Pierre-Henri de Valenciennes, the author of those sentiments, advised his students to paint the city of Rome from that high point,[3] and he followed his own advice; the Louvre owns a picture (fig. 26)[4] that he executed at exactly the spot where Corot painted the view of the Coliseum catalogued here. Several years later, about 1822, Achille-Etna Michallon, a student of Valenciennes and Corot's teacher, did yet another *Vue du Colisée*[5] taken from the same vantage point, although perhaps painted in his studio on his return to Paris; very likely Corot saw this work during his sessions in Michallon's atelier. Indeed, since the middle of the eighteenth century the site had been favored by artists working in Rome, and studies made there by Jean-Joseph Bidauld and Jean-Victor Bertin are known.

Fig. 27. Jacques-Raymond Brascassat (1804–1867). *Le Colisée vu des jardins Farnèse (The Coliseum Seen from the Farnese Gardens),* 1827. Musée des Beaux-Arts, Rouen

Fig. 28. Henri-Joseph Harpignies (1819–1916). *Le Colisée, à Rome (The Coliseum in Rome).* Oil on canvas, 18½ × 25¾ in. (47 × 65.5 cm). Musée du Louvre, Paris (R.F. 493)

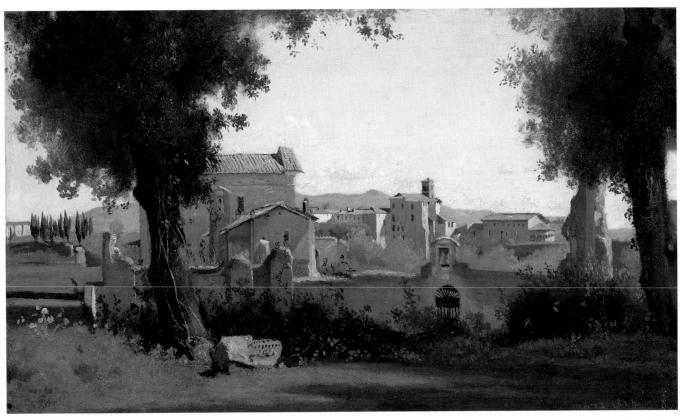

7. *Vue prise des jardins Farnèse (le matin)* (*View from the Farnese Gardens: Morning*), March 1826. Oil on paper mounted on canvas, 9⅝ × 15¾ in. (24.5 × 40.1 cm). Stamped lower left: VENTE COROT Dated lower right: mars 1826 The Phillips Collection, Washington, D.C. (0336) R 65 *New York and Paris only*

8. *Étude du Colisée*, also called *Vue prise des jardins Farnèse (le midi)* (*Study of the Coliseum*, also called *View from the Farnese Gardens: Noon*), March 1826. Oil on paper mounted on canvas, 11¾ × 19¼ in. (30 × 49 cm). Signed and dated lower right:[6] COROT mars 1826 Musée du Louvre, Paris (R.F. 154) R 66

9. *Le Forum vu des jardins Farnèse (le soir)* (*The Forum Seen from the Farnese Gardens: Evening*), March 1826. Oil on paper mounted on canvas, 11 × 19¾ in. (28 × 50 cm). Signed and dated lower right:[6] mars 1826 COROT On the back, in chalk: Au Museum Musée du Louvre, Paris (R.F. 153) R 67

So in March 1826 it was not as an innovator that Corot left his lodgings in the neighborhood of the Piazza di Spagna, traversed the Quirinale, passed alongside the Fontana di Trevi, and crossed the Piazza Venezia to set to work in the Farnese Gardens. At just about the same time, the German Ernst Fries and the young Jacques-Raymond Brascassat, winner of the Prix de Rome for historical landscape, were also painting views from the Farnese Gardens (fig. 27). However, Corot's decision to work simultaneously on three plein air studies, painted from three different viewpoints and at three different times of the day, is more original.

It is true that as early as 1708, Roger de Piles had advised young students of landscape to study "in the same way [after nature] the effects of the sky at different times of day, in different seasons, with different cloud formations. . . ."[7] Many painters of the eighteenth century—beginning with the most

noted of them, like Joseph Vernet—had maintained this classical tradition, taking up again in their studio paintings the theme of the hours of the day, which had become fashionable along with that of the seasons. A century later, Valenciennes detailed with his usual precision the four times of day propitious for landscape study: "The divisions adopted by Artists for the four parts of the day are: morning, noon, evening, and night."[8]

Corot, in the studio first of Michallon and then of Bertin—two ardent admirers of Valenciennes's teaching—must have learned the characteristics of the dewy, fresh light of morning, that moment "when the sun, fully risen on the horizon, casts its brilliant light on all the objects of Nature, endowing them with the sensation of life through the advance of its salutary warmth." He would also have received recommendations for seizing the intense luminosity of noon, when "Nature [is] prey to the devouring fires of high summer [and] the shadows cast

Fig. 29. Louise-Joséphine Sarazin de Belmont (1790–1870). *Vue du Forum, le matin (View of the Forum, Morning)*. Musée des Beaux-Arts, Tours

Fig. 30. Louise-Joséphine Sarazin de Belmont (1790–1870). *Vue du Forum, le soir (View of the Forum, Evening)*. Musée des Beaux-Arts, Tours

are barely longer than the bodies that produce them." He would have been able to copy a variety of studies by Michallon and Bertin painted in the evening, when "illuminated objects have a golden hue that contrasts strikingly with the bluish shadows one always sees at sunset."[9]

Thus, when he set to work in the Farnese Gardens, Corot had in mind a precise dictate: a young painter must habituate eye and hand to capturing the way light looks at the various hours of the day. Peter Galassi quite rightly pointed out in his *Corot in Italy* that Corot carried out his work according to a system and that the orientation he chose for each of his studies faithfully followed that of the sun; in the morning, he looked toward the church of San Sebastiano (cat. no. 7), to the east; at noon, the Coliseum (cat. no. 8), to the northeast; and by the evening, he had sharply turned to the west, and the Forum (cat. no. 9).

But did Corot really work only out of doors in painting these three studies, and did he methodically proceed on them in sequence to follow the passage of each day? That way of working within prescribed time limits actually departs from the classic instruction, which favors instead the rapid and synthetic grasp of the light of a given hour without retouching on another day, since the light is rightly considered to be constantly changing. It seems remarkable that Corot, who otherwise proved faithful in so many particulars to Valenciennes's teaching, should deliberately turn away from this recommendation: "The effects of Nature are almost never the same at corresponding moments of the same hour. . . . What we have said must suffice to prove that it is absurd to spend an entire day copying a single view from Nature. . . . There are other [artists] who only copy Nature at two-hour intervals, and who return the following days at the same times to continue their studies. These latter are certainly more rational than the former . . . but how can they be sure, when they stop working today, that they will find again tomorrow the same air, the same color of the light, of shadows, of reflections?"[10]

Isn't it more likely that Corot alternated outdoor painting sessions, when he worked to get down the various topographical elements and absorb the luminous quality of a given hour,

with lengthy studio sessions carried out later in his lodgings? The cleanness of surface and unlabored handling of paint in these three works, along with the rigorous placement of the clearly delineated architectural elements, seem to suggest a mixed approach, combining the spontaneity of plein air observation with the exactitude of work in the studio. Corot's practice later and throughout his career of endlessly moving between the out-of-doors and the atelier reinforces this surmise.

The thesis is neither proven nor disproven by laboratory examinations of the two Louvre paintings. They show that the vegetation in the foreground was perfectly integrated from the first—possibly a sign that all the elements were painted in plein air, although if the studio work followed the outdoor session quickly enough, the difference between them would not be noticeable. Examination also reveals that the trees at the right in the study of the Coliseum were added later, perhaps in 1849, the year Corot exhibited the work at the Salon.

One fact is certain: Corot did not consider these three works finished paintings. Théophile Silvestre tells us that in 1853 Corot had not had them mounted on canvas. Apparently he was unconcerned by the fragility of their paper supports and did not feel the studies merited the same careful conservation as finished works. And when he exhibited the study of the Coliseum at the 1849 Salon alongside imposing pictures like the *Christ au jardin des oliviers* (*Christ in the Garden of Gethsemane*; R 610, Musée de Langres) and perfected canvases like the landscapes of Limousin, Volterra, and Ville-d'Avray, he retained the traditional distinction, calling the finished works "views" and this painting a "study."

Critics showed no interest in this picture, and it went unnoticed.[11] Only much later—perhaps not until 1873, when he decided to bequeath two of them to the Louvre—did Corot finally seem to regard these works as complete in themselves.[12] By then, aesthetic views had evolved and his own conception of landscape had matured.

Their importance in his oeuvre is nevertheless considerable. The works exhibit a technical mastery and feeling for light that signal the debut of an independent landscape painter utilizing his own personal approach. Moreover, throughout his career Corot continued to employ this theme of the times of day, particularly in his *souvenirs*. But Corot here omitted the fourth traditional time of day, or else the work has been lost: no study made at night concludes this series.

1. "Quinze fois de suite, il retourne s'asseoir, à la même heure, au même endroit et, sur un petit carré de toile trois fois grand comme la main, il détaille patiemment les splendeurs du lieu qu'il s'est proposé comme modèle. En face de lui, le Colisée, émergeant du sein d'antique cité, domine de sa masse rousse et chaude l'horizon bleu des montagnes. La lumière vient-elle à tourner, à cette étude, il en substitue une autre et, sans quitter la terrasse des jardins Farnèse, changeant seulement de point de vue, il poursuit obstinément sa tâche." Moreau-Nélaton 1924, vol. 1, p. 15.
2. "la ville par excellence"; "Rome moderne n'est plus que l'ombre de Rome ancienne." Valenciennes 1800, pp. 590–91.
3. Ibid., p. 598.
4. R.F. 2945. It entered the Louvre in 1930 with the gift of the princesse Louis de Croÿ.

5. An unfinished study (private collection, Paris), exhibited in Cambridge, London 1980–81, and in Paris 1994.
6. Perhaps forged, according to Hélène Toussaint in Paris 1975.
7. "de la même manière les effets du ciel dans les différentes heures du jour, dans les différentes saisons, dans les différentes dispositions des nuages. . . ." Piles 1989, p. 120.
8. "Les divisions adoptées par les Artistes pour les quatres parties du jour sont: le matin, le midi, le soir et la nuit." Valenciennes 1800, p. 427.
9. "où le soleil, entièrement élevé sur l'horizon, porte sa lumière éclatante sur tous les objets de la Nature, et leur donne le sentiment de la vie par la gradation de sa chaleur bienfaisante"; "la Nature en proie aux feux dévorants de la canicule . . . les ombres portées dépassent à peine les corps qui les produisent"; "les objets éclairés sont d'une teint dorée qui contraste singulièrement avec les ombres bleuâtres que l'on observe toujours au soleil couchant." Ibid., pp. 429, 435, 442.
10. "Les effets de la Nature ne sont presque jamais les mêmes aux mêmes instants à pareille heure. . . . Ce que nous avons dit doit suffir pour prouver qu'il est absurde de passer tout une journée à copier d'après Nature une seule vue. . . . Il en est d'autres . . . qui ne copient la Nature que pendant l'intervalle de deux heures, et qui reviennent les jours suivants aux mêmes instants pour continuer leurs études. Certainement, ceux-ci sont plus raisonnables que les premiers, . . . mais qui leur promet, quand ils quittent leur ouvrage aujourd'hui, qu'ils retrouveront demain la même vapeur, la même couleur de lumière, d'ombres et de reflets?" Ibid., pp. 406–7.
11. Except for a brief mention by Trianon 1849, p. 470.
12. They did not enter the Louvre until 1886.

Cat. no. 7 (R 65)

PROVENANCE: The artist; his posthumous sale, Hôtel Drouot, Paris, pt. 1, May 26–28, 1875, no. 17; purchased at that sale by Paul Détrimont,* Paris, for 3,750 francs; Détrimont collection, Paris, to the end of 1905 (according to Robaut); Quincy Adams Shaw, Boston (according to Robaut); Mrs. Malcolm Graeme Haughton, 1929; Paul Rosenberg & Co., New York; purchased by Duncan Phillips, 1942 (partially paid for by exchange for a painting by Matisse)

EXHIBITIONS: Cambridge 1929, no. 11, as *City on the Hill*, lent by Mrs. Malcolm Graeme Haughton; Philadelphia 1946, no. 1; Toronto 1950, no. 1; New York 1956, no. 2; Tokyo, Kobe, Sapporo, Hiroshima, Kitakyushu 1980, no. 19; San Francisco, Dallas, Minneapolis, Atlanta, Oklahoma City 1981–83, no. 11; Tokyo, Nara 1983, no. 7; New York 1983–84, no. 20; New York 1986, no. 3; New York 1990, no. 63

REFERENCES: Robaut 1905, vol. 2, pp. 24–25, no. 65, ill., and vol. 4, p. 195, no. 17; Venturi 1941, pp. 139–40; Washington, Phillips Collection 1952, p. 19; Hours 1972, p. 18, ill.; Fouchet 1975, pp. 48–51; Leymarie 1979, pp. 20–22, ill.; Washington, Phillips Collection 1985, no. 310, ill.; Selz 1988, pp. 32–34, ill., pp. 62–63; Galassi 1991a, pp. 149–55, ill.; Galassi 1991b, pp. 149–53, pl. 178

* Paul Détrimont purchased 19 works from Corot's posthumous sale.

Cat. no. 8 (R 66)

PROVENANCE: The artist; bequeathed by him to the Musée du Louvre, Paris, 1875; displayed at the Musée du Luxembourg, Paris, from 1878; entered the Louvre (after numerous objections), October 1886

EXHIBITIONS: Paris (Salon) 1849, no. 442, as *Étude du Colysée, à Rome*; Paris 1875a, no. 212; Paris 1936, no. 5; Lyons 1936, no. 4; Paris 1946b, no. 169; Paris 1948, no. 206; Rome, Florence 1955, no. 16 (Rome), no. 15 (Florence); Munich 1964–65, no. 34; Paris 1975, no. 5

REFERENCES: Asselineau 1851, p. 54; Silvestre 1853, p. 13; Michel 1896a, pp. 14–15; Michel 1905, pp. 12, 14; Robaut 1905, vol. 1, pp. 22, 122, and vol. 2, pp. 22–23, no. 66, ill.; Moreau-Nélaton 1913, pp. 11–15, ill.; Moreau-Nélaton 1914b, ill. opp. p. 16; Brière 1924, no. 140; Moreau-Nélaton 1924, vol. 1, pp. 15–16, ill. p. 14, and vol. 2, p. 105; Focillon 1927, p. 310, ill.; Michel 1928, pp. 129–31; Fosca 1930, pl. 11; Meier-Graefe 1930, pl. IV; Jamot 1936, p. 5, ill.; Venturi 1941, pp. 139–40; Bazin 1942, p. 33, no. 9, pl. 9; Escholier 1943, p. 146, ill.; Bazin

1951, p. 35, no. 13, pl. 13; Baud-Bovy 1957, p. 21, fig. 9; Sterling and Adhémar 1958, no. 353, fig. 95; Leymarie 1966, p. 30, fig. p. 28; Hours 1972, fig. 10; Paris, Musée du Louvre 1972, p. 86; Bazin 1973, pp. 28, 276, ill. p. 132; Fouchet 1975, pp. 48–51, ill.; Leymarie 1979, pp. 20–23, ill.; Compin and Roquebert 1986, p. 147; Selz 1988, pp. 33–37, ill.; Galassi 1991a, pp. 149–51, ill.; Galassi 1991b, pp. 149–53, ill. p. 155 (detail), pl. 179

Cat. no. 9 (R 67)

PROVENANCE: Left the artist's studio to be copied, but returned by 1873, when Corot wrote on the back, "Au Museum" (according to Robaut); bequeathed by the artist to the Musée du Louvre, Paris, 1875; displayed at the Musée du Luxembourg, Paris, from 1878; entered the Louvre (after numerous objections), October 1886

EXHIBITIONS: Paris 1875a, no. 211; Paris 1934, no. 60; Paris 1936, no. 6; Lyons 1936, no. 5; Buenos Aires, Montevideo 1939–40, no. 14; Rome, Florence 1955, no. 15 (Rome), no. 14 (Florence); Paris 1975, no. 6; Rome 1975–76, no. 8; Moscow 1982, no. 66; Lugano 1994, no. 1

REFERENCES: Silvestre 1853, p. 13; Michel 1896a, pp. 14–16; Michel 1905, p. 12; Robaut 1905, vol. 1, p. 22, and vol. 2, pp. 26–27, no. 67, ill.; Brière 1924, no. 139; Moreau-Nélaton 1924, vol. 1, ill., and vol. 2, p. 105; Focillon 1927, p. 310; Michel 1928, pp. 129–31; Meier-Graefe 1930, pl. 11; Blanche 1931, pp. 24–25; Bazin 1936, p. 47, fig. 25; Jamot 1936, pp. 10–11, ill.; Venturi 1941, pp. 139–40; Sterling and Adhémar 1958, no. 352, fig. 95; Leymarie 1966, p. 30, ill. p. 29; Hours 1972, p. 72; Paris, Musée du Louvre 1972, p. 86; Fouchet 1975, pp. 48–51, ill.; Leymarie 1979, pp. 20–23, ill.; Compin and Roquebert 1986, p. 147; Selz 1988, pp. 33–37, 66–67, ill.; Galassi 1991a, p. 151; Galassi 1991b, pp. 149–53, pl. 180

10

Le Forum vu des jardins Farnèse (The Forum Seen from the Farnese Gardens)

Ca. 1830
Oil on canvas
20⅞ × 38¼ in. (53 × 97 cm)
Signed lower left: COROT Stamped lower left: VENTE COROT
Lent from the Joan Whitney Payson Collection
New York and Ottawa only

R 68

Despite the technical problems he encountered, his time spent in the Farnese Gardens painting views of Rome at various hours of the day left Corot with delightful memories. These inspired him, no doubt soon after his return to France,[1] to create in the studio paintings of a larger format that were based on the small Roman studies. Of the three Roman views, clearly *Rome. Le Forum vu des jardins Farnèse* (cat. no. 9) is the one he considered the most successful—perhaps because of its superb effect of evening light—since he made two copies after it, one of which is shown here. Possibly he also wanted to evoke the memory of one of his heroes, Claude Lorrain, whose superb *Vue du Campo Vaccino* (fig. 31) he would have been able to study at the Louvre.

In making the copies Corot added figures to the foreground, thus conferring on them the status of finished works. The picture shown here retains the viewpoint of the small study in the Louvre. Corot simply enlarged the foreground, adding at the left a column lying in the grass, on which a young man sits. Those features responsible for the success of the original plein air study—the sense of light and the treatment of the architectural volumes of the Forum ruins—remain intact in this polished work.

The other version (R 69), which has disappeared, was painted for François-Parfait Robert, a friend from Mantes for whom Corot created the well-known bathroom decoration (R 435–R 440) now in the Louvre (R.F. 2605). It had an airier

Fig. 31. Claude Lorrain (1604/5?–1682). *Vue du Campo Vaccino*. Oil on canvas, 22 × 28⅜ in. (56 × 72 cm). Musée du Louvre, Paris (inv. 4713)

composition that allowed for more luxurious vegetation, and it too was animated by figures.

1. Robaut and Moreau-Nélaton date this picture to the years 1830–40 (Robaut 1905, vol. 2, p. 26, no. 68), but a date closer to 1830 is more convincing.

PROVENANCE: The artist; his posthumous sale, Hôtel Drouot, Paris, pt. 1, May 26–28, 1875, no. 52; purchased at that sale by Paul Détrimont, Paris, for 2,650 francs; the baron Denys Cochin, Paris, 1905 (according to Robaut); his sale, Galerie Georges Petit, Paris, March 26, 1919, no. 2; purchased at that sale by Bernheim-Jeune & Cie., Paris, for 57,000 francs; Wildenstein & Co., New York; from Wildenstein in 1958 to Joan Whitney Payson, New York and Manhasset, until 1975; bequeathed to the present owner

EXHIBITIONS: Paris 1952, no. 16; Kyoto, Tokyo 1980, no. 5

REFERENCES: Robaut 1905, vol. 2, pp. 26–27, no. 68, ill., and vol. 4, p. 198, no. 52

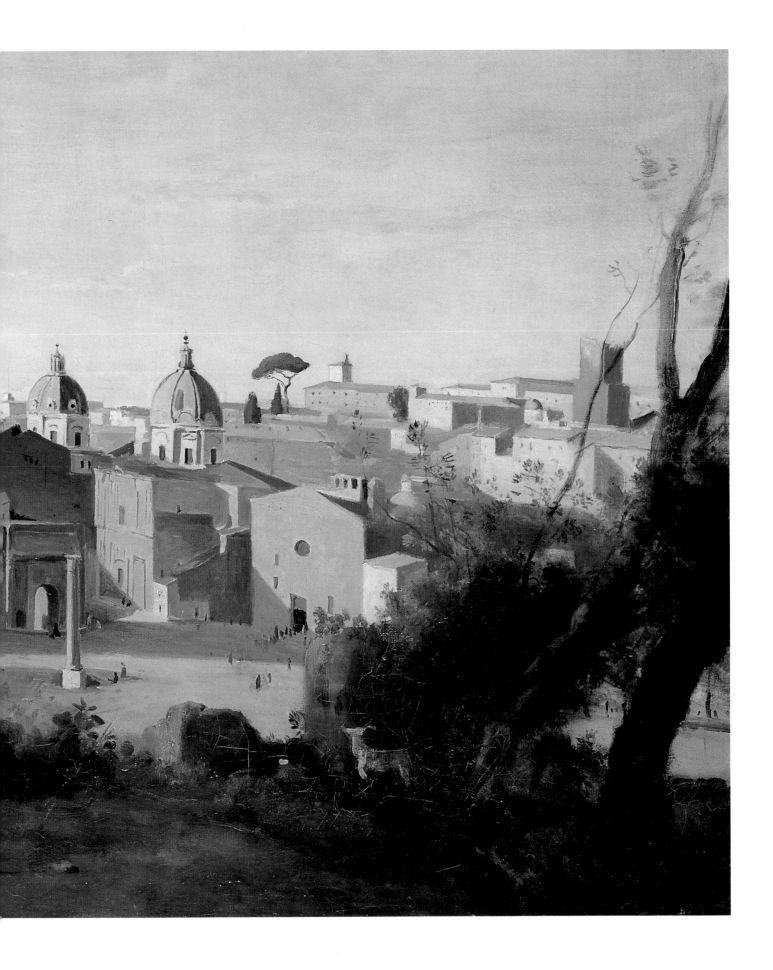

Rome. Le Château Saint-Ange (Rome: Castel Sant'Angelo)

Ca. 1826–27, revised by the artist ca. 1835
Oil on canvas
13½ × 18¼ in. (34.2 × 46.5 cm)
Signed lower left: COROT COROT COROT
Sterling and Francine Clark Art Institute, Williamstown,
Massachusetts 555

R 71

Begun by the Roman emperor Hadrian in A.D. 135 as an imperial mausoleum and completed in 139, the Castel Sant'Angelo became a fortress and then a prison. It was dismantled in 1378 but soon restored and fortified by the popes, who used it as a refuge in times of crisis. Great architects, among them Bernardo Rossellino, Bramante, and Sangallo, worked on it under Julius II and Clement VII.

Set on the banks of the Tiber River not far from Vatican City, Castel Sant'Angelo was a traditional subject for Italian *vedute* painters and French artists sojourning in Rome during the eighteenth century and a rite of passage for every landscapist, as well as a popular theme among lovers of art. There are delightful interpretations of the Castel by Joseph Vernet,[1] Victor-Jean Nicolle,[2] and Jean-Baptiste Lallemand,[3] among the French artists, and many by the Flemish artist Gaspar van Wittel. Other painters, including Jean-Louis Desprez,[4] Achille-Etna Michallon,[5] Joseph Wright of Derby,[6] and Léon Coignet,[7] depicted the Castel Sant'Angelo at night with fireworks being set off, as they were for religious festivals, official visits, or the election of a new pope.

Looking out the window of his room, from which he had painted the roofs of Rome on his arrival in December 1825,[8] Corot could see the dome of Saint Peter's basilica and could make out the massive form of the Castel just a short walk away. During his stay in Rome he took the fortress as his subject several times and from various vantage points. He drew it standing out starkly against the mountains in three panoramic views in pencil made from the Vatican,[9] and he painted it with its approaches as seen from the banks of the Tiber in oil on paper at least twice.

For his first oil study Corot set himself up in front of the Ospedale Santo Spirito, not far from the Via della Conciliazione; from there he could make the Castel Sant'Angelo the center of his composition and have the Ponte Sant'Angelo and several houses on the left bank of the Tiber appear at the right (fig. 32).[10] This spontaneous and fluid study, which he later gave to his friend Comairas,[11] entered the collection of Étienne Moreau-Nélaton and was given by him to the Musée du Louvre in 1906. The Musée des Beaux-Arts in Lille has another study, done from the same viewpoint but a little more tightly cropped, that has sometimes been attributed to Corot and sometimes to his contemporary Théodore Caruelle d'Aligny.[12]

Corot next planted his easel on the left bank of the Tiber, opposite the Castel and upriver from the Ponte Sant'Angelo. From this vantage point he could include in his composition a group of houses on the bank of the Tiber at the left, the dome of Saint Peter's looming above the bridge in the center, and the fortress itself at the right. The painting is without figures and displays very vigorous brushwork. It is now in San Francisco (fig. 33).[13]

Fig. 32. Corot. *Le Château Saint-Ange et le Tibre (Castel Sant'Angelo and the Tiber;* R 73). Oil on canvas, 9⅞ × 17½ in. (25 × 44.5 cm). Moreau-Nélaton Bequest, Musée du Louvre, Paris (R.F. 1622)

Fig. 33. Corot. *Pont et Château Saint-Ange avec le coupole de Saint-Pierre (The Bridge and Castel Sant'Angelo with the Cupola of Saint Peter's),* 1826–27. 10 × 16 in. (25.2 × 40.5 cm). Museum purchase, Archer M. Huntington Fund, The Fine Arts Museums of San Francisco

According to Moreau-Nélaton and Robaut, between 1825 and 1828 Corot painted only one work in plein air from that viewpoint. They propose that he made two other versions of the view, with figures, after his return to France—perhaps years later—basing them on the original study after nature. One of these was in a private collection in France in 1975;[14] the other is the present painting. Their argument gains credibility from the fact that the San Francisco work was painted on paper, the support customarily used by artists when working outdoors, while the other two are on canvas.

Robaut and Moreau-Nélaton date the painting in the private collection to 1828–35 and this one in the Clark Art Institute to 1835–40. The dating of the first work seems entirely plausible, since its technique is closely related to that of pictures exhibited at the Salon in the years around 1830. However, the wonderfully fluid and expressive brushwork of the painting shown here ties it to the works of the first Italian visit. Perhaps Corot began the picture at his studio in Rome right after making the study after nature, then later completed the canvas in Paris. Numerous alterations and the extreme thickness of the paint in the lower portions certainly give the impression that the work was painted in several stages.

Interestingly, the three figures placed on the riverbank at the lower left were at some time covered up, undoubtedly to make the work look like a painting after nature. A recent restoration uncovered them, and once again the painting appears as it did when photographed for Robaut and Moreau-Nélaton's catalogue raisonné. As testimony to the speculations that accompanied Corot's oeuvre for a century, this canvas carries three signatures.

1. *Le Pont et le Château Saint-Ange à Rome*, oil on canvas, Musée du Louvre, Paris. This painting has a companion work, *Le Ponte Rotto à Rome*.
2. *Le Château Saint-Ange*, watercolor, private collection, Paris.
3. *Le Pont Saint-Ange*, oil on canvas, Musée des Beaux-Arts, Dijon. This work has a pendant depicting the same subject as Vernet's: *Le Ponte Rotto et l'île Tiberina*.
4. *La Girandole au château Saint-Ange (Fireworks at the Castel Sant'Angelo)*, watercolor, Hôpital de la Salpêtrière, Paris.
5. *Le Feu d'artifice tiré du château Saint-Ange (Fireworks at the Castel Sant'Angelo)*, oil on paper mounted on canvas, Musée du Louvre, Paris, and oil on paper mounted on canvas, Musée des Beaux-Arts, Orléans.
6. *Fireworks at the Castle of Saint Angelo, Rome*, oil on canvas, Walker Art Gallery, Liverpool.
7. *Le Feu d'artifice tiré du château Saint-Ange*, oil on paper mounted on canvas, Musée des Beaux-Arts, Orléans.
8. *Rome. Vue prise de la fenêtre de Corot (Rome: View from Corot's Window)*; R 43, oil on paper mounted on wood, private collection, Paris.
9. R 2479, R 2486, R 2532.
10. On this study, see Hélène Toussaint's commentary in Paris 1975, no. 10, ill., and Vincent Pomarède's in Paris 1991, no. 42, p. 76, ill.
11. Corot and Comairas discussed this painting in their correspondence of 1852, and Corot even drew it in a letter (Cabinet des Dessins, Musée du Louvre, Paris).
12. The study, at the time attributed to Aligny, was acquired by Camille Benoit, an antiques dealer from Lille, at Aligny's posthumous sale on March 8–9, 1878 (no. 65). Benoit gave it to the Musée des Beaux-Arts, Lille, in 1882, at which time it carried a spurious signature by Corot. According to Alfred Robaut, "... it's by Aligny. Clear, regular, sometimes hard execution.... In the Musée de Lille, the school of Aligny (not to be confused with Corot) is smooth and regular, without imagination, too

dry to be by Corot." ("... c'est d'Aligny. Exécution propre, régulière et parfois dure.... Au Musée de Lille, École d'Aligny [ne pas confondre avec Corot], c'est lisse et régulier, sans caprice avec sécheresses trop nombreuses pour Corot.") Robaut "Corot. Tableaux faux," fol. 81. See also "Corot Forgeries" in this volume. Germain Bazin followed Robaut in refuting Corot's authorship of this work after studying a report by the Laboratoire de Recherche of the Louvre (Bazin 1973, pp. 88–89). Hélène Toussaint believes it an authentic work by Corot, proposing a later date, perhaps even 1843 (in Paris 1975, no. 10, p. 26). Marie-Madeleine Aubrun attributes it to Aligny (Aubrun 1988, no. 8). I have summarized elsewhere the history of the attribution of this work while affirming my own conviction that it is by Corot (in London 1993, pp. 103–4). Anne Norton contributed an excellent commentary on this painting to the catalogue of the exhibition of masterpieces from Lille held at The Metropolitan Museum of Art, New York (in New York 1992–93, p. 172).
13. This study was bought by Paul Détrimont at Corot's posthumous sale of 1875 (no. 24) for 5,000 francs.
14. It is cited in Robaut 1905, vol. 2, no. 70 bis, without illustration but precisely described. This painting was bought by Brame, Paris, for 3,500 francs at Corot's posthumous sale in 1875 (no. 53). It was last exhibited at Paris 1975, no. 21, ill., and is documented and reproduced in Schoeller and Dieterle 1948, no. 2.

PROVENANCE: Paul Tesse, Paris; his sale, March 11, 1876, no. 22, as *Rome*, sold for 2,720 francs; Ernest May, Paris; his sale, Galerie Georges Petit, Paris, June 4, 1890, no. 18, sold for 21,100 francs; Anthony Roux, Paris; his sale, Galerie Georges Petit, Paris, May 9–10, 1914, no. 4; purchased at that sale by Robert Sterling Clark for Edward S. Clark through M. Knoedler & Co., New York; Edward S. Clark, New York; Stephen C. Clark, New York, by 1934; Durand-Ruel, New York; Robert Sterling Clark, June 28, 1946; given by him to the Sterling and Francine Clark Art Institute, Williamstown, Massachusetts, 1955

EXHIBITIONS: Paris 1875a, no. 77, lent by Paul Tesse; New York 1934b, no. 5; New York 1936, no. 11; Williamstown 1956, no. 90; Williamstown 1959; New York 1967b, no. 6; London 1969b, no. 181; Williamstown 1984, no. 63; San Diego, Williamstown 1988, no. 11

REFERENCES: Roger-Milès 1895, pl. 14; Michel 1896a, pp. 15–16; Michel 1905, p. 12, ill.; Robaut 1905, vol. 2, pp. 28–29, no. 71, ill.; Michel 1928, p. 131; Venturi 1941, p. 139; Bazin 1942, p. 45; Bazin 1951, p. 23, ill.; Anon. 1959 (R. F. C.), p. 76; Williamstown, Sterling and Francine Clark Art Institute 1972, p. 24, no. 555, ill.; Williamstown, Sterling and Francine Clark Art Institute 1981, pp. 38–39, ill.; Williamstown, Sterling and Francine Clark Art Institute 1984, p. 10, no. 555, ill.; Selz 1988, p. 34; Varriano 1991, pp. 215–17, 264, ill.

Three views of the Trinità dei Monti

12. *Rome. Monte Pincio. La Trinité des Monts (vue prise des jardins de l'Académie de France)* (Rome, the Trinità dei Monti: View from the Gardens of the Académie de France)

A few steps from Corot's Roman lodgings was the Piazza di Spagna, where he often stopped in at the Caffè Greco. This meeting place for artists staying in Rome, where Goethe, Stendhal, and later Berlioz and Wagner passed the time, was the neighborhood center for painters. From that spot Corot could admire the architecture of the church of La Trinité des Monts—or Trinità dei Monti—which dominated the Piazza di Spagna and was one of Corot's favorite places to paint. Set on one of Rome's seven hills, this church, one of five French churches in Rome, had been built by order of the French king Charles VIII starting in 1495, pillaged by Napoleon's troops during the wars with Italy, and restored by Louis XVIII several years before Corot came to Rome.

"From the height of Trinité-des-Monts, the steeples and the faraway buildings look like the rubbed-out sketches of a painter," wrote Chateaubriand.[1] Corot painted four important pictures showing the church of Trinità dei Monti and the view of Rome that it commanded. Robaut and Moreau-Nélaton illustrated one done to the southeast of the church, descending toward the Quirinale, at what is today the Via Sistina.[2] Three other versions were painted north of Trinità dei Monti and show the church as seen from the entrance of the Villa Medici (home to the Académie de France) slightly below, Corot having set himself up on what is today the Viale della Trinità dei Monti. A drawing in the Louvre (fig. 34) has the same viewpoint.

The Geneva painting shown here seems to be a study done from nature, the first one painted of the subject. Its technique is spontaneous and fluid, glossing over the details in the foreground and concentrating on the effect of light on the architectural volumes: the church, the obelisk erected in 1789, and the Palazzo del Quirinale in the distance are painted with precision, while the roofs of Rome and the other monuments are submerged in hazy blue and violet shadows that call to mind the studies of Valenciennes. In this work Corot was visibly applying the precepts of his illustrious predecessor, seeking to set down his visual impressions quickly and emphasizing a pictorial treatment of the sky—which is perfectly transparent—to build the space and the volumes.

Corot repeated this composition in another work painted in the studio, adding figures as was the usual practice. An oil on canvas now in a private collection in Zurich includes at the left a monk talking with a peasant; it was undoubtedly made in Rome and retains all the spontaneity of a plein air study (fig. 35).[3] Catalogue number 14, a copy after the Zurich painting, contains three additional figures, a peasant reclining on a grassy patch and two men walking on the road in the foreground. Later Corot painted a variant

Fig. 34. Corot. *Rome, la Trinité vu du Pincio (Rome: The Trinità Seen from the Pincio)*. Graphite on paper Département des Arts Graphiques, Musée du Louvre, Paris (R.F. 8992)

from a different viewpoint and in a larger format (cat. no. 13).

The ringing of changes on his subject, first studying it outdoors and then painting it again in the studio with small variations in the setting, perfectly exemplifies Corot's working method. The present painting is one of the artist's most successful treatments of light and architectural volumes.

1. "Du haut de la Trinité-des-Monts, les clochers et les édifices lointain paraissent comme les ébauches effacés d'un peintre." Letter in Chateaubriand 1859, vol. 6, p. 292.
2. R 82. This painting was bought at Corot's posthumous sale of 1875 (no. 41) by Gillet for 620 francs. Its present location is unknown.
3. R 85, private collection, Zurich. See cat. no. 14. Robaut and Moreau-Nélaton proposed a date of 1840–50 for this painting, but I do not agree.

PROVENANCE: Acquired from the artist by the Swiss painter Jean-Gabriel Scheffer (1797–1876); bequeathed by him to the Musée d'Art et d'Histoire, Geneva, 1876

EXHIBITIONS: Paris 1934; Fribourg 1943; Bern 1960, no. 3; Chicago 1960, no. 16; Rome, Turin 1961; Schaffhausen 1963, no. 13

REFERENCES: Robaut 1905, vol. 2, pp. 34–35, no. 84, ill.; Jean 1931, p. 6

13. *Rome. Monte Pincio. La Trinité des Monts (vue prise de la villa Médicis)* (*Rome, the Trinità dei Monti: View from the Villa Medici*)

Here once again Corot took as his subject the Trinità dei Monti viewed from the Pincio. The church is seen from closer up than in the Geneva and Chicago views (cat. nos. 12, 14), perhaps even from a window of the Villa Medici, as tradition has it. This celebrated picture poses two questions that have a bearing on its dating: the circumstances of its making (was it done out of doors or in the studio?) and the reasons the work was left unfinished.

Technical considerations suggest that the painting was a studio work. Its large size would have made plein air execution hard to manage, given the equipment then available for artists; its support is canvas, while, as we have seen, plein air studies were done on paper, which could be more easily carried; and the painting is built up with impasto, with a much-worked surface and a thick layer of paint on the architectural elements, suggesting a picture fully developed in the studio more than a spontaneous creation from nature. It is reasonable to conclude that this is a studio work, one of those pictures *de souvenir*, or recollections, made later on, rather than a direct product of Corot's pictorial research in Rome.

Moreover, its facture is much closer to that of paintings like *Saint-Lô. Vue générale de la ville* (cat. no. 42), also incomplete, and *Pierrefonds (Oise). Vue générale* (cat. no. 66), which themselves pose dating problems, since the dates advanced for them by Moreau-Nélaton and Robaut appear to be too late.[1] If a date of 1830–34 is accepted as probable for them, it seems feasible to assign this version of *La Trinité des Monts* to the same years, a time when Corot was working in Paris, before his second trip to Italy.

The work's unfinished state should be considered in the light of these observations. During this period Corot was working without a painting companion or the pressure of institutional obligations, so nothing prevented him from interrupting his artistic procedure at will. Thus it is more appropriate to see this work's incompletion as resulting from dissatisfaction or impatience, from the sense of being stymied, or, perhaps more in line with the artist's temperament and habits, simply from the interruption of work meant to be resumed later—not from an aesthetic choice to leave unfinished a work considered perfect in its present state, as several critics have implied, among them Hélène Toussaint.[2]

It is true that only a few years later, in 1845, Baudelaire would write his famous text regarding what is fully developed (*le fait*) and what is finished (*le fini*), using a painting by Corot to illustrate his point: "In general, that which is fully developed is not finished, and . . . something highly finished can be quite far from fully developed." However, Baudelaire was discussing the "supposed awkwardness of M. Corot" and not the principle of exhibiting uncompleted works.[3] In any case, Corot exhibited three perfectly finished works that year[4] and in fact never showed an unfinished work at the Salon. Baudelaire had simply found in Corot an excellent vehicle for presenting his own aesthetic beliefs.

A careful study of Corot's ideas reveals something quite the opposite—that continuous reworking of a picture until it reached a point the artist deemed finished, or sometimes even of a canvas abandoned years earlier, was as natural a matter for him

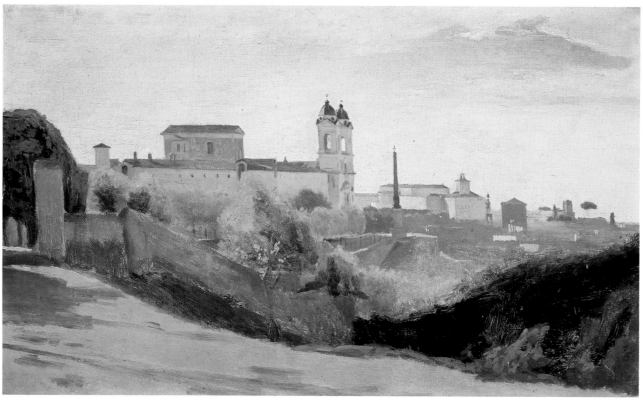

12. *Rome. Monte Pincio. La Trinité des Monts (vue prise des jardins de l'Académie de France)* *(Rome, the Trinità dei Monti: View from the Gardens of the Académie de France)*, ca. 1826–28. Oil on paper mounted on canvas, 10¾ × 17⅝ in. (27.3 × 44.7 cm). Musée d'Art et d'Histoire, Geneva (1876-6) R 84

as was the link between making a study of a subject outdoors and reworking the subject in the studio. "I paint up to the point when I discover what I have done. I never push myself to arrive at a detail. . . . I return again and again, without being stopped by anything and without any system," he wrote.[5] In 1825, in Italy, he had declared, "Nothing should be left imprecise."[6]

1. Robaut and Moreau-Nélaton proposed the date 1850–55 for *Saint-Lô. Vue générale de la ville* and 1840–45 for *Pierrefonds (Oise). Vue générale* (Robaut 1905, vol. 2, nos. 756, 474). Hélène Toussaint has already pushed back the date of the former to about 1830–35 on the basis of Robaut's preliminary notes and has suggested 1833 as a date for the latter, pointing to a letter of July 23, 1833 (in Paris 1975, no. 29).
2. In Paris 1975, no. 12.
3. "En général ce qui est *fait* n'est pas *fini*, et . . . une chose très-*finie* peut n'être pas *faite* du tout"; "prétendue gaucherie de M. Corot." Charles Baudelaire, "Salon de 1845," in Baudelaire 1923, p. 56.
4. *Homère et les bergers* (cat. no. 90); *Daphnis et Chloé*, R 465, present location unknown; and *Un paysage*, R 463, published by Robaut as *Vue de la campagne romaine*, present location unknown.
5. "Je peins jusqu'à ce que je m'aperçoive de ce que j'ai fait. Je ne suis jamais pressé d'arriver au détail. . . . Je reviens sans cesse, sans être arrêté par rien et sans système." Corot, *carnet* 68, ca. 1840–45, quoted in Robaut 1905, vol. 4, p. 97, no. 3105.
6. "Il ne faut laisser d'indécision dans aucune chose." Corot, *carnet*, 1825.

PROVENANCE: The artist; his posthumous sale, Hôtel Drouot, Paris, pt. 1, May 26–28, 1875, no. 33; purchased at that sale by Jean Dollfus, Paris, for 1,705 francs; his sale, Galerie Georges Petit, Paris, March 2, 1912, no. 9; purchased at that sale by the Musée du Louvre, Paris, with interest from the Audéoud bequest

EXHIBITIONS: Paris 1885, no. 72; Paris 1900, no. 138; Paris 1936, no. 10; Lyons 1936, no. 9; Geneva 1937, no. 12; Paris 1946b, no. 171; Venice 1952, no. 11; New York 1955; Dieppe 1958, no. 4; London 1963, no. 8; Lisbon 1965, no. 27; Paris 1966a; Montauban 1967, no. 197; Saint-Paul-de-Vence 1973, no. 769; Paris 1975, no. 12; Rome 1975–76, no. 10; Tokyo, Kobe, Sapporo, Hiroshima, Kitakyushu 1980, no. 2

REFERENCES: Robaut 1905, vol. 2, pp. 34–35, no. 83, ill., and vol. 4, p. 196, no. 33; Brière 1924, no. 3045; Lafargue 1925, pp. 13–20, ill.; Fosca 1930, pl. 10; Meier-Graefe 1930, p. 36, pl. VI; Bazin 1942, p. 37; Escholier 1943, pp. 146–47, ill.; Bazin 1951, p. 35; Sterling and Adhémar 1958, no. 364, fig. XCVIII; Leymarie 1966, p. 31; Paris, Musée du Louvre 1972, p. 95; Fouchet 1975, p. 55, ill.; Leymarie 1979, p. 23, ill.; Compin and Roquebert 1986, p. 155; Laclotte et al. 1989, p. 139

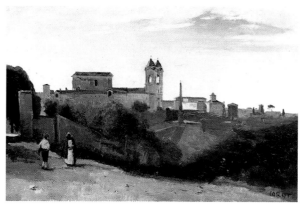

Fig. 35. Corot. *Rome. Monte Pincio. La Trinité des Monts (vue prise des jardins de l'Académie de France)* *(Rome, the Trinità dei Monti: View from the Gardens of the Académie de France;* R85). Oil on canvas, 10½ × 15¾ in. (26.7 × 40 cm). Private collection, Zurich

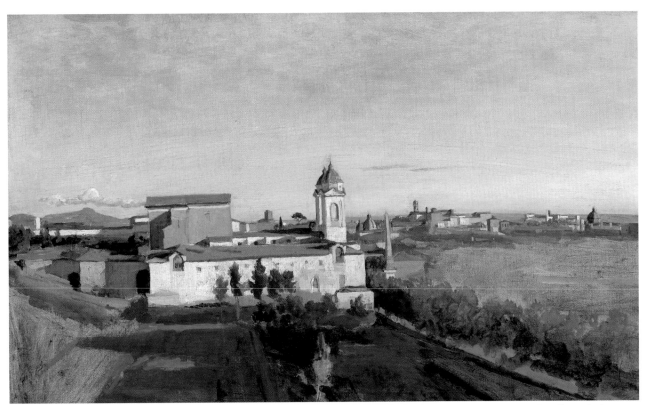

13. *Rome. Monte Pincio. La Trinité des Monts (vue prise de la villa Médicis)* *(Rome, the Trinità dei Monti: View from the Villa Medici)*, ca. 1830–34. Oil on canvas, 17³⁄₄ × 29¹⁄₈ in. (45 × 74 cm). Stamped lower right: VENTE COROT Musée du Louvre, Paris (R.F. 2041) R 83

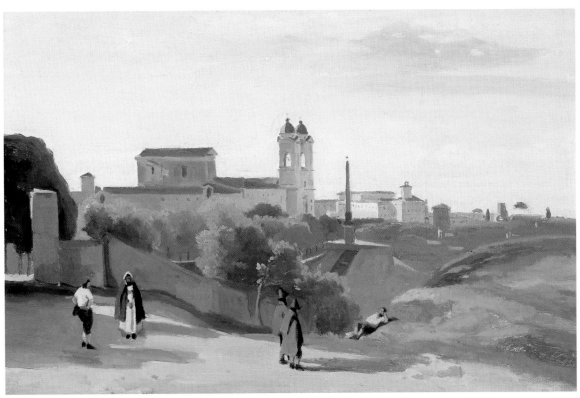

14. *Rome. Monte Pincio. La Trinité des Monts*, R 85 (fig. 35). Oil on canvas, 10⁵⁄₈ × 16¹⁄₈ in. (27 × 41 cm). The Art Institute of Chicago, Mr. and Mrs. Lewis Larned Coburn Memorial Collection (1942.466) Not in Robaut 1905

14. *Rome. Monte Pincio. La Trinité des Monts (vue prise des jardins de l'Académie de France)* (*Rome, the Trinità dei Monti: View from the Gardens of the Académie de France*)

This painting is a copy after the painting in Zurich (fig. 35), which Corot based on the plein air oil study he had painted in Rome (cat. no. 12). On the left can be seen the same monk conversing with a peasant that Corot depicted in the Zurich version,[1] as well as two men in the foreground walking along the Viale della Trinità dei Monti and a peasant leaning on his elbow as he lounges on a knoll.

Robaut and Moreau-Nélaton did not record this work. The history of this painting has often been confused with that of the work in Zurich. The Zurich picture (according to Robaut and Moreau-Nélaton) was sold in 1871[2] under the title *Campagne romaine* and next turned up in 1873 in the collection of Paul Tesse. The early history of this copy in Chicago is not known. When it was installed in Paris in the present exhibition, doubts were raised about the attribution to Corot. A comparison with the Zurich painting (fig. 35) and an investigation into the present picture's whereabouts before 1925 may shed further light on its authorship as well as on the vexing question of copies by Corot himself, by his friends, and by later followers; see pp. 383–96.

1. During his stay in Italy Corot painted a study of a monk (R 106) whose costume is identical to that worn by the monk in the Zurich and Chicago versions of *La Trinité des Monts.*
2. Anonymous sale, Hôtel Drouot, Paris, December 1871, for 400 francs.

PROVENANCE: Henry Marcel, Paris, 1925; Mme Henry Marcel, 1936; A. Weil, New York; Annie Swan Coburn; her gift to the Mr. and Mrs. Lewis Larned Coburn Memorial, The Art Institute of Chicago, 1942

EXHIBITIONS: Paris 1925, no. 724; Paris 1936, no. 9; Philadelphia 1946, no. 3; Toronto 1950, no. 4; Washington 1956–57, no. 4; Rome, Turin 1961

REFERENCES: Chicago, The Art Institute of Chicago 1961, p. 85, ill.; Selz 1988, pp. 146–47, ill.; Hours 1972, p. 104

15

Rome. La Vasque de l'Académie de France (Rome: The Fountain of the Académie de France)

Ca. 1826–27
Oil on wood
7 × 11½ in. (18 × 29 cm)
Signed at lower left (perhaps forged): COROT
Private collection

R 79

The two Roman monuments close to Corot's lodgings that particularly lent themselves to open-air painting were the church of Trinità dei Monti and the Villa Medici, on the Pincio. The Académie de France, housed in the Villa Medici since 1803, offered hospitality to the laureates of the Prix de Rome and was for Corot a privileged place in which to meet colleagues: painters, engravers, and sculptors, among whom were the winners of the grand prize for landscape painting.

The Villa Medici stood a few hundred yards from the stairs to Trinità dei Monti. Built in the 1540s for Cardinal Giovanni Ricci de Montepulciano, it was acquired by Cardinal Ferdinand de' Medici in 1576. Sometime between 1576 and 1593 the fountain was installed, an enormous ancient seashell carved in marble that looked down over the roofs of Rome. Corot liked to work before this splendid panorama, one doubtless described many a time by his teacher Michallon, whose three years in Rome had been spent as a guest at the villa. In addition to the fountain, serenely shaded by trees that create a curtain of shadow visible in the foreground, Corot could admire the sunlit prospect of the Castel Sant'Angelo and the dome of Saint Peter's.

The fountain and the view it commanded had already attracted the attention of artists. Valenciennes in 1778,[1] Goethe in 1787,[2] and Ingres in 1806,[3] to name a few of them, had drawn the fountain with the roofs of Rome in the background (fig. 38). While Corot is unlikely to have known their drawings,[4] Villa Medici tradition must have preserved the memory of these studies—so logical was it, even for history painters, to paint this superb panorama of the city. Michallon had probably shown Corot his own studies, one of which depicts the same site from a different angle.[5] Corot could also have seen in Paris the handsome view exhibited at the Salon of 1824 by Pierre-Athanase Chauvin, a veteran painter of the Italian landscape.[6]

Fig. 36. Corot. *Rome, la Vasque de l'Académie de France (Rome: The Fountain of the Académie de France)*. Oil on canvas, 7⅛ × 11⅜ in. (18 × 29 cm). Hugh Lane Municipal Gallery of Modern Art, Dublin

Fig. 37. Corot. *Rome, la Vasque de l'Académie de France (Rome: The Fountain of the Académie de France)*. Oil on canvas. Musée Départemental de l'Oise, Beauvais (84.32)

Robaut and Moreau-Nélaton note the existence of three views of the Villa Medici fountain painted by Corot, but they do not attempt to fix a date for each.[7] The first, which had been part of the Forbes collection and is the work that Moreau-Nélaton and Robaut selected to reproduce in their catalogue, is today in the Hugh Lane Municipal Gallery of Modern Art in Dublin (fig. 36). The second was a version that Corot had offered to his friend the painter Hippolyte Flandrin and that is now in Beauvais (fig. 37), and a third, which belonged to Henri Rouart, is the picture catalogued here. A fourth view came to light when it was given to the Musée des Beaux-Arts in Reims in 1928. Finally, a pencil drawing that had belonged to Moreau-Nélaton is now in the collection of the Département des Arts Graphiques of the Louvre (R.F. 8993).

There is little doubt that the drawing in the Moreau-Nélaton collection preceded the other works. The essential question, is

partly addressed by Robaut and Moreau-Nélaton, is in what order the four paintings were made. The authors asserted in their catalogue raisonné that the Dublin study served as the "matrix" for the other paintings; in all likelihood Corot painted it out of doors, then copied it several times in the studio, a traditional process followed by artists while in Rome and on their return to France. Marie-José Salmon added that the Beauvais view is the most mature work and was certainly made last, in the studio, as the culmination of the series.[8]

One avenue of exploration that might shed light on the dating of the four paintings concerns the supports used by Corot. Canvas was employed for the Dublin, Reims, and Beauvais paintings and wood for the picture shown here. None of the works appear to have been painted on paper, the customary support for plein air painting—unless a more thorough laboratory examination reveals pasted-on paper, which is sometimes hard to detect.

Fig. 38. Jean-Auguste-Dominique Ingres (1780–1867). *La Vasque de la villa Médicis* (*The Fountain at the Villa Medici*), 1806–10. Brown ink and wash on paper, 3¾ × 4¾ in. (9.5 × 12.2 cm). Musée Ingres, Montauban (867-4438)

Is it possible that Corot painted all four pictures in the studio working from one or more drawings or perhaps an oil study not known today? Did he paint outside directly on canvas—which would have been a novel procedure then, not just for Corot but for the era—or on wood, which would mean that the work shown here was painted first? It is worth noting the dimensions of the different versions. The Beauvais painting is somewhat larger than the rest, which suggests that it is a studio work made later, while the Dublin picture and the one catalogued here are about the same size, 7 by 11 inches. The Reims painting is about the same height but almost 3 inches narrower, making a squarer format.

When one examines the pictorial qualities and details of the architecture, as well as the dimensions, it is clear that the Dublin view and the present painting are related. The Beauvais work has all the earmarks of a painting reworked in the studio, more precisely drawn than the others and with a smoother facture. The Reims work displays significant stylistic differences

from the other three, suggesting that it is a later copy painted after 1850.

Organizational difficulties made it impossible to unite all four "fountain" pictures here. Since an opportunity to compare the three paintings from Dublin, Reims, and Beauvais was offered by the exhibition at Beauvais in 1987, we have chosen to present this fourth version, which has not been exhibited in France since 1936. This work formerly belonged to Henri Rouart (1833–1912), an engineer who was also a painter, a friend of Degas, a collector of Renoir, Monet, and Degas, and the owner of forty-seven paintings by Corot.

1. *À la villa Médicis*, pen and ink and gray wash, 1778, in an album, "Vues de Rome et de ses environs," Bibliothèque Nationale de France, Paris (Réserve, Vf31c, petit fol.).
2. *The Fountain of the Villa Medici*, Goethe Nationalmuseum, Weimar, 197.
3. *Vue prise de la villa Médicis en direction du Capitole*, Musée Ingres, Montauban (MI 867-4442) and *Vue prise de la villa Médicis*, Musée Ingres, Montauban (MI 867-4448) as well as the drawing shown in figure 38.
4. As Marie-José Salmon argues convincingly in a remarkable catalogue devoted to artists' representations of the Villa Medici: Beauvais 1987, p. 23.
5. *Vue de Rome*, 1819, sepia drawing, Musée des Beaux-Arts, Orléans, 905 B, bequest of Mme Léon Coigniet.
6. *Saint-Pierre de Rome vue du Pincio*, oil on canvas, private collection; sold at Christie's, London, March 20, 1981.
7. Robaut 1905, vol. 2, no. 79.
8. Beauvais 1987, p. 24.

PROVENANCE: Henri Rouart, Paris; his sale, Galerie Manzi Joyant, Paris, December 10, 1912, no. 129 (withdrawn from the sale); his son, Paul Rouart, Paris; Galerie Dubourg, Paris; Dr. Albert Charpentier, Paris, from 1932; his descendants, from 1953; private collection

EXHIBITIONS: Paris 1900, no. 28, lent by H. Rouart; Paris 1925, no. 723; Paris 1934, no. 63; Paris 1936, no. 8, lent by Paul Rouart; London 1989, no. 6

REFERENCES: Robaut 1905, vol. 2, pp. 32–33, no. 79 (but illustrated with a different painting, the view owned by the Hugh Lane Municipal Gallery of Modern Art, Dublin); Faure 1931, p. 5, ill.; Fouchet 1975, p. 55; Beauvais 1987, pp. 24–25; Selz 1988, p. 90; Tokyo, Osaka, Yokohama 1989–90, p. 141, no. 4 (for the Dublin painting); Galassi 1991a, pp. 158–62; Galassi 1991b, pp. 158–61

16

Vieillard assis sur une malle de Corot (Old Man Seated on Corot's Trunk)

1826
Oil on paper mounted on wood
12⅝ × 9 in. (32 × 23 cm)
Signed lower right: COROT Inscribed lower left: janvier 1826
Originally stamped lower left but now effaced: VENTE COROT
Museum of Fine Arts, Boston
The Henry C. and Martha B. Angell Collection 19.79

R 89

The study of the human figure based on models found among the local populace was a preoccupation second only to plein air landscape study for artists during their sojourn in Italy. Peter Galassi has pointed out that this practice not only afforded experience in working directly from the model but also enabled the artist to build a store of documents record-

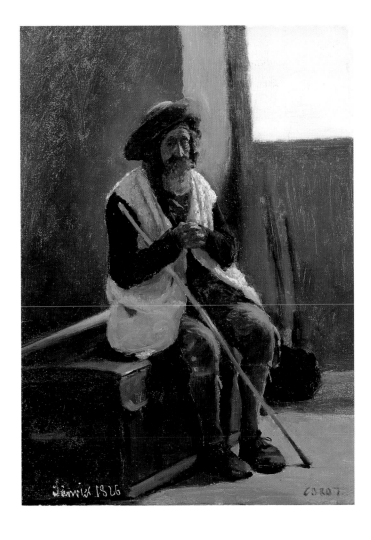

ing costumes and poses, on which he could draw later when working up compositions on pastoral themes in his studio.[1]

Classic instruction in landscape painting, of which historical landscape represented the principal genre, recommended the study of the human figure and insisted on an attentive study of anatomy, "without which a draftsman would be like a copyist transcribing a language he does not understand, or a translator who tries to handle a subject of which he has no knowledge," in the words of Valenciennes.[2] A century earlier, Roger de Piles had emphasized the necessity of making figures correspond perfectly to the landscape in which they are placed: "I am convinced that the best way to set off the figures is to bring them into such harmony with the character of the landscape that it seems as if the landscape was made expressly for the figures."[3]

Thus, this type of figure study had been the rule since the first half of the eighteenth century, when an example was set by studies of Italian costumes done about 1730 by Nicolas Vleughels, one of the most celebrated directors of the Académie de France. Italian painters like Bartolomeo Pinelli, French painters like Jean Barbault, and Swiss painters like the Sablet brothers all carefully depicted the costumes and postures of Italian peasants. These studies from the model of local costumes and traditions complemented the painters' more

usual exercises based on engravings and lent an authentic note to their paintings on Italian themes.

In 1820, Achille-Etna Michallon and his Swiss friend Léopold Robert made studies in the Roman prisons in the Termini that marked a new stage: their intention was to present each regional costume with complete fidelity. Robert would soon turn these studies into a completely separate genre. The methodical nature of their research inevitably influenced painters who followed them to Rome, beginning with Michallon's students, who had been able to copy the studies in his studio. Corot, of course, was one of those students.

Corot worked extensively on the human figure during his stay in Italy, and this study of an old man is one of his truest and most touching efforts. In the man's slightly stooped posture Corot effectively conveyed the weariness of old age and the pride that disguises it. He made several oil studies of this model. The one shown here was painted from life; a second version, known only from Robaut and Moreau-Nélaton's catalogue raisonné, seems to be a copy of it in which the model's pose and costume have been changed (R 90). A third study showed the figure standing (R 92).

This *Vieillard* immediately reveals what was original about Corot's approach to the exercise. While he shows considerable interest in documenting regional costumes, he is even more intrigued by the physical expression, the position of the body, the psychological suggestion of a personality. In this small studio tableau, which anticipates the much later imaginary figures from the last third of the artist's career, the urge to extract a timeless human type is already evident.

1. Galassi 1991a, pp. 144–45.
2. "sans laquelle il en sera, d'un dessinateur, comme d'un copiste qui transcrit une langue qu'il n'entend pas, ou d'un traducteur qui veut traiter, dans sa langue, une matière dont il n'a pas connaissance." Valenciennes 1800, p. 400.
3. "Je suis persuadé que le meilleur moyen de faire valoir les figures est de les accorder tellement au caractère du paysage qu'il semble que le paysage n'ait été fait que pour les figures." Piles 1989, p. 113.

PROVENANCE: Bought back by Corot about 1872–73 for 800 francs (according to Robaut); Corot's posthumous sale, Hôtel Drouot, Paris, pt. 1, May 26–28, 1875, no. 26; purchased at that sale by Galerie Fèbvre et Diot, Paris, for 750 francs; purchased from them by Henry C. Angell, 1880; Henry C. and Martha B. Angell, Boston; gift of Martha B. Angell to the Museum of Fine Arts, Boston, 1916

EXHIBITIONS: Chicago 1893; Boston 1915; New York 1942, no. 5; Philadelphia 1946, no. 4; Toronto 1950, no. 2; Chicago 1960, no. 7; Yokohama, Chiba, Nara 1995, no. 8

REFERENCES: Robaut 1905, vol. 2, pp. 36–37, no. 89, ill., and vol. 4, p. 196, no. 26; Boston, Museum of Fine Arts 1921, no. 199, ill.; Bernheim de Villers 1930a, no. 19, ill.; Cunningham 1936, p. 100; Edgell 1949, p. 12; Boston, Museum of Fine Arts 1955, p. 14; Leymarie 1966, p. 38; Leymarie 1979, pp. 34–35, ill.; Murphy 1985, p. 58; Selz 1988, p. 65, ill.

Moine italien assis, lisant (Rome) (Italian Monk Reading)

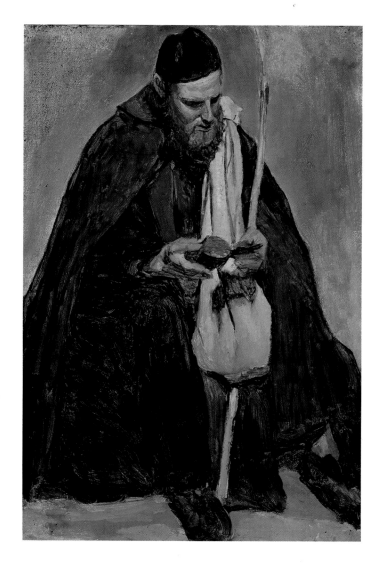

Ca. 1826–28
Oil on canvas
15³⁄₄ × 10³⁄₄ in. (40 × 27.2 cm)
Stamped lower left: VENTE COROT
Albright-Knox Art Gallery, Buffalo
George B. and Jenny R. Mathews Fund, 1964 64:11

R 105

This monumental figure, rapidly brushed in, depicts above all a posture, that of a man absorbed in his reading. It departs from the generally more realistic studies of the human figure that Corot produced in his studio in Rome between 1825 and 1828. The theme of the monk offered him both the stylistic exercise of dealing with the subject's monochromatic raiment and the challenge of creating a poetic description of meditation. Treated here for the first time, the monk was to recur often in Corot's work (figs. 103, 104, cat. nos. 108, 163).

Painted as a "massive pyramid, stable and autonomous,"[1] this figure retains the pedagogical character of a study after the model, yet becomes almost an archetype. The youthful study seems instinctively to anticipate the artist's later development. After producing many works in the portrait genre, from about 1850 on Corot would depart more and more from its true-to-life realism to invent a depersonalized, poetic treatment of the human figure.

1. Galassi 1991a, p. 146.

PROVENANCE: The artist; his posthumous sale, Hôtel Drouot, Paris, pt. 2, May 31–June 4, 1875, no. 306; purchased at that sale by J. F. P. Berthelier for 150 francs; his sale, Galerie Georges Petit, May 9, 1889, no. 32, sold for 310 francs; Wildenstein & Co., New York; purchased from them by A. Conger Goodyear, 1928; his gift to the Albright-Knox Art Gallery, Buffalo, January 7, 1943; allocated to the A. C. Goodyear Fund, 1964; purchased by the Gallery with the George B. and Jenny R. Mathews Fund, 1964

EXHIBITIONS: Buffalo 1928, no. 5; New York 1942, no. 8; Philadelphia 1946, no. 5; New York 1956, no. 5; Washington 1956–57, no. 5; Chicago 1960, no. 17; New Haven 1961; Paris 1962, no. 7; Buffalo 1962–63, p. 5; Edinburgh, London 1965, no. 7; Buffalo 1966, no. 3; Washington 1968; New York 1969, no. 3

REFERENCES: Robaut 1905, vol. 2, pp. 40–41, no. 105, ill., and vol. 4, p. 229, no. 306; Bernheim de Villers 1930a, pp. 32, 39; Meier-Graefe 1930, p. 87; Roberts 1965, pp. 33–41; Leymarie 1966, p. 38; Leymarie 1979, pp. 34–35, ill.; Nash 1979, p. 201, ill.; Selz 1988, pp. 134–35, ill.; Galassi 1991a; Galassi 1991b, p. 146, pl. 174; Gale 1994, p. 54, ill.

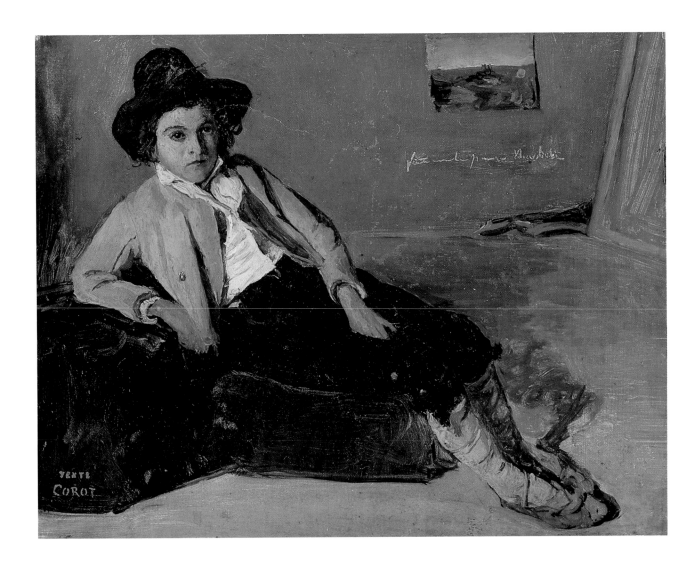

18

Jeune Italien assis dans la chambre de Corot à Rome (Italian Youth Sitting in Corot's Room in Rome)

1825 (according to Robaut)
Oil on paper mounted on canvas
9½ × 11⅞ in. (24 × 30 cm)
Stamped lower left: VENTE COROT Inscribed on wall: fait avec le
pauvre Plumkett[1]
Musée des Beaux-Arts, Reims

R 57

Corot's first series of studies of Italian models, painted during the winter of 1825–26, still shows the influence of costume studies by Michallon that he had copied: the same concern with realism in the treatment of fabrics, the same rapidity of execution, the same preoccupation with the human body and lack of interest in the background, which remains undefined (see fig. 40). But Michallon had been concerned merely to record examples of regional costumes for use in the future, when he would set figures into his paintings of Italian sites done in the studio. Corot, while his aim was similar, also

attentively depicted his model's face and posture, paving the way for the portraits he would paint on his return from Italy in 1829. The dimension of visual experimentation that he added to the basic study of the model foreshadowed the imaginary figures he painted later, after about 1850.

For this study of a young Italian adolescent posing in his studio room at the Palazzo dei Pupazzi, Corot chose to have the model adopt a half-reclining, half-sitting posture, an absolutely classical position familiar from Etruscan sarcophagi, Roman sculpture, nudes from the Fontainebleau school, the nymphs of Jean Goujon, and even Titian's *Venus* in the Prado. The pose reappears frequently in later works by Corot—for example the small study *Napolitain, assis, accoudé* (*Neapolitan, Seated, Leaning;* R 168, private collection) and an allegorical nude of the 1840s, *La Source* (*The Spring;* R 660, location unknown), once owned by Henri Rouart. We also find it, reversed this time, in the

female figure seen from the back at the left in *Silène* (cat. no. 64) and in *La Bacchante au tambourin* (cat. no. 117).

Corot had used a seated boy as the subject of a previous study, *Jeune Garçon coiffé d'un chapeau haut de forme, assis par terre (Boy in a Top Hat Sitting on the Ground)*, probably done in the forest of Fontainebleau, perhaps before his departure for Italy.[2] In the present study he tried to specify his setting more fully by including some paintings leaning against a wall on the right and, hanging behind the model, a study easily identified as a view of the Italian countryside, *Le Pont Nomentano*, painted at the beginning of 1826 (R 72, Museum Boymans-van Beuningen, Rotterdam).

The image of this reclining youth was taken up again several times by Corot, who seemed to find in it a harmonious balance between technical experimentation, the evocation of classical themes, and the everyday simplicity, the realism, of this adolescent and his clothing. The present painting is the original version, painted from life in Italy and described by Robaut as the only one with an inscription.[3] It remained in the artist's studio throughout his career and was sold posthumously in 1875.

Corot made other versions, some with variations, during the last months of his Italian sojourn and later in Paris.[4] He also placed the figure deep in a landscape.[5] His systematic repetition of the theme in several versions indicates that he felt particular pride at the success of his study. It passed into one of the largest collections of Corot works, that of Jules Paton, who also owned *La Ville et le lac de Côme* (cat. no. 57) and two versions of *L'Atelier* (cat. nos. 136, 139).

1. Robaut recorded the inscription. The name Plumkett does not appear anywhere else and does not seem to belong to any painter, architect, or friend of Corot's of the time.
2. R 56, private collection, dated by Robaut and Moreau-Nélaton to 1823–24 on the basis of a remark by Corot.
3. See n. 1.
4. One of the most famous is in the National Gallery of Art, Washington, D.C., from the Chester Dale collection. Another was sold in 1912 at the auction of the Rouart collection.
5. R 58, private collection.

PROVENANCE: The artist; his posthumous sale, Hôtel Drouot, Paris, pt. 1, May 26–28, 1875, no. 12; purchased at that sale by Brame, Paris, for 620 francs; Jules Paton, Paris; his sale, Paris, April 1883, no. 34, sold for 770 francs; Charles Leroux, Paris; his sale, 1888; purchased at that sale by Dillais, Paris, for 350 francs; his sale, May 30, 1892, no. 12, sold for 2,000 francs; private collection, Paris; acquired by the Musée des Beaux-Arts, Reims, 1995

REFERENCES: Robaut 1905, vol. 2, pp. 22–23, no. 57, ill., and vol. 4, p. 194, no. 12

19

Jeune Italienne de Papigno avec sa quenouille (Young Italian Woman from Papigno with Her Distaff)

August–September 1826
Oil on board
11¾ × 7¾ in. (30 × 19.5 cm)
Stamped lower right: VENTE COROT
Collection of Jon and Barbara Landau

R 62

When he was staying in Papigno, near Terni, in August and September of 1826, before he went off to confront the arcades of the bridge at Narni, Corot painted this study of a female figure, working on it between two landscape sessions. During the same period and in the same village he also painted the figure of a young Italian boy, who, equally sober and poised, stares calmly back at the viewer.[1]

In 1826 and 1827 Corot painted several other female figures that he treated in the same spirit, with the model's bearing and pose suggested in a similar way and with the same realistic depiction of the costumes. *L'Italienne Maria di Sorre assise* (fig. 12),

Italienne mélancolique (R 63, private collection), and *Italienne d'Albano en grand costume* (R 61, private collection) are three excellent examples of female figures from the first Italian trip; each is endowed with great sensuality and set off against a uniform, almost undefined background. In his studio in Rome Corot also painted studies of figures in more complicated poses, such as *Italienne de profil, une cruche sur la tête* (*Italian Woman with a Pitcher on Her Head, in Profile;* R 86) and *Italienne appuyée sur sa cruche* (*Italian Woman Leaning on Her Pitcher;* R 88), both in private collections.

Whereas Michallon in his studies of female figures (fig. 40)[2] had primarily been interested in the shimmer and precise

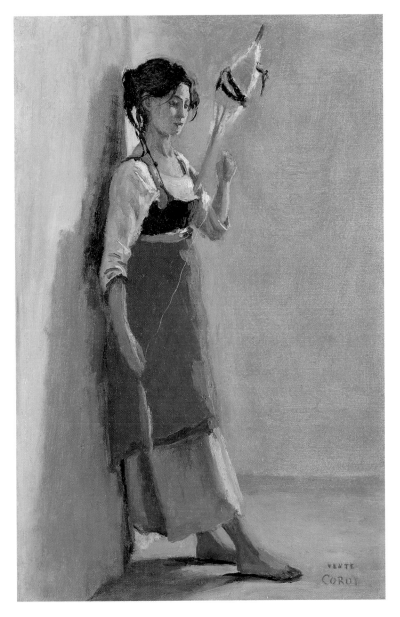

Fig. 39. Corot. *Italienne assise (Seated Italian Woman;*
R 109). Oil on paper mounted on canvas,
10⅞ × 8⅞ in. (27.5 × 22.5 cm). Moreau-Nélaton
Bequest, Musée du Louvre, Paris (R.F. 1636)

Fig. 40. Achille-Etna Michallon (1796–1822).
*Paysanne des environs de Rome (Woman from the Roman
Countryside).* Oil on paper mounted on canvas,
14⅛ × 9⅞ in. (36 × 25 cm). Musée du Louvre,
Paris (R.F. 2886)

rendering of the costumes, Corot was more intent on capturing the attitudes, which are often sensual; and already there emanates from his figures an indescribable melancholy. Still, these studies are significant primarily as stages in his development. In this study Corot was working largely in the spirit of Michallon and Léopold Robert, concentrating on describing the model's costume and physical bearing rather than on creating a dramatic, timeless figure like the *Moine italien assis, lisant* (cat. no. 17).

This painting had already become part of a private American collection by 1905. A copy of it, made during Corot's lifetime by Charles Desavary, belonged to Alfred Robaut.

1. *Italien de Papigno assis, de face*, R 107, location unknown.
2. The Louvre owns two particularly interesting examples, both called *Paysanne des environs de Rome*, R.F. 2886 (fig. 40) and R.F. 2887.

PROVENANCE: The artist; his posthumous sale, Hôtel Drouot, Paris, pt. 1, May 26–28, 1875, no. 37; purchased at that sale by Vuillermoz, Paris, for 390 francs; the artist Charles-Édouard Elmerich (1813–1889), Paris; sold by him to Corot's student Achille-François Oudinot, Paris, December 1883; Wildenstein, Paris; in 1905, mentioned by Alfred Robaut as having "gone to America" (Robaut *carton* 26, fol. 2); Edwin C. Vogel, New York, 1960; his sale, Oct. 17, 1973, Sotheby Parke Bernet, New York, no. 13; Walter Feilchenfeldt, Zurich; anonymous gift to the Westmoreland County Museum of Art, Greensburg, Pennsylvania; by exchange to Kennedy Galleries, New York, 1986; Martha Parrish and James Reinish, Inc., New York; sold by them to Jon and Barbara Landau, New York, 1994

EXHIBITIONS: Chicago 1960, no. 12; Paris 1962, no. 5

REFERENCES: Robaut 1905, vol. 2, pp. 22–23, no. 62, ill., and vol. 4, p. 197, no. 37; Bernheim de Villers 1930a, p. 39, no. 7; Bazin 1942, pp. 104, 120, no. 22; Baud-Bovy 1957, p. 80; Leymarie 1979, p. 35, ill.; Selz 1988, p. 60, ill.

20

Rome. Le Couvent Sant'Onofrio sur le Janicule, also called *Campagne de Rome* (*Rome: The Convent of Sant'Onofrio, on the Janiculum*)

February 1826
Oil on paper mounted on canvas
9 × 13 in. (22 × 33 cm)
Dated lower right (with the handle of a brush): février 1826
The Fitzwilliam Museum, Cambridge PD-1-1960
Paris only

R 97

After proposing numerous sites as the possible subject of this study, from the Civita Castellana region to the vicinity of Naples, André and Renée Jullien succeeded in identifying the view represented. In Rome, from the gardens of the Vatican, Corot painted the Sant'Onofrio convent on the Janiculum, where the poet Tasso (1544–1595), the famous author of *Jerusalem Delivered*, spent his last years, insane. To the right of the convent, on a knoll, one can see "Tasso's oak"; the story goes that the poet came to meditate in its shade. At the left is the tower of the Palazzo Senatorio of the Capitoline, while in the background rise the Alban Hills, which close the composition.[1]

This work has an extremely fluid, sketchy facture that reveals its origin as a rapid plein air study. It demonstrates that from the first months of his Italian trip, Corot looked at nature with a realist's eye, aiming for a swiftness of execution that would enable him to seize his immediate visual impressions. At heart, he was following Valenciennes's advice: "At first, limit yourself

Fig. 41. Corot. *Campagne romaine, le monte Testaccio* (*The Roman Countryside: Monte Testaccio*), 1825. Oil on paper mounted on canvas, 6¼ × 11¾ in. (16 × 30 cm). Moreau-Nélaton Bequest, Musée du Louvre, Paris (R.F. 1629)

to copying, as well as you can, the principal tones of Nature in your chosen effect; start your study with the sky, which sets the tones of the background; from them to those of the planes that are linked to them, and by degrees you arrive at the foreground." [2] Corot worked often in this area of the Castelli Romani, at Frascati, Grottaferrata, Marino, Castel Gandolfo, and Genzano, at the foot of mounts Iano and Cavo, which can be seen in the background of this study.

According to Robaut, this painting left Corot's studio before the posthumous sale of 1875, perhaps in 1874. The Julliens rightly point out that a copy of this work was in the sale (no. 259 bis), catalogued by Robaut under the title *Naples et le Vésuve vus d'Ischia* (R 191).

1. Jullien and Jullien 1987, p. 111.
2. "Il faut d'abord se borner à ne copier, le mieux possible, que les tons principaux de la Nature dans l'effet que l'on choisit; commencer son étude par le ciel, qui donne les tons de fond; ceux-ci, celui des plans qui leur sont liés, et venir progressivement jusques sur les devants." Valenciennes 1800, p. 407.

PROVENANCE: Kept in Corot's studio until about 1874, when it was given away or sold by the artist (according to Robaut); Percy Moore Turner, London, 1930; acquired from him by Captain S. W. Sikes; his gift to The Fitzwilliam Museum, Cambridge, 1960

EXHIBITIONS: Manchester, Norwich 1991, no. 8

REFERENCES: Robaut 1905, vol. 2, pp. 38–39, no. 97, ill.; Cambridge, Fitzwilliam Museum 1982, no. 94; Jullien and Jullien 1987, pp. 109–30, fig. 1b; Galassi 1991a, p. 140, ill.; Galassi 1991b, pp. 140–41, pl. 167

La Promenade du Poussin (Campagne de Rome) (The Poussin Promenade [Roman Campagna])

Ca. 1826–28
Oil on paper mounted on canvas
13 × 20⅛ in. (33 × 51 cm)
Stamped lower right: VENTE COROT
Musée du Louvre, Paris R.F. 1941–6

R 53

Gazing at the *Autumn* of the *Four Seasons* by Poussin, Corot exclaimed, "*There* is nature!"[1] His admiration for the great French painter who lived in Rome, already well developed by virtue of his Neoclassical training, was further intensified by his own aesthetic reflections and methods. Corot, who owned a painting, *Paysage d'Italie,* attributed to Poussin (it sold for 41 francs at his posthumous sale in 1875), must surely have pondered Valenciennes's observation, "If, after this great man [Poussin], no one to equal him can be found, do not believe the thing impossible: the flame of genius has not gone out."[2] Thus it was to be expected that during his first trip to Rome, Corot would seek to retrace the steps of his illustrious predecessor.

Lodging near the Piazza di Spagna, not far from the Quirinale and the Villa Borghese—in the same neighborhood where Poussin, who stayed on the Via Paolina, had lived—Corot had only to walk a few hundred feet to find himself at the beginning of the celebrated "Poussin Promenade," so named because Poussin was said to have gone there for long, solitary reveries. Starting at the Piazza del Popolo and following the Tiber north on the road toward Acqua Acetosa and Civita Castellana, Poussin would have come across the landscapes that inspired his *Moïse sauvé des eaux* (fig. 42) and *Paysage avec saint Mathieu et l'ange* (*Landscape with Saint Matthew and the Angel;* Gemäldegalerie, Berlin).

The dating of this painting by Corot is far from clear-cut.[3] It is known that he and his friend Johann Karl Baehr began a painting trip at Civita Castellana in February 1826 and thus would have been working along the Tiber at that time. But since Corot was living close to this "Promenade," he surely returned to the site frequently between 1826 and 1828. Robaut and Moreau-Nélaton did not give a precise date for this work, nor for *Le Tibre près de Rome (Acqua Acetosa),* another study painted on the northern Tiber,[4] nor again for the pen drawing that shows the same view as the Louvre painting, done from the same angle (R 2481). They did date, even to the month (December 1825), *Fabriques du Poussin (Campagne de Rome)*[5] and two other landscapes painted on the banks of the Tiber north of Rome (January 1826). As for the date of this landscape, its pictorial mastery compared with the still-hesitant quality of the views of Rome done from the Farnese Gardens (cat. nos. 7–9)

suggests that Corot made the study toward the end of his Italian sojourn, in 1827 or even 1828.

Painted in oil on paper, undoubtedly out of doors, and reworked very little or not at all in the studio, this picture has a strong sense of cohesion and an astonishing liveliness of touch. The transparency of the sky, whose luminosity is reflected in the waters of the river, artfully contrasts with the greens and browns that almost entirely make up Corot's palette in the work.

After entering the personal collection of the dealer Alexis-Joseph Fèbvre, who had gathered a fine group of eighteenth- and nineteenth-century paintings,[6] this important picture was acquired by another well-known professional, Paul Jamot, former curator at the Musée du Louvre, who studied and collected Corot's work.[7]

The site retained its renown throughout the nineteenth century and was a source of inspiration to numerous artists, some of whom painted explicit *hommages* to Poussin, before being overtaken by urbanization in the twentieth century.

1. "Voilà la nature!" Cited by Pierre Rosenberg in Paris, London 1994–95, p. 515 (French ed.).
2. "Si depuis ce grand homme, il ne s'est trouvé personne qui l'ait égalé, il ne faut pas croire la chose impossible: le flambeau du génie n'est pas éteint." Valenciennes 1800, p. 385.
3. Hélène Toussaint dates this study as well as *Le Pont de Narni* (cat. no. 26) to the last trip to Rome in 1843 (in Paris 1975, no. 48, p. 56). Because the technique of this study is very close to that of other studies painted in the Roman countryside between 1825 and 1828, I cannot accept her dating.
4. R 76. This painting was bought by the painter Daubigny at the posthumous sale of 1875 (no. 273) for 110 francs (present location unknown).
5. *Poussin's Buildings, Roman Campagna;* R 48, private collection. This painting was in Corot's posthumous 1875 sale.
6. Alexis-Joseph Fèbvre (1810–1881), who had a gilding studio in Brussels, became involved in the sale and collection of old and modern paintings and by 1850 had become an expert, returning to establish himself in Paris. An original personality, he collected paintings by Boucher, Desportes, Fragonard, Greuze, Lancret, Watteau, Prud'hon, Cuyp, Van Dyck, Guardi, Hals, Jordaens, Memling, Rubens, Géricault, Diaz, Delacroix, and Théodore Rousseau, which were dispersed at his sale at the Hôtel Drouot, Paris, in April 1882.
7. Paul Jamot (1863–1939), an *école normale* graduate with a teaching qualification in literature, began his career in the department of Egyptian antiquities in the Louvre before becoming curator in the department of paintings in 1919 and head of the department in 1934. A great art historian, he wrote important monographs on the Le Nain brothers, Rubens, Degas, Manet,

Fig. 42. Nicolas Poussin (1594–1665). *Moïse sauvé des eaux (The Finding of Moses)*. Oil on canvas, 36³/₄ × 47⁵/₈ in. (93.5 × 121 cm). Musée du Louvre, Paris (inv. 7271)

Fig. 43. François-Marius Granet (1775–1849). *Le Tibre près de la Porte du Peuple (The Tiber near the Porta del Popolo)*. Oil on paper mounted on canvas, 8⁵/₈ × 12 in. (22 × 30.4 cm). Musée Granet, Aix-en-Provence

Corot, Poussin, and Georges de La Tour. The personal collection he assembled, which included works by Le Nain, Gauguin, Bonnard, and Corot, he gave to the Louvre and to the Musée des Beaux-Arts in Reims, his native city.

PROVENANCE: The artist; his posthumous sale, Hôtel Drouot, Paris, pt. 1, May 26–28, 1875, no. 22; purchased at that sale by [Alexis-Joseph] Fèbvre, Paris, for 450 francs; his sale, Hôtel Drouot, Paris, April 17–20, 1882; purchased at that sale by Arnold et Tripp, Paris; Bernheim-Jeune & Cie., Paris; purchased from them in 1910 by Paul Jamot, Paris, for 6,000 francs; bequeathed by him to the Musée du Louvre, Paris, 1939; entered the Louvre, 1941

EXHIBITIONS: Paris 1925, no. 60; Paris 1934, no. 95; Zurich 1934, no. 34; Paris 1936, no. 7; Paris 1937, no. 261; Amsterdam 1938, no. 39; Belgrade 1939, no. 12; Paris 1941, no. 17; Paris 1945a, no. 76; Paris 1946b, no. 168; Paris 1948, no. 207; Venice 1952, no. 5; Dieppe 1958, no. 3; Rome, Turin 1961, no. 78; Montauban 1967, no. 198; Atlanta 1968, no. 40; Paris 1975, no. 48; Rome 1975–76, no. 30; Bremen 1977–78, no. 18; Bologna 1985–86, no. 119; Edinburgh 1990; Lugano 1994, no. 3

REFERENCES: Robaut 1905, vol. 1, p. 17, vol. 2, pp. 20–21, no. 53, ill., vol. 4, p. 195, no. 22; Moreau-Nélaton 1924, vol. 1, fig. 25; Lafargue 1925, p. 18, ill.; Benoist 1926, p. 171; Jamot 1936, p. 8, ill.; Venturi 1941, p. 143, ill. p. 144; Bazin 1942, p. 100; Escholier 1943, p. 146; Sterling and Adhémar 1958, no. 356, fig. 96; Leymarie 1966, p. 32; Leymarie 1979, p. 24, ill.; Jullien and Jullien 1982, pp. 180–83; Compin and Roquebert 1986, p. 158; Galassi 1991a, pp. 163–64; Galassi 1991b, pp. 162–65, ill. p. 164 (detail), pl. 195; Néto-Daguerre and Coutagne 1992, p. 227

22

Le Mont Soracte (Mount Soracte)

Ca. 1826–27
Oil on paper mounted on canvas
12¼ × 17¼ in. (31.1 × 43.8 cm)
Signed and dated lower right (ca. 1850): COROT 1826
Private collection
Paris only

R 169

During his stays in Civita Castellana, in June and July 1826 and September 1827, Corot conscientiously carried out the prescribed course of study for mastering the Neoclassical landscape, systematically painting the region's rocks and slopes, dense undergrowth, and streams. But Mount Soracte, which majestically dominates the area, inspired him especially—as would another peak, Mount Cavo, to the south of Rome, near Albano—and he made it the subject of a number of studies.[1] In these he could put into practice what he had learned about making panoramic views. None of the other studies Corot painted during his stay in Civita Castellana matches the expressive power of this work in its treatment of the foreground, in which the boulders to the left curiously echo the soulless, lifeless plain to the right. The sky, rendered sensitively and realistically, confers on the site a strange romanticism, as it does again in the study *Monte Cavo* done several months later.

Corot reused his studies of the Civita Castellana area later on in ambitious compositions intended for the Salon; in 1831 the monumental "figure" of Mount Soracte reappeared in the background of *La Campagne romaine avec le mont Soracte* (cat. no. 30), which was exhibited at the Salon that year.

1. *Le Mont Soracte*, R 124, Musée d'Art et d'Histoire, Geneva; *Le Mont Soracte*, R 125, location unknown; *Le Mont Soracte vu de Civita Castellana*, R 170, Ny Carlsberg Glyptotek, Copenhagen.

PROVENANCE: Gift of the artist to his friend the painter Comairas, Fontainebleau, about 1850; sold by him to Mme Peltier, Fontainebleau, about 1880; Lord Berners, Faringdon, Berkshire; his sale, London, May 1935; Robert Heber-Percy, London; to the present owner

EXHIBITIONS: London 1979, no. 2; London 1989, no. 4

REFERENCES: Robaut 1905, vol. 2, pp. 62–63, no. 169, ill.; Jullien and Jullien 1982, pp. 190, 198, n. 33; Galassi 1991a, p. 183, ill.; Galassi 1991b, pp. 184–85, pl. 228

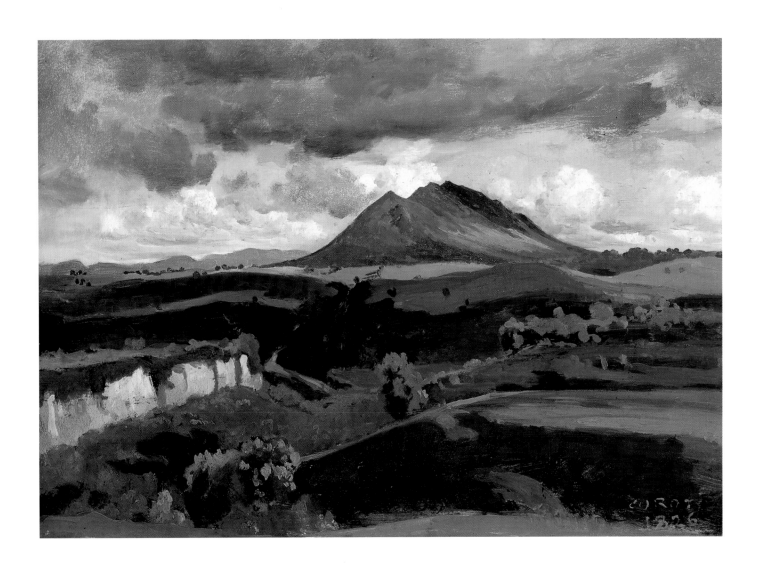

Civita Castellana. Fabriques au sommet des rochers, also called La Porta San Salvatore (Civita Castellana: Buildings High in the Rocks)

Ca. 1826–27
Oil on canvas
10 × 14 in. (25.4 × 35.5 cm)
Stamped lower right: VENTE COROT
Private collection

R 139

On May 10, 1826, Corot left Rome and his meticulous studies of antique monuments to journey a while in northern Latium, in the heart of the Sabine Mountains, with his faithful companion Johann Karl Baehr. The two men settled in the small town of Civita Castellana, about fifty miles north of Rome. From Civita Castellana they explored the nearby villages before returning to Rome at the end of June, then set out again to the northeast until October, discovering Narni, Terni, and Papigno.[1]

Corot revisited Civita Castellana in September and October of 1827 with a different painting friend, Léon Fleury. The Sabine Mountain region seems to have particularly inspired Corot; he made many sketches and painted some thirty oil studies there—a full quarter of his output for his entire stay in Italy between 1825 and 1828.[2]

Civita Castellana, an old Etruscan city set on a plateau overlooking the rocky gorges of three rivers, was at that time a market town of about 2,500 people and looked much as it had when Valenciennes visited it at the end of the eighteenth century. It was planned as a fortified town, arranged around the Duomo, a cathedral begun in the twelfth century, and the Rocca, a fortified castle built at the end of the fifteenth century by Sangallo the Elder and Sangallo the Younger, two leading architects of the papacy. Many painters frequented this wild area, which lent itself to studies of vegetation and rocks; in May of 1826, Baehr and Corot found themselves working beside Édouard Bertin and the German Ernst Fries.[3]

On both visits to Civita Castellana, the two friends undoubtedly stayed at the Albergo di Tre Re, an inn that sat at the eastern edge of the town at the foot of a cliff.[4] The study shown here was painted not far from this inn, which can almost be seen behind the ramshackle structure in the lower left of the picture. Corot depicted the gorges of the Treja River below and east of the town, and one of the town's ancient gates, the Porta San Salvatore (demolished in 1854), can be made out on top of the cliff. The composition is constructed on a strict diagonal: from the high cliffs and the gateway, which dominate the right side of the picture, it plunges toward the left into the narrow valley carved out of the rocks by the Treja River.

Fig. 44. Corot. *Civita Castellana. Rochers rouges* (*Civita Castellana: Red Rocks*; R 137), 1826–27. Oil on canvas, 14⅛ × 20⅛ in. (36 × 51 cm). Nationalmuseum, Stockholm

In this study, as in most of the views he painted at Civita Castellana (fig. 44), Corot seems inspired by two elements that according to classical teaching should command the attention of a landscapist working in Italy: the buildings, "majestic ornaments in a landscape" that "elevate thought as one imagines the use for which they were intended," and, of course, the rocks. Studying rocks after nature, as well as trees, was in classical doctrine a required stage of a landscapist's apprenticeship. "Though the rocks be of all shapes and partake of all sorts of colors, they nevertheless have in their diversity a certain character that cannot be adequately expressed until they have been examined in nature," long-windedly explained Roger de Piles, whose *Cours de peinture par principes* set an example for the entire eighteenth century.[5] And Valenciennes added an injunction that was transmitted to the young Corot by his teachers Michallon and Bertin, cautioning "against the practice of certain artists who make use of small branches and stones when drawing or painting entire trees and large rocks.... The structure of a branch has a character completely different from the structure of an entire tree."[6]

It must be remembered that these studies of cliffs, vegetation, and rocks, which preoccupied Corot during his travels and

especially on his visits to Civita Castellana, were not finished pictures. They were simple exercises, "kept in one's portfolio to consult and to make use of on occasion."[7] The development of Corot's technique between the time of the first trip to Civita Castellana in 1826 and the second one a year later is very noticeable; he became increasingly assured and adept at using light to render the volumes of rocks.

1. André and Renée Jullien carefully worked out this chronology, especially Corot and Baehr's return to Rome before the trip to the northeast. A drawing of the Forum (R 2480) in the Département des Arts Graphiques of the Louvre, R.F. 8995, is dated June 1826. Jullien and Jullien 1982, p. 201, n. 58.

2. Some of these studies are in public collections: *Civita Castellana. Rochers rouges (Civita Castellana: Red Rocks)*, R 137, Nationalmuseum, Stockholm (fig. 44); *Civita Castellana. Rochers dominant la vallée boisée (Civita Castellana: Rocks Rising over the Wooded Valley)*, R 140, Staatliche Kunsthalle, Karlsruhe; *Le Mont Soracte* (R 171) and *Civita Castellana. Pic rocheux (Civita Castellana: Rocky Peak)*, R 174, Neue Pinakothek, Munich; *Le Mont Soracte* (R 124), Musée d'Art et d'Histoire, Geneva; *Le Mont Soracte vu de Civita-Castellana* (R 170), Ny Carlsberg Glyptotek, Copenhagen; and *Civita Castellana. Rochers humides (Civita Castellana: Wet Rocks)*, R 176, Ackland Art Museum, University of North Carolina, Chapel Hill.

3. See Munich 1979–80, no. 27, and Jullien and Jullien 1982, p. 197, nn. 23, 24.

4. Corot actually made one study from the windows of the Tre Re (R 136), and André and Renée Jullien seem right to deduce that Corot and Baehr stayed at this inn.

5. "grand ornement dans une paysage"; "élevent la pensée par l'usage auquel on s'imagine qu'elles sont destinées"; "Quoique les roches soient de toutes formes et qu'elles participent de toutes sortes de couleurs, elles ont pourtant dans leur diversité certains caractères qui ne peuvent bien s'exprimer qu'après les avoir examinées sur le naturel." Piles 1989, pp. 109, 107.

6. "contre la pratique de certains Artistes qui se servent de petites branches d'arbres et de pierres pour dessiner et peindre des arbres entiers ou de gros rochers. . . . La conformation d'une branche a tout autre caractère que la conformation de l'arbre entier." Valenciennes 1800, p. 410.

7. "on les garde dans le porte-feuille pour les consulter et en faire son profit dans l'occasion." Ibid.

PROVENANCE: The artist; his posthumous sale, Hôtel Drouot, Paris, pt. 2, May 31–June 4, 1875, no. 296; purchased at that sale by Paul Détrimont, Paris, for 390 francs; Détrimont collection, Paris, until 1905 (according to Robaut); Lord Berners, Faringdon, Berkshire; his sale, London, May 1935, no. 5; Robert Heber-Percy, London; his sale, Christie's, London, April 2, 1990, no. 4; the present owner

EXHIBITIONS: Chicago 1960, no. 14; London 1989, no. 5

REFERENCES: Robaut 1905, vol. 2, pp. 50–51, no. 139, ill., and vol. 4, p. 228, no. 296; Jullien and Jullien 1982, pp. 191, 199, n. 38; Galassi 1991a, p. 192, ill.; Galassi 1991b, p. 191, pl. 244

24

Papigno. Fabriques dominant la vallée (Papigno: Buildings Overlooking the Valley)

1826
Oil on canvas
11⅜ × 16⅛ in. (29 × 41 cm)
Stamped lower left: VENTE COROT
Private collection

R 121

During his several stays in Italy Corot went to Papigno only once, from July to September of 1826. From this singular village, perched on a rocky promontory surrounded by a majestic crown of mountains, he made side trips to the Marmore waterfall and to Terni on the Nera River, or toward Lake Piediluco, high in the mountains ringing Papigno. In September he went on to settle at Narni, where he could pursue his program of studies in a less untamed region (see cat. no. 26).

Corot made three studies of the village of Papigno: one (the painting shown here) from the east, from the Nera valley, where the Cascata delle Marmore plunges down; another from the west, coming from Terni (R 115); and the last from the south, descending the road that leads to Piediluco (R 114).[1] Peter Galassi has convincingly demonstrated that Corot made use of a classical technique in composing his views of Papigno, placing the foreground in shadow and making the light stronger as the subject grew more distant.

In Papigno and the surrounding mountains Corot painted two superb canvases showing the Nera River plunging across the gorges (R 116, R 118; locations unknown). He paid much less attention to the surrounding rocky areas than he had at Civita Castellana,[2] choosing instead the magnificent spectacle of the Marmore waterfall, which he painted and sketched many times, or the poetic tranquillity of the shores of Lake Piediluco (cat. no. 25).

The work shown here demonstrates the real progress Corot had made since his serious and painstaking studies of the monuments of Rome and his first studies at Civita Castellana, which already were livelier and more spontaneous. If the bluish luminosity of the mountains in the background here still recalls the type of effect found in paintings by Valenciennes and, even more, Jean-Joseph Bidauld or Michallon, the high-key brushwork of the vegetation and rocks in the foreground and the intense sunlight on the meadow at the right reveal a more personal approach, as well as the experience acquired by six months of constant work in the open air. The attentive viewer can admire the fluid, economically executed trunk of an umbrella pine on the right; a few dabs of the brush create reflections of light on the trunk, defining its volume.[3]

1. Both R 115 and R 114 are in private collections in France.
2. But see R 122.
3. A copy of this work, smaller than the original, was mentioned by Robaut and Moreau-Nélaton as being offered at the comte de Tramecourt sale in March 1883. Its current location is unknown.

PROVENANCE: The artist; his posthumous sale, Hôtel Drouot, Paris, pt. 1, May 26–28, 1875, no. 23; purchased at that sale by Diot for 670 francs; the comte Armand Doria (1824–1896), Paris; his sale, Galerie Georges Petit, Paris, May 1899, no. 69; purchased at that sale by Paul Gallimard, Paris, for 3,900 francs; Paul Cassirer, Amsterdam; Stähli, Küsnacht; Alfred Jäggi, Basel; Fritz Nathan, Zurich; to the present owner

EXHIBITIONS: Zurich 1943, no. 40; Winterthur 1955, no. 39; Paris 1959, no. 24; Bern 1960, no. 5; Chicago 1960, no. 10, lent by Fritz Nathan, Zurich; Schaffhausen 1963; Edinburgh, London 1965, no. 10; Bremen 1977–78, no. 6

REFERENCES: Robaut 1905, vol. 2, pp. 44–45, no. 121, ill., and vol. 4, p. 195, no. 23; Galassi 1991a, pp. 196–200, ill.; Galassi 1991b, pp. 196–98, ill. p. 130 (detail), pl. 251

25

Le Lac de Piediluco
(Lake Piediluco)

1826
Oil on canvas
8⅝ × 16⅛ in. (22 × 41 cm)
Stamped lower left: VENTE COROT
The Visitors of the Ashmolean Museum, Oxford A403
New York and Ottawa only

R 123

From Papigno Corot explored the surrounding region of Terni. Rather than face a difficult climb to the top of the mountains, he took a two-mile walk to the shores of Lake Piediluco. This magnificent site, a lake literally nestled amid the Sabine Mountains and overlooked by two gently sloping hills, must have struck his imagination. His study was painted from the road approaching from Terni, as if to recall the sublime moment when, coming around a bend in the mountain road, the traveler suddenly catches his first view of the lake.

The treatment of the two hills and the lake seems particularly realistic, with the church tower from the village on the hill at left piercing the sky. Corot chose to depict the scene in the light of morning, when the lake is gradually emerging from the mist amid an overall tonality of blue, white, and violet. On the other hand, he did not represent the chain of mountains overlooking the lake as they really appear. Whether because the morning light minimized their height or because he did not wish to give them much emphasis, preferring to focus the viewer's attention, and his own memories, on the lake and its surroundings, he clearly made the mountains lower than they actually are in relation to the two hills that rise above the lake.

Corot was apparently very fond of this site, and the sketch that he painted there was drawn upon often for his paintings after 1860.[1] The hill on the left can be seen without the other shore in *Site d'Italie au soleil levant* (*Italian Site at Sunrise,* The J. Paul Getty Museum, Malibu) and *Souvenir d'Italie* (cat. no. 121). While the lake was not a high point on tourist routes, it seems to have evoked emotions in Corot that spurred him to use these studies over and over again in composing his studio works.

1. Robaut and Moreau-Nélaton note many copies of this study made by Corot and his students; one of the copies was offered at the comte de Tramecourt sale in March 1883.

PROVENANCE: The artist; his posthumous sale, Hôtel Drouot, Paris, pt. 2, May 31–June 4, 1875, no. 278; purchased at that sale by Dubuisson for 750 francs; given by Sir Michael Sadler to the Ashmolean Museum, Oxford, in memory of Lady Sadler, 1931

EXHIBITIONS: Rome, Turin 1961, no. 71; Leeds 1962, no. 11; London 1962, no. 215; Manchester, Norwich 1991, no. 10

REFERENCES: Robaut 1905, vol. 2, pp. 44–45, no. 123, ill., and vol. 4, p. 226, no. 278; Jean 1931, ill.; Leymarie 1979, pp. 24–25, ill.; Galassi 1991a, p. 200; Galassi 1991b, pp. 199–200, pl. 255

Narni. *Le Pont d'Auguste sur la Néra*, also called *Le Pont de Narni* (*Narni: The Ponte Augusto over the Nera*)

September 1826
Oil on paper mounted on canvas
13⅜ × 18⅞ in. (34 × 48 cm)
Inscribed on back: Corot Pont de Narni étude donnée par Corot à
son ami le peintre Lapito
Musée du Louvre, Paris
Bequest of Étienne Moreau-Nélaton, 1906 R.F. 1613
Paris only

R 130

In mid-September of 1826, Corot left the region of Terni and Papigno, where he had been working since early July, and settled for some days at Narni, a small town on a hill overlooking the Nera River. Known for its cathedral and its ancient monuments, Narni had attracted the attention of painters since the end of the eighteenth century because of the astonishing ruins of a magnificent Roman bridge, one hundred feet high and over four hundred feet long, built across the Nera by Augustus.

In 1800 Valenciennes recommended that painters come to work in this region and see the antiquities of Narni,[1] and his disciples, among them Corot's teachers Michallon and Bertin, descended on the site. Most of them took a position below the bridge, where, having emerged from the Terni Plain, the Nera constricts to enter narrow gorges before flowing into the Tiber. In June 1821 Michallon made a drawing of the bridge seen from much farther away, through the branches of pine trees.[2] The German Ernst Fries, who had been working in the area since May 1826, made a wonderful drawing from just the viewpoint that Corot would choose a few months later.[3]

From the moment he arrived in Narni, Corot was inspired by the majestic site. Besides this study from nature, we know of two drawings, one a realistic study of the site and one a freer interpretation;[4] they show the various directions his explorations took as he prepared to make the painting he exhibited at the Salon of 1827 (cat. no. 27). The oil study after nature shown here[5] is astonishingly powerful in its effects of light and atmospheric transparency as well as its treatment of the mountains in the background, painted in the spirit of Bidauld and Valenciennes. The foreground was deliberately left vague as Corot focused on the look of the light illuminating the piers of the bridge, the river, and the surrounding vegetation.

Hélène Toussaint has convincingly explained the importance of the sketchy foreground treatment in this study, a strategy that Corot employed in many other works of the period as well, and, she believes, a principal contribution of the artist to the evolution of landscape painting: "One of the revolutionary principles of landscape theory in France in the nineteenth century recommended that space be suggested solely through analysis of the light and the values, neutralizing the foreground. Théodore Rousseau explained about 1830 that someone taking a walk and looking at the view does not see what is at his feet."[6]

Actually, in getting down this lifelike view Corot was relying on a solid sense of composition, acquired from Bertin and Michallon. The horizon marks off the upper third of the work, while the river and the mountains take up the bottom two-thirds. The lower part of the study is further divided into three sections: at left, the slope of a mountain, lit by the sun; at right, another slope, this one in shadow; at center, the river, which flows from the center of the picture to disappear at the lower right corner, like a receding perspective line skillfully shifted to suit the artist's point of view. The line of the mountains in the distance and the ruined piers of the bridge assure visual continuity from one part to the next.

All the same, there is something instinctive about the painting's structure, an automatic quality that Corot acquired in the course of his studies. Fundamentally he painted what he saw, and once he had selected his point of view he concerned himself mainly with working out in a systematic way the contrasts of light and shadow, which become the true subject of this study. Corot made the painting in the morning, when the penetrating light of the sun comes from the east, here the right side. His technical preoccupation with light was well summed up by Lionello Venturi: "The masterpiece of this period is the study of the bridge of Narni.... With some vigorous blacks, the painter takes a part in the struggle waged between light and shadow on a jagged terrain and on the broken bridge—a struggle that fades into nothing in the blue distance."[7]

However, there is no objective difference in facture or in aesthetic preoccupation between this study and those painted during the preceding months, for instance *Civita Castellana. Rochers rouges* (fig. 44) in the Nationalmuseum, Stockholm. A big brushstroke, fresh colors, a sketchy foreground, and the rigorous working out of light effects characterize all these oil studies. Corot was not thinking about making a definitive work or preparing for an important studio painting; he was

attempting to teach his eye and his hand to work together. He was determined still to work as a student, looking at nature without creating.

Thus, Corot never viewed the Narni study as a finished work, nor did critics of the nineteenth and very early twentieth centuries, who reserved most of their commentary for the painting shown at the Salon of 1827 (cat. no. 27) for which this study served as a partial model. But the contemporary eye—accustomed to the Impressionist aesthetic and attracted by what is sketchy and unfinished—has wanted to see the study as an avant-garde work taking a fundamental step in the history of French landscape painting rather than as an instance of Corot's increasing mastery of his technical means in relation to his aesthetic ambitions. Corot has been made out to be a precursor of Impressionism: "In short, this painting was made according to an Impressionist aesthetic . . . all by himself, without any program, entirely naturally, Corot leapt over fifty years of painting, moving from the Neoclassical style to the Impressionist style,"[8] wrote Venturi.

"*Agar dans le désert* of 1835 does not retain any of the freshness or finesse of notation . . . demonstrated by the *Pont de Narni* of 1827," lamented Léon Rosenthal;[9] Henri Focillon asserted that "with [Corot], the study would always have the authority of truth" and that the artist "precedes and prepares the way for Sisley."[10] In his preface to the catalogue of the "Centenaire de l'Impressionnisme," René Huyghe wrote, "Soon Daubigny—admittedly, after Corot, painter of running and singing waters—succumbed to the attraction of the liquid world . . . here is where Impressionism begins."[11] Indeed, a "pre-Impressionist" analysis of Corot's work was widespread in the first half of the twentieth century.

The modern art historian must make a distinction between various tasks: understanding the artist's actual intention, which was to put himself through the training sessions mandated by classical landscape teaching; describing the aesthetic result, articulated around the problem of light and shadow, which would become a crucial issue in nineteenth-century landscape painting; and evaluating the a posteriori analyses of certain historians. While *Le Pont de Narni* may reflect the preoccupations of the generation of 1870, Corot's own aesthetic course was perfectly Neoclassical.

Corot gave this study to his faithful friend and student Louis-Auguste Lapito (1803–1874), who, like Corot, exhibited for the first time at the Salon of 1827 and who subsequently became one of his most fervent admirers. It passed to the exceptional collection of the comte Armand Doria (1824–1896) and eventually to Étienne Moreau-Nélaton, who, understanding its importance, gave it to the Musée du Louvre in 1906.

1. Valenciennes 1800, p. 601.
2. Michallon, *Le Pont d'Auguste à Narni*, graphite on paper, Département des Arts Graphiques, Musée du Louvre, Paris, R.F. 13821.
3. Ernst Fries, *Le Pont d'Auguste à Narni*, graphite on paper, Kurpfälzisches Museum, Heidelberg.
4. *Narni. Vue panoramique (Narni: Panoramic View)*, R 2491, dates from 1826 and was offered at Corot's posthumous sale. It entered the Musée du Louvre in 1927 with the Moreau-Nélaton collection. Several years ago the National Gallery of Canada, Ottawa, acquired another drawing made at Narni that is closer to the oil study.
5. Because of stipulations of the Étienne Moreau-Nélaton bequest, this painting is unfortunately exhibited only in Paris.
6. "Un des principes révolutionnaires de la théorie du paysage, en France au XIXème siècle, voulait que l'espace fut suggéré exclusivement par une analyse de la lumière et des valeurs, en neutralisant le premier plan. Théodore Rousseau expliqua, vers 1830, qu'un promeneur regardant un panorama ne voit pas ce qui est à ses pieds." Hélène Toussaint in Paris 1975, pp. 51–53, no. 43. However, I cannot agree with her new dating of this work to 1843, during the second journey to Italy. It is too closely connected with the brilliant early studies Corot painted at Civita Castellana, Papigno, and Terni, and, with its adherence to a classical idea of landscape painting, it evokes rather the first ten years of Corot's career.
7. "Le chef-d'oeuvre de cette période est l'étude du Pont de Narni. . . . Par quelques noirs vigoureux, le peintre prend part à la lutte de la lumière et de l'ombre sur un terrain déchiqueté et sur le pont brisé,—lutte qui s'atténue dans le lointain bleu." Venturi 1941, p. 140.
8. "En somme, ce tableau est fait d'après une esthétique impressionniste . . . tout seul, sans programme, de la façon la plus naturelle possible, Corot sautait cinquante ans de peinture, et passait du goût néo-classique au goût impressionniste." Ibid., p. 141.
9. "*Agar dans le désert*, en 1835, ne retenait plus rien de la fraîcheur et de la finesse de notation . . . que le *Pont de Narni* avaient témoignées en 1827." Rosenthal 1914, p. 285.
10. "toujours l'étude aura chez lui la fine autorité du vrai"; "il précède et il prépare Sisley." Focillon 1927, pp. 312, 322.
11. "Bientôt Daubigny, après, il est vrai, Corot, peintre des eaux courantes et chantantes, succomba à l'attirance du monde liquide . . . ici commence l'Impressionnisme." Paris, New York 1974–75, p. 17 (French ed.).

PROVENANCE: Gift of the artist to Louis-Auguste Lapito, Paris (according to Robaut); purchased from Lapito's widow by the comte Armand Doria, Paris, June 15, 1877, for 900 francs; his sale, Galerie Georges Petit, Paris, May 1899, no. 65; purchased at that sale by Étienne Moreau-Nélaton, Paris, for 8,000 francs, as *Ruines à Narni*; given by him to the Musée du Louvre, Paris, 1906; exhibited at the Musée des Arts Décoratifs, Paris, from 1907; entered the Louvre, 1934

EXHIBITIONS: Paris 1907; Paris 1936, no. 11; Paris 1945b, no. 8; Paris 1946b, no. 167; Paris 1975, no. 43; Paris 1991, no. 37

REFERENCES: Michel 1896a, p. 13; Michel 1905, p. 12; Robaut 1905, vol. 2, pp. 48–49, no. 130, ill.; Brière 1924, no. M 9; Moreau-Nélaton 1924, vol. 1, fig. 29; Lafargue 1925, pp. 7, 22, 25, 55, ill.; Focillon 1927, p. 312; Michel 1928, pp. 127–28; Fosca 1930, pp. 19, 34; Meier-Graefe 1930, pl. v; Venturi 1941, pp. 141–43, 148, ill.; Bazin 1942, no. 10, pl. 10; Bazin 1951, pp. 3, 5, no. 14, pls. v, 14; Baud-Bovy 1957, p. 24, fig. 8; Sterling and Adhémar 1958, no. 354, fig. 96; Leymarie 1966, p. 32, ill. p. 33; Paris, Musée du Louvre 1972, p. 88; Bazin 1973, p. 30, ill. p. 31; Fouchet 1975, pp. 56–58, ill.; Leymarie 1979, p. 25, ill.; Compin and Roquebert 1986, p. 149; Selz 1988, pp. 34–36, ill., pp. 42, 47; Galassi 1991a, pp. 166–70, ill.; Galassi 1991b, pp. 166–70, ill. p. vi (detail), pl. 200

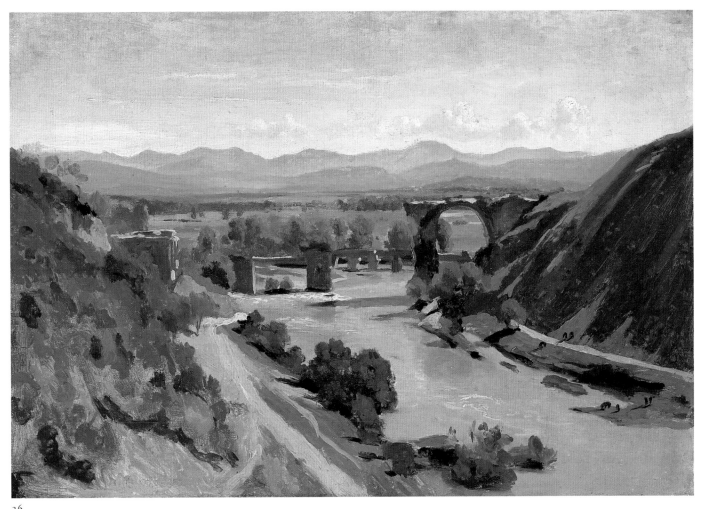

26

27

Vue prise à Narni
(View at Narni)

Ca. 1826–27
Oil on canvas
26¾ × 36⅝ in. (68 × 93 cm)
Stamped lower left: VENTE COROT
National Gallery of Canada, Ottawa 4526

R 199

Comparing the plein air study of the bridge at Narni made during Corot's stay in Italy (cat. no. 26) with this painting exhibited at the Salon of 1827 has been a stylistic exercise for art historians ever since the study was given to the Louvre, and especially after this larger work entered a public collection in 1939, by which time the Impressionist movement had long been embraced by critics as the culmination of French nineteenth-century landscape painting.

Art historians have clearly favored Corot's study over his Salon painting. The *Pont de Narni* study was a spontaneous on-the-spot sketch that conveyed the master's initial ideas; it was realistic, expressive, honest, complete. The Salon picture, on the other hand, was created in the studio and thus was artificial, cold, divorced from reality, and, by definition, academic. "There is weakening not only in the execution . . . but in the entire composition. The splendid original motif, which was seen from above and close up, recedes and disappears in the midst of an elaborate pastoral decoration that stiltedly imitates Claude Lorrain. The powerfully unified light and vision are dispersed into clever effects of lighting and scene setting,"[1] wrote Jean Leymarie, who is nevertheless one of Corot's most fervent defenders. Although Henri Focillon had earlier discovered some lesser charms in the Salon work, where "the terrain bathed in a transparent light [and] the poetry of inaccessible distances make themselves felt even in an academic composition,"[2] the painting is generally deemed a lifeless studio replica, "more forced and more conventional" than its predecessor.[3] Art historians ponder Corot's motivations, since in their opinion he could not have shown the picture at the Salon without violating his integrity: torn between his true nature and his Neoclassical training, through fear, timidity, or frustration, he made a concession to the academic tradition and exhibited this painting. "In creating it for the Salon, perhaps Corot wished . . . to reassure the members of the jury—perhaps also to reassure himself. . . ."[4]

In fact, exhibiting two complementary paintings—morning and evening scenes (see cat. no. 29)—at the Salon of 1827, both of them composed in the studio on the basis of his work and experiences in Italy, was for Corot the logical outcome of all his efforts from the time he had entered Achille-Etna Michallon's studio. It had nothing to do with concessions to the Salon jury or renunciation of a visual quest for the real, and everything to do with the fulfillment of his pictorial education. Having studied nature sufficiently, having acquired the visual reflexes and technical skills he needed, he could finally draw on his recollections to describe the "beau ideal," creating a work of imagination as well as of visual observation. It was a procedure urged by Valenciennes. "[The artist's]

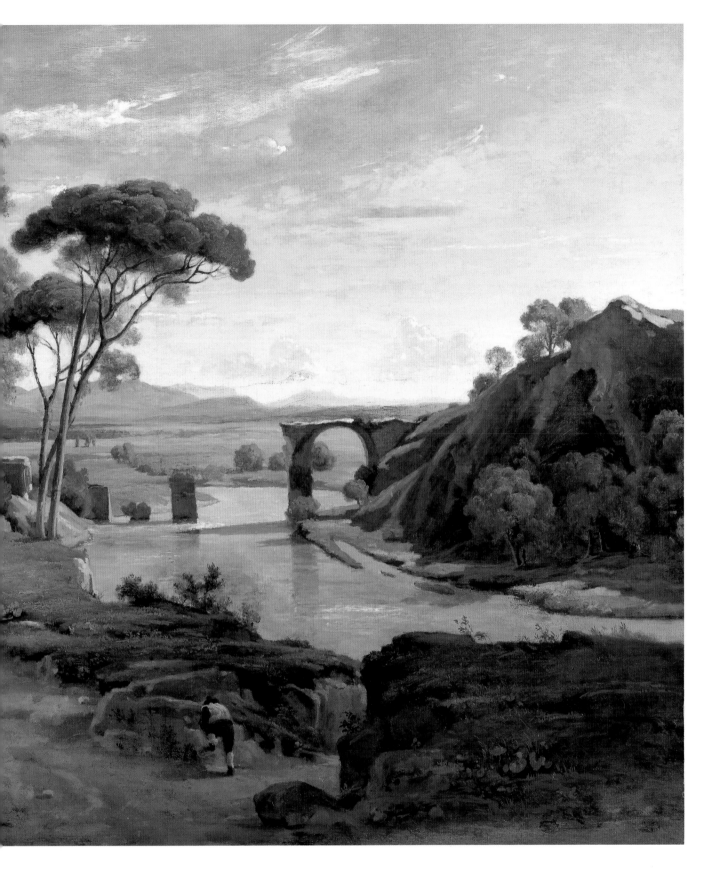

imagination, constantly warmed and nourished by the descriptions of poets, recasts and multiplies itself to infinity. . . . detaching himself from the minute particulars of reality that fetter him, he enlarges these rocks, he thrusts the crest of the mountains into the skies."[5] Corot selected the paintings *Vue prise à Narni* and *La Cervara* (cat. no. 29) to show his contemporaries that he was capable of inventing nature; he had

mastered his métier, he had attained technical and artistic maturity.

His contemporaries, taking nothing on faith, commented on the works' intrinsic virtues or defects. In any case, there were few critics; Corot was still an unknown. Of those taking notice, some reproached him for too discreet a touch, likening his views to the decorations on Sèvres porcelain.[6] Others offered

encouragement while suggesting that he work somewhat harder: "[Corot] has good color tones, lively effects, freshness, and transparency. We invite him to take more pains with the composition and the variety of his trees. . . ."[7] The most prestigious among them reserved judgment, remaining vague: "A *Vue prise à Narni* and a *Campagne de Rome* by M. Corot well evoke that mixture of charm and severity in which the country of Italy abounds."[8]

It is true that seventeenth-century French painting, especially that of Claude Lorrain, immediately leaps to mind as the source for this work, a reflection of its Neoclassical foundation. The device of blocking up one side of the painting, as occurs here on the left with a curtain of trees, and opening up most of the other side to the sky clearly derives from the classical tradition. Corot had perfectly mastered this method of composition and went on to use it throughout his career; see, for example, *Souvenir de Mortefontaine* (cat. no. 126). The same technique was employed by Joseph Vernet, Jean-Joseph Bidauld, Pierre-Athanase Chauvin, and most importantly Michallon, who in 1822, while the young Corot was studying with him, had painted a picture intended for the Salon, working in his studio from his recollections of Italy (*Paysage inspiré d'une vue de Frascati*, fig. 8).

A preparatory drawing for Corot's painting, in the National Gallery of Canada, Ottawa, shows the composition at an already advanced stage. It reveals that from the beginning Corot chose a more distant point of view than that in his plein air study, using the foreground to integrate the figures, and at the same early stage composed the group of trees at the left and the two umbrella pines near the center. The drawing differs from the painting only in showing a drove of cattle, perhaps done from nature, crossing the Nera. In the painting the cattle have been replaced by a herd of goats on the road at the left.

Photography with an infrared filter and radiography have revealed that Corot reworked this picture many times. Some of the retouches are visible; the most important covers a tree in the foreground that Corot decided to remove, opening up the painting's composition.

The play of light on the road at left and on the figures is particularly well handled, and it is clear that Corot's two years of plein air study in Italy had borne fruit. The light and its effects on large landscape masses are almost as intense in this studio painting as in the open-air study. It is evident that Corot did not use the view from nature as a preparatory study for the large painting, as Robaut believed he had,[9] but rather referred to it from time to time to refresh his memory of the colors and light he had admired that morning at Narni. In this way he could convincingly illuminate a landscape that he had just invented in the studio, allowing this ideal picture of a tranquil morning in the Italian countryside to retain its realism.

Corot kept this painting in his bedroom until his death.[10]

1. "Le dédoublement ne se produit pas seulement dans l'exécution . . . mais dans toute la composition. Le splendide motif initial, qui s'offrait en surplomb et de près, recule et disparait au sein d'un profus décor pastoral artificiellement imité de Claude Lorrain. La forte unité de lumière et de vision se disperse en savants effets d'éclairage et de mise en scène." Leymarie 1979, p. 27. See also Leymarie 1993, vol. 1, pp. 108–9.

2. "des terrains baignés d'une lumière transparente, la poésie des lointains inaccessibles et nets s'imposent encore à une composition scolaire." Focillon 1927, p. 312.

3. "plus poussé et plus conventionnel." Selz 1988, p. 34.

4. "En l'exécutant pour le Salon, peut-être Corot désirait-il . . . rassurer les membres du jury officiel,—peut-être aussi se rassurer lui-même. . . ." Fouchet 1975, p. 59.

5. "son imagination, toujours échauffée et nourrie par les descriptions des poëtes, se varie et se multiplie à l'infini. . . . se dégageant des vérités minutieuses qui le tenaient enchaîné, il grandit ces rochers, il porte la cime des montagnes dans les nues." Valenciennes 1800, pp. 384–85.

6. Anon. 1827, pt. 2, p. 5.

7. "[Corot] a un bon ton de couleur, des effets piquants, de la fraîcheur et de la transparence. Nous l'invitons à mieux soigner le dessin et la variété de ses arbres. . . ." Anon. 1828, pp. 138–39.

8. "Une *Vue prise à Narni* et une *Campagne de Rome* par M. Corot rappellent bien ce mélange de grâce et de sévérité dont la terre d'Italie offre tant d'examples." Delécluze 1827.

9. Robaut 1905, vol. 2, p. 70, no. 199.

10. Sale cat., anonymous sale (Charles André), Hôtel Drouot, Paris, May 17, 1893, no. 3.

PROVENANCE: The artist; his posthumous sale, Hôtel Drouot, Paris, pt. 1, May 26–28, 1875, no. 21; purchased at that sale by Georges Lemaistre, nephew of the artist, Paris, for 2,300 francs; Charles André, nephew of the artist, Paris; anonymous sale (Charles André), Hôtel Drouot, Paris, May 17, 1893, no. 3, sold for 48,000 francs; Victor Desfossés, Paris; his sale, Paris, April 26, 1899, no. 16; purchased at that sale by Bernheim-Jeune & Cie., Paris, for 10,000 francs; Royal Galleries Ltd., New York; F. Schnittjer & Son, New York; acquired from them by the National Gallery of Canada, Ottawa, 1939

EXHIBITIONS: Paris (Salon) 1827, no. 221, as *Vue prise à Narni*; Paris 1895, no. 116; Toronto 1940, no. 89; Montreal 1942, no. 54; New York 1942, no. 9; Philadelphia 1946, no. 6; Saint Louis 1947, no. 8; Montreal 1949; Toronto 1949, no. 129; Philadelphia 1950–51, no. 56; Venice 1952, no. 2; Fort Worth 1954, no. 14; Toronto, Ottawa, Montreal 1954, no. 46; Bern 1960, no. 17; Edinburgh, London 1965, no. 17; New York 1969, no. 9; Ottawa 1972, no. 18; Paris, Detroit, New York 1974–75, no. 22; New York 1978, no. 19

REFERENCES: Roger-Milès 1891, p. 25; Roger-Milès 1895, p. 24; Michel 1896a, p. 13; Michel 1896b, p. 919; Geffroy 1902, p. 4; Hamel 1905, pl. 1; Michel 1905, p. 16; Robaut 1905, vol. 1, p. 46, vol. 2, pp. 70–71, no. 199, ill., vol. 4, p. 195, no. 21; Cornu 1911, p. 149, ill.; Moreau-Nélaton 1924, vol. 1, fig. 31; Lafargue 1925, p. 25; Michel 1928, pp. 127–28; Fosca 1930, p. 34, ill.; Jean 1931, p. 13; Venturi 1941, p. 143, ill.; Bazin 1942, p. 37; Escholier 1943, p. 147; Corot 1946, vol. 1, pp. 39–40; Venturi 1946, p. 141; Malraux 1947, p. 67, ill.; Francastel 1955, p. 79; Huyghe 1955, p. 213, ill.; Baud-Bovy 1957, p. 79; Hubbard 1959, p. 12, no. 4526; Bazin 1973, p. 30, ill.; Fouchet 1975, pp. 56–58; Leymarie 1979, p. 26, ill.; Selz 1988, pp. 34–36, ill. p. 45; Galassi 1991a, pp. 166–71, ill.; Galassi 1991b, pp. 166–70, pl. 203

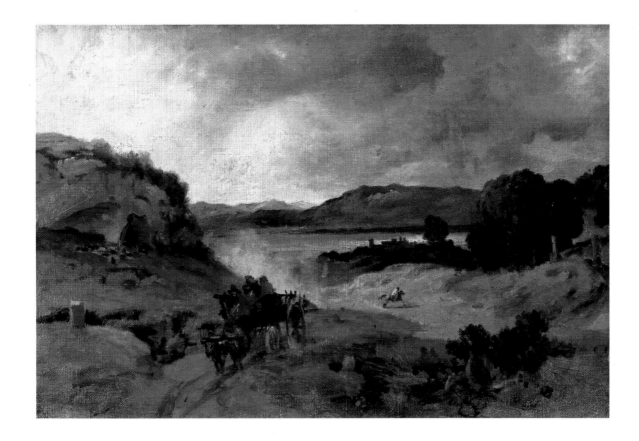

28

Campagne de Rome, also called La Cervara
(The Roman Campagna, also called La Cervara)

1827
Oil on canvas
11⅝ × 17⅛ in. (29.5 × 43.5 cm)
Dated lower left: 1827
Musée du Louvre, Paris R.F. 3943

R 2459 (B)

This small canvas was in the collection of the painter Prosper Barbot (1798–1878), a friend of Corot's who had been in Italy the same time he was.[1] It has often been mistakenly classified as a plein air study for the painting of the same subject exhibited at the Salon of 1827 (cat. no. 29).

Although this painting may be considered a preparatory study for the definitive composition presented at the Salon, it should be seen first and foremost as a work developed in the studio. It is done on canvas, not the paper Corot usually employed for open-air sessions, and its composition is already very polished, as if he had been referring to a preexisting study from nature.

The differences between the large painting and this work are significant: both the mountains in the background and the figures, including the horseman—who irresistibly recalls certain figures by Jean-Victor Bertin[2]—are transformed in the Salon picture. On the other hand, the arrangement of the large landscape elements and the color relationships have already been established in this earlier version, as has the effect of light, concentrated at the center of the composition.

1. Several authors, including Peter Galassi (in Galassi 1991a, p. 241, n. 12), have noted the importance of the *Journal de voyage* kept by Barbot during his stay in Italy from 1825 to 1828. Although the manuscript of this journal has been lost, all the passages touching on Corot had been copied by Robaut (Robaut "Corot. Peintre. Graveur," boîte 4).
2. See, for example, Bertin's *Paysage d'Italie avec un cavalier* (Bibliothèque Marmottan, Boulogne-Billancourt).

PROVENANCE: Gift of the artist to his friend the painter Prosper Barbot, Paris; Georges Le Châtelier (1857–1935), Barbot's grandson, by 1905; given by him to the Musée du Louvre, Paris, 1935

EXHIBITIONS: Manchester, Norwich 1991, no. 13

REFERENCES: Robaut 1905, vol. 3, pp. 392–33, no. 2459 (B), ill.; Sterling and Adhémar 1958, no. 355, ill.; Paris, Musée du Louvre 1972, p. 98; Jullien and Jullien 1982, pp. 193–94, 202, n. 67; Compin and Roquebert 1986, p. 158; Galassi 1991a, pp. 170–72, ill.; Galassi 1991b, p. 151, pl. 206

Campagne de Rome, also called La Cervara (The Roman Campagna, also called La Cervara)

Ca. 1826–27
Oil on canvas
26 × 37⅜ in. (66 × 95 cm)
Signed lower right: COROT
Kunsthaus, Zurich
Gift of G. A. Hahnloser-Hotz in memoriam Emil Hahnloser 2611

R 200

Until Hélène Toussaint's research for the 1975 retrospective exhibition celebrating Corot's centennial, this painting was thought to be *La Cervara, campagne de Rome*, which Corot exhibited at the Salon of 1831.[1] Robaut and Moreau-Nélaton had been the first to link that title appearing in the 1831 Salon booklet with this painting, then in a private collection. Subsequent art historians did not challenge their claim, despite obvious questions about the painting's dimensions.

The "Registre des entrées du Salon," an inventory of all works admitted to the Salon, gives the framed dimensions of the painting shown at the 1831 Salon as 115 by 150 centimeters. For the present painting to fit that description, the frame would have had to add an astonishing 49 centimeters in height and 55 centimeters in width. Clearly this Zurich painting cannot be the work that was registered in 1831. The register does show, on the other hand, that at the Salon of 1827 Corot exhibited a painting he called *Campagne de Rome* whose framed dimensions were 85 by 110 centimeters, the same as those of the *Vue prise à Narni* (cat. no. 27) exhibited the same year.[2] Without frames these two works are very nearly the same size, and thus we can conclude that they were pendant paintings, sent by Corot from Rome to the Salon of 1827.

Vue prise à Narni and the *La Cervara* shown here were reunited in the 1974 exhibition "De David à Delacroix," but not with any awareness that the two paintings had been shown together at the Salon of 1827. Robaut and Moreau-Nélaton's identification was then still accepted without question, as was their assertion that the painting shown alongside *Vue prise à Narni* at the Salon of 1827 had been destroyed. Toussaint was the first to point out, in 1975, that *Vue prise à Narni* in Ottawa and this *La Cervara* in Zurich must be a pair of paintings, one a morning landscape and the other an evening view, that were exhibited at the Salon of 1827.[3] Since then this analysis has been unanimously accepted. It was most recently restated by Peter Galassi.[4]

The histories of the two paintings, almost identical until the end of the nineteenth century, might in themselves have been a reason to rethink Robaut and Moreau-Nélaton's conclusions. *Vue prise à Narni* remained with Corot until his death, while *La Cervara* belonged to Corot's mother, testimony to the interest the family took in it. Mme Corot willed it to her grandson Georges Lemaistre. Lemaistre bought *Vue prise à Narni* at Corot's posthumous sale in 1875, undoubtedly because he knew that the two works were pendants. The two paintings remained together in his collection and then in that of Charles André; in André's sale on May 17, 1893, they were assigned successive numbers, 3 and 4. At that point they were separated and thereafter were no longer seen together, except in temporary exhibitions.

Whereas *Vue prise à Narni* received a lukewarm response from critics reviewing the Salon of 1827, *La Cervara* earned Corot his only frankly negative criticism: "It is not possible that the artist painted from nature . . . ; nothing resolved in this composition, choppy tones, tints that fall into violet. It seems to us that another choice would have given a better idea of the Roman Campagna. Nevertheless, M. Corot is a talented painter. . . ."[5] Could it be that unfavorable judgments such as these gradually pushed the painting into obscurity, so that ultimately the second picture at the Salon of 1827 was believed destroyed?

While *Vue prise à Narni* represents a calm morning scene, the Zurich *La Cervara* has been associated with the evening and with the threat of a storm. Corot thus took up a major theme of classical painting, the description of times of day, here treated in a more narrative manner than in his studies made in the Farnese Gardens (cat. nos. 7, 8, 9). Joseph Vernet, among many other artists, had often developed the times of day into dramatic stories: morning brought the poetic departure of fishermen, evening engulfed a shipwreck caught in a sublime and terrible tempest.

Corot embraced the idea of contrasting treatments for two paintings, evoking in his *Vue prise à Narni* the tranquil poetry of Claude Lorrain while imbuing *La Cervara* with a sense of drama and the overpowering force of nature that recalls certain paintings by Poussin (as do the buildings set in the distance). But the left side of the picture, a magisterial piece of painting with very subtly colored shadows, and also the effect of strong light in the center of the canvas are touches personal to Corot. They call to mind the plein air studies he made at Civita Castellana, Papigno, and La Cervara, a small village near Tivoli that he visited in 1827.

The small preparatory study for this painting in the Louvre (cat. no. 28) has often mistakenly been regarded as an open-air

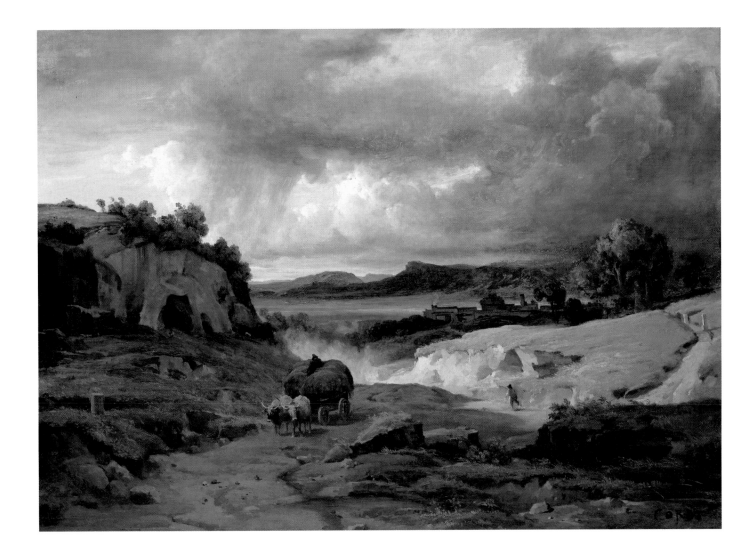

study but seems rather to be a working out in the studio of the large picture's composition. The changes between the two are significant: a flock of sheep, at left in the study, has disappeared from the final work, and a small horseman has been replaced by a peasant running on the road. On the other hand, the large masses of landscape and the chosen colors are already in place in the study, and the effect of light in the center, where sunlight still falls, is already defined.

The striking illumination in *La Cervara*, the play of contrasting light and shadow, the drama of the approaching storm—of which a Romantic artist would not be ashamed—and the realistic treatment of the entire landscape make this painting Corot's first large masterpiece. He seems in perfect agreement with Valenciennes's characterization of evening as a time "superb for painting."[6] But Corot set himself the additional challenge of representing the arrival of a storm, a phenomenon Valenciennes had advised treating by the light of midday.

1. At the Salon of 1831, Corot exhibited four paintings: no. 397, *Vue de Furia (l'île d'Ischia, royaume de Naples) (View of Furia [Island of Ischia, Kingdom of*

Naples]); no. 398, *Couvent sur les bords de l'Adriatique (Convent on the Shores of the Adriatic)*; no. 399, *Vue de la Cervara. Campagne de Rome (View of La Cervara: The Roman Campagna)*; and no. 400, *Vue prise dans la forêt de Fontainebleau (View in the Forest of Fontainebleau)*.
2. "Registre des entrées du Salon," Salon de 1827, KK 24, and Salon de 1831, KK 26 (Archives des Musées Nationaux, Musée du Louvre, Paris).
3. Hélène Toussaint in Paris 1975, pp. 21–22.
4. Galassi 1991a, pp. 169–71.
5. "Il n'est pas possible que l'auteur ait peint d'après nature . . . ; rien d'arrêté dans sa composition, des tons hachés, des teintes qui tombent dans le violet. Il nous semble qu'on aurait pu mieux choisir pour nous donner une idée de la campagne de Rome. M. Corot est cependant un peintre de mérite." Société de Gens de Lettres et d'Artistes 1828, p. 103.
6. "superbe pour la Peinture." Valenciennes 1800, p. 442. See cat. no. 9, discussion and n. 9.

PROVENANCE: The artist's mother (1768–1851); bequeathed to her grandson Georges Lemaistre, Paris;* Charles André, nephew of the artist, Paris; anonymous sale (Charles André), Hôtel Drouot, Paris, May 17, 1893, no. 4, sold for 48,000 francs; Bernheim-Jeune & Cie., Paris; Emil Hahnloser, Winterthur; given by G. A. Hahnloser-Hotz to the Kunsthaus, Zurich, in memory of Emil Hahnloser, 1942

EXHIBITIONS: Paris (Salon) 1827, no. 222, as *Campagne de Rome*; Zurich 1934, no. 38, lent by Dr. E. Hahnloser; Zurich 1943, no. 55; Paris 1959, no. 25; Bern

1960, no. 14; Chicago 1960, no. 3; Paris, Detroit, New York 1974–75; Bremen 1977–78, no. 32; Edinburgh 1986, no. 2

REFERENCES: Michel 1905, p. 16; Robaut 1905, vol. 2, pp. 70–71, no. 200, ill.; Gensel 1906, ill.; Moreau-Nélaton 1924, vol. 1, p. 29, ill.; Gilardoni 1952, ill.; Zurich, Kunsthaus 1959, ill.; Paris 1975, p. 21; Leymarie 1979, pp. 50–51,

ill.; Selz 1988, pp. 50–51, ill.; Galassi 1991a, pp. 170–72, ill.; Galassi 1991b, pp. 150–51, pl. 205

* According to Robaut 1905, vol. 2, p. 70, no. 200, the painting had been unsigned until then, and Corot signed it at Lemaistre's request.

30

La Cervara. Campagne de Rome, also called La Campagne romaine avec le mont Soracte (La Cervara, the Roman Campagna)

Ca. 1830–31
Oil on canvas
38¼ × 53¼ in. (97.2 × 135.2 cm)
The Cleveland Museum of Art
Leonard C. Hanna Jr. Fund 63.91
New York and Ottawa only

Not in Robaut 1905

The identification of paintings exhibited by Corot at the Salon is sometimes difficult because the often-elliptical Salon titles (*Site d'Italie, Une Marine, Campagne de Rome en hiver*, and so on) cannot easily be matched with paintings known only through their illustration in the catalogue raisonné by Alfred Robaut and Étienne Moreau-Nélaton or with paintings that have never been reproduced at all. Moreover, two works painted in the same period were sometimes exhibited in different Salons under similar titles, such as *Vue prise dans la forêt de Fontainebleau*, exhibited at the Salon of 1831, and *Vue de la forêt de Fontainebleau*, shown at the Salon of 1833.[1] Moreau-Nélaton and Robaut accomplished a remarkable feat, identifying most of the works exhibited at the Salons with a high degree of accuracy.[2] One of their rare confusions concerned the painting *La Cervara* exhibited at the Salon of 1827, as was just discussed (cat. no. 29).

In identifying works from the Salons, the art historian has three main sources of information: the Salon catalogues, which list the titles of all the paintings exhibited; the Salon registers, which record the receipt of each work together with its dimensions;[3] and the critical reviews of each Salon, in which paintings under discussion are frequently described. In Corot's case the last source is often disappointing for the years before 1840, because he was not yet famous and the critics spent little time on him.

Collating these sources is useful in discussing the present canvas and in addressing the questions that surround its inclusion in the Salon of 1831. This painting, although long attributed to Corot, was not catalogued by Robaut and Moreau-Nélaton, and it was not included in the supplements published

by the Dieterle family. Its technique seems to match Corot's of the 1830s. A drawing by him—*Campagne de Rome. Horizon de montagnes* (Fogg Art Museum, Cambridge, Massachusetts)[4]—has the same composition as the present painting, and both can be related to a study of Mount Soracte cited by Robaut and Moreau-Nélaton.[5] Mount Soracte is clearly identifiable in the background, while the foreground is reminiscent of the Zurich painting *La Cervara* (cat. no. 29), with its valley at the foot of a rocky elevation.

The work is skillfully constructed: the trees to the right create a pleasing asymmetrical effect, while the left side is occupied by the vertical of the steep slope. At the center a sparse copse, echoed by a few shrubs in the distance, allows a smooth transition between foreground and background. The foreground is enlivened by two groups of figures: a cowherd on horseback drives his herd forward; another rider talks with two young shepherds.

Was this work, with its ambitious dimensions, exhibited at a Salon during the 1830s? As Hélène Toussaint points out, if this is not the painting exhibited at the Salon of 1827 (see cat. no. 29), it can be related through the register to a canvas with similar dimensions exhibited at the Salon of 1831.[6] This was *La Cervara, campagne de Rome*, which measured 45¼ by 59 inches (115 × 150 cm) when framed, dimensions close to those of the present painting if allowance is made for a frame about 6 inches (15 cm) wide. But according to its title, the landscape exhibited in 1831[7] depicted La Cervara, a small village near Tivoli, and not the area around Civita Castellana, north of Rome, where Mount Soracte, seen in this painting, is located. Moreover,

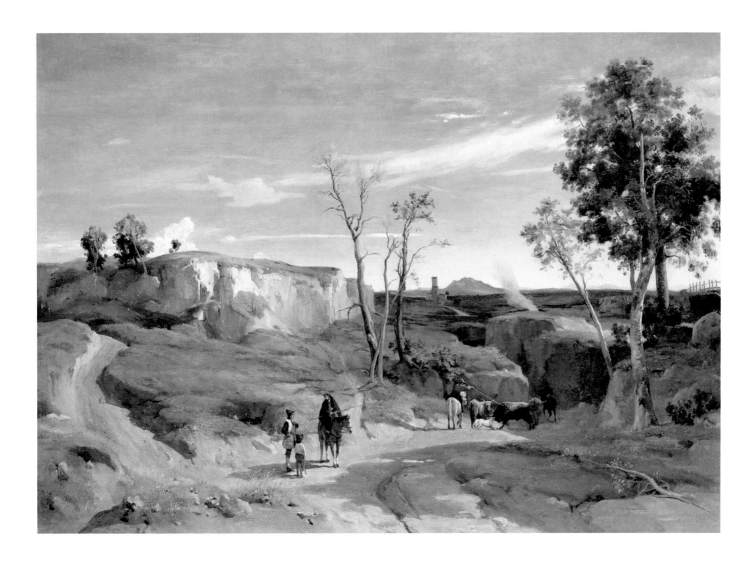

the hillside to the left is very close to studies Corot painted during his stay at Civita Castellana.

It seems unlikely that the painting was logged in at the Salon under the wrong title. Could Corot, giving his imagination free rein, have juxtaposed two sites that in fact lie sixty miles apart? The traditional understanding of the genre of the "view"—a topographically exact depiction of an area as it really exists, rather than a composite landscape—might seem to preclude such a procedure on his part. However, Corot was perfectly capable of taking a few liberties with the genre.

The Salon reviews give no further information, as they dwell on similarities between the works of Corot, Bertin, and Aligny rather than describing Corot's actual painting: "Without saying that their compositions look alike, there is an analogy between those of Messrs. Aligny, Corot, and Édouard Bertin, which gives this talented confraternity all the appearances of having founded a school of landscape artists,"[8] or "Messrs. Aligny, Corot, and Édouard Bertin use beautiful tones, and their landscapes have beautiful lines; but, because of the uniformity of their colors as much as of their touch, they produce flat, lifeless paintings."[9] The critic Victor Schoelcher is more precise, and the work he describes could be the present

painting: "M. Corot's imagination has a serious quality, but we would prefer it to bring forth a form of nature less stark, less arid, less monotonous; nor would we mind if he searched his palette for more cheerful colors."[10]

Thus, there is good reason to assume that the present painting is the one exhibited at the Salon of 1831; and although the title in the Salon catalogue leaves some room for doubt, I believe that the arguments in favor are sufficiently strong to justify making this identification.

One more question has to be addressed: did the painting have a companion piece? Corot during that period seems to have been fond of painting landscapes in pairs, one picture evoking the morning and the other the evening, as with *Vue prise à Narni* (cat. no. 27) and *La Cervara* (cat. no. 29). He wrote to his friend Abel Osmond in 1828, "I can tell you that we're having a superb winter, and I would feel very guilty if I didn't take advantage of it by working outdoors. And so I've sketched out two paintings that I won't start working on in earnest until I get back to Paris."[11]

Peter Galassi, following Ann T. Lurie, has suggested that one of the two pictures begun in Rome and finished later in Paris was the present painting.[12] It is interesting to note that a

painting in Norfolk, Virginia, *Campagne de Rome en hiver* (cat. no. 31), has dimensions almost identical to those of the present landscape and therefore could be the companion piece alluded to in Corot's letter to Osmond. The Norfolk painting would be the evening scene, while the Cleveland one would be the evocation of morning. But despite their probable conception as companion pieces, the two paintings were ultimately not exhibited together. Corot waited for the Salon of 1836 to present the Norfolk painting, perhaps because he was dissatisfied with it or perhaps because he had not finished it in 1831.

Regardless of these questions, the present painting demonstrates a rare mastery of space and light in animating a panoramic view. Its depiction of a desert landscape prefigures *Agar dans le désert* (cat. no. 61).

1. Probably R 255 (National Gallery of Art, Washington, D.C.) and R 257 (location unknown).
2. In Robaut 1905, vol. 4, pp. 167–79, is a complete list of the exhibitions in which Corot's works were shown during his lifetime, including a list of the paintings he exhibited at the Salon.
3. *Enregistrement des ouvrages du Salon*, Musée du Louvre, Paris, archives of the Musées Nationaux (series KK).
4. R 2562. The comparison between this drawing and the painting in Cleveland was made in Chicago 1960, in which the authors cited comments by Alexandre Rosenberg, then the owner (p. 17, no. 19).
5. R 169. The work is not reproduced but is illustrated by a drawing by Robaut.
6. *Enregistrement des ouvrages. Salon de 1831*, Musée du Louvre, Paris, archives of the Musées Nationaux, KK 26. Hélène Toussaint advanced this thesis in a note of 1976 preserved in the file for R.F. 3943, Département des Peintures, Musée du Louvre. See also the discussion for cat. no. 29.
7. No. 399 in the catalogue for the Salon of 1831.
8. "Sans que leurs compositions se ressemblent, il y a une analogie entre celles de MM. Aligny, Corot et Édouard Bertin, qui donnerait à cette confraternité de talent toutes les apparences d'une fondation d'école de paysagistes." Delécluze 1831.
9. "Messieurs Aligny, Corot et Édouard Bertin emploient de beaux tons, ils ont de belles lignes dans leurs paysages; mais autant par l'uniformité de leur couleur que par celle de leur touche, ils font de la peinture plate et sans ressort." Jal 1831, p. 153.
10. "L'imagination de M. Corot a quelque chose de grave, mais on aimerait qu'il lui demandât une nature moins nue, moins sèche, moins monotone, et qu'il cherchât sur la palette de plus riantes couleurs." Schoelcher 1831, p. 2.
11. "Je te dirai que nous avons un hiver superbe et que je me croirais coupable de ne pas en profiter pour aller travailler dehors. Ainsi donc, d'après cela, j'ai ébauché deux tableaux que je n'exécuterai qu'à Paris." Letter (a.l.s.), Corot to Abel Osmond, Rome, February 2, 1828, Département des Arts Graphiques, Musée du Louvre, Paris, Moreau-Nélaton Bequest, 1927, A.R. 8 L 10, quoted in Robaut 1905, vol. 4, p. 44.
12. Lurie 1966, pp. 51–57; Galassi 1991a, p. 241, n. 6.

PROVENANCE: Clément Jourdan, Paris, 1889; Seganville collection, Château Saint-Pierre-de-Granoupiac; Paul Rosenberg & Co., New York; acquired by The Cleveland Museum of Art, 1963, Leonard C. Hanna Jr. Fund

EXHIBITIONS: Paris (Salon) 1831, no. 399, as *La Cervara, campagne de Rome*; Chicago 1960, no. 19; Edinburgh, London 1965, no. 18; San Diego, Williamstown 1988, no. 9

REFERENCES: Henning 1963, p. 482, ill.; Lurie 1966, pp. 51–57, ill.; Paris 1975, pp. 21–22; Talbot 1978, pp. 84–85, ill.; Morse 1979, p. 66; Cleveland Museum of Art 1991, p. 126; Galassi 1991a, p. 241, n. 6; Galassi 1991b, p. 241, n. 6; Chong 1993, p. 44

31

Campagne de Rome en hiver, also called *Campagne romaine. Vallée rocheuse avec un troupeau de porcs* (*The Roman Campagna in Winter*)

Ca. 1830
Oil on canvas
38½ × 53¼ in. (97.8 × 135.3 cm)
Signed and dated lower left: COROT 1856 [probably dated when the painting was retouched]
The Chrysler Museum, Norfolk, Virginia
Gift of Walter P. Chrysler Jr., 1971 71.632

R 259

Like catalogue number 30, this work is a beautifully painted, rather large composition, which must have been exhibited at the Salon before 1840. The setting, no doubt taken from a study painted in the Roman Campagna, is difficult to identify.

The signature and date have been partially erased, and following Moreau-Nélaton's lead, the date is generally read as

Fig. 45. Achille-Etna Michallon (1796–1822). *Thésée poursuivant les Centaures (Theseus Pursuing the Centaurs)*. Oil on canvas, 85⅞ × 107½ in. (218 × 273 cm). Musée du Louvre, Paris (inv. 6631)

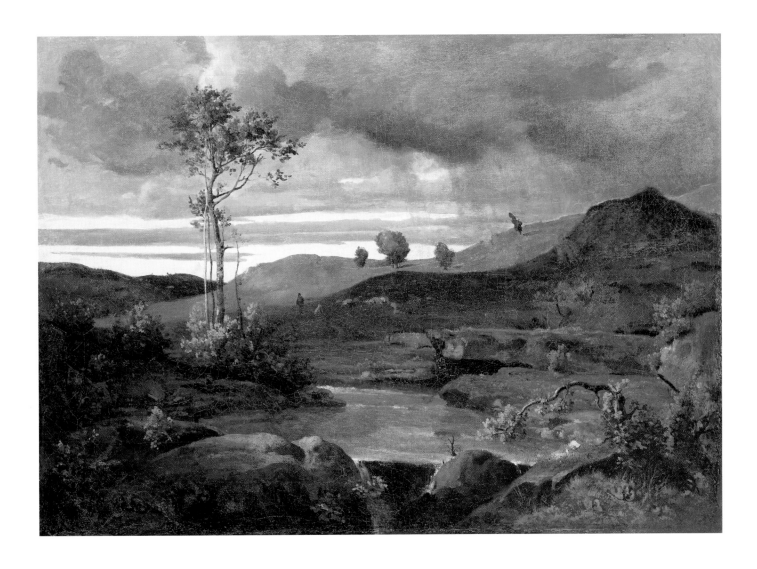

1856, which does not, however, seem to correspond to the painting's style. Robaut and Moreau-Nélaton have suggested that this canvas, though painted earlier, was signed by Corot during a retouching session. The execution of the present work is similar to that of landscapes painted between 1830 and 1835; even a date of 1836 would seem credible. At the Salon of 1836 Corot exhibited a *Campagne de Rome en hiver* whose dimensions, as recorded in the Salon register, could correspond to those of the present painting when framed: 130 by 160 centimeters (51 × 63 in.).[1] As suggested above, this painting's dimensions also permit it to be seen as a companion piece to *La Cervara. Campagne de Rome* (cat. no. 30).

The surface of this painting, partially damaged by crackling, seems to have been retouched several times by Corot, which would support the thesis that some time elapsed between the work's creation and its exhibition at the Salon. The landscape itself is remarkably interesting. The effect of a storm is reminiscent of certain studies by Valenciennes, and the waterfall in the foreground is not unlike that seen in *Thésée poursuivant les Centaures*, Michallon's Salon entry for 1821 (fig. 45).

1. *Enregistrement des ouvrages. Salon de 1836*, no. 404; Musée du Louvre, Paris, archives of the Musées Nationaux, KK 7.

PROVENANCE: Anonymous sale, Hôtel Drouot, Paris, May 12, 1896, no. 32; purchased at that sale by Bernheim-Jeune & Cie., Paris, for 3,000 francs; Conrad Pineus, Göteborg, Sweden, 1924; Walter Halvorsen, Paris; Thannhauser Galleries, Berlin and Lucerne, 1927; Leicester Galleries, London, 1926; Acquavella Galleries, New York, 1949; Walter P. Chrysler Jr., New York; given by him to The Chrysler Museum, Norfolk, Virginia, 1971

EXHIBITIONS: Stockholm 1924, no. 2; New York 1930c, no. 15; Portland et al. 1956–57, no. 75; Provincetown 1958, no. 12; Dayton 1960, no. 26; Provincetown, Ottawa 1962; New York 1965–66, no. 15; New York 1969, no. 20; Raleigh, Birmingham 1986–87, no. 23

REFERENCES: Robaut 1905, vol. 2, pp. 92–93, no. 259, ill.; Barker 1930, ill. p. 17

Ville-d'Avray. Chemin bordé d'un mur conduisant aux étangs (Ville-d'Avray: Road to the Ponds, Bordered by a Wall)

Ca. 1828, retouched by the artist ca. 1835–40
Oil on paper mounted on canvas
10⅞ × 11⅝ in. (27.6 × 29.4 cm)
Signed lower right: COROT
Philadelphia Museum of Art
The John G. Johnson Collection JC cat. 931

R 207

"Ville-d'Avray is where he rejoins his beloved goddess, nature."[1]
From the moment he returned to France, Corot wanted to apply to the familiar landscapes of the Île-de-France the plein air techniques he had acquired during his stay in Italy. According to Robaut and Moreau-Nélaton, who provide the only account, this view looking along the wall of his parents' property from the wooded hills that rise behind the ponds of Ville-d'Avray was the first painting Corot made on returning from his initial Italian journey.[2]

But dating this work turns out to be a complex matter. It is true that when the painting is compared with *Ville-d'Avray. Entrée du bois avec une vachère* (cat. no. 4), which was clearly made about 1825, that Edinburgh work appears, stylistically, to be earlier. Moreover, the picture seen here, a study painted out of doors on paper, is in a technique that Corot brought to a high level in Italy, making a date of 1828 plausible. However, in some places the painting's facture better recalls the style of works made about 1835–40 than those of 1828–30. Corot seems to have considerably retouched the right side of the composition sometime after 1835. On the other hand, the left side is completely compatible with the period after the first Italian journey, as proposed by Robaut and Moreau-Nélaton. Therefore it seems likely that the study, having been begun outdoors in 1828, was taken up again and finished by Corot about 1840, perhaps when it was scheduled to leave his studio. Probably the figures and the cow at the right, as well as the signature, were added at that time.

In any event, the picture's asymmetrical construction—its left side luminous and enlivened by the thick, bright substance of the wall, its right side dark and more densely painted—has produced a true success. Above the wall Corot forcefully painted a cloudy sky that extends toward Chaville, Viroflay, and Versailles. Strangely serene and devoid of activity, this work has an undeniable charm, which is not owed, as it is in the Italian paintings, to the light or the realism, but to the solitary poetic universe Corot created.

1. "Ville-d'Avray, c'est là qu'il rejoint sa chère déesse, la nature." Lafargue 1925, p. 23.
2. Robaut 1905, vol. 2, p. 74, no. 207.

PROVENANCE: Thurwanger collection (according to Paris 1875a); John G. Johnson, Philadelphia; bequeathed by him with the rest of his collection to the city of Philadelphia, 1917; transferred to the Philadelphia Museum of Art, 1933

EXHIBITIONS: Paris 1875a, no. 189; Northampton 1934; Philadelphia 1946, no. 9; Toronto 1950, no. 5; Chicago 1960, no. 21

REFERENCES: Paris 1875a, p. 74, no. 189; Robaut 1905, vol. 2, pp. 74–75, no. 207, ill.; Valentiner 1914, p. 93, no. 931; *Johnson Collection* 1953, no. 931; Leymarie 1966, p. 45; Leymarie 1979, p. 41, ill.

33

Fontainebleau. Le Rageur
(Fontainebleau: "The Raging One")

Ca. 1830
Oil on canvas
20 × 24 in. (50.8 × 61 cm)
Signed lower left: COROT
Private collection

R 266

Beginning in 1822, Corot found in the forest of Fontainebleau subject matter that was appropriate to the study of landscape and that allowed him to practice what he had been taught in the studio (he was probably following the advice of his teacher Michallon and later that of Édouard Bertin, his friend from Italy). Corot went there very soon after he returned from Italy, looking for sites with a combination of hills, rocks, and forests that could provide a pictorial variety as rich as that of the Roman Campagna. "Fontainebleau was then a very popular spot among painters," wrote Moreau-Nélaton. "It was like a branch office of Italy."[1]

Striving to further his visual and technical training, which he did not consider completed, Corot traveled regularly to the forest of Fontainebleau between 1828 and 1834, when he left for his second trip to Italy. He continued to work there occasionally, generally in the spring or summer, throughout his career.

In the first three years following his return to France, Corot aimed to exhibit paintings of the forest of Fontainebleau at the Salon alongside views composed from his Italian studies. In 1831 he showed *Vue prise dans la forêt de Fontainebleau;*[2] in 1833, *Vue de la forêt de Fontainebleau;*[3] and in 1834, *Une Forêt.*[4] Robaut and Moreau-Nélaton catalogued some twenty oil studies painted in the Fontainebleau forest between 1828 and 1834,[5] as well as some drawings, which reveal Corot's systematic investigations into making the most faithful possible description of trees, rocks, and sky. Besides the traditional exercise of studying trees, the foundation of a classical education, he was particularly interested in the depiction of rocks.

Of the works he painted at Fontainebleau in this period, *Le Rageur* is one in which Corot most painstakingly synthesized his researches. The centerpiece of this view is an oak tree with twisted trunk and knotted branches that towered above a rocky, barren plain and that strollers in the forest had given the evocative nickname "The Raging One." Émile Michel wrote about Corot's painting in 1905: "*Le Rageur* should be cited as absolutely truthful testimony of the profound changes that time ceaselessly wreaks on the contours of the ancient forest. With its harsh, angry outline, the gnarled oak—which gave the painting its expressive title—tells the story of the assaults it has withstood from wind and lightning. Today, this faithful image is all that remains of it."[6]

From his beginnings as a painter, Corot liked to enliven his landscapes with a human presence—in this case a young shepherdess, silent companion to the tree's majesty, who stares fixedly at the viewer (see cat. no. 34). Germain Bazin, like so many others, was struck by that figure; it "appears to have been imported from beyond the mountains," he said, noting its resemblance to the figures that sometimes embellish Corot's landscapes of sites around Rome.[7] Thus Bazin astutely defined the archetypal nature of these figures, which Corot used without geographical reference—here, simply to enliven the foreground and introduce an element of softness into this landscape of barren rocks.

Many critics and historians have mentioned Théodore Rousseau when discussing this painting's technique and aesthetic totality. "Corot's painting . . . , in the sureness of its drawing and modeling, is reminiscent of Rousseau's best works," wrote Michel.[8] Bazin echoed that opinion nearly seventy years later: "The landscape of *Le Rageur* is painted with a scrupulous attention worthy of Théodore Rousseau. Corot's craft takes on an ascetic quality before the austerity of his subject. The canvas has been covered regularly and evenly by strokes of a slow, reflective brush."[9] Rousseau, it should be remembered, was just starting his career in 1828 and had so far made only brief excursions to the Fontainebleau forest.

A goal of uncompromising realism surely guided Corot in the making of this painting. Some retouching was done afterward in the studio; the shepherdess, for example, was very likely added at that point. The pictorial techniques, notably the painterly effects that convey the ruggedness of the trees and rocks, are so many processes that Corot had perfected during his first stay in Italy and suggest an early date for this painting, probably about 1830, although Robaut and Moreau-Nélaton date it less precisely, between 1830 and 1835.

1. "Fontainebleau est alors un séjour à la mode parmi les peintres. C'est comme une succursale de l'Italie." Moreau-Nélaton 1924, vol. 1, p. 29. Moreau-Nélaton bequeathed to the Département des Arts Graphiques, Musée du Louvre, Paris, a lovely letter Corot wrote to Abel Osmond (1927, P.P. 8 L 11) in which the painter describes his joy at working in the forest of Fontainebleau: "I frolic, I'm invited to wedding feasts in the village, I gambol with the wood nymphs!" ("Je folâtre, je vais à la noce aux fêtes du village, je saute avec les dryades!")

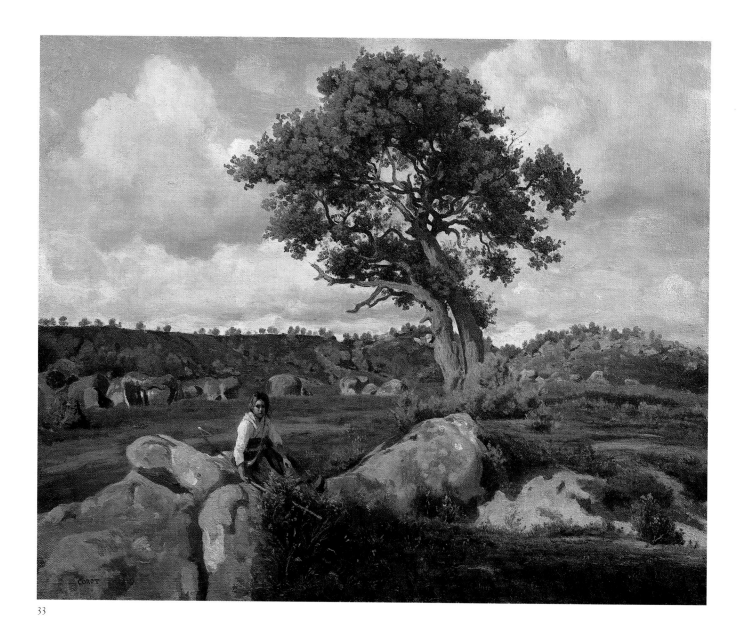

33

2. Perhaps R 255, National Gallery of Art, Washington, D.C., Chester Dale Collection; Robaut and Moreau-Nélaton were not sure whether this was the work shown at the 1831 Salon or the one shown at the 1834 Salon.

3. R 257, location unknown.

4. Perhaps R 255 (see n. 2).

5. Robaut 1905, vol. 2, pp. 94–99.

6. "*Le Rageur*, doit être signalé comme un témoignage absolument véridique des modifications profondes que le temps ne cesse pas d'apporter dans la configuration de l'antique forêt. Avec sa silhouette hargneuse et revêche, le chêne rabougri—qui a donné à ce tableau son nom expressif—raconte son histoire et les assauts qu'il a subis du vent et de la foudre. Aujourd'hui, d'ailleurs, il ne reste plus de lui que cette fidèle image." Michel 1905, p. 20.

7. "apparaît bien transplanté d'outremont." Bazin 1973, p. 35.

8. "La peinture de Corot . . . par la sûreté du dessin et du modelé, rappelle les meilleurs ouvrages de Rousseau." Michel 1905, p. 20.

9. "Le paysage du Rageur est peint avec une attention scrupuleuse, digne de Théodore Rousseau; le métier de Corot se fait ascétique devant l'austérité

du sujet; la toile est bien couverte, régulièrement et également, d'un pinceau lent et réfléchi." Bazin 1973, p. 35.

PROVENANCE: Gift of the artist to de Tournemine, director of the Musée du Luxembourg, Paris, 1867; Galerie Georges Petit, Paris, 1882; Obach & Co., London, 1887; Seymour collection, London, about 1902; Bernheim-Jeune & Cie., Paris, 1910; Paul Rosenberg & Cie., Paris, 1921; Georges Renand, Paris, about 1928; Dr. Fuchs, Dresden, 1942; Albert Wagner, Leipzig, 1960; Marie Bissinger, Leipzig, 1971; private collection, Switzerland, 1991; sale, Sotheby's, New York, May 24, 1995, no. 26; private collection

EXHIBITIONS: Paris 1875a, no. 20; Paris 1895; Paris 1922a

REFERENCES: Michel 1905, pp. 20–21, ill.; Robaut 1905, vol. 2, pp. 94–95, no. 266, ill.; Michel 1909, pl. 3; Bazin 1942; Bazin 1951, p. 39, no. 36, pl. 36; Bazin 1973, pp. 35, 263

34
Vue dans la forêt de Fontainebleau (The Forest of Fontainebleau)

Ca. 1830–32
Oil on paper mounted on canvas
10⅝ × 15⅜ in. (27 × 39 cm)
Signed lower left (signature partially effaced): COROT
Musée d'Art, Senlis 00.6.61

Not in Robaut 1905

Rarely exhibited, this surprising work was not documented by Robaut and Moreau-Nélaton, who apparently were unaware of its existence, and it has never been included in any catalogue raisonné of the artist. Its attribution to Corot seems entirely tenable. The tree at the right resembles other trees painted by Corot in the forest of Fontainebleau before 1834, and the rock on the left and the handling of light throughout the space are also completely convincing.

The same passion for a rough, realistic treatment of rocks is evident in a painting Robaut and Moreau-Nélaton dated to 1828–30, *Forêt de Fontainebleau. Boules rocheuses (Forest of Fontainebleau: Rocky Mounds).*[1] Even closer is *Fontainebleau. Le Rageur* (cat. no. 33), which presents an equally uncompromising rocky landscape. Both *Le Rageur* and the present painting include the amusing representation of a small figure, another factor that confirms the attribution to Corot. In this work it is a young peasant

woman, who looks straight at the viewer and whose unexpected presence only heightens the effect of the landscape.

We cannot say if this native type was painted from life when Corot was on the site at Fontainebleau or if he added in the studio a figure that he had sketched on one of his walks. Théophile Silvestre, who had lengthy discussions with Corot, reported that he "very much likes figures animating his landscapes; he wants to have company in the woods, in the valleys, along rivers, to see animals and people rambling around the countryside, where he could not live absolutely alone."[2] With a classical training in landscape painting and a humanist cast of mind, Corot had a hard time imagining landscape without the human presence, and his landscapes, in contrast to those of Rousseau or Daubigny, are frequently inhabited.

Unlike most of the figures in Corot's early works, which were clearly added later in the studio, these stiff, enigmatic

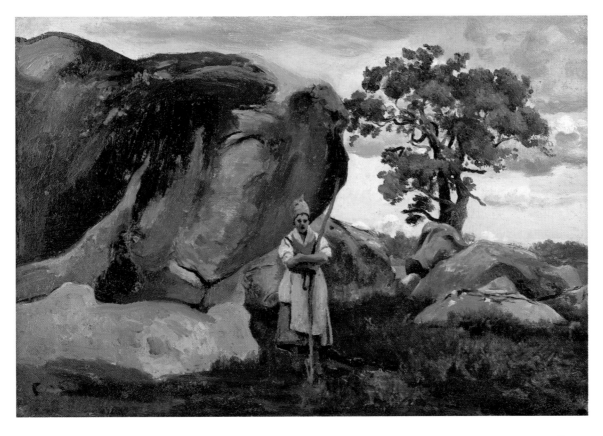

figures, who stare at the viewer as if to reject any possibility of anecdote or personality, are perfectly integrated into their natural setting and seem to have been conceived together with the landscape. Their presentation, deliberately realistic and commonplace, corresponds exactly to the spirit of the landscapes themselves. Corot had already done something similar in a small study of the west portal of Chartres Cathedral, in which two children on the steps watch the painter (R 222). This use of the human figure as a kind of punctuation for the landscape, enlivening it with a strange, silent, unmoving presence, became systematic with Corot after 1830. It is found in his odd landscapes of the Morvan and the Nièvre. Later, of course, this original use of the human figure will contribute to the poetry of certain works, such as the two paintings of 1843 done in Italy, *Genzano. Chevrier en vue d'un village* and *Tivoli. Les Jardins de la villa d'Este* (cat. nos. 82, 83).

In this Senlis painting Corot chose to emphasize the woman, putting her in the center of the composition as if she were the main actor in the landscape. The man who spoke of painting a woman's breast as if he were painting "a bottle of milk" used the same touch for this figure as for a tree or a rock—although with her formal, symmetrical pose, which radically distinguishes her from her environment, she irresistibly attracts the eye.

1. R 217. This study is known only through a drawing by Alfred Robaut; Robaut and Moreau-Nélaton indicated that it was so restretched and retouched by Corot in 1874 that it became unrecognizable.
2. "aime beaucoup les figures animant les paysages, il veut être en compagnie dans les bois, dans les vallées, au bord des rivières, voir bêtes et gens courir la campagne où il ne pourrait vivre absolument seul." Silvestre 1853, p. 77.

PROVENANCE: Musée d'Art, Senlis, by 1887

EXHIBITIONS: Tokyo, Osaka, Yokohama 1989–90, no. 6; Manchester, Norwich 1991, no. 14

35

Fontainebleau. Chênes noirs du Bas-Bréau (Fontainebleau: Black Oaks of Bas-Bréau)

Ca. 1832–33
Oil on paper mounted on wood panel
15⅝ × 19½ in. (39.7 × 49.5 cm)
Inscribed on back of wooden panel, in ink: Cette étude de mon maître Corot peinte vers 1830 / qui lui a servi pour son tableau d'Hagar dans le désert / fut donné par lui à [?] Célestin Nanteuil en 183[5?] / Je l'ai retrouvé en fort mauvais état en 1884 / à Ma...lle [Marseille?] / Je l'ai nettoyée et fait mettre / sur panneau dans l'état où elle se trouve / Corot l'estimait comme une de ses meilleures. / Français (This study by my master Corot, painted about 1830, / which he used for his painting of Hagar in the wilderness / was given by him to [?] Célestin Nanteuil in 183[5?] / I found it again in very bad shape in 1884 / at Ma...lle [Marseilles?] / I cleaned it and mounted it on wood panel in its current state / Corot thought it one of his best. / Français)
The Metropolitan Museum of Art, New York
Catharine Lorillard Wolfe Collection, Wolfe Fund, 1979 1979.404

R 278

This study, almost certainly painted during the summer of 1832 or 1833, is one of the most vigorous and precise made by Corot in the forest of Fontainebleau. The intense blue of the sky finds a response in the sustained green of the oaks' leaves and the delicate range of grays, yellows, and browns on the ground. As in his Italian studies, Corot left the foreground of his composition undefined, even unfinished, in order to concentrate on the treatment of the foliage, the tree trunks, and the rocks. Masterly in its technique, this "morsel" was acclaimed for the quality of its execution. In 1896 André Michel held it

up as a work to show to Corot's detractors or to those weary of his landscapes of the 1860s: "Those who know Corot only through his celebrated 'silvery mists'—which the writers, forgers, dealers, and perhaps even, at the end of his life, Corot himself, greatly exploited—should be shown this morsel. It is brilliantly executed, authoritative, direct and confident in its brushwork, rich in tone, as delicate as it is firm."[1]

This work also merits attention because Corot drew on it in making *Agar dans le désert* (cat. no. 60), exhibited at the Salon of 1835. The cluster of trees that he studied near the site of Bas-Bréau in a spot called the "Reine-Blanche" reappeared in the wild landscape of *Agar*, giving an excellent idea of Corot's working method. He literally "composed" his landscapes in the classical manner, using *souvenirs* amassed during his outdoor work sessions. Thus he could juxtapose a group of oaks sketched at Fontainebleau with a rock studied at Civita Castellana—as he seems to have done in *Agar*—to give more credibility to a scene that he wished to set in a wild, rocky wasteland.

Daniel Baud-Bovy's description of his first meeting with the painter François-Louis Français—one of the owners of this painting and the author of the inscription on its back—reveals the influence of certain of Corot's plein air studies on an entire generation of artists, who discovered his work about 1835 in the course of whole evenings of discussions at inns in

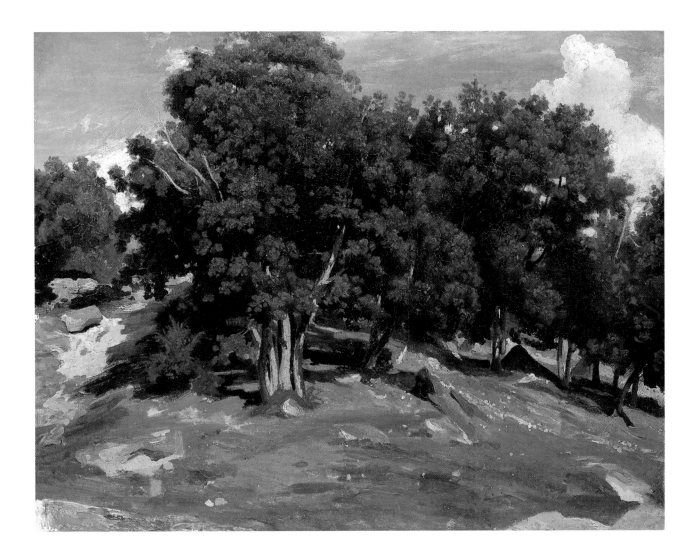

Chailly and Ganne de Barbizon. Français was enthusiastic about this work, fully comprehending Corot's essential contribution to the realistic painting of nature. He was tenacious in trying to obtain the picture from the painter Célestin Nanteuil (to whom Corot had given it, probably in thanks for Nanteuil's making an engraving after *Agar dans le désert*), and Nanteuil agreed to exchange it for a tapestry then valued at 5,000 francs.[2] But the exchange did not take place, and Français had to wait until about 1884 before recovering the work that so captivated him.[3] It had originally been painted on paper, but Nanteuil had mounted it on wood, damaging it in the process. Français carefully kept it in good repair and according to Robaut refused to sell it, preferring to "save it for the Louvre." For Français the picture must have evoked moving recollections of the joyous days spent at Barbizon or Chailly: "We were quite a group there and we were full of high spirits! Diaz, Rousseau, Barye, Decamps, Corot. Ladies, too, of course! Ah! what gaiety, my friends, what laughs! Each morning Corot, who had a good voice, would awaken us, greeting the dawn with an opera aria or a song."[4]

1. "À ceux qui ne connaissent de Corot que les fameux 'brouillards argentés' dont les littérateurs, les contrefacteurs, les marchands et Corot lui-même, peut-être, à la fin de sa vie, ont fait un grand abus, il faudrait montrer ce morceau. Il est enlevé d'autorité, d'une facture directe et décidée, corsé de ton, délicat autant que ferme." Michel 1896a, p. 18.
2. Baud-Bovy 1957, p. 36; Robaut 1905, vol. 2, p. 98, no. 278.
3. It was then owned by Mme Larrieu, friend of both Nanteuil and Français, who sold it to Français for 1,000 francs. The painting was in very bad shape, since apparently Nanteuil had not cared for it properly from the beginning. This information is in Robaut *carton 2*, "Paysages 1827–1840," fol. 10.
4. "réserver au Louvre"; "Nous y étions une bande et qui n'engendrait pas la mélancolie! Diaz, Rousseau, Barye, Decamps, Corot. Des dames aussi, naturellement! Ah! quelle gaieté, mes amis, quels rires! Le matin Corot, qui avait une belle voix, nous réveillait en saluant l'aube avec un air d'opéra ou une chanson." Baud-Bovy 1957, p. 36.

PROVENANCE: Gift of the artist to the painter Célestin Nanteuil-Leboeuf (1813–1875), about 1835 (according to Robaut); M. and Mme Larrieu, Paris; Mme Larrieu; the painter François-Louis Français (1814–1897), Paris, about 1884 (according to Robaut and Baud-Bovy); sale, William Doyle Galleries, New York, May 16, 1979, no. 1, as School of Corot; Simon Parks, New York; sale, Sotheby Parke Bernet, New York, October 12, 1979, no. 222, as Corot; E. V. Thaw & Co., New York, 1979; purchased by The Metropolitan Museum of Art, New York, Catharine Lorillard Wolfe Collection, Wolfe Fund, 1979

EXHIBITIONS: Paris 1889, no. 148, lent by Français; New York 1987–88; New York 1992

REFERENCES: Roger-Milès 1891, p. 84; Michel 1896a, p. 18; Robaut 1905, vol. 2, pp. 98–99, no. 278, ill.; Moffett and Wagner 1980, p. 43, ill.; New York 1990, pp. 246–47, ill.; Galassi 1991a, p. 81, ill.; Galassi 1991b, p. 81, pl. 95

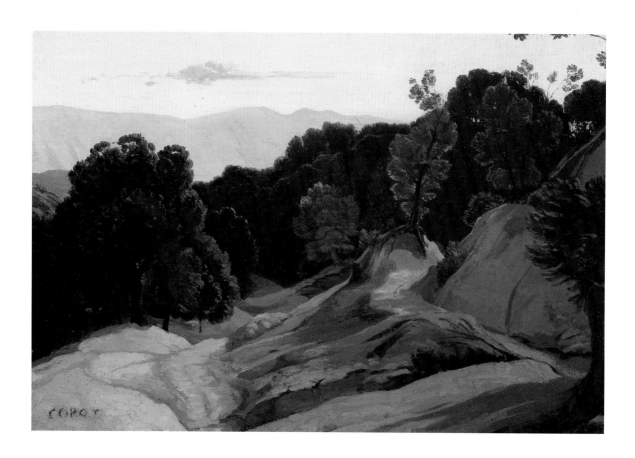

36

Chemin sur les monts boisés
(Road through Wooded Mountains)

Ca. 1830–35
Oil on paper mounted on canvas
12⅝ × 16½ in. (32 × 42 cm)
Signed lower left: COROT
Private collection, Switzerland
New York only

R 332

This study passed from the prestigious collection of the comte Armand Doria to that of the painter Jacques-Émile Blanche. While the location of the view is not specified, the work appears from its style to be contemporaneous with others Corot painted in the forest of Fontainebleau between 1830 and 1834. This mountainous landscape does not resemble any sites in that forest, however, although the technical preoccupations are the same: the study of trees and rocks, the treatment of light and the transparency of the sky, the rough, realistic depiction of material things—here, the dirt road in the foreground. The delicate strokes of bluish tones in the mountains and the built-up substance of the road call to mind the studies painted in Italy during the journey of 1825–28, and it seems that only a few years could have separated the views of Civita Castellana and this canvas.

Actually, it is the region of Auvergne—where Corot must have gone in 1831, barely a year after the influential visit of his colleague Théodore Rousseau—that is evoked by this work, with its luminosity and the configuration of the mountaintops discernible in the distance. Two other works undoubtedly painted in Auvergne (R 294, R 298) are particularly close to this one in facture and in their pictorial entirety.

PROVENANCE: The comte Armand Doria (1824–1896), Paris; his sale, Galerie Georges Petit, Paris, May 4, 1899, no. 91; purchased at that sale by Jacques-Émile Blanche, Paris, for 1,650 francs; Arthur Tooth & Sons, London; sale, Sotheby Parke Bernet, London, April 7, 1976, no. 37; Salander-O'Reilly Galleries, New York, 1986; the present owner

EXHIBITIONS: Dieppe 1958; Bern 1960, no. 25; Chicago 1960, no. 29; New York 1986, no. 9

REFERENCES: Robaut 1905, vol. 2, pp. 118–19, no. 332, ill.

37

La Cathédrale de Chartres
(Chartres Cathedral)

1830, retouched 1872
Oil on canvas
25¼ × 20¼ in. (64 × 51.5 cm)
Signed lower right:[1] Corot
Musée du Louvre, Paris R.F. 1614
Paris only

R 221

In 1194, just a few months after a terrible fire destroyed most of an older edifice, construction began anew on the cathedral of Chartres. The interior was largely finished by 1220, the cathedral was dedicated in 1264, and architectural additions continued to be made throughout the medieval period. When Corot visited this celebrated pilgrimage destination in 1830, the building had not yet been damaged by the fire of 1836.

We learn the circumstances of this trip from Étienne Moreau-Nélaton.[2] He offers a literary description of Corot's distress during the revolution of 1830, which erupted in Paris in the final days of July: "He was not, like Delacroix, tempted to contemplate Liberty waving the tricolor in the tumultuous excitement of the barricades. The whistling of bullets disturbed his peace. He packed his bags and seized the opportunity to go on a sketching tour of France. Although he had just come from classical lands, he joined in the raptures of the Romantics over the masterpieces of Gothic architecture; and this enthusiasm led him to Chartres, to a spot facing the towers and porch of the cathedral."[3] Corot traveled to Chartres and subsequently to Normandy with an artist friend, as he usually did on work tours: this time, with the architect Poirot, whom he had met in Tivoli in 1827.

Moreau-Nélaton's idea of the reason for this journey, which is based uncritically on Robaut's reminiscences, was accepted by Daniel Baud-Bovy and Hélène Toussaint.[4] However, in 1977 Gilbert Brunet suggested that this official version was no more than a myth, disputing above all the idea that Corot was drawn to Chartres by its cathedral. Corot went to Chartres, says Brunet, *"to leave Paris,"* and because he could stay with his childhood friend Théodore Scribe, whose uncle owned an estate a mile or so away in the village of Nogent-le-Phaye.[5] While he was there he painted the cathedral.

Although Brunet's documented study casts Moreau-Nélaton's account in a new light, it is still a fact that Corot painted the cathedral with passion and precision, displaying a strong interest in Gothic architecture and in Romantic motifs. "Romanticism had made the architecture of the Middle Ages fashionable," Moreau-Nélaton wrote elsewhere, pointing out that Corot's attention to Gothic architecture coincided with the fascination that the history and art of the Middle Ages held, beginning about 1810, for artists.[6] Clearly Corot was not generally drawn

to the motifs that attracted his young Romantic friends; but a vogue for the Middle Ages was in the air at the time, and it could not help but influence his work. This vogue manifested itself especially in theater and opera, which Corot had adored since his youth. On his return from Italy he could have gone to the Paris Opéra to see any of a number of new lyric pieces whose action unfolded in the Middle Ages: Auber's *La Muette de Portici*, set in 1440;[7] Rossini's *Le Comte Ory,* set about 1200, during the Crusades;[8] Bellini's *La Straniera,* which takes place in the fourteenth century;[9] and, opening a year later, Meyerbeer's famous opera *Robert le Diable*, with a time frame in the thirteenth century.[10] Moreover, Corot would have admired the stage sets for these sumptuous productions, often painted by colleagues and sometimes by friends such as Édouard Bertin, Jules Dieterle, Charles Cicéri, and the Johannot brothers—designs with ambitious medieval structures[11] and mysterious cathedrals that loomed over the set, as Corot's cathedral looms over the town of Chartres.

The "curious malady of our time, the Gothic mania," as Michelet defined this passion for the Middle Ages,[12] revealed itself under the Empire in Chateaubriand's Romantic literary work *La Génie du Christianisme,*[13] in the novels of Sir Walter Scott, and in the Musée des Monuments Français, which was conceived during the French Revolution by Alexandre Lenoir and was dispersed in 1816.[14] Corot, who was of a younger generation, did not belong to the circle of Romantics. While he probably embraced a Romantic motif like Chartres Cathedral largely because of the age in which he lived, his aesthetic motivations in making this painting seem more personal.

We need in any case to consider Corot's working procedure, because the question inevitably arises, did he paint *La Cathédrale de Chartres* in plein air, as has been traditionally reported, or did he work in the studio, as certain technical factors suggest?

In the painting the cathedral is seen from the southwest, from behind "the mound of the barricades," where the Châtelet square is today. Corot set himself up in a largely open area that is now the middle of rue Georges Fessard. The houses, gateway, and railing that he depicted are still on the site in slightly altered guise, but the mound of earth that gives an odd structure to the painting has disappeared.

The view was carefully composed. Corot chose to paint at noon, when the sun's rays strike the facade from the south (the church's main, "west" portal in fact faces southwest). The framing of the cathedral is particularly bold, since Corot placed the mound of earth at the center of his work, hiding the rest of the town and part of the cathedral; the strangeness of the composition has excited certain authors in search of modernity. The three small trees at the top of the mound parallel the towers of the cathedral. Following a practice that he had experimented with in Italy, Corot left the foreground entirely empty, until he retouched the work in 1872.

The Musée du Louvre owns a drawing that represents the cathedral and its surroundings (fig. 46).[15] Extremely detailed where the architecture of the cathedral is concerned and imprecise for the rest of the town, it is clearly a sketch made on the site, which Corot could have used in making this painting. Hélène Toussaint has pointed out that "the graphic intention carries over into the pictorial intention" of the painting,[16] reinforcing the idea that initially Corot worked in pencil.

It should be noted, finally, that this picture was painted directly on canvas originally measuring 54 by 40.5 centimeters (21¼ × 16 in.), according to Robaut—a support much more compatible with working in the studio than with painting in plein air. True, its modest size would have allowed the artist to work on it outdoors, especially on fine summer days; but in the period around 1830, before his second journey in Italy, he did not customarily paint directly on canvas in plein air. Robaut reports that when Corot saw the rediscovered canvas in 1871, he exclaimed that he would do some reworking: "But it's like a photographic postcard. It's the portrait of the towers without the atmosphere of Chartres. We can't leave matters in this state."[17] Perhaps he was recalling his working method. Could a drawing that set down the architectural details, carefully worked out in situ, have been followed by a painting done on canvas in the studio, perhaps enriched by some sessions outdoors? In fact, we do not even know whether Corot painted this canvas while he was staying at Chartres or later, after he had returned to Paris. In any case, he evidently considered it a study, since it was never exhibited in his lifetime.

The pictorial treatment of architecture seems to have preoccupied Corot after his stay in Italy. Even in the earliest years of his career he had painted architecture, as in his small study *Paris. Le Vieux Pont Saint-Michel* (R 15, private collection). The series of views of the church of Trinità dei Monti in Rome (cat. nos. 12, 13, 14) further demonstrates his interest in using light to describe architectural form. But he became more and more absorbed in experimenting with this technique from 1830 on, at the time that he was also working in the forest of Fontainebleau or at Ville-d'Avray. Some weeks before he left for Chartres, in June 1830, he painted *Paris. Le Pont au Change et le Palais de Justice* (R 220, private collection). At Chartres, the cathedral inspired a second study, a more detailed examination of the north portal.[18] Later, about 1833–35, Corot continued his pictorial study of architectural monuments (see cat. nos. 38,

41, 43, 66). His painting of Chartres Cathedral thus has its place in a coherent and systematic research that was carried on from 1828 to 1834 and was taken up again in subsequent years.

Realism was a continuing issue in this research, and some critics have alluded to this work's naïveté. But if *La Cathédrale de Chartres* can be interpreted as a naive work—in the sense that Michallon advised Corot to "naively paint nature"—it is, far more, a work of true technical mastery. "At first glance we take in the precision with which he represented the monument, drawing its facade with a scrupulous, even studious attention that evokes the style of today's 'Naïfs,'" writes Max-Pol Fouchet; but, he continues, "the naïveté disappears when one analyzes the internal structure of the work," and "the magisterial, powerful facade of the cathedral is balanced by the modesty of the other motifs, the pile of rocks, the mound, the fragment of a pillar, the peasant's wagon."[19] Toussaint sees a "naive spirit" bent on "documentary research."[20] But other art historians see a classic work: in the interesting words of Lionello Venturi, "The mastery of style is already complete, and already one senses the threat that this style will lessen the artist's emotional contact with what he is painting."[21]

For Baudelaire, Romanticism and Realism were linked. We might connect Corot's creative process, largely Realist in this work of 1830, with that of his contemporary Victor Hugo, whose famous Romantic novel *Notre-Dame de Paris* was written in the same year. Hugo's cathedral, not unlike Corot's, is a "vast symphony of stone" in which "everything holds together in this art born of itself, logical and well proportioned."[22]

La Cathédrale de Chartres has an exciting history. It had left Corot's studio—whether by sale or as a gift we do not know—until November 1871, when Robaut "brought it back in its

Fig. 46. Corot. *La Cathédrale de Chartres*. Graphite on paper. Département des Arts Graphiques, Musée du Louvre, Paris (R.F. 23335)

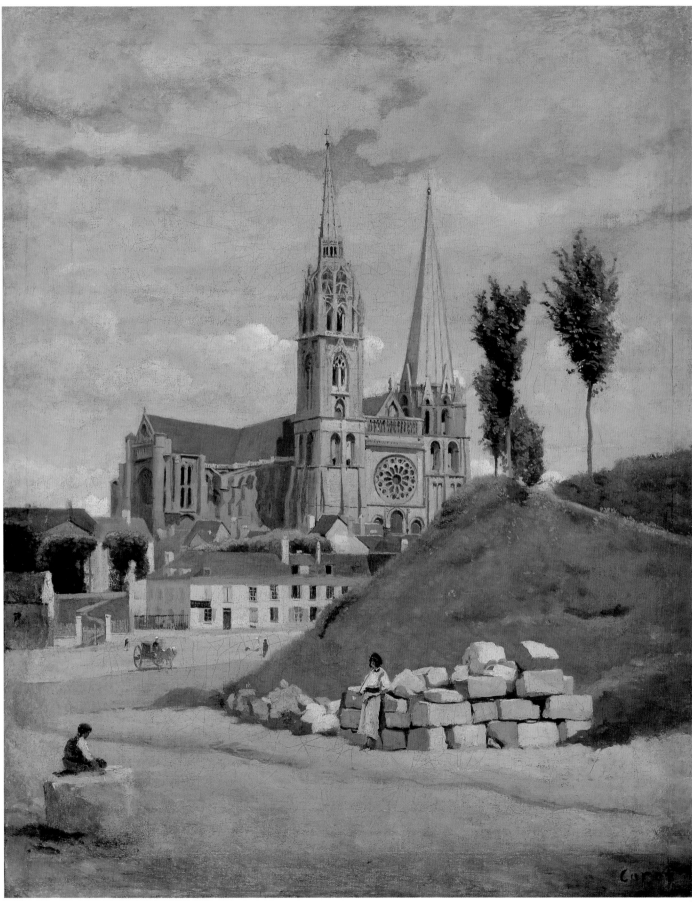

original state on the advice of the master, very angry to see it thus mutilated."[23] The canvas had been damaged, the edges of the painted portion having been folded over the stretchers, as the research laboratory of the Musées de France has confirmed. Wrote Robaut, "[Corot] promised me that the canvas would be enlarged and relined to the dimensions of 62 × 50 [for the current dimensions, see above]. A false signature at left was noted. While putting it back in order the master added the small seated figure . . . and he threw on the entire large shadow in the foreground."[24] Thus, after the canvas was enlarged and relined, Corot retouched the edges and added the foreground elements named by Robaut.

The painting remained with Robaut until 1874, when he added it to the sale of Constant Dutilleux's collection. An attempt was made by Camille and Eudoxe Marcille to acquire it for the developing Musée du Chartres, but the bidding surpassed the 800 francs authorized by the Commission of the Musée du Chartres (March 23, 1874). Later Étienne Moreau-Nélaton bought the picture, doubtless directly from the dealer Hector Brame, whom he regularly patronized, and in 1906 he gave it to the Musée du Louvre.[25] It was immediately perceived as a masterpiece. In *Swann's Way* from *Remembrance of Things Past*, Marcel Proust called the work one of the eight most important paintings in the Louvre.[26]

1. Perhaps forged, according to Hélène Toussaint in Paris 1975, p. 32.
2. He discusses the 1830 trip to Chartres in his three major works on Corot: Moreau-Nélaton in Robaut 1905, vol. 1, p. 54; Moreau-Nélaton 1913; Moreau-Nélaton 1924.
3. "Il ne fut pas tenté, comme Delacroix, de contempler la Liberté brandissant le drapeau tricolore dans l'émoi tumultueux des barricades. Le sifflement des balles dérangeait sa quiétude. Il fit son paquet et profita de l'occasion pour esquisser son tour de France. Bien qu'arrivant des terres classiques, il s'enthousiasmait avec les romantiques pour les chefs-d'oeuvre de l'architecture gothique; ce goût le conduisit à Chartres, en face des tours et du porche de la cathédrale." Moreau-Nélaton 1924, vol. 1, pp. 28–29.
4. Baud-Bovy 1957, p. 200; Hélène Toussaint in Paris 1975, no. 22.
5. "pour quitter Paris." Brunet 1977, pp. 19–23. See also cat. no. 47.
6. "Le romantisme avait mis à la mode l'architecture du moyen âge." Moreau-Nélaton 1913, p. 16.
7. Premiered in Paris on February 29, 1828.
8. This comic opera opened in Paris on August 20, 1828.
9. Premiered in Milan at La Scala on January 10, 1829.
10. Premiered at the Paris Opéra on November 21, 1831.
11. On this subject, see Join-Diéterle 1988.
12. "curieuse maladie de notre temps, la manie du gothique." Michelet 1855, preface.
13. Published on April 14, 1802.
14. On the influence of medieval art on Romanticism, see, in addition to works on Romanticism in painting, Aubert 1928, pp. 23–48.
15. The drawing was bequeathed to the Musée du Louvre by Raymond Koechlin, art historian and former president of the Amis du Louvre and curator of the Musée des Arts Décoratifs, Paris, as well as a childhood friend of Moreau-Nélaton.
16. "l'intention graphique l'emporte sur l'intention picturale." Hélène Toussaint in Paris 1975, p. 34.
17. "Mais c'est comme une carte photographique. C'est le portrait des tours sans l'atmosphère de Chartres. Nous ne pouvons pas laisser les choses dans cet état." Robaut *documents*.
18. R 222. His friend Poirot painted the portal from a different viewpoint.
19. "Au premier regard nous retient la minutie avec laquelle il représente le monument, consacrant à sa façade un dessin scrupuleux, appliqué même, qui évoque la manière des 'Naïfs' d'aujourd'hui." "La naïveté cesse quand on analyse la structure interne de l'oeuvre"; "à la magistrale et puissante façade de la cathédrale répond la modestie des autres motifs, les pierres accumulées, la butte, le fragment de pilier, la charrette paysanne." Fouchet 1975, p. 62.
20. "esprit naïf"; "recherche documentaire." Hélène Toussaint in Paris 1975, pp. 32, 34.
21. "La maîtrise du style est déjà parfaite, et déjà l'on sent la menace que ce style diminue le contact affectif de l'artiste avec ce qu'il peint." Venturi 1941, p. 146.
22. "cette vaste symphonie de pierre"; "tout se tient dans cet art venu de lui-même, logique et bien proportionné." Hugo 1830.
23. "[avait fait] rentrer dans son état primitif sur l'avis du maître, très colère de la voir ainsi mutilée." Robaut *documents*.
24. "[Corot] me promet agrandissement et rentoilage à la dimension de 62 × 50. On avait reporté une signature fausse à gauche. Le maître en arrangeant ajouta le petit assis . . . et il jeta toute la grande ombre portée du premier plan." Ibid.
25. Moreau-Nélaton appraised *La Cathédrale de Chartres* at 12,000 francs, probably approximately what he had paid for it, when he made the gift. He had appraised Corot's *L'Église de Marissel* at 104,000 francs.
26. Proust 1954, p. 40.

PROVENANCE: Sold or given by Corot to Alfred Robaut in 1872 (according to Robaut); placed in the Constant Dutilleux sale, Paris, May 26, 1874, no. 22, sold for 1,360 francs; Lolley collection, Paris; Lolley-Bauginaux sale, Paris, May 31, 1887, no. 14; purchased at that sale by Brame, Paris, for 1,450 francs; Étienne Moreau-Nélaton, 1900; his gift to the Musée du Louvre, Paris, 1906; exhibited at the Musée des Arts Décoratifs, Paris, from 1907; entered the Louvre, 1934

EXHIBITIONS: Paris 1900, no. 124; Paris 1907, no. 14; Paris 1936, no. 16; Paris 1945b, no. 7; Paris 1946b, no. 172; Paris 1965, no. 288; Paris 1975, no. 22; Paris 1989; Paris 1991, no. 72

REFERENCES: Michel 1905, p. 20; Moreau-Nélaton 1905b, p. 48, fig. 36; Robaut *carton 2*, fol. 116; Robaut *documents*, vol. 3, fols. 9, 18; Robaut 1905, vol. 2, pp. 76–77, no. 221, ill.; Moreau-Nélaton 1913, pp. 16–20, ill.; Brière 1924, no. M 14; Moreau-Nélaton 1924, vol. 1, p. 29, fig. 33; Focillon 1927, p. 314, ill.; Michel 1928, ill.; Fosca 1930, p. 19; Meier-Graefe 1930, p. 22, ill.; Faure 1931, pp. 20–21, 37, ill.; Jean 1931, ill.; Venturi 1941, pp. 145–46, ill.; Bazin 1942, p. 53, no. 21, pl. 21; Bazin 1951, p. 47, no. 25, pl. 25; Baud-Bovy 1957, p. 38, fig. XV; Sterling and Adhémar 1958, no. 364, fig. C; Leymarie 1966, p. 44, ill.; Taillandier 1967, pp. 17–28, 50–52, 70, 86, ill.; Hours 1972, p. 48; Paris, Musée du Louvre 1972, p. 88; Bazin 1973, p. 278, ill. p. 148; Fouchet 1975, pp. 13, 62–64; Émile-Mâle 1976, p. 52; Leymarie 1979, pp. 39–41, ill.; Compin and Roquebert 1986, p. 149; Lankheit 1988, pp. 167–68; Selz 1988, pp. 70–71, ill., pp. 72–74; Salerno 1991, p. 374

38

Orléans. Vue prise d'une fenêtre en regardant la tour Saint-Paterne (Orléans: View from a Window Overlooking the Saint-Paterne Tower)

Ca. 1830
Oil on canvas
11¼ × 16½ in. (28.5 × 42 cm)
Signed lower left: COROT
Lower right: traces of the stamp of the Corot sale, apparently
scratched off
Musée des Beaux-Arts, Strasbourg 1677

R 555

Corot probably painted this small study during the summer of 1830, when he left a turbulent Paris and traveled to Chartres, Normandy, and northern France. The picture seems close to the studies done in Rome between 1825 and 1828, not to those of about 1840–45, as Moreau-Nélaton and Robaut suggested. Hélène Toussaint argues that the influence of Michallon and Bertin is still present in this work, for instance in the foliage, "treated with a technique that the painter learned from Bertin and employed in his youth,"[1] and therefore proposes the same date of about 1830. Indeed, a taste for powerfully geometric architectural forms and for light that constructs the volumes characterized Corot's work in the period immediately following his return from Italy in 1828.

Framing a view of city rooftops had already interested the young artist when he was in Italy. As soon as he arrived in Rome, in December 1825, he painted *Rome. Vue prise de la fenêtre de Corot* (*Rome: View from Corot's Window*; R 43, private collection), an astonishing study presenting the landscape of rooftops visible from his lodgings in the Piazza di Spagna. He was clearly adhering to the course prescribed by Valenciennes, who had himself made many studies of the roofs of Rome, searching for a mode of painting appropriate to the quality of light and the chromatic values he had before his eyes.[2] Michallon had tried his hand at the same subject in Rome[3] and in Florence,[4] precisely depicting in pencil the architectural volumes of those cities' rooftops. So once again Corot was following the counsel of his teachers, as he also had in painting his view of Rome from the fountain of the Villa Medici (cat. no. 15) and the views of Trinità dei Monti (cat. nos. 12, 13).

The picture seen here takes the same point of view, but this time in France and utilizing a restricted color range. In this study Corot was mostly interested in the play of light creating the volumes of the diverse architectural forms. He used a similar vantage point sometime later in other works, such as *Vue de Lormes prise d'une fenêtre* (*View of Lormes from a Window,* private collection). The theme allowed him to paint a prospect from nature but have the convenience of working in a studio, since he painted indoors in front of a window. Thus these works were often executed directly on canvas, unlike most of the outdoor studies.

Robaut and Moreau-Nélaton mentioned a copy with the same motif as this work, probably done later, that was offered at the Doria sale in 1899; it is very close to the original, although slightly smaller.[5]

1. "traité avec une technique qui est celle que le peintre utilisait dans sa jeunesse, apprise de Bertin." Hélène Toussaint in Paris 1975, no. 23.
2. Valenciennes's oil studies on paper of the roofs of Rome are preserved in the Département des Peintures, Musée du Louvre, Paris, thanks to a gift

made in 1930 by the princesse Louis de Croÿ. They include *Vue de la porte du Peuple à Rome* (R.F. 3038), *Le Toit à l'ombre* (R.F. 2991), *Le Toit au soleil* (R.F. 3036), and *Étude de ciel au Quirinal* (R.F. 2987).
3. Département des Arts Graphiques, Musée du Louvre, Paris, R.F. 13881.
4. See Paris 1994, p. 140.
5. Musée des Beaux-Arts, Orléans. See Robaut 1905, vol. 2, p. 200, no. 555.

PROVENANCE: The artist; his posthumous sale, Hôtel Drouot, Paris, pt. 1, May 26–28, 1875, no. 87; purchased at that sale by Marion, the artist's grand-nephew, Paris, for 700 francs; Maurice Delacre, Paris; his sale, Hôtel Drouot, Paris, December 15, 1941, no. 41; acquired in the Parisian art market by the Musées de la Ville de Strasbourg, 1942

EXHIBITIONS: Basel 1947, no. 195; Strasbourg, Besançon, Nancy 1947, no. 50; Brussels 1947–48, no. 50; London 1949–50, no. 186; Amsterdam 1951, no. 22; Venice 1952, no. 19; Bern 1960, no. 35; Chicago 1960, no. 54; Munich 1964–65, no. 38; Lisbon 1965, no. 28; Paris 1966a, no. 41; Bourges 1973, no. 76; Bordeaux 1974, no. 38; Paris 1975, no. 23; Orléans, Dunkirk, Rennes 1979, no. 90; Ghent, The Hague, Paris 1985–86, no. 10; Tokyo, Osaka, Yokohama 1989–90, no. 7

REFERENCES: Robaut 1905, vol. 2, pp. 200–201, no. 555, ill., and vol. 4, p. 202, no. 87; Bazin 1942, no. 54, pl. 54; Bazin 1951, no. 60, pl. 60; Haug 1955; Hours 1972, pp. 100–101, ill.; Vergnet-Ruiz and Laclotte 1972, p. 143, ill.; Bazin 1973, p. 282, ill. p. 177; Selz 1988, pp. 98–99, ill.

39

Une Ferme dans la Nièvre (A Farm in the Nièvre)

1831
Oil on canvas
18¾ × 27⅝ in. (47.5 × 70.3 cm)
Signed and dated lower right: COROT 1831 COROT
Museum of Fine Arts, Boston
The Henry C. and Martha B. Angell Collection 19.82

R 292

Corot's trip to Burgundy and Auvergne in 1831 was little documented by Robaut and Moreau-Nélaton, and we know of it mainly through about ten works, some of them dated, all clearly linked in subject and style.[1] It was the first time Corot worked in the Morvan. Soon thereafter his relationship with the region was reinforced; on October 26, 1833, his niece Marie-Louise-Laure Sennegon (see cat. no. 48) married Philibert-Jules-Nicolas Baudot, who came from Lormes, and at times the young couple lived in the pleasant borough of the Nièvre, where they invited their painter uncle to visit.[2] The mountainous Morvan became one of Corot's favorite places to paint.

The site represented with a strange realism in this painting remains unidentified, despite the efforts of Philippe Berte-Langereau, a regional historian who has succeeded in locating other sites Corot painted in the Morvan and the Nièvre.[3] Corot here returned to the theme of the rustic farm and its surroundings that he had tackled early on[4] when he was working in the forest of Fontainebleau—notably in the exceptional

Intérieur d'une cour de ferme avec un puits (*Courtyard of a Farm with a Well;* R 24), painted with unvarnished realism. These pictures anticipate the work in the 1850s of Alexandre Decamps, whose paintings of farmyards in the Louvre and the Musée d'Orsay reveal a similar taste for the realistic depiction of rural life.

Corot describes the simplicity of the place matter-of-factly. Pursuing his investigation of how to integrate the human figure into a landscape, he enlivens the foreground of his painting with several figures. Two women are on the bank of the stream that crosses in front, one washing laundry, the other holding an infant in her arms, while a man carries kindling near a wagon full of hay pulled by two horses. The reference to realistic Dutch and Flemish peasant scenes is evident, and the influence of northern painting on Corot during this period is very clear. One is reminded of *La Charrette* (*The Cart*) by the Le Nain brothers, a similarly rustic outdoor scene, but that painting did not enter the Louvre until 1879, and Corot does not seem to have known it.

This work is, in fact, a forerunner of the realistic canvases that Corot painted later in his career along with the historical and lyrical landscapes, such as *Cour d'une boulangerie près de Paris* at the Musée d'Orsay (cat. no. 124) and especially a strange interior view that reveals a similar world, *Intérieur au Mas-Bilier près de Limoges* (R 824, Musée du Louvre, Paris, gift of Étienne Moreau-Nélaton), painted about 1850.

Another painting dated 1831, *Chaumières et moulins au bord d'un torrent (Cottages and Mills beside a Stream)*,[5] like the present work a study of a modest peasant dwelling in the Nièvre rendered with raw realism, demonstrates that Corot was methodical in his research, returning to a pictorial problem many times. Corot used the same peasant woman holding a child in both paintings.

The brushwork of this picture, its precise construction, and the fact that it is a fairly large work painted on canvas indicate that it was made entirely in the studio. That explains the perfect integration of the figures, which would have been painted at the same time as the landscape.

1. Robaut 1905, vol. 2, pp. 104–5, nos. 292–299; the subjects of some of these works cannot be pinned down to a specific region.
2. Marie-Louise-Laure Baudot died in childbirth on May 21, 1836, but Corot continued to visit the region, where he had developed friendships and which he appreciated for the variety of its landscapes.
3. Berte-Langereau 1993.
4. Corot painted two works representing a cottage at Bois-Guillaume between 1822 and 1824 (R 12 and R 13, present location unknown).
5. R 293, private collection. This painting belonged to Bernheim-Jeune and to Paul Baudry.

PROVENANCE: Gift of the artist to Pons (according to Robaut); Diot et Tempelaere, Paris, about 1895 (according to Robaut); Henry C. and Martha B. Angell, Boston, 1895; gift of Martha B. Angell to the Museum of Fine Arts, Boston, 1919

EXHIBITIONS: Atlanta, Denver 1979–80, no. 4

REFERENCES: Robaut 1905, vol. 2, pp. 104–5, no. 292, ill.; Boston, Museum of Fine Arts 1921, no. 201; Cunningham 1936, p. 100; Edgell 1949, pp. 10–11, ill.; Boston, Museum of Fine Arts 1955, p. 14; Leymarie 1966, p. 49; Geiger 1977, pp. 330–32; Leymarie 1979, p. 45, ill.; Murphy 1985, p. 59, ill.; Berte-Langereau 1993, p. 19, ill.

40

Soissons. Maison d'habitation et fabrique de M. Henry
(Soissons: House and Factory of Mr. Henry)

1833
Oil on canvas
32 × 39½ in. (81.4 × 100.3 cm)
Signed and dated lower right: C Corot 1833
Philadelphia Museum of Art
Purchased with the W. P. Wilstach Fund w'50-1-1

R 245

Étienne Moreau-Nélaton described in detail the circumstances of the commission Corot received from Philibert-Paulin Henry, an industrialist in Soissons, for two landscapes. Corot had just exhibited a view of the forest of Fontainebleau at the Salon of 1833 and received a second-class medal, although this recognition had not taken him very far.[1] "A merchant friend of the family took it into his head to commission some paintings from him. M. Henry, manufacturer of cloth at Soissons, lodged him at his home and had him paint his factory first, then the view from its windows. Corot executed the desired images with a perfect documentary precision. The conscientious diligence of a primitive could not have made a more exact depiction of the places and the objects. The client must have found it all he had looked for; but the painter was never paid. Corot was considered an amateur; does one offer money to such people?"[2]

Books on the local economy inform us that in 1826, Henry established a factory that made textiles for seats, sofas, armchairs, and the like in the buildings of the old Saint-Crépin-le-Grand abbey at Soissons.[3] The Saint-Crépin abbey had been founded at the end of the ninth century on the site of the sepulcher of Saints Crépin and Crépinien and was a pilgrimage destination during the Middle Ages. It fell into disuse in the fifteenth century but was reoccupied in the eighteenth century until the French Revolution, when the monks were driven out and some of the buildings were dismantled. The abbey was sold and became a soap factory before being taken over by Henry. Later it served as an orphanage, and the remains of the ancient structure now house a school.[4]

Henry, the "reclaimer" of the abbey's buildings, was a Parisian active in the cloth business who lived at 13, rue Poissonnière. He was a judge at the Tribunal de Commerce de la Seine, and he retained a foothold in Paris by keeping the head office of his warehouse there. His methodically organized textile factory seems to have worked at full capacity from the beginning, and some of his textiles, which were of high quality and durability, found their way to the Château des Tuileries.[5] Henry made use of a nearby prison for labor, thus lowering his manufacturing costs, while offering his workers lodging in the factory.[6] His factory prospered until his retirement in 1848, when he sold the enterprise.

Corot most probably met Henry in Paris through his father or the Delalain family while he was still working in the cloth and clothing businesses, before he began his career as an artist. Thus, when Henry asked Corot to do the paintings, he was calling on the son of one of his colleagues whom he knew as a cloth dealer but whose professional qualities as an artist he had no way of knowing anything about.

In this way Corot received a commission for two fairly large paintings in 1833 and promptly set to work on them on site. One imagines that Henry wanted the two views to be lifelike. Corot's procedure for making the landscapes is totally unknown, as is the time it took to paint them; he probably worked the entire spring of 1833.

This painting presents Henry's house, a fine bourgeois dwelling at the left of the composition behind a gate and a railing, and his textile factory, housed in the other buildings. The ancient abbey had been made taller—which explains the strange gable end decorated with a balcony, from which Corot painted the view of Soissons (cat. no. 41). The building's arched openings are seen at an angle. A one-story structure had been attached to the facade. (Today the original facade has been uncovered, the second-story balcony remains, and one can still admire the view that Corot depicted in the companion painting.)

Fig. 47. Pieter Jansz Saenredam (1597–1665). *The Old Town Hall in Amsterdam.* Oil on wood, 25⅜ × 32⅝ in. (64.5 × 83 cm). Rijksmuseum, Amsterdam (C1409)

In order to paint the factory, called by some a "grim vulgarity,"[7] Corot positioned himself under the large gate to the property, almost in the street that was then named rue de la Croix-Saint-Crépin (today, rue Dehaitre). We do not know if he painted this large canvas entirely on location or if he reworked it in the studio in Soissons or Paris. A letter he sent to Abel Osmond from Soissons in May 1833 implies that he did most of the work on site.[8] The importance of the drawing and the painting's solid construction, the realism of the light and of the walls, and the smooth, careful brushwork all suggest that the work was executed in the studio or at least indoors. While staying in Henry's house, Corot must have improvised a small studio that would allow him the best working conditions; he had only to go a few feet to check his composition or the lighting. It is conceivable that Henry wanted to be present during the execution of his commission and that Corot stayed at Soissons until he was finished.

The painting is astonishing in its realism. Especially successful is the effect of the light; Corot skillfully used the shadow on the right cast by the wall surrounding the property to emphasize the intensity of the light that strikes the facades of

the buildings, turning them white. The picture seems strangely empty, although Corot sought to animate it by showing several workers in their daily activities: two men having a discussion in the foreground, one of them holding the long pipe seen in *La Cathédrale de Chartres* (cat. no. 37); a woman with a spinning wheel and a little girl seated beside her; and three men on a break before going back to work.

Many critics have called the realism of this work naive, as they did that of *La Cathédrale de Chartres*. Yet, the painter Jacques-Émile Blanche reported this particularly telling anecdote: "André Lhote and I, at the exhibition 'One Hundred Years of Painting,' had juxtaposed two canvases, one by Corot, the *Filature de Beauvais*, [*Cloth Mill of Beauvais*, the present painting], and a large composition with figures and landscape by Henri Rousseau. . . . Same simplicity, same 'state of the soul,' perhaps. But their minds? In Corot's work one saw an acute intellect."[9]

Corot undeniably painted faithfully what he had before his eyes, but he did not approach this landscape without culture and without references. In that period following his three years in Italy he was rediscovering Dutch painting, whose influence is evident in most of his works made between 1830 and 1834.

Was he thinking of Vermeer or of Pieter de Hooch? Did he know *The Old Town Hall in Amsterdam* by Pieter Saenredam (fig. 47), whose construction and realism are evoked in this Philadelphia work? He certainly never saw that painting, but he might have seen a print or the watercolor of the same subject. Had he seen or studied *The Dam with the New Town Hall of Amsterdam* by Jan van der Heyden at the Louvre or examined the architectural precision of the two Steenwycks? Whatever his specific points of reference, it is clear that during this period Corot was influenced by northern painting.

This "portrait" of Henry's factory and its pendant painting (cat. no. 41) are reunited in the present exhibition after many years of separation.[10]

1. Moreau-Nélaton 1924, vol. 1, p. 30. During this period Corot collaborated on the execution of a painting by Roehn for the Galeries des Batailles at Versailles.
2. "Un négociant, ami de sa famille, s'avisa de lui commander de la peinture. M. Henry, fabricant d'étoffes à Soissons, l'hébergea chez lui et lui fit peindre sa fabrique d'abord, puis la vue qu'on avait de ses fenêtres. Corot exécuta les images souhaitées avec une précision documentaire parfaite. La consciencieuse application d'un primitif n'eût pas donné une ressemblance plus exacte des lieux et des objets. Le client dut y trouver son compte; mais la bourse du peintre l'a toujours ignoré. Corot passait pour un amateur; est-ce qu'on offre de l'argent à ses gens-là?" Ibid.
3. Brayer de Beauregard 1824, pp. 321–22. Although published in 1824, the book gives the date for Henry's factory as 1826.
4. Ancien n.d.
5. Brayer de Beauregard 1824, n. 3, p. 322.
6. An interesting article on the subject is Ancien 1960, pp. 100–109.
7. "vulgarité rébarbative." Ibid., p. 104.
8. In the Département des Arts Graphiques, Musée du Louvre, Paris, Moreau-Nélaton Bequest, A.R. 8 L 14.
9. "André Lhote et moi, lors d'une exposition *Cent ans de peinture*, avions juxtaposé deux toiles, l'une de Corot, la *Filature de Beauvais*, et une grande composition, figures et paysages, d'Henri Rousseau. . . . Même simplicité, même 'état d'âme', peut-être. Mais leur esprit? Chez Corot, on noterait l'esprit de finesse." Blanche 1931, pp. 19–20. Blanche, who was greatly taken with this painting, wrote, "Notice the shadow cast by the bell on the roof of the factory, its value in relation to the turquoise sky, a value that one couldn't copy, any more than one could successfully copy the rest of the painting—so firm and fluid, without appreciable contrasts of shadow and light, but real, standing out in relief." ("Voyez l'ombre portée de la cloche sur le toit de la filature, sa valeur sur le ciel turquoise, valeur que l'on ne saurait pas plus copier, que l'on ne réussirait à copier le reste du tableau si ferme et si fluide, sans oppositions appréciables de sombre et de clair, pourtant réel, d'un relief accusé.") Ibid., p. 20.
10. The two paintings have not otherwise been hung together since they left the collection of Hippolyte Lézaud about 1890.

PROVENANCE: Henry collection, Soissons; his sale, n.d.; purchased at that sale by an anonymous dealer from Nancy for 200 francs; Hippolyte Lézaud, former magistrate, Paris; Lézaud fils, Paris, about 1890 (according to Robaut); Jacques-Émile Blanche, Paris, 1905 (according to Robaut); Paul Rosenberg & Co., New York; purchased from them for $40,000 with the W. P. Wilstach Fund, October 1950; to the Philadelphia Museum of Art, 1950

EXHIBITIONS: Paris 1895, no. 19, as *Vue de l'hôpital de Beauvais*; Paris 1925, no. 67; Philadelphia 1946, no. 14; New York 1947, no. 3; Chicago 1960, no. 33; Richmond 1961

REFERENCES: Michel 1905, p. 20; Robaut 1905, vol. 2, pp. 86–87, no. 245, ill.; Moreau-Nélaton 1924, vol. 1, pp. 30–31, ill.; Blanche 1931, pp. 19–20; Delaroche-Vernet 1936, p. 19; Amsterdam 1938, no. 42; Canaday 1959, p. 129, ill.; Philadelphia Museum of Art 1965, p. 14; Bazin 1973, p. 278, ill. p. 146; Clarke 1991a, no. 54, p. 53, ill.

41

Soissons vu de la fabrique de M. Henry (Soissons Seen from Mr. Henry's Factory)

1833
Oil on canvas
31 1/2 × 39 in. (80 × 99 cm)
Signed and dated lower right: C Corot 1833
Rijksmuseum Kröller-Müller, Otterlo 61-12

R 244

Installed on the third floor of the factory (see previous entry) above what had once been the monks' refectory, Corot could paint the second canvas commissioned by Philibert-Paulin Henry under ideal conditions. The window gave out on a superb panorama of the town of Soissons, so he had no need to leave the room where he had improvised a studio. He could even bring his canvas out on the balcony. Thus it is possible that the entire upper part of the painting, the view of the town, was painted directly on the canvas from that "open-air atelier." On the other hand, it seems likely that Corot added in the studio the bushes in the left foreground, the knoll, and the two small figures stretched out on the right, as well as the trees in the center of the composition. The scene is strongly lit, and as in the pendant painting in Philadelphia (cat. no. 40), the contrasting dark comes from a shadow cast on the foreground.

The building shown at the lower left, the old Saint-Crépin mill, gives the work its structure, creating a receding line that establishes the perspective. Just above the building rise the two spires of the ruined church Saint-Jean-des-Vignes, painted with perfect precision, as are all the conventual buildings connected with it. The center of the composition is oddly empty, the eye being drawn by the gap in the trees that reveals a shabby cottage. In the background the rooftops of the town are summarily sketched in, and the cathedral, its towers answering

the spires of Saint-Jean-des-Vignes, is evoked even more economically. The representation of the site is topographically accurate, with all the distances and heights of buildings scrupulously transcribed. Only the foreground appears somewhat artificial, probably because it was done later in the studio, but the two figures that enliven the work make it look less conventional. Similar figures appear in some of the pictures shown at the Salon in this period, such as *La Forêt de Fontainebleau* (R 255, National Gallery of Art, Washington, D.C.).

Like its companion painting, this picture was clearly influenced by the vast panoramic landscapes of the Flemish and Dutch; the extent to which those views preoccupied Corot between 1830 and 1834 is discussed in the previous entry. In this work he reached a kind of perfection through the restraint of his means and the simple pursuit of an absolute realism.

Henry neglected to pay Corot for the two paintings, according to Robaut and Moreau-Nélaton, and the shy, generous young man—who was in fact thirty-seven years old!—did not dare remind him of his debt. Nevertheless, the businessman followed the subsequent career of his onetime colleague in the cloth trade, since he was the owner of at least two other interesting canvases by Corot,[1] also pendants: *Danse italienne à Frascati (Italian Dance at Frascati)*, copied after Michallon's *Paysage inspiré*

d'une vue de Frascati (fig. 8),[2] and *Couvent sur les bords de l'Adriatique (Convent on the Shores of the Adriatic)*.[3]

1. Robaut 1905, vol. 2, p. 68, no. 198, and p. 70, no. 201.
2. This copy, smaller than the original (33 × 45 in.) and one of the few known copies made by Corot, had been given to Henry by Corot, according to Robaut and Moreau-Nélaton. Like the two Soissons paintings, it went into the collection of Hippolyte Lézaud; then it disappeared until it turned up in a private collection in 1994.
3. Exhibited at the Salon of 1831 (no. 398), present location unknown. It had been acquired by Henry before 1832 and had passed to Lézaud's collection, then to his son.

PROVENANCE: Henry collection, Soissons; his sale, n.d.; purchased at that sale by an anonymous dealer from Nancy for about 200 francs; Hippolyte Lézaud, former magistrate, Paris; Lézaud fils, Paris, about 1890 (according to Robaut); Victor Desfossés, Paris; his sale, Paris, April 26, 1899, no. 15, sold for 10,600 francs; E. Gérard fils, Paris; C. Hoogendijk sale, Amsterdam, May 22–23, 1912, no. 9; Rijksmuseum Kröller-Müller, Otterlo, 1961

EXHIBITIONS: Lyons 1936, no. 15; Amsterdam 1951, no. 17; London 1963, no. 12; Ghent, The Hague, Paris 1985–86, no. 9

REFERENCES: Robaut 1905, vol. 2, pp. 86–87, no. 244, ill.; Moreau-Nélaton 1914a, p. 45; Bremmer 1921–28, no. 695; Moreau-Nélaton 1924, vol. 1, p. 30, ill.; Bazin 1936, p. 47, ill.; Delaroche-Vernet 1936, p. 19; Bazin 1951, p. 38, no. 31, pl. 31; Otterlo, Rijksmuseum Kröller-Müller 1957, no. 58, ill.; Jaffé 1969, no. 5; Otterlo, Rijksmuseum Kröller-Müller 1970, no. 58; Leymarie 1979, p. 41, ill.; Selz 1988, pp. 76, 86, ill.

42

Saint-Lô. Vue générale de la ville (View of Saint-Lô)

1833
Oil on canvas
18⅛ × 25⅝ in. (46 × 65 cm)
Stamped lower left: VENTE COROT
Musée du Louvre, Paris R.F. 2580

R 756

During the summer of 1833, Corot stayed at the home of Isidore Élie, a wine merchant who lived on the rue Saint-Thomas in Saint-Lô. Élie was a cousin of Mme Osmond, the aunt of Corot's dear friend Abel Osmond. The artist spent a few days away from Saint-Lô in Troisgots, the village where two of Élie's sisters lived, in order to paint the "beautiful and imposing" stones of Ham, where there was a medieval fortress.[1] According to a longstanding Élie family legend, Corot found that site so sublime that he fell to his knees before it, arms raised to the sky. On July 23 Corot wrote to Osmond from Troisgots: "I've promised myself that when I get back to Saint-Lô I will continue the view of the city I've begun, and when I'm back, you can ask me to make you a picture of whatever you like."[2]

In their catalogue, Robaut and Moreau-Nélaton cite thirteen paintings and several drawings of the Saint-Lô region, among them six views of the city itself, done from various angles.[3] They do not seem to have had a very clear sense of the chronology of Corot's stays with Élie in Saint-Lô, since they date one painting to 1835–40, another to 1840–45, a third to 1845–50, and most of the series, including the present work, to 1850–55. Stylistically, these views of Saint-Lô seem very close to the panoramic views that Corot painted after his return from Italy, between 1830 and 1835, such as *Rouen vu des collines dominant la ville* (cat. no. 43) or even *Avignon. Une vue prise de Villeneuve-les-Avignon*, painted in 1836 (cat. no. 67). There are also similarities of facture and composition between the Saint-Lô series and the two views of Volterra in the Louvre, painted in 1834 (cat. no. 54).

Hélène Toussaint, who had already drawn a connection between the present painting and Corot's letter to Abel Osmond, makes two further points crucial to the dating of this work, which she rightly puts at 1833. First, she points out that the bridge over Saint-Lô's river Vire, visible in the foreground of the painting, was washed away by a strong flood tide around 1850; obviously the work cannot have been made after that date. Second, she cites an anecdote reported by Auguste Davodet, according to which Corot did not return to Saint-Lô between 1837 and 1862 out of embarrassment at the memory of an evening during which he had "let himself enjoy a bit too

much of a treacherous brandy" and "had, it seemed, rather forgotten his manners" in the presence of a certain Mme Boudan.[4] In 1862 he resumed regular visits to the area until 1866. Thus Toussaint proposes to divide the works painted in Saint-Lô into two groups, those done before the incident and those dating from the 1860s. A distinction must be made, however, between most of the landscapes in this series, clearly painted from life and generally of small format,[5] and the present view, which is much larger and is unfinished. It is not impossible that this work was painted in Corot's studio in Paris.

Toussaint's dating of this work to 1833 is also convincing stylistically. The foreground, which remains undefined; the nervous, sketchy quality of the bushes that overlook the city; and the skillful play of light that models the buildings are technical clues reminiscent of works Corot painted during this period (see cat. no. 66). In taking as his subject the spires of the cathedral of Notre-Dame in Saint-Lô, could Corot, more experienced by now, have had in mind John Constable's multiple depictions of Salisbury Cathedral? Certain views of Saint-Lô are painted from angles similar to those in studies by the English painter and bespeak a kindred pictorial imagination, with Gothic spires rising toward the sky from amidst the foliage.

Charles Comiot (1861–1945), who gave the painting to the Louvre, was a wealthy industrialist and art lover who had acquired this important piece at the sale of an informed collector of Corot's works, the baron Denys Cochin.

1. "belles et d'aspects imposants." Letter (a.l.s.), Corot to Abel Osmond, Troisgots, July 23, 1833, Département des Arts Graphiques, Musée du Louvre, Paris, Moreau-Nélaton Bequest, 1927, A.R. 8 L 15. The fortress at Ham often served as a prison; Joan of Arc had been imprisoned there, and in 1840–46 it would hold Louis-Napoleon.
2. "Rentré à Saint-Lô, je me promets de continuer ma vue de la ville que j'ai entreprise et, en rentrant, tu me demanderas ce que tu désires que je te fasse en tableau." Ibid.
3. R 341, 529, 563, 747, 752, 753, 755 are views of the areas surrounding Saint-Lô; R 748–751 and R 754 are views of the city itself.
4. "laissé entraîner à savourer trop longuement une eau-de-vie traîtresse"; "avait quelque peu perdu, paraît-il, la notion des usages." Toussaint in Paris 1975, no. 30. The work cited is Davodet 1933. The descendants of the Élies of Saint-Lô have kept several archives concerning Corot and a portrait of André Osmond that might have been painted by the artist.

5. The paintings of Saint-Lô, sometimes on wood, are generally 10 × 12 (or 16) in. (about 25 × 30 [or 40] cm) maximum, dimensions that would be perfectly suitable for work in plein air.

PROVENANCE: The artist; his posthumous sale, Hôtel Drouot, Paris, pt. 1, May 26–28, 1875, no. 121; purchased at that sale by Gablerie Fèbvre, Paris, for 2,000 francs; probably his sale, Hôtel Drouot, Paris, April 17–20, 1882; the baron Gérard collection, Paris; the comte Foy collection, Paris; the baron Denys Cochin, Paris; his sale, Galerie Georges Petit, Paris, March 26, 1919, no. 6; purchased at that sale by Charles Comiot, Paris, for 39,000 francs; given by him to the Département des Peintures, Musée du Louvre, Paris, 1926, via the Société des Amis du Louvre

EXHIBITIONS: Paris 1886, no. 46 (to "Monsieur le baron Gérard"); Paris 1922b, no. 40; Paris 1933, no. 11; Paris 1936, no. 59; Lyons 1936, no. 52; Paris 1947, no. 56; Nice 1955, no. 1; Deauville 1973, no. 15; Paris 1975, no. 30; Rome 1975–76, no. 19; Paris 1976–77, no. 5; Tokyo 1982, no. 1; Manchester, Norwich 1991, no. 15

REFERENCES: Robaut 1905, vol. 2, pp. 250–51, no. 756, ill., and vol. 4, p. 206, no. 121; Moreau-Nélaton 1914b, p. 37, ill.; Moreau-Nélaton 1924, vol. 2, pp. 155–56, ill.; Guiffrey 1926, pp. 135–36, ill.; Meier-Graefe 1930, pl. XLIII; Davodet 1933, pp. 3–4; Bazin 1942, no. 76, pl. 76; Bazin 1951, no. 83, pl. 83; Baud-Bovy 1957, p. 212, ill.; Sterling and Adhémar 1958, no. 413, ill.; Leymarie 1966, p. 86, ill.; Hours 1972, p. 23, ill.; Paris, Musée du Louvre 1972, p. 97; Bazin 1973, p. 287, ill. p. 207; Leymarie 1979, p. 106, ill.; Compin and Roquebert 1986, p. 156, ill.; Selz 1988, p. 170, ill.

43

Rouen vu des collines dominant la ville (Rouen Seen from Hills Overlooking the City)

Ca. 1829–34
Oil on canvas
10⅜ × 16½ in. (26.4 × 41.9 cm)
Signed lower right:[1] COROT
The Wadsworth Atheneum, Hartford
The Ella Gallup Sumner and Mary Catlin Sumner Collection Fund
1931.187
Ottawa and Paris only

R 236

During his stays at Rouen, where he studied as an adolescent and produced his first pictorial efforts (cat. no. 1), Corot had appreciated the quality of light and variety of sites offered by the capital of Normandy and its environs, and he frequently depicted the area in his work. During one of his trips to Normandy, in 1829, 1830, or 1833,[2] he painted this small panoramic study, done from the hills of Sainte-Catherine. He had set himself up on a road winding above the Seine valley, on the right bank of the river. The Île Lacroix, which divides the Seine into two branches, is clearly visible in the middle of the composition, and the small village of Bois-Guillaume, where Corot ordinarily stayed with the Sennegon family, can be made out on the hill on the other side of the cathedral.

From the beginning of his career, Corot had several times attempted the technique of the panoramic view, imitating the realistic pictures of the Dutch and Flemish masters, with their sky effects and subtle pictorial descriptions of space modeled by light. By about 1823–24 he had already painted a panoramic view of Paris seen from the heights of Saint-Cloud (R 37, location unknown), as his friends Constant Troyon and Théodore Rousseau would later do. His travels in Italy gave him the opportunity to try other panoramas, this time of the Roman Campagna (one of the most fully realized being *La Cervara*, cat no. 29), of the city of Rome, and even of the Bay of Naples (R 189, private collection). During the period that preceded his second journey to Italy, Corot often returned to the panoramic view (see cat. nos. 41, 42, 66, 67).

Corot's explorations seem to parallel those conducted in the 1830s by other French artists who were influenced not only by the panoramic views of the Dutch painters Philips Koninck, Jacob van Ruisdael, and Meindert Hobbema, but also by English painters of the eighteenth and early nineteenth centuries who were rediscovered at the end of the Empire. Thus, John Constable's *Stour Valley and Dedham Church*, painted in 1814 (fig. 48), is in composition similar to this study of Rouen by Corot, although we do not know whether Corot saw the English work. In the same spirit, Rousseau in 1833 painted *Paris vu des coteaux de Bellevue* (Musées Royaux de Belgique, Brussels)

and *La Vallée du Bas-Meudon et l'Île Séguin* (National Gallery, Prague), landscapes showing the meanderings of the Seine and Paris seen from the heights of Saint-Cloud. It is very likely that at the Salon of 1831, Rousseau, like Corot, had admired Paul Huet's *Vue de Rouen prise du Mont-aux-Malades* (fig. 49). A large composition inspired by northern European painting, it had grown out of work done for a commissioned diorama over forty feet long showing the city of Rouen (present location unknown).

Corot thought well of his small study of Rouen done from nature and repeated the theme in a larger work,[3] this time painted in the studio, to which he added a group of trees and bushes on the left, as well as some figures. At the same time he may have retouched this study, adding the wagon in the foreground, which looks as if it was painted later than the rest of the landscape. For the composition and the effects of light in his studio work he may also have drawn on sketches of the Rouen area that he had accumulated in his sketchbooks since his youth[4] and perhaps on an early sketch mentioned by Robaut and Moreau-Nélaton.[5] The city of Rouen, always viewed from the heights surrounding it, continued to inspire Corot to make open-air sketches—in the years about 1850–60 and again in 1871.[6] But in those later works he never recaptured the spontaneous technique, arising from the years spent in Italy analyzing nature, that makes this small plein air study at Hartford a masterpiece in the treatment of light and space.

1. Robaut mentions no signature. The painting may have been signed by Prévost, according to Bazin 1956, p. 28.
2. Robaut and Moreau-Nélaton dated this landscape 1830–40 (Robaut 1905, vol. 2, no. 236), but its facture seems to tie it to paintings done in Rouen in 1829, 1830, and 1833. We know from a letter to Abel Osmond dated July 16, 1829 (Département des Arts Graphiques, Musée du Louvre, Paris, Moreau-Nélaton Bequest, A.R. 8 L 12), that Corot stayed at Honfleur in July 1829 and at Trouville that August; he would have come through Rouen on the way either to or from the Normandy coast. He also stayed there in the course of his travels during the revolution of 1830, and in 1833, when he visited with the Sennegon family; he sent a letter from Rouen dated February 26, 1833, to Achille Debray in Paris (Fondation Custodia, Paris, Collection Frits Lugt, no. 6871; see cat. no. 146, n. 2). Moreover, Robaut and Moreau-Nélaton quite reasonably date to 1833–34 the painting drawn from this study (R 258), implying that the study was painted earlier.

Fig. 48. John Constable (1776–1837). *Stour Valley and Dedham Church*, 1814. Oil on canvas, 21⁷/₈ × 30⁵/₈ in. (55.5 × 77.8 cm). Warren Collection, Courtesy Museum of Fine Arts, Boston

Fig. 49. Paul Huet (1803–1869). *Vue de Rouen prise du Mont-aux-Malades (View of Rouen from Mont-aux-Malades)*, 1831. Musée des Beaux-Arts, Rouen

3. *Rouen. Vue prise de la côte Sainte-Catherine*, 22⁷/₈ × 28³/₄ in. (58.1 × 73 cm); R 258, formerly the Chrysler Collection, Provincetown, Mass.

4. *Carnets* no. 3063, dated 1822–23, containing a drawing of an overall view of the city, and no. 3122, dated 1830–33, containing drawings of the countryside around Rouen (Robaut 1905, vol. 4, pp. 91, 99).

5. *Rouen vu de la campagne (Rouen Seen from the Countryside*; R 2469), ca. 1824–25, graphite on paper, in the Thiollier collection in 1905.

6. R 993, 994, 995, and 2032, 2033.

PROVENANCE: Posthumous sale of Annette-Octavie Sennegon, the artist's sister, Paris, 1874; purchased at that sale by Jules Chamouillet, Paris, for 300 francs; Édouard Kann, Paris; Wildenstein & Co., New York; purchased by

The Wadsworth Atheneum, Hartford, The Ella Gallup Sumner and Mary Catlin Sumner Collection Fund, 1931

EXHIBITIONS: Hartford 1931; Middletown 1931; Philadelphia 1934; Northampton 1934; Paris 1936, no. 18; Lyons 1936, no. 14; Cambridge 1937; New York 1942, no. 15; Columbus 1943; Philadelphia 1946, no. 13; Hartford 1949, no. 13; Toronto 1950, no. 10; Waterville 1952; New York 1956, no. 13; Washington 1956–57, no. 11; New York 1958; London 1959, no 77; New York 1969, no. 13; Chapel Hill 1978, no. 10; New York 1986, no. 10; Kanazawa, Tokyo, Takamatsu, Nagoya 1991–92

REFERENCES: Robaut 1905, vol. 2, pp. 84–85, no. 236, ill.; Meier-Graefe 1930, pl. XII; Jamot 1936, p. 12, ill.; Fouchet 1975, p. 64; Leymarie 1979, p. 41, ill.; Selz 1988, pp. 16, 74, 87, ill.

44

Honfleur. Un Bassin à flot (Honfleur: Fishing Boat)

Ca. 1830
Oil on paper mounted on ragboard
9¹/₈ × 12¹/₄ in. (23.2 × 31.1 cm)
Stamped lower right: VENTE COROT
Fogg Art Museum, Harvard University Art Museums, Cambridge, Massachusetts
Gift of Adele R. Levy Fund, Inc. 1962.88

R 240

During one of his visits to Normandy, in 1829 or 1830, Corot made this study of the port of Honfleur, sketched rapidly in the open air. In it he continued to explore techniques for painting reflections of light on the water and for depicting the materiality of boats. A principal quality of the study is the rapid brushwork, nervous and effective, which allowed the artist to evoke in a few strokes the hills overlooking the city—even though there is some awkwardness in the perspective and in the execution of the second boat beyond the dock. Its creation in plein air, visible touch, and clear colors are elements that link this work to the landscapes of Boudin and Jongkind

Fig. 50. Corot. *Trouville. Bateau échoué* (*Trouville: Beached Boat;* R 227), 1830–40. Moreau-Nélaton Bequest, Musée du Louvre, Paris (R.F. 1697)

painted some twenty years later. But Corot, in keeping with his classical training, was intent above all on accumulating visual experiences; he painted all these outdoor studies, just as he had done in Italy, in order to prepare for his large compositions for the Salon. In 1833 his many marine studies (fig. 50) would be of use in the realization of his large painting *Une Marine* (cat. no. 46), which he exhibited at the Salon of 1834.

PROVENANCE: The artist; his posthumous sale, Hôtel Drouot, Paris, pt. 1, May 26–28, 1875, no. 57; purchased at that sale by Paul Détrimont, Paris, for 1,500 francs; Adele R. Levy Fund, Inc., New York; given by the Adele R. Levy Fund to the Fogg Art Museum, Cambridge, Mass., 1962

EXHIBITIONS: New York 1961, p. 12; New York 1969; Cambridge 1977

REFERENCES: Robaut 1905, vol. 2, pp. 84–85, no. 240, ill., and vol. 4, p. 199, no. 57; Bowron 1990, p. 102, ill.

45

Honfleur. Calvaire de la côte de Grâce (Honfleur: Calvary on the Côte de Grâce)

Ca. 1829–30
Oil on wood
11³/₄ × 16¹/₈ in. (29.8 × 41 cm)
Signed lower left (perhaps forged): COROT
The Metropolitan Museum of Art, New York
Purchase, Mr. and Mrs. Richard J. Bernhard Gift, by exchange, 1974
1974.3

R 224 bis

Moreau-Nélaton and Robaut dated a group of landscapes painted in Normandy—at Honfleur, Le Havre, Trouville, and Sainte-Adresse (R 223–R 243)—to the summer of 1830, after Corot fled the revolutionary events in Paris and spent some days at Chartres. However, we also know that Corot, who had worked in Normandy before going to Italy (cat. no. 5), had gone back to the area during the summer of 1829 with one of his old friends from Bertin's studio, Rémy.[1] The works produced during these two landscape-painting campaigns a year apart are particularly difficult to pin down to either year.

In 1830 Corot definitely stayed on the Normandy coast for a part of August and September, painting mostly the ocean and the boats and skipping the houses of the port, which he depicted only once.[2] Usually setting himself up across from the beach and the cliffs or in one of the coastal ports, he studied the play of the sky and the waves as well as the lighting phenomena created by the air's perfect transparency along the coast.[3]

Leaving Honfleur to the west by a small road that climbs from the old docks and the church of Sainte-Catherine, one reaches the Côte de Grâce, which looks down over the estuary of the Seine and the Le Havre anchorage. The view there is still splendid today and has inspired many artists. The Ferme Saint-Siméon, "the inn of Mother Toutain," which welcomed painters traveling to Honfleur, was located right on the Côte de Grâce; Corot, who stayed there, could walk a few hundred feet and find himself at the famous calvary in the middle of a woods overlooking the ocean, a spot he painted at least twice.[4] Wonderfully luminous and ingeniously cropped, with the ocean and the cliffs of Le Havre in the background and a wooded area filling the entire left side of the painting, this work was, without doubt, painted largely out of doors; only some of the figures and the area at the left seem to have been reworked in the studio. Later Corot depicted this site on the Côte de Grâce in a painting that was retouched many times and that reached back to those inspired moments of creation on the Normandy coast.[5]

The spontaneous and realistic composition seen here, with its subtly devised lighting, its ocean theme, and above all its large brushstrokes—left visible because Corot painted a study like this with no thought of exhibiting it—is one of the paintings that originally inspired attempts to relate Corot to the Impressionist painters.

1. One album of work apparently carried this note: "I leave Monday, June 8, 1829, to go make some studies in Normandy and Brittany; I will return, I hope, toward the end of August, to throw myself into the arms of a family I adore. C. Corot." ("Je pars lundi 8 juin 1829 pour aller faire des études en Normandie et en Bretagne; je reviendrai, je l'espère, vers la fin août, pour me précipiter dans les bras d'une famille que j'adore.—C. Corot.") Moreau-Nélaton 1924, vol. 1, p. 26.
2. *Honfleur. Maisons sur les quais* (*Honfleur: Houses on the Quays*), R 223, private collection.
3. Examples of works from this session include *Honfleur. Un Bassin à flot* (cat. no. 44); *Trouville. Bateaux de pêche échoués dans le chenal* (*Trouville: Fishing Boats Stranded in the Channel*), R 231, Musée Picasso, Paris; and *Trouville. Bateau échoué*

45

(*Trouville: Stranded Boat*), R 227, *Maisons de pêcheurs à Sainte-Adresse (Fishermen's Houses at Sainte-Adresse)*, R 239, *Grosse Mer à Sainte-Adresse (Rough Sea at Sainte-Adresse)*, R 238, and *Le Havre. La Mer vue du haut des falaises (Le Havre: The Ocean Seen from the Top of the Cliffs)*, R 237; all, Musée du Louvre, Paris, gift of Moreau-Nélaton.

4. In addition to this painting, Moreau-Nélaton and Robaut mention a smaller study depicting only the calvary, with no figures (R 224), which was bought at Corot's posthumous sale, 1875, no. 56, by Durand-Ruel & Cie., Paris, for 485 francs; present location unknown.

5. R 1355, Musée des Beaux-Arts, Reims. Georges Petit, who owned the study between 1880 and 1888, had an etching made after it by Milius. There is also a painting by Gabrièle Smargiassi (1798–1882) in the Musée Eugène Boudin, Honfleur, that seems to be a copy of the study or a painting based on it, perhaps painted at Corot's side.

PROVENANCE: The painter Henri-Joseph Harpignies (1819–1916) until 1880 (according to Robaut); Galerie Georges Petit, Paris, about 1880–88; John H. Converse, Philadelphia, from 1888 to 1911; his sale, Mendelssohn Hall, New York, January 6, 1911, no. 35; purchased at that sale by Galerie Georges Petit, Paris, for $1,800; Georges Renand, Paris, by 1939, to 1967; Wildenstein & Co., New York, 1967; Mrs. Richard J. Bernhard, New York, from 1967 to 1969; The Bernhard Foundation, Inc., New York, from 1969 to 1974; The Metropolitan Museum of Art, New York, purchase, Mr. and Mrs. Richard J. Bernhard Gift, by exchange, 1974

EXHIBITIONS: Paris 1939, no. 13; Paris 1942b; Paris 1942a, possibly no. 35, as *Paysage*; Paris 1944, possibly no. 34, as *L'Estuaire de la Seine*; Paris 1951a, no. 40; Amsterdam 1951, no. 16; Paris 1957, no. 7; Dieppe 1958, no. 7; Chicago 1960, no. 28 (probably this painting, although it is documented as R 224); New York 1967a, no. 20; New York 1969, no. 7; Paris, New York 1974–75 (shown only in New York); New York 1975–76; New York 1992

REFERENCES: Robaut 1905, vol. 2, pp. 78–79, no. 224 bis, ill.; Converse sale 1911, no. 35; Bazin 1942, no. 24, pl. 24; Bazin 1951, p. 38, no. 28, pl. 28; Bazin 1973, pp. 34, 278, ill. p. 144; Clark 1975, p. 95, ill.; New York 1975–76, p. 43; Huyghe 1976, p. 272

Une Marine, also called Les Quais marchands de Rouen (Seascape, also called The Merchants' Quays at Rouen)

1834
Oil on canvas
43¼ × 68⅛ in. (110 × 173 cm)
Signed and dated lower left: COROT 1834
Musée des Beaux-Arts, Rouen D.951-2
New York and Ottawa only

R 256

We have seen that after he returned from Italy in 1828 Corot often visited Normandy and especially Rouen, a city he had known since his youth. There he painted the cathedral towers and the center of town seen from the hills (cat. no. 43), but he also worked on the port's quays along the Seine. During this period Corot was deeply interested in the pictorial treatment of the seaside, and he drew inspiration from the seascapes of seventeenth-century Dutch and Flemish painters, whose realism and everyday subjects he savored after three years in Italy.

In 1833 Corot spent January and February in Rouen, staying as usual with his friends the Sennegons. There he filled his sketchbooks with rapid drawings of sailors and longshoremen in action,[1] accumulating enough material to consider depicting the port of Rouen in a large painting to be shown at the Salon.

"I've started a Rouen seascape. It's on a canvas of five and a half feet, it's composed of small ships, 2 cottages, and background. If Ruysdael and Van de Velde wanted to help me, that wouldn't hurt," he wrote in March 1833,[2] a verbal confirmation of the influence of Dutch painters that at the time was particularly evident in his landscapes. He would have been able to admire the works of those two artists at the Louvre as well as the seascapes of Backhuysen and Van Goyen, and many masterpieces of the northern school could be studied in engravings.

Corot also used his older studies of 1823–25, and in the background of the present picture one can discover the echo of a tiny study painted on the Rouen quays before his trip to Italy.[3] Corot might have used any of numerous studies of sailboats that he did at Trouville, Le Havre, or Honfleur. But a drawing published by Moreau-Nélaton[4] seems to be the definitive sketch for the composition of the Rouen painting's foreground. It includes the cart, which appears in reverse in the painting.

An amusing article by Jean Ducros[5] points out the stylistic and compositional similarities between Corot's painting and the engraved seascapes published between 1823 and 1832 by Antoine-Louis Garneray (1783–1857), a former painter for the grand admiral of France who at that time was a curator at the Musée des Beaux-Arts in Rouen.[6] One can easily imagine other possible influences: for instance, that of Auguste-Xavier Leprince (1799–1826), who exhibited *Embarquement de bestiaux*

sur le Passager *dans le port d'Honfleur* (fig. 51) at the Salon of 1824, or certain paintings with maritime subjects by Boilly or Taunay, which also carry the imprint of the Dutch school.

Shown at the Salon of 1834 (no. 373), this work was no more successful than Corot's other entries.[7] Étienne Delécluze criticized him for resorting too often to "practices borrowed from the Dutch school,"[8] Louis Peisse for falling into "mannerism."[9] A century and a half later, Hélène Toussaint described the picture as "one of his rare works that have a quality of pastiche."[10]

In his methodical pursuit of a thorough grounding in landscape painting, Corot adopted an itinerary similar to that of his teacher Michallon, who, after studying the Italian masters and Poussin at length, copied pictures by Ruisdael and made paintings influenced by Flemish landscapes. Corot had long followed in the footsteps of Valenciennes, Michallon, and Bertin—and through them, of Poussin and Claude Lorrain—and he wanted to assimilate a different pictorial language. The imprint of seventeenth-century Flemish and Dutch painters would soon be evident on the Barbizon school as well.

Interestingly, at this stage of his aesthetic evolution Corot was seized with the desire to go back to Italy. He left in the spring of 1834, without taking the time to read the critical Salon reviews.

1. Moreau-Nélaton 1924, vol. 1, p. 31.
2. "J'ai mis en train une marine rouennaise. C'est sur une toile de cinq pied et demi, c'est composé de petits navires, 2 fabriques chaumières et de fonds. Si Ruysdael et Van de Velde voulaient m'aider, cela ne me nuirait pas." Corot, letter to Achille Debray, 41, rue des Martyrs, Paris (Rouen, February 26, 1833), cited by Hélène Toussaint in Paris 1975, p. 38. It was offered at the Alfred Dupont sale, December 11, 1956, and is currently in the Fondation Custodia, Paris, Collection Frits Lugt, no. 6871. The letter also describes Corot's attempts to ignore the advice of others: "At least it will be my work and not that of twenty people." ("Au moins ce sera mon ouvrage et non celui de vingt personnes.")
3. R 26. Robaut and Moreau-Nélaton point out the connection.
4. *Le Port de Rouen,* falsely dated 1856; Robaut 1905, vol. 1, p. 60.
5. Ducros 1975, pp. 11–14.
6. Garneray 1823–32. A series of engravings, accompanied by texts by Étienne de Jouy.
7. Corot's other *envois* were *Une Forêt* (*A Forest*), R 255, (?) National Gallery of Art, Washington, D.C., Chester Dale Collection, and *Site d'Italie,* R 361 (?), location unknown.

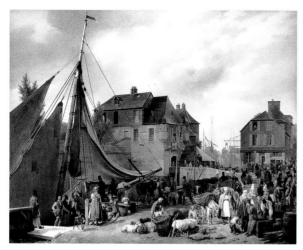

Fig. 51. Auguste-Xavier Leprince (1799–1826). *Embarquement de bestiaux sur le* Passager *dans le port d'Honfleur (Loading Livestock on the* Passager *at the Port of Honfleur).* Musée du Louvre, Paris (inv. 7332)

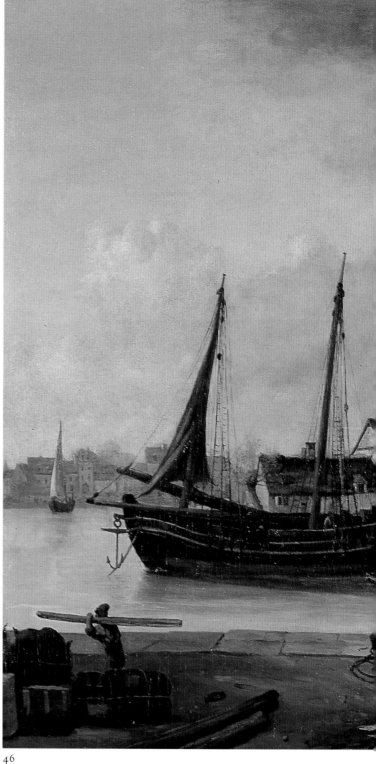

46

8. "pratiques empruntées à l'École hollandaise." Delécluze 1834.

9. Peisse 1834.

10. "une de ses rares oeuvres qui appellent une idée de pastiche." Paris 1975, p. 38.

PROVENANCE: The artist; given to his grandniece Marie-Anna Charmois-Lemarinier, 1872;* her son Georges Lemarinier, Paris; his sale, Galerie Georges Petit, Paris, June 15, 1926, no. 14; purchased at that sale by Hodebert for 162,000 francs; Galerie Barbazange, Paris; Galerie Georges Bernheim, Paris; Étienne Bignou, Paris; Thomasson (?), Paris; assigned to the Musée du Louvre, Paris, by the Office des Biens Privés, 1950 (M.N.R. 150); placed with the Musée des Beaux-Arts, Rouen, 1951

EXHIBITIONS: Paris (Salon) 1834, no. 372, as *Une Marine;* Glasgow 1927, no. 4; Amsterdam 1928, no. 11; New York 1930c, no. 13; New York 1935, no. 3; Moscow, Saint Petersburg, Warsaw 1956, no. 12; Paris 1975, no. 28

REFERENCES: Robaut 1905, vol. 1, p. 52, and vol. 2, pp. 90–91, no. 256; Moreau-Nélaton 1924, vol. 1, p. 31, and vol. 2, p. 154; Feuillet 1926, pp. 552–53, ill.; Rey 1926; Bazin 1942, p. 41, no. 29, pl. 29; Escholier 1943, p. 147; Bazin 1951, pp. 39–40, no. 39, pl. 39; Baud-Bovy 1957, p. 202; Bazin 1973, pp. 36, 279, ill. p. 157; Ducros 1975, pp. 11–14; Popovitch 1978, p. 29; Selz 1988, pp. 74–76, 82–83, ill.

* To thank her for safeguarding the family's possessions during the Franco-Prussian War and the Paris Commune, according to Robaut.

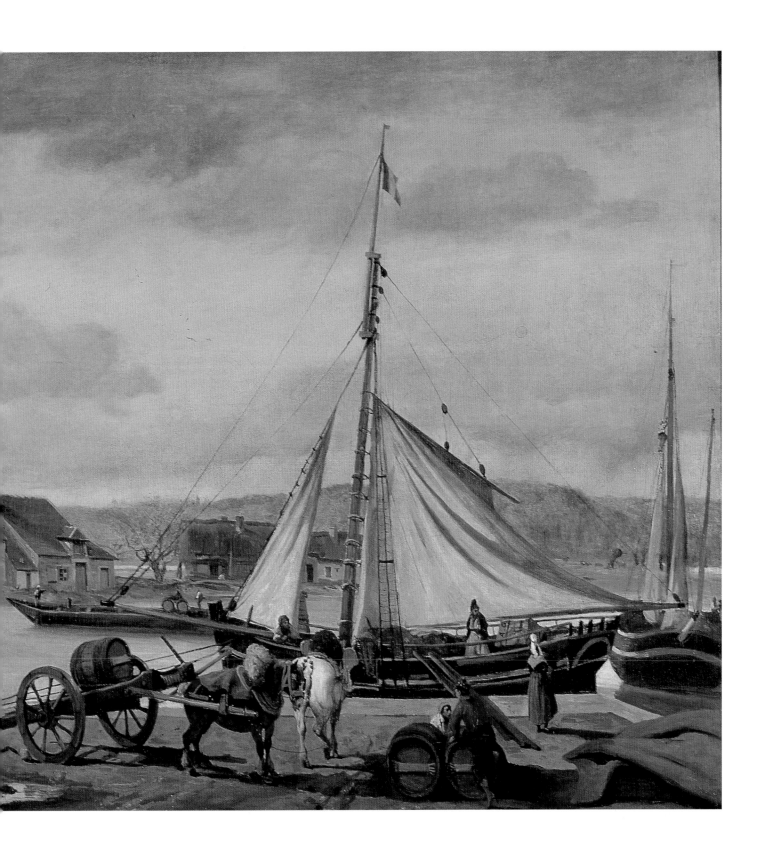

47

Louise Harduin en robe de deuil, also called *Jeune Fille assise dans la campagne*
(Louise Harduin in Mourning)

1831
Oil on canvas
21³/₈ × 18¹/₈ in. (54.3 × 45.9 cm)
Signed and dated lower right: C. Corot 1831
Sterling and Francine Clark Art Institute, Williamstown,
Massachusetts 539

Schoeller and Dieterle 1948, no. 7

This lovely painting of a woman in the open air, much influenced by English portraiture, was long thought to depict Mademoiselle de Puyparlier, a relative of Captain Auguste Faulte de Puyparlier. He was a friend of the Osmond brothers and later of Corot as well. The subject has since been identified by Gilbert Brunet as Louise Harduin, the daughter of Sophie Harduin, whose brother Théodore Scribe was a childhood friend of Corot.

We know that when he returned from Italy, full of optimism about his career, more confident in his technique, and, most important, more experienced in representing the human figure, Corot agreed to paint several portraits of friends and family, including Abel Osmond and Captain Faulte de Puyparlier.[1] All of his friends, considering him now "a full-fledged painter,"[2] were happy to have their portraits done. Thus it is not surprising that one of his best friends, Théodore Scribe, would request a portrait of his niece.

Théodore Scribe (1797–1873) came from the same commercial milieu as Corot; his father, Célestin Scribe, was a dealer in novelties, his uncle Henri Scribe a haberdasher.[3] Scribe followed a literary career. At the École Normale Supérieure he met Louis Hachette and Amédée Guyot, and partly through them he later became a printer-publisher, which gave him a social standing that he sometimes used to Corot's benefit.[4] Scribe owned six paintings by his friend.[5] He was a distant cousin of the dramatist Eugène Scribe, then a fashionable figure on the Parisian scene[6]—not, as some have claimed, a close relative. The Scribe family's patronage originated with Théodore's uncle Henri, who often invited Corot to visit his elegant manor at Nogent-le-Phaye, near Chartres.

Louise Harduin was born in 1816.[7] When Corot painted her in 1831, she had just turned fifteen and wore mourning for her parents, her mother having died in March 1830 and her father a year later. It is likely that her guardian, Théodore Scribe, entrusted Corot with a double mission: to paint her portrait and, more important, to distract her and communicate to her some of his own joie de vivre. The girl appears strangely serene. She is painted on a hilltop, with a panoramic landscape rapidly sketched in the background. While the location is difficult to pin down, it is very likely somewhere near Chartres.

The stiff posture of the young woman, who looks directly at the viewer, derives from the outdoor portraits of Reynolds and Gainsborough, while the sketchy style of the landscape closely resembles that in the background of Delacroix's famous *Nature morte au homard* (Musée du Louvre, Paris), painted four years earlier. But this work also brings to mind group portraits by the Sablet brothers, strongly influenced by English "conversation pieces," and especially portraits by Ingres, such as those of Granet (Musée Granet, Aix-en-Provence) and the comte Gouriev (The Hermitage, Saint Petersburg).

Many critics have noted the influence of Ingres in certain portraits by Corot, such as *Alexina Legoux* (fig. 52), painted in the same period. In fact, that portrait and the ones of Claire Sennegon (cat. no. 50) and François-Auguste Biard[8] are, with this one of Louise Harduin, among the very few portraits

Fig. 52. Corot. *Alexina Legoux* (Robaut 1905, vol. 4, p. 404, A), ca. 1830–35. Oil on canvas, 13³/₄ × 10⁵/₈ in. (35 × 27 cm). Moreau-Nélaton Bequest, Musée du Louvre, Paris (R.F. 1638)

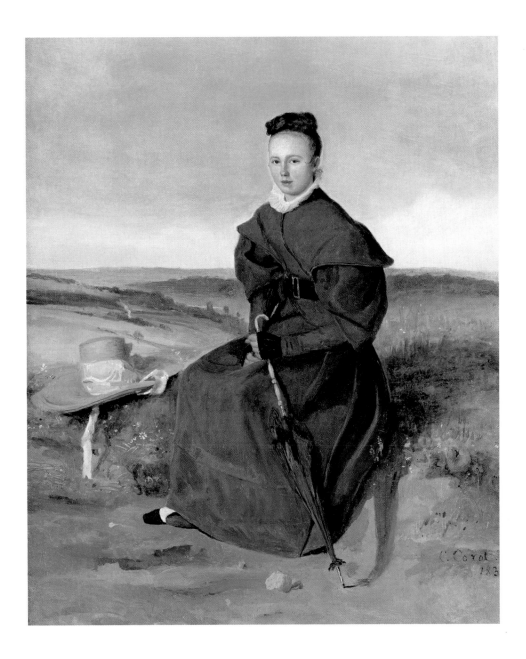

that Corot painted outdoors, although after 1835 he developed numerous imaginative works that show human figures in the midst of a natural world.

Like *Le Forum vu des jardins Farnèse* (cat. no. 10), this work went into the collection of the baron Denys Cochin (1851–1922), a minister under the Third Republic who wrote many books of political, social, and philosophical reflections. The portrait was later acquired by the painter André Derain (1880–1954), who kept it until his death.[9]

1. Moreau-Nélaton 1924, vol. 1, pp. 26–27. In 1829 Corot painted a rather austere portrait of Faulte de Puyparlier (R 206) that is now in the Cincinnati Art Museum.
2. "tout à fait peintre." Alexandre Clérambault, nephew of Corot's former employer in the cloth trade, letter to his sister, November 5, 1829, quoted ibid., p. 27.
3. Most of this information on the Scribe-Harduin family is from Brunet 1977.
4. See cat. no. 89. Scribe used his influence with David Michau, president of the Paris committee on the fine arts, to obtain a commission for Corot to make a large decorative painting for the church of Saint-Nicolas-du-Chardonnet.
5. R 326, 613, 639, 1631, 1632, 1909.
6. Eugène Scribe (1791–1861), French dramatist and especially opera librettist, collaborated on many of the most famous operas of the day.
7. Louise Harduin married Augustin Guillaumin, a lawyer, in 1835 and had five children. She died in 1878.
8. Private collection. The painting was not catalogued by Robaut and Moreau-Nélaton but was later attributed to Corot by Martin Dieterle.
9. Pierre Lévy recounted the following anecdote: "M. Bernheim accompanied Derain to the anteroom. A small painting by Corot hung there, a beautifully composed landscape. While saying good-bye, Derain never took his eyes from the painting. Bernheim observed: 'It seems to make a big impression on you.' 'Oh yes! I adore Corot, this little thing is really marvelous!' Bernheim took the painting off the wall, found some wrapping paper, and said to Derain, 'Take it, in memory of this evening.' Derain told me this many years later: 'I took the Corot, but the Bernheims never saw me again.'" ("M. Bernheim raccompagnait Derain dans l'antichambre. Une petite toile de Corot était accrochée là: un paysage finement encadré. Tout en faisant ses adieux, Derain ne quittait pas le tableau

des yeux. M. Bernheim s'en aperçut: 'Il a l'air de beaucoup vous impressionner.'—'Oh! oui. J'adore Corot, cette petite chose est vraiment très chouette!' M. Bernheim décrocha le tableau, trouva un papier pour l'emballer et dit à Derain: 'En souvenir de cette soirée, nous vous l'offrons.' Derain m'a raconté cela plusieurs années après: 'J'ai pris le Corot, mais les Bernheim ne m'ont jamais revu.' ") Lévy 1976, p. 64.

PROVENANCE: Louise Harduin, until her death in 1878; her daughter Marie Guillaumin, until her death in 1901; the latter's husband, Louis-Claude Brunet, until his death in 1913; M. and Mme Henri Binoche, Paris (Mme Binoche was the daughter of L.-C. Brunet and Marie Guillaumin); Galerie Georges Petit, Paris; the baron Denys Cochin, Paris; his sale, Galerie Georges Petit, Paris, March 26, 1919, no. 1, sold for 31,000 francs; André Derain, 1948 (according to Dieterle); his sale, Galerie Charpentier, Paris, March 22, 1955, no. 19; M. Knoedler & Co., Paris; Robert Sterling Clark; given by him to the Sterling and Francine Clark Art Institute, Williamstown, Massachusetts, 1955

EXHIBITIONS: Williamstown 1956, no. 93; Williamstown 1959; New York 1967b, no. 5; New York 1969, no. 11

REFERENCES: Schoeller and Dieterle 1948, no. 7, ill.; Anon. 1955a, p. 16, ill.; Anon. 1955c; Anon. 1957, p. 155, ill.; Bazin 1973, p. 279, as *Mademoiselle de Puyparlier* (?), ill. p. 153; Fouchet 1975, p. 70, as *Mademoiselle de Puyparlier;* Anon. 1977, ill.; Brunet 1977; Morse 1979, pp. 61–64, ill.; Williamstown, Sterling and Francine Clark Art Institute 1984, fig. 124

48

Laure Sennegon, nièce de Corot, plus tard Mme Baudot (Laure Sennegon, Corot's Niece, Later Mme Baudot)

1831
Oil on canvas
11¼ × 8½ in. (28.5 × 21.5 cm)
Signed and dated lower right: COROT 1831 Signed upper right
(forged, according to Robaut): COROT
Musée du Louvre, Paris R.F. 1965

R 248

Corot's sister Annette-Octavie (1793–1874) married Laurent-Denis Sennegon (1792–1865), the son of Corot's guardian at Bois-Guillaume, and they had seven children, whom Corot depicted in handsome portraits, carefully composed and soberly painted. Marie-Louise-Laure Sennegon, born in 1815, the oldest child, was the first to be painted by her uncle—in 1831, two years before she married Philibert-Jules-Nicolas Baudot. Next came her three sisters.[1] Apparently Corot generally represented each one in her sixteenth year, making two versions of each portrait, one for the model and the other, most likely, for the girls' mother.[2] Robaut and Moreau-Nélaton documented two portraits of Blanche Sennegon (R 246, R 247), and two portraits of Octavie are known.[3] There is only one known portrait of Claire Sennegon (cat. no. 50).

This portrait of Laure was clearly cut down, probably about 1873, since it originally measured 16½ × 13⅜ inches (42 × 34 cm).[4] A copy made by Robaut reveals the portrait's state before its reduction,[5] with a table visible on which the girl leans, as well as a sewing box and work-in-progress on the table. The portrait had been signed and dated 1831. The work's current appearance, focused entirely on the bust and face, is thus greatly changed from Corot's original intentions. He had used the same composition of the young woman leaning on the table in the portrait of Octavie Sennegon painted in 1833, merely reversing the pose. Why the painting was cut down is not known, since it remained in the artist's family.

Corot painted another portrait of this niece, who became Mme Baudot after her marriage, but it was made in 1837, after her death.[6] Hélène Toussaint has pointed out the resemblance between Robaut's copy and the posthumous painting; the similarity suggests that Corot reworked the 1831 version, which Robaut subsequently copied, to make it resemble the young woman as she looked shortly before her death in 1836.[7] After much retouching, the portrait of the girl of sixteen was turned into a portrait of the young woman at the age of twenty-one, the pose and accessories remaining identical while the clothing, the hairstyle, and the subject's features were altered. Thus we know that in 1831 Corot must have made two portraits of Marie-Louise-Laure Sennegon, as he had for two of the other sisters: one that was later reworked and that Robaut copied, and the present painting.

This portrait, in which Robaut saw the influence of Sebastiano del Piombo, is one of Corot's most successful, not only for its elegance and economy of means but also for its brilliant technique, especially in the rendering of the young woman's refined hairstyle and the scarf around her neck. The lack of decoration and the unified olive green background from which the figure emerges clearly recall the Neoclassical approach to portraiture of David and Ingres.

The work was inherited by Fernand Corot (1859–1911), grandson of Laure Sennegon, who became a composer. He named Étienne Moreau-Nélaton his executor and gave him

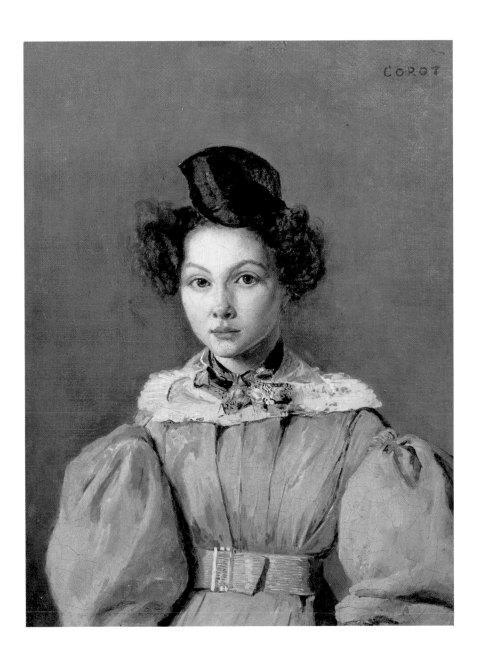

the task of deciding how best to distribute the family mementos relating to his great-great-uncle. Moreau-Nélaton carried out his wishes conscientiously, promptly giving this portrait to the Louvre.

1. Porphyre-Marie-Denise-Blanche Sennegon (b. 1816) married Toussaint Lemaistre, an architect (see cat. no. 49), and had two children. Marie-Dorothée-Joséphine Sennegon (b. 1817), called Octavie, married François-Joseph Chamouillet and had three sons. Louise-Claire Sennegon (b. 1821) married Christophe Charmois in 1844 and had a daughter, who was also portrayed by Corot (Musée du Louvre, Paris).
2. Hélène Toussaint in Paris 1975, p. 102.
3. One is known through a copy by Robaut and the other is at the Barnes Foundation, Merion, Pennsylvania.
4. According to Robaut. See also Hélène Toussaint in Paris 1975, p. 102.
5. Robaut *carton* 32, fol. 4.
6. *Portrait de Madame Baudot, née Laure Sennegon*, R 249, stolen from the Musée Municipal, Semur-en-Auxois, in 1984; sighted in Japan in 1989.
7. Toussaint in Paris 1975, pp. 104–6.

PROVENANCE: Offered by the artist to his sister Mme Sennegon (according to Robaut); given or sold by her to the husband of her granddaughter, Émile Corot; by inheritance to his son Fernand Corot (1859–1911); bequeathed by him to the Musée du Louvre, Paris, through Étienne Moreau-Nélaton, his executor; delivered to the Louvre by Moreau-Nélaton, 1911

EXHIBITIONS: Rome 1962, no. 50; Paris 1975, no. 88; Rome 1975–76, no. 17; Paris 1989; Tokyo 1991, no. 128

REFERENCES: Robaut 1905, vol. 2, pp. 88–89, no. 248, ill.; Brière 1924, no. 3044; Jean 1931, p. 12; Sterling and Adhémar 1958, no. 367; Taillandier 1967, p. 31, ill.; Paris, Musée du Louvre 1972, p. 95; Leymarie 1979, p. 91; Compin and Roquebert 1986, p. 154; Selz 1988, p. 73, ill. cover

49

Toussaint Lemaistre, architecte (Toussaint Lemaistre, Architect)

1833
Oil on canvas
15⅛ × 11⅝ in. (38.4 × 29.5 cm)
Signed and dated upper right: C. Corot. 1833.
The Metropolitan Museum of Art, New York
Bequest of Joan Whitney Payson, 1975 1976.201.13

R 250

Toussaint Lemaistre (1807–1888) married Porphyre-Marie-Denise-Blanche Sennegon, Corot's niece, on March 12, 1846, and they had two children, Alix and Georges. After his first wife's death, he remarried. He was an architect and something of an engineer as well.[1]

Robaut and Moreau-Nélaton note that this painting was long thought to be a portrait of the opera composer Giacomo Meyerbeer (1791–1864). The confusion is puzzling, since only fifteen years had passed between the time that the painting left the Lemaistre family and the publication of Robaut and Moreau-Nélaton's catalogue raisonné.

The grave, subdued figure is placed against a brownish background that emphasizes the model's face and left hand; the only pale elements, they emerge from the near-monochrome of the whole. The treatment of the clothing, matching the background almost tone for tone, is virtuosic. This figure of Toussaint Lemaistre is one of the most successful portraits of a man made by Corot, whose representations of masculine types (fig. 53) were not among his strongest works.

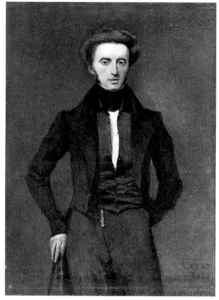

Fig. 53. Corot. *Portrait d'homme (Portrait of a Man)*, 1835. Musée du Louvre, Paris (R.F. 1995-4)

1. He wrote a pamphlet, Lemaistre 1862 (pointed out by Peter Galassi in a note to The Metropolitan Museum of Art, New York, December 1979).

PROVENANCE: Owned by the sitter (according to Robaut); sale, Hôtel Drouot, Paris, December 2, 1891, no. 14, sold for 600 francs; Groult collection, Paris; anonymous sale (Groult; Charley [?]), Galerie Georges Petit, Paris, June 21–22, 1920, no. 51, as *Portrait d'homme (Portrait of a Man)*; Albert S. Henraux, Paris, by 1928; Georges Ambroselli, Paris, until 1963; Joan Whitney Payson, New York and Manhasset, until 1975; her bequest to The Metropolitan Museum of Art, New York, 1975

EXHIBITIONS: Paris 1922a, no. 17; Paris 1928, no. 10; Paris 1936, no. 19, lent by Albert S. Henraux; Lyons 1936, no. 16; Kyoto, Tokyo 1980, no. 6; New York 1992

REFERENCES: Robaut 1905, vol. 2, pp. 88–89, no. 250, ill.; Bernheim de Villers 1930a, pp. 47–48, no. 41, ill.

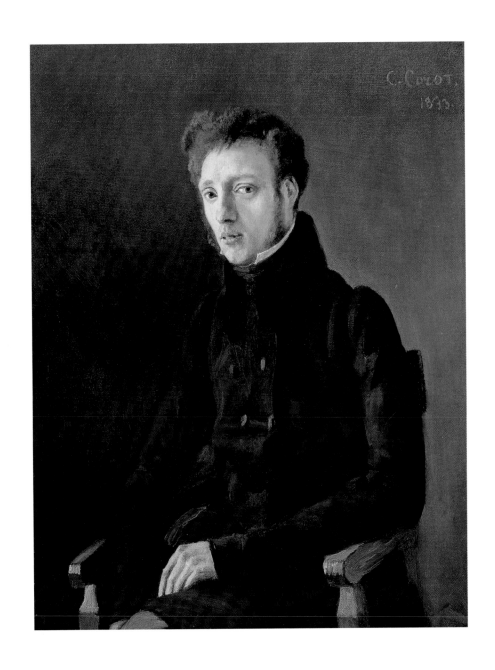

Claire Sennegon, nièce de Corot, plus tard Mme Charmois (Claire Sennegon, Corot's Niece, Later Mme Charmois)

1837
Oil on canvas
16⅞ × 13¾ in. (43 × 35 cm)
Stamped lower left: VENTE COROT[1]
Musée du Louvre, Paris R.F. 2560

R 587

The daughter of Corot's sister Annette-Octavie Sennegon and the youngest of his four nieces, Claire Sennegon was thus painted last, and in the year of her sixteenth birthday, following the tradition established for her three sisters (see cat. no. 48). To complete the series, the artist for the first time chose to depict his young model out of doors, before a landscape.

Louise-Claire Sennegon was born in 1821. In 1844 she married Christophe Charmois, by whom she had a daughter, Marie-Anna, called Blanche, who was also portrayed by Corot.[2] Hélène Toussaint proposed the date of 1837 for this portrait,[3] breaking with the traditional date of 1847 given by Robaut and Moreau-Nélaton. Her arguments, based on the way the canvas is painted, the style of the young woman's dress, and Corot's custom of portraying each niece at sixteen, seem entirely convincing.

Toussaint also stressed the work's Ingres-like quality. While one is immediately reminded of Ingres by the attentive description of the face and the elegant treatment of fabric, one thinks just as quickly of Romantic portraits, which were influenced by the outdoor portraits of the English school. The superb portrait *La Fille de l'artiste* by the painter-sculptor Antoine-Louis Barye (fig. 54) similarly presents a half-length female figure whose light-colored clothing stands out against a landscape darkened by the approach of evening.

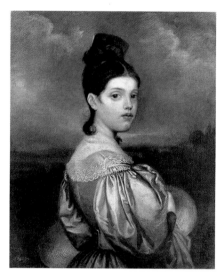

Fig. 54. Antoine-Louis Barye (1795–1875). *La Fille de l'artiste (The Artist's Daughter)*. Oil on canvas, 29½ × 23⅝ in. (75 × 60 cm). Musée du Louvre, Paris (R.F. 2221)

1. Although not offered for sale.
2. *Blanche Charmois, plus tard Mme Lemarinier, petite-nièce de l'artiste (1846–1926)*, R 1058, Musée du Louvre, Paris (R.F. 2561), donated in 1926 by her heirs.
3. In her commentary on the painting in Paris 1975.

PROVENANCE: Gift of the artist to his sister Annette-Octavie Sennegon; transferred by her to her daughter Claire Sennegon, subject of the portrait; by descent from her (then Mme Charmois) to her daughter, Blanche Lemarinier; on her death in 1926, given by her heirs to the Musée du Louvre, Paris

EXHIBITIONS: Venice 1934, no. 141; Paris 1936, no. 54; Lyons 1936, no. 43; Paris 1946b, no. 179; Paris 1950, no. 8; Paris 1962, no. 29; Paris 1975, no. 90; Rome 1975–76, no. 25; Manchester, Norwich 1991, no. 21

REFERENCES: Robaut 1905, vol. 2, pp. 204–5, no. 587, ill.; Lafargue 1925, p. 48; Jamot 1926a, pp. 278, 281, ill.; Rey 1926; Jamot 1929, pp. 83–85, ill.; Bernheim de Villers 1930a, p. 48, no. 94, ill.; Meier-Graefe 1930, pl. XXXII; Faure 1931, p. 79, ill.; Bazin 1951, no. 79, pl. 79; Baud-Bovy 1957, p. 123, ill.; Sterling and Adhémar 1958, no. 390, ill.; Hours 1962; Leymarie 1966, p. 72; Taillandier 1967, p. 68, ill.; Hours 1972, pp. 106–7, ill.; Paris, Musée du Louvre 1972, p. 96; Bazin 1973, p. 193, ill. p. 285; Leymarie 1979, pp. 90–92, ill.; Compin and Roquebert 1986, p. 156, ill.; Selz 1988, p. 146, ill. p. 153

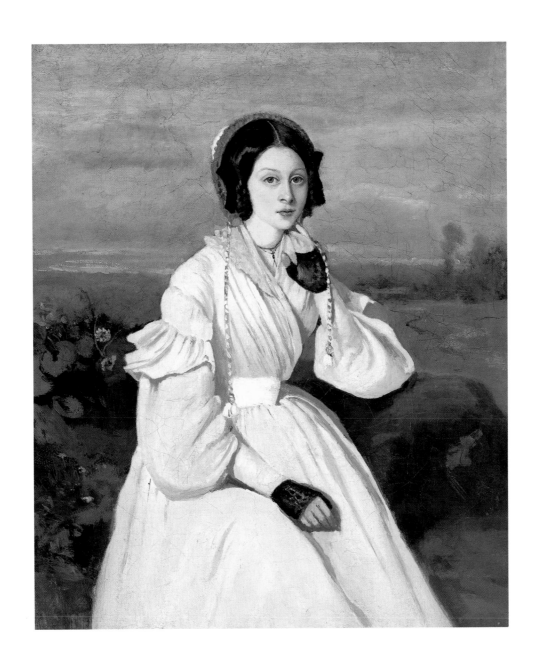

51

Corot, la palette à la main (Corot, Palette in Hand)

Ca. 1840
Oil on canvas
13 × 9⅞ in. (33 × 25 cm)
Galleria degli Uffizi, Florence
Collezione degli Autoritratti 1890 n. 2063
Paris only

R 370

In the catalogue of Corot's centennial exhibition, Hélène Toussaint, drawing on documents in the Bibliothèque Nationale de France, called attention to Robaut's written testimony about Corot's self-portraits.[1] One painting had been kept by the artist until his death, hanging above his bed at Ville-d'Avray; another was owned by the artist's sister Mme Annette-Octavie Sennegon. Identifying these works is problematic since their histories as given by Robaut do not entirely accord with those of the only two self-portraits known today.

The first known self-portrait by Corot (R 41), dated 1825, was acquired from Fernand Corot by Étienne Moreau-Nélaton and given to the Musée du Louvre in 1906 (fig. 1). It is paradoxical that the artist, generally described as modest, shy, and self-effacing, should have painted a portrait of himself in the beginning years of his career, when he was still engaged in his first efforts to depict the human figure. In fact, only two figure studies before 1825 are known, *Femme de pêcheur à Dieppe (Fisherman's Wife at Dieppe)* and *L'Enfant au chapeau haut-de-forme (Child in a Top Hat)*,[2] and these seem closer to the studies of costumes his teacher Michallon made in Rome than to actual portraits. According to legend, Corot painted the 1825 self-portrait because his parents would agree to their son's departure for Italy only if "the young artist left to his dear ones his likeness made by his own hand."[3] The resulting self-portrait, somber, still awkward, executed with "an attentive, strained, even somewhat anxious observation,"[4] in fact shows us an ambitious artist who is depicted concentrating on his painting as he sits at his easel and serves as a public assertion of his profession.[5] This painting remained in the Corot family; it was taken back by the artist after his mother's death—who but he would have hung it over his bed at Ville-d'Avray?—and then left to his nephew Georges Lemaistre, who in turn bequeathed it to Fernand Corot.

By contrast, nothing is known about the making of the second self-portrait, which was dated to about 1835 by Robaut and Moreau-Nélaton. They mention only its donation to the Uffizi in 1875 "some days before his death"[6] and the letter that Corot had received in 1872 from the museum's administration asking him for a self-portrait to adorn its famous gallery of self-portraits. Moved by this unambiguous sign of professional

recognition, Corot agonized over sending such an old work and, according to Robaut, even wondered whether he could send a portrait painted by his friend the painter Alexandre Bouché, which he thought an excellent likeness.[7] On Robaut's advice, he finally decided to give the Uffizi this old painting, which represents him at the age of about forty. Some signs of retouching, visible around the head and on the face, indicate that he may have modified his work a bit before sending it off, as was his customary practice.

Robaut and Moreau-Nélaton's date of about 1835 for this work is open to question. A comparison with figure paintings of that period—such as the 1833 portrait of Toussaint Lemaistre (cat. no. 49) or the one of Henri Sennegon done in 1835—and then with figures painted about 1840, for instance the *Jeune Femme assise, des fleurs entre les mains* (cat. no. 74), suggests that it may well have been painted closer to 1840–45, when the artist's command of the human figure and of the portrait had grown even stronger.

As with the self-portrait in the Louvre, Corot, who was making use of a mirror, represented himself in reverse; thus he holds his brush in his left hand. He composed the picture with effective simplicity, placing the figure against a smooth, undecorated background and emphasizing above all the realistically painted face.[8] It has often been suggested that the figure posed before a unified background of intense olive green shows the influence of portraits by David, and a similar approach characterizes most of Ingres's portraits; clearly this method of setting off the human form springs from Corot's Neoclassical training.

Finally, returning to the incomplete information in Robaut's documents in the Bibliothèque Nationale de France, mentioned earlier, we can reasonably ask: What became of the self-portrait owned by the artist's sister? Conceivably it was one and the same painting as this self-portrait at the Uffizi. If the work had previously belonged to Mme Sennegon, might not Corot have taken back the painting only after her death in 1874, and with it finally responded to the Uffizi administration's request?

1. Robaut *documents*, cited in Paris 1975, no. 85, p. 99.
2. *Femme de pêcheur*, R 41, Musée des Beaux-Arts, Lyons; *L'Enfant au chapeau*, R 56, private collection.

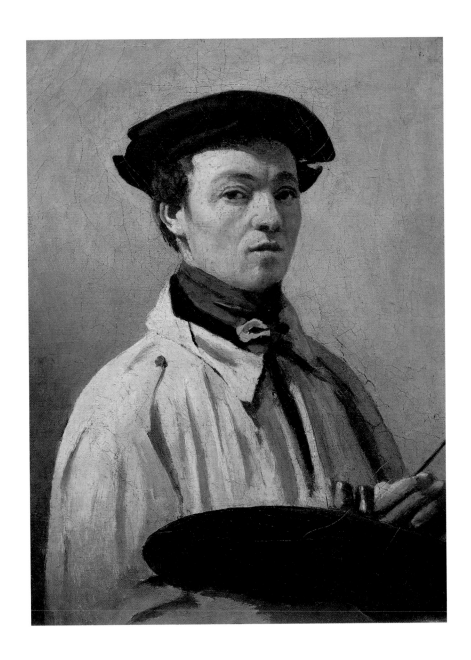

3. "le jeune artiste laissera aux siens son image de sa main." Moreau-Nélaton 1924, vol. 1, p. 13.
4. "une observation attentive, tendue, voir même quelque peu anxieuse." Bazin 1951, pp. 29, 104, 118.
5. Hélène Toussaint does not accept the *Portrait de l'artiste* that was owned by Moreau-Nélaton as the one Corot painted for his parents in 1825. She calls it technically awkward, with "jerky drawing, laboriously ground out" ("son dessin cahotique, sa trituration laborieuse") and believes it must date from before 1825 (in Paris 1975, no. 85).
6. "peu de jours avant sa mort." Robaut 1905, vol. 2, p. 134.
7. Valenciennes set the gallery of artists' self-portraits in perspective, noting that "one of Nicolas Poussin, so famous in Italy, cannot be found within" ("on n'y trouve pas celui de Nicolas Poussin, si célèbre en Italie"). Valenciennes 1800, p. 603.
8. A remarkable copy of this self-portrait in the collection of Fernand Corot was exhibited in Paris 1895, no. 51.

PROVENANCE: Kept in the artist's studio until 1875; offered to the Galleria degli Uffizi, Florence, in response to a request of about 1872; received by the Uffizi in 1875, before Corot's death

EXHIBITIONS: Rome 1946, no. 98; Paris 1951b, no. 7; Rome, Florence 1955, no. 14 (Rome), no. 13 (Florence); Bern 1960, no. 26; Rome, Turin 1961, no. 85; Paris 1962, no. 14

REFERENCES: Robaut 1905, vol. 2, pp. 134–35, no. 370, ill.; Cornu 1911, pp. 72–74; Moreau-Nélaton 1924, vol. 1, p. 45, pl. 66, and vol. 2, p. 95; Lafargue 1925, pl. XIV; Bernheim de Villers 1930a, p. 41, no. 43; Fosca 1930, ill. cover; Jean 1931, pl. XVII; Bazin 1936, p. 49, ill.; Faure 1936, ill.; Gobin 1939, pp. 268–69, ill.; Venturi 1941, p. 163, ill; Bazin 1942, p. 41, no. 58, pl. 58; Corot 1946, ill. cover; Poggi 1949, pp. 53–61; Gilardoni 1952; Baud-Bovy 1957, p. 123; Dieterle 1959, pl. 11; Hours 1962, pp. 14–17, ill.; Fouchet 1975, p. 71; Florence, Galleria degli Uffizi 1979, no. A253, p. 847; Leymarie 1979, ill.; Selz 1988, pp. 102–3, ill.

52

Madame Corot, mère de l'artiste, née Marie-Françoise Oberson (Madame Corot, the Artist's Mother, Born Marie-Françoise Oberson)

Ca. 1833–35
Oil on canvas
16 × 12⅞ in. (40.6 × 32.8 cm)
Signed upper right: COROT
National Galleries of Scotland, Edinburgh NG 1852

R 588

The social milieu, profession, and character of Mme Corot, the artist's mother, are briefly described above in "The Making of an Artist." Her strong personality played a crucial role in her son's artistic development; while Corot later claimed that it was his parents who taught him patience, in his unshakable determination to pursue an artistic career it was no doubt his mother's temperament that served as a model. His affection for the one he called "the beautiful lady" ("la belle dame") would last throughout his life. Although Corot made some drawings of his father, he never painted his portrait.

This painting of the artist's mother follows the traditional format of the seated half-length portrait but in certain ways is unconventional. Mme Corot wears a blue dress with puffed sleeves of a style fashionable in the 1830s and a lace bonnet whose ribbons, curiously, are untied and dangle at either side of her head as if she were about to remove it. She also wears gloves; they are a rare feature in indoor portraits, but there is no indication that she has been outdoors. The color harmonies are very subtle, but the draftsmanship is somewhat naive, except for the fully mastered drawing of the face, which is extraordinarily expressive and moving. It is difficult to define Mme Corot's expression: is it one of uncertainty? amazement? sadness? But when Corot received the copy that Robaut had made of the work, he wrote in reply, "I feel as if I'm seeing the dear woman with that surprised expression of hers."[1] It is interesting that this is his only portrait in which the model does not look at the spectator.

Robaut dated the painting to about 1848–49, an oddly late date that he could not have been given by Corot. Moreau-Nélaton put it about 1845, when Mme Corot was seventy-six years old. Since there is no reason to think that the portrait was meant to be flattering, the painting must have been done earlier than that, and Mme Corot's dress and hairstyle confirm this: the work was painted in the 1830s, probably about 1833–35.

MP

1. "Je crois voir la bonne femme avec son air étonné." Robaut *carton* 32, fol. 18.

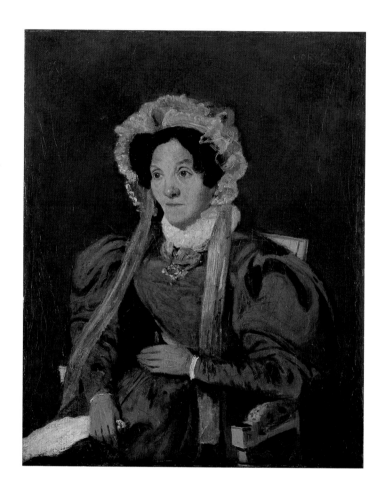

PROVENANCE: Gift of the artist to his sister Annette-Octavie Sennegon; her grandson Léon Chamouillet (d. 1933); his daughter Mme Thomas; Jean Dieterle et Cie., Paris; Wildenstein & Co., London; purchased by the National Gallery of Scotland, Edinburgh, 1936

EXHIBITIONS: Edinburgh, London 1965, no. 59; Manchester, Norwich 1991, no. 26

REFERENCES: Robaut *carton* 32, fol. 18; Robaut 1905, vol. 2, pp. 204–5, no. 588, ill.; Edinburgh, National Gallery of Scotland 1936, p. 103; Edinburgh, National Gallery of Scotland 1957, p. 53; Edinburgh, National Gallery of Scotland 1980, p. 25, ill.; Selz 1988, p. 146, ill. pp. 11, 151; Clarke 1991a, p. 14, fig. 10; Gale 1994, p. 80, ill. p. 81

53

Gênes vu de la promenade Acqua Sola (Genoa Seen from the Acquasola Promenade)

June 1834
Oil on paper mounted on canvas
11⅝ × 16⅜ in. (29.5 × 41.5 cm)
Stamped lower left: VENTE COROT
Inscribed lower right: Gênes 1834
The Art Institute of Chicago
Mr. and Mrs. Martin A. Ryerson Collection 1937.1017

R 301

Corot's second trip to Italy, which he took with a painter friend, Jean-Charles-Denis Grandjean, began in Genoa on June 1, 1834, and ended in Geneva on October 8. The journey was kept to under six months at the request of Corot's father, who did not want him to be away from his parents for too long.[1] Understandably, Corot did less work than he had during his longer first Italian journey. In a pragmatic spirit, he concentrated on just the picturesque sites, so that each of his studies could be used as the basis for a large picture after he returned to Paris.

Corot set to work promptly from the very beginning, in Genoa. His small sketchbook contains a drawing of a sailing ship at the entrance to the port of Genoa and another representing a Genoese palace. He sketched with great precision the bay of Genoa from the height of the San Tommaso gate (R 2659) and painted at least three oil studies.[2] The view shown here was painted from the esplanade of the Acquasola, a terraced promenade overlooking the city, not far from the Palazzo di Giustizia and the church of Santo Stefano. It is to the east of the old port; a lighthouse can be seen at the right. Rapidly sketched-in strokes depict the gardens of the Acquasola in the foreground. The rest of the study is more structured, with a very graphic representation of the white roofs below and a virtuosic handling of the houses, painted in carefully gradated tones of white. When compared with works from his first journey in Italy, this small study reveals how much Corot had learned in five years about the treatment of light and architectural volumes.

1. Moreau-Nélaton 1924, vol. 1, p. 34. Corot's father was evidently financing the trip, which enabled him to set conditions.

2. *Gênes. Vue prise de la terrasse d'un palais* (*Genoa: View from the Terrace of a Palace*), R 300, private collection; the present painting; *Gênes. Un Bout de la ville et les Apennins* (*Genoa: End of Town and the Apennines*), R 302, location unknown.

PROVENANCE: The artist; his posthumous sale, Hôtel Drouot, Paris, pt. 1, May 26–28, 1875, no. 68; purchased at that sale by Brame, Paris, for 3,550 francs; Ernest May, Paris; his sale, Galerie Georges Petit, Paris, June 4, 1890, no. 20, sold for 7,100 francs; Durand-Ruel & Cie., Paris; Ryerson collection, Chicago, 1905 (according to Robaut); Mr. and Mrs. Martin A. Ryerson, Chicago; on loan to The Art Institute of Chicago from 1934; his bequest to The Art Institute of Chicago, 1937

EXHIBITIONS: New York 1930c; New York 1934b, no. 2; New York 1942; Columbus 1943; Philadelphia 1946; Toronto 1950; Dayton 1951, no. 17; Venice 1952; Washington 1956–57, no. 9; Chicago 1960, no. 34; San Diego, Williamstown 1988, no. 10

REFERENCES: Robaut 1905, vol. 2, pp. 106–7, no. 301, ill., and vol. 4, p. 200, no. 68; Chicago, The Art Institute of Chicago 1961, p. 85; Leymarie 1966, ill. p. 50; Maxon 1970, pp. 70, 279, ill.; Hours 1972, p. 86, ill. p. 87; Fouchet 1975, p. 80; Leymarie 1979, pp. 52–53, ill.; Selz 1988, pp. 78, 100, ill.; Galassi 1991a, pp. 212–14, ill.; Galassi 1991b, p. 214, pl. 268

54

Volterra. La Citadelle (Volterra: The Citadel)

June–July 1834
Oil on canvas
18½ × 32¼ in. (47 × 82 cm)
Stamped lower right: VENTE COROT
Musée du Louvre, Paris R.F. 1619
Paris only

R 304

After spending a few days in Genoa and passing through Pisa, Corot stopped at Volterra, where he stayed from the end of June to the end of July 1834. Located in Tuscany, south of Pisa, west of Siena, and not far from San Gimignano, Volterra had been one of the twelve most important Etruscan cities before becoming a Roman city and then a medieval town of political and military importance. Set solidly on rock and fortified since the Middle Ages, this town greatly attracted Corot, who found in it an austere, luminous quality that lent itself to studies from nature.

The works Corot painted at Volterra during the summer of 1834 fall into two categories: first, three small oil studies on paper[1] and several rapid drawings, sketches done on site; then, two larger works, about 28 by 37 inches and 18 by 32 inches, painted on canvas, and apparently—uncharacteristically for Corot—painted from nature, judging from the liveliness of the brushwork (fig. 55).

Moreau-Nélaton noted, "The painter is no longer the timid student of the first Italian trip, but his brushwork has lost none of the conscientious precision that characterized his beginning works,"[2] a remark that seems to confirm the idea that these two works were painted from nature. But Moreau-Nélaton, whose point of reference was Impressionism, did not always differentiate between landscapes Corot painted outdoors and those he reworked in the studio. Lionello Venturi also regarded this view of Volterra as "a finished painting,"[3] and Peter Galassi arrived at a similar opinion: "At Volterra he painted

Fig. 55. Corot. *Volterra. Vue prise en regardant le municipe* (*Volterra: View of the Town;* R 303), 1834. Oil on canvas, 27¾ × 37 in. (70.5 × 94 cm). Moreau-Nélaton Bequest, Musée du Louvre, Paris (R.F. 1618)

two magnificent views, which in conception and execution constitute an unbroken extension of his work at Civita Castellana some seven or eight years earlier. What is new about these pictures is their size: the larger is nearly a meter wide. . . . At Volterra, Corot now tested his ability to deploy the style over a much broader field. In the larger view, perhaps, he overstepped his limits; the treatment of many details is uncertain. But the smaller view [the present painting]—in itself quite large—is vigorous and confident throughout, a faultless performance."[4]

Art historians thus unite in agreeing that these two large works were painted in plein air, which marks a turning point for Corot, who up to now had made a clear distinction between works painted outdoors and studio works in matters of format,

support, and technique. Hélène Toussaint pointed out that the other view of Volterra was exhibited at the Salon of 1838 and was Corot's first submission to the Salon of a painting done from nature rather than composed in the studio.[5]

Certainly the technique used in the foreground of these two landscapes indicates that they were painted in plein air. But Corot's way of working throughout his career was to go back and forth between the outdoors and the studio, and in this case the much more polished facture of the sky and buildings and some discoveries made by reflectography at the Laboratoire de Recherche des Musées de France—for example, Corot painted over a tree in the foreground—suggest, rather, a mixed technique: the artist began the pictures outdoors in order to capture the values, light, and sense of space, then finished them in the studio. If one of the works was exhibited at the Salon,[6] it seems inevitable that Corot reworked it considerably in the studio, something he accomplished without diminishing the spontaneity of his first impression. This method, perhaps less avant-garde than some critics would like to admit, produced two works of singular luminosity and intensity of brushwork.

1. *Route descendant la ville* (*Road Descending from the City*), R 305, location unknown, which must have been used for the first composition of *L'Incendie de Sodome* (see cat. no. 114); *Volterra. Groupe d'arbres en haut de rochers* (*Volterra: Group of Trees High on the Rocks*), R 306, location unknown, a study painted in the same spirit as the paintings of Civita Castellana, Olevano, and Marino, focusing on the trees and rocks; and *Église et campanile à Volterra* (*Church and Bell Tower at Volterra*), R 307, a study that Moreau-Nélaton and Robaut could not locate; they published a sketch of it made by Robaut in 1875.

2. "Le peintre n'est plus l'écolier timide qu'il se montrait à son premier séjour en Italie; cependant sa facture n'a rien perdu de la précision consciencieuse qui caractérisait ses ouvrages de débutant." Moreau-Nélaton 1913, p. 23.

3. Venturi 1941, p. 146.

4. Galassi 1991b, p. 214.

5. In Paris 1975, p. 41. The painting is *Vue prise à Volterra, Toscane*, Musée du Louvre, Paris, Salon of 1838, no. 342. The Salon register gives the dimensions as 85 × 110 cm (33½ × 43¼ in.), which with a frame 15 cm (5⅞ in.) wide would be compatible with those of the Louvre painting.

6. It is curious that critics of the 1838 Salon gave descriptions so unlike that painting—the pendant to the one shown here—speaking of a "cold, spiritless execution, totally lacking in brilliance and energy" ("exécution froide et terne, absolument dépourvus d'éclat et de ressort"; Anon. 1838, p. 135), and not commenting on the freedom of execution.

PROVENANCE: The artist; his posthumous sale, Hôtel Drouot, Paris, pt. 1, May 26–28, 1875, no. 72; purchased at that sale by Alfred Robaut, Paris, for 1,295 francs; Louis Dubuisson, Paris; anonymous sale, Paris, April 27, 1900, no. 7; purchased at that sale by Étienne Moreau-Nélaton, Paris, for 5,250 francs, as *Paysage d'Italie* (*Italian Landscape*); his gift to the Musée du Louvre, Paris, 1906; displayed at the Musée des Arts Décoratifs, Paris, from 1907; entered the Louvre, 1934

EXHIBITIONS: Paris 1907, no. 19; Paris 1975, no. 32; Paris 1989; Paris 1991, no. 38; Paris, Berlin 1992–93, no. 494

REFERENCES: Robaut 1905, vol. 2, pp. 108–9, no. 304, ill., and vol. 4, p. 200, no. 72; Moreau-Nélaton 1913, pp. 20–24; Brière 1924, no. M 19; Moreau-Nélaton 1924, vol. 1, p. 35, ill.; Focillon 1927, p. 315, ill.; Venturi 1941, p. 146, ill. p. 147; Sterling and Adhémar 1958, no. 369; Leymarie 1966, ill. p. 51; Paris, Musée du Louvre 1972, p. 89; Gabellieri Campani 1977, p. 19, ill.; Leymarie 1979, pp. 53–54, ill.; Compin and Roquebert 1986, p. 149; Selz 1988, p. 78; Galassi 1991a, pp. 213–15, ill.; Galassi 1991b, p. 214, pl. 269

55

Florence. Vue des jardins Boboli (Florence: The Boboli Gardens)

Ca. 1834–36
Oil on canvas
20⅛ × 29 in. (51 × 73.5 cm)
Signed lower right (forged, according to Hélène Toussaint): COROT
Musée du Louvre, Paris R.F. 2598

R 310

Corot and his friend Jean-Charles Grandjean reached Florence on July 21, 1834, and stayed until August 10 or 11, since they were in Bologna on August 12. "Florence! Art and nature combining their seductive allure to charm the eyes and the soul!" effused Étienne Moreau-Nélaton, evoking Corot's visit.[1] Although legend has it that Corot saw nothing in Italy but landscapes and ignored the masterpieces in churches and museums, the drawings after Florentine frescoes noted by Robaut and Moreau-Nélaton are evidence of the artist's fidelity to the Renaissance masters.[2]

But Corot evidently did few views of the city itself, since just one drawing (R 2664) and two oil studies are known. It seems, as Moreau-Nélaton confirmed, that Corot worked only in the Boboli Gardens, near the Pitti Palace. From these gardens, laid out about 1550 and the scene of sumptuous celebrations of the Medicis, Corot painted two small studies of the north of the city. One of these (R 311), whose current location is unknown, shows a view of Florence from the highest level of the terraced gardens; the Duomo seen from afar and the panorama of the mountains ringing the city are the real subjects of the painting. The other study (R 309), now in a private collection, is more tightly focused, giving a better view of the city's principal monuments, including the Duomo and the roofs of the Uffizi. Its composition and figures of monks repeat features of a study made the previous month in Genoa from the terrace of a palace (R 300).

Robaut and Moreau-Nélaton stated that several years later Corot painted an interpretation based on the second plein air study of Florence. This interpretation, the present painting, was in the collection of Corot's friend from Mantes, François-Parfait Robert (1814–1875). Robert, a magistrate, shared Corot's passion for Italy and commissioned him to create a now-famous decoration for his bathroom.[3]

In this painting based on the 1834 study, Corot retained the perspective and drew inspiration from the light on the buildings as he had painted it on site, but he greatly transformed the composition. He enlarged the foreground into a true terrace on which two monks converse and kept the figure of the monk descending the stairs. He stretched out the composition to include the entire cypress, which became an essential element in the construction of the space, and added a tree at the left to enhance the symmetry, as he often did. A comparison with an old photograph of the painting (fig. 56) shows that later, after 1850, Corot retouched the colonnade in the center of the canvas and the bushes at right.

The luminosity of this view of Florence—painted at the end of the day, when the setting sun is striking the steeples—and the beautiful treatment of the hills on the horizon easily compensate for the uncertainty caused by the reworking of the foreground.

1. "Florence! L'art et la nature combinant leurs séductions pour le charme des yeux et de l'âme!" Moreau-Nélaton 1924, vol. 1, p. 35.
2. *Au Couvent de San Miniato, près de Florence, juillet 1834*, R 2666, and *Florence. Santa Maria Novella, juillet 1834, dans la chapelle des Espagnols*, R 2665. Corot also made a drawing after a fresco by Giotto in Pisa during the same journey.
3. R 435–R 440, now in the Musée du Louvre, Paris, R.F. 2605. Christian and Maurice Robert, the heirs of François-Parfait, gave the paintings to the Louvre in 1926 along with several other Corots in their collection.

PROVENANCE: Bequeathed by Corot to his friends M. and Mme François-Parfait Robert, Mantes, 1875 (according to Robaut); their sons Christian and Maurice Robert, Mantes; their bequest to the Musée du Louvre, Paris, 1926

EXHIBITIONS: Paris 1936, no. 22; Lyons 1936, no. 18; Geneva 1937, no. 11; Cahors 1945; Liège 1946, no. 26; Rome, Florence 1955, no. 19 (Rome), no. 18 (Florence); Rome, Turin 1961, no. 92; Paris 1975, no. 35; Rome 1975–76, no. 20; Paris 1989; Florence 1994, no. 128

REFERENCES: Robaut 1905, vol. 1, p. 59, and vol. 2, pp. 110–11, no. 310, ill.; Moreau-Nélaton 1924, vol. 1, p. 35, fig. 52; Jamot 1926b, pp. 801–2; Meier-Graefe 1930, p. 47, ill.; Faure 1931, p. 22; Bazin 1936, p. 47, ill.; Jamot 1936, p. 7, ill.; Bazin 1942, no. 38, pl. 38; Escholier 1943, p. 146; Bazin 1951, no. 46, pl. 46; Baud-Bovy 1957, p. 84, ill.; Sterling and Adhémar 1958, no. 377; Taillandier 1967, ill.; Paris, Musée du Louvre 1972, p. 97; Bazin 1973, p. 280, ill. p. 161; Fouchet 1975, ill.; Gabellieri Campani 1977, p. 21; Leymarie 1979, p. 55; Compin and Roquebert 1986, p. 156, ill.; Walter 1986, p. 305

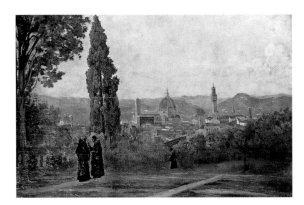

Fig. 56. First version of Corot's *Vue des jardins Boboli* in a
photograph by Charles Desavary, with Robaut's annota-
tion. Département des Peintures, Musée du Louvre, Paris

Venise, la Piazzetta. Vue du quai des Esclavons (Venice, the Piazzetta: View from the Riva degli Schiavoni)

Ca. 1835
Oil on canvas
18³/₈ × 28 in. (46.7 × 71.1 cm)
Signed lower left: COROT
The Norton Simon Foundation, Pasadena, California F. 1973.27.P
R 323

In October 1828, at the end of his first stay in Italy, Corot stopped in Venice on his way back to France; but, eager to see his family after a three-year absence, he spent only a few days there. Robaut and Moreau-Nélaton catalogued only two studies painted during this first Venetian visit (fig. 57).[1] However, I believe, along with Hélène Toussaint, that the small study acquired by the Louvre in 1909 (fig. 58) also dates from this trip.[2] In any case it seems unlikely that Corot painted more than two or three studies from nature during this stopover.

Dazzled by Venice, Corot returned in 1834 and stayed from August 18 to September 9 before going on to the Alpine lakes. During this second visit he painted his most luminous studies of the city and visited museums and churches containing scores of Venetian masterpieces—art that he had loved since the days when he copied paintings in the Louvre. "Venice had delighted him above all," wrote Émile Michel in 1905. "After visits to churches and palaces, where he paid homage to Titian, his favorite master, his days were filled with work. He was particularly struck by the transparency of the salt air, by the brilliance of the light, by the joyful coloration of the buildings that the waters of the Grand Canal reflect with still more delectable intonations."[3]

Michel also noted Corot's interest in the Venetian masters, whose work would inspire *Le Concert* (fig. 65) and *La Femme à la grande toque et à la mandoline* (R 1060, private collection). When Moreau-Nélaton wrote that "on six or eight small canvases [Corot] carried Venice away with him,"[4] he was overlooking the artist's visits to Venetian churches and thinking only of his plein air landscapes, particularly those done near the Piazza San Marco.

Inspired by his 1834 stay, Corot painted four depictions, including the present work, of the Piazzetta and the view of the mouth of the Grand Canal with Santa Maria della Salute in the background.[5] It is difficult to know which view was the first one, painted from life. The picture in Moscow (R 318), with its sketchy appearance and simple composition—there are only two or three figures on the quay—seems to possess all the qualities of a study from nature, especially since its small format (10¹/₂ × 15¹/₂ in.) is appropriate for this kind of work. The painting in Melbourne (fig. 59) and the one in a private collection (R 322) are slightly larger but seem more rigid in their composition and include a number of more prominent

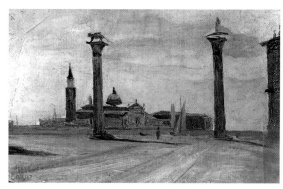

Fig. 57. Corot. *Venise. La Piazzetta* (*Venice. The Piazzetta;* R 193), 1828. Oil on paper mounted on board, 6¹/₄ × 9⁷/₈ in. (16 × 25 cm). Bequest of Frederick Frothingham, Museum of Fine Arts, Boston

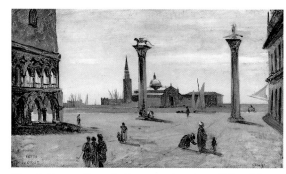

Fig. 58. Corot. *Venise. La Piazzetta et les colonnes* (*Venice. The Piazzetta and the Columns;* R 314), 1828. Oil on canvas, 7⁷/₈ × 13³/₈ in. (20 × 34 cm). Musée du Louvre, Paris (R.F. 1755)

Fig. 59. Corot. *Venise. Vue du quai des Esclavons* (*Venice. View from the Riva degli Schiavoni*). National Gallery of Victoria, Melbourne

figures. In fact, R 322 is clearly dated 1845, or eleven years after the trip to Italy, and thus must have been painted in Corot's studio in Paris.

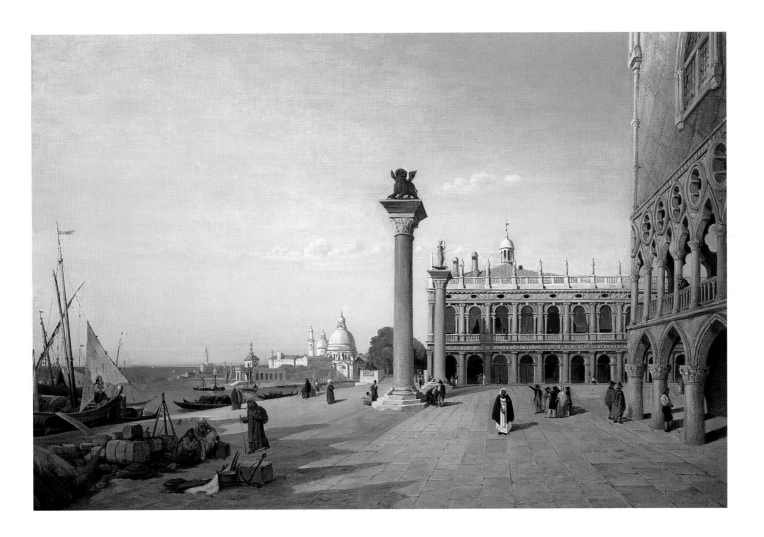

The present work was also painted on Corot's return to France, probably about 1835. The rendering is precise, even minutely detailed, but the Venetian topography has been modified. To the right is the rich facade of the Doges' Palace, with the Libreria Vecchia in the background. At the center are the two columns brought from Constantinople by Venetian sailors, surmounted by the lion of Saint Mark and the statue of Saint Theodore, and Santa Maria della Salute rises to the left of them, at the mouth of the Grand Canal. A boat on the left provides a counterweight to the buildings on the right. The boat does not appear in the other views from the Riva degli Schiavoni cited above.

In this work the islands that lie opposite the Piazzetta have disappeared—including the Island of San Giorgio Maggiore, whose church is perhaps the most beautiful Palladian structure in Venice. This inaccuracy supports the thesis advanced above that the Moscow version is the prototype of the other three. The small Moscow study is so tightly framed that the Island of San Giorgio Maggiore does not appear. When Corot later made several studio compositions from this study, he adopted a more distant viewpoint; he depicted an expanse of sea, but the two islands that should occupy the expanse are absent.

Corot used numerous figure groups to enliven this urban landscape: Italians in local costume walking under the arcades of the Doges' Palace, a party of tourists visiting the site, a white-bearded monk standing at the center, another monk

heading for the wharf, several Turks wearing turbans, and the romantic character on a crate, posing dejectedly, like Delacroix's Tasso in the insane asylum, with his head resting on his hand. The painting has humor and obvious commercial appeal, but it retains the intensity of light and the color contrasts that give such richness to Corot's views of Venice from his 1834 voyage.

1. R 193 (fig. 57) and R 194, location unknown.
2. This work is similar in composition and technique to R 193, the painting in Boston.
3. "Venise surtout l'avait ravi. Après la visite des églises et des palais, où il paie son tribut d'admiration à Titien, son maître préféré, ses journées sont remplies par le travail. Il est particulièrement frappé par la transparence de cet air salin, par l'éclat qu'y prend la lumière, par les joyeuses colorations des édifices que l'eau du Grand Canal reflète avec des intonations plus savoureuses encore." Michel 1905, p. 22.
4. "sur six ou huit petites toiles . . . [Corot] emporte Venise." Moreau-Nélaton in Robaut 1905, vol. 1, pp. 69–70.
5. The other paintings are R 318 (Pushkin Museum, Moscow), R 321 (National Gallery of Victoria, Melbourne), and R 322 (private collection).

PROVENANCE: Van Wessen collection; Arnold et Tripp, Paris, 1898; private collection, Paris; Michaux collection, Paris; Paul Rosenberg & Co., New York; Reid & Lefevre, London, about 1970; Paul Rosenberg & Co., New York; purchased from them by The Norton Simon Foundation, 1973

EXHIBITIONS: Amsterdam 1928, no. 5; New York 1928, no. 2; Paris 1936a, no. 6; San Francisco 1974, no. 13

REFERENCES: Michel 1905, p. 22; Robaut 1905, vol. 2, pp. 114–15, no. 323, ill.; Blanche 1920; Escholier 1943, p. 146; Alpatov 1961, pp. 169–75; Roberts 1976, pp. 877–79, ill.; Morse 1979, p. 62; Brommer 1988, p. 25

57

La Ville et le lac de Côme (Lake Como and the Town)

September 1834
Oil on canvas
11³⁄₈ × 16¹⁄₂ in. (29 × 42 cm)
Stamped: VENTE COROT
Private collection

R 308

The last leg of Corot's journey before going back to France was the Alpine lakes of northern Italy. As he noted in a *carnet*, he reached Lake Como on September 28, 1834. He stayed there only a few days, since he arrived in Geneva on October 8 after stopping at Baveno and Domodossola.

Lake Como, situated north of Milan at the edge of the Alps, truly inspired Corot, who sketched several landscapes and figures he saw in the area.[1] However, the brevity of his visit allowed him to paint only this one study from nature, very vivid and luminous, in which the town of Como, on the shore of the lake, is seen through foliage from the opposite bank.

The brushwork is brilliant and rapid. The landscape elements are sketched in a technique close to that in Valenciennes's best studies and recall the older artist's fluid brushwork and similar perspective in certain views of Lake Nemi in the Louvre

Fig. 60. Pierre-Henri de Valenciennes (1750–1819). *Vue du lac de Nemi et Genzano (View of Lake Nemi and Genzano)*. Oil on paper mounted on card, 8³⁄₄ × 12⁷⁄₈ in. (22.3 × 32.6 cm). Musée du Louvre, Paris (R.F. 3023)

(fig. 60).[2] This type of composition, which allowed the landscapist to study simultaneously the foreground vegetation and the elements in the distance, was surely an exercise Corot had practiced in Michallon's studio. The type illustrates how the landscape evolved in the space of three generations of painters—Valenciennes, Michallon, and Corot. It was transformed into a pure evocation of nature for its own sake: nature, seen beyond a screen of trees, has become the main player in the work.

1. *Carnet* 37, cited in Robaut 1905, vol. 4, p. 93, no. 3074. See also Robaut 1905, vol. 4, p. 38, no. 2671.
2. Four studies by Valenciennes in particular: Musée du Louvre, Paris, R.F. 2923, 2986, 2996, 3023.

PROVENANCE: The artist; his posthumous sale, Hôtel Drouot, Paris, pt. 1, May 26–28, 1875, no. 83; purchased at that sale by Hector Brame, Paris, for 1,650 francs; Jules Paton, Paris; his sale, Paris, April 1883, no. 39; purchased at that sale by the comte Armand Doria, Paris, for 1,850 francs; his sale, Galerie Georges Petit, Paris, May 1899, no. 58, sold for 16,300 francs; Pierre Peytel, Paris; Captain Edward Molyneux, Paris; Lefevre Gallery, London; Mrs. Albert D. Lasker, New York, 1951; Lefevre Gallery, London; Acquavella Galleries, New York, 1977; Tom Fee, United States; Lefevre Gallery, London; the present owner

EXHIBITIONS: Paris 1889, no. 171; Paris 1928, no. 14; Zurich 1934, no. 44, lent by P. Peytel, Paris; Paris 1936, no. 25, lent by Pierre Peytel; Lyons 1936, no. 21; Paris 1951b, no. 6; Dallas 1953, no. 15; Bern 1960, no. 223; Chicago 1960, no. 35, lent by Mrs. Albert D. Lasker, New York; Los Angeles 1961; New York 1969, no. 19; Oklahoma City 1977, no. 20; London 1989, no. 13; Manchester, Norwich 1991, no. 17; Lugano 1994, no. 4

REFERENCES: Michel 1905, p. 22; Robaut 1905, vol. 2, pp. 108–9, no. 308, ill., and vol. 4, p. 201, no. 83; Moreau-Nélaton 1924, vol. 1, pp. 36–37; Faure 1931, pl. 18; Jean 1931, pl. 15; Corot 1946, vol. 1, p. 97; Brockway and Frankfurter 1957, pl. 3; Leymarie 1966, ill. p. 55; Bazin 1973, p. 280; Leymarie 1979, p. 58, ill.; Selz 1988, pp. 78, 80, 92, ill.; Galassi 1991a, p. 215, ill.; Galassi 1991b, p. 215, pl. 271

Two views of Riva

58. *Vue prise à Riva, Tyrol italien*
(View at Riva, Italian Tirol)

Before going on to Lake Como, Corot stopped on the shore of Lake Garda from September 10 to 26, 1834.[1] He arrived at the small village of Desenzano, at the southern end of the lake, and undoubtedly took the steamboat to reach Riva, a town set in the Alps at the northernmost point of this very long lake. He stayed from September 16 to 22 in that small town, painting a single study from nature, which subsequently served him often as a source of inspiration.

On the steamboat Corot drew the pretty Italian women and also the lake's steep shores, whose majesty and strange luminosity deeply impressed him.[2] As soon as he arrived in Riva, he discovered on the road that ran along the lake and into town a site that particularly excited him and that became the subject of the present picture: at right, a mass of rocks, embellished with greenery and a tiny sanctuary; in the center, a boat emerging from the foliage and heading into the mist; at left, a small peninsula, on which one can barely make out two small figures. The remainder of the painting is given over to the play of morning light on the water and the mountains surrounded by haze.

This study from nature, with its skillful depictions of sunlight reflected in the water, would later inspire four variations that Corot painted in the studio, one soon afterward and the others later on in his career. The present exhibition reunites three of the paintings, allowing the viewer to understand how as time brought about a metamorphosis in the artist's memory, the site gradually became transformed through his brush.

The first was a large picture Corot made as soon as he returned to Paris, intending to exhibit it at the Salon (cat. no. 59).

Years later he painted three *souvenirs* of Riva. In the first of these (cat. no. 94), now in Marseilles, the picture has become a nighttime scene, remade through the filter of the artist's memory. Robaut and Moreau-Nélaton cite another version, painted about 1850–55 and marked by several differences in the treatment of the trees (R 360). Finally, about 1865–70, Corot took up this image to paint one last version, but this time set in an entirely different visual and poetic universe (cat. no. 131).

In this progression of four paintings made over thirty years, the viewer can begin to understand the importance to Corot of one of the major themes of his oeuvre, the *souvenir*.

1. *Carnet* 37, cited in Robaut 1905, vol. 4, p. 93, no. 3074. This notebook is in the Département des Arts Graphiques, Musée du Louvre, Paris, to which Moreau-Nélaton bequeathed it in 1927.
2. See Moreau-Nélaton 1924, vol. 1, pp. 36–38, where a pencil drawing depicting a young woman, made "on the steamboat," is reproduced, and Robaut 1905, vol. 4, no. 3074: a small drawing in this sketchbook shows "Lake Garda with mountains 'in the steamboat.' "

PROVENANCE: The artist; his posthumous sale, Hôtel Drouot, Paris, pt. 2, May 31–June 4, 1875, no. 415; purchased at that sale by Marion, Paris, for 1,450 francs; Dézermaux collection, Paris, 1905 (according to Robaut); Étienne Bignou, Paris (according to Robaut); probably purchased by the Kunstmuseum, Saint Gall, in 1936 or 1937, by exchange, to become part of the Sturzenegger Collection at the Kunstmuseum, Saint Gall

EXHIBITIONS: Zurich 1933, no. 50; Bern 1934, no. 19; Bern 1960, no. 24; Chicago 1960, no. 37; Bremen 1977–78, no. 9; Lugano 1994, no. 5

REFERENCES: Robaut 1905, vol. 2, pp. 124–25, no. 358, ill., and vol. 4, p. 240, no. 415; Bazin 1942, no. 40, pl. 40; Leymarie 1979, p. 58, ill.; Selz 1988, p. 80

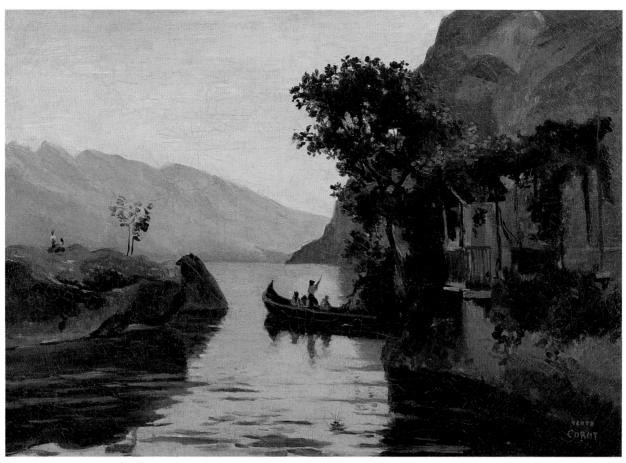

58. *Vue prise à Riva, Tyrol italien* (*View at Riva, Italian Tirol*), 1834. Oil on canvas, 11³⁄₈ × 16¹⁄₈ in. (29 × 41 cm). Stamped lower right: VENTE COROT Kunstmuseum, Saint Gall, Sturzeneggersche Gemäldesammlung (G 1936/3) R 358

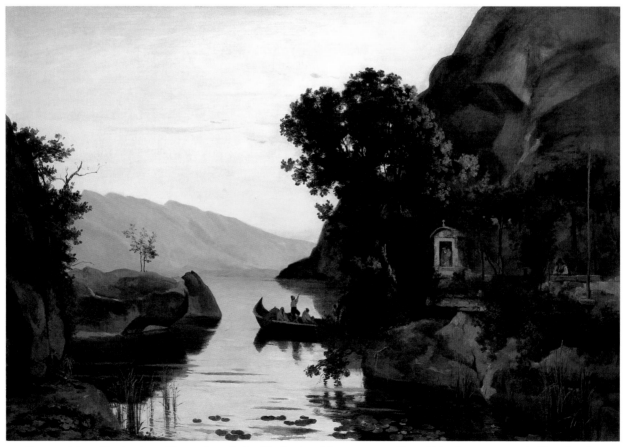

59. *Vue prise à Riva, Tyrol italien* (*View at Riva, Italian Tirol*), 1835. Oil on canvas, 38⁷⁄₈ × 55³⁄₄ in. (98.6 × 141.5 cm). Signed and dated lower left: COROT 1835 Bayerische Staatsgemäldesammlungen, Neue Pinakothek, Munich (14581) R 357

59. *Vue prise à Riva, Tyrol italien* (*View at Riva, Italian Tirol*)

When Corot returned to Paris after his Italian journey, he immediately set to work on this large painting based on the plein air study he had made at Lake Garda (cat. no. 58). He worked on it during the winter of 1834–35, intending to submit it to the Salon. The painting differs from the study in significant ways: the foreground is deeper and is enlivened by water lilies and reeds; the base of a cliff was added at left, balancing a composition that in the study had been asymmetrical; while the boat was kept in the same position, the right side of the work has greatly evolved, the cliff and the sanctuary being presented here almost head-on rather than at an angle, as in the study. As was his practice, Corot added a small figure, who regards the viewer from the corner. But while the composition has undergone many revisions, the pictorial impulse remains unchanged: the same morning effect, the same attention to reflections on the water, the same evocative depiction of the hazy mountains.

Corot exhibited this painting beside *Agar dans le désert* (cat. no. 61) at the Salon of 1835. The critics admired or were irritated by the grandiose landscape of *Agar dans le désert* but paid little attention to this view, despite the beauty of its painting. Although *Vue prise à Riva, Tyrol italien* lacks the grandeur of *Agar*, it is one of Corot's profound and particularly intimate reflections on nature.

PROVENANCE: Gift of the artist to the sculptor Dominique Molkenecht (Mahlknecht; 1793–1876), Paris (according to Robaut); his anonymous sale, Paris, June 6, 1876, sold for 1,200 francs; the comte Armand Doria (1824–1896), Paris; his sale, Galerie Georges Petit, Paris, May 1899, no. 59, sold for 34,500 francs; Bessonneau collection, Angers (according to Robaut); Mme Frappier; Poumayou collection; Wildenstein & Co., New York; acquired from them by the Neue Pinakothek, Munich, 1978

EXHIBITIONS: Paris (Salon) 1835, no. 441, as *Vue prise à Riva, Tyrol italien*; Chicago 1960, no. 38, lent by Wildenstein & Co., New York

REFERENCES: Robaut 1905, vol. 2, pp. 124–25, no. 357, ill.; Bazin 1942, p. 123; Leymarie 1979, p. 62, ill.; Selz 1988, p. 80

60

Genève. Vue d'une partie de la ville (*Geneva: View of Part of the City*)

1834?
Oil on canvas
10¼ × 13⅞ in. (26 × 35.2 cm)
Signed lower right: COROT
Philadelphia Museum of Art, Philadelphia
The John G. Johnson Collection JC cat. 925

R 407

Corot visited Switzerland more often than any other country, but his trips are not all documented and their dates are not always known. As noted in previous entries, his first visit was in 1834 on his return trip from Italy. He stopped at Geneva, where he is recorded at the Hôtel de la Balance on October 8.[1] In a memoir, Corot's friend the painter Armand Leleux placed a second visit to Switzerland in 1840. That journey, in fact, occurred in the summer of 1842, when Corot traveled with Henri Harduin, Louise Harduin's brother (see cat. no. 47). Ten years later, in 1852, Corot returned to Geneva with Leleux and his new friend Charles Daubigny, and the three were reunited again in Switzerland the following year. Several other visits, some unaccompanied, followed in August–September 1855, July 1857, August–September 1859, and finally July 1863.

Corot's circle of Swiss friends was large. It included the painter Antoine Bovy and his brother Daniel, who were to be found at La Boissière, later at the Château de Gruyères, and eventually at Saint-Jean, near Geneva; their sister (married to

Samuel Darier, an architect); Jean-Gabriel Scheffer (married to Jeanne Darier) and Barthélémy Menn, both painters, in Geneva; Louis Berthoud, also a painter, in Lausanne; and Suzanne and Charles Turrettini, friends of Menn's, at Chênes and Cologny. Corot tended to visit them in succession, each for a few days. Occasional records give a flavor of these sojourns, such as the diary entries written by a member of the Bovy family at La Boissière in August 1855: "The 27th, M. Corot works in Turrettini's fields in the morning, painting two charming studies.... The 29th ... in the evening they perform *Tambour battant* and *Cinderella*, much enjoyed by M. Corot and the whole family.... On the 30th they do *La Jeune Prude*, at M. Corot's request.... The 31st, the dear M. Corot departs at 5 A.M. His absence leaves a huge void."[2] It could be speculated that Corot's partly Swiss origins were a reason for his repeated visits, but abundant evidence indicates that his travels, more frequent after 1852, were largely connected with his many friends. An interest in specifically Swiss scenery, so widespread among

nineteenth-century artists, appears to have been a lesser incentive; as in Italy, Corot almost invariably turned his gaze to the least predictable subjects.

Corot painted several views of the Lake of Geneva, but only four depict the city itself. A work now in the Musée de La Rochelle (R 717) shows Geneva from a great distance. In another, inscribed 1852, his one dated work from Geneva (R 726), the city is seen from the countryside.[3] *Le Lac de Genève* (cat. no. 81) includes some of the city but looks toward the lake and the mountains. The present painting is Corot's only attempt at a direct view of Geneva. The scene, taken from the middle of the Rhone, shows the last two blocks of the Grand Quai du Lac with its recently refaced buildings, since completely altered.[4] To the right is the retaining wall of the Île des Barques, later renamed the Île Rousseau. Behind the buildings on the quay are the towers of the church of Saint-Pierre and, beyond, the mountain called the Grand Salève. When Robaut visited Geneva at the end of the century, he found the view considerably changed by trees grown up along the quay and by the new Mont Blanc bridge spanning the Rhone.[5]

The date of the work has never been certain, but a more serious question that has recently been raised concerns its attribution.[6] The work certainly was in Corot's studio at his death and had for some years enjoyed a measure of fame. It was one of the group of works photographed by Charles Desavary and was well known to Robaut, who never doubted it and described it in detail. Robaut's general comment was "very beautiful study, though a bit cold," and he noted that the boat so conspicuously placed at the center of the composition was added by Corot later.[7] The number of copies made from this study by students and amateurs in Corot's studio confirms that it was frequently seen.[8]

The question of this work's date necessarily affects other works, notably the more famous *Lac de Genève* (cat. no. 81). Robaut dated it between 1840 and 1850, but since Corot was in Geneva only at the beginning of the decade, it could not date to later than 1842. Owing to an editorial oversight in a text written over a period of years, Daniel Baud-Bovy gave it two different dates, first attaching it firmly to Corot's visit to Geneva in October 1834 and later proposing a date of July 1842.[9] The change was doubtless provoked by Pierre Borel's publication in 1947 of a letter Corot sent from Geneva in July 1842 to his friend the painter Paul Tavernier. Corot wrote:

> I'm staying on in Geneva, this charming city. With each step I discover delightful motifs. How pleasant it is to work here. And the light is just the way I like it, full of delicate nuances.

Last night in my hotel room I reread a page by Jean-Jacques Rousseau, that landscape artist of genius: "The appearance of the Lake of Geneva and its admirable banks," he writes, "has always held a particular attraction for my eyes which I cannot explain. It has to do not merely with the beauty of the spectacle, but with something unknown, something more interesting, that touches and softens me."

That's exactly what I feel here. Right now, I'm working on a painting of Geneva seen from the shore of the lake. The viewpoint delights me![10]

Borel contended that the letter concerned the *Lac de Genève.* Baud-Bovy argued that, on the contrary, the painting referred to was this landscape, which he dated to the summer of 1842. Much depends on whether by "Geneva" Corot meant the city or the lake. Robaut catalogued a painting called *Le Lac de Genève en face de Villeneuve* (R 410), which he dated 1840–50, noting that Corot, who could not remember the exact date, told him it was painted during a solar eclipse. In fact, an eclipse took place on July 8, 1842, during Corot's visit and near the time he wrote the letter. The view in the present painting is not "seen from the shore of the lake," which seems to rule it out as a candidate for the painting mentioned in the letter. But *Le Lac de Genève en face de Villeneuve* is, precisely, a view of the lake seen from the shore.

In style and handling, particularly of the buildings and the water, this painting in Philadelphia is very close to *La Ville et le lac de Côme* (cat. no. 57), securely dated to 1834; thus it seems likely that Baud-Bovy's original instinct was correct and that this work dates from 1834 and not later.

MP

1. Moreau-Nélaton in Robaut 1905, vol. 1, pp. 69–72.
2. "Le 27 M. Corot travaille dans la campagne Turrettini le matin, et fait là deux études charmantes.... Le 29 ... le soir on joue Tambour battant et Cendrillon ce qui fait plaisir à M. Corot et à la famille alliée.... Le 30 on exécute La Jeune Prude, à la demande de M. Corot.... Le 31 le cher M. Corot nous quitte à 5 h. du matin. Son absence fait gros vide." Baud-Bovy 1957, pp. 177–78.
3. See Paris, Musée du Louvre 1972, no. 28, ill.
4. For construction carried out in Geneva during that period, see El-Wakil 1977, pp. 153–198.
5. "How clear all that is if we leave out the *Pont du Montblanc,* which spoils the view a little because of the scaffolding on the docks." ("Combien tout cela est clair sans parler du *pont du Montblanc* qui gâte un peu la vue, les plantations du quai modifiant tout cela.") Robaut *carton 3*, fol. 150.
6. See Philadelphia Museum of Art 1994, p. 120.
7. "très belle étude, quoique un peu froide." Robaut's remark about the boat: "Painted on top!" ("Par dessus!") Robaut *carton 3*, fol. 150.
8. Robaut noted that copies in various dimensions existed, including one in the posthumous sale of the comte de Tramecourt on March 27, 1883, which,

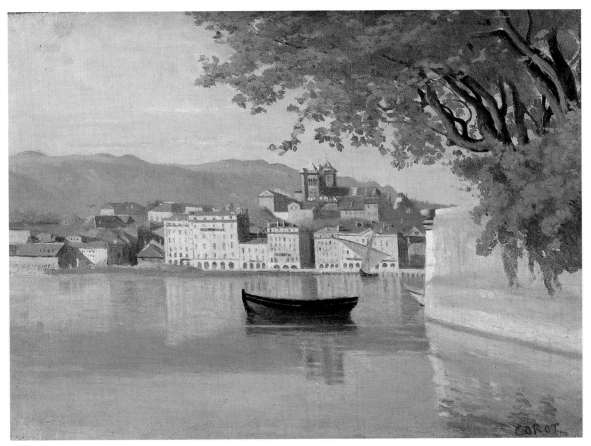

60

unlike the others, had figures in the boat. Another, which to Robaut's irritation was considered authentic by the expert Jules Féral, was at Arnold et Tripp, Paris, in 1892, described as a view of Lake Garda.

9. Baud-Bovy 1957, pp. 104, 174–75.

10. "Je m'attarde dans cette ville pleine de charme qu'est Genève. A chaque pas, je découvre des motifs charmants. Comme c'est agréable de travailler ici. Et puis, la lumière est comme je l'aime, pleine de nuances délicates.

"Hier soir, dans la chambre de mon hôtel, je relisais une page de Jean-Jacques Rousseau, ce paysagiste de génie: 'L'aspect du lac de Genève et de ses admirables côtes, écrit-il, ont toujours à mes yeux un attrait particulier que je ne saurais expliquer, et qui ne tient pas seulement à la beauté du spectacle, mais je ne sais quoi de plus intéressant qui m'affecte et m'attendrit.'

"C'est exactement ce que je ressens ici. Pour l'instant, je travaille à une toile qui représente Genève vue du bord du lac. Le point de vue me ravit!" Borel 1947, quoted in Baud-Bovy 1957, p. 174.

PROVENANCE: The artist; his posthumous sale, Hôtel Drouot, Paris, pt. 1, May 26–28, 1875, no. 91; purchased at that sale by Jules Chamouillet, the artist's grandnephew, for 2,600 francs (2,100, according to Robaut); Gentier collection; Crist Delmonico, New York; John G. Johnson, Philadelphia, November 23, 1892; given by him with the rest of his collection to the city of Philadelphia, 1917; transferred to the Philadelphia Museum of Art, 1933

EXHIBITIONS: Northampton 1934; Philadelphia 1946, no. 21; Toronto 1950, no. 12; Fort Worth 1954, no. 13; Washington 1956–57; Chicago 1960, no. 49

REFERENCES: Robaut 1905, vol. 2, pp. 148–49, no. 407, ill., and vol. 4, p. 202, no. 91; Abbot 1935b, pp. 4, 8, fig. 1; Baud-Bovy 1957, pp. 104, 146, 174–75, ill. opp. p. 174; Leymarie 1979, p. 76, ill. p. 74; Smits 1991, p. 266, n. 138, fig. 246 (location unknown); Philadelphia Museum of Art 1994, p. 120, ill.

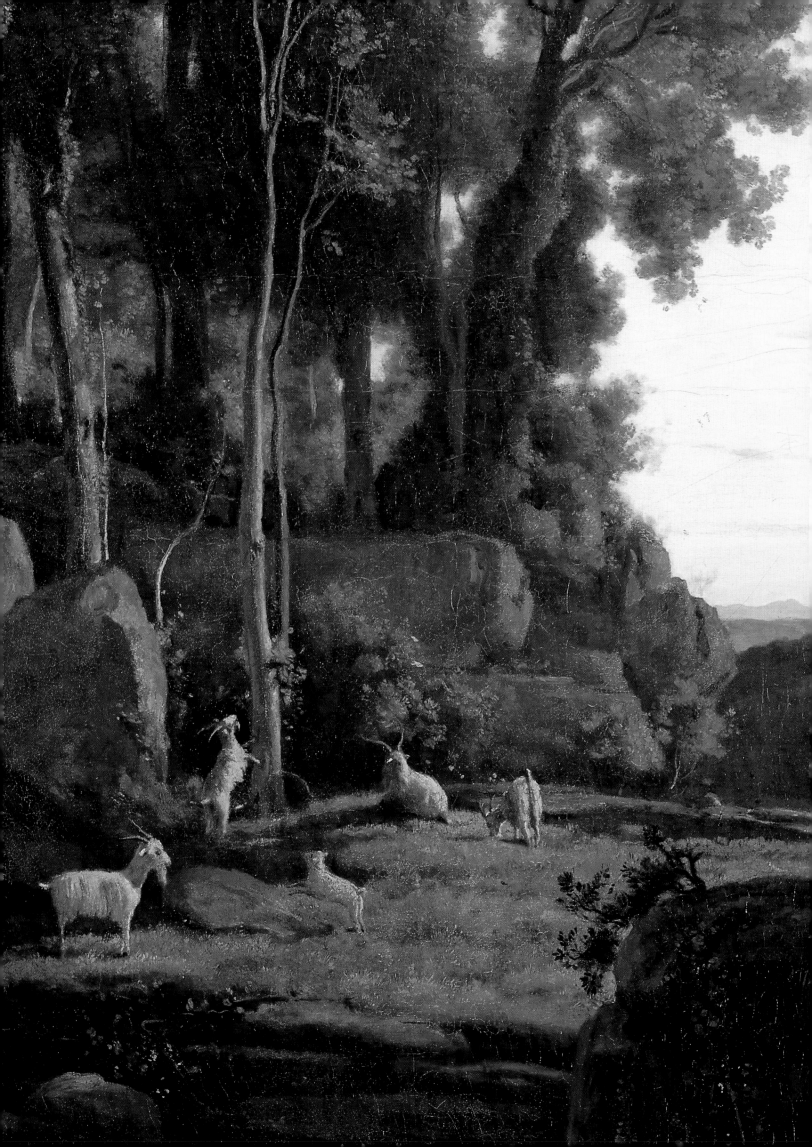

1835-58

Fig. 61. Grandguillaume. *Corot in Arras in 1859*. Published in Robaut 1905, vol. 4, p. 308

The Greatest Landscape Painter of Our Time[1]

Michael Pantazzi

In 1855, the year Corot was lionized at the Exposition Universelle, the writer Edmond de Goncourt developed an interest in him that would disappear as suddenly as it appeared. Brief jottings of traits or events were noted in Goncourt's *Journal.* There was, for instance, the question of Corot's regular "Friday dinners," organized with Paul de Musset and joined by various friends, including Louis Français and Célestin Nanteuil, Goncourt's chief informants.[2] He recorded anecdotes told him by Français as well as Nanteuil's succinct characterization of the artist's nature: "Corot's obsession? He is a worthy fellow who seeks beautiful hues and finds them! He is happy. That's enough for him."[3] Then Goncourt penned a quick sketch, his version of the growing legend: "Corot, the happy man par excellence. When he is painting, happy to paint; when he is not painting, happy to rest. Happy with his modest fortune before he inherited; happy with his inheritance when he inherited. Happy to live in obscurity when he was unknown; happy with his successes—and getting off a quick one every month with some filthy model who comes to see him."[4] It was a far cry from the public perception of Corot two decades earlier, before fame had distorted him, the Corot whose "calm, ascetic character" had led Théophile Thoré to regard him as "an austere, meditative man who sees nature as being the same."[5]

Two decades earlier, Corot's return from his second voyage to Italy had been accompanied by the success of his *Agar dans le désert* (fig. 62, cat. no. 61) at the Salon of 1835. The event revealed him as an artist of the first rank and launched an uneven period that culminated in his even greater recognition at the Salon of 1859. In the interim, his ascent was consecrated at the Exposition Universelle. Corot's reputation grew steadily. In 1835 Victor Schoelcher had predicted, "He will become one of the great names of the French school";[6] by 1839 Jules Janin was referring to him as "this great artist."[7] In 1843, the year his *Incendie de Sodome* was rejected at the Salon, Eugène Pelletan, for whom the artist had become "Corot, our great Corot," described him as "our greatest landscape painter";[8] in 1845 Charles Baudelaire acknowledged him as the leader of the modern school of landscape painting;[9] in 1851 Philippe de Chennevières, expanding Pelletan's statement, called him "the greatest landscape painter of our time."[10] In 1853, for Nadar, he was "always and eternally the master."[11]

Curiously, the achievement of *Agar* was followed in 1835 by a nameless sorrow, apparently with psychosomatic effects, which Corot described to his friend Jean-Gabriel Scheffer in one of his rare known letters of the period. He had experienced something that he would not identify; it had required distraction, the need to forget, much exercise and rest in the country. He also expressed

1. "le plus grand paysagiste de notre temps." Philippe de Chennevières, in Chennevières 1851, p. 75.
2. "dîner du Vendredi." Goncourt 1956, vol. 1, p. 206, entry for August 27 or 28, 1855.
3. "Le *dada* de Corot: c'est un brave homme, qui cherche des tons fins et qui les trouve! Il est heureux. Ça lui suffit." Ibid., p. 205.
4. "Corot, l'homme heureux par excellence. Quand il peint, heureux de peindre; quand il ne peint pas, heureux de se reposer. Heureux de sa petite fortune, quand il n'avait pas hérité; heureux de son héritage, quand il a hérité. Heureux de son obscurité, quand il n'était pas connu; heureux de ses succès,—et tirant tous les mois son coup avec quelque sale modèle qui vient le voir." Ibid., pp. 206–7.
5. "caractère calme et ascétique." Thoré 1838. "un homme austère et méditatif, qui comprend ainsi la nature." Thoré 1839.
6. "Il deviendra un des grands noms de l'École Française." Schoelcher 1835, p. 166.
7. "ce grand artiste." Janin 1839, p. 271.
8. "Corot, notre grand Corot"; "notre plus grand paysagiste." Pelletan 1843, p. 365.
9. See Baudelaire's remark: "The qualities by which he shines are so strong—because they are spiritual qualities from deep within—that Corot's influence is at present visible in almost all the works of the young landscapists, especially those who had the good sense to imitate him and borrow something from his approach before he became famous, when his reputation was still only within the world of artists. Corot, from the depths of his modesty, has affected a mass of minds." ("Les qualités par lesquelles il brille sont tellement fortes—parce qu'elles sont des qualités d'âme et de fond—que l'influence de M. Corot est actuellement visible dans presque toutes les oeuvres des jeunes paysagistes—surtout de quelques-uns qui avaient déjà le bon esprit de l'imiter et de tirer parti de sa manière avant qu'il fût célèbre et sa réputation ne dépassant pas encore le monde des artistes. M. Corot, du fond de sa modestie, a agi sur une foule d'esprits.") From "Salon de 1845," in Baudelaire 1923, pp. 55–56.
10. See note 1.
11. "toujours et éternellement le maître." Nadar 1853.

regret over the passing of the laughter and good times of earlier years, concluding: "My spirits . . . now lean toward sadness and melancholy. I too am beginning to feel my age. Then, as one moves on in life sorrows multiply, and necessarily it is harder to keep cheerful. . . ."[12] He was thirty-nine. So far as is known, this was the first and last time Corot confided such strongly worded sentiments in writing. Whatever melancholia he later experienced was sublimated in his painting, as Germain Bazin noted in connection with the artist's persistent depictions of isolated, withdrawn figures and the other subjects he chose to represent.[13]

The time between 1835 and 1859 in many ways constituted a delayed formative period, somewhat experimental, that led to a new maturity both personal and artistic. The years 1850 and 1851 proved to be dates of some significance for Corot. It is generally agreed that *Une Matinée* (fig. 69, cat. no. 103), which he exhibited at the Salon of 1850–51 to considerable acclaim, marked a turning point in his development and heralded the beginning of his late manner. In 1851, the last chapter of Corot's life with his parents also came to a close. His father, whom he had nursed at Ville-d'Avray and in Paris, had died in 1847. On February 27, 1851, his mother's life ended in their Paris home at 39, rue Neuve-des-Petits-Champs. Shortly afterward, Corot left the house and rented an apartment at 19, rue de Montholon, in a building that survives today as the Hôtel Montholon. In 1852 he also moved his studio from 10, rue des Beaux-Arts to 58, rue de Paradis-Poissonnière, an address nearer his apartment.

There is a discouraging scarcity of documentation for a substantial part of Corot's middle years, until about 1851, when he began living on his own. Few letters exist, and no true journal. His perfunctory notebooks were sometimes used over a period of years. Although those from the 1850s can to some degree be interpreted in the light of other evidence, those of the 1840s are tantalizing but obscure. Annual painting trips to various regions of France and occasionally to Switzerland, alone or with other artists, can be reconstructed only in part, and the chronology is rather speculative. An ostensibly enjoyable visit to the Midi and Auvergne in 1836, with Prosper Marilhat and two students, is known of from Marilhat's letters. Word of another visit to Auvergne and Royat in the summer of 1839, this time alone, comes through Auguste Ravier, who first met Corot there. Several important trips in 1840–42 to the Morvan region and to Lormes, where Corot's niece Marie-Laure Baudot lived, are documented by dated drawings and paintings. Other more frequent visits to regions closer to Paris are occasionally noted in letters. In 1842 there was certainly also a visit to the Jura and Switzerland. In 1843 Corot undertook at last his third voyage to Italy, from which no letters are known and which can be followed only by means of dated drawings.

We are much better informed about the public Corot: about his regular appearances at the Salon, his difficulties in the 1840s with the jury, and his growing reputation. With the exception of the first-class medal awarded him at the Exposition of 1855, most of the rewards from the state also date from this period: his nomination in 1846 as a chevalier of the Legion of Honor was followed by a second-class medal at the Salon of 1848.[14] In a world used to official rewards, this recognition was inadequate, if truth be told. State patronage, which was also less than enthusiastic for an artist of Corot's stature, ceased in 1851 after the purchase of five pictures. In May of 1839 Corot had made his first important sale: after a visit to the Salon, the young duc d'Orléans, King Louis-Philippe's

12. "J'ai l'esprit . . . porté maintenant à la tristesse et à la mélancolie. L'âge se fait sentir aussi chez moi. Puis en avançant dans la vie les chagrins se multiplient et nécessairement on ne peut plus être aussi gai. . . ." Corot also wrote that he experienced "violent disappointments, that I might even call grief" ("violentes contrariétés, que je pourrais même appeler chagrin"). Letter to Jean-Gabriel Scheffer, December 27, 1835, quoted in Baud-Bovy 1957, p. 147.

13. Bazin 1973, p. 12.

14. Delacroix noted in his *Journal* the troubles connected with Corot's 1855 medal: "This jury is keeping me busy. . . . Remember the fervor of M. Français, who, having voted for him [Corot] every time for the first-class medal, was filled with indignation that Corot had been forgotten when there was no longer a place for him. Dauzats and I had voted for him as a sort of reminder, and we had been the only ones." ("Je me suis occupé de ce jury. . . . Se rappeler la grande chaleur de M. Français qui, ayant voté pour lui tout le temps, pour la première médaille, se réveille indigné de ce qu'on avait oublié M. Corot, quand il ne se trouvait plus de place pour lui. Dauzats et moi avions, par une sorte de souvenir, voté pour lui, et nous avions été les seuls.") Delacroix 1932, vol. 2, entry for November 7, 1855, pp. 410–11.

Fig. 62. Detail of Corot, *Agar dans le désert (Hagar in the Desert)*, cat. no. 61

Fig. 63. Detail of Corot, *Le Lac de Genève (The Lake of Geneva)*, cat. no. 81

eldest son, purchased two works from his studio (see cat. no. 103). In 1847 the king commissioned *Le Chevrier italien* (cat. no. 92) as a tapestry cartoon. Like the previous purchase it was paid for privately, not by the state. When in 1855 Napoleon III bought for his personal collection Corot's *Souvenir de Marcoussis* (R 1101; Musée d'Orsay, Paris), he did so against the advice of his minister of Beaux-Arts, the comte de Nieuwerkerke.

Although his style became increasingly simplified, Corot's devotion to the lessons of Poussin remained with him, perhaps never as visibly as in his *Silène* of 1838 (cat. no. 64). The Dutch seventeenth-century landscape tradition, from which Corot learned so much, is manifest in a number of works, notably the *Vue de Volterra* of 1838 (National Gallery of Art, Washington, D.C.) and *Vue prise dans la forêt de Fontainebleau* of 1846 (cat. no. 91).[15] As Eugène Fromentin noted, Corot assimilated and so completely transformed Dutch formulas that the result was a *genre exclusivement français*.[16] It is interesting that a comparison of Corot's work with Rembrandt's, often thought to be a twentieth-century analogy, was in fact made in the middle of his career.[17] Yet in the 1840s Corot increasingly turned for inspiration to Claude Lorrain, as is very evident in the *Vue d'Italie. Soleil levant* of 1839 (fig. 83) and more subtly discernible in a series of highly lyrical compositions. A work exhibited in 1840 under the title *Paysage; soleil couchant*, now known as *Le Petit Berger* (cat. no. 76), was the first to draw acclaim for its expression of this new impulse. A type of pastoral evocation previously unknown, it suggested poetry, or a condition of the soul, rather as if melancholy had been given a face.

Corot's summary style, his attempt to reflect landscape directly, and the more dramatic images he produced were soon to be judged more harshly. In 1840 Corot committed one of his few public acts that could be termed political, and signed, with Théodore Rousseau, Jules Dupré, Paul Huet, and others, a petition asking for reform of the Salon's admission jury. That year he was delighted to see his *Fuite en Égypte* (R 369, in the church at Rosny) hung in the Salon Carré, but another work had been refused by the jury.[18] It was the first of a series of rejections that persisted through much of decade. When in later life Corot told Albert Darier, "These gentlemen of the juries have not always been gentle to me," he did not understate his case.[19] In 1842, two of his five entries were turned down.[20] In 1843, the rejection of *L'Incendie de Sodome* (see cat. no. 114) by a jury reviled for despising everything of interest in modern art provoked an almost unanimous outcry of sympathy. In 1844 another work was refused.[21] In 1846 three out of four works were rejected,[22] and the *Vue prise dans la forêt de Fontainebleau* alone survived. Critics again rallied: Théophile Gautier decried the jury's "barbarous stupidity," but Champfleury went further, raising the issue of the corrupting effect of official exhibitions. While Corot was hard at work, he maintained, "many landscape painters who are his colleagues make studies from nature at the ministry and the Chamber of Deputies."[23] In 1847 two more works were refused.[24] It was the last time that would happen.

Corot's annoyance with the jury ended in 1848, when it was suspended by the Revolution and he found himself elected a member of the commission charged with selecting the paintings for that year. When a reformed jury was reinstated in 1850, Corot was voted in again, and he served on several subsequent occasions, ironically himself being later accused by Monet of undue harshness toward the Impressionists.[25] Yet the pictures he exhibited at the Salon were still frequently

15. Wissman in San Diego, Williamstown 1988, n.p., figs. 16, 17; and Wissman 1989, pp. 20–21.

16. Fromentin 1965, p. 272.

17. In 1845 Henry Vermot remarked on *Daphnis et Chloé* (R 465), "M. Corot knows the marvelous secrets of light.... The water, the rocks, the sun, the least corners of the countryside, everything, even the shadows, are illuminated, as in Rembrandt." ("M. Corot possède les secrets merveilleux de la lumière.... L'eau, les rochers, le soleil, les moindres recoins de la campagne, tout, jusqu'à l'ombre même, est éclairé, comme chez Rembrandt.") Vermot 1845, p. 70. In 1849 the reviewer for *L'Artiste* invoked Rembrandt's name in connection with *Le Christ au jardin des oliviers* (R 610), now in the Musée de Langres; see Feu Diderot 1849, p. 117.

18. Letter to François-Parfait Robert, April 5, 1840, cited in Robaut 1905, vol. 4, p. 332, no. 11. The work refused was a *Paysage; environs de Rome* (unidentified); see Wissman 1989, p. 199.

19. "Ces messieurs des jurys n'on pas toujours été tendres pour moi." Baud-Bovy 1957, p. 186.

20. The works refused were *Vue de Rome* (unidentified) and *Vue prise à Saint-André* (R 424, Musée du Louvre, Paris), noted in Wissman 1989, p. 199. Roger-Milès, followe by Coquis, 1950, p. 31, claimed that a *Baptême du Christ* (unidentified) was also rejected, with three other pictures; see Roger-Milès 1895, p. 37.

21. It was *Environs de Papigno, Rome* (unidentified); see Wissman 1989, p. 200.

22. They were two works both entitled *Site d'Italie* and a *Vue d'Ischia*, all now unidentified; see Wissman 1989, p. 200.

23. "stupidité barbare." Gautier 1846. "beaucoup de paysagistes, ses confrères, vont faire des études d'après nature, au ministère et chez les députés." Champfleury 1894, p. 72.

24. They were a *Soleil couchant* and *Souvenir de Naples*, both unidentified; see Wissman 1989, p. 200.

25. See a conversation with Monet recorded by René Gimpel in October 1920: "[Monet says,] 'Hobbema sometimes understood light, as in his *Avenue* at the National Gallery, but the great landscapist is Corot!' 'The "good Corot," ' interrupts Georges Bernheim. 'The "good Corot," ' rejoins Monet, 'that I don't know about, but what I do know is that he was bad to us. Oh, that swine! He barred the door of the Salon to us. Oh, he slashed at us, he pursued us like criminals. And we were all able to admire him, without exception! I did not know him, I knew none of the masters of 1830, they did not want to know us....' " ("Hobbema a parfois deviné la lumière comme dans son allée de la National Gallery, mais le grand paysagiste, c'est Corot!—Le 'bon Corot,' interrompt Georges Bernheim.—Le 'bon Corot,' fait Claude Monet, ça je ne sais pas, mais ce que je sais c'est qu'il fut bien mauvais pour nous. Ah! le cochon! Il nous l'a barrée, la porte du Salon. Oh! il nous sabrait, il nous poursuivait comme des malfaiteurs. Et ce que nous avons pu l'admirer, tous sans exception! Je ne l'ai pas connu, je n'ai connu aucun des maîtres de 1830, ils ne voulaient pas nous connaître....") Gimpel 1963, p. 177. In fact, Monet did meet Corot. For a caution about the veracity of Monet's statement, see Clarke 1991a, p. 106.

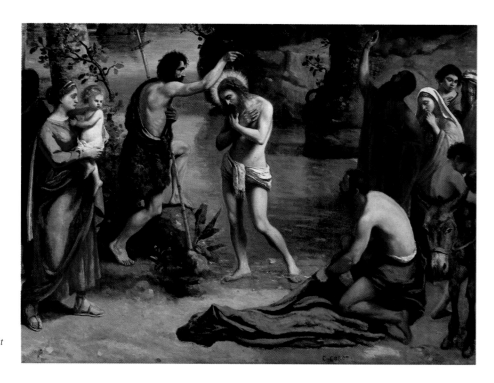

Fig. 64. Detail of Corot, *Le Baptême du Christ* (*The Baptism of Christ*), cat. no. 89

shown in unfavorable conditions. In 1842, critics had complained that his works were hidden in the temporary spaces called the "wooden gallery"; in the words of Louis Peisse, "in that dreaded section of the gallery that the artists call the catacombs!"[26] In 1850, the year Corot served on the jury, *Une Matinée* was removed from the Salon Carré for no evident reason and was reinstalled only when a friend, Auguste Faulte de Puyparlier, wrote to complain to the ministry.[27] In 1857 his pictures were hung so high that he finally asked the marquis de Chennevières to order them to be tilted at an angle so that they could be seen.[28]

The list of Corot's complete submissions to the Salon in the 1840s is revealing in its variety. Inasmuch as the works can be identified, it shows that until 1849 he tried repeatedly to exhibit, along with pieces specially destined for the Salon, more informal works: *études* from nature and earlier works that he probably touched up. In 1842, the two paintings rejected were the *Vue prise à Saint-André* (R 424; Musée du Louvre, Paris) and a *Vue de Rome* (unidentified), perhaps a study from his first Italian period or a studio repetition of a work of the 1820s. The *Vue prise à Saint-André* in fact depicted the very type of rural subject that critics complained Corot did not paint.[29] In 1844 an *Environs de Papigno, Rome* (unidentified), ostensibly a study from the 1820s, was also rejected. In 1848, the year of the liberal Salon, he managed to exhibit a view of Ville-d'Avray, followed the next year by another view of Ville-d'Avray, a *Site du Limousin* from his painting campaign of 1846, and an old *Étude du Colisée à Rome* (cat. no. 8).[30]

In May of 1843 Corot left for his third and last visit to Italy, in the company of his friend Brizard. He headed straight for Rome, which he had not seen in fifteen years. There Léon Benouville gave him the use of his studio. Later in May Corot was north of Rome, at Ronciglione. In June he went to Tivoli and Genzano, on Lake Nemi, and he spent all of July south of Rome in the area of the Castelli Romani: Ariccia, Nemi, and Genzano.[31] It seems that while there he once again met Ravier, whose address appears in a notebook containing sketches of Ariccia. In August he was back in Rome, where he dated a drawing of the

26. "galerie de bois"; "dans cette portion redoutée de la galerie que les artistes appellent les *catacombes!*" Peisse 1842, p. 240, and for the same complaint, Robert 1842.

27. See entry for cat. no. 103.

28. See Corot's letter of June 22, 1857, quoted in Robaut 1905, vol. 4, p. 337, no. 94.

29. For instance, the critic who wrote in 1843: "This artist has undoubtedly seen swans, but he is ignorant of ducks; the wooden shoes of our peasants are completely foreign to him." ("Cet artiste a vu assurément des cygnes; mais il ignore les canards; les sabots de nos paysans lui sont complètement étrangers.") See Bourgeois 1843.

30. Another of the works exhibited in 1849, a *Vue prise à Volterra (Toscane)*, was probably one of the views now in the Louvre (R 303 or R 304), but the matter is not certain.

31. For Corot's itinerary during his third Italian voyage, see Jullien and Jullien 1984, pp. 192–93, 197, n. 34, and Jullien and Jullien 1987, pp. 123–30.

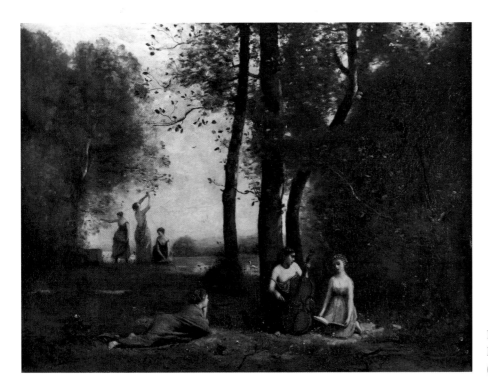

Fig. 65. Corot. *Le Concert* (*The Concert;* R461, R 1098), 1844. Oil on canvas, 38⅝ × 51⅛ in. (98 × 103 cm). Musée Condé, Chantilly

Villa Albani. He returned to Paris in September with a portfolio of drawings and some fifteen paintings. Among the latter were studies, for instance of the Villa Doria in Rome, but also a number of exceptional works such as *Genzano. Chevrier en vue d'un village* (cat. no. 82), *Tivoli. Les Jardins de la villa d'Este* (cat. no. 83), and perhaps his greatest nude, certainly the one he treasured most: *L'Odalisque romaine,* also called *Marietta* (cat. no. 85). In their essence, the landscapes differ from Corot's earlier Italian studies. They convey a mellower vision, limpid but touched with a powdery tonality that proceeded from his experience in France, rather as if the sensibility at work was now permanently of the north.

It would be difficult to claim that Corot's last voyage to Italy had an effect on his style, though in the subjects of his paintings he returned to memories of Lake Nemi and, obsessively, to a view he drew of the dome of the church at Ariccia, perched above a cliff. The Italianate views invented later were almost always based on sketches of other sites visited in earlier times—Volterra, Papigno, the Campagna, Naples, Ischia. In 1844 he submitted again to the Salon the ill-fated *Incendie de Sodome.* More ambitious plans fell into place in 1845—for a large, vertical altarpiece depicting the baptism of Christ, nothing short of heroic, which had been commissioned by the church of Saint-Nicolas-du-Chardonnet (fig. 64, cat. no. 89). This was followed in 1849 by the crepuscular, tragic *Christ au jardin des oliviers* (*Christ in the Garden of Gethsemane;* R 610, Musée de Langres) and four years later, in 1853, by *Saint Sébastien; paysage* (cat. no. 104). Corot continued to send historical landscapes to the Salon, notably, in 1845, the splendid *Homère et les bergers; paysage* (cat. no. 90). But it was apropos of a more unusual work, *Le Concert,* exhibited a year earlier in 1844, that his aptitude for idyllic compositions—already observed in *Le Petit Berger* (cat. no. 76)—drew praise.

Known in its original state only from reproductions, *Le Concert* (fig. 65) is interesting for the new direction it signals in Corot's work.[32] The subject, neither mythic nor biblical, is essentially an eighteenth-century motif reinterpreted by a modern sensibility. The painting brought to life a serene Arcadia with no specific

32. It was reproduced in its original state by Silvestre in 1853 and in Robaut 1905, vol. 2, p. 169, no. 461. The painting was reworked by Corot and exhibited again at the Salon of 1857 (the later version is R 1098). It is now in the Musée Condé, Chantilly.

Fig. 66. Various draftsmen. Portrait draw-
ings for the design of a platter for "Les
Amis du Vendredi" ("The Friday Friends").
Portrait of Corot, by A. Millet, is the third
in the top row. Private collection, New York

33. In 1847 Alfred de Menciaux observed that Corot
"is more a man of letters than a painter" ("est plus
littérateur que peintre"). Menciaux 1847. For Charles
Perrier in 1855, Corot was "a poet who speaks to
other poets" ("poëte qui s'adresse à d'autres poëtes").
Perrier 1855, p. 143. In 1858 Adolphe Meyer wrote,
"M. Corot has no twin brother among the poets,
but he himself is more poet than painter." ("M.
Corot n'a point de frère jumeau parmi les poètes,
mais c'est lui-même un poète, un poète plutôt
qu'un peintre.") Meyer 1858, quoted in Coquis
1959, pp. 81–82.
34. Janin 1840b, p. 254.
35. Perrier 1857, p. 133.
36. "On dirait La Fontaine traduisant *Anacréon* avec
une bonhomie nonchalante, et pourtant plus près
du sens antique que la recherche laborieuse des
savants." Gautier 1857, p. 114.
37. "Corot est un homme de principe, chrétien sans le
savoir, il donne à sa mère toute sa liberté, car il est
garçon, et serait le plus heureux des hommes s'il
pouvait retourner en Italie. Sa mère l'en empêche et
non la fortune, car il est riche. Il faut encore qu'il la
prie bien longtemps, pour lui laisser [obtenir] tous
les quinze jours son vendredi soir libre pour aller
dîner à St Cloud avec Decamps, Français et
Comairas ses grands amis. Je fus l'accompagner
jusqu'à St Cloud et il me développa, chemin
faisant, ses idées en morale. Ce fut un vrai cours de
philosophie pratique. Et cet amour de la nature!"
Léon Berthoud, letter to Charles Berthoud,
September 8, 1850, quoted in Baud-Bovy 1957,
p. 189.
38. See his letters to Theo van Gogh of Autumn 1883
and December 1883, quoted in Van Gogh 1958, vol.
2, pp. 149, 235.
39. Cabinet des Dessins, Musée du Louvre, Paris.
40. "à Vénus et à Bacchus"; " 'Monsieur Camille, lui
avait-elle dit, vous me faites beaucoup de peine.' Une
scène de larmes s'en était suivie, il n'avait pu l'apaiser
et il l'avait ramené chez elle en fiacre sans que sa
'petite maman' comme il l'appelait ne l'ait pardonné
malgré ses supplications." Dieterle 1980, p. 9.

historical or literary referent, removed equally from antiquity and from the nine-
teenth century. Corot's most complex and far more subtle attempt to refine the
same idea was made several years later in *Une Matinée* (fig. 69, cat. no. 103), exhib-
ited in 1850. In that painting, nature is woven together with reminiscences of the
works of Claude Lorrain, radiantly poised between reality and the ideal, to create
a vaporous atmosphere of unprecedented effect.

Poetic and musical associations in his paintings led to frequent observations
that Corot was more a poet than a painter.[33] Gautier is generally credited with
having first compared his pictures with the bucolic *Idylls* of Theocritus in 1844,
but it was in fact Janin who drew the first parallel, in 1840, specifically to *Le Petit
Berger*.[34] Thoré made the same comment in 1844, and in the years that followed
much was made of Corot's elegiac gifts. His paintings were perceived as visual
expressions of Horace and Virgil. By the mid-1850s, he was seen as the quintes-
sential painter of poetic landscapes, a poet who pursued, not visible form, but
an idea.[35] Gautier's perception of Corot's assimilation of poetry was neverthe-
less more qualified: "It's like La Fontaine interpreting *Anacreon* with nonchalant
simplicity, yet coming closer to the ancient spirit than the laborious research of
scholars."[36]

What seems to have passed unnoticed was Corot's extraordinary sense of
invention and the persistence of certain dominant themes. There are the figures
lost in thought and the people reading—nobody painted so many books—or
the curious emphasis on figures directly facing the spectator, disconcertingly
reversing the roles of the observer and the observed. There is also delight in the
oddly manipulated view, sometimes channeled directly as if through a tunnel
and sometimes, conversely, nearly hidden by a profusion of branches. Major
and minor formal motifs crop up almost subliminally and return with uncom-
mon insistence. In 1836, *Diane surprise au bain* (cat. no. 63) introduces the odd
motif of a nymph dangling from a branch, which is revived in *Le Verger* (*The Orchard*;
R 441, Musée Municipal, Semur-en-Auxois) of 1842 and the many later pictures
with bird's-nesters. In 1839, *Un Soir; paysage* (cat. no. 75) inaugurates the obsessive
series of variations on boatmen. *Le Concert* of 1844 introduces the favorite idea of a
woman picking branches or fruit; the theme is repeated in *La Cueillette du laurier*
(*Women Gathering Laurel*; R 614, Museum of Fine Arts, Boston) of 1848 and fre-
quently thereafter (and not only by Corot but by a host of other painters from
Puvis de Chavannes to Berthe Morisot).

In the summer of 1850, when Mme Corot was still alive, a visitor to Ville-
d'Avray, a Swiss student named Léon Berthoud, gave a revealing account of the
artist's situation at age fifty-four: "Corot is a man of principle, unconsciously
Christian; he surrenders all his freedom to his mother—for he is a bachelor, and
would be the happiest of men if he could go back to Italy. His mother prevents
him, not lack of wealth, for he is rich. Even so, he has to beg her repeatedly to
get permission to go out to Saint-Cloud for dinner every other Friday evening
with Decamps, Français, and Comairas, his great friends. I accompanied him
there and along the way he enlarged on his views on ethics. It was a real course
in practical philosophy. And what love of nature!"[37]

Corot's life at home surely was not altogether easy. That he adored his parents
cannot be questioned. Yet the cumulative weight of stories about his life with them
is disturbing, and it will probably never be known whether these anecdotes,

cheerfully repeated by the artist, were actually expressions of resentment years after the fact. It is interesting to see Vincent van Gogh in the early 1880s drawing parallels between Corot's relationship with his father and his own circumstances.[38] Mme Corot had *La Cervara* (cat. no. 29) hanging in her bedroom until the end of her days, but beyond that there is no indication that either parent took an interest in their son's painting. His reputation, made within their lifetime, seems to have carried no weight, although when Corot was awarded the Legion of Honor in 1846, his father wondered whether the allowance given his son—then aged fifty—should not be increased. The irony of Corot's careless dress in a house once devoted to fashion was doubtlessly an irritant, just as there is irony in his drawing a landscape on the back of an invitation to his mother's memorial mass in 1852.[39] Mme Corot disapproved of bohemia and of undue expressions of enthusiasm. Louise Dieterle recorded in her memoirs an incident that occurred at a dinner. Corot offered a toast "to Venus and Bacchus." The reaction was immediate: " 'Monsieur Camille,' she said to him, 'you hurt me deeply.' A tearful scene followed in which he failed to mollify her, and he took her back home in a carriage without being forgiven by his 'little mama,' as he called her, despite his entreaties."[40]

After 1851, Corot at last had almost complete freedom. He traveled more extensively, almost obsessively, attempting several trips each year. He was regularly at Ville-d'Avray and in the environs of Paris. In 1851 he visited La Rochelle, to which he did not return. But there were annual visits to the north of France, with an additional leg in 1854 to Belgium and Holland. He traveled several times to Normandy and the Dauphiné, to Brittany, the Sologne, the Limousin. There were at least four trips to Switzerland, in 1852, 1853, 1856, and 1857.

Corot's circle of old friends widened to include new additions. To family friends, such as Alexandre Clérambault, Abel Osmond, and Auguste Faulte de Puyparlier, who most often were in Saint-Lô and Rosny-sur-Seine, were added their cousins, the Roberts from Mantes. The death in 1840 of Abel Osmond did not interrupt Corot's relationship with Mme André Osmond, Abel's widowed aunt by marriage, for whom—according to tradition—he conceived a passion.[41] But his principal friendships, inevitably, were with artists. Some friendships had been made during a legendary moment for literary bohemia in 1834 or 1835—the date is unclear—when Corot had participated in the decoration of a room in the apartment shared by Camille Rogier, Gérard de Nerval, and Arsène Houssaye in the impasse du Doyenné, in what is now the courtyard of the Louvre. Corot, along with Adolphe Leleux, Célestin Nanteuil, Camille Rogier, Alcide Lorentz, Théodore Chassériau, Prosper Marilhat, and Théodore Rousseau, had contributed mural decorations for a fancy-dress ball that marked a milestone of sorts in the Romantic era.[42] Of this group, Leleux, Nanteuil, and Marilhat (until his death in 1847) remained close to Corot in later years.

Other older friends, mostly in Paris or its environs, included Édouard Brandon, Édouard Bertin, Théodore Caruelle d'Aligny, the architect Pierre-Achille Poirot, and at Orsay, the Étex brothers, Antoine and Louis-Jules. Alexandre Decamps, Louis Français, and Philippe Comairas were his closest friends about 1850. Through Leleux and Français he made new friends in Switzerland, scattered around Geneva and beyond; various branches of the Bovy family, the painter Barthélémy Menn, the architect Sam Darier, and many others preserved interesting

Fig. 67. Corot. *Bacchus* (a caricature), ca. 1840–45. Published in Robaut 1905, vol. 1, p. 87

41. On this subject, see Walter 1975, passim. For what was presumably a widespread idea that Corot had a mistress, evidently not Mme Osmond, see Vincent van Gogh's remark in a letter of Autumn 1883 to Theo van Gogh: "I have visited 'Père Lachaise' . . . I feel the same respect before the humble tombstone of Béranger's mistress, which I looked for on purpose . . . and there I particularly remembered Corot's mistress too. Silent muses these women were . . .". Quoted in Van Gogh 1958, vol. 2, p. 149.

42. The building was demolished about 1853. Most paintings were lost, but Chassériau's *Bacchanales* was saved: see Sandoz 1974, p. 98, nos. 4 and 5, with bibliographical references. For the apartment, see also Houssaye 1885, p. 299.

Fig. 68. Corot. Sketch on a letter to Édouard Brandon, March 31, 1857. Published in Robaut 1905, vol. 1, p. 169

43. "Les aperçus plein de verve sur l'étude d'après nature ou les mérites comparés du siccatif de Harlem et de l'huile grasse étaient souvent interrompus par une joyeuseté venant de l'esprit de l'un des convives, lesquels n'étaient autres que Corot, Daumier, Geoffroy-Dechaume, etc., etc." See Bracquemond 1897, p. 19, quoted in Fidell-Beaufort and Bailly-Herzberg 1975, p. 41.

44. Entry for March 14, 1847, in Delacroix's *Journal*: "Corot is a true artist. One has to see a painter in his own place to get an idea of his worth. I went back there and I appreciate in a new light the paintings that I had seen at the museum, and that had struck me as middling. . . . He told me to go a bit ahead of myself, abandoning myself to whatever might come; this is how he works most of the time. He does not accept that one can create beauty by taking infinite pains. Titian, Raphael, Rubens, etc., all painted easily. . . . Notwithstanding this facility, there is still work that is indispensable. Corot delves deeply into a subject: ideas come to him, and he adds while working; it's the right approach." ("Corot est un véritable artiste. Il faut voir un peintre chez lui pour avoir une idée de son mérite. J'ai revu là et apprécié tout autrement des tableaux que j'avais vu au Musée, et qui m'avaient frappé médiocrement. . . . Il m'a dit d'aller un peu devant moi, et en me livrant à ce qui viendrait; c'est ainsi qu'il fait la plupart du temps. Il n'admet pas qu'on puisse faire beau en se donnant des peines infinies. Titien, Raphaël, Rubens, etc., ont fait facilement. . . . Nonobstant cette facilité, il y a toutefois le travail indispensable. Corot creuse beaucoup sur un objet: les idées lui viennent, et il ajoute en travaillant; c'est la bonne manière.") Delacroix 1932, vol. 1, pp. 206–7.

45. See Scharf 1962, passim, for connections between Corot and photography.

46. The two artists are immortalized together, to Pissarro's disadvantage, in the song called "Beaux-Arts": "Elle était si gentille à voir / Quand ell' peignait les arbr's en noir, / Que je l'appelais Raphaël-le, / Elle m'a tant vanté Corot / Qu'ell' m'a dégoûté d' Pissarro, / J'ai changé ma manièr' pour elle." ("She was so nice to see / Painting black the trees, / That I called her Raphaelle, / She so praised Corot / That I scorned Pissarro, / For her I changed my style.") Salmon 1956, p. 89.

47. "J'envie à 28 ans la verdeur, l'entrain de ses 54; je n'ai jamais mieux senti qu'à côté de lui combien nous naissons vieux dans ce siècle-ci." Léon Berthoud, letter to Charles Berthoud, September 8, 1850, quoted in Baud-Bovy 1957, p. 189.

48. See Daubigny's comment, "He's a perfect Old Man Joy, this Father Corot" ("C'est un fameux père la joie, que ce père Corot"), in his letter from Crémieu to Adolphe-Victor Geoffroy-Dechaume, stamped July 20, 1852, quoted in Fidell-Beaufort and Bailly-Herzberg 1975, p. 256. See also Albert de Meuron's remarks in his letter of December 30, 1856, to Henri Berthoud: "It's rare to see a man in his sixties who seems so young and works the way he does." ("Il est rare de voir un homme dans les soixante aussi jeune d'impression et travaillant comme lui.") Quoted ibid., p. 190.

records of Corot's visits there in the 1850s and later. It was, oddly, through a visit to Geneva that Corot's friendship with Charles Daubigny began in 1852, a partnership soon joined by Auguste Ravier. Félix Bracquemond remembered Paris evenings around 1854 at Daubigny's, where "animated conversations on the direct study of nature or the comparative merits of Haarlem paint driers and thick oil paints were often interrupted by bursts of merriment greeting a witticism of one of the guests, who included none other than Corot, Daumier, Geoffroy-Dechaume, etc." [43]

In 1847, Constant Dutilleux, a painter from Arras who knew Delacroix well, discovered Corot's works at the Salon and on an impulse decided to buy a painting from the artist. This action, surely less spontaneous than Corot legend makes it out to be, was doubtless inspired by Delacroix, who had visited Corot's studio only a few weeks earlier, before the opening of the Salon, and who left an extremely interesting record of his visit. [44] The event marked the beginning of Corot's longest and most sustained friendship and one that would be invaluable to art historians. Between Arras and Paris an axis formed which in the course of the 1850s drew in Dutilleux's relatives and connections, his two sons-in-law—Charles Desavary, a painter and photographer, and Alfred Robaut, another painter and, eventually, author of the catalogue of Corot's works—a variety of friends such as Léandre Grandguillaume and Adalbert Cuvelier, and a small but effective group of art lovers who became Corot's clients.

Although Corot's groups of friends functioned like separate galactic systems, sometimes intersecting but seldom mixing, each provided an important focus that was reflected in some aspect of his oeuvre. Because of Mme Osmond, Corot's *Fuite en Égypte* (R 369) is at Rosny, along with a series of fourteen Stations of the Cross (R 1083–R 1096) completed in 1859. The Roberts were associated with a particular group of paintings of which some are now in the Louvre. Faulte de Puyparlier's intervention forced the purchase by the State of *Une Matinée* (fig. 69, cat. no. 103), now in the Musée d'Orsay; Barthélémy Menn invited Corot to exhibit in Geneva, where *Le Repos*, or *Nymphe couchée dans la campagne* (cat. no. 106) was awarded a medal in 1857. In Arras Corot was introduced by Desavary and his friends to photography and the *cliché-verre* technique, becoming in the process the most photographed artist of the nineteenth century. [45]

It was another aspect of Corot's freedom in the early 1850s that he was able to take students. For him this was always an informal arrangement. By all accounts he was an excellent teacher, and his remarks on artistic practice, as noted by Delacroix, were perceptive. Among the young artists who gravitated toward Corot were the brilliant but difficult Antoine Chintreuil; Eugène Lavieille, who accompanied him on painting expeditions north of Paris; and Achille Oudinot. Camille Pissarro, a devoted admirer, briefly moved into his orbit about 1856. [46] What struck most of his new acquaintances at the start of the 1850s was Corot's overwhelming sense of youth and energy. Léon Berthoud wrote, "At twenty-eight I envy the vigor and animation of his fifty-four years; I have never realized more clearly than I do at his side to what extent we are born old in this century." [47] After sharing lodgings with Corot for a few weeks in the summer of 1852, Charles Daubigny expressed surprise at his capacity for fun. [48] Théophile Silvestre, in the short monograph on Corot he published in 1853, offered a description of the artist just past fifty which has the virtue of being first-hand reporting and which has been much repeated:

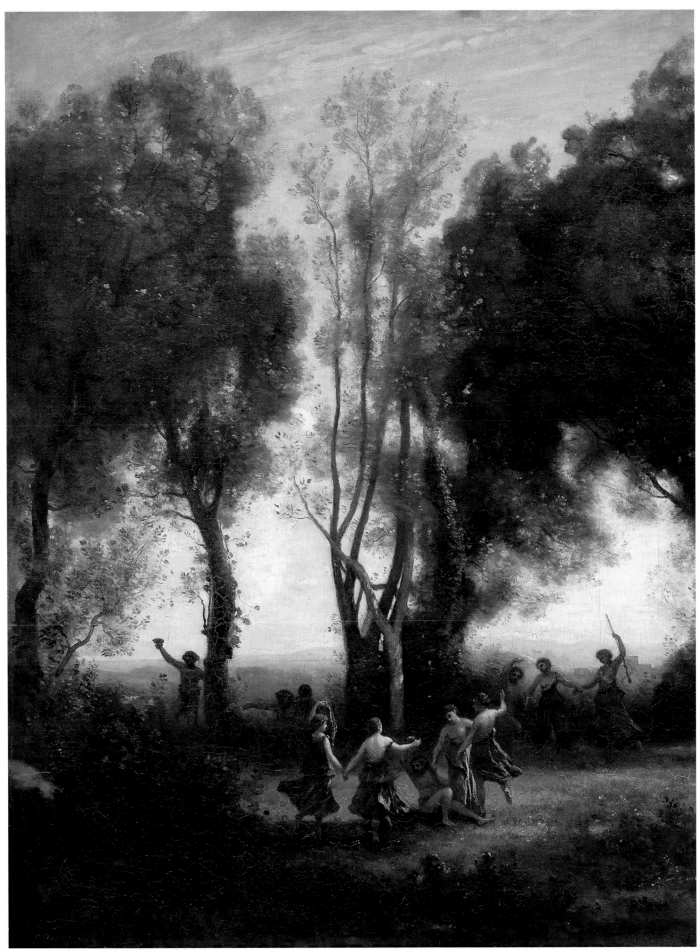

Fig. 69. Detail of Corot, *Une Matinée*, also called *Danse des nymphes* (*A Morning*, also called *Dance of the Nymphs*), cat. no. 103

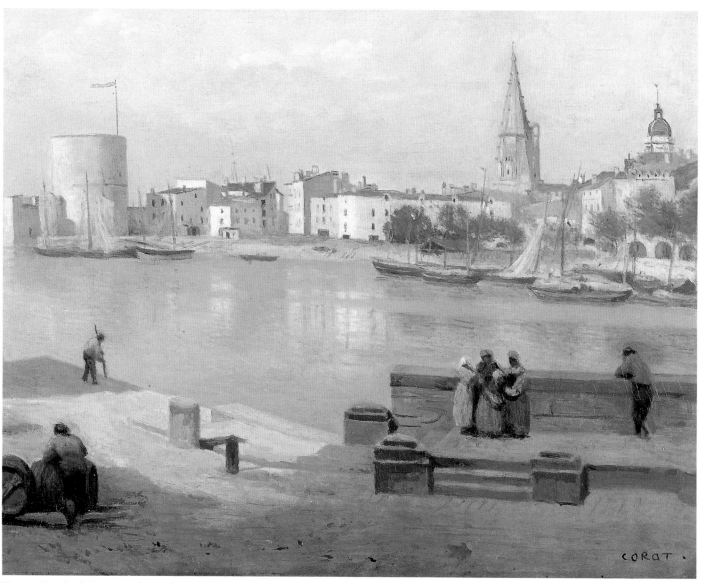

Fig. 70. Detail of Corot, *Vue du port de La Rochelle* (*View of the Port of La Rochelle*), cat. no. 96

49. "La première fois qu'il me reçut dans son atelier avec sa cordialité joyeuse, la face enluminée, le bonnet de coton rayé à mèche tricolore et la blouse bleue, il me fit l'effet d'un roi d'Yvetot: je ne pouvais retrouver du premier coup dans l'homme le caractère de ses ouvrages . . . les journaux l'avaient tellement défiguré Corot en lui mettant dans les mains Théocrite et Virgile que j'étais tout surpris de le trouver, sans grec ni latin, si avenant et si simple. . . . Son accueil est très-ouvert, très-libre, très-amusant: il vous parle, vous écoute en sautillant sur un pied ou sur deux; il chante d'une voix très-juste des morceaux d'opéra, travaille, fume la pipe, mange la soupe de vigneron sur son poêle, et vous invite même à la partager, oubliant un moment qu'il n'a devant lui qu'une soupière et une cuiller." Silvestre 1856 (republication), pp. 86, 98–99, cited by Moreau-Nélaton in Robaut 1905, vol. 1, pp. 148–49.

50. "Corot s'exagère parfois à lui-même la gaîté de son caractère, lorsque je vois la mélancolie si souvent présente dans ses ouvrages et l'accent de tristesse que par intervalles prennent ses traits"; "côté spirituel et mordant soigneusement caché dans sa bonhomie." Ibid., pp. 99, 100.

The first time he received me in his studio with his cheerful cordiality, his face ruddy, wearing his striped cotton cap with a tricolored tassel and his blue smock, he seemed like a sturdy French landowner: I couldn't at first find in the man the spirit of his works . . . the newspapers had so distorted Corot, putting Theocritus and Virgil in his hands, that I was quite surprised to find him knowing neither Greek nor Latin, very personable and simple. . . . His welcome is very open, very free, very amusing: he speaks or listens to you while hopping on one foot or on two; he sings snatches of opera in a very true voice, works, smokes a pipe, eats the country soup on his stove and even invites you to share it with him, forgetting that he has before him only one bowl and one spoon.[49]

Silvestre observed, nevertheless, that "Corot sometimes exaggerates even to himself the cheerfulness of his character, while I see the melancholy so often present in his work and the expression of sadness that occasionally takes possession of his features." He discerned as well a "shrewd, biting side carefully hidden behind his good nature."[50]

The contradictions of the man, who ultimately eluded interpretation, echoed the futility of attempts to decode his art. According to all, from the moment he

exhibited *Agar dans le désert*, the characteristics that distinguished him were his uncommon originality, his indisputable feeling for nature, and that pervasive, unblemished "fragrance of plein air" noted by Delécluze.[51] But it became commonplace to point out his naïveté, the narrow range of his colors, and the awkwardness of his figures, or to state that he had *le génie de l'ensemble* without *le talent du détail*. Already in 1835, Charles Lenormand had dismissed the issue of his figures with a wonderful phrase: "With a man like Corot, one overlooks the weakness of the figures, as one excuses the brevity of the melodies in Beethoven's *Fidelio*."[52] His purported *gaucheries* and the unfinished aspect of his work, in time seen as his chief virtues, were forcefully defended by Baudelaire in 1845.[53] Yet even hostile voices saw in Corot's work a mysterious magic, the performance of an enchanter, as when at the 1846 Salon Paul Mantz asked himself about the *Vue prise dans la forêt de Fontainebleau* (cat. no. 91), "Why, then, does this painting stop me in my tracks and disturb me, much as I dislike it?"[54] A year later at the Salon, Thoré concluded that "the slightly mystical painting of M. Corot acts on the viewer rather as music affects the amateur music lover—indirectly and inexplicably."[55]

51. "parfum du plein air." Delécluze 1848.
52. "On passe à un homme tel que M. Corot la faiblesse de ses figures, comme on excuse dans le *Fidelio* de Beethoven la brièveté des mélodies." Lenormant, "L'École française en 1835," in Lenormant 1861, vol. 1, p. 114.
53. Baudelaire, "Salon de 1845," in Baudelaire 1923, pp. 55–57.
54. "Comment se fait-il, cependant, que ce tableau m'arrête au passage et m'inquiète, quoi que j'en haie?" Mantz 1846, p. 72.
55. "La peinture un peu mystique de M. Corot agit sur le spectateur à peu près comme la musique sur le dilettante, par un moyen indirect et inexplicable." Thoré 1847, p. 96.

61

Agar dans le désert; paysage (Hagar in the Wilderness)

1835
Oil on canvas
71 × 97¼ in. (180.3 × 247 cm)
Signed and dated bottom left: COROT 1835. Stamped lower
right: VENTE COROT
The Metropolitan Museum of Art, New York
Rogers Fund, 1938 38.64
New York and Ottawa only

R 362

From the moment it was exhibited in 1835 and for some years
afterward, *Agar dans le désert*, Corot's most ambitious and arguably
his most successful painting to date, was the standard by which
the painter's Salon entries were judged. The story of Hagar,
Sarah's Egyptian handmaiden, is told in two related biblical
narratives. In Genesis 16:1–16, Sarah, Abraham's wife, cannot
bear children and gives Hagar to her husband as a concubine.
When Hagar conceives, she looks with contempt on her mis-

Fig. 71. Corot, *Fontainebleau. Chênes noirs du Bas-Bréau*,
cat. no. 35

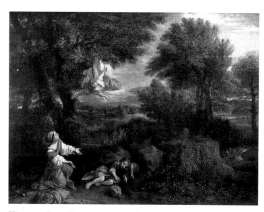

Fig. 72. Pier Francesco Mola (1612–1666). *The Angel
Appearing to Hagar in the Desert*. Oil on copper. Musée
du Louvre, Paris (393)

tress, who in turn deals harshly with her until she flees into the desert. There an angel persuades her to return to Abraham and Sarah, after which she gives birth to Ishmael. In Genesis 21:8–21, after Sarah bears Isaac, she demands that Hagar and her son be banished to the desert of Beersheba. As Hagar and the child Ishmael are dying of thirst, an angel saves them by giving them water. For his composition Corot chose the second episode from Genesis, a rather rare subject compared to the more popular first episode, in which the angel consoles Hagar.[1]

How the painting originated is unknown, but a preliminary study in a sketchbook used about 1833 indicates that Corot began work on the composition before his departure for Italy in May 1834.[2] According to Moreau-Nélaton, he was dissatisfied with the composition but picked it up again after his return.[3] A small oil sketch, published by Germain Bazin as a study for the painting, is identical to it in most respects but lacks the angel and a tuft of vegetation at the center.[4] In fact, the similarities of detail between the sketch and the finished painting suggest that the sketch is not a study for the larger work but rather a derivation from it. Robaut, presumably relying on information from Corot, notes that the landscape was composed from studies made at Fontainebleau and in the environs of Montpellier.[5] There is no surviving evidence of studies from Montpellier, which Robaut may have confused with studies used for the *Saint Jérôme* (cat. no. 62). The rocks, however, are definitely based on work done at Fontainebleau, and a study of oaks at Bas-Bréau (fig. 71) served for the trees. Studies made in Italy, principally at Civita Castellana during Corot's first Italian visit, were very probably used for the background.[6]

A drawing in the Louvre of a young woman about whom Corot said many years later, "This is my Hagar," has been associated with the painting. It is not clear, however, if she posed for Hagar or if she was Hagar to Corot's Abraham (that is, a woman his family forced him to reject).[7] Whatever the case, the facsimile of the drawing published by Charles Desavary in 1873, when Corot was still alive, has the added inscription *Agar, vers 1830*, suggesting that the artist confirmed a connection between the drawing and the painting.[8]

Nothing in Corot's earlier work anticipates the forcefulness with which he treated, in this painting, the theme of despair. He may have been inspired by such pictures as *The Angel Appearing to Hagar in the Desert* by Pier Francesco Mola, in the Louvre (fig. 72). Vincent Pomarède has suggested in conversation the possibility of a link with Corot's friend Mme André Osmond, who in 1824 had lost her only child, a three-month-old girl who had been put to nurse with a cousin at Rosny, Marie-Sophie Varin.[9] In 1839–40 Corot painted a *Fuite en Égypte* (Flight into Egypt; R 369) for Mme Osmond; Marie-Sophie Varin's seven-year-old daughter, Victoire, posed for the figure of the Virgin.[10] Corot loved children, although he had none of his own, and painted them with a rare intuitive understanding. The subject of motherhood is one to which he returned with some insistence in later life, in the second half of the 1850s and the 1860s. Only one of these works places a mother in a context that implies danger.[11]

Corot's originality and impressive attempt at the grand manner were widely praised, and *Agar* was hailed as one of the year's triumphs. The anonymous reviewer for *L'Artiste*, perhaps Jules Janin, wrote:

M. Corot knows as well as M. Delacroix how not to look like his predecessors. M. Corot has made his picture a landscape: the earth is barren and burnt, the rocks are bare, and a few meager clumps of trees can be seen in the distance—a sterile, useless shadow giving neither shade nor fruit. And even this shadow is quite distant, and poor Hagar will never manage to drag herself that far.... The angel in that vast landscape, the distant hope that the despairing mother cannot see, ... that great landscape: this is what I find a noble and great idea, admirably realized.... Thought, freshness, color, line, soul, spirit, movement: it is all there.[12]

For Victor Schoelcher, Corot's landscape was the most beautiful, "because it is the one that best satisfies my spirit and gives me the most food for thought."[13] The suggestive qualities of the landscape were recognized by Charles Lenormant, who admired the work with some reservations but observed: "M. Corot's landscape contains something that grips your heart even before you become aware of the subject matter. That is the particular merit of historical landscapes: the harmony between the setting and the passion or suffering that the painter chooses to depict in it."[14]

Some critics complained that the figures were too small, and Louis Viardot wrote, "One gets the impression that he had some difficulty filling his canvas. If he wants his tufts of vegetation sparsely scattered, fine—this isn't the Bois de Boulogne—but the rocks should be better grouped and matched. The angel coming to Israel to answer the mother's cries and save the Arab race is flying awfully high and far away!"[15] The painting was not sold during Corot's lifetime but was the principal lot in the posthumous sale of 1875, where it was purchased by Prince Nicolas J. Soutzo, who sold it almost immediately afterward; by then it was described as painted in Corot's "slightly hard manner."[16] Larthe-Ménager's curious statement in 1894 that Corot "willed to the Louvre *Agar dans le désert* and *Dante et Virgile aux enfers*" was manifestly mistaken.[17]

1. The subject was depicted relatively frequently in seventeenth-century Dutch art. Alexandre Belle exhibited an *Agar dans le désert* at the Salon of 1819 (no. 47).
2. *Carnet*, R 3097, Musée du Louvre, Paris, R.F. 8722. The *carnet* contains studies for *Une Marine* (cat. no. 46), which Corot exhibited at the Salon of 1834.
3. In Robaut 1905, vol. 1, p. 62.
4. Bazin 1942, p. 115, no. 44 and pl. 44; Bazin 1973, p. 281, ill. p. 168.
5. In Robaut *carton* 16, fol. 456.
6. See particularly the studies R 140 and R 172.
7. The drawing is R 2652, Musée du Louvre, Paris, R.F. 3352. Moreau-Nélaton stated on the basis of Robaut's notes, "His Hagar was named Rose or Zoé and did a bit of dressmaking with her mother on rue du Bac." ("Son Agar s'appelait Rose ou Zoé et chiffonait avec la maman,

rue du Bac.") Robaut 1905, vol. 1, p. 54. Baud-Bovy dubiously claimed that the model for Hagar was Alexina Legoux, whose portrait Corot later painted (fig. 52) and for whom, according to Moreau-Nélaton, he conceived a passion (Baud-Bovy 1957, pp. 122–23; Moreau-Nélaton 1924, vol. 2, p. 151). For Hélène Toussaint's cautious opinion, see Paris 1975, no. 142.

8. Desavary 1873.

9. For Marie-Sophie Varin, see Walter 1975, pp. 32, 84, n. 8.

10. For Victoire-Sophie Varin, see ibid., pp. 34, 84, n. 14.

11. See R 1268, 1344, 1345, 1379, 1380, 1382, 1383, and particularly 1264, *Mère protégeant son enfant*. In 1871 Corot executed a *cliché-verre* on the theme of Hagar and the angel (R 3207; Delteil 1910, no. 87).

12. "M. Corot a trouvé le moyen, aussi bien que M. Delacroix, de ne pas ressembler à ses prédécesseurs. M. Corot a fait de son tableau un paysage: la terre est nue et brûlée, le rocher est à découvert, quelques maigres bouquets d'arbres se montrent au loin, ombre vaine et stérile, sans fraîcheur et sans fruits; mais encore cette ombre est bien loin, et la pauvre Agar ne pourra jamais se traîner jusque-là. . . . Cet ange dans ce vaste paysage, cet espoir lointain que ne voit pas la mère désolée, ce grand paysage, voilà, à mon sens, une noble et grande idée admirablement exécutée. . . . Pensée, nouveauté, couleur, dessin, âme, esprit, mouvement, tout est là." Anon. 1835b, p. 90.

13. "parce que c'est celui qui satisfait le mieux mon esprit, et donne le plus d'aliment à ma pensée." Schoelcher 1835, p. 166.

14. "Le paysage de M. Corot a quelque chose qui serre le coeur avant même qu'on se soit rendu compte du sujet. C'est là le mérite propre au paysage historique, c'est-à-dire l'harmonie du site avec la passion ou la souffrance que le peintre veut y placer." Lenormant, "L'École française en 1835," in Lenormant 1861, vol. 1, p. 114.

15. "On dirait qu'il a eu quelque embarras à couvrir sa toile. Que les touffes d'arbustes soient dispersées, passe; nous ne sommes pas dans le Bois de Boulogne, mais les blocs de rochers devraient être mieux groupés et mieux assortis. L'ange qui vient, aux cris de la mère, sauver en Israël toute la race arabe, vole très loin et très haut!" Viardot 1835.

16. "manière un peu dure." Daliphard 1875, p. 159.

17. "a laissé par testament au musée du Louvre *Agar dans le désert* and *Dante et Virgile aux enfers.*" Larthe-Ménager 1894, p. 14.

PROVENANCE: The artist; his posthumous sale, Hôtel Drouot, Paris, pt. 1, May 26–28, 1875, no. 85; purchased at that sale by "Fauché," doubtlessly a *nom de vente*, for 3,500 francs; Prince Nicolas J. Soutzo, 1875; anonymous sale (probably Soutzo), Hôtel Drouot, Paris, November 9, 1875; purchased at that sale by the comte Arthur Doria (1824–1896), Paris, for 2,900 francs; Paul Gallimard, Paris, 1900; Mlle Dieterle, 1914; Simon; Wildenstein & Co., New York, 1938; The Metropolitan Museum of Art, Purchase, Rogers Fund, 1938

EXHIBITIONS: Paris (Salon) 1835, no. 440, as *Agar dans le désert; paysage*; Paris 1861; Paris 1862; Paris 1875a, no. 226; Paris 1900, no. 129; Copenhagen 1914, no. 34; Philadelphia 1946, no. 18; Detroit, Toronto, Saint Louis, Seattle 1951–52; Chicago 1960, no. 39; Edinburgh, London 1965, no. 33; New York 1992

REFERENCES: Anon. 1835a, p. 266; Anon. 1835b, p. 90; *Chiarivari* 1835, ill. (lithograph by Céléstin Nanteuil); Decamps 1835, pp. 82–84; Schoelcher 1835, p. 166; Vergnaud 1835; Viardot 1835; Anon. 1836; Anon. 1837, p. 147; Silvestre 1856, pp. 94, 102; Lenormant, "L'École française en 1835," in Lenormant 1861, vol. 1, p. 114; Mantz 1861, p. 422; Anon. 1862; Daliphard 1875, p. 159; Rousseau 1875, p. 246; Bigot 1888, p. 51; Roger-Milès 1891, pp. 26–28, 32; Larthe-Ménager 1894, p. 14; Roger-Milès 1895, ill.; Michel 1896a, pp. 18–19, 24; Geffroy 1903, pp. cxi, cxxiii; Hamel 1905, p. 18, pl. 7; Meier-Graefe 1905, pp. 29–31; Michel 1905, p. 24; Robaut 1905, vol. 2, pp. 126–27, no. 362, ill., and vol. 4, p. 202, no. 85; Madsen 1920, pp. 18–20, ill.; Moreau-Nélaton 1924, vol. 1, pp. 32, 39, 43–44, and vol. 2, p. 58; Lafargue 1926, p. 39; Bernheim de Villers 1930a, p. 31; Fosca 1930, pl. 16; Meier-Graefe 1930, p. 48; Wehle 1938, pp. 246–49, ill.; Bazin 1942, pp. 45, 115, no. 44, pl. 44; Sloane 1951, p. 125, fig. 3; Baud-Bovy 1957, pp. 45, 85, 121–22, 187, 202–4; Fosca 1958, pp. 23, 145, 190; Coquis 1959, pp. 18–20, 22, 25, 46, 70–71; Sterling and Salinger 1966, pp. 48–50, ill.; Selz 1988, p. 134, ill. p. 107; Wissman 1989, pp. 96–99; Clarke 1991a, pp. 56, 60, 94, fig. 63; Gale 1994, p. 70, ill. p. 71

62

Saint Jérôme; paysage (Saint Jerome)

1837
Oil on canvas
70⅞ × 96½ in. (180 × 245 cm)
Signed and dated lower right: C. COROT 1837.
Church of Saint-Nicolas-Saint-Marc, Ville-d'Avray

R 366

According to Moreau-Nélaton, *Saint Jérôme* was intended to match *Agar dans le désert* (cat. no. 61). Corot may have regarded the pair as a study in contrasts, a possibility supported by the fact that the paintings are the same size and related, to a degree, in conception. In *Saint Jérôme* Corot again turned to the theme of an isolated individual, but here he achieved a contemplative mood, devoid of tragic overtones. An undated oil study in Reims (R 365) shows that Corot originally imagined the composition in reverse, with the saint kneeling in ecstasy, his arms stretched out in supplication. In the final design the effect was subdued: the saint is shown looking upward in prayer, and the lion—incongruous in this landscape on the edge of the desert—is asleep, peacefully indifferent to the saint's mystical devotion.

Hélène Toussaint remarked that the painting was inspired by a Saint Jerome attributed to Poussin in the Prado, Madrid, but that work appears not to have been engraved.[1] A drawing in the Louvre of a seated elderly model has been generally connected with the painting and may well represent the model who, according to Corot, died in the winter of 1836–37 after falling ill from posing in his poorly heated studio.[2] Toussaint also pointed out that there is a study of a lion in a notebook that Corot used in 1833.[3] It has been said that the austere landscape was inspired by the region around Montpellier, where Corot traveled in the summer of 1836, but it seems to evoke with greater conviction the rocky formations he observed in Italy in the late 1820s.

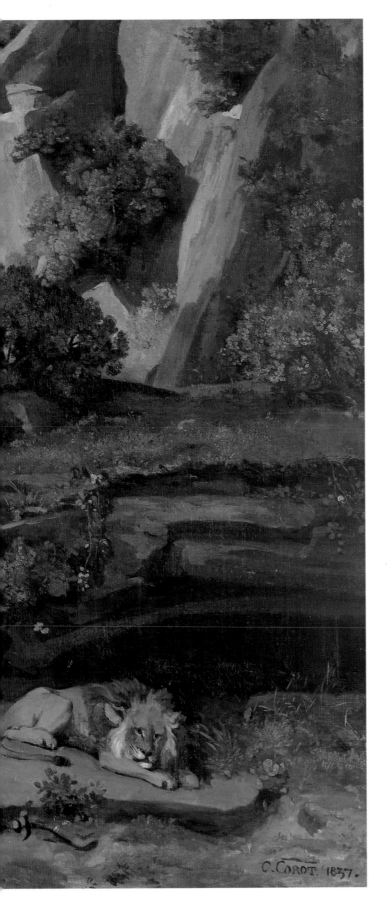

The starkness of the landscape, so well suited to the subject, was undoubtedly the chief cause of the largely negative reaction to the painting at the Salon of 1837. Alexandre Decamps expressed reservations. The reviewer for *L'Artiste* deplored "those mournful, unadorned rocks, those distant lands, those sparse, twisted trees."[4] Gustave Planche's verdict was severe: "M. Corot's Saint Jerome contains an unfortunate mixture of truth, lifelessness, and indecision. There is no grandeur in the lines, but rather naïveté in the colors and awkwardness in the drawing; the overall effect is a failure."[5] Théophile Gautier, however, thought the painting as fine as *Agar*, though in a very different way, and an unexpected admirer, Louis Viardot, who had disliked *Agar*, called it "a very distinguished, very remarkable work."[6] Étienne Delécluze noted the praise Corot had received but wrote the harshest lines: "Only by referring to the catalogue could I in fact be sure that I was standing before the work that has been so highly praised. Such ill-considered applause necessarily invites harsh criticism, and in this case I would be within my rights to avenge my small disappointment."[7]

About 1849 Corot gave the painting to the church of Ville-d'Avray, where it has hung in the nave ever since and where it was seen by Van Gogh in August of 1875.[8]

1. Toussaint in Paris 1975, no. 66.
2. The drawing is R.F. 8795, published in Robaut 1905, vol. 1, p. 79. In Robaut's words, "Never will I forget the master's emotion when he recalled the death of his model . . . two weeks after the last sitting. . . . 'His death is on my conscience. . . .' Corot was short of money back then, he economized too much on the heating in his studio." ("Jamais je ne saurais oublier l'émotion du maître en se rappelant la mort de son modèle . . . quinze jours après la dernière séance. . . . 'J'ai sa mort sur la conscience. . . .' Corot a court d'argent en ce moment, economisait trop le chauffage de l'atelier.") Robaut *carton* 16, fol. 442. The incident is described again in Larthe-Ménager 1894, p. 12.
3. *Carnet*, R 3044, R.F. 8705. See Toussaint in Paris 1975, no. 66.
4. "ces rochers tristes et dénudés, ces terres lointaines, ces arbres rares et tordus." Anon. 1837, p. 146.
5. "Le *Saint Jérôme* de M. Corot présente un mélange malheureux de vérité, de mollesse et d'indécision. Nulle grandeur dans les lignes, mais de la naïveté dans la couleur, de la gaucherie dans le dessin, et un effet manqué." Planche, "Salon de 1837," in Planche 1855, vol. 2, p. 98.
6. "oeuvre fort distinguée et fort remarquable." Viardot 1837.
7. "Il nous a fallu le secours du livret pour être certain que nous étions en effet devant une production dont on nous avait parlé si avantageusement. Les éloges inconsidérés attirent nécessairement des critiques sévères et dans cette occasion nous serions en droit de nous venger du petit désappointement que nous avons éprouvé." Delécluze 1837.
8. Vincent van Gogh, letter to Theo van Gogh, August 13, 1875. Van Gogh 1958, vol. 1, p. 31.

PROVENANCE: Gift of the artist to the church of Ville-d'Avray, about 1849

EXHIBITIONS: Paris (Salon) 1837, no. 388, as *Saint Jérôme; paysage*; Paris 1875a, no. 163; Paris 1936, no. 31; Lyons 1936, no. 26; Paris 1962, no. 15; Paris 1975, no. 66

REFERENCES: Anon. 1837, p. 146; Barbier 1837, p. 165; Decamps 1837; Delécluze 1837; Gautier 1837; Viardot 1837; Planche, "Salon de 1837," in Planche 1855, vol. 2, p. 98; Daliphard 1875, p. 159; Rousseau 1875, p. 245; Bigot 1888, p. 51; Larthe-Ménager 1894, p. 12; Hamel 1905, p. 18, pl. 8; Maugeant 1905, p. 125; Robaut *carton* 16, fol. 442; Robaut 1905, vol. 2, pp. 130–31, no. 366, ill.; Fosca 1930, pl. 17; Baud-Bovy 1957, p. 85; Selz 1988, p. 108; Wissman 1989, pp. 98–100; Clarke 1991a, pp. 58–60, fig. 64; Gale 1994, pp. 21, 23, ill. p. 24

63

Diane surprise au bain (Diana Surprised in Her Bath)

1836
Oil on canvas
61⅝ × 44⅜ in. (156.5 × 112.7 cm)
Signed and dated lower right: COROT 1836
The Metropolitan Museum of Art, New York
The Robert Lehman Collection, 1975 1975.1.162

R 363

This ambitious composition was exhibited at the Salon of 1836 with a *Campagne de Rome en hiver*, probably the equally large painting now in Norfolk (cat. no. 31), which overshadowed it. In a sense *Diane* was an unexpected work from the author of *Agar*, who was associated with a specific form of modern landscape. The painting, listed in the Salon booklet without the qualifier "paysage," was only Corot's second attempt at a mythological subject: before his departure for Italy in 1825, he had considered a composition about Orpheus but had not developed it beyond the level of a sketch (R 195). The sense of confusion generated by this highly independent artist, essentially beyond classification, was noted by the critic of *L'Artiste:* "M. Corot belongs neither to the classical landscape school nor to the Anglo-French school, and still less to the one inspired by the Flemish masters. When it comes to landscape painting, he seems to follow only his own convictions, from which we would not wish to dissuade him.... Perhaps we might compare the approach he favors, which is slightly stilted, to the stiff, mannered style of those historical painters who follow the banner waved by the painter of the *Saint-Symphorien*.... The shady, isolated spot where Diana bathes with her companions is full of grace."[1] This comparison with Ingres, though somewhat surprising, was perhaps not completely unjustified, since Corot had taken greater care than usual in executing details.

Corot depicts the moment when the goddess Diana, surprised while bathing by Actaeon, transforms him into a stag. The metamorphosis has already taken place in the left background, and Diana's companions react variously to the event: one holds back a dog about to run off toward Actaeon; two more, near Diana, attempt to hide themselves, while two others appear not to have noticed or understood the event. One of the last two—the most unusual figure—is merrily suspended from a tree branch. The small oil study for the composition in Reims (R 364) shows a different design with only four figures, including Diana, about to step into the water, and a seated, dressed woman at the right. Actaeon is not present, and the disposition of the figures suggests that in the composition's early stages Corot intended to represent only the bath of Diana.

Fig. 73. Corot. *Les Baigneuses des îles Borromées* (*The Bathers of the Borromean Isles;* R 1653), 1865–70. Oil on canvas, 31 × 22⅛ in. (78.7 × 56.2 cm). Sterling and Francine Clark Art Institute, Williamstown, Massachusetts (537)

The landscape, with a group of trees set against a massive rock, is among the more complex devised by Corot. The feeling for light recalls the Italianate Dutch landscape painters: the rock is presented against the light, and light filters gently through an arched hollow to the right. The fantastic dead tree cutting an arch in space and the figure suspended from it are motifs that reappear in later works of Corot, for example, *Les Baigneuses des îles Borromées* (fig. 73). In 1874 the left section with the figure of Actaeon was reworked by Corot when the dealer Tedesco asked him to simplify the composition.[2] Robaut's drawing after the composition was made before the alterations and shows that the revisions were quite extensive.[3]

1. "M. Corot n'appartient ni à l'école classique du paysage, ni à l'école anglo-française, encore moins à celle qui s'inspire des maîtres flamands. Il paraît avoir sur la peinture de paysage des convictions à lui, que nous ne chercherons pas à lui faire perdre.... Peut-être pourrait-on comparer le style qu'il affectionne et qui est tant soit peu guindé au style raide et

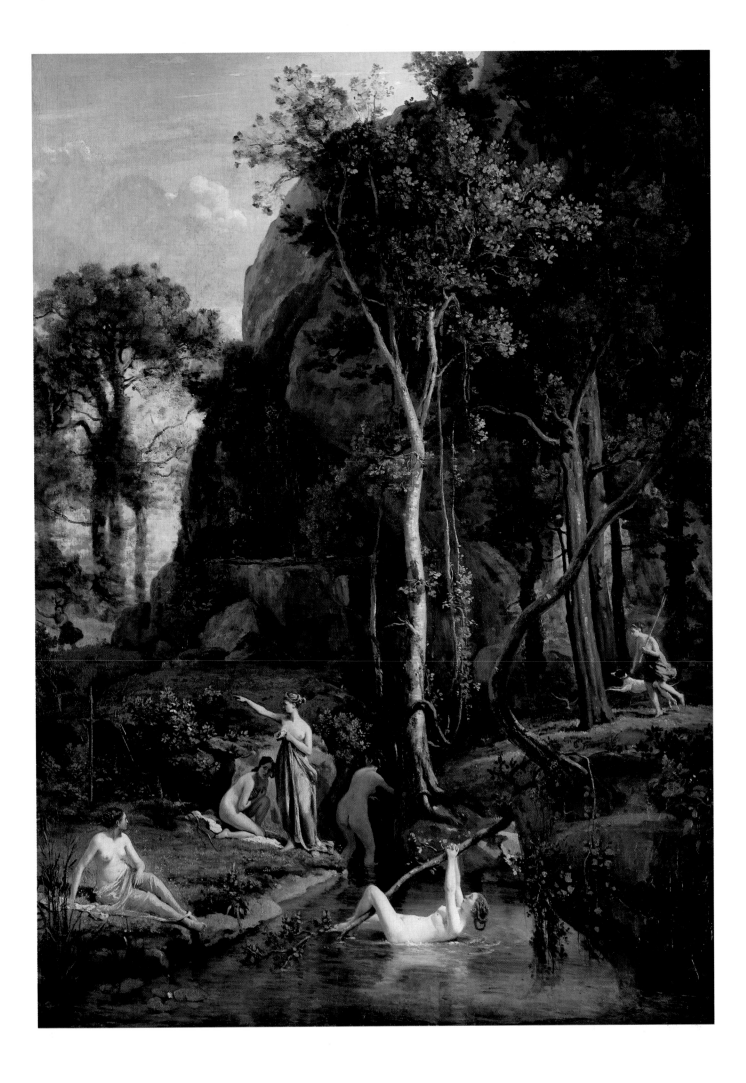

maniéré de cette fraction de nos peintres d'histoire qui suit la bannière de l'auteur du *Saint Symphorien. . . .* Il y a de la grace dans le site retiré et plein de fraîcheur où Diane se baigne avec ses compagnes." Anon. 1836, p. 136.

2. Robaut *carton* 16, fol. 439. In the same source it is indicated that in 1894 this painting was said to be inscribed "Rome 1836," an impossibility that Robaut dismissed.

3. Robaut 1905, vol. 2, no. 363.

PROVENANCE: Louis Lenormant, Paris, until 1862; by descent, Bouvier-Lenormant, Paris; sold in 1873 to Reitlinger and Tedesco, who asked 3,500 francs for it; Gellinard collection, Paris; Gellinard sale, Hôtel Drouot, Paris, March 19, 1888, lot 41, sold for 10,200 francs; Mellerio collection, Paris, 1894; anonymous sale, Hôtel Drouot, Paris, March 28, 1908, no. 13; Robert Lehman, New York, before 1956; The Robert Lehman Collection, The Metropolitan Museum of Art, New York, 1975

EXHIBITIONS: Paris (Salon) 1836, no. 403, as *Diane surprise au bain;* New Haven 1956; New York 1956a, no. 21; Edinburgh, London 1965, no. 34; New York 1966b, no. 7; New York 1992

REFERENCES: Anon. 1836, p. 136; Rousseau 1875, p. 246; Hamel 1905, p. 18; Michel 1905, p. 24; Robaut *carton* 16, fol. 439; Robaut 1905, vol. 2, pp. 128–29, no. 63, ill. (before retouching in 1874); Bazin 1942, pp. 46, 101; Baud-Bovy 1957, p. 85; Leymarie 1966, p. 60; Leymarie 1979, p. 64, ill. p. 65; *Corot* 1981, p. 114, no. 26, ill.; Selz 1988, pp. 108, 126, ill. p. 127

64

Silène (Silenus)

1838
Oil on canvas
97½ × 70½ in. (247.7 × 179.1 cm)
Signed and dated lower right: C. COROT. 1838.
Lent by The Minneapolis Institute of Arts
Bequest of J. Jerome Hill 73.42.2

R 368

After his relatively disappointing experience at the Salon in 1837, Corot's hopes for a success in 1838 proved in the end vain. That year he exhibited *Vue prise à Volterra, Toscane* and *Silène*. The latter was a mythological subject as large as *Saint Jérôme* of the previous year but this time with many figures, clearly intended to demonstrate the artist's ability to orchestrate a complex composition. The picture failed to impress, but most critics found something admirable in his flawed effort. Gustave Planche, favorably disposed to anything that leaned toward *élévation de style* rather than *la réalité vulgaire*, thought the landscape almost perfect but found the figures poorly integrated. He advised Corot to look at Poussin: "Since M. Corot claims to be re-creating historical and mythological landscapes, he would do well to remember that Nicolas Poussin always closely related his figures to his settings. . . . M. Corot seems not to recognize that harmony."[1] But Étienne Delécluze, while praising the artist's "true, deep feeling for nature," concluded that "too often, M. Corot lets himself be shaken by an apparition of the great ghost of Poussin."[2]

Modern critics have tended to agree with both Planche and Delécluze in believing that *Silène* exemplifies the dilemma Corot faced as a painter of historical landscapes. Germain Bazin has stated that his talents were essentially those of a naturalist, ill-suited for *l'expression mythologique.*[3] *Silène* is regarded as the painting of Corot's most influenced by Poussin, and its similarities to a lost *Triumph of Silenus* by Poussin, known only from

Fig. 74. After Nicolas Poussin (1594–1665). *Bacchanale (Le Triomphe de Silène)* (*Bacchanal: The Triumph of Silenus*). Oil on canvas. National Gallery, London (42)

copies (fig. 74), have been pointed out.[4] A specific relationship between the two paintings is not readily apparent at any level, but this does not weaken the otherwise solid argument that in *Silène* Corot attempted to emulate Poussin.

Bazin remarks that Corot's austere genre works are invariably more convincing than his idyllic subjects.[5] In *Silène*, the Bacchanalia is so consciously controlled that it suffers from a want of lust, which is all the more apparent when the painting is compared with corresponding scenes in Poussin. In *Diane surprise au bain* (cat. no. 63), a frolicsome nymph disrupts a dramatic subject; in *Silène*, in contrast, a withdrawn figure, reclining on the grass at the left and regarding the viewer, tempers the revelry. This figure is evidently based on a drawing that also suggested the much later *Le Repos* (cat. no. 117).[6]

In his unpublished notes on this painting, Robaut remarked that "Corot was never able to sell it, any more than he was able to sell the other large canvases. Most of these large works he gave away, or let go for ridiculous amounts."[7] He also stated that in 1872 Corot consigned the painting to the dealer Weyl, who paid for it only when Corot's heirs claimed ownership after the artist's death.

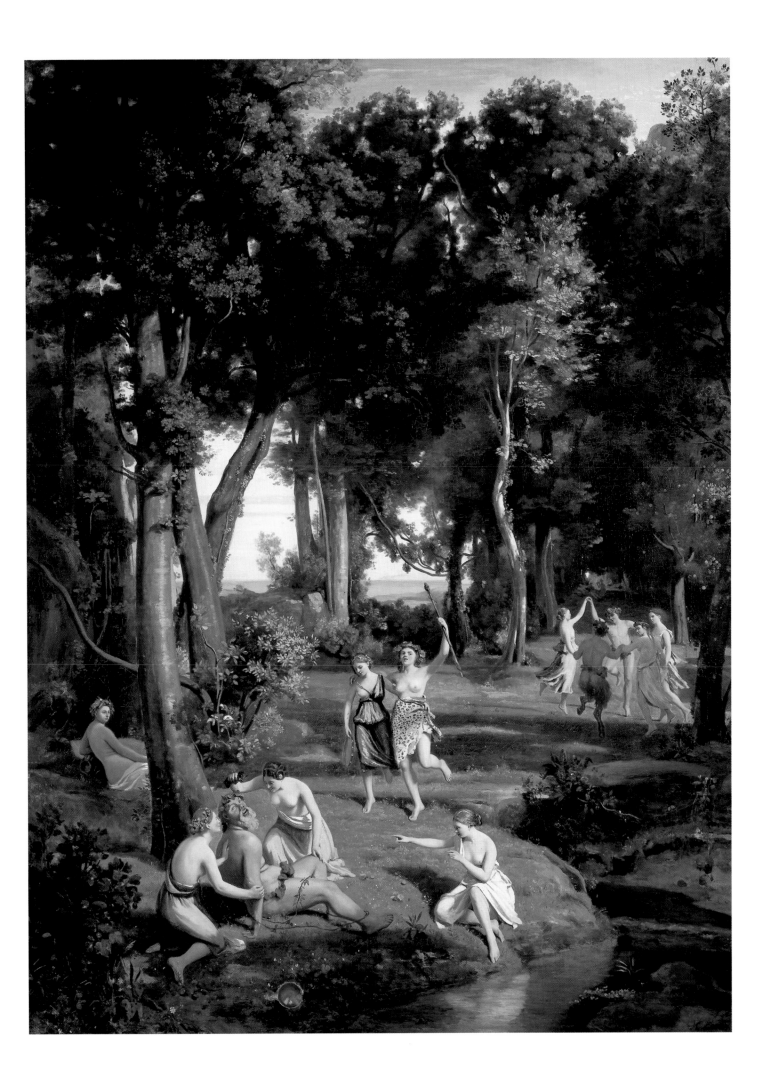

1. "Puisque M. Corot a la prétention de créer des paysages historiques et mythologiques, il ne doit pas oublier que Nicolas Poussin a toujours étroitement relié ses figures et ses paysages. . . . M. Corot semble méconnaître la nécessité de cette union." Planche, "Salon de 1838," in Planche 1855, vol. 2, p. 141. See also Mercey 1838, p. 401. The reviewer for *L'Artiste,* however, wrote, "His landscapes, which always show a beautiful sense of composition, this year are colder and duller than ever in their execution, absolutely without brilliance or spirit." ("Ses paysages qui sont toujours d'un beau sentiment de composition, sont plus que jamais, cette année, d'une exécution froide et terne, absolument dépourvus d'éclat et de ressort.") See Anon. 1838, p. 135.

2. "sentiment profond et vrai de la nature"; "M. Corot se laisse agiter trop souvent par les apparitions de la grande ombre de Poussin." Delécluze 1838.

3. Bazin 1973, p. 42.

4. Ibid., p. 281; see also Wissman 1989, pp. 110–11.

5. Bazin 1973, p. 42.

6. The figure also appears in a sketch inscribed *La Bergère de Luzancy* on fol. 72 of *carnet* 27 (R 3065, Musée du Louvre, Paris, R.F. 8711), dated about 1857–58, reproduced in Robaut 1905, vol. 1, p. 190.

7. "Corot ne put jamais le vendre, pas plus que les autres grands tableaux. La plupart de ces grandes oeuvres furent données par lui ou cédées à des prix dérisoires." See Robaut *carton* 16, fol. 443.

PROVENANCE: Sold by Corot to the dealer Weyl in 1872, but not paid for until after the artist's death; Cadart, Paris; anonymous sale, Hôtel Drouot, Paris, February 19, 1877, no. 5 (according to Robaut for about 2,000 to 3,000 francs); Jean Dollfus, Paris; his sale, Galerie Georges Petit, Paris, March 2, 1912, no. 4; purchased at that sale by Durand-Ruel, for James J. Hill, Saint Paul, Minnesota, for 81,000 francs; James J. Hill, Saint Paul (inventory no. 242); Louis W. Hill Sr.; J. Jerome Hill, New York; bequeathed by him to The Minneapolis Institute of Arts, 1973

EXHIBITIONS: Paris (Salon) 1838, no. 341, as *Silène;* Chicago 1934, no. 168; Minneapolis 1958; Chicago 1960, no. 45; San Francisco, Toledo, Cleveland, Boston 1962–63, no. 4; Minneapolis 1975; Saint Paul 1991, no. 8

REFERENCES: Delécluze 1838; Mercey 1838, p. 401; Thoré 1838, pp. 57, 58; Planche, "Salon de 1838," in Planche 1855, vol. 2, pp. 141–42; Rousseau 1875, p. 246; Hamel 1905, p. 18, pl. 14; Michel 1905, p. 24; Robaut 1905, vol. 2, pp. 132–33, no. 368, ill.; Jaccaci 1913, pp. 77–78; Fosca 1930, pl. 23; Meier-Graefe 1930, p. 49; Bazin 1942, pp. 8, 46, 115, no. 43, pl. 43; Baud-Bovy 1957, p. 85; Fosca 1958, p. 23; Leymarie 1966, p. 60; Bazin 1973, pp. 42, 264, 281, ill. p. 166; Hedberg and Hirschler 1974, pp. 93–94, 101, fig. 2; Leymarie 1985, p. 64; Selz 1988, p. 108; Wissman 1989, pp. 110–14, 118; Clarke 1991a, pp. 61–62; Gale 1994, p. 23

65

La Nymphe de la Seine (The Nymph of the Seine)

1837
Oil on canvas
11⅞ × 17¼ in. (30 × 45 cm)
Signed lower right: COROT Dated lower left: 1837
Private collection
New York and Ottawa only

R 379

This is Corot's earliest surviving painting of a nude and is probably connected with the great Salon compositions he worked on in the mid-1830s, *Diane surprise au bain* (cat. no. 63) and *Silène* (cat. no. 64). The pose of the nymph does not figure in either of those compositions, but the sketchy group of bathers in the right background, including that favorite motif, a figure reaching to a branch, provides an indirect connection with the *Diane.* Because there are few oil studies painted from the nude in Corot's work, this figure has special significance. In later life he was known to advise young landscape painters to start with life painting: "The study of the nude, you see, is the best lesson that a landscape painter can have. If someone knows how, without any tricks, to get down a figure, he is able to make a landscape; otherwise he can never do it."[1]

The nymph, more erotically charged than her counterparts in *Diane surprise au bain,* reclines in a landscape that Corot reworked, particularly at the center, where there is a pentimento of a tree. The flowers loosely sprinkled in the grass, like

scattered confetti, can also be observed in *Rébecca* (cat. no. 71), painted two years later. The early history of this painting is unknown, but it must have left Corot's studio before the 1860s. Alfred Robaut, who admired the figure but disliked the landscape, apparently saw the work for the first time in January 1887 at the Mainard sale, at which time he made a drawing and a tracing of the signature and date.[2] Nevertheless, he passed up the opportunity to buy it, instead purchasing the *Moissonneuse* (cat. no. 70).

1. "L'étude du nu, voyez-vous, c'est la meilleure leçon qu'un paysagiste puisse prendre. Quand on sait camper un bonhomme sans tricherie, on est capable de faire du paysage; on n'en est jamais capable autrement." Louis Français, cited in Baud-Bovy 1957, p. 128.

2. Robaut *carton* 26, fol. 6.

PROVENANCE: Vicomte Léon Mainard; his sale, Paris, January 28, 1887, no. 6; purchased at that sale by Closel for 600 francs; Paul Gallimard, Paris, by 1900; Paul Cassirer, Berlin, after 1932; private collection, since 1936

EXHIBITIONS: Paris 1900, no. 131; Copenhagen 1914, no. 35; Paris 1931, no. 9; London 1932, no. 353; Paris 1936, no. 32; Dieppe 1958, no. 13

REFERENCES: Meier-Graefe 1905, pl. 38; Robaut *carton* 26, fol. 6; Robaut 1905, vol. 2, pp. 140–41, no. 379, ill.; Goujon 1909, ill. p. 477; Lafargue 1925, p. 47, pl. 17; Bernheim de Villers 1930a, no. 46; Mauclair 1930, pl. 31; Meier-Graefe 1930, p. 58; Zahar 1931, p. 103; Bazin 1942, p. 45, pl. 49; Fosca 1958, ill. p. 58; Bazin 1973, pp. 40, 264; Selz 1988, p. 146

Pierrefonds (Oise). Vue générale (View of Pierrefonds)

Ca. 1834
Oil on canvas
20¼ × 30¾ in. (51.5 × 78 cm)
Signed lower left: COROT Unclear, incomplete signature lower
right: JC CO
Musée des Beaux-Arts, Quimper 873-1-778

R 474

The castle of Pierrefonds, near Compiègne, was in large part built at the end of the fourteenth century for Louis d'Orléans, brother of Charles VI. The building remained relatively intact until the seventeenth century, when, in the conflict between Louis XIII and the prince of Condé, it came under siege and was dismantled by order of the king. The ruins were purchased in 1813 by Napoleon I, but he left it in its fallen state. It was only in 1857 that Napoleon III charged Viollet-le-Duc with the radical restoration of the castle, which then became an imperial residence.

In the late eighteenth and early nineteenth centuries, the majestic ruins, positioned on a picturesque height dominating the village and a small lake, were frequently visited by artists.[1] An early sketch by Corot (R 212), possibly dating from 1828–30, was identified as a view of Pierrefonds in the posthumous Corot sale of 1875.[2] The celebrated landscape seen here has little in common with contemporaneous views of the castle, which generally presented a romantic vision of the medieval past. Here the ruins rise above the village, which is hidden by trees, and are viewed from a height at some distance in an almost panoramic landscape. At the center a figure in blue, reduced to a dark note, descends along the road toward the lake. As often with Corot, the middle ground and the background are in sharper focus than the vast foreground, which was worked up only lightly and at the right was left in the sketch state. Corot, who signed the painting twice, ostensibly considered it complete. The signature at right is somewhat atypical in having the initials intertwined; Robaut read it as JB and assumed it meant Jean-Baptiste.[3] The simplicity of the composition, the clarity of expression, and the abstraction of forms have inspired comparisons to Cézanne.[4] In his notes Robaut proposed a date about 1830–35, that is, before Corot's second trip to Italy.[5] Moreau-Nélaton, however, adjusted the date by a decade, to 1840–45. More recently Hélène Toussaint argued in favor of the earlier date (which is now generally accepted), noting similarities to *Saint-Lô. Vue générale de la ville* (cat. no. 42), which she dated to a visit to Saint-Lô in 1834.[6]

Fig. 75. Corot. *Les Ruines du château de Pierrefonds* (*Ruins of the Château of Pierrefonds*; R 475 B), ca. 1840–45, reworked shortly before 1867. Oil on canvas, 29⅛ × 41⅜ in. (74 × 105 cm). Emilie L. Heine Collection, Cincinnati Art Museum (1940.965)

The painting was owned by the founder of the Musée de la ville de Quimper, whose collection also included works by Valenciennes and Michallon. A closer view that Corot painted of the castle, now in the Cincinnati Art Museum (fig. 75), was said by Robaut to have been contemporaneous with this work. After extensive repainting, the Cincinnati picture was shown at the Exposition Universelle of 1867, perhaps with the thought that it might attract the attention of Napoleon III, who then lived at Pierrefonds. A view of the castle from the opposite direction (R 965), dated by Robaut to the early 1860s, gives the impression of being an early study that was later reworked. A *Souvenir de Pierrefonds* in the Pushkin Museum, Moscow (R 964 bis), dated about 1850–60, includes figures in historical costume—an interesting if late adoption of the neomedieval fashion that Corot had ignored in his youth.

1. Views of Pierrefonds were exhibited at the Salon by many artists, including Boisselier in 1819, Regnier in 1819 and 1822, L. A. Gérard in 1827, Boisselin and Langlacé in 1831, and Parmentier in 1833.
2. *Glacis d'un château fort en ruine*, R 212, Armand Hammer Museum of Art, Los Angeles; in Corot sale 1875, no. 329, as *Pierrefonds; au pied du château*.

3. Robaut *carton* 3, fol. 165.
4. André Cariou in 's Hertogenbosch 1992, p. 166.
5. Robaut *documents*, vol. 1, fol. 30.
6. Toussaint in Paris 1975, p. 39. Jean Selz has dated the work as early as
 about 1830; see Selz 1988, p. 87.

PROVENANCE: Anonymous sale (estate of W. Coquebert & Cie.), Paris, January 21–22, 1850, no. 1; the comte Toussaint de Silguy; bequeathed by him to the Musée des Beaux-Arts, Quimper, 1864

EXHIBITIONS: Paris 1900, no. 115; London 1932, no. 176; Zurich 1934, no. 53; Paris 1936, no. 51; Lyons 1936, no. 40; London 1949–50, no. 176; Rome, Florence 1955, no. 20 (Rome), no. 19 (Florence); Tokyo, Kyoto 1961–62, no. 65; Berlin 1963, no. 1; Edinburgh, London 1965, no. 52; Bordeaux 1974, no. 39; Paris 1975, no. 29, as ca. 1834; Rome 1975–76; Beauvais 1987, no. 81; Beauvais 1990–91, no. 69; Manchester, Norwich 1991, no. 16, as ca. 1834; La Coruña, Saragossa, Valencia 1992, no. 54; 's Hertogenbosch 1992, no. 91

REFERENCES: Quimper, Musée des Beaux-Arts 1873, no. 574; Robaut 1905, vol. 2, pp. 176–77, no. 474, ill.; Bazin 1942, p. 118, pl. 66; Bazin 1973, p. 266; Quimper, Musée des Beaux-Arts 1976; Selz 1988, p. 86, ill. p. 87; Clarke 1991a, p. 53, fig. 57; Smits 1991, p. 369, fig. 238; Gale 1994, p. 66, ill. p. 67

67

Avignon. Une Vue prise de Villeneuve-les-Avignon (Avignon Seen from Villeneuve-les-Avignon)

1836
Oil on canvas
13¼ × 28¾ in. (33.7 × 73 cm)
Signed lower right: COROT
The Trustees of the National Gallery, London NG 3237

R 328

In the summer of 1836 Corot's wanderings took him to Provence, where he painted with several friends: Gaspard Lacroix, a certain Francey, and Prosper Marilhat, who described their high spirits: "We got up at 4 in the morning . . . we worked until 11 o'clock; then we went back to eat up a storm. . . . After dinner we slept until 2, then we went out again until night. On return, more gluttony and then to bed."[1]

The schoolboy antics of these men in their forties obviously included hard work, and at Avignon Corot painted several oil studies of a stunning luminosity. Lionello Venturi was one of the art historians to call his 1836 Provence landscapes masterpieces: "The power of the lights and the shadows, the chromatic richness of the grays, a gentle wind of emotion that blows over everything, reveal that Corot had again struck a balance between the confidence of the craftsman and the imaginative, sensitive qualities of the artist."[2]

Robaut and Moreau-Nélaton mention six paintings Corot made during the trip.[3] The most successful of them is unquestionably this panoramic view of the city of Avignon, painted from Villeneuve-les-Avignon, on the opposite bank of the Rhone. In this work Corot recaptured the spirit of his Italian views. The disposition of light and volume is peerless—in the characteristically sketchy foreground, in the highly modulated center section that recalls the two views of Volterra (cat. no. 54), and especially in the treatment of the city's buildings, dominated by the Palace of the Popes, with the architectural forms powerful in the strong sunlight. The view is effectively constructed: the sinuous lines of a road at right correspond to the curves of the Rhone at left, while an isolated tree interrupts the composition's symmetry, enlivening the landscape (a device Corot often employed). Here once again Corot paints a panoramic view, this time related not to the Flemish and Dutch tradition but rather to the city views he himself painted in Genoa and Florence during his second trip to Italy. The same kind of framing of an extensive panoramic view appears in *Villeneuve-les-Avignon. Vue prise du midi en regardant le village* (fig. 67). A study in the Louvre (fig. 68) is done from a different vantage point.

The views Marilhat was painting at Avignon and Villeneuve-les-Avignon were similar enough to be confused later with Corot's work.[4]

VP

1. "Nous nous levions à 4 heures du matin . . . nous travaillions jusqu'à 11 heures; puis nous rentrions pour dîner comme des diables. . . . Après le dîner, nous dormions jusqu'à 2 heures, et alors nous repartions jusqu'à la nuit. Au retour, nouvelle bâfre et nous dormions." Prosper Marilhat, letter, quoted in Moreau-Nélaton 1924, vol. 1, p. 42.
2. "L'énergie des lumières et des ombres, la richesse chromatique des gris, un vent modéré de passion qui souffle sur toute chose, révèlent que Corot a retrouvé son équilibre entre la certitude de l'artisan et les qualités sensibles et imaginatives de l'artiste." Venturi 1941, p. 146.
3. The other five, all done from Villeneuve-les-Avignon, are *Vue prise du midi en regardant le village*, R 329, Indianapolis Museum of Art; *Vue prise d'Avignon*, R 330, Musée du Louvre, Paris; *Vue prise dans le jardin de l'hospice*, R 331, Musée du Louvre, Paris; *Le Fort Saint-André*, R 333, Museum Mesdag, The Hague; and *Études de cyprès*, R 334.
4. In the Musée des Beaux-Arts in Reims is a view of Avignon that was long attributed to Corot until Germain Bazin called for its reattribution to Prosper Marilhat.

PROVENANCE: Given by Corot to the painter Édouard Brandon in 1873 (according to Robaut); anonymous sale, March 23, 1877, as *Ville d'Italie*; purchased at that sale by Brame, Paris, for 1,400 francs; Ernest May, Paris; his sale, June 4, 1890, no. 21, sold for 7,100 francs; James Staats Forbes; Sir Hugh Lane, 1904?; Lane Bequest to The National Gallery, London, 1917

EXHIBITIONS: Dublin 1904, no. 53; London 1949–50, no. 180; Edinburgh, London 1965, no. 30

REFERENCES: Robaut 1905, vol. 2, pp. 116–17, no. 328; Venturi 1941, pp. 146–47, ill. p. 147; Escholier 1943, pp. 148–49; Fouchet 1975, p. 65, ill.; Leymarie 1979, pp. 60–61, ill.; Levey 1987, p. 233; Selz 1988, p. 106

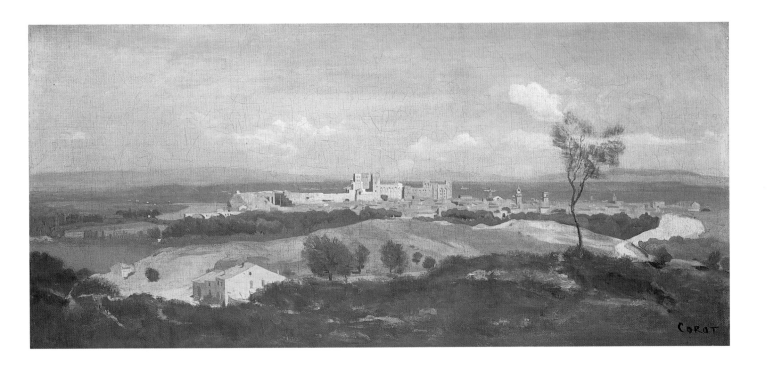

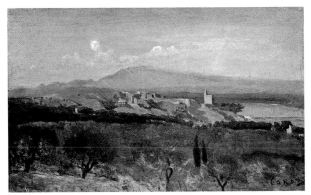

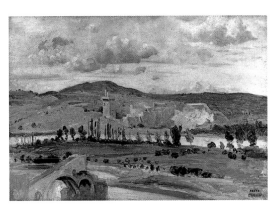

Fig. 76. Corot. *Villeneuve-les-Avignon. Vue prise du midi en regardant le village* (*Villeneuve-les-Avignon: View of the Village from the South;* R 329), 1836. Oil on canvas board, 10¼ × 16¾ in. (26 × 42.5 cm). Indianapolis Museum of Art, Legacy of James W. Fesler (IMA52.15)

Fig. 77. Corot. *Villeneuve-les-Avignon. Vue prise d'Avignon* (*Villeneuve-les-Avignon; View of Avignon;* R 330), 1836. 11 × 15¾ in. (28 × 40 cm). Musée du Louvre, Paris (R.F. 1610)

68

Carrière de la Chaise-Marie à Fontainebleau
(Quarry of the Chaise-Marie at Fontainebleau)

Ca. 1830–35
Oil on paper mounted on canvas
13¼ × 23⅛ in. (33.6 × 58.8 cm)
Signed lower right: COROT
Museum voor Schone Kunsten, Ghent 1914 D I

R 271

This study is among the most deliberate of those Corot executed in the forest of Fontainebleau, not only in the way volumes in the natural world are brought out by the light falling on them but also in the inclusion of human figures. While the Italian studies are generally organized only around a landscape, this painting is an investigation into how to integrate the human figure into a landscape painted in plein air. Once in the studio, Corot often added figures to studies he had made outdoors, but this landscape seems painted entirely from nature; the three figures depicted—the woman gathering wood in the center and the two figures high on the cliff—give the impression of having been painted on site at the same time as the landscape itself. (The work is on a paper support, which indicates that it was made outdoors.) Thus in this period Corot reached a new level. In his spring and summer sessions outdoors at Fontainebleau he was preparing for his winter work in the studio on paintings intended for exhibition at the Salon—pictures that would necessarily incorporate figures.

VP

PROVENANCE: Lévy-Bing sale, 1876; purchased at that sale by Galerie Fèbvre, Paris, for 1,000 francs; Galerie Tempelaere, Brussels, 1879; Chéréméteff collection, Paris; Chéréméteff sale, Paris, December 11–12, 1908, no. 7; purchased at that sale by F. Scribe for 3,750 francs; bequeathed by him to the Museum voor Schone Kunsten, Ghent, 1914

EXHIBITIONS: Venice 1952; Brussels, Liège, Luxembourg, Lille 1949; Bern 1960; Ghent, The Hague, Paris 1985–86, no. 13; Edinburgh 1986, no. 45

REFERENCES: Robaut 1905, vol. 2, pp. 96–97, no. 271, ill.; Thienen 1950, pp. 289–90; Chabot 1951, no. 37, p. 26; Leymarie 1966, ill. p. 47; Ghent, Museum voor Schone Kunsten 1967, pp. 112–13; Cauwels 1969, no. 5; Fouchet 1975, p. 65; Leymarie 1979, p. 43, ill.; Selz 1988, p. 98, ill.

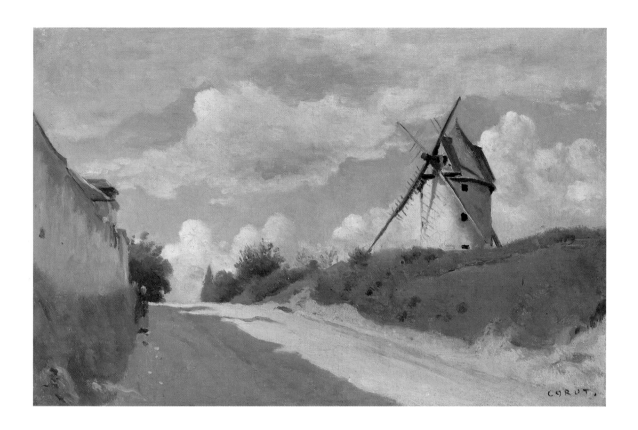

69

Moulin à vent sur la côte de Picardie (environs de Versailles) (Windmill on the Côte de Picardie, near Versailles)

Ca. 1835–40
Oil on canvas
9⅞ × 15½ in. (25 × 39.5 cm)
Signed lower right: COROT.
Ordrupgaardsamlingen, Copenhagen Cat. 1992, no. 6

R 343

Corot had friends in Versailles and must have visited the area rather frequently, but he appears to have taken only a limited interest in painting there. A painting of the parterre in front of the Grand Trianon is his only work connected with the palace complex; there are also a few studies painted or drawn on the outskirts of the town.[1] On a height known as the Côte de Picardie, outside the Porte de Versailles, was a series of windmills that attracted his attention, and these he painted on two different occasions quite separate in time. This picture in Copenhagen, the earlier of two studies of the subject, was manifestly painted on the spot. The work's supreme luminosity and the great simplicity of its expression well exemplify the qualities Corot's fellow artists are known to have admired in his plein air painting. One has the impression that an atmosphere and a sense of place have been conjured out of almost nothing. Comparison with the smaller and very different view

Fig. 78. Corot. *Moulins à vent jumeaux sur la Butte de Picardie, près de Versailles* (*Twin Windmills on the Hillside of Picardy, near Versailles*; R 861), ca. 1855–65. Oil on canvas, 7⅛ × 11⅜ in. (18 × 29 cm). Moreau-Nélaton Bequest, Musée du Louvre, Paris (R.F. 1631)

in the Louvre (fig. 78), sketched on a darker day some twenty years later, is instructive: there is the same economy of means and the same assurance of touch, but the effect of the later picture is more nervous.

1. *Carnet* 13 (R 3050), which dates from the later 1840s; see Robaut 1905, vol. 4, p. 89, no. 3050.

PROVENANCE: Dr. Georges Viau, Paris, 1905; Herman Heilbuth, Copenhagen; Winkel & Magnussen, Copenhagen, 1918; Wilhelm Hansen (1868–1936), Copenhagen, 1925; his wife, Hetty Hansen; her bequest to the Ordrupgaard-samlingen, Copenhagen, 1951

EXHIBITIONS: Geneva 1918, no. 32; Copenhagen 1918a, no. 9; Stockholm, Oslo 1919, no. 5; Copenhagen, Stockholm, Oslo 1928, no. 171 (Copenhagen), no. 9 (Stockholm); Paris 1936, no. 29; Lyons 1936, no. 24; Copenhagen 1957–58, no. 25a; Paris 1981, no. 5; Ghent, The Hague, Paris 1985–86, no. 12; Tokyo, Yokohama, Toyohashi, Kyoto 1989–90, no. 2

REFERENCES: Robaut 1905, vol. 2, pp. 120–21, no. 343, ill.; Bovy 1920, p. 12, ill. p. 3; Madsen 1920, p. 32, ill. p. 29; Petersen 1928a, pp. 121–30, ill.; Swane 1930, ill. p. 40; Faure 1936, ill. p. 19; Jamot 1936, ill. p. 13; Bazin 1942, p. 116, pl. 52; Marcus 1942, ill. p. 513; Borchsenius 1945, pp. 17–40, ill. p. 119; Vinding 1948, pp. 118, 119, ill. p. 119; Roger-Marx 1952, ill. p. 32; Swane 1954, no. 5, ill.; Copenhagen, Ordrupgaardsamlingen 1958, no. 5, pl. 4; Fosca 1958, ill. p. 90; Copenhagen, Ordrupgaardsamlingen 1973, no. 5; Brayer 1981, pp. 26–33, ill. p. 26; Copenhagen, Ordrupgaardsamlingen 1982, no. 6, ill.; Wivel 1993, p. 9, ill.

70

Moissonneuse tenant sa faucille (Harvester Holding Her Sickle)

1838
Oil on canvas
13⁷⁄₈ × 10⁵⁄₈ in. (35.3 × 27 cm)
Signed and dated lower left: C. COROT. 1838
Museum of Fine Arts, Boston
Bequest of William A. Coolidge 1993.36

R 380

This extraordinary figure, contemporary with the *Silène* (cat. no. 64), retains something of the jovial atmosphere of that larger composition, with a slightly teasing smile directed at the viewer. As Daniel Baud-Bovy observed, this may well be Corot's only depiction of a completely happy person.[1] The picture is remarkable on several counts, not least as the artist's earliest composition of a type: a half-length figure of a woman set against a landscape. He returned to this type with some frequency in years to come. More important, at the time it was painted the figure was one the most direct depictions of a peasant to be found in French art. No precedent exists in Corot's work, nor are there true precedents in the works of his contemporaries, though a remote kinship could be claimed to the work of Léopold Robert, whose highly romantic *Arrivée des Moissonneurs dans les Marais Pontins* (Musée du Louvre, Paris) had created a sensation at the Salon of 1831. If so, the initial impulse was so thoroughly transmuted as to become altogether new and original. An unusual parallel, probably not known to Corot, is found in Johann Friedrich Overbeck's *Vittoria Caldoni* of 1821 (fig. 79), which had left Rome before his arrival.

The inescapable impression that Corot's picture was painted in the open air gives the measure of his considerable ability in a genre new to him. He repeated the pose, with variations and apparently diminished effect, in an oval composition (R 663)

known to Robaut only from an unfinished copy.[2] A different *Moissonneuse* (R 662), in full costume and with a sickle, was probably the picture included by Corot in his sale of 1858. This work belonged briefly to Robaut, who, curiously, drew it, described the colors, and made no comment about it.[3]

1. Baud-Bovy 1957, p. 35.
2. See also Robaut *carton* 26, fol. 140.
3. Ibid., fol. 6.

PROVENANCE: Vicomte Léon Meinard; his sale, Hôtel Drouot, Paris, January 28, 1887, no. 5; purchased at that sale by Alfred Robaut for 350 francs; sold by him to Paul-Arthur Chéramy, 1889; Philippe de Saint-Aubin; Paul Rosenberg & Cie., Paris; Albert S. Henraux, Paris, 1942; William A. Coolidge, Topsfield, Massachusetts; bequeathed by him to the Museum of Fine Arts, Boston, 1993

EXHIBITIONS: Paris 1889, no. 158 bis; Paris 1928, no. 18; Paris 1936, no. 33; Lyons 1936, no. 27; Chicago 1960, no. 46; Edinburgh, London 1965, no. 38; New York 1969, no. 24; Yokohama, Chiba, Nara 1995, no. 9

REFERENCES: Hamel 1905, pl. 9; Robaut *carton* 26, fol. 6; Robaut 1905, vol. 2, pp. 140–41, no. 380, ill.; Meynell 1908, p. 209; Bouyer 1909, p. 300; Goujon 1909, p. 472; Lafargue 1925, pl. 18; Bernheim de Villers 1930a, no. 48; Fosca 1930, pl. 18; Faure 1931, pl. 31; Jean 1931, pl. 23; Bazin 1936, p. 50, fig. 31; Cooper 1936, p. 195; Jamot 1936, ill. p. 19; Baud-Bovy 1957, pp. 35, 109, 274, n. 21; Fosca 1958, ill. p. 68; Delahoyd 1969, p. 39; Leymarie 1979, pp. 92–94, ill.; Selz 1988, pp. 108–10, ill.; Sutton 1995, no. 14, ill.

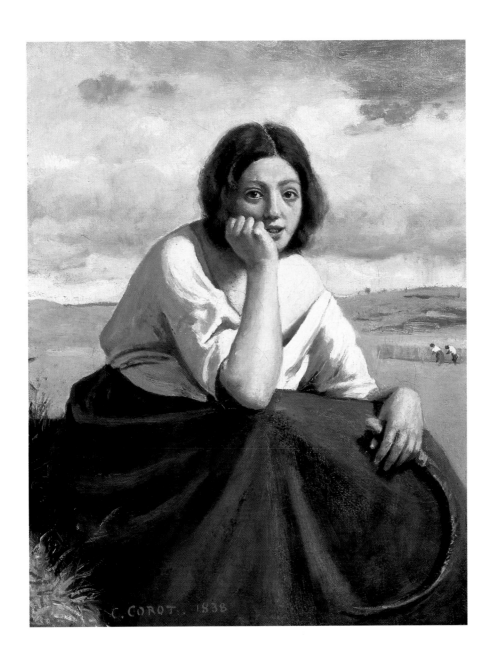

Fig. 79. Johann Friedrich Overbeck (1789–1869). *Vittoria Caldoni*, 1821. Oil on canvas, 35 × 25⅞ in. (89 × 65.8 cm). Bayerisches Nationalmuseum, Munich (WAF 757)

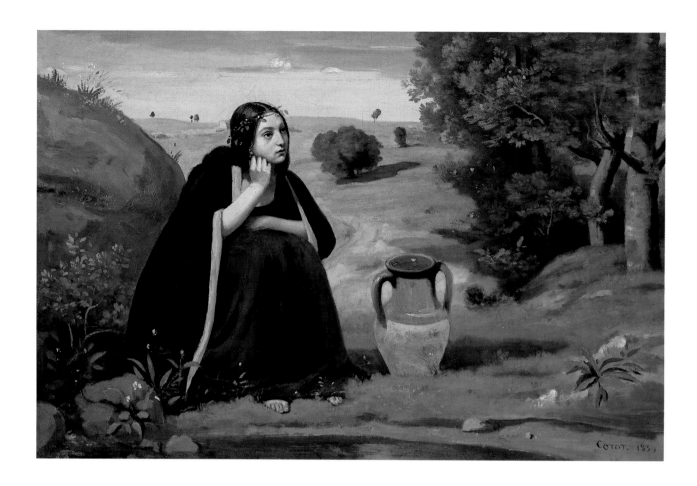

71

Rébecca

1839
Oil on canvas
19³⁄₄ × 29¹⁄₈ in. (50 × 74 cm)
Signed and dated lower right: COROT. 1839
The Norton Simon Foundation, Pasadena, California F. 1972.21.P

R 382

When the time came for his son Isaac to be married, Abraham
sent his servant Eliezer to Mesopotamia, the land of Abraham's
birth, to find a wife. As Eliezer approached the city of Nahor
in the evening he came to a spring, and there he met Rebecca,
Abraham's niece, the daughter of Bethu'el. She offered water
she had drawn for him and his camels to drink, and Eliezer,
grateful for her good deed and recognizing in her the bride
providence intended for Isaac, gave her a ring and gold bracelets.
The meeting of Eliezer and Rebecca has been depicted often,
more frequently than her marriage to Isaac, but Corot's inter-
pretation of the biblical episode is wholly novel in focusing
on Rebecca alone. Corot shows her seated near the spring, her
jar of water at her side. The bracelets are absent, but she wears
earrings, which Eliezer gives her in popular versions of the
narrative. The moment seems to be just after the meeting

Fig. 80. Corot. *Liseuse couronnée de fleurs*
(*Woman Crowned with Flowers, Reading*; R 389),
1845. Oil on canvas, 18¹⁄₈ × 13³⁄₄ in. (46 ×
35 cm). Bequest of Christian and Maurice
Robert, 1926, Musée du Louvre, Paris
(R.F. 2599)

with Eliezer, as Rebecca ponders the consequences of the encounter.

Nothing is known about the genesis of this work or the circumstances that led Corot to paint it. Of all his religious compositions up to that date, it was the first in which the figure so powerfully dominated the landscape. The picture can be read as the antithesis of *Agar* (cat. no. 61)—as a hopeful meditation on destiny. The pose of the young woman, adapted from the *Moissonneuse* of a year earlier (cat. no. 70), looks further back to Dürer's *Melancholia* and also to a series of modern variations by other artists, such as Léopold Robert's *Le Lendemain du tremblement de terre*, now at the Musée Condé, Chantilly. But here the drama is turned inward, as Rebecca's intense gaze concentrates on the vision of her as-yet-unknown future.

In November of 1883, when Robaut first saw the painting, he noted its "execution, very precise in every respect and as naive as can be. The master copied his model even to her earrings."[1] It is actually the figure and the jar that are quite carefully painted, although perhaps not as meticulously as Robaut perceived. The landscape is treated with remarkable freedom in almost every aspect, from the sky to the flowers sprinkled in the foreground. In 1845 Corot returned to the motif of a seated figure absorbed in thought in the *Liseuse couronnée de fleurs* (fig. 80), a more concentrated view of the subject in which the figure occupies almost the entire canvas.

1. "exécution très serrée de tous points et aussi naïve que possible. Le maître a copié jusqu'aux boucles d'oreille de son modèle." Robaut *carton* 26, fol. 6.

PROVENANCE: M. Chailloux, 1883; Manzi collection, Paris; Alphonse Portier, Paris, 1890 (who was asking 3,000 francs); Paul Gallimard, Paris; Jules Strauss; his sale, Paris, May 3, 1902, no. 12; purchased at that sale by Hazard for 9,000 francs; his sale, Paris, December 1–3, 1919, no. 75; purchased at that sale by Bernheim-Jeune & Cie., Paris, for 35,000 francs; D. David-Weill, Paris, 1936; Galerie Schmit, Paris, 1971; purchased by The Norton Simon Foundation, Los Angeles, 1972

EXHIBITIONS: Paris 1928, no. 20; Paris 1936, no. 36; Lyons 1936, no. 29; Paris 1971, no. 13; San Francisco 1973, no. 20

REFERENCES: Robaut *carton* 26, fol. 6; Robaut 1905, vol. 2, pp. 140–41, no. 382, ill.; Moreau-Nélaton 1924, vol. 2, p. 158, fig. 281; Fosca 1928, ill. p. 161; Anon. 1929, pp. 84–92; Meier-Graefe 1930, p. 58; Faure 1936, fig. 24; Fosca 1958, ill. p. 70; Anon. 1971, p. 59; Zimmermann 1986, pp. 91, 364, pl. 104; Selz 1988, ill. p. 126

72

La Blonde Gasconne (The Blonde Gascon)

Ca. 1850
Oil on canvas
15³/₄ × 11⁷/₈ in. (40 × 30.2 cm)
Stamped lower left: VENTE COROT
Smith College Museum of Art, Northampton, Massachusetts
Purchased 1934 1934:7

R 459 bis

The sitter's great beauty, the simplicity of the presentation, and a degree of stylization compatible with modern sensibility have made this painting one of Corot's most celebrated and popular representations of women. Yet the work is to a degree uncharacteristic. While Corot's female subjects often seem melancholy, this woman appears self-possessed, serene, and somewhat remote; her pose is perfectly still; her rounded arms and her features are idealized; her large eyes have a steady and hypnotic gaze. The figure, with a slightly undone bodice, is meant to fascinate, but her pose conveys detachment and a sense of distance. Corot apparently reworked the painting to heighten and concentrate the effect; previously the figure was in a landscape and the pentimento of a tree can be seen in the sky at the right. The nearest equivalent to what Corot may have originally intended is probably a *Moissonneuse* (R 662), said to be later, in which the woman is seated in a landscape with her arms held in the same way but with the pose reversed.

The picture belongs to a small group of similarly conceived works of apparently uncertain purpose, neither portraits nor allegorical figures, perhaps originating from the earlier *Moissonneuse* (cat. no. 70) but without a specific setting, such as a harvest, to provide a context. However, they may have been Corot's answer to female figures of the Venetian Renaissance of a type Palma Vecchio painted, as implied in Robaut's notes about Corot and the *Blonde Gasconne:* "It is made so that in seeing it, one cannot help but think of the masters he loved, such as Giovanni Bellini and Sebastian del Piombo."[1] Corot does not appear to have tried to sell any of these figures. At least one, *La Petite Jeannette* (R 459, private collection), was revised to enhance its erotic appeal. Corot also made drawings of the models, always dressed in simple skirts and blouses, as they were in his paintings.

La Blonde Gasconne remained in Corot's studio until his death, and he included it in a fictitious wall arrangement in two versions of the *Atelier* (cat. nos. 136, 137). The title of the painting

72

was not explained and the date is far from clear. At the posthumous sale it was listed with works of 1870–75, but in his copy of the sale catalogue Robaut noted, "placed here by mistake, since it dates from the quai Voltaire studio, ca. 1848–50."[2] But in his notes Robaut changed his mind: the original remark, "[18]48–51, au quai Voltaire," was crossed out and replaced by "[18]55–60."[3] Moreau-Nélaton retained Robaut's original date of about 1850, surely closer to the actual date.[4]

1. "Il est de fait qu'en la voyant, on ne peut s'empêcher de songer aux maîtres qu'il aimait tant, entre autres Jean Bellin et Sébastien del Piombo." Robaut *carton* 26, fol. 13.
2. "placé ici par erreur, car cela date de l'atelier du quai Voltaire, vers 1848–50." Robaut 1905, vol. 4, p. 213.
3. Robaut *carton* 26, fol. 13.
4. Robaut 1905, vol. 2, p. 166.

PROVENANCE: The artist; his posthumous sale, Hôtel Drouot, Paris, pt. 1, May 26–28, 1875, no. 185; purchased at that sale by Aimé-François-Désiré Diot for 520 francs; Bonnemaison-Bascle sale, May 3, 1890, no. 11; purchased at that sale by Leclanché for 1,400 francs; Bernheim-Jeune & Cie., Paris; Édouard Warneck-Sambon, Paris; Warneck sale, Hôtel Drouot, Paris, May 27–28, 1926, no. 91; purchased at that sale by Paul Cassirer, Amsterdam, for 180,000 francs; private collection, the Netherlands; Reid & Lefevre, London; Georges Keller, Paris; purchased by the Smith College Museum of Art, Northampton, Massachusetts, 1934

EXHIBITIONS: Paris 1923, no. 171; Cambridge 1934; London 1934, no. 12; Northampton 1934, no. 12; Cleveland 1936, no. 258; Hartford 1937, no. 36; New York 1937, no. 5; Buffalo 1938; Toronto 1938, no. 39; Montreal 1942, no. 53; Philadelphia 1946, no. 23; Worcester 1949; Toronto 1950, no. 13; Seattle 1951; New York 1953, no. 6; Winnipeg 1954, no. 37; New York 1956, no. 17; Chicago 1960, no. 65; Paris 1962, no. 36; Edinburgh, London 1965, no. 48; Waterville, Manchester 1969, no. 22; Washington et al. 1970–72, no. 12

REFERENCES: Robaut 1905, vol. 2, pp. 166–67, no. 459 bis, ill., and vol. 4, p. 213, no. 185; Bouyer 1909, pp. 295–306; Jamot 1925, pp. 50–52, pl. x; Bernheim de Villers 1930a, p. 44, no. 73, ill.; Mauclair 1930, pl. 48; Meier-Graefe 1930, p. 87; Abbott 1934, p. 4, ill. cover; Zander 1934, pp. 54–62, ill. p. 57; Zervos 1934, ill. p. 128; Abbott 1935a, p. 163, ill.; Abbott 1935b, pp. 3–9, ill. p. 2 and fig. 6; Faure 1936, pl. 32; Northampton, Smith College Museum of Art 1937, pp. 13–14, ill. p. 73; Bazin 1942, pp. 45, 118, no. 68, pl. 68; Northampton, Smith College Museum of Art 1953, no. 13, pp. iv, xix, ill.; Baud-Bovy 1957, p. 126; Chetham 1965, p. 74, ill.; Leymarie 1966, p. 77, ill. p. 73; Chetham 1969, p. 774, ill. p. 771; Bazin 1973, p. 284, ill. p. 190; Leymarie 1979, pp. 93, 95, ill.; Selz 1988, p. 162, ill. p. 163; Gale 1994, pp. 32–33, 86, ill. p. 87, as 185

73

Jeune Femme
(Young Woman)

1840–45
Oil on canvas
18⅞ × 15⅜ in. (47.9 × 39.1 cm)
Sterling and Francine Clark Art Institute, Williamstown,
Massachusetts 541

R 394

Robaut's original title for the work, *Ouvrière aux cheveux blonds frisés (Worker with Curly Blond Hair)*, suggested more than usual—although still not enough—about this figure, one of the most remarkable of Corot's early depictions of women. Much of the power of the image comes from the contrast between the

model's conventional pose and her intense expression. Its effect might be compared with that of *Moissonneuse tenant sa faucille* (cat. no. 70), except that in that work a cheerful, conspiratorial bond is implied between the subject and the viewer. Here the sitter looks upward just above the viewer's gaze, as if

unwilling or unable to establish contact. Her expression, if not altogether tragic, seems haunted by something of which the viewer is unaware.

The sitter's loose blouse was part of the costume Corot's models wore for studio sessions and is seen in many of his drawings. Robaut suggested that in this painting the blouse was meant to indicate the woman's class, but this hypothesis is difficult to confirm, especially since the picture's subject and intention are not certain. The painting does not seem to be a conventional portrait. Despite the woman's costume and her beauty, it would be difficult to regard the picture as a mildly provocative image like, for instance, *La Blonde Gasconne* (cat. no. 72). Rather, this may be one of Corot's early attempts at depicting a mood—here, melancholia, of which the slightly

disheveled costume is a traditional emblem. The sense of sadness is all the more convincing because the picture incorporates none of the conventional gestures, such as a hand to the forehead, that signify thought.

PROVENANCE: Gift of the artist to the Anastasi benefit sale, Hôtel Drouot, Paris, December 14, 1871, sold for 450 francs; anonymous sale, Hôtel Drouot, Paris, January 5, 1872, sold for 500 francs; Jules Paton, Paris, 1880; M. Knoedler & Cie., Paris; purchased by Robert Sterling Clark, 1919; given by him to the Sterling and Francine Clark Art Institute, Williamstown, Massachusetts, 1955

EXHIBITIONS: Williamstown 1956, no. 95; New York 1967b, no. 7

REFERENCES: Robaut 1905, vol. 2, pp. 142–43, no. 394, ill.; Williamstown, Sterling and Francine Clark Art Institute 1970, p. 6; Williamstown, Sterling and Francine Clark Art Institute 1972, p. 24, no. 541, ill.; Williamstown, Sterling and Francine Clark Art Institute 1992, p. 33, ill.

74

Jeune Femme assise, des fleurs entre les mains, also called *Madame Legois (Young Woman with Flowers in Her Lap)*

1840–45
Oil on canvas
21⅝ × 15¾ in. (55 × 40 cm)
Signed lower left: COROT
Österreichische Galerie im Belvedere, Vienna

R 381

According to Robaut, who noted the data without comment, this painting dates from 1838 and the sitter was a Mme Legois, about whom nothing is known. The work, however, is not dated, and recently Stephan Koja has ascribed it to 1840–45.[1] The woman has also been called "Marietta," the name of the Italian model who posed in 1843 for *L'Odalisque romaine* (cat. no. 85) and a name also attached, with no documentary evidence, to some of Corot's other figures. In spite of the specificity of the face, it is difficult to say if Corot intended the work as a portrait: the style, the pensive mood, and the pose, with the beautiful hands resting artlessly on the lap where a few flowers have dropped, are not in Corot's characteristic portrait mode and suggest an exercise in figure painting, bordering on genre or allegory, as in Jean-Louis Janmot's *Fleurs des champs*, exhibited at the Salon of 1845 (fig. 82).[2] The sitter's regional costume is an early indication of Corot's interest in finding substitutes for modern dress removed from any notion of fashion or time, something very evident in his later genre pieces. The costume's unexpectedly vivid shades of red and pink, colors of which Corot was very fond, were never again used so daringly either in isolation or in combination.[3] The effect is stupendous and enhances rather than detracts from the figure's essentially melancholy mood.

The background was originally a landscape.

1. Vienna, Österreichische Galerie 1991, p. 14.
2. There is a slight resemblance between the subject of this painting and the seminude model for the *Jeune Fille à la boucle d'oreille* (R 661) in the Burrell collection, Glasgow.
3. When asked during a question-and-answer game for his favorite color and flower, at Gruyères in 1855 or 1856 and again about 1872 at Alexis Rouart's, Corot answered "le et la rose" ("rose and the rose"). See Baud-Bovy 1957, p. 98.

PROVENANCE: The artist; his posthumous sale, Hôtel Drouot, Paris, pt. 1, May 26–28, 1875, no. 112; purchased at that sale by Martin for 510 francs (according to Robaut; sold to Paschal for 535 francs according to annotations in a copy of the sale catalogue in the library of M. Knoedler & Co., New York); Nicolas-Auguste Hazard, Orrouy; his sale, December 1–3, 1919, no. 73; purchased at that sale by Hessel for 59,100 francs; purchased by the Österreichische Galerie, Vienna, 1923, with the help of the Friends of the Museum

EXHIBITIONS: Exhibited by Corot in the provinces (according to Robaut); Paris 1883a, no. 27, as *Marietta*; Vienna 1930; Paris 1936, no. 34; Vienna 1936; Vienna 1951; Paris 1962, no. 21; Paris 1966a, no. 42

REFERENCES: Robaut 1905, vol. 2, pp. 140–41, no. 381, ill., and vol. 4, p. 204, no. 112; Vienna, Österreichische Galerie 1924, no. 61, ill.; Parker 1926, ill. p. 34; Bernheim de Villers 1930a, p. 43, no. 50; Meier-Graefe 1930, pl. XXIII; Vienna, Österreichische Galerie 1937, p. 14; Sérullaz 1951, pl. 6; Baud-Bovy 1957, p. 124; Fosca 1958, ill. p. 66; Dieterle 1959, pl. 15; Vienna, Österreichische Galerie 1966, p. 21, pl. 2; Vienna, Österreichische Galerie 1967, p. 7, ill. cover; Vienna, Österreichische Galerie 1991, p. 14, ill. p. 15

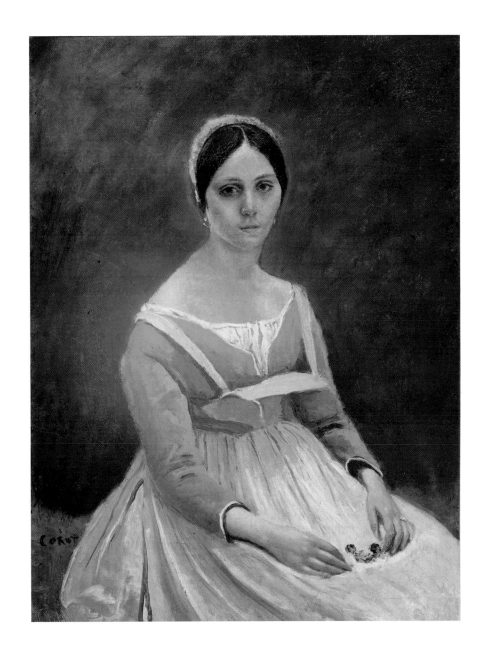

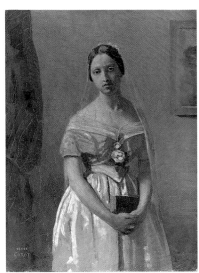

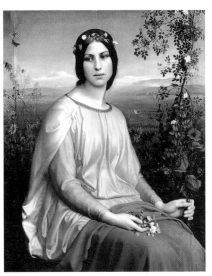

Fig. 81. Corot. *La Mariée* (*The Bride*; R 458 bis), ca. 1845. Oil on canvas, 12⅝ × 9½ in. (32 × 24 cm). Moreau-Nélaton Bequest, Musée du Louvre, Paris (R.F. 1634)

Fig. 82. Jean-Louis Janmot (1814–1892). *Fleurs des Champs* (*Wildflowers*), 1845. Oil on wood, 40½ × 32⅝ in. (103 × 83 cm). Musée des Beaux-Arts, Lyons (B-502)

Un Soir; paysage, also called *Le Batelier (effet de soir)* (Evening Landscape, also called *The Ferryman, Evening*)

1839
Oil on canvas
24⅝ × 40¼ in. (62.5 × 102.2 cm)
Signed and dated lower left: COROT. 1839.
Collection of the J. Paul Getty Museum, Malibu, California
84.PA.79

R 372

In 1839 Corot exhibited at the Salon two works, a *Site d'Italie* that has eluded identification and *Un Soir; paysage,* this painting. For the first time in four years he showed no work in which a figure or figures took center stage. Reviews followed the usual pattern, though it was the less ambitious work, *Un Soir,* that attracted more attention. As he had in the past, Étienne Delécluze complained that Corot's manner had become so unconstrained as to suggest deliberate carelessness, while Alexandre Barbier criticized the absence of color, and critics agreed that the overall cast of his work was somber indeed.[1] Théophile Thoré encapsulated the general opinion when he wrote: "M. Corot is an austere, meditative man who sees nature as being the same. He needed no lessons for this. Quite naturally he produces calm, sad paintings, full of thought and lofty in character. He has exhibited two small landscapes. *Le Soir* is a masterpiece for its quality of line and the gentle harmony of its light."[2] The anonymous reviewer of the *Journal des Artistes* also preferred *Un Soir;* and Théophile Gautier, who was more enthusiastic, described the painting in verse:

> See now how evening from the mount descends;
> The shadow darker grows, and wider too;
> The sky wears citrus tones on greenish hue;
> The sunset narrows, its border inward bends;
> The cicada hushes and the only sound
> Is water sighing as it splits and flows.
> All on the dozing world, the quiet hours
> Twist brown locks dampened by nocturnal tears.
> Scarcely enough daylight remains to see
> Your name, Corot, so modestly inscribed.[3]

In the absence of *Paysage; soleil couchant,* the lost painting that Corot exhibited in 1837, *Un Soir* becomes the earliest surviving work by Corot with a fully developed use of the dramatic lighting he first experimented with in *Vue prise à Riva* (cat. no. 59). More important, this painting is the first to introduce the theme of a boatman, one of the dominant motifs of his later work. The composition is uncommon in several respects: the elongated format, the bold asymmetrical design, the great contrasts of dark and light, the subtle curves that echo each other above and below the horizon line. Robaut's belief that the landscape was a *souvenir* of Lake Albano appears unfounded; it is likely

Fig. 83. Corot. *Vue d'Italie. Soleil levant (View of Italy, Sunrise),* 1839. Oil on canvas, 25 × 39⅞ in. (63.5 × 101.4 cm). The J. Paul Getty Museum, Malibu (84.PA.78)

that Corot had a different site in mind, very possibly spots along the Tiber and the Promenade du Poussin.[4] This theatrical, if gentle, depiction of twilight was probably intended as an antithesis to the other work Corot exhibited in 1839, the *Site d'Italie,* a majestic "Poussinesque landscape" that represented, according to Jules Janin, "a field burnt by the sun, a barren bush, some pigs, a shepherd in rags."[5] Janin's remark that *Un Soir* "provides little rest from that dust, that sun, that profound misery toward which the painter is merciless [in *Site d'Italie*]" suggests that the contrast was considerable.[6]

The first known owner of *Un Soir* was the great banker Moïse Millaud, but when he bought it is by no means clear. Corollary issues touch on the purchase by the duc d'Orléans of two other paintings by Corot in 1839. The identity of those works long remained elusive: Robaut was clearly unable to identify them, and Moreau-Nélaton mentioned them only in passing.[7] Hervé Robert's publications on the duke's collection confirm, however, that he bought for 1,000 francs each a *Vue d'Italie. Soleil levant* (63 × 100 cm) on May 4, 1839, and *L'Île de Capri* (54 × 80 cm) three days later.[8] *L'Île de Capri,* now lost and not catalogued by Robaut, was likely the *Vue prise dans l'île d'Ischia,* with Capri in the background, shown by Corot at the Salon of 1837. The *Vue d'Italie. Soleil levant (View of Italy, Sunrise),* virtually the same size as *Un Soir* and also dated 1839, is

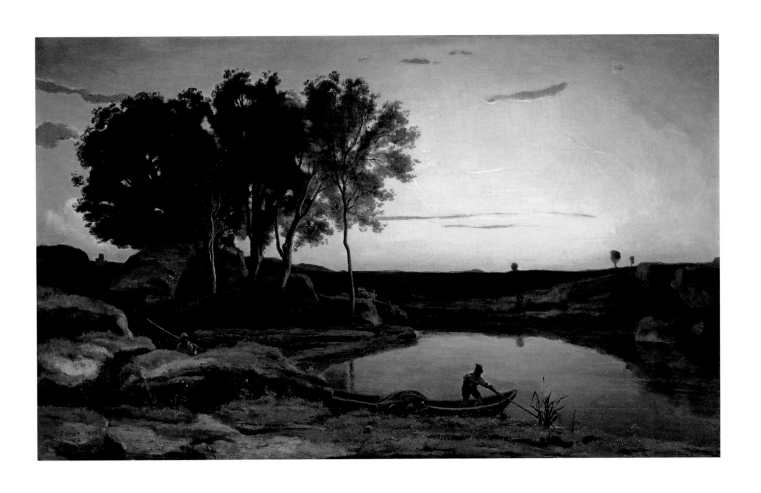

unquestionably a painting unknown to Robaut that is now in the Getty Museum (fig. 83). In 1985 it was proposed, with some reason, that the two Getty paintings are pendants, and, more speculatively, that they were the paintings exhibited together in 1839.[9] But if Janin's description of the work shown in 1839 is accurate, it would rule out the possibility of identifying *Vue d'Italie. Soleil levant* with the *Site d'Italie* of 1839.[10]

That the two pictures in the Getty Museum were intended as pendants depicting different times of the day has been convincingly argued by Fronia Wissman.[11] One suspects, however, that the *Vue d'Italie. Soleil levant* preceded *Un Soir* by some years and was signed and dated in 1839 only when it was bought by the duc d'Orléans. Its style is closer to the *Vue prise à Narni* (cat. no. 27) of 1827 than to anything Corot painted in the late 1830s. Interestingly, the drawing associated with the Narni painting has, like these two paintings, an elongated horizontal format which does not conform to the final proportions of the painting, and contains a herd of cows crossing the river. Robaut recorded under the title *Villa Bella (esquisse)* (R 634) a preparatory study for *Vue d'Italie. Soleil levant* that he later owned; according to him, on the back of the study was a sketch of Saint-Lô, which Corot visited in 1833 and was not to visit again until the 1860s.[12]

1. Delécluze 1839; Barbier 1839, p. 139.
2. "M. Corot est un homme austère et méditatif, qui comprend ainsi la nature. Il n'a pas besoin de se faire la leçon pour cela. Il produit tout naturellement de la peinture calme, triste, pleine de pensée et d'élévation. Il a exposé deux petits paysages. *Le Soir* est un chef-d'oeuvre pour le caractère du dessin et la douce harmonie de la lumière." Thoré 1839.
3. "Mais voici que le *soir* du haut des monts descend;
 L'ombre devient plus grise et va s'élargissant;
 Le ciel vert a des tons de citron et d'orange;
 Le couchant s'amincit et va plier sa frange;
 La cigale se tait et l'on n'entend de bruit
 Que le soupir de l'eau qui se divise et fuit.
 Sur le monde assoupi les heures taciturnes
 Tordent leurs cheveux bruns mouillés de pleurs nocturnes.
 À peine reste-t-il assez de jour pour voir,
 Corot, ton nom modeste écrit dans un coin noir."
 Gautier 1839, cited in Robaut 1905, vol. 1, p. 85.
4. Robaut made a drawing of the painting and tracings of the two figures on May 25, 1872, giving it the title *Souvenir du lac d'Albano. Campagne de Rome.* Robaut *carton* 16, fol. 448.
5. "un terrain brûlé du soleil, un buisson stérile, des pourceaux, un berger en guenilles." Janin 1839, p. 271. See also Huard 1839, p. 186: "a Poussinesque landscape depicting an *Italian Site . . .* by M. Corot; its composition is severe, its lines beautiful and grand, its effect majestic. The only thing it might lack is a little finesse. The *Soir . . .* is another charming landscape: M. Corot has an austere talent and a very good understanding of what is called the historical style." ("un paysage poussinesque représentant un *Site d'Italie . . .* par M. Corot; la composition en est sévère; les lignes belles et grandes; l'effet en est majestueux; il ne lui manque peut-être qu'un peu de finesse; le *Soir . . .* est encore un charmant paysage: M. Corot possède un talent sévère et comprend très bien le style dit historique.")
6. "vous repose quelque peu de cette poussière, de ce soleil, de cette misère profonde pour laquelle le peintre est sans pitié." Janin 1839, p. 271.
7. Moreau-Nélaton 1924, vol. 1, p. 86. Robaut's annotated copy of Victor Frond's short monograph on Corot of 1865, in the Bibliothèque Nationale de France, shows he assumed Frond made a mistake when he listed among Corot's works "two *Views of Italy* that were once in the duc d'Orléans's gallery." Robaut's comment was, "Where has that been seen before? *Nowhere.*" ("deux *Vues d'Italie* qui on fait partie de la galerie du duc d'Orléans"; "Où a-t-on vu cela? *Nulle part.*")
8. See Robert 1991, pp. 47, 52, 58, n. 98, where it is said that *Vue d'Italie. Soleil levant* was bought at the Salon of 1839, and Robert 1993, pp. 93, 108, n. 41. Dimensions are given in the sale catalogue of the Orléans collection, Paris, January 18, 1853: no. 12, *L'Île de Capri* (sold to Delannoue for 700 francs) and no. 13, *Vue d'Italie. Soleil levant* (sold to de Saint-Aignan Boucher for 2,200 francs).
9. Anon. 1985, pp. 212–13, nos. 145, 146; Wissman 1989, pp. 47–49.
10. It may be added that Robaut's identification of the *Site d'Italie* of 1839 with a work dated 1839 (R 371) now belonging to The Norton Simon Foundation, Pasadena, also conflicts with Janin's review.
11. Wissman 1989, pp. 47–49, 198.
12. For the dating of Corot's views of Saint-Lô, see Hélène Toussaint in Paris 1975, no. 30.

PROVENANCE: Moïse Millaud, Paris; his sale, Charles Vignals auctioneer, 51, rue Saint-Georges, Paris, May 27–29, 1872, no. 1, sold for 3,000 francs; anonymous sale, Hôtel Drouot, Paris, May 8, 1875, no. 48, sold for 4,150 francs; Laurent-Richard collection, Paris; Laurent-Richard sale, Hôtel Drouot, Paris, May 23, 1878, no. 5, as *Le Soir*; purchased at that sale by Vernon for 3,000 francs, until at least 1878; Moreau-Chaslon collection; Moreau-Chaslon sale, Hôtel Drouot, Paris, February 6, 1882, no. 13, as *Coucher de soleil sur le lac d'Albano,* sold for 10,000 francs; the comte Armand Doria, Paris; thence by descent to an unidentified owner; purchased by the J. Paul Getty Museum, Malibu, California, 1984

EXHIBITIONS: Paris (Salon) 1839, no. 404, as *Un soir; paysage*; Paris 1878b, no. 128, as *Le Soir. Souvenir d'Italie,* lent by Vernon; Manchester, New York, Dallas, Atlanta 1991–92, no. 15 (New York, Dallas, Atlanta only)

REFERENCES: Frond 1865, p. 2; Hamel 1905, p. 20; Robaut *carton* 16, fol. 448; Robaut 1905, vol. 1, pp. 85–86, and vol. 2, pp. 136–37, no. 372, ill.; Baud-Bovy 1957, p. 86, as *Site d'Italie*; Anon. 1985, pp. 212–13, no. 145, ill.; Frederickson 1985, p. 268

Paysage; soleil couchant, also called *Le Petit Berger* (*Landscape, Setting Sun*, also called *The Little Shepherd*)

1840
Oil on canvas
54 × 43¼ in. (137 × 110 cm)
Signed lower left: COROT
La Cour d'Or, Musées de Metz 13.523

R 374

Intimations of a new, more poetic direction, evident in *Un Soir; paysage* (cat. no. 75) in 1839, were fully realized in 1840 when Corot sent *Paysage; soleil couchant* to the Salon. In many respects this work was a milestone in his career and brought him his greatest success since *Agar dans le désert* (cat. no. 61). The painting, one of three he exhibited at the Salon that year,[1] was derived—as noted by Robaut—from a study of trees painted at Volterra in the summer of 1834 (R 306), which he adapted in reverse and substantially transformed. To the right a great rock serves as a stage for a nude (thus antique) shepherd, who plays a pipe while his goats roam freely. The twilight illumination is one that Corot would increasingly favor, leading Baudelaire to observe, "One gets the impression that for him, the light that shines down on the world is dimmed by one or two shades."[2] The mood and format of the painting have been likened to those of the *Paysage champêtre* by Claude Lorrain in the National Gallery, London (fig. 84), which Corot could have known from engravings. Claude may have supplied a direction rather than an actual model, as a critic noted in 1840: "M. Corot's *Setting Sun* is reminiscent of the finest pieces by Claude Lorrain and Vernet. . . . I am sure no one will accuse me of mere infatuation, for this work has inspired widespread acclaim."[3]

Jules Janin was the first to associate the painting with the bucolics of Theocritus, the Greek poet of the third century B.C.:

> So it is that you stop first before a certain Corot landscape that reminds you of the gentlest idyll of Theocritus, one of those charming dramas between two rival shepherds reciting verses, enacted to the sound of a flute and the bleating of sheep. Obviously M. Corot's landscape was inspired by antiquity: the trees are slender and willowy; the prairie, a bit dry but tufted and fertile, stretches into the distance; the goats in the herd, capricious and whimsical, nibble on flowering laburnum. . . . At a crossing in the forest, standing atop a small mound like some ancient statue, the goatherd, a comely youth, is playing the flute. . . . You cannot believe how much M. Corot's painting recalls the happy images of Grecian idylls, how filled it is with grace and tranquillity![4]

Another critic stressed Corot's originality and his "rare quality of having a sense of style, color, and arrangement that are his alone and no one else's."[5] This opinion was echoed by Charles Blanc: "M. Corot follows no one's dictates but his own. I would wager that in the realm of painting no one else has

Fig. 84. Claude Lorrain (1604/5?–1682). *Paysage champêtre (Rustic Landscape)*, ca. 1636. Oil on canvas. National Gallery, London (58)

understood the idyll the same way. . . . There is an inexpressible refinement of sensuality in the appearance of this temperate nature, in which reality blends marvelously with the ideal."[6]

The painting was not to everyone's taste, and the critic Alphonse Royer, in a diatribe against the "the parodists of Poussin, dreamers of the mystic landscape," singled out Corot for his "stance of premeditated revolt against any principle of color or line. His skies are green, his faces raw sienna, his trees are shaped like plumes. No. 308, entitled *Soleil couchant*, is a kind of rough sketch that looks as if it was brushed in on a dare with whatever was left on his palette. By accepting this incredible piece, the Beaux-Arts jury has been quite unjust to its author."[7] The work's critical success nevertheless ensured its purchase by the state and its transfer in 1841 to the Musée de Metz at the request of a M. Lucy, the collector-general of the department of Moselle.[8] Corot repeated the composition in 1855–56 in a series of three *cliché-verre* plates of increasingly darker tone.[9] A same-size copy of the painting signed and dated 1850, not recorded in Robaut, was included in the Corot exhibition in Chicago in 1960.[10]

The connection with Theocritus suggested by Janin, who knew Corot well, most probably came from the artist himself. Corot owned a copy of *Idylles de Théocrite*, an edition in Greek, Latin, and French published by Gail in 1792. Later he lost it, and in an 1853 letter to Ernestine Clerc de Landresse, daughter of a librarian at the Institut, he wrote that he had asked her father to find him a replacement.[11]

1. The other two were *La Fuite en Égypte* (R 369) and *Un Moine* (R 375).
2. "On dirait que pour lui toute la lumière qui inonde le monde est partout baissée d'un ou de plusieurs tons." Baudelaire, "Salon de 1859," in Baudelaire 1923, p. 337.
3. "Le *Soleil couchant* de M. Corot nous a rappelé les belles pages de Claude Lorrain et de Vernet.... Certes, on ne nous accusera pas d'engouement pour cette production qui a excité l'admiration générale." Mac'Carthy 1840, p. 210.
4. "C'est ainsi que vous vous arrêtez tout d'abord devant un certain paysage de Corot, qui vous rappelle les plus douces idylles de Théocrite, ces drames charmants qui se passent au son de la flûte, au bêlement des agneaux, entre deux bergers rivaux qui récitent des vers. Évidemment ce paysage de M. Corot est une inspiration de l'antiquité; les arbres sont élancés et sveltes; la prairie un peu desséchée, mais touffue et féconde, s'étend au loin; les chèvres du troupeau, capricieuses et fantasques, broutent du bout des dents le cithyse en fleurs.... Au carrefour de la forêt, debout sur un tertre, comme une statue antique, le chèvrier, qui est un beau jeune homme, joue de la flûte.... On ne saurait croire combien le tableau de M. Corot nous a rappelé ces heureuses images de l'idylle grecque, tant il est rempli de grâce et de repos!" Janin 1840b, pp. 254–55.
5. "rare qualité d'avoir un style, une couleur, une disposition, qui sont à lui et non à d'autres." Anon. 1840 (St. L.).
6. "M. Corot ne procède que de lui-même. Je ne gage pas que dans le domaine de la peinture personne aît compris l'idylle de cette manière.... Il y a un raffinement inexprimable de volupté dans l'aspect de cette nature attiédie où la réalité se confond merveilleusement avec l'idéal." Blanc 1840.
7. "parodistes de Poussin, des rêveurs du paysage mystique"; "parti-pris d'insurrection préméditée contre tout principe de couleur et de dessin. Les ciels sont verts, les visages humains terre de sienne, les arbres affectent la forme de plumets. Le n° 308, intitulé *Soleil couchant*, est une espèce d'esquisse première qu'on croirait brossée, par suite d'un défi, avec les restes d'une palette. En acceptant cet incroyable morceau, le jury des Beaux-Arts s'est montré bien sévère pour son auteur." Royer 1840.
8. Anon. 1841a, p. 34; Anon. 1841b, p. 91.
9. Delteil 1910, no. 49 (R 3170), no. 50 (R 3172), no. 62 (R 3183).
10. See Chicago 1960, no. 7, ill., and the sale, Parke-Bernet, New York, April 17, 1969, no. 96, ill.
11. See Robaut 1905, vol. 4, p. 334, no. 46.

PROVENANCE: Purchased for 1,500 francs by the state for the Musée de Metz, 1841

EXHIBITIONS: Paris (Salon) 1840, no. 308, as *Paysage; soleil couchant*; Paris 1936, no. 40; Lyons 1936, no. 32; Edinburgh, London 1965, no. 37

REFERENCES: Blanc 1840, p. 358; Delécluze 1840; Gautier 1840; Janin 1840a, p. 123; Janin 1840b, pp. 165, 254–55, ill. p. 231 (lithograph by Français); Mac'Carthy 1840, p. 210; Planche 1840; Royer 1840; Anon. 1841b, p. 91, as *Berger d'Arcadie*; Anon. 1841c, p. 77, as *Berger d'Arcadie*; Anon. 1841e, p. 301; *Annuaire* 1875, ill. (etching by A.-P. Martial); Robaut 1905, vol. 2, pp. 138–39, no. 374, ill.; Moreau-Nélaton 1924, vol. 1, pp. 48, 49, fig. 70; Lafargue 1925, p. 32; Meier-Graefe 1930, pp. 50, 52, pl. XXV; Faure 1936, fig. 26; Jamot 1936, p. 15, ill. p. 16; Baud-Bovy 1957, p. 86; Fosca 1958, p. 24, ill. p. 69; Leymarie 1979, p. 66; Wissman 1989, pp. 53–56; Gale 1994, p. 25

77

Site des environs de Naples (View near Naples)

1841
Oil on canvas
27¾ × 43 in. (70.5 × 109.2 cm)
Signed and dated lower left: COROT. 1841.
Museum of Fine Arts, Springfield, Massachusetts
The James Philip Gray Collection 34.01

R 377

This painting was upstaged at the Salon of 1841 by Corot's *Démocrite et les Abdéritains* (cat. no. 78). The reviewer for *L'Artiste*, usually well disposed toward Corot, nevertheless observed that it was "commendable for its very fine detail, but one would like to see a bit more polish and especially a little more sun."[1] Étienne Delécluze, often hostile, had a similar objection to both paintings but admitted that "although M. Corot's works are executed with, if not negligence, too much indifference to detail, there is always something about them that catches the viewer's notice and attracts him. Usually the piece as a whole exudes a feeling of the outdoors, the smell of woods, in other words the sense of a real countryside that charms the imagination, even if the eye is not wholly satisfied."[2] On the other hand, Louis Peisse thought that, as with Aligny, Corot's purity

Fig. 85. Richard Earlom (1743–1822) after Claude Lorrain (1604/5?–1682). *Paysage, la danse (Landscape, the Dance)*, 1775. Engraving. National Gallery of Canada, Ottawa

of style could be mistaken for coldness and his simplicity could result in his paintings' going unnoticed.[3]

In retrospect, *Site des environs de Naples* has a particular significance in Corot's work as, in Robaut's words, the "painting that inaugurates the new era of 'joyful Corots,' if I may be allowed the expression."[4] Freed from the constraints of a serious subject, he composed an imaginary coastal site that owes little to Naples proper, with figures engaged in a rustic dance. The painting is also the first major work to show Corot's highly idiosyncratic manner of grouping trees according to almost mathematical rhythms: here there appear, from right to left, a large clump with branches almost joining at the top, next a group of thin, wispy trees, then another, more substantial group.

As in *Agar* (cat. no. 61) and *Démocrite*, the foreground of the composition is plunged into shadow, and the middle ground and background are strongly lit. The movement from dark to light is remarkable, and it is perhaps this painting rather than the *Démocrite* that Eugène Pelletan remembered when he wrote that no one since Claude Lorrain had observed light better than Corot.[5] Corot's debt to Claude has been pointed out: the composition is distantly related to Claude's *Marriage of Isaac and Rebecca* in the National Gallery, London, which he probably knew from engravings (for another Claude composition of somewhat similar type reproduced in an engraving, see fig. 85).[6] The principal motif—dancers performing in a landscape—had enjoyed a revival toward the end of the eighteenth century. It was used, for example, in a painting Jean-François Hue exhibited at the Salon of 1787[7] and, closer to Corot, in Achille-Etna Michallon's *Paysage inspiré d'une vue de Frascati*, shown at the Salon of 1822 (fig. 8). Vincent Pomarède notes that Corot copied the painting by Michallon when he was already an established artist.[8]

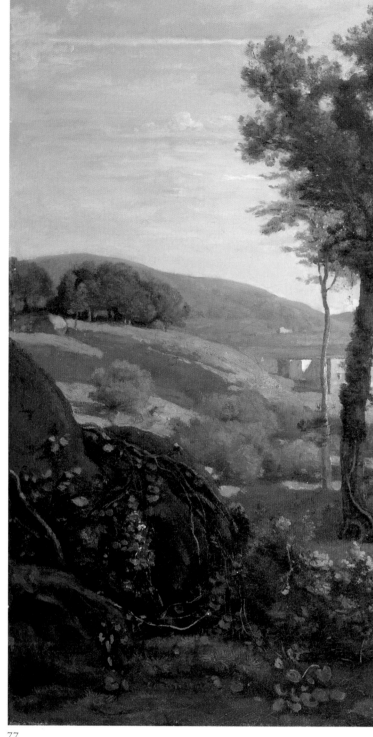

77

1. "se recommande par des détails très-fins, mais où l'on désirerait un peu plus de fini, et surtout un peu plus de soleil." Anon. 1841e, p. 301.

2. "Bien que les ouvrages de M. Corot soient exécutés, non pas avec négligence, mais avec une indifférence trop marquée des détails, ils ont toujours un aspect qui frappe et attache; il règne ordinairement dans le tout ensemble un sentiment du plein air, de l'odeur des bois, du vrai paysage, en un mot, qui charme l'imagination, bien que les yeux ne soient pas toujours complètement satisfaits." Delécluze 1841.

3. Peisse 1841.

4. "premier tableau inaugurant l'ère nouvelle des 'Corot à la joie' si je puis ainsi dire." Robaut *carton* 16, fol. 454.

5. Pelletan 1841.

6. Wissman 1989, p. 51.

7. *Le Temple de la Sibylle & la campagne de Tivoli, éclairés au soleil couchant: on y voit une danse de Paysans, appellée la Tarentaine;* Salon of 1787, no. 88; now in a private collection, Washington, D.C. For an early Claude of similar subject and a composition in a Neapolitan setting by Joseph Rebell dated 1819, see Munich 1983, nos. 3, 82, ill.

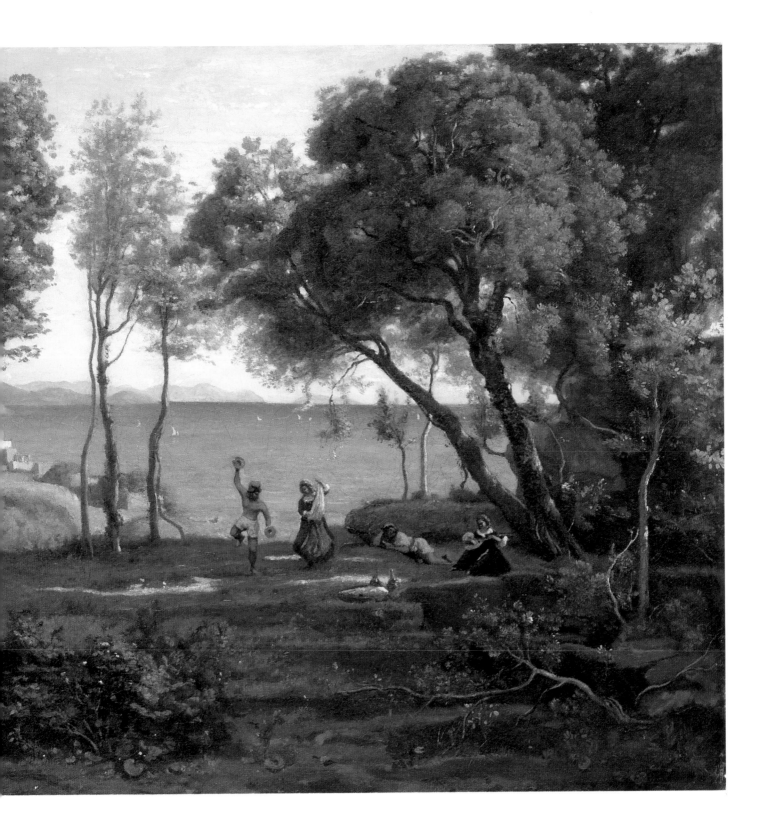

8. Corot's copy is R 198 (not illustrated). See also Vincent Pomarède in Paris 1994, p. 122; and the sale, Drouot Montaigne, Paris, October 19, 1995, no. 6, ill.

PROVENANCE: Gift of the artist to Louis Robert, Mantes; Robert family, until about 1926; Paul Rosenberg & Cie., Paris, 1928; Wildenstein & Co., New York; purchased by the Museum of Fine Arts, Springfield, Massachusetts, 1934

EXHIBITIONS: Paris (Salon) 1841, no. 398, as Site des environs de Naples; Paris 1928, no. 21; New York 1930c, no. 16; Saint Louis 1931, no. 4; Los Angeles 1933, no. 41; Chicago 1934, no. 169; Northampton 1934, no. 10; Springfield 1935, no. 5; Paris 1936, no. 42; New York 1942, no. 20; Philadelphia 1946, no. 19; Pomona 1950; Montreal 1952, no. 43; New York 1956, no. 14; Washington 1956–57, no. 12; Houston 1959, no. 1; Chicago 1960, no. 55; New York 1963, no. 16; Tokyo, Kobe, Sapporo, Hiroshima, Kitakyushu 1980; New York 1986, no. 12; San Diego, Williamstown 1988, no. 13; Tokyo, Osaka, Yokohama 1989–90, no. 12; Manchester, New York, Dallas, Atlanta 1991–92, no. 17 (Manchester and New York only)

REFERENCES: Anon. 1841d, p. 195; Anon. 1841e, p. 301; Delécluze 1841; Robaut 1905, vol. 2, pp. 138–39, no. 377, ill.; Moreau-Nélaton 1924, vol. 1, p. 51, pl. 76; Régamey 1928, p. 151, ill. p. 146; Burrows 1930, p. 452, ill. p. 453; Meier-Graefe 1930, pl. XXIX; Bazin 1942, no. 63, pl. 63; Baud-Bovy 1957, p. 86; Roberts 1965, p. 43, pl. 27; Bazin 1973, p. 283, ill. p. 182; Leymarie 1979, p. 66, ill. p. 68; Selz 1988, p. 128; Wissman 1989, pp. 4, 50, 51; Clarke 1991a, p. 74, fig. 78; Leymarie 1992, p. 81, ill. p. 82; Gale 1994, pp. 25, 29, 74, ill. p. 75

78
Démocrite et les Abdéritains; paysage (Democritus and the Abderites)

1841
Oil on canvas
65 × 51⅝ in. (165 × 131 cm)
Signed and dated bottom, center: COROT. 1841.
Musée des Beaux-Arts, Nantes 871

R 376

The subject is derived from La Fontaine's treatment of a Greek story about the philosopher Democritus of Abdera. Although celebrated by his fellow citizens, Democritus laughed at the vanity of humankind and withdrew to the solitude of meditation and study. Slighted and fearing he might be mad, the Abderites sent the physician Hippocrates to determine his state of mind. When Hippocrates met the philosopher, he declared that Democritus was sane and his enemies mad. Corot depicts the moment when Hippocrates arrives and finds Democritus

'Neath foliage dense, and seated by a stream.
The furrows of a brain
Were on his mind, and books lay at his feet,
Thus, scarcely did he see his friend approach. . . .[1]

The same subject had been depicted in a very different fashion by Corot's teacher Michallon in a work of 1817 that won the first Prix de Rome for historical landscape (fig. 7).

Germain Bazin and Hélène Toussaint have observed that the story of Democritus echoed Corot's own circumstances, a connection intimated earlier by Henri Ténint, who wrote in 1841: "A happy man, this Democritus, who could laugh at the poverty and vices of the Abderites. . . . Oh, yes! if life did not make you cry, it would certainly make you laugh. But for the student of Leucippus, living today would be too demanding a task; his laughter would turn into a veritable death rattle in these times, when great words have become the stilts of little thinkers and great vices the stilts of little nobodies." He went on to say that the picture had been conceived and visualized "with the rare simplicity of a man who loves nature and sees it as beautiful. Too bad for those who seek in his landscapes the banal qualities that assure the success of other landscape artists: they do not understand the extent of M. Corot's talent."[2]

The implications of this subject were also brought up by the anonymous reviewer for *L'Artiste*, who observed, "After all, M. Corot could have called this character Saint Jerome or any other saint [sic] in the Thebaid, and his composition would have worked just as well; but that is only a minor issue. Despite the adaptability of the subject to any cast of characters, there still remains in this work of an artist who is enthusiastic by nature, although skeptical and irresolute by virtue of his modesty, an indefinable feeling of poetry that alone would compensate for much more serious imperfections."[3]

Unexpectedly, *Démocrite et les Abdéritains* was very much admired at the Salon. For the reviewer of *Le Siècle*, the painting was a "beautiful piece, filled with truth, calm, and melancholy,"[4] while Eugène Pelletan observed:

No painter since Claude Lorrain has studied light better. M. Corot seeks out not only the shape, the line, in a word the anatomy of nature, but also the very life of the landscape, the attitudes of the trees, the different ways that leaves move, the smoke that fills a glade at certain hours of the evening, the diversity and value of the tones in relation to each other. Without making the landscape into a kind of architecture dominated by symmetry, where the hand of man eclipses the hand of God, he has managed to strike a balance between the ideal, which is the painter's soul, and the reality that is nature. All of M. Corot's qualities are united in the great landscape that he is exhibiting this year.[5]

Toussaint observed that the landscape is constructed on the same principles as that in *Diane surprise au bain* (cat. no. 63) of five years earlier.[6] Here, however, the trees form a screen in the foreground and the overall tonality is darker.

1. "Sous un ombrage épais, assis près d'un ruisseau, / Les labyrinthes d'un cerveau / L'occupoient. Il avoit à ses pieds maint volume, / Et ne vit presque pas son ami s'avancer." La Fontaine 1954, p. 213.
2. "L'heureux homme que ce Démocrite qui riait tant de la misère et des vices des Abdéritains. . . . Oh! oui, si la vie ne faisait pas pleurer, elle ferait bien rire. Mais pour l'élève de Leucippe, vivre aujourd'hui, ce serait métier trop rude; son rire deviendrait un véritable râle par ce temps où les grands mots sont les échasses des petits penseurs et les grands vices les échasses des petites nullités." "avec la simplicité rare de l'homme qui aime la nature et qui la voit belle. Tant pis pour ceux qui cherchent dans ses paysages les qualités banales qui font le succès d'autres paysagistes: ils ne comprennent pas l'élévation du talent de M. Corot." Ténint 1841, pp. 36–37.
3. "Après tout, M. Corot aurait appelé ce personnage saint Jérôme, ou tout autre saint de la Thébaïde, que sa composition s'y fût tout aussi bien prêtée; mais ce n'est là qu'une question secondaire, et la complaisance du sujet à tolérer toute substitution de personnes une fois admise, il restera toujours dans cette oeuvre d'un artiste enthousiaste de sa nature, bien que sceptique et irrésolu par modestie, un sentiment de poésie indéfinissable qui suffirait seul à racheter de bien plus graves imperfections." Anon. 1841e, p. 301.
4. "belle page pleine de vérité, de calme, et de mélancolie." Bourgeois 1841.
5. "Depuis Claude Lorrain, aucun peintre n'avait mieux étudié la lumière. M. Corot ne cherche pas seulement la forme, la ligne, l'anatomie en quelque sorte de la nature, mais bien la vie du paysage, les attitudes des arbres, la variété de l'animation du feuillage, les fumées qui remplissent les clairières à certaines heures du soir, la diversité et la valeur de tons, des uns par rap-

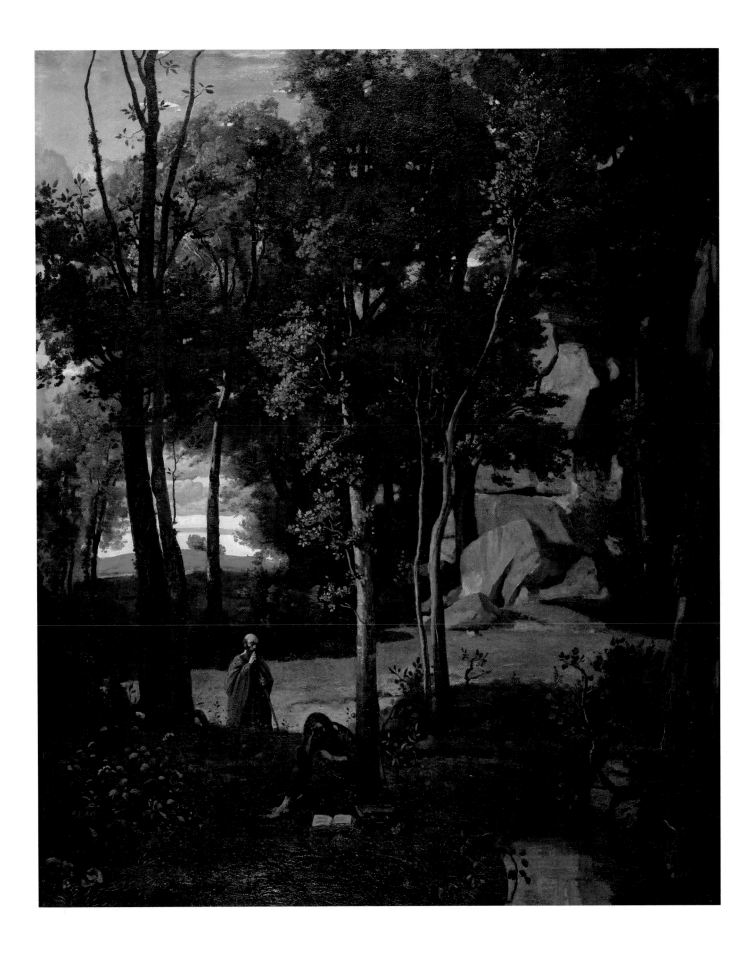

port aux autres. Sans faire du paysage une sorte d'architecture où la symétrie domine, où la main de l'homme efface la main de Dieu, il a su garder l'équilibre entre l'idéal, qui est l'âme du peintre, et la réalité, qui est la nature. Toutes les qualités de M. Corot se trouvent réunies dans le grand paysage qu'il expose cette année." Pelletan 1841.

6. Toussaint in Paris 1975, no. 69.

PROVENANCE: Purchased for 1,500 francs by the city of Nantes from the Exposition Triennale de Nantes for the Musée de Nantes (now the Musée des Beaux-Arts), 1858

EXHIBITIONS: Paris (Salon) 1841, no. 397, as *Démocrite et les Abdéritains; paysage;* Nantes 1858; Paris 1895, no. 9; Saarbrücken 1966, no. 6; Paris 1973; Paris 1975, no. 69; Rome 1975–76, no. 34; Cholet 1983–84, no. 7

REFERENCES: Anon. 1841a, p. 34; Anon. 1841e, p. 301; Bourgeois 1841; Delécluze 1841; Gautier 1841, pp. 264–65; Peisse 1841; Pelletan 1841; Robert 1841; Ténint 1841, pp. 36–37, ill. (etching by H. Berthoud); Anon. 1843a, ill. (lithograph by Louis Français); St.-Georges 1858, p. 218; Nantes, Musée des Beaux-Arts 1859, no. 53; Mantz 1861, p. 423; Dumesnil 1875, p. 45; Rousseau 1875, p. 246; Merson 1887, p. 21; Larthe-Ménager 1894, p. 14; Hamel 1905, pl. 10; Michel 1905, p. 24; Moreau-Nélaton 1905b, p. 87, fig. 78; Robaut 1905, vol. 2, pp. 138–39, no. 376, ill.; Nicolle 1919, p. 54, ill.; Moreau-Nélaton 1924, vol. 1, p. 51, fig. 75; Fosca 1930, pl. 19; Bazin 1936, pp. 49, 51; Bazin 1942, p. 46; Bazin 1951, p. 42; Baud-Bovy 1957, pp. 85, 86, 209, pl. XXIII; Leymarie 1966, p. 60; Bazin 1973, p. 42; Leymarie 1979, p. 64, ill.; Selz 1988, p. 128; Wissman 1989, pp. 94, 99–101, 102; Clarke 1991a, p. 78; Gale 1994, p. 25

79

Lormes. Une Chevrière assise au bord d'un torrent sous bois (Lormes: Shepherdess Sitting under Trees beside a Stream)

1842
Oil on canvas
20½ × 27¼ in. (52 × 69.3 cm)
Signed and dated lower right: COROT. 1842
The Cleveland Museum of Art
Leonard C. Hanna Jr. Fund 62.35

R 428

Corot visited the Morvan in 1831 and again in April 1834, on his way to Italy.[1] Its extremely varied landscape, soon to be noticed by other artists, must have held his attention, because in the early 1840s he returned three times for extended visits.[2] There are dated drawings for the period July–September 1841, when he went to Vézelay, Lormes, and Saint-André-du-Morvan; further works from the summer of 1842, when he returned to Lormes and Saint-André-du-Morvan before traveling to Switzerland; and some dated drawings of September and October 1844 at Le Cousin and Saint-André-du-Morvan. The fifteen or so paintings associated with this region form a chapter in Corot's work to which attention has been drawn only in the last fifty years. The treatment of light, the invariably original compositions—occasionally in unusual wide formats—the inclusion of figures, and the overwhelming sense of a direct perception of nature place them among his most interesting creations. Corot was doubtlessly aware of the accomplishment: in 1842 he tried to exhibit one of the paintings at the Salon, probably *Saint-André-du-Morvan (Nièvre)* (fig. 86), while *Un Ravin du Morvan (environs de Lormes)* (R 427), now in the High Museum of Art, Atlanta, hung in his living room at Ville-d'Avray.

Painted in 1842, *Une Chevrière assise au bord d'un torrent sous bois* belongs, along with *Un Ravin du Morvan,* to a small group of depictions of woods near Lormes that are oddly reminiscent of Corot's studies of trees and rocks from Civita Castellana

Fig. 86. Corot. *Saint-André-du-Morvan (Nièvre)* (R 424), 1842. Oil on canvas. Moreau-Nélaton Bequest, Musée du Louvre, Paris (R.F. 1615)

Fig. 87. Antoine Watteau (1684–1721). *L'Indiscret (Indiscreet),* ca. 1713–15. Oil on canvas, 22 × 26¾ in. (56 × 68 cm). Museum Boymans-van Beuningen, Rotterdam

in 1827. The apparent spontaneity conceals a carefully thought out design articulated by the cluster of knotty, intertwined branches: Robaut estimated that it took Corot ten or twelve sessions to bring the painting to completion.[3] The shepherdess in the foreground is a modern variation on a theme depicted by Watteau (fig. 87) and others, a reminder that the artist looked more often at his eighteenth-century predecessors than is generally supposed. In Corot's hands, however, the subject is devoid of erotic implications and develops in a whimsical direction, with the goat looking out at the viewer. In a related painting (R 426) the figure of a shepherdess is standing.

1. See cat. no. 39; for Corot's visit in 1834, see a *carnet* (R.F. 8714) and his letter to Abel Osmond of April 25, 1834, cited in Moreau-Nélaton 1924, vol. 2, p. 157.

2. For Corot's visits to Burgundy and the Morvan, see Geiger 1977, p. 334, passim, and Berte-Langereau 1993, passim.
3. See Robaut *carton* 3, fol. 156, "étude d'amateur—dix à douze séances"; noted in 1878, when Robaut made a drawing and took tracings.

PROVENANCE: Anonymous sale, Hôtel Drouot (Escribe & Bloche auctioneers), Paris, March 29, 1878, no. 15, sold for 1,300 francs; Hugo Nathan, Frankfurt; Wildenstein & Co., New York, 1950; J. K. Thannhauser, New York; purchased by The Cleveland Museum of Art, Leonard C. Hanna Jr. Fund, 1962

EXHIBITIONS: Pau 1872 (according to Robaut); Toronto 1950, no. 11; Houston 1959, p. 7; Chicago 1960, no. 56, lent by J. K. Thannhauser, New York; Manchester, New York, Dallas, Atlanta 1991–92, no. 18

REFERENCES: Robaut *carton* 3, fol. 156; Robaut 1905, vol. 2, pp. 154–55, no. 428, ill.; Leymarie 1966, p. 66; Geiger 1977, p. 334; Chong 1993, p. 44, ill.

80

Lormes. L'Église
(The Church at Lormes)

Ca. 1842
Oil on canvas
13½ × 18¼ in. (34.3 × 46.4 cm)
Signed twice lower right: COROT
Wadsworth Atheneum, Hartford
The Ella Gallup Sumner and Mary Catlin Sumner
Collection Fund 1950.439

R 423

At both Lormes and Saint-André-du-Morvan the church can be seen from afar, dominating the countryside from a hilltop. A panoramic view of Lormes in an atypically wide format in the Metropolitan Museum (fig. 88) gives a sense of the site and of the commanding position of the old Romanesque structure, which has since been enlarged and transformed. In the present painting the building is seen at a sharp angle from the road, which winds up to the entrance. There are impressive perspectival effects and a sensitive handling of light. The design is enlivened by touches of bright color in the costumes of the villager at the far right and the two children at the left and in the unexpected rooster near them. The painting's miraculous simplicity becomes vividly apparent when it is

compared to the modern photograph of the church from the same angle published by Philippe Berte-Langereau.[1] As is often the case with Corot's most distinguished work, modern critics have compared the painting to those of Vermeer.

Only two paintings from the Morvan were dated by Corot: *Lormes. Une Chevrière assise au bord d'un torrent sous bois* (cat. no. 79) and *Saint-André-du-Morvan (Nièvre)* (fig. 86) are both inscribed 1842. The latter, however, may have been painted in 1841 and inscribed only the following spring, when it was submitted to the Salon. The other Morvan paintings are generally placed in the years 1840 to 1845, but many were done in the summer, pointing to the painting campaigns of 1841 or 1842.[2] The view of Lormes in the Metropolitan Museum was probably

painted the same summer as the equally wide *La Moisson dans une vallée (Morvan)* (R 429) in the Musée des Beaux-Arts, Strasbourg. The present painting is assumed to be from 1842, but this dating remains speculative. A small painting on panel said to represent the same church shows an altogether different structure with a tall spire.[3] The church in the background of *Enfants au bord d'un ruisseau dans la campagne* (R 392), however, is certainly the church at Lormes and was probably borrowed, in reverse, from the painting now in the Metropolitan.

1. Berte-Langereau 1993, ill. p. 8.
2. A sketch (R 434), recorded but not reproduced by Robaut, must date from autumn 1844, since on its reverse is a study for *Homère et les bergers,* which was exhibited the following year.
3. *Paysage de Lormes (Nièvre),* Schoeller and Dieterle 1948, no. 16.

PROVENANCE: Offered by the artist to the sale for the aid of Fromanger, Paris, April 27, 1874, sold for 1,020 francs; anonymous sale, Hôtel Drouot, Paris, March 29, 1877, no. 14; purchased at that sale by Perreau for 1,110 francs; R. F. Dietrich, New York, from 1880 to 1927; Arthur Tooth & Sons, New York and London, 1927–28; Lord Ashfield, Sunningdale, Berkshire, England; Arthur Tooth & Sons, London; purchased by the Wadsworth Atheneum, Hartford, 1950

EXHIBITIONS: London 1949–50, no. 4; Chicago 1960, no. 50; San Francisco, Toledo, Cleveland, Boston 1962–63, no. 7; Edinburgh, London 1965, no. 43; New York 1969, no. 26; New York 1986, no. 15; Kanazawa, Tokyo, Takamatsu, Nagoya 1991–92, no. 11

REFERENCES: Robaut *carton* 3, fol. 155; Robaut 1905, vol. 2, pp. 152–53, no. 423, ill.; Anon. 1950, p. 1, ill.; Leymarie 1966, p. 66; Wilmerding 1972, p. 77, pl. 2–30; Smits 1991, p. 263, fig. 244; Leymarie 1992, ill. p. 85; Berte-Langereau 1993, ill. p. 7

Fig. 88. Corot. *Lormes (Nièvre). Vue d'ensemble* (*View of Lormes;* R 421), ca. 1841–42. Oil on canvas, 6½ × 21⅝ in. (16.5 × 54.9 cm). Jointly owned by The Metropolitan Museum of Art and Mrs. Walter Mendelsohn, 1980, The Metropolitan Museum of Art, New York (1980.203.4)

81

Le Lac de Genève (The Lake of Geneva)

1842?
Oil on canvas
13⅜ × 18⅛ in. (34 × 46 cm)
Signed lower left: COROT. Written in pencil on the stretcher: Vue du [inscription obscured by a label] Genève 1841
Musée d'Art et d'Histoire, Geneva 1919-29

R 411

When Alfred Robaut examined the present painting at the Ernest May sale in June 1890, he noted: "To the right, plane trees on the quays of Lake Léman [the Lake of Geneva] where a young man is walking, facing the lake. Farther on, at the end of a jetty, is the guardian's lodge (now torn down). To the left is a washerwoman passing behind a stone wall. On the same side a boat is gliding, all sails set. In the background are the Grand and Petit Salève, and below them the shore lined with houses among the trees. Bright sunlight effect— eleven A.M. Real local color. How different all this is in 1890! The quays have been widened, shored up—Farewell to the picturesque!"[1] By a curious coincidence, two weeks earlier Robaut had met Daniel Baud-Bovy, a young Swiss student and member of the Baud-Bovy family whom he considered employing as an assistant for his Corot catalogue (the role subsequently assumed by Moreau-Nélaton). The painting was later acquired by Geneva connections of Baud-Bovy.[2]

Justly famous for its extraordinary clarity and effects of light, the painting depicts a view taken from the quai des Pâquis on the right bank of the Rhone; in the distance is the shoreline to the east, seen in *Genève. Vue d'une partie de la ville* in Philadelphia (cat. no. 60). The remarkable blue of the

water in Geneva, which Lord Byron and others remarked upon, was described in an 1838 guidebook as resembling "nothing so much as the discharge of indigo from a dyer's vat."[3] As with the Philadelphia painting, the date of this work has been much debated. An apparently spurious inscription on the stretcher, not in the artist's hand, states it was painted in 1841, a year in which Corot—as far as is known—did not visit Switzerland. When Robaut last saw the painting in 1890, he made no reference to an inscription and dated it very broadly to 1840–50. When Pierre Borel published Corot's July 1842 letter from Geneva, he proposed 1842 as the date (see cat. no. 60). Subsequently Baud-Bovy added to the confusion by reassigning the work to a much later period, 1859–63, a dating that has been generally accepted as plausible.[4]

According to Baud-Bovy, the painter Jules Crosnier (1843–1917), a student of Barthélémy Menn, told him that as a young man he carried Corot's equipment to the quai des Pâquis and was with him when he painted this view. At that time Corot was a guest of the Bovy family at the Tour Saint-Jean, near Geneva, while Crosnier lived next door in a house belonging to the ballerina Carlotta Grisi. In Crosnier's words, "Corot devoted to it more than twenty sessions of two hours each. When I think of it, I'm amazed at the time it took him to establish the composition. And for five days running, he reworked the bluish green of those shutters, without ever managing to get the color exactly right."[5] Baud-Bovy was writing when he was an old man, recording things told him decades before about events that had taken place a century earlier. Since his account presents considerable problems, one wonders whether he remembered accurately.

Corot's last visits to Geneva, as Baud-Bovy knew, took place in 1859 and 1863. It seems more likely that these events (if they took place at all) occurred in 1863 when Corot was at Saint-Jean and Crosnier was nineteen, rather than in 1859, when he was only fifteen. Some evidence suggests, however, that Corot's visit to Geneva and its vicinity in 1863 was not very long, certainly not long enough to accommodate extensive working sessions; in a letter to Mme Darier of July 25, 1863, he told her he might not be able to see her at Gruyères.[6] There is no visible evidence in the painting of substantial reworking except on the parapet in the foreground, which appears to have been lightly retouched. A painting entitled *Genève* included by Corot in the auction sale of his works held on April 14, 1858, and sold as lot 28 for 200 francs to A. Moreau, presumably Moreau-Nélaton's father, was one of the few depictions of Geneva he

sold and may have been the present work. The major argument against a late date, however, is the crisp style of the work. It seems some years earlier than Corot's painting of Geneva dated 1852 (R 726), which is in the livelier manner characteristic of his later work. A lake view inscribed by Corot *Bellevue—Genève*, ascribed by Jean Dieterle to the painter's visit in the summer of 1857, is painted with the same later, vibrant touch as R 726.[7] In the present painting, on the other hand, the light is fresh and direct, the color unencumbered by atmospheric subtleties, the touch broad and secure. The inscription on the stretcher, inaccurate as it is, may prove close to the truth, and the painting may after all date from Corot's visit of 1842.

1. "À droite les platanes du quai du Léman où passe un homme, en face de la vue du Léman. Plus loin, au bas d'une jetée, est une logette de gardien (démolie aujourd'hui). À gauche, une lavandière passe derrière les margelles de pierre. Du même coté une barque glisse, toutes voiles dehors. Au fond le grand et le petit Salève, à la base dequels un rivage bordé d'habitations parmi les arbres. Effet de soleil vif—onze heures. Vraie couleur locale. Combien tout cela est changé en 1890! Les quais sont élargis, redressés—Adieu le pittoresque!" Robaut *carton* 3, fol. 154.
2. Frédéric Mayor was the brother of Isaac Mayor, who was married to Laure Bovy.
3. *Hand-Book for Travellers in Switzerland 1838*, p. 131.
4. Borel 1947; Baud-Bovy 1957, pp. 170, 174–75; Lugano, Geneva 1991–92, no. 71.
5. "Corot a mis là-dessus plus de vingt séances de deux heures chacune. Quand j'y pense, je m'étonne du temps qu'il lui a fallu pour en établir la mise en place. Et, cinq jours de suite, il a retouché le vert, lavé de bleu, de ces volets. Il ne parvenait pas à en rendre la valeur exacte." Baud-Bovy 1957, p. 174.
6. Robaut 1905, vol. 4, p. 340, no. 137.
7. See London 1989, no. 20, ill.

PROVENANCE: Ernest May, Paris; his sale, Galerie Georges Petit, Paris, June 4, 1890, no. 24, sold for 10,000 francs; M. and Mme Frédéric Mayor, Geneva; his bequest to the Musée d'Art et d'Histoire, Geneva, 1919

EXHIBITIONS: Zurich 1934, no. 123; Paris 1936, no. 45; Lyons 1936, no. 35; Paris 1937, no. 264; Fribourg 1943; Paris 1951b, no. 11; Venice 1952, no. 12; Paris 1959, no. 26; Bern 1960, no. 36; Edinburgh, London 1965, no. 42; Lugano, Geneva 1991–92, no. 71

REFERENCES: Robaut *carton* 3, fol. 154; Robaut 1905, vol. 2, pp. 148–149, no. 411, ill., as *Le Lac de Genève*; Deonna 1915, ill.; Pisteur 1920, p. 77; Courthion 1926, ill. p. 2; Gielly 1928, no. 55; Faure 1931, pl. 44; Jean 1931, pl. 28; Karl 1934, p. 29; Bazin 1936, fig. 41; Faure 1936, fig. 25; Jamot 1936, ill. p. 15; Bazin 1942, p. 8; Neuweiler 1945, pl. 94; Hautecoeur 1948, no. 19; Baud-Bovy 1957, pp. 170, 173–75, ill. opp. p. 110; Fosca 1958, p. 199, ill. p. 80; Dieterle 1959, pl. 126; Geneva, Musée d'Art et d'Histoire 1960, pl. 45; Geneva, Musée d'Art et d'Histoire 1968, p. 47; Bazin 1973, p. 282, ill. p. 178; Leymarie 1979, p. 75, ill.; Selz 1988, ill. p. 160; Lapaire 1991, no. 123, p. 94, ill.; Smits 1991, p. 266, fig. 247; Leymarie 1992, pp. 89–91

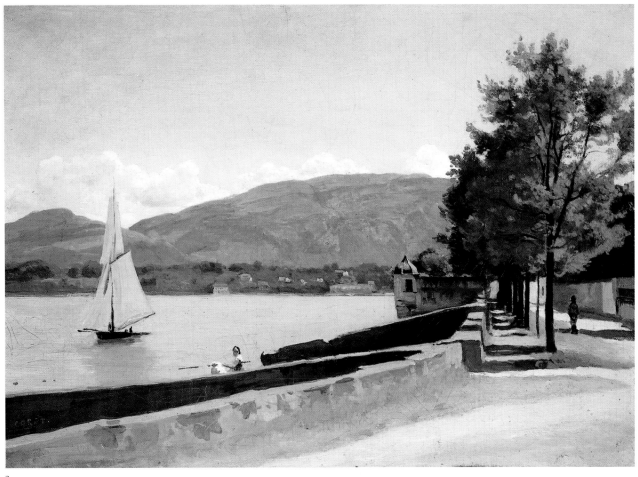

81

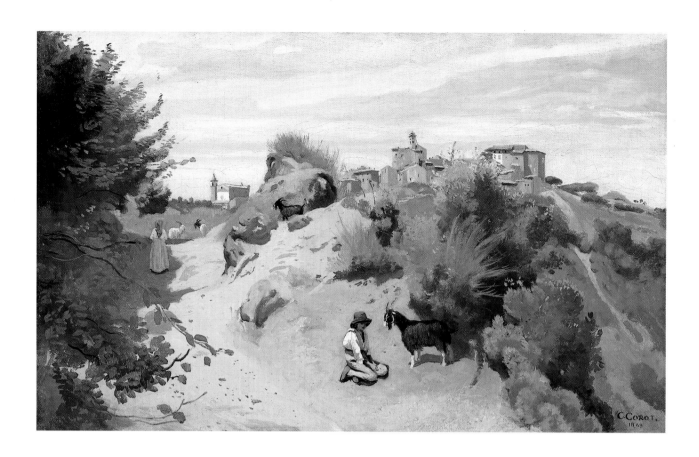

82

Genzano. Chevrier en vue du village (Genzano: Goatherd and Village)

1843
Oil on canvas
14⅛ × 22½ in. (35.8 × 57.1 cm)
Signed and dated lower right: C. COROT. 1843
The Phillips Collection, Washington, D.C. 0334

R 457 bis

A small oil sketch on wood with Genzano seen in the distance on a mountain ridge, dated June 26, 1843 (R 454), and drawings dated at Genzano on July 25 and July 26 indicate when Corot worked in the environs of Lake Nemi and the Castelli Romani region southeast of Rome.[1] Genzano is seen at best advantage from the lake, and it is interesting that Corot characteristically chose to depict it from a vantage point that has never been considered picturesque, with the town glimpsed in the background. His interest in, even preoccupation with, buildings rising on mountain crests is one to which he returned often during his first Italian visit and then in France, when painting in the Morvan.

Here Genzano is seen against the sky but is partly obscured by another of Corot's favorite motifs, a rocky formation in the foreground. Both the oil sketch and one of the dated

Fig. 89. Corot. *Genzano* (R 2772), July 26, 1843. Graphite on paper. Département des Arts Graphiques, Musée du Louvre, Paris (R.F. 9030)

drawings (fig. 89), taken from a closer viewpoint and showing the Palazzo Cesarini and the campanile of Santa Maria della Cima, indicate that Corot explored other possibilities before deciding on this masterly evocation of a dusty mountain road in the Roman Campagna on a hot day.

In contrast to the contemporary view of Tivoli (cat. no. 83), the moment depicted here is high noon, with its almost blinding light eliminating all superfluous detail. The young shepherd idling in the foreground, the antithesis of the antique shepherd in *Le Petit Berger* (cat. no. 76), draws the viewer into the scene, just as the young girl in the background leads the eye along the meandering road toward Genzano. Robaut, who thought Corot spent some twelve sessions on the painting, wrote that he found the most difficult part to be the green bushes, partly in shade, at the far left.[2]

1. See the drawings R 2787 (Musée du Louvre, Paris, R.F. 9028) and

R 2788, dated July 25; and R 2785 (R.F. 9039), dated July 26, and R 2772 (R.F. 9030).
2. Robaut *carton* 3, fol. 160.

PROVENANCE: Gift of the artist to Brizard, Paris; Chame (according to Robaut; see n. 2); anonymous sale, Hôtel Drout, Paris, January 1886; purchased at that sale by Closel for 700 francs; Alfred Robaut, Paris; Paul-Arthur Chéramy, Paris, by 1889; his sale, Galerie Georges Petit, Paris, May 5–7, 1908, no. 131; purchased at that sale by Gutmann, Paris, for 4,200 francs; Renan collection, Paris; Wildenstein & Co., New York, by 1952; purchased from them by Duncan Phillips, 1955; The Phillips Collection, Washington, D.C.

EXHIBITIONS: Paris 1889, no. 166, as *Genzano, près de Nemi*; Paris 1895, no. 31; Venice 1952, no. 15; New York 1956, no. 15; Washington 1956–57, no. 13; New York 1969, no. 29; Tokyo, Nara 1983, no. 8; New York 1983–84, no. 21; Washington 1986; Canberra, Perth, Adelaide 1987–88, no. 6; London, Frankfurt, Madrid 1988–89, no. 6 (London and Frankfurt only); Washington 1988–89, no. 107

REFERENCES: Robaut 1905, vol. 2, pp. 164–65, no. 457 bis, ill.; Meier-Graefe 1930, pl. XXXI; Leymarie 1979, pp. 81–83, ill. p. 80; Selz 1988, pp. 142, 146, ill. p. 147; Smits 1991, p. 292, fig. 271

83

Tivoli. Les Jardins de la villa d'Este *(Tivoli: The Gardens of the Villa d'Este)*

1843
Oil on canvas
17 1/8 × 23 7/8 in. (43.5 × 60.5 cm)
Stamped lower right: VENTE COROT
Musée du Louvre, Paris R.F. 1943-5

R 457

Corot visited the Villa d'Este in December 1827 but did little more there than sketch a partial view on the verso of a drawing of Tivoli (R 2496, Musée du Louvre, Paris, R.F. 9018). When he returned to Tivoli in June 1843 he stayed longer and drew, took notes in a sketchbook, and painted a view of the Cascatelle (fig. 90) and three views of the Villa d'Este: a distant view of the villa towering above the terraced gardens (R 453), a close view from just beneath the main terrace (R 452), and the largest, this view from the terrace.[1]

Alfred Robaut, the first owner of the present painting, thought it "the marvel par excellence of all the master's studies done in Italy," a verdict sustained by its fame since it has been on public view.[2] In the 1890s Daniel Baud-Bovy saw it in Henri Rouart's house and wrote: "Amazing landscape! The range of grays, just slightly enriched here and there by a local

tone, is so right that the most dazzling spangles of Impressionism could not have colored it so truly."[3] The extraordinary tonalities, suffused with a silvery-gray haze that seems northern, have been pointed out by Germain Bazin and Peter Galassi as evidence of the transformation of Corot's art after his first Italian period.[4] However, it may be noted that the light is different in the paintings of Genzano (cat. no. 82) and Rome; perhaps different weather conditions played a part in the change. A recent technical examination of the present work reveals that the young boy on the balustrade was added later, to give a center to the composition.[5]

In 1877 Robaut traveled to Rome on a Corot pilgrimage. He brought back to Paris some laurel leaves from the Villa d'Este and attached them to Corot's palette (now in the Louvre), together with a note: "A few leaves from a laurel branch gathered in Tivoli near Rome on April 6, 1877, for our illustrious COROT/From the laurel tree in the foreground of his admirable Study made in the garden of the Villa d'Este in 1843, I have plucked this precious object/Alfred Robaut-Dutilleux."

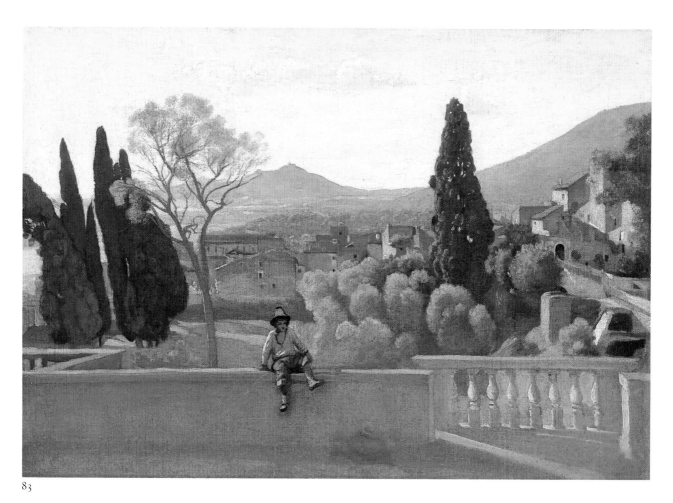

83

When the laurel was lost, he added a further note: "The leaves have fallen, alas!"[6]

1. Four drawings connected with Tivoli (R 2790 and Musée du Louvre R.F. 9014–9016) are dated June 1843; additional drawings include: R 2764–R 2767, R 2786, and *carnet* 51 (R 3088).
2. "la merveille par excellence de toutes les études du maître, en Italie." Robaut *carton* 3, fol. 162.
3. "Surprenant paysage! La gamme des gris, à peine enrichie çà et là par un ton local, y est si juste que les plus éclatantes paillettes de l'impressionnisme n'auraient su le rendre aussi véritablement coloré." Baud-Bovy 1957, p. 40. Baud-Bovy also saw a copy by E. Damoye; see p. 44.
4. Bazin 1973, p. 39; Galassi 1991b, pp. 216–17.
5. Corot returned to the motif of a young peasant seated on a wall in *Le Château Sainte-Marie à Crémieu (Isère)* of 1852 (R 715).
6. "Quelques feuilles d'une branche de laurier cueillie à Tivoli près Rome le 6 avril 1877 à l'intention de notre illustre COROT/Au laurier du premier plan de son admirable Étude faite au jardin de la 'Villa d'Este' en 1843, j'ai cueilli ce précieux objet/Alfred Robaut-Dutilleux." "Hélas! ces feuilles sont tombées."

PROVENANCE: The artist; his posthumous sale, Hôtel Drouot, Paris, pt. 1, May 26–28, 1875, no. 95; purchased at that sale by Alfred Robaut for 4,000 francs; Henri Rouart, Paris, by 1895 (purchased for 8,000 francs, according to Robaut *carton* 3, fol. 162); his sale, Paris, December 9–11, 1912, no. 114; purchased at that sale by the Rouart family for 70,000 francs; Ernest Rouart, Paris; given to the Musée du Louvre, Paris, by the descendants of Ernest Rouart, 1943

EXHIBITIONS: Paris 1878b, no. 99, lent by Alfred Robaut; Paris 1900, no. 126; Copenhagen 1914, no. 31; Paris 1922b, no. 41; Paris 1925, no. 59; Paris 1928, no. 22;

Fig. 90. Corot. *Tivoli. Les Cascatelles* (R 451), 1843. Oil on canvas, 9⅞ × 15¾ in. (25 × 40 cm). Moreau-Nélaton Bequest, Musée du Louvre, Paris (R.F. 1628)

London 1932, no. 373; Paris 1934, no. 85; Zurich 1934, no. 55; Paris 1936, no. 46; Lyons 1936, no. 36; Paris 1937, no. 265; Amsterdam 1938, no. 46; Paris 1945a, no. 79; Paris 1975, no. 75; Rome 1975–76, no. 36; Hamburg 1976, no. 274; Beijing, Shanghai 1982, no. 69; Sydney, Melbourne 1980–81, no. 12

REFERENCES: Alexandre 1902, p. 3, ill.; Hamel 1905, pl. 12; Moreau-Nélaton 1905b, p. 102, fig. 90; Robaut *carton* 3, fol. 162; Robaut 1905, vol. 2, pp. 164–65, no. 457, ill., and vol. 4, p. 203, no. 95; Michel 1906, p. 388; Moreau-Nélaton 1924, vol. 1, fig. 86; Lafargue 1925, p. 34, pl. 22; Fosca 1930, pl. 21; Meier-Graefe 1930, p. 55; Jamot 1936, ill. p. 7; Bazin 1942, no. 60, pl. 60; Bazin 1943, pp. 276–78, ill.; Bazin 1951, p. 45, no. 68, pl. 68; Baud-Bovy 1957, pp. 39–40, 44, 86; Fosca 1958, p. 24, ill. p. 87; Sterling and Adhémar 1958, no. 384, pl. CIX; Leymarie 1966, p. 68, ill. p. 67; Hours 1972, pp. 26, 98–99, ill.; Bazin 1973, p. 283, ill. p. 184; Leymarie 1979, pp. 83–84, ill.; Selz 1988, p. 142, ill. p. 143; Clarke 1991a, p. 65, fig. 66; Smits 1991, pp. 287–88, fig. 267; Gale 1994, p. 76, ill. p. 77

84

Nemi. Le Lac vu à travers les arbres (Lake Nemi, Seen through Trees)

1843
Oil on canvas
9 × 11⅜ in. (23 × 29 cm)
Stamped lower right: VENTE COROT
Österreichische Galerie im Belvedere, Vienna 3149

R 455

From the French landscapist Joseph Vernet (1714–1789) into the early nineteenth century, Lake Nemi was the sanctum sanctorum of proto-Romantic landscape painting. The lake is an almost perfect oval surrounded by high, rocky hills. It is crowned on one side by the castle and village of Nemi and on the other by the town of Genzano. This famously picturesque site was also known as the "mirror of Diana" from an ancient sanctuary devoted to the goddess, and its waters were associated with the mythical spring of the nymph Egeria. Its renown was by no means recent; it had been consecrated in the seventeenth century by Claude Lorrain, who made drawings of Nemi and included a view of the lake in one of his ideal compositions. Pierre-Henri de Valenciennes, one of Corot's immediate precursors, had made many sketches of the area.

During his first Italian visit in the late 1820s Corot visited Nemi at least twice. A drawing in the Louvre dated November 1826 shows an unusual vertical view of the lake seen from far away, with Genzano above it to the left in the distance (R.F. 9023). He evidently returned in April 1827, since there is also in the Louvre a dated drawing of Genzano from that month (R.F. 9025). A small painting, *Nemi. Le Pêcheur d'écrevisses* (R 165, private collection), which is generally dated to Corot's first Italian period, shows a close view of a thicket by the water, typical of the living, inhabited landscape that would later attract him.

Corot returned to the Castelli Romani in 1843, when dated works indicate that from June 26 to July 26 he was in the area around Lake Nemi, principally at Genzano but also in the village of Nemi.[1] Two paintings are associated with the visit to Nemi in July 1843, but only one, the present work, can be said unquestionably to date from that month. The view, taken from the low level of the lakeside, looks across the water to the hills towering above the opposite shore. There is an interesting counterpoint between the arabesque of interlaced trees and branches, which form an asymmetrical frame, and the calm background hills, which are reflected in the still water.

As Germain Bazin and Peter Galassi have pointed out, Corot used this compositional scheme, in reverse, to great effect in *Souvenir de Mortefontaine* (cat. no. 126) some twenty years later.[2] The refined tonalities, to some degree specific to works the artist painted in the summer of 1843, nevertheless reflect a note he made on a sketch at Nemi: "The vapor rising from the lake was golden."[3]

1. See cat. no. 82, n. 1. For Corot's peregrinations around Nemi in 1843, see Jullien and Jullien 1987, p. 130, n. 43.
2. Bazin 1973, pp. 39, 282; Galassi 1991b, p. 217.
3. "Il sortait du lac une vapeur qui était dorée." Baud-Bovy 1957, p. 64.

PROVENANCE: The artist; his posthumous sale, Hôtel Drouot, Paris, pt. 1, May 26–28, 1875, no. 98; purchased at that sale by Rousset for 195 francs; Haro sale, Hôtel Drouot, Paris, May 31, 1892, no. 66, sold for 1,020 francs; Mme J[omani] sale, pt. 2, Hôtel Drouot, Paris, March 21, 1927, no. 9, sold for 24,500 francs; Gaillard; E. Bignou collection, Paris; Roussel collection, Paris; Paul Cassirer, Berlin; purchased by the Österreichische Galerie im Belvedere, Vienna, 1930

EXHIBITIONS: Vienna 1930; Vienna 1951

REFERENCES: Robaut 1905, vol. 2, pp. 162–63, no. 455, ill., and vol. 4, p. 203, no. 98; Vienna, Österreichische Galerie 1937, p. 14; Vienna, Österreichische Galerie 1966, p. 21; Vienna, Österreichische Galerie 1967, p. 7, fig. 5; Bazin 1973, pp. 39, 49, 265, 282, ill. p. 180; Galassi 1991b, p. 217, fig. 275; Vienna, Österreichische Galerie 1991, p. 16, ill. p. 17

85

L'Odalisque romaine, also called *Marietta*
(*The Roman Odalisque*, also called *Marietta*)

1843
Oil on paper mounted on canvas
11½ × 17⅜ in. (29.3 × 44.2 cm)
Inscribed upper left: Marietta—à Rome Stamped lower left: VENTE COROT
Musée du Petit Palais, Paris P. DUT. 1158
Paris only

R 458

This study was painted in Rome in the studio of Léon Benouville. Its great fame renders dispassionate comment difficult. As Hélène Toussaint points out, the work is exceptional in Corot's oeuvre in several respects: it is his only known nude depicted indoors and his only nude devoid of allegorical or mythological context.[1] No parallel is easily found in the work of Corot's contemporaries; the astonishing modernism of its conception and execution makes the work fit more comfortably with late-nineteenth-century or early-twentieth-century painting. It is perhaps of consequence that the *Odalisque* was not shown in Corot's lifetime, nor was it lent to any of the posthumous retrospective exhibitions held in the nineteenth century. Corot, however, was known to have been pleased with it, and Robaut noted that he "was really proud to exhibit this study when he got hold of a true connoisseur (*rara avis*)."[2]

L'Odalisque was sketched on a pink-wash preparation over light notations in lead pencil. The pose of the model, the torsion of her body reminiscent of Ingres's odalisques, determined the format of the work. Corot was particularly proud of his scale of color values, a difficult and daring exercise in variations on pink, flesh tone, and ocher. The spatial ambiguities, the extraordinary alternation of flat and modeled surfaces, the delicately suggested contours strengthened by an occasional

Fig. 91. Corot. *Femme nue, de dos, couchée sur le côté gauche (Nude Woman Lying on Her Left Side, Seen from the Back)*, 1830–40. Graphite on paper. Département des Arts Graphiques, Musée du Louvre, Paris (R.F. 8767)

harsh note, and the provocatively emphasized head, characteristically facing the viewer, speak of a matchless control of pictorial means.

1. Toussaint in Paris 1975, no. 96.
2. "était vraiment fier d'exhiber cette étude quand il tenait (*rara avis*) un véritable connaisseur." Robaut *carton* 26, fol. 13. Germain Bazin has pointed out that Corot used the sketch for the principal figure in *Combat d'amours (le soir)*, R 1070; see Bazin 1936, p. 50, fig. 32.

PROVENANCE: The artist; his posthumous sale, Hôtel Drouot, Paris, pt. 2, May 31–June 4, 1875, no. 374; purchased at that sale by Durand-Ruel & Cie., Paris, for 300 francs; Nicolas-Auguste Hazard, Orrouy; his sale, Paris, December 1–3, 1919, no. 74; purchased at that sale by Victor Rosenthal for 37,000 francs; sale, A. G., Galerie Charpentier, Paris, May 8–9, 1934, no. 68; purchased at that sale for 125,000 francs by the city of Paris for the Musée du Petit Palais with funds from the Dutuit bequest

EXHIBITIONS: Paris 1928, no. 23; Paris 1934, no. 83; Paris 1936, no. 47; Lyons 1936, no. 37; Paris 1946b, no. 177; Zurich 1947, no. 184; Brussels 1947–48, no. 47; Venice 1952, no. 14; Rotterdam 1952–53, no. 19; Paris 1953, no. 14; Bern 1960, no. 40; Paris 1962, no. 22; Paris 1975, no. 96

REFERENCES: Hamel 1905, p. 28; Moreau-Nélaton 1905b, p. 102, fig. 89; Robaut carton 26, fol. 13; Robaut 1905, vol. 2, pp. 166–67, no. 458, ill., and vol. 4, p. 235, no. 374; Moreau-Nélaton 1924, vol. 1, p. 57, fig. 84; Lafargue 1925, pl. 47; Meier-Graefe 1930, p. 58; Faure 1931, p. 46, pl. 47; Jean 1931, pl. 29; Bazin 1936, p. 50, fig. 33; Faure 1936, fig. 9; Jamot 1936, ill. p. 20; Gobin 1939, p. 270; Bazin 1942, no. 61, pl. 61; Bazin 1951, no. 69, pl. 69; Sérullaz 1951, pl. 17; Bazin 1956, p. 20, figs. 4, 5; Baud-Bovy 1957, pp. 86–87, 109, pl. xxv; Fosca 1958, p. 145, ill. p. 87; Klossowski 1960, ill. p. 112; Leymarie 1966, p. 68; Hours 1972, pp. 96–97, ill.; Bazin 1973, p. 283, ill. p. 185; Paris 1975, no. 96; Leymarie 1979, pp. 84–85, ill.; Selz 1988, p. 142, ill. pp. 144–45; Clarke 1991a, p. 65, fig. 73; Gale 1994, pp. 32, 78, ill. p. 79

86

Deux Italiens (vieillard et jeune garçon)
(Two Italians, an Old Man and a Young Boy)

1843?
Oil on canvas
11⅝ × 7 in. (29.5 × 17.8 cm)
Signed lower left: COROT
Walters Art Gallery, Baltimore 37.201

R 1040

Alfred Robaut bought this work from Corot in 1858 along with two others, *Bretonne en prière* (*Breton Woman at Prayer;* R 1039) and *La Femme à la pensée* (*Woman with a Pansy;* R 1041, Denver Art Museum). He was evidently very fond of it, later writing with characteristic enthusiasm: "Very beautiful study, broadly handled and bearing all the marks of a great master."[1] He gave it the title *Vieux et Jeune Italiens au repos* (*Old Italian and Young Italian, Resting*), perhaps based on information given to him by Corot, noted that it represented a "father and young son," and dated it 1850–56, that is, a few years before he purchased it.[2] For unexplained reasons Moreau-Nélaton changed the date slightly to 1850–58 and remarked in the catalogue, "study painted in the studio, in Paris," a conclusion that was probably derived from the work's putative date.[3] At Robaut's insistence it was added at the last moment to the Corot retrospective of 1875 under the title *Mendiants jeune et vieux (étude)* (*Beggars, Old and Young: Study*), the only study of this type in the exhibition. In 1895, when the picture was lent by the great collector Paul-Arthur Chéramy to Corot's centenary exhibition, again as the only work of its kind, the title *Mendiants* was retained.[4]

This small study of a weary man at rest with his young companion is not related to any of Corot's mature works and has no parallel in the studies he painted in Paris. Robaut's notes include no comments by Corot about the circumstances in which the work was painted, perhaps indicating that the question was not raised. An *Italienne assise par terre* (*Italian Woman Sitting on the Ground;* R 1037), a larger study also ascribed by Robaut to the mid-1850s and also later owned by Robaut and Chéramy, is the nearest—and only—equivalent. It is certainly possible

that Corot sketched Italian models in Paris in the mid-1850s, and the study of a woman may be connected with the half-length figures in Italian costume he began thinking about in the late 1850s. But another date is also possible, perhaps 1843, during his visit to Italy. Although one hesitates to contradict Robaut on pictures he owned, he was occasionally wrong—as he was by a few years when he dated *La Femme à la pensée*.[5] The present study is close to studies Corot painted in Rome during his first visit in the late 1820s, such as *Vieillard assis sur une malle de Corot* in Boston (cat. no. 16). The regional dress of the man in that picture is different and the handling is less broad and more nervous, but the same feeling and the same muted tonalities inform both paintings, and the contrasts of light and shadow in the present study are fairly typical of his earlier work.

Whatever its date, this sketch transcends its genre—the direct recording of a model's appearance for the purpose of study. Corot infuses a measure of emotion into his observation of the old man—withdrawn, lost in thought, or perhaps simply exhausted—and the alert child, who looks straight out at the viewer.

1. "Fort belle étude traitée largement et portant les vraies marques d'un grand maître." Robaut *carton* 26, fol. 17.
2. "père et jeune fils." Ibid.
3. "étude peinte à l'atelier, à Paris." Robaut 1905, vol. 2, p. 318.
4. In the Chéramy sale catalogue of 1908 the title was given as *Deux Italiens, vieillard et jeune garçon, assis sur un banc*.
5. See discussion for cat. no. 107.

PROVENANCE: Purchased from the artist by Alfred Robaut for 100 francs, 1858; Constant Dutilleux, Arras (according to the catalogue of the Chéramy sale in 1908); sold by Robaut to Paul-Arthur Chéramy, Paris, 1886; his sale, Galerie Georges Petit, Paris, May 5–7, 1908, no. 138; purchased at that sale by Henry Walters, Baltimore, for 1,150 francs; Walters Art Gallery, Baltimore

EXHIBITIONS: Paris 1875a, no. 228; Paris 1895, no. 32; Philadelphia 1946, no. 36; Baltimore 1951, no. 36; Chicago 1960, no. 72

REFERENCES: Robaut 1905, vol. 2, pp. 318–319, no. 1040, ill.; Walters 1909, no. 201; Watkins 1946, p. 373, ill.; Baud-Bovy 1957, p. 34; Johnston 1982, p. 59, no. 34, ill.

87

Louis Robert, enfant (Louis Robert as a Child)

1843–44
Oil on canvas
10⅝ × 8⅝ in. (27 × 22 cm)
Musée du Louvre, Paris R.F. 2601

R 589

During a visit to Mme Osmond at Rosny, Corot was introduced to her widowed sister, Marie-Sylvie Robert, whose portrait he later painted (R 590).[1] Her son François-Parfait Robert (1814–1875), a magistrate, had recently married Louise-Adèle Finet at Mantes.[2] A friendship developed between Corot and the younger Robert, and the artist gave advice with great gusto for the couple's delayed honeymoon trip to Italy in the spring of 1840. The following year, on September 16, their first child, François-Louis Robert, was born. It was probably on a visit to Mantes in the summer of 1842 that Corot embarked on his largest project for his friends, the mural decoration of a bathroom (R 435–R 440), now in the Louvre. This portrait of their son Louis was likely undertaken later, in 1843–44 judging by the age of the child. Probably also in 1843–44 Corot painted a view of Mme Osmond's garden at Rosny (R 400, private collection), in which Louis Robert is seen seated on the ground with a child's gardening implements.

As Germain Bazin has pointed out, Corot's manner changed radically when he was painting children. As if to better depict their innocence, he adopted an almost naive style which both Bazin and Jean Leymarie have compared to that of Le Douanier Rousseau.[3] This portrait, which exemplifies that approach, shows the child frontally, holding the reins of a toy horse in his left hand and a whip in his right.

Louise Robert died in 1847, and in early 1849 François-Parfait Robert married Marie-Adrienne-Eugénie l'Évesque, by whom he had three more sons. In 1857 Corot painted an oval portrait of the four-year-old Maurice Robert, Louis's half brother (fig. 92). It was most probably afterward that, to make the portraits of Louis and Maurice pendants, the Robert family framed Louis's portrait with an oval mat, which left a slight mark on the canvas at the upper right. Robaut's tracing from the portrait, manifestly made while it was in its frame, shows it as an oval, as do a number of early reproductions.

87

Fig. 92. Corot. *Maurice Robert, enfant*
(*Maurice Robert as a Child*; R 1052), 1857.
10⅝ × 8¼ in. (27 × 21 cm). Bequest of
Christian and Maurice Robert, Musée du
Louvre, Paris (R.F. 2600)

Louis Robert survived Corot by only two years, dying in
Paris on January 28, 1877.[4] His half brothers Maurice and
Charles maintained the house at Mantes intact, with its many
splendid pictures by Corot, some of which were gifts from
the artist. In a September 1924 letter to Monet, Louis Gillet
described it, exaggerating the number of paintings by Corot,
as "a delightful old house, full of Corots. Just imagine, there
are about thirty of them, from every period, and even a small
bathroom decorated with admirable Italian landscapes painted
in oils directly on the wall. This house is one of the gems of
France, the way Fragonard's house in Grasse once was."[5] In
1926, on the death of Christian Robert, the last surviving
brother, a number of paintings by Corot, including the pres-
ent work, were bequeathed to the Louvre.[6]

1. For the Robert family, see Walter 1986, passim.
2. Ibid., p. 301, letter I, n. 8.
3. Bazin 1973, p. 59; Leymarie 1979, p. 92.
4. Walter 1986, p. 303, letter x, n. 1.
5. "une délicieuse maison d'autrefois, toute pleine de Corot. Figurez-vous

qu'il y en là une trentaine, de toutes les époques, et même une toute petite salle de bains, peinte à l'huile sur le mur d'admirables paysages d'Italie. Cette maison est un des bijoux de la France, comme était autrefois la maison de Fragonard à Grasse." Ibid., p. 304, letter XIV, n. 2. In a letter of October 2, 1924, Gillet reduced the number of works to "twenty Corots from every period, each one more charming or more beautiful than the next" ("vingt Corot de toutes les époques, tous plus charmants ou plus beaux les uns que les autres"). Ibid., p. 305, letter XIV, n. 3.

6. *Site des environs de Naples* (cat. no. 77); *Florence. Vue prise des jardins Boboli* (cat. no. 55); *Liseuse couronnée de fleurs* (fig. 80); *Rosny. Vue du village au printemps* (R 397); *Rosny. Le Château de la duchesse de Berry* (R 398); *Louis Robert, enfant*; *Maurice Robert, enfant* (fig. 92); *Moine blanc, assis, lisant* (cat. no. 108); and the mural decoration of the bathroom (6 panels, R 435–R 440).

PROVENANCE: Robert family, Mantes; bequest of Christian and Maurice Robert to the Musée du Louvre, Paris, 1926

EXHIBITION: Venice 1952, no. 16

REFERENCES: Robaut *carton* 32, fol. 13; Robaut 1905, vol. 2, pp. 206–7, no. 589, ill.; Bazin 1942, no. 70, pl. 70; Bazin 1973, p. 284, ill. p. 189; Leymarie 1979, p. 92, ill. p. 91; Compin and Roquebert 1986, p. 157, ill.

88

Jeune Garçon de la famille de Corot (Young Boy of the Corot Family)

Ca. 1850
Oil on paper mounted on canvas
13⅝ × 6¾ in. (34.5 × 17 cm)
Musée Municipal, Semur-en-Auxois

R 1054

The name of the adolescent is unknown, but, as Robaut believed, he was likely related to the artist, being most probably a descendant of his sister Annette-Octavie Sennegon. Her eldest daughter, Laure, who died prematurely in 1836, lived at Lormes with her husband, Philibert Baudot.[1] Laure Baudot's own daughter, also named Laure, returned to Burgundy in 1858 when she married Émile Corot, a young tax collector from Semur-en-Auxois, whose name alone endeared him to the artist.[2] Annette Sennegon's third daughter, Octavie, in 1837 married François-Joseph Chamouillet, a mirror maker, by whom she had three sons: Octave, Jules, and Léon Chamouillet.[3] Since the portrait remained in the Chamouillet family, it is likely that it depicts one of these boys rather than one of the descendants of Laure Corot. Unfortunately, Jules Chamouillet—perhaps the sitter, and the last owner before it was inherited by his cousin Fernand Corot—gave no indication of the portrait's identity.

This small painting is one of Corot's rare attempts at a full-length portrait and is posed with greater ease than his likenesses of younger children. The treatment is deliberately simple and the colors, a range of grays, are muted, but the expression is alert and direct. Robaut's date of about 1850–55 was changed by Moreau-Nélaton to about 1850, presumably to bring the portrait in line with the ages of the Chamouillet children. On Fernand Corot's death the work entered the collection of the Musée Municipal in Semur-en-Auxois, to which the artist had donated *Le Verger* (R 441) after his first visit to the region

in 1858. As noted elsewhere in this catalogue, Corot's paternal great-grandfather was a farmer from Mussy-la-Fosse, near Semur-en-Auxois. Henri Dumesnil engagingly reported Corot's delight at finding an entire Corot tribe in this area: "The region is full of good laborers who all have the same name as I do. They call to each other in the fields: 'Hey, Corot!' That's all you hear. I kept thinking that they were calling me, and I felt as though I were among family."[4]

1. For Laure Baudot, see Hélène Toussaint in Paris 1975, nos. 88, 91.
2. See his letter to Dutilleux, March 2, 1858: "The funny thing is that her husband's name is Corot, like ours." ("Ce qui est plaisant, c'est que son mari s'appelle Corot comme nous.") Quoted in Robaut 1905, vol. 4, p. 337, no. 97.

3. See Hélène Toussaint in Paris 1975, no. 89.
4. "La contrée est remplie de bons travailleurs qui portent le même nom que moi; ils s'appellent dans les champs: 'Hé! Corot!' on n'entend que ça. Je croyais toujours qu'on me demandait, et il me semblait que j'étais là comme en famille." Cited in Corot 1946, vol. 1, p. 133.

PROVENANCE: Jules Chamouillet, the artist's grandnephew; Fernand Corot (1859–1911), Semur-en-Auxois, 1905; his bequest to the Musée Municipal, Semur-en-Auxois, 1912

EXHIBITION: Dijon 1952, no. 88

REFERENCES: Robaut *carton* 32, fol. 32; Robaut 1905, vol. 2, pp. 324–25, no. 1054, ill.; Vergnet-Ruiz and Laclotte 1962, p. 231; Pontefract 1971, pl. 22, fig. 2; Geiger 1977, p. 336

89

Le Baptême du Christ
(The Baptism of Christ)

1845–47
Oil on canvas
153½ × 82⅝ in. (390 × 210 cm)
Signed lower right: C. COROT.
Church of Saint-Nicolas-du-Chardonnet, Paris
Paris only

R 466

This painting was Corot's first and only official commission, arguably the most important event in his life after his last journey to Italy. The work is poorly documented, but the circumstances surrounding it have been partially pieced together by Étienne Moreau-Nélaton and particularly the comte Armand Doria. According to Moreau-Nélaton, in autumn 1843, Corot's friend Théodore Scribe, who "had the ear" of the president of the Paris Commission des Beaux-Arts, intervened on the artist's behalf for a commission from the city.[1] Corot's brief and dignified letter requesting that he be considered, written on January 17, 1844, to the comte de Rambuteau, the prefect of the Seine department, has survived. It bears marginal notes of recommendation by David Michaud and Armand Bertin, the latter an influential journalist who met Corot in Italy in the late 1820s.[2] Michaud's undated comment recommends that Corot be given a commission for a "paysage historique," but no site is mentioned. However, the first of two brief archival notes published by Doria, dated September 1, 1845, concerns the church of Saint-Nicolas-du-Chardonnet and states that following deliberations on January 31 and August 12, 1845, Corot was commissioned to paint a *paysage* for the sum of three thousand francs.[3]

The church, on the rue Saint-Victor where the boulevard Saint-Germain and the rue Monge join, is a seventeenth-century building on which work continued intermittently until the twentieth century. The interior decoration was by Charles Le Brun, who is buried in the church. Many of the paintings were removed during the Revolution, but altarpieces by Claude

Fig. 93. Corot. *Jésus et Saint-Jean* (*Jesus and Saint John*; R 468), study for *Le Baptême du Christ*, ca. 1844–45. Oil on canvas. Private collection, New York

Vignon, Nicolas Coypel, and Jean Restout survived. In the nineteenth century the great revival of religious painting, particularly after the Restoration, left its mark on the church.[4] Earlier in the century Jean Vignaud and Paul-Émile Destouches had received commissions for altarpieces, but apparently no further requests were issued by the city of Paris until the 1840s, when Corot and the obscure Auguste Marquet were each awarded one work.[5] Corot was assigned the baptismal chapel, for which the parish priest, according to Moreau-Nélaton, wanted a Saint Philip the Deacon Baptizing the Eunuch of the Queen of Ethiopia, but Corot insisted on a Baptism of Christ and won his case.

As noted by Doria, it was only in the autumn of 1845 that Corot began work on the altarpiece. A number of drawings and sketches are known, showing to some extent the evolution of the composition. The painting was still in Corot's studio on March 14, 1847, when Delacroix saw it and noted in his journal, "His large Baptême du Christ [is] full of naive beauties. His trees are superb."[6] The work was probably installed in the chapel later that year. It is not known why Corot did not submit it to the Salon—perhaps he wanted to avoid the possible embarrassment of having a commissioned work refused.

Corot's studies for the composition show a number of transformations, eventually resulting in an oil sketch (R 467, private collection) in which most of the major elements are in place. Hélène Toussaint notes that the large group of trees is derived from that in Le Petit Berger (cat. no. 76), but in reverse. Originally Corot thought of placing the Holy Spirit above Christ's head, but he rejected the idea in favor of the angel with the band inscribed Hic est filius meus dilectus. A kneeling man in oriental dress in the right foreground was replaced in the final composition with the half-nude man awaiting baptism.

Corot attempted several variations for the group of Saint John and Christ, which proved the most difficult. In an early sketch John stands on a rock above Christ. In the compositional sketch (R 467) the figures stand side by side, but a subsequent oil sketch (fig. 93) showing John kneeling on a rock rehearses the pose eventually adopted. Toussaint suggests that to resolve his difficulties Corot consulted three treatments of the same subject by Poussin, a possible but not certain hypothesis.[7] Bruno Foucart points out that in conception Corot's painting is undeniably traditional when compared with the more experimental and abstract contemporary productions of Aligny or even Flandrin.[8] Yet the general effect is both oddly modern and, owing to its high, Venetian color, in perfect harmony with the chapel.

Moreau-Nélaton recounts that through a bureaucratic misunderstanding, Corot was passed over for the pendant altarpiece in the same chapel. His pride prevented him from applying for the commission, and instead he recommended his friend Aligny to the architect Victor Baltard, then the overseer of fine arts for the city of Paris.[9] In any case, the commission for a Christ Healing the Blind at Jericho was awarded on July 15, 1850, to Alexandre Desgoffe, who exhibited his painting at the Salon of 1852.[10] Whether Aligny would have been given yet another commission is in question; he had received a commission in 1842 for a Baptism of Christ for the church of Saint-Paul–Saint-Louis, and in 1850 he was engaged on another Baptism of Christ for the church of Saint-Étienne-du-Mont.[11]

Corot's failure to obtain the commission for the second altarpiece was likely compensated for by an unexpected pleasure: in 1850 the state commissioned Jean-Marius Fouque to make a copy of his Baptism of Christ for the church at Avessac in Brittany, a rare instance of a copy being commissioned from a modern religious painting.[12] Corot himself used the studies for the main group of this Baptism for one of the four small mural paintings he executed in 1856 in the transept of the church at Ville-d'Avray (R 1075).

1. In Robaut 1905, vol. 1, p. 112. For Scribe, who was not Eugène Scribe's brother as is sometimes claimed, see cat. no. 47 and Brunet 1977, pp. 7–13.
2. See Moreau-Nélaton in Robaut 1905, vol. 1, p. 112, and Doria 1954a, p. 97.
3. See Doria 1954a, pp. 97–98; the second, undated document repeats the substance of the first. On the subject of the price and the apparently unsubstantiated story, circulated after 1875 and repeated in Larthe-Ménager 1894, p. 4, that Corot was offered 1,500 francs but was eventually paid double, see Doria 1954b, p. 324, n. 18.
4. For the revival of religious painting in France, see Foucart 1987.
5. Ibid., pp. 359, 361, 367.
6. "Son grand Baptême du Christ plein de beautés naïves. Ses arbres sont superbes." Delacroix 1932, vol. 1, pp. 206–7.
7. The Baptisms in question, which were all engraved, are in the National Gallery of Art, Washington, D.C.; in the Johnson Collection, Philadelphia Museum of Art; and in a private collection, New York (Thuillier 1974, no. 147). See Toussaint in Paris 1975, no. 72.
8. Foucart 1987, p. 308.
9. Robaut 1905, vol. 1, p. 113.
10. See Doria 1954a, p. 98.
11. See Foucart 1987, p. 362, fig. 277, and p. 369.
12. See Lacambre 1993, p. 31, n. 6.

PROVENANCE: Commissioned by the city of Paris on September 1, 1845; entered the church of Saint-Nicolas-du-Chardonnet, baptismal chapel, 1847(?)

EXHIBITIONS: Paris 1875a, no. 187; Paris 1875b, no. 2; Paris 1946a, no. 10; Paris 1975, no. 72

REFERENCES: Mantz 1861, pp. 424–26; Cousin 1862, p. 368; Dumesnil 1875, pp. 42–43; France illustrée 1875, ill. (woodcut after a drawing by Robaut); Larthe-Ménager 1894, p. 4; Hamel 1905, p. 21; Moreau-Nélaton 1905b, pp. 109–13, fig. 99; Robaut carton 17, fol. 464; Robaut documents, vol. 2, fol. 19; Robaut 1905, vol. 2, pp. 172–73, no. 466, ill.; Bazin 1942, p. 46; Bazin 1951, p. 46; Doria 1954a, pp. 96–104; Doria 1954b, pp. 317–38, fig. 1; Baud-Bovy 1957, pp. 213, 244, 259, pl. XXVII; Fosca 1958, pp. 31, 32, 146, 154, ill. p. 96; Leymarie 1966, p. 72; Hours 1972, pp. 110–11, ill.; Bazin 1973, p. 42; Brunet 1977, pp. 7, 12; Leymarie 1979, pp. 88–89, ill.; Foucart 1987, pp. 94, 95, 308–9, 310, 311, 312, 318–19; Selz 1988, pp. 144, 150; Gale 1994, pp. 28, 84, ill. p. 85

90

Homère et les bergers; paysage (Homer and the Shepherds)

1845
Oil on canvas
31½ × 51⅛ in. (80 × 130 cm)
Signed lower left: COROT
Musée des Beaux-Arts, Saint-Lô

R 464

As indicated in the catalogue of the Salon of 1845, the subject of this painting was derived from André Chénier's poem "L'Aveugle."[1] The composition was inspired by the verses:

> And so the blind man ended, with a sigh;
> And near the woods he feebly walked, and on a stone he sat.
> Three shepherds, children of this land, followed him,
> Brought by the fervent barking of the hounds
> That guard their bleating flocks. Restraining their
> Unthinking fury, they protected the old man's uneasy weakness,
> Listened from afar, and to him came.[2]

The subject was by no means rare. It appeared relatively frequently at the Salon in the early nineteenth century;[3] in 1834 it was the *sujet définitif* for the Prix de Rome, and in 1841 Auguste

Fig. 94. Corot. Study for *Homère et les bergers*, ca. 1845–50. Graphite on paper. *Carnet* 67, fol. 24v. Département des Arts Graphiques, Musée du Louvre, Paris (R.F. 8727)

Leloir's *Homer*, now in the Louvre, was purchased by the state. In 1844 Corot's friend Achille Benouville exhibited a painting, now lost, on the theme, which may have prompted Corot.

A dated drawing Corot made in 1839 in the environs of Royat suggested the grouping of trees for the landscape.[4] *Carnet* 67 in the Louvre contains two studies for the figure of Homer (fig. 94),[5] with variations in the pose, and Robaut purchased a drawing for the composition on canvas at the artist's posthumous sale. Hélène Toussaint proposed that for the figure of Homer, Corot consulted Poussin's *Orphée et Eurydice* in the Louvre, while Volpi Orlandini found other possible sources in Poussin's *Dance to the Music of Time* (Wallace Collection, London) and in Claude Lorrain's derivations from Poussin.[6] Claude's etching of the motif does bear a certain resemblance, which may well be fortuitous, to the present work. An undated painting by Corot's contemporary Théodore Caruelle d'Aligny (formerly on loan to the Cleveland Museum of Art) has a figure grouping so close to that of Corot as to suggest a definite relationship. The possibility that it was known to Corot has been discussed;[7] but Aligny's painting may well date from about 1850 and thus postdate Corot's, so perhaps Aligny borrowed from Corot. There is, in fact, no known instance in Corot's oeuvre of his so closely imitating a contemporary.

Homère et les bergers closed Corot's series of subject pictures on the theme of isolation. Here dramatic tension is lessened, as Homer, isolated by blindness, has found a sort of peace. Now considered Corot's most accomplished historical landscape, the painting was received in 1845 with unusually severe reviews. If Gautier's remarks about Corot's "almost infantile naïveté"[8] could have been mistaken for praise, there was no doubt about what Delécluze meant: "The casualness and banality to be seen in heroic scenes today are utterly shocking."[9] Baudelaire alone rose to the defense: "With regard to M. Corot's supposed clumsiness, it seems to me that there is a small prejudice to be overcome.—All the semi-experts, after conscientiously admiring a Corot canvas and loyally paying him tribute, find that it falls down in its execution and agree that M. Corot decidedly does not know how to paint.—Good people! who do not know first of all that a work of genius—or, we might say, a work of soul—in which everything is well seen, well observed, well understood, and well imagined, is always well executed, when it is done sufficiently."[10]

1. The title Corot gave it was *Homère et les bergers; paysage. (André Chénier.—L'Aveugle)*. He wrote to his young nephew asking to borrow his copy of

Chénier on June 16, 1845 (after the exhibition), presumably for further use. Robaut 1905, vol. 1, p. 108, and vol. 4, p. 332, no. 13.

2. "C'est ainsi qu'achevait l'aveugle en soupirant, / Et près des bois marchait, faible, et sur une pierre, / S'asseyait. Trois pasteurs, enfants de cette terre, / Le suivaient, accourus aux abois turbulents / Des molosses, gardiens de leur troupeaux bélants. / Ils avaient, retenant leur fureur indiscrète, / Protégé du vieillard la faiblesse inquiète / Et de loin, et s'approchant de lui." Chénier 1958, p. 42.

3. See Whiteley 1974, passim.

4. See Paris 1938b, no. 28, ill.

5. *Carnet* 67, R 3104, R.F. 8727: fol. 24v and a faint study on fol. 25r.

6. Paris 1975, no. 71; Volpi Orlandini 1976, pp. 22–24.

7. Wissman 1989, pp. 103–4. The painting appeared at Christie's, London, June 30, 1978, no. 303, ill., and, again, at Sotheby's, London, November 26, 1980, no. 23, ill.

8. "naïveté presque enfantine." Gautier 1845.

9. "Le laisser-aller et le prosaïsme introduits aujourd'hui dans les scènes héroïques sont tout à fait choquants." Delécluze 1845.

10. "À propos de cette prétendue gaucherie de M. Corot, il nous semble qu'il y a ici un petit préjugé à relever.—Tous les demi-savants, après avoir consciencieusement admiré un tableau de Corot, et lui avoir loyalement payé leur tribut d'éloges, trouvent que cela pèche par l'exécution, et s'accordent en ceci, que définitivement M. Corot ne sait pas peindre.—Braves gens! qui ignorent d'abord qu'une oeuvre de génie—ou si l'on veut—une oeuvre d'âme—où tout est bien vu, bien observé, bien compris, bien imaginé—est toujours très-bien exécutée, quand elle l'est suffisamment." Baudelaire, "Salon de 1845," in Baudelaire 1923, p. 56. However, Baudelaire had complaints of his own, remarking that the figure of Homer resembled David's *Belisarius* too closely (ibid., p. 57).

PROVENANCE: Gift of the artist to the city of Saint-Lô, about 1863

EXHIBITIONS: Paris (Salon) 1845, no. 364, as *Homère et les bergers; paysage (André Chénier.—L'Aveugle)*; Paris 1846; Paris 1895, no. 14; Paris 1900, no. 116; Paris 1925, no. 73; Paris 1936, no. 49; Lyons 1936, no. 38; Paris 1937, no. 266; London 1949–50, no. 164; Belgrade 1950, no. 11; Venice 1952, no. 18; Paris 1962, no. 24; Paris 1968–69, no. 127; Paris 1975, no. 71; Manchester, Norwich 1991, no. 25

REFERENCES: Anon. 1845, ill. (wood engraving); Anon. 1845 (M.), p. 181; Blanc 1845; Delécluze 1845; Gautier 1845; Thoré, "Salon de 1868," in Thoré 1870, vol. 2, p. 187; Rousseau 1875, p. 246; Bigot 1888, p. 50; Hamel 1905, pp. 22, 23–24, pl. 15; Moreau-Nélaton 1905b, p. 105, fig. 94; Robaut *carton* 17, fol. 470; Robaut 1905, vol. 2, pp. 170–71, no. 464, ill.; Baudelaire, "Salon de 1845," in Baudelaire 1923, p. 57; Moreau-Nélaton 1924, vol. 1, p. 59, fig. 96; Lafargue 1925, pp. 11, 36, 57; Fosca 1930, pl. 24; Meier-Graefe 1930, p. 61, pl. XXXIV; Faure 1931, p. 34, pl. 48; Jean 1931, pl. 31; Bazin 1936, pp. 49, 54, fig. 44; Faure 1936, fig. 11; Jamot 1936, p. 40, ill. p. 17; Venturi 1941, pp. 151–52, 163, fig. 95; Bazin 1942, p. 46, no. 64, pl. 64; Bazin 1951, p. 42, no. 74, pl. 74; Baud-Bovy 1957, pp. 212–13, pl. XXVIII; Fosca 1958, pp. 24, 146, ill. p. 50; Leymarie 1966, pp. 68–69, ill.; Hours 1972, pp. 102–3, ill.; Bazin 1973, p. 283, ill. p. 183; Volpi Orlandini 1976, p. 22, figs. 2, 23, 24; Leymarie 1979, pp. 86–87, ill.; Selz 1988, pp. 128–30, ill. p. 131; Wissman 1989, pp. 94, 101–6; Clarke 1991a, pp. 71, 78, fig. 76; Gale 1994, pp. 21, 27, 82, ill. p. 83

91

Vue prise dans la forêt de Fontainebleau
(View in the Forest of Fontainebleau)

1846
Oil on canvas
35½ × 50¾ in. (90.2 × 128.8 cm)
Signed lower left: COROT
Museum of Fine Arts, Boston
Gift of Mrs. Samuel Dennis Warren 90.199

R 502

A few weeks before the opening of the 1846 Salon, Corot learned that of the four paintings he had submitted three had been refused by the jury and only *Vue prise dans la forêt de Fontainebleau*, perhaps the greatest pure landscape of his middle years, had been accepted. The painting was not a great success; and ironically, in a show of sympathy for "ce bon Corot," critics upbraided the jury not so much for rejecting three works as for choosing the least interesting of the four. In the event, Corot was awarded the cross of the Legion of Honor for his participation, a consolation after reviews such as those of

Delaunay, who wrote, "There are those who call that painting. They are very kind,"[1] and another critic, who concluded, "M. Corot, the famous landscape artist, paints everything with the dirt that falls from his boots as they're being cleaned."[2]

Champfleury, who saw the painting in Corot's studio, thought it "a remarkable work, but it is different from Corot's usual manner. It's more a serious *study*, a rigorous and well-considered sketch, than a painting."[3] Théophile Gautier's banal remarks about "the harmonious simplicity, modest charm, and naive awkwardness"[4] of Corot's work were echoed by Haussard.[5] Théophile Thoré found the painting colorless: "The temperament is good, the mood poetic; there is honesty of heart and nobility of spirit. But the skin is too pale."[6] Reacting to the same aspect of Corot's art, Baudelaire remarked—presciently, in view of the direction it would soon take: "M. Corot is more a harmonist than a colorist, and his compositions, which are always entirely free of pedantry, are seductive just because of their simplicity of color. Almost all his works have the particular gift of unity, which is a necessary condition of memory."[7]

This painting was Corot's last exercise in a traditional form of composed landscape—studied in nature but reconstituted in the studio. Robaut noted that the disposition of the trees was inspired by a sketch painted twelve years earlier in the Gorges d'Apremont (R 272). Corot added an imaginary pond and the large boulders, partly derived from *Vue dans la forêt de Fontainebleau* (cat. no. 34). This metamorphosis of the subject begs for comparison with Corot's more direct depiction of the region in paintings like *Le Rageur* (cat. no. 33). The effect here is much like that of Dutch landscapes, but the treatment is free enough to justify Champfleury's remark that a certain freshness and the air of an *étude* have survived in the painting. The arrangement of trees, with a vista open toward the background, is more contrived than in the *Homère et les bergers* of a year earlier (cat. no. 90). This device, common in stage design, was refined by Corot with greater effect in *Une Matinée* (cat. no. 103).

1. "Il y a des gens qui appellent cela de la peinture. Ils sont bien bons." Delaunay 1846, p. 29.
2. "M. Corot, le célèbre paysagiste, il peint tout avec la terre qui tombe de ses bottes quand on les lui nettoie." Anon. 1846, p. 96.
3. "une oeuvre remarquable; mais elle sort de la manière de M. Corot. C'est plutôt une *étude* sérieuse, d'un dessin sévère et très étudié, qu'un tableau." "Salon de 1846," in Champfleury 1894, p. 72.
4. "la simplicité harmonieuse, le charme modeste et la naïve gaucherie." Gautier 1846.
5. Haussard 1846.

6. "Le tempérament est bon, l'humeur poétique, le coeur honnête, l'esprit distingué; mais la peau est trop pâle." Thoré 1846, pp. 147–48.
7. "M. Corot est plutôt un harmoniste qu'un coloriste; et ses compositions, toujours dénuées de pédanterie, ont un aspect séduisant par la simplicité même de la couleur. Presque toutes ses oeuvres ont le don particulier de l'unité, qui est un des besoins de la mémoire." Baudelaire, "Salon de 1846," in Baudelaire 1923, p. 180.

PROVENANCE: Gift of the artist to the Anastasi benefit sale, Hôtel Drouot, Paris, February 6, 1872, no. 26; purchased at that sale by Alfred Robaut for 4,000 francs; Barbedienne, Paris, until 1881; S. M. Vose, Boston; Beriah Wall, Providence, Rhode Island; sale, The American Art Galleries, New York, Chickering Hall, April 1, 1886, no. 263; purchased by Vose Gallery, Boston, for Mrs. Samuel Dennis Warren, Boston; given by her to the Museum of Fine Arts, Boston, 1890

EXHIBITIONS: Paris (Salon) 1846, no. 422, as *Vue prise dans la forêt de Fontainebleau*; Paris 1875a, no. 74; Paris 1878b; Providence 1886, no. 96; Philadelphia 1946, no. 24; Detroit 1950, no. 75; Venice 1952, no. 21; San Francisco, Toledo, Cleveland, Boston 1962–63, no. 10; Paris 1968–69, no. 181; New York 1969, no. 28; Atlanta, Denver 1979–80, no. 3; Boston 1985, no. 30; Manchester, New York, Dallas, Atlanta 1991–92, no. 19

REFERENCES: Anon. 1846, p. 96; Delaunay 1846, p. 29; Gautier 1846; Haussard 1846; Houssaye 1846, p. 41; Mantz 1846, p. 71; Menciaux 1846; Planche 1846; Thoré 1846, p. 147; Dumesnil 1875, p. 41; Robaut 1881, p. 188; Van Rensselaer 1889a, ill. (woodcut); Van Rensselaer 1889b, pp. 158, 176; Leymarie 1893, p. 75, ill., as *À Fontainebleau*; Champfleury, "Salon de 1846," in Champfleury 1894, pp. 71–74; Hamel 1905, p. 24; Michel 1905, ill. p. 19 (lithograph by Anastasi, in reverse); Robaut 1905, vol. 2, pp. 184–85, no. 502, ill.; Boston, Museum of Fine Arts 1921, p. 83, no. 202; Baudelaire, "Salon de 1846," in Baudelaire 1923, p. 180; Boston, Museum of Fine Arts 1955, p. 14; Leymarie 1979, pp. 86–88, ill.; *Corot* 1981, p. 113, no. 21, ill.; Murphy 1985, p. 58, ill.; Selz 1988, pp. 160, 161, ill.; Wissman 1989, pp. 21–24; Clarke 1991a, pp. 130, 134, ill.; Gale 1994, pp. 27–28

92

Le Chevrier italien (effet du soir)
(The Italian Goatherd, Evening)

Ca. 1847
Oil on canvas
76⅝ × 57⅞ in. (194.5 × 147 cm)
Signed lower right: COROT
Musée du Louvre, Paris R.F. 899 bis

R 608

Much about this work remains undocumented, but its presence at the Manufacture de Beauvais confirms the tradition that it was commissioned as a cartoon for a tapestry. The painting remained at Beauvais until shortly after Corot's death, when it resurfaced briefly in the memorial exhibition of 1875. No tapestry of this design was manufactured, and in 1876 the work was moved to the Manufacture de Sèvres, where Alfred Robaut saw it on October 6, 1881, and made a drawing from it. Following a debate in the press, largely instigated by Robaut, the painting was transferred to the Louvre in 1894 and exhibited there

until 1901, when it was removed from view. From 1904 it has been intermittently on display. The work is generally dated to 1848. Its history suggests that it was commissioned by the king sometime earlier and was delivered to the state at an unknown date, possibly after the Revolution of 1848.

Moreau-Nélaton supposed that the complexity of the image prevented it from being successfully translated into tapestry, but it has also been suggested that the commission was abrogated by the Revolution of 1848.[1] Corot knew the painter Pierre-Adolphe Badin, who became director of the Manufacture

des Gobelins in 1848 and moved two years later to the Manufacture Nationale at Beauvais, where he assumed the same position. When the Manufacture de Beauvais merged with the Gobelins in 1860, he took charge of the combined operations. In 1882 his son Jules Badin, a student of Corot, succeeded Jules Dieterle, another of Corot's friends, as administrator at Beauvais.[2] According to Moreau-Nélaton, Corot met Badin in Italy.[3] Corot's correspondence shows that he and Badin were friends in the late 1850s; the artist visited Beauvais, and the two men traveled together to London in 1862.[4] This relationship makes it difficult to believe that Corot's cartoon was abandoned for other than technical reasons.

Both Robaut and Moreau-Nélaton, and then others, assumed that the painting was one of the nine works Corot exhibited at the Salon of 1848. However, nothing in the Salon records connects this cartoon with the exhibition, nor do Salon reviews mention it. Robaut also maintained that the design was not a pastoral subject of the type Corot had already exhibited at the Salon but a depiction of the young Giotto and thus called it in his notes *Giottino à l'Arricia. Campagne de Rome.*[5] That subject, derived from Vasari's Life of Giotto, concerns Cimabue's discovery of Giotto as a child, tending goats and drawing on the ground with a stick. Illustrative of the precocious manifestation of genius and of the very origins of Italian painting, the theme had been introduced in France in the early years of the nineteenth century. *Paysage historique (Cimabué trouve . . . le jeune Giotto)* by Édouard Bertin, Corot's teacher, and *Origine de l'école italienne, ou Cimabué et Giotto* by Magimel, Corot's friend, were shown at the Salon of 1827, and a dozen or so variations, depicting Giotto alone or with his master, had been exhibited by 1850. In 1844, when three renditions of the subject were shown at the Salon, Paul Mantz remarked with some irritation that he had seen half a dozen every year.[6]

Although Robaut claimed that Corot himself referred to the work as "my little Giotto sitting on a stone,"[7] except for a shepherd the painting is devoid of any elements pertinent to the subject. Whether Corot intended the work to depict Giotto or whether this significance was added after the fact remains open to interpretation. The picture was certainly the most serious attempt he made at decorative painting after completing the mural decorations for the Robert bathroom at Mantes (R 435–R 440) and stands in considerable contrast to the charming but naive panels he painted for his mother during the same period in the kiosk at Ville-d'Avray (R 600–R 607). The execution is lively, and the composition, as Bazin remarked, is a consummate résumé of Corot's experience in Italy and Fontainebleau. In Bazin's opinion the painting assumed a symbolic quality, "the melancholy value of a memory; and the little shepherd seems to be the soul of Corot himself bending over his past."[8]

The site is certainly not derived from Arricia, as Robaut believed, but it may well have been based on a memory of Castel Gandolfo, as Bazin suggested. In the Georges Feydeau sale of 1903 there was a close but not identical small sketch, erroneously called *Lac de Garde*, which Moreau-Nélaton listed as a "sketch, reminiscence, or copy" without giving it a separate catalogue number.[9] Corot loosely adapted the composition, with considerable changes and sometimes reversed, for a number of later works, but never as effectively as in two *clichés-verres*, the splendid *Le Songeur* (R 3164; Delteil 1910, no. 43) and *Le Poète et la muse* (R 3215; Delteil 1910, no. 94).

1. See Robaut 1905, vol. 2, no. 608, and Vincent Pomarède in Kobe, Yokohama 1993, no. 47.
2. A painting by Jules Badin was mistakenly included as a work of Corot in the posthumous Corot sale of 1875; see Robaut 1905, vol. 4, p. 244, no. 463.
3. See Robaut 1905, vol. 1, p. 173.
4. Ibid., pp. 173, 211, 229, 232, 268, 312.
5. Robaut *carton* 17, fol. 480.
6. See Haskell 1987, p. 99.
7. "mon petit Giotto assis sur un pierre." Robaut 1892b.
8. "une valeur mélancolique de souvenir et le petit pâtre semble l'âme de Corot lui-même se penchant sur son passé." Bazin 1942, p. 51.
9. "esquisse, réminiscence ou copie." Robaut 1905, vol. 2, p. 212, no. 608. See also Feydeau sale, Hôtel Drouot, Paris, April 4, 1903, no. 11, ill.

PROVENANCE: Commissioned as a tapestry cartoon for the Manufacture de Beauvais for 1,500 francs (according to the civil list of King Louis-Philippe), but no tapestry was executed; transferred to the Manufacture de Sèvres, 1876; entered the Musée du Louvre, Paris, 1894

EXHIBITIONS: Paris 1875a, no. 35; Laval 1876; Lyons 1936, no. 46; Avignon 1990; Kobe, Yokohama 1993, no. 47

REFERENCES: Anon. 1892b; Baumgart 1892; Robaut 1892a; Robaut 1892b; Robaut 1894; Robaut 1905, vol. 2, pp. 212–13, no. 608, ill.; Brière 1924, no. 141 A; Moreau-Nélaton 1924, vol. 1, p. 69, fig. 108; Meier-Graefe 1930, pl. XXXVII; Bazin 1942, p. 51; Sterling and Adhémar 1958, p. 393; Boime 1971, p. 94; Compin and Roquebert 1986, p. 147, ill.

93

Nemi. Les Bords du lac (Nemi, the Lake's Edge)

1843–45
Oil on canvas
23⅝ × 36 in. (60 × 91.4 cm)
Signed lower right: COROT
Philadelphia Museum of Art
The John G. Johnson Collection JC cat. 940
R 456

Robaut and Moreau-Nélaton agreed that this fairly large work was painted in Italy during Corot's 1843 visit to Nemi.[1] Its relationship with known works from that period is in fact tenuous, and the composition gives every impression of having been painted afterward in Paris, as a *souvenir* of the site. The broad, vigorous style argues against its creation in Italy, as do the picture's scale and the highly thought-out design. A study drawn at Nemi in 1843[2] shows a similar formation of trees, in reverse, on the lakeshore and doubtless was used in the elaboration of the present landscape. The figure near the shore animates the composition and relates to such earlier fictitious re-creations of the Italian scene as *Un Soir; paysage* of 1839 (cat. no. 75).

While absolutely consistent with Corot's ideal, certainly as expressed in his later works, the trees in this landscape are also derived from the bent, ancient trees around the lake which had fascinated at least two generations of artists. Valenciennes

Fig. 95. Pierre-Henri de Valenciennes (1750–1819). *Sous-bois, arbres aux branches tortueuses (Undergrowth, Trees with Twisted Branches)*, 1823. Paper mounted on board. Musée du Louvre, Paris (R.F. 2944)

drew and sketched in oil some of the more extraordinary tree trunks leaning over the lake (fig. 95), and long afterward photographers still haunted Lake Nemi's shores.

1. Robaut *carton* 3, fol. 165.
2. Département des Arts Graphiques, Musée du Louvre, Paris (R.F. 9021).

PROVENANCE: Purchased from the artist by Grédelue, 1872; Hoschedé sale, Hôtel Drouot, Paris, April 20, 1875, no. 22, as *Au bord de l'eau (Lac Nemi)*, 1843; purchased at that sale by Auguste Breysse for 4,000 francs; John G. Johnson, Philadelphia, by 1892; bequeathed by him with the rest of his collection to the city of Philadelphia, 1917; transferred to the Philadelphia Museum of Art, 1933

EXHIBITIONS: Paris 1875a, no. 53

REFERENCES: Robaut *carton* 3, fol. 165; Robaut 1905, vol. 2, pp. 162–63, no. 456, ill.; *Johnson Collection* 1953, ill. p. 244; Philadelphia Museum of Art 1994, p. 117, ill.

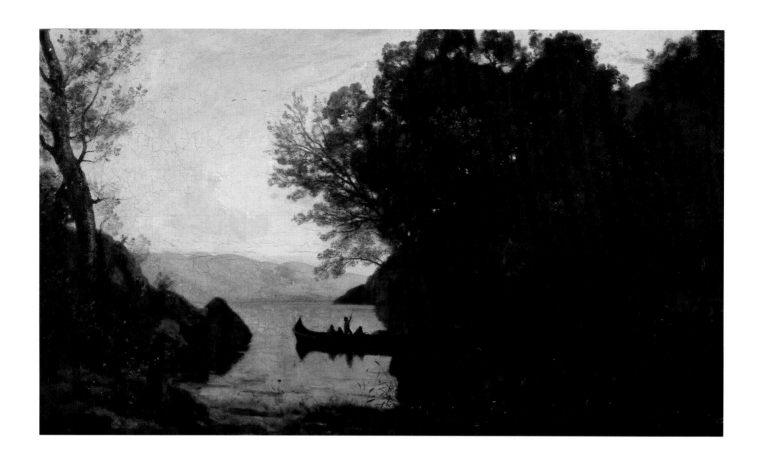

94

Soleil couchant, site du Tyrol italien, also called *Vue prise à Riva.*
Tyrol italien
(Setting Sun, Italian Tirol)

Ca. 1850
Oil on canvas
28¾ × 48⅜ in. (73 × 123 cm)
Signed lower left: COROT.
Musée des Beaux-Arts, Marseilles 138

R 359

This *souvenir* of Corot's 1834 visit to Riva took as its starting point two paintings of the site done fifteen years earlier (cat. nos. 58, 59). But the artist let his imagination work on the subject, and compared with those paintings this one is considerably darker; we are shown the site at night. The boat is still at the center of the composition, and the overall structure remains the same, although both the sanctuary and the small peasant leaning on the parapet have disappeared. The cliff itself is largely obscured by the foliage of trees on the right. This work demonstrates the aesthetic logic of Corot's *souvenirs,* in which, after initially consulting a study made from nature, he relied largely on memory.

Corot's entries to the Salon of 1850–51, which included this painting, enjoyed a mostly enthusiastic critical reception.[1]

The work was subsequently acquired by the Musée de Marseille (now the Musée des Beaux-Arts) after a complex negotiation conducted by E. Marcotte, president of the Société Artistique des Bouches du Rhône. Since the society could not afford to buy the picture, Marcotte asked for a considerable reduction of the price, to 1,000 francs. Corot agreed.[2]

VP

1. Robaut 1905, vol. 4, p. 168. Corot exhibited four works that year.
2. Ibid., p. 173, n. 2. E. Marcotte, letters to Binant, October 22 and November 5, 1853. Archives Binant, consulted by Robaut.

PROVENANCE: Acquired from the artist by the Société Artistique des Bouches du Rhône; presented by that organization to the Musée de Marseille (now the Musée des Beaux-Arts), 1853

EXHIBITIONS: Paris (Salon) 1851, no. 644, as *Soleil couchant, site du Tyrol italien;* Marseilles 1853, as *Un Paysage,* priced at 1,500 francs (sold for 1,000 francs); Paris 1895, no. 7; Paris 1975, no. 74; Lugano 1994, no. 6

REFERENCES: Silvestre 1853, p. 14; Bouillon-Landais 1876, no. 30; Robaut 1905, vol. 2, pp. 124–25, no. 359, ill.; Auquier 1908; Bazin 1936, p. 58, ill.; Bazin 1942, p. 52, ill.; Corot 1946, vol. 1, p. 60; Leymarie 1966, p. 83; Fouchet 1975, p. 80; Leymarie 1979, p. 101; Marseilles, Musée des Beaux-Arts 1990, p. 128

Pêche à l'épervier, le soir (Fishing with Nets, Evening)

1845–50
Oil on canvas
12⅞ × 9⅝ in. (32.7 × 24.5 cm)
Signed lower left: COROT
Musée Fabre, Montpellier 868.1.13

R 1136

In 1847 Corot submitted four works to the Salon, but only two were accepted: *Paysage* (no. 380 at the Salon) and *Paysage; berger jouant avec sa chèvre* (no. 381). The paintings were very successful in spite of dissenting voices that claimed his style was becoming increasingly eccentric. In fact, it was at this exhibition that Corot's work was a revelation to Delacroix and particularly to Constant Dutilleux. Alfred de Menciaux, not usually among Corot's admirers, wrote in *Le Siècle,* "Despite the clumsiness and heaviness of his touch, M. Corrot [*sic*] has such a feeling for the poetry and intelligence of art that he manages to obtain astonishing results. Seen from up close, his canvas *Paysage* is a jumble of gray and chalky tones; seen from a few steps back, it is a painting filled with truth." [1] Menciaux's observations were taken up by both admirers and detractors, and much was made of Corot's sketchy style and indefinite forms. Étienne Delécluze wrote of "the incorrigible M. Corot [who] has made us two little landscapes that we shouldn't look at too closely." [2] Clément de Ris repeated his advice to viewers: "It sometimes took great self-control for me not to

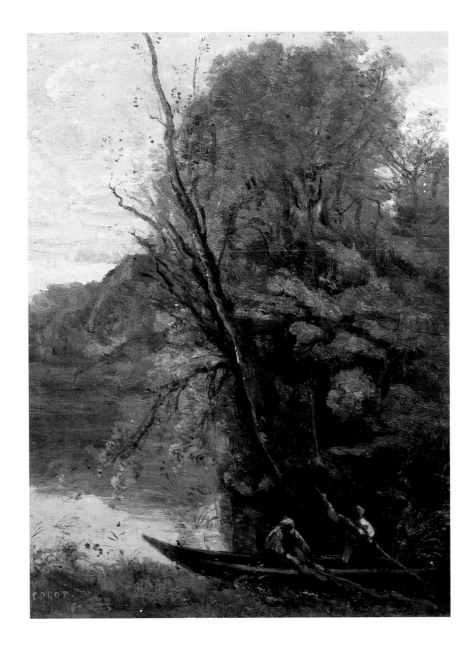

Fig. 96a. Corot. *Pêcheurs tendant leurs filets, le soir* (*Fisherman Spreading Their Nets, Evening;* R 504), ca. 1847. Oil on canvas. Private collection. Courtesy of Sotheby's, Inc., New York.

go tug at the coattails of certain people who were looking at Corot's paintings as if they were nearsighted—right before their noses, as it were—and make them take a few steps back to the point from which the paintings should be viewed. Then everything takes on a different aspect. The blacks become transparent, the grays fine; the smears take the dryness out of the lines; the smudgings of the fields and leafage are filled with light, charming touches. The whole thing blurs in a gentle, harmonious vapor."[3]

While *Paysage; berger jouant avec sa chèvre* (*Landscape: Shepherd Playing with His Goat;* R 503, private collection) was undoubtedly one of the works exhibited in 1847, there has been some confusion about the identity of the other painting, *Paysage.* Traditionally it has been thought to be the present work, a belief perpetuated by the 1876 catalogue published by its owner, Alfred Bruyas. Robaut, however, listed a larger picture, of similar subject but horizontal in format, *Pêcheurs tendant leurs filets, le soir* (fig. 96a), as the painting shown at the Salon.[4] A careful reading of the 1847 reviews shows that Robaut was right and that the gray-and-black tonality, the chalky color of the water, the great streaks in the sky, and the very sketchy character of the work noted by several critics in fact correspond to the design and the exceptionally narrow color range of *Pêcheurs tendant leurs filets, le soir* rather than to this painting in Montpellier. Robaut had not seen the present painting; he knew it only from engraved reproductions, some of which reversed the image, and he did not know the direction in which

the composition faced. He dated the work to 1855–60, whereas ostensibly it was already engraved in 1857.

The purchase of the work by Alfred Bruyas (1821–1877), a famous collector and patron of Delacroix and Courbet and a friend of Théophile Silvestre, suggests that Corot was reaching a new and more informed public. Bruyas is said to have owned the painting by 1851, but no firm documentation has surfaced. In all probability the work dates from the late 1840s, and Bruyas may have bought it as early as 1847, which may explain the confusion with the Salon picture of that year. The vigorous handling of paint suggests direct contact with nature; perhaps this is a study begun on site and finished in the studio. A subtle and moving rendition of a favorite motif and moment of day, it is very different from Corot's earlier composition on a related subject (cat. no. 75). The picture conveys a surprisingly grand realization of the theme; indeed, with only a reproduction as reference, it would be hard to imagine the small scale of the work.

1. "Malgré la maladresse et la lourdeur de sa touche, M. Corrot a tellement le sentiment de la poésie et l'intelligence de l'art qu'il arrive à des résultats étonnants. Vue de près, sa toile intitulée *Paysage* est un fouillis de tons gris et plâtreux; vu à quelques pas, c'est une peinture pleine de vérité." Menciaux 1847.
2. "l'incorrigible M. Corot [qui] nous a fait deux petits paysages qu'il ne faut pas regarder de près." Delécluze 1847.
3. "Il nous a fallu souvent une grande puissance sur nous-mêmes pour ne pas aller tirer par le pan de leur habit certaines gens qui regardent les tableaux de Corot, comme s'ils étaient myopes, sous le nez, pour ainsi parler, et les faire reculer de deux ou trois pas, afin de les placer au point où ils doivent être vus. Tout prend alors un aspect différent. Les tons noirs deviennent transparents; les tons gris, fins; les bavochures ôtent aux lignes leur sécheresse, les maculatures des terrains et des feuillages se remplissent de touches charmantes et légères; tout l'ensemble s'estompe d'une vapeur harmonieuse et douce." Clément de Ris 1847, p. 105.
4. Robaut 1905, vol. 4, p. 168. See the sale at Sotheby's, New York, February 20, 1992, no. 13, ill. The painting was briefly in the Secrétan and Havemeyer collections.

PROVENANCE: Alfred Bruyas, possibly by 1851; his gift to the Musée Fabre, Montpellier, 1868

EXHIBITIONS: Perhaps Paris (Salon) 1847, no. 380, as *Paysage*; Tokyo, Okayama, Kanazawa, Tokushima, Kumamoto 1982–83, no. 47; Tokyo, Osaka, Yokohama 1989–90, no. 15

REFERENCES: *École moderne* 1857, pl. 8 (lithograph by Jules Laurens); Bruyas 1876, pl. 6 (lithograph by Jules Laurens); *Magasin pittoresque* 1877; Fournel 1884, ill. (wood engraving after Laurens); Larthe-Ménager 1894, ill. p. 9 (wood engraving after Laurens), as *Vue prise dans la forêt de Fontainebleau*; Robaut *carton* 19, fol. 552, also called *Le Soir*; Robaut 1905, vol. 2, pp. 336–37, no. 1136, ill.; Joubin 1926, p. 129, no. 416; Baud-Bovy 1957, pp. 17, 50

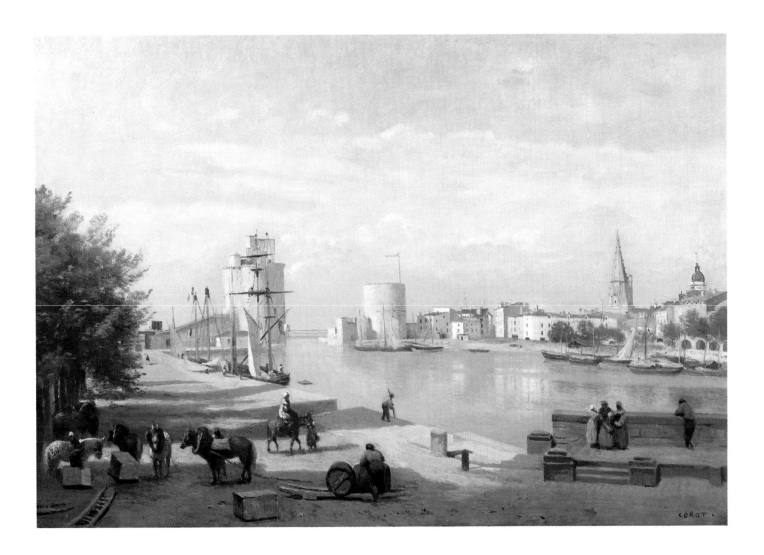

96

Vue du port de La Rochelle
(View of the Port of La Rochelle)

1851
Oil on canvas
19⁷⁄₈ × 28¼ in. (50.5 × 71.8 cm)
Signed lower right: COROT.
Yale University Art Gallery, New Haven
Bequest of Stephen Carlton Clark, B.A. 1903 1961.18.14

R 669

When exhibited at the 1852 Salon with two other works that have not been identified, *Soleil couchant* and *Le Repos*, this painting failed to attract attention, although it was reproduced in *L'Illustration*.[1] When sent by Corot to exhibitions in the provinces—in Bordeaux, Rouen, Saintes, Toulouse, and Amiens—it returned unsold. In 1868, when the painting was shown at Arras at the Société des Amis des Arts, probably at Robaut's instigation, it was offered for sale for 1,200 francs, the same price asked for it in 1854. The committee voted against it, however, and Robaut bought it himself.[2] As late as 1889 there was opposition

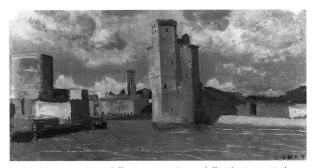

Fig. 96b. Corot. *La Rochelle. Avant-port* (*La Rochelle: The Outer Harbor;* R 672), 1851. Oil on canvas, 7½ × 14⁵⁄₈ in. (19 × 37 cm). Ny Carlsberg Glyptotek, Copenhagen (1390)

to including it with the group of forty-five paintings by Corot shown at the Exposition Centennale. Robaut turned to the artist Félix Bracquemond for help and petitions were written, but when the painting was finally exhibited, it was hung in a corner where it could not be seen. Further protests to

Claude Roger-Marx, the principal organizer of the exhibition who was highly sympathetic to modern art, were met with kindness, but by then it was too late to change the installation.[3]

In 1851, after his mother's death in February, Corot traveled part of the summer to Arras and in Brittany and Normandy. During the second half of July he went to La Rochelle with his friends Brizard and Comairas, whose parents lived there.[4] Corot lodged with a local merchant, a M. Monlun on rue Porte-Neuve, and painted frequently with his friends. After a three-week stay he returned to Paris with some eight oil studies (R 670–677; fig. 96b) and the present work, a larger view of the port. The studies, a varied group, were entirely painted on site; one of them (R 671), later owned by Alexandre Dumas and now in the Louvre, Lionello Venturi thought was Corot's most Impressionist painting.[5] This larger view of the port was painted from the second-floor window of a house on the quai Valin. Robaut, who visited the site, thought the house was the Maison des Cantonniers, at number 6, but was not certain.[6] The painting was presumably finished in Paris, since Robaut was told that Corot had worked on it for six weeks.

The picture is remarkable on several counts, not least in its uncharacteristic degree of finish. The overall blond tonality and the extraordinary variations of white on white set it apart from Corot's other works, as acknowledged by Bracquemond in his comment to Robaut about "this picture, *so particularly unusual in the master's oeuvre.*"[7] The view looks toward the port entrance, with the Tour Saint-Nicolas at left, the Tour de la Chaîne at center, and the steeple of the church of Saint-Nicolas with the Tour de la Lanterne at right. The same angle was used by Joseph Vernet for his 1762 view of the port. Both Vernet's works and Claude Lorrain's paintings of imaginary ports have been proposed as sources, although at some remove. Théophile Silvestre, who was Robaut's neighbor in the 1870s and often saw the present painting, subscribed to this theory, remarking: "It's a Claude Lorrain from the land of pearls!"[8] More recently Venturi compared it to works by Vermeer, while adding that "there is a spontaneous and fervent love for every created object, which Ver Meer did not dream of."[9]

Renoir saw both this work and several of the La Rochelle studies, and in 1918 he told the art dealer René Gimpel: "There you have the greatest genius of the century, the greatest landscape artist who ever lived. He was called a poet. What a misnomer! He was a naturalist. I have studied ceaselessly without ever being able to approach his art. I have often gone to the places where he painted: Venice, La Rochelle. I've never come anywhere near him. The towers of La Rochelle, ah, what trouble they've given me! It was his fault, Corot's, that I wanted to emulate him. The towers of La Rochelle—he got the color of the stones exactly, and I never could do it."[10]

1. *Soleil couchant* and *Le Repos* were praised by Gustave Planche, who thought them Corot's best work since *Le Petit Berger* of 1840 (cat. no. 76); see Planche 1852, p. 685.
2. See Robaut's note: "I bought it in that last town where the acquisition that some friends had proposed—for 1,200 francs—was shamefully rejected by [a vote of] nine members to three." ("Je l'achète dans cette d^re ville où l'acquisition proposée par des amis fut repoussée honteusement—à 1,200 francs—par neuf membres contre trois.") Robaut *carton* 14, fol. 191.
3. Ibid. for a discussion of the issue. The painting was insured for 75,000 francs.
4. A letter to Dutilleux of July 29, 1852, indicates Corot was then at La Rochelle; see Robaut 1905, vol. 4, p. 333, no. 28. Comairas's father also owned a house at La Repentie, near La Rochelle, where Corot was probably a guest. For Corot's letters and the gift of two studies (R 73 and R 169) to Comairas père (confused by Moreau-Nélaton with the son), see Moreau-Nélaton 1924, vol. 2, pp. 165–69.
5. Venturi 1947, vol. 1, p. 152.
6. Robaut's notes show he thought the house may instead have been number 3 or 4, quai Valin.
7. "ce tableau *si particulièrement original dans l'oeuvre du maître.*" Letter from Bracquemond in 1889, cited in Robaut *carton* 14, fol. 191.
8. "C'est un Claude Lorrain du pays de perles!" Cited in Robaut's notes. Ibid.
9. Venturi 1947, vol. 1, p. 152.
10. "Ce fut le grand génie du siècle, le plus grand paysagiste qui ait jamais vécu. On l'appelle un poète. Quelle erreur! Ce fut un naturaliste. Je l'ai étudié sans pouvoir jamais parvenir à son art. Je me suis souvent placé dans les endroits où il a peint, à Venise, à la Rochelle. Jamais je ne l'ai approché. Les tours de La Rochelle, ah! ce qu'elles m'ont donné du mal! Ce fut sa faute à lui, Corot, j'ai voulu l'imiter; les tours de La Rochelle, mais il donnait la couleur de la pierre, et moi je ne l'ai jamais pu." Gimpel 1963, entry for March 20, 1918, p. 28; translated by John Rosenberg in Gimpel 1966, pp. 13–14.

PROVENANCE: Purchased from the artist by Alfred Robaut, Paris, at the Arras exhibition, 1868; Constant Dutilleux, Paris; his sale, Hôtel Drouot, Paris, March 26, 1874, no. 23, withdrawn at 10,000 francs; Durand-Ruel, New York; the baron Nathaniel de Rothschild; the baron Léonin Henri de Rothschild; Wildenstein & Co., New York; Stephen C. Clark, New York; bequeathed by him to the Yale University Art Gallery, New Haven, 1961

EXHIBITIONS: Paris (Salon) 1852, no. 283, as *Vue du port de La Rochelle*; Bordeaux 1854; Rouen 1856; Toulouse 1865, no. 482; Amiens 1868; Arras 1868; Paris 1875a, no. 97; Paris 1878b, no. 95; Paris 1889, no. 155; Paris 1930b, no. 21; Paris 1931, no. 11; New York 1934a, no. 5; New York 1934b, no. 9; New York 1936, no. 12; New York 1940, no. 253; New York 1942, no. 22; Philadelphia 1946, no. 26; New Haven 1950, no. 4; New York 1954, no. 5; Paris 1955b, no. 8; New Haven 1960, no. 39; Chicago 1960, no. 76; The Hague 1966, no. 40

REFERENCES: Silvestre 1856, p. 404; Mantz 1861, pp. 429, 431, ill. (engraving by H. Delaville, after E. Lavieille); Dumesnil 1875, p. 126, no. 58; Silvestre 1878, p. 265; Roger-Milès 1891, pp. 46, 83; Roger-Milès 1895, ill.; Hamel 1905, p. 28; Robaut *carton* 14, fol. 191; Robaut 1905, vol. 1, pp. 128–32, 137–38, and vol. 2, pp. 230–31, no. 669, ill.; Moreau-Nélaton 1924, vol. 1, pp. 76–77, 82, fig. 118; Lafargue 1925, p. 39, pl. 25; Meier-Graefe 1930, p. 69; Faure 1931, p. 50, pl. 53; Jean 1931, pl. 36; Corot 1946, vol. 1, p. 60, and vol. 2, p. 145; Bazin 1951, pp. 48, 128, no. 85, pl. 85; Baud-Bovy 1957, p. 200; Fosca 1958, ill. p. 106; Coquis 1959, p. 61; Anon. 1961–62, p. 118, ill.; Forster-Hahn 1968, pp. 4–5, ill.; Bazin 1973, p. 286, ill. p. 200; Leymarie 1979, pp. 91–92; Selz 1988, pp. 164–66, 170, ill. p. 171; Clarke 1991a, pp. 91–92, 111, fig. 94; Smits 1991, pp. 18, 320–22, fig. 298; Gale 1994, p. 92, ill. p. 93

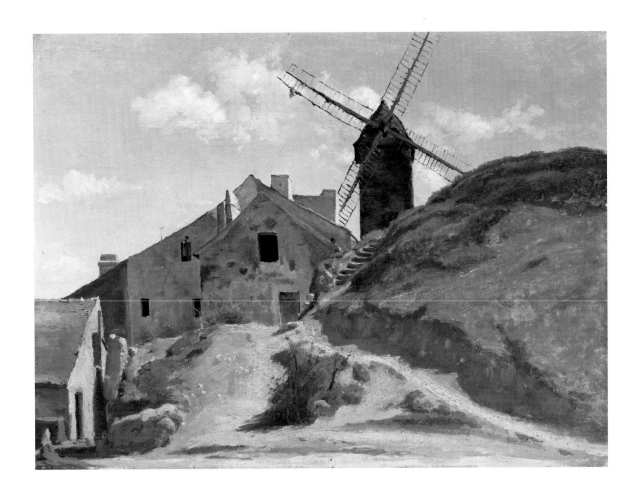

97

Un Moulin à Montmartre
(A Windmill in Montmartre)

Ca. 1845
Oil on paper mounted on canvas
9½ × 13⅜ in. (24 × 34 cm)
Written on the back: Cette étude nous a été donnée par notre ami
Corot dans son atelier du quai Voltaire / Jeanne Scheffer née Darier
(This study was given to us by our friend Corot in his studio on the
quai Voltaire / Jeanne Scheffer, née Darier)
Musée d'Art et d'Histoire, Geneva 1876-8

R 556

The old Radet windmill, known from 1834 as the Moulin
de la Galette, was one of the thirteen mills then active on
Paris's Butte Montmartre, of which only two have survived.
It was painted, from some distance, by Georges Michel and
Théodore Rousseau and later gained immense celebrity from
Renoir's more famous depiction of the popular, contiguous
guinguette (café with music and dancing). Until relatively
recently there was some confusion about the identity of the
site because the nearby Bout-à-Fin windmill was renamed the
Moulin de la Galette at the end of the nineteenth century. In
Corot's day the original mill was owned by Nicolas-Charles
Debray. It was reached through the rue Girardon and the

Fig. 97. Corot. *La Rue des Saules à
Montmartre* (S-D 1948, no. 27). Oil on
canvas, 19½ × 13¾ in. (49.5 × 35 cm).
Musée des Beaux-Arts, Lyons (B673)

chemin des Deux-Frères or by a flight of steps that led to the rue Lepic.[1]

Corot painted little in Montmartre. A small picture included in the posthumous sale as no. 224 was described by Robaut as "dry and uninteresting" and was not included in his catalogue.[2] A later view now in the Musée des Beaux-Arts, Lyons (fig. 97), of which Robaut made a sketch at an exhibition in 1898, was also omitted from the catalogue but was subsequently added in the supplement published by Schoeller and Dieterle.[3] The present work, a deservedly famous study of exceptional luminosity, is perhaps the finest of Corot's small number of views of Paris.

The inscription on the back of the painting records Corot's friendship with Jean-Gabriel Scheffer, his Swiss colleague in Rome in the 1820s. Scheffer, though living mostly in Geneva, exhibited occasionally at the Salon and intermittently kept a studio in Paris until the mid-1840s. When he returned to Paris in 1837 he settled at 8, rue Vivienne, not far from the house of the Corot family. After his travels in Italy in 1834, Corot himself took a studio on the Left Bank at 15, quai Voltaire, where he shared the building with the painter Adolphe Roehn and his son Alphonse. In the 1840s the painter Jules Étex and briefly the architect Victor Gay also moved into the building. When Corot left the quai Voltaire studio in 1848, the small colony dispersed.

Corot's friendship with Scheffer extended to his wife and her relatives, the Darier family of Geneva, and in the 1860s Albert Darier, Jeanne Scheffer's nephew, was Corot's student. Scheffer, in turn, knew Corot's family, and in a letter of

December 27, 1835, Corot referred to portraits Scheffer had recently painted of four members of the Corot family, presumably himself, his sister Annette-Octavie, and M. and Mme Corot.[4] (No trace of these portraits appears to have survived, and, oddly, no works by Scheffer figured in Corot's posthumous sale.) Thus, the present view of Montmartre has the particular significance of being a gift to close friends. The inscription suggests the work dates from before 1848, when Corot left the quai Voltaire, and most likely before 1846, when the Scheffers were last in Paris.

1. Martin Dieterle has kindly shown me his annotated Robaut containing a note to the effect that the mill represented is the Moulin Rollin (that is, the Moulin de la Tour-à-Rollin) at the corner of the rue des Brouillards. He has also indicated that there were records of a copy of the painting measuring 30 × 45 cm (11¾ × 17¾ in.).
2. "sans intérêt et sec." Robaut 1905, vol. 4, p. 221. The picture has not been identified.
3. See Robaut 1905, vol. 4, p. 294, no. 125. The painting was known in 1885 as *La Rue des Saules,* but the site has been identified by Schoeller and Dieterle as the rue Saint-Vincent. Schoeller and Dieterle 1948, no. 27.
4. See Baud-Bovy 1957, pp. 147–48.

PROVENANCE: Gift of the artist to Jean-Gabriel Scheffer, Geneva; given by him to the Musée d'Art et d'Histoire, Geneva, December 8, 1876

EXHIBITIONS: Zurich 1934; Fribourg 1943; Bern 1960, no. 33; Paris 1961; Edinburgh, London 1965, no. 57

REFERENCES: Geneva, Musée Rath 1878, no. 31; Robaut 1905, vol. 2, pp. 200–201, no. 556, ill.; Geneva, Musée Rath 1906, no. 87; Pisteur 1920, ill. p. 83; Hautecoeur 1948, p. 19; Gilardoni 1952, p. 43; Courthion 1956, pp. 19–20, ill. frontispiece and p. 19; Baud-Bovy 1957, pp. 170–71, ill. p. 30; Lapaire 1982, no. 74, ill.; Lapaire 1991, no. 124, p. 94

98

Environs de Beauvais, du côté de Voisinlieu (A Village near Beauvais)

Ca. 1850–55
Oil on canvas
15¾ × 11⅞ in. (40 × 30 cm)
Signed lower right: COROT
Musée du Louvre, Paris R.F. 1357

R 1003

From about 1857 Corot's occasional travels to Beauvais, at first to see his friend Adolphe Badin and later to visit an expanding circle of friends, can be inferred from correspondence and notes. Earlier visits remain undocumented. According to Moreau-Nélaton, a fairly varied group of works Corot painted in the region of Beauvais, including *Plaines des environs de Beauvais* (cat. no. 123), dates from 1855 to 1865, roughly when the artist is known to have visited Badin. The present small work was ascribed by Moreau-Nélaton to this period, but Robaut believed

it dated earlier, from 1845–48.[1] While the work looks early and it is tempting to agree with Robaut, it may well date from the mid-1850s. Robaut relates that the painting disappeared from Corot's studio without his knowledge, reappearing in 1874 when a Lyons collector brought it to the artist to be signed.[2]

Executed in plein air, the landscape is painted with remarkable vigor. The brushstrokes are assertive and lively, and Corot even used the handle of the brush to scratch lines in the trees' lower foliage and the roof at the center. The sky gives the impression of having been spontaneously worked up, although examination shows it was revised. The direct, even artless grasp of nature, free of strictures, and the vivid sense of light

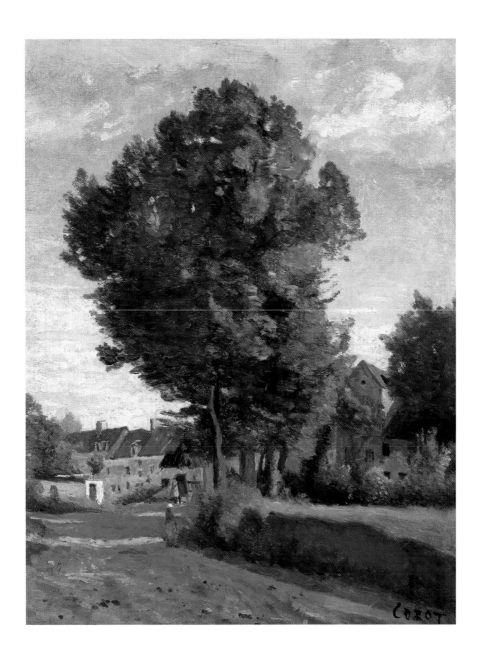

anticipate the direction in which Sisley and Pissarro, an admirer of Corot, would travel two decades later. A comparison with the work of the younger generation was possible in the first half of the 1880s, when the painting was owned by Léon Clapisson, an early collector of Impressionist painting.

1. Robaut *carton* 4, fols. 216, 216 bis.
2. Ibid.

PROVENANCE: Private collection, Lyons, 1874 (according to Robaut); Dr. Verdier, Paris(?); Léon-Marie Clapisson, Paris; his sale, Hôtel Drouot, Paris, March 14, 1885, sold for 3,600 francs; George Thomy Thiéry, Paris; given by him to the Musée du Louvre, Paris, 1902

EXHIBITIONS: Lyons 1936, no 62; France 1956, no. 6; Agen, Grenoble, Nancy 1958, no. 6; San Francisco, Toledo, Cleveland, Boston 1962–63, no. 18; Saint Petersburg, Moscow, Madrid 1970–71; Bourges 1973, no. 64; Bremen 1977–78, no. 16; Tokyo 1983, no. 20; Beauvais 1990–91; Cologne, Zurich 1990, no. 37

REFERENCES: Lafenestre 1902, p. 292; Guiffrey 1903, no. 1808; Robaut 1905, vol. 2, pp. 308–9, no. 1003, ill.; Brière 1924, no. T 2808; Meier-Graefe 1930, pl. LXXIII; Fosca 1958, p. 175, ill. opp. p. 118; Sterling and Adhémar 1958, p. 422; Paris, Musée du Louvre 1972, p. 422; Gache-Patin and Lassaigne 1983, p. 26, fig. 99; Selz 1988, ill. p. 195; Smits 1991, pp. 344–45, fig. 329; Gale 1994, p. 98, ill. p. 99

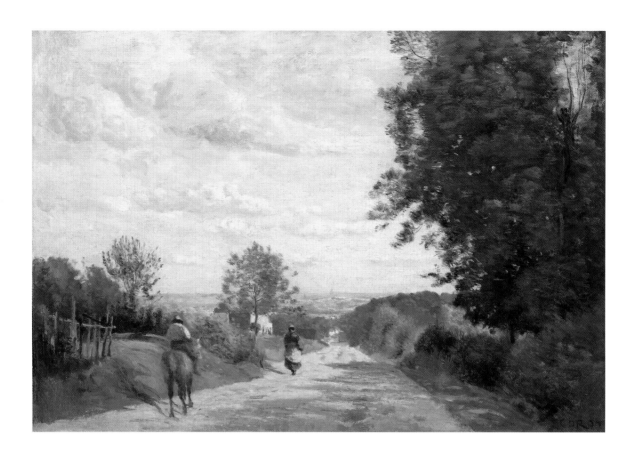

99

Chemin de Sèvres, also called *Sèvres-Brimborion. Vue prise en regardant Paris*
(The Sèvres Road)

1858–59?
Oil on canvas
13³/₈ in. × 19¹/₄ in. (34 × 49 cm)
Signed lower right: COROT
Musée du Louvre, Paris R.F. 1352

R 1464

Roads and paths are recurring motifs in Corot's work, and from his youth the artist appears to have been particularly fond of lanes that ascend or descend. The road near Ville-d'Avray that descended from the height of Sèvres toward Paris offered a view of the city shimmering indistinctly in the distance. It was a sight the artist saw countless times, but he did not begin to paint it until the late 1850s.

Four additional versions of this subject are known, with variations in composition and mood. The variants closest to the present painting are in The Metropolitan Museum of Art, New York (fig. 98), and in the Lucas Collection, on deposit at the Baltimore Museum of Art (R 1463). The New York example is almost the same size as this landscape in Paris but differs from it in having only one figure at the left, a more uniform shadow across the foreground, and a brighter atmos-phere and coloration.[1] The painting in Baltimore, larger and darker than the Paris view, has greater masses of trees and two figures at the left; Robaut recorded that it was sold in 1864 to the dealer George A. Lucas and that it had suffered some earlier damage when it had been lined.[2] A third variant (R 1469, location unknown), similar in design to the Paris and New York paintings but of a more elongated format, belonged to the singer Faure, who lent it to the Corot memorial exhibition of 1875 (no. 144). A fourth, small work (R 1465), which shows the road farther to the right, was given by Corot to the painter William Haussoullier.

Lucas's diary confirms Robaut's notes about the versions he knew. It documents that during his visit to Corot with William Walters on February 9, 1864, Lucas bought for himself a *Landscape near Amiens,* now also in the Baltimore Museum

Fig. 98. Corot. *Ville-d'Avray. Sur les Hauteurs* (*Ville-d'Avray, on the Hills;* R 1485). Oil on wood, 13½ × 20¼ in. (34.3 × 51.4 cm). Theodore M. Davis Collection, Bequest of Theodore M. Davis, 1915, The Metropolitan Museum of Art, New York (30.95.272)

paintings, since he was familiar only with those still in Corot's studio in the 1860s. He saw the present painting very briefly, late in his life, and was prompted to write, "So many differences that I cannot detail, having merely glimpsed this painting at M. Thomy Thiéry's." He ascribed it and the Baltimore picture to the period 1858–62.[6] The implication is that this painting had been sold sometime before Lucas purchased the Baltimore version, which by 1864 had already undergone some treatment. The small Haussoullier landscape, which Robaut knew well and admired, he placed about 1865–68.[7]

1. Recorded in Robaut 1905, vol. 3, no. 1485, with the wrong dimensions and dated about 1860–70.
2. Recorded in ibid., no. 1463, and dated 1855–65.
3. Lucas 1979, vol. 2, pp. 171, 172.
4. Ibid., p. 176.
5. Ibid., p. 177.
6. "Tant de différences que je ne puis noter parce que je n'ai fait qu'entrevoir ce tableau chez M. Thomy Thiéry." Robaut *carton* 9, fol. 384.
7. Robaut made a color drawing of it and wrote, "extraord[inary] execution of innocent . . . almost feminine freshness" ("exécution extraord. de fraîcheur naïve . . . presque féminine"). Ibid., fol. 384.

PROVENANCE: George Thomy Thiéry; his bequest to the Musée du Louvre, Paris, 1902

EXHIBITIONS: Lyons 1936, no. 71; Saint Petersburg, Moscow, Madrid 1970–71, no. 10

REFERENCES: Lafenestre 1902, p. 292; Robaut 1905, vol. 3, pp. 72–73, no. 1464, ill. (with wrong dimensions, ca. 45 × 60 cm); Brière 1924, no. T 2803; Bazin 1942, pp. 8, 105; Sterling and Adhémar 1958, p. 443; Paris, Musée du Louvre 1972, p. 87; Bazin 1973, p. 269; Compin and Roquebert 1986, p. 148; Clarke 1991a, p. 111, fig. 105; Gale 1994, p. 96, ill.

100

Une Route aux environs d'Arras, also called *Les Chaumières* (*A Road near Arras,* also called *The Cottages*)

Ca. 1853–58
Oil on canvas
13¾ × 18⅛ in. (35 × 46 cm)
Signed lower left: COROT
Musée des Beaux-Arts, Arras D 955.1

R 964

On April 16, 1853, Corot wrote from Mantes to Ernestine Clerc de Landresse about his plans to visit Arras "to attend a wedding, and after the ceremony I plan to roam around the area to do several paintings I have in mind. The region has the reputation of not being very suitable for painters, and I think I can do some interesting work there, if the Lord guides my brush. I also think that it isn't so much the site as the interpretation that makes the work."[1] The frequent visits to Arras that he had begun in 1851 continued for the rest of his life,

and he worked a good deal around Arras at Achicourt, Blangy-sur-Ternoise, Sainte-Catherine-les-Arras, and Saint-Nicolas-les-Arras, often with Constant Dutilleux, who sometimes painted the same sites.

Alfred Robaut, who identified the site in this painting as the environs of Arras, dated it in his notes to 1853–58, that is, to the period following his own marriage. Seeing it again at a later date, he observed that the colors had somewhat altered: "very beautiful study whose greens have faded to blue."[2] This tranquil, reassuring depiction of the countryside is the sort of image that contributed greatly to Corot's fame at the turn of the century. Although modest in dimensions, it was among

100

the artist's first works to be widely reproduced in color. In 1910 it was published in an anonymous but much reprinted book with the statement that such sketches "by their brilliance and sincerity of tones rank high among the most beautiful works of the master's career."[3]

1. "pour assister à un mariage et, après la noce, je circulerai dans le département pour y faire plusieurs tableaux que j'ai en vue. C'est un pays qui passe pour être peu convenable aux peintres, et je pense que j'y ferai des choses intéressantes, si le Seigneur veut soutenir mon pinceau. Je pense aussi que ce n'est pas tant le site, mais l'interprétation qui fait l'ouvrage." Robaut 1905, vol. 4, p. 334, no. 46. Corot left for Arras on May 15 to attend the wedding of Alfred Robaut and Élisa Dutilleux on the next day. Robaut 1905, vol. 1, p. 146.

2. "très belle étude dont les verts ont bleui." Robaut *carton* 5, fol. 268.
3. "par leur éclat et la sincérité des tons occupent un des premiers rangs dans les plus belles productions de la carrière du maître." *Corot* 1910, p. 23.

PROVENANCE: Reignard, 1878; George Thomy Thiéry, Paris; given by him to the Museé du Louvre, Paris, 1902; deposited in the Musée des Beaux-Arts, Arras, 1955

EXHIBITIONS: Paris 1878b, no. 124, as *Un Faubourg d'Arras*; Arras, Douai 1992–93, no. 81

REFERENCES: Lafenestre 1902, p. 292, as *Les Chaumières*; Guiffrey 1903, no. 2809; Robaut 1905, vol. 2, pp. 298–99, no. 964, ill., as *Une Route aux environs d'Arras*; *Corot* 1910, p. 23, pl. III, as *Les Chaumières*; Meier-Graefe 1930, pl. LXI

101

Premières Feuilles près de Mantes (First Leaves, near Mantes)

Ca. 1855
Oil on canvas
13³⁄₈ × 18¹⁄₈ in. (34 × 46 cm)
Signed lower right: COROT
The Carnegie Museum of Art, Pittsburgh
Acquired through the generosity of the Sarah Mellon Scaife Family, 1966 66.19.3
R 815

From about 1850, Corot's reputation as a highly original interpreter of springtime in the French countryside was secure. In a review of the Salon of 1850–51 the critic Auguste Desplaces was among the first to express an opinion that would prevail for the next quarter of a century: "M. Corot excels . . . in reproducing vegetation in its fresh beginnings; he marvelously renders the firstlings of the new world. Grass that has as yet felt only the warmth of May, the first new leaves just emerged from the bud, all that adolescence of newly green nature finds

101

in M. Corot an innocent and well-informed interpreter. This is no academic tracing, no copy of earlier masters: one senses a familiarity with and inspired knowledge of the subject."[1] Also in 1851 Ève de Balzac, repeating a widespread view, wrote in a letter to Champfleury, "Nature seen through the eyes of a Dupré or a Corot! . . . Oh, how lovely it is! . . . One could not be more innately, more finely original."[2] It was a far cry from the critics' detection of "brutal naïveté" in his work only a few years earlier. Even Champfleury, often a reluctant admirer, admitted that "having seen the paintings, I have finally come round to appreciating the green fields of Jules Dupré and the misty mornings of Corot."[3]

The present painting, likely finished in the studio rather than in plein air, exemplifies Corot's gift for capturing the "fresh beginnings" of springtime. The quiet effect of morning light and the faintly misty atmosphere are counterbalanced by a solid but subtle composition articulated in a screen of tree trunks whose shapes echo each other. Corot's visits to Mantes beginning about 1840 to see his friends the Robert family appear to have produced little in the way of plein air painting until the later 1850s. This work has been associated by Robaut and Moreau-Nélaton with the first group of works depicting Mantes, dating probably from the mid-1850s.

1. "M. Corot excelle . . . à reproduire la verdure dans sa fraîcheur toute pre-mière, il rend à merveille les prémices du nouveau. L'herbe qui n'a ressenti encore que les tiédeurs de mai, les premières feuilles nouvelles a peine sor-ties du bourgeon, toute cette adolescence de la nature reverdie trouve en M. Corot un interprète naïf et bien renseigné. Ce n'est plus un calque académique, une copie d'après les maîtres antérieurs, on sent là une con-naissance et une fréquentation inspiré du modèle." Desplaces 1851, writing about an *Étude à Ville-d'Avray* exhibited that year.
2. "Et la nature vue à travers les Dupré & Corot? . . . Oh que c'est joli! . . . Il est impossible d'être plus nativement, plus finement original." Letter, April 27, 1851, quoted in Balzac 1989, p. 14.
3. "à force de voir de la peinture, je me suis pris à aimer les prés verts de Jules Dupré et les matinées brumeuses de Corot." Champfleury 1854, p. 281.

PROVENANCE: Léon Michel-Lévy; his widow, Mme Michel-Lévy; her sale, Hôtel Drouot, Paris, March 17, 1876, bought in for 960 francs; Durand-Ruel & Cie., Paris; Harry Samuel Henry, Philadelphia, 1907; Eugene Glaenzer, New York, 1912; Henry Walters, 1940; Wildenstein & Co., New York, 1942–66; purchased by The Carnegie Museum of Art, Pittsburgh, 1966

EXHIBITIONS: Paris 1895, no. 110, as *Ville-d'Avray*, lent by Mme Michel-Lévy; New York 1942, no. 33; Toronto 1950, no. 18; Venice 1952, no. 22; New York 1963, no. 18; New York 1969, no. 41; New York 1973b; Atlanta 1974

REFERENCES: Robaut *carton* 5, fols. 233, 233 bis; Robaut 1905, vol. 2, pp. 262–63, no. 815, ill.; Henry 1907, n.p., ill.; Bazin 1952, p. 4, ill.; Farrell 1967, p. 42, ill. cover; Delahoyd 1969, p. 76, ill. p. 41; Werner 1969, p. 32, ill.; Pittsburgh, Carnegie Museum of Art 1973, p. 43

Ville-d'Avray. L'Étang et les maisons Cabassud (The Pond and the Cabassud Houses at Ville-d'Avray)

1855–60
Oil on canvas
18¼ × 21¾ in. (46.4 × 55.2 cm)
Signed lower left: COROT
Purchased with funds from the Coffin Fine Arts Trust, Nathan Emory
Coffin Collection of the Des Moines Art Center 1962.20

R 917

The house in Ville-d'Avray at 3, rue du Lac, where Corot lived for the greater part of his life, is first recorded on September 24, 1783, when it was sold to Charlotte-Catherine Delaplanche, widow of Jean Pothenot. After Mme Pothenot's death the house was rented to the *citoyen* Lamiral; subsequently, on September 1, 1799 (the 15th of Fructidor in year VII of the Republic), a lease was taken in the name of the *citoyenne* Vié, who was associated with the stage and who appears in later documents as the widow Vié-Sulpouze. Her rent was paid by the *citoyen* Thierriet de Grandpré. At that time the house was enlarged and the garden transformed into a *jardin à l'anglaise*, with a kiosk that Corot would eventually decorate with paintings. On April 26, 1808, the Pothenot heirs sold the house for 17,500 francs to Charles-Guillaume Étienne, a member of parliament and of the Institut, who also bought the garden furnishings, including bronze vases, for 3,800 francs. The house was further enlarged. Nine years later, on March 4, 1817, Étienne sold it for 25,000 francs to Louis-Jacques Corot, Camille's father. By now the house was fairly substantial, with two floors and an attic. Until his death, Corot occupied a very small room, with two windows overlooking the lake, on the third floor at one end of the house.[1]

The rue du Lac, which became the legendary "chemin de Corot" ("Corot's road"), connected the forest of Sèvres with Ville-d'Avray and separated the Corot property from a nearby pond. Down the road, before the curve that brought it into Ville-d'Avray, stood the large Cabassud houses. This site, now almost as familiar as the frequently depicted pond, is one that Corot painted with a certain regularity at different stages of his life, yet never twice in the same manner. Among the artist's earliest great works is a view of the pond and the Cabassud houses (fig. 19), dated about 1835–40 by its former owner, Étienne Moreau-Nélaton,[2] but rightly assigned to the 1820s by Hélène Toussaint.[3] The chronology of the later works has been difficult to establish despite aid provided by external evidence. Toussaint has shown that extensive work was carried out in the area; in 1849 the rue du Lac was realigned and consolidated, and the pond, which had steadily receded, was allowed to fill.[4] This new state of the terrain, with a straight road, is recorded in a painting in a private collection (R 516)

which Robaut (who disliked it) dated to 1840–45 but which must in fact date to after 1849.[5] What appears to be a slightly later view (R 916, private collection), dated by Robaut to 1850–55, hung in the painter's living room until his death. Corot executed the more curious version exhibited here in the 1850s.

Unlike the other views, the Des Moines painting presents a road largely obscured by a sizable clump of birch trees, with the Cabassud houses only partially glimpsed across the water.[6] The vantage point is the shore of the pond, where a seated woman, her back turned to the viewer, holds a child. The season is spring, the mood quiet, somewhat gray and reflective. Robaut thought the painting had great appeal, but he noted that in 1881, when he first saw and drew the work, the scene also included a peasant leading a cow down the path at the right, which he immediately doubted were by Corot.[7] When the picture reappeared in public some years later, the peasant and cow had been painted over, one suspects on Robaut's advice.

There is a small, related composition that gives every impression of being the sketch from which the present painting was developed.[8] Although when it was exhibited in 1987 it was said to be on its original canvas,[9] Robaut wrote in both his notes and his catalogue that the sketch was on a panel that had on its other side a view of Saint-Lô (R 751). In 1873 Corot asked Robaut to have the panel separated and subsequently gave him the portion depicting Ville-d'Avray. Although there is some confusion about the dimensions of the two sides of the panel as published, the fact that the two landscapes were originally on the same support has some bearing on their date.[10] Toussaint has demonstrated that Corot visited Saint-Lô in 1834 and did not return again until much later, in 1862; after that he spent several successive summers in the region.[11] This would suggest that the sketch of Ville-d'Avray was painted substantially earlier than the present painting.

1. For the history of the building, see Guinon 1925, passim. See also "The Making of an Artist" in this volume.
2. Robaut 1905, vol. 2, p. 100, n. 284. The painting is in the Musée du Louvre, Paris, R.F. 2640.
3. In Paris 1975.
4. Ibid., no. 36.

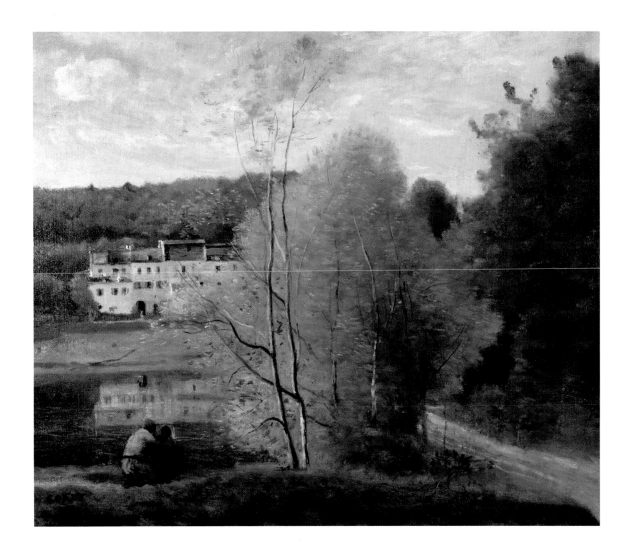

5. Robaut *carton* 6, fol. 173; there is a small, related study (R 513), in which trees cover much of the view, which Robaut found more interesting.

6. Here the houses appear fully built, whereas earlier there was a gap between two buildings. Corot apparently painted some of the later versions of the view from studies done years earlier, without regard to the most current topography; thus, the later paintings may show the buildings as they no longer appeared. Robaut noticed this inconsistency and ascribed it to Corot's use of old sketches as models.

7. "Two figures to the right on the side of the road, a woman and a cow, which I don't believe are by Corot.... It's lifeless, fuzzy and glairy in its execution, while the rest is firm and straightforward." ("Deux figures à droite au bord de la route, une femme et une vache, que nous ne croyons pas de la main de Corot.... C'est mou, estompé et d'exécution glaireuse quand tout le reste est ferme et de la plus franche exécution.") Robaut *carton* 6, fol. 258.

8. *Ville-d'Avray. Premières Feuilles au bord de l'étang en vue de la propriété Corot*, 10⅝ × 15⅝ in. (27 × 39 cm), R 924, private collection.

9. See Ville-d'Avray 1987, no. 5, ill.

10. There are discrepancies between Robaut's notes and the text published by Moreau-Nélaton in Robaut 1905, vol. 2, p. 290. The published version

states that Corot gave Robaut the panel in 1875 and that the separation of the sides occurred afterward. Robaut did not own the side with the view of Saint-Lô and was forced to make a drawing from a smaller copy, which explains the discrepancy in dimensions.

11. In Paris 1975, no. 30.

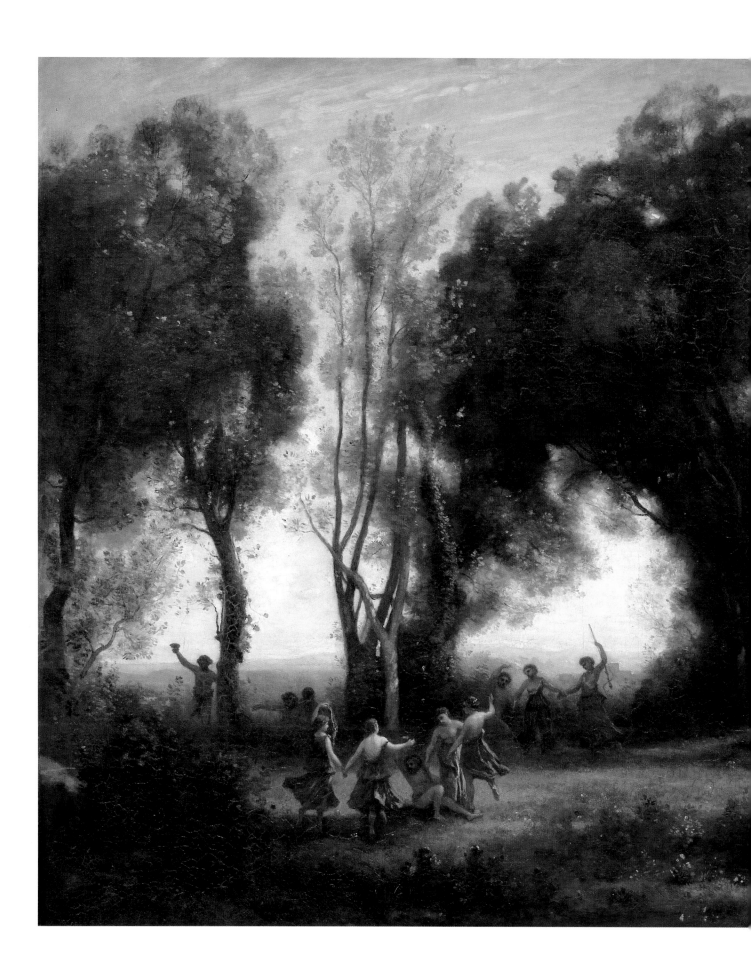

103

Une Matinée, also called *La Danse des nymphes (A Morning)*

1850
Oil on canvas
38⅝ × 51⅝ in. (98 × 131 cm)
Signed lower left: COROT
Musée d'Orsay, Paris R.F. 73

R 1061

In 1850 Corot was elected to the jury for the Salon of 1850–51.[1] Perhaps unsurprisingly, the four paintings he submitted were all accepted, and this work—an unqualified success—met with almost unanimous critical praise. Philippe de Chennevières, on the strength of this painting, called Corot the greatest landscape painter of the age and compared him to the greatest masters of the past: "The most beautiful landscape of 1850 was his *Danse de nymphes.* . . . In truth, this good man, by the breadth and tranquillity of his talent, his disregard of sterile methods, his intimate charm and mellowness of sentiment, is to our other makers of landscape what Poussin is to Allegrain or Claude to Lantara."[2] But success also took other forms: Louis Français's lithograph, done from the painting before it was finished, proved enormously popular; Corot himself painted several replicas and variants;[3] Gustave Colin, soon to become a friend, wrote a poem about the picture. The composition even had commercial success, being used to illustrate the sheet music for "Les Faunes," a waltz for piano by Olivier Métra dedicated to the Prince of Orange: "Simplified edition (5 francs), for solo piano (6 francs), and for piano four hands (9 francs)."

More important, the painting represented the turning point toward Corot's late, vaporous manner and an increasing reliance

Fig. 99. Richard Earlom (1743–1822), after Claude Lorrain (1604/5?–1682). *La Métamorphose du berger (The Metamorphosis of the Shepherd),* 1776. Etching. National Gallery of Canada, Ottawa

on dramatic effects of mood, the culmination of a development begun ten years before with *Le Petit Berger* (cat. no. 76). The somewhat euphemistic title was explained in Français's lithograph by a verse from Horace.[4] In fact, the subject is a bacchanal, and as Hélène Toussaint points out, the work is a distant recasting of the *Silène* (cat. no. 64) of 1838, whose two nymphs reappear here at the center of the composition.[5] The satyr at the far left is a reprise of the Neapolitan youngster dancing in *Site des environs de Naples* (cat. no. 77). The splendid group of trees closely follows a sketch made in the 1820s in the Farnese Gardens in Rome (R 54). The dancing nymphs can be related to drawings Corot made at the Opéra, but the general disposition, as already noted by scholars, echoes chains of dancers from the antique through Mantegna, Giulio Romano, and Poussin.[6] To this series one may add Claude Lorrain's *Metamorphosis of the Shepherd* (see fig. 99). The painting has been linked to Claude's *La Fête villageoise* in the Louvre, partly because of the fortuitous resemblance in the grouping of trees, and in fact in both conception and effect it is Corot's most consciously Claudian effort.

The curious misadventures that befell the present painting after such a happy beginning have been described in detail by Geneviève Lacambre.[7] Sometime after the Salon exhibition opened, Corot noticed that *Une Matinée* had been removed. After a formal inquiry by his friend Auguste Faulte du Puyparlier, the painting was restored to view, but Faulte followed up on April 14, 1851, with a written complaint in which he accused the exhibition's administration and jury of having deliberately slighted the artist. The inadvertent result of the letter was the purchase of the work by the Ministry of the Interior on October 8, 1851. There were, however, difficulties over payments, which were finally settled, after a letter from Corot, on March 20, 1852.[8] (It was typical of Corot's sense of humor that he told an anecdote concerning the unflattering remarks about one of his paintings a visitor to the Salon made to her husband.)[9]

The painting lingered for another two years at the Ministry of the Interior until in 1854, at Philippe de Chennevières's insistence, it was transferred to the Musée du Luxembourg, becoming Corot's first—and for long his only—painting in a Paris museum.[10] Thirty years later the painting had deteriorated somewhat, which was exceptional in Corot's oeuvre. Robaut, who wanted Corot to be better represented in the national collection, complained in print in 1883 about its condition: "While the composition is remarkable, the fact is that this painting has lost all the warmth of its color and is now almost disguised under a bluish layer that intensifies each day, doubtless because of a bad commercial preparation."[11]

1. Robaut 1905, vol. 1, p. 123.
2. "Le plus beau paysage de 1850 était sa *Danse de Nymphes*. . . . En vérité, ce bonhomme, par l'ampleur et la tranquillité du talent, par l'insouciance du procédé stérile, par le charme intime et la suavité du sentiment, est à nos autres faiseurs de paysages ce que Poussin est à Allegrain, ce que Claude est à Lantara." Chennevières 1851, p. 75.
3. Among the variants are R 1619, 1627–1629, 2002, 2328.
4. The lithograph is inscribed: "Junctaeque Nymphis Gratiae decentes / Alterno terram quatiunt pede." ("And the comely Graces dance / Hand in hand with the Nymphs.") Horace, "Ad Sextium," *Carmina*, Book 1, no. 4.
5. See Toussaint in Paris 1975, no. 73, with a list of suggested sources for the figures.
6. Wissman 1989, pp. 61–62.
7. In Paris 1974, no. 55.
8. Ibid.
9. "A young couple stops. The man says, 'That's not bad. It seems to me there's something about it.' But his wife, who seems quite sweet, tugs at his sleeve and replies, 'It's horrible. Please let's go.' And I (it's Corot speaking) silently add to myself: Aha! You wanted to know what the public thought: are you happy now?" ("Un jeune couple s'arrête; le monsieur dit: 'Ce n'est pas mal, il me semble qu'il y a quelque chose là.' Mais sa femme, qui avait l'air doux, le tirant par le bras, répondit: 'C'est affreux, allons-nous-en.' Et moi—c'est Corot qui parle—d'ajouter en moi-même: Attrape! Tu as voulu connaître l'opinion du public: es-tu content?") Larthe-Ménager 1894, p. 4.
10. "Once, even before being connected with the [Musée du] Luxembourg, I had been able to point out the ministry in one of whose salons was hidden his masterpiece *Une Matinée*—a marvel of his Virgilian art that for a long time was the only one of his pieces represented in our museum." ("Jadis, avant même d'être attaché au Luxembourg, j'avais pu désigner le ministère, dans l'un des salons duquel se cachait son chef-d'oeuvre d'*Une matinée*, merveille de son art Virgilien et qui l'a longtemps seul représenté dans notre musée.") Chennevières 1979, pt. 2, p. 36.
11. "Si la composition en est remarquable, on sait en revanche que cette peinture a perdu tout entrain de couleur, presque déguisée qu'elle est maintenant sous une couche bleuâtre qui augmente chaque jour à cause sans doute d'une mauvaise préparation commerciale." Robaut 1883, p. 138.

PROVENANCE: Purchased by the state for 1,500 francs, October 8, 1851; claimed by the Direction des Musées on March 21, 1853, and again, successfully, on February 6, 1854; displayed at the Musée du Luxembourg, Paris; entered the Musée du Louvre, Paris, 1886; transferred to the Musée d'Orsay, Paris, 1986

EXHIBITIONS: Paris (Salon) 1850–51, no. 643, as *Une Matinée*; Vienna 1873, no. 158; Edinburgh, London 1965, no. 71; London 1969a, no. 143; Paris 1974, no. 55; Paris 1975, no. 73; Munich 1983, no. 159

REFERENCES: Peisse 1850; Chennevières 1851, pp. 74–75; Clément de Ris 1851, pp. 18–19; Silvestre 1853, p. 103; Robaut 1881, p. 162; Montrosier 1882, p. 111; Roger-Milès 1891, p. 52; Leymarie 1893, p. 74, ill.; Roger-Milès 1895, ill.; Hamel 1905, pl. 18; Michel 1905, p. 25; Moreau-Nélaton 1905b, pp. 125–26, fig. 109; Robaut *carton* 18, fol. 497; Robaut 1905, vol. 2, pp. 328–29, no. 1061, ill.; Michel 1906, p. 393, ill.; Moreau-Nélaton 1924, vol. 1, p. 72, fig. 109; Lafargue 1925, pp. 42–43; Fosca 1930, pl. 43; Jean 1931, p. 18; Bazin 1942, pp. 51–52, no. 72, pl. 72; Bazin 1951, pp. 45–46, no. 84, pl. 84; Baud-Bovy 1957, p. 219; Sterling and Adhémar 1958, no. 394, pl. CXII; Hofmann 1960, p. 275, fig. 257; Leymarie 1966, p. 66, ill. p. 81; Hours 1972, pp. 116–17, ill.; Paris, Musée du Louvre 1972, p. 86; Bazin 1973, pp. 49–50, 288, ill. p. 217; Volpi Orlandini 1976, pp. 22–26; Leymarie 1979, pp. 98–99, ill.; Selz 1988, pp. 166, 186, ill. p. 169; Wissman 1989, pp. 61–62, 116–17, 145–46; Clarke 1991a, pp. 74–75, 79, fig. 77; Gale 1994, pp. 29–30, 33, 35, 88, ill. p. 89

104

Saint Sébastien; paysage (Saint Sebastian in a Landscape)

1853, reworked later
Oil on canvas
101⅝ × 66⅛ in. (258 × 168 cm)
Signed lower right: COROT
Walters Art Gallery, Baltimore 37.192

R 1063

The present painting, the largest work Corot had undertaken since the *Baptême du Christ* of 1845–47 (cat. no. 89), was exhibited at the Salon of 1853. According to Robaut, Corot retouched it soon after the exhibition and later reworked it extensively in a studio on the rue Fontaine in preparation for the Exposition Universelle of 1867. An old photograph published by Robaut shows the painting at an intermediary stage before it was modified in 1866–67, and a drawing Corot made for an album published on the occasion of the 1867 exposition records its appearance at that time, when it still had an arched top (R 2990). In 1871 Corot offered the painting to the lottery to aid orphans of victims of the Franco-Prussian War, where it was bought in partnership by Robaut and Paul Durand-Ruel. In 1873, before it was offered for sale to the state, Corot again retouched the picture and adjusted the top to a rectangular shape—its present format, which is at some remove from the original design. On February 14, 1874, at the instigation of Robaut and Durand-Ruel, Corot wrote to the Administration des Beaux-Arts proposing to sell it and *Dante et Virgile* (cat. no. 115) for 15,000 francs each, but he received no answer. Perhaps in anticipation of the sale, Corot had Robaut and Desmarest sketch a reduced replica about half the size of the original, which Corot finished at Coubron in October 1874 (R 2316, National Gallery of Art, Washington, D.C.).[1]

The original composition was elaborated over a period of almost two years. The first indication that Corot was at work on the project appears in a letter to Dutilleux of November 23, 1851: "I'm working on a historical landscape featuring a Saint Sebastian being tended by the holy women. With care and work, I hope that, Heaven willing, we'll make a fine painting."[2] Almost a year later, on October 29, 1852, again in a letter to Dutilleux, Corot hinted at difficulties with the painting and promised a visit to Arras "when the Saint Sebastian is figured out and I'm feeling calmer."[3] Letters to Dutilleux of November 25 and December 10, 1852, indicate that the picture had reached a critical stage. The first mentions that the painting "is moving forward, but slowly," while the second confirms that Corot had been on the verge of abandoning it but that he had been advised to finish: "They want me to keep on with it; I'll have to take the big risk."[4] Finally, on February 4, 1853, he told Dutilleux, "The *Saint Sébastien* is getting near the end. Let's

hope it does its job."[5] On April 16, 1853, after the opening of the Salon, Corot wrote to Mlle Clerc de Landresse: "I sent three paintings to the exhibition. The main one is a Saint Sebastian tended by holy women. People have seemed pleased this winter. We'll see if the public will like it."[6]

The subject is an exemplar of charity—the virtue Corot ranked highest. It concerns two Christian women, Irene and a companion, who nursed Sebastian, an officer in the Praetorian guard at the time of Diocletian who was shot with arrows after declaring his Christian faith. Drawings show that Corot originally planned a rectangular composition, with Sebastian pierced by arrows standing at the center flanked by the holy women. Another drawing has him standing to the left in a vast vertical landscape. It has been suggested that the decision to show Sebastian recumbent was influenced by Delacroix's *Saint Sébastien* shown at the Salon of 1836, but Corot may just as well have been remembering Georges de la Tour's interpretation of the subject in the Musée des Beaux-Arts in Rouen.[7] A study for the recumbent Saint Sebastian, now in the Louvre (fig. 100), is inscribed, "It has been suggested I not place it too high / M. Cibot, historical painter,"[8] indicating that he consulted his friend, an intensely spiritual figure painter who also exhibited an allegory of Charity at the Salon of 1853, now in the Musée d'Art, Amiens.

The reception of the painting at the Salon of 1853 was not enthusiastic, but moderate praise came from Delécluze and from Clément de Ris, who nevertheless had to admit that Corot's paintings "don't show us anything new."[9] The many alterations of the painting affected chiefly the landscape; Corot reworked the central group of trees several times and then suppressed a tree left of center and opened up the vista to the background. Of the figures, also partly remodeled, only Saint Irene, nearest to Saint Sebastian, was radically recast and eventually shown in profile. When he saw the altered painting at the Exposition Universelle, Théophile Silvestre thought it had been improved: "*Saint Sébastien*, taken up and revised since 1855, now seems grander in style and more profoundly expressive. The sky has opened up, the shape and position of the trees have changed. The steep slope of the countryside slows the climb of the Roman horsemen, leaving those good women more time to tend to the martyr's wounds."[10]

Fig. 100. Corot. Study for *Saint Sébastien* (R 2836), 1852–53.
Graphite on paper. Musée du Louvre, Paris (R.F. 8800)

At the time of the 1871 lottery, William Reymond had praise for the picture, perhaps to help the sale: "It is noble like Poussin, huge and profound like Claude Lorrain, without ceasing to bear the original, powerful stamp of the master. This grandiose landscape, conceived on a somber note, at the moment when the sun sinks into the horizon, corresponds to the sorrowful theme eloquently expressed in the foreground. . . . At the moment when Saint Sebastian suffers and dies, the vegetable kingdom itself seems to share his pain and weep over his loss. . . . One can see the band of murderers on the far slopes disappearing behind the hillside, while to the left larger weeping birches seem to be hovering over the dying man. And so the sky, the trees, the ground sunken in mysterious shadow—everything seems to join in the mourning."[11]

One wonders why Corot painted such a large religious composition without a specific destination in mind. Did he hope the state would purchase the work and place it in a church? His friend Richomme had depicted the same subject in a painting acquired by the state in 1843 for the church at Colombey-les-Belles (Meurthe-et-Moselle), and a Saint Sebastian by another friend, Antoine Étex, was bought a year later for the Musée de Rouen. More recently, the city of Paris had extended a commission to Alexandre Dupuis for a Martyrdom of Saint Sebastian for the church of Saint-Nicolas-du-Chardonnet, where Corot had himself fulfilled a commission (cat. no. 89) and hoped to paint again.[12] Ironically, the painting by Dupuis was also exhibited at the Salon of 1853.

1. See Eric Zafran in Atlanta, Norfolk, Raleigh, Sarasota 1983, no. 20, ill. Elyse Klein, who has observed that the replica also underwent various transformations, is preparing a study of the Baltimore and Washington *Saint Sébastien*s.

2. "Je suis en train de travailler un paysage historique embelli par un Saint-Sébastien assisté par les saintes femmes. Avec du soin et du travail, j'espère que, le Ciel aidant, nous ferons un joli tableau." Robaut 1905, vol. 1, p. 132, and vol. 4, p. 333, no. 29.
3. "lorsque le Saint-Sébastien sera débrouillé et quand je serai plus tranquille." Ibid., vol. 1, p. 140, and vol. 4, p. 333, no. 34.
4. "marche, mais doucement"; "On veut que je le conserve . . . ; il faut risquer le paquet." Ibid., vol. 1, pp. 140, 145.
5. "Le *Saint-Sébastien* approche de sa fin. Espérons qu'il fera ses affaires." Ibid., vol. 1, p. 146, and vol. 4, p. 334, no. 39.
6. "J'ai envoyé à l'exposition trois tableaux. Le principal est un Saint Sébastien assisté par des saintes femmes. On a paru content cet hiver. Nous verrons bien si le public sera favorable." Ibid., vol 4, p. 334, no. 46.
7. At the time it had not yet been attributed to Georges de la Tour.
8. "On m'a recommandé de ne pas trop le monter / M Cibot peintre d'histoire." Robaut 1905, vol. 1, p. 134, ill. Other studies exist, including one for the composition in the Walters Art Gallery, Baltimore.
9. "ne nous apprendront rien de nouveau." Clément de Ris 1853, p. 146.
10. "*Saint Sébastien*, pris, repris depuis 1855, nous parut d'un style agrandi et d'une expression plus profonde. Le ciel s'était ouvert, les arbres avaient changé de forme et de place. L'escarpement du paysage retardait la montée des cavaliers romains et laissait plus de temps à ces bonnes dames pour étancher les blessures du martyr." Silvestre 1873, quoted in Robaut 1905, vol. 1, pp. 238–39.
11. "C'est noble comme Poussin, vaste et profond comme Claude Lorrain, sans cesser de porter le cachet original et puissant du maître. Ce paysage grandiose, conçu dans la note sombre, au moment où le soleil s'abaisse sur l'horizon, correspond à l'idée douloureuse éloquemment exprimée au premier plan. . . . Au moment où Saint-Sébastien souffre et meurt, la nature végétale semble partager ses douleurs et pleurer sa perte. . . . On aperçoit sur le versant opposé les assassins, dont le groupe décroît derrière les coteaux tandis qu'à gauche de grands bouleaux éplorés semblent se pencher sur l'agonisant. Ainsi le ciel, les arbres, les terrains noyés dans une pénombre mystérieuse, tout semble prendre part à ce deuil." Reymond 1871, pp. 2–3.
12. Foucart 1987, p. 371.

PROVENANCE: Gift of the artist to the Lottery in Aid of the Orphans of the Victims of the War, 1871; purchased by Alfred Robaut in partnership with Paul Durand-Ruel for 9,000 francs; offered by Corot to the Administration des Beaux-Arts, February 14, 1874, for 15,000 francs, but rejected; Samuel Barlow, Stakehill, Lancashire; purchased by William Walters, Baltimore, August 11, 1883, through Tom Wallis, London, for 50,000 francs; Walters Art Gallery, Baltimore

EXHIBITIONS: Paris (Salon) 1853, no. 287, as *St-Sébastien; paysage*; Paris 1867, no. 161; Paris 1872, no. 1; New York 1889–90, no. 528

REFERENCES: Clément de Ris 1853, p. 146; Delécluze 1853; Reymond 1871, pp. 2–3; Silvestre 1873, pp. 238–39; Rousseau 1875, p. 246; Walters 1884, pp. 10–12, no. 13; Champlin and Perkins 1886–87, vol. 1, p. 335; Durand-Gréville 1887, pp. 72–73; Mathews 1889, p. 5; Constant 1890; Lamb 1892, pp. 245–46; Reizenstein 1895, pp. 551, 553; Hamel 1905, pl. 20; Moreau-Nélaton 1905b, pp. 135–36, 145, fig. 127; Robaut *carton* 28, fol. 299; Robaut 1905, vol. 2, pp. 330–31, no. 1063, ill.; Meynell 1908, p. 256; Fosca 1930, pl. 29; Corot 1946, vol. 1, p. 60; Coquis 1959, p. 63; Bazin 1973, pp. 19, 102, 268, 271; Lucas 1979, vol. 2, pp. 573, 574, 576, 578, 580–81, 583; Johnston 1982, pp. 59–60, ill. p. 59; Selz 1988, p. 174; Gale 1994, p. 31

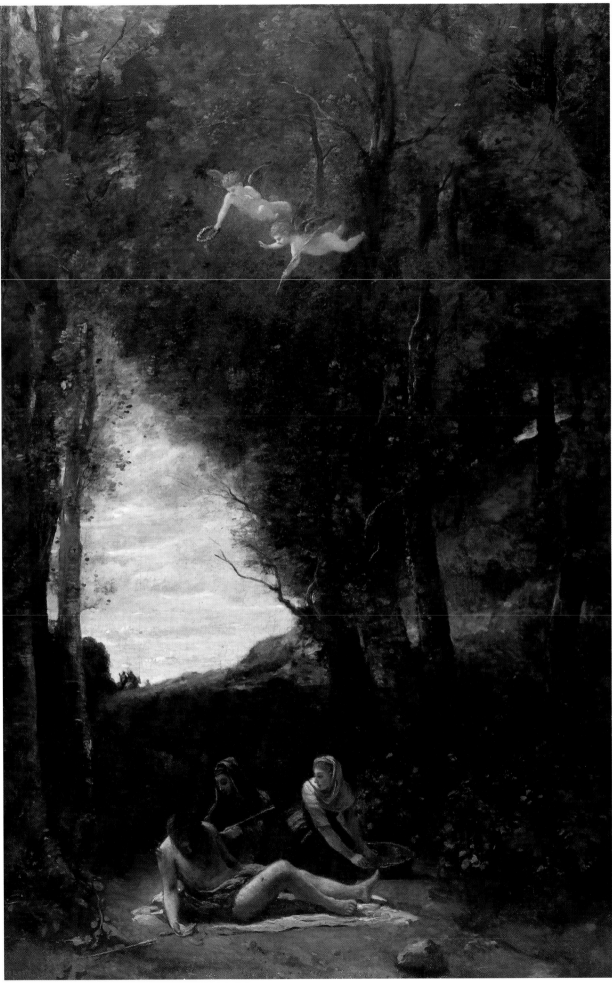

Effet du matin, also called *La Compagnie de Diane* (*Impression of Morning*)

1855
Oil on canvas
66⅛ × 101⅛ in. (168 × 257 cm)
Signed lower right: COROT
Musée des Beaux-Arts, Bordeaux BX E 489, BX M 7028
Paris only

R 1065

The Exposition Universelle of 1855 was the high point of Corot's career. His critical triumph was based almost entirely on works in his late manner, particularly *Souvenir de Marcoussis* (R 1101), bought at the exhibition by Napoleon III, and the present work, which was titled *Effet du matin.* Coming some twenty years after his first depiction of Diana at her bath (cat. no. 63), this painting belongs to a different world, dreamlike and lyrical. The figures play a secondary part, as expressions of the mood established by the landscape, and the subject, to the extent that it exists, is alluded to only by Diana's hounds.[1] Charles Perrier observed that "Corot . . . borrows from nature only its effects and, so to speak, the moral impression the view makes on us. Thus the painter himself only rarely gives his paintings the name *landscape.* He calls them *impression of morning, twilight, an evening, remembrance,* all things that bear no relation to the conscientious reproduction of material objects. . . . What he is aiming for is not the tangible form, but the idea. . . . As a painter, Corot follows in no one's footsteps; he is sometimes reminiscent of Claude Lorrain, but only distantly."[2]

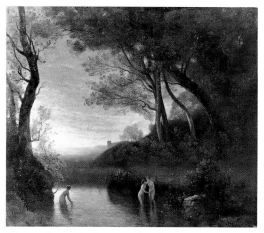

Fig. 101. Corot. *Les Baigneuses de Bellinzona. Effet de soir* (*The Bathers of Bellinzona, evening;* Robaut 1905, vol. 4, p. 404, D), ca. 1855. Oil on canvas, 31½ × 37 in. (80 × 94 cm). Bequest of Mme Hélène Cuvelier, 1905, Musée du Louvre, Paris (R.F. 1591)

In 1855, Corot's poetic sense and his pervasive taste for abstraction were universally remarked. In Edmond About's words, typical of those used to describe Corot's later paintings, the creative process assumes an almost mystical dimension: "No artist has more style or can better communicate his ideas in a landscape. He transforms everything he touches, he appropriates everything he paints, he never copies, and, even when he works directly from nature, he invents. As they pass through his imagination, objects take on a vague and delightful form. Colors soften and melt; everything becomes fresh, young, harmonious: he is the poet of landscape. . . . One can easily

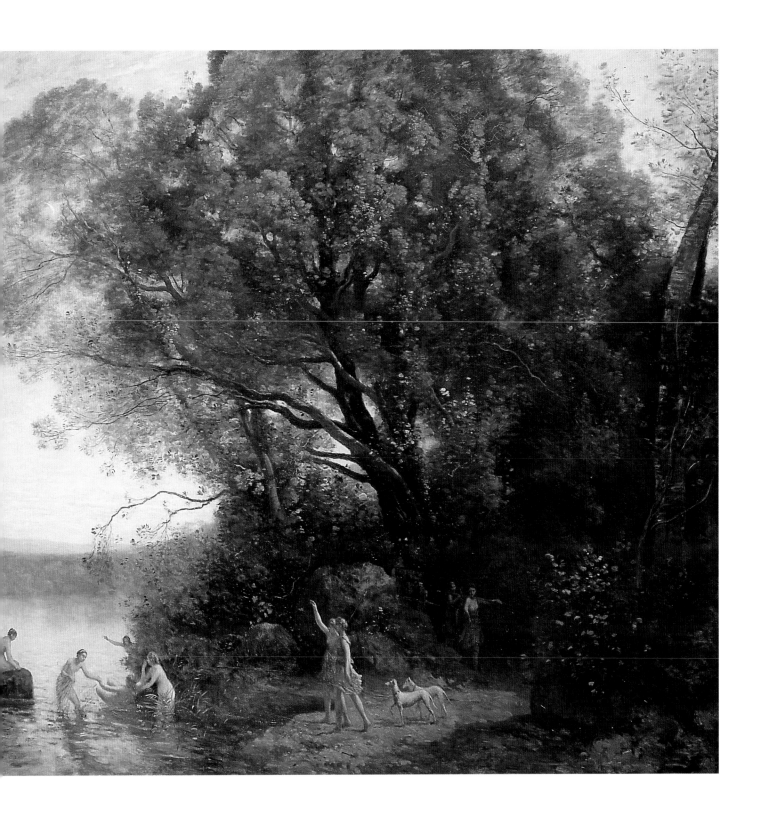

see that air floods his paintings, but we will never know by what secret he manages to paint air. His water has an intoxicating limpidity; but even if we camped out in his studio, we would never learn in ten years how he succeeds in rendering the beauty of water. His trees are drawn without contour and painted without color: how is it done? Even he doesn't know." [3]

Indeed, *Effet du matin* was praised beyond reason. Perrier considered it "a miracle of beauty and expression." "What can one say," he wrote, "about this sunrise that, reflected with so much veracity and especially so much charm in the crystal of the stream and the leaves of the trees, sheds the most mellow and most poetic harmony over the entire painting? What can one say of those nymphs who in their giddy play flaunt bodies damp with multicolored pearls, and who equal in beauty, grace, and freshness the radiant forms that appear only in the golden dreams of twenty-year-old poets?" [4] This dreamlike quality, increasingly frequent in Corot's work, is also to be found in the contemporaneous *Baigneuses de Bellinzona* in the Louvre (fig. 101), a painting devoid of mythological content that illustrates, as Vincent Pomarède observed, how easily the artist moved from historical landscape to modern *baigneuses*. [5]

1. There is a drawing for a figure of Diana, not as actually painted, on fol. 27v of *carnet 70* in the Musée du Louvre, Paris (R 3107; R.F. 8728); ill. in Robaut 1905, vol. 1, p. 159.
2. "Corot . . . n'emprunte à la nature que ses effets, et, pour ainsi dire, que l'impression morale que nous cause sa vue. Aussi le peintre lui-même ne donne-t-il que rarement à ses tableaux le nom de *paysages*. Il les appelle, *effet du matin, crépuscule, une soirée, souvenir*, toutes choses qui n'ont rien à voir avec la reproduction sincère des objets matériels. . . . Ce qu'il poursuit, ce n'est pas la forme palpable, c'est l'idée. . . . Comme peintre, Corot ne procède de personne; s'il rappelle quelquefois Claude Lorrain, ce n'est jamais que de loin." Perrier 1855, p. 143. For links with Claude Lorrain, see also Marcel Roethlisberger in Munich 1983, no. 160.
3. "Aucun artiste n'a plus de style et ne fait mieux passer ses idées dans le paysage. Il transforme tout ce qu'il touche, il s'approprie tout ce qu'il peint, il ne copie jamais, et lors même qu'il travaille d'après nature, il invente. En traversant son imagination, les objets revêtent une forme vague et charmante; les couleurs s'adoucissent et se fondent; tout devient frais, jeune, harmonieux: il est le poëte du paysage. . . . On voit bien que l'air inonde sa peinture, mais on ne saura jamais par quel secret il est parvenu à peindre l'air. Ses eaux sont d'une limpidité enivrante; mais on aurait beau coucher dans son atelier, on n'apprendrait pas en dix ans comment il arrive à rendre la beauté de l'eau. Ses arbres sont dessinés sans contours et peints sans couleur: comment cela s'est-il fait? Il l'ignore lui-même." About 1855, pp. 217–18.
4. "prodige de beauté et d'expression"; "Que dire de ce lever de soleil, qui, en se reflétant avec tant de vérité et surtout avec tant de charme dans le cristal du ruisseau et dans les feuilles des arbres, répand sur tout ce tableau l'harmonie la plus suave et la plus poétique? Que dire de ces nymphes qui étalent dans leur jeux folâtres leurs corps humides de perles diaprées, et qui égalent en beauté, en grâce et en fraîcheur ces formes radieuses qui ne se dévoilent que dans les rêves d'or des poëtes de vingt ans?" Perrier 1855, p. 143.
5. Pomarède in Lugano 1994, no. 7. See also Robaut 1905, vol. 4, p. 404, D.

PROVENANCE: Purchased by the city of Bordeaux for 5,000 francs at the Exposition de la Société des Amis des Arts, Bordeaux, 1858

EXHIBITIONS: Paris 1855, no. 2791, as *Effet du matin;* Bordeaux 1858, no. 122, as *Les Baigneuses;* Paris 1889, no. 174, as *Le Bain de Diane;* Paris 1936, no. 69; Lyons 1936, no. 64; Tel Aviv 1964, no. 82; Edinburgh, London 1965, no. 72; Laren, Ghent 1970, no. 46; Nagoya, Kamakura, Osaka, Fukuoka 1971–72, no. 41; Paris 1975, no. 75; Rome 1975–76, no. 52; Munich 1983, no. 160; Fukuoka, Hiroshima, Tokyo, Kanazawa 1983–84, no. 41; Barcelona 1984; Bordeaux 1987–88

REFERENCES: About 1855, p. 215; Du Camp 1855, p. 257; Du Pays 1855; Perrier 1855, p. 143; Calonne 1889; Flat 1895, p. 818; Michel 1905, p. 26, as *Bain de Diane;* Moreau-Nélaton 1905b, pp. 164–65, fig. 131; Robaut *carton 18*, fol. 504; Robaut 1905, vol. 2, pp. 332–33, no. 1065, ill.; Moreau-Nélaton 1924, vol. 1, p. 100, fig. 132; Bazin 1936, fig. 58; Faure 1936, fig. 38; Jamot 1936, p. 26, ill. p. 25; Hours 1972, p. 40, fig. 50; *Corot* 1981, p. 115, no. 27, ill.; Selz 1988, p. 186; Lugano 1994, no. 7

106

Le Repos, also called *Nymphe couchée dans la campagne (Repose)*

1857–59
Oil on canvas
19¼ × 29½ in. (49 × 75 cm)
Signed lower left: COROT
Musée d'Art et d'Histoire, Geneva 1875-5

R 1046

Among the papers Robaut obtained from his brother-in-law, Charles Desavary, were three drawings copied from paintings by Corot of nudes reclining in landscapes. Although Desavary recalled that he had made the drawings in 1857 and 1858, he had no further memory of the works.[1] The drawings perplexed Robaut, but we now know that they show earlier states of three paintings, currently in Geneva (the present work), in Washington (cat. no. 117), and in Shelburne (cat. no. 118). Desavary's sketch associated with the Geneva *Le Repos* is inscribed and dated 1857 (fig. 102). In the mid-1850s Corot undertook a series of landscapes with single figures, larger than his previous efforts, all of which were probably completed by 1857 or 1858. Variations in their sizes rule out the idea that Corot intended the paintings to form a set or that they were related in any manner other than by subject.

Corot appears to have modified these works over a period of time. The first to undergo a revision was probably the present painting. When asked by Barthélémy Menn to exhibit at the Geneva Salon in 1857, Corot sent two landscapes, *Matin* and *Soir,* for which he was awarded the medal of honor.[2] In August of 1859 Corot again exhibited in Geneva, this time a *Souvenir à Volterra* (not identified), a *Ville-d'Avray,* and *Le Repos.* Both *Ville-d'Avray* (R 1114) and *Le Repos* were bought by Geneva's Institut National; they were the first of Corot's paintings to enter a museum outside France. The date of purchase, however, has been variously recorded as 1857 and 1859 (as it appears in

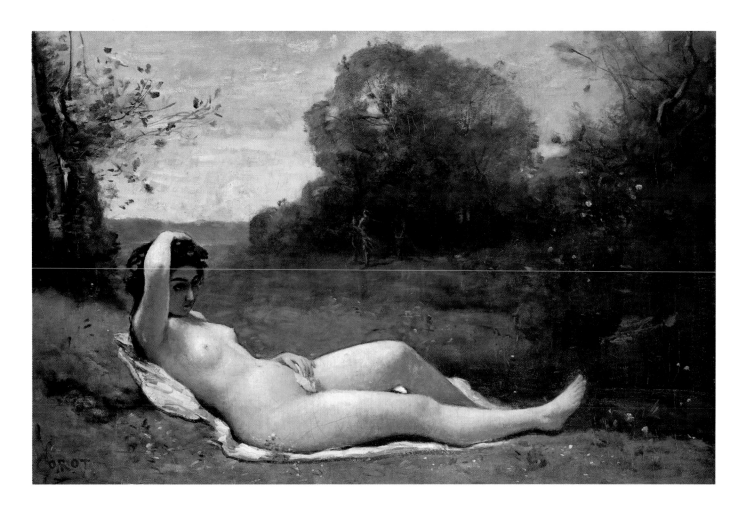

Robaut's notes).[3] The 1859 exhibition catalogue listed only *Souvenir à Volterra* as being for sale, suggesting that the other two entries were already reserved.[4]

The sequence of events indicates that Corot reworked *Le Repos* between 1857 and 1859, during the period in which he created his largest figure piece, *La Toilette* (cat. no. 116). Desavary's drawing after *Le Repos* reveals that Corot altered the drapery, particularly around the legs, and that he substantially recast the landscape: he enlarged the trees in the background, changed those at far right and left, and added the figures dancing in the background. There is something oddly compelling about this modern reinterpretation of Giorgione's *Sleeping Venus* (Gemäldegalerie, Dresden), poised in a trance midway between

Fig. 102. Charles-Paul Desavary (1837–1885). Drawing after Corot's *Nymphe couchée dans la campagne* (original version), 1857. Robaut *carton* 25, fol. 29. Musée du Louvre, Paris

myth and reality. The remarkable effects of the light falling on the nymph from above and behind, and the dreamlike atmosphere generated thereby, reveal Corot's consummate instinct for transforming the ordinary.

1. Robaut *carton* 25, fol. 29. In Robaut's notes, Corot's painting is called *L'Aurore.*
2. Baud-Bovy 1957, p. 167, and Corot, letter to Dutilleux, January 4, 1858, cited in Robaut 1905, vol. 4, p. 337, no. 96.
3. Robaut *carton* 25, fol. 29; *Ville-d'Avray* (or *Un Soir à Ville-d'Avray*) is called *Rêverie sur l'étang* in Robaut 1905, vol. 2, p. 360, no. 1114.
4. Baud-Bovy 1957, p. 168.

PROVENANCE: Purchased by the canton of Geneva for 800 francs at the Exposition Cantonale, 1859; deposited at the Musée d'Art et d'Histoire, Geneva, 1875

EXHIBITIONS: Geneva 1859; Zurich 1934, no. 125; Paris 1936, no. 68; Paris 1937, no. 268; Fribourg 1943; Paris 1959, no. 28; Bern 1960, no. 62; Schaffhausen 1963, no. 17

REFERENCES: Geneva, Musée Rath 1878, no. 27; Robaut *carton* 25, fol. 29; Robaut 1905, vol. 2, pp. 320–21, no. 1046, ill.; Geneva, Musée Rath 1906, no. 83; Gielly 1928, no. 54; Bernheim de Villers 1930a, no. 141; Bazin 1936, p. 60, ill.; Bazin 1942, p. 120, no. 82, pl. 82, as ca. 1855; Hautecoeur 1948; Baud-Bovy 1957, pp. 169, 270, n. 98, pl. XLIV; Fosca 1958, pp. 145, 176, ill. p. 113; Dieterle 1959, pl. 23; Klee 1959, p. 163; Geneva, Musée d'Art et d'Histoire 1968, p. 47; Leymarie 1979, p. 126; *Corot* 1981, p. 116, no. 31, fig. 31; Lapaire 1982, no. 76; Selz 1988, p. 146, as ca. 1855; Lapaire 1991, no. 122, p. 94; Leymarie 1992, pp. 144–46; Gale 1994, p. 100, ill. p. 101

107

La Femme à la perle (The Woman with the Pearl)

Ca. 1858–68
Oil on canvas
27$^{1}/_{2}$ × 21$^{5}/_{8}$ in. (70 × 55 cm)
Apocryphal signature lower right: COROT
Musée du Louvre, Paris R.F. 2040

R 1507

This canvas, the most famous and best loved of Corot's figure paintings, has been misnamed *La Femme à la perle* since 1889, when it was shown at the Exposition Universelle with forty-six other works by the artist. As explained with some irritation in his notes by Robaut, who proposed calling the work *Ferronnière végétale (Diadem of Plants)*, the object that graces the young woman's forehead is not a pearl but "a small leaf projecting from a garland that gives the effect of the shadow of a jewel."[1] Although it is widely known that the painting was one of Corot's favorites and that the model was a young woman named Berthe Goldschmidt, it is not altogether clear how this information originated.

In the early 1890s, when the young Daniel Baud-Bovy saw this picture in the house of Jean Dollfus, who had bought it at the posthumous sale in 1875, the work was displayed between *L'Algérienne* (cat. no. 143) and *La Jeune Femme à la marguerite* (*Young Woman with a Daisy;* R 1429, Szépmüvészeti Múzeum, Budapest). The myth surrounding the painting was already well established. Dollfus told Baud-Bovy:

> That Berthe Goldschmidt . . . seemed to be about 16 or 17 years old. Her parents had an antique fabrics business. She was the perfect example of her race. . . . At the sale, what first struck me about her face was the nobility with which the bridge of the nose spreads out to form the double arch of the eyebrows. And beneath those twin vaults, there is so much nostalgic charm in

Fig. 103. X-radiograph of *La Femme à la perle.* Laboratory, Musée du Louvre, Paris

the dreamy gaze of those beautiful brown eyes. Can't one imagine how happy the painter must have felt when he captured the imperceptible smile on that small mouth with its moist, perfectly modeled lips. The more I look at that smooth brow, the more it enchants me. Ah! I understand why the man who made her eternal never wanted to let her go.[2]

Is the painting a portrait? The very seductive but highly idealized face and numerous visible pentimenti suggest a picture that underwent one or several transformations to reach the state of perfection Corot desired. Laboratory studies carried out under the direction of Madeleine Hours in the early 1960s revealed the revisions, extensive and characteristic, that were carried out by the artist. Radiographs show subtle if significant modifications to the head, which at first turned

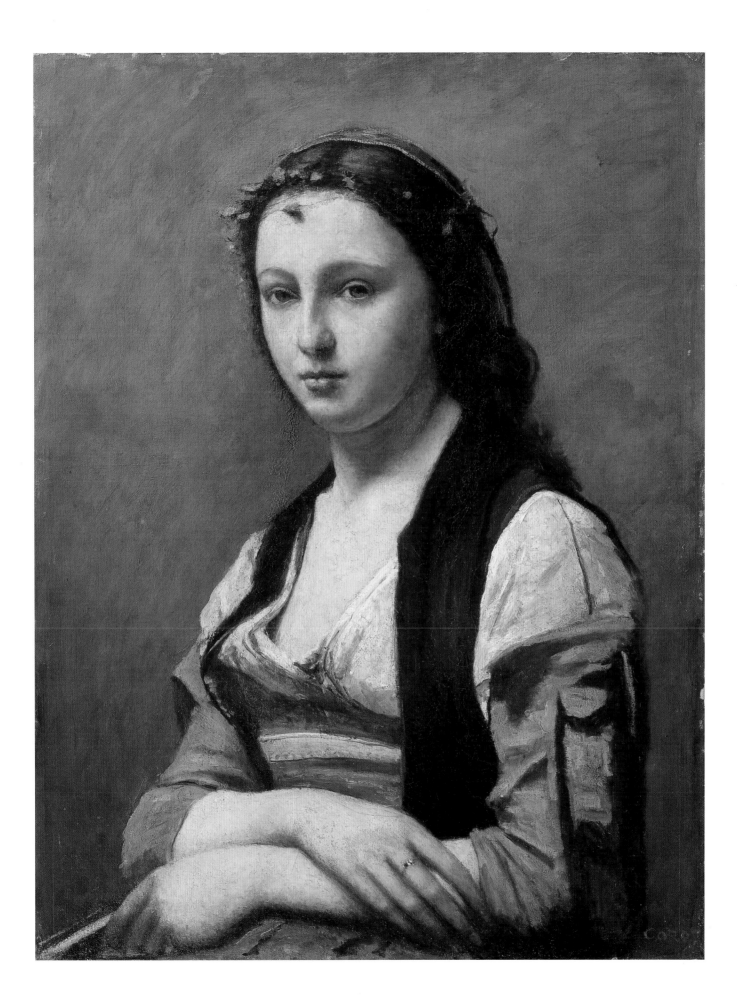

more to the left and was altered so as to face the viewer (fig. 103). The face was originally less childish, its oval contour more irregular; the nose occupied a different position; and the eyes were situated slightly lower and were perhaps larger as well as more intense. The hair fell onto the shoulders, and at one stage there may have been a veil, although this is not certain. The Italian costume also underwent some changes, particularly in the dark sleeveless jacket and the position of the detachable sleeve on the model's right arm. In her left hand she once held a letter or a book.

In its final configuration, the painting transcended portraiture to become a contemporary response to the masterpieces of the Renaissance. As Hélène Toussaint demonstrated, the pose was derived partly from Leonardo's Mona Lisa and partly from a famous drawing formerly attributed to Raphael that itself was based on the Mona Lisa.[3] The head decoration is evocative of that of Leonardo's *Belle Ferronnière* in the Louvre, which inspired Robaut's title; the face, however, owes little to that example, aspiring instead to the peaceful beauty of a Raphael. The pose of the hands (which Robaut found objectionably elongated) echoes that of the Mona Lisa.

Corot began to think about this type of half-length figure in costume about 1857, after he had undertaken a series of nudes. Letters to the painter Édouard Brandon in Rome during the period 1856–58 throw some light on Corot's otherwise undeclared intentions: a letter of January 10, 1856, concerns his desire to obtain the habit of a Franciscan monk (see cat. no. 108); a year later, on January 17, 1857, the artist asked Brandon to send a woman's costume from Albano or Genzano.[4] The major elements of the costume from Albano were sent soon afterward through Brandon's brother Jules, since on March 31, 1857, Corot wrote to thank him and to tell him, "To be complete, the costume from Albano needs only a yellow or pink silk dress, the kind I saw in Spilla, and also a crown of silk ribbon. Only, I'm in no hurry; at your convenience. I'd also like you to tell me how much I owe you for all this; the old merchant wants to settle his accounts."[5] We do not know when the additional materials were received. The earliest use of the Italian costume seems to have been in *La Femme à la pensée* (*Woman with a Pansy;* R 1041, Denver Art Museum), which Robaut bought in 1858, not realizing how recent a work it was.[6] The next documented work, in which the attendant figures— not the subject—wear the costume, is *La Toilette* (cat. no. 116), which was worked on over a period of time but was exhibited at the Salon of 1859. Corot may have obtained additional Italian costumes afterward, judging by variations in the sleeves and bodices of the clothing worn by models for later paintings.

The documentation of the costume helps to clarify a number of dating questions about various half-length representations of women by Corot; these have traditionally been assigned dates of 1855 onward, but the correspondence with Brandon shows that they could have been initiated no earlier than the spring of 1857. These depictions were conceived in the manner of Renaissance allegorical figures, yet the women remained thoroughly modern. Unlike *La Femme à la grande toque et à la mandoline* (R 1060, private collection), they were clothed in a regional dress that removed them from fashion without placing them in a historical or historicizing context. *La Femme à la perle* was undertaken distinctly in this spirit and was perhaps begun, with Berthe Goldschmidt as model, in the late 1850s, to be reworked later, as was Corot's habit; such a date is certainly suggested by the painting's relationship with *La Femme à la pensée.*

Little is known about Corot's models during this period. In a notebook dated about 1855, the artist listed a Mlle Berthe at 99, rue Vieille-du-Temple, and a Rosine at 13, rue des Écouffes.[7] Whether Berthe, most likely a professional model, can be connected with the young woman Dollfus said was the daughter of an antique fabrics dealer remains a matter of speculation. It may be noted that a small *Souvenir d'Italie* (R 1820) was lent to the Corot retrospective of 1875 by a Mlle Goldschmidt, identified by Moreau-Nélaton in the index to the catalogue raisonné as Berthe Goldschmidt.[8] However, the name is not rare, and there were two documented Goldschmidts in Paris at that time, an artist and a collector.

Rather more information on Corot's models can be gathered from Eugène Delacroix, to whom, in 1859, Corot recommended people he knew and presumably had used. Delacroix listed them, with comments, in his *Journal:* Mme Hirsch at 6, rue Lamée, "Superb head of dark hair, in the style of Ristori"; Adèle Rosenfeld at 5, rue du Marché-Sainte-Catherine, "Will pose reclining, seemed superb"; Joséphine Leclaire at 4, rue de Calais, "Very elegant, well put together, thin arms"; and Rosine Gompel (or Gompelle), 17, rue du Petit-Carreau.[9] Rosine Gompel, probably the same Rosine listed in Corot's *carnet,* posed for Delacroix in July 1860.

On April 1, 1892, a drawing purporting to be a study for *La Femme à la perle* was sold at auction. Amid controversy, Robaut, in consultation with Jean Dollfus, concluded that it was a copy done from a photograph. Robaut's exasperated notes on the subject give some indication of the vicissitudes the painting had experienced during Corot's last years. In March 1870 the work was photographed by Lavand, but only a few prints were made. Robaut, who believed that three or four painted copies had been produced by various students of Corot, himself made a drawing from it on August 21, 1872, when the picture was in the artist's apartment in the rue Paradis-Poissonnière. The work was later moved to Corot's studio, where his friend Jules-Antoine Demeur copied it. In September and October of 1874 the picture was lent to the dealer and restorer Grédelue, apparently to be copied; on its return, during Corot's illness, it was sent to the studio of Eugène Dévé in the rue d'Abbeville, where he copied it in oils while his wife made drawings from it.[10]

1. "une petite feuille saillant d'une couronne qui produit l'effet d'ombre d'un bijou." Robaut *carton* 27, fol. 54.
2. "Cette Berthe Goldschmidt ... semblait avoir de 16 à 17 ans. Ses parents vivaient d'un commerce d'étoffes anciennes. Elle présentait le type accompli de sa race.... Dans ce visage, ce qui m'a d'abord frappé, à la

Vente, c'est la noblesse avec laquelle l'arête du nez s'épanouit pour for-
mer la double arcade sourcilière. Et sous cette voûte jumelle, combien le
regard songeur des beaux yeux bruns a de charme nostalgique. On ima-
gine, n'est-ce pas, le bonheur qu'éprouvait le peintre, en reproduisant
l'imperceptible sourire de cette petite bouche, aux lèvres humides, si par-
faitement modelée. Plus je regarde ce visage au front sans ride, plus il
m'enchante. Ah! je comprends celui qui l'a éternisé, de n'avoir jamais
consenti à s'en dessaisir." Baud-Bovy 1957, p. 29.

3. Toussaint in Paris 1975, no. 113, and Jean-Pierre Cuzin in Paris 1993, no. 314.

3. Robaut *carton* 27, fol. 54.

4. Robaut 1905, vol. 1, p. 179.

5. "Il manque seulement pour le costume d'Albano une robe en soie ou
jaune ou rose, comme j'en ai vu à Spilla; plus, une couronne en ruban de
soie. Seulement, je ne suis pas pressé; à votre aise. Je voudrais aussi que
vous me disiez ce que je vous devrai pour le tout; car le vieux négociant
voudrait s'acquitter." Ibid., p. 180.

6. Ibid., vol. 2, p. 318, no. 1041, there dated 1855–58.

7. Ibid., vol. 4, p. 95, no. 3095. The notebook is *carnet* 58 (Musée du Louvre,
Paris, R.F. 8720).

8. The *Souvenir d'Italie* was no. 162 in the exhibition. Ibid., vol. 5, *Tables*, p. 57.

9. "Superbe tête brune, dans le genre de la Ristori"; "Pose couchée, m'a
paru superbe"; "Très élégante, bel ensemble, bras maigres." Delacroix
1932, vol. 3, p. 218.

10. Robaut *carton* 27, fol. 54.

PROVENANCE: The artist; his posthumous sale, Hôtel Drouot, Paris, pt. 1,
May 26–28, 1875, no. 166, as *Jeune Femme assise, les mains croisées, des fleurs dans les
cheveux*; purchased at that sale by Jean Dollfus for 4,000 francs; his sale,
Galerie Georges Petit, Paris, 1912, no. 6; purchased by the Musée du Louvre,
Paris, with funds from the Audéoud bequest

EXHIBITIONS: Paris 1885, no. 78, as *Portrait de femme*; Paris 1889, no. 149 bis;
Paris 1936, no. 88; Lyons 1936, no. 93; London 1936a, no. 19; Brussels 1953, no.
22; Paris 1962, no. 72; Bordeaux 1964, no. 30; Edinburgh, London 1965, no. 85;
Lisbon 1965, no. 30; The Hague 1966, no. 41; Paris 1966a, no. 43; Paris 1975,
no. 113

REFERENCES: Hamel 1905, p. 26; Moreau-Nélaton 1905a, ill. p. 70; Moreau-
Nélaton 1905b, fig. 202; Robaut 1905, vol. 3, pp. 90–91, no. 1507, and vol. 4,
p. 210, no. 166; Moreau-Nélaton 1924, vol. 2, fig. 206; Lafargue 1925, pp. 14,
52; Jean 1931, p. 20; Bazin 1936, p. 70, fig. 89; Jamot 1936, pp. 50, 54, ill. p. 47;
Venturi 1941, pp. 162, 169, fig. 112; Bazin 1942, no. 110, pl. 110; Bazin 1951, no. 122,
pl. 122; Baud-Bovy 1957, pp. 29–30, 109, 274, n. 17; Fosca 1958, p. 144, ill. p. 149;
Sterling and Adhémar 1958, no. 451, pl. CXXXIII; Hours 1962, p. 4, ill. pp. 18,
19; Leymarie 1966, p. 96; Taillandier 1967, p. 42; Hours 1972, fig. 45, pp. 150–51,
ill.; Paris, Musée du Louvre 1972, p. 95; Bazin 1973, p. 291, ill. p. 236;
McMullen 1975, fig. 103; Clarke 1991a, pp. 101, 104, fig. 101

108

Moine blanc, assis, lisant (Monk in White, Seated, Reading)

Ca. 1857
Oil on canvas
21⅝ × 17⅞ in. (55 × 45.5 cm)
Signed lower left: COROT.
Musée du Louvre, Paris R.F. 2604

R 1044

This splendid sketch, painted with extraordinary assurance—
even bravado—seems to be the first in a series of composi-
tions devoted to monks reading that Corot began in the late
1850s. The subject, ultimately the nature of meditation, calls
to mind other works by Corot, variations on a theme that
preoccupied the artist throughout his life: women absorbed in
books, such as Mary Magdalene in the *Vue prise dans la forêt de
Fontainebleau*, shown at the Salon of 1831 (R 255, National Gallery
of Art, Washington, D.C.), and the allegory of poetry herself,
Liseuse couronnée de fleurs (fig. 80); or monks seen reading along
the paths in the Italian countryside, of which the most obvious
and perhaps the strangest example he exhibited at the Salon
of 1841 (*Un Moine*; R 375, Musée du Louvre, Paris). Women
tended to predominate among Corot's abstract personifications

of thought, although among artists generally, a monk meditat-
ing in a vast landscape was a more frequent subject. Théodore
Caruelle d'Aligny, Corot's friend, painted several such scenes,
among them *La Solitude*, shown at the Salon of 1850 (Musée
des Beaux-Arts, Rennes). For his later series of monastics, to
which this introspective image belongs, Corot returned to his
earliest portrayal of a monk reading (cat. no. 17), which he
had painted from life during his first Italian period. As it had
in that early work, here once again the focus narrows, the
image becomes more direct, the imagination is less distracted
by landscape.

In his notes, Robaut assumed that this painting dated from
about 1840–45. Moreau-Nélaton changed this in the published
catalogue to 1850–55, a date he also assigned to two depictions

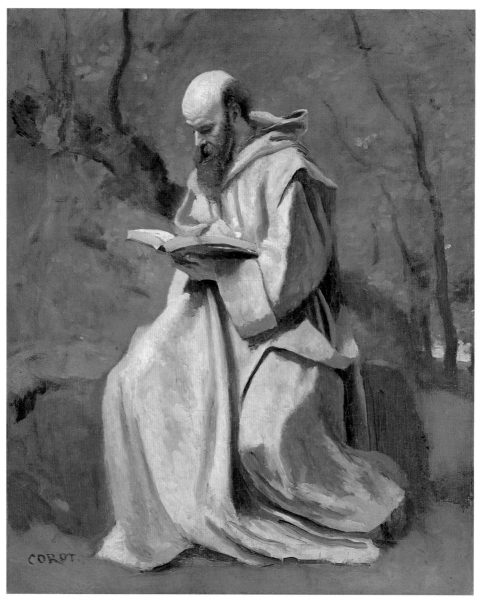

108

Fig. 104a. Corot. *Moine assis lisant*
(*Seated Monk Reading;* R 1332), ca. 1865.
Oil on canvas, 29⅛ × 19¼ in. (74 ×
50 cm). Bührle Collection, Zurich

Fig. 104b. Corot. *Moine en blanc lisant*
(*Monk in White, Reading*), ca. 1865. Oil on
canvas, 29 × 19¾ in. (73.7 × 50.2 cm).
Private collection, New York

of monks in dark Franciscan habits (R 1043, R 1045). Both dates are certainly too early, as shown by Corot's correspondence of 1856–58 with Édouard Brandon in Rome, already cited in connection with *La Femme à la perle* (cat. no. 107). The letters give a sense of the moment when Corot began thinking about these compositions, most likely in 1855, and of the vicissitudes of the process of acquiring outfits for the models. On January 10, 1856, Corot was expecting at any moment the return of an acquaintance from Rome, M. David, with a Franciscan habit that he had ordered.[1] In the course of events, the delay in delivery was far greater than either Corot or Brandon anticipated. Undaunted by failure, a year later, on January 17, 1857, Corot asked Brandon for two different outfits, one for a Capuchin monk.[2] The white habit was evidently received soon enough, since on March 31, 1857, Corot wrote to thank Brandon for it, but he remarked that the Franciscan outfit was still missing.[3] A year and a half later in the autumn of 1858, in the last known letter on the subject, a resigned Corot told Brandon: "I still haven't seen the gentleman with the Franciscan costume! Let us hope."[4]

The picture was probably executed in 1857. The brown preparation of the canvas is visible in the areas not covered by paint, and the landscape is indicated with bold brushstrokes. In every aspect it is a daring work, which Corot most likely gave to his friend François-Parfait Robert. Robaut, who wrote ecstatically about it in his notes, saw in its devotional intensity a parallel to early Flemish painting (not one of Corot's great interests), which he assumed the artist understood—by osmosis—better than any of his contemporaries.[5] Whether the desire to represent solitary, reflective older men can be held as evidence of Corot's own mood as he turned sixty is a subject for speculation. Two later and larger reinterpretations of the subject, with older monks as models, are of quite different effect. Both are dated to about 1865. One (fig. 104a), recorded by Robaut and owned by him at one point, is treated in a similarly free manner; the other (fig. 104b), which was unknown until 1907, was executed with a greater degree of finish.

1. Robaut 1905, vol. 1, p. 165, and vol. 4, p. 336, no. 76.
2. Ibid., vol. 1, pp. 168, 179, and vol. 4, p. 337, no. 86.
3. Ibid., vol. 1, p. 169, and vol. 4, p. 337, no. 91.
4. "Je n'ai pas encore vu le Monsieur au costume franciscain! Espérons." Ibid., vol. 4, p. 338, no. 101. There is also an undated letter to Brandon regarding payment for the costumes. Ibid., vol. 4, p. 336, no. 75.
5. Robaut *carton* 27, fol. 5.

PROVENANCE: Louis Robert, Mantes; gift of Christian and Maurice Robert to the Musée du Louvre, Paris, 1926

EXHIBITIONS: Munich 1958, no. 17; Paris 1962, no. 40

REFERENCES: Robaut 1905, vol. 2, pp. 320–21, no. 1044, ill.; Jamot 1929, pp. 78, 81, pl. 92; Bernheim de Villers 1930a, p. 57, no. 138; Meier-Graefe 1930, pp. 86, 87; Sterling and Adhémar 1958, no. 400, pl. CXIV; Leymarie 1979, p. 125, ill.; Selz 1988, p. 132, ill. p. 137

109

Entrée d'un chalet de l'Oberland bernois (Entrance to a Chalet in the Bernese Oberland)

Ca. 1842
Oil on canvas
10¼ × 14⅛ in. (26 × 36 cm)
Stamped lower left: VENTE COROT
Museum of Art, Rhode Island School of Design, Providence
54.175

R 731

The traditional title of this lively, informal sketch is a misnomer. In fact, as the catalogue of the posthumous sale records, the study depicts an outdoor scene. Robaut preferred Corot's more deliberate works and commented in his notes, possibly at the time of the sale, "unimportant sketch."[1] Little is known about Corot's visit to the Bernese Oberland, but there are reasons to believe it took place in 1842. Famous for its mountains and lakes, the region had attracted painters since the later eighteenth century. Two inscribed works (R 419, R 2720) show Corot was at Unterseen, near Interlaken, on the narrow isthmus between the Lake of Thun and the Lake of Brienz. He was intrigued by the women's costumes and sketched several in oil and pencil, twice inscribing the model's name. He probably also painted this sketch and some views, including *Lac de Brienz* (R 409).[2]

In his notes, Robaut dated the present work to 1850–52, a date adjusted to 1850–55 in the published catalogue. In 1895, however, he recalled that Corot had told him that *Lac de Brienz* and the figure sketches dated from a visit to the Oberland with Swiss friends, among them Daniel Bovy.[3] The remark points to 1842, when Corot, Armand Leleux, Bovy, and others traveled around the upper shore of the Lake of Geneva but apparently no farther than Montreux.[4] In addition, two Swiss friends of Corot's reported that when looking with them at some drawings by Théodore Caruelle d'Aligny, he remarked, "Look, here's a view of your mountains. We were together in

109

110

the Oberland."[5] Aligny was in the Oberland in 1832 and again in the summer of 1842, when Corot was in Switzerland. Corot owned two of Aligny's paintings of the Oberland as well as eleven unidentified drawings.[6] It is possible that in June–July 1842, before or after he was with his Swiss friends, Corot joined Aligny for part of an expedition, which would suggest that Corot's group of related works dates from 1842.

1. "ébauche sans importance." Robaut *carton* 14, fol. 212, as *Berne-Oberland. Entrée d'un chalet (Intérieur de chalet d'ouvrier)*, and dated 1850–52.
2. See *Suissesse de l'Oberland* (R 418); *Maria Heggi, d'Unterseen* (R 419); *Laitière d'Oberland* (R 420), dated 1845–50 by Moreau-Nélaton; *Un Lac de l'Oberland (Thoune ou Brienz)* (R 408); *Le Lac de Brienz* (R 409), dated 1840–45 by Moreau-Nélaton; and the drawing *Madeleine, Unterseen* (R 2720), dated 1840–50. For the suggestion that *Lac de Brienz* represents the Lake of Thun, see Baud-Bovy 1957, p. 277, n. 90.
3. Ibid., p. 142.
4. Leleux's memoir of the trip (which he wrongly dates to 1840) concerns only a journey along the upper shore of the Lake of Geneva, after which

the group disbanded. See Leleux 1882, passim.
5. "Tenez, voici une vue de vos montagnes. Nous étions ensemble dans l'Oberland." Auguste Baud-Bovy and Albert Darier, as cited in Baud-Bovy 1957, p. 186.
6. The paintings were in Corot's posthumous sale of 1875, nos. 633, 636; the drawings, nos. 793–803, sold as a group, were not individually listed.

PROVENANCE: The artist; his posthumous sale, Hôtel Drouot, Paris, pt. 1, May 26–28, 1875, no. 124; purchased at that sale by C. Rousset for 180 francs; Lord Berners; heirs of Lord Berners; purchased by the Museum of Art, Rhode Island School of Design, Providence, Jesse Metcalf, Helen M. Danforth, Murray S. Danforth Funds, 1954

EXHIBITIONS: Chicago 1960, no. 70; Edinburgh, London 1965, no. 61; Waltham 1967, no. 16; New York 1969; Monterey, Gainesville, Miami Beach, Owensboro, Elmira, Montgomery 1986–88, no. 3

REFERENCES: Robaut 1905, vol. 2, pp. 244–45, no. 731, ill., and vol. 4, p. 206, no. 124; Anon. 1955b, fig. 6; Providence, Museum of Art 1956, n.p., ill. Baud-Bovy 1957, p. 277, n. 90; Rosenfeld 1991, pp. 61–62, fig. 16; Smits 1991, pp. 360–61, fig. 349

110

Vache à l'étable, also called *La Vache noire* (*Cow in a Stable*, also called *The Black Cow*)

Ca. 1840–45
Oil on canvas
7⅞ × 10⅝ in. (20 × 27 cm)
Stamped lower left: VENTE COROT
Private collection, New York
New York and Ottawa only

R 559

Although Corot included a fairly diverse range of fauna in his landscapes, oil sketches of animals by the artist are very rare, and there are only a few finished paintings to suggest he took an interest in the genre. Corot returned from his first visit to Italy with a small study, *Boeufs d'Italie* (*Italian Oxen*; R 146), copied after Léopold Robert, witness to a friendship that remains little known. In the succeeding period he made a few portraits of horses, among them a painting signed and dated 1833 that was discovered by Germain Bazin[1] and the *Cheval de selle en prairie* (*Saddle Horse in a Meadow*; R 874, private collection), painted for his friend Auguste Faulte du Puyparlier, who certified in a handwritten note glued on the back of the work that the signature was "indeed that of our friend, the illustrious landscape painter Corot."[2]

This spirited study of a cow is unique in Corot's oeuvre. At the time of the posthumous sale in 1875 the painting was believed to date from about 1844–53, but in the published version of Robaut's catalogue it was more precisely dated to about 1845. In the absence of a context that would give a sense of the animal's size, the breed is difficult to identify: it could be a Breton cow or perhaps a Fribourg, both fairly widespread

types and therefore of limited help in suggesting whether France or Switzerland is the locale. A similar black cow, also shown in profile—a favorite device for Corot—appears in *Ville-d'Avray. L'Étang vu à travers les arbres avec une vache sur la chaussée* (*Ville-d'Avray: The Pond Seen through Trees, with a Cow on the Embankment*; R 283), painted in the 1830s. The present sketch is distinguished by an interesting contrast between the dark animal, outlined with wonderfully sinuous contours, and the blond tonality of the stable, defined with a few straight lines.

1. See Paris 1962, no. 12, ill., and Bazin 1973, p. 284, ill. p. 187.
2. "bien celle de notre ami, l'illustre paysagiste Corot." Robaut 1905, vol. 2, no. 874.

PROVENANCE: The artist; his posthumous sale, Hôtel Drouot, Paris, pt. 1, May 26–28, 1875, no. 373; purchased at that sale by Arsène Houssaye for 101 francs; his sale, Hôtel Drouot, Paris, November 25, 1905; sale, Parke Bernet, Los Angeles, November 13–14, 1972, no. 137; purchased at that sale by the current owner

REFERENCES: Robaut 1905, vol. 2, pp. 200–201, no. 559, ill., and vol. 4, p. 235, no. 373

Dardagny (près de Genève). Une Rue du village (A Village Street, Dardagny)

Ca. 1853
Oil on canvas
13½ × 9½ in. (34.3 × 24.1 cm)
Signed lower left: COROT
The Metropolitan Museum of Art, New York
Bequest of Collis P. Huntington, 1900 25.110.17

R 718

Corot traveled in Switzerland in the summer of 1852 with Charles Daubigny and Armand Leleux, whose wife, Émilie, was also a painter. It seems fairly certain that Corot did not visit Dardagny during this stay. On June 14, 1852, Charles Bovy-Lysberg wrote from Dardagny to his parents to say that he had seen the "good old face of that dear papa" only briefly in Geneva; on June 16, Laure Mayor, Antoine Bovy's daughter, wrote to her mother that Corot and several guests, including the painters Alexandre Alméras and Henri Baron (who later married Octavie Bovy), had arrived at Daniel Bovy's château at Gruyères.[1]

Corot appears to have made his first visit to Dardagny in 1853. When he and Daubigny arrived in Geneva in July of that year, Leleux invited them to stay with his parents-in-law, Jacques and Élise Giraud, at Dardagny. While there they painted a screen for Mme Giraud of which only the central section—by Corot—has survived (R 1073, National Gallery of Ireland, Dublin). There appear to be no secure records for visits to Dardagny when Corot was in Switzerland in 1855, 1857, or 1859, but it seems unlikely that Corot would not have visited his friends, particularly in 1855, when he was in Switzerland for almost a month, and in 1859. He returned to Dardagny for the last time in early August 1863, and Léon Gaud remembered that during this visit Corot noticed the sparkle of Mme Giraud's silver shoe buckle on the moonlit terrace: "Corot pointed out to all of us how mysterious and evocative the brilliance of that buckle was, and he went on from there to define what should constitute the 'effect' in a picture."[2]

It is likely that most of the relatively small group of pictures painted at Dardagny and broadly dated 1850–60 will remain very difficult to date with greater precision. At least one painting, *Souvenir de Dardagny* (R 722), was painted later in Paris. *Vallée aux environs de Dardagny* (R 723), which Corot gave to Daubigny, who traveled with him in Switzerland beyond Geneva only in 1853, probably dates from this first visit. *Dardagny. Un Chemin dans la campagne, le matin* (R 720), painted in the company of Leleux, could perhaps be ascribed to 1859, as Corot seems to

have left it and some other studies with Suzanne Turrettini, who wanted to copy them; Daniel Baud-Bovy saw her copying it. On November 6, 1859, Corot wrote to Mme Darier asking her help in the recovery of sketches he had left in Switzerland to be used as models: "If you could tell Menn that it would be very kind of him to ask Mlle Tintine [Turrettini] again for those studies back, and also Berthoud, from Lausanne, who has one, and Scheffer."[3] Robert Herbert dates this work to 1853, and on stylistic grounds a date associated with an early visit seems very likely.[4] The light is strong, the architecture clearly defined, and there is a lucidity of conception which is generally associated with the earlier 1850s. A related work (R 719), composed along similar lines but in a narrower vertical format, shows two different buildings on a lane and was probably painted on the same occasion.[5] At a later date Corot extended this painting at the extreme top and bottom.

1. "bonne trogne de cet aimable papa." See Baud-Bovy 1957, p. 176. Laure Bovy was married to Isaac Mayor, brother of Frédéric Mayor, who later owned *Le Lac de Genève* (cat. no. 81).
2. "Corot nous fit remarquer tout ce que l'éclat de cette boucle avait de mystérieux et d'évocateur, et il partit de là pour définir ce que doit être l'*effet* dans un tableau." Ibid., p. 187.
3. "Si vous pouviez dire à Menn qu'il serait bien aimable de redemander à Mlle Tintine les études, ainsi qu'à Berthoud, de Lausanne, qui en a une, et à Scheffer." See Robaut 1905, vol. 1, p. 198, and vol. 4, p. 338; Baud-Bovy 1957, p. 163.
4. San Francisco, Toledo, Cleveland, Boston 1962–63, p. 88.
5. Private collection. Paris 1971, no. 27, ill.

PROVENANCE: Anonymous sale, Hôtel Drouot, Paris, April 15, 1873; purchased at that sale by Louis Fréret for 605 francs; Albert Wolff, Paris, 1875; Th. Bascle, Paris; his sale, Hôtel Drouot, Paris, April 12–14, 1883, no. 19, as *Rue de village*; Collis P. Huntington, New York; his bequest to The Metropolitan Museum of Art, New York, 1900; acquired by the Museum, 1925

EXHIBITIONS: Paris 1875a, no. 18, lent by Albert Wolff; Newark 1946, no. 2; Atlanta 1951; New Orleans 1952; San Francisco, Toledo, Cleveland, Boston 1962–63, no. 11; Carouge 1978; Naples, Milan 1986–87, no. 9; New York 1992

REFERENCES: Robaut 1905, vol. 2, pp. 242–43, no. 718, ill.; Sterling and Salinger 1966, pp. 51–52, ill.

Bretonnes à la fontaine
(Breton Women at the Fountain)

Ca. 1840–44
Oil on canvas
15⅛ × 21⅝ in. (38.5 × 55 cm)
Signed lower left: COROT.
Musée du Louvre, Paris R.F. 1941–4

R 684

Corot's first visit to Brittany in the summer of 1829 is known from a short mention in a notebook (*carnet* 64, R 3101). A second visit in the early 1840s is documented by two views of a fountain at Mur (fig. 105), on which was modeled the principal architectural motif in *L'Incendie de Sodome* of 1843 (see cat. no. 114).[1] Travel in Brittany about that date may be inferred from a letter of June 30, 1845, that Corot wrote to a Breton friend, Charles Leroux, in which he asked him to serve as guide "to my friend M. Étex, who would like to visit your area. I have told him about the banks of the Erdre and about Croisic."[2] Leroux, who began calling himself a "student of M. Corot" only in 1852, was born at Nantes and seems to have traveled with Corot in a region of Brittany that he knew well and painted often. It remains an open question whether the journey implied in the letter is a third visit of about 1843–44 or the one taken before 1843. Corot returned to Brittany in 1851, 1855, 1857, and again about 1860, in the company of Jules Étex and Ernest Dumax.[3]

Alfred Robaut, first owner of *Bretonnes à la fontaine*, thought that the painting dated from one of the later visits, about 1850–55. For stylistic reasons Hélène Toussaint rightly dated it earlier, toward 1840, closer in time to the visit with Leroux on the southern coast of Brittany.[4] In his notes Robaut indicated that the landscape represents Batz, near Croisic, information not retained by Étienne Moreau-Nélaton in the published version of the catalogue. It should be noted that Robaut was somewhat vague on questions of Breton geography; in his remarks on the tracing of *Mur (Côtes-du-Nord). Une Fontaine* (fig. 105) he wrote, "almost the same location as my painting of Croisic," which is certainly not the case.[5] However, he was right about the locale of *Bretonnes à la fontaine*; it is very likely that Corot had given him some details on its origins. Radiographs and obvious pentimenti confirm that the landscape originally represented Batz: at right of center one can detect the tower of the church of Saint-Guénolé and at the far right

the ruins of the church of Notre-Dame du Mûrier. A similar view of Batz, from the same vantage point, figures in an engraving and a painting by Leroux, possibly his *Vue du bourg de Batz* exhibited at the Salon of 1850–51.[6] However, Corot retained from his initial composition only the principal motif—the fountain surrounded by peasant women—and the background of undulating dunes. In this final, simplified form the landscape assumed, in Toussaint's apposite words, "an antique or biblical grandeur, composed of rustic elements but evoking the noblest classical paintings."[7]

1. According to Hélène Toussaint, the two versions of *Mur (Côtes-du-Nord). Une Fontaine*—R 476 (location unknown) and R 685 (fig. 105)—represent the fountain of Sainte-Marguerite. See Paris 1975, no. 38.
2. "à M. Étex, mon ami, qui désire visiter vos environs. Je lui ai parlé des bords de l'Erdre et du Croisic." Quoted in Baud-Bovy 1957, p. 278, n. 116.
3. For a discussion of Corot's visits to Brittany, see Delouche 1977, pp. 256–57.
4. Paris 1975, no. 38.
5. "presque la même localité que le mien du Croisic." Robaut *carton* 14, fol. 201.
6. See Delouche 1977, p. 261.
7. "une grandeur antique ou biblique évoquant, avec des éléments rustiques, les plus nobles peintures classiques." Paris 1975, no. 39.

PROVENANCE: Gift of the artist to Alfred Robaut; his sale, Hôtel Drouot, Paris, December 18, 1907, no. 10; purchased at that sale by Paul Jamot for 8,700 francs; bequeathed by him to the Musée du Louvre, Paris, 1939; entered the Louvre, 1941

EXHIBITIONS: Paris 1875a, no. 100; Paris 1925, no. 72; Copenhagen, Stockholm, Oslo 1928, no. 10 (Copenhagen), no. 11 (Stockholm), no. 7 (Oslo); Paris 1930b, no. 24; London 1932, no. 362; Zurich 1934, no. 64; Paris 1936, no. 57; Lyons 1936, no. 50; Paris 1941, no. 21; Paris 1945a, no. 77; Brussels 1947–48, no. 48; Paris 1962, no. 37; Dallas 1966, no. 4; Vannes, Brest, Caen 1971–72, no. 11; Bourges 1973, no. 52; Paris 1975, no. 39

REFERENCES: Robaut *carton* 14, fol. 199; Robaut 1905, vol. 2, pp. 236–37, no. 684, ill.; Jamot 1936, ill. p. 28; Bazin 1942, pl. 79, no. 79; Bazin 1951, no. 87, pl. 87; Sterling and Adhémar 1958, no. 402, ill.; Leymarie 1966, p. 93; Paris, Musée du Louvre 1972, p. 99; Delouche 1977, pp. 260–61, ill.; Compin and Roquebert 1986, p. 158, ill.; Gale 1994, p. 90, ill. p. 91

Fig. 105. Corot. *Mur (Côtes-du-Nord). Une Fontaine entourée de paysannes puisant de l'eau (Mur, Côtes-du-Nord: Fountain Surrounded by Peasants Drawing Water;* R 685), ca. 1850–55. Oil on canvas, 13 × 21⅝ in. (33 × 55 cm). John G. Johnson Collection, Philadelphia Museum of Art (992)

113

Dunkerque. Les Bassins de pêche (Dunkirk, Fishing Docks)

Ca. 1857
Oil on canvas
14¾ × 18¾ in. (37.5 × 47.5 cm)
Stamped lower right: VENTE COROT
Musée des Beaux-Arts, Dunkirk P 391
Ottawa and Paris only

R 766

In 1857 Corot planned an excursion to the north of France with Constant Dutilleux and Charles Desavary, Dutilleux's future son-in-law. On September 2 he wrote to Dutilleux from Boulogne-sur-Mer: "Since yesterday I've been in Boulogne, where I'll stay until the 12th, when I hope to meet you in Arras and embrace you all. Shouldn't Colin be joining up with us in Dunkirk?"[1] In the event, Gustave Colin did not join the group. At Dunkirk, Dutilleux, Desavary, and Corot stayed first at the Chapeau Rouge and then at the more modest Chaloupe Nationale, an "abri des mariniers" (seamen's shelter). Later in September they moved to the auberge Louis Vendamme in nearby Zuydcoote, where they remained until about the twenty-

eighth.[2] Some ten oil sketches are ascribed to this visit, as are quick studies of Dunkirk and Zuydcoote in two notebooks. The artist evidently had an enjoyable sojourn. *Carnet 27* contains, along with notes, a tantalizing menu from the Chaloupe Nationale: "fried eggs, ham, chicken pie, veal with chicory, pâté, chicken with rice, turkey with chestnuts, pike, chocolate cream, meringues, a cream cheese, frangipani, petits fours, marzipan."[3]

This vivid and direct sketch, the only work purchased by a museum at Corot's posthumous sale, is generally ascribed to the 1857 visit. The view, much altered since, is seen from the Citadel; it looks across the bassin du Commerce toward the quai des Hollandais and the skyline of Dunkirk. To the left is the octagonal Tour de Leughenaër (or Tour des Pilotes), and at the center there is a glimpse of the old Hôtel de Ville and the tall belfry of the church of Saint-Éloi. The treatment of the background buildings, relatively close to that in the view of Orléans with the Tour Saint-Paterne of about

1830 (cat. no. 38), might suggest an earlier date for the present work, but the probability is remote. Corot did indeed visit Dunkirk in 1830; however, a comparison with works of that period, notably *Dunkerque. Bateaux de pêche amarrés à quai* (fig. 22), is at best inconclusive. The broadly indicated foreground, with paint lightly rubbed in, and the obstruction of the view by buildings are elements that Corot used on other occasions, for instance in *Arras. Le Beffroi et la cathédrale vus des remparts* (R 970, Kunstmuseum, Basel), painted with Dutilleux in 1852.

The background of the composition was repeated by Corot as the central motif of a larger and more luminous landscape, generally dated 1873, in a private Swiss collection (R 2117). That work, however, has a different foreground—dunes and figures—and shows a perplexing addition, a small tower to the right of the Tour Saint-Éloi (the latter change was noticed by Robaut when he made a tracing from the painting at the 1888 Gellinard sale).[4] Robaut, who considered the sketch now in Dunkirk to be "merely documentary,"[5] tentatively supposed that the larger version was also begun in 1857, from a viewpoint farther to the right. This suggestion, however, seems highly unlikely, as virtually every other feature of this sketch, including the position of the sailboats, was used in the larger painting.

1. "Me voici depuis hier à Boulogne, où je reste jusqu'au 12, jour où je compte aller vous retrouver à Arras et vous embrasser tous. Colin ne doit-il pas être de notre course à Dunkerque?" Moreau-Nélaton in Robaut 1905, vol. 1, p. 175.
2. Ibid., vol. 1, p. 177, and vol. 4, p. 91, *carnet* 27, no. 3064.
3. "oeufs sur le plat, jambon, tourte à la volaille, veau à la chicorée, un pâté, volaille au riz, une dinde au marrons, un brochet, une crème au chocolat, meringues, fromage à la crème, franchipane [*sic*], petits fours, massepains." Ibid., vol. 1, pp. 177–78, and vol. 4, p. 91, no. 3064.
4. Robaut *carton* 8, fol. 403.
5. "seulement documentaire." Ibid.

PROVENANCE: The artist; his posthumous sale, Hôtel Drouot, Paris, pt. 1, May 26–28, 1875, no. 142; purchased at that sale by Dumesnil for 400 francs for the Musée des Beaux-Arts, Dunkirk

EXHIBITIONS: Bourges 1973, no. 74; Tokyo, Osaka, Yokohama 1989–90, no. 36

REFERENCES: Robaut 1905, vol. 2, pp. 252–53, no. 766, ill., and vol. 4, p. 208, no. 142; Dunkirk, Musée des Beaux-Arts 1974, p. 15; Dunkirk, Musée des Beaux-Arts 1976, p. 16; Smits 1991, p. 325, fig. 301

114

Destruction de Sodome (The Destruction of Sodom)

1843–57
Oil on canvas
36⅜ × 71⅜ in. (92.4 × 181.3 cm)
Signed lower left: COROT.
The Metropolitan Museum of Art, New York
H. O. Havemeyer Collection, Bequest of Mrs. H. O. Havemeyer, 1929
29.100.18

R 460, R 1097

Destruction de Sodome, originally entitled *L'Incendie de Sodome*, had the unusual distinction of being famous before it was exhibited. The painting, Corot's largest to date, became the cause célèbre of the Salon of 1843 when its refusal by the jury triggered a general outcry of protest. Critics, who presumably had seen it, referred to the "major picture" *(tableau capital)* and the "admirable composition," and even the king was reported to have been disturbed by the rejection.[1] In 1844, when Corot again submitted the work, unchanged except in name, it was accepted at the Salon. Yet much of the previous year's praise turned to disapproval. "How poetic is the biblical story! How prosaic the painting!" wrote the reviewer for *Les Beaux-Arts.* "His tones are dirty, his figures gashed with strokes of the brush, his trees a blackish green, his earth mired in thick paint."[2]

Even sympathetic critics qualified their remarks: "There are those who don't understand M. Corot's genius: pity them. . . . As for *L'Incendie de Sodome*, in which the feeling of desolation is expressed with uncommon power, we rightly reproach M. Corot for not having given to the burning Sodom the grandiose and sumptuous character we imagine the city to have had."[3]

Although the genesis of the painting exhibited in 1844 is vague, a drawing of 1843 in the Louvre (R.F. 8797) shows the general plan, and an oil sketch in the Metropolitan Museum further elaborates the composition (fig. 106). Lot's wife is seen behind the principal group, and the cistern, not present in the drawing, appears in the sketch as a minor motif in the middle ground behind her. Various poses for the figures must have been considered; a study of a man fleeing (R 2735) was not used in the final design.[4] As noted by Robaut, the right side of the landscape was derived from a sketch made at Volterra in the summer of 1834 (R 304). The engraving after the finished 1844 painting (fig. 107) shows that Corot decided on an

Fig. 106. Corot. Study for *L'Incendie de Sodome* (R 460 bis), 1843. Oil on canvas, 14⅛ × 19⅝ in. (35.9 × 49.8 cm). Catharine Lorillard Wolfe Collection, Wolfe Fund, 1984, The Metropolitan Museum of Art, New York (1984.75)

Fig. 107. *L'Incendie de Sodome.* Anonymous engraving after the first state of Corot's painting, published in *L'Illustration*, March 16, 1844. Robaut *cartons*, Musée du Louvre, Paris

oblong format, moved Lot's wife in line with the other figures, gave great prominence to the cistern, and modified the trees. The cistern has been related to Corot's painting of a fountain at Mur in Brittany, known in two variants of somewhat uncertain dating (fig. 105 and R 476, private collection).[5] However, Gérard de Wallens has pointed out its curious similarity to a cistern in Paul Flandrin's *Les Pénitents dans la Campagne de Rome*, shown at the Salon of 1840.[6]

It was probably in 1856 that Corot decided to revise his painting radically. In Moreau-Nélaton's words, "Cut down, recast, crushed between the wheels of a mind without pity for its earlier creations, the work is unrecognizable. It is a new *Sodome*, which bears only a distant resemblance to the old one."[7] The entire upper half of the painting and a large portion on the right were discarded, leaving only the frieze of figures and the immediate landscape surrounding them, both of which were reworked. The three principal figures at the right were brought closer together, the angel lost its wings, the arm of Lot's wife was lowered, Sodom's ramparts and the group of trees in the left background were almost entirely removed. A vast Poussinesque landscape was reduced to a ravaged, scorched

desert, dominated by a huge, useless cistern acting as a foil for the desolate figures.

It is not known why Corot altered the painting, but it has been suggested that Théophile Silvestre's published remarks prompted the changes.[8] It is more likely, however, that the revisions reflected Corot's increasing interest in the human figure, which, as François Fosca remarked, is prominent here.[9] In the new *Sodome* the subject is not the cataclysm itself but its effects on the protagonists. Corot moved closer to traditional depictions of the scene, such as those in the Louvre by Rubens and the studio of Veronese. The transformation process is undocumented; the first reference to revisions is in a letter of March 31, 1857, to Édouard Brandon, in which Corot included a sketch of the altered work and said he planned to exhibit it at the Salon.[10] *Carnet* 56 contains a study for the new composition and another summary sketch that may be related.[11]

In June 1857 Corot included the painting, once again entitled *L'Incendie de Sodome*, in the group of seven pictures he sent to the Salon. He later told Jules Claretie that it had been poorly exhibited, with the frame of a painting below hiding all of its lower part.[12] In the event, the critical reception was more adverse than in 1844. Gustave Planche and later Paul Mantz found the picture interesting, but Théophile Gautier ignored it. Louis Leroy wrote in *La Semaine politique:* "Oh, Monsieur Corot, why did you repaint *L'Incendie de Sodome*? The work was bad in 1844; today it is vile."[13] Bertall published a caricature mocking the purple tonalities of the painting with the caption: "Sodom in licorice juice, by M. Corot.—The Bible tells us that Sodom was consumed by fire. M. Corot claims that the punishment was not so terrible as all that, and that the reprehensible city was simply showered in licorice. M. Corot's faith is honorable and seems to be that of a fine fellow."[14]

Corot described the painting as one of his favorites, and in later life he told Claretie: "That wife of Lot isn't very famous. Well! if my studio caught fire, that's the first painting I'd want to save."[15] In 1869, however, he sold it to Durand-Ruel.[16]

1. Moreau-Nélaton in Robaut 1905, vol. 1, p. 101. See also Houssaye 1843, pp. 34–35, and Karr's amusing aside in Karr 1843, p. 28: "M. Corot, one of our finest landscape artists—whose reputation was established some time ago—has had his *Incendie de Sodome*, a very effective and poetic canvas, refused, after working on it for an entire year.... A member of the jury said, 'Corot, Corot—I don't think I know him—Oh, wait, of course I do. He's the one who does everything in gray. You say we rejected him? It's possible—but why would he paint a fire if he does everything in gray?'" ("M. Corot, un de nos meilleurs paysagistes—et dont la réputation est faite depuis longtemps,—s'est vu refuser un *Incendie de Sodome*,—tableau plein d'effet et de poésie,—qu'il avait travaillé toute une année.... Un des membres du jury disait:—*Corot, Corot*,—je ne connais pas.—Ah! oui, pardon, *Corot* j'y suis,—celui qui fait *si gris*.—vous dites que nous l'avons refusé,—c'est possible—mais pourquoi faire un incendie quand on fait *si gris*?")

2. "Quelle poésie dans le récit biblique! quel prosaïsme dans le tableau!" "Ses tons sont sales, ses figures balafrées de coups de pinceau, ses arbres d'un vert noirâtre, ses terrains lourdement empâtés." Anon. 1844a, pp. 2–3.

3. "Il y a des gens qui ne comprennent pas le génie de M. Corot. Plaignons leur malheur.... Quant à l'*Incendie de Sodome*, où le sentiment de la désolation est exprimé avec une rare puissance, on reproche avec raison à M.

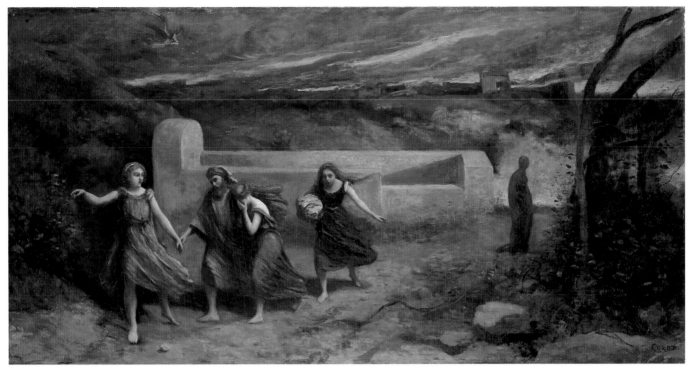

114

Corot de ne pas avoir donné à Sodome incendiée le caractère grandiose et somptueux que nous supposons à cette cité." Laverdant 1844.

4. See Robaut 1905, vol. 1, p. 102, ill.

5. For Corot's early visits to Brittany, see cat. no. 112 and Delouche 1977, p. 256.

6. Musée des Beaux-Arts, Lyons. See Wallens in Paris, Lyons 1984–85, no. 167, ill.

7. "Coupée, refondue, passée au laminoir d'un esprit impitoyable pour ce qui est sorti de lui-même, l'oeuvre est méconnaissable: c'est un nouveau *Sodome*, qui n'a plus qu'une lointaine analogie avec l'ancien." See Robaut 1905, vol. 1, p. 170.

8. See Sterling and Salinger 1966, p. 52.

9. Fosca 1958, p. 170.

10. See Robaut 1905, vol. 1, p. 170, ill. p. 169.

11. See *carnet* 56, R 3093, Musée du Louvre, Paris, R.F. 8719, fols. 32, 45.

12. Cited in Coquis 1959, p. 80.

13. "Ah! Monsieur Corot, pourquoi avoir refait l'*Incendie de Sodome*? Ce tableau était mauvais en 1844; aujourd'hui, il est détestable." Cited in Tabarant 1963, p. 242.

14. "Sodome au jus de réglisse, par M. Corot.—La Bible assure que Sodome fut dévorée par l'incendie. M. Corot prétend que la punition ne fut pas si terrible, et que cette ville coupable fut simplement passée au jus de réglisse. La croyance de M. Corot est respectable et nous paraît émaner d'un brave homme." Bertall 1857.

15. "Cette femme de Loth n'est pas célèbre. Eh bien! si le feu prenait à mon atelier, je voudrais qu'on sauvât d'abord cela." Cited in Coquis 1959, p. 80.

16. For the purchase, usually said to have taken place in 1868, see Paul Durand-Ruel's memoirs in Venturi 1939, vol. 2, p. 185. A letter Corot wrote on June 20, 1869, from Coubron, where he was on vacation, about the delivery of the painting gives the correct date. It reads in part: "I am very sorry that the painting has not been delivered to you. M. Grédelue the gilder at 54 f[aubour]g Poissonnière was supposed to have it picked up. The canvas should be removed from its frame to take it down more easily. It depicts the destruction of Sodom." ("Je regrette bien qu'on ne vous ait pas livré le tableau. Mr. Grédelue le doreur 54 fg Poissonnière devait le faire prendre. Il faudrait ôter la toile du cadre pour le descendre plus facilement. Il représente la destruction de Sodome.") See Gutekunst & Klipstein, Bern, sale 89, May 14, 1958, no. 15.

PROVENANCE: Purchased by Durand-Ruel & Cie., Paris, for 15,000 francs, 1869; purchased by the comte Abraham de Camondo, Paris, for 20,000 francs, 1873; his son, the comte Isaac de Camondo, Paris, 1889; bought back by Durand-Ruel & Cie., Paris, for 100,000 francs, 1899; sold to Mr. and Mrs. H. O. Havemeyer, New York, for 125,000 francs, August 1, 1889; Mrs. H. O. Havemeyer, New York, 1907–29; her bequest to The Metropolitan Museum of Art, New York, 1929

EXHIBITIONS: Paris (Salon) 1844, no. 399, as *Destruction de Sodome* (first version); Paris (Salon) 1857, no. 593, as *L'Incendie de Sodome* (second version); Toulouse 1865, no. 184; Paris 1875a, no. 209; New York 1890–91, no. 6; Chicago 1893, no. 2886; New York 1930b, no. 12; Newark 1946, no. 4; San Francisco, Toledo, Cleveland, Boston 1962–63, no. 9; Edinburgh, London 1965, no. 75; Saint Petersburg, Moscow 1988; New York 1992; New York 1993, no. 100

REFERENCES: Anon. 1843a, p. 25; Anon. 1843b, p. 178; Houssaye 1843, pp. 34–35; Karr 1843, p. 28; Peisse 1843; Anon. 1844a; Anon. 1844b, ill. (first version, woodcut); Anon. 1844 (M.), p. 104; Laverdant 1844; Silvestre 1856, p. 102; Bertall 1857, ill.; Du Pays 1857, p. 202; Perrier 1857, p. 138; Mantz 1861, pp. 427–28; Frond 1865, p. 2; Rousseau 1875, p. 246; Claretie 1882, p. 112; Montrosier 1882, p. 111; Montezuma 1889a, p. 67; Montezuma 1889b, p. 114; Roger-Milès 1891, pp. 38, 48, 50; Larthe-Ménager 1894, p. 14; Thomson 1902, pp. 40, 66, ill.; Geffroy 1903, pp. cxvi, cxvii, cxx; Hamel 1905, pp. 22, 28, pl. 23; Meier-Graefe 1905, pp. 49, 50, 64; Michel 1905, p. 30; Robaut 1905, vol. 2, pp. 160–61, no. 460, ill.; Jaccaci 1913, p. 77; Moreau-Nélaton 1924, vol. 1, pp. 55–56, 58–59, 108, fig. 140; Bernheim de Villers 1930a, p. 32, no. 173, fig. 173; Chassé 1930, p. 334; Fosca 1930, p. 53, pl. 31; Mather 1930, pp. 470–71, ill. p. 488; Meier-Graefe 1930, pp. 54, 75–76; *Havemeyer Collection* 1931, pp. 72–73, ill.; Venturi 1939, vol. 2, p. 185; Bazin 1942, pp. 52, 105; Baud-Bovy 1957, pp. 38, 86, 187, 210–12, 230–31, pl. XLII; Fosca 1958, pp. 24, 32, 146, 190; *Havemeyer Collection* 1958, p. 14, no. 70; Coquis 1959, pp. 35–36, 72, 77, 80; Tabarant 1963, pp. 61, 71, 242; Sterling and Salinger 1966, pp. 52–54, ill.; Leymarie 1979, p. 78, ill.; Weitzenhoffer 1982, pp. 112, 115, 131–32, 187–88, fig. 20; Weitzenhoffer 1986, pp. 60, 66, 89, 255, pl. 18; Selz 1988, pp. 128, 142, 144; Wissman 1989, pp. 88–92, 173; Clarke 1991a, pp. 67–69, fig. 74; Smits 1991, pp. 268–70, 304, fig. 250 (first version); Gale 1994, pp. 26, 27, 36, 39

1859-75

Fig. 108. Charles-Paul Desavary (1837–1885). *Corot at Arras*, 1871. Published in Robaut 1905, vol. 1, p. 264

Le Père Corot: The Very Poet of Landscape[1]

GARY TINTEROW

"LE PATRIARCHE DES PAYSAGISTES"[2]

"I am fine," Corot wrote to a friend in 1872. "I'm working as if I were seventy...."[3] If the seventy-six-year-old painter was surprised to find himself so sprightly, the public at large was simply astonished. In the tumultuous climate of the infant Third Republic, Corot was firmly fixed in the popular imagination as an artist of the Second Empire, now the *ancien régime.* He whose vaporous landscapes had provoked the emperor to exclaim "I have never gotten up early enough in the morning to understand M. Corot"[4] had disappeared in his fading mists, so people assumed, as quickly as the old government had dissolved. It was almost beyond comprehension that the author of the *Danse des nymphes* (cat. no. 103) could still be active, stalking the woods at Ville-d'Avray for yet another motif, while a very modern Paris was renewing itself in the aftermath of the Franco-Prussian War of 1870-71 and the Commune.

Corot was thus a remnant from an easier age, already wrapped in the cloak of nostalgia. When his paintings appeared at the Salon of 1874 (his last), the critic Jules Castagnary felt it necessary to explain to the disbelieving that the artist "is still alive and shows no signs of decline.... Fifty years ago this dean of our painters, unhappy with academic teaching, left for Italy, so he might drink directly from the sacred spring. Since that time he has seen the school of convention tumble and a taste for real nature be reborn. He played his role in the revolution from which the modern landscape emerged. He was one of that first glorious group who so boldly battled the influence, then supreme, of the Michallons and Bertins, and now at the end he is the last surviving victor. A master in his turn, he saw many generations of young men pass through his studio. They came to ask him the secret of his strength."[5] As was noted by the eminent arts administrator Charles Blanc, a deeply conservative man who appreciated Corot's sterling character more than his painting, the artist's long life had made it possible for him to enjoy a curious revival of popularity long after his critical successes in the 1850s. "It is what happens to prudent women who save out-of-style dresses in their wardrobes; one fine day, because of changes in taste and revivals foreseen or unforeseen, they find themselves in fashion again. [Corot,] dedicated to historical landscape for half a century, went through an era when no one wanted it anymore, but, strange to say, he was loved, he was extolled by the Realist school—he who was so little a Realist, he whose exquisite paintings were hardly anything but the dawn in one picture, or twilight in another."[6]

During the last fifteen years of his life, from 1859 to 1875, affection for Corot deepened.[7] "He was loved like a comrade and respected like a master," Blanc

1. Daubigny and other near-contemporaries began to call Corot "le père Corot" (Father Corot) in the 1850s. In the 1860s and 1870s, Berthe Morisot, Edgar Degas, and others of their generation called him, with some slight mockery, "Papa Corot." Théodore de Banville described him as "le poète même du paysage" ("the very poet of landscape") in his review of the 1861 Salon (Banville 1861, p. 235).

2. The critic Georges Lafenestre called Corot "le patriarche des paysagistes" ("the patriarch of landscape painters") in his review of the 1870 Salon (Lafenestre 1870, p. 703). Lafenestre used the phrase again in his review of the 1873 Salon (Lafenestre 1873, p. 54), as did Jules Castagnary ("Salon de 1873," in Castagnary 1892, vol. 2, p. 73) and Jules Claretie that same year (Claretie 1873, p. 73).

3. "Je vais bien"; "Je travaille comme si j'avais 70 ans." Corot, letter to Jean de la Rochenoire, August 29, 1872, quoted in Robaut 1905, vol. 4, p. 345, no. 211.

4. "Je ne me suis jamais levé assez matin pour comprendre M. Corot." As reported by Jules Claretie in "L'Art français en 1872: Revue du Salon," in Claretie 1873, p. 292.

5. "vit encore et ne connaît même pas le déclin.... Il y a cinquante ans que ce doyen de nos peintres, mécontent des enseignements académiques, partait pour l'Italie afin d'y puiser directement à la source sacrée. Depuis ce temps, il a vu tomber l'école de la convention et renaître le goût de la nature vraie. Il a pris sa part de la révolution qui a préparé et constitué le paysage moderne. Il était de la glorieuse pléiade du début qui engagea si audacieusement le combat contre l'influence alors souveraine des Michallon et des Bertin, et il reste le dernier survivant parmi les vainqueurs de la fin. Devenu maître à son tour, il a vu passer dans son atelier plusieurs générations de jeunes hommes venus pour lui demander le secret d'être forts." "Salon de 1874," in Castagnary 1892, vol. 2, p. 101. For the quote in its entirety, see the entry for cat. no. 161.

6. "Il lui arriva ce qui arrive à ces femmes prudentes qui conservent dans leur garde-robe les costumes démodés, et qui, un beau jour, par suite des variations du goût et de ses retours prévus ou imprévus, se retrouvent à la mode. Voué durant un demi-siècle au paysage historique, il traversa une époque où l'on n'en voulait plus, mais, chose étrange! il fut aimé, il fut prôné par l'école réaliste, lui qui en était si peu, lui dont les peintures exquises n'étaient guère que l'aurore d'un tableau ou le crépuscule d'un autre." Blanc 1876, pp. 376–77.

7. Corot died on February 22, 1875, but his final illness had already overtaken him by the end of 1874.

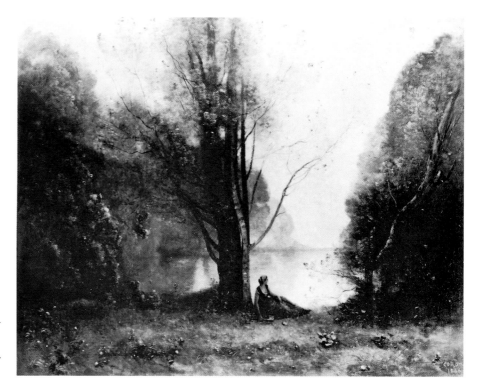

Fig. 109. Corot. *La Solitude. Souvenir de Vigen (Lim-ousin)* (*Solitude:* Souvenir *of Vigen, Limousin;* R 1638), 1866. Oil on canvas, 37⅜ × 51⅛ in. (95 × 130 cm). Private collection

wrote.[8] Collectors, dealers, runners, and sycophants waited impatiently for his paintings to dry so that they could be whisked off to quick profit. Despite the disdain of the powerful officer of culture comte Émilien de Nieuwerkerke, the emperor personally bought paintings by Corot on two occasions, giving one, *La Solitude* (fig. 109), to the empress.[9] At the Salon Corot experienced few of the disappointments that marked his dealings with juries in the 1840s and 1850s: throughout most of the 1860s and 1870s he was either on the jury himself or *hors concours,* automatically accepted. *Salonistes* (reviewers of the Salons) wrote long eulogies about the poet of landscape. Young painters, among them Berthe Morisot, elicited his instruction and approval; Pissarro described himself as a pupil of Corot in the Salon brochures as a measure of respect, and others did the same. Although some contemporaries, such as the critics Théophile Thoré and Castagnary, grew tired of Corot's imagery, they vaunted his talent to the end. And, just as Blanc wrote, Corot was unexpectedly adopted by the proponents of the New Painting; Émile Zola, Théodore Duret, and Edmond Duranty, the key writers on the new school, considered Corot a progenitor of Impressionism. At one point or another in the course of the 1860s, Monet, Renoir, and Sisley each experimented with some of Corot's methods and techniques. Unexpectedly too, Corot, at the very end of his life, dabbled with the blond palette and motifs of modern life that had come to characterize the New Painting.

THE VERY POET OF LANDSCAPE

Few of these developments could have been anticipated in 1859, when Corot exhibited ambitious compositions with large-scale figures—*Macbeth* (fig. 110), *Dante et Virgile,* and *La Toilette* (cat. nos. 115, 116)—in addition to his predictable *pastorales* and *souvenirs.* Although the lugubrious mood of *Dante et Virgile* and the

8. "Il était aimé comme un camarade et respecté comme un maître." Blanc 1876, pp. 375–76.
9. The emperor bought *Souvenir de Mortefontaine* (cat. no. 126) from the Salon of 1864 for 3,000 francs; he bought *La Solitude* (fig. 109) from the Salon of 1866 for 18,000 francs.

dramatic landscape of *Macbeth* aroused interest, *La Toilette*—viewed today as a masterpiece—was deemed mediocre.[10] As Moreau-Nélaton summed it up, "It was claimed that the indistinctness of early and late day served to veil the imperfections of his technique. The mysterious charm in which he wrapped his skill provided ammunition against him. It is the old story of genius grappling with ignorance and habit."[11] But the critical winds began to shift when Corot showed *Le Repos* and *Orphée* (cat. nos. 117, 120), among other works, at the Salon of 1861. The habitual refrain was sung: M. Corot always paints the same one picture[12]— but a new note was sounded as well: Corot is a poet.[13] Poetry became the catch-all concept that explained the unsophisticated drawing, the indecisive forms, and the vagueness of the landscape views. Corot's paintings were dreams, "movement into a reverie,"[14] "musings on nature."[15] After seeing *Souvenir de Mortefontaine* at the Salon of 1864 (fig. 111, cat. no. 126), Maxime Du Camp explained that Corot "never copies nature, he dreams it and reproduces it as he sees it in his reveries: gracious reveries that belong to the land of fairies. . . . Is his color correct? Is his drawing exact and pure? It doesn't even occur to me to think about it, so powerfully does this poetry move and captivate me."[16]

Théodore Duret defined a key quality of Corot's art in 1867 when he noted that the painter fixed on canvas not only the visual spectacle before him but also "the exact sensation that he has experienced." For Duret, this created a problem: "The poetic feeling that the sight of nature arouses in him sometimes becomes so intense that in order to transmit it better, he falsifies and denatures the spectacle before him; and the object represented, no longer real, thus loses the very power that he wished to give it in order to communicate emotion."[17] To communicate emotion, however, was one of the tenets of Romantic landscape to which Corot was most faithful. Théodore de Banville understood this perfectly.

10. Mantz 1859, p. 295.
11. "On accusait l'indécision des heures extrêmes du jour de servir de voile à l'imperfection de sa pratique. Le charme mystérieux dont il enveloppait sa science prêtait des armes contre elle. C'est l'éternelle histoire du génie aux prises avec l'ignorance et la routine." Moreau-Nélaton in Robaut 1905, vol. 1, p. 193.
12. "M. Corot has always painted just one landscape." ("M. Corot n'a jamais peint qu'un paysage.") Castellan 1861, p. 103. Also, "For the last thirty years he has exhibited only one painting." ("Depuis trente ans il n'a jamais exposé qu'un tableau.") Delvau 1861, p. 272.
13. "Corot est un poète." Callias 1861, p. 246.
14. "des acheminements à la rêverie." Mantz 1863, p. 38.
15. "la nature rêvée." Castagnary, "Salon de 1864," in Castagnary 1892, vol. 1, p. 206.
16. "ne copie jamais la nature, il y songe et la reproduit telle qu'il la voit dans ses rêveries; rêveries gracieuses qui conviendraient au pays des péris et des fées. . . . Sa couleur est-elle juste? son dessin est-il exact et pur? Je ne pense même pas à m'en inquiéter, tant cette poésie me frappe et me captive." Du Camp 1864, p. 690.
17. "la sensation exacte qu'il a ressentie"; "Le sentiment poétique qui existe en lui à l'aspect de la nature, devient quelquefois si intense que, pour mieux le transmettre, il fausse et dénature le spectacle vu, et l'objet représenté, cessant d'être vrai, perd par cela même la puissance qu'on voulait lui donner de communiquer une émotion." Duret 1867, p. 27.

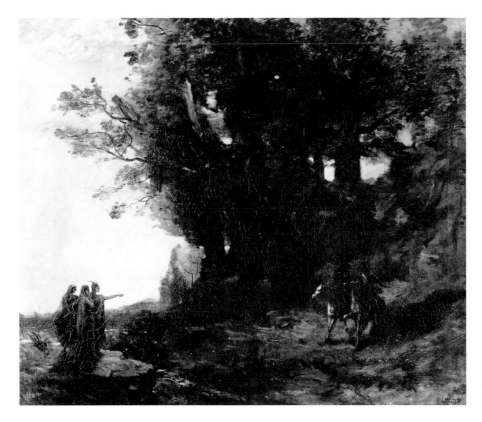

Fig. 110. Corot. *Macbeth* (R 1109), 1859. Oil on canvas, 43¾ × 53⅜ in. (111 × 135.7 cm). Wallace Collection, London (P281)

"This is not a landscape painter, this is the very poet of landscape . . . who breathes the sadnesses and joys of nature. . . . The bond, the great bond that makes us the brothers of brooks and trees, he sees it; his figures, as poetic as his forests, are not strangers in the woodland that surrounds them. He knows more than anyone, he has discovered all the customs of boughs and leaves; and now that he is sure he will not distort their inner life, he can dispense with all servile imitation."[18]

During the 1860s and 1870s the vehicle for these sentiments was often a *souvenir*, the reminiscence of a particular place that Corot distilled into a picture. Sometimes based on a plein air sketch, as is *Le Batelier amarré* (cat. no. 121), sometimes invented wholly in the studio, like *Souvenir de Mortefontaine* (cat. no. 126), Corot's *souvenirs* are more often than not suffused with a silver light that seems to result from the filtering of images through his memory. Between 1855 and 1874 Corot exhibited nearly thirty works with the word *souvenir* in the title, about one fifth of the works he displayed publicly. The term is now inextricably linked with Corot,[19] but in fact it commonly appeared at the Salons. Although, as Ann Dumas has shown,[20] specific *vues* far outnumbered *souvenirs*, in the years between 1859 and 1874 there were never fewer than ten and sometimes as many as thirty-six *souvenirs* at the Salon. While that is a small figure in relation to the total number of exhibits—from three to five thousand each year—it is large enough to register as significant.[21] Some of the *souvenirs* are directly linked to Corot's influence, such as the *Souvenir des bords de l'Oise* exhibited at the 1864 Salon by Morisot; she listed herself as a student of Joseph Guichard and Achille Oudinot, who was himself a student of Corot. Other *souvenirs* seem only coincidentally related to Corot's, among them Caruelle d'Aligny's *Souvenir de Mortefontaine*, shown at the Salon of 1859, and François-Jean Schaeffer's *Souvenir d'Italie*, shown at the Salon of 1864. The term as used in painting probably derives from manuals of the Neoclassical theorist Valenciennes, who characterized his composed landscapes as *ressouvenirs* of earlier sketches. But it is perhaps more important, as Iain Gale has noted, that Romantic poets such as Lamartine and Hugo frequently used the term *souvenir* in their titles.[22] This connection is underscored by Charles Rolland's remark in 1866, "M. Corot is reproached for not making his compositions sufficiently varied. The objection is not entirely groundless, but it does not make him any less the Lamartine of contemporary landscape—which for me is the highest possible praise."[23]

Corot made his sentiments visible by rendering the *effet*, the *impression*. He was the painter intimately associated with this approach: in 1866 Charles Blanc went out of his way to criticize followers of Corot for contenting themselves with an impression,[24] and in 1864 Claude Monet remarked to Frédéric Bazille, "I've begun a simple study that you haven't seen, it is done entirely from nature, you may find in it a certain kinship to Corot but there was no imitation involved. The subject and especially the calm, hazy *effet* are the only reasons for the resemblance."[25] What Blanc objected to was not simply the informality of a seemingly haphazard composition, it was the very core of Corot's method: the emphasis on form and tone at the expense of detail. Corot's notebooks are filled with comments that underscore his thinking. "I never hurry to arrive at details; the masses and the character of a picture interest me before anything else."[26] Even when Corot was painting outdoors, he positioned himself far from his motif in

18. "Ce n'est pas un paysagiste, c'est le poète même du paysage . . . qui respire les tristesses et les joies de la nature. . . . Le lien, le grand lien qui fait de nous les frères des ruisseaux et des arbres, il le voit; ses figures, poétiques aussi comme ses forêts, ne sont pas des étrangères dans la forêt qui les entoure. Plus savant que personne, ayant surpris toutes les habitudes des rameaux et des feuilles, maintenant, comme il est sûr de ne pas fausser leur sentiment, il peut se dégager de toute imitation servile." Banville 1861, pp. 235–36. For a fuller quotation, see cat. no. 120 n. 10.

19. Corot exhibited *Souvenir de Marcoussis, près Monthléry* (R 1101) and *Souvenir d'Italie* (unidentified) at the 1855 Exposition Universelle.

20. Dumas in London, Boston 1995–96, p. 34.

21. In 1859 there were 13 *souvenirs* out of 3,894 entries; in 1861, 31 out of 4,102; in 1863, 19 out of 2,923; in 1864, 25 out of 3,473; in 1865, 29 out of 3,559; in 1866, 36 out of 3,338; in 1867, 20 out of 2,745; in 1868, 32 out of 4,213; in 1869, 25 out of 4,230; in 1870, 36 out of 5,434; in 1872, 22 out of 2,067; in 1873, 10 out of 2,142; in 1874, 21 out of 3,657.

22. Gale 1994, p. 35.

23. "On reproche à M. Corot de n'être pas assez varié dans ses compositions. L'objection n'est pas tout à fait fausse, mais il n'en reste pas moins, et pour moi c'est le suprême éloge, le Lamartine du paysage contemporain." Rolland 1865, p. 202.

24. Blanc 1866, p. 40.

25. "Il y a une simple étude que vous n'avez pas vu commencer, elle est entièrement faite sur nature, vous y trouverez peut-être un certain rapport avec Corot, mais c'est bien sans imitation aucune qu'il en est ainsi. Le motif et surtout l'effet calme et vaporeux en est seul la cause." Monet, letter to Bazille, October 14, 1864, quoted in Wildenstein 1974–91, vol. 1, p. 421, no. 11.

26. "Je ne suis jamais pressé d'arriver au détail; les masses et le caractère d'un tableau m'intéressent avant tout." From a notebook of about 1848–52, cited in Anon. 1936, p. 72.

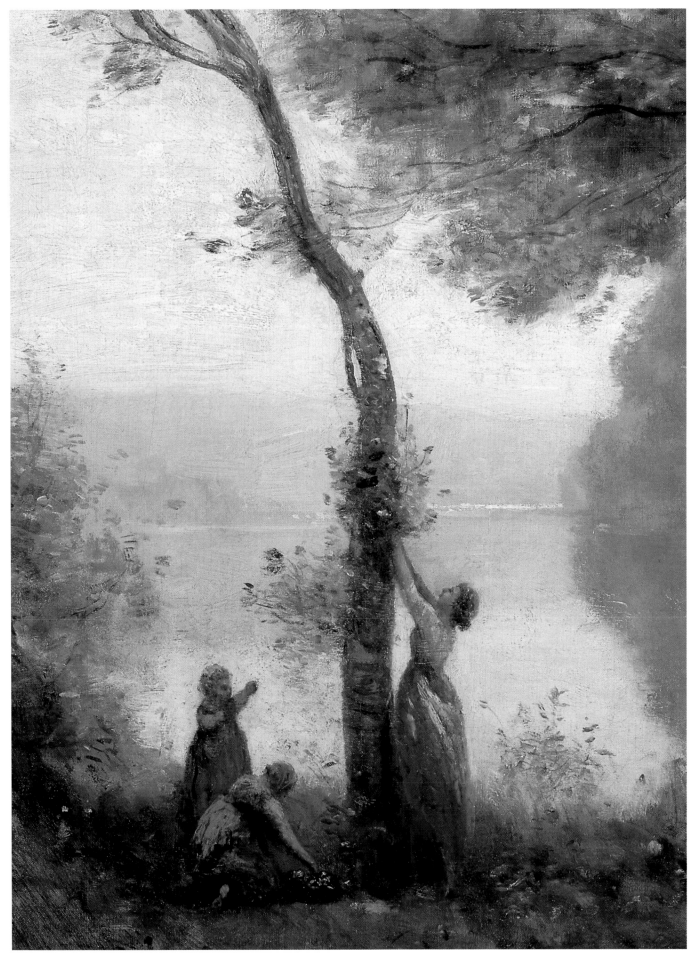

Fig. III. Detail of Corot, *Souvenir de Mortefontaine* (Souvenir of Mortefontaine), cat. no. 126

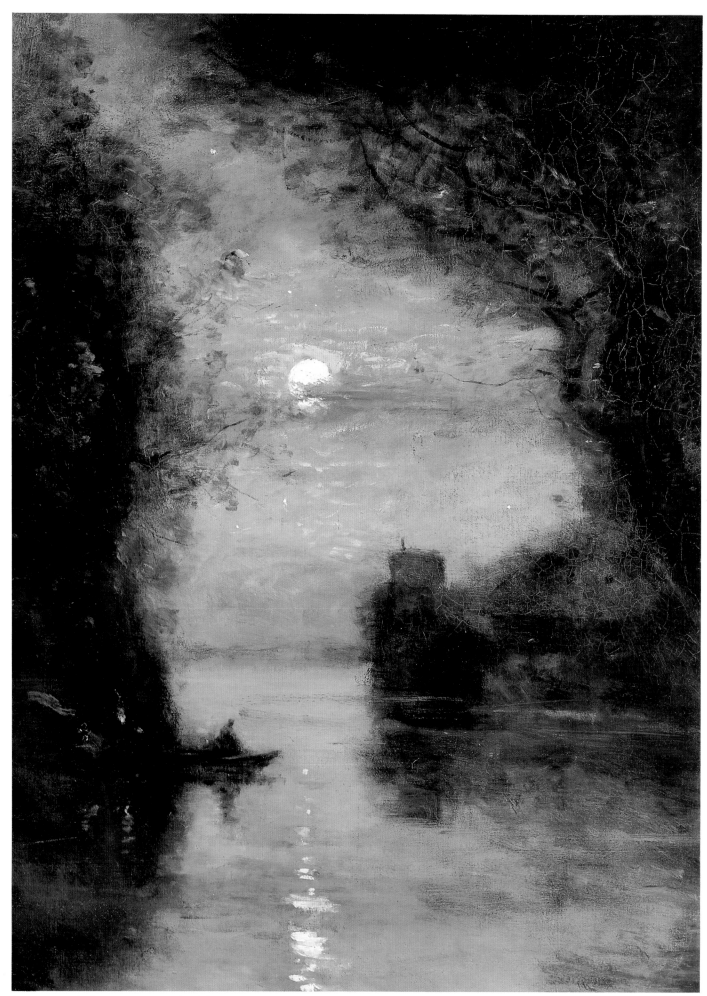

Fig. 112. Detail of Corot, *Paysage au clair de lune (Moonlit Landscape)*, cat. no. 161

Fig. 113. Ernest-Joachim Dumax (b. 1811). *Corot at Marcoussis*, 1874. Published in Robaut 1905, vol. 1, p. 307

order to comprehend the whole more clearly. George Moore, the Irish critic who was a friend of Manet's, told a revealing anecdote: "I only saw Corot once.... It was in some woods near Paris, where I had gone to paint, and I came across the old gentleman unexpectedly, seated in front of his easel in a pleasant glade. After admiring his work I ventured to say, 'Master, what you are doing is lovely, but I cannot find your composition in the landscape before us.' He said, 'My foreground is a long way ahead,' and sure enough, nearly two hundred yards away, his picture rose out of the dimness of the dell, stretching beyond the vista into the meadow."[27]

For Corot, the masses, or forms, were indicated by drawing, whereas the character was imparted by correct tonality. "The first two things to study are the form, then the values. For me, those are the mainstays of art. Color and touch give the work its charm."[28] Corot's decorative panels done in the 1860s reveal this approach most clearly. Whether painted for his close friend the painter Charles Daubigny (cat. no. 128), for an old family friend, Mme Castaignet (cat. nos. 129, 130), or for the Russian Prince Demidoff, these decorations are organizations of broad masses marked by calligraphic contours and rendered in hues close in value. When he was acting as a decorator, Corot harked back to the arcadian visions of Hubert Robert and Fragonard, but he evoked their world with his own palette of muddy colors far removed from the peacock greens and blues of Rococo landscape. Perhaps the most extreme example of Corot's method is *Clair de lune* (fig. 112, cat. no. 161), in which the artist's nervous line animates forms that coalesce in a moody, nearly monochrome palette.

Corot became increasingly suspicious of color in the 1860s and 1870s. This turn of events perhaps reflected a shift taking place in public taste, or possibly a change in his own mood. Almost certainly it was bound up with the rise of landscape photography and the development of monotone calotypes printed in a range of browns, grays, or greens.[29] Corot was enormously interested in photography during the 1860s. He took photographs himself, made *clichés-verres* (drawings on a photographic plate that could be printed like photographs), and surrounded himself with photographers, among others his surrogate nephew Charles Desavary. His suppression of color was something quite conscious and considered. He wrote:

27. From Moore's *Modern Painting*, quoted in Halton 1906, p. 10.

28. "Les deux premiers choses à étudier—c'est la form, puis les valeurs. Ces deux choses sont pour moi les points d'appuis sérieux dans l'art. La couleur et l'exécution mettent le charm dans l'oeuvre." *Carnet* B, fol. 3, 1865–70, R 3118, Cabinet des Dessins, Musée du Louvre, Paris, R.F. 1870-08732. Paraphrased in Anon. 1936, p. 72.

29. For discussions of Corot and photography, see Jammes and Janis 1983; Manchester, New York, Dallas, Atlanta 1991–92; Stuffmann 1993.

30. "Ce qu'il y a à voir en peinture, ou plutôt ce que je cherche, c'est la forme, l'ensemble, la valeur des tons.... C'est pourquoi pour moi la couleur vient après, car j'aime avant tout l'ensemble, l'harmonie dans les tons, tandis que la couleur vous donne quelque chose de heurté que je n'aime pas. C'est peut-être l'excès de ce principe qui fait dire que j'ai les tons plombés." From a notebook of about 1870, quoted in Anon. 1936, p. 72.

31. See Monet's remarks to René Gimpel in Gimpel 1966, p. 151.

32. "Son champ de coquelicots est aveuglant. Il y en a trop!" Moreau-Nélaton in Robaut 1905, vol. 1, p. 306.

33. Ibid., p. 281.

34. "Corot et surtout Courbet prétendaient rendre les aspects de la nature sans rien y ajouter. Ils appliquaient à fixer avec exactitude les chose vues, mais les voyant en véritables artistes...ils en saisissaient les côtés caractéristiques et négligeaient les détails, les traits accessoires." Duret, quoted in Bonniot 1973, p. 103. Corot painted a *Vue de Saintes* (R 1279, Musée de Liège) while Courbet painted *Vue de Saintes, de Lormont* (done in 1862 but dated 1865; private collection). Bonniot 1973.

35. Duranty 1876, cited in Washington, San Francisco 1986, p. 480.

36. "Si M. Corot consentait à tuer une fois pour toutes les nymphes dont il peuple ses bois, et à les remplacer par des paysannes, je l'aimerais outre mesure." "Adieu d'un critique d'art," May 20, 1866, in Zola 1991, p. 132.

37. "Par là, Corot se distinguait des chefs de la nouvelle école, Cabat, Rousseau et Jules Dupré, qui, rompant avec le paysage académique, disaient dans leur coeur: 'Soyons vrais: la nature se chargera d'être belle, sans avoir besoin de naïades ni de héros.'" Blanc 1876, p. 374.

38. "Tout cela heureusement se trouvait racheté par une harmonie à la fois optique et morale, par un admirable accord entre le paysage et les figures qui l'habitent. Jamais, au grand jamais, Corot n'aurait commis en ce genre une invraisemblance; jamais il n'aurait placé les personnages de la Bible dans une contrée virgilienne, ni les pasteurs de Théocrite dans les États de l'Église. Il savait par coeur ou plutôt il devinait par son coeur cette géographie du sentiment que l'on enseigne point, et il se doutait bien, sans l'avoir lu dans les livres, que Daphnis et Chloé avaient dû s'aimer quelque part, dans une île de la mer Égée, non loin de Mitylène." Ibid., p. 375.

39. Vincent van Gogh, letter to Theo van Gogh, May 31, 1875, quoted in Van Gogh 1958, vol. 1, p. 27, no. 27.

"What there is to see in painting, or rather what I am looking for, is the form, the whole, the value of the tones.... That is why for me the color comes after, because I love more than anything else the overall effect, the harmony of the tones, while color gives you a kind of shock that I don't like. Perhaps it is the excess of this principle that makes people say I have leaden tones."[30] This statement confirms Corot's hostility toward the Impressionists in general[31] and explains his reaction in particular to Daubigny's *Le Champs de coquelicots* (Herbert F. Johnson Museum of Art, Ithaca), an homage to the Impressionists, exhibited at the Salon of 1874: "His field of corn poppies is blinding. There are too many of them!"[32] No wonder Corot was delighted when he discovered in 1873 that the Parisian draper's shop À Pygmalion was selling fabrics in a color called "Corot gray" ("gris-Corot").[33]

Corot's gentle reveries were of course completely unlike the brute or prosaic landscapes associated with the Realists, who included Courbet, Daubigny, and their followers Pissarro, Monet, Renoir, and Sisley. But, oddly enough, enemies of Realism and proponents of the New Painting were happy to identify Corot as a predecessor of the modern school. In a fascinating reversal, critics (and presumably artists) saw Corot's landscapes as true, and therefore real, because they were poetic. Seeing Corot and Courbet work side by side at Saintes in 1862, Duret wrote, "Corot and especially Courbet aspire to render the appearances of nature without adding anything. They work at getting down with precision the things seen, but, since they see them as true artists . . . they grasp the characteristic aspects and ignore the details, the secondary traits."[34]

The connection seemed confirmed in the early 1870s, when a slight shift in Corot's palette toward the light tonalities that Pissarro, Sisley, and Monet were using could be observed in his paintings. Despite himself, he was entering the modern era. In his manifesto of the New Painting, Duranty wrote of "le grand Corot" as an antecedent of the new tendency in art.[35]

Nevertheless, in his imagery Corot remained true to his Neoclassical roots. Zola lamented in 1866, "If M. Corot would kill, once and for all, the nymphs of his woods and replace them with peasants, I should like him beyond measure."[36] But Blanc recognized that Corot's nymphs were inseparable from his landscapes, a fact that "distinguishes Corot from the leaders of the new school, Cabat, Rousseau, and Jules Dupré, who, breaking with academic landscape, say in their hearts: 'Let's be honest; nature will take care of being beautiful without relying on naiads and heroes.'"[37] To Blanc, Corot's *naïades* were not arbitrary or artificial, but perfectly natural. "Fortunately, all that is redeemed by a harmony both optical and moral, by a wonderful unity between the landscape and the figures who inhabit it. Never in all eternity would Corot have committed an anachronism within the genre: he would never have placed figures from the Bible in a Virgilian countryside, nor the shepherds of Theocritus in the Papal States. He knew by heart, or, better, he divined with his heart this geography of feeling which no one had ever taught him, and, without having read it in books, he surmised that Daphnis and Chloe must have loved each other somewhere—on an island in the Aegean Sea, not far from Mytilene."[38] Right up to the end of his life, Corot sent landscapes with antique figures to the Salon. And after his death, his executors sent the 1874 work *Les Plaisirs du soir: danse antique* (R 2195, Armand Hammer Museum, Los Angeles) to the Salon of 1875. For Vincent van Gogh it was one of the three "very fine" Corots at the Salon, although not his favorite.[39]

Van Gogh observed in 1881 that "Corot's figures aren't so well known as his landscapes, but it cannot be denied that he has done them. Besides, Corot drew and modeled every tree trunk with the same devotion and love as if it were a figure."[40] In the 1860s and 1870s Corot painted more pictures whose subject was a human figure than he had at any previous time in his career. Alfred Robaut catalogued some 145 figure paintings out of about 1,800 canvases executed between 1859 and 1874. Yet it seems that, from the beginning, Corot refused to grant much importance to his work as a figure painter. He declared his interest in the figure by exhibiting *La Toilette* (fig. 114, cat. no. 116) at the Salon of 1859 and *Le Repos* (cat. no. 117) at the Salon of 1861. But then he retreated from this initiative, and for the rest of his life he sent only landscapes, with the exception of the modest *Une Liseuse* (cat. no. 141), exhibited in 1869.

Corot's ambivalence about his figure painting is visible in the pictures themselves. Some nudes, including *Le Repos* and *La Bacchante à la panthère* (cat. no. 118), were extensively revised and repainted, as if the artist could not be satisfied with his work. Yet others, such as *Bacchante couchée au bord de la mer* (cat. no. 119), were painted with speed and assurance. The figure paintings found ready buyers as soon as the artist was willing to release them. There was a lively market for these works during Corot's lifetime, as the provenances of the figure paintings in the present exhibition show,[41] and very few remained in Corot's hands at the time of his death. Robaut related an anecdote about his brother-in-law Desavary finding, by accident, the armoire in which Corot reputedly kept his figure studies[42]— the suggestion being that these paintings were a secret treasure trove—but this cannot be the entire story. Corot's own paintings of his studio (cat. nos. 134–139) show that he hung works like *La Blonde Gasconne* (cat. no. 72) on its walls, and it is known from descriptions that *La Femme à la perle* (cat. no. 107) was displayed in Corot's sitting room.

Corot considered painting from the figure an activity apart from his normal routine. According to Robaut and Moreau-Nélaton, from time to time he would take a week to paint from the model, but fitting it into his schedule was often a problem. "M. Robaut overheard him one morning [in 1873] replying to an Italian woman who was inquiring about modeling sessions, 'Come back sometime later, my child; I can't take a vacation at the moment.'"[43] Corot would pose these models in his studio, dressed in something from his collection of costumes and textiles and holding a book or a mandolin. Inevitably, the resulting painting would be called *Mélancolie* (R 1267), *La Lettre*, or *Une Liseuse* (cat. nos. 133, 141), or, for the more extravagant costume pieces, *La Jeune Grecque, Orientale rêveuse* (cat. nos. 151, 153), or *Agostina* (fig. 115)—the largest of his figure paintings. Corot delighted in the models' presence. Some, like Emma Dobigny (who also posed for Puvis de Chavannes and Degas), had the run of the place. When someone complained that Dobigny "prattled, sang, laughed, didn't stay put," Corot replied, "It's just that changeability that I love in her. . . . I am not one of those specialists who makes set pieces. My object is to express life. I need a model who moves around."[44]

The noisy studio described by Corot's friends seems far removed from the mysterious and silent spaces the artist depicted in his versions of *L'Atelier*

40. Vincent van Gogh, letter to Theo van Gogh, ca. April–September 1881, quoted in ibid., p. 237, no. 149 (I).

41. This is confirmed by Claude Bernheim de Villers. Bernheim de Villers 1930a, p. 69.

42. Robaut *document* 2, fol. 17. Information courtesy of David Ogawa.

43. "M. Robaut l'entend un matin répondre à une Italienne qui demande des séances: 'Repassez dans quelque temps, mon enfant; je ne peux pas me donner de vacances en ce moment.'" Moreau-Nélaton in Robaut 1905, vol. 1, p. 300.

44. "babillait, chantait, riait, ne tenait pas en place"; "C'est justement cette mobilité que j'aime en elle. . . . Moi, je ne suis pas de ces spécialistes qui font le morceau. Mon but, c'est d'exprimer la vie. Il me faut un modèle qui remue." Ibid., pp. 244–45.

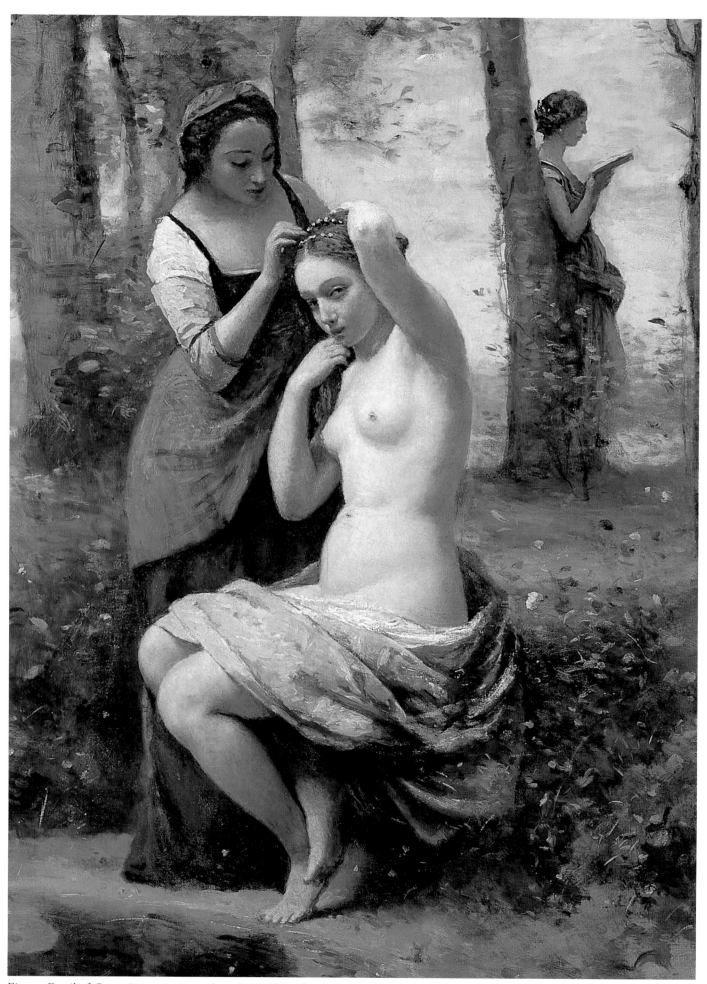

Fig. 114. Detail of Corot, *Paysage avec figures,* also called *La Toilette (Landscape with Figures),* cat. no. 116

(cat. nos. 134–139). Once again these paintings reveal Corot the poet rather than Corot the Realist. The meditative models are, in Pierre Georgel's words, "the image of his dreams in the midst of his memories."[45] Corot painted only two actual self-portraits (fig. 1, cat. no. 51), but the paintings of his studio are projections of how he felt about himself and his art. Unlike the grand drama and public spectacle of Gustave Courbet's personal theater (fig. 137), what Corot created was chamber music for a select group of cognoscenti. With these pictures Corot recalled the intimate genre scenes of Chardin and his predecessors in seventeenth-century Holland, which were very much in vogue in Paris during the Second Empire.

But in his half-length figure paintings, Corot evoked the great masters of the Renaissance, Leonardo and Raphael. Raphael, above all others, was a touchstone in French painting. As Jacques Thuillier put it, "As long as painting searches for the impossible and necessary union of the 'ideas' of the painter and 'natural' forms, as long as it insists on expressing ineffable visions of the inspired mind in a language as close as possible to reality, Raphael will remain the necessary reference, the point of equilibrium that no one can recapture but that represents the essential experience."[46] The poetry and grace of Leonardo were equally important for Corot. Surely it is no coincidence that near the end of Corot's life Robaut once found him asleep over a presentation copy of Arsène Houssaye's book on da Vinci.[47]

The significance of Corot's figure paintings and the role played in them by the Italian masters were obscured by the artist's reluctance to exhibit these works publicly. A rather small number of dealers and collectors were aware of their existence, and only a few of the paintings came to light in the retrospective exhibition held immediately after Corot's death. The writer Gonzague Privat lamented that none of Corot's figures were exhibited in the 1875 Salon. "We still regret that the admirable *Baigneuse* [*Vénus au bain;* R 2179, private collection] acquired by our dear, clever brother Albert Wolf did not take the place of one of the beautiful landscapes shown at the Salon. In this almost divine work, the master shines with the purest brilliance. One must go back to Giorgione and Correggio to pick up again the trace of such ineffable gracefulness, evoked, by the illustrious poet, in an enchanted landscape."[48] Not until the turn of the century did the figure paintings make their full impact, when the *Dame en bleu* (cat. no. 162) owned by Henri Rouart created a sensation at the 1900 Exposition Universelle. It was recognized that in this work and a few others—*Mme Stumpf et sa fille* (R 2125, private collection), *Le Départ pour la promenade* (R 2127, National Gallery of Art, Washington), and *Les Enfants à la montre* (R 2128, location unknown)—Corot came close to what was called the painting of modern life. The publication of Robaut's catalogue in 1905 helped further to redress an unbalanced public perception. The American painter John La Farge observed in 1908, "In the same way that the subtleness and completeness of his landscapes were not understood on account of their very existing, the extraordinary attainment of Corot in the painting of figures is scarcely understood to-day even by many of his admirers and most students. And yet the people he represents, and which he represents with the innocence of a Greek, have a quality which has skipped generations of painters."[49] Finally, in 1909, the exhibition of twenty-four figure paintings at the Salon d'Automne permanently altered the way Corot's achievement

Fig. 115. Corot. *Agostina* (R 1562), 1866. Oil on canvas, 52⅛ × 38⅜ in. (132.4 × 97.6 cm). Chester Dale Collection, National Gallery of Art, Washington, D.C. (1963.10.108)

45. "l'image de ses rêves au milieu de ses souvenirs." Georgel in Dijon 1982–83, p. 185.
46. "Tant que la peinture cherchera l'impossible et nécessaire union des 'idées' du peintre et des formes 'naturelles,' tant qu'elle s'obstinera à traduire l'ineffable de l'inspiration par un langage aussi proche que possible de la réalité, Raphaël restera la référence nécessaire, le point d'équilibre que nul ne peut retrouver, mais qui désigne l'expérience essentielle." Thuillier in Paris 1983–84, pp. 19–20.
47. Robaut 1905, vol. 1, p. 312.
48. "Nous regrettons toutefois que l'admirable *Baigneuse* acquise par notre cher et spirituel frère Albert Wolf n'ait pas remplacé un des beaux paysages exposé au Salon. En cette oeuvre presque divine, le maître brille du plus pur éclat. Il faut remonter à Giorgione et au Corrège pour retrouver la trace de cette grâce ineffable que l'illustre poëte évoque dans sons paysage enchanté." Privat 1875, p. 3.
49. La Farge 1908, p. 162; cited in Clarke 1991a, pp. 142–43.

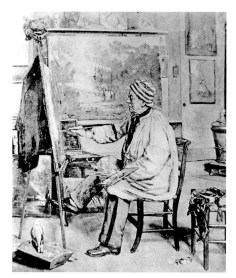

Fig. 116. Charles-Paul Desavary (1837–1885).
Corot dans l'ancien atelier de Dutilleux, à Arras (Corot in Dutilleux's Former Studio at Arras), 1871. Published in Robaut 1905, vol. 1, p. 255

was appreciated. It provoked lengthy articles by Raymond Bouyer and Pierre Goujon and inspired Claude Bernheim de Villers to write a thesis on the subject of Corot's figures.[50] Since then most twentieth-century writers have sided with Degas, who, when asked to agree that Corot knew how to draw a tree, replied, "Yes, indeed . . . and I think he is even finer in his figures."[51]

LE PÈRE COROT

During the last fifteen years of his life Corot surrounded himself with loving admirers. Having lost his parents in the 1850s, he adopted the family of the painter Constant Dutilleux; when his dear Dutilleux died in 1865, he became a surrogate grandfather in the families of Dutilleux's two daughters, the Desavarys and the Robauts. Corot usually spent the winter months in Paris or in neighboring Ville-d'Avray. Then, from May until October, he traveled extensively, staying a week or two at each residence of his extended surrogate family: the Desavarys in Arras, the Robauts in Douai, the Baud-Bovys in Switzerland, the Daubignys in Auvers, and so on. In one of his notebooks he planned an entire year—probably 1857—in one sitting:[52]

Domfront		Ville-d'Avray—juin
St. Lô	} mai	juillet—Genève
Brest		aôut—Auvergne
Mantes		sept.—Dunkerque
		8bre—Ville-d'Avray Fleury Dumas
		9bre—M Degallard

Each visit was preceded by a letter in which Corot promised to throw himself into the arms of his hosts on the day of his arrival. Charles Blanc observed in his biographical note that even as an adult Corot had acted like a little boy in his parents' household: "In their home he retained the timidity and submissiveness of his childhood."[53] Now an old man among friends, he expected to be received like a well-loved child.

In his studio, however, Corot was the lenient conductor of an orchestra of models, students, friends, dealers, and collectors. His policy was laissez-faire. Moreau-Nélaton wrote, "The atelier was no longer Corot's. Henceforth he painted under the eye of a crowd, a heterogeneous and continually changing company. Friends and students, motley schemers, greedy dealers too pressing in their attentions, solicitors either unabashed or covert, were all there in the band that surrounded his easel. The decent man tolerated indulgently the burden of this intrusion, carrying on his work in front of them and stopping only now and then to throw out his own sort of witticism. 'Why is it,' he would say, for example, 'that there are ten of you around me, and not one of you thinks to relight my pipe?'"[54]

But, of course, the atelier did belong to Corot, and it was on account of him that everyone else was there. His situation in the 1860s had already changed greatly from that of 1856, when Corot had written his friend and pupil Édouard Brandon to say that "the collectors are beginning to flock in."[55] Now, not only was he making occasional sales to the state and to provincial museums such as the Musée des Augustins in Toulouse (fig. 118, cat. no. 125) but he had begun

50. Bouyer 1909; Goujon 1909; Bernheim de Villers 1930a.

51. "Certes . . . et même je l'estime encore supérieur dans ses figures." According to Moreau-Nélaton, Degas was asked this by Frémiet, in Gérôme's atelier. Moreau-Nélaton in Robaut 1905, vol. 1, p. 336.

52. *Carnet* 38, fol. 5, R 3075, Cabinet des Dessins, Musée du Louvre, Paris, R.F. 1870-07252.

53. "Il avait conservé chez eux la timidité et la soumission de son enfance." Blanc 1876, p. 366.

54. "Cet atelier, Corot ne s'y appartenait plus. Il peignait dorénavant sous le regard d'une compagnie sans cesse renouvelée et composée de la façon la plus hétéroclite. Amis et élèves, bigarrés d'intrigants, marchands avides, trop pressants dans leurs assiduités, solliciteurs ouverts ou déguisés, il y avait de tout cela dans la bande attachée à son chevalet. L'excellent homme tolérait avec indulgence le fardeau de cette cour importune, poursuivant devant elle son labeur, et ne l'interrompant que pour lancer de temps à autre une boutade à sa façon. 'Comment, faisait-il par exemple, vous voilà dix autour de moi; et pas un ne songerait à rallumer ma pipe?'" Moreau-Nélaton 1913, p. 99.

55. "les amateurs commencent à affluer." Corot, letter to Édouard Brandon, January 10, 1856, quoted in Robaut 1905, vol. 1, p. 165, and vol. 4, p. 336, no. 76.

to sell directly to individuals. The American collector William Walters visited the studio in 1864 and placed an order for a replica of *L'Étoile du berger;* when price was discussed, Corot was quietly firm.[56] In 1867 he wrote to a friend to brag, "I sold my Mariselle to a M. Laurent-Richard, tailor, for 4,000 [francs]. I'm content; if in high places they're willing to pay that much, I'll have the *Toilette* brought down; then we'll see...."[57] (*La Toilette* [fig. 114, cat. no. 116], which Corot greatly esteemed, was the painting he always proposed to a client when he sensed that money was no object.) By January 1873, Corot had almost nothing left in his studio that he was willing to sell or to exhibit. Asked to contribute to an exhibition in Bordeaux, he replied, "I have absolutely nothing available for the exhibition.... All I would have is an old Hagar in the Desert [cat. no. 61]; it's not in fashion now."[58]

From the mid-1860s until the artist's death in 1875, the demand for Corot's work was inexhaustible. Hardly a day passed without a dealer knocking on the door. Robaut, the primary witness to the last decade of the artist's life, recalled their names to Moreau-Nélaton: "Brame, Tedesco, Beugniet, Durand-Ruel, Breysse, Weyl, Audry, not counting Cléophas and his nephew Bardon, Surville, Oscar Simon, Hermann, the dentist Verdier and the doctor Cambay...."[59] Robaut recalled a day at Ville-d'Avray in May 1873 when the dealer Tedesco was visiting. No sooner had Corot sat down to noon dinner than another dealer, Weyl, showed up.[60] They all wanted paintings for a clientele that was not only French but also English, German, and, above all, American, and they had to content themselves with whatever the artist would consent to sell. On at least one occasion, however, Corot made a painting that had been commissioned by Tedesco (cat. no. 163), and of course he occasionally made a replica for a private client.

Corot's "students" were also frequent visitors to his studio. Some, like Georges Rodrigues-Henriquez, Achille Oudinot, or Berthe Morisot, truly sought instruction. Others, like Robaut and Desavary or Jules Badin and Pierre-Georges Dieterle, were sons or sons-in-law of the artist's friends who provided companionship in return for informal advice. Whenever he could, Corot attempted to advance the careers of his younger friends, writing letters to public officials to obtain favors or even signing their works with his own name.[61] As he grew older, Corot's friends tended to be younger. Former associates like François-Louis Français and Antoine Chintreuil were no longer close to the artist at the end of his life.

Corot's relationship with Charles Daubigny was by far his most important friendship with another artist during the 1860s and 1870s. Daubigny was the only painter among his intimates who was his peer. The two were fast friends from their first encounter. Daubigny wrote in 1852, "My traveling companion has just abandoned me. He's a perfect Father Joy, this Father Corot. He is altogether a wonderful man, who mixes jokes in with his very good advice."[62] Because of Corot, Daubigny bought property in Auvers in 1860: "Father Corot finds Auvers very beautiful and has persuaded me to settle there for a part of the year."[63] Corot followed that by decorating the studio and entrance hall of Daubigny's Villa des Vallées with beautiful murals (cat. no. 128, fig. 133) about 1864.

More important, it was largely through Daubigny that Corot assumed a public role as an elder of the community of artists. Financially and morally independent, Corot had never sought affiliation with the academy or the École des Beaux-Arts. But when the operation of the Salon was reorganized after the

56. See the entry for cat. no. 125 for an account of the transaction.

57. "J'ai vendu mon Mariselle à un M. Laurent-Richard, tailleur, 4000. Je suis content; si en haut lieu on est si monté pour eux, je ferai descendre la Toilette; nous verrons bien...." Corot, letter to Jean de la Rochenoire, June 30, 1867, quoted in Robaut 1905, vol. 1, p. 239, and vol. 4, p. 342, no. 168.

58. "Je n'ai absolument rien de disponible pour l'exposition.... Je n'aurais qu'un ancien Agar dans le désert; ce n'est pas le chique [*sic*] d'aujourd'hui." Corot, letter to Auguin, January 15, 1873, quoted in ibid., vol. 4, p. 345, no. 215.

59. "Les Brame, les Tedesco, les Beugniet, les Durand-Ruel, les Breysse, les Weyl, les Audry, sans compter Cléophas et son neveu Bardon, Surville, Oscar Simon, Hermann, le dentiste Verdier et le médecin Cambay...." Moreau-Nélaton in ibid., vol. 1, pp. 281–82.

60. Ibid., pp. 284–85.

61. For example, on June 17, 1865, Corot wrote asking the Administration des Beaux-Arts to commission a work from Victor Teinturier, explaining that Teinturier, injured in an accident, needed a boost in morale: Corot, letter to the marquis of Chennevières, quoted in ibid., vol. 4, p. 341, no. 150. On May 17, 1874, Corot wrote to Busson, an administrator of the Salon, to request that a painting by a friend named Méry, *Les Exploits d'un macaque,* be hung in a better position: quoted in ibid., vol. 4, p. 346, no. 233. For Corot's practice of signing the works of others, see the essay on forgeries in this volume.

62. "Mon compagnon de voyage vient de m'abandonner. C'est un fameux Père la Joie que ce père Corot. C'est, en somme, un très excellent homme, et qui entremêle de très bons conseils ses plaisanteries." Moreau-Nélaton 1925, p. 57.

63. "Le père Corot a trouvé Auvers très beau et m'a bien engagé à m'y fixer une partie de l'année." Ibid., p. 79.

Fig. 117. E. Forest. *Corot at Marcoussis,* 1873. Published in Robaut 1905, vol. 1, p. 290

debacle of the Salon of 1863 (in which public protest led to the creation of the Salon des Refusés), Corot was elected a member of the jury by the constituent artists. He served in 1864, 1865, 1866, and 1870. When the Société Nationale des Artistes was formed in 1874 in connection with yet another reorganization of the Salon, Corot received the greatest number of votes to be a commissioner— 313.[64] Corot always served together with Daubigny, and more often than not he followed Daubigny's lead. When Daubigny, for example, declared that he "preferred paintings full of daring to the nullities welcomed into every Salon" and joined in the fracas between the comte de Nieuwerkerke and Gustave Courbet over the state's purchase of Courbet's *Femme au perroquet* (*Woman with a Parrot*, Metropolitan Museum of Art, New York), insisting, "Speak to me no more of the old masters. Not one of them can stand up to this sturdy fellow," Corot weighed in, quite uncharacteristically, with the prayer, "I thank heaven that I was born in the same century as this remarkable artist."[65] In 1870, when Daubigny took an active role in the attempt to exclude members of the academy from the Salon jury, Corot went along, and after that coup failed, Corot sat with Daubigny on the jury. During a second battle, this time over whether to admit works by Monet and other innovators, Daubigny resigned in protest, and to please his friend so did Corot, even though he was not an admirer of Monet.[66]

Corot's independence from the academy and his apolitical sensibility probably contributed to the state's lamentable failure to recognize his talent. While fellow artists voted him first among equals, while the market showed a huge demand for his work, on the part of the state there was hardly any response. Although it is true that the emperor bought the *Souvenir de Mortefontaine* in 1864 and *La Solitude* (fig. 109) in 1866, Corot's promotion to the rank of officer in the Legion of Honor came embarrassingly late, in 1867. He had previously been refused the gold medal at the Salon of 1865 and had been insulted with a second-class medal at the 1867 Exposition Universelle (where the *grands prix* of the Exposition Universelle were given to Cabanel, Gérôme, Meissonier, and Rousseau, and the first-class medals to Bida, Breton, Daubigny, Français, Fromentin, Millet, Pils, and Robert-Fleury).[67] In 1874, many of Corot's friends felt certain that the Salon's medal of honor would be his,[68] but it went instead to Jean-Louis Gérôme, a political insider whose skill at intrigue matched that of the famous figure in the court of Louis XIV whose portrait won Gérôme the prize (*Éminence grise*; Museum of Fine Arts, Boston). Corot's friends thought that the medal had eluded him because he refused to exhibit any of his figure paintings, and they were probably right: Charles Blanc, then the superintendent of the Administration of Beaux-Arts, was committed to reviving history painting at the expense of landscape. Although, as Blanc observed, Corot found himself newly in fashion, he could not transcend his own self-definition. The "patriarch of *paysagistes*" would not allow himself to be known as a painter of figures.

True to character, Corot took no notice of these developments. He prided himself on his modesty and found contentment in humility. Not for nothing did he reread the devotional book *The Imitation of Christ* every night before retiring. "It is this book that has helped me lead my life with such serenity and has always left me with a contented heart. It has taught me that men should not puff themselves up with pride, whether they are emperors adding this or that province to their empires or painters who gain a reputation. . . ."[69] Corot lived

64. Moreau-Nélaton in Robaut 1905, vol. 1, pp. 302–4.
65. "préférait les tableaux chargés de hardiesse aux nullités accueilles à chaque Salon"; "qu'on ne me parle plus des anciens. Il n'y en a pas un pour résister à coté de ce gaillard-là"; "Je remercie le ciel de m'avoir fait naître dans le même siècle que cet admirable artiste." These remarks are quoted and translated in part in Fidell-Beaufort and Bailly-Herzberg 1975, pp. 57–58. Corot assumed a submissive role in dealing with Courbet, as he had also done with Delacroix, of whom he said, "C'est un aigle et je ne suis qu'une alouette." ("He is an eagle, I am only a lark.") Bazin 1936, p. 53.
66. Moreau-Nélaton 1925, pp. 99–100.
67. Moreau-Nélaton in Robaut 1905, vol. 1, p. 240.
68. Ibid., p. 304. See also the entry for cat. no. 161.

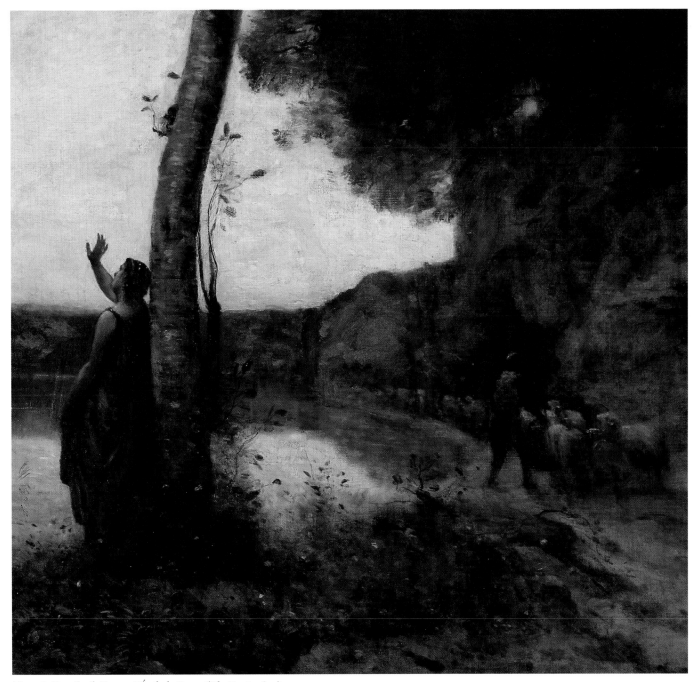

Fig. 118. Detail of Corot, *L'Étoile du Berger* (*The Evening Star*), cat. no. 125

his last days as if he were preparing for beatification. After the close of the 1874 Salon, for which he had received excellent reviews, he traveled extensively through northern France, visiting family and friends. Although weakened by the digestive disorder that would soon kill him, he attended his sister Annette-Octavie Sennegon in her final days in October 1874. Her death depressed him profoundly, but he continued to paint. Unable to disappoint his friends, he attended a grand fête in his honor on December 29, 1874, and there was presented with a gold medal struck by his admirers as a substitute for the Salon prize that he had never received. Despite his own infirmities, Corot did not forget his old companions. Too weak to walk, he accompanied the remains of his old friend Aligny to their final resting place. Near death himself, he sent a check for ten thousand francs to the widow of Jean-François Millet soon after his passing. "Le père Corot" lived like a saint; he died like one on February 22, 1875.

69. "C'est ce livre qui m'a aidé à passer la vie avec autant de calme et qui m'a toujours laissé avec le coeur content. Il m'a appris que les hommes ne doivent pas s'enorgueillir, qu'ils soient empereurs et qu'ils ajoutent à leur empire telle ou telle province, ou qu'ils soient peintres et qu'ils acquièrent un nom. . . ." Corot's words recorded by Mme Aviat and quoted in Corot 1946, vol. 1, pp. 137–38.

Dante et Virgile
(Dante and Virgil)

1859
Oil on canvas
102½ × 67⅛ in. (260.5 × 170.5 cm)
Signed lower right: C. COROT.
Museum of Fine Arts, Boston
Gift of Quincy Adams Shaw 75.2

R 1099

"It's superb; I just cannot believe that *I* made it!"[1] So exceptional is this work in Corot's oeuvre that when he found the vast and dusty canvas in his studio some fourteen years after its exhibition in the 1859 Salon, he barely recognized it. Inspired by Dante's *Divine Comedy,* the painting is one of only three works that take their themes from post-classical literary sources, the other two being Shakespearean: *Macbeth* (fig. 110), which also was shown in the Salon of 1859, and *Hamlet et le fossoyeur* (cat. no. 158), which was painted in the last years of the artist's life.[2] To reach for the sublime through *terribilità* was an unusual operation for Corot, and it appears that he expressly sought to widen his known repertoire by sending this work and *Macbeth* to the same Salon. For many critics, the gambit worked: Paul Mantz wrote, "In this ominous landscape there is nothing but gloom and terror. The figures are strikingly expressive, and the animals, by their lifelike movement and their powerful contours, recall those of Barye, which I think is no small accomplishment."[3]

Corot chose his scene from canto 1 of the *Inferno,* in which Dante, lost in a dark and dense forest, encounters three frightening beasts at dawn: a leopard, a lion, and a wolf.

> And almost where the hillside starts to rise—
> look there!—a leopard, very quick and lithe,
> a leopard covered with a spotted hide.
> …
> but hope was hardly able to prevent
> the fear I felt when I beheld a lion.
> His head held high and ravenous with hunger—
> …
> And then a she-wolf showed herself; she seemed
> to carry every craving in her leanness;
> she had already brought despair to many.[4]

Just then Dante encounters Virgil, who offers to serve as his guide through Hell and Purgatory.

Unfortunately, Virgil's tour did not include an explanation of the specific symbolism of the animals. There is a great deal of disagreement on this subject. Although the lion is almost universally recognized as pride, the leopard (painted by Corot with the stripes of a tiger) has been variously understood to represent fraud, lust, or ambition, while the wolf has been interpreted both as cupidity and as luxury.

Corot worked on this enormous canvas throughout 1858. In a letter to Constant Dutilleux of January 4, 1858, he described and sketched the composition.[5] Sometime during the year he went to the Jardin des Plantes and made drawings of a large cat in his notebook.[6] He laid out the composition on a page of another notebook (fig. 119).[7] He was still at work on the picture on November 27, 1858, when he wrote Édouard Brandon to say that in his studio he had "first of all, the Dante and Virgil, at the beginning of the *Inferno,*" which he did not then expect to have completed in time for the 1859 Salon.[8] There are several studies for the figures of Dante and Virgil at the Louvre[9] and a *cliché-verre* of the entire composition. According to Robaut's unpublished notes, its landscape was based on a study painted in 1854 in Tréport.[10] After the painting was completed, Corot made a charcoal sketch of it for Dutilleux at Arras on April 5, 1859.[11] Moreau-Nélaton later recounted

Fig. 119. Corot. Study for *Dante et Virgile.*
Graphite on paper, 5½ × 3¾ in. (14 × 9.4 cm).
Notebook, ca. 1855–60, fol. 11r. Private
collection

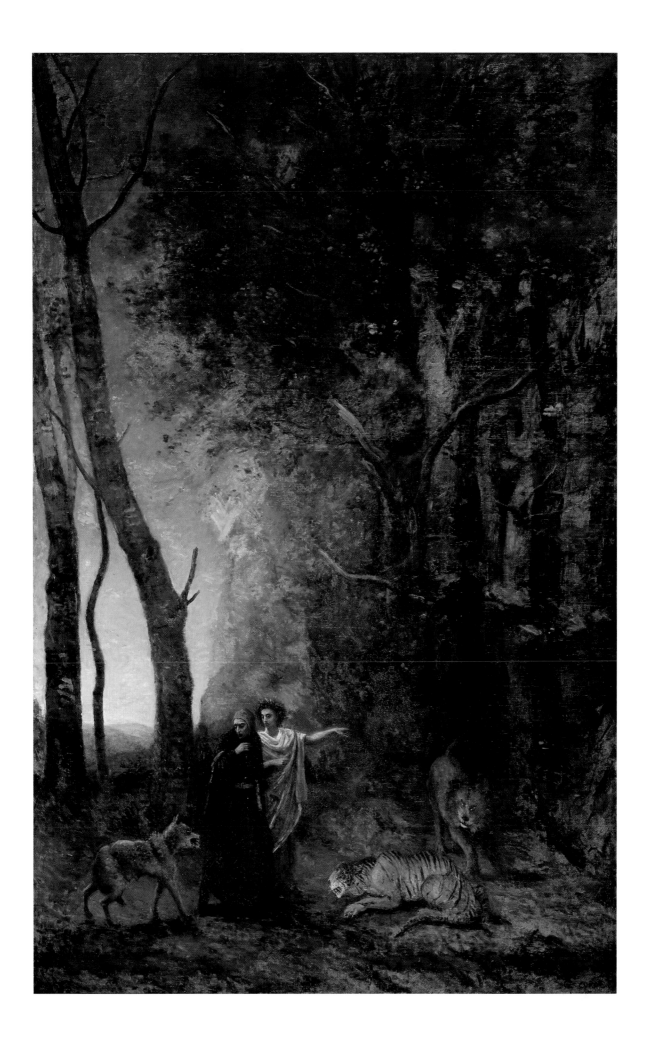

that Corot asked his friend Antoine-Louis Barye to paint the wild beasts and he complied, but that Corot then found Barye's *anatomie impeccable* incompatible with his fantastic vision and repainted the animals completely.[12] Moreau-Nélaton offers no documentation for this assertion, and since the episode is not mentioned at all by Corot's contemporaries, it is almost certainly apocryphal.[13] The animal drawings in Corot's sketchbooks seem proof enough of the authenticity of the entire work, which in style is consistently powerful and evocative.

The critical reaction to *Dante et Virgile* was predictable: critics were unanimous in praising the artist's poetic gifts while criticizing the drawing, the color, or the composition. Nevertheless, almost everyone admired *Dante et Virgile* and the capacity of the painting to arouse emotion. Jules Castagnary alone objected that "Dante's expression and posture express puerile fear, not the mystical and intellectual horror that ought to seize him."[14] Théophile Gautier, however, called it "one of the greatest and most original of the artist's conceptions. . . . Never was Dante better understood than by the good and simple Corot."[15] Zacharie Astruc was bowled over: "Nothing can compare to the effect of powerful simplicity."[16] Baudelaire did not specifically address this painting.

Bertall published a caricature (fig. 120) with this caption: "The two poets, disguised as umbrellas—to maintain strict incognito—visit a landscape by Corot, populated by felt animals and painted with a combination of licorice and soot. They have been told that the landscape represents Hell; they avow that it's not good enough for the devil!"[17]

Corot made a smaller version of the painting for his student Georges Rodrigues-Henriquez in 1873. Moreau-Nélaton recorded in 1905 that Corot allowed his student to sketch in the composition before completing the canvas himself. However, when the copy was sold at Parke-Bernet in New York on May 23, 1913, it was accompanied by a letter from Moreau-Nélaton stating that he had erred and that the entire copy was autograph. Moreau-Nélaton nevertheless repeated his earlier account in his 1924 monograph. Corot's student Achille Oudinot also made a copy of the huge work.[18]

In a letter dated February 15, 1874, Corot offered *Dante et Virgile* and *Saint Sébastien* (cat. no. 104) to the Administration des Beaux-Arts for 15,000 francs each. The offer was declined. The great American collector Quincy Adams Shaw acquired this painting immediately after the posthumous sale of Corot's works and presented it to the Museum of Fine Arts, Boston, in 1876.

1. "Mais, c'est superbe; je ne puis me figurer que c'est moi qui ai fait cela!" Corot to Georges Rodrigues-Henriquez, March 25, 1873, recorded in Moreau-Nélaton 1924, vol. 2, p. 65.
2. Two other works with comparable themes do not properly belong in this context: *Don Quichotte et Sancho*, R 1645 (Cincinnati Art Museum), in which the figures are small and completely incidental to the landscape (see fig. 133); and *Marguerite passant devant Faust et Méphisto*, R 1588, which according to Robaut was a only a fleshing out by Corot in June 1871 of a doodle made by the daughter of the artist Charles Desavary.
3. "Tout est deuil, tout est terreur dans ce lugubre paysage. Quant aux figures, elles sont d'une expression saisissante, et les animaux, par la justesse

Le Dante et Virgile, par COROT

Les deux poètes, déguisés en parapluies — pour conserver un sévère incognito, — visitent un paysage de Corot, peuplé d'animaux en feutre, et peint avec du jus de réglisse et de la suie combinés. On leur avait dit que ce paysage représentait l'enfer; ils assurent que cela ne vaut pas le diable.

Fig. 120. Bertall (Charles-Albert d'Arnoux, 1820–1882). *Le Dante et Virgile, par Corot*, 1859. Bertall 1859

de leur mouvement et leur robuste silhouette, font penser à ceux de Barye, ce qui n'est pas, j'imagine, un médiocre résultat." Mantz 1861, p. 428.
4. Dante 1980, lines 31–51.
5. Moreau-Nélaton 1924, vol. 1, p. 115 and fig. 157.
6. Ibid., p. 121 and fig. 160, and R 3065, *carnet* 28; see also R 356. In addition, there is a compositional sketch in *carnet* 34, fol. 5 ter, R 3071, Musée Carnavalet, Paris, D 03593.
7. I thank Ay-Whang Hsia for bringing this drawing to my attention.
8. "D'abord le Dante et Virgile, tout le commencement de l'Enfer." Moreau-Nélaton 1924, vol. 1, p. 121.
9. R 2845–49, Cabinet des Dessins, Musée du Louvre, Paris, R.F. 8803-6.
10. Robaut *carton* 18, fol. 520.
11. R 2844, Cabinet des Dessins, Musée du Louvre, Paris, R.F. 3394.
12. Moreau-Nélaton 1924, vol. 1, p. 121.
13. See Alixe Murphy's note of January 22, 1982, in the files of the Museum of Fine Arts, Boston, where she suggests that it was Paul Mantz's mention of Barye in his review that provoked the confusion.
14. "La physionomie et l'attitude de Dante expriment une peur puérile et non la mystique et toute intellectuelle horreur qui dut le prendre." "Salon de 1859," in Castagnary 1892, vol. 1, p. 89.
15. ". . . une des plus hautes et des plus originales conceptions de l'artiste. . . . Jamais Dante n'a été mieux compris que par ce bon et simple Corot." Gautier 1992, pp. 185–86.
16. "Rien de comparable à cet effet d'une simplicité puissante." Astruc 1859, p. 178.
17. "Les deux poètes, déguisés en parapluies—pour conserver un sévère incognito—visitent un paysage de Corot, peuplé d'animaux en feutre, et peint avec du jus de réglisse et de la suie combinés. On leur avait dit que ce paysage représentait l'enfer; ils assurent que cela ne vaut pas le diable." Bertall 1859, quoted in Paris 1968–69, p. 106.
18. Robaut wrote the following in his unpublished notes: "On a reduced-size copy prepared by M. Rodrigues, an amateur painter on the rue de Londres, Corot himself did some work several times, with the picture, which he had brought there for the purpose, in front of him. This painting decorates a panel of the mantelpiece (in the dining room, I believe). There are no changes from the large picture. Do not confuse this copy, considerably retouched by Corot (and, naturally, showing some small

changes) with the copy without the master's retouching done by Oudinot, about [18]65–70, which is larger than the original and was sold for 9,500 francs by the D.R. [Durand-Ruel] in America. Well played." ("Sur une réduction préparé par M. Rodrigues peintre amateur rue de Londres, Corot alla lui-même y travailler plusiers fois, devant le tableau qu'il y avait fait porter à cet effet. Cette peinture orne un panneau de cheminée [salle à manger, je crois]. Il n'y a pas de changements avec le grand tableau. Ne pas confondre cette copie sensiblement retouchée par Corot [et tout naturellement, présentant quelques petits changements], avec la copie, sans retouches du maître, de la main d'Oudinot, vers 65–70, laquelle copie passe en dimensions mêmes et finit par être vendu 9500 fr par la D.R. en Amérique. Bien joué.") Robaut *carton* 18, fol. 520.

PROVENANCE: The artist; his posthumous sale, Hôtel Drouot, Paris, pt. 1, May 26–28, 1875, no. 149; purchased at that sale by Paul Détrimont for 15,000 francs;* sold to Quincy Adams Shaw (1825–1908), Boston, for 35,000 francs;** presented by him to the Museum of Fine Arts, Boston, 1876

EXHIBITIONS: Paris (Salon) 1859, no. 688, as *Dante et Virgile; paysage*; Paris 1968–69, no. 472; Paris, New York 1994–95, no. 36A

REFERENCES: Anon. 1859, pp. 209–10, ill.; Astruc 1859, pp. 175–80, 184; Aubert 1859, p. 26; Bertall 1859, ill.; Cadoudal 1859, p. 307; Cantrel 1859, p. 70; Chalons d'Argé 1859, p. 51; Chesneau 1859, p. 164; Dollfus 1859, p. 249; Du Camp 1859, p. 151; Dumesnil 1859, pp. 16–17; Du Pays 1859, p. 339; Duplessis 1859, p. 177; Guyot de Fère 1859, p. 358; Habeneck 1859, p. 222; Lépinois 1859, p. 195; Leroy 1859; Mantz 1859, p. 295; Renault 1859; Rousseau 1859a; Saint-Victor 1859; Thierray 1859, p. 261; Mantz 1861, p. 428; Claretie, "L'Art français en 1872: Revue du Salon," in Claretie 1873, p. 3, n. 1; Dumesnil 1875, pp. 63–65, 127; Paris 1875a, p. 23; Claretie 1876, p. 393; Rousseau 1884, pp. 20, 26–28; Roger-Milès 1891, pp. 52, 83; Castagnary, "Salon de 1859," in Castagnary 1892, vol. 1, p. 89; Larthe-Ménager 1894, p. 14; Thomson 1902, p. 41, ill. p. 42; Geffroy 1903, p. cxxii; Hamel 1905, p. 28, pl. 24; Michel 1905, p. 30; Robaut *carton* 18, fol. 520; Robaut 1905, vol. 1, pp. 178, 189–91, 331, vol. 2, pp. 346–47, no. 1099, ill., vol. 4, pp. 169, 208, no. 149, 337–38, 367–68, 380; Meynell 1908, pp. 211–12; Cornu 1911, pp. 14, 90, 114, 128, 176, 179; Meier-Graefe 1913, p. 56; Moreau-Nélaton 1924, vol. 1, pp. 115, 120, and vol. 2, p. 89; Bernheim de Villers 1930a, p. 33, no. 174, ill.; Meier-Graefe 1930, p. 80; Bazin 1936, pp. 55, 61; Jamot 1936, p. 40; New York 1942, p. 28; Sloane 1951, p. 126, fig. 47; Baud-Bovy 1957, pp. 235–37, 280, nn. 131, 133; Fosca 1958, p. 34; Coquis 1959, pp. 83–84, 86–87; Whitehill 1970, vol. 1, p. 22; Hours 1972, p. 34, fig. 29; Bazin 1973, pp. 19, 47, 102, 269; Leymarie 1979, p. 108, ill. p. 107; Boston 1985, p. 19; Selz 1988, p. 209; Wissman 1989, pp. 84, 160, 163–69, 171, 173, fig. 97; Clarke 1991a, pp. 78, 134, fig. 124; Manchester, New York, Dallas, Atlanta 1991–92, p. 71, fig. 6; Gautier 1992, pp. 185–86, fig. 154; Leymarie 1992, p. 124, ill.; Gale 1994, pp. 31, 102, 116

* Robaut 1905, vol. 4, p. 208. Détrimont purchased 19 works from Corot's posthumous sale.
** Robaut *carton* 18, fol. 520.

116

Paysage avec figures, also called *La Toilette* (*Landscape with Figures*)

1859
Oil on canvas
59 × 35¼ in. (150 × 89.5 cm)
Signed lower right: COROT
Private collection, Paris
New York and Paris only

R 1108

This magnificent canvas is clearly one of Corot's masterpieces, and its creation was not an easy effort. Placing a large nude in a landscape was an ambitious proposition for Corot; it required finding a technique suitable for rendering both the specificity of figure painting and the approximation of landscape painting. The artist recalled the struggle for his biographer Alfred Robaut.

> You can see the pains I take to hide the attachment [of the muscles] at the clavicles and sternum, to soften the modeling of the ribs where it seems that the breasts just begin to swell; I try to go about it entirely differently from the usual way, which is above all to show what one knows. As this is not an anatomy lesson, I must bind together as seen in nature everything covering the armatures that make up and support the body, in order to put down only what I experience faced with these tissues of flesh that let one sense the blood beneath while they reflect the light of the sky. In a word, I must bring to the painting of that breast the same artlessness I would employ in painting a bottle of milk.[1]

It appears that the naïveté Corot sought was not appreciated at the 1859 Salon, where the painting was exhibited with the lugubrious *Dante et Virgile* (cat. no. 115). While an enthusiastic Zacharie Astruc concluded that Corot was "one of the most robust, virile, individual, poetic, charming, and true talents of our time,"[2] Paul Mantz was typical of the critics when he called the painting "middlingly antique,"[3] and Étienne Moreau-Nélaton, looking back at the Salon of 1859 over the distance of a half century, remarked, "Corot was considered to be a poet who could not spell, inextricably entangled in syntax and grammar. . . . The mysterious charm in which he wrapped his skill provided ammunition against him."[4]

Fig. 121. Corot. Study for *Paysage avec figures.* Graphite on paper, 5½ × 3¾ in. (14 × 9.4 cm). Notebook, ca. 1855–60, fol. 17 r. Private collection

Fig. 122. Corot. *Jeune Fille à la toilette* (R 2841). Graphite on gray paper, 11¼ × 5⅞ in. (28.6 × 14.9 cm). Collection Rothschild, Département des Arts Graphiques, Musée du Louvre, Paris (R.F. 3408)

Corot obviously prized this work and reexhibited it at the Exposition Universelle of 1867. The painting was widely discussed then, and a comparison of the critics' remarks with those of 1859 reveals how far the gap had widened between Corot and the general direction of contemporary art. More than anything else he was criticized for the absence of realism. Théodore Duret, the champion of Manet, wrote, "It is only in ceasing to be entirely true that the artist will cease rendering the precise effect that has struck him, and this is what happens to Corot all those times when, too eager to idealize, he gets lost in forms and colors that have no equivalent in nature."[5] Théophile Thoré, the champion of Courbet, castigated Corot for incomplete execution and for the veil of fog he drew over his pictures. He also observed, however, that "the remarkable thing is that this misty painter sometimes succeeds very well with rather large figures in his almost immaterial landscapes and . . . *La Toilette* . . . evokes I don't know what poetic world."[6] The jury, headed by Théodore Rousseau, awarded Corot only a second-class medal, while the imperial household, perhaps in compensation, offered him a promotion to officer in the Legion of Honor.[7] Nevertheless, Corot remained lighthearted. Viewing *La Toilette* at the exhibition with Théophile Silvestre, he remarked, "Look a bit at how they are enjoying the country, these poor children!"[8] And he continued to esteem the canvas. When he exhibited it in Marseilles in the autumn of 1859 he placed the enormous price of 6,000 francs on the work and rejected an offer of 2,500 to 3,000 francs.[9] He asked a more reasonable but still very high price, 4,000 francs, when he exhibited the painting in Limoges in 1862.[10] When in 1867 an agent for Queen Victoria

Fig. 123. Jean-Antoine Watteau (1684–1721). *A Lady at Her Toilet (La Toilette).* Oil on canvas, 17¾ × 14⅞ in. (45.2 × 37.8 cm). Wallace Collection, London (P 439)

failed to secure another painting by Corot, the artist considered offering this work.[11] He finally sold it for 10,000 francs sometime after 1867.

Corot seems to have created the painting expressly for the 1859 Salon. He included it in a list of works he sent to his friend Édouard Brandon in a letter of November 27, 1858, and drew it adjacent to a sketch of *Dante et Virgile.*[12] He sketched the

two principal figures in his notebook (fig. 121).[13] A drawing now at the Musée Grobet-Labadié, Marseilles, has been called a preparatory sketch for the canvas, but it shows the composition precisely as it is today and thus probably records the work under way.[14] A charcoal drawing, now at the Louvre (R.F. 8817), is known to have been made by Corot after the completed canvas for his student Constant Dutilleux.[15] With a dramatic chiaroscuro Corot emphasized in this drawing the exquisite rhythms he had established between the graceful tree trunks and the carefully posed figures. There are related studies in Corot's notebooks[16] and an important sheet in the Rothschild Collection at the Louvre (fig. 122). It shows a barely pubescent girl seated, her legs slightly akimbo and her arms raised to the back of her head. But the figure that appears in the painting is more sophisticated and mature. The pose has assumed a complicated contraposto closely related to that of the woman in Watteau's *La Toilette* (fig. 123), and, like Watteau's model, Corot's now has womanly hips and breasts. According to Victor Desfossés, Mme Hector Malot posed for the head of the nude figure.[17]

Corot initially exhibited the work as *Paysage avec figures*, but this modest title seems to have annoyed some critics. Émile Cantrel, for example, took exception, explaining that the painting actually depicted "the toilet of some Virgilian nymph, close up."[18] Corot responded by calling the work *La Toilette; paysage avec figures* when he reexhibited it in 1867. By refusing to locate his bather in antiquity, as Cantrel wanted, Corot allows a contemporary reading of the scene. And the emphasis on the duality of the picture—on its being a landscape with figures and not just a figure painting—connects it to an important development in contemporary French painting. Like Manet's 1863 *Déjeuner sur l'herbe*, initially exhibited under the title *Le Bain*, or, more aptly, like Courbet's *Baigneuses*,[19] which provoked scandal at the 1853 Salon, Corot's picture insists on being understood as a landscape with figures, the genre that in the 1860s was the rallying point for the New Painters, who included Manet, Monet, Bazille, and Renoir. Although Corot stood at the opposite extreme from the avant-garde, like them he rooted his contemporary art in the work of past masters, such as Boucher, Watteau, and Giorgione.

1. "Vous voyez quel mal je me donne pour dissimuler ces attaches des clavicules et du sternum, pour fondre le modelé des côtes que l'on soupçonne à la naissance des seins; je cherche à procéder tout autrement qu'il est d'usage de faire, c'est-à-dire en prouvant avant tout que l'on sait. Puisqu'il ne s'agit pas ici d'une leçon d'anatomie, je dois lier comme le montre la nature toutes les enveloppes des armatures qui construisent et soutiennent le corps, afin de ne rendre que ce que j'éprouve devant ces tissus de chair qui laissent deviner le sang par-dessous, tandis qu'ils renvoient la lumière du ciel. En un mot, je dois apporter en peignant cette poitrine la naïveté que je mettrais à peindre une boîte au lait." Quoted in Paris 1975, no. 103.
2. "un des talents les plus robustes, les plus virils et individuels, les plus poétiques, les plus charmants et les plus vrais de notre époque." Astruc 1859, p. 184.
3. "médiocrement antique." Mantz 1859, p. 295.
4. "Corot passait pour un poète sans orthographe, irrémédiablement

brouillé avec la syntaxe et la grammaire. . . . Le charme mystérieux dont il enveloppait sa science prêtait des armes contre elle." Moreau-Nélaton in Robaut 1905, vol. 1, p. 193. See the fuller quotation above in "*Le Père Corot*: The Very Poet of Landscape," n. 11.
5. "C'est donc seulement en cessant d'être vrai au fond que l'artiste cessera de rendre l'effet exact qui l'a frappé et c'est ce qui arrive à Corot toutes les fois que, voulant trop idéaliser, il se perd dans des formes et dans un coloris qui n'ont nulle part d'équivalent dans la nature." Duret 1867, p. 30, reprinted in Miquel 1975, vol. 2, p. 49.
6. "chose singulière, ce peintre vaporeux réussit parfois très-bien les figures assez grandes dans ses paysages presque immatériels, et . . . la *Toilette . . .* évoque je ne sais quel monde poétique." "Exposition Universelle de 1867," in Thoré 1870, vol. 2, p. 358.
7. Miquel 1975, vol. 2, p. 49.
8. "Voyez un peu comme ils s'en donnent, de la campagne, ces pauvres enfants!" Silvestre, "Salon de 1873," quoted in Corot 1946, vol. 1, p. 115; see also Moreau-Nélaton in Robaut 1905, vol. 1, p. 239.
9. Robaut 1905, vol. 4, p. 175.
10. Moreau-Nélaton, ibid., vol. 1, p. 203, and vol. 4, p. 176.
11. Ibid., vol. 1, p. 235.
12. Reproduced in ibid., p. 192.
13. Robaut *carnet* fol. 17 recto; private collection. I thank Ay-Whang Hsia for bringing this drawing to my attention.
14. See Paris 1962, no. 51.
15. See Paris 1975, no. 162.
16. R 3107, *carnet* 70, fols. 21v and 22r (Cabinet des Dessins, Musée du Louvre, Paris, R.F. 1870/08728); R 3071, *carnet* 34, fol. 43r (Musée Carnavalet, Paris, DO 3593).
17. Robaut recorded in his unpublished notes: "Mme H[ect]or Malot (au dire de M V[ict]or Desfossés—31 mai 96)—aurait posé pour la tête seulement de la figure principal—celle assise—?" Robaut *carton* 18, fol. 522. See also Paris 1975, no. 103, and Selz 1988, p. 192.
18. "la toilette de quelque virgilienne nymphe de près." Cantrel 1859, p. 70.
19. Musée Fabre, Montepellier. I thank Andrew Shelton for proposing this comparison to me. Fronia Wissman's comparison of Corot's *La Toilette* with Manet's *Olympia*—despite the obvious mistress/servant commonality—appears to me less pertinent. See Wissman 1989, pp. 179–82, where she notes that in 1859 Cantrel compared Corot's painting to Courbet's *Demoiselles au bord de la Seine*.

PROVENANCE: Purchased from the artist by Durand-Ruel & Cie., Paris, for 10,000 francs, after 1867; sold to James Duncan, Benmore, Scotland, before 1872; Victor Desfossés, Paris, by 1889; his posthumous sale, Hôtel Enjon, Paris, April 26, 1899, no. 11, bought in by Mme Desfossés for 175,000 francs;* Wildenstein, Paris, by 1932; sold to present owner ca. 1936–40

EXHIBITIONS: Marseilles 1859, no. 114, as *Paysage avec figures*; Paris (Salon) 1859, no. 691, as *Paysage avec figures*; Limoges 1862, as *La Toilette*;** Paris 1867, no. 162, as *La Toilette; paysage avec figures*, lent by the artist; Glasgow 1872, lent by James Duncan;† Vienna 1873, no. 159; Paris 1889, no. 178, lent by V. Desfossés; Paris 1895, no. 61, erroneously dated 1864; Paris 1910b, no. 1; London 1932, no. 304, lent by Wildenstein; Paris 1936, no. 70; Lyons 1936, no. 66; Paris 1975, no. 103; Rome 1975–76, no. 56

REFERENCES: Astruc 1859, pp. 182–84; Aubert 1859, p. 27; Cantrel 1859, p. 70; Chesneau 1859, pp. 78–79, 164; Delécluze 1859; Dollfus 1859, pp. 249–50; Dumas 1859, p. 143; Dumesnil 1859, pp. 18–19; Du Pays 1859, p. 339, ill. p. 341; Duplessis 1859, p. 177; Guyot de Fère 1859, p. 358; Habeneck 1859, p. 222; Jourdan 1859, pp. 20–21; Lagrange 1859, p. 185; Mantz 1859, p. 295, ill. (erroneously titled *Idylle*) p. 297; Nettement 1859, p. 537; Renault 1859; Rousseau 1859b; Saint-Victor 1859; Mantz 1861, p. 430; Clément 1867; Mantz 1867, p. 336; Thoré, "Exposition Universelle de 1867," in Thoré 1870, vol. 2, p. 358; Buisson 1875, p. 334; Dumesnil 1875, pp. 66, 78, 101; Paris 1875a, p. 23; Blanc 1876, ill. p. 369; Robaut 1881, n.p.; Roger-Milès 1891, p. 84; Castagnary, "Salon de 1859," in Castagnary 1892, vol. 1, p. 89; Thomson 1902, pp. 45–56, ill. p. 43; Geffroy 1903, pp. cxxii–cxxiii, cxxviii; Hamel 1905, p. 27, pl. 25; Robaut *carton* 18, fols. 521–23; Robaut 1905, vol. 1, pp. 190–92, 203, 235, 238–39, 338, vol. 2, pp. 354–55, no. 1108, ill., vol. 4, pp. 169, 175–76, 287, 291, 338, 367; Gensel 1906, p. 46, fig. 39; Meynell 1908, p. 256; Bouyer 1909, pp. 301–2, ill. p. 300;

Cornu 1911, pp. 71, 176, 179, 183; Meier-Graefe 1913, pp. 42–45, ill. p. 43; Moreau-Nélaton 1924, vol. 1, pp. 121, 129, fig. 162, and vol. 2, pp. 28, 30–31, 111; Lafargue 1926, p. 49; Michel 1928, p. 137; Meier-Graefe 1930, pp. 80–82, fig. LXXXII; Bazin 1932, p. 29, fig. 83; Bazin 1936, p. 61, fig. 59; Jamot 1936, pp. 26, 52, ill. p. 27; Venturi 1939, vol. 1, p. 19, and vol. 2, p. 185; New York 1942, pp. 28, 32; Corot 1946, vol. 1, pp. 114–15; Baud-Bovy 1957, pp. 173, 235–37, 244, 280 n. 131, pl. XLV; Fosca 1958, p. 34; Coquis 1959, pp. 83, 85; Edinburgh, London 1965, n.p.; Bazin 1973, pp. 65, 269, 271, 288, ill. p. 215; Miquel 1975, vol. 2, p. 49; Leymarie 1979, p. 108, ill. pp. 109, 111 (detail); Van Liere 1980, pp. 106–7, fig. 6; Selz 1988, pp. 188–92, ill. p. 193; Tokyo, Osaka, Yokohama 1989–90, p. 31; Wissman 1989, pp. 179–84, fig. 107; Gautier 1992, pp. 187–88, fig. 157; Leymarie 1992, p. 124, ill. pp. 127 (detail), 128

* For the early history of this work, see the memoirs of Paul Durand-Ruel (in Venturi 1939, vol. 2, p. 185).
** On the early provincial exhibitions, see Robaut 1905, vol. 4, pp. 175–76.
† Thomson 1902, p. 45.

117

Le Repos
(Repose)

1860, reworked ca. 1865–70
Oil on canvas
23⅛ × 40⅛ in. (58.6 × 101.9 cm)
Signed and dated lower left: COROT 1860.
In the Collection of The Corcoran Gallery of Art, Washington, D.C.
William A. Clark Collection 26.41

R 1277

Despite the mixed reviews his work had garnered at the previous Salon, Corot sent six new paintings to the Salon of 1861, three pure landscapes and three landscapes with figures: *Danse des nymphes* (R 1619), *Orphée* (cat. no. 120), and *Le Repos.* Undoubtedly Corot meant *Le Repos* to follow the great nude he had exhibited in 1859, *La Toilette,* to refute critics like Hector de Callias—who, himself adopting the motif of Orpheus, had written of the artist that "his lyre has only one string, or, rather, he wishes to pluck only one string of his lyre." The clever Callias understood Corot's position perfectly: "Since he has been reproached for painting the figure as a landscape painter, Corot made a study of a woman in *Le Repos.* We would rather see him paint the figure as a landscape painter than the landscape as a painter of figures."[1]

Inexplicably, the present painting has not been associated with the work exhibited in 1861, even though the critics described it in great detail.[2] Jean Rousseau wrote, "In the foreground of the landscape *Le Repos* is a large nude female, lying on a panther skin. . . . The heavy, clear tones of the whites render perfectly the look of open air; the unbelievably solid painting effectively transmits the thickness of flesh. How far we are from the glassy, artificial brilliance of so many so-called colorists! Certainly, the drawing does not reproduce every detail meticulously, but how deeply felt and exact it is in its overall structure! The basic tonality could not be firmer, nor the form more accurate in its masses."[3] Jules Thierray paid a grudging compliment: "The bacchante lying in the foreground of the *Repos* is, uncharacteristically for the painter, rather well drawn and modeled; but the badly drawn figures

in the background are impossible."[4] Alfred Delvau, in remarks typical of the disparaging critics, complained quite implausibly that Corot's model was dirty. "*Le Repos* is M. Corot's response to a few scribblers who accused him of painting nothing but trees because he did not know how to paint people: it's a nude done from the model, a woman on a leopard skin. As a study of a nude, it seems beyond reproach to me; as a woman, it leaves something to be desired—with regard to cleanliness: in the brown hues of certain parts of this lovely body, one detects a scaly skin that could not but be highly unpleasant to the eye. I find this astonishing, for M. Corot's landscapes have quite enough water in them to provide an opportunity for bathing."[5] The same curious reproach about an unwashed model would soon be hurled at Manet's *Olympia* in 1865 and at Courbet's *Femme au perroquet* in 1866.[6]

The name of Corot's model is not known, but she is unmistakably a model: "Gracefully childlike, pleasingly guileless. She is very careful not to stir while facing the painter; she is passive and wears a little smile," as Gustave Geffroy wrote in 1907.[7] Corot's realism was incompatible with any attempt to mask the model's appearance, despite the mythological pretext and exotic accessories. "This bacchante is a model," wrote Geffroy, "and the honest painter, who is a great painter, and who is also very naive, very methodical, inimical to fits of the imagination (he understood Delacroix only in his later years), has tried not at all to make us forget that we, like he, have a model before our eyes."[8]

There are some thirteen reclining nudes in Corot's oeuvre, beginning with the remarkable *Nymphe de la Seine* of 1837 (cat.

no. 65). One of them, in the 1838 *Silène* (cat. no. 64),[9] reclines in the same position as this one in *Le Repos.* Behind them all lay the specter of Ingres, and this was especially true after the 1855 retrospective of Ingres's work at the Exposition Universelle, where the *Grande Odalisque* (fig. 124) and the Valpinçon *Baigneuse*, both now at the Louvre, were displayed. Julius Meier-Graefe (in 1905) and Lionello Venturi (in 1941) both remarked on Corot's dialogue with the master of Montauban. Meier-Graefe regarded Corot's nudes as more human than Ingres's: "Ingres's brilliant figure unites every splendor of modelling of contour. But it does not breathe.... Ingres sought to concentrate everything in the one body, and surrounded it with other beautiful forms. Corot sought to blend his material with space, not only to harmonize his lines, but to make a continuous atmosphere of the whole. The progressive development of his Odalisques continued till he was past sixty.... In the course of fifty years this body seems to grow and take on broader, more majestic contours. The forms become rounder, the limbs learn movement, the flesh becomes more elastic and finally, perfected beauty emerges."[10] Venturi, on the other hand, saw Corot as an inferior rival of the great Ingres. "Unquestionably it is an admirable thing, Corot's attempt to rediscover the beauty of the female form through planes of light. And, certainly, the *Bacchante* (1855–1860) is an agreeable image. But we must ask ourselves if the ideal of beauty that Corot wishes to show us is not the product of a taste and a world too distant in time, too different from himself for him to realize it fully. Compare it to the 'Valpinçon' *Baigneuse* by Ingres; despite all the sympathy we feel for Corot, we have to admit that Ingres is more coherent."[11]

Charles Desavary made a drawing that shows this painting in its original state (fig. 125). The figure turned her head to address the viewer much as Ingres's *Odalisque* does, and her headdress had a more Oriental look. She supported herself on her left elbow and leaned against a large cushionlike mass of fur and textiles. When Corot repainted the work to give it its present appearance, probably sometime in the second half of the 1860s, he altered the figure's pose, removed one of the five members of the bacchanalian group, and extended the limbs of the trees at right toward the center of the picture (fig. 126).[12]

1. "Sa lyre n'a qu'une corde, ou plutôt il ne veut faire vibrer qu'une corde de sa lyre." "Comme on lui reproche de peindre la figure en paysagiste, Corot a fait une étude de femme dans le *Repos*. Nous aimons mieux le voir peindre la figure en paysagiste, que le paysage en peintre de figures." Callias 1861, p. 246.

2. Robaut and Moreau-Nélaton were unable to identify the Salon painting. I thank Anne M. P. Norton for making the connection.

3. "Au premier plan du paysage, le *Repos*, apparaît une grande femme nue, couchée sur une peau de panthère.... Les blancheurs mates et saines du ton rendent admirablement un aspect de plein air; la peinture, d'une incroyable solidité, donne bien l'épaisseur des chairs. Comme nous voilà loin de l'éclat vitreux et faux de tant de soi-disant coloristes!—Assurément le dessin n'est pas étudié minutieusement, détail à détail; mais qu'il est profondément juste et senti dans sa construction générale! La base du ton ne saurait être plus ferme, ni la forme plus vraie dans ses masses." Rousseau 1861, p. 172.

Fig. 124. Jean-Auguste-Dominique Ingres (1780–1867). *Une Odalisque*, also called *La Grande Odalisque*, 1814. Oil on canvas, 35⅞ × 63¾ in. (91 × 162 cm). Musée du Louvre, Paris (R.F. 1158)

Fig. 125. Charles-Paul Desavary (1837–1885). Sketch after an early state of Corot, *Le Repos.* Graphite on paper. Robaut *carton* 25, fol. 30

Fig. 126. X-radiograph of Corot, *Le Repos.* William A. Clark Collection, The Corcoran Gallery of Art, Washington, D.C.

117

4. "La bacchante couchée au premier plan du *Repos* est, contrairement à l'habitude du peintre, assez heureusement dessinée et modelée; mais les *bonshommes* du fond sont impossibles." Thierray 1861, p. 6.

5. "*Le Repos* est une réponse que M. Corot a voulu donner à quelques barbouilleurs de papier, qui lui reprochaient de ne peindre que des arbres, parce qu'il ne savait pas peindre des personnages: c'est une académie, une femme nue sur une peau de tigre. Comme académie, cela me paraît irréprochable; comme femme, cela laisse un peu à désirer—sous le rapport de la propreté: on devine, aux tons bruns de certaines parties de ce beau corps, une infinité de furfurieules qui ne laissent pas que d'être fort déplaisantes à l'oeil. Cela m'étonne, car il y a assez d'eau dans les paysages de M. Corot pour qu'on ait l'occasion de s'y baigner." Delvau 1861, p. 273.

6. See Henri Loyrette in Paris, New York 1994–95, pp. 106–11.

7. "Gentiment enfantin, aimablement ingénue. Elle a bien soin de ne pas bouger devant le peintre, elle est passive et un peu souriante." Geffroy 1907, p. 363.

8. "Cette bacchante est un modèle, et l'honnête peintre, qui est un grand peintre, et qui est aussi très naïf, très méthodique, ennemi des mouvements d'imagination (il n'a compris Delacroix que sur le tard) n'a rien tenté pour nous faire oublier que nous avions sous les yeux, comme lui, un modèle." Ibid.

9. The dancing figures at the horizon are similar to those in *Silène* and reappear in *Une Matinée*, Salon of 1850–51 (cat. no. 103), and *Cache-cache* or *Idylle*, Salon of 1859 (R 1110, Musée des Beaux-Arts, Lille).

10. Meier-Graefe 1905, pp. 41–42, translated in New York 1986, n.p.

11. "Assurément, c'est une chose admirable que l'effort de Corot pour retrouver la beauté de la forme féminine à travers des plans de lumière. Et, certes, la *Bacchante* (1855–1860) est une image agréable. Mais on doit se demander si l'idéal de beauté que Corot veut nous présenter n'a pas été imaginé par un goût, par un monde trop éloignés dans le temps, trop différents de lui, pour qu'il pût le réaliser pleinement. Confrontez-la avec la *Baigneuse dite de Valpinçon* d'Ingres; malgré toute la sympathie que nous ressentons pour Corot, force nous est de convenir qu'Ingres est plus cohérent." Venturi 1941, pp. 163–65.

12. Robaut questioned whether Desavary's drawing showed a different painting or simply an early state. In his unpublished notes Robaut first proposed that the picture Desavary drew had been destroyed, but he later changed his mind and decided that the painting Desavary saw had been repainted. Radiographs have confirmed Robaut's later hypothesis. Robaut *carton* 25, fol. 30.

PROVENANCE: Th. Bascle, Paris, probably before 1872, by 1878, until his death; his estate sale, Hôtel Drouot, Paris, April 12–14, 1883, no. 11, as *Bacchante couchée*, sold for 10,100 francs; Lucas, 1897; sold to Durand-Ruel & Cie., Paris, February 25, 1897, and by them to Senator William Andrews Clark (1839–1925), New York, until his death; by his bequest to The Corcoran Gallery of Art, Washington, D.C., 1926

EXHIBITIONS: Paris (Salon) 1861, no. 698, as *Le Repos;* Paris 1878b, no. 113, as *Bacchante au repos*, lent by Bascle; New York 1959; Chicago 1960, no. 89; New York 1969, no. 46; Washington, Columbus, Evanston, Houston, Tampa, Omaha, Akron 1983–85, no. 26

REFERENCES: Callias 1861, p. 246; Delvau 1861, p. 273; Pelloquet 1861, p. 407; Rousseau 1861, p. 172; Thierray 1861, p. 6; Meier-Graefe 1905, pp. 41–42 (English translation in New York 1986, n.p.); Robaut *carton* 25, fol. 30; Robaut 1905, vol. 1, p. 244, vol. 3, pp. 12–13, no. 1277, ill., vol. 4, p. 281; Geffroy 1907, p. 363, ill.; Bernheim de Villers 1930a, p. 59, no. 192, ill.; Meier-Graefe 1930, pl. LXVII; Venturi 1941, pp. 163–65, fig. 106 (English translation in Philadelphia 1946, p. 22); Bazin 1942, p. 105; Ruhmer 1973, p. 310; Selz 1988, p. 147; Shelburne 1994, n.p., n. 4

La Bacchante à la panthère (Bacchante with a Panther)

1860, reworked ca. 1865–70
Oil on canvas
21½ × 37½ in. (54.6 × 95.3 cm)
Signed lower left: COROT
Shelburne Museum, Shelburne, Vermont 27.1.1-226

R 1276

Nearly all the twentieth-century writers on Corot have singled this work out as exceptional in the artist's oeuvre, even though the painting itself, held in private collections from the time it left his studio until 1993, was only rarely on public display. Julius Meier-Graefe wrote about it extensively in 1905:

> Among these numerous Odalisque pictures there is one, painted rather earlier, perhaps the most surprising thing in Corot's whole work, which alone would have sufficed to immortalize him, the *Bacchante à la panthère.* This is not one of Decamps's quadrupeds; it has nothing in common with Delacroix's bloodthirsty beasts, nor with Barye's stealthy great cats. Corot has put a naked child to ride upon his panther. I do not think he painted it from life, though the skin makes a magnificent effect. Rather did he find it in that fairer world, where Titian also saw it, yoked with its fellow to the chariot of Bacchus, when the victorious god flamed forth upon Ariadne; where Poussin found it later too, in the same Dionysiac cortège whence enthusiastic Greeks once lured it into gleaming reliefs. The group occupies the foreground of a faintly indicated landscape, and extends nearly the whole length of the long canvas. The panther and the nymph are almost on the same plane, both in sharp profile, so that the antithesis of the long, outstretched feminine limbs and the heavy beast is strongly emphasized. In her extended hand the nymph holds out a dead bird to the panther. The curve of her arm, completed by the little chubby rider, seems to have surprised the most secret charms of beauty.[1]

August Jaccaci, who appears to have read Meier-Graefe on the subject, wrote in 1913 that "before the celebrated *Bacchante à la panthère* in the collection of Colonel O. H. Payne, it seems hard to realize that it is the work of one of the few great landscape painters of the world, for it would establish the reputation of a figure painter. It is a masterly performance, magnificent in composition, with its rhythm of simple and noble lines, its figures conceived and executed as a Greek artist of the great period would have conceived and executed them. The balance is perfect throughout, and there is such a suggestive marriage of background and figures, such beauty expressed everywhere in detail and ensemble."[2] Raymond Bouyer, writing in 1909, made an interesting comparison between Corot's nudes and those by Degas: "There are two ways to represent the nude: copy the unvarnished reality with all the incidental ugly details, or uncover the eternal beauty beneath fleeting life and bring out the nymph within the woman. The first method is that of

Fig. 127. Peter Paul Rubens (1577–1640). *Meeting of the King and Marie de' Medici at Lyons, November 9, 1600,* ca. 1621–25. Oil on canvas, 155½ × 116¼ in. (394 × 295 cm). Musée du Louvre, Paris (inv. 1775)

the pitiless observer, the second that of a poet motivated by love. The modernity of Degas will always be opposed by Corot's figures, which are called *Eurydice blessé, Bacchante à la panthère, Bacchante au tambourin* [*Le Repos,* cat. no. 117], *Bacchante couchée* beside a blue pagan sea."[3]

Meier-Graefe was correct to cite Titian and Poussin as sources for the bacchanalian motif of a putto on a panther (properly speaking a leopard), but the specific sources were closer to home. One of the canvases in Rubens's Medici cycle at the Louvre, the *Meeting of the King and Marie de' Medici at Lyons* (fig. 127), and Charles La Fosse's *Triumph of Bacchus* of 1700, also at the Louvre, both include mounted panthers, which traditionally pulled Bacchus's chariot. Corot's panther itself is rather similar to one in the reliefs Clodion executed about 1781

Fig. 128. X-radiograph of Corot, *La Bacchante à la panthère.*
Shelburne Museum, Shelburne, Vermont

Fig. 129. Charles-Paul Desavary (1837–1885). Sketch after Corot,
La Bacchante à la panthère. Graphite on paper. Robaut *carton* 25,
fol. 31

for the courtyard of the Hôtel de Bourbon-Condé in Paris. However, by giving the reclining nude a bow and arrow, Corot identifies her not as a bacchante, or female follower of Bacchus, but as Diana the huntress, who inhabited legends quite different from Bacchus's. Diana was a chaste goddess who jealously guarded the virginity of her maids. Nevertheless, here she is feeding Bacchus's panther, thereby fanning the flames of passion: the little cupid seems to know that something unexpected may soon occur. About 1872, Corot repeated the depiction of panther and boy in a landscape entitled *La Bacchanale à la source. Souvenir de Marly-le-Roi* (*Bacchanal at the Spring: Souvenir of Marly-le-Roi;* R 2201, Museum of Fine Arts, Boston).

Recent radiographs show that Corot significantly changed the positions of the figures in the course of working on this canvas (fig. 128).[4] The painting may have been begun about 1857, along with the nude now in Geneva (see cat. no. 106) and *Le Repos.* Originally, the panther came so close to the nude that its nose was next to the head of the dead bird. The putto, with both hands on the reins, leaned forward, while the woman looked squarely at the panther's head. Her left leg was not extended as it is in the finished work, but bent at the same angle as her right leg. The original composition was thus much more compact and dramatic, and almost entirely concentrated at the center. The effect of Corot's changes was to attenuate the figural group. He also shifted the landscape elements, moving the clump of trees from the extreme right to the extreme left. The alterations seem to have been carried out about 1865–70, that is, about five years after the original composition was completed. Charles Desavary made a pencil sketch of the original composition (fig. 129), but its date is not known. Robaut saw the painting only after it had been retouched, and he was unable to decide whether Desavary's drawing represented some other variant of the painting or its earlier state.[5] The radiographs confirm that Desavary's drawing shows the original appearance of the picture.

It is not known when Corot released the painting, but it was not in his studio in 1872. According to Robaut, the painter Daubigny acquired it from Galerie Durand-Ruel about 1872. When Daubigny died in 1878, the Corot, which hung in his salon, was appraised at 4,000 francs, a value higher than that assigned to any other work of art in the artist's estate except a painting by Daubigny of Villerville appraised at 6,000 francs and another Daubigny appraised at 4,000 francs. In marked contrast, the next highest value after the Corot was 800 francs, the value assigned to oil paintings by Daumier.[6]

1. Meier-Graefe 1905, pp. 41–42, translated in New York 1986, n.p.
2. Jaccaci 1913, pp. 87–88.
3. "Il y a deux façons d'imiter le nu: copier la réalité dévoilée dans toutes les contingences de sa laideur; ou retrouver la beauté permanente sous la vie fugitive et faire pressentir la nymphe dans la femme. La première méthode est celle d'un impitoyable observateur; la seconde est celle d'un poète par amour: à la modernité de M. Degas s'opposeront toujours les figures de Corot qui s'appellent *Eurydice blessé, la Bacchante à la panthère, la Bacchante au tambourin, la Bacchante couchée* au bord d'une mer païenne et bleue." Bouyer 1909, p. 302.
4. These radiographs were first published by Lauren B. Hewes and Richard Kerschner in Hewes and Kerschner 1994.
5. Robaut noted "considerable differences from no. 344 [the Shelburne painting]. . . . We know this variant only from what is certainly a sketch of it made by Ch. Desavary, who couldn't recall the dimensions." ("grandes différences avec le no. 344. . . . Nous ne connaissons cette variante que par le fusain assuré qu'en a fait Ch. Desavary, qui n'a pu se rappeler les dimensions.") Robaut *carton* 25, fol. 32.
6. Daubigny's inventory is reproduced in Fidell-Beaufort and Bailly-Herzberg 1975, p. 269.

PROVENANCE: Durand-Ruel & Cie., Paris, by about 1872; sold to the artist Charles-François Daubigny (1817–1878), in exchange for a Daubigny painting valued at 8,000 francs, by about 1872, until 1878;* acquired, probably from Daubigny's estate, by the baron Étienne Martin de Beurnonville (d. 1881), Paris; his sale, Hôtel Drouot, Paris, April 29, 1880, no. 5, as *La Chasse, sujet allégorique;* purchased at that sale by Clapisson (Léon-Marie Clapisson [1837–1894], Paris) for 9,500 francs; his sale, "Collection de M. C.●●[lapisson]," Hôtel Drouot, Paris, March 14, 1885, no. 11, as *La Femme au tigre;* Émile Dekens, Brussels, by 1895; purchased from him by Durand-Ruel & Cie., Paris, January 7, 1897; sold to H. O. Havemeyer, New York, along with two other pictures by Corot, for Colonel Oliver H. Payne (1839–1917), New York, January 9, 1897, for 125,000 francs;** by inheritance to his nephew Harry Payne Bingham (1889–1955), New York, 1917; by inheritance to his widow, Melissa Y. Bingham (d. 1986), New York, 1955; by descent in 1986 to the donor of the anonymous gift to the Shelburne Museum, Shelburne, Vermont, 1993

EXHIBITIONS: Paris 1875a, no. 3, as *La Femme au tigre,* lent by Daubigny; Paris 1878b, no. 86, as *Bacchante à la panthère,* lent by Daubigny; Paris 1883b, no. 4, as *La Femme au tigre,* lent by Clapisson; Paris 1895, no. 57, as *Femme au tigre,* collection of Émile Dekens, Brussels; New York 1942, no. 35; Philadelphia 1946, no. 39; Paris 1955b, no. 9; Shelburne 1994

REFERENCES: Roger-Milès 1895, p. 45; Meier-Graefe 1905, pp. 41–42 (English translation in New York 1986, n.p.); Robaut *carton* 25, fols. 31, 32; Robaut 1905, vol. 1, p. 244, vol. 3, pp. 12–13, no. 1276, ill., vol. 4, pp. 269, 280, 282, 290, 302; Bouyer 1909, p. 302; Waldmann 1910a, p. 96; Waldmann 1910b, p. 65; Jaccaci 1913, p. 87, fig. 12; Alexandre 1929, p. 281, ill. p. 276; Bernheim de Villers 1930a, no. 191, ill.; Meier-Graefe 1930, pl. LXVIII; Venturi 1939, vol. 2, p. 184; Bazin 1942, p. 105; Bazin 1951, p. 110; Baud-Bovy 1957, p. 171; Bazin 1973, p. 269; Ruhmer 1973, pp. 305–10, fig. 5; Weitzenhoffer 1986, pp. 125–26, fig. 77; Zimmermann 1986, p. 109; Selz 1988, p. 147; Hewes and Kerschner 1994, pp. 3, 7, ill.

* Robaut *carton* 25, fol. 31. *Bacchante à la panthère* was hanging in Daubigny's salon at the time of his death. Fidell-Beaufort and Bailly-Herzberg 1975, p. 269.
** Susan Alyson Stein in New York 1993, p. 220. See also cat. no. 152.

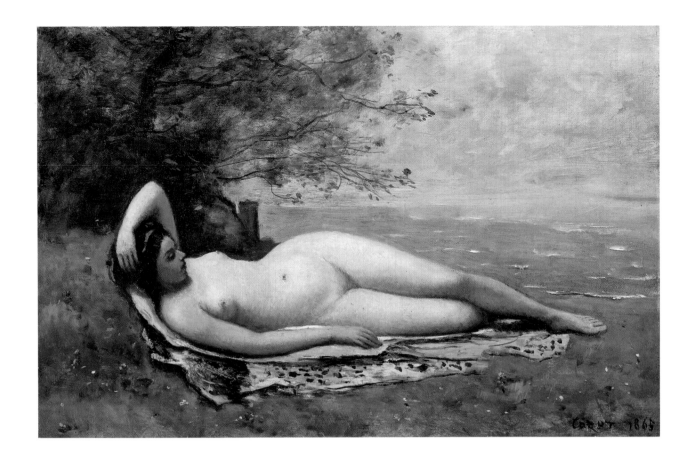

119

Bacchante couchée au bord de la mer (Bacchante by the Sea)

1865
Oil on panel
15¼ × 23⅜ in. (38.7 × 59.4 cm)
Signed and dated lower right: COROT 1865
The Metropolitan Museum of Art, New York
H. O. Havemeyer Collection, Bequest of Mrs. H. O. Havemeyer, 1929
29.100.19

R 1376

This work, signed and dated 1865, was almost certainly created to supply the growing market for Corot's figure paintings. The formula, a recumbent nude in a landscape, is loosely based on *Le Repos* (cat. no. 117), which was well received at the 1861 Salon. The artist reduced the scale to make the work suitable for a private collector, while adding the cottony foliage, distant tower, and limpid sea—"fluid and caressing as silk"[1]— that marked a typical Corot. The earliest description of the painting, written in 1889 by Paul Cornu, is in the language of a connoisseur's delectation: "Before the *Bacchante couchée*, do we wonder about the name of that sea, about the oddity of the spotted skin beneath that fresh nudity, about the bizarreness

of the foliage, so unlike seashore vegetation, covering her with a felicitous shadow? It is the assuaging harmonies of lines, etched in the background by the crests of waves, in the foreground by the curves of the folded arm, the hollow of the hip, the extended leg, that caress our eyes."[2] Indeed, the picture was owned by a succession of distinguished collectors, including Henri Vever and, later, H. O. and Louisine Havemeyer of New York, before it came to the Metropolitan Museum in 1929. Robaut considered it a "very carefully executed work. Great power. Superb harmony."[3]

Corot placed his model in a pose similar to that in his 1837 *Nymphe de la Seine* (cat. no. 65), but here it is more self-consciously Titianesque yet somehow less elegant. The pose is predicated on there being a support for the model's head and shoulders, but the landscape does not comply. Radiographs do not show a pillow or grassy knoll where one might be expected, but they do indicate that Corot shifted all the significant contours of the figure while finishing the painting: the upper hip and leg were originally slightly higher, as was the top of the thigh. There was a small change in the position of the pointed foot, and the sheet on which the figure lies originally extended behind the head. During examination a curious and inexplicable technical feature came to light: a series of parallel scratches in the section of sea at mid-right that have no descriptive function.[4]

1. "fluide et caressante comme une soie." Alexandre 1929, p. 281.

2. "Devant la *Bacchante couchée*, songeons-nous au nom de cette mer, à l'étrangeté de la peau tigrée qui supporte cette fraîche nudité, à la bizarrerie du feuillage, si peu maritime, qui la couvre d'une ombre propice?—Ce sont les apaisants accords de lignes déterminés au fond par la crête des flots, au premier plan par la courbe du bras replié, de la hanche creuse, de la jambe étendue, qui flattent notre regard." Cornu 1911 (republication), p. 71.

3. "oeuvre très soigneusement exécutée. Grande puissance; harmonie superbe." Robaut also thought he recognized the *première pensée* for this figure in number 386 of the posthumous sale. Robaut *carton* 25, fol. 42.

4. Charlotte Hale, report, March 8, 1995. Archives, Department of European Paintings, The Metropolitan Museum of Art, New York.

PROVENANCE: The artist, to "M. Senateur du Midi"; Armand Frères; to Bernheim-Jeune & Cie., Paris, March 1891;* the jeweler Henri Vever (1854–1942), Paris, by 1895; his sale, Galerie Georges Petit, Paris, February 1–2, 1897, no. 23, as *Nymphe couchée au bord de la mer*; purchased at that sale by Durand-Ruel & Cie., Paris, for 30,750 francs (stock no. 4037); sold to H. O. (1847–1907) and Louisine (1855–1929) Havemeyer, for 31,500 francs, February 3, 1897 (consigned to Durand-Ruel, New York, January 19–February 14, 1898 [deposit no. 5657]), until 1929; bequest of Louisine Havemeyer to The Metropolitan Museum of Art, New York, 1929

EXHIBITIONS: Paris 1895, no. 139, as *Nymphe au bord de la mer*, lent by Henri Vever, Paris; New York 1930b, no. 16, as *Bacchante by the Sea*; Paris 1936, no. 77; Lyons 1936, no. 82, as *Bacchante couchée au bord de la mer*; Philadelphia 1946, no. 42; Chicago 1960, no. 96; New York 1969, no. 58; New York 1993, no. A106

REFERENCES: Meier-Graefe 1905, p. 41 (English translation in New York 1986, n.p.); Michel 1905, p. 28; Robaut *carton* 25, fol. 44; Robaut 1905, vol. 1, p. 244, vol. 3, pp. 48–49, no. 1376, ill., vol. 4, p. 293; Gensel 1906, p. 47, fig. 40; Bouyer 1909, p. 302, ill.; Cornu 1911, p. 71; Meier-Graefe 1913, p. 46, ill. p. 127; Madsen 1920, pp. 64, 84, ill.; Moreau-Nélaton 1924, vol. 2, p. 35, fig. 207; Alexandre 1929, p. 281, ill. p. 278; Bernheim de Villers 1930a, p. 59, no. 208; Mather 1930, p. 471; Meier-Graefe 1930, pl. CIII; Wehle 1930, p. 56, ill.; *Havemeyer Collection* 1931, pp. 70–71, ill.; Bazin 1936, p. 60, fig. 62; Lyons 1936, pp. 38, 54–55, no. 82, pl. XXIII; Paris 1936, p. 39, no. 77; Bazin 1942, p. 106; Philadelphia 1946, p. 37, no. 42, fig. 42; Bazin 1951, p. 112; Baud-Bovy 1957, p. 171; Fosca 1958, ill. p. 134; *Havemeyer Collection* 1958, p. 14, no. 69; Sterling and Salinger 1966, p. 59; Andersen 1971, p. 95, fig. 14; Bazin 1973, p. 270; Huyghe 1976, pp. 270–71, ill.; London 1978, p. 180; Leymarie 1979, p. 125, ill. frontispiece; Weitzenhoffer 1982, pp. xiv, 291, no. 99, fig. 99; Weitzenhoffer 1986, pp. 126, 176, pl. 78; Zimmermann 1986, pp. 109, 367, no. 120; Selz 1988, pp. 226, 281, ill.; Leymarie 1992, pp. 144, 147, ill.; New York 1993, pp. 21, 22, 308–9, no. A106, pl. 207, fig. 106, ill. p. 308

* Robaut *carton* 25, fol. 42.

120

Orphée (Orpheus)

1861
Oil on canvas
44¼ × 54 in. (112.3 × 137.1 cm)
Signed lower left: COROT
The Museum of Fine Arts, Houston
Museum purchase with funds provided by the
Agnes Cullen Arnold Endowment Fund 87.190

R 1622

Although Corot sent a variety of new works to the 1861 Salon, among them a figure painting (*Le Repos*, cat. no. 117) and this canvas, which was inspired by an opera, the critics found themselves repeating each other as they rushed to accuse Corot of repeating himself. After Hector de Callias wrote, "His lyre has only one string,"[1] Étienne Delécluze wrote, "We also agree that his lyre has only one string, that his brush reproduces only one tone."[2] Edmond Castellan wrote, "Corot has painted only one landscape, which he redoes religiously each time he gets hold of a fresh canvas."[3] Alfred Delvau wrote, "For thirty years he has exhibited nothing but one painting—always the same, effect of morning or effect of evening."[4] Paul de Saint-Victor wrote, "Corot's paintings are all cut from the same cloth."[5] Théophile Thoré wrote that Corot "has only a single octave, extremely limited and in a minor key, a musician would

Fig. 130. Corot. *Orphée salue la lumière* (*Orpheus Greeting the Dawn;* R 1634), 1865. Oil on canvas, 78¾ × 54 in. (200 × 137.2 cm). Gift in memory of Earl William and Eugenia Brant Quirk, Class of 1910, by their children, Elvehjem Museum of Art, Madison, Wisconsin (1981.136)

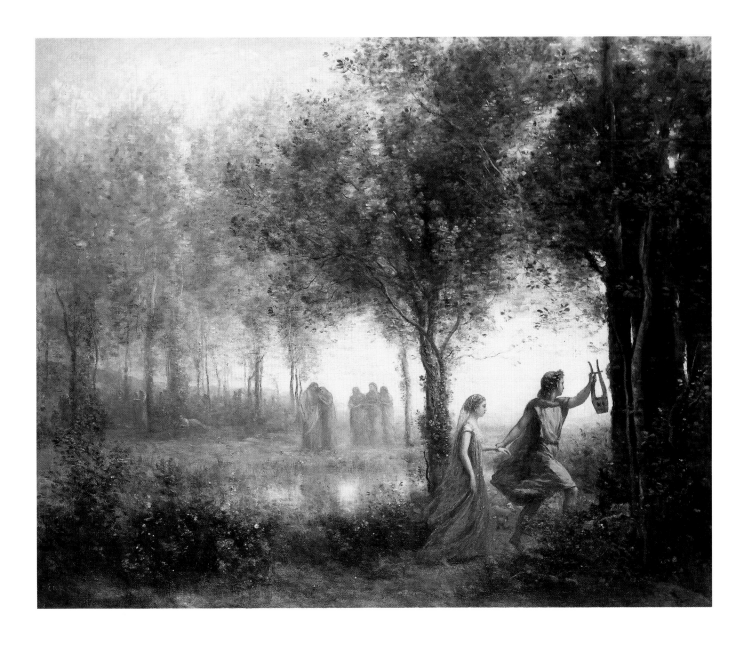

say. He knows scarcely more than a single time of day, the morning, and a single color, pale gray."[6] But despite this monotonous—and patently inaccurate—refrain, many writers found *Orphée* admirable. Callias, for example, went on: "The subject is always the same; but it is a subject from which one can draw nourishment for days on end." Corot's penchant for shady night scenes and early-morning fogs had worked well in *Dante et Virgile* (cat. no. 115, shown at the 1859 Salon), he noted, and "It also served him well in *Orphée.* The shadows of the Elysian fields disappear admirably into this general haziness."[7]

Rousseau and Castagnary likewise mounted spirited, though qualified, defenses of Corot. Rousseau began with a list of

the artist's supposed faults and then admitted that certain reproaches were justified. Regretting, as Castagnary did, that Corot chose not to exhibit his studies of nature, he went on to extol the landscape of *Orphée:* "It's a miracle of brushwork . . . and excellent in its sense of form, of movement, of view. Yet it is scarcely more than a few strokes, placed at random on a light scumble; but, as we know, chance accords well with genius! . . . It has the most supple, varied, and spontaneous execution, all the more admirable because the method is never apparent."[8] Castagnary, always analytical, saw two distinct and opposing styles in Corot's art: "The first, energetic, emphatic, fond of precise lines and defined contours, seeking ultimately

to reveal nature rather than the painter's impression; this is the style of his Italian studies and the paintings inspired by them. The second, hazy, indistinct, seeking the harmony of tones more than the forms of things, pursuing the expression of inner feeling rather than objective truth, and stopping when that feeling is expressed, not caring whether the form has been realized; this is his current style, the one that has brought Corot fame." Castagnary considered *Orphée* to be the best of Corot's paintings in the 1861 Salon: "In it are found all of the virtues and defects that constitute the artist's originality: an exquisite sentiment, an elevated meaning, an impeccable harmony, and, combined with all that, a slack, perpetually careless execution."[9] The most enthusiastic defense was elaborated by Théodore de Banville: "This Corot, whose persistent genius begins to wear out his admirers by the perpetuity of his untiring noble effort, is not a landscape painter but the very poet of landscape, who feels, who suffers, who searches within himself, who breathes the sadnesses and joys of nature; he knows the anguish of the desolate forests, the ineffable melancholy of evenings, the bursting joy of springtime and daybreaks; he understands what notion bends the branches and folds up the leaves; he knows what the paths deep in the woods would say, if they could speak. . . . Like his Orpheus, when he sets foot on the land of the living he returns from the land of dreams, where trees, brooks, horizons are only serene visions, floating souls that speak directly to our souls."[10]

Since each critic discussed hundreds of paintings in his Salon review, it is hardly surprising that not one mentioned the link between Corot's painting and its inspiration—Gluck's *Orfeo ed Euridice* as revived by Berlioz, which Corot saw at the Théâtre-Lyrique in Paris in November 1859.[11] Evidently Corot preferred Berlioz's stately production to Offenbach's raucous comic opera *Orphée aux enfers,* which had opened at the Bouffes-Parisiens in October 1858. Robaut recorded Corot's description: "In [Gluck's] *Orphée* there is an infinitely charming scene: it's when he finds Eurydice again in the Elysian fields; you are truly transported to a heavenly world . . . it's the infinite and purest canopy, with intoxicating fragrances never before known."[12] According to Berlioz, "At the beginning of the first act of *Orphée,* his poses before Eurydice's tomb recall those of certain figures in Poussin's landscapes, or, rather, certain bas-reliefs that Poussin took as models."[13] We cannot know whether Corot recognized Poussin in Berlioz's staging, but surely he sensed the formal affinity. Both Corot and Berlioz would have known Poussin's *Paysage avec Orphée et Eurydice* in the Louvre, but that painting has little in common with Corot's picture. The Poussin shows Orpheus rapt in his music as his betrothed, Eurydice, is bitten by a snake, in a landscape with extensive and incisively drawn Roman architecture; it could not be more different from Corot's vaporous vision of Orpheus purposefully leading his dead wife out of Hades. Nevertheless, Corot was profoundly impressed by the opera, as his numerous notebook sketches attest.[14] Henri Dumesnil, Corot's first biographer, even saw in Corot's

Orpheus the features of the lead singer, Pauline Viardot, who played the role "with so much majesty and power."[15] Robaut took strong exception to this suggestion; in his notes he accused Dumesnil of confusing this painting with Corot's decoration for the Hôtel Demidoff, *Orphée salue la lumière* (fig. 130).[16] In any event, there is a general harmony between Corot's scene and the sets at the Théâtre-Lyrique. A review of the opera in the *Gazette des beaux-arts* savored the theatrical decor as if it were the canvas of an old master: "These flowery arbors, this charming architecture mixed in with trees and roses, this lawn that by a previously assayed, happy improvement is represented by a painted canvas; this blue light that is not the daylight of the living, this painter's magic that joins the magic of the music, all console and put to rest feelings of sorrow. This painting is a masterpiece of stage setting."[17]

Corot worked on the painting throughout the winter of 1859–60, then finished it just before the opening of the Salon in the spring of 1861. According to Dumesnil, Corot told him, "I spent the winter in the Elysian fields, where I was very happy; you must admit that if painting is a folly, it's a sweet folly that men should not only forgive but seek out."[18] Originally, Corot placed a thin tree between the figures of Orpheus and Eurydice, as if to symbolize their future of eternal separation; after the Salon he painted it out and reinforced the two principal figures. A drawing of their clasped hands (R 2957) may date from this revision. Robaut regarded the removal of the tree as a concession to public opinion,[19] but in fact no reviewer had objected to its presence.

Corot had first alluded to the myth of Orpheus in a small oil sketch of 1824–25 (R 195). In the 1860s he made a number of pictures that draw on the story.[20] Berlioz's revival of the Gluck opera and Offenbach's concurrent farce no doubt acted as stimuli, but perhaps the artist also identified with the legendary Thracian poet whose love for his muse inspired him to play ever more beautiful music.[21]

1. "Sa lyre n'a qu'une corde." Callias 1861, p. 246. See cat. no. 117, first paragraph and n. 1.

2. "On convient aussi que sa lyre n'a qu'une corde, que son pinceau ne reproduit qu'un ton." Delécluze 1861b.

3. "M. Corot n'a jamais peint qu'un paysage, qu'il refait religieusement chaque fois qu'il s'empare d'une toile nouvelle." Castellan 1861, p. 103.

4. "Depuis trente ans il n'a jamais exposé qu'un tableau—toujour le même, effet de matin ou effet de soir." Delvau 1861, p. 272.

5. "Les tableaux de M. Corot sont toujours de la même farine." Saint-Victor 1861.

6. "ne possède qu'une seule gamme, très bornée, et en mineur, dirait un musicien. Il ne connaît guère qu'une seule heure, le matin, qu'une seule couleur, le gris pâle." "Salon de 1861," in Thoré 1870, vol. 1, p. 51.

7. "Le motif est toujours le même; mais il est des motifs dont on se nourrit pendant des journées entières." "Elle lui a encore réussi dans Orphée. Les ombres des champs Élysiens se perdent admirablement dans ce vague général." Callias 1861, p. 246.

8. "C'est le miracle même de la facture . . . et bien dans le sens de la forme, du mouvement, de l'aspect. À peine quelques touches pourtant, posées *au hasard* sur un frottis léger; mais on sait comme le hasard s'entend bien avec le génie! . . . C'est l'exécution la plus souple, la plus variée, la plus primesautière,

en ceci admirable surtout que le procédé ne paraît jamais." Rousseau 1861, p. 172.

9. "La première, énergique, accentuée, s'attachant aux lignes précises et aux contours arrêtés, cherchant enfin le rendu de la nature beaucoup plus que l'impression du peintre; c'est la manière des études d'Italie et des tableaux inspirés. La seconde, vague, indécise, cherchant l'harmonie des tons beaucoup plus que les formes des choses, poursuivant l'expression du sentiment intérieur beaucoup plus que la vérité objective, et s'arrêtant quand ce sentiment est exprimé, sans souci que la forme ne soit pas atteinte; c'est la manière actuelle, celle qui a fait connaître et illustré Corot." "On y retrouve l'ensemble des qualités et des défauts qui constituent l'originalité de l'artiste: un sentiment exquis, une haute entente de la composition, une irréprochable harmonie, et, mêlée à tout cela, une exécution molle et perpétuellement lâchée." Castagnary 1861, p. 2.

10. "Ce Corot, dont le génie persistant commence à fatiguer ses admirateurs par la perpétuité de son noble effort que rien ne lasse, ce n'est pas un paysagiste, c'est le poëte même du paysage, qui sent, qui souffre, qui trouve en lui, qui respire les tristesses et les joies de la nature; il connaît la douleur des forêts éplorées, l'ineffable mélancolie des soirs, l'éclatante joie des printemps et des aurores; il devine quelle pensée incline les branches et fait pliers le feuillages; il sait ce que diraient, s'ils pouvaient parler, les chemins perdus dans les bois. . . . Comme son Orphée, quand il touche du pied la terre des vivants, c'est qu'il revient du pays des rêves, où arbres, ruisseaux, horizons, ne sont que des visions sereines, âmes flottantes parlant directement à nos âmes." Banville 1861, pp. 235–36. See also, above, "Le Père Corot: The Very Poet of Landscape," n. 18.

11. Wissman 1989, p. 149, cites Robaut's statement that Corot kept his ticket stub from a performance, but there is no such mention on the page Wissman cites (at the entry for R 3052).

12. "Il y a dans Orphée un morceau de charme infini; c'est lorsqu'il retrouve Eurydice aux Champs Elysées; vous êtes véritablement transporté dans un monde céleste . . . c'est la voute infinie & la plus pure avec des odeurs énivrantes que nous ne connaissions pas jusqu'alors." Robaut documents, vol. 2, cited ibid., pp. 150–51.

13. "Au début du premier acte d'Orphée, ses poses auprès du tombeau d'Eurydice rappellent celles de certains personnages des paysages de Poussin, ou plutôt certains bas-reliefs que Poussin prit pour modèles." Berlioz, "L'Orphée de Gluck, au Théâtre-Lyrique," in Berlioz 1862, p. 117, cited in Wissman 1989, p. 153.

14. Several sketches in Corot's notebooks are believed to represent moments of the opera: see the discussion in Wissman 1989, p. 153.

15. "avec tant de grandeur et de puissance." Dumesnil 1875, p. 79.

16. "It is a complete and gross error to confuse all these subjects with one another, for they differ essentially." ("C'est une erreur tout aussi grosse que de confondre tous ces sujets entr'eux, puisqu'ils diffèrent essentiellement.") Robaut carton 21, fol. 611.

17. "Ces bosquets fleuris, cette architecture charmante qui se mêle aux arbres et aux roses, ce gazon que par une heureuse amélioration déjà tentée, on a représenté par une toile peinte; cette lumière bleue qui n'est plus le jour des vivants, cette magie du pinceau qui s'ajoute à la magie de la musique, tout console et repose des sensations lugubres. Ce tableau est un chef-d'oeuvre de mise en scène." Ulbach 1860, p. 103, cited in Wissman 1989, p. 151.

18. "J'ai passé l'hiver dans les Champs-Elysées où je me suis trouvé très-heureux; il faut convenir que si la peinture est une folie, c'est une folie douce que les hommes doivent non-seulement pardonner, mais rechercher." Dumesnil 1875, p. 79.

19. Robaut carton 21, fol. 611.

20. Orphée salue la lumière, 1865, R 1634, Elvehjem Museum of Art, Madison, Wisconsin; Orphée charme les humains, 1865–70, R 1734, Kimbell Art Museum, Fort Worth; Eurydice blessée, three versions: 1868–70 (R 1999, Minneapolis Institute of Arts); 1870 (R 2000, private collection, London); 1868–70 (R 2001, The Art Institute of Chicago). There are also two related clichés-verres: Orphée entraînant Eurydice, R 3197, whose composition is that of the Houston painting, reversed, and Orphée charmant les faunes, R 3198.

21. See Stein 1992 for a discussion of the Orpheus theme in Corot's art, and Kosinski 1985 for a discussion of the Orpheus theme in nineteenth-century European painting.

PROVENANCE: John Saulnier (d. 1886), Bordeaux, probably before 1872, by 1875; his posthumous sale, Hôtel Drouot, Paris, June 5, 1886, no. 3, as Orphée ramenant Eurydice; purchased at that sale by Arnold et Tripp, Paris, for 20,000 francs;* Mrs. S. D. Warren, Boston; her posthumous sale, The American Art Association, New York, January 9, 1903, no. 114, sold for 107,500 francs;** Emerson McMillin (1844–1922), New York; his sale, The American Art Association, New York, January 20–23, 1913, no. 169; purchased at that sale by M. Knoedler & Co., New York, on behalf of Edmund Stevenson Burke, Cleveland, for $75,200;† Edmund Stevenson Burke Jr., Cleveland; his posthumous sale, Parke-Bernet, New York, November 6, 1963, no. 55, sold for $37,000; private collection, Switzerland; The Museum of Fine Arts, Houston, 1987

EXHIBITIONS: Paris (Salon) 1861, no. 695, as Orphée; Limoges 1862, as for sale for 3,000 francs; Bordeaux 1865, as for sale for 4,000 francs;‡ Paris 1875a, no. 161, lent by John Saulnier; Paris 1886, no. 33; Cleveland 1913, no. 28; Cleveland 1929; Cleveland 1936, no. 259; Philadelphia 1946, no. 63; New York 1969, no. 51; Tokyo, Kyoto, Fukuoka 1970, no. 64

REFERENCES: Banville 1861, p. 236; Callias 1861, p. 246; Cantaloube 1861, p. 104; Castagnary 1861, p. 2; Delécluze 1861a; Delécluze 1861b; Delvau 1861, p. 272; Enval 1861, pp. 29–30; Galleti 1861; Gautier 1861, p. 112; Lagrange 1861, p. 98; Merson 1861, p. 329; Rousseau 1861, p. 172; Saint-Victor 1861; Thierray 1861, p. 6; Vinet 1861, p. 613; Thoré, "Salon de 1861," in Thoré 1870, vol. 1, p. 52; Dumesnil 1875, pp. 78–80, 128; Rousseau 1884, p. 20; Thomson 1902, p. 41; Geffroy 1903, pp. cxxii–cxxiii, cxxxi; Hamel 1905, p. 28, fig. 38; Michel 1905, p. 30; Robaut carton 21, fol. 611; Robaut 1905, vol. 1, pp. 202–3, vol. 2, pp. 132–33, no. 1622, ill., vol. 4, pp. 169, 176–77, 275, 368; Meynell 1908, p. 190; Cornu 1911, pp. 87, 107, 127; Moreau-Nélaton 1913, p. 67; Townsend 1913, p. 5; Moreau-Nélaton 1924, vol. 1, pp. 128–29, fig. 170 (original state); Lafargue 1926, p. 47; Fosca 1930, p. 52, fig. 47; Mauclair 1930, pp. 16–17; Meier-Graefe 1930, p. 90; Faure 1931, p. 34; Jamot 1936, p. 29; Baud-Bovy 1957, pp. 238–39; Fosca 1958, pp. 34–35, 71; Coquis 1959, pp. 90–92; Delahoyd 1969, ill. p. 41; Boime 1970, p. 127, fig. 73; Bazin 1973, p. 269; Miquel 1975, vol. 2, pp. 42–43, 47; Kosinski 1985, vol. 1, pp. 173–74, 184, fig. 141; Marzio 1989, pp. 172–73, ill.; Wissman 1989, pp. 149–55, fig. 88; Stein 1992, passim, fig. 3

* Robaut 1905, vol. 3, p. 132.
** Ibid.
† An annotated copy of the catalogue (Watson Library, The Metropolitan Museum of Art, New York) designates Knoedler as the buyer of this canvas. The eventual owner is identified in Anon. 1913, p. 11.
‡ For the early provincial exhibitions, see Robaut 1905, vol. 4, pp. 175–76. The prices are taken from lists in Corot's carnets; see Moreau-Nélaton in Robaut 1905, vol. 1, p. 203.

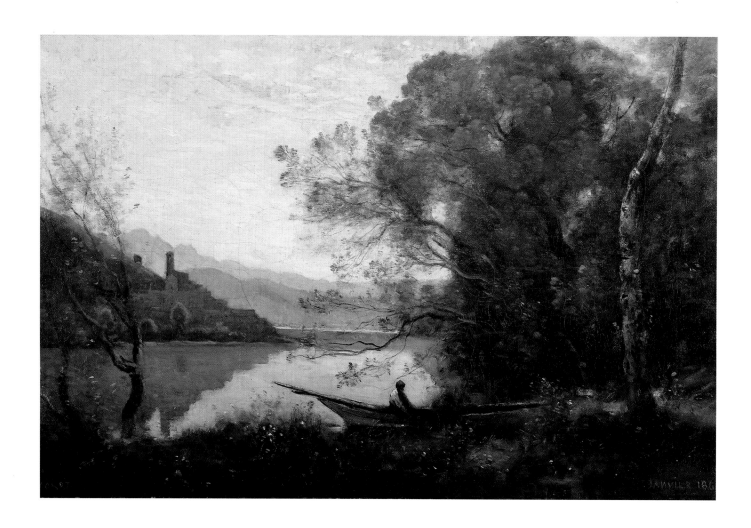

121

Souvenir d'Italie[?], also called *Le Batelier amarré* (*The Moored Boat*)

1864
Oil on canvas
24⅛ × 35⅜ in. (61.3 × 89.9 cm)
Signed lower left: COROT Dated lower right: JANVIER 1864 [N reversed]
In the Collection of The Corcoran Gallery of Art, Washington, D. C.,
William A. Clark Collection 26.51

R 1943

This handsome painting is one of the most successful of those that Corot produced to satisfy the burgeoning demand for typical examples of his work. The early history of the canvas is not known, but it was probably sold before Corot's death, very likely passing directly from the artist to one of the several dealers who served as his commercial outlets.

Fronia Wissman has suggested that this painting in particular, as well as this type of composition in general, depends upon the theatrical set designs of Second Empire Paris.[1] Corot was an avid theatergoer, and his notebooks are filled with costume studies and notations of dancers from operas—by Meyerbeer, Verdi, Offenbach—in the Paris repertory. The master stage designer Pierre-Luc-Charles Cicéri (1782–1868) and his students created the lush Romantic vistas, with projecting wings of landscape elements framing asymmetrical views of distant lakes and mountains, that in the second half of the nineteenth century became the standard backdrop for outdoor sequences in operas and ballets. It is true that Corot's typical invented landscape conforms, in structure and palette, to the scenes he saw repeatedly on the stage; still, it is unlikely

that their influence on him was decisive. For one thing, artist and set designer alike were subject to the pressures of fashion and taste that affect all the arts at any given moment, thus producing the markers that identify a period style. More important, however, is the fact that Corot and Cicéri (who was trained as a landscape painter) depended on the same compositional devices—formulas that they learned from their painting manuals and observed in the works of painters from Claude and Poussin to Hubert Robert and Fragonard, and that inspired artists and artisans alike. No better proof can be offered than a sketch Corot made of the lake at Piediluco (cat. no. 25) in 1826, well before he became an habitué of the opera.[2] The composition of this painting is borrowed not from a modern stage set but from that early plein air sketch, which displays the same architectonic composition as the late work, the same insistent use of *repoussoirs* and planar recession, and the same exquisite pale-blue-and-gray harmony. In the finished painting, only the mass of trees reaching for the water, the boatman, and the sprinkling of foreground flowers denote vintage late Corot. (The red-hatted boatman is probably the most ubiquitous staffage figure in Corot's late oeuvre. One scholar has counted over forty works in which he appears,[3] his hat always providing a strong note of color to complement the verdant foreground of the landscape.)

Since there is no early exhibition history for this work, the title Corot gave it is not known. As modern writers have divined, the title used in the mid-twentieth century, *Lac de Terni*, is untenable because there is no lake at Terni. Robaut and Moreau-Nélaton, conscious perhaps that the painting is rooted in the sketch of Piediluco, are not wrong to call it *Souvenir d'un lac italien*,

but the entire issue of Corot's *souvenirs* needs to be approached with caution.

This is one of the very few canvases that Corot inscribed with the month and year of completion. Apart from a number of annotated studies made during his trips to Italy, Robaut catalogues only three other paintings that Corot dated in this manner.[4] There has been, however, some confusion over the date, which is difficult to read. In his unpublished notes, Robaut transcribed the inscription as *Janvier 1861*. But when he saw the painting at the Goupil gallery in June 1898, he interpreted the date as *1r Janvier 1864*,[5] which modern examination confirms. It appears that Corot was in Paris on January 1, 1864.

1. Wissman 1989, p. 145.
2. McClanahan in Washington, Columbus, Evanston, Houston, Tampa, Omaha, Akron 1983–85, p. 29.
3. Ibid.
4. R 1306 and R 1308; Schoeller and Dieterle 1956, no. 37.
5. Robaut *carton* 22, fol. 761.

PROVENANCE: Galerie Georges Petit, 1898; Senator William Andrews Clark (1839–1925), New York, until his death; his bequest to The Corcoran Gallery of Art, Washington, D.C., 1926

EXHIBITIONS: New York 1959, as *The Lake of Terni*; Chicago 1960, no. 93; Peoria 1966; New York 1969, no. 50, as *Lac de Terni*; Washington 1978; Washington, Columbus, Evanston, Houston, Tampa, Omaha, Akron 1983–85, no. 3; Billings, Helena 1989; Manchester, New York, Dallas, Atlanta 1991–92, no. 27

REFERENCES: Robaut *carton* 22, fol. 761, as *Remise de Pêcheur au lac Némi*; Robaut 1905, vol. 3, pp. 224–25, no. 1943, ill.; Delahoyd 1969, p. 76, ill. p. 40; Wissman 1989, p. 145, fig. 82; Manchester, New York, Dallas, Atlanta 1991–92, p. 70

122

La Rive verte (The Verdant Bank)

Ca. 1860–65
Oil on canvas
23⅞ × 32⅛ in. (60.5 × 81.5 cm)
Signed lower right: COROT
National Gallery of Art, Washington, D.C.
Gift of Mr. and Mrs. P. H. B. Frelinghuysen in memory of her father and mother, Mr. and Mrs. H. O. Havemeyer 1943.15.1

R 1532 bis

On occasion Corot rendered a dense *sous-bois* (underbrush) scene as a foil to the open and light-filled Claudian *souvenirs* that dominated the output of his last decade. As he did in

Lormes. Une Chevrière assise au bord d'un torrent sous bois (cat. no. 79), Corot here carves out a deep, tunnel-like space that stands in contrast to the orderly recession of his typical compositions in which distant vistas are framed by flat planes of trees. In this painting, foliage literally fills the canvas, suffusing it with an intense green, but the leafy screen does not inhibit the artist from indulging in characteristically elaborate surface patterning, with heavily painted trees snaking elegantly across the canvas.

The painting was not exhibited during Corot's lifetime. It was an "entirely beautiful study," as Robaut called it,[1] of the type that the artist made in order to delight his growing

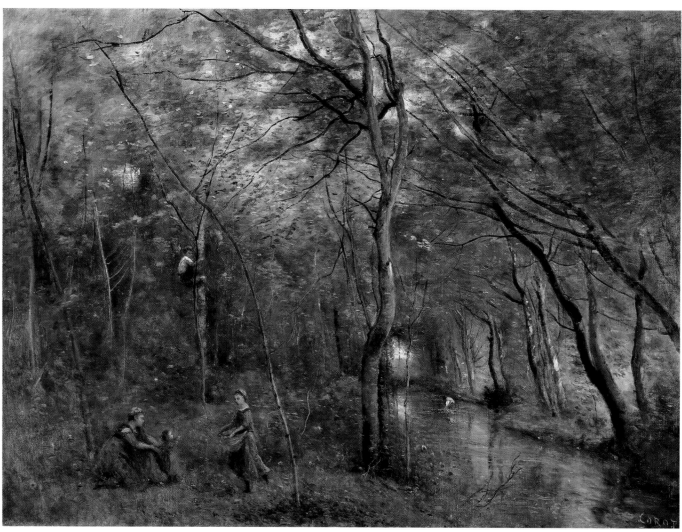

122

coterie of collectors. One such collector, Alfred de Knyff, lent the painting to the 1878 Exposition Universelle. Its traditional title, *Les Pêcheurs d'anguilles (The Eel Fishers)*, was bestowed on the painting only in 1893, when the Durand-Ruel gallery bought the work in New York from the adventurous collector Erwin Davis (who gave Manet's *Woman with a Parrot* and *Boy with a Sword* to the Metropolitan Museum in 1889). But this later title is too specific, since only one person is actually in the water, and the five figures seem to have been assembled by Corot without any particular narrative in mind.

1. "étude de toute beauté." Unpublished note in Robaut *carton* 6, fol. 345.

PROVENANCE: Chevalier Alfred de Knyff (1819–1885),* Paris, probably before 1872, by 1878; Erwin Davis (b. 1830), New York; sold to Durand-Ruel,

New York, for $10,000, May 1, 1893 (stock no. 1070, as *Les Pêcheurs d'anguilles*); sold to H. O. (1847–1907) and Louisine (1855–1929) Havemeyer, New York, for $12,000, May 1, 1893; bequeathed to their daughter Adaline Havemeyer Frelinghuysen, Morristown, N.J., 1929; given by Mr. and Mrs. P. H. B. Frelinghuysen to the National Gallery of Art, Washington, D.C., 1943

EXHIBITIONS: Paris 1878a, no. 204, as *La Rive verte*, lent by Alfred de Knyff; New York 1993, no. 109

REFERENCES: Robaut *carton* 6, fol. 345; Robaut 1905, vol. 3, pp. 104–5, no. 1532 bis, and vol. 4, p. 278; *Havemeyer Collection* 1931, p. 332; Walker 1976, p. 436, fig. 629; Weitzenhoffer 1982, pp. 199, 217, n. 3

* Chevalier Alfred de Knyff was a Belgian artist who became a successful landscapist in France. Owner of a country house near Fontainebleau, he was acquainted with the artists who congregated in Barbizon and regularly purchased their works. Knyff owned several other paintings by Corot, including R 405, 566, 1316, 1509, 1685, 1998, and 2264.

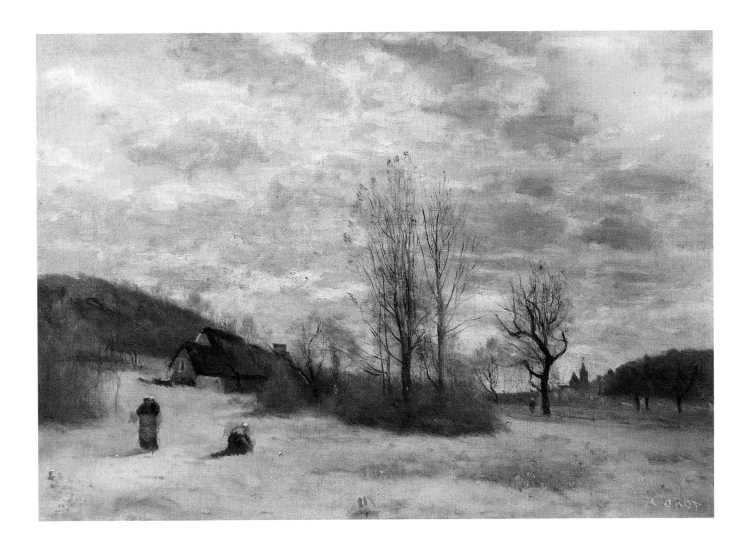

123

Plaines des environs de Beauvais du côté du Faubourg Saint-Jean (Plains near Beauvais)

Ca. 1860–70
Oil on canvas mounted on board
12³/₄ × 18¹/₈ in. (32.5 × 46 cm)
Signed lower right: COROT
Château-Musée de Boulogne-sur-Mer 54 L

R 1009

An important aspect of Corot's incessant traveling was the opportunity it gave him to paint out of doors. Although there was almost always a good friend or family member waiting for him at his destination, Corot seems to have spent a part of each day *sur le motif* before allowing himself his *pipette* and the pleasures of companionship. For an artist accused of always painting the same picture (more likely than not his critics had in mind a *souvenir* of Ville-d'Avray) he was attracted to a wide range of types of sites, from dense woods to open meadows. But whether the spot was Arras, Beauvais, Coulommiers, or Douai,

his usual practice was to situate himself on the outskirts and take his view looking toward the town, which he identified by including an architectural monument—as he did here.

The distant spires probably belong to Beauvais's church of Saint-Étienne, known for its odd combination of a Romanesque nave and transept with a flamboyant Gothic choir.[1] But in Corot's day, the most famous attraction in Beauvais was the State Tapestry Manufactory, founded under Louis XIV. Its director from 1848 to 1871 was Pierre-Adolphe Badin, a painter whom Corot had first met in Italy. The two were able to renew

their friendship while Corot worked on a cartoon for a tapestry commissioned by Louis-Philippe's administration. Corot's composition, *Le Chevrier italien* (R 608, Musée du Louvre, R.F. 899 bis), was shown at the Salon of 1848, but because of the difficulty of transcribing the artist's painterly effects it was never woven.

Corot was a frequent visitor to Beauvais throughout the 1860s, staying with Badin until 1866 and afterward with a wealthy collector named Wallet.[2] When painting in this region, Corot preferred wooded scenes or sites along streams.[3] Thus, this painting stands apart. The bleak, wintry scene, with no hint of either the autumn passed or the spring to come, holds little joy, except perhaps the promise offered by a lightening sky. Instead of impressing us with a sense of natural beauty, Corot directs our attention to his gift for extracting a picture from almost any setting—painting the heather and brambles with scumbled strokes, matching the asymmetry of the towers on the horizon with the bent branches of the adjacent tree.

Robaut and Moreau-Nélaton dated this work to 1855–65. The palette and touch, however, more closely resemble those of Corot's small paintings of the 1860s.

1. The same spires are visible in *Environs de Beauvais du côté du Faubourg Saint-Jean*, R 1010, which Moreau-Nélaton dated to 1850–65 but which was probably made during the same visit as the present picture.
2. Moreau-Nélaton in Robaut 1905, vol. 1, p. 229.
3. *Environs de Beauvais du côté du Faubourg Saint-Jean*, 1850–65, R 1010; *Marissel, près Beauvais. Prairie entourée d'arbres*, 1855–65, R 1011; *Environs de Beauvais du côté de Voisinlieu*, 1855–65, R 1003; *Voisinlieu près Beauvais. Maisons au bord de l'eau*, 1855–65, R 1004; *Environs de Beauvais vers Marissel. Le Ruisseau à l'arbre tordu*, 1855–65, R 1005; *Environs de Beauvais vers Pentemont-Saint-Jean. La Petite École de natation*, 1855–65, R 1012; *Environs de Beauvais (Marissel ou Voisinlieu). Un Ruisseau*, 1860–70, R 1373.

PROVENANCE: John Saulnier (d. 1886), Bordeaux; his posthumous sale, Hôtel Drouot, Paris, June 5, 1886, no. 21, as *Paysage: Matinée. Environs de Beauvais*; purchased at that sale by Charles Lebeau (1842–1916), Boulogne-sur-Mer, for 2,350 francs; his bequest to the Château-Musée de Boulogne-sur-Mer, 1916*

EXHIBITIONS: Paris 1886, no. 52; Boulogne-sur-Mer 1926, no. 55, as *Paysage, Matinée; Environs de Beauvais*

REFERENCES: Robaut 1905, vol. 2, pp. 310–11, no. 1009, ill.

* Because Charles Lebeau's death occurred during World War I, his collection was housed in the local library until 1925.

124

Cour d'une boulangerie près de Paris (Courtyard of a Bakery near Paris)

Ca. 1865–70
Oil on canvas
18¼ × 22 in. (46.5 × 56 cm)
Signed lower left: COROT
Musée d'Orsay, Paris, on deposit from the Musée du Louvre
R.F. 2441

R 1402

Étienne Moreau-Nélaton mentioned in passing that this work was executed in Fontainebleau and in the same sentence quoted from a letter by Corot dated August 6, 1865.[1] Thus, if Moreau-Nélaton is correct, the painting's locale and date can be identified. However, Alfred Robaut, in the notes for the catalogue raisonné he wrote at the end of the century, gave the painting a title that more specifically identified its subject as a bakery near Paris.[2] The long narrow baskets for baguettes and the piles of carefully dressed tinder for the ovens attest to the purpose of the building, a subject that has in fact been ignored by every commentator since Moreau-Nélaton reworked Robaut's catalogue at the beginning of the century. This particular courtyard appears nowhere else in the artist's oeuvre, but pictures of tidy barnyards and kitchen yards recur with regularity over the last twenty years of his career, almost always with the peasant women, children, and chickens that populate this scene.[3] Visions of timeless rural contentment that emanate from deep within the psyche of the French people, these paintings retain their power to evoke a compelling alternative to cramped, modern urban life.

Such scenes had become a speciality of the Barbizon painters, and it was in this rural genre that Corot most closely approached the activity of his contemporaries. Works by Alexandre Decamps, Charles Jacque, Louis-Adolphe Hervier, and Alexandre Defaux, one of Corot's pupils, are strikingly similar to this painting, not only in subject and staffage but in palette and facture as well.[4] The greatest practitioner of the genre was Corot's friend Jean-François Millet. Although his style differs from Corot's—Millet emphasized the figures rather than the setting, and the focus necessarily shifts from the picturesque rustic vernacular to the lives and conditions of the peasants—there is a commonality of spirit.[5]

In the 1860s this genre became the means through which the New Painters, the future Impressionists, could explore Corot's work. They were Realists who had little patience for Corot's arcadian visions, but his naturalistic pictures proved instructive. That Monet, Sisley, and Bazille actually saw such paintings by Corot cannot be proved, although each painted similar scenes.[6] It may be that Pissarro, who exhibited at the

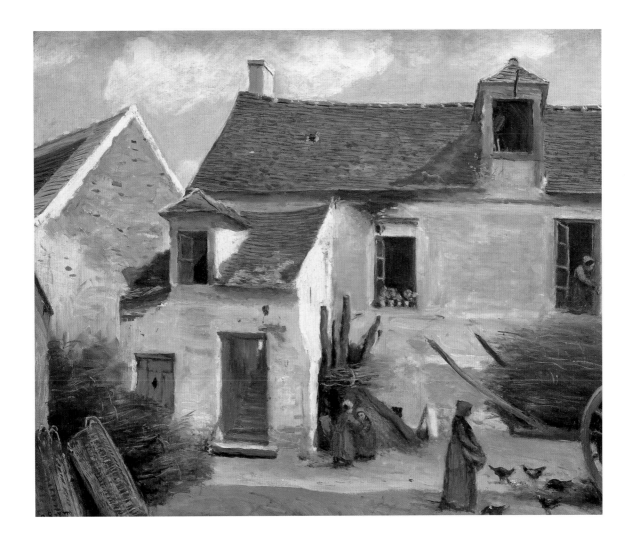

Salon during the 1860s under the rubric "élève de Corot" (student of Corot), provided the essential link, with paintings like his *Cour de ferme* of about 1863 and *Coin de village* of 1863.[7]

1. "Back in Fontainebleau (fig. 189 [this picture] and 190), Corot mapped out his future and told his plans to Dumax. (August 6, 1865)." ("Rentré à Fontainebleau [fig. 189 et 190], Corot escompte d'avance l'avenir et raconte ses plans à Dumax [6 août 1865].") Moreau-Nélaton 1924, vol. 2, p. 18.
2. Robaut *carton* 9, fol. 314, where Robaut dated the work 1865–70.
3. See, for instance, *Fontainebleau . . .*, 1824–25, R 24; *Cour . . . dans le Limousin*, ca. 1850, Dieterle 1974, no. 14; *Cour rustique*, ca. 1850–60, Dieterle 1974, no. 21; *Une Cour rustique . . .*, 1850–55, R 689; *Mantes . . . cour rustique*, 1855–60, R 821; *Fontainebleau . . .*, 1860–70, R 1316; *Trois Paysannes . . .*, ca. 1870, R 1991; *Douai. La Cour de la maison de M. . . . Robaut . . .*, 1871, R 2006; *Coubron. Cour d'une maison de paysans*, 1873, R 2176.
4. For example: Alexandre Decamps, *Intérieur de cour rustique à Fontainebleau*, ca. 1844, Musée du Louvre, Paris; Alexandre Defaux, *La Maison de Millet*, undated, Ville de Fontainebleau; Adolphe Hervier and Charles Jacque, *La Maison de Jacque*, 1856, private collection, The Hague.
5. See, for example, Millet's *Le Bout du village de Gréville*, 1865–66, Museum of Fine Arts, Boston.
6. Monet, *Cour de ferme en Normandie*, ca. 1863, Musée d'Orsay, Paris; Sisley,

Une Rue à Marlotte, 1866, Albright-Knox Art Gallery, Buffalo; Bazille, *Petite Cour de ferme (Saint Siméon)*, 1864, private collection.
7. Pissarro and Venturi 1939, nos. 26, 27.

PROVENANCE: Jaquette, Lisieux;* Boussod, Valadon & Cie., Paris, by 1893;** their sale, The American Art Galleries, New York, February 26–28, 1902, no. 233; purchased at that sale for $1,000 by Cottier and Co., New York; Ernest May (1845–1925), Paris, until his death; his bequest to the Musée du Louvre, Paris, retaining life interest, 1923; deposited in the Louvre, 1926

EXHIBITIONS: Paris 1895, no. 22, lent by Boussod, Valadon & Cie.; Paris 1936, no. 86; Lyons 1936, no. 89; Montreal 1967; Vannes, Brest, Caen 1971–72, no. 14; Besançon, Bourg-en-Bresse, Aix-les-Bains 1973, no. 18; Berlin, Munich 1979–80, no. 138; Paris, New York 1994–95, no. 37

REFERENCES: Robaut *carton* 9, fol. 314, as *Cour de boulangerie aux environs de Paris*, 1868–70; Robaut 1905, vol. 3, pp. 54–55, no. 1402, ill., and vol. 4, p. 289; Moreau-Nélaton 1924, vol. 2, p. 18, fig. 189; Anon. 1926 (J. G.), p. 56, ill.; Jamot 1929, pp. 86–87, pl. 97; Meier-Graefe 1930, pl. LII; Fosca 1958, ill. p. 148; Compin and Roquebert 1986, p. 156, ill.; Smits 1991, pp. 359–60, fig. 347

* Robaut lists Jaquette as the owner of the following works as well: R 479, 1377, 1468, 1543, 1816, 1985, 1991, 2064, 2099, 2142, 2320, and 2322. Unfortunately, little is known about this collector.
** Robaut *carton* 9, fol. 314.

125

L'Étoile du berger
(The Evening Star)

1864
Oil on canvas
50¾ × 63 in. (129 × 160 cm)
Signed and dated lower left: COROT. 1864 [two superimposed signatures]
Musée des Augustins, Toulouse RO 60

R 1623

This great painting, with the branches of its single foreground tree boldly echoing the salute given by the figure at its base, has been heaped with justifiable praise from its first appearance to the present day. To Moreau-Nélaton it was "one of those evening paintings, golden and melancholy, that were a specialty of his and that he rendered with such deep feeling."[1] Yet the origins of the work remain cloudy, being described in contradictory tales by several witnesses to its creation.

Daniel Baud-Bovy records that Corot was moved to make this picture in 1864 after hearing a song sung by Baud-Bovy's mother, Zoe. She often combed Corot's hair while he painted at the Château de Gruyères, the Baud-Bovy house outside Geneva, earning her the sobriquet "la petite coiffeuse" (the little hairdresser).[2] The song she sang was a poem by Alfred de Musset set to music by Charles Bovy-Lysberg.[3] Musset's poem had been inspired by one of James Macpherson's tales of Ossian:

> Pale evening star, far-off messenger
> Whose face shines out through the veil of fading light,
> From your azure palace deep in the heavens,
> What are you gazing at on the plain?[4]

On hearing the song, Corot reputedly responded, "Ah! Musset, what a poet! . . . He too suffered greatly. He brought my name to attention long ago, when no one knew me. I owe a *souvenir* to his memory."[5] Musset had mentioned Corot favorably in his article on the Salon of 1836 in the *Revue des deux mondes*.[6] Henri Dumesnil, writing immediately after Corot's death, said that Musset's remark "was his [Corot's] first public success; slender as it was, it was worth a lot, considering that, in a rare conjunction, this word of encouragement came from a poet and applied to another poet well qualified to understand it. Between these two spirits there must have been a natural affinity, and the painter later responded to the small tribute he had received by creating the painting he titled *L'Étoile du soir*."[7] Dumesnil quoted some lines from Musset's poem, but he did not mention the role of "la petite coiffeuse." Hélène Toussaint has further suggested that Corot conflated his *souvenir* of Musset with his memory of the celebrated singer Maria Malibran, to whom Musset had dedicated some verses.[8]

Corot sent the completed painting, signed and dated 1864, to an exhibition of the Union Artistique de Toulouse. As Moreau-Nélaton put it, "The people of Toulouse were smart enough not to let it get away from them and to keep it for their museum, without its costing them more than 3,000 francs. They were just in time; America already had its eye on Corot. A collector from Baltimore, Mr. Walters, had come knocking on the door of the studio, and the work-in-progress, sitting on the easel, had inspired lust in his heart. But he vacillated, happily for France, and carried off only a copy to take overseas."[9] William Walters could not agree to the price of the work-in-progress, Moreau-Nélaton wrote.[10]

But George A. Lucas, Walters's agent in Paris and a compulsive note taker, gives a different and presumably more reliable account. Lucas recorded that on Monday, February 8, 1864, he went to Corot's studio and "ordered repetition of evening star for 1000 fs for Ws [Walters] & small landscape near Amiens for 300 fs for myself." The next day Lucas returned to the studio with Walters himself: "In morning early to Corot with Ws & gave him an order for 2 pictures at 400 fs each & the repetition of the Evening star for 1000 fs & panel for myself for 300 fs—Asked if he could not put the whole at 2000 fs, replied in an indefinite manner that it was too little, but did not positively say that he would not."[11] Robaut noted that Walters dared suggest an improvement to the composition:

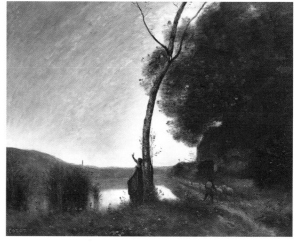

Fig. 131. Corot, *L'Étoile du berger (The Evening Star)*, 1864. Oil on canvas, 28 × 35⅛ in. (71 × 90 cm). Walters Art Gallery, Baltimore (37.154)

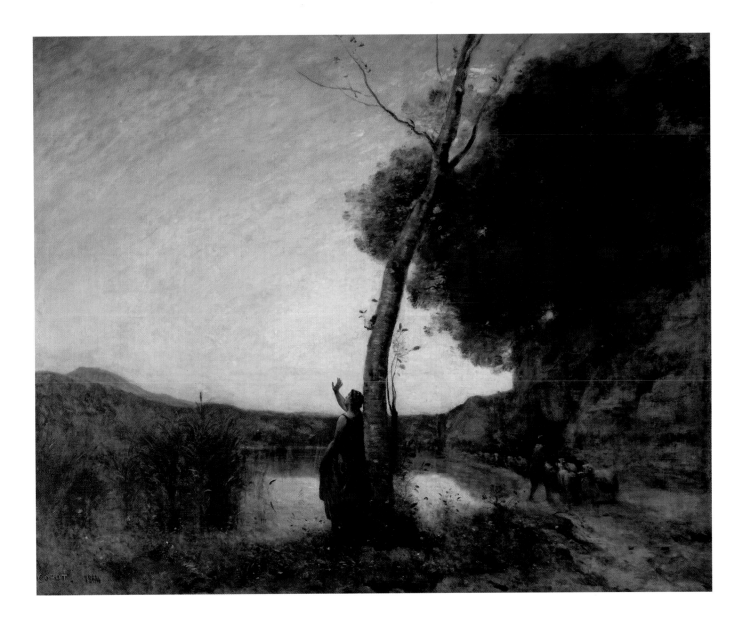

"While placing his order, he risked an observation to the artist (probably because he thought that the execution of the sheep was not sufficiently complete) and asked if it wouldn't be better to eliminate the flock.—At which Corot turned round, making a face as if to say that this request had been rejected in advance, and so it was."[12] Lucas picked up his Amiens landscape on March 5; he saw the repetition of the *Étoile du soir* on May 31 (fig. 131), but could not retrieve it until January 17, 1865, when he noted that he carried the picture to Ottoz to be varnished.[13]

Since a replica of the painting was already being ordered in February 1864, the incident described by Baud-Bovy could not have taken place as late as 1864. Moreover, although both Lucas and Walters saw the original painting on Corot's easel, and despite the story given by Zoe Baud-Bovy, Moreau-Nélaton suspected that the *Étoile du berger* had had an earlier life. "Either I'm sadly mistaken, or *L'Étoile du berger* of 1864 hides a previous 'state,' exhibited earlier with a less suggestive title and recorded

in the Paris register under the somewhat vague name *Soirée*— easy for an artist who leaves to others the task of baptizing his works 'literally.'" Indeed, it would have been uncharacteristic for Corot to reserve a good-sized and beautiful painting for a provincial exhibition. Moreau-Nélaton even considered the date on the canvas suspicious, calling it "an unusual addition to the master's signature."[14] Confirming Moreau-Nélaton's doubts, Dumesnil asserted in 1875—as has been overlooked by subsequent historians—that *L'Étoile du soir* was exhibited at the Galerie Martinet on the boulevard des Italiens in February 1860.[15] The Martinet exhibition, which opened January 21, 1859, was periodically renewed, so it is possible that *L'Étoile* was introduced after that date. Unfortunately, Martinet's house publication, *Le Courrier artistique*, did not begin publication until June 15, 1861. Corot exhibited a *Paysage* and a *Paysage: soleil levant* at Martinet's in 1862, and it is just possible that one of them was *L'Étoile*. In his notes Robaut asked himself, "How would it be possible for this to be the same picture that was

exhibited in 1860 when it is dated 1864, unless the master went back to his work after an interval of some years? Besides, that has happened so many times!"[16]

A number of pentimenti, such as a tree that was once to the right of the figure, are visible in ordinary light. Radiographs have not been taken of this work, so it cannot yet be determined whether a painting of 1860 or 1862 was modified by Corot in 1864 and sent to Toulouse. Studies might answer the question, but the only known study is a "première pensée" formerly in the Henri Rouart collection and sold in 1912,[17] which was not illustrated or listed by Robaut. Corot included a similar motif of an antique figure reaching toward the sky in his 1865 decoration for Prince Demidoff, *Orphée salue la lumière* (fig. 130), which, unlike *L'Étoile*, represents the dawn. There is, in fact, considerable confusion over the time of day Corot represented in the present work. By 1908 the painting was known in Toulouse as *L'Étoile du matin*, and that title has been taken up by some writers.[18] However, Lucas's 1864 diary entry definitely calls the picture "the Evening star," and that name, we can presume, issued from Corot's mouth.

While Corot was at work on the replica of this painting for William Walters, he sent to the Salon his *Souvenir de Morte-fontaine* (cat. no. 126), in which he repeated some of the extraordinary effects of light that are so successful here.

1. "un de ces effets du soir, dorés et mélancoliques, dont il s'était fait une spécialité et qu'il rendait avec un sentiment si profond." Moreau-Nélaton 1913, p. 72.
2. Baud-Bovy 1957, pp. 190, 192–93. William Johnston repeats the anecdote and the date of 1864: Johnston 1982, p. 61.
3. Charles Bovy-Lysberg, a cousin of Zoe Baud-Bovy, was a composer and pianist who had studied with Liszt and Chopin.
4. "Pâle étoile du soir, messagère lointaine/Dont le front sort brillant des voiles du couchant,/De ton palais d'azur, au sein du firmament,/Que regardes-tu dans la plaine?" From Alfred de Musset, "Le Saule: Fragment," in Musset 1961, p. 169.
5. "Ah! Musset, quel poète! . . . Lui aussi il a bien souffert. Il m'a signalé jadis à l'attention, alors que personne ne me connaissait. Je dois un souvenir à sa mémoire." Baud-Bovy 1957, p. 193.
6. Musset's comment, "Corot, whose 'Campagna de Rome' finds admirers," was quoted in John W. Mollett's *The Painters of Barbizon: Corot, Daubigny, and Dupré* (London 1890), cited in Gruelle 1895, p. 16.
7. "fut son premier succès en face du public; quoique mince, il avait son prix, si l'on considère, rapprochement singulier, que ce mot d'encouragement venait d'un poëte et s'adressait à un autre poëte bien fait pour l'en-

tendre. Entre ces deux esprits l'affinité devait être facile, et le peintre répondit dans la suite au petit éloge qu'il avait reçu en faisant le tableau qu'il a intitulé *L'Étoile du soir.*" Dumesnil 1875, pp. 35–36.
8. Toussaint in Paris 1975, no. 80.
9. "les Toulousains eurent le bon esprit de ne pas laisser sortir de chez eux et de retenir pour leur musée, sans qu'il leur en coûtât plus de 3.000 francs. Il était temps; l'Amérique avait déjà l'oeil sur Corot. Un amateur de Baltimore, M. Walters, était venu frapper à la porte de l'atelier et l'oeuvre, en train sur le chevalet, avait allumé la convoitise dans son esprit. Il tergiversa, par bonheur pour la France, et n'emporta qu'une réplique au-delà des mers." Moreau-Nélaton 1924, vol. 2, p. 16.
10. The replica is now in the Walters Art Gallery, Baltimore. See Johnston 1982, pp. 15, 61.
11. Lucas 1979, vol. 2, p. 171.
12. "En faisant sa commande, il risque une observation à l'artiste (car il trouvait sans doute que les moutons sont insuffisamment exécutés) il demande s'il ne vaudrait pas mieux supprimer le troupeau. À quoi Corot se retourne en faisant une grimace qui voulait dire que cette demande était rejetée d'avance, et quoiqu'il advînt." Robaut *carton* 21, fol. 645.
13. Lucas 1979, vol. 2, pp. 173, 179, 191.
14. "Ou je me trompe fort, ou *L'Étoile du berger* de 1864 cache un 'état' antérieur, exposé auparavant avec un titre moins suggestif et enregistré au livret parisien sous le vocable un peu vague de *Soirée*, familier à un artiste qui laissait à autrui le soin de baptiser 'littérairement' ses ouvrages"; "addition insolite à la signature du maître." Moreau-Nélaton 1913, p. 72.
15. Dumesnil 1875, p. 36. I thank Andrew Shelton for bringing this to my attention.
16. "Comment serait-il possible que ce fût le même tableau exposé en 1860 puisqu'il est daté 1864, à moins que le maître ait repris son oeuvre à quelques années d'intervalle? Cela a eu lieu du reste tant de fois!" Robaut *carton* 21, fol. 645.
17. Rouart sale 1912, no. 146.
18. See Roschach in Ministère de l'Instruction Publique 1908, p. 54, no. 60.

PROVENANCE: Purchased from the artist following the Exposition de l'Union Artistique de Toulouse by the city of Toulouse, for the Musée des Augustins, for 3,000 francs, 1864

EXHIBITIONS: Toulouse 1864; Paris 1936, no. 74; Lyons 1936, no. 79; Bordeaux 1959, no. 185; Paris 1975, no. 80; Tokyo, Osaka, Yokohama 1989–90, no. 44; Lugano 1994, no. 8

REFERENCES: Buisson 1864; Dumesnil 1875, p. 36; Buisson 1904, p. 35; Robaut *carton* 21, fol. 645; Robaut 1905, vol. 1, p. 222, vol. 3, pp. 134–35, no. 1623, ill., vol. 4, p. 371; Ministère de l'Instruction Publique 1908, p. 54, no. 60; Cornu 1911, p. 96; Moreau-Nélaton 1913, pp. 72–75, pl. 16; Moreau-Nélaton 1924, vol. 2, p. 16, fig. 194; Lafargue 1925, p. 45; Lafargue 1926, p. 47; Bazin 1936, p. 65, fig. 73; Jamot 1936, p. 40, ill. p. 41; Baud-Bovy 1957, pp. 192–93, 242; Fosca 1958, p. 36; Coquis 1959, pp. 96, 98–99; Bazin 1973, pp. 270, 282; Johnston 1982, pp. 15, 61; Selz 1988, p. 216; Clarke 1991a, p. 77, fig. 80; Gale 1994, pp. 37, 114, ill. p. 115

Souvenir de Mortefontaine (Souvenir of Mortefontaine)

1864
Oil on canvas
25⅝ × 35 in. (65 × 89 cm)
Signed lower right: COROT
Musée du Louvre, Paris MI 692 bis

R 1625

"Always the same thing: a masterpiece. But what do you expect? . . . Corot doesn't know how to do anything else."[1] So read one of several cartoons that mocked Corot's envoi to the 1864 Salon; but the cartoonists were right. The painting was selected by the emperor, bought for 3,000 francs, and sent to the palace at Fontainebleau. It was the emperor's most astute purchase. While even admirers of the once immensely popular painter Alexandre Cabanel deplore his *Naissance de Vénus* (Musée d'Orsay, Paris), which Louis-Napoleon bought in 1863, the year of the Salon des Refusés, those who esteem Corot, such as Germain Bazin, consider *Souvenir de Mortefontaine* one of the artist's most perfect paintings.[2] Contemporary critics, however, were of several minds. Théophile Thoré, who usually was critical, called the painting "delicious . . . with the morning mists caressing a lake. Great trees etch lacy designs on the silvery air. At the edge of the water three young girls are playing among the branches of an elegant ash tree. Corot is incomparable at creating poetic images with next to nothing. Even if it is barely painted, the impression is there, and it is communicated from the artist to the viewer."[3] Jules Castagnary demurred: "I prefer the last one [Corot's other submission, *Coup de vent*, R 1683; see cat. no 146]. It is like all the others by this master of imagined nature; but I find in it a dramatic element."[4] Charles Clément referred to the two Corots at the Salon as only "lovely studies," while regretting generally that "our painters apply themselves to copying inanimate nature narrowly and prosaically rather than to interpreting it, as Poussin and Claude Lorrain did with such brilliance."[5]

But, of course, to interpret like Poussin and Claude was precisely Corot's aim. "He never copies nature, he dreams about it and reproduces what he sees in his reveries," wrote Maxime Du Camp, who waxed enthusiastic over this "small canvas full of brightness, which possesses and gives off a natural, essential kind of light." He concluded, "M. Corot has a remarkable quality that has eluded most of our artists today: he knows how to invent. His point of departure is always in nature; but when he arrives at the interpretation of it, he no longer copies, he remembers it, and immediately reaches an altitude that is higher and entirely purified."[6]

Mortefontaine, a small village northeast of Paris near Chantilly, is best known for its estate with an English-style park and artificial lakes, built in the late eighteenth century for the Parisian Le Pelletier but much embellished by Napoleon's brother Joseph Bonaparte, who acquired the place in 1798. During the first years of the nineteenth century it was the site of numerous court festivities—treaty signings and the marriages of Napoleon's siblings. After a long decline, the grounds were refurbished in 1862, when the duc de Gramont built a new château in the "grand parc." In the 1850s Corot painted some four works based on the landscape at Mortefontaine.[7] The present painting, however, while suggesting the great "mirrors" of the park, more closely recalls his views of the Italian lakes Riva (cat. nos. 58, 59, 94) and Nemi (cat. no. 84). "This Italy," wrote Bazin, "appears to the old man through northern mists; and the image he gives us, as Henri Focillon profoundly observed, is that of a Gallic Italy."[8]

Corot was entranced by the motif of reaching branches that echo the action of the principal figure, and he made several variants of this picture. (A photograph of the work hung above his bed.) Three versions refer specifically to Mortefontaine: two show a boat and a boatman at the left, and one, oriented vertically, depicts a young woman reaching into the tree at left.[9] But he also made many more pictures that rely on the combination of water, a clump of trees, and a single, dramatically leaning tree, as seen here.[10] Some of those paintings are based on the pond at Ville-d'Avray, and one is called *Souvenir de Castel Gandolfo*—giving credibility to assertions that Corot painted the same painting over and over again.[11] Hélène Toussaint has suggested that the screen of trees Corot used in the foreground reflects his scrutiny of Japanese prints, which were much admired in Corot's circle during the 1860s.[12] Other writers have interpreted the misty mood as deriving from Corot's interest in photography, which is also well known. As Deborah Johnson has shown, the two notions are not incompatible.[13]

The painting remained at Fontainebleau, "hidden from the public," as Robaut wrote in his notes,[14] until it was transferred to the Louvre in 1889. It was well known, however, through the two engravings published while the canvas was on view at the Salon. On March 17, 1864, *L'Autographe* published a drawing of the composition that Corot made at the journal's request (fig. 132). It was reproduced alongside Corot's kind note: "As you requested, I send you the sketch of a painting, *Souvenir de*

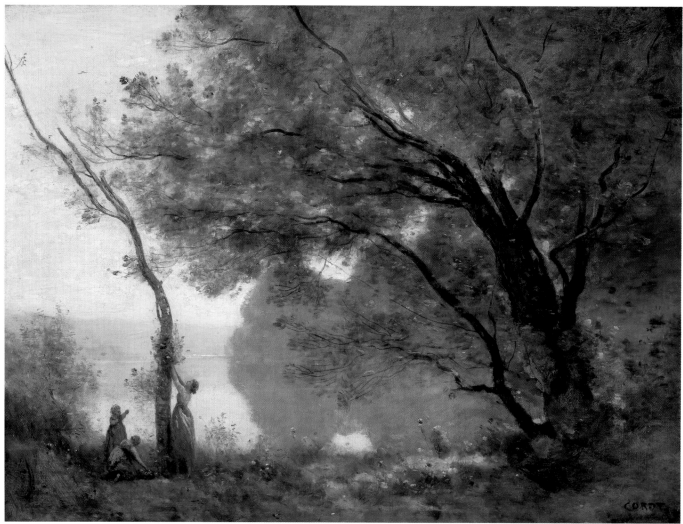

126

Mortefontaine, that I'm sending to the Salon this year."[15] Robaut observed, "With its firmness and the simplicity of its execution in forty strokes of the pen, this sketch by the master allows us to understand better the eloquence of this lovely composition. This is something apart from the painting itself, it's the poetry of it, if I may say so."[16]

Corot repeated elements of this composition in many subsequent landscapes.

1. "Toujours la même chose: un chef-d'oeuvre. Que voulez-vous? . . . Corot ne sait faire que ça." Gill 1864, quoted in Robaut 1905, vol. 4, p. 370.
2. Bazin 1951, p. 53.
3. "délicieux . . . avec les vapeurs du matin caressant un lac. De grands arbres dessinent des guipures sur l'atmosphère argentine. Au bord de l'eau trois fillettes s'amusent avec les branches d'un frêne élégant. Corot est incomparable pour susciter, avec presque rien, des images poétiques. À peine si c'est peint, mais l'impression y est, et de l'artiste elle se communique au spectateur." Thoré, "Salon de 1864," in Thoré 1870, vol. 2, pp. 75–76.
4. "Je préfère ce dernier. C'est comme toujours chez ce maître de la nature rêvée; mais j'y trouve un élément dramatique." Castagnary, "Salon de 1864," in Castagnary 1892, vol. 1, p. 206.
5. "belles études"; "nos peintres s'attachent à copier la nature inanimée

Fig. 132. Corot. Drawing after *Souvenir de Mortefontaine*. Published in *L'Autographe*, March 17, 1864

d'une manière mesquine et prosaïque plutôt qu'à l'interpréter comme l'ont fait avec tant d'éclat Poussin et Claude Lorrain." Clément 1864.
6. "Il ne copie jamais la nature, il y songe et la reproduit telle qu'il la voit dans ses rêveries"; "petite toile pleine de clarté, qui possède et répand

autour d'elle une sorte de lumière essentielle et native." "M. Corot a une qualité remarquable qui échappe à la plupart des artistes de notre temps; il sait créer. Son point de départ est toujours dans la nature; mais lorsqu'il en arrive à l'interprétation, il ne copie plus, il se rappelle et atteint immédiatement à une altitude supérieure et tout à fait épurée." Du Camp 1864, pp. 690–91.

7. *Mortefontaine. L'Étang aux canards*, R 889; *Mortefontaine. Le Pêcheur à la ligne*, R 898; *Mortefontaine. Le Chemin à la petite barrière*, R 899; *Mortefontaine. Arbres penchés sur l'étang*, R 900.

8. "Cette Italie . . . elle apparaît au vieillard à travers les brouillards nordiques; et l'image qu'il nous en donne est, selon le mot profond de M. Henri Focillon, celle d'une 'Italie des Gaules.'" Bazin 1936, p. 63.

9. *Vapeurs matinales à Mortefontaine*, R 1669, and *Le Batelier de Mortefontaine*, R 1671, The Frick Collection, New York; *La Cueillette à Mortefontaine*, R 1670.

10. Bazin has traced some early precedents in Corot's own work for the motifs in this painting. See Bazin 1973, pp. 48–50.

11. R 1497 and R 1498, both called *Ville-d'Avray. L'Étang à l'arbre penché*; *Souvenir de Castel Gandolfo*, R 1626, Musée du Louvre, Paris.

12. Toussaint in Paris 1975, p. 88.

13. In her essay, "Confluence and Influence: Photography and the Japanese Print in 1850," in Manchester, New York, Dallas, Atlanta 1991–92.

14. "caché au public." Unpublished note in Robaut *carton 21*, fol. 613.

15. "D'après votre désir, je vous fais remettre le croquis d'un tableau 'Souvenir de Morte-fontaine' que j'envoie cette année au Salon." Robaut *carton 21*, fol. 614.

16. "Par sa fermeté, et la simplicité de son exécution en quarante coup de plume, ce croquis de maître nous fait mieux comprendre l'éloquence de cette belle composition. C'est encore autre chose que le tableau lui-même, c'en est la poësie, si j'ose dire." Unpublished note in ibid.

PROVENANCE: Purchased by the emperor Napoleon III at the Salon of 1864 for 3,000 francs; Palais de Fontainebleau, 1864–89; allotted to the Musées Nationaux as part of the settlement of the estate of Napoleon III, 1879; transferred to the Musée du Louvre, Paris, 1889

EXHIBITIONS: Paris (Salon) 1864, no. 442, as *Souvenir de Mortefontaine*; London 1932, no. 361; Paris 1936, no. 75; Lyons 1936, no. 80; Paris 1946b, no. 182; Paris 1955a, no. 282; London 1959, no. 78; San Francisco, Toledo, Cleveland, Boston 1962–63, no. 16; Paris 1975, no. 78; Tokyo, Utsunomiya, Kumamoto, Nara, Nagoya 1976–77, no. 6; Philadelphia, Detroit, Paris 1978–79, no. VI–26 (Philadelphia and Detroit), no. 194 (Paris); Beauvais 1987, no. 84; Manchester, New York, Dallas, Atlanta 1991–92, no. 29

REFERENCES: About 1864, p. 105; Anon. (A. M.) 1864; Chesneau 1864, p. 3; Clément 1864; Du Camp 1864, pp. 690–91; Gautier 1864, p. 1004; Gill 1864, cited in Robaut 1905, vol. 4, p. 370; Lagrange 1864, p. 10; Lorne and Guyot de Fère 1864, pp. 70, 77, 94; Merson 1864, cited in Robaut 1905, vol. 4, p. 371; Nettement 1864, pp. 609–10; Saint-Victor 1864, p. 3; Sancerre 1864, pp. 322–23; Thoré, "Salon de 1864," in Thoré 1870, vol. 2, pp. 75–76; Claretie, "L'Art français en 1872: Revue du Salon," in Claretie 1873, p. 112; Claretie 1882, p. 112; Castagnary, "Salon de 1864," in Castagnary 1892, vol. 1, p. 206; Thomson 1902, p. 71; Hamel 1905, pl. 43, as *Paysage, effet de matin*; Meier-Graefe 1905, p. 97; Michel 1905, p. 40; Moreau-Nélaton 1905b, p. 232, fig. 180; Robaut *carton 21*, fols. 613, 614; Robaut 1905, vol. 1, p. 221, vol. 3, pp. 136–37, no. 1625, ill., vol. 4, pp. 69, 370–71; *Corot* 1910, pl. 5; Cornu 1911, pp. 94–98, 107; Meier-Graefe 1913, p. 97; Moreau-Nélaton 1913, pp. 64–71, pl. 15; Moreau-Nélaton 1924, vol. 2, p. 16, fig. 185; Guinon 1925, p. 9; Jamot 1929, p. 34, pl. 44; Bazin 1936, pp. 63, 65–67, fig. 78; Venturi 1941, p. 148, fig. 97; Bazin 1942, pp. 53, 106, pl. 98; Philadelphia 1946, pp. 15–16; Bazin 1951, pp. 26, 47–48, 51, 53, pl. 110; Fosca 1958, p. 36; Coquis 1959, pp. 96–98; Paris 1962, p. 7; Leymarie 1966, p. 87, ill. p. 89; Hours 1972, pp. 136–37, ill.; Bazin 1973, pp. 48–50, 270; Paris 1975, no. 78, pp. 88–90, ill.; Geiger 1977, p. 334; Janson 1978, p. 303; Philadelphia, Detroit, Paris 1978–79, pp. 272–73 (English ed.), p. 327, no. 194 (French ed.); Leymarie 1979, pp. 114–15; Compin and Roquebert 1986, p. 147, ill.; Beauvais 1987, p. 80, no. 84; Selz 1988, p. 216, ill. p. 211; Wissman 1989, pp. 144–45, 157–58, 161, 178, 186–89, 204, no. 104; Clarke 1991a, pp. 84–85, no. 85; Galassi 1991b, pp. 217, 219, pl. 276; Leymarie 1992, pp. 132–33, 196, ill.; Adams 1994, pp. 186–87, no. 131; Gale 1994, pp. 112–13, ill.

127

Souvenir des environs du lac de Nemi (Souvenir of the Lake Nemi Region)

1865
Oil on canvas
38¾ × 52⅞ in. (98.4 × 134.3 cm)
Signed and dated lower left: COROT 1865
The Art Institute of Chicago
Bequest of Florence S. McCormick 1979.1280

R 1636

The radical socialist Théophile Thoré repeated his favorite mantra after viewing Corot's entries to the Salon of 1865: "Corot almost never made anything besides the same one landscape, but it is good." For all his mocking tone, Thoré respected Corot's accomplishment. "Corot is the success of the Salon in landscape painting. Can we believe that this traitor of a Corot has made his little tour of Italy? Yes, truly, he has been to see the color of the weather on the other side of the Alps: for he exhibited a *Lac de Nemi* and a splendid etching, *Souvenir d'Italie*.

What is odd is that he has brought back from the banks of the Tiber and Lake Nemi only his usual fog from the banks of the Seine. If he went to Constantinople he would see the Bosporus at high noon under a vaporous veil, in silvery tones. My friend, do not trouble yourself; simply go for a morning walk in lower Meudon, or smoke a pipe beside the pond at Auteuil; you will find the mist there even better than in the lands beyond the Alps."[1]

Thoré, like most critics, was sensitive to the poetry of

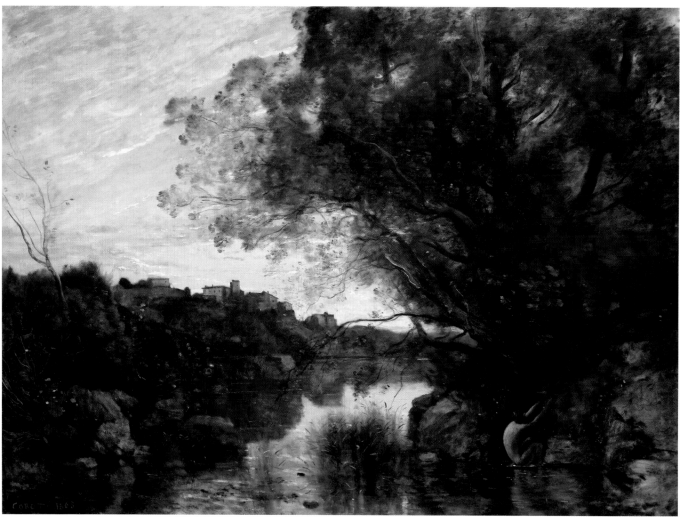

127

Corot's vision and the primacy of his position. "Of his two paintings, hung face-to-face in the square Salon, one near the portrait of the emperor, the other near the portrait of the queen of Spain, which of the two represents Lake Nemi? [The other painting was *Matin. La Bacchante retenant l'Amour* (R 1635, present location unknown).][2] I'm not too sure: in both the one and the other there are water, masses of foliage, and a delicious impression of morning and of freshness. It's very poetic and very engaging. The objection is raised that these are oil sketches of a sort, and practical people would like to recognize more clearly the species of the trees, the shapes of the branches, the lay of the land, and all the rest. But this is not about botany or arboriculture. It's a matter of evoking in the viewer of these subtle images the feeling that he must be in the country, on a peaceful morning, at the shore of a lake. If Corot's painting makes you want to get up early, all is well."[3]

Though his tone was sarcastic, Thoré spoke with the majority of critics. Paul Mantz opined that "no landscape is as fresh, tender, bathed in dawn as the *Matin;* nothing is as poetic as the *Lac de Nemi,* for Corot is the painter of tranquil still waters, of broad, pale horizons, of misty skies, of drowsy woods, of cool dusks."[4] Marc de Montifaud concurred: "Corot is the painter of dawns and twilights. He was born to interpret their delicate beauties."[5]

In his posthumous *Souvenirs intimes* of 1875, Henri Dumesnil gives an account of this painting's genesis, which, if true, curiously confirms Thoré's tongue-in-cheek inference that topography had no real role in Corot's art. "In its first version, the subject was Ville-d'Avray, where, one evening in his living room, the master was struck by a vivid impression, which he transcribed starting the next day. Sometime later this canvas was rolled up, brought to Paris, and then forgotten for five years. When he came upon it again, he thought the effect would better suit a recollection of Italy that came back to him at the time, and he made it into what we saw [at the Salon of 1865], a firm painting in harmony with the subject and of an execution in keeping with the one he practiced in that country."[6] This text, so manifestly important to an understanding of Corot's creative process, has evidently been ignored by modern historians. (Examination of the painting has produced nothing to either corroborate or contradict Dumesnil's assertion.)

The picture's composition relates to the *souvenir* "type" that Corot exploited throughout the 1860s and early 1870s, in

works that include *Souvenir de Riva* (cat. no. 131) and *Souvenir de Mortefontaine* (cat. no. 126). The motif of a bather holding onto a tree recurs with some regularity, albeit with changes in the sex of the figure. The first example may be found in *Diane surprise au bain* (cat. no. 63), shown at the Salon of 1836.[7] Corot recognized the success of this painting and included it among the seven that were shown at the 1867 Exposition Universelle. This time the critics, beginning with Thoré, were less forgiving. However, the numerous photographs and reproductive prints after the painting listed in Robaut attest to its popularity. And Robaut himself called it "one of Corot's most beautiful works."[8]

1. "Corot n'a presque jamais fait qu'un seul et même paysage, mais il est bon." "C'est Corot qui a le succès du Salon comme paysagiste. Croirait-on que ce traître de Corot a fait son petit tour en Italie? Oui vraiment, il a été voir la couleur du temps de l'autre côté des Alpes: car il a exposé un *Lac de Nemi* et une superbe eau-forte, *Souvenir d'Italie.* Ce qu'il y a de curieux, c'est qu'il n'a rapporté des bords du Tibre et du lac de Nemi que son brouillard habituel des bords de la Seine. Il irait à Constantinople, qu'il verrait le Bosphore, en plein midi, sous un voile vaporeux dans les tons argentins. Mon ami, ne vous tourmentez pas, allez simplement vous promener le matin au bas Meudon, ou fumer une pipe devant la mare d'Auteuil; vous y trouverez la brume encore mieux qu'au pays ultramontain." "Salon de 1865," in Thoré 1870, vol. 2, p. 223.
2. Sold at Christie's, London, "Important Impressionist and Modern Drawings, Paintings, and Sculpture," June 30, 1967, no. 82, as *La Bacchante retenant l'Amour.*
3. "De ses deux tableaux, placés face à face dans le Salon carré, l'un près du portrait de l'Empereur, l'autre près du portrait de la reine d'Espagne, lequel des deux représente le lac de Nemi? Je ne sais trop: dans l'un et dans l'autre il y a de l'eau, des massifs de feuillage, et une délicieuse impression d'effet matinal et de fraîcheur. C'est très-poétique et très-attrayant. On objecte que ce sont des espèces d'ébauches, et les gens positifs voudraient y reconnaître plus distinctement l'essence des arbres, la forme des branches, le plan des terrains, et le reste. Mais il ne s'agit pas de botanique ou d'arboriculture. Il s'agit d'évoquer chez le spectateur de ces images subtiles le sentiment qu'il aurait à la campagne, par une douce matinée, au bord d'un lac. Si la peinture de Corot vous donne envie de vous lever de bonne heure, alors tout est bien." "Salon de 1865," in Thoré 1870, vol. 2, pp. 223–24.
4. "aucun paysage n'est, autant que le *Matin*, frais, tendre, baigné d'aurore; rien n'est poétique comme le *Lac de Némi*, car M. Corot est le peintre des eaux tranquilles et dormantes, des grands horizons pâles, des ciels voilés, des bois sommeillants, des crépuscules attiédis." Mantz 1865, p. 16.

Mantz's article in the *Gazette des beaux-arts* was illustrated with a reproduction (reversed) of *Le Lac de Némi* (fig. 19).
5. "Corot est le peintre des aubes et des crépuscules; il est né pour en traduire les délicates beautés." Montifaud 1865, pp. 218–19.
6. "Dans son premier état, c'était un motif de Ville-d'Avray, où, certain soir, étant dans son salon, le maître fut frappé par une impression vive, qu'il avait traduite dès le lendemain. À quelque temps de là, cette toile fut roulée, conduite à Paris et finalement oubliée pendant cinq ans. Lorsqu'il la retrouva, il crut que l'effet s'arrangerait mieux avec un souvenir d'Italie qui lui revint alors et il en fit ce qu'on a vu [Salon de 1865], une peinture ferme, en rapport avec le sujet et d'une exécution analogue à celle qu'il avait dans ce pays." Dumesnil 1875, p. 48.
7. See also R 441A and B, R 1653, and R 1654 (a copy of R 1653).
8. "une des plus belles oeuvres de Corot." Unpublished note, Robaut *carton* 21, fol. 621.

PROVENANCE: The collector "M. L.," by 1867; Albert Hecht (1842–1889), Paris, by 1875; William Schaus, New York, 1884; Mrs. Mary J. Morgan; her posthumous sale, Chickering Hall, New York, March 5, 1886, no. 216, as *Lake Nemi*, sold to Thomas Newcomb; Mrs. Alice Newcomb; sale, "Important Paintings Belonging to the Estates of the Late George Crocker, Alice Newcomb, Emily H. Moir, Frederic Bonner," The American Art Galleries, New York, January 24, 1912, no. 26, as *Lake Nemi*; Cyrus Hall McCormick Jr. (1859–1936), on sporadic loan to The Art Institute of Chicago for exhibition and storage from 1918 to 1948, as *Lake Nemi*; turned over to his son, Cyrus McCormick III (1890–1970), Chicago, on October 15, 1941;* his second wife, Florence Nicks Sittenham Davey McCormick (1891–1979), New York; her bequest to The Art Institute of Chicago, 1979, as *Nymphs Bathing*

EXHIBITIONS: Paris (Salon) 1865, no. 507, as *Souvenir des environs du lac de Nemi*; Paris 1867, no. 164, lent by L.; Paris 1875a, no. 23, as *Le Lac de Némi*, lent by Hecht; Tokyo, Fukuoka, Kyoto 1985–86, no. 7; Edinburgh 1986, no. 13

REFERENCES: Arpentigny 1865, p. 222; Audéoud 1865, pp. 749–50; Auvray 1865, p. 239; Gautier 1865, p. 835; Guyot de Fère 1865, p. 83; Jahyer 1865, pp. 182–84; Lagrange 1865, p. 153; Laincel 1865, p. 94; Moüy 1865, p. 202; Rolland 1865, p. 202; Anon. 1866, p. 66; Dumesnil 1875, p. 48; Thomson 1902, p. 46; Robaut *carton* 21, fols. 620–23; Robaut 1905, vol. 1, pp. 222, 235–36, 238, vol. 3, pp. 146–47, no. 1636, ill., vol. 4, pp. 169, 270, 371; Moreau-Nélaton 1924, vol. 2, pp. 17, 28, fig. 192; Guinon 1925, p. 9; Bazin 1942, p. 106; Coquis 1959, pp. 99–103; Bazin 1973, p. 270; Brettell 1987, pp. 68–69, 117, ill. p. 71; Clarke 1991a, pp. 84, 135, 138, fig. 125

* Letter from Judson F. Stone, Agence McCormick Properties/Investments, October 15, 1941, Department of Archives, The Art Institute of Chicago. Information courtesy of Gloria Gloom.

128

L'Île heureuse
(The Happy Isle)

Ca. 1865–68
Oil on canvas
74 × 56⅛ in. (188 × 142.5 cm)
Signed lower left: COROT
Collection of The Montreal Museum of Fine Arts
Gift of the Family of Sir George Drummond in memory of
Arthur Lennox Drummond and of Captain Guy Melfort
Drummond 1919.30

R 1644

This painting is perhaps the most beautiful of five works executed by Corot to decorate the vestibule of Charles-François Daubigny's new house at Auvers, the Villa des Vallés. A pendant, *Don Quichotte et Sancho* (fig. 133), now in the Cincinnati Art Museum, responded to Daumier's great *Don Quichotte*, now in the Musée d'Orsay, which also hung in Daubigny's entrance hall. Corot painted three more panels for the suite: *Cavalier dans une gorge* (*Cavalier in a Gorge*; R 1648), *Saulaie, le matin* (*Willow*

Grove, Morning; R 1646), and *Bouquets d'arbres, le soir* (*Clusters of Trees, Evening;* R 1647).

Daubigny, who is often erroneously called a student of Corot, had acquired the property at Auvers on Corot's recommendation in June 1860.[1] He remembered that "Father Corot finds Auvers very beautiful and has persuaded me to settle there for a part of the year."[2] His house was designed by a pupil of Corot, the architect Achille-François Oudinot, and built soon thereafter. Daubigny decorated his daughter's bedroom and with his son Karl decorated the dining room, while the studio featured three large panels painted by Oudinot and Karl Daubigny after charcoal cartoons by Corot. For the entrance hall Daubigny executed a painting called *Printemps* (*Spring;* now lost);[3] it showed a woman riding a mule, led by a man. Evidently Daumier, who settled in nearby Valmondois in 1864, painted his *Don Quichotte* about 1868 to hang with Daubigny's *Printemps.* Robaut recounted in 1882 that Corot painted his panels for the hall about 1868 as well.[4]

In selecting his scene for this panel, Corot made no motion toward the prosaic Realism for which Daubigny was known at the Salon. (Indeed, Daubigny's own decorations for the house were quite fanciful.) Instead Corot created an archetypal work, drawing on the Claudian imagery and effects that had recently brought him worldwide fame. The pose of the reaching woman at right recalls that of the figure in *Souvenir de Mortefontaine* (cat. no. 126), while the basic composition mirrors those of *Les Deux Soeurs sous les arbres au bord du lac* (*Two Sisters beneath Trees at the Edge of the Lake;* R 1680, Musée des Beaux-Arts, Reims); *Le Sommeil de Diane* (*Diana Asleep;* R 1633), one of two decorative panels painted about 1865 for the Hôtel Demidoff in Paris; and *La Cueillette à Mortefontaine* (*Harvest Time at Mortefontaine*),[5] one of the variants of the famous *Souvenir.* The lake, although it has no identifying features, is reminiscent of Lake Albano,[6] and the domed tower, generically Italian, can be found in numerous paintings and drawings.

The title appears to have originated with Robaut. No explanation for it has been given. A reduced version of the painting, purportedly sold by Corot to a member of the Shchukin family of Moscow, was exhibited in New York in 1942.[7] A variant in reverse, *Cueillette à l'Arricia* (*Gleaner at Arricia;* R 2320, The Corcoran Gallery of Art, Washington, D.C.), conforms in all important respects to the composition of the Montreal painting, although the principal woman wears an Italian rather than a French peasant's costume, and the trees and distant view are slightly modified. It is at present impossible to ascertain which of the three versions was made first; all three seem to date from the late 1860s.

1. For modern descriptions of the house and its decoration, see Cooper 1955, p. 100, and Fidell-Beaufort and Bailly-Herzberg 1975, pp. 50–52. The best single source is Bourges 1894. Bourges does not mention the panels by Corot in the vestibule because they had already been sold.
2. "Le père Corot a trouvé Auvers très beau et m'a bien engagé à m'y fixer une partie de l'année." Daubigny, letter to Frédéric Henriet, in Moreau-Nélaton 1925, p. 79.
3. Not in Hellebranth 1976. A print after this painting is reproduced in Bourges 1894, p. 8.
4. Robaut 1882, p. 49.
5. Schoeller and Dieterle 1948, no. 58.
6. According to Vincent Pomarède in Tokyo, Osaka, Yokohama 1989–90, no. 4, in a discussion of *Les Deux Soeurs.*
7. New York 1942, no. 51.

PROVENANCE: One of a set of five decorative panels executed for the vestibule of the house of Charles-François Daubigny (1817–1878) in Auvers; sold after Daubigny's death by his daughter-in-law;* Sir George A. Drummond (1829–1910), Montreal, probably by 1899, until his death; his estate; his estate sale, Christie's, London, June 26, 1919, no. 18; purchased at that sale by Croal Thomson for 6,800 guineas (£7,140) on behalf of Huntley Drummond for presentation to the Montreal Museum;** given by the Drummond family to The Montreal Museum of Fine Arts, 1919

EXHIBITIONS: Montreal 1899, no. 7, as *Landscape;* Montreal 1918, no. 9; Montreal 1952, no. 44; Paris 1954–55, no. 23; Montreal 1960, no. 27; Ottawa 1962, no. 3; Sarasota, Buffalo, Rochester, Raleigh, Philadelphia, Columbus, Pittsburgh 1966–67, no. 16; Montreal 1970, no. 2; Victoria et al. 1973–75, no. 5; Manchester, New York, Dallas, Atlanta 1991–92, no. 31

REFERENCES: Robaut 1882, p. 49, ill. p. 50; Rousseau 1884, ill. p. 49; Roger-Milès 1891, ill. p. 45; Thomson 1902, p. 44; Michel 1905, ill. p. 41; Robaut 1905, vol. 3, pp. 152–53, no. 1644, ill.; Waldmann 1910b, pp. 62, 65; Cooper 1955, p. 100; Montreal Museum of Fine Arts 1960a, p. 57; Montreal Museum of Fine Arts 1960b, p. 103, ill. p. 102; Hubbard 1962, p. 4, ill. p. 5; Funke 1970, pp. 11, 13; Bazin 1973, p. 271; Fidell-Beaufort and Bailly-Herzberg 1975, p. 52; Johnston 1976, p. 420, fig. 4; Montreal Museum of Fine Arts 1977, p. 103, fig. 68; Selz 1988, p. 178

* Moreau-Nélaton 1925, p. 89. Corot's two paintings in the vestibule are not mentioned in Bourges 1894, which offers a detailed description of Daubigny's house as it existed near the end of the century; it seems that they had been replaced by two works by Karl Daubigny.
** Anon. 1919, p. 88.

Fig. 133. Corot. *Don Quichotte* (R 1645). Oil on canvas, 74 × 54 in. (188 × 137.2 cm). Bequest of Mary M. Emery, Cincinnati Art Museum (1919.1)

129

Le Matin (gardeuse de vaches) (Morning: Woman Herding Cows)

Ca. 1860–65
Oil on canvas
42⅞ × 45⅝ in. (109 × 116 cm)
Signed lower right: COROT
Musée d'Orsay, Paris R.F. 1792

R 1797

Fig. 134. Corot. Study for *Le Soir* (*Evening;* R 3060), ca. 1860–65. *Carnet* 23, fol. 69r. Musée Carnavalet, Paris (D 03591)

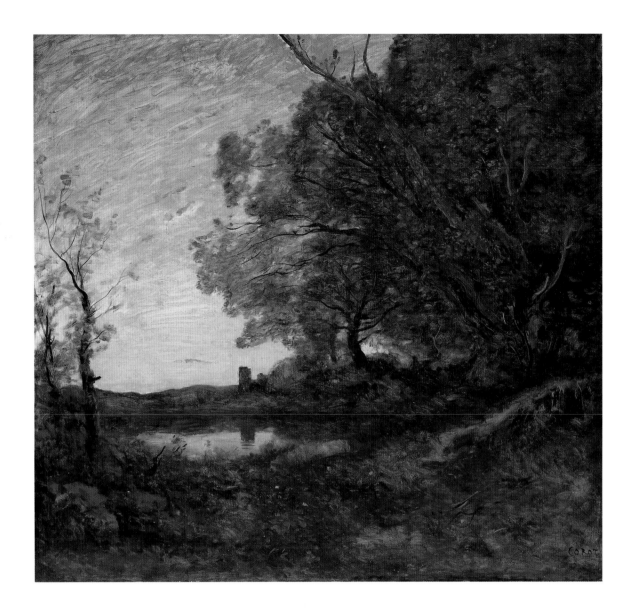

130

Le Soir (tour lointaine)
(Evening: Distant Tower)

Ca. 1860–65
Oil on canvas
42⅞ × 45⅝ in. (109 × 116 cm)
Signed lower right: COROT
Musée d'Orsay, Paris R.F. 1793

R 1798

These two canvases were painted to decorate the home of Mme Castaignet, an old friend of the artist who had a house at Montlhéry, south of Paris in the direction of Orléans. Moreau-Nélaton wrote that "Mme Castaignet . . . the daughter of Mme Herbault, rivals Corot's mother in the art of arranging a pretty woman's hair. He has known her for fifty

years. A charming intimacy reigns in that house, where the sculptor Farochon and the musician de Bériot come to visit, where Corot smokes a pipe in the evening, quite informally, sitting at a corner of the piano from which the mistress of the establishment excels at drawing harmonious enchantments."[1] Moreau-Nélaton was describing a visit made in August 1859. As for the two paintings, unfortunately neither the date nor the nature of their commission is known, but stylistic indicators suggest that they were executed in the mid-1860s.

Like his forebears Claude-Joseph Vernet and Hubert Robert, Corot built these decorative landscapes on contrast and complement. The compositions are almost mirror images, each with a mass of trees on one side and a few individual trees on the other framing a watery expanse, distant hills, and a tall, square tower. But the artist intentionally worked these similar compositions in different ways. *Le Matin* is done in paints

mixed with white to lend them greater substance and density. The gently leaning birch tree at the far left is carefully finished with these thicker paints, as are the two cows and the figure in the middle ground. A variety of painterly effects, from drawing done with the end of the brush handle to a sprinkling of stalkless flowers, throws the foreground into relief and firmly pushes the background into the distance. *Le Soir* is executed differently. Its nearly monochrome palette of drab browns contrasts markedly with the fresh greens of *Le Matin*. The paint is thinly applied, and its effect relies on translucencies of glazes and scumbles. No part of the canvas is worked with either the precision of detail or the density of pigment that one sees in *Le Matin*. In *Le Soir* Corot put his oft-repeated advice to the test. He rendered the *effet*—the dominant impression, conveyed by the composition and the palette—and no more. Evidently he allowed himself a freer and more summary execution in paintings destined for decoration than in his commercial work. The Salon paintings, even when deliberately naive or *bonhomme* (to use the jargon of the day), were always carefully finished, although they were often of the same large size as the decorative pictures.

The view seen in *Le Matin* recalls Mme Castaignet's village of Montlhéry.[2] The thirteenth-century dungeon of its feudal castle, which rises to a height of one hundred feet, is Montlhéry's great monument; Corot depicted it through the trees at the left of the painting. He painted the tower on at least two other occasions, and on the back of one of these paintings is the annotation "chez Mme Castaignet à Montlhéry" (R 1299; the second painting is R 1300). The tower in *Le Soir*,

however, seems only generically related to the dungeon of Montlhéry. A drawing in a sketchbook now at the Musée Carnavalet in Paris may be a "première pensée" for *Le Soir* (fig. 134).[3]

1. "Mme Castaignet . . . est la fille de Mme Herbault, la rivale de la mère Corot dans l'art de coiffer une tête de jolie femme. On se connaît depuis cinquante ans. Une douce intimité règne dans cette maison, où fréquentent le sculpteur Farochon et le musicien de Bériot, où, le soir, Corot fume *pipette*, sans façon, au coin du piano, dont la maîtresse du logis excelle à tirer d'harmonieux enchantements." In Robaut 1905, vol. 1, p. 197.
2. I thank Rebecca A. Rabinow for bringing this to my attention.
3. I thank Anne M. P. Norton for bringing it to my attention.

Cat. no. 129:

PROVENANCE: Painted for Mme Castaignet, Montlhéry; her son, by 1875; Alfred Chauchard (1821–1909), until his death; his bequest to the Musée du Louvre, Paris, 1909; transferred to the Musée d'Orsay, Paris, 1986

EXHIBITIONS: Paris 1910a, no. 17, as *Le Matin*

REFERENCES: Robaut 1905, vol. 3, p. 196, no. 1797; Compin, Lacambre, and Roquebert 1990, pp. 122–23, ill.

Cat. no. 130:

PROVENANCE: Painted for Mme Castaignet, Montlhéry; her son, by 1875; Alfred Chauchard (1821–1909), until his death; his bequest to the Musée du Louvre, Paris, 1909; transferred to the Musée d'Orsay, Paris, 1986

EXHIBITIONS: Paris 1910a, no. 18, as *Le Soir*

REFERENCES: Robaut 1905, vol. 3, p. 196, no. 1798; *Corot* 1910, pl. IV; Compin, Lacambre, and Roquebert 1990, pp. 122–23, ill.

131

Souvenir de Riva
(Souvenir of Riva)

Ca. 1865–70
Oil on canvas
25¼ × 36¼ in. (64.1 × 92.2 cm)
Signed lower right: COROT
The Taft Museum, Cincinnati, Ohio
Bequest of Mr. and Mrs. Charles Phelps Taft 1931.439

R 1805

This work is the culmination of Corot's long engagement with the North Italian site it depicts. He visited Riva, a picturesque village spectacularly situated at the northern tip of Lake Garda, in 1834 on his second trip to Italy, and at that time he made the small oil sketch now at Saint Gall (cat. no. 58). That sketch established the composition for the great painting

Fig. 135. Corot. *Vue prise à Riva (Tyrol italien)* (*View of Riva, Italian Tyrol*; R 360). Oil on canvas, 10⅜ × 15¾ in. (26.5 × 40 cm). Private collection

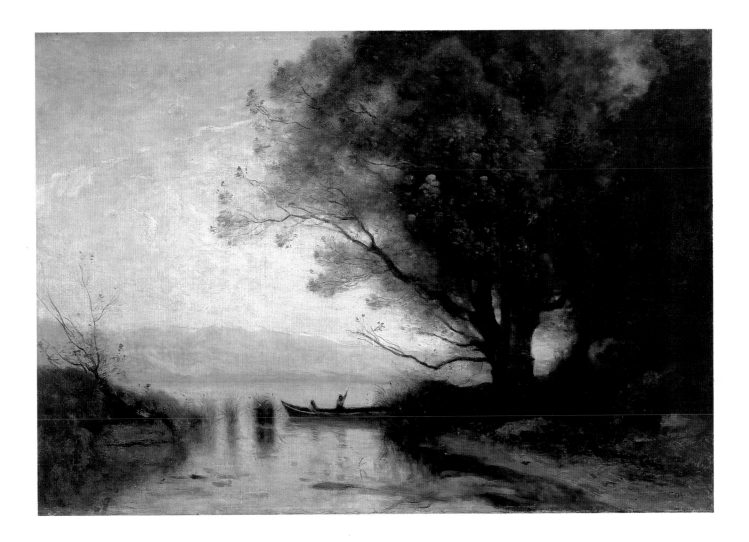

now in Munich, which Corot sent to the 1835 Salon (cat. no. 59). About 1850, Corot returned to the composition—he still owned the Salon painting[1] and its sketch—and made a reprise that was largely faithful to the site but with less topographical detail (cat. no. 94). Sometime in the following decade, he painted a new version shrouded in mist (fig. 135). The rocky scenery of Lake Garda no longer carried the composition; rather, the massing of trees and their reflections constituted the essential effect. A final variant of that version is the painting catalogued here. The Italian Alps are still visible on the horizon, but the trees are those extraordinary specimens native only to Corot's imagination. Unlike the young growth seen in early versions of the scene, these trees—Robaut identified them as oaks[2]— are grizzled eminences.

The strength of the picture, and indeed its content, lie in the Rorschach-like pattern of inky reflections rendered in subtly harmonized hues close in tone. Some twenty years after Corot painted this work, Monet would arrive at a similar point of abstraction in his series of "mornings on the Seine," not by emulating Corot but through an identical procedure of reducing his paintings to their bare essentials. As early as 1847, critics such as Théophile Thoré had recognized that this process was the basis of Corot's genius: "Two notes only, which either meld or play off one another, dark sepia and dull silver; a simple and restrained execution, a very melancholy feeling; silence and reverie; that's it."[3]

There are a number of related pictures, ranging from the celebrated *Souvenir de Mortefontaine* (cat. no. 126) and *Souvenir des environs du lac de Nemi* (cat. no. 127) to an 1871 *cliché-verre* of a similar scene.[4] Corot also represented Riva and Lake Garda in several other works that are compositionally unrelated to the present painting.[5] Robaut pronounced the work "of the highest order" when he saw it at the gallery of Arnold et Tripp in May 1894, but he did not associate it with Riva. In his notes he entitled it *Bouquets d'arbres à l'étang de pêche, matin (Cluster of Trees at the Fishing Pond, Morning)* and dated it to 1865–70.[6]

1. It is not known when Corot gave the Salon painting to the sculptor Molkenecht, but I have assumed here that he still had it in 1850.
2. Unpublished note in Robaut *carton* 23, fol. 720.

3. "Deux notes seulement qui se combinent ou qui se répondent, le bistre foncé et l'argent mat, une exécution simple et sobre, un sentiment très-mélancolique, le silence et la rêverie; voilà." Thoré, speaking of *Effet du soir*, also known as *Pêcheurs tendant leurs filets, le soir* (R 504), in Thoré 1847, p. 95, quoted in Wissman 1989, pp. 67–68.
4. Delteil 1910, no. 89, Cabinet Cantonal des Estampes, Vevey, Switzerland.
5. See, for instance, R 319, 1667, 2328, 2400, and Dieterle 1974, no. 19.
6. Robaut *carton* 23, fol. 720.

PROVENANCE: Arnold et Tripp, Paris, by May 1894;* Alexander Young, London; Thos. Agnew & Sons, London, by November 1906;** Scott and Fowles, New York; entered the Taft collection, Cincinnati, January 22, 1908; bequeathed by Mr. and Mrs. Charles Phelps Taft to The Taft Museum, Cincinnati, 1931

REFERENCES: Robaut *carton* 23, fol. 720, as *Bouquets d'arbres à l'étang de pêche, matin*, erroneously identified as part of the Moreau-Nélaton bequest to the Musée du Louvre, Paris; Robaut 1905, vol. 2, pp. 196–97, no. 1805, ill.; Halton 1906, pp. 9–10, ill. p. 17; Hoeber 1915, p. 116; Meyer 1995, pp. 251–52, ill.

* Robaut *carton* 23, fol. 720.
** Halton 1906, p. 3.

132

Les Chevriers des îles Borromées (Goatherds on the Borromean Islands)

1866?
Oil on canvas
23⅝ × 30¾ in. (60 × 78 cm)
Signed and dated lower left: COROT 1866 [two superimposed signatures]
Musée des Beaux-Arts, Caen, on deposit from the Musée du Louvre R.F. 1784

R 1731

When this celebrated painting was shown for the first time at Corot's memorial exhibition in 1875, it was given the generic title *Pâtre au bord d'un lac (Shepherd on the Shore of a Lake)*. In their catalogue raisonné of 1905, Robaut and Moreau-Nélaton identified the locale, calling the work *Les Chevriers des îles Borromées*. Paul Jamot, curator of painting at the Louvre, took exception to this title, arguing that Corot had depicted Lake Albano—recognizable by the glimpsed town of Castel Gandolfo crowned by Bernini's splendid domed church, San Tommaso di Villanova. As proof Jamot pointed to Corot's *Souvenir de Castel Gandolfo* (R 1626), also at the Louvre. However, the architectural motifs in these two paintings, while similar, are not identical, and neither of the domed structures represented actually resembles San Tommaso, which Corot convincingly painted with its ribs and lantern in his *Souvenir d'Albano* (R 1679, Musée des Beaux-Arts, Reims).[1]

Robaut, Moreau-Nélaton, and Jamot nevertheless detected an important component of this work, its evocation of an idyllic Mediterranean spot. Obviously Corot's interest was not topographical but rather inspirational. He sought to conjure a beautiful world that differed emphatically from the domesticated landscape of the Île-de-France or the bustling streets of Haussmann's Paris. Elements of this imaginary world—the screen of trees through which one sees a lake, a town, and perhaps a distant mountain—recur in any number of Corot's late, Italianate landscapes. Josine Smits put it right when she observed that "the more Corot's memories of Italy were transformed into a pastoral dream, the more the architectural motifs receded toward a faint horizon, shrinking in importance to become vague symbols of a culture and locality."[2] A culture and a locale, one should add, that were sanctioned by time and precedent as the fitting objects of French reverie. Corot was simply following a tradition established by Claude and Poussin, extended by Joseph Vernet and Hubert Robert, and codified by Henri Valenciennes. It is interesting that Moreau-Nélaton and Jamot nevertheless felt obliged to find a specific site for Corot's view when clearly there cannot be one—evidence, perhaps, that in the early twentieth century it was not enough for Corot to be a poet: the emerging culture of Modernism required that he be a Realist too.

1. I thank Andrew Shelton for bringing this to my attention.
2. Smits 1991, p. 295.

PROVENANCE: Mme Alfred Koechlin, probably before 1872, by 1875;* Count Daupias, Lisbon; his sale, Galerie Georges Petit, Paris, May 16–17, 1892, no.

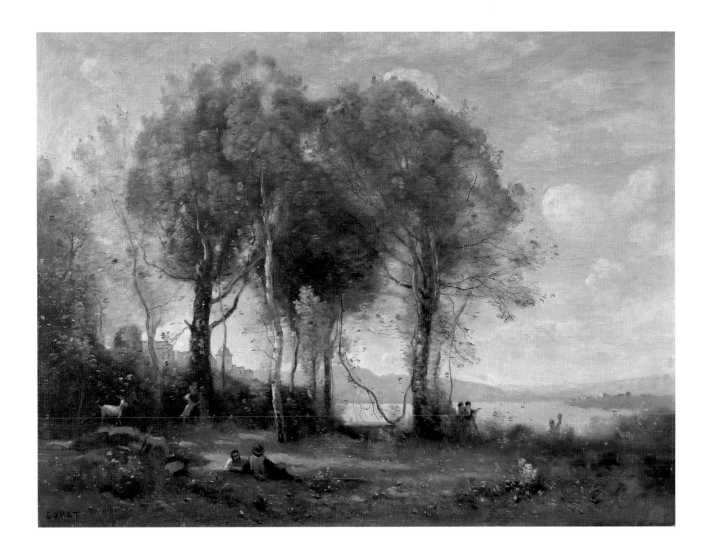

102, as *Le Lac*, sold for 85,000 francs;** Alfred Chauchard (1821–1909), until his death; his bequest to the Musée du Louvre, Paris, 1909; transferred to the Musée des Beaux-Arts, Caen, 1975

EXHIBITIONS: Paris 1875a, no. 200, as *Pâtre au bord d'un lac*; Paris 1910a, no. 9; Lyons 1936, no. 75

REFERENCES: Robaut 1905, vol. 3, pp. 182–83, no. 1731, ill., and vol. 4, p. 276; Cornu 1911, p. 127, ill. p. 141; Guiffrey 1911, pp. 10, 69, ill.; Jamot 1929, pp. 33–34,

pl. 42, as *Les Chevriers de Castel Gandolfo*; Bazin 1973, p. 288; Compin and Roquebert 1986, p. 228

* Mme Alfred Koechlin owned two other works in the 1875 memorial exhibition: *Effet du soir*, no. 198 (R 1900), and *Vaches à l'abreuvoir*, no. 199 (R 1907). Might this Mme Koechlin be the wife of the artist Alfred-Eugène Koechlin (1845–1878), who was a student of Corot's friend François-Louis Français?
** See Anon. 1892a.

133

La Lettre (The Letter)

Ca. 1865
Oil on panel
21½ × 14¼ in. (54.6 × 36.2 cm)
Signed lower left: COROT
The Metropolitan Museum of Art, New York
H. O. Havemeyer Collection, Gift of Horace Havemeyer, 1929
29.160.33

R 1426

Here Corot achieves the traditional goal of genre painting: he depicts a scene of everyday life, and we willingly enter into his deception. A woman, lost in thought, absorbs the meaning of the letter that she holds in her lap. Nothing in the scene alludes to the contents of the letter—there are no hidden clues—so we are left to imagine a scenario entirely on our own. Perhaps the woman has received instructions for a tryst, or perhaps she has lost a love. Many observers interpret her slumped posture as a sign of disappointment, loss, or grief. One writer thought that she held an old letter from a lover, a soldier who had just died.[1]

Such a scene has many roots. Art historians have suggested as sources the eighteenth-century French painter Chardin and the seventeenth-century Dutch painters de Hooch and Vermeer. Chardin's works were accessible and well known to Corot, who admired his gift for unaffected painting. It is also recorded that Corot's appreciation of Netherlandish painting increased after his trip to Holland with Constant Dutilleux in 1854. (One should remember, however, that Vermeer was rediscovered during Corot's life not in Holland but in France.) Still, in seventeenth- and eighteenth-century genre scenes the figure is invariably placed in a credible interior, a bedroom or sitting room, and most frequently is shown in the act of writing or reading. To record the aftermath of reading is rare before the mid-nineteenth century, when Realist painters such as François Bonvin, Armand Leleux, and Victor Chavet, or more fashionable painters like Alfred Stevens and James Tissot, began to invest the genre scene with a stronger psychological dimension. Antje Zimmermann sees a connection between this painting and Leleux's *Le Message* (Musée des Beaux-Arts, Dijon), which may have been shown at the Salon of 1859;[2] Chavet's *La Dormeuse* (lost), certainly exhibited at the Salon of 1859, has also been proposed as a source.[3]

Corot, however, distinguishes his genre pictures in important ways from those of other painters. Examination reveals that the figure sits in an artist's studio and thus that she is a model. The chair in which she sits is a recognizable furnishing of the little office that opened onto Corot's studio, which was lined with small paintings and sketches like those visible in the picture.

In the course of painting this work on panel, Corot as usual made some minor adjustments: the position of the letter was shifted, the neckline of the chemise moved, and the model's right shoulder lowered.[4] Presumably her chemise has been loosened so that the artist—and thus, the viewer—may enjoy the sight of her beautiful shoulder and neck. Corot's relationship with earlier genre painting is indeed "a meeting of two similar sensibilities that give expression to two related bourgeois societies."[5] But by locating his scene in the studio he gives it an air at once timeless and responsive to modern trends away from sentimentality.

This painting was owned by a Parisian collector named Gustave Arosa, whose sale in 1878 included eight works by Corot, two of them figure paintings—an indication that

Fig. 136. Paul Gauguin (1848–1903). *Faaturuma (Melancholic)*, 1891. Oil on canvas, 37 × 26⅞ in. (94 × 68.3 cm). Purchase, Nelson Trust, The Nelson-Atkins Museum of Art, Kansas City

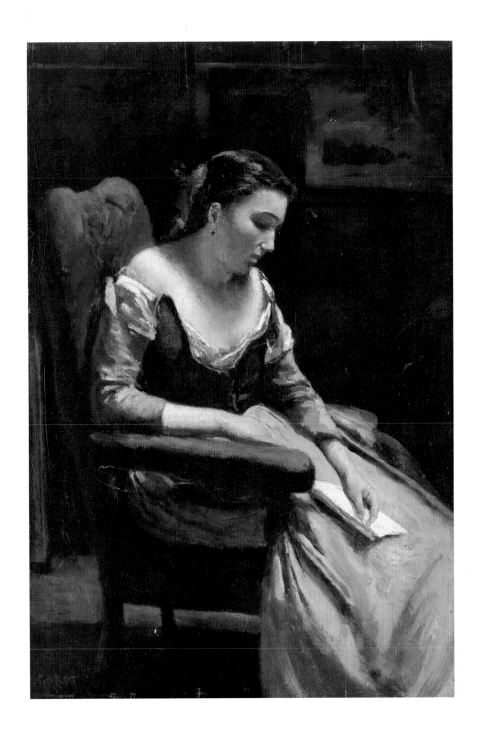

Corot's figure paintings were by no means hidden; they circulated freely on the art market.[6] Arosa had an album made containing photographs of the paintings in his collection; Gauguin owned one copy of the album. It has been suggested that the photograph in it of *La Lettre* directly inspired Gauguin's *Faaturuma* (fig. 136).[7]

1. Shea 1972.
2. Zimmermann 1986, p. 160.
3. I thank Anne M. P. Norton for this suggestion. For a reproduction, see Paris 1974, p. 47, fig. 46.
4. Charlotte Hale, report, March 8, 1995. Archives, Department of European Paintings, The Metropolitan Museum of Art, New York.
5. "une rencontre de deux sensibilités analogues, exprimant deux civilisations bourgeoises apparentées." Charles Sterling, note; Archives, Department of European Paintings, The Metropolitan Museum of Art, New York.
6. The other figure painting was *Italienne assise, jouant de la mandoline, dans l'atelier*, R 1427.
7. Field 1977, p. 334.

PROVENANCE: Gustave Arosa (1818–1883), Paris, probably before 1872, until 1878; his sale, Hôtel Drouot, Paris, February 25, 1878, no. 13, as *La Lettre*; purchased at that sale by Pinart for 3,300 francs; Louisine Havemeyer (1855–1929), New York; bequeathed to her son Horace Havemeyer (1886–1957), 1929; his gift to The Metropolitan Museum of Art, New York, 1929

EXHIBITIONS: New York 1930b, no. 19, as *The Letter*; New York 1971, no. 15; New York 1993, no. A108

REFERENCES: Robaut 1905, vol. 3, pp. 60–61, no. 1426, ill.; Bernheim de Villers 1930a, p. 61, no. 232, ill.; Wehle 1930, p. 56; *Havemeyer Collection* 1931, p. 66, ill. p. 67, as *Figure Piece—The Letter*; Rosen and Marceau 1937, p. 86, fig. 19; Jewell and Crane 1944, ill. p. 97; *Havemeyer Collection* 1958, p. 14, no. 72; Chicago 1960, p. 12; Leymarie 1961, pp. 80–82, ill.; Sterling and Salinger 1966, pp. 60–61, ill.; New York 1971, p. 9, no. 15, ill.; Shea 1972; Field 1977, p. 334, fig. 83; Bühler 1979, p. 145, fig. 35; Zimmermann 1986, pp. 133, 160, 163, 371, fig. 135; Selz 1988, pp. 242–44, ill.; New York 1993, pp. 249, 286, 309, no. A108, ill. p. 308

L'Atelier de Corot
(The Artist's Studio)

Ca. 1865–66
Oil on canvas
22 × 18⅛ in. (56 × 46 cm)
Signed lower left: COROT
Musée d'Orsay, Paris, on deposit from the Musée du Louvre
R.F. 3745
Ottawa and Paris only

R 1557

Robaut placed this work at the beginning of the series of six paintings depicting a model seated beside an easel in Corot's studio. He dated it to about 1865, a date that was corroborated many years later by information given by a former owner to the director of the Louvre. "The history of the master's *Atelier* is short: it was bought in 1866 or 1867, in the studio itself, by his friend Louis Briand, and it remained in the same apartment for sixty-seven years . . . near the Louvre, at 5, rue Bonaparte."[1] The date of 1865 is further confirmed in Henri Dumesnil's book written in 1875: "In 1865 and later [Corot] started once again to paint figures and nudes from the model, but much larger than those ordinarily seen in his paintings . . . among these studies are delightful works, including the picture that represents a *Woman in an Interior;* she is dressed in a red blouse and a yellow skirt; at her left is an upholstered chair that was in the studio—of a beautiful color. This 'morsel' and other, similar ones display wonderful impressionistic qualities and the distinct feeling of harmony one finds in all his creations."[2]

All six of Corot's "atelier" paintings are set in his studio at 58, rue de Paradis-Poissonnière (now rue du Faubourg Poissonnière), but this work and the one in Lyons show, more specifically, the antechamber adjacent to the studio. Here the figure takes approximately the same position as the model does in *La Lettre* (cat. no. 133) and *Italienne assise* (fig. 139), both of which immediately anticipate the series of "atelier" paintings; indeed, the model in *Italienne assise* and the figure in the present painting hold the same mandolin. In this work and in the last of the series, the painting in Lyons (cat. no. 138), which is inscribed with the date 1870, the model sits near a framed picture without looking at it, as if she were resting on an available chair before taking up her pose for the artist. In this sense she is the opposite of the nude model in Courbet's enormous *Atelier du peintre* (fig. 137), who gazes adoringly at the painter's work. Several writers have attempted without success to identify the picture on Corot's easel,[3] but the only likely candidate appears to be the 1864 sketch for one of the decorations of the Hôtel Demidoff, *Orphée salue la lumière* (fig. 130).

On the occasion of the acquisition of this picture for the Louvre in 1933, Paul Jamot, curator and great connoisseur of

French painting, wrote a fine appreciation of the work:

Among Corot's "figures," it stands as one of the most beautiful and most charming. . . . Corot painted seven or eight variations on this modest theme, a theme that he particularly liked. He was never more inspired than in the canvas that has recently come to the Louvre. . . . The orange-red of the blouse that bursts out from amid a discreet harmony of gray and black is almost unique in Corot's work. The painter orchestrated his composition with such instinctive refinement and precision that this flame of brilliant, ruddy crimson at its center draws out the muted reds—the fabric that covers the chair in the foreground, and, in the background, the glimpse of a setting sun in one of the paintings propped on a shelf that runs along the wall—while the dark background, a more mysterious dark than one ordinarily finds in Corot's work, helps make the red blouse look even richer and more resonant! Perhaps no other painting of Corot so imperiously calls for comparison with Vermeer.[4]

Radiographs reveal an earlier figure composition.

1. "*L'Atelier* du maître n'a qu'une histoire bien courte, il fut acheté en 1866 ou 1867, dans l'atelier même du maître par son ami, M. Louis Briand, et il est resté soixante-sept ans dans le même appartement . . . à la porte du Louvre, au no. 5 de la rue Bonaparte." Director, Musées Nationaux and École du Louvre, Paris, letter to M. Guiffrey, curator, Département des Peintures, Musée du Louvre, Paris, March 25, 1933. Archives, Département des Peintures, Musée du Louvre, Paris.
2. "En 1865, et plus tard, il se mit à peindre de nouveau des figures et des académies, mais plus grandes que celles qu'on voit d'ordinaire dans ses tableaux . . . parmi ces études, il y en a qui sont agréables, entre autres, celle qui représente une *Femme dans un intérieur;* elle est vêtue d'un corsage rouge et d'une jupe jaune; à gauche est placée une chaise en tapisserie, laquelle était dans l'atelier: c'est d'une belle couleur; ce morceau et d'autres analogues offrent de belles qualités d'impression et le juste sentiment de l'harmonie qu'on rencontre dans toutes ses productions." Dumesnil 1875, pp. 82–83.

Fig. 137. Jean-Désiré-Gustave Courbet (1819–1877). *L'Atelier du peintre. Allégorie réelle (The Painter's Studio)*, 1855. Oil on canvas, 142⅛ × 235½ in. (361 × 598 cm). Musée d'Orsay, Paris (R.F. 2257)

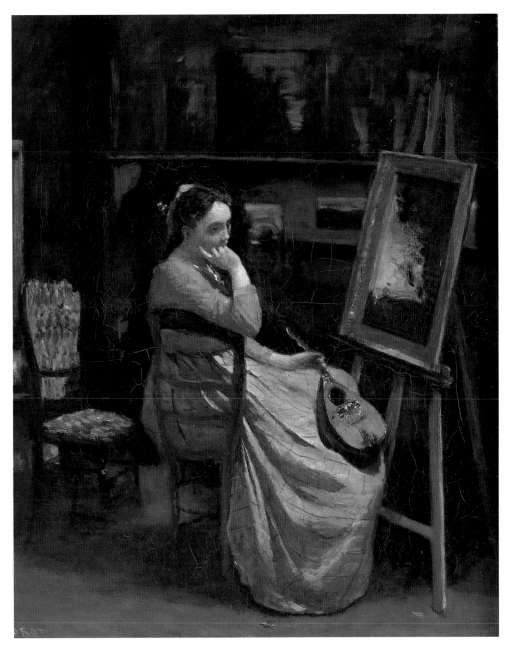

3. See, for example, Gale 1994, p. 116, where *Macbeth* (fig. 110), *Dante et Virgile*, and *L'Étoile du berger* (cat. nos. 115, 125) are proposed, even though these canvases differ greatly in both dimensions and proportions from the picture Corot shows.

4. "Parmi les 'figures' de Corot, elle compte comme une des plus belles et des plus charmantes.... Corot a peint sept ou huit variantes de ce thème modeste qui lui plaisait particulièrement. Il ne fut jamais mieux inspiré que dans la toile qui est depuis peu au Louvre.... Le rouge orangé du corsage qui éclate au milieu d'une harmonie discrète en gris et noir est un cas presque unique chez Corot. Avec quel raffinement instinctif et quelle justesse le peintre a-t-il orchestré sa composition de façon qu'à cette flamme d'éclatante et rutilante pourpre qui en fait le centre répondissent des rougeoiements étouffés, ceux de la tapisserie qui recouvre une chaise au premier plan, et, dans le fond, la note d'un soleil couchant sur un des tableaux que supporte une tablette le long du mur, tandis que le fond noir, d'un noir plus ténébreux qu'on ne le rencontre d'ordinaire chez Corot, contribue à faire paraître plus riche et plus sonore la note du corsage rouge! Aucun tableau de Corot n'appelle peut-être plus impérieusement la comparaison avec Vermeer." Jamot 1933, p. 66.

PROVENANCE: Purchased from the artist by Louis Briand, Paris, about 1866; by inheritance to Hubert Briand;* sale, "Tableaux—aquarelles—pastels—dessins: Appartenant à Divers . . . ," Hôtel Drouot, Paris, March 3, 1933, no. 49, as *L'Atelier du maître en 1865;* purchased at that sale by the Musée du Louvre for 211,000 francs, with the assistance of Mme Morand, in memory of her husband, Hubert Morand

EXHIBITIONS: Paris 1933, no. 70; Lyons 1938–39, no. 7; Paris 1946b, no. 183; Agen, Grenoble, Nancy 1958, no. 5; Paris 1962, no. 61; Edinburgh, London 1965, no. 88; Bordeaux 1969, no. 110; Saint-Paul-de-Vence 1973, no. 770; Paris 1975, no. 109; Marseilles 1979, no. 97; Dijon 1982–83

REFERENCES: Dumesnil 1875, p. 83; Meier-Graefe 1905, p. 84 (English translation in New York 1986, n.p.); Robaut *carton* 27, fol. 57 quarto; Robaut 1905, vol. 1, pp. 225–26, and vol. 3, pp. 112–13, no. 1557, ill.; Goujon 1909, p. 473; Meier-Graefe 1913, pp. 104, 108; Bernheim de Villers 1930a, p. 64, no. 256, ill.; Jamot 1933, p. 66, ill. p. 1; Jamot 1936, p. 66; Bazin 1942, pp. 59, 107, 122, pl. 105; Corot 1946, vol. 2, pp. 100–101; Bazin 1951, pp. 112, 132, pl. 117; Baud-Bovy 1957, pp. 128–29; Hours 1962, p. 4, ill.; Leymarie 1962, p. 112; Hours 1972, pp. 140–41, ill.; Bazin 1973, pp. 61, 271, 292, ill. p. 242; Leymarie 1979, p. 138, ill. p. 139; Dijon 1982–83, p. 174, n. 34, p. 185, fig. 325; Zimmermann 1985, pp. 405–6; Compin and Roquebert 1986, p. 158, ill.; Zimmermann 1986, pp. 112, 114–16, 120, 123–25, 127, 132–33, 138–40, 145, 215, 224–25, 368, pl. 124; Selz 1988, pp. 236, 238, 240, ill. p. 237; Rosenblum 1989, p. 102, ill.; Wissman 1989, pp. 110, 193; Clarke 1991a, p. 104, fig. 98; Gale 1994, p. 116, ill. p. 117

* Director, Musées Nationaux and École du Louvre, Paris, letter to M. Guiffrey, curator, Département des Peintures, Musée du Louvre, Paris, March 25, 1933. Archives, Département des Peintures, Musée du Louvre, Paris.

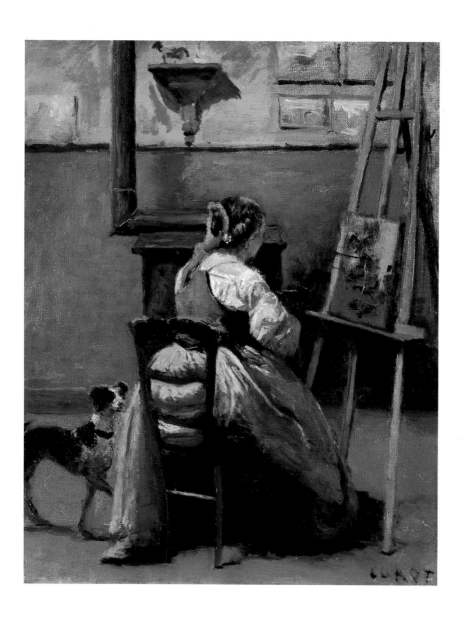

135

L'Atelier de Corot
(The Artist's Studio)

Ca. 1865–68
Oil on panel
16 × 13 in. (40.6 × 33 cm)
Signed lower right: COROT
The Baltimore Museum of Art
The Cone Collection, formed by Dr. Claribel Cone and
Miss Etta Cone of Baltimore, Maryland
New York and Ottawa only

R 1559 bis

This delicious morsel of painting, to use the phrase favored by nineteenth-century connoisseurs, probably represents Corot's first idea for the atelier scene he amplified on the panel now in Washington (cat. no. 136) and the canvas now at the Louvre (cat. no. 137). A model, dressed in the costume of an Italian

peasant, sits down momentarily on the artist's chair to inspect a landscape in progress. A whippet lifts its paw pleadingly, but the model is too engrossed in her thoughts to notice. The fluid brushstrokes and absence of fine detail are indicators that Corot left this work in the state of an *ébauche*, that is, a well-developed sketch that has not been carried to the same degree of finish as a completed work. It seems logical to assume that Corot refined the composition he worked out here into the finished painting in Washington (cat. no. 136), which he displayed in his salon in a place of honor. The picture in the Louvre (cat. no. 137) is probably a replica of the Washington

painting made for a client. Corot's sketches and *ébauches* were also prized by collectors in the 1860s and 1870s; critics such as Jules Castagnary preferred them to his finished paintings. It is not known when or to whom Corot first sold this work, but it had left his studio by 1872, when all of the works still in his possession were photographed by his friend Charles Desavary.

The painting on the easel is a small sketch called *Ville-d'Avray. Un Bouquet d'arbres* (*Ville-d'Avray: A Cluster of Trees;* R 291, location unknown).[1]

1. I thank Anne M. P. Norton for this identification.

PROVENANCE: Eugène Ducasse, Paris, probably before 1872, by 1878; Paul Rosenberg & Co., New York, until 1947; sold to Etta Cone (1870–1949), Baltimore, for $15,000, December 17, 1947; her bequest to The Baltimore Museum of Art, 1950

EXHIBITIONS: Paris 1878b, no. 94, as *La Femme peintre à son chevalet,* lent by Ducasse; Chicago 1960, no. 97; Williamstown 1981, no. 17

REFERENCES: Meier-Graefe 1905, p. 84; Robaut *carton* 27, fol. 59; Robaut 1905, vol. 3, pp. 112–13, no. 1559 bis, ill., and vol. 4, p. 279; Bouyer 1909, p. 305; Goujon 1909, pp. 472–73; Meier-Graefe 1913, pp. 103–4; Jamot 1929, p. 35; Bernheim de Villers 1930a, no. 255, ill.; Meier-Graefe 1930, p. 95; Bazin 1942, pp. 59, 107, 122; Corot 1946, vol. 2, pp. 100–101; Bazin 1951, pp. 112, 132; Baud-Bovy 1957, pp. 128–29; Leymarie 1962, p. 112; Baltimore Museum of Art 1967, no. 13, ill.; Bazin 1973, pp. 61, 271, 290–91; Paris 1975, p. 124; Leymarie 1979, pp. 138, 140, ill.; Richardson 1985, p. 194; Zimmermann 1985, pp. 405–6, fig. 8; Zimmermann 1986, pp. 113, 115–18, 122–23, 125–26, 369, pl. 127; Wissman 1989, p. 110; Leymarie 1992, pp. 158–60, ill.; Kobe, Yokohama 1993, p. 313

136

L'Atelier de Corot (The Artist's Studio)

Ca. 1865–68
Oil on panel
24⅜ × 15¾ in. (61.8 × 40 cm)
Signed lower right: COROT
National Gallery of Art, Washington, D.C.
Widener Collection 1942.9.11
New York and Ottawa only

R 1558

Fortunately, an early appreciation of this work exists that gives some insight into how such a painting was understood by Corot's contemporaries. It was written for an 1883 auction catalogue by Bernheim-Jeune, a frequent visitor to the studio and one of the most active dealers in Corot works during the last decade of the artist's life. He described the painting thus: "*L'Atelier.*—The model, at rest for a moment, looks closely at a still-wet canvas that the artist has just finished. She is about to take the canvas in her left hand to see it better, and one senses that she finds the landscape moving. What a marvel of reality and truth is in this studio! How it pervades the very air! Everything is alive and stirring; we ask ourselves, where is Corot? We look for him, for he must be there, and it is with a feeling of deep sadness that we do not find him. The painting is large, firm, without hesitation; the strokes are well placed, done on the first try."[1]

The sureness and suavity of execution that Bernheim-Jeune describes may have been the result of Corot's reliance on the sketch he had made at about half scale (cat. no. 135). While there is some dispute as to which work came first, in all likelihood the Baltimore painting, which was not brought to the same high finish that one typically finds in Corot's figure paintings, served as an *ébauche* for the present picture. The point of view is slightly different—in painting the Baltimore sketch Corot stood closer to the model and the model was closer to the wall—but otherwise this painting largely conforms to the Baltimore sketch. This Washington panel, which remained in Corot's hands until his death, seems to have been used, in turn, as the model for the canvas now at the Louvre (cat. no. 137), although this chronology too has been disputed.[2] In the catalogue for Corot's posthumous sale, the entry for this painting reads, "This picture was in the master's drawing room in Paris."[3]

Corot posed his model against the back wall of his studio on what was then the rue de Paradis-Poissonnière (see cat. no. 134). The studio appears here much as it did at the time of his death, when Alfred Robaut made a careful drawing showing the way it was furnished (fig. 138). As he always did when depicting this particular view, Corot omitted one of the twin stovepipes in order not to crowd the plaster casts hanging to the right of the little shelf. On the wall, from left to right, are *Rome. La Vasque de l'Académie de France* (cat. no. 15);[4] an unidentified unframed landscape; plaster models;[5] *Moulins à vent jumeaux sur la butte de Picardie, près de Versailles* (fig. 78); a

small framed picture, unidentified; *La Blonde Gasconne* (cat. no. 72); and an unidentified landscape to the right of the easel. The painting on the easel may be *La Danse italienne* (R 1678, Musée Saint-Denis, Reims).[6] August Jaccaci, an acute and accurate observer of Corot's work, wrote in 1913 that "being a portrait of a place, each of the little pictures on the walls having been identified, [this work] has the added interest of an invaluable historical document. As a picture pure and simple of a woman in an interior, it represents the supreme achievement of the artist. Everything is true. The real, solid woman, seated, with her face in shadow turned away from us, the light falling on her shoulders as in a Vermeer, gives us the sensation of life itself. She is not posing, she is poised for an instant like a bird on a branch, caught in something she is doing and that we expect her to go on with as we are looking. Every familiar object in that reduced space is given straightforwardly and with masterly authority. In everything, in tone, atmosphere, color, we find here Corot at his highest."[7]

The model's costume is, except for minor color shifts, the same in all three of the versions: yellow skirt, green corset, white shirt, and red hair-ribbon. The detachable sleeves are also seen in the canvases at the Louvre (cat. no. 137) and in Lyons (cat. no. 138), as well as in the earlier painting *La Femme à la perle* (cat. no. 107). The whippet, however, appears only here and in the Baltimore sketch. Since Corot is not known to have had a dog at the time he made these paintings, one can only speculate as to why he included it. It could have been the dog of a neighbor or a visitor to the studio, or, perhaps more likely, he put it in to enrich his allegory. If the mandolin-playing model is a muse of Corot's art, the dog may symbolize the muse's fidelity to her artist.

1. "*L'Atelier.*—Le modèle, un moment reposé, regarde avec attention la toile encore fraîche que le maître vient de terminer. De sa main gauche, elle va prendre le tableau pour le mieux voir, et on sent qu'elle est impressionnée en voyant ce paysage. Quelle merveille de réalité et de vérité dans cet atelier! comme cela est bien enveloppé dans l'air! Tout vit et se meut, on se demande où est Corot; on le cherche, car il doit y être, et c'est avec un sentiment de profonde tristesse qu'on ne le découvre pas. Peinture large, ferme, sans hésitation; les touches sont bien placées, cela a été fait du premier coup." Bernheim-Jeune in Paton sale 1883, pp. 4–5.
2. Robaut and Moreau-Nélaton regarded the Washington panel as the primary work and the Baltimore and Louvre pictures as later variants. Paul Jamot considered the Louvre painting to be a later replica of the Washington panel (Jamot 1929, p. 35); Hélène Toussaint thought the Washington version was a later replica of the Louvre painting (in Paris 1975, p. 124). Lorenz Eitner rightly states that the Louvre composition was traced from this panel. Eitner forthcoming, n.p.
3. "Ce tableau était dans le salon du maître à Paris." Corot's posthumous sale, Hôtel Drouot, Paris, pt. 1, May 26–28, 1875, no. 134, quoted in Robaut 1905, vol. 4, p. 207.
4. Of the four versions of this picture, the one now in Dublin (R 79) was

Fig. 138. Alfred Robaut (1830–1909). *L'Atelier de Corot, 58 rue de Paradis-Poissonnière*, February 1875. Published in Robaut 1905, vol. 1, pp. 316–17

the only one in Corot's possession at his death. See Marie-José Salmon in Beauvais 1987, pp. 24–25.
5. Sold in Corot's posthumous sale, Hôtel Drouot, Paris, pt. 3, June 7–9, 1875.
6. I thank Anne M. P. Norton for this identification.
7. Jaccaci 1913, p. 90.

PROVENANCE: The artist; his posthumous sale, Hôtel Drouot, Paris, pt. 1, May 26–28, 1875, no. 134, as *Jeune Femme assise peignant à l'atelier, un chien debout auprès d'elle*; purchased at that sale by the dealer Hector-Henri-Clément Brame (1831–1899), Paris, for 4,420 francs; Jules Paton, Paris; his sale, Hôtel Drouot, Paris, April 24, 1883, no. 35, as *L'Atelier*; purchased at that sale by Galerie Georges Bernheim, Paris, until at least 1889; Duz and Van den Eynde;* Durand-Ruel & Cie., Paris; sold by them to Peter Arrell Brown Widener (1834–1915), Elkins Park, Pennsylvania, 1892; by inheritance to his son Joseph Early Widener (1872–1943), Elkins Park, Pennsylvania, 1915; given by him to the National Gallery of Art, Washington, D.C., 1942

EXHIBITIONS: Paris 1889, no. 163, as *L'Atelier*, lent by Bernheim

REFERENCES: Roger-Milès 1895, p. 58, as *Femme devant un chevalet*, collection of Brame fils; Widener 1900, p. 14, ill.; Meier-Graefe 1905, p. 84; Robaut *carton* 27, fol. 59 (legend 341); Robaut 1905, vol. 3, pp. 112–13, no. 1558, ill., and vol. 4, p. 207, no. 134, p. 286; Geffroy 1907, p. 364, ill.; Bouyer 1909, pp. 305–6; Goujon 1909, pp. 472–73; Waldmann 1910a, p. 96, ill. p. 86; Jaccaci 1913, p. 90; Meier-Graefe 1913, pp. 103–8, ill. p. 133; Roberts 1915, n.p., pl. 28; Berenson et al. 1923, n.p., ill.; Jamot 1929, p. 35; Bernheim de Villers 1930a, pp. 64, 68, no. 253, ill.; Meier-Graefe 1930, pl. CIV; Berenson et al. 1931, p. 202, ill. p. 203; Waldmann 1938, p. 335, ill. opp. p. 342; Bazin 1942, pp. 59, 107, 122; Corot 1946, vol. 2, pp. 100–101; Bazin 1951, pp. 112, 132; Baud-Bovy 1957, pp. 128–29, 276, n. 74; Leymarie 1962, p. 112; Hours 1972, pp. 38, 40, 140, fig. 42; Bazin 1973, pp. 61, 271, 290–91; Paris 1975, p. 124; Leymarie 1979, pp. 138, 140, ill.; Washington, National Gallery of Art 1985, p. 94; Zimmermann 1986, pp. 112–13, 115–19, 122–23, 125–26, 132–33, 138–39, 143, 146, 215, 220, 369, pl. 125; Selz 1988, p. 240; Wissman 1989, p. 110; Leymarie 1992, pp. 158–60, ill.; Kobe, Yokohama 1993, p. 313, ill.; Gale 1994, pp. 104–5, ill.; Eitner forthcoming

* Widener 1900, p. 14.

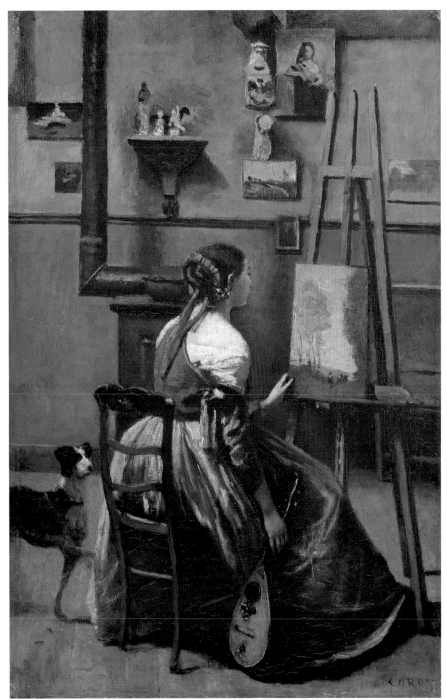

136

L'Atelier de Corot
(The Artist's Studio)

1868–70
Oil on canvas
24¾ × 16½ in. (63 × 42 cm)
Signed lower left: COROT
Musée du Louvre, Paris R.F. 1974

R 1559

This work is a close replica of the panel in Washington (cat. no. 136), at almost exactly the same size but on canvas rather than wood. It reproduces the panel in all important respects, except that an open box of colors replaces the whippet. Hélène Toussaint has argued that this canvas is the primary work from which the Washington and Baltimore pictures were copied, but the reverse seems more likely: the Baltimore picture (cat. no. 135) is manifestly a sketch for the Washington picture, and a sketch would not have been necessary if this canvas already existed. Rather, Corot probably referred to the Washington panel, which he never sold, while he painted this one. When that took place is not known. Robaut thought that all three related works were painted between 1865 and 1868. Most scholars have followed Robaut, although Moreau-Nélaton was inclined to date this work to 1870.[1] Toussaint, however, regarded the "smooth, slightly soapy" facture as an indication of a later date, perhaps 1873, which could be the case.[2] But by 1873 Robaut was always in the studio, and almost nothing escaped his attention; had Corot been working on this canvas, he would have seen it.

In the first years of this century Corot's figure paintings suddenly received a great deal of attention, probably because of the publication in 1905 of Robaut and Moreau-Nélaton's catalogue raisonné. In 1909 Pierre Goujon wrote a particularly fine appreciation of the atelier paintings:

It is known that Corot made several images of his studio.... All of them are from the end of his life. They conclude this long career with an unequivocal expression of sincerity and good faith. And, perhaps more than any other paintings, they provide a completely positive picture of Corot. On the wall, only canvases; no sign of idleness. The model whom he has seated before an easel with a landscape on it is the very muse of his painting. One can tell that the subject has deeply engaged her. Six versions are known. They demonstrate that this painter possesses the gift of universality and nothing of a specialist. They reveal his toil, his experimentation, the richness of his color, his strength, and his imagination. The background, dark and full, all the verve that he demonstrated in constructing the jointed stovepipe, the introduction of a greyhound's undulating movement beside the figure, the relaxed suppleness of the female body, and, on the easel, the lovely warm gold of the frame, the precious open-air study, which is a glimpse of another atmosphere and another light, these show us every aspect of a complete genius.[3]

1. Moreau-Nélaton 1913, pp. 88–91; Moreau-Nélaton 1924, vol. 1, p. 35.
2. "lisse, légèrement savonneuse." Toussaint in Paris 1975, no. 111.
3. "On sait que Corot a donné plusieurs images de son atelier.... Toutes appartiennent à la fin de sa vie. Elles sont pour cette longue carrière une indiscutable conclusion de sincérité et de bonne foi. Au surplus, elles nous donnent, peut-être mieux qu'aucun autre tableau, une définition parfaitement favorable de Corot. Aux murs, rien que des toiles; aucune trace de l'oisiveté. Le modèle qu'il assoit devant un chevalet qui supporte un paysage, c'est la muse même de sa peinture. On devine que le thème l'a profondément diverti. On en connaît six interprétations. Elles démontrent que ce peintre a des dons universels, qu'il n'a rien d'un spécialiste. Elles révèlent son labeur, ses recherches, la richesse de sa couleur, sa force et sa fantaisie. Le fond sombre et plein, tout ce qu'il y a de verve à construire avec aplomb les tuyaux coudés du poêle, à introduire, à côté du personnage, les mouvements onduleux d'une levrette, la souplesse abandonnée du corps féminin, et, sur le chevalet, le bel or chaud du cadre, la chère étude de plein air, qui est un morceau d'une autre atmosphère et d'une autre lumière, nous permettent de faire le tour d'un génie complet." Goujon 1909, pp. 472–73.

PROVENANCE: F. Guillaume, Paris, probably before 1872, by 1875; Victor-Antoine Desfossés (1836–1899), Paris, by 1895; his posthumous sale, Hôtel Desfossés, Paris, April 26, 1899, no. 13, as L'Atelier du peintre; purchased at that sale by the comte Isaac de Camondo (1851–1911), Paris, for 32,000 francs; his bequest to the Musée du Louvre, Paris, 1911

EXHIBITIONS: Paris 1875a, no. 140, as Jeune Fille regardant un paysage et tenant une mandoline, lent by Guillaume; Paris 1895, no. 64, as L'Atelier de Corot, collection of Victor Desfossés, Paris; New York 1946, no. 1; Winterthur 1955, no. 51; New York 1956, no. 25; Paris 1962, no. 60; Paris 1975, no. 111; Kobe, Yokohama 1993, no. 58

REFERENCES: Meier-Graefe 1905, p. 84; Robaut carton 27, fol. 59; Robaut 1905, vol. 3, pp. 112–13, no. 1559, ill., and vol. 4, pp. 274, 291; Bouyer 1909, pp. 305–6; Goujon 1909, pp. 472–73; Jaccaci 1913, p. 90; Meier-Graefe 1913, pp. 103–4; Moreau-Nélaton 1913, pp. 88–91, pl. 21; Moreau-Nélaton 1924, vol. 1, p. 35, fig. 205; Jamot 1929, p. 35; Bernheim de Villers 1930a, pp. 64, no. 254, ill.; Bazin 1936, p. 63, fig. 92; Venturi 1941, pp. 165–66, fig. 108 (English translation in Philadelphia 1946, p. 22); Bazin 1942, pp. 59, 107, 122; Corot 1946, vol. 2, pp. 100–101; Bazin 1951, pp. 112, 132; Baud-Bovy 1957, pp. 129–30, 276, n. 74, pl. XLVIII; Leymarie 1962, p. 112; Hours 1972, pp. 38, 40, 140, fig. 43; Bazin 1973, pp. 61, 271, 290–91; Janson 1978, p. 314, fig. 12; Leymarie 1979, pp. 138, 140, ill.; Zimmermann 1985, pp. 405–6, fig. 8; Compin and Roquebert 1986, p. 154, ill.; Zimmermann 1986, pp. 112–13, 115–19, 122–23, 125–26, 131–32, 138–39, 143, 146, 215, 220, 369, pl. 126; Selz 1988, p. 240; Wissman 1989, p. 110; Leymarie 1992, pp. 158–60, ill.

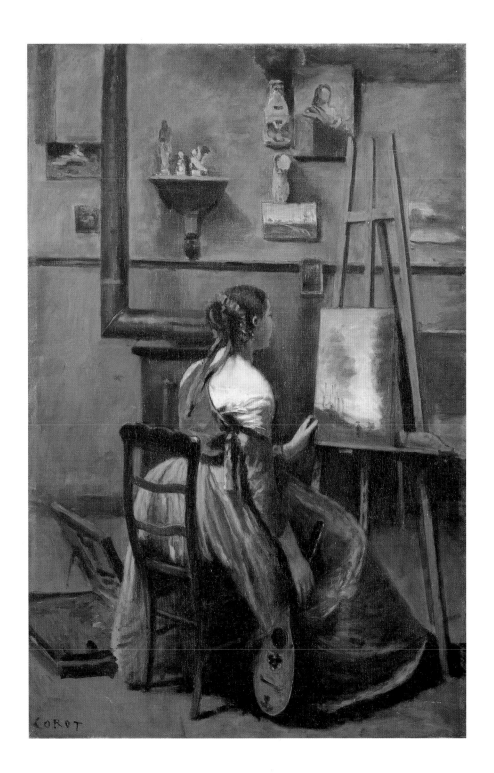

L'Atelier de Corot
(The Artist's Studio)

1870
Oil on canvas
25 × 18⅞ in. (63.5 × 48 cm)
Signed and dated lower left: COROT 1870
Musée des Beaux-Arts, Lyons B-627

R 1561

Many scholars view this work, which is inscribed with the date 1870, as the last in a series of six paintings set in Corot's atelier (cat. nos. 134–139). Moreau-Nélaton placed all six on the same page in his and Robaut's 1905 catalogue raisonné, and they have been considered as a group ever since. However, these six paintings form neither a group nor a series. Properly speaking, this painting is simply a later variant of the painting of about 1865 now at the Musée d'Orsay (cat. no. 134). It and the present work are set in the antechamber to Corot's studio, while the painting now in Washington (cat. no. 136), its sketch in Baltimore (cat. no. 135), and its later variant now at the Louvre (cat. no. 137) are all set in the adjacent studio. In mood and setting, the present work is closer to *La Lettre* (cat. no. 133) and the *Italienne assise* (fig. 139).

The model, who appears to be the same woman who posed for *Sibylle* (cat. no. 142), wears the same detachable sleeves that Berthe Goldschmidt wore for *La Femme à la perle* (cat. no. 107). Otherwise, unlike the other paintings set in Corot's workrooms, this one presents little that is identifiable. The depiction of the paintings on the wall is too summary to reveal which works they are, and the view of the framed picture on the easel is too oblique to allow its identification. It is as if Corot wished to concentrate not on the hallmarks of his art but on the sense of distraction that he creates in this picture. Hélène Toussaint explained the mood of the work by noting that 1870 was a year of loss for Corot: not only was there the turmoil and destruction wrought by the war with Prussia but, on a personal level, Corot suffered the deaths of his nephew Camille Sennegon and of his beloved niece Laure Baudot-Corot.[1] But this painting does not convey melancholy as much as reverie. Jean Leymarie struck the right note when he wrote that of all the atelier pictures, this work "is the most moving in its restraint. The mandolin has disappeared, replaced by the half-open book on her knees, which has given rise to the reverie that floods the lovely face in three-quarter profile, with its firm oval shape and large, melancholy eyes. A captive of her own longings and of the geometric network that encloses her, the model here wears a black velvet skirt with red border whose colors fade in the light one can sense filtering in through the windows. A bouquet of flowers glows softly on the shelf in the background, between the head of the young girl outlined

Fig. 139. Corot. *Italienne assise, jouant de la mandoline, dans l'atelier* (*Seated Italian Woman Playing a Mandolin, in the Studio*; R 1427), ca. 1865–70. Oil on canvas, 23⅝ × 18⅞ in. (60 × 48 cm). Location unknown

against the wall in a sort of square niche and the framed canvas on the easel."[2]

The modest vase of flowers on the shelf serves as a reminder of the rarity of still life in Corot's work. There are only a handful of independent still lifes recorded, all done in the last years of the artist's life (R 2152–R 2154).

1. Toussaint in Paris 1975, p. 123.
2. "est le plus émouvant dans sa sobriété. La mandoline a disparu, remplacée par le livre entrouvert sur les genoux, source de la rêverie qui noie le beau visage de trois quarts, à l'ovale ferme et aux grands yeux mélancoliques. Captif de sa propre attente et du réseau géométrique qui l'enserre, le modèle porte ici la jupe de velours noir à frange rouge dont les couleurs s'amortissent sous la lumière que l'on devine tamisée par le vitrage. Un bouquet de fleurs rayonne doucement sur l'étagère du fond, entre la tête de la jeune fille inscrite contre le mur dans une sorte de niche carrée et la toile encadrée sur le chevalet." Leymarie 1992, p. 160.

PROVENANCE: The banker Alfred Edwards (1856–1914),* by 1878; his sale, "Collection d'un amateur," Hôtel Drouot, Paris, February 24, 1881, no. 10, as *L'Atelier*; purchased at that sale by Durand-Ruel & Cie., Paris, for 5,400 francs; Gustave Tempelaere, Paris, in 1887, until 1888;** the dealer Alexander Reid

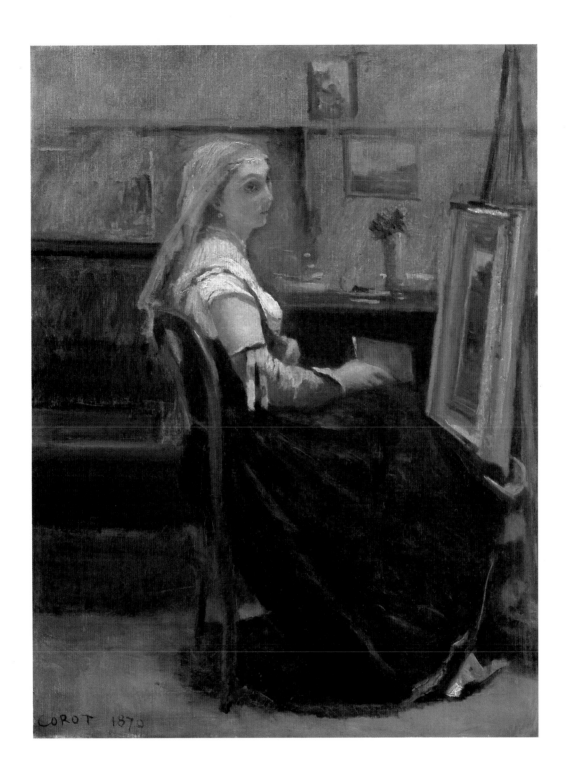

(1854–1932), Glasgow; his sale, "Catalogue des tableaux modernes . . . provenant de la collection de M. A. [lexander Reid] (de Glasgow)," Hôtel Drouot, Paris, June 10, 1898, no. 17, as *L'Atelier;* purchased at that sale by the dealer Gustave Tempelaere, Paris, for 13,300 francs; sold by him to the Musée des Beaux-Arts, Lyons, 1901

EXHIBITIONS: Paris 1878b, no. 57, as *Femme assise devant un chevalet, un livre en mains,* lent by Edwards; Paris 1936, no. 91; Lyons 1936, no. 95; Belgrade 1939, no. 19; Paris 1950, no. 21a; Venice 1952, no. 24; Bordeaux 1959, no. 186

REFERENCES: Heilbut 1905, ill. p. 104; Meier-Graefe 1905, p. 84; Robaut *carton* 27, fol. 60; Robaut 1905, vol. 3, pp. 112–13, no. 1561, ill., and vol. 4, p. 279; Meynell 1908, ill. opp. p. 258, as *The Model at Rest;* Bouyer 1909, pp. 305–6, ill. opp. p. 304; Goujon 1909, pp. 472–73; Meier-Graefe 1913, pp. 104, 108, ill.

p. 149; Jamot 1929, p. 35; Bernheim de Villers 1930a, p. 64, no. 258, ill.; Meier-Graefe 1930, p. 95, pl. CXXIX; Delaroche-Vernet 1936, ill. p. 20; Jamot 1936, ill. p. 55; Bazin 1942, pp. 59, 122; Bazin 1951, pp. 48, 132; Baud-Bovy 1957, pp. 129–30, pl. XLVI; Hours 1972, pp. 38, 40, 140, fig. 44; Janson 1978, pp. 313–14; Leymarie 1979, pp. 138, 140, ill. p. 141; Zimmermann 1985, pp. 405–6; Zimmermann 1986, pp. 113–16, 121, 123, 124–25, 132, 280, 281–82; Durey 1988, p. 102, no. 1, ill.; Selz 1988, p. 240, ill. p. 239; Wissman 1989, pp. 108–9; Leymarie 1992, pp. 158, 160, ill. p. 161

* According to Lionello Venturi, the collection of paintings sold by Edwards in 1881 had come from Durand-Ruel & Cie., Paris, as collateral against a business loan. Venturi 1939, vol. 2, p. 210.

** Robaut *carton* 27, fol. 60.

139

L'Atelier de Corot
(The Artist's Studio)

Ca. 1870–72
Oil on canvas
25¼ × 19 in. (64 × 48.4 cm)
Signed lower right: COROT Signed on painting on easel: COROT
Spencer and Marlene Hays

R 1560

Since the publication of Germain Bazin's book in 1942, most scholars have accepted his suggestion that this painting is the first one of the atelier pictures Corot made.[1] On the contrary, it seems more likely to be the last: it is the supremely confident summation of his work on this theme. The sparse setting and light palette are not, as David C. Ogawa has argued, signs of Corot's style in the early 1860s but rather the marks of his work of about 1870 and after. Some of the confusion surrounding the picture has undoubtedly been caused by its summary execution. But, as Robaut remarked, "although this painting is not a fully finished work, it creates a sensation."[2] Indeed, if it were not known that the painting shown on the easel, *Prairie au bord d'une rivière* (fig. 140),[3] belonged to Durand-Ruel in 1872, one could think this *Atelier* contemporaneous with the great *Dame en bleu* (cat. no. 162), which is inscribed 1874. Both exhibit the clarity of design and absence of anecdote that characterize Corot's late work. And, unlike any painting earlier in Corot's career, each takes its primary hue from the sumptuous color of the model's clothes: exquisite salmon pink or a splendid kingfisher blue.

Daniel Baud-Bovy suggested that the model was Emma Dobigny,[4] but clearly she is not (see cat. nos. 151, 154, 162). Her name is not yet known, but it has been recognized since 1942 that she assumes the same pose as the subject of a figure study Corot painted on his first trip to Italy, but in reverse (fig. 141).[5] According to Robaut, that early study was given away in 1873 or 1874, a date that provides another *terminus ante quem* for the *Atelier.* However, the Italian study was still in Corot's possession when Charles Desavary photographed the contents of his studio in 1872, while the *Atelier* was not. Thus it appears that the *Atelier* was sold soon after it was made, as were most of the late figure paintings, and before the 1872 photography campaign. The first owner is not known, but the picture probably passed rather quickly to Jules Paton, a distinguished collector who owned a large group of Corots, including another *Atelier* (cat. no. 136). Paton sold it with the rest of his Corots and his Courbets in 1883, at auction.

Fig. 140. Corot. *Prairie au bord d'une rivière* (*Plain on the Bank of a River;* R 1762), ca. 1865–70. Oil on canvas, 14⅝ × 25¼ in. (37 × 64 cm). Location unknown

Fig. 141. Corot. *Femme assise, tenant une mandoline* (*Seated Woman Holding a Mandolin;* R 94), 1826–38. Oil on canvas. Location unknown

I thank Anne M. P. Norton for this identification. Ogawa suggests that the painting is *La Cueillette dans le pacage,* R 1204, which is not as wide as the canvas on Corot's easel. Ogawa 1994, p. 27.
4. Baud-Bovy 1957, p. 129.
5. Bazin 1942, p. 122.

PROVENANCE: Jules Paton, Paris, probably in 1872, until 1883; his sale, Hôtel Drouot, Paris, April 24, 1883, no. 42, as *L'Atelier;* Arnold et Tripp, Paris, in

1. Bazin 1942, p. 122; Leymarie 1979, p. 138; Ogawa 1994, p. 27.
2. "quoique cette peinture ne soit pas très poussée, elle fait sensation."
 Robaut *carton* 27, fol. 58.
3. R 1762 seems to be a perfect match in terms of dimension and composition.

November 1891;* Mme Albert Esnault-Pelterie (d. ca. 1937), Paris, by 1900, until her death;** by descent to her son Robert Esnault-Pelterie (b. 1881), Paris and Geneva, who lent it to the Philadelphia Museum of Art from April 1937 until March 1950; sold by him to Germain Seligmann of Jacques Seligmann & Co., New York, March 1950;† Sam Salz, New York, until 1954; sold by him to William S. Paley (1901–1990), New York, June 4, 1954; his gift to his wife, Barbara Cushing Paley (d. 1978), New York; thence by descent, from 1978 until its sale at "Impressionist and Modern Paintings, Drawings, and Sculpture," Christie's, New York, November 9, 1994, no. 6; purchased at that sale by the present owners

EXHIBITIONS: Paris 1900, no. 118, as *L'Atelier*, lent by Mme Esnault-Pelterie; Paris 1910b, no. 23, as *L'Atelier*, collection of Mme Esnault-Pelterie; Paris 1931, no. 13; Philadelphia 1946, no. 55, as *L'Atelier de Corot*, lent anonymously; Chicago 1960, no. 114, as *Corot's Studio*, lent by Mr. and Mrs. William S. Paley, New York; New York 1969, no. 66

REFERENCES: Heilbut 1905, p. 102, ill.; Meier-Graefe 1905, p. 84; Robaut *carton 27*, fol. 58; Robaut 1905, vol. 3, pp. 112–13, no. 1560, ill., and vol. 4, p. 295;

Rouart 1906, p. 10, ill. p. 11; Bouyer 1909, p. 305, n. 2; Goujon 1909, pp. 472–73; Dorbec 1910, pp. 12–13; Jaccaci 1913, p. 90; Meier-Graefe 1913, pp. 103–4; Jamot 1929, p. 35; Bernheim de Villers 1930a, pp. 64, 68–69, no. 257, ill.; Meier-Graefe 1930, pl. CXVII; Bazin 1942, pp. 59, 107, 122, no. 103, pl. 103; Corot 1946, vol. 2, pp. 100–101, 152, ill. opp. p. 145; Bazin 1951, pp. 34, 54, 112, 132, no. 115, pl. 115; Baud-Bovy 1957, pp. 128–29; Bazin 1973, pp. 61, 271, 290–91, ill. p. 233; Paris 1975, p. 122; Leymarie 1979, p. 138, ill.; Zimmermann 1986, pp. 112–13, 115–17, 119, 121–22, 125–26, 138, 140, 220, 369, pl. 128; Selz 1988, p. 240; Wissman 1989, p. 110; Leymarie 1992, p. 158, ill.; Ogawa 1994, pp. 24–29, ill.; Sartori 1994, pp. 17–19, ill.

* See Robaut *carton 27*, fol. 58.
** Mme Albert Esnault-Pelterie (née Testart) was a significant collector of French nineteenth-century art, notably works by Daumier, Delacroix, Corot, Fantin-Latour, and Millet. See Laughton 1991, pp. 8–11. See also Rouart 1906, pp. 2–21.
† Archives, European Paintings Department, and Registrar, The Philadelphia Museum of Art.

140

Le Chevalier (The Knight)

1868
Oil on canvas
41⅜ × 25⅝ in. (105 × 65 cm)
Signed and inscribed lower left: a mon Eleve & ami Lavieille. C. Corot
Dated lower right: 1868
Musée du Louvre, Paris R.F. 2319

R 1510

"'Correggio, or Giorgione . . . lend me your brushes,' he said, his eye brightening—and livelier, more rapid accents bloomed on his canvas."[1] Corot recorded his interest in Giorgione on this canvas, one of three that depict men in armor.[2] These knights

and the monks featured in some works (see cat. nos. 108, 163) constitute the only male genre subjects painted by the artist. Whether it was Giorgione's figure of Saint Liberale in his Castelfranco *Madonna* or the copy after that figure, now in the National Gallery, London (fig. 142),[3] that inspired Corot most we cannot be sure; but clearly he sought to evoke the Italian painter's hand in his rendering of light glinting off the polished surfaces of the sixteenth-century German armor in which he dressed his model.[4] Further stimuli to Corot may have been Ingres's *Condottière* (1821) and *Jeanne d'Arc au sacre du roi Charles VII, dans la cathédrale de Reims* (1854), both of which were exhibited in the retrospective mounted in 1867, just a year before Corot's canvas was painted.

Fig. 142. Imitator of Giorgione. *A Man in Armor.* Oil on panel, 15⅝ × 10⅝ in. (39.7 × 27 cm). Bequeathed by Samuel Rogers, 1855, National Gallery, London

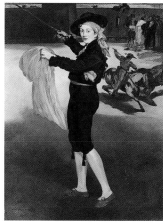

Fig. 143. Édouard Manet (1832–1883). *Mademoiselle V . . . in the Costume of an Espada,* 1862. Oil on canvas, 65 × 50¼ in. (165.1 × 127.6 cm). H. O. Havemeyer Collection, Bequest of Mrs. H. O. Havemeyer, 1929, The Metropolitan Museum of Art, New York (29.100.53)

enormous scale and dramatic contrasts of color and perspective. Although Corot heartily disapproved of the direction modern art was taking, disapproval did not prevent him from absorbing some of its lessons or responding to the subtle pressures of an evolving art market.

As usual, Corot made a number of modifications while painting the canvas. Radiographs reveal that the figure first wore a metal helmet, which was replaced by a soft felt cap.[6] The painting's summary execution led Robaut to consider it a sketch.[7]

In choosing his subject Corot might have drawn, consciously or unconsciously, on a variety of other sources, from the many men in armor at the opera—Meyerbeer's *Robert le diable* and Gounod's *Faust* were both frequently performed in Paris—to the ubiquitous medieval motifs in Romantic painting and literature. A possible source that has gone unnoticed is Manet's *Mlle V . . . en costume d'espada* (fig. 143), which acquired instant notoriety at the Salon des Refusées of 1863.[5] Like Manet, Corot has dressed a model in a capricious costume, and, like Manet, he has placed a vignette in the background to reinforce the subject of the picture. Both paintings are demonstrably fictions: they are obviously studio pictures. Yet Corot's work remains comfortably within the well-established realm of genre painting, while Manet's challenges tradition with its

1. " 'Corrège ou Giorgione (par exemple), prête-moi tes pinceaux,' disait-il, et son oeil s'animait: et les accents naissaient sur la toile, plus rapides et plus vifs." Corot 1946, vol. 2, p. 96.
2. The others are R 1509, Musée du Louvre, Paris, and R 1511, private collection.
3. In Corot's day believed to be by Giorgione.
4. As identified by Stuart W. Pyhrr, curator of Arms and Armor, The Metropolitan Museum of Art, New York. In his unpublished notes, Robaut called the armor fifteenth-century Venetian: Robaut *carton* 27, fol. 57.
5. I thank Anne M. P. Norton for this observation.
6. Hours 1962, p. 4.
7. Robaut *carton* 27, fol. 53.

PROVENANCE: Gift of the artist to his friend and student Eugène Lavieille (1820–1889), Paris, 1868; his posthumous sale, Hôtel Drouot, Paris, April 24–25, 1889, no. 241, as *Étude de guerrier;* purchased at that sale by Durand-Ruel & Cie, Paris, for 900 francs; sold to Brame, Paris, April 30, 1889; Paul Arthur Chéramy (d. 1912), by 1895; his sale, May 5, 1908, Galerie Georges Petit, Paris, no. 124, as *Le Modèle en armure ou le Chevalier;* purchased at that sale by H. Brame, Paris, for 7,000 francs (stock no. 2073); sold to Joseph Reinach (1856–1921), Paris, for 10,000 francs, March 18, 1909; his bequest to the Musée du Louvre, Paris, 1921

EXHIBITIONS: Paris 1895, no. 27, as *Le Chevalier,* collection of Chéramy; Paris (Salon d'Automne) 1909, no. 16, as *L'Homme à l'armure,* lent by Joseph Reinach; Paris 1962, no. 66

REFERENCES: Robaut *carton* 27, fols. 57, 57 bis; Robaut 1905, vol. 1, p. 244, vol. 3, pp. 94–95, no. 1510, ill., vol. 4, p. 290; Vauxcelles 1905, ill. p. 131, as *Le Figurant de théatre;* Goujon 1909, p. 473, ill. p. 475; Moreau-Nélaton 1924, vol. 2, p. 36, fig. 213; Bernheim de Villers 1930a, p. 57, no. 242, ill.; Meier-Graefe 1930, p. 88; Bazin 1942, p. 107; Bazin 1951, p. 113; Hours 1962, p. 4, ill., pp. 34–35, ill.; Leymarie 1962, p. 112; Paris 1962, p. 154, no. 66, ill. p. 155; Bazin 1973, p. 271; Compin and Roquebert 1986, p. 155, ill.; Clarke 1991a, p. 104

141

Une Liseuse (A Woman Reading)

1869–70
Oil on canvas
21⅝ × 14¾ in. (54.3 × 37.5 cm)
Signed lower left: COROT [partially worn away]
The Metropolitan Museum of Art, New York
Gift of Louise Senff Cameron, in memory of her uncle, Charles H. Senff, 1928 28.90

R 1563

In his continuing effort to convince his critics that there was "more than one string to his instrument," Corot sent this work, one of only four figure paintings exhibited during his lifetime,[1]

to the 1869 Salon. When it was first shown, the landscape elements were more prominent—a large tree stood at the left, and the bushy trees to the right were larger and closer—but the critics still recognized the novelty of this *envoi.* Théophile Gautier wrote, "The *Liseuse* is a curiosity among Corot's work in that a figure dominates the landscape. Although the drawing is inaccurate, the subject is pleasing in its naive emotion and its true rustic colors; it's a *bonhomme,* to use a word in studio slang that expresses our thought better than any other and that Corot uses often."[2] The term *bonhomme* was used to describe an awkward or badly drawn figure. Thus, although Corot had responded to the charge that he did nothing but

"begin the same painting all over again,"[3] he was hung for his legendary "incorrect" drawing style by Gautier, the great defender of "style" above all else. Ernest Hache faulted Corot for lacking both realism and style: "His figures are as mystical as his landscapes: it's a vision, this vague, watery *liseuse*." And, ironically, "What style, in the full sense of the word—if it's true that in painting too, the style is the man."[4] Of the regular *salonistes* only Jules Castagnary, heretofore often critical of Corot, discerned in his method "such penetrating, triumphant poetry. . . ."[5]

Perhaps because of its unenthusiastic reception, Corot modified the painting soon after the Salon closed. The photograph by Goupil (fig. 144) shows the work as it first appeared, while a lithographic reproduction by Émile Vernier, deposited at the Bibliothèque Nationale by the printmaker in 1870, shows the work as it is now. As the curator William Ivins pronounced in 1928, "*Voilà ce qui prouve*, that between the Salon of 1869 and the time it took a man to make an elaborate reproduction and have it finished and entered for copyright in 1870, the tree had vanished—and as the litho proclaimed itself as a Corot and Corot was alive and the picture quite new, the change can only have been made by Corot himself."[6] Infrared reflectography undertaken by Charlotte Hale at the Metropolitan Museum reveals the contours of the tree precisely as they appear in the Goupil photograph.

Radiographs show that Corot had made a number of small changes earlier, before the work was photographed. The figure originally turned toward the viewer rather squarely; her left arm was in a slightly different place; the line of the back was somewhat different; the book was held closer to the figure's waist, and her fingers were longer and less foreshortened. The coiled braid of hair was changed twice before it received its definitive placement.[7] Close examination by daylight shows that Corot painted the black skirt over the apron, evidently to divide the mass in two. The skirt is remarkably freely painted, with enlivening strokes of color that conform to nothing other than the artist's whim. In the manner typical of his late work, Corot added bright dashes in the left and right foreground that suggest flowers without describing them.

A woman reading is the most durable of Corot's genre subjects. The overwhelming majority of his approximately 350 figure paintings depict a woman who is engrossed in her reading, meditating on what she has read, or simply asleep with a book in her hand. According to Théophile Silvestre, a contemporary of Corot, the artist hardly ever read, but he bought books along the quays "exclusively for their shapes and colors,"[8] in order to put them in the hands of his models. The reading woman is a motif frequently encountered in French painting, especially in the eighteenth century, when it often had voyeuristic overtones; but here Corot refers directly to his idol Raphael, whose *Belle Jardinière* in the Louvre holds a book, the Scriptures, while seated in a landscape, with the infant Jesus and Saint John the Baptist playing at her knees.

The photographer Louis-Rémy Robert, a contemporary of Corot, produced a photograph similar in spirit to this picture (fig. 145). The photograph dates to the 1850s, and it is possible that Corot knew it.

1. That is, in which the figure plays the dominant role. The other three were *Moine* (R 375, Musée du Louvre, Paris), shown at the Salon of 1840; *La Toilette* (R 1108, private collection), Salon of 1859; *Le Repos* (R 1277, The Corcoran Gallery of Art, Washington, D.C.), Salon of 1861 (cat. nos. 116, 117).
2. "*La liseuse* offre cette curiosité, chez Corot, que la figure domine ici le paysage. Bien qu'assez incorrecte de dessin, la liseuse plaît par sa naïveté de sentiment et sa sincérité de couleur rustique: *c'est bonhomme*, pour nous servir d'un mot de l'argot des ateliers qui rend mieux notre pensée que tout autre, et que Corot emploie souvent." Gautier 1869, p. 364.
3. "recommencer toujours le même tableau." Moreau-Nélaton in Robaut 1905, vol. 1, pp. 243–44.
4. "Ses figures sont aussi mystiques que ses paysages: c'est une vision que cette *liseuse* incertaine et noyée. Quel style, dans toute l'étendue du mot, s'il est vrai qu'en peinture aussi, le style, c'est l'homme!" Hache 1869, p. 298.
5. "poésie si pénétrante, si victorieuse. . . ." Castagnary, "Salon de 1869," in Castagnary 1892, vol. 1, p. 371.
6. William Ivins, letter to Bryson Burroughs, September 1928. Archives, Department of European Paintings, The Metropolitan Museum of Art, New York.
7. Charlotte Hale, report, March 8, 1995; Archives, Department of European Paintings, The Metropolitan Museum of Art, New York. Hale also noted curious parallel scratches in the paint surface, clearly made by the artist, in the area between the woman's head and the ferryman. Their purpose is not evident.
8. "rien que pour leur forme et leur couleur." Quoted in Paris 1962, no. 25.

PROVENANCE: Oscar Simon, Dinard; Boussod, Valadon & Cie., Paris, 1894;* M. Knoedler & Co., New York, 1895; Charles H. Senff, New York; his sale, The Anderson Galleries, New York, March 28–29, 1928, no. 61; purchased at the sale by his niece Louise Senff Cameron for $31,000; her gift to The Metropolitan Museum of Art, New York, 1928

EXHIBITIONS: Paris (Salon) 1869, no. 550, as *Une Liseuse*; Paris 1936, no. 90; Lyons 1936, no. 94, as *Liseuse dans la campagne*; Philadelphia 1946, no. 56; New York 1952–53, no. 144; Chicago 1960, no. 111; New York 1970–71, no. 365; Saint Petersburg, Moscow 1975, no. 58; Naples, Milan 1986–87, no. 10

REFERENCES: Gautier 1869, p. 364; Hache 1869, p. 298; Paris 1875a, p. 30; Lafenestre 1881, pp. 117–19; Roger-Milès 1891, p. 84; Robaut *carton* 27, fol. 53; Robaut 1905, vol. 1, p. 243–44, vol. 3, pp. 114–15, no. 1563, ill. (before alteration), vol. 4, pp. 170, 375; Moreau-Nélaton 1913, p. 84; Moreau-Nélaton 1924, vol. 2, p. 35, fig. 212 (before alteration); Burroughs 1928, pp. 154–56, figs. 1, 2; Bernheim de Villers 1930a, p. 34, no. 262, ill.; Jamot 1936, ill.; Lyons 1936, pp. 43, 54, no. 94; Paris 1936, pp. 45–46, no. 90; Watt 1936, p. 226, ill.; Bazin 1942, p. 107; Philadelphia 1946, p. 20, no. 56, fig. 56; Bazin 1951, p. 113; Sloane 1951, pp. xii, 125, n. 29, pp. 126–28, fig. 83; New York 1952–53, p. 233, no. 144, pl. 144; Fosca 1958, p. 221, ill. p. 155; Coquis 1959, pp. 117–19; Paris 1962, p. 172; San Francisco, Toledo, Cleveland, Boston 1962–63, p. 53; Leymarie 1966, p. 94; Sterling and Salinger 1966, pp. 63–65, ill.; Bazin 1973, p. 271; Paris 1975, p. 184; Atlanta, Denver 1979–80, p. 4; Leymarie 1979, pp. 128–29, ill.; Zimmermann 1986, pp. 51, 57, 139, 352, no. 46, fig. 46; Selz 1988, pp. 132, 133, 136, ill.; Philadelphia, Washington, Los Angeles, New York 1989–91, pp. 2, 130, n. 2, fig. 1; Wissman 1989, pp. ix, 107–10, 205, no. 117, fig. 53; Clarke 1991a, p. 139; Leymarie 1992, p. 148, ill. p. 149; Sartori 1994, p. 17

* Alfred Robaut refers to "the collection of Oscar Simon of Dinard, who is selling his entire small collection to MM. Boussod and Valadon." ("Collection Oscar Simon à Dinard qui vend toute sa petite collection à MM. Boussod et Valadon.") Robaut *carton* 27, fol. 53.

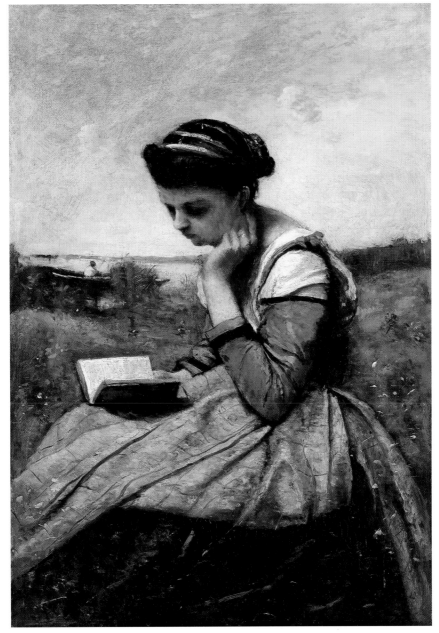

141

Fig. 144. Photograph of Corot's *Une Liseuse*. Retailed by Goupil

Fig. 145. Louis-Rémy Robert. *Caroline Robert*, 1850s. Salted paper print from paper negative. Purchase, Joyce and Robert Menschel Gift and The Horace W. Goldsmith Foundation Gift, 1995, The Metropolitan Museum of Art, New York (1995.3)

Sibylle

Ca. 1870–73
Oil on canvas
32¼ × 25½ in. (81.9 × 64.8 cm)
The Metropolitan Museum of Art, New York
H. O. Havemeyer Collection, Bequest of Mrs. H. O. Havemeyer, 1929
29.100.565

R 2130

With the important exceptions of *La Femme à la perle* (cat. no. 107) and *La Femme à la grande toque et à la mandoline* (*Woman with a Large Tocque and a Mandolin;* R 1060, private collection), this work ranks as Corot's most Raphaelesque painting. It is virtually a transcription of the Renaissance master's *Portrait of Bindo Altoviti* (fig. 146), thought in Corot's day to be a self-portrait, with a little dash of Sebastiano del Piombo thrown in for painterly pleasure. (See, for example, Sebastiano's *Girl with a Basket,* Staatliche Museen Preussischer Kulturbesitz, Berlin.) Corot could not have known either work in the original, but engravings of them were ubiquitous and even were reproduced in standard books on Italian painting. Yet for all the self-conscious *disegno* of the pose—the arch of the back mirrored in the swanlike curve of the neck—Corot arrived at this composition not by design but through an incremental evolution that can be followed in a radiograph of the canvas. His first conception had the model playing a cello: the left hand held the neck of the instrument and the right hand, slightly raised, held the bow. Corot adjusted the contour of the cello several times and made numerous attempts to find the correct angle for the bow before he painted out the musical instrument altogether, dropped the right hand to the model's lap, and inserted a rose or pink in her left hand.

Corot's first idea, then, seems to have been to depict Polymnia, the cello-playing muse of music. Music is a leitmotif throughout Corot's oeuvre,[1] and the ivy[2] in the woman's hair may allude to the immortality of the arts. But this reference to Polymnia apparently specifically harks back to the artist's *Le Concert* (fig. 65), which he exhibited first in the Salon of 1844 and then again, after repainting, in the Salon of 1857. Corot adapted the two central figures in his *Concert* from Le Sueur's *Melpomène, Erato et Polymnie* (Musée du Louvre, Paris), painted in 1652–55 for the Salon des Muses of the Hôtel Lambert.[3] Corot painted another figure holding a stringed instrument, this time a mandolin (R 1338, location unknown; also the related drawing at the Musée du Louvre, R.F. 8772), at about the same time as the present work. It appears that the same woman posed for both.

Only after Corot painted out the cello did he work to perfect the graceful form of the figure by adjusting the contours of the back, chest, and left shoulder. He seems to have recognized that achieving a Raphaelesque beauty of line did not

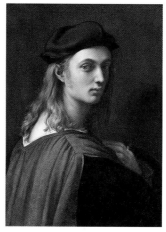 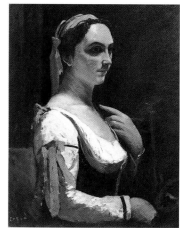

Fig. 146. Raphael (1483–1520). *Portrait of Bindo Altoviti,* ca. 1515. Oil on panel, 23½ × 17¼ in. (59.7 × 43.8 cm). Samuel H. Kress Collection, National Gallery of Art, Washington, D.C.

Fig. 147. Corot. *La Femme à la manche jaune* (*Woman with a Yellow Sleeve;* R 1583), ca. 1870. Oil on canvas, 28¾ × 23¼ in. (73 × 59 cm). Private collection

require niggling perfection in the description of the surfaces, so he left everything save the head roughly painted with wide brushstrokes. The picture is thus unfinished—it is not signed, nor was it exhibited during the artist's life—but it is not by any means incomplete. Perhaps because of the broad brushwork, all scholars except Moreau-Nélaton, who dated the painting about 1855, have placed this work about 1870.[4] In his personal notes, Alfred Robaut characterized this painting as an *"ébauche"* and a "sketch" (*esquisse*).[5] In a sense, *La Femme à la manche jaune* (fig. 147) is a "finished" version of the composition that Corot sketched out in *Sibylle.*[6]

The traditional title of the work, *Sibylle,* seems to have been accorded it by its first owner, Corot's cataloguer and disciple Robaut. He called it *Sibylle. Étude de femme à mi-corps.* Sibylle, as Sylvie Béguin pointed out, is a woman's name and thus not a reference to the ancient female prophets called sibyls.[7] However, when Robaut sold the painting to Durand-Ruel in 1899, the title was recorded as *L'Italienne.* And the model does seem to be the same woman—Agostina, known as "l'Italienne de Montparnasse"—who posed for the great three-quarter-length painting now at the National Gallery of Art in Washington

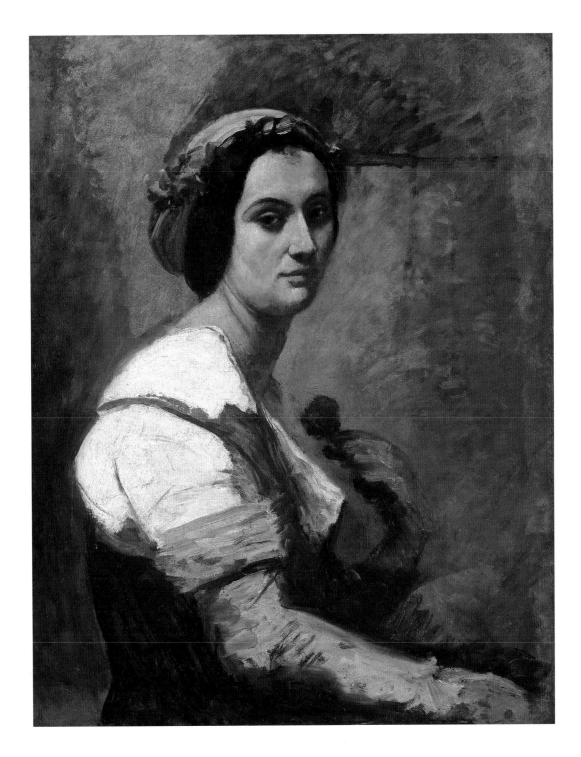

(fig. 115). Arsène Alexandre described her: "This other beautiful, pensive *Italian Woman*, created to live all the romances you please, draws to her bosom a small bouquet whose symbolism is entirely uncomplicated." But, as he noted further, "what matters to us is to notice here how much Corot experienced, remembered, and understood—I would go so far as to say, equaled—Raphael, infinitely more than Ingres did. How gentle and strong this man is!"[8]

The greatest revelation to come from the radiographs of the painting (fig. 148) is the discovery of a seated nude, posed in the manner of Boucher's *Diane sortant du bain* (fig. 149), underneath the present picture.[9] The model for this figure is the woman who posed for *La Zingara* (The Gypsy; R 1387, Reid & Lefevre, London), whose name is not recorded. The nude

appears to have been fairly well developed before Corot abandoned it. In pose it does not relate to any known painting and thus was probably conceived as an independent work. In his unpublished notes, Robaut recorded that on the back of the canvas was a drawing of a woman writing at a table.[10]

1. See also *Le Moine au violoncelle* (cat. no. 163).
2. Or is it laurel?
3. Hopp 1990, p. 136.
4. Robaut, Bernheim de Villers, Bazin, Béguin, Salinger, Hours (1865–70), and Zimmermann. See references for page citations.
5. Robaut *carton 27*, fol. 68.
6. Sylvie Béguin noted the similarities these two paintings share in Paris 1962, p. 162.
7. Ibid., p. 160.

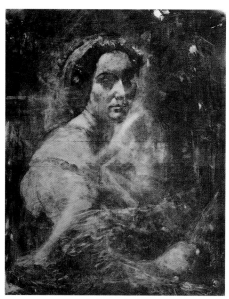

Fig. 148. X-radiograph of Corot's *Sibylle*

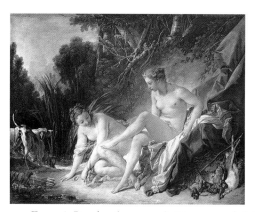

Fig. 149. François Boucher (1703–1770). *Diane sortant du bain*
(*Diana after the Bath*), 1742. Oil on canvas, 22½ × 28¾ in. (57 ×
73 cm). Musée du Louvre, Paris (R.F. 2712)

8. "Cette autre belle *Italienne* pensive, faite pour vivre tous les romans qu'il vous plaira, ramène vers sa poitrine un petit bouquet du symbolique le moins compliqué"; "ce qui nous importe c'est de remarquer combien ici Corot ressentait, rappelait et comprenait—j'allais dire égalait—Raphaël, infiniment plus que ne faisait Ingres. Que cet homme est doux et fort!" Alexandre 1929, p. 281.
9. Charlotte Hale, report, March 1, 1995. Archives, Department of European Paintings, The Metropolitan Museum of Art, New York.
10. Robaut *carton* 27, fol. 68.

PROVENANCE: Alfred Robaut (1830–1909), Paris; sold to Durand-Ruel & Cie., Paris, for 6,000 francs, February 21, 1899 (stock no. 5026, as *L'Italienne*); transferred to Durand-Ruel, New York, December 8, 1899, or January 25, 1900 (stock no. 2286); sold to H. O. (1847–1907) and Louisine (1855–1929) Havemeyer, New York, for $6,000, February 7, 1903; her bequest to The Metropolitan Museum of Art, New York, 1929

EXHIBITIONS: New York 1930b, no. 18, as *The Sibyl*; Toledo, Toronto 1946–47, no. 35, as *The Sybil* [*sic*]; Fort Worth 1949, no. 2, as *The Sibyl*; Paris 1962, no. 69, as *Sibylle*; New York 1969, no. 64; Boston 1970; New York 1993, no. A114

REFERENCES: Robaut *carton* 27, fols. 68, 68 bis; Robaut 1905, vol. 3, pp. 292–93, no. 2130, ill.; Jaccaci 1913, p. 5; Meier-Graefe 1913, ill. p. 153; Moreau-Nélaton 1924, vol. 1, p. 115, fig. 143, as *Italienne de Montparnasse*; Alexandre 1929, pp. 277, 281, ill.; Anon. 1930, ill. p. 37; Bernheim de Villers 1930a, p. 62, no. 303, ill.; Meier-Graefe 1930, p. 102, pl. 128; *Havemeyer Collection* 1931, pp. 64–65, ill., as *Figure Piece—The Sibyl*; Rosen and Marceau 1937, p. 86, figs. 16–17; Bazin 1942, p. 107; Bazin 1951, p. 113; Fosca 1958, pp. 138, 145, as *L'Italienne*; *Havemeyer Collection* 1958, p. 15, no. 77, ill.; Paris 1962, pp. 150, 160–62, 172, 182, no. 69, ill.; Sutton 1962, pp. 506, 508, ill.; Sterling and Salinger 1966, pp. 65–67, ill.; Boston 1970, p. 76, ill.; Hours 1972, pp. 152–53, ill.; Bazin 1973, pp. 65, 272; Janson 1978, pp. 308–10, 313, fig. 8; Zimmermann 1986, pp. 171–73, 177, 377, fig. 164; Wissman 1989, p. 127; Gale 1994, pp. 124–25, 144, ill.

143

*L'Algérienne
(Algerian Woman)*

Ca. 1870–73
Oil on canvas
31⅛ × 23⅝ in. (79 × 60 cm)
Stamped lower right: VENTE COROT
Fondation Rau pour le Tiers-Monde, Zurich GR 1.553

R 1576

As part of his series of half-length figures painted nearly life-size,[1] Corot made this extraordinary picture of a woman wearing a burnoose. The title, *L'Algérienne*, almost certainly postdates

Corot's death,[2] and there is no evidence that the model was North African.[3] With his love of rich, exotic fabrics, it is not surprising that Corot kept a burnoose in his studio; with his forthright approach to painting, it is equally unsurprising that he did not ask the model to remove her street dress. Employing a simple pyramidal composition, loose, summary brushwork, and a palette both restricted and muted, Corot created a powerful, monumental image. Robaut considered it a "beautiful study, left, unhappily, in the sketch stage."[4]

Jean Dollfus bought this painting at the artist's posthumous sale for 850 francs. It was one of some twenty works by Corot that Dollfus owned at the time of his death, of which six were

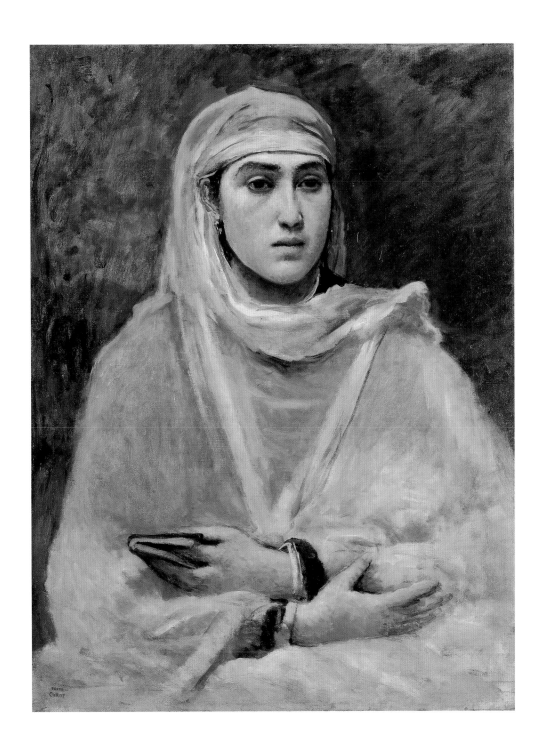

figure paintings, including *La Femme à la perle* (cat. no. 107). In his foreword to the catalogue of Dollfus's posthumous sale, the writer André Michel observed, "Let us add that Corot, so long unrecognized as a 'figure painter,' emerges here with incomparable brilliance. In his work you will find few pieces more powerful than *L'Algérienne* and none more accomplished, more harmonious, more worthy of a great painter than *Femme à la perle.*"[5]

Some historians have suggested that this work demonstrates the affinity that Corot toward the end of his life felt for Delacroix.[6] While there is something of interest to be said about Corot's connection to Romanticism, the relationship is not in evidence here: Corot has not taken a literary theme, does not explore the passions, has not provided even a glimpse of North African color. He has simply placed a burnoose over a model and found a very plastic means of portraying her.

1. See, for example, cat. nos. 142, 151, 152.
2. Hélène Toussaint in Marseilles 1994, p. 10. Robaut called this work *Algérienne drapée de blanc* in his unpublished notes. Robaut *carton 25*, fol. 44.
3. There are drawings of the head of this figure in *carnet 11*, fol. 16 (R 3048, Cabinet des Dessins, Musée du Louvre, Paris, R.F. 1870.07253). Unlike Hélène Toussaint and others, I do not recognize in this woman the model who posed for *Sibylle* (cat. no. 142) and *L'Albanaise* (R 2147).
4. "belle étude, laissé, malheureusement, à l'état d'esquisse." Robaut *carton 25*, fol. 44.

5. "Ajoutons que, comme 'peintre de figures,' Corot, si longtemps méconnu, parait ici avec un incomparable éclat. On ne trouverait pas dans son oeuvre beaucoup de morceaux plus puissants que *L'Algérienne;* on n'en trouverait pas de plus complet, de plus harmonieux, de plus digne d'un grand peintre que la *Femme à la perle.*" Michel in Dollfus sale 1912, pp. 10–11.

6. Sylvie Béguin in Paris 1962, p. 29.

PROVENANCE: The artist; his posthumous sale, Hôtel Drouot, Paris, pt. 1, May 26–28, 1875, no. 178, as *Algérienne drapée de blanc;* purchased at that sale by Jean Dollfus (1823–1911), Mulhouse, for 850 francs; his posthumous sale, Galerie Georges Petit, March 2, 1912, no. 11, as *L'Algérienne;* purchased at that sale by the dealer Florine Ebstein-Langweil; her gift to her daughter Mme André Noufflard (neé Berthe Ebstein-Langweil); sold by her to Galerie Hector Brame, Paris, 1970; Fondation Rau pour le Tiers-Monde, Zurich

EXHIBITIONS: Paris 1912, no. 61; Paris 1928, no. 42; Paris 1957, no. 25; Bern 1960, no. 83; Paris 1962, no. 65; Marseilles 1979, no. 98; Marseilles 1994

REFERENCES: Robaut *carton* 25, fol. 44; Robaut 1905, vol. 3, pp. 120–21, no. 1576, ill., and vol. 4, p. 245, no. 178; Bernheim de Villers 1930a, no. 273, ill.; Bazin 1942, p. 107; Bazin 1951, p. 113; Baud-Bovy 1957, pp. 29, 245; Bazin 1973, p. 271

144

La Lecture interrompue (Interrupted Reading)

Ca. 1870–73
Oil on canvas mounted on board
36⅜ × 25⅝ in. (92.5 × 65.1 cm)
Signed center left: COROT
The Art Institute of Chicago
Potter Palmer Collection 1922.410

R 1431

In many ways this can be considered one of Corot's most modern paintings. It is modern in precisely the way that Manet's paintings of the 1860s were: the figure is nearly life-size and fills the frame; the brushwork is bold and fluent, with many areas of the picture obviously left unfinished; and, of particular importance, the subject, "interrupted reading," is revealed to be a mere pretext. What Corot shows us is not a woman who pauses to think during reading, but rather a model sitting in his studio with a book in her hand.[1] This blunt exposure of the artifice of painting is precisely what made Manet's paintings so controversial, and Corot, in his own nonconfrontational manner, explores the same conceit.

This painting, with its "nobility and monumentalism,"[2] has inspired rapturous praise from modernist critics. Lionello Venturi, for example, sought to place it within no less than four different movements in nineteenth-century art, as "the masterpiece among Corot's figures. The composition recalls Corot's neo-classical origins: the theme is romantic, the scope is realistic, the execution comes close to impressionism. All this is . . . spontaneously fused."[3] Much of the interest surrounding the picture has been generated by its painting technique. Corot used wide brushes and liberally mixed his colors with white, making a thick paste that would retain the marks made by the brush.[4] Thus his revisions are still plainly visible: he shifted the positions of the model's coral comb and earring, her arms, her skirt, and so forth.[5] Because of its summary technique, Corot regarded this work, like *Sibylle* (cat. no. 142), as an *ébauche.*[6]

The writer Alexandre Dumas fils bought this painting on the art market in Paris sometime in the late 1870s. He tried unsuccessfully to sell it at auction in 1882 and succeeded ten years later. Mrs. Potter Palmer, one of the most active collectors of modern French painting in America, purchased it in 1892.

1. There is a little-known but closely related painting currently being held at the Pushkin Museum of Fine Arts, Moscow, *La Songerie de Mariette,* about 1869–70 (R 1565).

2. Leymarie 1979, p. 130.

3. Venturi in Philadelphia 1946, p. 22 (translation of Venturi 1941, p. 166). Jean Leymarie obviously concurred, since he borrowed Venturi's words when he wrote "the structure is classical, the spirit romantic, the artist's vision realistic, the execution almost impressionistic." Leymarie 1979, p. 130.

4. Hours 1972, p. 152.

5. Timothy Lennon, conservator of paintings, The Art Institute of Chicago, letter, March 14, 1995. Archives, Department of European Paintings, The Metropolitan Museum of Art, New York.

6. In his unpublished notes, Robaut catalogued this work as "*La Belle Romaine.* 68–70. Ébauche." Elsewhere in his notes he characterized the style as "manière ébauche." Robaut *carton* 27, fol. 50.

PROVENANCE: Jules de La Rochenoire (1825–1899), Paris, by 1875; Alexandre Dumas fils (1824–1895), Paris, by 1882, until 1892; his sale, "Collection de M. D***[umas]," Hôtel Drouot, Paris, February 16, 1882, no. 15, as *La Rêverie, figure,* bought in for 2,450 francs; his sale, Hôtel Drouot, Paris, May 12–13, 1892, no. 24, as *Rêverie;* purchased at that sale by Durand-Ruel & Cie., Paris,

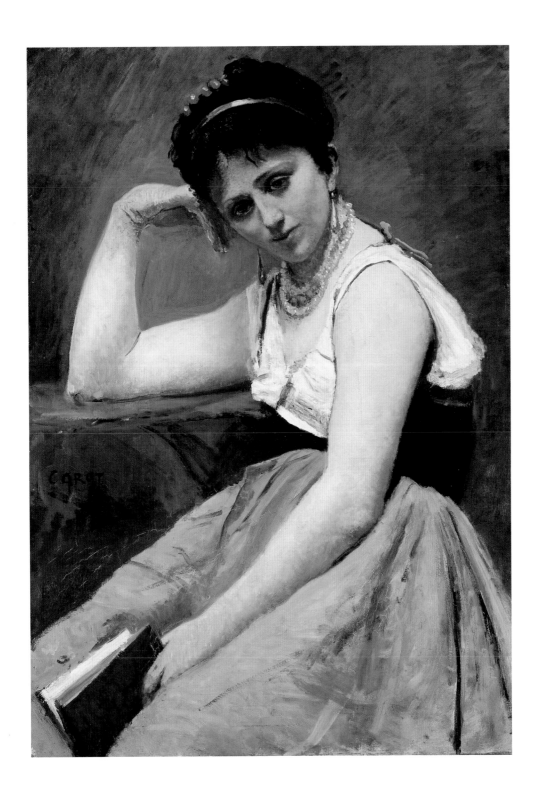

for 4,500 francs (stock no. 2212); sold to Potter (1826–1902) and Bertha Honoré (1849–1918) Palmer, Chicago, for 20,000 francs, May 17, 1892; Potter Palmer II (d. 1943), Chicago, 1918; to The Art Institute of Chicago, 1922

EXHIBITIONS: Paris 1875a, no. 93, as *Femme romaine*, lent by J. de La Rochenoire; Cambridge 1929, no. 12, as *Interrupted Reading*; New York 1930c, no. 29; Chicago 1933, no. 231; Chicago 1934, no. 164; New York 1934b, no. 20; Paris 1936, no. 82; Philadelphia 1946, no. 49; Chicago 1960, no. 99; New York 1961, no. 32; Sarasota 1963, no. 7; Edinburgh, London 1965, no. 81; New York 1966b, no. 15; New York 1969, no. 63

REFERENCES: Robaut *carton* 27, fol. 50; Robaut 1905, vol. 3, pp. 62–63, no. 1431, ill., and vol. 4, p. 272; Jaccaci 1913, p. 5, fig. 2; Anon. 1924 (M. C.), p. 102, ill.; Meier-Graefe 1929, ill. p. 51; Bernheim de Villers 1930a, no. 235, ill.; Meier-Graefe 1930, pl. CVII; Bazin 1936, pp. 63–64, fig. 70; Delaroche-Vernet 1936, p. 20, ill. cover; Lyons 1936, p. xviii; Paris 1936, p. xx, pl. XXI; Watt 1936, p. 225; Venturi 1941, pp. 166, 169, fig. 110 (English translation in Philadelphia 1946, p. 22); Bazin 1942, p. 107; Bazin 1951, p. 112, as *Lecture interrompue* and erroneously as belonging to "Musée de New-York"; Baud-Bovy 1957, p. 245; Fosca 1958, pp. 138–39, ill.; Leymarie 1962, p. 112, ill. p. 111; Sweet 1966, p. 193, fig. 2; Werner 1969, ill. p. 33; Bazin 1973, p. 271, erroneously as belonging to "Musée de New-York"; Leymarie 1979, pp. 130–31, ill.; Zimmermann 1986, pp. 152, 351, fig. 44; Selz 1988, pp. 136, 222, ill.; Leymarie 1992, p. 154, ill.

Mantes. La Cathédrale et la ville vue à travers les arbres (Mantes: The Cathedral and the City Seen through the Trees)

Ca. 1865–69
Oil on canvas
20½ × 12⅞ in. (52.1 × 32.6 cm)
Signed lower left: COROT.
Musée des Beaux-Arts, Reims 899.16.25

R 1522

During the 1860s Corot traveled frequently to the ancient town of Mantes, some thirty miles west of Paris, in order to stay with friends, François-Parfait Robert and his wife. Robert was a local magistrate and the nephew of Corot's friend Mme Osmond, who lived in nearby Rosny. Mantes, founded on the left bank of the Seine by Celts and later inhabited by Merovingians, has been dominated since the end of the twelfth century by the handsome collegiate church of Notre-Dame, built about the same time as Notre-Dame de Paris and in a similar early Gothic style. Corot seems to have been much taken with the town's monuments, since he painted the cathedral and the eighteenth-century stone bridge beneath it many times during the second half of his career. The cathedral first appears in a painting that Robaut dated to about 1845 (R 401, private collection) but that must have been made sometime earlier, according to Rodolphe Walter, because the old north tower of the church, visible in Corot's painting, was demolished that year.[1] Corot visited Mantes in the summer of 1842, when he decorated the Roberts' bathroom with murals,[2] and it is likely that the early view of the cathedral, which belonged to the Roberts, was painted then. He next depicted the cathedral after the rebuilding of the north tower was completed in 1855 but before the restoration of the south tower in 1860 (R 818, Reid & Lefevre, London).[3] Two additional paintings, dated by Robaut to 1855–60, must have been made after the entire restoration was completed, that is, after 1860 (R 816, R 817). According to Robaut, the present painting, a vertical canvas (R 1522), and three horizontal canvases (R 1518, R 1519, R 1523) were all executed in the second half of the 1860s. Corot is known to have been in Mantes in 1865, 1866, 1868, and 1869.[4] These paintings could well date to any of these years.

Unlike the horizontal canvases, studio productions in which Corot reverts to his favorite composition of a distant view framed by screens of trees in the foreground, this work contains features indicating that it is an attentive study painted in plein air from the Île de Limay, across the Seine. Nevertheless, the houses along the quai des Cordeliers and the tower of Saint-Maclou, seen to the left of the cathedral, are not rendered precisely as they were, nor as they appear in the similar view also in the Musée des Beaux-Arts at Reims (R 1518). As he did in painting the Cabassud houses at Ville-d'Avray (see, for example, cat. no. 102), Corot here took liberties with the scene before him. The trees and the fisherman in the foreground were no doubt added in the studio to render the picture a more salable commodity. Jules Warnier-David, an affluent collector in Reims, may have owned the painting by 1869; he lent it to the exhibition at the Exposition Centennale in 1889.

1. Walter 1966, p. 219.
2. See the chronology in this volume.
3. Walter 1966, pp. 226–27.
4. See the chronology.

PROVENANCE: Purchased from the artist by Jules Warnier-David, Reims, probably before 1869; his bequest to the Musée des Beaux-Arts, Reims, June 1899

EXHIBITIONS: Reims 1869, no. 18;* Paris 1889, no. 154; Paris 1895, no. 141; London 1932, no. 165; Zurich 1934, no. 105; Paris 1936, no. 84; Lyons 1936, no. 86; Paris 1937, no. 269; Paris 1938c, no. 7; Buenos Aires, Montevideo 1939–40;** Chicago 1941, no. 21; New York 1941, no. 16; Reims 1948, no. 34; London 1949–50, no. 165; Amsterdam 1951, no. 25; Moscow, Saint Petersburg, Warsaw 1956, no. 16; Munich 1964–65, no. 41; Lisbon 1965, no. 29; Bordeaux 1974, no. 45; Paris 1975, no. 57; Tokyo, Osaka, Yokohama 1989–90, no. 3

REFERENCES: Hamel 1905, pl. 49; Robaut 1905, vol. 3, pp. 100–101, no. 1522, ill., and vol. 4, pp. 178, 286, 293; Gensel 1906, p. 24, fig. 11; Belval 1907, no. 7; Sartor 1909, p. 32, no. 120, ill.; Meier-Graefe 1913, ill. p. 130; Fosca 1930, pl. 58; Faure 1931, pl. 66; Jamot 1936, p. 22, ill. p. 33; Colombier 1940, p. 8, ill. cover; Baud-Bovy 1957, pl. II; Colombier 1963, ill.; Walter 1966, pp. 219, 223–26, fig. 8; Hours 1972, pp. 148–49, ill.; Bazin 1973, p. 292; Leymarie 1979, ill. p. 119; Selz 1988, pp. 244–45, ill.; Smits 1991, pp. 373–74, fig. 361; Leymarie 1992, ill. p. 139

* Hélène Toussaint in Paris 1975, no. 57. Robaut lists a "Vue de Mantes (à M. Warnier)" as having been exhibited in Reims in 1869 but does not identify the picture. Robaut 1905, vol. 4, p. 178.
** Argul 1941, pp. 14–15.

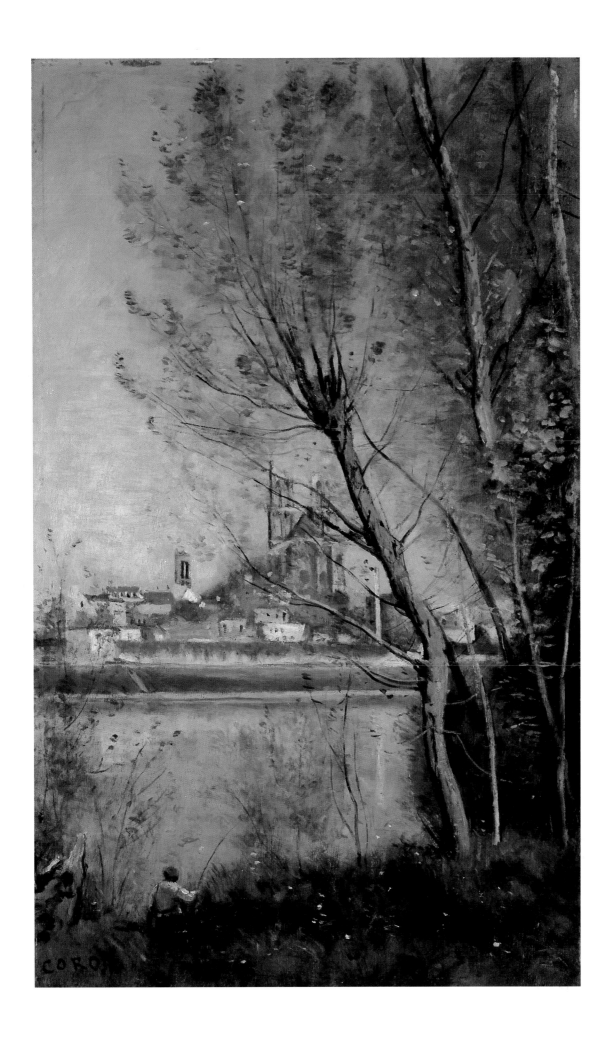

146

Le Coup de vent
(The Gust of Wind)

Ca. 1865–70
Oil on canvas
18⅝ × 23⅛ in. (47.4 × 58.9 cm)
Signed lower right: COROT
Musée des Beaux-Arts, Reims 899.16.23

R 1906

Bazin traced the origins of the wind-tossed landscape in Corot's oeuvre to his 1853 trip to Cayeux, which was marked by bad weather,[1] while Robaut claimed that the idea first came to Corot during his trip to Holland in 1854.[2] According to the diary kept by Corot's travel companion, Constant Dutilleux, both Dutilleux and Corot made sketches of dunes on September 1 and 2, 1854.[3] Thereafter, many of Corot's windy landscapes were set near the sea. The motif made its public debut at the Salon of 1864, where Corot exhibited *Coup de vent au bord de la mer* (fig. 150)[4] alongside *Souvenir de Mortefontaine* (cat. no. 126). The contrast between the two works could not have been more striking—the idyllic calm of Mortefontaine made the storm depicted in the *Coup de vent* appear even more tempestuous—and the comparison, which must have been deliberate, was duly noted by the critics. Théophile Thoré began his landscape section with a preamble pronouncing, "In the end, there have never been more than two schools of landscape painting: that of Poussin and Claude, and that of Ruisdael and Hobbema . . . the artist who starts off from an ideal conceived in his own mind and the artist who starts off from nature."[5] By exhibiting the Claudian *Mortefontaine* with the Ruisdaelian *Coup de vent*, Corot clearly sought to show that he was a master of both genres. Jules Castagnary preferred the latter: "It is what one expects from this master of imagined nature; but I find in it a dramatic element that I haven't seen in his work since his beautiful painting the *Destruction of Sodom.*" Because the *Coup de vent* of the 1864 Salon is similar to the present work, Castagnary's description is worth repeating: "We are on the edge of a wood. The wind blows; shivers sweep across the meadows and plains. The branches twisting, the trees shake off their leaves. A peasant woman returning home with a bundle of wood has trouble keeping her balance and stumbles, caught in the whirlwind. This work has an extraordinary power and unity of impact. It's a shame that the land ends somewhat abruptly; by prolonging it toward the horizon, the artist would have given more breadth to his canvas and more intensity to the squall."[6]

No doubt the success of the 1864 painting spawned Corot's many subsequent repetitions of the theme; of these, the painting catalogued here, now in Reims, is the most famous.[7] It almost appears that Corot took Castagnary's remark to heart

Fig. 150. Corot. *Coup de vent au bord de la mer* (*Gust of Wind at the Seashore;* R 1683), 1864. Oil on canvas, 32⅝ × 44⅛ in. (83 × 112 cm). Private collection

and improved the landscape by extending the foreground just as the critic suggested. And while the scene cannot be pinned to a specific locale, the mood is one particular to Corot. Art historians have cited Ruisdael's *The Thicket* of 1647 (Musée du Louvre, Paris), with its great oak bending in the wind, as a prototype for Corot's wind-strained trees,[8] but Corot's bleak gray scenes have little in common with Ruisdael's picture. In the latter, nature is strong, but man and his works—the town on the horizon—hold their own. In Corot's storm pictures, man is but a speck of dust fighting against enormous and overwhelming forces. Corot's work in this genre thus approaches French Romanticism as practiced by Isabey, Huet, and Georges Michel. But it is not necessary, as Jean Selz has done, to discern autobiographical elements in Corot's landscapes.[9] These turbulent scenes are, quite simply, the corollary to the pacific *souvenirs* that we have wrongly come to regard as the artist's sole mode of expression.

It has often been suggested that this is the work Corot sent to the 1867 Salon,[10] but the reviews are too scanty to permit a definitive identification.[11] Because most critics focused their writing on the Exposition Universelle, the Salon reviews were often summary. Millet's *Coup de vent* of about 1871 seems to have been inspired by this canvas or by one of the related compositions.

1. Bazin 1942, p. 121. See *Souvenir d'un coup de vent à Cayeux* (R 1132) and *Souvenir de la grève de Cayeux* (R 2883); the latter was executed, according to Robaut, "to make known the desolate nature of a region that had been highly praised to him, in his opinion unjustifiably, and that he found so disagreeable that he vowed never to return." ("pour expliquer la désolation d'un pays qu'on lui avait vanté, injustement selon lui, et qui lui avait si peu agréé qu'il jura de n'y plus retourner.") Robaut 1905, vol. 4, p. 64, no. 2883.

2. Note in the Robaut *cartons*, cited by Hélène Toussaint in Paris 1975, no. 81.

3. Fierens 1952, p. 126.

4. According to Wissman 1989, p. 204.

5. "Finalement, il n'y a jamais eu que deux genres d'école dans la peinture du paysage: celle de Poussin et de Claude,—celle de Ruisdael et de Hobbema . . . l'artiste qui part d'un idéal conçu en lui-même, et l'artiste qui part de la nature." "Salon de 1864," in Thoré 1870, vol. 2, p. 69.

6. "C'est comme toujours chez ce maître de la nature rêvée; mais j'y trouve un élément dramatique que je n'avais pas vu chez lui depuis son beau tableau de la *Destruction de Sodome.*" "Nous sommes sur la lisière d'un bois. Le vent souffle; de grands frissons courent sur les champs et les plaines. Les arbres tordent leurs branches en secouant leurs feuilles. Une paysanne, qui rentrait avec sa provision de bois, a de la peine à se maintenir et trébuche, prise dans le tourbillon. Il y a dans cette oeuvre une puissance et une unité d'impression extraordinaires. Je regrette que le terrain finisse un peu brusquement; en le prolongeant vers l'horizon, l'auteur donnerait à sa toile plus d'ampleur, et à la bourrasque plus d'intensité." "Salon de 1864," in Castagnary 1892, vol. 1, pp. 206–7.

7. Other related works: *Coup de vent sur la prairie* (ca. 1860), R 1828; *Vent du soir* (1865–70), R 1842; *Coup de vent dans les dunes* (1865–70), R 1964; *Un Coup de vent au bord de la mer* (1865–72), R 2266, a variant of R 1638; *Coup de vent sur la Manche* (1870–72), R 2267; *Le Petit Coup de vent* (1869), R 1777; *Paysage composée, impression de gros temps dans le marais* (Schoeller and Dieterle 1956, no. 54; this painting was executed over a half-length figure of a woman, which now is visible because the landscape has been removed); *Coup de vent* (1871), R 3146; and three works not in Robaut: *Coup de vent*, Pushkin Museum, Moscow, no. 956, erroneously identified by Jean Leymarie as R 2266;

Le Coup de vent, Musée du Louvre, R.F. 2038, catalogued as "genre de Corot"; *Der Windstoss*, published in Meier-Graefe 1913, p. 139, with a photograph supplied by Durand-Ruel. Two early works not before cited are: *Vent de mer* (1855–58), R 122; and *Coup de vent dans un pâturage* (ca. 1865), R 1666.

8. See, for instance, Gale 1994, p. 37.

9. "He transfers to his paintings the obsessions . . . of his life as an aged orphan. But to this transposition of solitude are juxtaposed those of anguish and the rejection of solitude; to isolated trees [are juxtaposed] trees in pairs." ("Il transmit à sa peinture les hantises . . . de son existence de vieil orphelin. Mais, à cette transposition de la solitude se juxtaposent celles de l'angoisse et du refus de la solitude, aux arbres isolés, les arbres appariés.") Selz 1988, p. 206.

10. Hours 1972, p. 142; Miquel 1975, vol. 2, p. 49.

11. According to Hélène Toussaint in Paris 1975, no. 81.

PROVENANCE: Anonymous sale, Hôtel Drouot, Paris, April 1874;* purchased at that sale by Alfred Robaut (1830–1909) for 1,750 francs; Jules Warnier-David, Reims, by 1892; his bequest to the Musée des Beaux-Arts, Reims, June 1899

EXHIBITIONS: Paris 1892, no. 57, lent by Jules Warnier; Paris 1895, no. 142, lent by Warnier; Zurich 1934, no. 104; Paris 1936, no. 87; Lyons 1936, no. 90; Paris 1938c, no. 9; Moscow, Saint Petersburg, Warsaw 1956, no. 17; Munich 1958; Bern 1960, no. 85; Munich 1964–65, no. 42; Paris 1975, no. 81; Rome 1975–76; Bremen 1977–78; Tokyo, Osaka, Yokohama 1989–90, no. 5; Dijon 1995

REFERENCES: Robaut 1905, vol. 3, pp. 216–17, no. 1906, ill., and vol. 4, pp. 288, 293; Gensel 1906, fig. 16; Belval 1907, no. 16; Sartor 1909, p. 32, no. 118, ill. opp. p. 30; Jamot 1936, ill. p. 49; Bazin 1942, p. 121, no. 99, ill.; Sérullaz 1951, p. 20; Baud-Bovy 1957, pp. 49–50, pl. LII; Hours 1972, pp. 50, 142–43, ill.; Bazin 1973, p. 289; Miquel 1975, vol. 2, p. 49, ill. p. 50; Leymarie 1979, p. 116, ill. p. 120; Selz 1988, pp. 204–6, ill. p. 207; Leymarie 1992, p. 138, ill. p. 140; Gale 1994, pp. 37, 40, 118, ill. p. 119

* Robaut 1905, vol. 3, p. 216.

147

*Un Matin à Ville-d'Avray
(Morning at Ville-d'Avray)*

1868
Oil on canvas
40⅛ × 60⅞ in. (102 × 154.5 cm)
Signed lower left: COROT
Musée des Beaux-Arts, Rouen 869.3.1
New York and Ottawa only

R 1641

Corot sent this painting to the Salon of 1868, where it received tremendous acclaim. Jules Castagnary and Émile Zola were only two of those who declared their affection for the artist's plein air studies—"I must admit that I vastly prefer the more honest, more striking studies made in the open meadows to his large canvases, where he orchestrates nature in a muffled, dreamy key"[1]—but still pronounced this painting admirable. "*Un Matin à Ville-d'Avray* and *Le Soir* are the most beautiful of the master's paintings," wrote Castagnary. "The public does not pay them nearly enough attention. People have become a little blasé about this style and these effects, and find their annual reappearance monotonous."[2] Ignoring the blasé public, Zola wrote that as far as the modern school of landscapists was concerned, "There are hardly any I could place beside Jongkind except Corot, a master whose talent is so well known that I can dispense with an analysis of it. . . . Moreover, Corot has painting in his blood, he is highly personal, highly skilled, and he must be acknowledged the dean of the naturalists, despite his predilection for misty effects. . . . The better of the two pictures he has at the Salon is, in my opinion, the one entitled *Un Matin à Ville-d'Avray.* It is a simple curtain of trees, whose roots plunge into still water and whose tops disappear into the whitish haze of dawn. One would call it an Elysian world, but it is in fact reality, a bit softened, perhaps."[3] Théophile Thoré, never a great enthusiast of Corot, praised grudgingly: "Corot has never done anything but the same one landscape. This example is one of the better products of his reproduction studio."[4]

The conservative critics were enraptured by Corot's sweetened vision of pastoral life. "In painting nature," wrote Marc de Montifaud, "[Corot] puts something human in it: reverie, sadness, joy."[5] "In front of his two landscapes, the *Matin* and the *Soir*," J. Grangedor found, "one cannot help being struck by the energy that heightens the impression produced by the light, by the choice and arrangement of shapes in the composition; a composition where one doesn't sense the effort and might, on a superficial level, discern traces of hasty technical negligence. . . . [But] here, it is morning: several trees emerge from the mist; the indistinctness that belongs to the hour is in accord with these soft masses of foliage, seemingly tossed there

at random, without clearly marked underpinnings. The harmony comes from elsewhere; it is given by the light that gradually penetrates the mist, establishing gradated, nuanced planes and creating order where no precise shapes are indicated."[6]

But for others, Corot's indistinct forms were bothersome. "When you come to a Corot," warned Castagnary, "it is better not to get too close. Nothing is finished, nothing is carried through. In vain you seek the ground, some foliage; your eye makes out only a few large branches, slender and unmoored, that trail along the sky, and here and there greenish masses that vaguely shade off into a cloud of mist. Keep your distance."[7] It has often been suggested that Corot's misty effects were encouraged by his work with *clichés-verres* (drawings on a photographic plate that could be printed like photographs), but the corollary is also true: Corot's interest in *clichés-verres* lay in their ability to reproduce in a new medium the very effects he sought on canvas.[8] Here he seems to exaggerate the play of light, not only in the haze at the horizon but also in the bright spots of paint sprinkled across the foreground. By showing this work at the Salon with the contrasting *Le Soir* (fig. 151), he further directed attention to the range of effects he was able to produce so masterfully.

There is a very close copy of this painting, at about half scale, in the Minneapolis Institute of Arts. It is not included in Robaut's catalogue raisonné. Robaut did include a small study in oil for the Salon painting, which he identified as an "étude d'après nature," but it is so close in appearance to the finished painting that it is difficult to accept Robaut's description of it as a preparatory study.

1. "J'avoue préférer mille fois à ses grandes toiles, où il arrange la nature dans une gamme sourde et rêveuse, les études plus sincères et plus éclatantes qu'il fait en pleins champs." Zola, "Mon Salon (1868)," in Zola 1991, p. 216.
2. "*Un Matin à Ville-d'Avray* et *Le Soir* sont des plus beaux parmi les tableaux du maître. Le public n'y donne point assez d'attention, blasé qu'il est un peu sur cette manière et sur ces effets, dont la reproduction annuelle lui semble monotone." Castagnary, "Salon de 1868," in Castagnary 1892, vol. 1, pp. 275–76.
3. "À côté de Jongkind, je n'ai guère à citer que Corot, le maître dont le talent est si connu que je puis me dispenser d'en faire l'analyse. . . . D'ailleurs, Corot est un peintre de race, très personnel, très savant, et on doit le reconnaître comme le doyen des naturalistes, malgré ses prédilections pour les effets de brouillard. . . . Le meilleur des deux tableaux qu'il a au

Fig. 151. Corot. *Le Soir*, also called *Le Passage du Gué* (*Evening*, also called *Crossing the Ford*; R 1642), 1868. Oil on canvas, 39⅜ × 53⅛ in. (100 × 135 cm). Location unknown

Salon, est, selon moi, la toile intitulée: *Un Matin à Ville-d'Avray*. C'est un simple rideau d'arbres, dont les pieds plongent dans une eau dormante et dont les cimes se perdent dans les vapeurs blanchâtres de l'aube. On dirait une nature élyséenne, et ce n'est là cependant que de la réalité, un peu adoucie peut-être." Zola, "Mon Salon (1868)," in Zola 1991, p. 216.

4. "Corot n'a jamais fait qu'un seul et même paysage. Celui-ci est une des meilleures épreuves de son atelier de reproduction." Thoré, "Salon de 1868," in Thoré 1870, vol. 2, p. 491.

5. "En peignant la nature, il y met quelque chose de l'homme: la rêverie, la tristesse, la joie." Montifaud 1868, p. 50.

6. "Devant ses deux paysages, le *Matin* et le *Soir*, il est impossible de ne point être frappé de l'énergie qu'ajoutent à l'impression produite par la lumière le choix et l'agencement des formes dans la composition; composition où l'effort ne se fait pas sentir, et que, superficiellement, on pourrait juger

comme portant les traces d'une hâtive négligence matérielle. . . . [Mais] ici, c'est le matin: plusieurs arbres se dégagent de la brume, l'indécision de l'heure concorde aussi avec les silhouettes de ces légères masses de feuillages, jétées comme au hasard, sans subordination écrite. L'accord est ailleurs; il est donné par la lumière qui pénètre graduellement dans la brume et met des plans échelonnés, nuancés, et de l'ordre là où la forme n'indiquerait rien de précis." Grangedor 1868, p. 30.

7. "Quand on arrive devant un Corot, il ne faut pas s'approcher de trop près. Rien n'est fait, rien n'est exécuté. En vain vous chercheriez un terrain, du feuillage; votre oeil n'aperçoit que quelques grandes branches, minces et déliées, qui trainent le long du ciel, et puis çà et là des masses verdâtres qui s'estompent vaguement dans la nuée d'un brouillard. Tenez-vous à distance." Castagnary, "Salon de 1868," in Castagnary 1892, vol. 1, p. 276.

8. See the texts on Corot in Manchester, New York, Dallas, Atlanta 1991–92, where the subject of Corot and photography is considered at length.

PROVENANCE: Acquired from the artist for 5,000 francs,* after the twenty-second Exposition Municipale, by the Musée des Beaux-Arts, Rouen, 1869

EXHIBITIONS: Paris (Salon) 1868, no. 587, as *Un Matin à Ville-d'Avray*; Rouen 1869, no. 85; Paris 1875a, no. 38, as *Étangs de Ville-d'Avray*; Paris 1895, no. 12; Manchester, Norwich 1991, no. 35, as *The Ponds at Ville-d'Avray: Morning Mist*; Tokyo, Fukuoka, Sapporo, Shizuoka, Chiba, Kawasaki, Osaka 1993, no. 55

REFERENCES: Auvray 1868, p. 66; Fillonneau 1868, p. 2; Grangedor 1868, p. 30; Lafenestre 1868, p. 532; Montifaud 1868, p. 50; Nettement 1868, p. 558; Rochefort 1868, cited in Robaut 1905, vol. 4, p. 374; Thoré, "Salon de 1868," in Thoré 1870, vol. 2, p. 491; Chaumelin 1873, p. 158; Claretie, "L'Art français en 1872: Revue du Salon," in Claretie 1873, p. 112; Claretie 1882, p. 112; Castagnary, "Salon de 1868," in Castagnary 1892, vol. 1, pp. 275–76; Robaut *carton* 21, fols. 631–33; Robaut 1905, vol. 1, p. 240, and vol. 3, pp. 150–51, no. 1641, ill.; Nicolle 1920, p. 58; Moreau-Nélaton 1924, vol. 2, p. 32, pl. 197, as *Le Matin à Ville-d'Avray*; Bazin 1942, p. 107; Bazin 1951, p. 113; Coquis 1959, pp. 115–17; Walter 1969, pp. 225–27; Bazin 1973, p. 271; Zola 1991, p. 216; Adams 1994, p. 87, pl. 64, as *The Ponds of Ville-d'Avray, Morning Mist*

* Departmental archives, Musée des Beaux-Arts, Rouen, series T. 69.3.

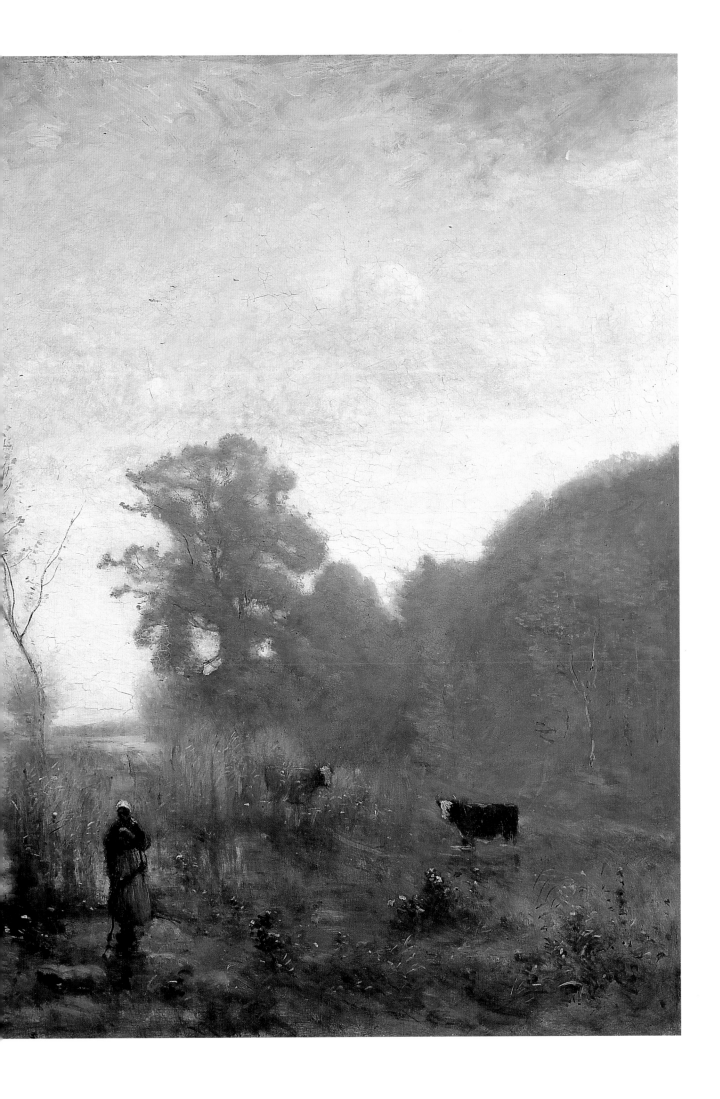

Ville-d'Avray

1870
Oil on canvas
21⅝ × 31½ in. (54.9 × 80 cm)
Signed lower right: COROT
The Metropolitan Museum of Art, New York
Catharine Lorillard Wolfe Collection, Bequest of Catharine
Lorillard Wolfe, 1887 87.15.141

R 2003

"It's morning and all is well. I open the window and I am at home, in the home of poets, that is to say, in nature. . . . All the dewdrops of dawn glisten in this canvas, through the delicate veil of mists gently lit by the sun. The awakening fertility of spring already joins the trees together, entwining their green branches. . . . Corot is the charmer par excellence in these representations of fresh and dewy nature in the early hours. How pure it all is! How young!"[1] Such was the ecstasy of Camille Lemonnier before this modest painting at the Salon of 1870. Corot, long since *hors concours* (able to exhibit without jury approval) at the Salon and long secure in his reputation and his market, sent this small canvas and one other to the Salon. It was as if he meant to reassure the world of art in the face of national calamity—the war with Prussia was about to break out—that all was well at Ville-d'Avray, all was well in his studio.

Corot still had his admirers at the Salon. They were those who sought poetry above all else in art. René Ménard spoke with a representative voice: "He is no seeker after reality, he is a dreamer, who, through all the changing and varied aspects of nature, pursues always the same poetic, uniform note. . . . They still say that when he paints *Ville-d'Avray* he knows how to be realistic when he feels like it. Well, no; what he sees everywhere is not what is in nature, it is what is in himself. If you sent him to Egypt to paint beside the pyramids, he would find there his silvery tones and mysterious thickets."[2] But the majority of critics considered Corot and his art passé, although they respected his past accomplishment. The critic for *L'Illustration* wrote, "In my opinion, this painting is not one of the artist's best; nevertheless, one finds in it the great qualities he has shown: an exquisite feeling for nature and an incomparable freshness of tone. Let us stay with the charm of the first impression; if one began a detailed examination, there would be too much to say."[3]

Corot's view shows the villas on the far bank of the large pond—*l'étang neuf*—at Ville-d'Avray. It is a scene that he depicted many times, but always taking certain liberties. The handsome tree in the left foreground, for example, acquires a different form from painting to painting. Radiographs reveal that the woman was originally accompanied by a small child just to her right, standing with arms outstretched toward the woman, who in turn reached for the child. Evidently the change

was made before the painting was exhibited, since none of the reviewers mention the child: perhaps Corot found the scene too anecdotal, or perhaps he did not wish to distract the viewer from the distant landscape visible through the screen of trees. Because of this heavily screened effect, Robaut noted, the painting was called "the spider's web."[4] The radiographs show a distinctive cutout effect created when the trunks and branches of the trees are left in reserve. There is as well a clear distinction between the sky, painted with lead white, and the rest of the landscape. An examination by Charlotte Hale revealed that Corot's mature painting technique is quite varied: "Thin washes of transparent greens and browns (underlayers); translucent scumbles [above them]; impasted brush and knife applications in the sky; thin calligraphic lines delineating the tree branches; small dabs for leaves and highlights and skimming strokes of light paint and some light scrapes with the butt end of the brush to indicate grasses in the foreground."[5]

The American collector Catharine Lorillard Wolfe acquired this painting by the early 1880s. She lent it to the 1883 Pedestal Fund Art Loan Exhibition in New York, where an important display of modern painting was mounted to raise funds for the construction of the pedestal of the Statue of Liberty. Miss Wolfe's Corot, singled out by the American painter Theodore Robinson,[6] was one of several lent by New York collectors, a sign that New York art dealers like Daniel Cottier and Adolphe Goupil had succeeded in permeating the market with Corot's recent work just a few years after the artist's death.

1. "C'est le bon Dieu et c'est le matin. J'ouvre la fenêtre et je suis chez moi, dans le chez moi des poètes, je veux dire la nature. . . . Toutes les rosées de l'aube perlent dans cette toile, à travers le tendre voile des brumes doucement illuminées de soleil. La naissante fécondité du printemps mêle déjà les arbres entre eux par des enlacements de branches verdoyantes. . . . Corot est le charmeur par excellence en ces représentations de la nature fraîche et mouillée des premières heures. Comme tout est pur en lui! Comme tout est jeune!" Lemonnier 1870, pp. 176–77.
2. "Ce n'est pas un chercheur de réalité, c'est un rêveur qui, à travers les aspects changeants et variés de la nature, poursuit toujours la même note poétique et uniforme. . . . On dira encore que quand il peint *Ville-d'Avray*, il sait être réel à ses heures. Eh bien, non; ce qu'il voit partout, ce n'est pas ce qui est dans la nature, c'est ce qui est en lui, et vous l'enverriez en Égypte

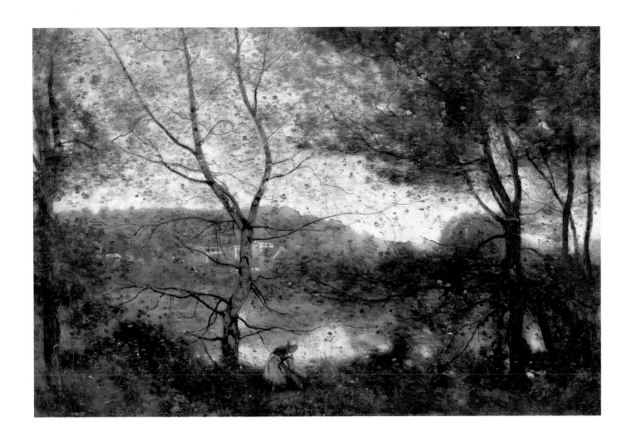

peindre à côté des Pyramides, il y trouverait ses tons argentins et ses bocages mystérieux." Ménard 1870, p. 54.

3. "Ce tableau n'est pas, à mon avis, un des meilleurs du maître; on y retrouve cependant les grandes qualités qui l'ont illustré: un sentiment exquis de la nature et une fraîcheur de tons incomparable. Restons sous le charme de l'impression première; il y aurait trop à dire, si l'on voulait aborder la critique de détail." Lostalot 1870, p. 335.

4. "la toile d'araignée." Robaut *carton* 22, fol. 769.

5. Charlotte Hale, report, March 30, 1995. Archives, Department of European Paintings, The Metropolitan Museum of Art, New York.

6. Southampton, New York 1986, pp. 138–40.

PROVENANCE: Catharine Lorillard Wolfe (1828–1887), New York, probably before 1872, by December 1883, until her death; her bequest to The Metropolitan Museum of Art, New York, 1887

EXHIBITIONS: Paris (Salon) 1870, no. 649, as *Ville-d'Avray;* New York 1883,

no. 13, lent by Miss Catharine Wolfe; Shizuoka, Kobe 1986, no. 9; Southampton, New York 1986, no. 13; Ville-d'Avray 1987, pl. 25; Manchester, New York, Dallas, Atlanta 1991–92, no. 37 (exhibited only in New York)

REFERENCES: Burty 1870, cited in Robaut 1905, vol. 4, p. 375; Clément 1870; Herton 1870, cited in Robaut 1905, vol. 4, p. 376; Lemonnier 1870, pp. 176–79; Lostalot 1870, pp. 333, 335, ill.; Ménard 1870, p. 54; Chaumelin 1873, p. 436; Roger-Milès 1891, p. 84; Castagnary, "Salon de 1870," in Castagnary 1892, vol. 1, pp. 398, 415; Robinson 1896, p. 115; Hamel 1905, pl. 65, as *Bord d'Étang;* Robaut 1905, vol. 1, p. 247, vol. 3, pp. 244–45, no. 2003, ill., vol. 4, pp. 170, 375–76; Fowler 1908, p. 383; Moreau-Nélaton 1924, vol. 2, p. 37, fig. 217; Fosca 1930, pl. 73; Bazin 1942, p. 107; Bazin 1951, p. 113; Coquis 1959, pp. 120–21; Chicago 1960, p. 15; Sterling and Salinger 1966, pp. 66–67; Bazin 1973, p. 272; Miquel 1975, vol. 2, p. 52; Paris 1975, p. 184; Baetjer 1980, vol. 1, p. 33, and vol. 3, ill. p. 553; Southampton, New York 1986, pp. 24, 32, 95, 138, 140, no. 13, pl. VIII; Young 1986, pp. 50–51, pl. IX; Wissman 1989, pp. 187–88, 205; Brenson 1991, p. C22; Leymarie 1992, pp. 162, 197

149

Souvenir de Ville-d'Avray
(Souvenir of Ville-d'Avray)

1872
Oil on canvas
39⅛ × 52¾ in. (100 × 134 cm)
Signed lower left: COROT
Musée d'Orsay, Paris R.F. 1795

R 2038

"France, where all the forms of beauty and enticement meet, of which Corot sings harmonious idylls, whose rustic life Millet describes with strokes of grandeur, whose sunlit rocks and shaded meadows Courbet reproduces with a brilliance never before equaled, France will again become what she should never have ceased being, what she would have remained without the expeditions to the Peloponnese and Algeria: the mother of French painters, the majestic inspiration of all those who, faced with the indifference or hostility of the foreigner, feel the need to affirm the vigor of the French soul."[1] After the profound shock of defeat in 1871 in the war with Prussia and of the atrocities committed in the name of the Paris Commune, the critic Jules Castagnary, among many, sought consolation in the works of the French landscape painters shown at the 1872 Salon. "Landscape remains the strength and glory of our French school. Although the jury went through it like a plow through a green field, there are still enough beautiful examples to prove to foreigners that we have not degenerated, at least not in this area." But Castagnary did not waste his words on Corot. "We won't say more than a word on Daubigny, Corot, or Chintreuil: these masters are on a par with their long-standing reputations."[2]

Corot sent "this wonderful masterpiece," as the conservative writer Camille Pelletan called the ambitious canvas,[3] to the 1872 Salon. It stands in marked contrast to the modest work based on the landscape at Ville-d'Avray that Corot exhibited at the previous Salon, held in 1870 (cat. no. 148). While it explores a similar device, a distant view visible through a screen of trees, the large size of the canvas and the attendant enlargement of the painterly effect drew attention. "One thing for sure is that the trees, as seen here, look something like mashed peas," was one observation.[4] Jules Claretie remarked, "As for *Souvenir de Ville-d'Avray*, picture one of those landscapes, charming in the way that Corot dreams them, and drop onto it a shower of small pieces of paper; you will have the speckled effect of this canvas. Yet what poetry still dwells in his works!" Nevertheless, Claretie considered Corot's two *envois* to the Salon "very much inferior to the luminous little *Vue de Douai*, which the artist exhibited at the place Vendôme not long ago."[5] Evidently Corot's more informal and painterly pictures, preferred by modern critics and collectors, had begun to win acclaim.

However, Henri Fantin-Latour told Robaut years later that this painting was "a work that made a powerful impression on him."[6]

Robaut, who was very close to Corot at this time, indicated that the view was taken from a spot behind the artist's property at Ville-d'Avray that Corot passed by every day on his way up to the woods of Sèvres-Ville-d'Avray.[7] It was begun from nature in either 1869 or 1870 and finished expressly for the Salon in the winter of 1871–72. The action, as the critics noted, is fanciful.[8] The seated woman, who becomes a surrogate for the viewer, may be meant vaguely to suggest Diana, mistress of the hunt. Corot had sold the picture to a dealer named Breysse even before it was shown at the Salon. The speculative collector Jean-Baptiste Faure had bought it in time to sell it at auction in 1878, where, much to Robaut's dismay, it was wrongly titled *La Fôret de Coubron*. After the painting was owned by John Saulnier, Alfred Chauchard, a wealthy retailer, acquired it for his large collection of works of the Barbizon school, which he donated to the Louvre.

1. "La France, où toutes les beautés et toutes les séductions se rencontrent, dont Corot chante les idylles gracieuses, dont Millet écrit la vie rustique en traits grandioses, dont Courbet reproduit les roches ensoleillées ou les prés ombreux avec un éclat qui ne fut jamais atteint, la France va redevenir ce qu'elle n'aurait pas dû cesser d'être, ce qu'elle eût été constamment sans les expéditions de Morée et d'Algérie: la mère des peintres français, l'inspiratrice auguste de tous ceux qui, devant l'étranger indifférent ou hostile, sentiront le besoin d'affirmer les énergies de l'âme française." Castagnary, "Salon de 1872," in Castagnary 1892, vol. 1, p. 31.
2. "Le paysage est toujours la force et la gloire de notre école française. Quoique le jury ait passé sur lui comme une charrue dans un pré vert, il en reste d'assez beaux et d'assez nombreux spécimens pour montrer aux étrangers que sous ce rapport au moins nous n'avons pas dégénéré." "Nous ne dirons qu'un mot de Daubigny, de Corot, de Chintreuil: ces maîtres sont à la hauteur de leur vieille réputation." Ibid., pp. 26–28.
3. "cet admirable chef-d'oeuvre." Pelletan 1872, quoted in Robaut 1905, vol. 4, p. 376.
4. "Une chose certaine, c'est que les arbres, sous cet aspect, rappellent vaguement celui d'une purée de pois." Selden 1872, p. 1140, quoted in Robaut 1905, vol. 4, p. 376.
5. "Quant au *Souvenir de Ville-d'Avray*, imaginez un de ces paysages charmants comme en rêve Corot, et laissez tomber sur lui une pluie de petits morceaux de papier, vous obtiendrez l'effet papillottant que produit cette toile. Et pourtant, quelle poésie demeure encore dans ses oeuvres!" "bien inférieurs à une lumineuse petite *Vue de Douai*, que l'artiste avait exposée peu auparavant place Vendôme." Claretie, "L'Art français en 1872: Revue du Salon," in Claretie 1873, pp. 291–92.

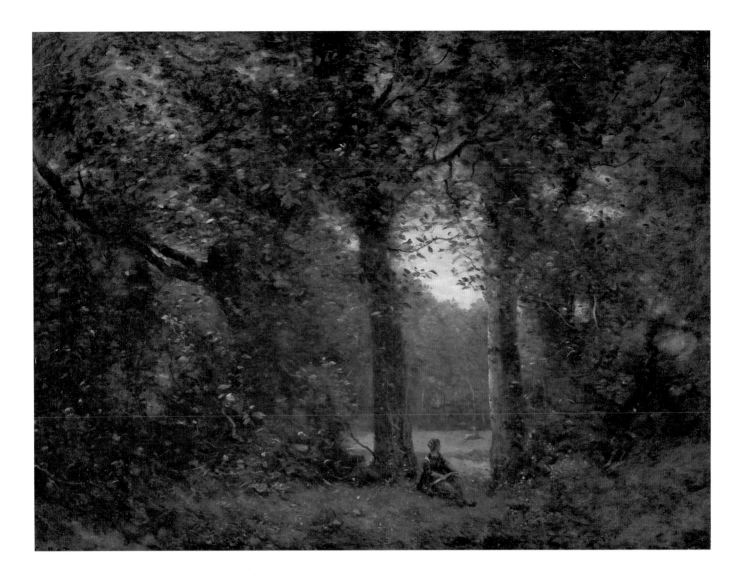

6. "une oeuvre qui l'a fortement impressionée." Robaut *carton* 22, fol. 390.

7. Ibid.

8. "fantastique." Stop 1872, quoted in Robaut 1905, vol. 4, p. 376.

PROVENANCE: The art dealer Breysse, by 1872; Jean-Baptiste Faure (1830–1914), Paris; his sale, April 29, 1878, Hôtel Drouot, Paris, no. 9, as *La Forêt de Coubron*, sold for 11,000 francs; John Saulnier (d. 1886), Bordeaux; his posthumous sale, Hôtel Drouot, Paris, June 5, 1886, no. 4, as *Forêt de Coubron. La Clairière*, sold for 25,500 francs; Alfred Chauchard (1821–1909), until his death; his bequest to the Musée du Louvre, Paris; transferred to the Musée d'Orsay, Paris, 1986

EXHIBITIONS: Paris (Salon) 1872, no. 389, as *Souvenir de Ville-d'Avray*, lent by Breysse; Paris 1875a, no. 60, as *Près Ville-d'Avray*; Paris 1886, no. 34, as *La Forêt de Coubron*, collection of John Saulnier; Paris 1910a, no. 20; Ville-d'Avray 1987, no. 47

REFERENCES: Pelletan 1872, cited in Robaut 1905, vol. 4, p. 376; Stop 1872, cited in Robaut 1905, vol. 4, p. 376; Claretie, "L'Art français en 1872: Revue du Salon," in Claretie 1873, pp. 291–92; Claretie 1882, p. 113; Robaut 1905, vol. 1, p. 262, vol. 3, pp. 258–59, no. 2038, ill., vol. 4, p. 376; Paris 1910a, p. 13, no. 20; Moreau-Nélaton 1924, vol. 2, p. 48, fig. 219; Bazin 1942, p. 108; Bazin 1951, p. 114; Coquis 1959, pp. 122–25; Bazin 1973, p. 272; Compin and Roquebert 1986, p. 154; Selz 1988, p. 256; Rosenblum 1989, p. 107; Wissman 1989, pp. 107–8, 115, fig. 52

Pastorale

1873
Oil on canvas
68 × 56⅞ in. (172.7 × 144.4 cm)
Signed lower left: COROT.
Glasgow Museums: Art Gallery and Museum, Kelvingrove
Presented by the sons of James Reid of Auchterarder, 1896 732

R 2107

Corot was received at the Salon of 1873 as a great old master from another era. Seemingly out of touch with current developments—although that was not entirely the case—he was at once revered and dismissed. Jules Castagnary, no youngster himself, delivered a kind of eulogy upon seeing *Pastorale* and Corot's second entry, *Le Passeur* (*The Ferryman*; R 2108, Musée du Louvre, Paris, R.F. 2670).

> Corot is the patriarch of the French landscape. He has been painting for fifty years. If fame came late to him, talent did not. In the revolution begun by Constable's two paintings, he was there, enrolled with the innovators. He saw the school born and saw it grow, himself developing and evolving through the double action of years of reflection.... I have already said that, among his works, I prefer his studies of nature to his own compositions. That is why I call the *Passeur* superior to the *Pastorale*. A river, a boat, people on the bank, a background of rocks, their upper ridges lit by the sun: it is a study arranged into a picture. When one thinks that the hand that placed these deft touches carries the weight of seventy-seven years, such fortitude comes as a surprise and a marvel. The illustrious old man is the lone survivor of a vanished past.[1]

Castagnary was neither the only person nor the first to proclaim a preference for the artist's informal studies over his large Salon "machines." However, Corot stubbornly continued to mount large canvases with mythological pretexts, as if still competing for the gold medal for history painting that had always eluded him.

Corot painted this work in a studio that had been made available by the art dealer Cléophas;[2] Cléophas acquired the canvas, one of fourteen Corots that he owned at one time or another,[3] and lent it to the Salon. Unlike many of Corot's Salon pictures, which spawned copies and variants, this composition was itself assembled of motifs from existing works.[4] The setting is virtually an enlargement of a detail from a small landscape of the late 1860s, *Paysannes à l'herbe dans une prairie, le matin* (fig. 152), formerly in Henri Vever's collection, while the figures were adapted from another work, *Danseuses des bois* (fig. 153), which seems to have been the prototype for the artist's *envoi* to his last Salon (1874), *Les Plaisirs du soir* (*Evening Pleasures*; R 2195, Armand Hammer Museum of Art and Cultural Center, Los Angeles). The music-making faun at the left had appeared in a work of about 1870, *Le Faune dansant* (*Dancing Faun*; R 2226).

Robaut admired this work for its "very delicate effect of the rising sun" and its "freshest possible sky with orange-tinted clouds." But he noted that Corot had been reproached for having carried out the painting too slowly; it took nine sessions "in secrecy" in the studio in March and April 1873.

Fig. 152. Corot. *Paysannes à l'herbe dans une prairie, le matin* (*Peasants on the Grass in a Plain, Morning*; R 1802), ca. 1865–70. Oil on canvas, 12⅝ × 17⅞ in. (32 × 44 cm). Private collection

Fig. 153. Corot. *Danseuses des bois* (*Dancers in the Woods*; R 2209), ca. 1871–72. Oil on canvas, 25⅝ × 30½ in. (65 × 80 cm). Private collection

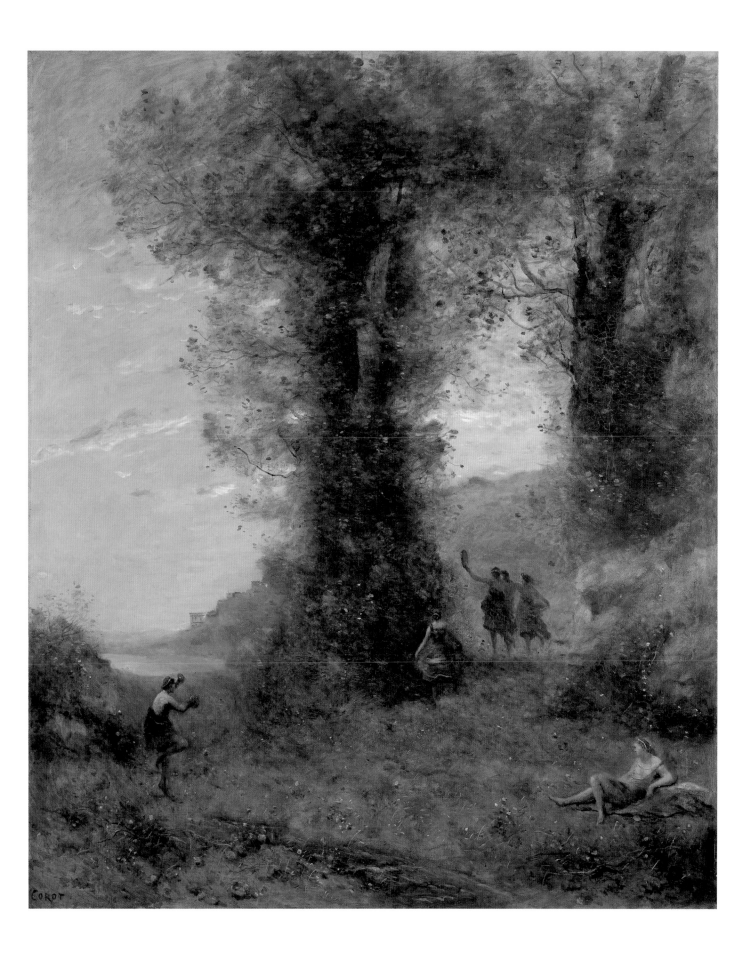

Conceding one point to the critics, he agreed that "the drawing especially of the tree in the center is a bit soft and round, and from the formal point of view, the canvas is too lightly painted." He also noted that when the painting was hung in the Exposition Centennale in 1889, it was quite inexplicably "exhibited the entire time with a very white label in the middle of the sky."[5]

1. "Corot est le patriarche du paysage français. Depuis cinquante ans, il peint. Si la gloire lui est venue tard, il n'en a pas été de même du talent. Il était à la révolution commencée par les deux tableaux de Constable, enrôlé parmi les novateurs. Il a vu naître et grandir l'école, grandissant lui-même et évoluant, sous la double action de la réflexion des années. . . . J'ai déjà dit que, dans ses oeuvres, je préférais les études sur nature aux compositions personnelles. C'est ce qui fait que je donne le *Passeur* pour supérieur à la *Pastorale*. Une rivière, une barque, des gens sur la rive, au fond des rochers dont le soleil éclaire les hautes arêtes: c'est une étude arrangée en tableau. Quand on songe que la main qui a posé ces touches légères porte le poids de soixante-dix-sept années, on est surpris et émerveillé de tant de vaillance. L'illustre vieillard surnage seul de tout un passé disparu." Castagnary, "Salon de 1873," in Castagnary 1892, vol. 2, p. 73.
2. Robaut 1905, vol. 1, p. 278, and vol. 3, p. 388, no. 2456.
3. The others are R 962, 1031, 1380, 2037, 2175, 2295, 2298, 2310, 2354, 2404, 2433, 2456, 2987.
4. I thank Rebecca A. Rabinow for bringing this to my attention. While R 1802 does appear to predate *Pastorale*, it is possible that R 2209, *Danseuses des bois*, was made after *Pastorale*.

5. "effet très tendre de soleil levant"; "ciel de la plus grande fraîcheur avec des nuages orangés"; "en cachette"; "il est vrai que le dessin de l'arbre du milieu surtout est un peu mol et rond, et qu'au point de vue pictoral, la toile est trop légèrement garnie"; "exposé toute le temps avec une etiquette bien blanche au milieu du ciel." Unpublished notes in Robaut *carton* 22, fol. 314.

PROVENANCE: Cléophas,* by 1873; John Forbes-White, possibly acquired through Cottier and Co., New York, from 1873 until at least 1889; sons of James Reid of Auchterarder (1823–1894);** their gift to the Glasgow Art Gallery and Museum, 1896

EXHIBITIONS: Paris (Salon) 1873, no. 359, as *Pastorale*, lent by Cléophas; Edinburgh 1886; Glasgow 1888, as *Pastorale—Souvenir d'Italie*, lent by John Forbes White, Esq. LL.D., no. 651; Paris 1889, no. 161, as *Pastorale*, lent by Forbes-White; Manchester, Norwich 1991, no. 38

REFERENCES: Thomson 1902, pp. 54, 57; Hamel 1905, pl. 86, as *Danse de nymphes*; Robaut 1905, vol. 1, p. 278, and vol. 3, pp. 280–81, no. 2107; Fosca 1930, pl. 92; Glasgow Art Gallery and Museum 1985, pp. 7, 32; Clarke 1991a, pp. 131, 135, fig. 123; Leymarie 1992, pp. 172–73, 197

* Cléophas was a former performer turned art agent. Corot occasionally worked "incognito" in Cléophas's Parisian studio at 19 bis, rue Fontaine and was acquainted with the dealer's nephew, the painter G. Bardon. See cat. no. 162.
** James Reid of Auchterarder (1823–1894) was the chief director and sole partner for many years of Neilson, Reid & Co., Hydepark Locomotive Works, Glasgow, the largest locomotive manufacturers in Europe.

151

La Jeune Grecque (The Greek Girl)

Ca. 1870–73
Oil on canvas
33⅛ × 21¾ in. (84.2 × 55.2 cm)
Signed lower right: COROT
Shelburne Museum, Shelburne, Vermont 27.1.1–149

R 1995

Robaut recorded what the eye can confirm: that Emma Dobigny, one of Corot's favorite models, posed for this work. Born Marie Emma Thuilleux in Montmacq, Oise, in 1851, she died in Paris in 1925. During the late 1860s she lived in a poor section of Montmartre and posed for Puvis de Chavannes, Degas, and possibly Tissot, in addition to Corot.[1] Although, as Moreau-Nélaton recounted, Dobigny moved impatiently about the studio, "prattled, sang, laughed, didn't stay put," Corot maintained that "it's just that changeability that I love in her. . . . My object is to express life."[2]

Corot had Dobigny wear an embroidered Greek coatdress with wide sleeves (*kavádi*) over a silk or cotton chemise (*pokámiso*) and a green, red, and white *chotózi*—"the fez of old Athens"—clothing she also wears in three related paintings.[3] This work is one of the few in which Dobigny plainly poses in the studio (see also *La Dame en bleu*, cat. no. 162), and it is a much larger canvas than the ones that show her in imaginary landscapes. The painted design on the dado—Robaut calls it a "frise Parthénienne"[4]—is less visible now than in early photographs of the picture, which seems to have suffered somewhat from cleaning.[5] While Robaut ascribes to these paintings various

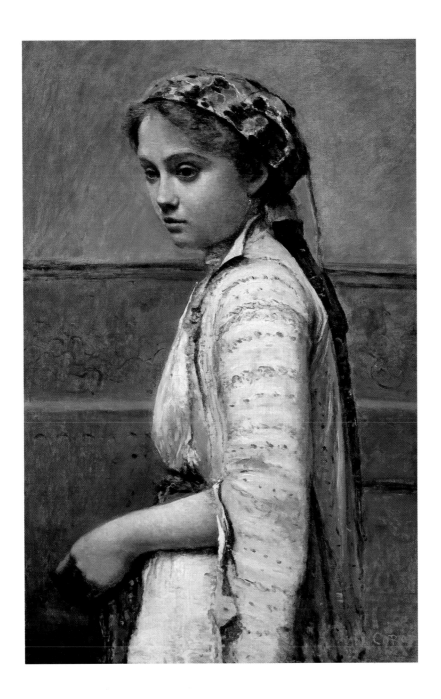

dates between 1865 and 1872, it seems likely that all four were painted in the years around 1870.

Writers in the twentieth century have been attracted to the monumentality of these figure paintings, but inevitably they impose their own aesthetic on Corot. August Jaccaci saw it in terms that are better suited to describing Cubism: "To give the bulk and the planes of the figure bathed into the particular light of an enclosed space, to express the density of the air as well as that of the figure and of all solid objects, to place each thing at its plane, and to relate it with each other thing, that is the problem Corot solves in these pictures, with an entirely different technique, a more modern technique, more free, less *poussée* than that of Ver Meer, but with much of the success with which Ver Meer solved it."[6] Lionello Venturi, however, saw the painting as an exercise not in volume but in a restricted palette. "It is a portrait of Mlle Dobigny whom

Corot had clothed in Greek costume in order to play with colour. . . . But the various colours are accessories; the form, volume, and every expression are due to the nuances and transparencies in grey. If this is no longer a model or an academic study but an image of grace, goodness, exquisite civilization and subdued modesty—in short if it is the image of Corot's soul, we owe it to those few nuances of grey."[7]

Of the twenty-eight works by Corot in John Saulnier's 1886 sale, this canvas was the only figure painting. It was also the only work that did not sell; it was bought in at 1,100 francs. The picture was reoffered in 1892, when Durand-Ruel bought it for 4,500 francs.

1. This information on Emma Dobigny was published by Henri Loyrette in Paris, Ottawa, New York 1988–89, p. 148.
2. "babillait, chantait, riait, ne tenait pas en place"; "c'est justement cette

mobilité que j'aime en elle. . . . Mon but, c'est d'exprimer la vie." Moreau-Nélaton in Robaut 1905, vol. 1, pp. 244–45. See above, "*Le Père Corot: The Very Poet of Landscape*," n. 44.

3. *Jeune Fille grecque à la fontaine*, R 1574, Musée du Louvre, Paris; *Jeunes Filles de Sparte*, R 1575, The Brooklyn Museum; *Haydée*, R 1997, Musée du Louvre, Paris. The costume Corot depicts agrees precisely with those described by Hatzimichali 1984, vol. 2, pp. 40, 442, 446, 448.

4. Robaut *carton* 27, fol. 66. Robaut also noted that the arm and hand were not very finished ("peu exécutée") and the face was too wide ("trop de largeur faciale").

5. Photographs in the archives of the Shelburne Museum show designs on the wall to the right of the figure that are no longer discernible.

6. Jaccaci 1913, pp. 5–6.

7. Venturi in Philadelphia 1946, p. 22.

PROVENANCE: John Saulnier (d. 1886), Bordeaux, probably by 1873; his posthumous sale, Hôtel Drouot, Paris, June 5, 1886, no. 17, as *Portrait: Jeune Fille costumée en grecque*, bought in for 1,100 francs; his estate until 1892; his estate sale, Galerie Sedelmeyer, Paris, May 25, 1892, no. 3, as *Jeune Fille costumée en grecque*; purchased at that sale by Durand-Ruel & Cie., Paris, for 4,500

francs; Bernheim-Jeune & Cie., Paris, from 1892 (stock no. 6.164, as *Jeune Fille à la grecque*); sold by them to Durand-Ruel & Cie., Paris, for 10,000 francs, May 28, 1895 (stock no. 3315); sold by them to H. O. (1847–1907) and Louisine (1855–1929) Havemeyer, New York, for 25,000 francs, September 19, 1895; by inheritance to their daughter Electra Havemeyer Webb (1888–1960), 1929; her bequest to the Shelburne Museum, Shelburne, Vermont, 1960

EXHIBITIONS: Chicago 1934, no. 162; New York 1934b, no. 24, as *Mademoiselle Dobigny: La Femme grecque*; New York 1940, no. 254; New York 1942, no. 63; Philadelphia 1946, no. 64; New Haven 1950, no. 3; Chicago 1960, no. 118; New York 1966a, no. 5; New York 1993, no. 113

REFERENCES: Roger-Milès 1895, p. 57, as *Jeune Grecque (buste)*, collection of Durand-Ruel; Meier-Graefe 1905, p. 85 (English translation in New York 1986, n.p.); Robaut *carton* 27, fol. 66; Robaut 1905, vol. 3, pp. 238–39, no. 1995, ill.; Bouyer 1909, p. 304; Jaccaci 1913, p. 5, fig. 1; Meier-Graefe 1913, pp. 108, 112, 117, ill. p. 147; Alexandre 1929, ill. p. 277; Bernheim de Villers 1930a, p. 62, no. 287, ill.; Meier-Graefe 1930, p. 90, pl. CXX; *Havemeyer Collection* 1931, p. 338, ill. p. 339; Venturi 1941, p. 169, fig. 111; Bazin 1942, pp. 61, 102, no. 108, pl. 108; Bazin 1951, pp. 56, 133, pl. 120; Dieterle 1959, n.p., pl. 27; Bazin 1973, pp. 65, 271, 289, ill. p. 227; Weitzenhoffer 1986, p. 107, pl. 62; Zimmermann 1986, pp. 101, 365, fig. 108; Shelburne 1994, n.p., ill.

152

Mademoiselle de Foudras

1872
Oil on canvas
35 × 23⅜ in. (88.9 × 59.3 cm)
Signed lower right: COROT
Glasgow Museums: Art Gallery and Museum, Kelvingrove
Presented by the Trustees of David W. T. Cargill, 1950 2858

R 2133

This is perhaps the most haunting of the half-length figure paintings that Corot executed in his last years. He clearly favored this format and lifesize scale, for there are at least ten works that belong in the category—among them *Sibylle* (cat. no. 142), *La Lecture interrompue* (cat. no. 144), and *L'Algérienne* (cat. no. 143). With the exception of *La Femme à la perle* (cat. no. 107) and *La Femme à la grande toque* (R 1060, private collection), they all were done in the late 1860s or early 1870s. Unfortunately there is insufficient information to make clear whether Corot painted these pictures to satisfy a commercial demand, a private desire, or an urge to measure himself against similar works by Courbet and, perhaps more pertinently, Rembrandt.

The demure gaze and three-quarter profile bring to mind Rembrandt, whose works Corot increasingly valued. He placed flowers in the hair of his model like those adorning *Flora* (fig. 154) in the Louvre, now given to Govert Flinck but in Corot's day prized as a Rembrandt. Although the hands of Corot's model rest in her lap, the foursquare presentation recalls the Dutch penchant for figures seen through a door or window. The Dutch, however, borrowed that device from Italian Renaissance painting, a fact Corot seems to acknowledge in giving his model a smile like that of the Mona Lisa.

Robaut told Moreau-Nélaton that Mlle de Foudras was the daughter of a tobacconist who kept a shop at the rue Lafayette, near the Faubourg Poissonnière.[1] This painting is clearly not a portrait, for the clothes and setting are not the subject's but Corot's: he had the woman don a Greek *kavádi* and embroidered waistcoat over her black street clothes,[2] and he sat her against the painted dado of his studio, visible at the right. But the painter's attentiveness to the physiognomy of the young woman, especially the deepset orbs of her eyes, gives the work a compelling psychological quality akin to that of portraiture.

Picasso, who, like Juan Gris, became interested in Corot in the 1910s, made a free copy of this work in 1920 (fig. 155), presumably from a photograph. The Havemeyers, the New York collectors who owned *La Destruction de Sodom* and *Orientale rêveuse* (cat. nos. 114, 153) among many other works by Corot, bought this painting on January 7, 1897, on behalf of their neighbor Colonel Oliver Payne, whom they advised. He declined to purchase the work, however, so it was returned to Durand-Ruel.[3]

1. Robaut 1905, vol. 3, p. 292, no. 2133.

2. The same *kavádi* appears in *La Jeune Grecque* (cat. no. 151) and the same waistcoat in *L'Albanaise*, R 2147, The Brooklyn Museum.

3. See Shelburne 1994, n.p., and Susan Alyson Stein in New York 1993, p. 220.

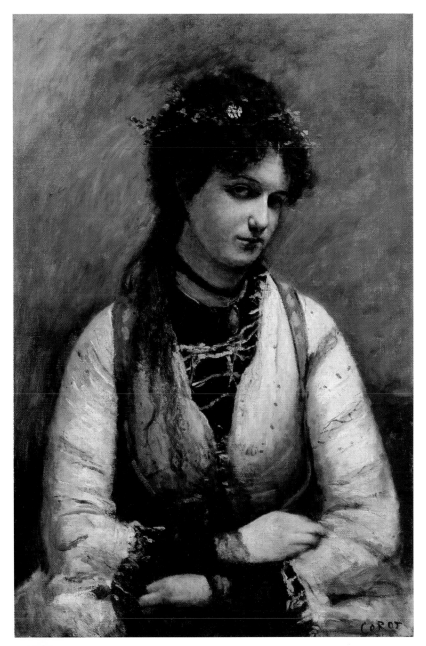

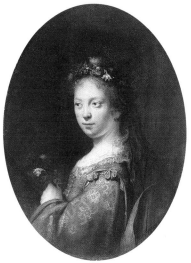

Fig. 154. Govert Flinck (1615–1660).
Flora. Oil on canvas, 17⅛ × 20½ in.
(69 × 52 cm). Musée du Louvre, Paris
(R.F. 1961–69)

Fig. 155. Pablo Picasso (1881–1973). *Buste de femme.*
D'après Corot (Bust of a Woman, after Corot), 1920.
Graphite on paper, 7⅞ × 5⅛ in. (20 × 13 cm).
Location unknown. Published in Zervos 1951
(vol. 4), fig. 3

PROVENANCE: Émile Dekens, Brussels, by 1895; purchased from him by Durand-Ruel & Cie., Paris, January 7, 1897; sold to H. O. Havemeyer, New York, along with two other pictures by Corot, for Colonel Oliver H. Payne (1839–1917), New York, January 7, 1897; returned by Payne to Durand-Ruel, New York, February 8, 1897;* kept by them until purchased jointly by Durand-Ruel & Cie., Paris, and Bernheim-Jeune & Cie., Paris, February 21, 1910; Durand-Ruel & Cie., Paris, sold their half share to Bernheim-Jeune & Cie., Paris, April 1, 1910; Galerie Georges Petit, Paris, by 1930; M. Knoedler and Co., New York, in November 1930; David William Traill Cargill (1872–1939), Glasgow, until his death; placed on consignment by his estate with the Bignou Galleries, New York, and Reid & Lefevre, London; presented by the trustees of David W. T. Cargill to the Glasgow Art Gallery and Museum, 1950

EXHIBITIONS: Paris 1895, no. 59, as *Portrait de jeune fille*, collection of Émile Dekens, Brussels; Paris 1930a, no. 3; New York 1930a, no. 3, as *Portrait de Mademoiselle de Foudras*; London 1936b, no. 10; Dallas 1942, as *Portrait of Mlle. de Foudras*, lent by the Bignou Galleries; Portland 1944; New York 1945, no. 3; Philadelphia 1946, no. 68, lent by the Bignou Galleries; Chicago 1960, no. 133; London 1962, no. 216; Paris 1962, no. 79; Edinburgh, London 1965, no. 98

REFERENCES: Robaut *carton* 27, fol. 68; Robaut 1905, vol. 3, pp. 292–93, no. 2133, ill., and vol. 4, p. 290; Bernheim de Villers 1930a, no. 306, ill.; Meier-Graefe 1930, pl. CXLIII, as belonging to a private collection, North America; Bazin 1942, p. 108; Bazin 1951, p. 114; Baud-Bovy 1957, p. 126; Hours 1972, pp. 156–57, ill.; Bazin 1973, p. 273; Janson 1978, p. 313; Leymarie 1979, p. 155, ill.; Zimmermann 1986, pp. 170–71, 377, fig. 162; Clarke 1991a, p. 143, fig. 129; Leymarie 1992, p. 180; New York 1993, p. 220; Gale 1994, pp. 128–29, ill.

* See cat. no. 118.

153

Orientale rêveuse (Pensive Oriental)

Ca. 1870–73
Oil on panel
31⅛ × 19¼ in. (79.1 × 48.9 cm)
Signed lower right: COROT
Shelburne Museum, Shelburne, Vermont 27.1.1-154

R 1573

This sublime picture must be counted one of Corot's most successful figure paintings. The downcast gaze and slumped shoulders of the model conspire with the barren landscape to evoke a mood of melancholy, but that mood is brightened by a few tender leaves, sprigs of flowers, and the opulent ruby-red skirt. The model, whose name is not known, wears a complete Greek costume: a thin embroidered *pokámiso* or *kavádi* under a *kondogoúni* (a heavily embroidered wool waistcoat with elbow-length sleeves), a silk cummerbund, and a thick wool skirt lined with a contrasting fabric.[1] Although Arsène Alexandre suggested in 1929 that Emma Dobigny posed for this picture, he cannot be right.[2] The model is instead the woman who posed for *L'Albanaise* (R 2147, The Brooklyn Museum) and for the beautiful half-length painting in which she wears this same costume (R 2144, private collection); it, like the *Orientale rêveuse*, belonged to the Havemeyers, who frequently bought related works by an artist.

In his unpublished notes, Robaut called this painting a "work of the highest order, as much for the landscape as for the figure." He insisted on the quality of the landscape, which, "while very simple, is of an entirely oriental beauty."[3]

The early history of this painting is not known, but it was already part of the distinguished Benoist collection by the early 1880s, since it was sold by Mme Benoist's estate in 1883. To Robaut's surprise, it brought only 3,280 francs at auction. However, when the Durand-Ruel gallery bought it from

Bernheim-Jeune in 1901, they paid the considerable sum of 22,000 francs. For some perspective on how Corot's figure painting had appreciated in value in the twenty-five years since his death, one need only remember that in the 1860s the artist unsuccessfully attempted to sell the much larger *La Toilette* (cat. no. 116) for 4,000 to 6,000 francs. The highest price he himself received for a canvas seems to be the 18,000 francs paid by the emperor for *La Solitude* (fig. 109) after its exhibition at the Salon of 1866.

1. See the descriptions of Greek costume in Hatzimichali 1984, vol. 2, pp. 10, 32, fig. 18, kindly brought to my attention by Deirdre Donohue and Harold Koda of The Costume Institute, The Metropolitan Museum of Art, New York.
2. Alexandre 1929, p. 280.
3. "oeuvre de tout premier ordre, autant pour le paysage que pour la figure"; "quoique très simple, est de toute beauté orientale." Robaut *carton* 27, fol. 57.

PROVENANCE: Mme. Benoist, Paris; her posthumous sale, "Vente après décès. Tableaux modernes, objets de curiosité," Hôtel Drouot, Paris, March 9–10, 1883, no. 9, as *Jeune Femme turque*; purchased at that sale by the dealer Diot for 3,280 francs;* Bessonneau (d. 1913), Angers, 1900; Bernheim-Jeune & Cie., Paris; sold by them to Durand-Ruel & Cie., Paris, for 22,000 francs, March 29, 1901 (stock no. 6261, as *Mademoiselle Daubigny*); sold to H. O. (1847–1907) and Louisine (1855–1929) Havemeyer, New York, April 22, 1901; by inheritance to their daughter Electra Havemeyer Webb (1888–1960), 1929; her bequest to the Shelburne Museum, Shelburne, Vermont, 1960

EXHIBITIONS: Paris 1900, no. 119, as *Femme orientale*, lent by Bessonneau; Chicago 1934, no. 160; New York 1934b, no. 19, as *Mademoiselle Dobigny: La Robe rouge*; Philadelphia 1946, no. 61, as *Orientale rêveuse—The Red Dress*; Chicago 1960, no. 103; New York 1966a, no. 4; New York 1993, no. 110

REFERENCES: Robaut *carton* 27, fol. 57; Robaut 1905, vol. 3, pp. 118–19, no. 1573, ill.; Jaccaci 1913, p. 2, as *Orientale rêveuse*; Meier-Graefe 1913, ill. p. 135, as *Porträt einer Damer als Italienerin*; Alexandre 1929, p. 281, ill. p. 280, as *Portrait de Mme D. en italienne*; Bernheim de Villers 1930a, p. 57, no. 270, ill., as *Orientale rêveuse*; Meier-Graefe 1930, pl. CXXII, as *Emma Dobigny als Italienerin*; Havemeyer Collection 1931, p. 337, ill. p. 338, as *Portrait of Mlle. Dobigny—The Red Dress*; Baud-Bovy 1957, p. 126; Weitzenhoffer 1986, p. 143, fig. 109; Zimmermann 1986, p. 97, p. 275, fig. 111

* Robaut *carton* 27, fol. 57.

154

Jeune Algérienne couchée sur le gazon (Young Algerian Woman Lying on the Grass)

1871–ca. 1873
Oil on canvas
16⅛ × 23⅝ in. (41 × 60 cm)
Signed lower left: COROT.
Rijksmuseum, Amsterdam SK-A-2883

R 2140

Robaut observed Corot working on the present painting in January 1871, during the siege of Paris. After the work was completed in 1872, it was photographed by Robaut's brother-in-law, Charles Desavary (fig. 156). In March 1873, Robaut noticed that Corot had added an infant on the knee of the reclining figure. But later, when he saw the painting in its present state, he could no longer be sure whether this was the painting he had seen in 1871 or a new one.[1] Radiographs taken in Paris in 1961 confirm Robaut's account of alteration. There the woman's raised knee is clearly visible, although the child is not. The exotic pelt on which the figure lies is also a later addition.[2]

Although much ink has been expended on Corot's interest in the work of Delacroix, this painting is one of the few to suggest a concrete relationship. In its present form it directly alludes to the woman at the left in Delacroix's *Femmes d'Alger* (fig. 157), which was bought from the Salon of 1834 by Louis-Philippe, displayed at the Musée du Luxembourg, and exhibited at the Exposition Universelle of 1855 and at Delacroix's posthumous retrospective in 1864. Not only does Corot utilize the pose and costume that appear in what Baudelaire called Delacroix's "poem of an interior, filled with repose and silence, crowded with rich fabrics and bits of finery,"[3] but his fluent brushwork and divided color seem to be a nod toward the great Romantic as well. However, this argument is weakened by the fact that in the picture's first state the pose is not the same as the one Delacroix used; thus it is impossible to argue that Corot set out to quote Delacroix. Further, by placing his odalisque in a landscape Corot denied his picture what Baudelaire called the "strong perfume of a bordello that leads us straight into the unfathomed depths of sadness."[4] It seems, rather, that what began as an essay in Orientalism became an *hommage* to Delacroix, made wholesome in Corot's manner.

Corot made two variants of this painting, each with the figure's pose a mirror image of the pose in this work: *Jeunes Filles de Sparte* (*Girls of Sparta*; R 1575, The Brooklyn Museum) and *L'Odalisque sicilienne* (*Sicilian Odalisque*; R 2134, location unknown). The features of Emma Dobigny are clearly recognizable in this painting in Amsterdam, but less so in the two variant versions.

many other elements in this canvas, seem highly suspect to me. I am not convinced.... Except for a harmony of the countenance that lies in the left eye, and that readily calls to mind COROT, which would not be hard to support, the rest is quite poor. I must also point out that Messrs. Dieterle and Badin fils painted the same study with the master in his studio.—I saw that at Bernheim Jeune's in April 1883 and I retained a poor impression of it.—I did not see it again at D. R. [Durand-Ruel], where it was for a while. The execution of the trees is deplorably loose and undefined. Conclusion: Very Dubious!" ("Ces accessoires, comme bien d'autres choses du reste en cette toile, me semblent fort louches. Je n'ai guère confiance.... Pour un accord de physionomie qui réside dans l'oeil gauche et qui rappelle assez bien COROT, ce qui du reste n'est pas difficile à insister, le reste est bien pauvre. Ce que je dois dire encore, c'est que MM Dieterle et Badin fils ont peint avec le maître la même étude dans son atelier.—J'avais vu cela chez M Bernheim Jne en avril 1883 et j'en ai gardé une pauvre impression—Je ne l'ai pas revu chez M D. R. [Durand-Ruel] où elle a pourtant passé. Les arbres sont d'une exécution déplorablement molle et indécise. Conclusion à tirer: 'Pas Confiance!'") Robaut *carton 27, fol. 70.* What Robaut could not know was that radiographs would reveal the first state of Corot's painting under the present surface. It hardly seems likely that Dieterle or Badin fils would have repainted one of Corot's pictures.

2. See Sylvie Béguin in Paris 1962, p. 178; Hours 1972, pp. 40, 158.
3. "poëme d'intérieur, plein de repos et de silence, encombré de riches étoffes et de brimborions de toilette." Charles Baudelaire, "Salon de 1846," in Baudelaire 1923, p. 120.
4. "haut parfum de mauvais lieu qui nous guide assez vite vers les limbes insondés de la tristesse." Ibid.

PROVENANCE: The artist; his posthumous sale, Hôtel Drouot, Paris, pt. 2, May 31–June 4, 1875, no. 473, as *Algérienne assise à terre*; purchased at that sale by Breysse for 310 francs;* George A. Hearn, New York; his posthumous sale, The American Art Galleries, New York, February 25–March 4, 1918, no. 204, as *Girl Reclining*; purchased at that sale by Ruth Teschner, for $4,400;** A. Von Wezel, by 1922; his gift to the Rijksmuseum, 1922; on deposit at the Stedelijk Museum, Amsterdam, from August 1949

EXHIBITIONS: Paris 1928, no. 48; Paris 1962, no. 77; Edinburgh, London 1965, no. 99

REFERENCES: Heilbut 1905, ill. p. 99; Meier-Graefe 1905, ill. p. 79; Robaut *carton 27, fol. 70*; Robaut 1905, vol. 3, pp. 294–95, nos. 2139 (as photographed in 1872), 2140, ill., and vol. 4, p. 245, no. 473; Meier-Graefe 1913, ill. p. 96; Bernheim de Villers 1930a, p. 57, no. 314; Meier-Graefe 1930, pl. CXXXIX; Bazin 1951, p. 114; Baud-Bovy 1957, p. 249; Hours 1962, p. 5, ill. pp. 38–39; Hours 1972, pp. 40, 158, fig. 46, pl. 158; Bazin 1973, pp. 273, 292, ill. p. 244; Rochester, Purchase 1982, pp. 56–57, fig. 55; Zimmermann 1986, p. 108, fig. 119; Selz 1988, pp. 254, 256, ill. p. 258; Gale 1994, p. 130, ill. p. 131

1. Hours 1962, p. 39. Indeed, Robaut wondered whether this painting was authentic. In his unpublished notes he wrote, "These accessories, like

* Robaut 1905, vol. 4, p. 245.
** *American Art Annual* 1918, p. 299.

Fig. 156. First state of Corot's *Jeune Algérienne couchée sur le gazon* (R 2139), photograph by Charles-Paul Desavary, 1872. Published in Robaut 1905, vol. 3, no. 2139

Fig. 157. Eugène Delacroix (1798–1863). *Les Femmes d'Alger dans leur appartement (Women of Algiers)*, 1834. Oil on canvas, 70⅞ × 90⅛ in. (180 × 229 cm). Musée du Louvre, Paris (inv. 3824)

155

L'Odalisque
(The Odalisque)

Ca. 1871–73
Oil on canvas
20⅛ × 24 in. (51 × 61 cm)
Signed lower right: COROT
Dr. Peter Nathan, Zurich
Paris only

Dieterle and Pacitti 1992, no. 44

Corot demonstrated an interest in Orientalism in the 1860s and 1870s, and as time passed this interest grew more pronounced. While many of his figure paintings of the 1860s could just as easily be entitled *L'Italienne* as *L'Algérienne*, the ones he made from about 1870 on deliberately evoke North Africa, even if most of the costumes Corot had his models wear were Greek. Why this shift occurred is not clear. It is difficult to attribute it to one specific set of circumstances, but several separate elements may have converged. Corot probably would not have dared to

poach Delacroix's imagery while he was still alive. He had said of Delacroix, "He is an eagle, I am only a lark."[1] But by 1870 the great "eagle" was long gone. Another factor might be a change in the taste of Corot's collectors. Perhaps the pretty Italian girl, a staple motif of French painters who went to Italy early in the century, had simply become woefully old-fashioned by this time.

In some respects, this small painting is the most Orientalist of Corot's genre paintings. The costume seems authentic,

there are North African accessories, and the setting is an interior with a view onto a Mediterranean port, whereas many of his paintings of figures in Oriental costumes are set in northern landscapes. Still, unlike Delacroix, Corot gives no real sense of attempting to understand Islamic culture or express deep appreciation for it. He sought instead a picturesque motif; and, inspired by rich textiles and a beautiful model, he made an exquisite jewel.

Robaut and Moreau-Nélaton did not include this painting in their catalogue. It appeared on the art market only in 1911.

1. "C'est un aigle et je ne suis qu'une alouette." Bazin 1936, p. 53.

PROVENANCE: Gift of the artist to his friend Paul Vayson (1842–1911), Paris; Galerie Georges Bernheim, Paris, 1911; Joseph (Josse) Bernheim-Jeune (1870–1941) and Gaston Bernheim-Jeune (1870–1953), Paris, by 1930, until 1936; Dr. Peter Nathan, Zurich

EXHIBITIONS: New York 1930c, no. 34, as collection of Josse and Gaston Bernheim-Jeune, Paris; Zurich 1934, no. 72; Paris 1936, no. 94, lent by Josse Bernheim-Jeune; Lyons 1936, lent by Josse Bernheim-Jeune; Bern 1960, no. 89

REFERENCES: Meier-Graefe 1930, pl. CXXVII; Bernheim de Villers 1930a, no. 344, as *Femme turque*; Bazin 1942, p. 124, pl. 120; Zimmermann 1986, pp. 107–8, 367, no. 118, pl. 118; Dieterle and Pacitti 1992, no. 44, ill.

156

Le Beffroi de Douai
(The Belfry, Douai)

May 1871
Oil on canvas
18¼ × 15⅛ in. (46.5 × 38.5 cm)
Signed lower left: COROT
Musée du Louvre, Paris R.F. 1710

R 2004

Corot remained in Paris despite the unrest there until April 1, 1871, when he finally surrendered to Alfred Robaut's urgings and with him fled the Commune.[1] He traveled first to Arras to stay with Charles Desavary, then to Douai, where he stayed with the Robauts. Robaut and Desavary were each married to a daughter of Corot's much-loved friend Constant Dutilleux, who had died of a stroke in 1865.

Robaut was thus witness to the creation of this work, "from a window on the second floor of a house at the corner of the rue du Pont-à-l'herbe and the rue de la Cloris."[2] Nevertheless, there has been some confusion as to where Corot worked and to whom the house belonged. The monogrammist P. A. wrote in 1911 that Corot worked in Robaut's house,[3] which cannot be true, since Robaut lived at 45, rue de Bellain.[4] Daniel Baud-Bovy recorded that Robaut told him the house belonged to an acquaintance.[5] Another eyewitness to the making of the painting, an artist named Adrien Breton, informed Baud-Bovy that the house belonged to a certain M. Hornez.[6] The choice of motif, according to Moreau-Nélaton, was the ingenious result of Robaut's efforts to find a subject "that would not subject him to bad weather."[7] The belfry, constructed during the fourteenth and fifteenth centuries, was the great symbol of Douai and was thought to be one of the finest medieval towers in northeast France. In his composition Corot was guided by the lithograph of a minor artist named Charles Motte that Robaut had published sometime between 1845 and 1850 (fig. 158). Victor Doiteau pointed out in 1936 that Corot

positioned himself farther back from the tower than Motte had done but still based his figures on the lithograph, transforming its elegantly dressed bourgeois couple into a peasant woman and a male figure that Robaut identified as a self-portrait of the artist.[8]

Robaut considered the result a "great masterpiece." In 1890 he reminisced, "The painter thought as much, since he wrote, half in jest, half seriously, to my brother-in-law Desavary, that he had accomplished 'a splendid work.'"[9] Robaut continued, "That was in the thick of the Commune in '71.... France's defeat, the revolution, the unexpected death of his dear friend Aligny in Lyons in February, had all chased away his good humor. But, with brushes in hand, he recovered his smile and his songs. To enable him to work comfortably, I set him up in the second floor of a house belonging to an acquaintance of mine, at the intersection of the rue Clovis [*sic*] and the rue du Pont-à-l'herbe. From the window one could look down the street to the town hall. What trouble he had placing the tower! It would not do to disturb him. As soon as he finished his nap, he set to work; he slaved away at it from two o'clock until the evening, for more than twenty sessions.... It has all the qualities of the *Colisée* [cat. no. 8], with something else besides. The man in the smock chatting with a woman, that's him.... What a lesson for the idiots who accuse him of not knowing how to paint anything but a succession of ponds! And he's going on seventy-five!"[10]

Robaut was not alone in his esteem for the canvas, which Corot had given to him. It was exhibited at the Cercle des Mirlitons gallery in Paris in 1871–72, when the critic Jules Claretie saw it. Of Corot's paintings on view at the 1872 Salon (see cat. no. 149) Claretie subsequently wrote, "The two paintings by Corot . . . in no way constitute an advance, and are very much inferior to the luminous little *Vue de Douai*, which the artist exhibited at the place Vendôme not long ago."[11] But others demurred. When the Louvre bought this painting from Robaut's sale in 1907, Edgar Degas told Moreau-Nélaton, "Yes, well, I'm not sure if I much like it. . . . Personally, I would have preferred the *Monte Cavo*. Those black mountains really give me a thrill. In fact, this Robaut, he seems to be completely gaga. We won't hear him whine his 'Papa Corot' and his 'Papa Dutilleux' anymore. What a rascally junk dealer!"[12] Madeleine Hours has suggested that Corot always intended to have this work and the *Cathédral de Chartres* (cat. no. 37) go to the Louvre,[13] but surely if this were true he would have told Robaut, who would have repeated it to others.

Once the painting entered the Louvre, writers began comparing it to architectural views by old masters. Paul Jamot, in a generous mood, said, "The painter's diligence in reproducing the architectural details and the minute street scenes deserve comparison with those perspectives of cities that the primitives display behind their *Virgins* surrounded by saints and pious donors. On the other hand, with the quality of light, the softness of its caress on the old tiles of the roofs, on the stone or plaster of the facades, rendered with so much love and truth, one wonders if any of Corot's successors has been able to go any farther on the same path."[14] Later Jamot compared Corot to Vermeer, realizing, however, that the comparison was flawed: "While Corot does not offer us quite the enchantments of pictorial perfection that we find in Vermeer, his means—less flawless, less confident, simpler and more familiar—allow him to charge the message of eye and hand with a subtle poetry and a touching spirituality. Is it rash to confess that for these reasons, one prefers the *Beffroi de Douai* by the good Corot to Vermeer's admirable *Little Street*, which Corot certainly never saw and did not even know existed?"[15]

Perhaps the more interesting comparison is with near-contemporaneous street scenes by Monet and Sisley, such as their views of Argenteuil done in 1872 (fig. 159).[16] Although Corot could not have known these paintings, Monet and Sisley might have seen the *Beffroi* while it was briefly on view in Paris in 1871–72.[17] And while Monet, Sisley, and, for that matter, Pissarro had already adopted a blond palette and fluid brushwork, they might have found a kind of validation for this new direction in Corot's picture.

As for Corot, it is unlikely that he would consciously have emulated the work of the New Painters, whose Salon pictures he had seen and disliked. Still, the light palette of the *Beffroi* could be his response to the lightening in tone that occurred in landscape painting in general at the end of the 1860s. And the Impressionist-like technique is perhaps explained by Corot's

Fig. 158. Charles-Étienne-Pierre Motte (1785–1836). *Beffroi de Douai (The Belfry of Douai)*. Lithograph. Published in Doiteau 1936, p. 220, following Robaut

Fig. 159. Alfred Sisley (1839–1899). *Rue de la Chaussée à Argenteuil*, also called *Place à Argenteuil*, 1872. Oil on canvas, 18¼ × 26 in. (46.5 × 66 cm). Musée d'Orsay, Paris (R.F. 1692)

particular method in making this painting, which Robaut described in his notes: "After each 'sitting' from nature, one saw him scraping the canvas with a razor, often even when the paint was still wet. I saw this many times for the *Beffroi de Douai*. I objected that he would erase important things on which he had spent a long time. 'That doesn't matter to me,' he rejoined, 'at least I will find an excellent underlayer, for it must be nice and fat, well fed.' "[18]

1. Moreau-Nélaton 1924, vol. 2, p. 41.
2. "d'une fenêtre au premier étage d'une maison formant l'angle de la rue du Pont-à-l'herbe et de la rue de la Cloris." Robaut 1905, vol. 3, p. 246.
3. Anon. 1911 (P. A.), p. 31.
4. Doiteau 1936, p. 220.

156

5. Baud-Bovy 1957, p. 14.

6. Ibid., pp. 110–11. This assertion is repeated in Hours 1972, p. 154, where the name is spelled Hurnez.

7. "qui ne l'exposât pas aux intempéries." Moreau-Nélaton 1913, p. 92.

8. Doiteau 1936, p. 220.

9. "grand chef-d'oeuvre"; "Le peintre s'en doutait bien, lorsqu'il écrivait à son propos, moitié plaisant, moitié sérieux, à mon beau-frère Desavary, qu'il achevait 'une oeuvre splendide.'" Robaut quoted in Baud-Bovy 1957, p. 14. On May 8, 1871, Corot wrote to Desavary: "I am putting the final touches on the *Douai Belfry*, a splendid work." ("Je mets la dernière main au *Beffroi de Douai*, oeuvre splendide.") See Robaut 1905, vol. 3, p. 246.

10. "C'était en pleine Commune, en 71. . . . La défaite de la France, la révolution, la mort de son cher camarade Aligny, survenue à Lyon en février, avaient eu raison de sa jovialité. Mais, les pinceaux en main, il retrouvait son sourire et ses chansons. Pour lui permettre de travailler à son aise, je l'avais installé chez une personne de ma connaissance, au premier étage d'une maison qui fait l'angle de la rue Clovis et de la rue du Pont-à-l'herbe. De la fenêtre, le regard enfilait la rue de la Mairie. Ah! il a eu du mal pour mettre le clocher en place! Il ne fallait pas le déranger. Sitôt sa sieste faite, il se mettait à la besogne; il s'y acharna dès deux heures jusqu'au soir, durant plus de vingt séances. . . . Il y a là-dedans toutes les qualités du *Colisée*, avec quelque chose en plus. Le bonhomme en blouse qui cause avec une femme, c'est lui. . . . Quelle leçon pour les idiots qui l'accusaient de ne plus savoir peindre que des étangs en série! Et il allait avoir 75 ans!" Robaut quoted in Baud-Bovy 1957, pp. 14–15.

11. "Les deux tableaux de M. Corot . . . ne constituent point un progrès, et sont bien inférieurs à une lumineuse petite *Vue de Douai*, que l'artiste avait

exposée peu auparavant place Vendôme." Claretie, "L'Art français en 1872: Revue du Salon," in Claretie 1873, p. 291.

12. "Oui, eh bien, je ne sais pas si j'aime beaucoup ça. . . . Ah! moi, ce que j'aurais préféré, c'est le MONTE CAVO. Ces montagnes noires m'emballaient. Au fait, ce Robaut, il paraît qu'il est tout à fait gâteux. On ne l'entendra plus pleurnicher ses PAPA COROT et ses PAPA DUTILLEUX! Quel infâme brocanteur!" Moreau-Nélaton 1931, p. 267, cited in Galassi 1991b, p. 5.

13. According to Hours, Corot wrote on the back of the *Chartres* "Pour le Museum des Arts." Hours 1972, p. 154.

14. "L'application du peintre pour reproduire les détails d'architecture et les menues scènes de la rue mérite d'être comparée à celle des primitifs dans ces perspectives de villes qu'ils déployaient derrière leurs *Vierges* entourées de saints et de pieux donateurs. D'autre part, la qualité de la lumière est telle, la douceur de sa caresse sur les vieilles tuiles des toits, sur la pierre ou le crépi des façades, est rendue avec tant d'amour et de vérité qu'on se demande si aucun des successeurs de Corot a pu aller plus loin dans la même voie." Jamot 1929, p. 38.

15. "Si Corot ne nous offre pas tout à fait ces enchantements de la perfection picturale que nous trouvons chez Vermeer, des moyens moins impeccables, moins sûrs, plus simples et plus familiers lui servent à charger d'une subtile poésie et d'une touchante spiritualité le message de l'oeil et de la main. Est-il téméraire d'avouer que, pour ces causes, à l'admirable *Petite Rue* de Vermeer on préfère le *Beffroi de Douai* du bon Corot, lequel n'avait certes jamais vu la *Petite Rue* et en ignorait même l'existence?" Jamot 1936, p. 54.

16. See also Monet's *L'Ancienne Rue de la Chaussée, Argenteuil*, 1872, private collection (Wildenstein 1974–91, no. 239).

17. Josine Smits suggests a direct link between Monet's and Sisley's street scenes and Corot's *Beffroi*. Smits 1991, pp. 353–54.

18. "On le voit, après chaque séance pour ainsi dire, d'après nature, passer le rasoir à plat sur la toile, souvent même lorsqu'elle n'est pas bien sèche. Je l'ai fait nombre de fois pour le Beffroi de Douai. Je lui en faisais la remarque et objectais qu'il allait effacer des choses importantes qui lui avaient demandé beaucoup de temps.—'Ça m'est égal, ajoutait-il, du moins je trouverai des dessous excellents, car il faut que ce soit bien gras, bien nourri.'" Robaut's

notes, Archives, Musée du Louvre, Paris, quoted by Hélène Toussaint in Paris 1975, no. 62. Bazin recorded the second sentence differently: "Je lui a vu faire nombre de fois pour le Beffroi de Douai." Bazin 1973, p. 292.

PROVENANCE: Gift of the artist to Alfred Robaut (1830–1909), Paris;* his sale, Hôtel Drouot, Paris, December 18, 1907, no. 4; purchased at that sale by the Musée du Louvre, Paris, for 46,000 francs

EXHIBITIONS: Paris 1871–72; Paris 1875a, no. 99; Paris 1878a, no. 209; Amsterdam 1926, no. 23; Copenhagen, Stockholm, Oslo 1928, no. 18 (Copenhagen), no. 16 (Stockholm), no. 11 (Oslo); London 1932, no. 309; Zurich 1934, no. 111; Paris 1936, no. 98; Lyons 1936, no. 99; Paris 1945b, no. 9; Paris 1946b, no. 187; Arras 1954, no. 12; Paris 1975, no. 62

REFERENCES: Claretie, "L'Art français en 1872; Revue du Salon," in Claretie 1873, p. 291, ill.; Robaut 1895, ill.; Anon. 1896, ill.; Geffroy 1903, p. cxxv; Robaut *carton* 11, fol. 368; Robaut *documents*, vol. 2, fol. 15; Robaut 1905, vol. 1, pp. 13, 251, vol. 3, pp. 246–47, no. 2004, ill., vol. 4, pp. 272, 278, 391; Leprieur 1908, pp. 2–4, pl. 1; Cornu 1911, pp. 55, 132; Anon. 1911 (P. A.), pp. 31–32, ill. (engraving); Meier-Graefe 1913, p. 89; Moreau-Nélaton 1913, pp. 92–94, pl. 22; Moreau-Nélaton 1924, vol. 2, p. 41, fig. 218; Lafargue 1926, pp. 56, 58, pl. 39; Jamot 1929, pp. 36–38, pl. 47; Meier-Graefe 1930, p. 96, pl. CXXXIV; Faure 1931, pp. 32, 56, fig. 71; Jean 1931, pl. 53; Moreau-Nélaton 1931, p. 267; Bazin 1936, pp. 63, 65–69, fig. 83; Doiteau 1936, p. 220, ill.; Jamot 1936, pp. 50–52, 54, ill. p. 56; Baud-Bovy 1957, pp. 13–15, 97, 110–11, 247, 259, 261, pl. LIII; Fosca 1958, pp. 42, 122, 187, ill. p. 74; Coquis 1959, pp. 121–22, ill. opp. p. 113; Hours 1972, pp. 32, 50, 118, 154–55, 162, ill., fig. 57; Bazin 1973, pp. 53, 272, 292–93, ill. p. 246; Leymarie 1979, p. 144, ill. p. 142; Gache-Patin and Lassaigne 1983, p. 67, fig. 88; Compin and Roquebert 1986, p. 152; Selz 1988, pp. 248–50, 281, ill. p. 249; Clarke 1991a, p. 101, ill. frontispiece; Galassi 1991b, p. 5; Smits 1991, pp. 350–54, fig. 337; Leymarie 1992, p. 164, ill. p. 165; London, Paris, Baltimore 1992–93, p. 106, fig. 66

* According to Robaut, he commissioned this painting from Corot: Robaut *carton* 11, fol. 368.

157

Sainte-Catherine-les-Arras. Saules et chaumières (Willows and Farmhouses at Saint-Catherine-les-Arras)

June 1871
Oil on canvas
14¼ × 17½ in. (36.3 × 44.4 cm)
Signed lower left: COROT
The Cleveland Museum of Art
Gift of Mr. and Mrs. J. H. Wade, 1916 16.1047

R 2013

In the spring and summer of 1871 Corot remained in the flatlands south of Lille, staying sometimes with the Robauts, who lived in Douai, and sometimes with the Desavarys, in Arras. These two towns and the villages between them retained the distinctive appearance and customs of neighboring Belgium, since the territory had been part of the Low Countries until the French king Louis XIV took it in battle in 1667. After a quick return to Paris and Ville-d'Avray in early June, Corot and the Robauts rented a house in Arleux-le-Nord, just east

of Arras, where Corot stayed until late July. Comfortably surrounded by his surrogate family, he revisited the rural sites that he had painted in the 1850s in the company of Constant Dutilleux, the father of Mme Robaut and Mme Desavary. The hamlet of Sainte-Catherine-les-Arras, between Arras and Arleux, was one such spot. This painting was executed in the company of Charles Desavary, Dutilleux's son-in-law, who, while Corot worked on his canvas, painted the same view.

Although Corot painted out of doors, his technique here was the same as that in his contemporary studio work; he no longer retained a distinction between methods used for informal

plein air sketches and for imaginary compositions. Thus, the leaves of the pollarded willows at the right are painted the same way as the leaves of his invented trees. The humble cottages at the left, however, have the appearance of solidity that comes from direct observation. In reviews of Salons from the last decade of Corot's life, critics routinely remarked that plein air studies like this one were superior to the more elaborate compositions he sent for exhibition.

PROVENANCE: Bernhard Stern, New York, probably before 1872, until 1890; sale, "Foreign Paintings, Being the Private Collections of the Late

Bernhard Stern, New York, and of William T. Evans, Jersey City (His Entire Collection of Foreign Works)," The American Art Galleries, New York, March 6, 1890, no. 125, as *Les Saules*; purchased at that sale by M. Knoedler and Co., New York, for $800; sold to Jeptha Homer Wade (1857–1926), Cleveland, for $1,500, April 12, 1890; given by Mr. and Mrs. J. H. Wade to The Cleveland Museum of Art, 1916

EXHIBITIONS: Cleveland 1936, no. 260, as *The Willows*; Chicago 1960, no. 126, as *The Willows*; Dallas 1961, no. 1

REFERENCES: Robaut 1905, vol. 3, pp. 250–51, no. 2013, ill.; Milliken 1936, p. 13; Morse 1979, p. 66; Chong 1993, p. 44, ill., as *Willows and Farmhouse at Sainte-Catherine-lez-Arras*

Hamlet et le Fossoyeur
(Hamlet and the Gravedigger)

Ca. 1873–74
Oil on canvas
19¾ × 31¾ in. (50 × 80.5 cm)
Stamped lower left: VENTE COROT
Ordrupgaardsamlingen, Copenhagen

R 2373

Corot had been an avid theatergoer throughout his adult life, but he went even more frequently in the late 1860s and early 1870s, when the infirmities of old age limited his activities. Moreau-Nélaton reported that in the winter of 1873–74, despite mounting fatigue, Corot continued to see friends and to attend the theater. "Besides," he wrote, "his work constantly draws on the theater for nourishment. A large painting that he is making for the dealer Détrimont and that he calls *Biblis* found its inspiration in October 1873 in the ballet *La Source.* In the same period, *Hamlet* gave him the subject for a small canvas left as an oil sketch."[1]

This is the small canvas that Moreau-Nélaton refers to, but whether it is in fact an *ébauche,* or oil sketch, is difficult to determine. The touch is broad but the effect is superbly realized, and the entire canvas is consistently finished. Still, Corot never sold the picture—even though by then the demand for his work exceeded his output—which may be proof that he considered the canvas unfinished.

Corot's inspiration was the opera *Hamlet,* composed by Ambroise Thomas and first performed at the Opéra-Comique in Paris on March 9, 1868. It was Thomas's most successful opera after *Mignon* and to his mind his best, but today it is considered lightweight and, like much music popular during the Second Empire, is rarely performed.[2] Thomas changed the lead role from a tenor to a baritone in order to accommodate the voice of the greatest star in Paris, Jean-Baptiste Faure, himself one of the leading collectors of contemporary French painting (see fig. 174). Faure's features are recognizable in some of the sketches Corot made in the little notebook he always took with him to the theater (figs. 160, 161), although the landscape in Corot's painting is at once more desolate and more dramatic than the scenery Corot actually saw on the stage. As he had in the *Macbeth* of 1859 (fig. 110) and in *Dante et Virgile* (cat. no. 115), Corot here entrusted to the landscape the task of conveying the scene's emotions. The figures and their actions are little more than ancillary props; it is the sunset that carries Hamlet's sentiments of loss and the transience of life.

Although this work is broadly assigned to 1870–75 in the catalogue raisonné, Moreau-Nélaton associated it with works of the winter of 1873–74, which seems appropriate. It was not

Fig. 160. Corot. Drawing of an actor in costume (R 3068), ca. 1854. Graphite on paper. *Carnet* 31, fol. 17 v. Musée Carnavalet, Paris (D 03594)

Fig. 161. Corot. Drawing of a stage set (R 3071), ca. 1854. Graphite on paper. *Carnet* 34, fol. 26 v. Musée Carnavalet, Paris (D 03593)

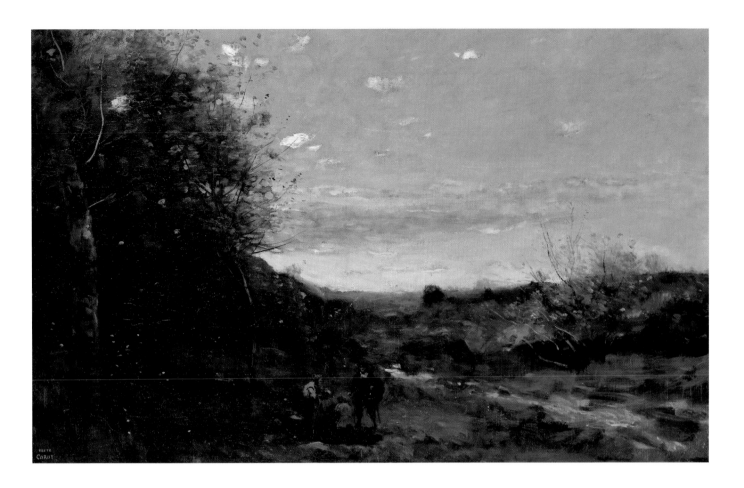

photographed along with the rest of the contents of Corot's studio in 1872 and thus almost certainly postdates that photographic campaign.

1. "D'ailleurs, son oeuvre puise sans cesse son aliment au théâtre. Un grand tableau, qui'il prépare pour le marchand Détrimont et qu'il intitule *Biblis*, lui a été inspiré, au mois d'octobre 1873, par le ballet de *la Source*. *Hamlet* lui fournit aussi, vers la même époque, le sujet d'une petite toile demeurée à l'état d'ébauche." Moreau-Nélaton in Robaut 1905, vol. 1, pp. 300–302. *Biblis* (R 2197, location unknown) was sold at Sotheby's, New York, May 24, 1988, lot 24.
2. Philip Robinson in *New Grove Dictionary of Music* 1980, p. 775.

PROVENANCE: The artist; his posthumous sale, Hôtel Drouot, Paris, pt. 1, May 26–28, 1875, no. 220, as *Paysage composé; scène d'Hamlet et le Fossoyeur; effet de soleil couchant;* purchased at that sale by Furtin, Paris, for 2,930 francs; Dr. Georges Viau (1855–1939), Paris; Winkel & Magnussen, Copenhagen;* Herman Heilbuth, November 1918; purchased from him by Wilhelm Hansen (1868–1936), Copenhagen, between 1923 and 1928; his wife, Hetty Hansen; her bequest to the Ordrupgaardsamlingen, Copenhagen, 1951

EXHIBITIONS: Copenhagen 1918a, no. 50; Copenhagen 1918b, no. 55; Stockholm, Oslo 1919, no. 33; Copenhagen, Stockholm, Oslo 1928, no. 17 (Copenhagen), no. 15 (Stockholm); Tokyo, Yokohama, Toyohashi, Kyoto 1989–90, no. 9

REFERENCES: Robaut 1905, vol. 1, p. 302, vol. 3, pp. 368–69, no. 2373, ill., vol. 4, p. 216, no. 220; Bazin 1942, p. 52; Bazin 1951, p. 46; Swane 1954, p. 32, no. 13, as *Hamlet et le fossoyeur;* Copenhagen, Ordgrupgaardsamlingen 1958, no. 13; Copenhagen, Ordrupgaardsamlingen 1966, no. 13; Bazin 1973, p. 47; Copenhagen, Ordrupgaardsamlingen 1982, no. 15, as *Hamlet and the Gravediggers;* Wissman 1989, pp. 172–73; Copenhagen, Ordrupgaardsamlingen 1992, no. 15; Wivel 1993, no. 12; Stjernfelt 1995, pp. 25–29, ill.

* A consortium was established in Copenhagen in early 1918 between the auction house Winkel & Magnussen and the collectors Wilhelm Hansen and Herman Heilbuth. At their first meeting on March 6, 1918, it was noted that 207 works of art from the collection of Georges Viau had already been purchased. *Hamlet et le fossoyeur* may well have been among them. Information courtesy of Mikael Wivel, curator, Ordrupgaardsamlingen.

La Route de Sin-le-Noble, près de Douai
(The Road to Sin-le-Noble, near Douai)

1873
Oil on canvas
23⅝ × 31⅞ in. (60 × 81 cm)
Signed lower left: COROT
Musée du Louvre, Paris R.F. 1359

R 2169

Corot was staying with Alfred Robaut in July 1873 when he made this painting. Robaut was already cognizant of his future role as cataloguer of the aged master's works—Corot was then seventy-seven—and he later explained to Moreau-Nélaton how this picture came to be:

> He selected a subject from the outskirts of the town, in the village of Sin-le-Noble, or *Sin l'nob'*, as they say there. Four or five cottages with red roofs along a grassy road from which they are separated by a thin line of trees, and, above, some clouds joining their light wisps to the blue canopy: for Corot, that's the material for a masterpiece. This ordinary landscape is a poem of light and air. Every morning for five days, like an honest laborer, the painter returned to his task. The incomparable magician, evoker of idyllic scenes, left his imagination at home during those hours. Faithful to the rigorous training of his early years, he was satisfied to let nature speak, happy with the role of conscientious and truthful interpreter. The painting was completely finished on site. However, it was not entirely as we see it today. When he was younger and less skilled, Corot would not add even the smallest dab of the brush in the studio to the studies he brought back from his countryside campaigns. However, with age, he sometimes compromised on this rule. Often it was to please a client who interfered, giving advice, instructing the artist. The fact remains that the fine Douai landscape was put back on the easel for a moment in Paris and that the artist tossed onto the foreground, to fill it in on the left, this large broken branch, which was familiar to him and had already appeared in more than one of his works.[1]

Before the fallen tree was added in the studio, Robaut, the dutiful cataloguer, had the work photographed in neighboring Arras in Charles Desavary's studio (fig. 162). Many years later Germain Bazin saw in this fallen tree "a feeling of sadness in the soul of an old man,"[2] but one wonders whether Corot would have invested a particular motif with so specific a meaning. After all, other motifs, such as square towers or trees with branches that reach down as if to drink from the ponds, also permeate the late work, and it would be foolish to attach great significance to all of them. In his unpublished notes Robaut wrote that Corot added the tree because it was "necessary for equilibrium."[3]

Yet another tale of revision concerns a hot-air balloon that Corot purportedly painted in the sky to commemorate the

Fig. 162. First state of Corot's *La Route de Sin-le-Noble* (R 2169a), photograph by Charles-Paul Desavary, 1872

"fête de Gayant" held in nearby Douai while he was there.[4] Robaut related that Corot painted it out soon after he had amazed the local peasants by painting it in, but radiographs of the picture taken in 1975 do not reveal a balloon.[5]

While Moreau-Nélaton stressed that this work demonstrated Corot's commitment to plein air painting long after he had become a fabricator of imaginary landscapes, modern scholars find in it a manifestation of Corot's attachment to the Dutch school of landscape.[6] The modest village is described with a frankness that is unusual for Corot, whose pastorales almost always present a tidy vision of the picturesque. The deteriorating roofs, the unmoving stream, and the dead tree suggest pictorial honesty in the Dutch tradition, even though we now know that the tree, for one, was an afterthought.

Félix Robaut bought the painting from Corot for 2,000 francs in 1873;[7] his son Alfred was the owner when it was lent to the 1875 posthumous exhibition and the 1878 exhibition at Durand-Ruel. Robaut then sold it for 8,000 francs to an individual who later asked 65,000 francs for the same painting. Robaut noted that the collector Thomy Thiéry insured it for 90,000 francs in January 1889.[8] These are huge sums.

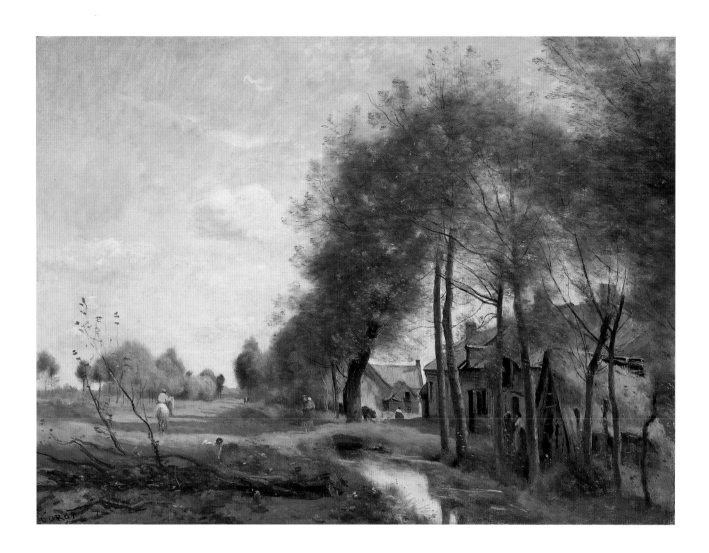

The many engravings and etchings reproducing the painting attest to its popularity at the end of the nineteenth and the beginning of the twentieth century.

1. "Il avait choisi un motif aux environs de la ville, dans le village de Sin-le-Noble, *Sin l'nob'*, comme on dit là-bas. Trois ou quatre chaumières à toit rouge au bord d'une route gazonnée dont les séparent une maigre rangée d'arbres et, au-dessus, quelques nuages mariant leur floconnement léger à l'azur de la voûte: voilà pour Corot la matière d'un chef-d'oeuvre. Ce paysage banal est un poème de lumière et d'air. Tous les matins pendant cinq jours, comme un honnête ouvrier, le peintre reprenait sa tâche. L'incomparable magicien, évocateur des scènes idylliques, laissait en ces heures-là son imagination au logis. Fidèle à la rigoureuse méthode de ses jeunes années, il se contentait de laisser parler la nature, satisfait du rôle d'interprète consciencieux et véridique. Le tableau fut entièrement achevé sur place. Toutefois, il n'était pas tout à fait tel que nous le voyons aujourd'hui. Lorsqu'il était plus jeune et moins habile, Corot se gardait de donner à l'atelier le moindre coup de pinceau sur les études qu'il rapportait de ses campagnes. Mais, avec l'âge, il transigea parfois avec ce principe. Souvent, c'était par complaisance pour un client qui se mêlait de donner son avis et de guider la main de l'artiste. Toujours est-il que le joli paysage douaisien fut remis un instant sur le chevalet à Paris et que l'artiste jeta alors sur le premier plan, pour le meubler dans sa partie gauche, cette grande branche cassée qui lui était familière et qu'on retrouve dans plus d'une de ses oeuvres." Moreau-Nélaton 1903, p. 491. This text is excerpted from an article in the *Gazette des beaux-arts* that Moreau-Nélaton devoted to

this painting on the occasion of its donation to the Louvre. A reproductive engraving of it by Antonio Georges Lopisgich accompanied the article.

2. "un sentiment de tristesse dans l'âme du vieillard." Bazin 1973, p. 289.

3. "pour l'exigence de l'équilibre." Robaut *carton* 8, fol. 423.

4. The "fête de Gayant," in which giant mannequins are paraded to commemorate events of 1479, is held on the first Sunday after July 5. Hence Corot was at work on this painting on Sunday, July 6, 1873.

5. Madeleine Hours, report, March 21, 1975, Documentation, Département de Peintures, Musée du Louvre, Paris. Anne Rocquebert recently indicated that inspection with infrared reflectography shows no trace of the balloon. However, Robaut, who was present while Corot worked, described in the manuscript for his catalogue raisonné the following episode: "'So, Alfred, tell me what the program is for this afternoon's games . . . ?' I told him, among other things, there was the launching of a balloon; he said nothing, then two minutes later, he called me over to see the balloon with all the details of [illegible]. And I think I recall that the unfinished canvas arrived in Paris in that version. [illegible] when he went back to the study in the studio to add the broken tree in the foreground, he covered up the sky." (" 'Alfred, dites-moi donc quel est le programme des jeux de cet après midi . . . ?' Comme je lui répondis qu'entr' autres choses, il y avait le départ d'un ballon; il ne dit rien, puis deux minutes après, il m'appelle à lui pour voir le ballon avec tous le détails de [illegible]. Et je crois me rappeler que la toile inachevée est arrivé en cet état à Paris. [illegible] quand il a repris l'étude à l'atelier pour y ajouter l'arbre tranché, au premier plan, il a couvert son ciel.") Robaut *carton* 8, fols. 414–16.

6. See, for example, Hélène Toussaint in Paris 1975, no. 64, and Smits 1991,

pp. 343–45, who refers generically to Corot's village scenes, but not specifically to this painting.

7. In a letter of January 1, 1874, Corot wrote to Félix Robaut expressing his hope that Robaut would continue to enjoy the painting after it was hung in his home. Thus, the painting must have been delivered in late 1873 or early 1874. The letter is quoted in Robaut 1905, vol. 4, p. 346, no. 229.

8. Robaut *carton* 8, fol. 414.

PROVENANCE: Purchased from the artist by Félix Robaut, 1873, for 2,000 francs; to Alfred Robaut by 1875; sold by him to the dealer Louis Tedesco for 8,000 francs; Alfred de Knyff (1819–1885), Paris; Finet collection, Brussels; George Thomy Thiéry (1823–1902), Paris, by 1889; his bequest to the Musée du Louvre, Paris, 1902

EXHIBITIONS: Paris 1875a, no. 98, as *Marais de Sin, près Douai*, lent by Robaut; Paris 1878b, no. 98, as *Vue du village de Sin, près Douai*, lent by Alfred Robaut; Copenhagen, Stockholm, Oslo 1928, no. 21 (Copenhagen), no. 17 (Stockholm), no. 13 (Oslo); Zurich 1934, no. 117; Lyons 1936, no. 104; London 1936a, no. 21; Paris 1938a; Belgrade 1939, no. 20; Arras 1954, no. 23; France 1956, no. 12; Paris 1975, no. 64

REFERENCES: Thomson 1902, pp. 47, ill. p. 52; Moreau-Nélaton 1903, pp. 490–93; Hamel 1905, pl. 84; Michel 1905, pp. 42–43; Moreau-Nélaton 1905b, p. 316, fig. 237; Robaut *carton* 8, fols. 414–16; Robaut 1905, vol. 1, pp. 288–90, and vol. 3, pp. 304–5, no. 2169, ill.; Meynell 1908, ill. opp. p. 172; Cornu 1911, p. 107; Meier-Graefe 1913, pp. 88, 165; Moreau-Nélaton 1913, pp. 94–96, 113, pl. 23; Moreau-Nélaton 1924, vol. 2, p. 72–73, figs. 240, 241; Petersen 1928, n.p.; Jamot 1929, p. 38, pl. 49; Faure 1931, pp. 56–57; Bazin 1942, pp. 8, 26, 109, 123, pl. 117; Bazin 1951, pp. 8, 26, 114, 129, 134; Baud-Bovy 1957, p. 260; Fosca 1958, p. 173, pl. 90; Coquis 1959, pp. 128–29; Leymarie 1966, pp. 110–12; Bazin 1973, pp. 19, 226, 273, 289; Leymarie 1979, pp. 150–51; Compin and Roquebert 1986, p. 148, ill.; Selz 1988, pp. 256, 281; Wissman 1989, pp. 187–88, fig. 109; Smits 1991, pp. 344–46, fig. 330; Leymarie 1992, pp. 174–75, 197

160

Sens. Intérieur de la cathédrale (Interior of Sens Cathedral)

1874
Oil on canvas
24 × 15¾ in. (61 × 40 cm)
Stamped lower left: VENTE COROT
Musée du Louvre, Paris R.F. 2225

R 2194

Despite symptoms of the digestive illness that would kill him within six months, Corot pursued his habitual *villégiature* in the summer of 1874, traveling throughout northern France to stop and stay for a week or two with friends old and young. The first week of September found him in Sens,[1] an ancient town known for its little sausages and its noble cathedral, where he had come for a wedding and stayed at a hotel.[2] Although Robaut did not see Corot until October, he recorded, no doubt directly from the artist, that he worked on this picture in two-hour sessions on three consecutive afternoons. It was probably the last painting to be executed *sur le motif.*[3] Evidently the light was bad one day, and Corot could work only a short time. As the artist was packing his bags, M. Duflot, the curator of the local museum, came by, and Corot said to him, "I couldn't do anything today; I'm sure that I haven't even earned my dinner."[4]

For this painting Corot stood in the right aisle of the triple-aisled cathedral of Saint-Étienne, looking across the south transept toward the ambulatory in the east end. The cathedral, largely built in the twelfth century and completed at the end of the fifteenth century, is celebrated for its majestic stained-glass windows. Accordingly, Corot shows sections of the brilliant red *Tree of Jesse* and *Legend of Saint Nicholas* windows installed in the Late Gothic transept. Jean Restout's 1741 canvas, *Assumption*

of the Virgin, is just visible in the chapel at middle right. The marvelous Louis XV wrought-iron screen, the work of Guillaume Doré in 1762, can be seen at center. A well-rehearsed legend accompanies this painting. The verger, or usher, in the red costume (called in French "le Suisse" because of the costume's resemblance to that of the Swiss Guards at the Vatican), a man named Marquet, told Germain Hédiard in 1889 that he and Corot had the following interchange when Corot had finished the painting. Marquet walked up to the artist to say, "But, sir, something's missing," while conspicuously standing in Corot's view. "Yes, yes, you are right," Corot responded. "Come forward a bit." Within minutes the figure appeared on the canvas. According to Marquet, Corot went on to discuss his style as well as his refusal to concede to public taste.[5] In 1975 Hélène Toussaint branded this charming story as apocryphal, noting that the color of the Suisse's costume is too important to the picture's design to have been left to a chance encounter.[6] The legend brings to mind the hot-air balloon that Corot allegedly painted in *La Route de Sin-le-Noble* (cat. no. 159). Yet radiographs recently taken at the Laboratoires du Musée du Louvre confirm Marquet's story: the "Suisse" was a later addition.

This is one of only three paintings by Corot of church interiors,[7] a number that stands in contrast to the countless

representations of churches seen in landscapes. Inevitably, art historians have compared the work to those of the seventeenth-century Dutch architectural painters, which Corot might have seen on his trip to Holland with Constant Dutilleux in 1854,[8] or indeed in London during his visit in 1862. It is difficult, however, to find a specific correspondence. The point of view is similar to that taken by Pieter Saenredam, but Corot's fluent brushwork could not be more unlike Saenredam's precise, linear style, and it is possible that he never saw a Saenredam, since this artist was rediscovered only at the end of the nineteenth century.[9] No Dutch painting that Corot is known to have seen throws any light on the present picture.

Art historians have also invoked Impressionism when describing this painting. Paul Jamot thought it was better than Impressionist works: "It even makes one doubt that Impressionism, with its investigations, its complexities, and its technical feats, has proved more effective than Corot's skill and modesty for rendering the transparency of the atmosphere and the variable nature of light."[10] But most writers have mistakenly seen the painting as a step toward Impressionism, even though Monet, Renoir, and Pissarro had already developed their Impressionist technique several years before Corot went to Sens. Germain Bazin wrote that Corot "was here showing the way to Impressionism" and commented that "through the uncharacteristic liveliness of the tones" this work "connects with Impressionism."[11] He comes closest to the truth with the last observation, for Corot—like many French painters, Impressionist or not—lightened and brightened his palette at the end of the 1860s. The character of the painting is probably best understood through Robaut's (previously unpublished) notes made late in the nineteenth century, since he was not prone to the determinism of Modernist art history: "Corot made this study on the occasion of a wedding; it's a bit soft and almost careless in its execution, as he needed one or two more sessions. Perhaps the last study made from nature, none of which prevents it from being a precious work for its unity and its appealing color."[12]

1. Moreau-Nélaton 1924, vol. 2, p. 88. However, this information is perhaps contradicted by a letter Corot wrote on August 13 from Luzancy, near Sens. He told his friend Mme Gratiot, "everything will be fine if the grille is good" ("tout sera bien si la grille est bonne"), quite possibly a reference to the grille in this painting. Robaut 1905, vol. 4, p. 346, no. 239.
2. Robaut *carton* 8, fol. 423.

3. In his manuscript notes for the catalogue raisonné, Robaut mentions that while in Sens Corot also made some studies "in the market gardens that surround the village" ("dans les jardins maraîchers qui entourent la ville"). Ibid.
4. "Aujourd'hui, je n'ai rien pu faire; je crois bien que je n'aurai même pas gagné mon dîner." Robaut 1905, vol. 3, p. 320, no. 2194.
5. "Mais, Monsieur, il manque quelque chose"; "Oui, oui, vous avez raison, . . . avancez encore un peu." Moreau-Nélaton in ibid., vol. 1, p. 310, n. 2, where it is stated that Hédiard interviewed Marquet on August 24, 1889. Hédiard was a writer—Moreau-Nélaton called him a "publiciste"—who in 1903 published an article on Corot's *clichés-verres* in the *Gazette des beaux-arts*.
6. Hélène Toussaint in Paris 1975, no. 65.
7. The other two are *Venise. Intérieur du baptistère de Saint-Marc* (August–September 1834), R 313, private collection; and *Mantes. Intérieur d'église* (1865–70), R 1530, location unknown.
8. See Fierens 1952.
9. Schwartz and Bok 1989, p. 248.
10. "On en vient même à douter si l'impressionnisme, avec ses recherches, ses complications et ses prouesses de technique, a été plus efficace que la sagesse et la modestie de Corot pour rendre la transparence de l'atmosphère et la mobilité de la lumière." Jamot 1929, p. 41. Jamot had earlier expressed a different point of view: "It is clear how much Impressionism and all the art of the end of the nineteenth century owes to this modest and beneficent genius." ("On comprend ce que l'impressionnisme et tout l'art de la fin du XIXe siècle doivent à ce modeste et bienfaisant génie.") Jamot 1920, p. 306.
11. "montrant ainsi la voie à l'impressionnisme"; "par sa vivacité inhabituelle de tons . . . s'apparente à l'impressionnisme." Bazin 1973, pp. 67, 293.
12. "C'est à l'occasion d'un mariage que Corot fit cette étude, un peu molle et d'exécution presque lâchée, parce qu'il y manque sur une ou deux séances. Peut-être la dernière étude faite sur nature ce qui n'empêche pas que ce soit une oeuvre précieuse par son unité et la charme de la couleur." Robaut *carton* 8, fol. 423.

PROVENANCE: The artist; his posthumous sale, Hôtel Drouot, Paris, pt. 1, May 26–28, 1875, no. 221; purchased at that sale by Gustave Tempelaere, Paris, for 6,000 francs; Perreau collection; Saint Albin collection; Jacques-Michel de Zoubaloff (1876–1941); his gift to the Société des Amis du Louvre, 1919

EXHIBITIONS: Amsterdam 1926, no. 24; Zurich 1934, no. 120; Paris 1936, no. 110; Lyons 1936, no. 108; Paris 1946b, no. 189; Paris 1947, no. 55; Paris 1966b, no. 100; Paris 1975, no. 65; Nice 1982, no. 272

REFERENCES: Robaut *carton* 8, fol. 423; Robaut 1905, vol. 1, pp. 308–10, vol. 3, pp. 320–21, no. 2194, ill., vol. 4, p. 217, no. 221; Jamot 1920, pp. 305–6, ill.; Moreau-Nélaton 1924, vol. 2, p. 88, fig. 260; Jamot 1929, pp. 40–41, pl. 50; Fosca 1930, p. 26, pl. 96; Faure 1931, pp. 32, 56, pl. 77; Bazin 1936, pp. 61, 69; Jamot 1936, p. 52, ill. p. 57; Fierens 1952, p. 127; Baud-Bovy 1957, p. 250, pl. LVI; Hours 1972, pp. 50, 162–63, ill., fig. 58; Bazin 1973, pp. 53, 67, 274, 293, ill. p. 247; Geiger 1977, p. 336; Leymarie 1979, p. 153, ill.; Compin and Roquebert 1986, p. 155, ill.; Selz 1988, p. 262, ill. p. 269; Smits 1991, pp. 1, 241, 377–81, fig. 366; Leymarie 1992, ill. p. 177

161

Paysage au clair de lune
(Moonlit Landscape)

1874
Oil on canvas
35⅜ × 45⅝ in. (90 × 116 cm)
Signed lower right: COROT
Private collection

R 2190

Corot exhibited this work and two others, *Souvenir d'Arleux-du-Nord* and *Le Soir* (R 2189, R 2191; present locations unknown), at the Salon of 1874, where they were greeted with a surprising measure of critical acclaim. That Corot still existed appeared to some observers extraordinary, and his physical presence was noteworthy. Ernest Chesneau took pains to describe in the *Paris journal* his appearance at the Salon, looking like "a well-to-do peasant, large and thickset, robust in his ample frock-coat of royal blue cloth, with a lively complexion, freshly shaved, in a solid collar emerging from a cravat of black satin; his eye clear and sharp good and smiling under the thick eyebrow."[1] Jules Castagnary announced that Corot

is still alive and shows no signs of decline. At seventy-eight he carries victoriously the weight of a flourishing old age. Yesterday his friends gathered at Argenteuil to help him celebrate the *fiftieth* anniversary, not of his marriage (he is a bachelor) but of his betrothal to art. Fifty years ago this dean of our painters, unhappy with academic teaching, left for Italy, so he might drink directly from the sacred spring. Since that time he has seen the school of convention tumble and a taste for real nature be reborn. He played his role in the revolution from which the modern landscape emerged. He was one of that first glorious group who so boldly battled the influence, then supreme, of the Michallons and Bertins, and now at the end he is the last surviving victor. A master in his turn, he saw many generations of young men pass through his studio. They came to ask him the secret of his

strength. "Feel deeply," he said to them, "and communicate your emotion." How many eyes did he open! How many hands unbind! How many brains set free! And there he is, still standing, still struggling, as young as ever. Last year I was afraid that his sight had weakened. I thought I noticed a certain bluish hue in his new canvases, and I remembered the learned tracts by our friend Georges Pouchet on the retinas of old people. Today, look at *Souvenir d'Arleux-du-Nord*—what brilliance! What liveliness! And this *Clair de lune*? How often have you come across hollows more profound, or clarity of air, sky, and water more thrilling? These scented banks exude the sensuality of amorous nights. One boat on this lake, and we will start reciting in unison the most inspired lines of our poets![2]

Castagnary was right about the repetition of Corot's inspired poetry, since the composition of *Clair de lune* is based on the familiar format of a mirror of water found in the series of *souvenirs* of Riva (see cat. nos. 58, 59, 94) and framed by the distinctive trees seen in *Souvenir de Mortefontaine* (cat. no. 126) and its many variants. The novelty here is the striking monochrome palette, which, because of its dark tonality, is worked in thin washes laid down one over the other. Corot rarely depicted the night, and his decision to exhibit this work alongside a morning scene (*Arleux-le-Nord*) and an evening scene (*Le Soir*) may have reflected a deliberate plan to display the range of his ability. He had his sights set on the gold medal at the Salon, which he had almost won in 1865, and he was greatly disappointed when he lost again in 1874.[3] Since the awards were almost always politically motivated, and since Charles Blanc, the head of the fine arts administration for the Third Republic, sought to curry favor at the academy and to promote grandiose history painting at the expense of landscape and genre painting,[4] the medal went rather predictably to Jean-Léon Gérôme, the conservative professor at the École des Beaux-Arts, for his *Éminence grise* (Museum of Fine Arts, Boston). To remedy the affront, Corot's friends contributed to a subscription organized by Marcotte to strike a gold medal expressly for him. Designed by Geoffrey de Chaume, it read "À Corot . . . ses confrères et ses admirateurs, Juin 1874." (Salon medals were awarded in June.) It was presented to the artist on December 29, 1874, and was reproduced on the monument to Corot erected at Ville-d'Avray after his death, two months later.

Robaut knew this painting very well, having seen it in Corot's studio, at the 1874 Salon, in an 1886 exhibition, and at auction the same year, yet he never completely deciphered the action of the ghostly woman in the right foreground. He noted "in the foreground, a seated woman in a pose that is hard to make out. She looks like she's touching her toes." Indeed, her gesture is unclear. Later in the century Robaut saw the painting again and observed that "since the Saulnier sale, this painting

has been relined, cleaned, and revarnished to the point of beginning to return to the state in which it was seen at Henri Garnier's in September '86."[5]

1. Quoted in Thomson 1902, p. 55.
2. "vit encore et ne connaît même pas le déclin. À soixante-dix-huit ans, il porte victorieusement le poids d'une vieillesse qui toujours verdoie et fleurit. Hier des amis, réunis à Argenteuil en une agape fraternelle, fêtaient avec lui sa *cinquantaine*, non pas l'anniversaire de son mariage (Corot est célibataire), mais l'anniversaire de ses fiançailles avec l'art. Il y a cinquante ans que ce doyen de nos peintres, mécontent des enseignements académiques, partait pour l'Italie afin d'y puiser directement à la source sacrée. Depuis ce temps, il a vu tomber l'école de la convention et renaître le goût de la nature vraie. Il a pris sa part de la révolution qui a préparé et constitué le paysage moderne. Il était de la glorieuse pléiade du début qui engagea si audacieusement le combat contre l'influence alors souveraine des Michallon et des Bertin, et il reste le dernier survivant parmi les vainqueurs de la fin. Devenu maître à son tour, il a vu passer dans son atelier plusieurs générations de jeunes hommes venus pour lui demander le secret d'être forts. 'Soyez ému, leur disait-il, et communiquez votre émotion.' Que d'écailles il a fait tomber des yeux! que de mains il a déliées! que de cerveaux il a affranchis! Et le voilà toujours debout, toujours luttant, aussi jeune qu'il l'a jamais été. J'ai eu peur l'an passé que sa vue n'eût faibli. Il me semblait remarquer une certaine teinte bleuâtre sur ses toiles nouvelles, et je me rappelais les savantes dissertations de notre ami Georges Pouchet sur la rétine des vieillards. Aujourd'hui voyez le *Souvenir d'Arleux-du-Nord*, quel éclat! quelle vivacité! Et ce *Clair de lune*? Avez-vous rencontré souvent des trouées plus profondes; des limpidités d'air, de ciel et d'eaux plus frissonnantes? Ces bords embaumés respirent la volupté des nuits amoureuses. Une barque sur ce lac, et nous allons répéter en choeur les vers du plus inspiré de nos poètes!" Castagnary, "Salon de 1874," in Castagnary 1892, vol. 2, pp. 101–2.
3. Bazin 1951, p. 115. In Robaut's unpublished notes on this painting he recorded, "This year Corot exhibited . . . a *Matin* [and] a *Soir* and he should have [been given] the medal of honor. It was a disgrace to give it again to Gérôme (who already had it in {18??}[1867])." ("Cette année Corot avait exposé . . . un Matin un Soir et il fallait lui médaille d'h[onneu]r. Ce fut une honte que la donner de nouveau à M. Gérôme [qui l'avait eu en {18??} déjà].") Robaut *carton* 22, fol. 784. See also Bazin 1951, p. 115.
4. See Mainardi 1993, p. 42.
5. "sur le devant, femme assise dans un mouvement qu'on n'explique pas très bien. Elle semble se toucher les pieds"; "depuis la vente Saulnier, ce tableau a été retoilé [*sic*], nettoyé et reverni au point d'être redevenu à peu près ce qu'il était vu chez M. Henri Garnier en 7bre 86." Robaut *carton* 22, fol. 784.

PROVENANCE: The dealer Hector-Henri-Clément Brame (1831–1899), Paris, 1875; John Saulnier (d. 1886), Bordeaux; his posthumous sale, Hôtel Drouot, Paris, June 5, 1886, either no. 16, *Le Soir: Souvenir du lac Nemi au clair de lune*, or no. 27, *Clair de lune*; purchased at that sale by Théodore Révill[i]on; Rachel Beer, London; her sale, Christie's, London, July 22, 1927, no. 61, as *Clair de lune sur les eaux*; purchased at that sale by William A. Coolidge, Boston, for 861 pounds; to the present owner

EXHIBITIONS: Paris (Salon) 1874, no. 460, as *Clair de lune*; Paris 1875a, no. 30, lent by Brame; Paris 1886, lent by Saulnier

REFERENCES: Castagnary, "Salon de 1874," in Castagnary 1892, vol. 2, pp. 101–2; Robaut 1905, vol. 3, pp. 316–17, no. 2190, ill.; Bazin 1942, p. 109; Bazin 1951, p. 115; Bazin 1973, p. 274; Carter 1981, p. 54; Selz 1988, p. 266; Wissman 1989, pp. 72–73, 206, fig. 34

La Dame en bleu
(Lady in Blue)

1874
Oil on canvas
31½ × 19⅞ in. (80 × 50.5 cm)
Signed and dated lower right: 1874. COROT.
Musée du Louvre, Paris R.F. 2056

R 2180

"*La Dame en bleu* belongs to the family of beautiful dreamers that were created joyously on a relaxed day, simply for the pleasure of painting, by the old man passionate about his art, within the four walls of his studio in Paris."[1] This eloquent sentence is Moreau-Nélaton's only pronouncement on this extraordinary work, which today is regarded as one of Corot's greatest achievements. Robaut was similarly restrained. He does not single out the painting for special discussion, nor does he describe its creation, although he was frequently present in Corot's studio in 1872 and 1873, the period to which he dates the work. Sylvie Béguin asserts without proof that the painting was displayed in Corot's salon alongside *La Femme à la perle* (cat. no. 107),[2] but if that is true it probably did not hang there for long: inscribed with the date 1874, it was not included in the posthumous inventory of Corot's possessions and thus did not belong to him when he died in February 1875. The painting had already been sold by its first owner, G. Bardon, in March 1875, when Robaut saw that the dealer de Villers (or Villars) was offering it for 8,000 to 10,000 francs.[3] Henri Rouart, a Parisian industrialist (and an amateur painter) known for his superb art collection and his close friendship with Edgar Degas, acquired the picture sometime in 1889. It was one of the brightest stars in his stellar collection. In 1912 Arsène Alexandre wrote in the catalogue of Rouart's posthumous sale that "this famous *Dame en bleu*" was the work "toward which the gazes of informed visitors to the rue de Lisbonne were invariably drawn, in preference to almost all the marvels that surrounded them."[4]

La Dame en bleu was known only to Rouart's guests until he lent it to the fine arts exhibition at the 1900 Exposition Universelle. Being of such high quality and so little known, it created a sensation. Struck by its strong color and its realism, writers almost immediately began to consider the painting the masterpiece of Corot's late career. Julius Meier-Graefe, emphasizing the importance of color, wrote that "the development of [Corot's] latest and strongest period was arrested only by death. His colour increased in beauty with every picture. The *Dame Bleu* in M. Henri Rouart's collection—a perfect parure in blue, the richness of which depends more upon the vehement brushing than upon the variety of tones."[5] Gustave Geffroy, emphasizing the realism, asked, "Wouldn't

one say that she is surprised in the midst of lively activity, in a momentary movement and pose? With this fleeting instant, Corot has created a definitive reality."[6] Raymond Bouyer saw this painting as the culmination of the artist's development: "From the first portrait of 1825 up to the sprightly *Dame en bleu* of 1874, these artless figures reflect, each in turn, the painter's transition from his severe period to his gentle period.... In this bachelor's studio, what a last-minute bonanza was the arrival of the *Lady in Blue!*"[7] Prosper Dorbec stressed the modernity of the late work: "The most subtle melodies realized by modern painting have their origin in the technique revealed in these two canvases [*La Dame en bleu* and *L'Atelier* (cat. no. 139)]; however, before Corot, nothing was less uncommon than the basic elements that compose it. It is the range of grays and browns that were used in most of the studios of the eighteenth century; the same one that still lingered on at the time of Corot's youth in the prosaic, finicky works of Drolling, to take him as an example, since then it was a matter of interiors. But Corot knows how to make it sing with a softness of which until then only Prud'hon had been able to give a sort of foretaste."[8]

By 1912, when Rouart's collection was sold at auction, the painting had acquired such a reputation that the Louvre bought it almost as a matter of course. It sold for a high price, 162,000 francs, but only a few complained. *L'Action française*, the right-wing organ of the royalist party, griped that "this 'morsel' isn't worth that much," and added, mistakenly, that the purchase was made without the accord of the museum's curators.[9] When the painting entered the Louvre, it was lifted out of its proper context within Corot's oeuvre to the realm inhabited by masterpieces of diverse times and cultures. Thus, Paul Jamot, writing in 1929, unhesitatingly invoked Gainsborough, Whistler, and Manet when he wrote what is probably the most evocative appreciation of this haunting painting.

In the painting *La Femme en bleu* there is no subtle intention, no delving into the subject. A young blond woman, wearing a blue dress with an overskirt bordered in bands of black velvet, leans her elbow on some kind of tall stand, in a pose that emphasizes the profile of her face and the curve of her bare arm; she holds a white glove in her left hand. We should not be fooled by the elegance and naturalness of her pose, her unaffected air of reverie,

and the sense of a truthful portrait that delivers to us the face and the body in their entirety. This lovely dreamer, named *La Femme en bleu*, just as Whistler and Gainsborough's celebrated figures are called *The Woman in White* and *The Blue Boy*, needs no other name. Neither more nor less than *La Femme à la perle* or the mandolin player of *L'Atelier*, this is a model; it is Corot's easel that one sees behind her, and it is the wall of his studio, with a framed study and an unframed canvas, that serves as background. The work is the recreation of a landscapist confined to his room because of the season or for other reasons and who paints whatever chance offers him, obedient to his vocation, which never deserts him and which is, above all, to paint well. Naturalism, proper values, an economical palette producing effects that are powerful and delicate in turn, always simple—by the grace of such virtues, this modest study of a studio figure in the most modest of interiors charms and satisfies us as much as art's richest creations. The subject recalls certain paintings made about the same time by Fantin-Latour, Stevens, Whistler, and even Manet. But for the magisterial quality of the painting, the only one of these contemporaries who merits comparison with Corot is Manet, the same Manet that Corot did not much like, even after the old master had been persuaded to join the Salon jury that had to fight over a list of artists, including the creator of *Déjeuner sur l'herbe* and *Olympia*. The clear blue of the dress embellished with black bands would have pleased Manet, it seems to us. The blue strongly resembles that of the sofa on which we see *Mme Manet* stretched out, as her husband painted her, also in the year 1874.[10]

Jamot correctly insisted that the woman is a model, but Sylvie Béguin, writing in 1962, suggested that Mme Gratiot, one of Corot's good friends, posed for the picture.[11] A number of writers have since accepted the identification, but Hélène Toussaint rejects it, writing that Corot would not have sold a portrait of a friend,[12] an observation that seems accurate. Moreover, to consider this work a portrait is to misunderstand Corot's penchant for posing models in his studio. The root of the confusion may be the image of modernity that the woman projects: unlike the Greek or Italian muses who often populated Corot's painting, the individual seen here is clearly someone who lives in the present, and this is what suggests comparison with the contemporary work of Degas (fig. 163), Stevens, or Tissot. Although there is no documentary evidence to substantiate the identification, the model closely resembles one of Corot's favorites, Emma Dobigny. The informal portrait of her painted by Degas in 1869 shows the same round face, pert nose, and even a similar hairstyle (fig. 164). The dress she wears is not a model's street dress but the evening dress of an affluent bourgeoise. The fan, the earrings, the diadem, and the lace trim on the décolleté of the silk dress all belong to an elaborate and expensive costume. The skirt is precisely the type that was fashionable in 1872–73, but the bodice, historians of costume note, is unusual: too revealing for an afternoon dress, not sufficiently decorated for an evening parure.[13] Originally, dark lace gloves were part of the ensemble, but Corot painted them out.

Radiographs show that in addition to removing the gloves, Corot adjusted the form of the diadem and the shape of the

dress's neckline. But the important revisions were made in the background. The U-shaped double stovepipe immediately behind the model was painted out, as was the little shelf that is visible in other paintings set in the studio (cat. nos. 135–137). The framed painting on the wall was made narrower, and what was originally a tall screen became the large canvas leaning against the easel.[14] The objects on the table have been read in various ways, but comparison with the radiographs suggests that the model leans on a large red velvet cushion which rests on two books or albums whose spines are decorated with swastikas.

1. "*La Dame en bleu* appartient à la famille des belles rêveuses créées avec joie, dans un jour de délassement, pour le plaisir de peindre, par le vieillard passionné de son art, entre les quatre murs de son atelier parisien." Moreau-Nélaton 1913, p. 99.
2. Béguin in Paris 1962, p. 190.
3. Robaut *carton* 27, fol. 74.

Fig. 163. Hilaire-Germain-Edgar Degas (1834–1917). *Sulking.* Oil on canvas, 12¾ × 18¼ in. (32.4 × 46.4 cm). H. O. Havemeyer Collection, Bequest of Mrs. H. O. Havemeyer, 1929, The Metropolitan Museum of Art (29.100.43)

Fig. 164. Hilaire-Germain-Edgar Degas (1834–1917). *Emma Dobigny*, 1869. Oil on panel, 12 × 16½ in. (30.5 × 16.5 cm). Private collection, Switzerland

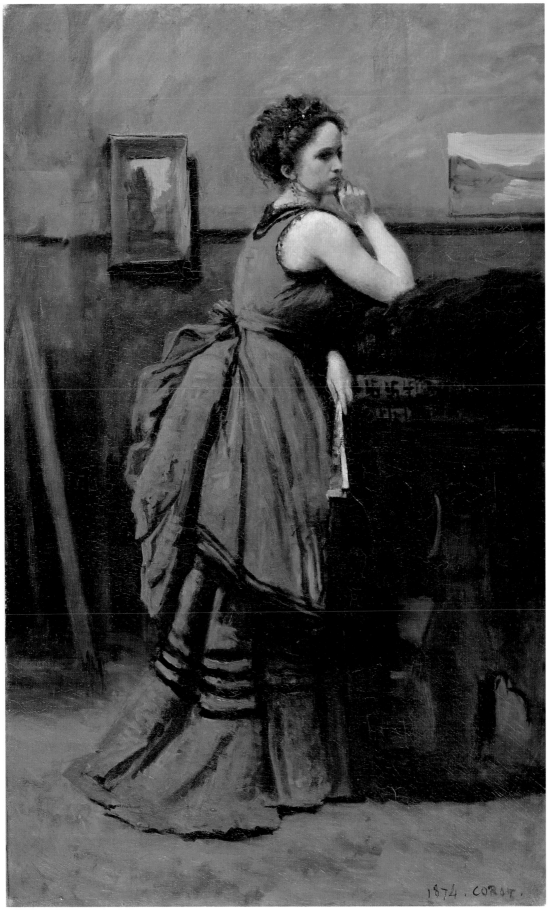

1874. COROT.

162

4. "vers laquelle les regards des visiteurs avertis de la rue de Lisbonne étaient invariablement attirés, presque de préférence à tant de merveilles, pourtant, qui l'entouraient." Alexandre in Rouart sale 1912, pp. xi–xii.

5. Meier-Graefe 1905, p. 111, translated in New York 1986, n.p.

6. Geffroy 1907, p. 365.

7. "Depuis le premier portrait de 1825 jusqu'à la sémillante *Dame en bleu* de 1874, ces figures ingénues reflètent, à leur tour, la transition d'un peintre de sa période sévère à sa période suave . . . Dans cet atelier de célibataire, quelle aubaine tardive sera la venue de *la Dame en bleu!*" Bouyer 1909, pp. 297–98, 304.

8. "Les mélodies les plus subtiles réalisées par la peinture moderne ont eu leur origine dans la technique à découvrir sur ces deux toiles; rien pourtant qui fût moins rare avant Corot, que les éléments de base qui la composent: c'est la gamme des gris et des bruns qui se voit appliquée dans la plupart des ateliers au XVIII^e siècle, la même sur laquelle, par exemple, puisqu'il s'agit là d'intérieurs, un Drolling, au temps de la jeunesse de Corot, s'attardait encore à son blaireautage prosaïque. . . . Mais Corot sait faire 'chanter' avec une suavité dont Prud'hon seul jusque-là avait pu comme donner un avant-goût." Dorbec 1910, pp. 12–13.

9. "ce morceau ne valait pas si cher." Dimier 1912, n.p.

10. "Dans ce tableau de *la Femme en bleu*, il n'y a pas d'intention subtile, il n'y a aucune recherche de sujet. Une jeune femme blonde, vêtue d'une robe bleue à double jupe, que bordent des galons de velours noir, est accoudée sur une espèce de haut pupitre, dans une pose qui fait valoir le profil de son visage et la courbe de son bras nu; sa main gauche tient un gant blanc. La distinction de l'attitude, si naturelle, l'air de rêverie non affectée et l'impression de portrait véridique que rendent le visage et la personne tout entière, ne doivent pas nous tromper. Cette belle rêveuse, qui s'appelle *la Femme en bleu*, comme des figures célèbres de Whistler et de Gainsborough s'appellent *the Woman in white* et *the Blue Boy*, n'a pas droit pour nous à un autre nom. Ni plus ni moins que *la Femme à la Perle* ou la joueuse de mandoline de *l'Atelier*, c'est un modèle; et c'est le chevalet de Corot qu'on aperçoit derrière elle, et c'est le mur de son atelier, avec une étude encadrée et une toile sans cadre, qui lui sert de fond. L'oeuvre est le délassement d'un paysagiste que la saison ou tout autre motif confine à la chambre et qui peint ce que l'occasion lui offre, tout en obéissant à cette vocation qui ne l'abandonne jamais et qui est, avant tout, de faire de bonne peinture. Naturel, justesse des valeurs, frugalité de la palette produisant des effets tour à tour puissants et délicats, toujours simples,—par la grâce de telles vertus, cette modeste étude d'une figure d'atelier dans le plus modeste intérieur nous charme et nous satisfait à l'égal des créations les plus riches de l'art. Le sujet rappelle certains tableaux faits vers le même temps par Fantin-Latour, Stevens, Whistler et même Manet. Mais, pour la qualité magistrale de la peinture, le seul parmi ces contemporains qui mérite ici d'être mis en parallèle avec Corot, c'est Manet, ce Manet que Corot n'aimait pas beaucoup, même après qu'on eut persuadé au vieux maître de se laisser porter au jury du Salon sur une 'liste de combat' où figurait l'auteur du *Déjeuner sur l'herbe* et de l'*Olympia*. Le bleu si franc de la robe rehaussée de galons noirs aurait plu, nous semble-t-il, à Manet. Ce bleu-là ressemble fort à celui du canapé sur lequel nous voyons *Mme Manet* étendue, telle que la peignit son mari, en cette même année 1874." Jamot 1929, pp. 39–40.

11. Béguin in Paris 1962, p. 160.

12. Hélène Toussaint in Paris 1975, no. 117.

13. I thank Harold Koda, Associate Curator of The Costume Institute, The Metropolitan Museum of Art, New York, for his observations.

14. The observations were very kindly related by Anne Rocquebert, conservator at the Laboratoire de Recherche of the Musées de France.

PROVENANCE: Probably sold by the artist to G. Bardon, 1874;* from him to de Villers, March 1875; F. Gérard; Henri Rouart (1833–1912), Paris, 1889;** his posthumous sale, Galerie Manzi Joyant, Paris, December 9–11, 1912, no. 125, as *La Femme en bleu;* purchased at that sale by the Musée du Louvre, Paris, for 162,000 francs, with interest from the Maurice Audéoud bequest and with the participation of Henri Rouart's children

EXHIBITIONS: Paris 1900, no. 128, as *Femme en bleu,* lent by Henri Rouart; Paris 1910b, no. 26; Amsterdam 1926, no. 22; Copenhagen, Stockholm, Oslo 1928, no. 22 (Copenhagen), no. 18 (Stockholm), no. 14 (Oslo); Paris 1936, no. 106; Lyons 1936, no. 109; Paris 1946b, no. 188; Paris 1962, no. 82; Moscow, Saint Petersburg 1965–66; Bordeaux 1974, no. 45; Paris 1975, no. 117

REFERENCES: Michel 1900, p. 305; Meier-Graefe 1905, p. 111, ill. p. 93 (English translation in New York 1986, n.p.); Robaut *carton* 27, fol. 74; Robaut 1905, vol. 3, pp. 312–13, no. 2180, ill., and vol. 4, p. 295; Geffroy 1907, p. 365; Bouyer 1909, pp. 297, 304; Dorbec 1910, p. 12; Hamel 1910, p. 12; Alexandre 1912, pp. 3, 4, 18, 28; Dimier 1912; Rouart sale 1912, p. xi; Moreau-Nélaton 1913, p. 99, pl. 24; Moreau-Nélaton 1924, vol. 2, p. 84, fig. 259; Jamot 1929, pp. 39–40; Bernheim de Villers 1930a, pp. 63, 69, no. 330, ill.; Bernheim de Villers 1930b, pp. 232, 233; Jamot 1936, pp. 50, 54, ill. p. 59; Gobin 1939, p. 271; Bazin 1942, pp. 61, 109, 124, pls. 123, 125; Bazin 1951, pp. 56, 115, 135, pls. 133, 136; Baud-Bovy 1957, pp. 40–41, 109, 126; Dieterle 1959, n.p., pl. 30; Hours 1972, pp. 49, 164–65, ill.; Bazin 1973, pp. 67, 274, 292, ill. pp. 240, 241; Leymarie 1979, p. 156, ill. p. 157; Compin and Roquebert 1986, p. 155, ill.; Zimmermann 1986, pp. 178–79, 297, 371, fig. 136; Selz 1988, p. 266, ill. p. 263; Laclotte et al. 1989, pp. 30, 139, 311; Leymarie 1992, p. 180, ill. p. 181; Gale 1994, p. 138, ill. p. 139

* A friend of Corot and nephew of the art agent Cléophas. See Robaut 1905, vol. 2, p. 280, no. 2107.

** Robaut *carton* 27, fol. 74.

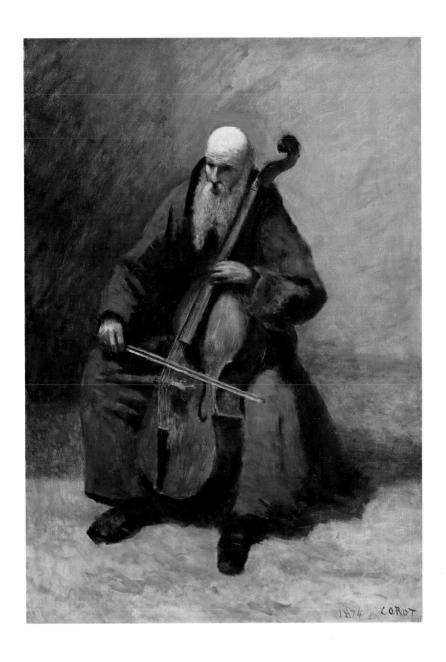

163

Le Moine au violoncelle
(Monk with a Cello)

1874
Oil on canvas
28½ × 20⅛ in. (72.5 × 51 cm)
Signed and dated lower right: 1874 COROT
Kunsthalle, Hamburg
Amsinck, 1921 2411

R 2129

Thanks to the presence of Corot's neighbor, student, and biographer, Alfred Robaut, we have a precise account, retold by Moreau-Nélaton, of the circumstances of this work's

making. "On entering the studio on January 2, 1874, Robaut finds him in the middle of posing, his two hands flat on his knees. His face betrays his impatience to have done with it and get back to work. When the sitting has ended, he gets up happily and, after a glance at his torturer's work, quickly pulls off his coat, puts on his smock, and dons his usual cotton cap. Waiting there at the pleasure of the master is his model Narcisse, come to pose as a 'monk' [for a painting] promised to Tedesco. Tedesco himself is there, as well as Bardon." And

Fig. 165. Édouard Moyse (b. 1827). *Chartreux jouant du violoncelle* (*Carthusian Monk Playing the Cello*), February 1, 1863. Etching published in the sixth album of the Société des Aquafortistes. Bibliothèque Nationale de France, Paris

Robaut describes Corot at work: "Pipe in mouth, he plants himself in front of the model and, on the still-virgin canvas, sketches the silhouette of the fellow in chalk.... He takes up a pencil and, in a quarter of an hour, sets down the outline of the figure. Next he grabs the palette and feverishly puts colors on the canvas. While he dabs in the brown robe, his brush continually hunts for a bit of white to mix in with the darkest tones."[1]

It is odd, however, that in his description of this process Robaut did not mention—as he does elsewhere—an identical painting on panel that Corot had already begun in February 1872.[2] The earlier panel is known only from a sketch by Robaut, which so closely resembles this canvas now in Hamburg that one is tempted to suspect that Robaut confused the two works. But it is possible that Tedesco, having bought and presumably sold the earlier panel, then ordered and eagerly awaited the new canvas.

This painting is the last, and in many respects the most touching, in a series of twelve paintings of monks that extend throughout Corot's career. The earliest (cat. no. 17), executed during the first trip to Italy, depicts a Franciscan or Capuchin monk reading out of doors. This would become a standard subject for Corot: six of his paintings of monks show them reading in a landscape,[3] while four show the subject in a moment of prayer or meditation.[4] Most of the monks are dressed in dark Capuchin robes; three wear light Carthusian robes (see cat. no. 108); one wears the dark cape over the light robes of a Dominican. The late pictures were all of posed models, and so too, most probably, were the earlier works. The Capuchin costume was provided by Édouard Brandon, a pupil of Corot's who was in Rome from 1856 to 1863. Corot wrote Brandon on January 17, 1857, asking him "to send me by means of a boarder [at the Villa Medici] or someone else, or you when you come, two costumes: one of a Capuchin

monk and the other of a woman of Albano or Genzano. We'll figure the cost of them together." Corot had received the costumes by March 31, 1857, when he wrote to thank Brandon and to tell him, "the Capuchin is very fine."[5]

The introduction of the cello is an innovation of the 1872 and 1874 pictures. Gisela Hopp has demonstrated that Corot may have borrowed the idea from a slightly earlier painting by Édouard Moyse, *Chartreux jouant du violoncelle*, which was exhibited at the Salon of 1853 and reproduced in 1863 in the *Sixième livraison de la Société des Aquafortistes,* to which Corot was a subscriber (fig. 165).[6] Behind both the Moyse and the Corot lay Joseph-Marie Vien's great *Ermite endormi* of 1750 (Musée du Louvre, Paris), in which a hermit, dressed as a monk, has fallen asleep against a tree with his violin and bow in his hands. Yet Corot's picture is at once more timeless and more emotive. He has removed the expected symbols of *vanitas* and the brevity of life and has declined even to place his monk in a specific setting, concentrating instead on the rich, sonorous browns and golds that are so harmonious with the subject.

If we are to believe Robaut, Corot painted this work for a dealer who was given the privilege of witnessing its creation. Yet the work carries a weight beyond its commercial intent. The longevity of the monastic motif in Corot's work is a clear signal of its importance for the painter; and there can be no doubt that the unmarried Corot identified with these men. That the monks grew progressively older as he did is one inescapable clue. That, as he told a friend, Corot kept at his bedside a copy of the devotional book *The Imitation of Christ* is another. "I always have in my bedroom a copy of the *Imitation of Christ* and I read from it almost every night.... It is this book that has helped me lead my life with such serenity and has always left me with a contented heart. It has taught me that men should not puff themselves up with pride, whether they are emperors adding this or that province to their empires or painters who gain a reputation."[7]

1. "En entrant à l'atelier le 2 janvier 1874, M. Robaut le trouve en train de poser, les deux mains à plat sur les genoux. Sa physionomie trahit l'impatience d'en avoir fini et de se remettre au travail. La séance terminée, il se lève avec joie et, après un coup d'oeil accordé à l'oeuvre de son tortionnaire, vite, il enlève sa redingote, passe sa blouse et coiffe l'habituel bonnet de coton. Il y a là, attendant le bon plaisir du maître, son modèle Narcisse, venu pour poser un 'moine' promis à Tedesco. Tedesco lui-même est présent, ainsi que Bardon.... La pipe à la bouche, il se campe en face du modèle et, sur la toile encore vierge, esquisse à la craie la silhouette du bonhomme ... il prend un crayon de mine de plomb et, un quart d'heure durant, il précise les contours de sa figure. Puis, il saisit la palette et fiévreusement la couleur s'abat sur la toile. Tandis qu'il ébauche la robe brune, sans cesse son pinceau va chercher un peu de blanc pour le mêler aux tons les plus foncés." Moreau-Nélaton in Robaut 1905, vol. 1, pp. 298–99.
2. R 2129 bis. Ibid., vol. 3, p. 290: "It's a variant of no. 2129. This study, begun by Corot in February 1872, was delivered to Tedesco as soon as it was finished." ("C'est une variante du no. 2129. Cette étude, commencée par Corot en février 1872, fut livrée à M. Tedesco une fois terminée.")
3. R 105 (cat. no. 17); R 375, Musée du Louvre, Paris; R 1044 (cat. no. 108); R 1045; Dieterle 1974, no. 28, Wildenstein & Co., New York; R 1332, Stiftung Bührle, Zurich (fig. 104).

4. R 106; R 388; R 1043, Musée du Louvre, Paris; R 538.
5. "de me faire arriver par un pensionnaire ou tout autre, ou vous quand vous reviendrez, deux costumes: un de moine capucin et un costume de femme d'Albano ou de Genzano. Nous compterons tout cela ensemble"; "le capucin est très beau." Moreau-Nélaton in Robaut 1905, vol. 1, pp. 179–80.
6. See Hopp's excellent article, Hopp 1990.
7. "J'ai toujours dans ma chambre un livre de l'*Imitation de Jésus-Christ* et j'en lis presque tous les soirs. C'est ce livre qui m'a aidé à passer la vie avec autant de calme et qui m'a toujours laissé avec le coeur content. Il m'a appris que les hommes ne doivent pas s'enorgueillir, qu'ils soient empereurs et qu'ils ajoutent à leur empire telle ou telle province, ou qu'ils soient peintres et qu'ils acquièrent un nom." Corot's words recorded by Mme Aviat and quoted in Corot 1946, vol. 1, pp. 137–38.

PROVENANCE: Presumably sold by the artist to the dealer Louis Tedesco, Paris, by 1874;* Gustave Tempelaere, Paris, 1888;** Durand-Ruel & Cie., Paris, 1891; Frau E. Amsinck-Lattmann, Hamburg, by 1905; her gift to the Kunsthalle, Hamburg, 1921

EXHIBITIONS: Bern 1960, no. 97

REFERENCES: Meier-Graefe 1905, p. 111 (English translation in New York 1986, n.p.); Robaut *carton* 27, fols. 65, 65 bis; Robaut 1905, vol. 1, pp. 244, 299, and vol. 3, pp. 290–91, no. 2129, ill.; Meier-Graefe 1913, p. 183, ill. p. 169; Moreau-Nélaton 1924, vol. 2, p. 81, fig. 249; Bernheim de Villers 1930a, pp. 57, 69, no. 301, ill.; Bazin 1942, pp. 61, 109, 124, pl. 127; Bazin 1951, pp. 56, 115, 135, pl. 139; Leymarie 1962, p. 112; Bazin 1973, pp. 67, 274; Reidemeister et al. 1973, p. 56; Leymarie 1979, p. 156, ill.; Zimmermann 1986, pp. 169, 292, 354, fig. 54; Selz 1988, pp. 264, 266, ill. p. 267; Hopp 1990, pp. 129–40, fig. 1; Leymarie 1992, p. 180, ill.

* Moreau-Nélaton in Robaut 1905, vol. 1, pp. 298–99.
** Robaut 1905, vol. 3, no. 2129; Bern 1960, no. 97.

Corot Forgeries: Is the Artist Responsible?

Vincent Pomarède

Of the myths surrounding Corot's works and personality, one of the most infamous and tenacious is based not on legend but on fact: the existence of numerous forgeries. A famous quip that was first set down in 1936 by René Huyghe, now a cliché among art professionals, goes, "Corot painted three thousand canvases, ten thousand of which have been sold in America."[1] It is true that false Corots were produced in abundance between 1870 and 1939, although the figure of ten thousand seems without foundation and is very likely excessive. And it would be wrong to mention the hundreds of dubious Corots in North America without acknowledging that there are surely an equal number in Europe.

Corot was one of the most copied and imitated painters in the history of French art, one of those artists who have most "inspired" forgers, and the extent to which quantity figured in these forgeries is astonishing. The most impressive lot of forged Corots—the Jousseaume collection, of which more will be said later—contained 2,414 works. A single studio in Ixelles, Belgium, produced 235 fake Corot landscapes in 1888 alone.[2] Preparations for the present exhibition, which required the examination of many hundreds of paintings, again confirmed the abundance of fakes. Largely between 1900 and 1940, donations, bequests, and even a few purchases "enriched" public collections the world over—including those of the Louvre[3]—with numerous false Corots, the study of which could fill a thesis in itself. And that's without considering private collections.

Obviously, most of the great painters attracted forgers when the scarcity of their works led collectors to seek them out avidly and art dealers to raise their prices. Corot was hardly an exception. Still, two characteristics make his case particularly delicate and unusual, and provide a base from which to study the question of Corot forgeries.

First of all, it was precisely when Corot's work became especially plentiful—at the end of his career, when he produced several hundred canvases—that forgers began to take an interest in him. Thus, it was not the scarcity of his works that created a market for forgeries but rather their abundance. Most Corot forgeries employ the kind of brushstroke used in these later pictures and are imbued with their poetic mood.

Second, Corot's odd behavior in the last twenty years of his life with respect to copies of his paintings and to the already bustling activities of forgers added to the confusion; one might legitimately wonder whether Corot's attitude toward his works and his astonishing conception of artistic property were not at the root of the explosion of forgeries that started even before his death. Huyghe asked,

1. "Corot était l'auteur de 3,000 tableaux dont 10,000 ont été vendus en Amérique." Huyghe 1936, p. 73.

2. This case is cited in an unsigned article by Paul Colin in the Belgian edition of *L'Amour de l'art* (February 1936). It also mentions the establishment of a forgery studio in Brussels during World War I.

3. Among the hundred or so works by Corot that it houses, the Louvre has its share of false or dubious paintings: *Bûcherons dans une clairière* (R.F. 3779), an oil on canvas-backed paper given to the museum in 1936, is a copy that came from a sale of works by the painter Édouard Brandon in 1897, probably the work of a student or an unfinished copy painted by Brandon himself, based on Corot's *Fontainebleau. Chênes inclinés dans une éclaircie*, R 896 (according to Bazin 1951, p. 79). *La Route*, Musée d'Orsay, Paris, R.F. 1785, from the bequest of Alfred Chauchard in 1909, must be a work painted in Corot's studio with many retouchings in the latter's hand. *Les Bords du Cousin* (R.F. 1937-24) is a more difficult painting: it is cited by Robaut (R 430), and one copy of it is known to exist; but it is quite possible that the version in the Musée d'Orsay is the original. *Le Coup de vent* (R.F. 2038), acquired by the Louvre in 1909 and traditionally excluded from the original works by Corot, might nonetheless be a purely original painting, a studio work entirely retouched by Corot. *Paysage de rivière* (fig. 168), *Paysage* (R.F. 1961-35), *Paysage avec un cavalier* (M.N.R. 152), *Arbres près d'un étang* (M.N.R. 170), *Paysage avec un moulin à vent* (M.N.R. 183), and *Le Lavoir* (fig. 169) are so many pastiches or fakes, all of them bearing apocryphal signatures.

Fig. 166. A page from Alfred Robaut's album documenting Corot forgeries. Robaut "Corot. Tableaux faux," fol. 85

4. "Quant aux 'Corots de la fin,' le meilleur faussaire n'est-il pas Corot lui-même, succombant aux commandes et aux sollicitations, multipliant une production hâtive et parfois bâclée?" Huyghe 1936, p. 73.

5. Robaut 1905, 5 vols. Reprint, Paris, 1965.

6. Robaut "Corot. Tableaux faux."

7. "Où cela s'arrêtera-t-il, si ceux qui sont réputés avoir les plus belles oeuvres tripotent à leur tour?" Ibid., fol. 55.

8. Robaut's writings in this inventory of forgeries are always impassioned and often interesting, offering precise descriptions of the paintings he had studied: "In October [18]86, I see at Chéramy's a large painting, 1.30 m wide, signed *Corot* in the lower right-hand corner (I believe even dated 1834). It's hard and dry all over with a tree at the right whose leaves are like parsley and all the same, as if they've come from a mold. In a word, it's horrible." ("En octobre 86, je vois chez Chéramy une grande toile de 1.30 m de large, signée en bas à droite Corot [je crois même avec la date 1834]. C'est dur et sec partout avec un arbre à droite dont les feuilles sont en persil et toutes pareilles comme passées au moule. En un mot, c'est horrible.") Ibid., fol. 97. Robaut was describing the *Forum romain*, today in the Walker Art Center, Minneapolis.

9. Bazin 1951, p. 61.

10. Bazin approached the question in two essential texts: chapter 6 of Bazin 1951 (rev. ed. 1973) and an article for the Laboratoire's newsletter, Bazin 1956.

11. "Corot reste un miracle poétique, mais non plus un miracle historique." Huyghe 1930, p. 5.

12. Rome, Turin 1961.

13. Bremen 1977–78 and Cambridge, London 1980–81.

14. Galassi 1991b.

"As for the 'last Corots,' wasn't the best forger Corot himself, who acceded to commissions and requests, multiplying his production through hasty, sometimes even sloppy work?"[4]

In truth, the question of Corot forgeries has barely been broached; two men have, however, greatly added to our knowledge of the matter. The first is Alfred Robaut, who between 1872 and 1905 tracked down Corot's works in preparation for his monumental catalogue raisonné, completed with the help of Étienne Moreau-Nélaton.[5] While seeking out original works from dealers and collectors throughout Europe, Robaut scrupulously kept a list of the dubious or forged paintings he came across, and by the time he completed his efforts in about 1900 he had already inventoried some five hundred forgeries, painstakingly sketched and annotated in a fascinating album that is now preserved at the Bibliothèque Nationale de France (fig. 166).[6] "Where will it end, if even those who are reputed to own the most magnificent works have been taken in?" he lamented.[7] Robaut probably hoped that such an inventory might one day halt the forgery machine.[8] Unfortunately, his manuscript was never made available. Germain Bazin, who lobbied strenuously for its publication,[9] is the second art historian to have deepened our thinking about Corot forgeries. He approached the question with greater objectivity and rigor, having the benefit of more historical hindsight and of new technical methods—in particular, those of the Laboratoire de Recherches des Musées de France—that were unavailable to Robaut and that have shed much new light on the topic.[10]

The present essay is meant to offer the reader a synthesis of this phenomenon's probable causes and a typology of the most frequently encountered cases of forgery.

ERRORS OF ATTRIBUTION

False or dubious works exist first of all because of errors of attribution, to which the works of all artists are liable. Once an artist's fame is established, there is a natural, though hardly defensible, tendency to ascribe to him any work with a subject or technique reminiscent of his own. With Corot there is a clear distinction between attribution problems of his early period, from 1822 to 1835, and those of his last twenty years. Corot's approach in making his early paintings had nothing to do with later errors about them, which were due mainly to stylistic resemblances, whereas in the late period his own working methods and behavior actually helped falsify attributions and spawn numerous confusions.

The works Corot painted during his first trip to Italy have long been presented as eminently personal and original, examples of an advanced style that paved the way for Impressionism and that had never before been practiced by any other artist. Only after the princesse de Croÿ's collection went to the Louvre in 1930 did viewers discover the open-air studies painted in Italy by Pierre-Henri de Valenciennes about 1780 and by Achille-Etna Michallon before 1820 and realize (in Huyghe's words at the time) that while "Corot remains a poetic miracle, he is no longer a historical one."[11] Later, exhibitions devoted to painters' sojourns in Italy[12] and to open-air paintings from the early nineteenth century onward,[13] and a fascinating book by Peter Galassi,[14] further corrected our belief in Corot's

originality vis-à-vis the landscape painters of his day and reminded us that other artists, such as Jean-Joseph Bidault, André Giroux, and Théodore Caruelle d'Aligny, also produced landscape studies in the Neoclassical spirit. But the old idea persisted, and from 1880 to 1930, any light-filled, colorful Italian landscape from the right period that was painted on paper in the size used for plein air work could only be by Corot, as far as art historians were concerned. Huyghe pointed out, however, that the "Italian Corots" are easily identifiable, "as long as one does not forget that this precise, luminous, natural style does not belong to Corot alone; he simply gave it its most refined expression."[15]

This is why we often encounter studies of Italy by Valenciennes, Bidault, or Aligny that were attributed to Corot, generally around the beginning of this century. An excellent example is the stunning canvas in the Musée des Beaux-Arts in Liège, *Vue de Rocca di Papa, le matin;*[16] it is traditionally said to be a Corot, but it is clearly a study by Valenciennes, similar in all respects to others by him in the Louvre.[17] When it is compared with a painting of the same site truly by Corot, *Le Monte Cavo* (Musée des Beaux-Arts, Reims), differences are revealed in technique and in the way nature is viewed. The painting in Liège was at first misattributed in error but became an actual forgery when a dishonest seller or collector added a false signature in the lower right-hand corner. This situation was common, and many forgers took advantage of the technical similarities between Corot's studies of Italy and those of his contemporaries. The same museum has another view of Italy, *Vue de l'Adriatique,*[18] also signed *Corot*, which may be by André Giroux (1801–1879), who was in Italy at the same time.[19]

There were many other painters in Italy when Corot was there, working on landscapes using the same techniques, having had an identical training, and this makes attributing paintings difficult. Corot was inspired by some and influenced some, and often he and another artist painted the same scene, sometimes in each other's company. Corot's open-air sessions in Rome or Olevano alongside Aligny are at the root of much confusion.[20] The Musée des Beaux-Arts in Lille owns a superb study of the Castel Sant'Angelo over which art historians have been divided for half a century. Is the painting by Corot or Aligny? Robaut believed it was by Aligny, and, as usual, he drafted a short note about it: "Camille Benoît, an art dealer and photographer in Lille, had offered the museum this painting, which he had bought at the Aligny sale, and on the strength of his mistaken assertion they put a plaque with Corot's name on it, whereas it's by Aligny. Clear, regular execution." Farther on he remarked: "Smooth and regular, without imagination; too dry to be by Corot."[21] Still, someone had apparently tried to deceive potential buyers—or perhaps in all good faith merely confirm the attribution to Corot—by adding an apocryphal signature to the right-hand corner. Bazin later studied the canvas in detail, comparing its facture with that of the absolutely authentic painting from the Moreau-Nélaton bequest,[22] and also reached the conclusion that it was by Aligny.[23] Bazin pointed out that the work had been acquired by its donor to the Musée de Lille at the sale of works from Aligny's studio held in Paris on March 8–9, 1878 (no. 65), which seemed to confirm the attribution to Aligny.[24] In 1975 Hélène Toussaint once again attributed the painting to Corot, suggesting that it might be a later work, perhaps dating from his third trip to Italy in 1843;[25] but in the catalogue of the 1979 Aligny exhibition, written by Marie M. Aubrun, it is unequivocally

15. "Corots d'Italie"; "à condition de ne pas oublier que cette manière sans artifice, précise et lumineuse, n'appartient pas à Corot seul, qui en donna seulement l'expression la plus raffinée." Huyghe 1936, p. 73.

16. Inv. no. 15, given in 1900 by Eugène Dumont. Cited in Liège, Musée des Beaux-Arts 1950, no. 26.

17. One is reminded of *Monte Cavo sous un ciel nuageux* (R.F. 3025) or *Monte Cavo pris de Nemi* (R.F. 2989).

18. Inv. no. 14, given in 1900 by Eugène Dumont. Cited in Liège, Musée des Beaux-Arts 1950.

19. Giroux had won the Prix de Rome for historical landscapes in 1825 and therefore arrived in Rome at the Villa Medici at exactly the same time as Corot.

20. Robaut listed several sites that they both depicted: *Ariccia. Palais Chigi* (R 159), *Olevano. La Serpentara* (R 162), and *Olevano. La ville et les rochers* (R 163).

21. "Camille Benoît, marchand de tableaux et photographe à Lille, avait offert au musée cette toile achetée par lui à la vente d'Aligny et sur son affirmation erronée on a posé sur le cadre un cartouche de Corot, tandis que c'est d'Aligny. Exécution propre, régulière." "C'est lisse et régulier, sans caprice avec sécheresses trop nombreuses pour Corot." Robaut "Corot. Tableaux faux," fol. 81.

22. R 73, Musée du Louvre, Paris, R.F. 1622.

23. Bazin 1956, pp. 30–35.

24. The sale was organized seven years after Aligny's death by his widow and heirs. On June 11, 1871, Corot had participated in the preparation of the posthumous sale. We do not know how he decided which were Aligny's studies and which were studies of his own that Aligny had kept in honor of their friendship. One of Corot's works could easily have been mixed in with Aligny's in the 1878 sale, as neither artist was there to advise.

25. Toussaint in Paris 1975, no. 10, p. 26.

attributed to Aligny.[26] Since then, the dance of attributions has continued unabated, and the question will probably not be settled for some time to come.[27]

Another example of the difficulties that arise when artists work together is provided by two landscapes at the Musée des Beaux-Arts in Angers, *Temple de Minerva Medica à Rome* and *Vue de Marino*, both bequeathed by the painter Guillaume Bodinier (1795–1872), whom Corot met in Rome during his first trip to Italy.[28] The paintings were attributed to Corot in an interesting article by Henry de Morant;[29] Bazin hesitantly ascribed them to Aligny in 1956; they were later attributed to Bodinier himself. Here again, the presence of a signature or an inscription proved nothing. These studies had the dates 1825 and 1826 inscribed on the back.

The works discussed so far were wrongly attributed, but the presence of forged signatures or dubious inscriptions shows that sometime in their histories, error was compounded by an actual intent to mislead. Attributing the works Corot painted in Italy is made even harder by the fact that Corot himself was not always able to tell the difference—if we can believe Robaut, who related the amusing anecdote of Léon Fleury and Corot lengthily debating which of them might have painted a study that had recently turned up.[30] (They never managed to decide.)

Difficulties in attributing Corot's youthful works occur with studies painted on trips other than his Italian sojourns. The *Vue de Villeneuve-lès-Avignon* at the Musée des Beaux-Arts in Reims, a famous painting exhibited several times before World War II and long ascribed to Corot, was definitively attributed by Bazin to Prosper Marilhat (1811–1847), who had worked alongside Corot during their trip to Provence in 1836.[31]

COLLABORATIVE WORKS

Although Corot's style became more distinctive after 1850, problems in telling his works apart from those of his colleagues remain, this time because of his habit of working in collaboration. Not only did Corot continue to paint on site in the company of other artists (Philippe Comairas, Aligny, and Édouard Bertin in the forest at Fontainebleau; Ernest-Joachim Dumax in Marcoussis; Bovy, Barthélémy Menn, and Adolphe Leleux in Switzerland; Auguste Ravier and Charles Daubigny in the Dauphiné;[32] Charles Desavary, Constant Dutilleux, and Robaut in the north), as was customary for landscape artists in his time, but he might sometimes begin a painting that one of his friends would finish, or he might retouch more or less extensively a work by one of his colleagues.[33] Unscrupulous sellers, taking advantage of the ambiguities created by shared sites and stylistic resemblances, authenticated paintings that bore false Corot signatures.

Moreover, as Corot's fame grew his commissions multiplied, leaving him with a surplus of work which he tried to handle by engaging students or collaborators. Already in 1855, when he was commissioned to decorate the transept of the church at Ville-d'Avray, he had been forced to turn to a colleague, Jules Richomme (1818–1903), in order to complete the four oil-painted scenes applied directly to the church walls.[34] Decorative painting by its nature implies assistance

26. Orléans, Dunkirk, Rennes 1979, no. 1.

27. Annie Scottez-De Wambrechies published the painting as Corot's in Yokohama, Hokkaido, Osaka, Yamaguchi 1991–92, no. 14, p. 157. I cautiously attributed it to Corot in London 1993, no. 30, pp. 103–4, and again with more enthusiasm in Jones 1993, pp. 288–92. Anne Norton recently published it, but without adding anything new to the discussion, in New York 1992–93, no. 41.

28. A genre painter and student of Guérin whose studies of costumes were admired by Corot, Bodinier lived in Italy between 1822 and 1847.

29. Morant 1951.

30. Robaut "Corot. Tableaux faux," fol. 28. The two men had worked side by side both in Italy and near Fleury's home in Magny-les-Hameaux.

31. Bazin and others have shown, from proofs of the catalogue raisonné preserved at the Bibliothèque Nationale, that Moreau-Nélaton and Robaut pulled this work from their catalogue, after first planning to include it.

32. The three artists worked in front of the same settings, but Ravier also copied landscapes painted by Corot during this trip. We know of one copy by Ravier (private collection) of Corot's *Optevos (Isère)*. *Blanchisseuses au bord de l'eau* (R 1278, Musée du Louvre, Paris, R.F. 1625), which had belonged to Ravier before becoming part of Moreau-Nélaton's collection. See Lyons 1996. For works painted alongside Comairas and Dumax, see Robaut 1905, vol. 3, nos. 1323, 1302.

33. Robaut mentions several on-site works painted with Dutilleux, which might later have been retouched by Corot: see Robaut 1905, vol. 3, nos. 2188, 2256, 2404.

34. See Moreau-Nélaton 1924, vol. 1, p. 107. The work includes four panels representing Adam and Eve Banished from Paradise, the Baptism of Christ, Christ in the Garden of Gethsemane, and the Magdalene in the Desert (R 1074–R 1077). They are still in their original location in the church at Ville-d'Avray.

Fig. 167. Corot, Charles-François Daubigny (1817–1878), Karl Daubigny (1846–1886), and Achille-François Oudinot (1820–1891). *Souvenir d'Italie* (Souvenir *of Italy*), partial view. Oil on canvas, mounted on the wall. Charles Daubigny studio, Auvers-sur-Oise

by other hands, but Corot sometimes let his students or friends paint the entire work, following a general plan that he laid out. Thus, the decor in Daubigny's studio in Auvers-sur-Oise (fig. 167) was done in the style of Corot, from Corot's charcoal sketch, by his student Achille-François Oudinot (1820–1891) and by Daubigny's son Karl.[35] Corot probably retouched the work a little when passing through Auvers-sur-Oise, since it was painted for one of his best friends.[36]

These are obviously not cases of forgery but rather of an old tradition: studio work. Moreau-Nélaton speaks of Corot, in particularly busy periods, entrusting the task of sketching out a painting according to his specifications to a certain Demeur-Charton and to Robaut himself; Robaut claims that he prepared the reduction of Corot's *Saint Sébastien* (R 2316; see cat. no. 104) with another student, Louis Desmaret, and also the replicas of the panels of the Ville-d'Avray church (R 2311–R 2314) and the *Souvenir d'Arleux* (R 2189). Another student, Georges Rodrigues-Henriquez, apparently prepared the reduced copies of *Dante*

35. R 1649, by Oudinot; R 1650, by Oudinot and Karl Daubigny; R 1651, probably by Karl Daubigny, with some additions by Oudinot. These decorations are still in place today.

36. Corot, Daubigny, and the Swiss painter Armand Leleux collaborated in 1853 on a decorative screen in Dardagny (R 1073). Corot's and Daubigny's signatures have remained, while that of the lesser-known Leleux has been removed.

Fig. 168. Circle of Corot. *Paysage de rivière (River Landscape)*. Musée du Louvre, Paris (MNR 686)

et Virgile (see cat. no. 115) and of *Le Tournant de la Seine à Port-Marly* (R 2206). This method of working obviously gave rise to considerable confusion, especially at a time when Impressionism was lending prominence to the notion of original works, works painted entirely by the artist. Indeed, we no longer know how to approach certain of Corot's works, which are authentic even though not entirely by his hand. Once a common situation, it was not common for modern landscape painters, and this created a zone of uncertainty in which forgers were able to insert their own works.

THE DELICATE QUESTION OF COPIES

Another source of error that developed even at the beginning of Corot's career and became widespread after 1860 is the unprecedented number of copies made from his works. Corot himself often seems to bear some responsibility for the confusion between originals and copies.

Strictly applying the advice given by Valenciennes, Corot got into the habit of recollecting by copying his own open-air studies back in his studio; he also frequently painted replicas of the studies he deemed most successful. For the sheer enjoyment of it he occasionally painted doubles of certain Italian landscapes or made alternate versions of them for friends and collectors. For example, he painted at least four variants of a view of Rome from the Villa Medici with the fountain basin in the foreground (cat. no. 15) and several versions of his study of the Trinità dei Monti church (cat. nos. 12–14). Of the view of Castel Sant'Angelo that he had originally painted from life he made three or four versions (cat. no. 11), working indoors in Rome and back in his Paris studio, while his students Brandon, Desavary, and Guillon made copies.

Copying works by the classical masters was an apprentice artist's first assignment. After that the young landscape painter also had to copy the studies or paintings of his teachers. Thus Corot himself, as we have seen, had copied

studies from nature made by his teacher Michallon and had even carefully reproduced one of his large paintings.[37] It was also common practice for colleagues to exchange works; landscape artists liked to work from studies painted by their most gifted friends. The studies from nature that Corot painted in Italy enjoyed great success early on, and requests to be allowed to copy them were numerous. One of Corot's notebooks contains a list of the paintings he lent to "a large number of artists": Berthoud, Darier, Poirot, Français, Scheffer, Aligny, Coignard, Étex, Lavieille, Léon Fleury, Armand Leleux, Rhoen, Desbrochers, Remy, Anastasi, Badin, Marilhat, Chevandier de Valdrôme, Chintreuil, Baudot, Henri Faure (from Lille), Prévost, Lambert, Oudinot, Devillers, Camus, Dourlans, Dutilleux, Legentil, Lepollart, Desavary, Lewis, Robaut, Audry, Mention, and so on.[38] These copies, emerging later from a provenance close to Corot, sometimes caused confusion.

Corot's first contact with a student generally involved the copying of his works—and sometimes their relations went no further. One of his favorite pupils, Antoine Chintreuil (1814–1873), described their first meeting: "'M. Corot, we have heard that you gladly encourage young people, and we would be most grateful for your advice.' 'What!' cried the master, 'but you can have anything you see here!' And after a few helpful remarks, he handed out to these young painters, whose names he did not even know, four painted studies and ten drawings, which came back the following year."[39] A talented student could produce an extremely faithful copy, which might later be transformed by an unscrupulous owner into a false Corot bearing an apocryphal signature.

How can one distinguish, then, between a signed replica and a good copy? For example, is the study at the Museum of Fine Arts in Boston, *Rome. Île et pont de San Bartolomeo*, in fact a replica or is it a copy of the authentic, privately owned version (R 75)? The original painting *Fabriques du Poussin* (R 48), also privately owned, is well known, but where is the copy that Corot's student Eugène Lavieille painted after 1860? When the replica of *Rome. Le Colisée vu des jardins Farnèse* (R 54, private collection) reappears, along with the various copies mentioned by Robaut and Moreau-Nélaton, the genesis of this work will no doubt be better understood.

The situation became still more complicated after 1860, when requests to copy works (including requests from professional copiers) increased. Jean Dieterle called attention to Corot's strange relations with certain "dispensaries" that specialized in the rental of paintings, either to decorate a salon for a large reception or, more frequently, to allow the copying of works of famous artists who had authorized such use.[40] Corot surely dealt with several of these agencies—the ease with which he lent works had become legendary—and we have precise information about his contract with one of them, the Agence des Beaux-Arts, located in Paris at 56, rue de l'Ouest and run by the Lyonnais painter François-Frédéric Grobon (1811–1901/2). The written agreement exists that spelled out the terms under which one could rent his works: "The minimum rental period will be half a month. After the first half-month, rentals must be extended for a full month at a time. Persons renting paintings are requested to settle all accounts upon return of the models. . . . Commercial reproduction of any kind will be prosecuted, including the rental of copies, which is prohibited."[41] On the same agreement is a handwritten list of paintings rented out by Corot, along with the fees—from 6 to 24 francs for two weeks—and a purchase price, should a renter

37. R 198 (private collection) is a copy by Corot after Michallon's *Paysage inspiré d'une vue de Frascati* (fig. 8).

38. From *carnet* 66, published in Robaut 1905, vol. 4, pp. 96–97, no. 3103. Numerous copies are cited in Robaut 1905: copies by Brandon (of R 70, R 328), Desavary (of R 52, 62, 70, 80, 101, 115, 300, 302, 309, 706, 889, 1016, 1038, 1287, 1333), Devillers (of R 1499, R 1501), Dutilleux (of R 700), Oudinot (of R 1099), among others.

39. "M. Corot, nous avons entendu dire que vous encouragez volontiers les jeunes gens, nous comptons sur votre complaisance pour obtenir quelques conseils. 'Comment! fit le maître, mais tout ce qui est ici est à vous!' Et, après de bons avis préliminaires, il remit à ces jeunes gens, sans savoir la première lettre de leur nom, quatre études peintes et une dizaine de dessins qui rentrèrent un an après." Robaut *documents*, vol. 1, fol. 11.

40. Dieterle in Dieterle and Bazin 1943.

41. "On ne loue pas moins du demi-mois. Le demi-mois dépassé, le mois devient exigible en entier. Les personnes qui louent des tableaux sont priées de solder le montant des locations en rendant les modèles. . . . Toute reproduction commerciale de quelque nature qu'elle soit sera rigoureusement poursuivie, y compris la mis en location des copies qui est interdite." Now housed at the Fondation Custodia, Paris: "Document Grobon," C. Corot, 1995-A-105b recto.

42. Written in the document by hand (Corot's?) is a list of studies "given to M. Grobon for study Rental": "Remis à M. Grobon pour étude Mis[e] en location les études suivantes:

Prix des Ouvrages	N°	Titres	Prix de location
200	1	Etude à [Abliri]	6
300	2	id. Villa Borghèse (non à vendre)	
400	3	id. près Beauvais	12
300	4	id. Ville-d'Avray	9
300	5	Château-Thierry	12
200	6	id. Boulogne sur mer	6
200	7	id. Aiserey côte d'or	6
300	8	Une figure la liseuse	9
300	9	Une jeune fille	9
800	10	Ville-d'Avray	24

Le 26 avril 1863 Corot."

A second such document is cited in "Corot and His Collectors," p. 398.

43. Robaut *documents*, vol. 2, fol. 75. The Corots were sold in two large sales on May 24 and June 10, 1887, but the sales did not have a great impact because of collectors' distrust: "Most of the paintings sold yesterday as being by Corot were originally studies or sketches that have been tampered with or repainted by other hands." ("La plupart des tableaux vendues hier comme étant de Corot étaient primitivement des études ou des esquisses qui ont été altérées et repeintes par des mains étrangères.") Anon. 1887.

44. "Le pinceau complaisant du créateur authentiquait ces répliques par quelques retouches personnelles et décisives. Lorsqu'il ne fut plus là pour achever ses Sosies, on continua d'en produire quand même." Moreau-Nélaton in Robaut 1905, vol. 1, pp. 333–34. Moreau-Nélaton 1905b, p. 106.

express interest in buying. The sale prices were extremely reasonable, between 200 and 800 francs.[42]

In a similar vein, but this time involving actual malfeasance and abuse of confidence, was the reproduction studio run by the painter-restorer André-Julien Prévost. A former student of Corot's who had won his friendship by relining several of his canvases, Prévost after 1860 borrowed the master's works in order to copy them himself or give them out to be copied by his apprentices and students. The number of paintings that passed through his hands was considerable, and Robaut claims to have seen as many as 250 copies of Corots in one visit to Prévost's studio. Prévost apparently owned, either through purchases or through loans that he "forgot" to return to Corot, as many as ninety-nine originals by the artist, which Robaut recorded; they were sold in 1887 in two large sales. Reproductions were often mixed in with the originals, and Robaut complained bitterly about Prévost, who clearly had no compunctions about retouching original Corot paintings to make them more salable or about extracting signatures from Corot in order to increase the value of the copies.[43]

According to Moreau-Nélaton, Corot offered no resistance to the copiers and pastiche artists: "The master's complacent brush authenticated these replicas with a few personal and decisive retouchings. When he was no longer there to finish his 'doubles,' they went on producing them without him."[44] Thus were Corot's principal masterworks copied, some of them several times. *La Route de Sin-le-Noble* (cat. no. 159), which had been replicated by Corot himself, was copied at least twice during his lifetime, by Louis-Théodore Mention, one of his later students, and by Demeur-Charton. *Le Pont de Mantes* (R 1516) was also copied by Mention; this copy was retouched by Corot and later belonged to François-Parfait Robert, one of Corot's best friends and a collector of his works, which makes attribution none the easier, as that provenance is perfectly credible for an original work.

Fig. 169. Circle of Corot. *Le Lavoir (The Wash-House)*. Musée du Louvre, Paris (MNR 536)

Fig. 170. Attributed to Corot. *Paysage (Landscape)*. Musée du Louvre, Paris (MNR 152)

Moreau-Nélaton emphasized Corot's peculiar attitude in authenticating these copies and imitations. Today it seems clear that Corot had an unusual idea of intellectual and artistic property. Taking an approach that we might liken to a contemporary "conceptual" painter's, he seemed to feel that since he was the creator and owner of the work's original form and of the initial idea behind its composition, its material realization could be handled elsewhere without any compromise of his artistic ownership. Although today the artist's gestures, original materials, and personal intervention are considered essential, Corot felt that if a painter had copied him and he liked the copy, he had every right to sign it—sometimes after touching it up a little. This attitude, which Corot maintained pretty much throughout his career—and which others of the period shared— makes it utterly impossible to call certain works imitations, copies, or forgeries, since they in fact contain some brushstrokes by Corot and an authentic signature.

IMITATIONS, PASTICHES, AND FAKES

Corot was not satisfied with signing good copies of his works. If he did some retouching on a painting, even if it was not strictly by him or even if it was an actual forgery, he felt that he could authenticate the work by his signature. In many Corot anecdotes the painter is directly confronted with forgeries of his work. Here are two interchanges that probably occurred during the last ten years of his career. "In comes a fellow with several paintings under his arm. 'Good day, M. Corot. Allow me to show you some small canvases of yours that I've just bought.' Corot examines the works in question with a frown: 'How the devil can you think I painted such horrors? And you actually paid money for these?' 'Well, yes, M. Corot. Here's a little painting that cost me five hundred francs.' 'You unfortunate wretch! . . . Well . . . Listen, leave it with me and . . . come back tomorrow.' The next day the master's brush has passed over the object in question and its owner walks off with an authentic Corot." [45] Another story revolves around Corot's legendary kindness: "One morning, someone brought in a small painting signed by him. 'That,' he said, 'is not a Corot!' 'In that case, I'm

45. "Entre un quidam avec plusieurs toiles sous le bras. 'Bonjour, M. Corot: je voudrais vous soumettre quelques petites peintures de vous, que je viens d'acheter?' Corot examine ce qu'on lui présente en faisant la moue: 'Comment, diable, pouvez-vous m'attribuer des infamies pareilles? Et vous avez acheté cela?—Mais oui, M. Corot; voici une petite toile que j'ai payée cinq cent francs.—Malheureux! . . . Enfin . . . laissez-moi cela et . . . revenez demain.' Le lendemain, le pinceau du maître est passé sur l'objet en question et son propriétaire remporte un véritable Corot." Moreau-Nélaton 1924, vol. 2, p. 64.

going to have that forger arrested,' cried the bearer of the painting. 'Arrested? But he has children, a wife. They'll be destitute!' 'So what? He's a forger, and the law says . . .' 'Oh, the law! It would take so little to make it a real Corot. Here!' And taking the small canvas, the master made the counterfeit into a real Corot, whose authenticity the happy owner could now guarantee twice over."[46]

Corot's mischievous temperament must sometimes have led to comical incidents that spawned still more confusion. Moreau-Nélaton tells a story about his grandfather, the collector Adolphe Moreau (1800–1859). "A visit he paid to Corot in 1854 had not led to further relations. Because of an unfortunate misidentification, the collector had brought along, not one of the artist's works, but a Chintreuil that hung on his wall among several Corots and that he had mistaken for one of them. The incident put a bit of a chill between the two men."[47] What Moreau-Nélaton doesn't say is that Corot would have been perfectly capable of signing that painting while knowing full well that it was not one of his.

This example reminds us just how widespread imitations and pastiches of Corots had become after 1850 and how difficult it sometimes was to distinguish his creations from those of his followers. Champfleury had already strenuously protested the quantity of Corot imitators at the Salon of 1846: "And so we are forced to view paintings by these imitators of M. Corot: they see nature with their master's eye. If a branch juts out other than the way M. Corot ordinarily does it, they say, 'That branch is not natural,' and they rectify it. But the visual aspect is the only thing they steal from their master; the moral aspect of the landscape eludes them."[48] After the 1860s, when Corot's style had become particularly distinctive and his misty landscapes had grown still more popular, imitators of his works became increasingly common. Huyghe, describing "the astonishing vogue for mists and fleecy trees" of that period, stresses the utter sincerity of these well-intentioned imitators, who were not trying to mislead the public but for whom Corot was an idol and in many cases also their teacher.[49] They included Dutilleux, Devillers, Oudinot, Édouard Brandon,[50] and Paul-Désiré Trouillebert (1829–1900).

Generally speaking, these imitators were not forgers themselves, and when an added signature turned their works into fake Corots, it was usually in spite of them. In 1883, Trouillebert, one of Corot's most famous imitators, called for a trial after the dealer Georges Petit sold Alexandre Dumas *fils* a landscape of his, *La Fontaine des Gabourets*, which was falsely signed *Corot*. The painting was "disattributed" by Robaut and Bernheim-Jeune, branded a fake, and returned to its first seller, Tedesco. Trouillebert (a former student of Corot), far from trying to pass his work off as Corot's, hauled all the parties involved into court to have his own name definitively reattached to the painting. The trial made all the newspapers and Trouillebert won his case. (The dealers were not indicted, since they clearly had acted in good faith.) But as a journalist of the time pointed out, whatever the judge's decision, the incident drew attention to Corot's paintings and undoubtedly further increased their value.

The existence of so many imitations of the master's landscapes (at the time this situation did not apply to the figure paintings) quite obviously aroused the interest of forgers, particularly since the value of Corots grew steadily in the last two decades of the nineteenth century. One needed only to add a false signature

46. "On lui apporta un matin un petit tableau qui était signé de lui. 'Ça, fit-il, ce n'est pas un Corot!—Eh bien! Je vais le faire arrêter, s'écria le porteur du tableau.—Qui? interrompit Corot, inquiet.—Mais celui qui me l'a vendu, le faussaire.—Arrêter? Mais il a des enfants, il est marié, c'est la misère pour eux!—Qu'importe, c'est un faussaire; la justice . . .—Oh! la justice! Il faut si peu de chose pour que ce soit un vrai Corot. Tenez!' Et, prenant le petit tableau, le maître fit, de la contrefaçon, un Corot dont l'heureux propriétaire pouvait garantir deux fois l'authenticité." Roger-Milès 1891, pp. 68, 70.

47. "Une visite rendue par lui à Corot en 1854 n'avait pas établi entre eux des relations suivies. Par suite d'une méprise fâcheuse, l'amateur avait emporté de chez l'artiste, au lieu d'une de ses toiles, un Chintreuil rencontré sur son mur parmi celles-ci et pris pour l'une d'entre elles. L'aventure avait jeté un certain froid entre les deux personnages." Moreau-Nélaton 1918, vol. 2.

48. "Ainsi faut-il voir les tableaux des imitateurs de M. Corot: ils regardent la nature avec l'oeil de leur maître. Si une branche sort du système ordinaire de M. Corot, ils disent: 'Cette branche n'est pas nature,' et ils la rectifient. Seulement, ils ne volent à leur maître que le côté plastique; le côté moral du paysage leur échappe." Champfleury 1846.

49. "la vogue étonnante des brumes et des arbres floconneux." Huyghe 1936, p. 73.

50. The Louvre owns a painting that can probably be attributed to Brandon, *Bûcherons dans une clairière* (R.F. 3779), which was sold at the Brandon auction on December 14, 1897 (for 410 francs), then given to the Louvre in 1936. Robaut had brought up the possibility that it might be Brandon's "quick copy" ("copie sommaire") of a work by Corot (R 896).

Fig. 171. Style of Corot. *Paysage du soir (Evening Landscape)*. Musée du Louvre, Paris (MNR 170)

to a painting by Oudinot, Félix Morel-Lamy, or Trouillebert to have it attributed to Corot, whose output had been plentiful enough to make anything possible.

ACTUAL FORGERIES

Thus, by the time Alfred Robaut and Étienne Moreau-Nélaton brought out their monumental catalogue raisonné in 1905, the situation regarding the authenticity of Corot's works had considerably deteriorated. What with countless errors of attribution and confusion with the works of friends and imitators, forgers had an easy time of it—especially once speculation became a factor and even Corot's huge body of work was not large enough to satisfy his many collectors, as Moreau-Nélaton noted. It was during this period that Moreau-Nélaton bought *L'Église de Marissel* (R 1370, Musée du Louvre, Paris) at public auction for the considerable sum of 104,000 francs, and that *La Toilette*, a masterpiece from the Salon of 1859 (cat. no. 116), fetched the record price of 169,000 francs. But paradoxically, it was because Corot's output had been abundant and his paintings had generally sold for reasonable prices that forgers were attracted to his oeuvre; the scrutiny of experts is less penetrating when the price of a work is not very high, so sales could be quick and without risk.

The appearance of the catalogue raisonné disturbed the forgers' peace of mind by providing an authoritative reference for settling disputes, at least as far as the authentic works were concerned. But this major work, intended to help do away with dubious pictures, only abetted the efforts of forgers. Filled with information about Corot's paintings, with a detailed chronology of his life and creations and many insights about this artist shrouded in legend, it was studied by forgers for gaps and clues that could help them make their productions credible. Veritable forgery studios in France, Belgium, and even the United States began flooding the art market with fake Corots.

The most "successful" and extensive lot of forged Corots, produced starting around 1910, came about in just that way. It was based on rather thorough

information about the last years of Corot's life, when he had had a studio built for him at the home of his friends the Gratiots in Coubron. In 1929 a collection of several oil paintings and hundreds of drawings, watercolors, engravings, and pastels—more than two thousand works in all—was exhibited in London as Corot's personal collection that had come directly from his studio in Coubron. A sumptuous catalogue accompanied the exhibition,[51] and a public auction followed soon thereafter. "Imagine for a moment a collection of 2,414 Corot paintings, distempers, watercolors, and drawings, all of them utterly, completely, and obviously fake, and each one, with artless regularity, bearing a short handwritten note in which false naïveté, improbabilities, and absurdities abound," wrote an astounded René Huyghe in 1936,[52] unable to believe that so many collectors, dealers, art historians, and museum curators could have been taken in by this hoax, especially when the works in question bore only the most distant resemblance to anything painted or drawn by Corot. It was, in fact, the verisimilitude of the little texts written on each drawing, which echoed the familiar style of the dialogues reported in Moreau-Nélaton's *Histoire de Corot et de ses oeuvres,* that had fooled the professionals.

The provenance of this collection—the entire lot had belonged to a doctor named Jousseaume—had also been invented with great care. Jousseaume, who died a paralytic in 1923, had published several scientific works of high quality and an amusing polemic defending the curators of the Louvre.[53] It was asserted without any evidence that this curious fellow had bought the collection from a M. Panneau, son-in-law of the Dr. Gratiot who had been Corot's host in Coubron. After Dr. Jousseaume's death the lot had allegedly gone to a certain Alfred Pornet from Beaulieu. Huyghe tellingly depicted the personality of this Dr. Jousseaume, who had begun with the principle that "a large-scale Corot that sold for 100,000 francs at a fancy gallery would not fetch 100 francs at a small dealer's,"[54] and that the trick was to buy these paintings as cheaply as possible. In his famous article Huyghe went on to demonstrate how all 2,414 drawings and paintings had been executed by the same hand, with no aesthetic evolution whatsoever despite the supposed chronological range, and that the entire collection was nothing more than a pile of false works and fake inscriptions. Those who defended the authenticity of the collection had honed their arguments, however, pointing out that Robaut had never set foot in Corot's studio in Coubron, which would explain why all these works had not figured in his inventory. And since Gratiot's son-in-law had sold these works to get out of debt, it was natural that his descendants, fearing complaints from Corot's heirs, preferred to keep the matter a secret. Thus, perfectly credible elements went into building the case, which fooled the European museums that bought the works.[55]

The incident demonstrates how much curiosity Corot aroused at the time. What is striking about the Jousseaume case, apart from the clumsiness with which the works were executed, is that the forgers took their inspiration from legends surrounding Corot the man and from the sometimes overly anecdotal testimony provided by the authors of the catalogue. The little "autograph" texts that accompanied the works were designed to match the personality described by Robaut and Moreau-Nélaton: they revealed naïveté, a passion for nature, love of women, a close network of friends, and so on. Similarly, the journeys during which Corot supposedly created these drawings were sometimes real excursions

51. Rienaecker 1929.

52. "Supposez un moment une collection de 2,414 peintures, détrempes, aquarelles et dessins de Corot, tous hautement, intégralement et manifestement faux, revêtus chacun avec une régularité ingénue, d'une petite note manuscrite, où se le disputent la pseudo-naïveté, les invraisemblances et les calembredaines." Huyghe 1936, p. 73.

53. Jousseaume 1899, Jousseaume 1910, Jousseaume 1911.

54. "Corot de belle envergure vendu 100,000 francs dans un luxueux magasin ne sera pas vendu 100 francs par un petit marchand." Dr. Jousseaume, quoted in Huyghe 1936, p. 74.

55. Numerous museums own forgeries that come from the Jousseaume collection, such as The British Museum, London (*Vue de Palerme,* allegedly done in 1834, whereas Corot never went to Sicily), and the Fitzwilliam Museum, Cambridge (*Civita Castellana,* also dated 1834).

described in the catalogue raisonné, sometimes concocted trips to places near the sites Corot had actually visited which therefore seemed credible.

The Jousseaume case was not unique; although not of such great proportions, other groups of forgeries appeared in the twentieth century. In one case a scholar named Édouard Gaillot took on Huyghe in several polemical newspaper articles. He claimed to have uncovered several dozen unknown works by Corot, in reality all forgeries, which came from a "secret closet" where Corot had supposedly stashed works that he did not want included in Robaut's inventory. In the end it seems that Gaillot was a harmless crackpot who saw secret Corot signatures everywhere. More serious episodes of the same period had to do with the fact that landscapes shrouded in silvery mist were falling out of fashion. The number of forgeries based on Corot's figure paintings thus began to rise. Forgers, knowing that collectors coveted his figures of fantasy, often sought to mislead potential buyers with marginal works such as studio nudes. Thus *Le Modèle, étude de nu*, owned by the National Gallery of Victoria in Melbourne, looks very much like a life study that Corot might have painted (albeit clumsily) during his years of training, between 1822 and 1830. The work, acquired about 1919 or 1920,[56] was obviously not listed by Robaut, any more than was the male nude *Étude de modèle nu couché* that is housed at the Musée Départemental de l'Oise in Beauvais and that appears to have been painted by the same hand. Neither work carries an apocryphal signature.

Since that time the value of Corot's work—perhaps because of all these uncertainties—has not risen rapidly, and apart from a few spectacular upsurges it has fetched prices much lower than those commanded by the Impressionist artists or modernist painters of the early twentieth century. The production of forgeries slowed considerably after World War II, but by that time there were enough of them to feed the market for many years.

This has been a short study of a difficult question. In essence, there are two leading reasons for the abundance of false Corots: the confusion fostered by Corot himself, who signed copies of his works and retouched forgeries and pastiches made from his paintings; and the phenomenal popularity of his misty landscapes from the 1860s, which perfectly matched the tastes of the provincial middle class of the late nineteenth century, buyers who could not easily tell the difference between an authentic Corot and the work of an imitator. Thus, although many other painters of the period worked with students as Corot did, retouched copies of their works, and painted in groups, for no other painter was there a conjunction of the two factors that left Corot's works vulnerable to an unprecedented wave of forgeries.

Today, although Robaut and Moreau-Nélaton's catalogue raisonné and various supplements published by the Dieterle family have provided us with an objective reference point and a list of paintings that we can consider authentic (or 95 percent authentic, since there are a few imprecisions and errors), false Corots from numerous private and public collections continue to circulate. The need is urgent for a comparative study of these dubious works that will make use of scientific methods, even though their scope is still rather limited, and will produce a systematic analysis of the forgeries. It is perhaps not necessary to publish a catalogue of false Corots (although Robaut's catalogue of false and dubious works is indispensable), but collectors and professionals require some

56. Hoff 1973.

reference points and technical guides that would make the problem more manageable: systematic studies of Corot's imitators, the publication of copies of his works, in-depth analyses of the pigments he used versus those of his imitators, and so on. A careful analysis of certain particularly significant forgeries housed in public collections, such as *Vue de l'église Saint-Salvi d'Albi*[57] or *Porte dans la cour ovale au château de Fontainebleau,*[58] would surely add much information and would enrich our knowledge of Corot's work in general. In any case, the question of forgeries remains one of the most fascinating aspects of Corot scholarship, astonishing in its range and variety. Finally, isn't it curious that of all the nineteenth-century painters, Corot is the one whose *authentic* pictures most often carry false signatures[59]—as if even in the most secure portion of his oeuvre, one last doubt remains?

57. The Art Institute of Chicago. Cited by Robaut: "This figure of a man (leaning against the door), his hat on his head and wearing a frock coat, would be proof enough—even if there weren't others— that this isn't a Corot: it's totally lacking in naïveté. It's shallow and glairy from top to bottom. On top of which, the straight lines look too straight, as if they were done with a ruler." ("Cette figure [contre la porte] d'un monsieur, son chapeau sur la tête et en redingote serait la preuve—à défaut de toutes les autres—que ce n'est pas de Corot: ça manque complètement de naïveté. C'est creux et glaireux d'un bout à l'autre. Ajoutez à cela une trop grande inflexibilité de toutes les lignes droites comme à la règle.") Robaut "Corot. Tableaux faux," fol. 5.
58. Philadelphia Museum of Art.
59. A few famous examples: *Étude du Colisée à Rome; Rome. Le Forum vu des jardins Farnèse; La Cathédrale de Chartres; Honfleur. Calvaire de la côte de Grâce* (cat. nos. 8, 9, 37, 45).

Corot and His Collectors

MICHAEL PANTAZZI

"On entering the hall where we had a 'Corot' hanging facing the door, he remarked, 'There's my dream. I dreamt last night I painted a Corot.'"[1]

In 1839, the year Corot sold his first two important paintings, Jules Janin predicted that his chances of success were less than good: "A strict and conscientious talent, who will never gain popularity. He deserves our utmost praise and respect."[2] Seven years later, Paul Mantz returned to the subject with equal pessimism, writing, "And so, the times being what they are, M. Corot is the perfect example of the artist who cannot sell his work. It is obvious that paintings of this kind will never win public favor."[3] Indeed, as late as 1857—when it no longer applied—Gustave Planche wrote with exasperation, "M. Corot has nothing to complain about. He has won the respect and sympathy of his fellow artists. He is not popular, nor should he be."[4] This had long been the view of Corot's family as well. Few could have predicted that his work would be avidly sought later in his lifetime and after.

From about 1850 there were signs of interest in Corot's painting. In 1852 Champfleury remarked: "Corot's name is popular these days—an occurrence made all the stranger by the fact that he is the *only great* French landscape artist. His painting does not buttonhole the public, it doesn't bang the big bass drum for bourgeois ears. And yet Corot's name is popular these days. . . . Without fuss or fanfare, a Corot landscape can be hung in a room and stared at *forever*. How many paintings today can be looked at for a month running without boring their owners?"[5] By 1854, Frédéric Henriet's survey of dealers on the rue Laffitte confirmed Champfleury's opinion. He wrote:

> Among the most pleasant surprises awaiting the stroller on the rue Laffitte is the unexpected encounter with one of those precious canvases by Corot—humid, misty, pale, still trembling with the chill morning air. It's a gentle, restful feeling: in that kind of dreamy contemplation, you forget all about Paris, the jostling crowd, the asphalt burning your feet, the deafening noise of carriages. Anyone who doesn't frequent the area around rue Laffitte now and again does not know Corot. In the so-called annual exhibits one sees only the ingenious stylist, the Corot of Posilipo or Tivoli. But it is on rue Laffitte that one can sample the intimate, familiar side of his talent, one can learn to love the good, simple Corot of Ville-d'Avray, Bougival, and Bas-Meudon.[6]

The turning point in Corot's fortunes seems to have been in the early 1850s, when, energized by a new sense of confidence and his fellowship with Charles Daubigny and Auguste Ravier, he took a more active part in showing his work to dealers and in the provinces. A letter of 1852 from Daubigny to

1. George Russell ("A. E."), the Irish writer, poet, and painter, cited in Lily McCormack, *I Hear You Calling Me: The Life of Count John McCormack* (London: W. H. Allen, n.d. [1949]), and quoted in Levey 1990, p. 30.

2. "Talent sévère, plein de conscience, qui ne sera jamais populaire, il mérite toute notre estime, tous nos éloges." Janin 1839, p. 271.

3. "Aussi M. Corot est-il, par le temps qui court, l'expression la plus entière de l'artiste qui ne vend pas ses tableaux. . . . Il est évident que des tableaux de ce genre ne seront jamais acceptés du public." Mantz 1846, p. 72.

4. "M. Corot n'a pas le droit de se plaindre. Il possède l'estime et la sympathie des hommes du métier; il n'est pas populaire et ne devait pas l'être." Planche 1857, p. 399.

5. "Le nom de Corot est populaire aujourd'hui, chose d'autant plus bizarre, que Corot est le *seul grand* paysagiste français. Sa peinture ne fait pas *psttt, psttt* au public, elle ne joue pas de la grosse caisse pour l'oreille du bourgeois. Et cependant le nom de Corot est populaire aujourd'hui. . . . Sans tapage, sans fracas, un paysage de Corot peut être accroché dans une chambre et regardé *toujours*. Combien de tableaux aujourd'hui peuvent être regardés un mois de suite, sans ennuyer le propriétaire?" Champfleury 1894, pp. 158–62.

6. "Une des plus agréables surprises qui attendent le flâneur, dans la rue Laffitte, c'est la rencontre imprévue d'une de ces précieuses toiles de Corot, humides, embrumées, blanchâtres, toutes frissonnantes encore de l'air vif du matin. C'est une douce émotion qui repose; on oublie, dans cette songeuse contemplation, Paris, et la foule qui vous heurte, et l'asphalte qui vous brûle les pieds, et les voitures qui vous assourdissent. Qui ne fréquente un peu les parages de la rue Laffitte ne connaît pas Corot. Aux expositions dites annuelles, on ne voit que le styliste ingénieux, le Corot de Pausilippe ou de Tivoli. Mais c'est rue Laffitte seulement que l'on peut goûter le côté intime, familier de son talent, et que l'on apprend à aimer le naïf et bon Corot de Ville-d'Avray, de Bougival et du Bas-Meudon." Henriet 1854, p. 115.

Ravier concerns works to be sent to Lyons and the pricing of Corot's pictures at 600 to 800 francs.[7] A further letter of March 8, 1853, informed Ravier that "Father Corot . . . is all the rage, and what will surprise you is that he can't handle all the commissions he gets."[8] Corot himself took longer to recognize that things were going well; but on January 10, 1856, he wrote to Édouard Brandon, "I'm working like a little devil. The collectors are starting to flock in. . . ."[9]

Corot's prices were low: his works were always less expensive than those of his contemporaries and seldom provoked headlines when sold at auction. He insisted on proper prices for Salon paintings but was otherwise of extreme modesty. A document dated April 3, 1864, at the height of his career, shows he offered paintings for rent at prices between 9 and 24 francs, the higher sum being asked for *Florence. Vue prise des jardins Boboli* (cat. no. 55).[10] That awareness of his low prices was widespread can be inferred from an anecdote published in 1860 about an unnamed *homme de goût* who sought five paintings for his mansion and received advice from the painter Narcisse-Virgile Diaz de la Peña, who recommended acquiring works by Delacroix, Rousseau, Millet, Corot, and Diaz himself:

> "Isn't all this going to run rather high?"
> "No, not too high. Corot is a child of genius who practically gives his paintings away. For five hundred francs, you'll have an admirable Corot."
> "And what about the others?"
> "Oh, the others are a bit more expensive, but not much."
> "All right, I'll think about it. Your idea appeals to me."
> Several days later Diaz met the man of taste. . . . They went into the living room, and Diaz could just make out five Corot landscapes spread across the five panels.
> "I know, I know. I would have preferred paintings by five different artists; there would have been more variety. But for 2,500 francs, I got my five Corots. I would have had to spend at least that much for one by each of the other four painters."
> "Oh, I see," Diaz answered, laughing. "What you really like about the charming and poetic Corot isn't his value, it's his price."[11]

Corot's later popularity was built largely on his reputation as an ideal interpreter of nature—a modern painter paradoxically untainted by the stigma of modernity. It can be argued that to a wide public in France, his later painting came to personify the French landscape itself. In fact, as early as 1863 Hector de Callias could write, "You will see a Corot every time you awake in a sleeping car on a French railway line at the moment when dawn begins to break, banishing the stars and the night's dreams to make way for the sun and the dreams of daytime."[12] Perhaps alone in the annals of art, Corot's name became synonymous with states of nature in all its variety: in Boston a "Corot day" was a misty day, while the bluest of skies at La Queue-en-Brie would prompt the Rouarts to say, "What a Corot—the Italian one, of course!"[13]

Corot's vast oeuvre, his diversity, and the extraordinary performances he was capable of were among the keys to his success with collectors. The variety of his work allowed him to mean different things to different people and appeal to viewers of temperaments as unlike as Edgar Degas and Alfred Chauchard. Moreover, his paintings are distinguished from the work of almost any other artist in that they were collected in numbers without parallel. There is hardly an instance where so many admirers of an artist's work enjoyed it only in large

7. Quoted in Miquel 1975, vol. 3, p. 569.

8. "le père Corot . . . est en grande vogue, et ce qui vous surprendra, c'est qu'il ne peut suffire aux nombreuses commandes qui lui sont faites." Ibid.

9. "Je travaille comme un petit coquin. Les amateurs commencent à affluer." Robaut 1905, vol. 1, p. 165, and vol. 4, p. 336, no. 76.

10. Reproduced in Miquel 1987, p. 340. Another document of the same type is quoted in "Corot Forgeries," pp. 389–90 and notes 41, 42.

11. "Mais tout cela va me coûter bien cher?—Non, pas trop, Corot est un enfant de génie qui donne ses tableaux. Pour cinq cents francs, vous aurez un admirable Corot.
 —Et les autres?—Oh, les autres sont plus chers, mais pas beaucoup.
 —Eh bien, j'y songerai. Votre idée me sourit. À quelques jours de là, Diaz rencontra l'homme de goût. . . . Ils entrent dans le salon et Diaz voit pas tout à fait cinq paysages de Corot se prélassant sur les cinq panneaux.
 —Je sais bien. J'aurais mieux aimé cinq tableaux d'artistes différents. Cela eût été plus varié; mais pour deux mille cinq cents francs, j'ai eu mes cinq Corot. Il m'aurait fallu mettre au moins la même somme pour chacun des quatre autres peintres.
 —Oui, je vois, répondit Diaz en riant. Ce qui vous a séduit dans ce charmant et poétique Corot, ce n'est pas sa valeur. . . . C'est son prix." Quoted in Miquel 1987, pp. 259–60.

12. "Vous verrez des Corot toutes les fois que vous vous réveillerez en wagon sur une ligne française, au moment où l'aurore qui approche, chasse les étoiles et les rêves de la nuit, pour préparer la place au soleil et aux rêves du jour." Callias 1863, p. 213.

13. "Quel Corot, mais d'Italie, bien sûr!" Agathe Valéry-Rouart in Sète 1995, p. 12. Saarinen 1958, p. 35.

quantities. If the anecdote told by Diaz suggests that cost alone accounted for this singular phenomenon, that conclusion is undoubtedly wrong. The reason is far more likely to be found in the elusive regions where admiration, desire, and availability meet.

Étienne Moreau-Nélaton, a supreme collector and a victim himself of the tyranny of quantity, described vividly Corot's last years, when the artist carried out "his chores, rushing to satisfy the numerous clients who were hounding him: Brame, Tedesco, Beugniet, Durand-Ruel, Breysse, Weyl, and Audry, not to mention Cléophas and his nephew Bardon, Surville, Oscar Simon, Hermann, the dentist Verdier, and the doctor Cambay."[14] Many of the names stand for dealers, but Dr. Cambay, an admirer rather than a collector, owned eleven works by Corot; Dr. Verdier had at least thirty-nine; the restorer André-Julien Prévost, who assisted Corot, accumulated some one hundred, mostly small works.[15] Alfred Robaut, admittedly an exceptional case as keeper of the flame, owned at one time or another over 215 paintings. Among well-known French collectors, Paul Tesse owned fourteen paintings; John Saulnier, twenty-seven; Henri Hecht, twenty-three; Jules Paton, twenty-six; Jean Dollfus, twenty; Armand Doria, seventy-six; Henri Rouart, at least fifty-six; Henri Vever, twenty-one. In almost every collection (Vever's is the exception), a disproportion between the number of paintings by Corot and those by other artists is evident.

The first known collector of Corot's work was the duc d'Orléans, who at the time of the Salon of 1839 purchased two paintings for 1,000 francs each.[16] The duke, who had been tutored by the artist Ary Scheffer, collected modern paintings by artists such as Delacroix, Paul Delaroche, Alexandre Decamps, and Théodore Caruelle d'Aligny (the last two were friends of Corot's). As Moreau-Nélaton observed, the duke's example did not increase Corot's success with private collectors, but it may have influenced the state's decision to purchase from the Salon of 1840 *Le Petit Berger* (cat. no. 76), for the Musée de Metz, and in 1842, *Site d'Italie* (R 442), for the Musée Calvet in Avignon. No further government interest came Corot's way until 1844, when, with considerable determination, he obtained from the city of Paris the commission for *Le Baptême du Christ* (cat. no. 89) for the church of Saint-Nicolas-du-Chardonnet. From the 1845 Salon the Ministry of the Interior bought *Homère et les bergers* (cat. no. 90) for the Musée des Beaux-Arts in Saint-Lô. In 1847 there was a commission for a tapestry cartoon, *Le Chevrier italien* (cat. no. 92), followed by a series of annual state acquisitions from the Salon: in 1848, *Le Bain du berger* (R 609) for the Musée de Douai; in 1850, *Christ au jardin des oliviers* (R 610), sent to the Musée de Langres; and from the Salon of 1850–51, *Une Matinée* (cat. no. 103), eventually bought for the Luxembourg Museum.

State acquisitions were not resumed until 1855, when Napoleon III bought *Le Chariot (Souvenir de Marcoussis)* (R 1101) from the Salon (although strictly speaking this was a private purchase); on his order as well, *Souvenir de Mortefontaine* (cat. no. 126) was purchased by the state from the Salon of 1864. In 1866 Napoleon III made a last personal acquisition when he bought *La Solitude* (fig. 109) for Empress Eugénie. In the intervening years, Corot had placed a few important works in provincial museums: in 1856 the Musée de Marseilles[17] bought a *Souvenir de Riva*, now called *Soleil couchant, site du Tyrol italien* (cat. no. 94); in 1858 the Musée de Bordeaux[18] purchased *La Compagnie de Diane* (cat. no. 105), and in 1864 the Musée des Augustins, Toulouse, acquired *L'Étoile du berger* (cat. no. 125).

Fig. 172. H. Humbricht. *Jean Dollfus*, from the frontispiece in the catalogue of the first Dollfus auction. Published in Distel 1990, p. 150

14. "sa besogne courante, pour satisfaire la nombreuse clientèle qui le harcelait: les Brame, les Tedesco, les Beugniet, les Durand-Ruel, les Breysse, les Weyl, les Audry, sans compter Cléophas et son neveu Bardon, Surville, Oscar Simon, Hermann, le dentiste Verdier et le médecin Cambay." Robaut 1905, vol. 1, pp. 281–82.
15. On Prévost, see "Corot Forgeries" in this volume.
16. See the entry for *Un Soir*, cat. no. 75.
17. Now the Musée des Beaux-Arts, Marseilles.
18. Now the Musée des Beaux-Arts, Bordeaux.

Fig. 173. *Paul Durand-Ruel*, ca. 1910. Photograph, Durand-Ruel, Paris, published in Distel 1990, p. 28

The sales to provincial museums were due to Corot's own efforts, and the one in Marseilles in 1856 was accomplished only after Corot lowered the asking price.[19] He had exhibited sporadically in Paris in the 1840s, but in 1853 he began sending works to provincial *sociétés artistiques,* to Bordeaux and Marseilles and later Toulouse, Rouen, Strasbourg, and elsewhere. He generally sent a Salon piece and a smaller work. Moreau-Nélaton has shown that almost always, the more important works, such as *Agar dans le désert, L'Incendie de Sodome, La Toilette,* and *Vue dans la fôret de Fontainebleau* (cat. nos. 61, 114, 116, 34) failed to sell. The *Vue du port de La Rochelle* (cat. no. 96) was sent to Bordeaux, Rouen, Saintes, Toulouse, and Amiens; when in 1868 it was offered to the Société des Amis des Arts in Arras for 1,200 francs, it was overwhelmingly refused by the committee.[20]

Outside Corot's circle of friends, particularly those in Arras, the names of only a handful of collectors are known, even into the early 1850s. Fleury in Versailles was a family friend. A certain de Férol in Bordeaux is otherwise unknown. Diaz bought a picture at the Salon of 1847. (Many years later Paul Mantz remembered that purchase of a painting that had moved him deeply in his youth.)[21] In 1852, Adolphe Moreau, Moreau-Nélaton's father, bought a painting (R 808). In the 1860s one finds Corot named in the collections of Khalil Bey, the Ottoman ambassador, owner of one work; the marquis and the comte de Lambertye; a Bourbon of Naples, Count d'Aquila; Prince Paul Demidoff, who kept for only a few years two works he had commissioned in 1865; the marquis du Lau, Demidoff's neighbor; the singer Antoine Marmontel; and other friends of Corot, the painters Jules Étex and Decamps. Records for sales do not begin before 1853 and until the 1860s are of interest only by virtue of their scarcity.

It is with Corot's first auction sale, the sale of thirty-eight works organized by the dealer Boussaton on April 14, 1858, that we first gain a sense of the dealers and collectors around him. The sale included five Salon paintings and a variety of smaller landscapes made during his travels. Two of the large pieces remained

19. See correspondence cited in Robaut 1905, vol. 4, p. 174, nn. 1, 2, and p. 175, n. 1.
20. According to Robaut: "I bought it in that last town, where the acquisition proposed—for 1,200 francs—by some of the friends [of the arts] was shamefully rejected, nine members to three." ("Je l'achète dans cette d[erniè]re ville où l'acquisition proposée par des amis fut repoussée honteusement—à 1200 francs—par neuf membres contre trois.") Robaut *carton* 14, fol. 191.
21. Mantz 1861, p. 426. The painting was *Pêcheurs tendant leurs filets, le soir,* R 504 (fig. 96a).

unsold, but Corot discovered with delight that the sale had produced 14,233 francs.[22] An inscribed copy of the catalogue gives the names of the buyers, friends such as Adalbert Cuvelier, Léon Berthoud, and the sculptor Adolphe-Victor Geoffroy-Dechaume; Corot's nephew Joseph Chamouillet; the dealers Beugniet, Détrimont, and Martin; and a series of unidentifiable persons, Bochet, Cile, Doryel, Bouzemont, Bouchaud, Cachardy, and others. A few of the remaining buyers can be identified: Paul Tesse and Barhoilet, collectors of Corot's work, and Claudon, who still owned his Corot (R 1113) in 1875. "A. Moreau," buyer of a view of Geneva, was likely Adolphe Moreau. The average price for smaller works was about 300 francs, which explains both why they sold with relative ease and how they could pass from hand to hand almost unnoticed.

From the moment Arras became a place of regular pilgrimage in 1852, Corot had a small group of admirers who purchased his works. Constant Dutilleux and his son-in-law Charles Desavary, close friends, were a special case, but there were also the Legentils, Dr. Camus, and Cuvelier, part of an expanding provincial clientele who were usually members of the professional classes.[23] Among the collectors—often friends of friends—who bought or commissioned works were Hébert in Essomes, Jules Lacroix in the Limousin, Stanislas Baron in Mont-de-Marsan, Étienne Baudry in Saintonge, Bellon in Rouen and Saint-Nicolas-les-Arras, Gabriel Admyrault in La Rochelle, and Dr. Gratiot in Coubron during Corot's last years.[24] In 1863 several Corot paintings belonging to owners in the Bordeaux region were lent to a local exhibition, and it was Bordeaux that later produced one of Corot's most obsessive admirers, John Saulnier, an industrialist. He purchased twenty paintings, mainly landscapes; five of them are in this exhibition.[25] On a lesser scale, the Roederer collection in Le Havre, partly dispersed in 1891, and the David and Warnier collections in Reims, the latter including a large group of works donated to the Musée des Beaux-Arts of Reims, are again representative of the interest in Corot evinced by collectors outside Paris, which continued well after the artist's death.[26]

In Paris a discernible shift in taste regarding Corot began in the late 1860s and early 1870s, partly determined by what the younger generation of artists admired in him. The emerging taste largely excluded his monochrome, abstracted works in favor of his more vigorous manner, early or late. This preference was shared by Paul Durand-Ruel, who tutored a generation of collectors. He saw modern French painting as a continuum extending from Corot to Monet. One collection he helped assemble belonged to Ernest Hoschedé; it was dispersed soon afterward, in 1875.[27] The Hoschedé sale included seventeen works by Corot, among them *Nemi. Les Bords du lac* (cat. no. 93) and three landscapes subsequently bought by Jean-Baptiste Faure. Faure owned some twenty-four paintings by Corot, chiefly mature and late works, such as the splendid *Pont de Mantes* (R 1516) and *Souvenir de Ville-d'Avray* (cat. no. 149). The list of collectors indebted to Durand-Ruel inevitably includes all the names associated with the early collectors of Impressionist painting: Léon Clapisson, owner of eight works by Corot, among them *Environs de Beauvais* (cat. no. 98); the Hecht brothers, Albert and particularly Henri, a collector of Impressionist paintings, who owned some twenty-three Corots; Gustave Arosa, who bought pictures at the Hoschedé sale, eventually owning nine works, including *La Lettre* (cat. no. 133); and the Camondos, father and son, who retained only two figure paintings by Corot, an *Atelier*

22. Robaut 1905, vol. 1, p. 186.
23. See Moreau-Nélaton in ibid., pp. 134–35, 144–45.
24. Of these, Admyrault donated works to the Musée des Beaux-Arts, La Rochelle. On Dr. Gratiot, see "Corot Forgeries" in this volume.
25. For Saulnier, see the Saulnier sales, Hôtel Drouot, Paris, June 5, 1886, and Galerie Sedelmeyer, Paris, March 25, 1892.
26. The Warnier collection included R 532, 1372–1374, 1446, 1522, 1676, 1677, 1906, 1918, 1988, 2008, 2305.
27. For Hoschedé, see Distel 1989, pp. 95–107, and the Hoschedé sales, Hôtel Drouot, Paris, January 13, 1874, and April 20, 1875.

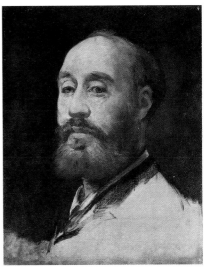

Fig. 174. Édouard Manet (1832–1883). *Head of Jean-Baptiste Faure*. Oil on canvas, 18⅛ × 14⅞ in. (46 × 37.8 cm). Gift of Mrs. Ralph J. Hines, 1959, The Metropolitan Museum of Art, New York (59.129)

(cat. no. 137) and *Fillette à sa toilette* (R 1346), also previously owned by Hoschedé and eventually bequeathed by Isaac de Camondo to the Louvre.[28]

The dispersal of Corot's studio in 1875, which after the 1858 sale was the only other auction sale devoted exclusively to his work, made visible the aesthetic gap dividing the dealers who had surrounded the aging artist and the new collectors of his work. The almost five hundred paintings in the sale were mostly early works, studies, and figures, rather than Salon pictures. Only one museum expressed interest, the Musée de Dunkerque, which bought a small sketch of Dunkirk (cat. no. 113). The group that only a few months earlier had besieged Corot for pictures was now conspicuously reticent: Cléophas, Audry, Weyl, Dr. Cambay, and Prévost bought nothing; Dr. Verdier, Bardon, Tempelaere, and Surville bid for one work each; Tedesco bought two. Among the dealers it was Durand-Ruel, Charles Deschamps, Diot, Brame, Fèbvre, and Détrimont who made the largest purchases. The collectors, however, represented the most interesting group. For Jean Dollfus the sale was a revelation: he bought twelve works, including *La Femme à la perle* (cat. no. 107) and *L'Algérienne* (cat. no. 143). The great *Agar dans le désert* (cat. no. 61) was bought under a *nom de vente* by Prince Nicolas Soutzo;[29] Georges de Bellio, a champion of Impressionism, bought four works. The marquis Arthur Doria, who was soon to buy *Agar*, purchased only one work, but his brother, the comte Armand Doria, bought twenty-two studies. Henri Hecht acquired five works. Arsène Houssaye, the critic, bought fourteen studies, and with him was a contingent of painters: Auguste Ravier acquired four works, Charles Daubigny nine, and his son Karl three more; Henri Fantin-Latour, never enthusiastic about the later Corot, bought six.

When he formed his collection of twenty-three paintings by Corot, Jules Paton scrupulously avoided typical late works and favored instead early sketches and figures, such as the *Jeune Femme* (cat. no. 73), and, interestingly, two versions of the *Atelier de Corot* (R 1558, R 1560; cat. nos. 136, 139).[30] At Paton's sale in 1883, Victor Desfossés purchased *La Femme à la grande toque et à la mandoline* (R 1060, private collection), the centerpiece of a group of seven pictures by Corot.[31] Armand Doria, who had been interested in Corot for a long time, accumulated a large number of paintings.[32] His taste was quite specific, with a preference for the artist's most direct impressions; yet he saw Corot's oeuvre very much as a whole and admired both his early and late work. A collection as significant as Doria's, but not as large, was formed by Henri Rouart, one of Degas's best friends. While the strongest part of Rouart's collection was a group of studies made in Italy, he also owned late works, none greater than *La Dame en bleu* (cat. no. 162), which must have made an extraordinary contrast to another painting he owned, Renoir's *Femme en bleu*.[33]

Jean Dollfus gathered a varied group of twenty-four Corots around the large *Silène* (cat. no. 64) of 1838, a courageous purchase. These works were kept together until 1912. Comparable, if smaller, were the collections formed by Paul-Arthur Chéramy; his friend Alexandre Dumas fils, owner of *La Lecture interrompue* (cat. no. 144); the publisher Paul Gallimard; and not least Ernest May, who, after collecting Impressionist paintings in the 1870s, discovered Corot almost as an afterthought.[34] Eventually these collections were dispersed and many pictures drifted abroad; but to an extent, that dispersal was counteracted by the collection of a

28. For Clapisson (who also exchanged paintings), see the Clapisson sales, Paris, March 14, 1885, and anonymous sale, Paris, April 28, 1894. For Hecht, see Distel 1989, pp. 71–73. For Arosa, see the Arosa sale, Paris, February 25, 1878.

29. Sometimes confused with his cousin Grégoire Soutzo, also a collector and Degas's friend. For the purchase of *Agar*, see Daliphard 1875, p. 159.

30. For Paton, see the Paton sale, Hôtel Drouot, Paris, April 24, 1883.

31. For Desfossés, see the Desfossés sale, Paris, April 26, 1899.

32. For Doria, see Distel 1989, pp. 171–73, and the Doria sale, Galerie Georges Petit, Paris, May 4–5 and 8–9, 1899.

33. For Henri Rouart, see Distel 1989, pp. 177–88, and the Rouart sale, Galerie Manzi-Joyant, Paris, December 9–11, 1912.

34. For Dollfus and May, see Distel 1989, pp. 151–55, 223–29; the Dollfus sale, Galerie Georges Petit, Paris, March 2, 1912; and the May sale, Galerie Georges Petit, Paris, June 4, 1890. For Chéramy, see the Chéramy sale, Galerie Georges Petit, Paris, May 5–7, 1908.

substantial, if conservative, group of landscapes by the industrialist George Thomy Thiéry (1823–1902), with advice from the dealer Mallet. Thomy Thiéry reputedly began collecting about 1880. He never lent to Corot exhibitions, but he amply made up for it in 1902, when he willed his collection, including twelve works by Corot, to the Louvre.[35]

Corot had a strong following in Belgium, largely owing to the dealers Paul Durand-Ruel and Alexandre Bernheim and the dealer-collector Arthur Stevens. In Brussels works could be found in the Wolff collection, sold in 1877, and the Lyon de Thuyn collection, but the largest group was formed by the painter Alfred de Knyff, who owned at least eight paintings, including *La Rive verte* (cat. no. 122). Senator Prosper Crabbe lent two of his seven paintings to the Exposition Centennale of 1889, and three pictures owned by Émile Dekens figured in Corot's centenary exhibition of 1895 in Paris, along with landscapes from the Cardon and Léon de Mot collections, since dispersed.

Elsewhere in Europe, the fifteen works assembled in the Netherlands by the painter Hendrik Mesdag fortunately have been preserved in the Mesdag Museum, The Hague. The Behrens collection in Hamburg included five paintings by Corot, and farther east, Serge Tretiakov in 1892 bequeathed ten works to the museum of Russian art his brother opened two years later in Moscow.[36] Earlier, the writer Ivan Turgenev had formed in Paris an interesting collection of French landscapes that included a Corot *Matin,* sold in Paris in 1878.[37]

In 1862 the comte Doria lent a landscape to the London International Exhibition of that year. Corot himself exhibited only once at the Royal Academy, in 1869. After 1871, however, Durand-Ruel imported numerous works by Corot for his London gallery, where in 1872 alone thirty-two Corots were exhibited, a number slightly diminished in 1873 and 1874. Durand-Ruel's rival Daniel Cottier promoted Corot's work on both sides of the Atlantic, and the Anglo-Belgian dealer Prosper Everard also organized auction sales of stock. In 1896, thirty-three Corots were shown in London in the exhibition of French art held at the Grafton Galleries; a critic noted at the time that he had seen an abundance of Barbizon pictures offered on the market and had counted as many as sixty-seven paintings by Corot for sale.[38]

The earliest English collectors in the 1870s were James Staats Forbes and William Thorburn, both of whom had lived in France. They were later joined by Constantine Ionides, Humphrey Roberts, Charles Roberts, Alexander Young, and Hamilton Bruce. Louis Huth and Henry Hill, early collectors of Impressionist paintings, owned works by Corot, as did Samuel Barlow, whose *Saint Sébastien* (cat. no. 104) was sold in 1883 to William Walters. Both Forbes and Young collected on a sufficiently large scale to rival their counterparts in France: Forbes sold six paintings by Corot in 1881 but still owned some forty works at the time of his death.[39] Young, whose eye was not as sharp, accumulated an equally large number of paintings but purchased a few doubtful works. The catalogue for the sale of his collection in 1910 listed forty-one works by Corot.[40] In Scotland, following the purchase of *Pastorale* (cat. no. 150) by James Forbes White in the mid-1870s, enthusiasm for Corot grew even stronger. In 1886, twenty works by Corot were lent to the Edinburgh International Exhibition, and in 1888, fourteen more were shown at the Glasgow Exhibition. The collectors Archibald Coats,

35. For the Thomy Thiéry collection, see Lafenestre 1902 and Guiffrey 1903.
36. See Moscow, Pushkin Museum 1961, p. 99, and Saint Petersburg, The Hermitage 1976, p. 266.
37. See the Turgenev sale, Paris, April 20, 1878. See also Marsh 1983, pp. 107–17.
38. Cited in Miquel 1987, p. 360.
39. See the Forbes sales, Christie's, London, April 22, 1882, June 2, 1916, June 14, 1918, and December 8, 1919; Fleischmann, Munich, March 28, 1905, and March 20, 1906; Puttick & Simpson, London, October 17, 1917.
40. See the Young sale, Christie's, London, June 30–July 4, 1910.

41. See Fink 1978, pp. 87–100, and Alexandra R. Murphy, "French Paintings in Boston: 1800–1900," in Atlanta, Denver 1979–80, pp. xvii–xlvi.
42. See Durand-Gréville 1887, pp. 65–75, 250–55.
43. See the entry for cat. no. 125 and Johnston 1982, pp. 59–62.

William A. Coats, and Andrew Maxwell owned important works which they lent to the Corot retrospective of 1895 in Paris.

The first painting by Corot known to have been shown in North America was exhibited in 1860 at the Goupil Gallery in New York, then managed by Michel Knoedler. Six years later an exhibition brought by Cadart from Paris and first shown in New York contained eleven paintings by Corot, including a work that may have been *La Toilette* (cat. no. 116). Part of the exhibition was sent to Philadelphia and then to Boston, where four of the five Corots were bought by Boston collectors—among whom were two painters, Albion Bicknell and Thomas Robinson.[41] Boston collectors of about 1868 included G. W. Long and George Snell, and that year the DeVries Art Gallery, a Boston dealer, offered for sale *Étude à Méry, près La Ferté-sous-Jouarre* (R 1286), Corot's painting from the Salon of 1863. Partly owing to the influence of William Morris Hunt, more substantial groups of Corot pictures showed up in Boston in the next decade in the collections of Thomas Wigglesworth, Dr. G. A. Bethune, T. G. Appleton, and Quincy Adams Shaw. Shaw was better known for his collection of Millets, but he owned several Corot landscapes and the *Dante et Virgile* (cat. no. 115), which he gave to Boston's Museum of Fine Arts. Mrs. Samuel D. Warren purchased a group of works that included *Vue prise dans la forêt de Fontainebleau* (cat. no. 91), still in Boston, and *Orphée* (cat. no. 120).

Pictures by Corot could also be found in Philadelphia in the early 1870s in the collections of J. G. Fell, W. H. Dougherty, James L. Claghorn, Joseph A. Clay, Henry E. Gibson, John D. Lankenau, W. P. Wilstach, and many others.[42] Baltimore had been introduced to Corot earlier through the dealer George Lucas, who knew Corot well (Corot called him "l'Haméricain"), and William Walters, who in 1864 commissioned the repetition of *L'Étoile du berger* (cat. no. 125) and later purchased other works.[43] In Providence there were paintings by Corot in the Brown, Richmond, and Wall collections, and farther afield in Saint Louis and

Fig. 175. Gallery room added in 1885 to the Saint Paul home of collector James J. Hill, photographed ca. 1922. The large painting on the right is Corot's *Silène* (cat. no. 64). Photograph, Minnesota Historical Society. Published in Saint Paul 1991, p. 46

Fig. 176. Main gallery in the home of Mr. and Mrs. Potter Palmer, Chicago, ca. 1900. Chicago Historial Society (ICHi-01266)

Cincinnati, works by Corot appeared before 1874. The activity of two American dealers in Paris, Lucas and Samuel P. Avery, contributed to disseminating the fashion for his paintings.[44]

Although the second exhibition in New York, brought by the dealer Cadart in 1867, proved a failure, by 1870 paintings by Corot could be found in various local collections, for instance that of Mrs. W. Langdon.[45] The next two decades saw an enormous increase in the number of Corot's pictures in New York collections, giving substance to the idea that by 1900 Corot was the "most popular romantic painter ever sponsored by the American public."[46] When pictures were gathered in 1883 for the Pedestal Fund Art Loan Exhibition, to which Catharine Lorillard Wolfe lent *Ville-d'Avray* (cat. no. 148), others who contributed works by Corot included the dealer Daniel Cottier, Erwin Davis, George Campbell Cooper, I. T. Williams, Mrs. Robert L. Stuart, and Charles A. Dana. They represented only a small number among the much larger group of Corot collectors that included George I. Seney, William Astor, Joseph W. Drexel, J. Pierpont Morgan, John Wolfe (Catharine Wolfe's cousin), Charles Stewart Smith, Albert Spencer, and both William H. Vanderbilt and Cornelius Vanderbilt, who were advised by Avery. Mrs. Mary-Jane Morgan's collection, which contained eight Corots, was sold in 1886, and there was a stir when *Souvenir des environs du lac de Nemi* (cat. no. 127) was sold for a record $14,000.

The ten years that separated the 1883 exhibition from the 1893 World's Columbian Exposition in Chicago marked Corot's ascent in America. In 1883, twelve of the 195 paintings exhibited had been by Corot. At the 1893 loan exhibition in Boston, the ratio of paintings by Corot to those of other artists was four to one.[47] In Chicago the most conspicuous collectors were Henry Field and Mrs. Potter Palmer, who had acquired Alexandre Dumas's *La Lecture interrompue* (cat. no. 144) along with a few other works. But the most interesting collector of Corot in America was a New Yorker, Mrs. H. O. Havemeyer, who in 1889 bought the first of the twenty-five works by Corot she would eventually own. As Gary Tinterow has observed, she purchased figures almost exclusively.[48]

44. See Avery 1979.
45. For works by Corot lent to exhibitions in New York and elsewhere in the United States before 1876, see Yarnall and Gerdts 1986, vol. 1, pp. 834–36. For New York collectors in 1883, see Maureen C. O'Brien, "European Paintings at the Pedestal Fund Art Loan Exhibition: An American Revolution in Taste," in Southampton, New York 1986, pp. 27–58.
46. See Towner 1970, p. 22.
47. Saarinen 1958, p. 14, quotes the words of a fictional character modeled after Mrs. Potter Palmer in a novel by Henry Fuller: "People in our position would naturally be expected to have a Corot."
48. See Gary Tinterow in New York 1993, p. 21.

Fig. 177. James Abbott McNeill Whistler (1834–1903). *Portrait of Théodore Duret*, 1883. Oil on canvas, 76⅛ × 35¾ in. (193.4 × 90.8 cm). Catharine Lorillard Wolfe Collection, Wolfe Fund, 1913, The Metropolitan Museum of Art, New York (13.20)

Eight works from the collection are included in this exhibition, among them *La Lettre; Sibylle*, formerly owned by Robaut; and one of her rare landscapes, *La Rive verte*, from the Knyff and Erwin Davis collections (cat. nos. 133, 142, 122). Frances Weitzenhoffer has shown that the Havemeyers considered other works by Corot, notably *Mademoiselle de Foudras* (cat. no. 152), *La Bacchante à la panthère* (cat. no. 118), and *Vénus retient l'Amour et lui coupe les ailes* (*Venus Clipping Cupid's Wings*; R 1998) from the Dekens collection. All three were purchased by them for Colonel Oliver H. Payne, who kept only the last two.[49]

In Montreal, Sir George Drummond bought *L'Île heureuse* (cat. no. 128) only at the beginning of the twentieth century, but before 1879 he owned at least one landscape (R 395), and by 1893 two more.[50] Landscapes, among them a late view of Coubron (R 2176), could be found in the collection of James Crathern, while Duncan McIntyre acquired the *Bacchante retenant l'Amour* (*Bacchante Holding Back Cupid*; R 1635) of 1865 from the Secrétan collection. Two paintings from the Camus collection in Arras, *La Rêveuse à la fontaine* (*Daydreamer at the Fountain*; R 1341) and *La Petite Curieuse* (R 1042), were bought by, respectively, R. B. Angus and Sir William van Horne, who also owned *Nourrice allaitant* (*Woman Nursing a Baby*; R 1382), previously in the Vever collection. By 1893 W. R. Elmenhorst had acquired the *Grez-sur-Loing. Pont et église* (R 895), once in the collection of the critic Philippe Burty, who wrote the catalogue for Corot's memorial exhibition in 1875.

It would be fitting to note that both critics, who were his judges, and artists, who were his contemporaries, lived in the company of pictures Corot painted. Jules Janin, Alphonse Karr, Frédéric Henriet, Jules Claretie, Edmond Duranty, and Théodore Duret all owned works by him. Arsène Houssaye, who had followed his career since the early 1830s and sometimes judged him harshly, bought ten of his paintings. Among artists, almost the entire spectrum—painters in every genre, from academic artists to modernists, from Ernst Meissonier, Ferdinand Roybet, and Antoine Vollon to Charles Jacque, Charles Frère, and Adolphe Cals—owned one or several works. Bellet du Poissat bequeathed the finest of his three Corots, *La Moisson dans une vallée* (*Harvest in the Valley*; R 429), to the Musée des Beaux-Arts, Lyons. Closer to Corot's circle, Théodore Rousseau, for a time his only rival, bought *Environs de Chatillon-sur-Seine* (R 683; later owned by Alfred Sensier and subsequently offered to Geoffroy-Dechaume in recognition of his having created the monument to Corot at Ville-d'Avray). Jules Dupré, somewhat unexpectedly, chose *Le Concert* (fig. 65). Diaz owned at least three paintings. After Decamps's death, the four mural panels Corot had painted for him (R 1104–R 1107) were purchased by Lord Leighton. Daubigny's inventory at the time of his death listed some eighteen works by Corot, a few of them doubtless gifts but the great majority purchased, including the striking *Bacchante à la panthère* (cat. no. 118).

Younger artists, critical though they may have been of Corot's abundant oeuvre, could not fail to admire his achievement. Fantin-Latour bought drawings as well as paintings. Léon Lhermitte gathered seven very carefully selected studies. Charles Cazin also owned studies, including *Rome. Le Colisée vu à travers les arcades de la basilique de Constantin* (cat. no. 6). Making choices typical of the new sensibility, Jacques-Émile Blanche (whose father, Dr. Blanche, had already collected pictures by Corot) owned *Soissons. Maison d'habitation et fabrique de M. Henry* and *Chemin sur les monts boisés* (cat. nos. 40, 36). But nothing could have flattered

49. Weitzenhoffer 1986, pp. 125–26.
50. See Janet M. Brooke in Montreal 1989–90, p. 182.

Corot more than the impulse that led that most difficult of artists, Edgar Degas, to buy, in a very short period of time, seven paintings destined for the museum of modern art that he never succeeded in creating.[51] Alongside the great masters of the century in Degas's collection, from Ingres and Delacroix to Cézanne and Van Gogh, Corot found his place.

51. For Degas, see the Degas sale, Hôtel Drouot, Paris, November 15–16, 1918; Roquebert 1989, pp. 65–85; and Clarke 1991b, pp. 19–20.

Chronology

1793

May 6. Marriage of Louis-Jacques Corot (1771–1847) and Marie-Françoise Oberson (1768–1851) (marriage contract at the Archives Nationales, Paris: May 5, 1793, minute R, fol. 409, MC/ET/LVII/583). Louis-Jacques (whose name in some documents is given as Jacques-Louis), originally from Burgundy, was the grandson of a farmer in Mussy-la-Fosse, near Semur-en-Auxois, and the son of a wigmaker. Marie-Françoise, originally from the Swiss canton of Vaud, was the daughter of a wealthy wine merchant in Versailles. She opened a millinery shop which became well known in Paris and which her husband managed.

August 17. Birth of Annette-Octavie Corot (1793–1874).

1796

July 17 (28 Messidor). Birth of Jean-Baptiste-Camille Corot at 125, rue du Bac, Paris, at 1:30 a.m. (birth certificate, Archives de Paris, V 2 E 869; initially dated 27 Messidor [July 16] but corrected by hand to 28 Messidor [July 17]). He is placed in the care of a nurse in Presles, near L'Isle-Adam, with whom he stays until the age of four.

1797

Birth of Victoire-Anne Corot (1797–1821).

1803/4–07

Camille Corot is a student and boarder at a school headed by a man named Letellier on the rue de Vaugirard in Paris.

1807–12

Corot attends a secondary school in Rouen as a scholarship student; he has some academic problems but reaches the class of rhetoric, the next-to-last level. A friend of his father named Sennegon, who lives at Bois-Guillaume, near Rouen, serves as his guardian and takes him on long walks in the countryside.

1809

Corot's parents buy a house at 39, rue Neuve-des-Petits-Champs.

1812

They buy another house, at 23, rue des Moulins, as an investment.

1812–14

Corot is a student at a boarding school in Poissy, where he completes his studies.

1813

August 17. Corot's sister Annette-Octavie marries Laurent-Denis Sennegon, son of his walking companion in Rouen; the young couple help run the family millinery shop, on the rue du Bac.

1815

Corot begins an apprenticeship with a cloth merchant named Ratier, whose shop is on the rue de Richelieu. He soon moves to the shop of another cloth merchant, Delalain, on the rue Saint-Honoré. Forms a close friendship with the son of the Delalain family, Édouard (later will paint portraits of his wife and three children).

Tells his father that he wants to be a painter.

1816

August 1. Annette-Octavie Sennegon officially becomes proprietress of the Corots' millinery shop.

1817

March 4. Corot's parents buy a property in Ville-d'Avray for 25,000 francs.

Achille-Etna Michallon (1796–1822), Corot's future teacher, wins the Grand Prix de Rome for historical landscape.

1819

M. and Mme Corot file a new document that alters the terms of the couple's original marriage contract (Archives Nationales, November 17, 1819, MC/ET/I/CXV/1154).

1820

May 17. The lease for the house on the rue du Bac, where the Corots have their shop, is renewed for nine years.

Corot continues working for the cloth merchant Delalain.

1821

August 16. Death of the sixteen-month-old daughter of Corot's younger sister, Victoire-Anne, who is married to a man named Froment.

September 8. Death of Victoire-Anne.

1822

Corot's parents agree to let him study painting. They give him

the interest from his deceased sister Victoire-Anne's dowry, a yearly sum of 1,500 francs, on which to live.

Spring. Corot enters Michallon's studio. He works outdoors at Saint-Cloud, in the forest of Fontainebleau, and in Normandy.

Summer. Travels to Dieppe and makes his first figure studies, including *Dieppe. Une Femme de pêcheur* (*Fisherman's Wife, Dieppe*; R 55, Musée des Beaux-Arts, Lyons).

August. Paints landscapes while staying with the Sennegon family at Bois-Guillaume.

September 24. Death of Michallon. Corot joins the studio of Jean-Victor Bertin (1767–1842).

October. Works in the forest of Fontainebleau and in Moret.

1823
Spring. Stays at Ville-d'Avray. Paints his first views of the ponds.

1823–24
Continues studying with Bertin. Paints along the quays in Paris; see *Paris. Le Vieux Pont Saint-Michel* (fig. 9).

Paints his first historical landscape, *Orphée charme les humains* (*Orpheus Charms the Mortals*; R 195, private collection).

1825
Corot's first journey to Italy begins. Throughout his stay in Italy he carries on a correspondence with his friend Abel Osmond (1794–1840) which will later be valuable to scholars.

September. Leaves for Italy, traveling with his friend Johann Karl Baehr (1801–1896), a painter.

October. At Lausanne, paints a view of the city with the Lake of Geneva (R 42, private collection; copy at the Musée Cantonal de Lausanne).

December. Arrives in Rome and lodges in a rented room in the Palazzo dei Pupazzi on the Via Capo di Case, near the Piazza di Spagna. Paints a view of the roofs of Rome from his window (R 43, private collection). Paints the Coliseum and several panoramas of the city.

1826
January–February. Works along the Tiber River, following Poussin's example. During bad weather paints local models in the studio.

March. Makes studies of Roman monuments and executes a series of views from the Farnese Gardens.

May. Goes along the Tiber toward the Sabine Mountains with Baehr and works at Mount Soracte.

June–July. Stays at Civita Castellana; visits Viterbo and Castel Sant'Elia.

August–September. Stays at Papigno; visits Terni, Piediluco, and Narni.

August 8. Writes from Papigno in a letter to his friend Osmond: "I have only one goal in life that I want to pursue faithfully: to make landscapes. This firm resolution keeps me from a serious attachment. That is to say, in marriage." ("Je n'ai qu'un but dans la vie, que je veux poursuivre avec constance: c'est faire des paysages. Cette ferme résolution m'empêchera de m'attacher sérieusement. Je veux dire en mariage.") Département des Arts Graphiques, Musée du Louvre, Paris, A.R. 8 L 5.

October. Returns to Rome.

November. Journeys south of Rome, to Lake Albano and Lake Nemi: Rocca di Papa, Ariccia, Frascati, Marino.

December. Works briefly in Tivoli.

1827
January–April. In Rome.

Sends two paintings to Paris for the Salon of 1827: *Vue prise à Narni* (cat. no. 27) and *Campagne de Rome*, also called *La Cervara* (cat. no. 29).

April–May. Works at Olevano and Marino.

July–August. Journeys to Lake Albano, Civitella, and the area around Subiaco.

August 23. Returns to Rome. Goes to Tivoli with Léon Fleury.

September–October. Second trip north of Rome; stays at Civita Castellana and Castel Sant'Elia.

November 14. Returns to Rome.

1827–28
Winter. Works on ambitious paintings intended for the Salon.

1828
Spring. Visits Naples, Mount Vesuvius, Capri, and Ischia.

Returns to France from Rome by way of Venice, the Alpine lakes, and Switzerland.

Paints a portrait of Fanchette, his mother's maid (R 203, private collection).

1829
Spring. In Ville-d'Avray. Paints in the forest of Fontainebleau.

June–August. Travels to Normandy and makes his first visit to Brittany.

Paints portraits of friends: Alexandre Clérambault (R 204, location unknown), Abel Osmond (R 205, private collection), and Auguste Faulte de Puyparlier (fig. 16).

Exhibits two paintings at Galerie Lebrun, Paris, *Vue du château Saint-Ange* and *Vue de la place Saint-Marc à Venise* (both unidentified).

1830

July. When the Revolution of 1830 erupts in Paris, Corot leaves the city. Goes to Chartres with the architect Pierre-Achille Poirot; there paints *La Cathédrale de Chartres* (cat. no. 37). Then travels to the coast of Normandy (Honfleur, Trouville, Le Havre) and to Picardy and the north of France (Dunkirk, Boulogne, Bergues, Saint-Omer).

1831

Shows four paintings at the Salon: *Vue de Furia* (*View of Furia;* unidentified), *Couvent sur les bords de l'Adriatique* (*Convent on the Shores of the Adriatic;* R 201, private collection), *La Cervara. Campagne de Rome* (cat. no. 30), and *Vue prise dans la forêt de Fontainebleau* (*View in the Forest of Fontainebleau;* probably R 255, National Gallery of Art, Washington, D.C.).

Lists his professional address as 39, rue Neuve-des-Petits-Champs, his parents' home.

Summer. Travels in the Morvan, Burgundy, and Auvergne.

July. Stays in Chailly, in the forest of Fontainebleau.

Paints portraits of his nieces Blanche Sennegon (R 247, location unknown) and Marie-Louise-Laure Sennegon (cat. no. 48).

1833

January–February. Stays at Bois-Guillaume with his old friends the Sennegons.

Sends one work to the Salon, *Vue de la forêt de Fontainebleau,* also called *Le Gué* (*View of the Forest of Fontainebleau,* also called *The Ford;* R 257, location unknown). Receives a second-class medal. But the state does not purchase any of his canvases, and Cayeax, the director of fine arts, advises him not to make such large paintings.

May–June. Paints two canvases for the industrialist Philibert Henry of Soissons, a friend of his father (cat. nos. 40, 41).

July–August. Travels in Normandy, to Saint-Lô, Saint-Évremond-du-Bon-Fossé, Saint-Martin, Troisgots (July 13), and Granville (August 11).

Paints more portraits of family members: of Marie-Louise-Laure Sennegon (R 249, Musée Municipal, Semur-en-Auxois), Octavie Sennegon (R 251, private collection), and Toussaint Lemaistre (cat. no. 49).

1834

At the Salon exhibits *Une Forêt* (*A Forest;* unidentified), *Une Marine* (cat no. 46), and *Site d'Italie* (*Italian Site;* R 361, location unknown).

April. Paints in Lormes, where he is visiting his niece Marie-Louise-Laure Baudot, née Sennegon.

May. Leaves on his second journey to Italy, which will be limited to northern Italy, with the painter Jean-Charles-Denis Grand-jean. Goes by way of Clamecy, Lormes, Beaune (Hôtel du

Chevreuil), Lyons (Hôtel du Cheval Blanc), Avignon (Hôtel du Palais-Royal), Marseilles (Hôtel du Midi), Toulon (Hôtel de la Croix d'Or), then through Antibes, Nice, La Turbie, Monaco, Roquebrune, and Menton; enters Italy at Ventimiglia. Visits San Remo, Taggia, San Maurizio, Oneglia (Hôtel du Jardin).

June. Arrives in Genoa (Hôtel du Petit Paris) on June 1. Paints studies of the city (cat. no. 53). Visits La Spezia. In Pisa on June 19 (Albergo della Pace or the Trattoria dell'Europa).

June 22–July 20. In Volterra (Albergo della Corona di Luigi Cherici e di Malta). Perhaps paints the two views of Volterra in the Musée du Louvre, Paris.

July 21. In Florence (Albergo della Fontana).

August 18–September 8. His second visit to Venice. Paints views of the Grand Canal and the Piazzetta that he will use in later works (see cat. no. 56).

September. Visits the Italian lake country, staying in Desenzano and Riva on Lake Garda. Stops in Milan.

October 8. In Geneva (Hôtel de la Balance).

Returns to Paris by way of Dôle.

Spends six weeks painting in the forest of Fontainebleau.

1835

At the Salon exhibits two major works, *Agar dans le désert* (cat. no. 61) and *Vue prise à Riva, Tyrol italien* (cat. no. 59).

Takes a studio at 15, quai Voltaire, where he will remain through 1849.

Postpones another journey to Italy because of a cholera epidemic. Makes a long summer visit to the forest of Fontainebleau.

Perhaps paints the portraits of his nephews Camille Sennegon (R 254, location unknown) and Henri Sennegon (R 253, private collection).

1836

At the Salon shows *Diane surprise au bain* (cat. no. 63) and *Campagne de Rome en hiver* (probably cat. no. 31).

July. Works in Provence (Avignon, Montpellier), then in Auvergne with Prosper Marilhat (1811–1847).

1837

Paints the large *Saint Jérôme; paysage* (cat. no. 62) and exhibits it at the Salon along with a *Vue prise dans l'île d'Ischia* (*View on the Isle of Ischia*) and a *Soleil couchant* (*Sunset*), both unidentified.

Paints some of his first nudes, *Jeune Femme assise, la poitrine découverte* (*Seated Young Woman with Bare Bosom;* R 383, private collection) and *La Nymphe de la Seine* (*The Nymph of the Seine;* R 379, private collection, Zurich).

Perhaps paints the portrait of his niece Claire Sennegon (cat. no. 50).

1838

At the Salon exhibits *Silène* (cat. no. 64) and *Vue prise à Volterra, Toscane* (perhaps one of the two views in the Louvre, R 303 or 304; see cat. no. 54). Travels to Orléans, Villers-Cotterêts, and Compiègne.

1839

Stays frequently at Rosny-sur-Seine with his friend Mme Osmond, a widow.

At the Salon exhibits *Site d'Italie* and *Un Soir; paysage* (cat. no. 75). Théophile Gautier writes verses inspired by *Un Soir.* The duc d'Orléans buys the *Vue prise dans l'île d'Ischia* exhibited in 1837 and a *Vue d'Italie, soleil levant* dated 1839 (J. Paul Getty Museum, Malibu).

Summer. Meets the painter François-Auguste Ravier (1814–1895). In August, travels in Auvergne.

1840

At the Salon exhibits *La Fuite en Égypte* (*The Flight into Egypt;* R 369, Church of Rosny-sur-Seine), *Un Moine* (*A Monk;* R 375, Musée du Louvre, Paris), and *Paysage, soleil couchant,* also called *Le Petit Berger* (cat. no. 76). The state buys *Le Petit Berger* for 1,500 francs and sends it to the Musée d'Art et d'Histoire, Metz. Corot receives favorable reviews.

Summer. Stays in the Morvan, a favorite place of his to work.

Meets François-Parfait Robert, a nephew of Mme Osmond, who will regularly invite Corot to visit him in Mantes.

1841

At the Salon exhibits *Site des environs de Naples* (cat. no. 77) and *Démocrite et les Abdéritains* (cat. no. 78).

Summer. Travels to Vézelay, Lormes, and Saint-André-du-Morvan.

1842

At the Salon exhibits *Paysage, effet du matin,* also called *Le Verger* (*The Orchard;* R 441 A and B, Musée Municipal, Semur-en-Auxois) and *Site d'Italie* (R 442), which the state buys for the Musée Calvet, Avignon, its present location.

Spends time in the Morvan.

Travels in the Jura and in Switzerland (Gex, Geneva, Fribourg, Montreux, Mornex, Vevey).

Stays in Orsay with his friend Jules Étex, then in Mantes with his friends the Roberts. Decorates the bathroom of the Robert residence (R 435–R 440, Musée du Louvre, Paris). Stays in Fontainebleau and in Provins.

1843

At the Salon shows *Un Soir* (*Evening;* R 633) and *Jeunes filles au bain* (*Young Girls Bathing;* R 462), both, location unknown. The jury

rejects *L'Incendie de Sodome* (R 460); a protest is lodged by a group of artists (see cat. no. 114).

May–October. Corot's third and last journey to Italy. Stays in Rome with his painter friend Brizard and travels south of Rome, to Tivoli, Genzano, Lake Nemi. In Rome, works at the Villa Borghese, the Vatican, and San Giovanni in Laterano.

Paints one of his most sensual nudes, *Marietta,* also called *L'Odalisque romaine* (cat. no. 85).

Sells a painting to an individual buyer, a man named Tichner, for 500 francs (Département des Arts Graphiques, Musée du Louvre, Paris, BC. b2. L 25).

1844

Has become friends with Théodore Rousseau.

This year *Destruction de Sodome* is accepted by the Salon jury (see cat. no. 114). Corot also exhibits *Paysage avec figures,* also called *Le Concert* (fig. 65), and *Vue de la campagne de Rome* (*View of the Roman Campagna;* R 617).

During the winter, begins a series of studies from the model (R 467–R 473) in preparation for painting his first important commission (see **1845**).

1845

At the Salon exhibits *Daphnis et Chloé* (R 465, location unknown), *Homère et les bergers* (cat. no. 90), and *Paysage* (*Landscape;* R 463, location unknown).

Is endorsed by the critics Charles Baudelaire, Théophile Thoré, and Champfleury.

Stays in Alençon with his friends the Clérambaults, in Mortain with the Delalains, and in Saint-Lô with the Élies, cousins of the Osmonds. Travels in Brittany (Mûr-de-Bretagne) and works in the forest of Fontainebleau in the autumn.

September. Is awarded a commission by the city of Paris to execute an altarpiece for the church of Saint-Nicolas-du-Chardonnet (*Le Baptême du Christ,* cat. no. 89).

1846

At the Salon exhibits only one painting, *Vue prise dans la forêt de Fontainebleau* (cat. no. 91).

Travels in the Limousin, Brittany, and Normandy.

July 5. Is named Chevalier of the Legion of Honor.

1847

At the Salon shows *Berger jouant avec sa chèvre* (*Shepherd Playing with His Goat;* R 503, private collection) and *Paysage,* also called *Pêcheurs tendant leurs filets, le soir* (fig. 96a). Two other paintings are rejected by the jury.

May–November. Stays almost entirely in Paris and in Ville-d'Avray

in order to attend his seriously ill father. Decorates his father's summerhouse on the Ville-d'Avray property (these decorative paintings have long been dispersed).

The painter Constant Dutilleux buys *Petit Étang avec un berger au pied de trois grands arbres* (*Small Pond with a Shepherd beneath Three Large Trees*; R 612, private collection). This initiates a close friendship between the two artists.

Receives a commission to do a tapesty cartoon for the Beauvais factory for 1,500 francs, from the civil list of Louis-Philippe. Paints *Le Chevrier italien* (cat. no. 92), but the tapestry is never made because of the downfall of the monarchy.

Meets Eugène Delacroix (1798–1863).

November 28. Death of Corot's father, Louis-Jacques Corot.

1848
Corot participates in the reform of the Salon jury after the February Revolution and is elected to the jury by his colleagues. Thanks to this advantageous position and the new atmosphere of freedom at the Salon, exhibits nine paintings: *Site d'Italie*, also called *Le Bain du berger* (*The Shepherd's Bath*; R 609 A and B, Musée de la Chartreuse, Douai), and *Intérieur de bois*, *Une Matinée*, *Crépuscule*, *Un Soir*, *Effet du matin*, *Un Matin*, *Un Soir*, and *Vue de Ville-d'Avray* (all unidentified). Wins a second-class medal at the Salon. The state buys *Le Bain du berger* for the Musée de Douai.

1849
Is once again elected a jury member of the Salon. Exhibits *Le Christ au jardin des Oliviers* (*Christ in the Garden of Gethsemane*; R 610, Musée de Langres), *Étude du Colisée* (cat. no. 8), and *Vue prise à Ville-d'Avray*, *Vue prise à Volterra*, and *Site du Limousin* (*Site in the Limousin*), all unidentified. The government buys *Le Christ au jardin des Oliviers* for the Musée de Langres; it is not well received there.

1850
July. In Ville-d'Avray.

Moves his studio from the quai Voltaire to 10, rue des Beaux-Arts.

Serves on the jury for the Salon of 1850–51. Exhibits *Une Matinée* (cat. no. 103), *Soleil couchant, site du Tyrol italien* (cat. no. 94), and *Lever du soleil* (*Sunrise*) and *Étude à Ville-d'Avray* (*Study at Ville-d'Avray*), both unidentified. At the conclusion of the Salon the state buys *Une Matinée* for 1,500 francs.

1851
January 15. Writes to a painter friend, "We are all getting old, becoming deaf and lazier. We are getting together at Grandjean's, Brizard's, and my house." ("Nous vieillissons tous. On devient sourd et plus paresseux: nous nous réunissons chez Grandjean, Brizard et à la maison.") Private archives.

February 27. Death of Corot's mother, Marie-Françoise Corot.

March 13. Corot writes, "I had prepared myself thoroughly for the misery that struck; nonetheless, the shock hit me terribly hard. I return to the studio starting today; work will help me greatly, I hope." ("Je m'étais bien préparé au malheur qui m'a frappé; mais cependant j'en ai senti affreusement les coups. Je retourne dès aujourd'hui à l'atelier; le travail me fera beaucoup de bien, j'espère.") Robaut 1905, vol. 4, p. 333, no. 26 bis.

Early June. Stays with his friend Dutilleux in Arras. Free now of family obligations, Corot intensifies his traveling.

July. Travels in Normandy and Brittany. In La Rochelle, stays with his friend Monlun for three weeks and paints the very fine *Vue du port de La Rochelle* (cat. no. 96).

Late August. Stays with Jules Lacroix in Mas-Bilier, near Limoges.

November. Is back in his Paris studio.

Moves out of his parents' house at 39, rue Neuve-des-Petits-Champs and rents an apartment at 19, rue Montholon, where he will live at least until 1858.

1852
At the Salon exhibits *Vue du port de La Rochelle* (cat. no. 96) and also *Le Repos* (*Repose*) and *Soleil couchant* (*Sunset*), both unidentified.

April. Stays in Arras with Dutilleux. There meets Alfred Robaut, his future biographer.

Summer. Travels in the Dauphiné (Crémieu, Optevoz, and Morestel), where he works with Ravier. Meets Charles-François Daubigny (1817–1878).

Late summer. Stays with the family of Armand Leleux in Dardagny, near Geneva. Works in the area around the Lake of Geneva.

1853
February 14–18. Visits Dutilleux in Arras.

At the Salon exhibits *Saint Sébastien* (cat. no. 104), *Coucher de soleil* (*Sunset*; R 1064, location unknown), and *Matinée* (*Morning*; unidentified). Writes to Dutilleux, "I've been to see the exhibition Mlle [Rosa] Bonheur, nothing to get excited about: it's striking, that's all. It has no vigor. Hébert left me cold. Courbet, except for the fat mother, is good." ("J'ai été voir l'exposition Mlle Bonheur, pas de délire: c'est éclatant, voilà tout. Il n'y a pas de nerf. Hébert ne m'a pas touché. Courbet, à part la grosse mère, c'est bon.") Cabinet des Estampes, Bibliothèque Nationale de France, Paris, Yb3 946, rés.

April. Stays with Mme Osmond in Rosny-sur-Seine.

May. First paints in the forest of Fontainebleau, then goes to Arras for the wedding of Dutilleux's daughter and Alfred Robaut. Makes his first *clichés-verres* with Grandguillaume and Cuvelier, inventors of the technique. Returns to Paris on May 23 and arrives at Ville-d'Avray on May 25.

June. Stays in Arras. Travels in Normandy—Abbeville and

Saint-Valéry. Returns to the Dutilleux in mid-month.

July–August. Stays with Leleux in Dardagny, Switzerland. With his friend Daubigny, paints a large screen (R 1073, location unknown). In late August stays with the Charpentiers in Alençon, in Normandy, then with the Clérambault family in Saint-Germain-du-Corbéis.

September. Stays with Édouard Delalain in Bourberouge, near Mortain. Visits his sister in Ville-d'Avray.

October 8–12. Works in the forest of Fontainebleau; stays at the Hôtel de la Sirène.

Enters the circuit of exhibitions organized by provincial art societies with the help of the Paris dealer A. Binant, a connection of his relatives the Chamouillets. *Le matin; vue prise sur les hauteurs de Ville-d'Avray* (unidentified), priced at 350 francs, is sent to the Société des Amis des Arts, Bordeaux; *Un paysage* (cat. no. 94), priced at 1,500 francs, is shown at the Société Artistique des Beaux-Arts du Rhône, Marseilles, and purchased by the society for the Musée des Beaux-Arts for 1,000 francs.

Rents a studio near his new lodgings, at 58, rue de Paradis-Poissonnière, which he will keep until his death.

1854
June. Stays at his friend Guillaume's in Presles. Paints in the vicinity of Auvers with Daubigny.

July. Travels in the Périgord, to Notron.

August 5. Returns to Ville-d'Avray.

August 18. Goes to Arras to stay with the Dutilleux.

August–September. Takes a trip in Belgium and Holland with Dutilleux, who keeps a journal documenting the journey. They are in Brussels on August 28 (Hôtel du Miroir), in Antwerp on August 29 (Hôtel Saint-Automne and restaurant Le Petit Paris), in Rotterdam at Corot's nephew's on August 30, in The Hague on August 31 (Hôtel du Lion d'Or). On September 1, Corot paints on the Scheveningen beach. September 3–6 stays in Amsterdam and works on views from nature. Revisits Rotterdam September 6–15 and paints on the banks of the Meuse. Returns to Arras through Douai.

1855
March. Stays in Arras with the Dutilleux and in Douai with the Robauts.

From May 15. At the Exposition Universelle exhibits six paintings, for which he receives a first-class medal: *Effet de matin,* also called *La Compagnie de Diane* (cat. no. 105), *Souvenir de Marcoussis* (R 1101, Musée d'Orsay, Paris), *Printemps* (*Spring;* R 1062, private collection), *Soir* (*Evening;* R 1070, location unknown), *Souvenir d'Italie* (unidentified), and *Une Soirée* (*An Evening;* R 1066, location unknown). Napoleon III buys *Souvenir de Marcoussis* for his own collection. In 1858, the city of Bordeaux will buy *La Compagnie de Diane.*

Summer. Travels in Normandy and Brittany, to Geneva, in Sologne, and to La Ferté. Visits Mme Osmond in Rosny-sur-Seine, Ernest Dumax in Marcoussis, Léon Fleury in Magny-les-Hameaux, and the Roberts in Mantes. In Gruyères, plays a question game which he answers as follows:

Your favorite virtue	charity
Your favorite qualities in a man	feeling
Your favorite qualities in a woman	tenderness
Your favorite occupation	painting
Your characteristics	. . .
Your idea of happiness	in work
Your idea of unhappiness	the unhappiness of others
Your favorite color and flower	rose and the rose
Were you not yourself, what would you want to be	nothing
Where do you most like living	in Paris
Your favorite writers	Pascal, Bossuet
Your favorite poets	Shakespeare
Your favorite painters and composers	Leonardo da Vinci, Gluck
Your favorite heroes in real life	Saint Vincent de Paul
Your favorite heroines	Joan of Arc
What do you dislike most	envy
Which historical character do you dislike most	Aeneas
What is your present state of mind	very happy
Which mistakes are you most tolerant of	those provoked by love
Your favorite motto	Do what you must do, come what may

(Votre vertu favorite	la charité
Vos qualités favorites, chez un homme	le coeur
Vos qualités favorites, chez une femme	la douceur
Votre occupation favorite	la peinture
Votre caractéristique	. . .
Votre idée du bonheur	dans le travail
Votre idée du malheur	celui des autres
Votre couleur et votre fleur favorites	le et la rose
Si vous n'étiez pas vous-même, que voudriez-vous être	rien
Où aimez-vous à vivre	à Paris
Vos prosateurs favoris	Pascal, Bossuet
Vos poètes favoris	Shakespeare
Vos peintres et compositeurs favoris	Léonard de Vinci, Gluck
Vos héros favoris dans la vie réelle	Saint Vincent de Paul
Vos héroïnes favorites	Jeanne d'Arc
Votre aversion	l'envie
Quel caractère en histoire vous déplaît le plus	Eneas
Quel est votre présent état d'esprit	très heureux
Pour quelle faute avez-vous le plus de tolérance	l'amour
Votre devise favorite	Fais ce que dois, advienne que pourra)

Recorded in Baud-Bovy 1957, pp. 98–99.

September. In Ville-d'Avray. Paints four panels on religious subjects for the church: *Adam et Ève chassés du paradis* (*Adam and Eve Expelled from Paradise*), *Le Baptême du Christ* (*The Baptism of Christ*), *Le Christ au*

jardin des Oliviers (Christ in the Garden of Gethsemane), and *Madeleine au désert (The Magdalene in the Wilderness)*, which are still in the church (R 1074–R 1077).

Systematically makes studies from the model. Perhaps this year paints one of his first great works in the genre of half-length figures, *La Femme à la grande toque et à la mandoline (Woman with a Large Toque and a Mandolin;* R 1060, private collection).

1856

April. Stays with Mme Osmond in Rosny-sur Seine. At her request, begins a Stations of the Cross for the church (R 1083–R 1096, church of Rosny-sur-Seine).

Summer. Stays in Essones, in Luzancy at Hébert's (about June 14), and in Château-Thierry. About July 14 is in Normandy. Travels to Switzerland and stays in Neuchâtel at the end of the summer.

1857

January 17. Writes to his friend and student Édouard Brandon, who is in Rome, asking Brandon to send him Italian peasant costumes and the habit of a Capuchin monk in which to have his models pose.

March. Attends the carnival festivities in Arras.

May. Sends seven paintings to the Salon, including two works exhibited in earlier states at the 1844 Salon, *L'Incendie de Sodome* (cat. no. 114) and *Paysage avec figures,* also called *Le Concert* (fig. 65). The other paintings are *Une Nymphe jouant avec un amour (Nymph Playing with a Cupid;* R 1100, Musée d'Orsay, Paris), *Soleil couchant (Sunset;* R 1069, location unknown), and *Un Soir (Evening), Souvenir de Ville-d'Avray,* and *Une Matinée; souvenir de Ville-d'Avray (A Morning: Souvenir of Ville-d'Avray),* all unidentified.

Summer. In May travels in Brittany (Brest and Saint-Brieuc) and in Normandy (Granville, Troisgots, Saint-Lô, Caen). Stays with the Roberts in Mantes. Visits Badin, director of the tapestry manufactory in Beauvais, about June 26. On June 30 is in Clermont. In July goes to Switzerland, staying in Geneva and at the château de Gruyères as the guest of the Bovy family. In August stays with Dumax in Marcoussis, then travels in Auvergne.

Fall. September 1–12, stays in Boulogne-sur-Mer. September 13–28, travels with Dutilleux and Charles Desavary to Dunkirk and to Zuydcoote. Toward the end of the year, spends his time in Mantes, Marcoussis, Ville-d'Avray, and Rosny-sur-Seine.

Contributes two landscapes (unidentified) to the first Salon held in Geneva, where he is awarded the medal of honor.

1858

Makes his first experiments in etching.

April 11. Places thirty-eight paintings in an auction at the Hôtel Drouot, Paris, through the appraiser Thirault. The sale brings 14,233 francs, but many paintings go unsold.

Summer. In May stays in Aiseray (Côte d'Or). In June is at Ville-d'Avray, then travels to Normandy and stays at Luzancy. In the summer, spends some days in Troyes near the newly married Baudots, his grandniece and her husband. On September 6, in Arras for the wedding of Dutilleux's younger daughter to the painter Charles Desavary.

Probably this year executes a four-panel decoration for the house of Alexandre-Gabriel Decamps at Fontainebleau.

1859

Sends several ambitious works to the Salon: two with literary themes, *Dante et Virgile* (cat. no. 115) and *Macbeth* (fig. 110); an idyllic landscape, *Idylle* (R 1110, Musée des Beaux-Arts, Lille); a nude, *Paysage avec figures,* also called *La Toilette* (cat. no. 116); and three landscapes, *Souvenir du Limousin, Tyrol italien,* and *Étude à Ville-d'Avray,* all unidentified. This year marks a crucial turning point in Corot's career. He has many students and is considered a leading landscape painter of the era by the younger generation of artists. An increasing number of collectors and dealers are eager to have his paintings. In addition to painting landscapes he is pursuing his interest in the human figure.

April 2. Stays with the Dutilleux in Arras.

May 22. Inauguration of the Stations of the Cross, begun in 1856 for the church of Rosny-sur-Seine.

Summer. Stays with the Bovy family in Switzerland. Perhaps at this time paints the decorative series for the living room of their château at Gruyères (R 1078–R 1081). On August 22 stays in Montlhéry with Mme Castaignet, the daughter of Mme Herbault, an old rival of Mme Corot in the fashion world.

October. Stays in Arras and at Ville-d'Avray.

November. Works in the forest of Fontainebleau. Becomes friendly with a new generation of landscape painters, especially Jean-François Millet (1814–1875).

1860

June. Corot stays in Auvers-sur-Oise with Daubigny, who has become a very close friend, and portrays him painting in his famous boat-studio.

August. Travels in Brittany with Dumax and Estienne, to Saint-Malo, Dinan, Saint-Servan, and Granville.

A *Paysage; soleil couchant* (unidentified) is exhibited at the Brussels Salon. The Goupil gallery in New York includes in its third annual exhibition *Souvenir of Lake Garda (Italy)* (unidentified), offered for $250; this is the first record of a Corot painting being shown in public in the United States.

1861

January 14. Sells a *Bacchante* to the dealer Haro for 1,000 francs, according to a signed receipt; thus, is by this time selling his figures and nudes.

At the Salon exhibits *Danse des nymphes (Dance of the Nymphs;*

R 1619), *Soleil levant* (*Sunrise;* R 1620), and *Le Lac* (*The Lake;* R 1621), all, location unknown; *Souvenir d'Italie,* unidentified; *Le Repos* (cat. no. 117); and *Orphée* (cat. no. 120).

Early summer. Spends time in Ville-d'Avray because his sister and his brother-in-law Sennegon are ill.

September 12–October. Works at Fontainebleau.

November. Back in Paris.

Perhaps this year, Dutilleux establishes a residence in Paris, and he and Corot meet often.

1862

June. Stays in Luzancy.

Summer. Stays in Ville-d'Avray with his sick sister and brother-in-law. In July, travels briefly to London for the World's Fair with his friend Badin. Paints studies on the banks of the Thames, at the Crystal Palace, and at Richmond.

September. Travels in Saintonge and stays with the collector E. Baudry, a friend, at the estate of Port Breteau in the commune of Rochemont. Meets Gustave Courbet (1819–1877), whose work he has long admired. They will remain friendly, although they never develop a close friendship.

1863

At the Salon exhibits *Soleil levant* and *Étude à Ville-d'Avray* (both unidentified), and *Étude à Méry* (R 1286, private collection).

April. In Château-Thierry for the wedding of his grandnephew Léon Chamouillet. Paints *Les Remparts de Château-Thierry* (*The Ramparts of Château-Thierry;* Calouste Gulbenkian Foundation, Lisbon).

April 26. Agrees to send a certain number of works, so they can be copied, to an agency that leases paintings, the Agence des Beaux-Arts, run by F. F. Grobon. Leases ten paintings (four views of Italy, two views of Ville-d'Avray, one of Château-Thierry, one of Boulogne-sur-Mer, and two figure paintings) for prices ranging from 6 to 24 francs (Fondation Custodia, Paris, "Document Grobon," C. Corot, 1995-A-105b recto).

Summer. In June stays in Épernon. In July travels to Dardagny and stays at La Châtelaine and Saint-Jean.

Autumn. Stays in Flesselles, returning to Paris the beginning of November.

November 2. Writes in a letter: "These art dealers are stupid. They buy landscapes but place on them the condition that they be as far removed from nature as possible. Now, I have no idea how to make a landscape that isn't a landscape. I cannot show trees otherwise than the way they grow, any more than a man without a head, trunk, or legs." ("Ces marchands de tableaux sont stupides. Ils achètent des paysages, mais y mettent cette condition qu'ils s'éloigneront le plus possible de la nature. Or, je ne saurai jamais faire du paysage qui n'en soit pas. Je ne peux pas me représenter des arbres autrement qu'ils ne poussent, pas plus qu'un homme

sans tête, sans tronc ou sans jambes.") Documentation, fichier Moreau-Nélaton, Département des Peintures, Musée du Louvre, Paris.

1864

Is a member of the Salon jury. Exhibits *Souvenir de Mortefontaine* (cat. no. 126) and *Coup de vent* (*Gust of Wind;* R 1683, location unknown). Napoleon III buys *Souvenir de Mortefontaine;* it will later enter the Louvre.

April 2. Signs a receipt at the Agence des Beaux-Arts for 665 francs, collected for the sale of studies he had left the previous year to be copied (Fondation Custodia, Paris, 1995-1-105a).

June. Stays in Luzancy and La Ferté-sous-Jouarre.

Exhibits *L'Étoile du berger* (cat. no. 125) at an exhibition in Toulouse; the city of Toulouse buys the painting.

1865

February 15. Stays in Auvers-sur-Oise with his friend Daubigny. Perhaps this year, begins the decoration of Daubigny's house at Auvers, with Daubigny and Honoré Daumier (1808–1879). For the vestibule he paints five panels (no longer in the house; R 1644–R 1648), and Karl Daubigny and Achille Oudinot execute three large compositions from his drawings that are still in place in the studio (R 1649–R 1651; fig. 167).

At the Salon exhibits *Le Matin* (*Morning;* R 1635, location unknown), *Souvenir des environs du lac de Nemi* (cat. no. 127), and *Souvenir d'Italie* (Delteil 5), an etching.

Spring. Stays with the Roberts in Mantes, painting on the banks of the Seine and across from the cathedral.

August 15–29. Stays in Fontainebleau, where he decorates the dining room of a town house for Prince Demidoff, who had also commissioned paintings from Dupré, Rousseau, and Fromentin. Corot paints *Le Sommeil de Diane* (*Diana Sleeping;* R 1633, private collection) and *Orphée salue la lumière* (fig. 130).

September 1. Stays with Briand in Normandy, near Vimoutiers.

Death of Constant Dutilleux, Corot's close friend and painting companion.

1866

Pays increasing attention to studying the figure, while continuing to paint landscapes. Collectors prize his figure paintings. Paints the monumental, lifesize *Agostina* (fig. 115).

At the Salon exhibits *La Solitude* (fig. 109) and *Le Soir* (*Evening;* R 1637), both, location unknown, and *Environs de Rome* (Delteil 6), an etching. Napoleon III buys *La Solitude* for the empress's private collection for 1,800 francs.

Ten paintings by Corot, including *A Lady at her Toilet* (conceivably cat. no. 116), are shown at the Fine Arts Gallery in New York in the first exhibition of modern French art brought over from France

by the publisher/dealer Alphonse Cadart; the works are subsequently shown in Boston and at Birch's Gallery in Philadelphia. Later in the year, six paintings by Corot are lent by Boston collectors to the first annual exhibition of the Allston Club in Boston.

Stays in Beauvais with a friend, Wallet. Paints two studies of the church of Marissel.

June. Stays in Noisy-le-Grand, where he works outdoors a great deal. Suffers a sudden attack of gout, and cancels most of his travel plans.

1867

At the Salon exhibits *Vue de Marissel, près Beauvais* (R 1370, Musée du Louvre, Paris) and *Coup de vent* (*Gust of Wind;* unidentified).

June 30–July 20. Stays with Mme Gratiot in Coubron, near Montfermeil.

August. Stays in Marcoussis, returns to Paris, goes to Ville-d'Avray. Works in Essoyes and Méry-sur-Seine.

Exhibits seven important paintings at the Exposition Universelle: *Saint Sébastien* (cat. no. 104), *La Toilette* (cat. no. 116), *Macbeth* (fig. 110), *Souvenir des environs du lac de Nemi* (cat. no. 127), *Un Matin* (R 1639), *Un Soir* (*Evening;* R 1640, location unknown), *Les Ruines du château de Pierrefonds* (R 475, Musée des Beaux-Arts, Quimper), and two decorative paintings on silk intended to be fire screens, *Le Pêcheur* (*The Fisherman;* R 1799) and *Le Berger* (*The Shepherd;* R 1800). Corot is celebrated by critics and by the public. Receives a second-class medal at the Exposition Universelle, and the state names him Officier of the Legion of Honor.

1868

At the Salon shows *Un Matin à Ville-d'Avray* (cat. no. 147) and *Le Soir,* also called *Le Passage du Gué* (fig. 151).

June 2. At Coubron with Mme Gratiot.

Stays with his friend the lawyer Preschez in Coulommiers. Most of the year is spent in Ville-d'Avray.

1869

At the Salon exhibits *Souvenir de Ville-d'Avray,* also called *Le Catalpa* (R 1643, Musée d'Orsay, Paris), and *Une Liseuse* (cat. no. 141).

Exhibits at the Royal Academy, London, and the International Exhibition in Munich, where the king of Bavaria appoints him a knight of the Order of St. Michael, first class.

Stays at Coubron with the Gratiot family. On September 14 is in Yport.

September 22. Writes in a letter that because of ill health he is canceling all fall trips except for a stay with the Roberts in Mantes.

1870

Works in his studio on the rue de Paradis-Poissonnière during the Franco-Prussian War and the siege of Paris. Paints an astonishing view, *Paris incendié par les Allemands* (*Paris Burned by the Germans;* R 2352, location unknown).

At the Salon exhibits *Paysage avec figures* (*Landscape with Figures;* R 2002, location unknown) and *Ville-d'Avray* (cat. no. 148).

1871

February 3. Writes to a collector of autographs named de Beauchesne: "In answer to your request, I offer you some biographical notes. I attended secondary school in Rouen until the age of 18. After that I spent 8 years in business: unable to stay with that any longer, I became a landscape painter; a student of Michallon at first. After losing him, I entered the studio of Vor [Victor] Bertin & after that I went out into nature by myself & there we are." ("D'après votre désir, je vous remets quelques notes biographiques. J'ai été au collège de Rouen jusqu'à 18 ans. De là j'ai passé 8 ans dans le commerce: ne pouvant plus y tenir je me suis fait peintre de paysages; élève de Michallon d'abord. L'ayant perdu, je suis entré dans l'atelier de Vor Bertin. & après je me suis lancé tout seul dans la nature & voilà.") Département des Arts Graphiques, Musée du Louvre, Paris, BC. b2. L 20.

April 14. Leaves for Arras to stay with his friend Desavary; then stays with Robaut in Douai.

May. Paints one of his most beautiful works from nature, *Le Beffroi de Douai* (cat. no. 156). Works in Wagnonville, near Douai, and makes a painting of Robaut's house.

Spring–Summer. Paints in Arras, Arleux, Fampoux, and Sainte-Catherine-les-Arras. Paints one of his rare still lifes, *Un Bouquet de fleurs* (*A Bouquet of Flowers;* private collection). Restores order to the property at Ville-d'Avray for the return of his sister, who had taken refuge in Marseilles during the war. Paints in the region of Rouen.

1872

At the Salon exhibits *Souvenir de Ville-d'Avray* (cat. no. 149) and *Près Arras* (*Near Arras;* R 2039, Musée du Louvre, Paris, on deposit at the Musée des Beaux-Arts, Arras).

This year, despite his seventy-six years, Corot travels continually, painting in every location: April 15–27, in Beauvais. May 1–20, in Ville-d'Avray. May 20–28, in Fumay (Ardennes). June, in Coubron. July 1–8, with Robaut in Douai. July 8–12, with Desavary in Arras. July 13–20, in Rouen with Robaut and Bellon. July 20–28, in Yport and Criqueboeuf with Badin and Dieterle. August 1–8, with Dumax at Marcoussis. August 9–19, at Port-Marly. August 21, in Luzancy. August 29–30, in Argenteuil. September 1–7, in Fontainebleau (Hôtel Sirène). September 8–21, stays in Étretat with the Stumpf family, collectors of his paintings. September 26–October 7, with the Roberts in Mantes. October 9–27, in the Landes and in Bordeaux, Mont-de-Marsan, Biarritz, Saint-Jean-de-Luz; and in Spain, in Irún, Fuenterrabía, and San Sebastián. November 1–15, in Coubron.

December. In Douai for the golden wedding anniversary of Alfred Robaut's parents.

In London, Durand-Ruel shows a total of eighteen paintings by Corot in exhibitions of the Society of French Artists.

In the times between trips he is in Paris and Ville-d'Avray. During the winter, paints figures in his studio.

1873

Sets up a second studio at 19 bis, rue Fontaine, where he can work undisturbed by petitioners for paintings and assistance.

At the Salon exhibits *Pastorale* (cat. no. 150) and *Le Passeur* (*The Ferryman*; R 2108, Musée du Louvre, Paris).

Works by Corot are shown in Dieppe and Bordeaux. In London, Durand-Ruel shows seven Corot paintings. In the United States, his works are seen at the Union League Club, Philadelphia, in a gallery at 625 Broadway in New York, and in two exhibitions at the Boston Art Club. Corot sends *Souvenir de Ville-d'Avray* (R 1643) and *Paysage avec figures* (cat. no. 116) to the World's Fair in Vienna.

April 15. Has a studio built in Coubron adjoining the house of his friends the Gratiots.

May. In Saintry, near Corbeil, on May 1. May 24–June 2, stays with the Dubuisson family, collectors of his works, in Brunoy.

June 11. In Paris to help the widow of the painter Théodore Caruelle d'Aligny (1798–1871), a friend from his first journey in Italy. Organizes the posthumous sale of Aligny's work.

July. In northern France. July 21–26, travels to Dunkirk and Zuydcoote and paints there with Daubigny and Oudinot.

August 2. With Dumax in Marcoussis.

September. Stays with the Roberts in Mantes. Paints an unusually realistic work, *Les Tanneries de Mantes* (*The Tanneries of Mantes*; R 2177, Musée du Louvre, Paris).

September 20. Stays with Mme Coutelle in Fontainebleau, along with friends Comairas and Brizard. Paints in plein air with painters of the younger generation.

October 7–20. Works in Gisors with his student Oudinot.

1874

January 1. Appears in excellent health at the wedding of an employee of a nephew near Beaune.

March 4–early April. Stays with the Gratiots in Coubron.

At the Salon exhibits *Souvenir d'Arleux-du-Nord* (R 2189) and *Le Soir* (R 2191), both, location unknown, and *Clair de lune* (cat. no. 161). To the surprise of many, he is not awarded the Salon's medal of honor.

Late spring. In Coubron.

July–September. July 1, leaves with Robaut for northern France, going to Arras, Douai, Sin-le-Noble, Arleux, and Béthune.

Paints *La Route de Sin-le-Noble, près de Douai* (cat. no. 159). Returns to Paris July 20. July 21, stays with Devé in Gallius, near Rambouillet. July 28, is in Ville-d'Avray for his sister's birthday. August 5–10, stays in Luzancy. August 13–20, stays with Dumax in Marcoussis. August 23–30, stays with Eugène Decan in La Queue-en-Brie. September 1–15, stays in Sens, where he paints *Sens. Intérieur de la cathédrale* (cat. no. 160).

Autumn. His health is failing. He stays in Ville-d'Avray and Coubron.

October 14. Death of Corot's sister Mme Sennegon. Corot is deeply affected. Withdraws to Coubron.

November 25. Is back in Paris.

December 29. Is fêted at the Grand Hôtel. His friends present him with a gold medal designed by Geoffroy-Dechaume to make up for the injustice of the Salon administration, which never awarded him a medal of honor.

During this year makes his last figure paintings, including *Le Moine au violoncelle* (cat. no. 163), *Nilsson ou La Gitana à la mandoline* (*Nilsson, or The Gypsy with a Mandolin*; Museu de Artes, São Paulo), and *La Dame en bleu* (cat. no. 162).

Works by Corot are shown in Rouen, in Ghent, at a loan exhibition held at The Metropolitan Museum of Art, New York, at the Cincinnati Industrial Exhibition, at the Pennsylvania Academy of the Fine Arts, Philadelphia, and in two exhibitions at the Boston Art Club. In London, Durand-Ruel shows fourteen works by Corot, including *Dante et Virgile* (cat. no. 115).

1875

January 9–25. In Coubron.

January 26. Writes to Mme Gratiot, "The consultation has taken place. It has been decided by the Areopagus [in ancient Athens, the supreme tribunal] that the cure will consist of cow's milk alone. Two liters a day. So, this puts an end to all my plans for February." ("La consultation a eu lieu. Il a été décidé par l'aréopage que la cure serait de lait de vache seul. Deux litres par jour. Ainsi, voilà mes affaires de février arrêtées.") Cabinet des Estampes, Bibliothèque Nationale de France, Paris, Yb3 947, rés.

February 22. Death of Jean-Baptiste-Camille Corot.

February 25. Corot is buried in Père Lachaise cemetery after a funeral service at the church of Saint-Eugène, rue Sainte-Cécile, Paris.

At the Salon three late works are exhibited posthumously: *Les Bûcheronnes* (*The Woodcutters*; R 2196, private collection), *Les Plaisirs du soir* (*Evening Pleasures*; R 2191, Armand Hammer Museum, Los Angeles), and *Biblis* (R 2197, private collection).

May 26–28, 31, and June 1–4, 7–9. Posthumous sale of Corot's studio and his collection at the Hôtel Drouot, Paris, organized by Robaut and other friends. Simultaneously, a large retrospective exhibition of his work is held in Paris at the École des Beaux-Arts.

Bibliography

Abbott 1934
Jere Abbott. "Smith College Acquires Corot." *Art News* 33, no. 3 (October 20, 1934), p. 4.

Abbott 1935a
Jere Abbott. "Notes on Corot." *Smith Alumnae Quarterly* 26 (February 1935), p. 163.

Abbott 1935b
Jere Abbott. "The Two Corots." *Bulletin of Smith College Museum of Art*, no. 16 (June 1935), pp. 3–9.

About 1855
Edmond About. *Voyage à travers l'Exposition des beaux-arts (peinture et sculpture)*. Paris, 1855.

About 1864
Edmond About. *Salon de 1864*. Paris, 1864.

Adams 1994
Steven Adams. *The Barbizon School and the Origins of Impressionism*. London, 1994.

Agen, Grenoble, Nancy 1958
Romantiques et réalistes au XIX^e siècle. Agen, Musée des Beaux-Arts; Musée de Grenoble; Nancy, Musée des Beaux-Arts; May–December 1958. Exh. cat. Paris, 1958.

Alexandre 1902
Arsène Alexandre. "La Collection de M. Henri Rouart." *Les Arts*, no. 3 (April 1902), pp. 14–21; no. 5 (June 1902), pp. 2–10; no. 6 (July 1902), pp. 17–22.

Alexandre 1912
Arsène Alexandre. "La Collection Henri Rouart." *Les Arts*, no. 132 (December 1912), pp. 2–32.

Alexandre 1929
Arsène Alexandre. "La Collection Havemeyer: Courbet et Corot." *La Renaissance* 12 (June 1929), pp. 270–81.

Alpatov 1961
Michel Alpatov. "Corot à Venise: Une Tableau du Musée Pouchkine à Moscou." *Art de France* (1961), pp. 169–75.

American Art Annual 1918
American Art Annual. Vol. 15. Washington, D.C., 1918.

Amiens 1868
Amiens, 1868. Cited in Robaut 1905, vol. 2, p. 230, no. 669.

Amsterdam 1926
Exposition rétrospective d'art français. Amsterdam, Rijksmuseum, July 3–October 3, 1926. Exh. cat. Amsterdam, 1926.

Amsterdam 1928
Cent Ans de peinture française: Exposition. Amsterdam, E. J. van Wisselingh & Co., April 16–May 5, 1928. Exh. cat. Amsterdam, 1928.

Amsterdam 1938
Honderd jaar Fransche kunst. Amsterdam, Stedelijk Museum, July 2–September 25, 1938. Exh. cat. Amsterdam, 1938.

Amsterdam 1951
Het Franse landschap van Poussin tot Cézanne. Amsterdam, Rijksmuseum, March 18–June 4, 1951. Exh. cat. Amsterdam, 1951.

Ancien 1960
Bernard Ancien. "Les Destinées de l'ancienne abbaye de Saint-Crépin-le-Grand depuis la Révolution (sur les pas de Corot)." *Bulletin de la Société Historique et Scientifique de Soissons*, 4th ser., 11 (1957–60), pp. 100–109.

Ancien n.d.
Bernard Ancien. "Les Antiquités de Saint-Crépin-le-Grand." Manuscript. Archives Municipales, Soissons.

Andersen 1971
Wayne Andersen. "Gauguin's Calvary of the Maiden." *Art Quarterly* 34 (spring 1971), pp. 87–104.

Annuaire 1875
Annuaire des beaux-arts, notes and etchings by A.-P. Martial, vol. 1, no. 3 (March 1875).

Anon. 1827
Anonymous [A.-D. Vergnaud]. *Examen du Salon de 1827*. Paris, 1827.

Anon. 1828
Anonymous [C. Farcy]. "Exposition de 1827." *Journal des artistes*, March 2, 1828, pp. 138–39.

Anon. 1835a
Anonymous. "Exposition de 1835, au Musée du Louvre." *Journal des artistes* 17 (April 26, 1835), pp. 257–69.

Anon. 1835b
Anonymous [Jules Janin?]. "Salon de 1835. (III^e Article). Les Peintres et les poètes." *L'Artiste* 9 (1835), pp. 85–90.

Anon. 1836
Anonymous. "Salon de 1836. (VII^e Article.) Marines et paysages." *L'Artiste* 11 (1836), pp. 133–38.

Anon. 1837
Anonymous [Louis Batissier?]. "Salon de 1837. (VII^e Article). Marines—paysages." *L'Artiste* 13 (1837), pp. 145–52.

Anon. 1838
Anonymous. "Salon de 1838. (Sixième Article)." *L'Artiste* 15 (1838), pp. 133–36.

Anon. 1840 (St. L.)
St. L. [Louis-Stéphane Leclerc?]. "Exposition de 1840." *Le National*, March 19, 1840.

Anon. 1841a
Anonymous. "Beaux-Arts." *L'Artiste*, 2nd ser., 7 (1841), pp. 33–34.

Anon. 1841b
Anonymous [Ulysse Ladet]. "Beaux-Arts." *L'Artiste*, 2nd ser., 7 (1841), pp. 89–91.

Anon. 1841c
Anonymous [Ulysse Ladet]. "Bruits du Salon." *L'Artiste*, 2nd ser., 7 (1841), pp. 71–77.

Anon. 1841d
Anonymous [Ulysse Ladet]. "Salon de 1841. Coup d'oeil général." *L'Artiste*, 2nd ser., 7 (1841), pp. 191–96.

Anon. 1841e
Anonymous [Ulysse Ladet]. "Salon de 1841. Paysages, intérieurs et marines. I^e Article." *L'Artiste*, 2nd ser., 7 (1841), pp. 298–303.

Anon. 1843a
Anonymous. "Salon de 1843." *Les Beaux-Arts: Illustration des arts et de la littérature* 1 (1843), pp. 25–29.

Anon. 1843b
Anonymous. "Salon de 1843. Iniquités du jury.—Coup d'oeil général." *L'Artiste*, 3rd ser., 3 (1843), pp. 177–82.

Anon. 1844a
Anonymous. "Salon de 1844." *Les Beaux-Arts: Illustration des arts et de la littérature* 3 (1844), pp. 1–4.

Anon. 1844b
Anonymous. "Salon de 1844." *L'Illustration* 3 (March 16, 1844), pp. 35–37.

Anon. 1844 (M.)
M. "Diderot au Salon de 1844." *La Chronique* 5 (1844), pp. 100–109.

Anon. 1845
Anonymous. "Beaux-Arts.—Salon de 1845." *L'Illustration* 5 (March 29, 1845), pp. 71–73.

Anon. 1845 (M.)
M. [Paul Mantz?]. "Lettres sur le Salon de 1845." *L'Artiste*, 4th ser., 3 (March 23, 1845), pp. 180–83.

Anon. 1846
Anonymous. [Félix Pyat or Isidore S. de Gosse (Bertrand-Isidore Salles)]. *Diogène au Salon*. Paris, 1846.

Anon. 1859
Anonymous. "Salon de 1859." *Le Magasin pittoresque* 27 (July 1859), pp. 209–10.

Anon. 1862
Anonymous. "Compte-rendu de l'exposition du Boulevard des Italiens." *Le Courrier artistique* 2 (June 15, 1862), p. 2.

Anon. 1864 (A. M.)
A. M. "Tableaux reproduits par *L'Illustration*." *L'Illustration* 43 (June 25, 1864), pp. 407–9.

Anon. 1866
Anonymous. "Salon de 1865." *Almanach de la littérature, du théâtre et des beaux-arts* (1866), pp. 64–74.

Anon. 1887
Anonymous. *Le Temps*, May 26, 1887.

Anon. 1892a
Anonymous. "Collection Daupias." *La Chronique des arts et de la curiosité*, May 21, 1892, pp. 161–62.

Anon. 1892b
Anonymous. "Encore le Corot." *Journal des arts*, March 8, 1892.

Anon. 1896
Anonymous. *Monde moderne*, August 1896.

Anon. 1911 (P. A.)
P. A. "Le Beffroi de Douai, par Corot." *La Revue de l'art ancien et moderne* 29 (January 1911), pp. 31–32.

Anon. 1913
Anonymous. "Burke Gets McMillin Corot." *American Art News* 11, no. 16 (January 25, 1913), p. 1.

Anon. 1919
Anonymous. "The Drummond Collection." *International Studio* 68 (September 1919), pp. 87–88.

Anon. 1924 (M. C.)
M. C. "Corots in The Art Institute." *Bulletin of The Art Institute of Chicago* 18 (November 1924), pp. 99–102.

Anon. 1926 (J. G.)
J. G. "La Donation Ernest May au Musée du Louvre." *Beaux-Arts* 4 (February 15, 1926), pp. 55–56.

Anon. 1929
Anonymous. "Jean-Baptiste Corot (1796–1875): Compositions classiques." *Documents: Doctrines, archéologie, beaux-arts, ethnographie* 1 (May 1929), pp. 84–92.

Anon. 1930
Anonymous. "Havemeyer Collection at Metropolitan Museum." *Art News* 28 (March 15, 1930), pp. 33–35, 41–54.

Anon. 1936
Anonymous. "Préceptes de Corot." *L'Amour de l'art* 17 (February 1936), p. 72.

Anon. 1943
"Honfleur, le vieux bassin, by Corot." *Museum Notes* (Rhode Island School of Design), February 1943.

Anon. 1950
Anonymous. "Church at Lormes by J. B. C. Corot." *Wadsworth Atheneum Bulletin*, 2nd ser., no. 20 (December 1950), p. 1.

Anon. 1955a
Anonymous. "André Derain." *Connaissance des arts*, January 15, 1955, p. 16.

Anon. 1955b
Anonymous. "Some Recent Accessions." *Museum Notes* (Rhode Island School of Design) 42, no. 2 (November 1955), pp. 14–20.

Anon. 1955c
Anonymous. *Le Figaro*, March 23, 1955.

Anon. 1957
Anonymous. "Art News of the Year." *Art News Annual* 26 (1957), pp. 21ff.

Anon. 1959 (R. F. C.)
R. F. C. "Williamstown: Nuove opere alle Galleria Clark." *Emporium* 129 (February 1959), pp. 76–80.

Anon. 1961–62
Anonymous. "Yale Exhibits Clark Bequest." *Art Journal* 21 (winter 1961–62), pp. 61, 116–18.

Anon. 1971
Anonymous. "Exposición Corot." *Goya*, no. 103 (July–August 1971), p. 59.

Anon. 1977
Anonymous. "La Petite Beauceronne de Corot." *L'Écho républicain*, October 5, 1977.

Anon. 1985
Anonymous. "Acquisitions/1984: Paintings." *J. Paul Getty Museum Journal* 13 (1985), pp. 205–14.

Argul 1941
José Pedro Argul. *Pintura francesa de los siglos XIX y XX: La exposición de David a nuestros días, Montevideo MCMXL*. Montevideo, 1941.

Arpentigny 1865
d'Arpentigny. "Salon de 1865." *Le Courrier artistique* 5 (June 25, 1865), pp. 221–22.

Arras 1868
"Exposition des beaux-arts de la ville d'Arras." Arras, August 23–October 15, 1868.

Arras 1954
Camille Corot, Constant Dutilleux: Leurs Amis et leurs élèves. Musée d'Arras, Palais Saint Vaast, June 20–October 24, 1954. Exh. cat. Arras, 1954.

Arras 1965
Constant Dutilleux 1807–1865: Commémoration du centenaire de la mort de l'artiste. Musée d'Arras, August–November 1965. Exh. cat. Arras, 1965.

Arras, Douai 1992–93
Constant Dutilleux 1807–1865: Peintures—dessins. Musée d'Arras; Musée de Douai; December 13, 1992–March 15, 1993. Exh. cat. Douai, 1992.

Asselineau 1851
Charles Asselineau. "Intérieurs d'atelier C. Corot." *L'Artiste*, 5th ser., 7 (September 15, 1851), pp. 53–55.

Astruc 1859
Zacharie Astruc. *Les 14 Stations du Salon: 1859*. Paris, 1859.

Atlanta 1951
Atlanta University, September 1–December 31, 1951.

Atlanta 1968
The Taste of Paris from Poussin to Picasso: A Group of French Works of Art from the Seventeenth to the Twentieth Century Lent by Museums in Paris on the Occasion of the Dedication of the Atlanta Memorial Arts Center. Atlanta, High Museum of Art, October 5–December 1, 1968. Exh. cat. Atlanta, 1968.

Atlanta 1974
A French Way of Seeing: An Exhibition of Paintings from the Museum of Art, Carnegie Institute, Pittsburgh. Atlanta, High Museum of Art, January 5–27, 1974. Exh. cat. Atlanta, 1974.

Atlanta, Denver 1979–80
Corot to Braque: French Paintings from the Museum of Fine Arts, Boston. Atlanta, High Museum of Art, April 21–June 17, 1979; The Denver Art Museum, February 13–April 20, 1980. Exh. cat. by Anne L. Poulet, with an essay by Alexandra R. Murphy. Boston, 1979. The show also traveled to Japan during 1979.

Atlanta, Norfolk, Raleigh, Sarasota 1983
French Salon Paintings from Southern Collections. Atlanta, High Museum of Art, January 21–March 3, 1983; Norfolk, Virginia, The Chrysler Museum, April 4–May 15; Raleigh, The North Carolina Museum of Art, June 25–August 21; Sarasota, Florida, John and Mable Ringling Museum of Art, September 15–October 23. Exh. cat. by Eric M. Zafran. Atlanta, 1982.

Aubert 1859
Maurice Aubert. *Souvenirs du Salon de 1859*. Paris, 1859.

Aubert 1928
Marcel Aubert. "Le Romantisme et le Moyen Âge." In Louis Hautecoeur et al., *Le Romantisme et l'art*, pp. 23–48. Paris, 1928.

Aubrun 1988
Marie-Madeleine Aubrun. *Théodore Caruelle d'Aligny 1798–1871: Catalogue raisonné de l'oeuvre peint, dessiné, gravé.* [France], 1988.

Audéoud 1865
Alph. Audéoud. "Salon de 1865." *Revue indépendante*, no. 24 (July 1, 1865), pp. 748–59.

Auquier 1908
Philippe Auquier. *Catalogue des peintures, sculptures, pastels, et dessins: Ville de Marseille, Musée des Beaux-Arts.* Marseilles, 1908.

Auvray 1859
Louis Auvray. *Exposition des beaux-arts: Salon de 1859.* Paris, 1859.

Auvray 1865
Louis Auvray. "Salon de 1865. III." *Revue artistique et littéraire* 8 (June 1, 1865), pp. 235–45.

Auvray 1868
Louis Auvray. "Salon de 1868. V." *Revue artistique et littéraire* 15 (August 1 and 15, 1868), pp. 62–68.

Avery 1979
Samuel P. Avery. *The Diaries, 1871–1882, of Samuel P. Avery: Art Dealer.* Edited by Madeleine Fidell-Beaufort, Herbert L. Kleinfield, and Jeanne K. Welcher. New York, 1979.

Avignon 1990
René Char. Avignon, Grande Chapelle, Palais des Papes, 1990. Exh. cat. by Marie-Claude Char. Avignon, 1990.

Baetjer 1980
Katharine Baetjer. *European Paintings in The Metropolitan Museum of Art by Artists Born in or before 1865: A Summary Catalogue.* 3 vols. New York, 1980.

Baltimore 1951
From Ingres to Gauguin: French Nineteenth Century Paintings Owned in Maryland. The Baltimore Museum of Art, November–December 1951. Exh. cat. Baltimore, 1951.

Baltimore Museum of Art 1967
The Baltimore Museum of Art. *Paintings, Sculpture and Drawings in the Cone Collection.* Rev. ed. Baltimore, 1967.

Balzac 1989
Éveline de Balzac (Éveline Hanska [Mme Honoré de Balzac]). *Lettres inédites à Champfleury (1851–1854): Les Lettres de la collection Lovenjoul.* Edited by Lorin A. Uffenbeck and Elizabeth Fudakowska. Paris and Geneva, 1989.

Balzer 1958
Wolfgang Balzer. *Der französische Impressionismus: Die Hauptmeister in der Malerei.* Dresden, 1958.

Banville 1861
Théodore de Banville. "Le Salon de 1861." *Revue fantaisiste* 2 (July 1, 1861), pp. 222–36.

Barbier 1837
A[uguste] B[arbier]. "Salon de 1837." *Revue des deux mondes*, 4th ser., 10 (April 15, 1837), pp. 145–76.

Barbier 1839
Alexandre Barbier. *Salon de 1839, par Alex. Barbier, auteur d'un compte-rendu du Salon de 1836.* Paris, 1839.

Barcelona 1984
"Pintura francesa del Museu de Bordeus." Barcelona, Museu d'Art Modern, 1984.

Barker 1930
Virgil Barker. "October Exhibitions." *Arts* 17 (October 1930), pp. 7–23, 50–52.

Bascle sale 1883
Catalogue des tableaux anciens et modernes, bronzes et objets d'art dépendant de la succession de M. Th. Bascle. Sale cat., Hôtel Drouot, Paris, April 12–14, 1883.

Basel 1942
Maurice Utrillo: Graphische Blätter von Corot und Daumier. Basel, Kunsthalle, June 13–July 12, 1942. Exh. cat. Basel, 1942.

Basel 1947
Kunstschätze aus den Strassburger Museen. Basel, Kunsthalle, January–March 1947. Exh. cat. Basel, 1947.

Baud-Bovy 1957
Daniel Baud-Bovy. *Corot.* Geneva, 1957.

Baudelaire 1923
Charles Baudelaire. *Curiosités esthétiques.* Edited by Jacques Crépet. Paris, 1923.

Baumgart 1892
E. Baumgart. "Correspondance." *Journal des arts*, March 4, 1892.

Bazin 1932
Germain Bazin. "Le XIX^me Siècle." *L'Amour de l'art* 13 (January 1932), pp. 24–40.

Bazin 1936
Germain Bazin. "Corot et son oeuvre." *L'Amour de l'art* 17 (February 1936), pp. 43–71.

Bazin 1942
Germain Bazin. *Corot.* Paris, 1942.

Bazin 1943
Germain Bazin. " 'La Vue de Tivoli' au Louvre." *Revue des beaux-arts de France*, no. 5 (June–July 1943), pp. 276–78.

Bazin 1951
Germain Bazin. *Corot.* 2nd ed., rev. Paris, 1951.

Bazin 1952
Germain Bazin. "Sotto gli occhi di Corot: La natura si disponeva come in un quadro." *La biennale di Venezia*, no. 8 (April 1952), pp. 3–6.

Bazin 1956
Germain Bazin. "Le Problème de l'authenticité dans l'oeuvre de Corot." *Bulletin du laboratoire du Musée du Louvre* 1 (1956), pp. 18–48.

Bazin 1973
Germain Bazin. *Corot.* 3rd ed., rev. Paris, 1973.

Beauvais 1987
Vasques de Rome, ombrages de Picardie: Hommage de l'Oise à Corot. Beauvais, Musée Départemental de l'Oise, October 1–November 30, 1987. Exh. cat. by Marie-José Salmon. Beauvais, 1987.

Beauvais 1990–91
D'Oudry à Le Sidaner: Ils ont aimé l'Oise. Beauvais, Musée Départemental de l'Oise, 1990–91. Exh. cat. by Marie-José Salmon. Beauvais, 1990.

Beijing, Shanghai 1982
"250 Ans de peinture française: De Poussin à Courbet (1620–1870)." Beijing, September 15–October 13, 1982; Shanghai, October 20–November 10, 1982.

Belgrade 1939
La Peinture française au XIX^e siècle / Francusko slikarstvo u XIX stoleću. Belgrade, Muzej Princa Pavla, 1939. Organized by L'Association Française d'Action Artistique. Exh. cat. Belgrade, 1939.

Belgrade 1950
Izlozba radova francuskih slikara XIX veka: Delakroa, Kurbea, Milea, Koroa, T. Rusoa. Belgrade, Umetnički Muzej, June 1950. Exh. cat. Belgrade, 1950.

Belloy 1859
A. de Belloy. "Salon de 1859.—IV." *L'Artiste*, 7th ser., 7 (May 8, 1859), pp. 17–20.

Belval 1907
E. Belval. *Les Corot du Musée de Reims.* Reims, 1907.

Benoist 1926
L. Benoist. "Corot." *L'Amateur d'art* (1926), p. 171.

Berenson et al. 1923
Bernard Berenson, Cornelis Hofstede de Groot, W. Roberts, and Wilhelm R. Valentiner. *Paintings in the Collection of Joseph Widener at Lynnewood Hall.* Elkins Park, Pa., 1923.

Berenson et al. 1931
Bernard Berenson, Cornelis Hofstede de Groot, W. Roberts, and Wilhelm R. Valentiner. *Paintings in the Collection of Joseph Widener at Lynnewood Hall.* Elkins Park, Pa., 1931.

Berlin 1963
Die Île de France und ihre Maler. Berlin, Nationalgalerie, Orangerie des Schlosses

Charlottenburg, September 29–November 24, 1963. Exh. cat. Berlin, 1963.

Berlin, Munich 1979–80
Max Liebermann in seiner Zeit. Berlin, Staatliche Museen Preussischer Kulturbesitz, September 6–November 4, 1979; Munich, Haus der Kunst, December 14, 1979–February 17, 1980. Exh. cat. Munich, 1979.

Berlioz 1862
Hector Berlioz. *À travers chants: Études musicales, adorations, boutades et critiques.* Paris, 1862.

Bern 1934
Französische Meister des 19. Jahrhunderts und Van Gogh. Bern, Kunsthalle, February 18–April 2, 1934. Exh. cat. Bern, 1934.

Bern 1960
Corot. Bern, Kunstmuseum, January 23–March 13, 1960. Exh. cat. Bern, 1960.

Bernheim de Villers 1930a
C. Bernheim de Villers. *Corot: Peintre de figures.* Paris, 1930.

Bernheim de Villers 1930b
C. Bernheim de Villers. "Les 'Figures' de Corot." *Bulletin des Musées de France* 2 (October 1930), pp. 230–34.

Bertall 1857
Bertall [Charles-Albert d'Arnoux]. "Le Salon de 1857 dépeint et dessiné par Bertall." *Le Journal amusant,* no. 90 (September 19, 1857), pp. 1–3.

Bertall 1859
Bertall [Charles-Albert d'Arnoux]. *Gazette de Paris,* July 7, 1859, pp. 4–5.

Berte-Langereau 1993
Philippe Berte-Langereau. *Jean-Baptiste-Camille Corot dans le Morvan.* Nevers, 1993.

Bertin 1816–24
Jean-Victor Bertin. *Recueil d'études d'arbres.* Paris, 1816–24.

Besançon, Bourg-en-Bresse, Aix-les-Bains 1973
"Le Paysage dans la peinture française du XIXᵉ siècle: 42 Tableaux du Louvre." Besançon, February–April 1973; Bourg-en-Bresse, May–June; Aix-les-Bains, July–September.

Bigot 1888
Charles Bigot. *Peintres français contemporains.* Paris, 1888.

Billings, Helena 1989
The William A. Clark Collection: Treasures of a Copper King. Billings, Yellowstone Art Center, May 6–July 30, 1989; Helena, Montana Historical Center, August 15–October 7. Exh. cat. Billings, Mont., 1989.

Blanc 1840
Charles Blanc. "Salon de 1840." *Revue du progrès* 3 (May 1, 1840), pp. 356–66.

Blanc 1845
Charles Blanc. "Salon de 1845." *La Réforme,* May 17, 1845.

Blanc 1866
Charles Blanc. "Salon de 1866." *Gazette des beaux-arts* 21 (July 1866), pp. 28–71.

Blanc 1876
Charles Blanc. *Les Artistes de mon temps.* Paris, 1876.

Blanche 1920
Jacques-Émile Blanche. *Quatre-Vingts Ans de peinture libre, 1800–1885.* Paris, 1920.

Blanche 1931
Jacques-Émile Blanche. *Les Arts plastiques.* Preface by Maurice Denis. Paris, 1931.

Boime 1970
Albert Boime. "New York: A Landscapist for All Seasons and Dr Jekyll and Martin Heade." *Burlington Magazine* 112 (February 1970), pp. 124–28.

Boime 1971
Albert Boime. *The Academy and French Painting in the Nineteenth Century.* London, 1971.

Bologna 1985–86
Morandi e il suo tempo. Bologna, Galleria Comunale d'Arte Moderna, November 9, 1985–February 10, 1986. Exh. cat. by Marilena Pasquali and Silvia Evangelisti. Milan, 1985.

Bonniot 1973
Roger Bonniot. *Gustave Courbet en Saintonge, 1862–1863.* Paris, 1973.

Borchsenius 1945
Kaj Borchsenius. "Ordrupgaard. II. Den franske samling." In *Kunst i privat eje,* edited by V. Winkel & Magnussen, vol. 2, pp. 17–40. Copenhagen, 1945.

Bordeaux 1852
"Exposition de la Société des Amis des Arts." Bordeaux, 1852.

Bordeaux 1854
"Exposition de la Société des Amis des Arts." Bordeaux, 1854.

Bordeaux 1858
"8ᵉ Exposition de la Société des Amis des Arts." Bordeaux, 1858.

Bordeaux 1959
La Découverte de la lumière des Primitifs aux Impressionnistes. Bordeaux, Galerie des Beaux-Arts, May 20–July 31, 1959. Exh. cat. by Gilberte Martin-Méry. Bordeaux, 1959.

Bordeaux 1964
La Femme et l'artiste de Bellini à Picasso. Bordeaux, Galerie des Beaux-Arts, May 22–September 20, 1964. Exh. cat. by Gilberte Martin-Méry. Bordeaux, 1964.

Bordeaux 1969
L'Art et la musique. Bordeaux, Galerie des Beaux-Arts, May 30–September 30, 1969. Exh. cat by Gilberte Martin-Méry. Bordeaux, 1969.

Bordeaux 1974
1874: Naissance de l'impressionnisme. Bordeaux, Galerie des Beaux-Arts, May 3–September 1, 1974. Exh. cat. Bordeaux, 1974.

Bordeaux 1987–88
D'autres XIXᵉᵐᵉˢ siècles. Bordeaux, Galerie des Beaux-Arts, November 21, 1987–January 11, 1988. Exh. cat. Bordeaux, 1987.

Borel 1947
Pierre Borel. "Une Lettre de Corot." *Tribune de Genève,* May 6, 1947.

Boston 1915
"Evans Memorial Galleries Opening Exhibition." Boston, Museum of Fine Arts, 1915. Catalogue published in *Bulletin of the Museum of Fine Arts* (Boston) 13 (February 1915), supplement.

Boston 1970
Masterpieces of Painting in The Metropolitan Museum of Art. Boston, Museum of Fine Arts, September 16–November 1, 1970. Exh. cat. by Edith A. Standen and Thomas M. Folds, with an introduction by Claus Virch. New York, 1970.

Boston 1985
The Great Boston Collectors: Paintings from the Museum of Fine Arts. Boston, Museum of Fine Arts, February 13–June 2, 1985. Exh. cat. by Carol Troyen and Pamela S. Tabbaa. Boston, 1984.

Boston, Museum of Fine Arts 1921
Boston, Museum of Fine Arts. *Catalogue of Paintings: Preliminary Edition.* Boston, 1921.

Boston, Museum of Fine Arts 1955
Boston, Museum of Fine Arts. *Summary Catalogue of European Paintings in Oil, Tempera and Pastel.* Boston, 1955.

Bouillon-Landais 1876
Bouillon-Landais. *Catalogue des objets d'art composant la collection du Musée de Marseille.* Marseilles, 1876.

Boulogne-sur-Mer 1926
Catalogue guide illustré de la collection Charles Lebeau. Boulogne-sur-Mer, Musée des Beaux-Arts et d'Archéologie, 1926. Exh. cat. by Camille Lorel and Henry Ménétrier. Boulogne-sur-Mer, 1926.

Bourgeois 1841
Un Bourgeois. "Salon de 1841." *Le Siècle,* April 11, 1841.

Bourgeois 1843
Un Bourgeois. "Salon de 1843." *Le Siècle,* May 9, 1843.

Bourges 1894
Léonide Bourges. *Daubigny: Souvenirs et croquis.* Paris, 1894.

Bourges 1973
Les Peintres de Barbizon à travers la France. Maison de la Culture, Musée de Bourges, 1973. Exh. cat. Bourges, 1973.

Bouyer 1909
Raymond Bouyer. "Corot Peintre de figures." *La Revue de l'art ancien et moderne* 26 (October 1909), pp. 295–306.

Bovy 1920
Adrien Bovy. *L'Exposition de peinture française au Musée d'Art et d'Histoire, 1918.* Geneva, 1920.

Bowron 1990
Edgar Peters Bowron. *European Paintings before 1900 in the Fogg Art Museum: A Summary Catalogue Including Paintings in the Busch-Reisinger Museum.* Cambridge, Mass., 1990.

Bracquemond 1897
F. Bracquemond. *Étude sur la gravure sur bois et la lithographie.* Paris, 1897.

Brayer 1981
Yves Brayer. "La Collection Wilhelm Hansen et le Musée d'Ordrupgaard." *L'Oeil,* no. 316 (November 1981), pp. 26–33.

Brayer de Beauregard 1824
Jean-Baptiste-Louis Brayer de Beauregard. *Statistique du département de l'Aisne.* Laon, 1824.

Bremen 1977–78
Zurück zur Natur: Die Künstlerkolonie von Barbizon. Ihre Vorgeschichte und ihre Auswirkung. Bremen, Kunsthalle, November 6, 1977–January 22, 1978. Exh. cat. Bremen, 1977.

Bremmer 1921–28
H. P. Bremmer. *Catalogus verzameling H. Kröller-Müller.* 2 vols. The Hague, 1921–28.

Brenson 1991
Michael Brenson. "French Landscape Painting: The Seed of Impressionism." *New York Times,* August 2, 1991, pp. C1, C22.

Brettell 1987
Richard R. Brettell. *French Salon Artists, 1800–1900.* Chicago, 1987.

Brière 1924
Gaston Brière. *Catalogue des peintures exposées dans les galeries.* Vol. 1, École française. Musée National du Louvre. Paris, 1924.

Brockway and Frankfurter 1957
Wallace Brockway and Alfred Frankfurter. *The Albert D. Lasker Collection: Renoir to Matisse.* New York, 1957.

Brommer 1988
Gerald F. Brommer. *Discovering Art History.* 2nd ed. Worcester, Mass., 1988.

Brooklyn Museum 1967
The Brooklyn Museum. *The Brooklyn Museum Handbook.* Brooklyn, 1967.

Brunet 1977
Gilbert Brunet. *Le Portrait de Louise Harduin par Corot: No. 7 du premier supplément au catalogue Robaut.* Paris, 1977.

Brussels 1947–48
De David à Cézanne. Brussels, Palais des Beaux-Arts, November 1947–January 1948. Exh. cat. Paris, 1947.

Brussels 1953
La Femme dans l'art français. Brussels, Palais des Beaux-Arts, March–May 1953. Exh. cat. Brussels, 1953.

Brussels 1960
Marines: Vues de ports et paysages fluviaux. Brussels, Musées Royaux des Beaux-Arts, November 20–December 18, 1960. Exh. cat. Brussels, 1960.

Brussels, Liège, Luxembourg, Lille 1949
Chefs-d'Oeuvre du Musée des Beaux-Arts de Gand. Brussels, Palais des Beaux-Arts; Liège; Luxembourg; Lille; February–June 1949. Brussels, 1949.

Brussels, Musées Royaux des Beaux-Arts de Belgique 1984
Brussels, Musées Royaux des Beaux-Arts de Belgique. *Catalogue inventaire de la peinture moderne.* Brussels, 1984.

Bruyas 1876
Alfred Bruyas. *La Galerie Bruyas, par A. Bruyas, avec le concours des écrivains et des artistes contemporains.* Introduction by Théophile Silvestre. Paris, 1876.

Buenos Aires, Montevideo 1939–40
La pintura francesa de David a nuestros días: Óleos, dibujos y acuarelas. Buenos Aires, Museo Nacional de Bellas Artes, July–August 1939; Montevideo, Salón Nacional de Bellas Artes, 1940. Exh. cat. Buenos Aires, 1939.

Buffalo 1928
A Selection of Paintings of the French Modern School from the Collection of A. C. Goodyear. Buffalo, Albright Art Gallery, June–August 1928. Exh. cat. Buffalo, 1928.

Buffalo 1938
"Picture of the Month—A Corot Portrait." Buffalo, Albright Art Gallery, April 1938.

Buffalo 1962–63
Gifts to the Albright-Knox Art Gallery from A. Conger Goodyear. Buffalo, Albright-Knox Art Gallery, December 14, 1962–January 6, 1963. Exh. cat. Buffalo, 1962.

Buffalo 1966
Paintings, Sculpture, Drawings, Prints Collected by A. Conger Goodyear. Buffalo, Albright-Knox Art Gallery, April 30–June 5, 1966. Exh. cat. Buffalo, 1966.

Bühler 1979
Hans-Peter Bühler. *Die Schule von Barbizon:*

Französische Landschaftsmalerei im 19. Jahrhundert. Munich, 1979.

Buisson 1864
J. Buisson. "Salon de 1864." *Union Artistique de Toulouse,* June 25, 1864.

Buisson 1875
J. Buisson. "À propos de Corot." *Gazette des beaux-arts,* 2nd ser., 11 (April 1875), pp. 330–36.

Buisson 1904
J. G. Buisson. *Revue de Toulouse* 20 (1904), p. 35.

Burroughs 1928
Bryson Burroughs. "Woman Reading in the Fields, by Corot." *Bulletin of The Metropolitan Museum of Art* 23 (June 1928), pp. 154–56.

Burrows 1930
Carlyle Burrows. "Letter from New York." *Apollo* 12 (December 1930), pp. 452–54.

Burty 1870
Ph[illipe] Burty. *Le Rappel,* May 20, 1870.

Cadoudal 1859
G. de Cadoudal. "À propos du Salon." *Journal des jeunes personnes,* no. 10 (August 1859), pp. 305–9.

Cahors 1945
"Treize Chefs-d'Oeuvre du Musée du Louvre." Cahors, Préfecture du Lot, 1945.

Callias 1861
Hector de Callias. "Salon de 1861. Les Lettres B. C. D. E." *L'Artiste,* 7th ser., 11 (June 1, 1861), pp. 241–48.

Callias 1863
Hector de Callias. "Salon de 1863. I." *L'Artiste,* 8th ser., 3 (May 15, 1863), pp. 209–16.

Calonne 1889
Alphonse de Calonne. *Exposition Universelle.* Paris, 1889. Supplement to *Le Soleil,* June 19, 1889.

Cambridge 1929
Exhibition of French Painting of the Nineteenth and Twentieth Centuries. Cambridge, Massachusetts, Fogg Art Museum, Harvard University, March 6–April 6, 1929. Exh. cat. Cambridge, Mass., 1929.

Cambridge 1934
"French Drawings and Paintings of the Nineteenth Century." Cambridge, Massachusetts, Fogg Art Museum, Harvard University, April–May 1934.

Cambridge 1937
"French Drawings and Paintings of the XIX Century." Cambridge, Massachusetts, Fogg Art Museum, Harvard University, May 10–June 1, 1937.

Cambridge 1977
"Master Paintings from the Fogg Collections." Cambridge, Massachusetts, Fogg

Art Museum, Harvard University, April 13–August 31, 1977.

Cambridge, Fitzwilliam Museum 1982
Cambridge, Fitzwilliam Museum. *Treasures of the Fitzwilliam Museum: An Illustrated Souvenir of the Collections.* Cambridge, 1982.

Cambridge, London 1980–81
Painting from Nature: The Tradition of Open-Air Oil Sketching from the Seventeenth to Nineteenth Centuries. Cambridge, Fitzwilliam Museum, November 25, 1980–January 11, 1981; London, Diploma Galleries, Royal Academy of Arts, January 31–March 15. Exh. cat. London, 1980.

Canaday 1959
John Canaday. *Mainstreams of Modern Art.* New York, 1959.

Canberra, Perth, Adelaide 1987–88
Old Masters—New Visions: El Greco to Rothko from The Phillips Collection, Washington D.C.. Canberra, Australian National Gallery, October 3–December 6, 1987; Perth, Art Gallery of Western Australia, December 22, 1987–February 21, 1988; Adelaide, Art Gallery of South Australia, March 4–May 1. Exh. cat. Canberra, 1987.

Cantaloube 1861
Amédée Cantaloube. *Lettre sur les expositions et le Salon de 1861.* Paris, 1861.

Cantrel 1859
Émile Cantrel. "Salon de 1859.—Les Paysagistes.—III." *L'Artiste,* 7th ser., 7 (May 29, 1859), pp. 69–71.

Carouge 1978
Carouge, Switzerland, Château Dardigny, September 9–10, 1978.

Carter 1981
Malcolm N. Carter. "Great Private Collections: A Brahmin's Old Masters." *Saturday Review,* February 1981, pp. 54–57.

Castagnary 1861
Jules-Antoine Castagnary. *Les Artistes au XIX^e siècle: Salon de 1861.* Paris, 1861.

Castagnary 1892
Jules-Antoine Castagnary. *Salons (1857–1870, 1872–1879).* 2 vols. Paris, 1892.

Castellan 1861
Edmond Castellan. "Le Salon de 1861." *Le Nouvel Organe,* no. 7 (June 13, 1861), pp. 102–4.

Cauwels 1969
Rony Cauwels. "Jean-Baptiste Corot: Steengroeve te Fontainebleau." *Openbaar kunstbezit in Vlaanderen* 7 (1969), pp. 5a–5b.

Chabot 1951
Georges Chabot. *Het Museum voor Schone Kunsten te Gent.* Brussels, 1951.

Chalons d'Argé 1859
A.-P. Chalons d'Argé. *Notice sur les principaux tableaux de l'exposition de 1859: Peintres français.* Paris, 1859.

Champa 1973
Kermit Swiler Champa. *Studies in Early Impressionism.* New Haven and London, 1973.

Champfleury 1846
Champfleury [Jules-François-Félix Husson]. "Salon de 1846." *Le Corsaire,* March 24–May 23, 1846.

Champfleury 1854
Champfleury [Jules-François-Félix Husson]. *Contes d'automne.* Paris, 1854.

Champfleury 1894
Champfleury [Jules-François-Félix Husson]. *Oeuvres posthumes de Champfleury: Salons, 1846–1851.* Introduction by Jules Troubat. Paris, 1894.

Champlin and Perkins 1886–87
John D. Champlin Jr. and Charles C. Perkins, eds. *Cyclopedia of Painters and Paintings.* 4 vols. New York, 1886–87.

Chapel Hill 1978
French Nineteenth Century Oil Sketches, David to Degas: An Exhibition in Honor of the Retirement of Joseph Curtis Sloane, Alumni Distinguished Professor of Art and Director of the Ackland Museum. Chapel Hill, The William Hayes Ackland Memorial Art Center, The University of North Carolina, March 5–April 16, 1978. Exh. cat. by John Minor Wisdom et al. Chapel Hill, N.C., 1978.

Charivari 1835
Le Charivari, May 29, 1835.

Chassé 1930
Charles Chassé. "Corot en Bretagne." *L'Art et les artistes,* n.s., 20 (July 1930), pp. 331–35.

Chateaubriand 1859
François-René Chateaubriand. *Oeuvres complètes.* Vol. 6. Paris, 1859.

Chaudonneret 1980
Marie-Claude Chaudonneret. *Fleury Richard et Pierre Révoil: La Peinture troubadour.* Paris, 1980.

Chaumelin 1873
Marius Chaumelin. *L'Art contemporain.* Paris, 1873.

Chénier 1958
André Chénier. *Oeuvres complètes.* Edited by Gérard Walter. Bibliothèque de la Pléiade. Paris, 1958.

Chennevières 1851
Philippe de Chennevières. *Lettres sur l'art français en 1850.* Paris, 1851.

Chennevières 1979
Philippe de Chennevières. *Souvenirs d'un directeur des Beaux-Arts.* Paris, 1979. [A collection of articles originally published in *L'Artiste,* 1883–89.]

Chesneau 1859
Ernest Chesneau. "Libre étude sur l'art contemporain.—Salon de 1859." *Revue des races latines* 14 (May, June 1859), pp. 11–168.

Chesneau 1864
Ernest Chesneau. "Salon de 1864." *Le Constitutionnel,* June 21, 1864, p. 3.

Chetham 1965
Charles Chetham. "Seeing Past the Book End." *Smith Alumnae Quarterly* 56 (winter 1965), pp. 73–76.

Chetham 1969
Charles Chetham. "The Smith College Museum of Art." *Antiques* 96 (November 1969), pp. 768–75.

Chicago 1893
Chicago, World's Columbian Exhibition, Department K, Fine Arts, "Loan Collection: Foreign Masterpieces Owned in the United States," May 1–October 30, 1893. Exh. cat. Chicago, 1893.

Chicago 1933
Catalogue of a Century of Progress Exhibition of Paintings and Sculpture Lent from American Collections. The Art Institute of Chicago, June 1–November 1, 1933. Exh. cat. Chicago, 1933.

Chicago 1934
Catalogue of a Century of Progress Exhibition of Paintings and Sculpture. The Art Institute of Chicago, June 1–November 1, 1934. Exh. cat. Chicago, 1934.

Chicago 1941
Masterpieces of French Art Lent by the Museums and Collectors of France. The Art Institute of Chicago, April 10–May 20, 1941. Exh. cat. Chicago, 1941.

Chicago 1960
Corot 1796–1875: An Exhibition of His Paintings and Graphic Works. The Art Institute of Chicago, October 6–November 13, 1960. Exh. cat. by S. Lane Faison Jr. and James Merrill. Chicago, 1960.

Chicago, The Art Institute of Chicago 1961
Chicago, The Art Institute of Chicago. *Paintings in The Art Institute of Chicago: A Catalogue of the Picture Collection.* Chicago, 1961.

Cholet 1983–84
Paysages: Tendances françaises du XIX^e siècle jusqu'à l'impressionnisme. Cholet, Musée des Arts, December 17, 1983–February 27, 1984. Exh. cat. Cholet, 1983.

Chong 1993
Alan Chong, comp. *European and American Painting in The Cleveland Museum of Art: A Summary Catalogue.* Cleveland, 1993.

Chronique 1964
La Chronique des arts, February 1964, p. 67.

Claretie 1873
Jules Claretie. *Peintres et sculpteurs contemporains.* Paris, 1873.

Claretie 1876
Jules Claretie. *L'Art et les artistes français contemporains.* Paris, 1876.

Claretie 1882
Jules Claretie. *Peintres et sculpteurs contemporains.* Vol. 1. Paris, 1882.

Clark 1975
Anthony M. Clark. "European Paintings." In *The Metropolitan Museum of Art: Notable Acquisitions, 1965–1975,* pp. 78–96. New York, 1975.

Clark 1979
Kenneth Clark. *Landscape into Art.* Rev. ed. New York, 1979.

Clarke 1991a
Michael Clarke. *Corot and the Art of Landscape.* London, 1991.

Clarke 1991b
Michael Clarke. "Degas and Corot: The Affinity between Two Artists' Artists." *Apollo* 132 (July 1991), pp. 15–20.

Clément 1864
Charles Clément. "Exposition de 1864." *Journal des débats,* April 30, 1864.

Clément 1867
Charles Clément. "Exposition Universelle. Beaux-Arts." *Journal des débats,* March 28, 1867.

Clément 1870
Charles Clément. "Exposition de 1870." *Journal des débats,* June 11, 1870.

Clément de Ris 1847
L. Clément de Ris. "Salon de 1847." *L'Artiste,* 4th ser., 9 (April 18, 1847), pp. 105–7.

Clément de Ris 1851
L. Clément de Ris. "Salon de 1851. IV." *L'Artiste,* 5th ser., 6 (February 15, 1851), pp. 17–21.

Clément de Ris 1853
L. Clément de Ris. "Le Salon de 1853. Lettres à un ami, à Bruxelles. II. Les Paysagistes." *L'Artiste,* 5th ser., 10 (June 15, 1853), pp. 145–49.

Cleveland 1913
Illustrated Catalogue of the Cleveland Art Loan Exposition under the Auspices of the Cleveland School of Art. Cleveland, Kinney & Levan Building, November 25–December 17, 1913. Exh. cat. Cleveland, 1913.

Cleveland 1929
"French Art Since Eighteen Hundred." The Cleveland Museum of Art, November 7–December 9, 1929. Catalogue published in *Bulletin of The Cleveland Museum of Art* 16 (November 1929), pp. 155–72.

Cleveland 1936
Catalogue of the Twentieth Anniversary Exhibition of The Cleveland Museum of Art: The Official Art Exhibit of the Great Lakes Exposition. The Cleveland Museum of Art, June 26–October 4, 1936. Exh. cat. Cleveland, 1936.

Cleveland Museum of Art 1991
The Cleveland Museum of Art. *Handbook of The Cleveland Museum of Art.* Cleveland, 1991.

Cologne, Zurich 1990
Landschaft im Licht: Impressionistische Malerei in Europa und Nordamerika, 1860–1910. Cologne, Wallraff-Richartz-Museum, April 6–July 1, 1990; Zurich, Kunsthaus, August 3–October 21. Exh. cat. edited by Götz Czymmek. Zurich, 1990.

Colombier 1940
Pierre du Colombier. *Corot.* Les Trésors de la peinture française. XIX^e Siècle, vol. 15. Paris, 1940.

Colombier 1963
Pierre du Colombier. "Corot au Musée de Reims." *La Revue française,* no. 151 (April 1963), pp. 23–34.

Columbus 1943
"Small Paintings by Corot." Columbus Gallery of Fine Arts, November 6–December 4, 1943. Catalogue published in *Columbus Gallery of Fine Arts Monthly Bulletin* 14, no. 2 (November 1943).

Compin and Roquebert 1986
Isabelle Compin and Anne Roquebert. *Catalogue sommaire illustré des peintures du Musée du Louvre et du Musée d'Orsay.* Vol. 3, *École française.* Paris, 1986.

Compin, Lacambre, and Roquebert 1990
Isabelle Compin, Geneviève Lacambre, and Anne Roquebert. *Catalogue sommaire illustré des peintures.* Vol. 1. Paris, 1990.

Constant 1890
Benjamin Constant. "L'Art à New York." *Le Temps,* January 8, 1890.

Converse sale 1911
Catalogue of the Modern Paintings Forming the Private Collection of the Late John H. Converse of Philadelphia. Sale cat., Mendelssohn Hall, The American Art Association, New York, January 6, 1911.

Cooper 1936
Douglas Cooper [Douglas Lord]. "Corot." *Burlington Magazine* 68 (April 1936), pp. 192–95.

Cooper 1955
Douglas Cooper [Douglas Lord]. "The Painters of Auvers-sur-Oise." *Burlington Magazine* 97 (April 1955), pp. 100–106.

Copenhagen 1914
Exposition d'art français du XIX^e siècle. Copenhagen, Statens Museum, May 15–

June 30, 1914. Exh. cat. Copenhagen, 1914.

Copenhagen 1918a
Corot-Udstilling. Copenhagen, Ny Carlsberg Glyptotek, October– November 1918. Exh. cat. Copenhagen, 1918.

Copenhagen 1918b
Fransk malerkunst. Copenhagen, Winkel & Magnussen, October 1918. Copenhagen, 1918.

Copenhagen 1957–58
Fransk kunst: Udvalgt fra Ny Carlsberg Glyptotek, Kunstakademiet, Nivaagaard, Ordrupgaard & Statens Museum for Kunst. Copenhagen, Statens Museum for Kunst, June 1, 1957–March 5, 1958. Exh. cat. Copenhagen, 1957.

Copenhagen, Ordrupgaardsamlingen 1958
Copenhagen, Ordrupgaardsamlingen. *Franske malerier i Ordrupgaardsamlingen: Udgivet af foreningen fransk kunst i anledning af 40-årsdagen for den stiftelse.* Text by Haavard Rostrup. Copenhagen, 1958.

Copenhagen, Ordrupgaardsamlingen 1966
Copenhagen, Ordrupgaardsamlingen. *Etatsraad Wilhelm Hansen og hustru Henny Hansens malerisamling: Catalogue of the Works of Art in the Ordrupgaard Collection.* Text by Haavard Rostrup. Copenhagen, 1966.

Copenhagen, Ordrupgaardsamlingen 1973
Copenhagen, Ordrupgaardsamlingen. *Etatsraad Wilhelm Hansen og hustru Henny Hansens malerisamling: Fortegnelse over kunstvaerkerne på Ordrupgaard.* Text by Haavard Rostrup. Copenhagen, 1973.

Copenhagen, Ordrupgaardsamlingen 1982
Copenhagen, Ordrupgaardsamlingen. *Katalog over Ordrupgaardsamlingen/ Catalogue du Musée d'Ordrupgaard/ Catalogue of the Ordrupgaard Collection.* Catalogue by Annette Stabell. Copenhagen, 1982.

Copenhagen, Ordrupgaardsamlingen 1992
Copenhagen, Ordrupgaardsamlingen. *Katalog over Ordrupgaardsamlingen/ Catalogue du Musée d'Ordrupgaard/ Catalogue of the Ordrupgaard Collection.* Catalogue by Annette Stabell. Copenhagen, 1992.

Copenhagen, Stockholm, Oslo 1928
Udstillingen af fransk malerkunst fra den første halvdel af det 19. aarhundrede. Copenhagen, Ny Carlsberg Glyptotek, March 31–April 21, 1928; Stockholm, Nationalmuseum, May 12–June 16; Oslo, Nasjonalgalleriet, July–August. Exh. cat. Copenhagen, 1928. Swedish ed., *Franskt måleri från David till Courbet.* Stockholm, 1928. Norwegian ed., *Fransk malerkunst fra David til Courbet.* Oslo, 1928.

Coquis 1959
André Coquis. *Corot et la critique contemporaine.* Paris, 1959.

Cornu 1911
Paul Cornu. *Corot.* Paris, 1911.

Corot 1910
Corot: Huit Reproductions fac-similé en couleurs. Les Peintres illustrés. Paris, 1910.

Corot 1946
Jean-Baptiste-Camille Corot. *Corot: Raconté par lui-même et par ses amis. Pensées et écrits du peintre.* 2 vols. Les Grands Artistes vus par eux-mêmes et par leurs amis, edited by Pierre Courthion and Pierre Cailler. Vésenaz-Genève (Geneva), 1946.

Corot 1952
Corot. Astra-Arengarium. Collection de monographies d'art. Peintres. Milan, 1952.

Corot 1981
Twenty-Five Great Masters of Modern Art: Corot. Tokyo, 1981.

Corot sale 1875
Catalogue des tableaux, études, esquisses, dessins et eaux-fortes par Corot, dressé par M. Alfred Robaut, artiste lithographe, et des tableaux, dessins, curiosités diverses composant sa collection particulière. Sale cat., Hôtel Drouot, Paris, pt. 1, May 26–28, 1875; pt. 2, May 31–June 4; pt. 3, June 7–9.

Courthion 1926
Pierre Courthion. "L'Art français dans les collections privées en Suisse." *L'Amour de l'art* 7 (1926), pp. 1–32, 37–68.

Courthion 1956
Pierre Courthion. *Montmartre.* Translated by Stuart Gilbert. Lausanne, 1956.

Cousin 1862
Jules Cousin. "Archéologie parisienne: L'Église de Saint-Nicolas-du-Chardonnet." *Revue universelle des arts* 16 (1862), pp. 359–69.

Cunningham 1936
C. C. Cunningham. "Some Corot Paintings in the Museum's Collection." *Bulletin of the Museum of Fine Arts* (Boston) 34 (December 1936), pp. 99–103.

Daliphard 1875
Édouard Daliphard. "Exposition des oeuvres de Corot." *L'Art* 12 (May 30, 1875), pp. 157–60; (June 13, 1875), pp. 257–59.

Dallas 1942
Exhibition of the Pendulum Swing from Classic to Romantic in French Painting. Dallas Museum of Fine Arts, January 25–February 22, 1942. Exh. cat. Dallas, 1942.

Dallas 1953
An Exhibition of Sixty-Nine Paintings from the Collection of Mrs. Albert D. Lasker for the Benefit of the American Cancer Society in memory of Albert D. Lasker (1880–1952). Dallas Museum of Fine Arts, March 6–March 29, 1953. Exh. cat. Dallas, 1953.

Dallas 1961
Impressionists and Their Forebears from Barbizon. Dallas Museum for Contemporary Arts, March 9–April 2, 1961. Exh. cat. Dallas, 1961.

Dallas 1966
"Landscapes of France of the XIXth Century." Dallas, Southern Methodist University, October 1966.

Dante 1980
Dante Alighieri. *The Divine Comedy of Dante Alighieri.* Translated with introductions and commentary by Allen Mandelbaum. Berkeley, Los Angeles, and London, 1980.

Davodet 1933
Auguste Davodet. *Quelques Notes sur le Corot au Musée de Saint-Lô.* Saint-Lô, 1933.

Dayton 1951
The City by the River and the Sea: Five Centuries of Skylines. Loan Exhibition. Dayton Art Institute, April 18–June 3, 1951. Exh. cat. by Esther Isabel Seaver. Dayton, Ohio, 1951.

Dayton 1960
French Paintings, 1789–1929, from the Collection of Walter P. Chrysler, Jr. Dayton Art Institute, March 25–May 22, 1960. Exh. cat. Dayton, Ohio, 1960.

Deauville 1973
La Normandie du pré-romantisme au post-impressionnisme: Cent Quarante Oeuvres signées par quatre-vingts peintres et consacrées à la Normandie. Deauville, July 4–August 22, 1973. Exh. cat. Deauville, 1973.

Decamps 1835
Alexandre Decamps. "Salon de 1835." *Revue républicaine* 5, no. 13 (April 10, 1835), pp. 69–86.

Decamps 1837
Alexandre Decamps. "Salon de 1837." *Le National de 1837,* April 30, 1837.

Delacroix 1932
Eugène Delacroix. *Journal de Eugène Delacroix.* Edited by André Joubin. 3 vols. Paris, 1932.

Delahoyd 1969
Mary Delahoyd. "Corot: Classic Romantic." *Art News* 68, no. 7 (November 1969), pp. 36–41, 74–78.

Delaroche-Vernet 1936
Marie Delaroche-Vernet. "Salles de l'Orangerie: L'Exposition Corot." *Bulletin des Musées de France* 7 (February 1936), pp. 18–20.

Delaunay 1846
A.-H. Delaunay. *Catalogue complet du Salon de 1846.* Paris, 1846.

Delécluze 1827
Étienne-Jean Delécluze. *Journal des débats,* April 4, 1827.

Delécluze 1831
Étienne-Jean Delécluze. "Exposition de

1831." *Journal des débats,* May 14, 1831.

Delécluze 1834
Étienne-Jean Delécluze. "Salon de 1834." *Journal des débats,* May 4, 1834.

Delécluze 1837
Étienne-Jean Delécluze. "Beaux-Arts: Salon de 1837." *Journal des débats,* March 18, 1837.

Delécluze 1838
Étienne-Jean Delécluze. "Salon de 1838." *Journal des débats,* April 27, 1838.

Delécluze 1839
Étienne-Jean Delécluze. "Salon de 1839." *Journal des débats,* March 21, 1839.

Delécluze 1840
Étienne-Jean Delécluze. "Salon de 1840." *Journal des débats,* March 19, 1840.

Delécluze 1841
Étienne-Jean Delécluze. "Salon de 1841." *Journal des débats,* May 18, 1841.

Delécluze 1845
Étienne-Jean Delécluze. "Salon de 1845." *Journal des débats,* May 12–13, 1845.

Delécluze 1847
Étienne-Jean Delécluze. "Salon de 1847." *Journal des débats,* May 16, 1847.

Delécluze 1848
Étienne-Jean Delécluze. "Salon de 1848." *Journal des débats,* April 16, 1848.

Delécluze 1853
Étienne-Jean Delécluze. "Exposition de 1853." *Journal des débats,* June 25, 1853.

Delécluze 1859
Étienne-Jean Delécluze. "Exposition de 1859." *Journal des débats,* May 26, 1859.

Delécluze 1861a
Étienne-Jean Delécluze. "Exposition de 1861." *Journal des débats,* May 1, 1861.

Delécluze 1861b
Étienne-Jean Delécluze. "Exposition de 1861." *Journal des débats,* June 22, 1861.

Delouche 1977
Denise Delouche. *Peintres de la Bretagne: Découverte d'une province.* Paris, 1977.

Delteil 1910
Loys Delteil. *Le Peintre-Graveur illustré (XIXe et XXe siècles).* Vol. 5, *Corot.* Paris, 1910.

Delvau 1861
Alfred Delvau. "Salon de 1861." *Revue des beaux-arts,* no. 23 (July 7, 1861), pp. 271–77.

Deonna 1915
W. Deonna. "Notre Vieille Genève." *Nos Anciens et leurs oeuvres,* n.s. 15 (1915), pp. 45–122.

Desavary 1873
Charles-Paul Desavary. *Album de fac-similé d'après les dessins de Corot.* Arras, 1873.

Des Moines Art Center 1981
Des Moines Art Center. *The Nathan Emory*

Coffin Collection. Des Moines, Iowa, 1981.

Desplaces 1851
Auguste Desplaces. "Salon de 1850." *L'Union* 17 (February 22, 1851), pp. 119–22.

Detroit 1950
French Painting from David to Courbet. The Detroit Institute of Arts, February 1–March 5, 1950. Exh. cat. Detroit, 1950.

Detroit, Toronto, Saint Louis, Seattle 1951–52
"Thirty-Eight Great Paintings from The Metropolitan Museum of Art." The Detroit Institute of Arts, October 2–28, 1951; Toronto, Art Gallery of Ottawa, November 14–December 12; Saint Louis Art Museum, January 6–February 4, 1952; Seattle Art Museum, March 1–June 30.

Dieppe 1958
Corot 1796–1875. Dieppe, Musée des Beaux-Arts, July–September 1958. Exh. cat. Dieppe, 1958.

Dieterle 1959
Jean Dieterle. *Jean-Baptiste Corot 1796–1875.* Le Grand Art en livres de poche. Paris, 1959.

Dieterle 1974
Jean Dieterle. *Corot: Troisième Supplément à "L'Oeuvre de Corot" par A. Robaut et Moreau-Nélaton, Éditions Floury.* Paris, 1974.

Dieterle 1980
Louise Dieterle. *Souvenirs.* Paris, 1980.

Dieterle and Bazin 1943
Jean Dieterle and Germain Bazin. "Une Leçon d'histoire de l'art." *Les Beaux-Arts,* January 30, 1943, pp. 8–9.

Dieterle and Pacitti 1992
Pierre Dieterle and André Pacitti. *Corot: Quatrième Supplément à "L'Oeuvre de Corot" par A. Robaut et Moreau-Nélaton, Éditions Floury, Paris—1905.* Paris, 1992.

Dijon 1952
Musées de Bourgogne. Dijon, Musée des Beaux-Arts, 1952. Exh. cat. Dijon, 1952.

Dijon 1982–83
La Peinture dans la peinture. Dijon, Musée des Beaux-Arts, December 18, 1982–February 28, 1983. Exh. cat. by Pierre Georgel and Anne-Marie Lecoq. Dijon, 1983.

Dijon 1995
Budapest, 1869–1914: Modernité hongroise et peinture européenne. Dijon, Musée des Beaux-Arts, July 2–October 8, 1995. Exh. cat. Dijon and Paris, 1995.

Dimier 1912
Louis Dimier. "La 'Femme en bleu' de Corot au Louvre." *L'Action française,* December 14, 1912.

Dimier 1914
Louis Dimier. *Histoire de la peinture française au XIXᵉ siècle (1793–1903).* Paris, 1914.

Distel 1989
Anne Distel. *Les Collectionneurs des Impressionnistes: Amateurs et marchands.* Paris, 1989.

Distel 1990
Anne Distel. *Impressionism: The First Collectors.* Translated by Barbara Perroud-Benson. New York, 1990.

Doiteau 1936
Victor Doiteau. "Sur l'origine du 'Beffroi de Douai.'" *L'Amour de l'art* 17 (June 1936), p. 220.

Dollfus 1859
Charles Dollfus. "Salon de 1859." *Revue germanique* 6 (April–June 1859), pp. 237–52.

Dollfus sale 1912
Catalogue de tableaux modernes . . . dépendant des collections de M. Jean Dollfus. Sale cat., Galerie Georges Petit, Paris, March 2, 1912.

Dorbec 1910
Prosper Dorbec. "L'Exposition des 'Vingt Peintres du XIXᵉ siècle' à la Galerie Georges Petit." *Gazette des beaux-arts,* 4th ser., 4 (July 1910), pp. 11–25.

Doria 1954a
Arnauld Doria. "Les Baptêmes du Christ de Corot." *Bulletin de la Société de l'Histoire de l'Art Français* (1953), pp. 96–104. Published 1954.

Doria 1954b
Arnauld Doria. "Corot et le *Baptême du Christ.*" *Gazette des beaux-arts,* 6th ser., 43 (May–June 1954), pp. 317–44.

Dublin 1904
Catalogue of Pictures Presented to the City of Dublin to Form the Nucleus of a Gallery of Modern Art; Also Pictures Lent by the Executors of the Late Mr. J. Staats Forbes and Others. Dublin, Royal Hibernian Academy, 1904. Exh. cat. Dublin, 1904.

Du Camp 1855
Maxime Du Camp. *Les Beaux-Arts à l'Exposition Universelle de 1855.* Paris, 1855.

Du Camp 1859
Maxime Du Camp. *Le Salon de 1859.* Paris, 1859.

Du Camp 1864
Maxime Du Camp. "La Salon de 1864." *Revue des deux mondes,* 2nd ser., 51 (June 1, 1864), pp. 678–712.

Ducros 1975
Jean Ducros. "Corot, disciple déçu de Garneray." *L'Art et la mer,* no. 7 (November 15, 1975), pp. 11–14.

Dumas 1859
Alexandre Dumas. *L'Art et les artistes contemporains au Salon de 1859.* Paris, 1859.

Dumesnil 1859
Henri Dumesnil. *Le Salon de 1859.* Paris, 1859.

Dumesnil 1875
Henri Dumesnil. *Corot: Souvenirs intimes.* Paris, 1875.

Dunkirk, Musée des Beaux-Arts 1974
Dunkirk, Musée des Beaux-Arts. *Catalogue des peintures du Musée de Dunkerque.* Dunkirk, 1974.

Dunkirk, Musée des Beaux-Arts 1976
Dunkirk, Musée des Beaux-Arts. *Catalogue des peintures du Musée de Dunkerque.* 2nd ed., rev. Dunkirk, 1976.

Du Pays 1855
A.-J. Du Pays. "Exposition Universelle des beaux-arts: École française—Decamps." *L'Illustration* 26 (September 8, 1855), pp. 167–70.

Du Pays 1857
A.-J. Du Pays. "Salon de 1857." *L'Illustration* 30 (September 26, 1857), pp. 202–4.

Du Pays 1859
A.-J. Du Pays. "Salon de 1859." *L'Illustration* 33 (May 21, 1859), pp. 339–42.

Duplessis 1859
Georges Duplessis. "Salon de 1859., *Revue des beaux-arts* 10 (1859), pp. 175–80.

Durand-Gréville 1887
E. Durand-Gréville. "La Peinture aux États-Unis: Les Galeries privées." *Gazette des beaux-arts,* 2nd ser., 36 (July, September 1887), pp. 65–75, 250–55.

Duranty 1876
Louis-Émile-Edmond Duranty. *La Nouvelle Peinture.* Paris, 1876.

Duret 1867
Théodore Duret. *Les Peintres français en 1867.* Paris, 1867.

Durey 1988
Philippe Durey. *Le Musée des Beaux Arts de Lyon.* Paris, 1988.

École moderne 1857
L'École moderne. Paris: chez Peyrol, 1857.

Edgell 1949
George Harold Edgell. *French Painters in the Museum of Fine Arts: Corot to Utrillo.* Boston, 1949.

Edinburgh 1886
"Edinburgh International Exhibition of Industry, Science, and Art," 1886.

Edinburgh 1986
Lighting up the Landscape: French Impressionism and Its Origins. Edinburgh, National Gallery of Scotland, August 1–October 19, 1986. Exh. cat. Edinburgh, 1986.

Edinburgh 1990
Cézanne and Poussin: The Classical Vision of

Landscape. Edinburgh, National Gallery of Scotland, August 9–October 21, 1990. Exh. cat. by Richard Verdi. Edinburgh, 1990.

Edinburgh, London 1965
Corot: An Exhibition of Paintings, Drawings and Prints. Edinburgh, Royal Scottish Academy, August 14–September 12, 1965; London, The National Gallery, October 1–November 7. Organized by the Arts Council of Great Britain in association with the Edinburgh Festival Society. Exh. cat. by Cecil Gould. London, 1965.

Edinburgh, National Gallery of Scotland 1936
Edinburgh, National Gallery of Scotland. *Catalogue: National Gallery of Scotland, Edinburgh.* 49th ed. Edinburgh, 1936.

Edinburgh, National Gallery of Scotland 1957
Edinburgh, National Gallery of Scotland. *Catalogue of Paintings and Sculpture.* 51st ed. Edinburgh, 1957.

Edinburgh, National Gallery of Scotland 1980
Edinburgh, National Gallery of Scotland. *National Gallery of Scotland: Illustrations.* Edinburgh, 1980.

Eitner forthcoming
Lorenz Eitner. *French Painting, 1800–1860.* The Collections of the National Gallery of Art (Washington, D. C.). Systematic Catalogue. Forthcoming.

El-Wakil 1977
Leïla El-Wakil. "Architecture et urbanisme à Genève sous la Restauration." *Genava,* n.s., 25 (1977), pp. 153–98.

Émile-Mâle 1976
Gilberte Émile-Mâle. *La Restauration des peintures de chevalet.* Fribourg and Paris, 1976. [Eng. ed., *The Restorer's Handbook of Easel Painting.* Translated by J. A. Underwood. New York, 1976.]

Enval 1861
Jane d'Enval. *Salon de 1861.* Paris, 1861.

Escholier 1943
Raymond Escholier. *La Peinture française: XIXᵉ Siècle.* Vol. 2. Paris, 1943.

Farrell 1967
Stephanie K. Farrell. "Three Important French Paintings." *Carnegie Magazine* 41 (February 1967), pp. 41–45.

Faure 1931
Élie Faure. *Corot.* Maîtres d'autrefois. Paris, 1931.

Faure 1936
Élie Faure. *Corot.* Collection des maîtres. Paris, 1936.

Feu Diderot 1849
Feu Diderot. "Salon de 1849. II." *L'Artiste,* 5th ser., 3 (July 15, 1849), pp. 113–17.

Feuillet 1926
Maurice Feuillet. "Les Grandes Ventes prochaines: Treize Tableaux par Corot." *Le Figaro artistique,* June 6, 1926, pp. 552–53.

Fidell-Beaufort and Bailly-Herzberg 1975
Madeleine Fidell-Beaufort and Janine Bailly-Herzberg. *Daubigny.* Paris, 1975.

Field 1977
Richard S. Field. *Paul Gauguin: The Paintings of the First Voyage to Tahiti.* Outstanding Dissertations in the Fine Arts. New York, 1977.

Fierens 1952
Paul Fierens. "Le Voyage de Corot en Belgique et aux Pays-Bas." *Gazette des beaux-arts,* 6th ser., 40 (September 1952), pp. 123–28.

Fillonneau 1868
Ernest Fillonneau. "Salon de 1868. II." *Moniteur des arts* 11 (May 8, 1868), pp. 1–2.

Fink 1978
Lois Marie Fink. "French Art in the United States, 1850–1870: Three Dealers and Collectors." *Gazette des beaux-arts,* 6th ser., 92 (September 1978), pp. 87–100.

Flat 1895
Paul Flat. "Notes d'art: L'Exposition Corot." *Revue bleue,* 4th ser., 3 (June 29, 1895), p. 818.

Florence 1994
Firenze e la sua immagine: Cinque secoli di vedutismo. Florence, Forte di Belvedere, June 29–September 30, 1994. Exh. cat. by Marco Chiarini and Alessandro Marabottini. Venice, 1994.

Florence, Galleria degli Uffizi 1979
Florence, Galleria degli Uffizi. *Gli Uffizi: Catalogo generale.* Florence, 1979.

Focillon 1927
Henri Focillon. *La Peinture au XIXᵉ siècle: Le Retour à l'antique.—Le Romantisme.* Manuels d'histoire de l'art. Paris, 1927.

Forster-Hahn 1968
Françoise Forster-Hahn. *French and School of Paris Paintings in the Yale University Art Gallery: A Catalogue Raisonné.* New Haven, 1968.

Fort Worth 1949
Homer, Eakins, Ryder, Inness and Their French Contemporaries: A Loan Exhibition of Famous Paintings from Foremost American Museums and Collectors Commemorating City of Fort Worth Centennial, 1849–1949. Fort Worth Art Association, March 11–April 15, 1949. Exh. cat. Fort Worth, Tex., 1949.

Fort Worth 1954
Inaugural Exhibition. Fort Worth Art Center, October 8–31, 1954. Exh. cat. Fort Worth, Tex., 1954.

Fosca 1928
François Fosca. "Corot chez P. Rosenberg: Paysages d'Italie et figures." *L'Amour de l'art* 9 (May 1928), pp. 161–73.

Fosca 1930
François Fosca. *Corot.* Paris, 1930.

Fosca 1958
François Fosca. *Corot: Sa Vie et son oeuvre.* Brussels, 1958.

Foucart 1987
Bruno Foucart. *Le Renouveau de la peinture religieuse en France, 1800–1860.* Paris, 1987.

Fouchet 1975
Max-Pol Fouchet. *Corot.* Paris, 1975.

Fournel 1859
Victor Fournel. "Le Salon de 1859." *Le Correspondant,* n.s. 11 (June 1859), pp. 266–82.

Fournel 1884
Victor Fournel. *Les Artistes français contemporains: Peintres, sculpteurs.* Tours, 1884.

Fowler 1908
Frank Fowler. "Modern Foreign Paintings at The Metropolitan Museum: Some Examples of the French School." *Scribner's Magazine* 44 (September 1908), pp. 381–84.

Francastel 1955
Pierre Francastel. *Histoire de la peinture française: La Peinture de chevalet du XIVᵉ au XXᵉ siècle.* 2 vols. Paris, 1955.

France 1956
"Le Paysage français de Poussin aux Impressionnistes." Traveling exhibition in France, 1956.

***France illustrée* 1875**
La France illustrée: Journal littéraire, scientifique et religieux, May 22, 1875.

Fredericksen 1985
Burton B. Fredericksen. "Recent Acquisitions of Paintings: The J. Paul Getty Museum." *Burlington Magazine* 127 (April 1985), pp. 261–68.

Fribourg 1943
Exposition de tableaux anciens du Musée de Genève. Fribourg, Musée d'Art et d'Histoire, June 19–August 31, 1943. Exh. cat. Fribourg, 1943.

Fromentin 1965
Eugène Fromentin. *Les Maîtres d'autrefois: Belgique—Hollande.* Edited by Jacques Foucart. Paris, 1965.

Frond 1865
Victor Frond, ed. *Corot.* Panthéon des illustrations françaises au XIXᵉ siècle, comprenant un portrait, une biographie et un autographe. Paris, 1865.

Fukuoka, Hiroshima, Tokyo, Kanazawa 1983–84
"De Rubens, Delacroix à Corot, Redon."

Fukuoka; Hiroshima; Tokyo; Kanazawa; 1983–84.

Funke 1970
Mary-Louise Funke. "From Daumier to Rouault: Aspects of the Nineteenth and Early Twentieth Century French Collection of The Montreal Museum of Fine Arts" / "De Daumier à Rouault: Cent Ans de peinture française à travers la collection d'oeuvres du dix-neuvième siècle et du début du vingtième siècle du Musée des Beaux-Arts de Montréal." *M.* (The Montreal Museum of Fine Arts), no. 4 (March 1970), pp. 7–12.

Gabellieri Campani 1977
Laura Gabellieri Campani. "Viaggio di Corot in Toscana." *Rassegna volterrana* 42–53 (1977), pp. 5–29.

Gache-Patin and Lassaigne 1983
Sylvie Gache-Patin and Jacques Lassaigne. *Sisley*. Paris, 1983.

Galassi 1991a
Peter Galassi. *Corot en Italie: La Peinture de plein air et la tradition classique.* Translated by Jeanne Bouniort. Paris, 1991.

Galassi 1991b
Peter Galassi. *Corot in Italy: Open-Air Painting and the Classical-Landscape Tradition.* New Haven and London, 1991.

Gale 1994
Iain Gale. *Corot.* London, 1994.

Galletti 1861
Galletti. *Salon de 1861: Album caricatural.* Paris, 1861.

Garneray 1823–32
Antoine-Louis Garneray. *Les Ports de France.* Text by Étienne de Jouy. 15 pts. Paris, 1823–32.

Gautier 1837
Théophile Gautier. "Salon de 1837." *La Presse,* March 8, 20, and 21, 1837.

Gautier 1839
Théophile Gautier. "Salon de 1839." *La Presse,* April 27, 1839.

Gautier 1840
Théophile Gautier. "Salon de 1840." *La Presse,* March 27, 1840.

Gautier 1841
Théophile Gautier. "Salon de 1841." *Revue de Paris,* 3rd ser., 28 (1841), pp. 255–70.

Gautier 1845
Théophile Gautier. "Salon de 1845." *La Presse,* April 17, 1845.

Gautier 1846
Théophile Gautier. "Salon de 1846." *La Presse,* April 4, 1846.

Gautier 1857
Théophile Gautier. "Salon de 1857. XVII."

L'Artiste, 7th ser., 2 (October 25, 1857), pp. 113–16.

Gautier 1861
Théophile Gautier. *Abécédaire du Salon de 1861.* Paris, 1861.

Gautier 1864
Théophile Gautier. "Salon de 1864." *Le Moniteur universel,* August 3, 1864, pp. 1004–5.

Gautier 1865
Théophile Gautier. "Salon de 1865. V. Peinture." *Le Moniteur universel,* June 18, 1865, pp. 834–35.

Gautier 1869
Théophile Gautier. "Le Salon de 1869." *L'Illustration* 53 (June 5, 1869), pp. 363–66.

Gautier 1992
Théophile Gautier. *Exposition de 1859.* Edited by Wolfgang Drost and Ulrike Henninges. Heidelberg, 1992.

Geffroy 1902
Gustave Geffroy. "Jean-Baptiste Camille Corot." In *Corot and Millet,* edited by Charles Holme, pp. ci–cxxxii. London, 1902.

Geffroy 1903
Gustave Geffroy. "Jean-Baptiste Camille Corot." In *Corot and Millet,* edited by Charles Holme, pp. ci–cxxxii. New York, 1903.

Geffroy 1907
Gustave Geffroy. "Corot: Peintre de la femme." *L'Art et les artistes* 4 (January 1907), pp. 363–67.

Geiger 1977
Monique Geiger. "Corot et la Bourgogne." *Mémoires de l'Académie des Sciences, Arts et Belles-Lettres de Dijon* 122 (1973–75), pp. 329–37. Published 1977.

Geneva 1859
Exposition Cantonale. Geneva, Musée Rath, October 1–November 15, 1857. Exh. cat. Geneva, 1859.

Geneva 1918
Exposition d'art français. Geneva, Musée d'Art et d'Histoire, May 15–June 16, 1918. Exh. cat. Geneva, 1918.

Geneva 1937
Paysage français avant les Impressionnistes. Geneva, Musée d'Art et d'Histoire, 1937. Exh. cat. Geneva, 1937.

Geneva 1982
Le Cliché-Verre: Corot et la gravure diaphane. Geneva, Musée d'Art et d'Histoire, July 16–October 10, 1982. Exh. cat. Geneva, 1982.

Geneva, Musée d'Art et d'Histoire 1960
Geneva, Musée d'Art et d'Histoire. *Le Musée d'Art et d'Histoire de Genève, 1910–1960: Album du cinquantenaire.* Introduction by Edmond Sollberger. Geneva, 1960.

Geneva, Musée d'Art et d'Histoire 1968
Geneva, Musée d'Art et d'Histoire. *Guides illustrés, 2: Beaux-Arts, salles 1–15.* Geneva, 1968.

Geneva, Musée Rath 1878
Geneva, Musée Rath. *Catalogue du Musée Rath à Genève.* Geneva, 1878.

Geneva, Musée Rath 1906
Geneva, Musée Rath. *Catalogue du Musée Rath à Genève.* Geneva, 1906.

Gensel 1906
Walther Gensel. *Corot und Troyon.* Bielefeld and Leipzig, 1906.

Ghent, Museum voor Schone Kunsten 1967
Ghent, Museum voor Schone Kunsten. *Oude en moderne kunst: Museum voor Schone Kunsten, Gent/ Art ancien et moderne: Musée des Beaux-Arts, Gand/ Alte und moderne Kunst: Museum der Schönen Künste, Gent/ Classical and Modern Art: Museum of Fine Arts, Ghent.* Ghent, 1967.

Ghent, The Hague, Paris 1985–86
De school van Barbizon: Franse meesters van de 19de eeuw. Ghent, Museum voor Schone Kunsten, September 13–November 28, 1985; The Hague, Gemeentemuseum, December 13, 1985–February 23, 1986; Paris, Institut Néerlandais, March 5–April 28. Exh. cat. Utrecht, 1985. Eng. ed., *The Barbizon School.* The Hague, 1985.

Gielly 1928
Louis Gielly. *Musée d'Art et d'Histoire de Genève: Catalogue des peintures et sculptures.* Geneva, 1928.

Gilardoni 1952
Virgilio Gilardoni. *Corot.* Biblioteca moderna Mondadori, 291. Milan, 1952.

Gill 1864
Gill. *Le Salon pour rire.* Paris, 1864.

Gimpel 1963
René Gimpel. *Journal d'un collectionneur, marchand de tableaux.* Preface by Jean Guéhenno. Paris, 1963.

Gimpel 1966
René Gimpel. *Diary of an Art Dealer.* Translated by John Rosenberg. New York, 1966.

Glasgow 1888
A Century of Artists: A Memorial of the Glasgow International Exhibition, 1888. Glasgow, 1888. Exh. cat. Glasgow and New York, 1889.

Glasgow 1927
A Century of French Painting. Glasgow, The McClellan Galleries, May 1927. Exh. cat. Glasgow, 1927.

Glasgow Art Gallery and Museum 1985
Glasgow Art Gallery and Museum. *French Paintings and Drawings: Illustrated Summary Catalogue.* Text by Anne Donald. Glasgow, 1985.

Gobin 1939
Maurice Gobin. "Corot: Peintre de portraits."

L'Art et les artistes, n.s., 37 (May 1939), pp. 266–71.

Goncourt 1956
Edmond de Goncourt and Jules de Goncourt. *Journal: Mémoires de la vie littéraire.* Edited by Robert Ricatte. 4 vols. Paris, 1956.

Goujon 1909
Pierre Goujon. "Corot Peintre de figures." *Gazette des beaux-arts*, 4th ser., 2 (December 1909), pp. 469–82.

Grangedor 1868
J. Grangedor. "Le Salon de 1868." *Gazette des beaux-arts* 25 (July 1868), pp. 5–30.

Gruelle 1895
R. B. Gruelle. *Notes: Critical and Biographical. Collection of W. T. Walters.* Indianapolis, 1895.

Guiffrey 1903
Jean Guiffrey. *La Collection Thomy-Thiéry au Musée du Louvre: Catalogue descriptif & historique.* Paris, 1903.

Guiffrey 1911
Jean Guiffrey. *Les Peintures de la collection Chauchard.* Paris, 1911.

Guiffrey 1926
Jules Guiffrey. "La Donation Comiot." *Beaux-Arts*, May 1, 1926, pp. 135–36.

Guinon 1925
Louis Guinon. *Petite Histoire de la maison de Corot à Ville-d'Avray.* Paris, 1925.

Gutwirth 1974
Suzanne Gutwirth. "Jean-Victor Bertin: Un Paysagiste néo-classique (1767–1842)." *Gazette des beaux-arts*, 6th ser., 83 (May–June 1974), pp. 337–58.

Guyot de Fère 1859
Guyot de Fère. "Salon de 1859." *Journal des arts, des sciences et des lettres*, no. 12 (July 8, 1859), pp. 357–60.

Guyot de Fère 1865
Guyot de Fère. "Salon de 1865." *Journal des arts, des sciences et des lettres*, no. 11 (June 1, 1865), pp. 81–84.

Habeneck 1859
Charles Habeneck. "Le Salon de 1859. VI." *Le Causeur* 1 (March–August 1859), pp. 220–24.

Hache 1869
Ernest Hache. "Salon de 1869." In Alfred Darcel, *Les Merveilles de l'art et de l'industrie: Antiquité, Moyen-Âge, Renaissance, temps modernes*, pp. 231–330. Paris, 1869.

Halton 1906
E. G. Halton. "The Collection of Mr. Alexander Young. I.—The Corots." *International Studio* 30 (November 1906), pp. 3–20.

Hamburg 1976
William Turner und die Landschaft seiner Zeit.

Hamburg, Kunsthalle, May 19–July 18, 1976. Exh. cat. edited by Werner Hofmann. Munich, 1976.

Hamel 1905
Maurice Hamel. *Corot et son oeuvre.* Paris, 1905.

Hamel 1910
Maurice Hamel. "Exposition de chefs-d'oeuvre de l'école française: Vingt Peintres du XIXᵉ siècle." *Les Arts*, no. 104 (August 1910), pp. 1–32.

Hand-Book for Travellers in Switzerland 1838
A Hand-Book for Travellers in Switzerland and the Alps of Savoy and Piedmont. London: John Murray & Son, 1838.

Harrison 1991
Jefferson C. Harrison. *The Chrysler Museum: Handbook of the European and American Collections. Selected Paintings, Sculpture and Drawings.* Norfolk, Va., 1991.

Hartford 1931
Retrospective Exhibition of Landscape Painting. Hartford, Wadsworth Atheneum, January 20–February 9, 1931. Exh. cat. by Henry Russell Hitchcock. Hartford, 1931.

Hartford 1937
Forty-Three Portraits: An Exhibition of the Wadsworth Atheneum. Hartford, Wadsworth Atheneum, January 26–February 10, 1937. Exh. cat. Hartford, 1937.

Hartford 1949
"In Retrospect: Twenty-One Years of Museum Collecting." Hartford, Wadsworth Atheneum, April 1–May 29, 1949. Catalogue published in *Wadsworth Atheneum Bulletin*, 2nd ser., no. 8 (April 1949).

Haskell 1987
Francis Haskell. *Past and Present in Art and Taste: Selected Essays.* New Haven, 1987.

Hatzimichali 1984
Angeliki Hatzimichali. *The Greek Folk Costume.* 2 vols. [Greece], 1984.

Haug 1955
Hans Haug. *La Peinture française au Musée des Beaux-Arts de Strasbourg.* Strasbourg, 1955.

Haussard 1846
Pr[osper] H[aussard]. "Salon de 1846." *Le National*, April 28, 1846.

Hautecoeur 1948
Louis Hautecoeur. *Catalogue de la galerie des beaux-arts.* Musée d'Art et d'Histoire. Geneva, 1948.

Havemeyer Collection 1931
H. O. Havemeyer Collection: Catalogue of Paintings, Prints, Sculpture and Objects of Art. New York, 1931.

Havemeyer Collection 1958
New York, The Metropolitan Museum of Art. *The H. O. Havemeyer Collection.* 2nd ed. New York, 1958.

Hedberg and Hirschler 1974
Gregory Hedberg and Marion Hirschler. "The Jerome Hill Bequest: Corot's *Silenus* and Delacroix's *Fanatics of Tangiers.*" *The Minneapolis Institute of Arts Bulletin* 61 (1974), pp. 92–103.

Heilbut 1905
Emil Heilbut. "Figurenbilder von Corot." *Kunst und Künstler* 3 (1905), pp. 93–109.

Hellebranth 1976
Robert Hellebranth. *Charles-François Daubigny 1817–1878.* Morges, 1976.

Henning 1963
Edward B. Henning. "Cleveland Museum of Art: From Turner to Guston." *Apollo* 68 (December 1963), pp. 481–88.

Henriet 1854
Frédéric Henriet. "Le Musée des rues. I. Le Marchand de tableaux." *L'Artiste*, 5th ser., 13 (November 15, 1854), pp. 113–15.

Henry 1907
Harry Samuel Henry. *Illustrated Catalogue of Paintings by "the Men of 1830" Forming the Private Collection of Mr. H. S. Henry, Philadelphia.* Philadelphia, 1907.

Herton 1870
Jeanne Herton. *Le Temps*, May 22, 1870.

Hewes and Kerschner 1994
Lauren B. Hewes and Richard Kerschner. "Corot Conservation: Corot's *La Bacchante à la panthère.*" *Shelburne Museum National Collectors' Circle Newsletter* 3 (summer 1994), pp. 3–7.

Hoeber 1915
Arthur Hoeber. *The Barbizon Painters.* New York, 1915.

Hoff 1973
Ursula Hoff. *European Painting and Sculpture before 1800.* National Gallery of Victoria. 3rd ed. Melbourne, 1973.

Hofmann 1960
Werner Hofmann. *Das irdische Paradies: Kunst im neunzehnten Jahrhundert.* Munich, 1960.

Hopp 1990
Gisela Hopp. "Une Oeuvre tardive de Camille Corot: *Le Moine au violoncelle.*" *Gazette des beaux-arts*, 6th ser., 115 (March 1990), pp. 129–40.

Hours 1962
Madeleine Hours. "Figures de Corot: Étude photographique et radiographique." *Bulletin du laboratoire du Musée du Louvre* 7 (1962), pp. 3–39.

Hours 1972
Madeleine Hours. *Jean-Baptiste-Camille Corot.* New York, 1972.

Houssaye 1843
Arsène Houssaye. "Le Salon de 1843." *Revue de Paris*, 4th ser., 16 (April 2, 1843), pp. 32–46.

Houssaye 1846
Arsène Houssaye. "Le Salon de 1846. I." *L'Artiste*, 4th ser., 6 (March 22, 1846), pp. 37–43.

Houssaye 1859
Arsène Houssaye. "Salon de 1859." *Le Monde illustré* 4 (June 4, 1859), pp. 359–62.

Houssaye 1885
Arsène Houssaye. *Les Confessions: Souvenirs d'un demi siècle, 1830–1880.* Vol. 1. Paris, 1885.

Houston 1959
Corot and His Contemporaries. Houston, Museum of Fine Arts, May 8–June 21, 1959. Exh. cat. Introduction by Edmund B. Nielsen. Houston, 1959.

Huard 1839
H. [Étienne Huard]. "Exposition de 1839." *Journal des artistes* 25 (March 24, 1839), pp. 177–88.

Hubbard 1959
R. H. Hubbard. *The National Gallery of Canada: Catalogue of Paintings and Sculpture.* Vol. 2, *Modern European Schools.* Toronto, 1959.

Hubbard 1962
R. H. Hubbard, ed. *European Paintings in Canadian Collections. II: Modern Schools.* Toronto, 1962.

Hugo 1830
Victor Hugo. *Notre-Dame de Paris.* Paris, 1830.

Huyghe 1930
René Huyghe. "Le Don de Mme la princesse de Croÿ." *Beaux-Arts*, October 20, 1930, pp. 4–6.

Huyghe 1936
René Huyghe. "Simple Histoire de 2,414 faux Corots." *L'Amour de l'art* 17 (February 1936), pp. 73–76.

Huyghe 1955
René Huyghe. *Dialogue avec le visible.* Paris, 1955.

Huyghe 1976
René Huyghe. *La Relève de l'imaginaire: La Peinture française au XIXᵉ siècle—réalisme, romantisme.* Paris, 1976.

Jaccaci 1913
August F. Jaccaci. "Figure Pieces of Corot in America." *Art in America* 1 (April 1913), pp. 77–91; 2 (December 1913), pp. 1–15.

Jaffé 1969
H. L. C. Jaffé. "Corot: Gezicht op Soissons." *Openbaar kunstbezit* (1969).

Jahyer 1865
Félix Jahyer. *Étude sur les beaux-arts: Salon de 1865.* Paris, 1865.

Jal 1831
Auguste Jal. *Salon de 1831: Ébauches critiques.* Paris, 1831.

Jammes and Janis 1983
André Jammes and Eugenia Parry Janis. *The Art of French Calotype, with Critical Dictionary of Photographers, 1845–1870.* Princeton, 1983.

Jamot 1920
Paul Jamot. " 'La Cathédrale de Sens', par Corot au Musée du Louvre." *La Revue de l'art ancien et moderne* 37 (May 1920), pp. 305–6.

Jamot 1925
Paul Jamot. "La Blonde Gascone." *Le Musée* 8 (1925), pp. 50–52.

Jamot 1926a
Paul Jamot. "Corot portraitiste au Musée du Louvre." *La Revue de l'art ancien et moderne* 50 (December 1926), pp. 273–81.

Jamot 1926b
Paul Jamot. "Le Don Robert: De nouveaux Corot au Musée du Louvre." *L'Art vivant*, November 5, 1926, pp. 801–2.

Jamot 1929
Paul Jamot. *La Peinture au Musée du Louvre: École française. XIXᵉ Siècle.* Pt. 2. Paris, 1929.

Jamot 1933
Paul Jamot. " 'L'Atelier' de Corot." *Bulletin des Musées de France* 5 (May 1933), p. 66.

Jamot 1936
Paul Jamot. *Corot.* Paris, 1936.

Janin 1839
Jules Janin. "Salon de 1839. (Cinquième Article.) Paysages, marines." *L'Artiste*, 2nd ser., 2 (1839), pp. 269–76.

Janin 1840a
Jules Janin. "Une Matinée aux portes du Louvre." *L'Artiste*, 2nd ser., 5 (1840), pp. 121–25.

Janin 1840b
Jules Janin. "Le Salon de 1840. Premier Article." *L'Artiste*, 2nd ser., 5 (1840), pp. 165–71; "Cinquième Article," pp. 233–43; "Sixième Article," pp. 253–64.

Janson 1978
Anthony F. Janson. "Corot: Tradition and the Muse." *Art Quarterly*, n.s., 1 (autumn 1978), pp. 294–317.

Jean 1931
René Jean. *Corot.* Paris, 1931.

Jewell and Crane 1944
Edward Alden Jewell and Aimée Crane. *French Impressionists and Their Contemporaries Represented in American Collections.* New York, 1944.

Johnson Collection 1953
Johnson Collection: Two Hundred and Eighty-Eight Reproductions. Philadelphia, 1953.

Johnston 1976
William R. Johnston. "Sylvan Vistas and Other Nineteenth-Century Paintings." *Apollo* 103 (May 1976), pp. 418–23.

Johnston 1982
William R. Johnston. *The Nineteenth Century Paintings in the Walters Art Gallery.* Baltimore, 1982.

Join-Diéterle 1988
Catherine Join-Diéterle. *Les Décors de scène de l'Opéra de Paris à l'époque romantique.* Paris, 1988.

Jones 1993
Mark Jones. *Sembrare e non essere: I falsi nell'arte e nella civiltà.* Milan, 1993.

Joubin 1926
André Joubin. *Catalogue des peintures et sculptures exposées dans les galeries du Musée Fabre de la ville de Montpellier.* Paris, 1926.

Jouin 1887
Henri-Auguste Jouin. *Maîtres contemporains.* Paris, 1887.

Jourdan 1859
Louis Jourdan. *Les Peintres français: Salon de 1859.* Paris, 1859.

Jousseaume 1899
Félix Jousseaume. *La Philosophie aux prises avec la Mer Rouge, le darwinisme et les 3 règnes des corps organisés.* Paris, 1899.

Jousseaume 1910
Félix Jousseaume. *Les Vandales du Louvre.* Paris, 1910.

Jousseaume 1911
Félix Jousseaume. *Réflexions sur la faune malacologique de la Mer Rouge.* Paris, 1911.

Jullien and Jullien 1982
André Jullien and Renée Jullien. "Les Campagnes de Corot au nord de Rome (1826–1827)." *Gazette des beaux-arts*, 6th ser., 99 (May–June 1982), pp. 179–202.

Jullien and Jullien 1984
André Jullien and Renée Jullien. "Corot dans les montagnes de la Sabine." *Gazette des beaux-arts*, 6th ser., 103 (May–June 1984), pp. 179–97.

Jullien and Jullien 1987
André Jullien and Renée Jullien. "Corot dans les Castelli Romani." *Gazette des beaux-arts*, 6th ser., 110 (October 1987), pp. 109–30.

Kanazawa, Tokyo, Takamatsu, Nagoya 1991–92
Goya to Matisse: Paintings, Sculpture and Drawings from the Wadsworth Atheneum of Hartford, Connecticut. Kanazawa, Ishikawa Prefectural Museum of Art; Tokyo, Isetan Museum of Art; Takamatsu City Museum of Art; Nagoya, Matsuzakaya Art Gallery; September 14, 1991–February 23, 1992. Exh. cat. Tokyo, 1991.

Karl 1934
Louis Karl. "Corot et la Suisse à propos de l'exposition à Zurich." *L'Art et les artistes*, n.s., 29 (October 1934), pp. 29–30.

Karr 1843
Alphonse Karr. "Exposition des tableaux." *Les Guêpes* 11 (April 1843), pp. 19–30.

Karr 1913
Alphonse Karr. "Eine Corot-Anekdote." *Kunst und Künstler* 11 (September 1913), pp. 625–27.

Klee 1959
Paul Klee. *Journal.* Translated by Pierre Klossowski. Paris, 1959.

Klossowski 1960
Pierre Klossowski. "The Falling Nymphs." *Portfolio and Art News Annual*, no. 3 (1960), pp. 104–30.

Kobe, Yokohama 1993
Exposition du bicentenaire du Musée du Louvre: Les Peintures du Louvre. Des collections royales au Grand Louvre. Kobe, Municipal Museum, March 20–May 9, 1993; Yokohama, May 22–July 25. Exh. cat. by Pierre Rosenberg, Claude Ressort, Brigitte Gallini, and Shuji Takashina, with contributions by Vincent Pomarède. [Japan], 1993.

Koechlin 1927
Raymond Koechlin. "Claude Monet (1840–1926)." *Art et décoration* 51 (February 1927), pp. 33–47.

Kosinski 1985
Dorothy M. Kosinski. "The Image of Orpheus in Symbolist Art and Literature." 4 vols. Ph.D. diss., New York University, 1985.

Kyoto, Tokyo 1980
From Goya to Wyeth: The Joan Whitney Payson Collection. Kyoto Municipal Museum, September 13–October 12, 1980; Tokyo, Isetan Museum of Art, October 17–December 9. Exh. cat. Kyoto, 1980.

Lacambre 1993
Geneviève Lacambre. "Pouvoir central et peinture religieuse en Bretagne au XIXᵉ siècle." In *Autour de Delacroix: La Peinture religieuse en Bretagne au XIXᵉ siècle*, pp. 27–31. Vannes, Musée Municipal de la Cohue, May 1993. Exh. cat. Vannes, 1993.

Laclotte et al. 1989
Michel Laclotte et al. *Les Donateurs du Louvre.* Paris, 1989.

La Coruña, Saragossa, Valencia 1992
Un siglo de pintura francesa, 1750–1850 (Colección Museo de Quimper). La Coruña, Kiosco Alfonso, February 21–March 29, 1992; Museo de Zaragoza, April 8–May 8; Valencia, Museu Sant Pius V, May 13–June 14. Exh. cat. Valencia, 1993.

La Farge 1908
John La Farge. *The Higher Life in Art: A Series of Lectures on the Barbizon School of France Inaugurating the Scammon Course at The Art Institute of Chicago.* New York, 1908.

Lafargue 1925
Marc Lafargue. *Corot.* Paris, 1925.

Lafargue 1926
Marc Lafargue. *Corot.* Translated by Lindsay Wellington. London, 1926.

Lafenestre 1868
Georges Lafenestre. "L'Art au Salon de 1868." *Revue contemporaine*, 2nd ser., 63 (May–June 1868), pp. 503–33.

Lafenestre 1870
Georges Lafenestre. "Salon de 1870." *Le Moniteur universel*, May 17, 1870, p. 703.

Lafenestre 1873
Georges Lafenestre. "Salon de 1873." *Gazette des beaux-arts*, 2nd ser., 8 (1873), pp. 29–61.

Lafenestre 1881
Georges Lafenestre. *L'Art vivant: La Peinture et la sculpture aux Salons de 1868 à 1877.* Paris, 1881.

Lafenestre 1902
Georges Lafenestre. "La Collection Thomy-Thiéry." *Gazette des beaux-arts*, 3rd ser., 27 (April 1902), pp. 289–98.

La Fontaine 1954
Jean de La Fontaine. *Oeuvres complètes.* Edited by René Groos and Jacques Schiffrin. Vol. 1. Bibliothèque de la Pléiade. Paris, 1954.

Lagrange 1859
Léon Lagrange. "Exposition de Marseille." *Gazette des beaux-arts* 4 (November 1, 1859), pp. 185–89.

Lagrange 1861
Léon Lagrange. *La Peinture et la sculpture au Salon de 1861.* Paris, 1861.

Lagrange 1864
Léon Lagrange. "Le Salon de 1864." *Gazette des beaux-arts* 17 (July 1864), pp. 5–44.

Lagrange 1865
Léon Lagrange. "Le Salon de 1865." *Le Correspondant*, n.s., 29 (May 1865), pp. 128–68.

Laincel 1865
Louis de Laincel. *Promenade aux Champs-Élysées: L'Art et la démocratie. Causes de décadence. Le Salon de 1865.* Paris, 1865.

Lamb 1892
Martha J. Lamb. "The Walters Collection of Art Treasures: Its History and Educational Importance." *Magazine of American History* 27 (April 1892), pp. 241–64.

Lankheit 1988
Klaus Lankheit. *Revolution und Restauration, 1785–1855.* Cologne, 1988.

Lapaire 1982
Claude Lapaire. *Cinq Siècles de peinture au Musée d'Art et d'Histoire de Genève.* Geneva, 1982.

Lapaire 1991
Claude Lapaire. *Musée d'Art et d'Histoire, Genève.* Geneva, 1991.

Laren, Ghent 1970
Chefs-d'Oeuvre du Musée des Beaux-Arts de Bordeaux. Laren, Singer Museum; Ghent, Museum voor Schone Kunsten, April 17–June 14, 1970. Exh. cat. by Gilberte Martin-Méry and Paul Eeckhout. Ghent, 1970.

Larthe-Ménager 1894
A. Larthe-Ménager. "Corot (1796–1875)." *Les Contemporains*, no. 104 (October 7, 1894), pp. 2–16.

Laughton 1991
Bruce Laughton. "Important French Nineteenth Century Paintings and Drawings (from the Collection Formed by Madame Esnault-Pelterie)." In *Important Nineteenth Century French Paintings, Drawings and Watercolours.* Sale cat., Sotheby's, London, December 3, 1991, pp. 8–11.

Laval 1876
Catalogue des oeuvres modernes. Laval, Société des Arts Réunis de Laval, September 1–October 3, 1876. Exh. cat. Laval, 1876.

Laverdant 1844
Désiré Laverdant. "Salon de 1844." *La Démocratie pacifique* 2 (May 16, 1844).

Leeds 1962
"Sir Michael Sadler." Leeds, 1962.

Leleux 1882
Armand Leleux. "Corot à Montreux: Une Excursion d'artistes." *Bibliothèque universelle et revue suisse*, 3rd ser., 15 (September 1882), pp. 470–95.

Lemaistre 1862
Toussaint Lemaistre. *Ventilateur continu et désinfectant appliqué aux fosses d'aisances.* Paris, 1862.

Lemonnier 1870
Camille Lemonnier. *Salon de Paris: 1870.* Paris, 1870.

Lenormant 1861
Charles Lenormant. *Beaux-Arts et voyages. Précédés d'une lettre par M. Guizot.* 2 vols. Paris, 1861.

Lépinois 1859
Eugène de Buchère de Lépinois. *L'Art dans la rue et l'art au Salon.* Paris, 1859.

Leprieur 1908
Paul Leprieur. "Le Beffroi de Douai, par Corot: Acquisition récente du Musée du Louvre." *Bulletin des Musées de France* (1908), pp. 2–4.

Leroy 1859
Louis Leroy. "Le Charivari au Salon de 1859. V." *Le Charivari*, May 4, 1859.

Levey 1987
Michael Levey, ed. *The National Gallery Collections.* London, 1987.

Levey 1990
Michael Levey, ed. *The Soul of the Eye: An Anthology of Painters and Painting.* London, 1990.

Lévy 1976
Pierre Lévy. *Des artistes et un collectionneur.* Paris, 1976.

Leymarie 1893
Camille Leymarie. "Corot à Mont-de-Marsan." *L'Art* 54 (February 1, 1893), pp. 74–76.

Leymarie 1951
Jean Leymarie. *Musée de l'impressionnisme (salles du Jeu de Paume des Tuileries): Guide du visiteur.* Paris, 1951.

Leymarie 1961
Jean Leymarie. *The Spirit of the Letter in Painting.* Kansas City, Mo., 1961.

Leymarie 1962
Jean Leymarie. *La Peinture française: Le Dix-Neuvième Siècle.* Geneva, 1962. Eng. ed., *French Painting: The Nineteenth Century.* Translated by James Emmons. Geneva, 1962.

Leymarie 1966
Jean Leymarie. *Corot: Étude biographique et critique.* Geneva, 1966. Eng. ed., *Corot: Biographical and Critical Study.* Translated by Stuart Gilbert. Geneva, 1966.

Leymarie 1979
Jean Leymarie. *Corot.* Geneva, 1979. Eng. ed., *Corot.* Translated by Stuart Gilbert. Geneva and New York, 1979.

Leymarie 1985
Jean Leymarie. *Corot.* Geneva, 1985.

Leymarie 1992
Jean Leymarie. *Corot.* Geneva, 1992.

Leymarie 1993
Jean Leymarie. *La Peinture française: XIXᵉ Siècle.* 2 vols. Geneva, 1993.

Lhote 1923
André Lhote. *Corot.* Paris, 1923.

Liège 1939
Rétrospective d'art: Peinture, sculpture, tapisserie, gravure, art japonais. Liège, Exposition Internationale de l'Eau, 1939. Exh. cat. Liège, 1939.

Liège 1946
Salon de la libération hommage à la résistance liégeoise: Peinture française de David à Picasso. Liège, Musée des Beaux-Arts, 1946. Exh. cat. Liège, 1946.

Liège, Musée des Beaux-Arts 1950
Liège, Musée des Beaux-Arts. *Catalogue des peintures françaises.* Brussels, 1950.

Lisbon 1965
Un Siècle de peinture française, 1850–1950/Um século de pintura francesa, 1850–1950. Lisbon, Fundação Calouste Gulbenkian, 1965. Exh. cat. Lisbon, 1965.

London 1932
Exhibition of French Art, 1200–1900. London, Royal Academy of Arts, January 4–March 5, 1932. Exh. cat. London, 1932.

London 1934
Renoir, Cézanne and Their Contemporaries. London, Reid & Lefevre, June 1934. Exh. cat. London, 1934.

London 1936a
"Exhibition of Masters of French XIXth Century Painting." London, New Burlington Galleries, October 1–31, 1936.

London 1936b
Corot to Cézanne. London, Reid & Lefevre, June 1936. Exh. cat. London, 1936.

London 1949–50
Catalogue of an Exhibition of Landscape in French Art, 1550–1900. London, Royal Academy of Arts, December 10, 1949–March 5, 1950. Organized by the Arts Council of Great Britain. Exh. cat. London, 1949.

London 1951
French Masters of the XIXth and XXth Centuries. London, Marlborough Fine Art Ltd., 1951. Exh. cat. London, 1951.

London 1959
The Romantic Movement: Fifth Exhibition to Celebrate the Tenth Anniversary of the Council of Europe. London, The Tate Gallery and the Arts Council Gallery, July 10–September 27, 1959. Organized by the Arts Council of Great Britain. Exh. cat. London, 1959.

London 1962
Primitives to Picasso: An Exhibition from Municipal and University Collections in Great Britain. London, Royal Academy of Arts, January 6–March 7, 1962. Exh. cat. London, 1962.

London 1963
Corot: Loan Exhibition in Aid of the Royal Opera House Benevolent Fund. London, Marlborough Fine Art Ltd., October–December 1963. Exh. cat. London, 1963.

London 1969a
The Art of Claude Lorrain. London, Hayward Gallery, November 7–December 14, 1969. Organized by the Arts Council of Great Britain and the Northern Arts Association. Exh. cat. London, 1969.

London 1969b
Berlioz and the Romantic Imagination. London, Victoria and Albert Museum, October 17–December 14, 1969. Organized by the Arts Council of Great Britain. Exh. cat. London, 1969.

London 1974
Impressionism: Its Masters, Its Precursors, and Its Influence in Britain. London, Diploma Galleries, Royal Academy of Arts, February 9–April 28, 1974. Exh. cat. London, 1974.

London 1978
Gustave Courbet 1819–1877. London, Royal Academy of Arts, January 19–March 19, 1978. Exh. cat. London, 1978.

London 1979
Corot and Courbet. London, David Carritt Ltd., June 12–July 13, 1979. Exh. cat. London, 1979.

London 1989
Corot. London, Lefevre Gallery, April 6–28, 1989. Exh. cat. London, 1989.

London 1993
Tradition and Revolution in French Art, 1700–1880: Paintings and Drawings from Lille. London, The National Gallery, March 24–July 11, 1993. Exh. cat. with essays by Humphrey Wine, Jon Whitely, Linda Whitely, and Alain Gérard. London, 1993.

London, Boston 1995–96
Landscapes of France: Impressionism and Its Rivals. London, Hayward Gallery, May 18–August 28, 1995; Boston, Museum of Fine Arts, October 4, 1995–January 14, 1996. Exh. cat. by John House. London, 1995.

London, Frankfurt, Madrid 1988–89
Master Paintings from The Phillips Collection, Washington. London, Hayward Gallery, May 19–August 14, 1988; Frankfurt, Schirn Kunsthalle, August 27–November 6; Madrid, Centro de Arte Reina Sofia, November 30, 1988–February 16, 1989. Exh. cat. London, 1988.

London, Paris, Baltimore 1992–93
Alfred Sisley. London, Royal Academy of Arts, July 3–October 18, 1992; Paris, Musée d'Orsay, October 28, 1992–January 31, 1993; Baltimore, Walters Art Gallery, March 14–June 13. Exh. cat. edited by Mary Anne Stevens. New Haven and London, 1992.

Lorne and Guyot de Fère 1864
De Lorne and Guyot de Fère. "Salon de 1864." *Journal des arts, des sciences et des lettres,* no. 9 (May 16, 1864), pp. 69–71; no. 10 (June 1, 1864), pp. 77–79; no. 12 (July 3, 1864), pp. 94–95.

Los Angeles 1933
Five Centuries of European Painting. Los Angeles Museum of History, Science and Art, Department of Art, 1933. Exh. cat. Los Angeles, 1933.

Los Angeles 1961
French Masters, Rococo to Romanticism: An Exhibition of Paintings, Drawings and Prints. Los Angeles, University of California Art

Galleries, March 5–April 18, 1961. Exh. cat. Los Angeles, 1961.

Lostalot 1870
A[lfred] de L[ostalot]. "Le Salon de 1870: Oeuvres reproduites par *L'Illustration.*" *L'Illustration* 55 (May 7, 1870), pp. 332–36.

Lucas 1979
George A. Lucas. *The Diary of George A. Lucas: An American Art Agent in Paris, 1857–1909.* Transcribed and with an introduction by Lilian M. C. Randall. 2 vols. Princeton, 1979.

Lugano 1994
Jean-Baptiste Camille Corot: Un sentimento particolare del paesaggio. Lugano, Museo Cantonale d'Arte, September 3–November 6, 1994. Exh. cat. with an introduction by Manuela Kahn-Rossi and essays by Vincent Pomarède, François Fossier, and Florian Rodari. Lugano, 1994.

Lugano, Geneva 1991–92
Svizzera meravigliosa: Vedute di artisti stranieri, 1770–1914 / Magnificent Switzerland: Views by Foreign Artists, 1770–1914. Lugano, Fondazione Thyssen-Bornemisza, Villa Favorita, August 1–October 27, 1991; Geneva, Musée d'Art et d'Histoire, November 14, 1991–February 2, 1992. Exh. cat. by William Hauptman. Milan, 1991.

Lurie 1966
Ann Tzeutschler Lurie. "Corot: *The Roman Compagna.*" *Bulletin of The Cleveland Museum of Art* 53 (February 1966), pp. 51–57.

Lyons 1936
Exposition Corot. Musée de Lyon, May 24–June 28, 1936. Exh. cat. by Marie Delaroche-Vernet, with a preface by Paul Jamot. Lyons, 1936.

Lyons 1938–39
Salon du sud-est, 1938: D'Ingres à Cézanne. Musée de Lyon, December 3, 1938–January 15, 1939. Exh. cat. Lyons, 1938.

Lyons 1996
"Ravier." Lyons, Musée des Beaux-Arts, 1996.

Mac'Carthy 1840
Oscar Mac'Carthy. "Salon de 1840." *Journal de l'Institut Historique* 11 (March 1840), pp. 208–14.

McMullen 1975
Roy McMullen. *Mona Lisa: The Picture and the Myth.* Boston, 1975.

Madsen 1920
Karl Madsen. *Corot og hans billeder: I nordisk eie.* Copenhagen, 1920.

***Magasin pittoresque* 1877**
Le Magasin pittoresque, February 1877.

Mainardi 1993
Patricia Mainardi. *The End of the Salon: Art and the State in the Early Third Republic.* Cambridge and New York, 1993.

Malraux 1947
André Malraux. *Psychologie de l'art.* Vol. 1, *Le Musée imaginaire.* Geneva, 1947.

Manchester, New York, Dallas, Atlanta 1991–92
The Rise of Landscape Painting in France: Corot to Monet. Manchester, The Currier Gallery of Art, January 29–April 28, 1991; New York, IBM Gallery of Science and Art, July 30–September 28; Dallas Museum of Art, November 10, 1991–January 5, 1992; Atlanta, High Museum of Art, January 28–March 29. Exh. cat. by Kermit Swiler Champa, Fronia E. Wissman, and Deborah Johnson. Manchester, N.H., 1991.

Manchester, Norwich 1991
Corot: A National Touring Exhibition from the South Bank Centre. Manchester City Art Gallery, May 18–June 30, 1991; Norwich Castle Museum, July 6–August 18. Exh. cat. London, 1991.

Mandevare 1804
Alphonse-Nicolas Mandevare. *Principes raisonnés du paysage, à l'usage des écoles des départements de l'empire français, dessinés d'après nature.* Paris, 1804.

Mantz 1846
Paul Mantz. "Le Salon. Les Paysages." *L'Artiste,* 4th ser., 6 (April 5, 1846), pp. 71–74.

Mantz 1859
Paul Mantz. "Salon de 1859." *Gazette des beaux-arts* 2 (June 1, 1859), pp. 271–99.

Mantz 1861
Paul Mantz. "Corot." *Gazette des beaux-arts* 11 (November 1861), pp. 416–32.

Mantz 1863
Paul Mantz. "Le Salon de 1863." *Gazette des beaux-arts* 15 (July 1863), pp. 32–64.

Mantz 1865
Paul Mantz. "Salon de 1865." *Gazette des beaux-arts* 19 (July 1865), pp. 5–42.

Mantz 1867
Paul Mantz. "Les Beaux-Arts à l'Exposition Universelle. XI. France." *Gazette des beaux-arts* 23 (October 1867), pp. 319–45.

Marcus 1942
Aage Marcus. *Billedkunsten.* Copenhagen, 1942.

Marseilles 1853
"Exposition de la Société Artistique des Beaux-Arts du Rhône." Marseilles, 1853.

Marseilles 1859
"Exposition de la Société Artistique des Bouches-du-Rhône." Marseilles, 1859.

Marseilles 1979
Daumier et ses amis républicains. Marseilles, Musée Cantini, June 1–August 31, 1979. Exh. cat. Marseilles, 1979.

Marseilles 1994
Toiles solaires, paysages provençaux: Dix Oeuvres de la collection du docteur Rau présentées à Marseille. Galeries Contemporaines des Musées de Marseille and Musée Cantini, 1994. Exh. cat. Zurich, 1994.

Marseilles, Musée des Beaux-Arts 1990
Marseilles, Musée des Beaux-Arts. *Parcours: Catalogue guide du Musée des Beaux-Arts de Marseille.* Marseilles, 1990.

Marsh 1983
Cynthia Marsh. "Turgenev and Corot: An Analysis of the Comparison." *Slavonic and East European Review* 61 (January 1983), pp. 107–17.

Marzio 1989
A Permanent Legacy: 150 Works from the Collection of the Museum of Fine Arts, Houston. Introduction by Peter C. Marzio. New York, 1989.

Mather 1930
Frank Jewett Mather Jr. "The Havemeyer Pictures." *Arts* 16 (March 1930), pp. 445–83.

Mathews 1889
Alfred Mathews. "The Walters Art Collection at Baltimore." *Magazine of Western History* 10 (May 1889), pp. 1–16.

Mauclair 1930
Camille Mauclair. *Corot.* Paris, 1930.

Maugeant 1905
P.-E. Maugeant. "Ville d'Avray." *Versailles illustré* 9 (February 1905), pp. 121–28.

Maxon 1970
John Maxon. *The Art Institute of Chicago.* New York, 1970.

Meier-Graefe 1905
Julius Meier-Graefe. *Corot und Courbet.* Leipzig, 1905.

Meier-Graefe 1913
Julius Meier-Graefe. *Camille Corot.* 3rd ed. Munich, 1913.

Meier-Graefe 1929
Julius Meier-Graefe. "Corots Wahlspruch." *Kunst und Künstler* 28 (November 1929), pp. 47–54.

Meier-Graefe 1930
Julius Meier-Graefe. *Corot.* Berlin, 1930.

Melot 1978
Michel Melot. *L'Oeuvre gravé de Boudin, Corot, Daubigny, Dupré, Jongkind, Millet, Théodore Rousseau.* Paris, 1978.

Memphis, Oberlin, Louisville 1987–88
From Arcadia to Barbizon: A Journey in French Landscape Painting. Memphis, Dixon Gallery and Gardens, November 22, 1987–January 4, 1988; Oberlin, Ohio, Allen Memorial Art Museum, Oberlin College, January 17–March 13; Louisville, J. B. Speed Art Museum, March 27–May 15. Exh. cat. by Lisa A. Simpson. Memphis, 1987.

Ménard 1870
René Ménard. "Salon de 1870." *Gazette des beaux-arts*, 2nd ser., 4 (July 1870), pp. 38–71.

Menciaux 1846
Alfred de Menciaux. "Salon de 1846." *Le Siècle*, March 25, 1846.

Menciaux 1847
Alfred de Menciaux. "Salon de 1847." *Le Siècle*, May 14, 1847.

Mercey 1838
Frédéric Mercey. "Salon de 1838." *Revue des deux mondes*, 4th ser., 14 (May 1, 1838), pp. 367–408.

Merson 1861
Olivier Merson. *La Peinture en France.* Paris, 1861.

Merson 1864
Olivier Merson. *L'Opinion nationale*, July 19, 1864.

Merson 1887
Olivier Merson. "Musée de Nantes." In *Inventaire général des richesses d'art de la France: Province, monuments civils.* Vol. 2, pp. 1–196. Paris, 1887.

Meyer 1858
Adolphe Meyer. *Le Sémaphore*, October 21, 1858.

Meyer 1995
Ruth Krueger Meyer. "Barbizon School Paintings." In *The Taft Museum: Its History and Collections*, edited by Edward J. Sullivan and Ruth Krueger Meyer, vol. 1, pp. 246–70. New York, 1995.

Meynell 1908
Everard Meynell. *Corot and His Friends.* London, 1908.

Michel 1896a
André Michel. *Notes sur l'art moderne (peinture): Corot, Ingres, Millet, Eug. Delacroix, Raffet, Meissonier, Puvis de Chavannes. À travers les Salons.* Paris, 1896.

Michel 1896b
André Michel. "L'Oeuvre de Corot et le paysage moderne." *Revue des deux mondes* 133 (February 15, 1896), pp. 913–30.

Michel 1900
André Michel. "Les Arts à L'Exposition Universelle de 1900.—L'Exposition Centennale: La Peinture française (quatrième article)." *Gazette des beaux-arts*, 3rd ser., 24 (October 1900), pp. 284–306.

Michel 1905
Émile Michel. *Corot.* Les Artistes célèbres. Paris, 1905.

Michel 1906
Émile Michel. *Les Maîtres du paysage.* Paris, 1906.

Michel 1909
Émile Michel. *La Forêt de Fontainebleau dans la nature, dans l'histoire, dans la littérature et dans l'art.* Paris, 1909.

Michel 1928
André Michel. *Sur la peinture française au XIXe siècle.* Paris, 1928.

Michelet 1855
J. Michelet. *Histoire de France au XVIème siècle.* Paris, 1855.

Middletown 1931
Middletown, Connecticut, Wesleyan University, 1931.

Milliken 1936
William M. Milliken. "The Twentieth Anniversary Exhibition of The Cleveland Museum of Art." *Art News* 34, no. 37 (June 13, 1936), pp. 7–16.

Ministère de l'Instruction Publique 1908
Ministère de l'Instruction Publique et des Beaux-Arts. *Inventaire général des richesses d'art de la France: Province, monuments civils.* Vol. 8. Paris, 1908.

Minneapolis 1958
Collection of James J. Hill. The Minneapolis Institute of Arts, April 15–June 1, 1958. Exh. cat. by Richard S. Davis. Minneapolis, 1958.

Minneapolis 1975
"The Barbizon School: French Painting, 1830–1880." The Minneapolis Institute of Arts, summer 1975.

Miquel 1975
Pierre Miquel. *Le Paysage français au XIXe siècle.* Vols. 1–3, *1824–1874. L'École de la nature*, vols. 1–3. Maurs-la-Jolie, 1975.

Miquel 1987
Pierre Miquel. *Art et argent, 1800–1900. L'École de la nature*, vol. 6. Maurs-la-Jolie, 1987.

Moffett and Wagner 1980
Charles S. Moffett and Anne Wagner. "Camille Corot, *Fontainebleau: Oak Trees at Bas-Bréau*." In The Metropolitan Museum of Art, *Notable Acquisitions, 1979–1980*, p. 43. New York, 1980.

Montauban 1967
Ingres et son temps: Exposition organisée pour le centenaire de la mort d'Ingres (Montauban 1780–Paris 1867). Montauban, Musée Ingres, June 24–September 15, 1967. Exh. cat. Montauban, 1967.

Monterey, Gainesville, Miami Beach, Owensboro, Elmira, Montgomery 1986–88
The Spirit of Barbizon: France and America. Monterey, California, Monterey Peninsula Museum of Art Association, June 14–August 17, 1986; Gainesville, University Gallery, University of Florida, September 6–November 1; Miami Beach, Bass Museum of Art, December 6–January 31, 1987; Owensboro, Kentucky, Owensboro Museum of Fine Art, March 1–April 26; Elmira, New York, Arnot Art Museum, May 10–September 13; Montgomery Museum of Fine Arts, November 8, 1987–January 3, 1988. Exh. cat. by Daniel Rosenfeld, and Robert G. Workman. San Francisco 1986.

Montezuma 1889a
Montezuma. "My Note Book." *Art Amateur* 21 (September 1889), pp. 66–67.

Montezuma 1889b
Montezuma. "My Note Book." *Art Amateur* 21 (November 1889), pp. 114–15.

Montifaud 1865
Marc de Montifaud. "Salon de 1865. II." *L'Artiste*, 8th ser., 7 (May 15, 1865), pp. 218–24.

Montifaud 1868
Marc de Montifaud. "Salon de 1868. III. Le Genre, le paysage, la sculpture." *L'Artiste*, 9th ser., 6 (July 1, 1868), pp. 41–64.

Montreal 1899
Twenty-First Loan Exhibition of Paintings, in the Art Gallery, Phillips Square. Montreal, The Art Association, opened February 20, 1899. Exh. cat. Montreal, 1899.

Montreal 1918
A Catalogue of Paintings from the Collection of the Late Sir George A. Drummond. Montreal, The Art Association, January 31–March 16, 1918. Exh. cat. Montreal, 1918.

Montreal 1942
Loan Exhibition of Masterpieces of Painting/Exposition de chefs-d'oeuvre de la peinture. Museum of Fine Arts, The Art Association of Montreal, February 5–March 8, 1942. Exh. cat. Montreal, 1942.

Montreal 1949
"Masterpieces from the National Gallery." The Montreal Museum of Fine Arts, October 6–30, 1949.

Montreal 1952
Six Centuries of Landscape/Six Siècles de paysage. The Montreal Museum of Fine Arts, March 7–April 13, 1952. Exh. cat. Preface by R. T. Davis. Montreal, 1952.

Montreal 1960
Canada Collects: European Painting, 1860–1960/Le Canada collectionne: Peinture européenne, 1860–1960. The Montreal Museum of Fine Arts, January 19–February 21, 1960. Exh. cat. Montreal, 1960.

Montreal 1967
Exposition Universelle de Montréal. May 15–December 31, 1967.

Montreal 1970
"From Daumier to Rouault"/"De Daumier à Rouault." The Montreal Museum of Fine Arts, March 24–April 25, 1970. Catalogue by Germain Lefebvre published in M. (The Montreal Museum of

Fine Arts), no. 4 (March 1970), pp. 13–34.

Montreal 1989–90
Discerning Tastes: Montreal Collectors, 1880–1920. The Montreal Museum of Fine Arts, December 8, 1989–February 15, 1990. Exh. cat. by Janet M. Brooke. Montreal, 1989.

Montreal Museum of Fine Arts 1960a
The Montreal Museum of Fine Arts. *Catalogue of Paintings.* Compiled by John Steegman. Montreal, 1960.

Montreal Museum of Fine Arts 1960b
The Montreal Museum of Fine Arts. *The Montreal Museum of Fine Arts: Painting, Sculpture, Decorative Arts.* Montreal, 1960.

Montreal Museum of Fine Arts 1977
The Montreal Museum of Fine Arts. *Guide.* Montreal, 1977.

Montrosier 1882
Eugène Montrosier. *Les Artistes modernes.* Vol. 3, *Les Peintres d'histoire, paysagistes, portraitistes et sculpteurs.* Paris, 1882.

Morant 1951
Henry de Morant. "Deux Corot inconnus au Musée d'Angers." *Les Cahiers de Pincé et des Musées de la ville d'Angers,* n.s., no. 18 (1950), pp. 1–10. Published 1951.

Moreau-Nélaton 1903
Étienne Moreau-Nélaton. "La Vue de Sin-le-Noble, près Douai, par Corot." *Gazette des beaux-arts,* 3rd ser., 29 (June 1903), pp. 490–93.

Moreau-Nélaton 1905a
Étienne Moreau-Nélaton. "Les Figures de Corot." *L'Art et les artistes* 2 (December 1905), pp. 69–70.

Moreau-Nélaton 1905b
Étienne Moreau-Nélaton. *Histoire de Corot et de ses oeuvres, d'après les documents recueillis par Alfred Robaut.* Paris, 1905.

Moreau-Nélaton 1913
Étienne Moreau-Nélaton. *Corot: Biographie critique.* Paris, 1913.

Moreau-Nélaton 1914a
Étienne Moreau-Nélaton. *Mon Bon Ami Henriet.* Paris, 1914.

Moreau-Nélaton 1914b
Étienne Moreau-Nélaton. *Le Roman de Corot.* Paris, 1914.

Moreau-Nélaton 1918
Étienne Moreau-Nélaton. *Mémorial de famille.* 5 vols. Paris, 1918.

Moreau-Nélaton 1924
Étienne Moreau-Nélaton. *Corot: Raconté par lui-même.* 2 vols. Paris, 1924.

Moreau-Nélaton 1925
Étienne Moreau-Nélaton. *Daubigny: Raconté par lui-même.* Paris, 1925.

Moreau-Nélaton 1931
Étienne Moreau-Nélaton. "Deux Heures avec Degas: Interview posthume." *L'Amour de l'art* 12 (July 1931), pp. 267–70.

Morse 1979
John D. Morse. *Old Master Paintings in North America.* 2nd ed. New York, 1979.

Moscow 1982
Antiquity in European Painting from the Fifteenth Century to the Early Twentieth Century: Exhibition of Paintings in the Museums of the Soviet Union, East Germany, Netherlands, and France. Moscow, Pushkin Museum. Exh. cat. In Russian. Moscow, 1982.

Moscow, Pushkin Museum 1961
Moscow, Pushkin Museum. *Catalogue of the Painting Gallery: Painting, Sculpture.* In Russian. Moscow, 1961.

Moscow, Saint Petersburg 1965–66
Exhibition of Paintings by Western European Artists from the Louvre, Bordeaux Museum, and Other Museums of France. Moscow, Pushkin Museum, July–October 1965; Saint Petersburg (formerly Leningrad), The Hermitage, November 1965–January 1966. Exh. cat. In Russian. Moscow, 1965.

Moscow, Saint Petersburg, Warsaw 1956
Malarstwo Francuskie od Davida do Cézanne'a. Moscow, Pushkin Museum; Saint Petersburg (formerly Leningrad); Warsaw, Muzeum Narodowe, June 15–July 31, 1956. Exh. cat. Warsaw, 1956.

Moüy 1865
Charles de Moüy. "Salon de 1865." *Revue française* 11 (June 1, 1865), pp. 177–207.

Munich 1958
München, 1869–1958, Aufbruch zur modernen Kunst: Rekonstruktion der ersten internationalen Kunstausstellung, 1869. Munich, Haus der Kunst, June 21–October 5, 1958. Exh. cat. Munich, 1958.

Munich 1964–65
Französische Malerei des 19. Jahrhunderts: Von David bis Cézanne. Munich, Haus der Kunst, October 7, 1964–January 6, 1965. Exh. cat. Munich, 1964.

Munich 1979–80
Von Dillis bis Piloty: Deutsche und österreichische Zeichnungen, Aquarelle, Ölskizzen, 1790–1850, aus eigenem Besitz. Munich, Staatliche Graphische Sammlung, December 14, 1979–March 16, 1980. Exh. cat. by Gisela Scheffler and Barbara Hardtwig. Munich, 1979.

Munich 1983
Im Licht von Claude Lorrain: Landschaftsmalerei aus drei Jahrhunderten. Munich, Haus der Kunst, March 12–May 29, 1983. Exh. cat. by Marcel Roethlisberger. Munich, 1983.

Murphy 1985
Alexandra R. Murphy. *European Paintings in the Museum of Fine Arts, Boston.* Boston, 1985.

Musset 1961
Alfred de Musset. *Premières Poésies.* Edited by A. Bouvet. Paris, 1961.

Nadar 1853
Nadar [Gaspard-Félix Tournachon]. *Nadar jury au Salon de 1853.* Paris, 1853.

Nagoya, Kamakura, Osaka, Fukuoka 1971–72
Exposition des chefs-d'oeuvre du Musée des Beaux-Arts de Bordeaux. Nagoya, Aichi Prefectural Art Gallery, 1971; Kamakura, Museum of Modern Art, November 19, 1971–January 15, 1972; Osaka, National Museum of Art, 1972; Fukuoka, Municipal Museum, 1972. Exh. cat. Tokyo, 1971.

Nantes 1858
"Exposition Triennale." Nantes, 1858.

Nantes, Musée des Beaux-Arts 1859
Nantes, Musée des Beaux-Arts. *Catalogue des tableaux et statues du Musée de Nantes.* 7th ed. Nantes, 1859.

Naples, Milan 1986–87
Capolavori impressionisti dei musei americani. Naples, Museo di Capodimonte, December 3, 1986–February 8, 1987; Milan, Pinacoteca di Brera, March 4–May 10. Exh. cat. Milan, 1987.

Nash 1979
Steven A. Nash, with Katy Kline, Charlotta Kotik, and Emese Wood. *Albright-Knox Art Gallery: Painting and Sculpture from Antiquity to 1942.* New York, 1979.

Néto-Daguerre and Coutagne 1992
Isabelle Néto-Daguerre and Denis Coutagne. *Granet: Peintre de Rome.* Aix-en-Provence, 1992.

Nettement 1859
Alfred Nettement. "Salon de 1859." *La Semaine des familles,* no. 34 (May 21, 1859), pp. 535–38.

Nettement 1864
Alfred Nettement. "Salon de 1864." *La Semaine des familles,* no. 39 (June 25, 1864), pp. 609–12.

Nettement 1868
Alfred Nettement. "Salon de 1868." *La Semaine des familles,* no. 35 (May 30, 1868), pp. 557–60.

Neuweiler 1945
Arnold Neuweiler. *La Peinture à Genève de 1700 à 1900.* Geneva, 1945.

Newark 1946
Nineteenth Century French and American Paintings from the Collection of The Metropolitan Museum of Art. The Newark Museum, April 9–May 15, 1946. Exh. cat. Newark, 1946.

New Grove Dictionary of Music 1980
New Grove Dictionary of Music and Musicians.
Vol. 18. London, 1980.

New Haven 1950
"French Paintings of the Latter Half of
the Nineteenth Century from the Collec-
tions of Alumni and Friends of Yale."
New Haven, Yale University Art Gallery,
April 17–May 21, 1950. Catalogue published
in *Bulletin of the Associates in Fine Arts at Yale
University* 18, no. 2 (April 1950).

New Haven 1956
Pictures Collected by Yale Alumni. New Haven,
Yale University Art Gallery, May 8–June 18,
1956. Exh. cat. New Haven, 1956.

New Haven 1960
*Paintings, Drawings and Sculpture Collected by Yale
Alumni.* New Haven, Yale University Art
Gallery, May 19–June 26, 1960. Exh. cat.
New Haven, 1960.

New Haven 1961
*Paintings and Sculpture from the Albright Art
Gallery.* New Haven, Yale University Art
Gallery, April 27–September 3, 1961. Exh.
cat. New Haven, 1961.

New Orleans 1952
New Orleans, Willard University, January 1–
April 30, 1952.

New York 1883
*Catalogue of the Pedestal Fund Art Loan Exhibi-
tion.* New York, National Academy of
Design, December 1883. Exh. cat. New
York, 1883.

New York 1889–90
*Catalogue of the Works of Antoine-Louis Barye
Exhibited at The American Art Galleries under the
Auspices of the Barye Monument Association.* New
York, The American Art Galleries, Novem-
ber 15, 1889–January 15, 1890. Exh. cat. New
York, 1889.

New York 1890–91
Loan Collections and Recent Gifts to the Museum.
New York, The Metropolitan Museum of
Art, May 1890–November 1891. Exh. cat.
New York, 1890.

New York 1928
*A Century of French Painting: Exhibition Organ-
ised for the Benefit of the French Hospital of New
York.* New York, M. Knoedler & Co.,
November 12–December 8, 1928. Exh. cat.
New York, 1928.

New York 1930a
Masterpieces by Nineteenth Century French Painters.
New York, M. Knoedler & Co., October–
November 1930. Exh. cat. New York, 1930.

New York 1930b
*The H. O. Havemeyer Collection: A Catalogue
of the Temporary Exhibition.* New York, The

Metropolitan Museum of Art, March 10–
November 2, 1930. Exh. cat. New York, 1930.

New York 1930c
Corot, Daumier: Eighth Loan Exhibition. New
York, The Museum of Modern Art, Octo-
ber 16–November 23, 1930. Exh. cat. New
York, 1930.

New York 1934a
*Exhibition of Important Paintings by Great French
Masters of the Nineteenth Century Organized by
Paul Rosenberg and Durand-Ruel for the Benefit of
the Children's Aid Society and the French Hospital
of New York.* New York, Durand-Ruel, Feb-
ruary 12– March 10, 1934. Exh. cat. New
York, 1934.

New York 1934b
*Loan Exhibition of Figure and Landscape Paintings
by J. B. C. Corot.* New York, M. Knoedler &
Co., November 12–December 1, 1934. Exh.
cat. New York, 1934.

New York 1935
A Nineteenth Century Selection: French Paintings.
New York, Bignou Galleries, March 1935.
Exh. cat. New York, 1935.

New York 1936
*Exhibition of French Masterpieces of the Nineteenth
Century Loaned by Several Members of The Century
Club.* New York, The Century Club, Janu-
ary 11–February 10, 1936. Exh. cat. Foreword
by Augustus Vincent Tack. New York, 1936.

New York 1937
Figure Pieces: Loan Exhibition. New York, M.
Knoedler & Co., March 29–April 10, 1937.
Exh. cat. New York, 1937.

New York 1940
*Catalogue of European and American Paintings,
1500–1900.* New York World's Fair, May–
October 1940. Exh. cat. New York, 1940.

New York 1941
*French Painting from David to Toulouse-Lautrec:
Loans from French and American Museums and
Collections.* New York, The Metropolitan
Museum of Art, February 6–March 26,
1941. Exh. cat. New York, 1941.

New York 1942
*The Serene World of Corot: An Exhibition in Aid
of the Salvation Army War Fund.* New York,
Wildenstein & Co., November 11–Decem-
ber 12, 1942. Exh. cat. New York, 1942.

New York 1945
A Selection of Nineteenth Century French Paintings.
New York, Bignou Galleries, October 22–
November 17, 1945. Exh. cat. New York, 1945.

New York 1946
*Exhibition Celebrating Knoedler: One Hundred
Years, 1846–1946.* New York, M. Knoedler
& Co., April 1–27, 1946. Exh. cat. New
York, 1946.

New York 1947
"Paintings of the Great French Masters of
the Nineteenth Century." New York, Paul
Rosenberg & Co., November 17–December
6, 1947.

New York 1952–53
*Art Treasures of the Metropolitan: A Selection from
the European and Asiatic Collections of The Metro-
politan Museum of Art.* New York, The Met-
ropolitan Museum of Art, November 7,
1952–September 7, 1953. Exh. cat. New
York, 1952.

New York 1953
*Paintings and Drawings from the Smith College
Collection.* New York, M. Knoedler & Co.,
March 30–April 11, 1953. Exh. cat. New
York, 1953.

New York 1954
*A Collector's Taste: Selections from the Collection
of Mr. and Mrs. Stephen C. Clark. A Benefit Exhi-
bition of Paintings for the Benefit of The Fresh Air
Association of St. John.* New York, M. Knoedler
& Co., January 12–30, 1954. Exh. cat. New
York, 1954.

New York 1955
"Fifteen Paintings by French Masters of
the Nineteenth Century Lent by the Louvre
and the Museums of Albi and Lyon." New
York, The Museum of Modern Art, 1955.
Catalogue published in *The Museum of Mod-
ern Art Bulletin* 12, no. 3 (spring 1955).

New York 1956
*Loan Exhibition of Paintings by J. B. C. Corot
(1796–1875).* New York, Paul Rosenberg &
Co., November 5–December 1, 1956. Exh.
cat. New York, 1956.

New York 1956a
*Nude in Painting: A Loan Exhibition for the Benefit
of Recording for the Blind, Inc.* New York, Wilden-
stein & Co., November 1–December 1, 1956.
Exh. cat. New York, 1956.

New York 1958
"Paintings Exhibited by the Wadsworth
Atheneum at Knoedler Galleries." New York,
M. Knoedler & Co., January 31–April 11, 1958.

New York 1959
*Masterpieces of the Corcoran Gallery of Art: A Ben-
efit Exhibition in Honor of the Gallery's Centenary.*
New York, Wildenstein & Co., January 28–
March 7, 1959. Exh. cat. New York, 1959.

New York 1961
*Masterpieces: A Memorial Exhibition for Adele R.
Levy. Benefit of the Citizens' Committee for Chil-
dren of New York, Inc.* New York, Wildenstein
& Co., April 6–May 7, 1961. Exh. cat. New
York, 1961.

New York 1963
Birth of Impressionism: Loan Exhibition. New

York, Wildenstein & Co., March 7–April 6, 1963. Exh. cat. New York, 1963.

New York 1965–66
French Landscape Painters from Four Centuries. New York, Finch College Museum of Art, October 20, 1965–January 9, 1966. Exh. cat. New York, 1965.

New York 1966a
Paintings and Prints: Collection of the Electra Havemeyer Webb Fund. An Exhibition for the Shelburne Museum, Shelburne, Vermont. New York, M. Knoedler & Co., March 29–April 23, 1966. Exh. cat. New York, 1966.

New York 1966b
Romantics and Realists: A Loan Exhibition for the Benefit of the Citizens' Committee for Children of New York, Inc. New York, Wildenstein & Co., April 7–May 7, 1966. Exh. cat. New York, 1966.

New York 1967a
Summer Loan Exhibition: Paintings from Private Collections. New York, The Metropolitan Museum of Art, 1967. Exh. cat. New York, 1967.

New York 1967b
Treasures from the Sterling and Francine Clark Art Institute, Williamstown, Massachusetts: Paintings, Drawings and Rare Silver. New York, Wildenstein & Co., February 2–15, 1967. Exh. cat. New York, 1967.

New York 1969
Corot: A Loan Exhibition for the Benefit of the Citizens' Committee for Children of New York, Inc. New York, Wildenstein & Co., October 30–December 6, 1969. Exh. cat. Preface by Jean Dieterle. New York, 1969.

New York 1970–71
Masterpieces of Fifty Centuries: The Metropolitan Museum of Art. New York, The Metropolitan Museum of Art, November 15, 1970–February 15, 1971. Exh. cat. Introduction by Kenneth Clark. New York, 1970.

New York 1971
The Painter's Light. New York, The Metropolitan Museum of Art, October 5–November 10, 1971. Exh. cat. by John Walsh. New York, 1971.

New York 1972
The Forest of Fontainebleau, Refuge of Reality: French Landscape, 1800 to 1870. New York, Shepherd Gallery, April 22–June 10, 1972. Exh. cat. by John Ittmann et al. New York, 1972.

New York 1973a
Retrospective of a Gallery: Twenty Years. New York, Hirschl & Adler Galleries, November 8–December 1, 1973. Exh. cat. New York, 1973.

New York 1973b
Twelve Years of Collecting: A Loan Exhibition from the Collection of the Museum of Art, Carnegie Institute, Pittsburgh. New York, Wildenstein & Co., Inc., November 8–December 15, 1973. Exh. cat. New York, 1973.

New York 1975–76
Patterns of Collecting: Selected Acquisitions, 1965–1975. New York, The Metropolitan Museum of Art, December 6, 1975–March 23, 1976. Exh. cat. New York, 1975.

New York 1978
Romance and Reality: Aspects of Landscape Painting. For the Benefit of the Memorial Sloan-Kettering Cancer Center. New York, Wildenstein & Co., October 18–November 22, 1978. Exh. cat. New York, 1978.

New York 1983–84
"Paintings and Drawings from The Phillips Collection." New York, IBM Gallery of Science and Art, December 9, 1983–January 21, 1984.

New York 1986
Jean-Baptiste-Camille Corot (1796–1875), Eugène Delacroix (1798–1863): An Exhibition—Paintings, Drawings, Watercolours. New York, Salander-O'Reilly Galleries, 1986. Exh. cat. with an introduction by S. Lane Faison Jr. and essays by Julius Meier-Graefe. New York, 1986.

New York 1987–88
"Landscapes by French Artists, 1780–1880." New York, The Metropolitan Museum of Art, November 17, 1987–February 7, 1988.

New York 1988
"Eighteenth–Twentieth Century European and American Painting and Sculpture: Highlights from the Collection of the Museum of Art, Rhode Island School of Design." New York, IBM Gallery of Science and Art, July 5–September 10, 1988.

New York 1990
Claude to Corot: The Development of Landscape Painting in France. New York, Colnaghi, November 1–December 15, 1990. Exh. cat. edited by Alan Wintermute, with essays by Michael Kitson et al. New York, 1990.

New York 1992
"Barbizon: French Landscapes of the Nineteenth Century." New York, The Metropolitan Museum of Art, February 4–May 10, 1992.

New York 1992–93
Masterworks from the Musée des Beaux-Arts, Lille. New York, The Metropolitan Museum of Art, October 27, 1992–January 17, 1993. Exh. cat. by Marc Fumaroli et al. New York, 1992.

New York 1993
Splendid Legacy: The Havemeyer Collection. New York, The Metropolitan Museum of Art, March 27–June 20, 1993. Exh. cat. by Alice Cooney Frelinghuysen, Gary Tinterow, Susan Alyson Stein, Gretchen Wold, and Julia Meech. New York, 1993.

New York, Omaha, Los Angeles, Chicago 1981–82
Before Photography: Painting and the Invention of Photography. New York, The Museum of Modern Art, May 9–July 5, 1981; Omaha, Nebraska, Joslyn Art Museum, September 12–November 8; Los Angeles, Frederick S. Wight Art Gallery, University of California, January 4–February 21, 1982; The Art Institute of Chicago, March 15–May 9. Exh. cat. by Peter Galassi. New York, 1981.

Nice 1955
"Chefs-d'Oeuvre du Louvre." Nice, Musée Massena, 1955.

Nice 1982
Le Temple: Représentations de l'architecture sacrée. Nice, Musée National Message Biblique Marc Chagall, July 3–October 4, 1982. Exh. cat. Paris, 1982.

Nicolle 1919
Marcel Nicolle. *Le Musée de Nantes: Peintures.* Paris, 1919.

Nicolle 1920
Marcel Nicolle. *Le Musée de Rouen: Peintures.* Paris, 1920.

Northampton 1934
"Exhibition of Portraits and Early Landscapes by J. B. C. Corot." Northampton, Massachusetts, Smith College Museum of Art, November 12–December 9, 1934. Catalogue by Elizabeth H. Payne published in *Bulletin of Smith College Museum of Art*, no. 16 (June 1935), pp. 19–28.

Northampton, Smith College Museum of Art 1937
Northampton, Smith College Museum of Art. *Catalogue.* Northampton, Mass., 1937.

Northampton, Smith College Museum of Art 1953
Northampton, Smith College Museum of Art. *Forty French Pictures in the Smith College Museum of Art.* Foreword by George Heard Hamilton. Northampton, Mass., 1953.

Ogawa 1994
David C. Ogawa. "Jean-Baptiste Camille Corot (1796–1875): L'Atelier de Corot (Jeune Femme en robe rose, assise devant un chevalet et tenant une mandoline)." In *Impressionist and Modern Paintings, Drawings and Sculpture (Part 1)*, pp. 24–29. Sale cat., Christie's, New York, November 9, 1994.

Oklahoma City 1977
Masters of the Landscape, 1650–1900. Oklahoma City, Oklahoma Museum of Art, 1977.

Exh. cat. Oklahoma City, 1977.

Orléans, Dunkirk, Rennes 1979
Théodore Caruelle d'Aligny (1798–1871) et ses compagnons. Orléans, Musée des Beaux-Arts, February 28–April 20, 1979; Dunkirk, Musée des Beaux-Arts, April 25–June 20; Rennes, Musée des Beaux-Arts, June 25–September 4. Exh. cat. by Marie-Madeleine Aubrun. Dunkirk, 1979.

Ottawa 1962
Corot to Picasso: European Paintings in Canadian Collections. Ottawa, National Gallery of Canada, February 9–March 4, 1962. Exh. cat. Ottawa, 1962.

Ottawa 1972
Progress in Conservation/Progrès en conservation et en restauration. Ottawa, National Gallery of Canada, January 14–February 13, 1972. Exh. cat. edited by Nathan Stolow. Ottawa, 1972.

Otterlo, Rijksmuseum Kröller-Müller 1957
Otterlo, Rijksmuseum Kröller-Müller. *Catalogue of Nineteenth and Twentieth Century Painting, with a Selection from the Drawings of That Period.* Otterlo, 1957.

Otterlo, Rijksmuseum Kröller-Müller 1970
Otterlo, Rijksmuseum Kröller-Müller. *Schilderijen van het Rijksmuseum Kröller-Müller.* Otterlo, 1970.

Paris 1846
Paris, L'Odéon (foyer), Association des Artistes, 1846.

Paris 1855
Exposition Universelle de 1855. Paris, Palais des Beaux-Arts, opened May 15, 1855. Exh. cat. Paris, 1855.

Paris 1861
Tableaux de l'école moderne tirés de collections d'amateurs. Paris, Société Nationale des Beaux-Arts, opened August 15, 1861. Organized at the Boulevard des Italiens by L. Martinet. Exh. cat. Paris, 1861.

Paris 1862
Tableaux de l'école moderne tirés de collections d'amateurs. Paris, Société Nationale des Beaux-Arts, opened March 1, 1862. Organized at the Boulevard des Italiens by L. Martinet. Exh. cat. Paris, 1862.

Paris 1867
Exposition Universelle de 1867. Paris, Palais du Champ de Mars, 1867. Exh. cat. Paris, 1867.

Paris 1871–72
"Exposition du Cercle des Mirlitons." Paris, 1871–72.

Paris 1872
Exposition des lots de la loterie pour les orphelins des victimes de la guerre. Paris, L'Opéra, 1872. Exh. cat. Paris, 1872.

Paris 1875a
Exposition de l'oeuvre de Corot. Paris, École Nationale des Beaux-Arts, May 1875. Exh. cat. Biographical note by Ph[ilippe] Burty. Paris, 1875.

Paris 1875b
Liste des oeuvres d'art exposées par la ville de Paris. Paris, École Nationale des Beaux-Arts, July 1875. Exh. cat. Paris, 1875.

Paris 1878a
Exposition Universelle de 1878. Paris, 1878. Exh. cat. Paris, 1878.

Paris 1878b
Exposition rétrospective de tableaux et dessins des maîtres modernes. Paris, Durand-Ruel & Cie., 1878. Exh. cat. Paris, 1878.

Paris 1883a
Portraits du siècle. Paris, École Nationale des Beaux-Arts, 1883. Exh. cat. Paris, 1883.

Paris 1883b
Exposition de cent chefs-d'oeuvre des collections parisiennes. Paris, Galerie Georges Petit, June–July 1883. Exh. cat. Paris, 1883.

Paris 1885
Exposition de tableaux, statues et objets d'art au profit de l'oeuvre des orphelins d'Alsace-Lorraine. Paris, Palais du Louvre, 1885. Exh. cat. Paris, 1885.

Paris 1886
"Exposition de maîtres du siècle." Paris, April–May 1886.

Paris 1887
Exposition de tableaux modernes français & étrangers. Paris, Galerie Georges Petit, September–October 1887. Exh. cat. Paris, 1887.

Paris 1889
Exposition Universelle de 1889. Paris, Palais du Champ de Mars, Galerie des Beaux-Arts, "Exposition centennale de l'art français," 1889. Exh. cat. Paris, 1889.

Paris 1892
Exposition de cent chefs-d'oeuvre des écoles française & étrangères. Paris, Galerie Georges Petit, opened June 8, 1892. Exh. cat. Paris, 1892.

Paris 1895
Exposition organisée au profit du monument du centenaire de Corot: Catalogue des chefs-d'oeuvre prêtés par les musées de l'état et les grandes collections de France et de l'étranger. Paris, Palais Galliera, May–June 1895. Exh. cat. Paris, 1895.

Paris 1900
Exposition Universelle de 1900. Paris, Grand Palais, "Exposition centennale de l'art français (1800–1889)," 1900. Exh. cat. Paris, 1900.

Paris 1907
Catalogue de la collection Moreau (tableaux, dessins, aquarelles et pastels) offerte à l'état français et exposée au Musée des Arts Décoratifs. Paris, Musée des Arts Décoratifs, 1907. Exh. cat. Paris, 1907.

Paris 1910a
Catalogue de la collection Chauchard. Paris, Musée National du Louvre, 1910. Exh. cat. Paris, 1910.

Paris 1910b
Exposition de chefs-d'oeuvre de l'école française: Vingt Peintres du XIXᵉ siècle. Paris, Galerie Georges Petit, May 2–31, 1910. Exh. cat. Paris, 1910.

Paris 1912
Paris, Salon d'Automne, Grand Palais, "Exposition de portraits du XIXᵉ siècle," October 1–November 8, 1912. Exh. cat. Paris, 1912.

Paris 1922a
Exposition d'oeuvres de grand maîtres du dix-neuvième siècle. Paris, Paul Rosenberg & Cie., May 3–June 3, 1922. Exh. cat. Paris, 1922.

Paris 1922b
Cent Ans de peinture française. Paris, rue de la Ville-l'Évêque, March 15–April 20, 1922.

Paris 1923
Exposition d'oeuvres d'art des XVIIIᵉ, XIXᵉ et XXᵉ siècles au profit du Comité National d'Aide à la Recherche Scientifique. Paris, April 25–May 15, 1923. Organized by the Chambre Syndicale de la Curiosité et des Beaux-Arts. Exh. cat. Paris, 1923.

Paris 1925
Exposition du paysage français de Poussin à Corot. Paris, Petit Palais, May–June 1925. Exh. cat. by Henry Lapauze, Camille Gronkowski, and Adrien Fauchier-Magnan. Paris, 1925.

Paris 1928
Exposition d'oeuvres de Camille J.-B. Corot (1796–1875): Figures et paysages d'Italie. Au profit de la Bibliothèque d'Art & d'Archéologie de l'Université de Paris. Paris, Paul Rosenberg & Cie., June 6–July 7, 1928. Exh. cat. Paris, 1928.

Paris 1930a
Cent Ans de peinture française "programme": Exposition organisée au profit de la Cité Universitaire. Paris, Galerie Georges Petit, June 15–30, 1930. Exh. cat. Paris, 1930.

Paris 1930b
Exposition d'oeuvres de Corot (1796–1875): Paysages de France et figures. Au profit de l'oeuvre de l'allaitement maternel. Paris, Paul Rosenberg & Cie., June 2–July 5, 1930. Exh. cat. Paris, 1930.

Paris 1931
Exposition d'oeuvres importantes de grands maîtres du dix-neuvième siècle. Paris, Paul Rosenberg & Cie., May 18–June 27, 1931. Exh. cat. Paris, 1931.

Paris 1933
Les Achats du Musée du Louvre et les dons de la Société des Amis du Louvre, 1922–1932. Paris,

Musée de l'Orangerie, April–May 1933.
Exh. cat. Paris, 1933.

Paris 1934
Les Artistes français en Italie de Poussin à Renoir.
Paris, Musée des Arts Décoratifs,
May–July 1934. Exh. cat. Paris, 1934.

Paris 1936
Corot. Paris, Musée de l'Orangerie, 1936.
Exh. cat. by Marie Delaroche-Vernet, with
a preface by Paul Jamot. Paris, 1936.

Paris 1936a
*Exposition "Le Grand Siècle": Organisée au profit de
la Société des Amis du Louvre.* Paris, Paul Rosen-
berg & Cie., June 15–July 11, 1936. Exh. cat.
Paris, 1936.

Paris 1937
Chefs-d'Oeuvre de l'art français. Paris, Palais
National des Arts, 1937. Exh. cat. Paris,
1937.

Paris 1938a
*Exposition de tableaux et dessins: Quelques Maîtres
du 18ᵉ et du 19ᵉ siècle. Au profit de la Société des
Amis du Louvre et de l'oeuvre de l'enfance mal-
heureuse.* Paris, Durand-Ruel & Cie., 1938.
Exh. cat. Paris, 1938.

Paris 1938b
*Exposition de dessins et de quelques peintures par
C. Corot 1796–1875.* Paris, Maurice Gobin,
November 25–December 17, 1938. Exh. cat.
Paris, 1938.

Paris 1938c
Exposition des trésors de Reims. Paris, Musée de
l'Orangerie, July 1938. Exh. cat. Paris, 1938.

Paris 1939
*Quelques Oeuvres choisies du XIXᵉ et du XXᵉ
siècle.* Paris, Galerie Raphaël Gérard, March
17–April 1, 1939. Exh. cat. Paris, 1939.

Paris 1941
Donation Paul Jamot. Paris, Musée de l'Or-
angerie, April–May 1941. Exh. cat. Preface
by Maurice Denis. Paris, 1941.

Paris 1942a
Le Paysage français de Corot à nos jours. Paris,
Galerie Charpentier, 1942. Exh. cat. Paris,
1942.

Paris 1942b
"Rivages de France." Paris, Galerie René
Drouin, May 1942.

Paris 1944
Marines. Paris, Galerie Charpentier, 1944.
Exh. cat. Paris, 1944.

Paris 1945a
*Nouvelles Acquisitions, 2 septembre 1939–2 septem-
bre 1945.* Paris, Musée de l'Orangerie, 1945.
Exh. cat. Paris, 1945.

Paris 1945b
Chefs-d'Oeuvre de la peinture. Paris, Musée du
Louvre, 1945. Exh. cat. Paris, 1945.

Paris 1946a
*Peintures méconnues des églises de Paris: Retour
d'évacuation.* Paris, Musée Galliera, 1946. Exh.
cat. Paris, 1946.

Paris 1946b
*Chefs-d'Oeuvre de la peinture française du Louvre:
Des Primitifs à Manet.* Paris, Petit Palais, 1946.
Exh. cat. Paris, 1946.

Paris 1947
Cinquantenaire des "Amis du Louvre," 1897–1947.
Paris, Musée de l'Orangerie, 1947. Exh. cat.
Paris, 1947.

Paris 1948
*Chateaubriand 1768–1848: Exposition du cente-
naire.* Paris, Bibliothèque Nationale, 1948.
Exh. cat. Paris, 1948.

Paris 1950
*Cent Portraits de femmes: Du XVᵉ siècle à nos
jours.* Paris, Galerie Charpentier, 1950. Exh.
cat. Paris, 1950.

Paris 1951a
Plaisir de France. Paris, Galerie Charpentier,
1951. Exh. cat. Paris, 1951.

Paris 1951b
*Le Divin Corot: Exposition du 155ᵉ anniversaire
de la naissance, 1796–1951, au profit de la Maison
Nationale de Retraite des Peintres, Sculpteurs et
Graveurs de Nogent-sur-Marne.* Paris, Alfred
Daber, 1951. Exh. cat. Paris, 1951.

Paris 1952
Delacroix et les maîtres de la couleur. Paris, Ate-
lier de Delacroix, opened May 17, 1952.
Exh. cat. by Ph. de Gabrielli. Paris, 1952.

Paris 1953
Un Siècle d'art français, 1850–1950. Paris, Petit
Palais, 1953. Exh. cat. Paris, 1953.

Paris 1954–55
Van Gogh et les peintres d'Auvers-sur-Oise. Paris,
Musée de l'Orangerie, November 26, 1954–
February 28, 1955. Exh. cat. Paris, 1954.

Paris 1955a
*Gérard de Nerval: Exposition organisée pour le cen-
tième anniversaire de sa mort.* Paris, Bibliothèque
Nationale, 1955. Exh. cat. Paris, 1955.

Paris 1955b
*De David à Toulouse-Lautrec: Chefs-d'Oeuvre des
collections américaines.* Paris, Musée de l'Or-
angerie, 1955. Exh. cat. Paris, 1955.

Paris 1957
C. Corot: Peintures—dessins. Paris, Hector
Brame, June 14–July 5, 1957. Exh. cat. Paris,
1957.

Paris 1959
*De Géricault à Matisse: Chefs-d'Oeuvre français
des collections suisses.* Paris, Petit Palais,
March–May 1959. Exh. cat. Paris, 1959.

Paris 1961
Paris vu par les maîtres de Corot à Utrillo. Paris,

Musée Carnavalet, March–May 1961. Exh.
cat. Paris, 1961.

Paris 1962
Figures de Corot. Paris, Musée du Louvre,
June–September 1962. Exh. cat. by Germain
Bazin, with contributions by Marie-Thérèse
Lemoyne de Forges, Madeleine Dreyfus-
Bruhl, and Sylvie Béguin. Paris, 1962.

Paris 1965
Marcel Proust. Paris, Bibliothèque Nationale,
1965. Exh. cat. Paris, 1965.

Paris 1966a
Dans la lumière de Vermeer: Cinq Siècles de peinture.
Paris, Musée de l'Orangerie, September 24–
November 28, 1966. Exh. cat. Paris, 1966.

Paris 1966b
Bonington: Une Romantique anglais à Paris. Paris,
Musée Jacquemart-André, 1966. Exh. cat.
by Pierre Georgel. Paris, 1966.

Paris 1968–69
Baudelaire. Paris, Petit Palais, November 23,
1968–March 17, 1969. Exh. cat. Paris, 1968.

Paris 1971
Corot 1796–1875. Paris, Galerie Schmit,
May 12–June 12, 1971. Exh. cat. Paris, 1971.

Paris 1973
Équivoques: Peintures françaises du XIXᵉ siècle.
Paris, Musée des Arts Décoratifs, March 9–
May 14, 1973. Exh. cat. Paris, 1973.

Paris 1974
Le Musée du Luxembourg en 1874: Peintures.
Paris, Grand Palais, May 31–November 18,
1974. Exh. cat. by Geneviève Lacambre.
Paris, 1974.

Paris 1975
*Hommage à Corot: Peintures et dessins des collections
françaises.* Paris, Musée de l'Orangerie, June 6–
September 29, 1975. Exh. cat. by Hélène
Toussaint, Geneviève Monnier, and Martine
Servot. Paris, 1975.

Paris 1976–77
*L'Art et l'écrivain: Centenaire de Louis Gillet
(1876–1943).* Paris, Musée Jacquemart-
André, December 1976–January 1977. Exh.
cat. by Germain Bazin. Paris, 1976.

Paris 1981
*Gauguin et les chefs-d'oeuvre de l'Ordrupgaard de
Copenhague.* Paris, Musée Marmottan, Octo-
ber–November 1981. Exh. cat. Paris, 1981.

Paris 1983–84
Raphaël et l'art français. Paris, Grand Palais,
November 15, 1983–February 13, 1984. Exh.
cat. Paris, 1983.

Paris 1989
"Hommage aux donateurs." Paris, Musée
du Louvre, 1989.

Paris 1991
De Corot aux Impressionnistes: Donations Moreau-

Nélaton. Paris, Grand Palais, April 30–July 22, 1991. Exh. cat. Paris, 1991.

Paris 1993
Copier créer, de Turner à Picasso: 300 Oeuvres inspirées par les maîtres du Louvre. Paris, Musée du Louvre, April 26–July 26, 1993. Exh. cat. Paris, 1993.

Paris 1994
Achille-Etna Michallon. Paris, Musée du Louvre, March 10–June 10, 1994. Exh. cat. by Vincent Pomarède, Blandine Lesage, and Chiara Stefani. Paris, 1994.

Paris, Berlin 1992–93
Les Étrusques et l'Europe. Paris, Grand Palais, September 15–December 14, 1992; Berlin, Altes Museum, February 25–May 31, 1993. Exh. cat. Paris and Milan, 1992.

Paris, Detroit, New York 1974–75
French Painting, 1774–1830: The Age of Revolution. Paris, Grand Palais, November 16, 1974–February 3, 1975; The Detroit Institute of Arts, March 5–May 4; New York, The Metropolitan Museum of Art, June 12–September 7. Exh. cat. Detroit, 1975.

Paris, London 1994–95
Nicolas Poussin (1594–1665). Paris, Grand Palais, September 27, 1994–January 2, 1995; London, Royal Academy of Arts, January 19–April 9, 1995. Exh. cat. Paris, 1994. Eng. ed., *Nicolas Poussin (1594–1665).* London, 1995.

Paris, Lyons 1984–85
Hippolyte, Auguste et Paul Flandrin: Une Fraternité picturale au XIXᵉ siècle. Paris, Musée de Luxembourg, November 16, 1984–February 10, 1985; Lyons, Musée des Beaux-Arts, March 5–May 19. Exh. cat. Paris, 1984.

Paris, Musée du Louvre 1972
Paris, Musée du Louvre. *Catalogue des peintures.* Vol. 1. Paris, 1972.

Paris, New York 1974–75
Centenaire de l'impressionnisme. Paris, Grand Palais, September 21–November 24, 1974; New York, The Metropolitan Museum of Art, December 12, 1974–February 10, 1975. Exh. cat. by Anne Dayez, Michel Hoog, and Charles S. Moffett. Paris, 1974. Eng. ed., *Impressionism: A Centenary Exhibition.* New York, 1974.

Paris, New York 1994–95
Impressionnisme: Les Origines, 1859–1869. Paris, Grand Palais, April 19–August 8, 1994; New York, The Metropolitan Museum of Art, September 27, 1994–January 8, 1995. Exh. cat. by Henri Loyrette and Gary Tinterow. Paris, 1994. Eng. ed., *Origins of Impressionism.* New York, 1994.

Paris, Ottawa, New York 1988–89
Degas. Paris, Grand Palais, February 9–May 16, 1988; Ottawa, National Gallery of Canada, June 16–August 28; New York, The Metropolitan Museum of Art, September 27, 1988–January 8, 1989. Exh. cat. by Jean Sutherland Boggs, Douglas W. Druick, Henri Loyrette, Michael Pantazzi, and Gary Tinterow. Paris, 1988. Eng. ed., *Degas.* New York and Ottawa, 1988.

Paris (Salon)
Paris, Salon, 1827, 1831, 1833–53, 1855, 1857, 1859, 1861, 1863–70, 1872–75. Catalogues were published every year in connection with the Paris Salon.

Paris (Salon d'Automne) 1909
Paris, Salon d'Automne, Grand Palais, "Figures de Corot," October 1–November 8, 1909. Exh. cat. Paris, 1909.

Parker 1926
Robert Allerton Parker. "The Re-Discovery of Camille Corot." *International Studio* 83 (April 1926), pp. 31–36.

Paton sale 1883
Collection Jules Paton. Paris, Hôtel Drouot, April 24, 1883.

Pau 1872
"Exposition de la Société des Amis des Arts de Pau." Pau, Musée des Beaux-Arts, 1872.

Peisse 1834
Louis Peisse. *Le National,* April 23, 1834.

Peisse 1841
Louis Peisse. "Salon de 1841." *Revue des deux mondes,* 4th ser., 26 (April 1, 1841), pp. 5–49.

Peisse 1842
Louis Peisse. "Le Salon de 1842." *Revue des deux mondes,* 4th ser., 30 (April 15, 1842), pp. 229–53.

Peisse 1843
Louis Peisse. "Le Salon de 1843." *Revue des deux mondes,* n.s., 2 (April 1, 1843), pp. 85–109; (April 15, 1843), pp. 255–87.

Peisse 1850
Louis Peisse. "Salon de 1850." *Le Constitutionnel,* December 31, 1850.

Pelletan 1841
Eugène Pelletan. "Salon de 1841." *La Presse,* May 5, 1841.

Pelletan 1843
Eugène Pelletan. "Salon de 1843." *La Sylphide* 7 (May 6, 1843), pp. 364–66.

Pelletan 1872
Camille Pelletan. *Le Rappel,* May 11 and June 26, 1872.

Pelloquet 1861
Théodore Pelloquet [Frédéric Bernard]. "Salon de 1861." *Le Monde illustré* 8 (June 29, 1861), pp. 406–7.

Peoria 1966
Barbizon: First Anniversary Exhibition of Lakeview Center. Peoria, Lakeview Center for the Arts and Sciences, April 6–May 16, 1966. Exh. cat. Peoria, Ill., 1966.

Perrier 1855
Charles Perrier. "Exposition Universelle des beaux-arts. IX. La Peinture française.—Paysage." *L'Artiste,* 5th ser., 15 (July 15, 1855), pp. 141–44.

Perrier 1857
Charles Perrier. *L'Art français au Salon de 1857: Peinture—sculpture—architecture.* Paris, 1857.

Perrier 1859
Charles Perrier. "Le Salon de 1859." *Revue contemporaine,* 2nd ser., 9 (1859), pp. 287–324.

Petersen 1928
Carl V. Petersen. "Den franske kunstudstilling i Ny Carlsberg Glyptotek: Klassicisme—romantik—realisme." *Tilskueren* (April 1928), special issue.

Petersen 1928a
Carl V. Petersen. "Fransk malerkunst i det nittende aarhundrede. II. Romantik og realisme." *Frem,* no. 82 (April 25, 1928), pp. 121–30.

Philadelphia 1934
"Romanticists and Realists: 1860." Philadelphia, Pennsylvania Museum of Art, September 29–October 24, 1934.

Philadelphia 1946
Corot 1796–1875. Philadelphia Museum of Art, May 11–June 16, 1946. Exh. cat. by Henri Marceau, with contributions by Carl Zigrosser and an essay by Lionello Venturi (translation by Henry Furst of Venturi 1941, chap. 6). Philadelphia, 1946.

Philadelphia 1950–51
Diamond Jubilee Exhibition: Masterpieces of Painting. Philadelphia Museum of Art, November 4, 1950–February 11, 1951. Exh. cat. Philadelphia, 1950.

Philadelphia, Detroit, Paris 1978–79
The Second Empire, 1852–1870: Art in France under Napoleon III. Philadelphia Museum of Art, October 1–November 26, 1978; The Detroit Institute of Arts, January 15–March 18, 1979; Paris, Grand Palais, April 24–July 2. Exh. cat. Philadelphia, 1978.

Philadelphia Museum of Art 1965
Philadelphia Museum of Art. *Checklist of Paintings in the Philadelphia Museum of Art.* Prepared by Henry G. Gardiner. Philadelphia, 1965.

Philadelphia Museum of Art 1994
Philadelphia Museum of Art. *Paintings from Europe and the Americas in the Philadelphia*

Museum of Art: A Concise Catalogue. Philadelphia, 1994.

Philadelphia, Washington, Los Angeles, New York 1989–91
Masterpieces of Impressionism and Post-Impressionism: The Annenberg Collection. Philadelphia Museum of Art, May 21–September 17, 1989; Washington, D.C., National Gallery of Art, May 6–August 5, 1990; Los Angeles County Museum of Art, August 16–November 11; New York, The Metropolitan Museum of Art, June 4–October 13, 1991. Exh. cat. by Colin B. Bailey and Joseph J. Rishel. Philadelphia, 1989. Rev. ed., 1991.

Piles 1989
Roger de Piles. *Cours de peinture par principes.* Preface by Jacques Thuillier. Paris, 1989.

Pissarro and Venturi 1939
Ludovic Rodo Pissarro and Lionello Venturi. *Camille Pissarro: Son Art—son oeuvre.* 2 vols. Paris, 1939.

Pisteur 1920
J[ohn] P[isteur]. "Les 'Corot' du Musée de Genève." *Pages d'art* 6 (March 1920), pp. 73–76.

Pittsburgh, Carnegie Museum of Art 1973
Pittsburgh, Carnegie Museum of Art. *Catalogue of Painting Collection, Museum of Art, Carnegie Institute, Pittsburgh.* Pittsburgh, 1973.

Planche 1840
Gustave Planche. "Salon de 1840." *Revue des deux mondes,* 4th ser., 22 (April 1, 1840), pp. 100–121.

Planche 1846
Gustave Planche. "Le Salon de 1846." *Revue des deux mondes,* n.s., 14 (April 15, 1846), pp. 283–99.

Planche 1852
Gustave Planche. "Le Salon de 1852." *Revue des deux mondes,* n.s., 14 (May 15, 1852), pp. 667–93.

Planche 1855
Gustave Planche. *Études sur l'école française (1831–1852): Peinture et sculpture.* 2 vols. Paris, 1855.

Planche 1857
Gustave Planche. "Salon de 1857: La Peinture." *Revue des deux mondes,* 2nd ser., 10 (July 15, 1857), pp. 377–403.

Poggi 1949
Giovanni Poggi. "La collezione degli autoritratti nella Galleria degli Uffizi. I. Reynolds, Ingres, Corot." *Arte Mediterranea* (January–February 1949), pp. 53–61.

Pomona 1950
Masters of Art from 1790 to 1950. Pomona, Art Building, September 15–October 1, 1950. Presented by the Los Angeles County Fair. Exh. cat. Pomona, Calif., 1950.

Pontefract 1971
J. Pontefract. "Inventaire des collections de sculptures modernes et de peintures du Musée de Semur-en-Auxois." Vol. 1. M.A. thesis, Dijon, 1971.

Popovitch 1978
Olga Popovitch. *Catalogue des peintures du Musée des Beaux-Arts de Rouen.* Rouen, 1978.

Portland 1944
Eight Masterpieces of Painting. Portland Art Museum, December 1944. Exh. cat. Portland, Oreg., 1944.

Portland et al. 1956–57
Paintings from the Collection of Walter P. Chrysler, Jr. Portland Art Museum; Seattle Art Museum; San Francisco, California Palace of the Legion of Honor; Los Angeles County Museum; The Minneapolis Institute of Arts; City Art Museum of Saint Louis; Kansas City, Missouri, William Rockhill Nelson Gallery of Art; The Detroit Institute of Arts; Boston, Museum of Fine Arts. Traveling exhibition, March 2, 1956– April 14, 1957. Exh. cat. by Bertina S. Manning. Portland, Oreg., 1956.

Privat 1875
Gonzague Privat. "Les Peintres et les sculpteurs au Salon de 1875." *L'Événement* 4 (May 20, 1875).

Proust 1954
Marcel Proust. *Du côté de chez Swann.* Paris, 1954.

Providence 1886
Loan Exhibition of Paintings in Aid of the First Light Infantry. Providence, January 18–28, 1886. Exh. cat. Providence, R.I., 1886.

Providence 1942
French Art of the Nineteenth and Twentieth Centuries: An Exhibition Held in Cooperation with the Rhode Island Chapter of France Forever to Honor the Cause of De Gaulle for Free France. Providence, Museum of Art, Rhode Island School of Design, November 1942. Exh. cat. Providence, R.I., 1942.

Providence 1972
To Look on Nature: European and American Landscape, 1800–1874. Providence, Museum of Art, Rhode Island School of Design, February 3–March 5, 1972. Exh. cat. Providence, R.I., 1972.

Providence, Museum of Art 1956
Providence, Museum of Art, Rhode Island School of Design. *Treasures in the Museum of Art, Rhode Island School of Design.* Providence, R.I., 1956.

Provincetown 1958
Chrysler Art Museum of Provincetown: Inaugural Exhibition. Chrysler Art Museum of Provincetown, Massachusetts, 1958. Exh. cat. by Bertina S. Manning. Provincetown, Mass., 1958.

Provincetown, Ottawa 1962
The Controversial Century, 1850–1950: Paintings from the Collection of Walter P. Chrysler, Jr. Chrysler Art Museum of Provincetown, Massachusetts, June 15–September 2, 1962; Ottawa, National Gallery of Canada, September 28–November 4. Exh. cat. Ottawa, 1962.

Quimper, Musée des Beaux-Arts 1873
Quimper, Musée des Beaux-Arts. *Catalogue des tableaux exposés dans les galeries du Musée de la ville de Quimper, dit Musée de Silguy, dressé par MM. Gauguet . . . et H. Hombron.* Brest, 1873.

Quimper, Musée des Beaux-Arts 1976
Quimper, Musée des Beaux-Arts. *Musée des Beaux-Arts, Quimper.* Quimper, 1976.

Raleigh, Birmingham 1986–87
French Paintings from The Chrysler Museum. Raleigh, The North Carolina Museum of Art, May 31–September 14, 1986; Birmingham Museum of Art, November 6, 1986–January 18, 1987. Exh. cat. by Jefferson C. Harrison. Norfolk, Va., 1986.

Régamey 1928
Raymond Régamey. "A Corot Exhibition." *Arts* 14 (September 1928), pp. 143–53.

Reidemeister et al. 1973
Leopold Reidemeister et al. *Stiftung Sammlung Emil G. Bührle/Fondation Collection Emil G. Bührle/Foundation Emil G. Bührle Collection.* Zurich, 1973.

Reims 1869
"Exposition des Amis des Arts." Reims, 1869.

Reims 1948
La Peinture française au XIXᵉ siècle: De Delacroix à Gauguin. Reims, Musée des Beaux-Arts, 1948. Exh. cat. Reims, 1948.

Reizenstein 1895
Milton Reizenstein. "The Walters Art Gallery." *New England Magazine,* n.s., 12 (July 1895), pp. 545–60.

Renault 1859
Edmond Renault. "Salon de 1859." *La Presse théâtrale,* July 10, 1859.

Rey 1926
Robert Rey. Preface to *Catalogue de 13 tableaux par Corot.* Sale cat., Galerie Georges Petit, Paris, June 15, 1926.

Reymond 1871
William Reymond. *Coup d'oeil sur l'exposition de loterie nationale, au profit des victimes de la guerre.* Paris, 1871.

Richardson 1985
Brenda Richardson. *Dr Claribel and Miss Etta:*

The Cone Collection of The Baltimore Museum of Art. Baltimore, 1985.

Richmond 1961
"Twenty-Fifth Anniversary Exhibition." Richmond, Virginia Museum of Fine Arts, January 13–March 5, 1961.

Rienaecker 1929
Victor Rienaecker. *The Paintings and Drawings of J. B. C. Corot in the Artist's Own Collection, with an Introduction by Victor Rienaecker and a Complete Catalogue.* London, 1929.

Robaut 1875
Alfred Robaut. "L'Atelier de Corot." *L'Illustration* 65 (March 6, 1875), p. 158.

Robaut 1881
Alfred Robaut. "Corot." *La Galerie contemporaine,* nos. 27–29 (1881).

Robaut 1882
Alfred Robaut. "Corot: Peintures décoratives." *L'Art* 31 (October 15, 1882), pp. 45–53.

Robaut 1883
Alfred Robaut. "La 'Bacchante' de Corot." *L'Art* 32 (February 18, 1883), pp. 135–38.

Robaut 1892a
Alfred Robaut. "Correspondance." *Journal des arts,* March 5, 1892.

Robaut 1892b
Alfred Robaut. "Correspondance." *Journal des arts,* November 24, 1892.

Robaut 1894
Alfred Robaut. "L'Odyssée d'un tableau de Corot et une publication attendue." *Journal des arts,* November 1894.

Robaut 1895
Alfred Robaut. *L'Art français,* March 16, 1895.

Robaut 1905
Alfred Robaut. *L'Oeuvre de Corot: Catalogue raisonné et illustré. Précédé de l'Histoire de Corot et de ses oeuvres par Étienne Moreau-Nélaton, ornée de dessins et croquis originaux du maître.* 5 vols. in 4. Paris, 1905. Reprint ed., Paris, 1965.

Robaut *carton*
Alfred Robaut. "Cartons Alfred Robaut. Notes, croquis, calques, photographies, estampes." 35 cartons. Cabinet des Estampes, Bibliothèque Nationale de France, Paris, BN/CE S.N.R. On deposit at the Service d'Étude et de Documentation, Département des Peintures, Musée du Louvre, Paris.

Robaut "Corot. Peintre. Graveur"
Alfred Robaut. "Corot. Peintre. Graveur." Documents. 6 boxes. Cabinet des Estampes, Bibliothèque Nationale de France, Paris, BN/CE S.N.R.

Robaut "Corot. Tableaux faux"
Alfred Robaut. "Corot. Tableaux faux et douteux." Manuscript, sketches, documents. Cabinet des Estampes, Bibliothèque

Nationale de France, Paris, BN/CE DC 282n.

Robaut *documents*
Alfred Robaut. "Documents sur Corot." Manuscript. 3 vols. Cabinet des Estampes, Bibliothèque Nationale de France, Paris, BN/CE YB3 949 4.

Robert 1841
Henri Robert [Henri-Robert Feugueray]. "Salon de 1841." *Le National,* April 6, 1841.

Robert 1842
Henri Robert [Henri-Robert Feugueray]. "Beaux-Arts. Salon de 1842." *Le National,* May 8, 1842.

Robert 1991
Hervé Robert. "Le Destin d'une grande collection princière au XIXᵉ siècle: L'Exemple de la galerie de tableaux du duc d'Orléans, prince royal." *Gazette des beaux-arts,* 6th ser., 118 (July–August 1991), pp. 37–60.

Robert 1993
Hervé Robert. "Une Prestigieuse Galerie de tableaux." In *Le Mécénat du duc d'Orléans, 1830–1842,* edited by Hervé Robert, pp. 88–109. Paris, 1993.

Roberts 1915
W. Roberts. *Pictures in the Collection of P. A. B. Widener at Lynnewood Hall, Elkins Park, Pennsylvania: British and Modern French Schools.* Philadelphia, 1915.

Roberts 1965
Keith Roberts. *Corot.* London, 1965.

Roberts 1976
Keith Roberts. "The Lefevre Gallery." In "Current and Forthcoming Exhibitions." *Burlington Magazine* 118 (December 1976), pp. 876–78.

Robinson 1896
Theodore Robinson. "Jean-Baptiste-Camille Corot (1796–1875)." In *Modern French Masters: A Series of Biographical and Critical Reviews by American Artists,* edited by John C. Van Dyke, pp. 107–16. New York, 1896.

Rochefort 1868
Henri Rochefort. *Le Figaro,* May 15, 1868.

Rochester, Purchase 1982
Orientalism: The Near East in French Painting, 1800–1880. Memorial Art Gallery of the University of Rochester, August 27–October 17, 1982; Neuberger Museum, State University of New York College at Purchase, November 14–December 23. Exh. cat. by Donald A. Rosenthal. Rochester, N.Y., 1982.

Roger-Marx 1952
Claude Roger-Marx. *Le Paysage français de Corot à nos jours; ou, le dialogue de l'homme et du ciel.* Paris, 1952.

Roger-Milès 1891
L. Roger-Milès. *Corot.* Les Artistes célèbres. Paris, 1891.

Roger-Milès 1895
L. Roger-Milès. *Album classique des chefs-d'oeuvre de Corot, comprenant 40 reproductions d'après les toiles les plus célèbres du maître. Précédées d'un essai critique.* Paris, 1895.

Rolland 1865
Charles Rolland. "Le Salon de 1865." *L'Universel* 7 (June 29, 1865), pp. 199, 202.

Rome 1946
Tableaux français en Italie (XIVᵉ–XXᵉ siècles)—tableaux italiens en France (Zandomeneghi, De Nittis, Boldini, Modigliani). Rome, Palazzetto Venezia, 1946. Exh. cat. Rome, 1946.

Rome 1962
Il ritratto francese da Clouet a Degas. Rome, Palazzo Venezia, 1962. Exh. cat. Rome, 1962.

Rome 1975–76
Corot 1796–1875: Dipinti e disegni di collezioni francesi. Rome, Accademia di Francia, Villa Medici, October 25, 1975–January 11, 1976. Exh. cat. Rome, 1975.

Rome, Florence 1955
Mostra di capolavori della pittura francese dell'ottocento. Rome, February–March 1955; Florence, Palazzo Strozzi, April–May. Exh. cat. edited by Albert Châtelet. Rome, 1955.

Rome, Turin 1961
L'Italia vista dai pittori francesi del XVIII e XIX secolo: Catalogo della mostra. Rome, Palazzo delle Esposizioni, February 8–March 26, 1961; Turin, Galleria Civica d'Arte Moderna, April 20–May 25. Exh. cat. Rome, 1961.

Roquebert 1989
Anne Roquebert. "Degas collectionneur." In *Degas inédit: Actes du colloque Degas, Musée d'Orsay, 18–21 avril 1988,* pp. 65–85. Paris, 1989.

Rosen and Marceau 1937
David Rosen and Henri Marceau. "A Study in the Use of Photographs in the Identification of Paintings." *Technical Studies in the Field of the Fine Arts* 6 (October 1937), pp. 75–105.

Rosenblum 1989
Robert Rosenblum. *Paintings in the Musée d'Orsay.* New York, 1989.

Rosenfeld 1991
Daniel Rosenfeld, ed. *European Painting and Sculpture, ca. 1770–1937, in the Museum of Art, Rhode Island School of Design.* Providence, R.I., 1991.

Rosenthal 1914
Léon Rosenthal. *Du romantisme au réalisme:*

Essai sur l'évolution de la peinture en France de 1830 à 1848. Paris, 1914.

Rotterdam 1952–53
Franse meesters uit het Petit Palais, Musée de la ville de Paris. Rotterdam, Museum Boymans, 1952–53. Exh. cat. Rotterdam, 1953.

Rouart 1906
Louis Rouart. "Collection de Madame Esnault-Pelterie." *Les Arts* (American ed.), no. 54 (June 1906), pp. 2–21.

Rouart sale 1912
Catalogue des tableaux anciens . . . et des tableaux modernes . . . composant la collection de feu M. Henri Rouart. Sale cat., Galerie Manzi Joyant, Paris, December 9–11, 1912.

Rouen 1856
Rouen, 1856. Cited in Robaut 1905, vol. 2, p. 230, no. 669.

Rouen 1869
"22ᵉ Exposition municipale." Rouen, Musée des Beaux-Arts, April 1869.

Rousseau 1859a
Jean Rousseau. "Salon de 1859." *Le Figaro*, May 7, 1859.

Rousseau 1859b
Jean Rousseau. "Salon de 1859." *Le Figaro*, May 17, 1859.

Rousseau 1861
Jean Rousseau. "Salon de 1861." *Le Voleur illustré*, n.s., 10 (1861), pp. 171–73.

Rousseau 1875
Jean Rousseau. "Corot." *L'Art* 1 (March 14, 1875), pp. 241–47; (March 21, 1875), pp. 269–75.

Rousseau 1884
Jean Rousseau. *Camille Corot.* Appendix by Alfred Robaut. Paris, 1884.

Roy 1869
Élie Roy. "Salon de 1869: Pérégrinations dans les ateliers." *L'Artiste*, 9th ser., 9 (April 1, 1869), pp. 97–109.

Royer 1840
Alphonse Royer. "Salon de 1840." *Le Siècle*, March 28, 1840.

Ruhmer 1973
Eberhard Ruhmer. "Corots 'Bacchantin mit dem Tiger'." *Pantheon* 31 (July–September 1973), pp. 306–10.

Saarbrücken 1966
Chefs-d'Oeuvre du Musée de Nantes. Saarbrücken, Saarland Museum, 1966. Exh. cat. Saarbrücken, 1966.

Saarinen 1958
Aline B. Saarinen. *The Proud Possessors: The Lives, Times and Tastes of Some Adventurous American Art Collectors.* New York, 1958.

St.-Georges 1858
Henri de St.-Georges. *Notice historique sur le*

Musée de Peinture de Nantes d'après des documents officiels et inédits. Nantes and Paris, 1858.

Saint Louis 1931
"Loan Exhibition of French Painting, 1800–1880." City Art Museum of Saint Louis, January 1931. Catalogue published in *Bulletin of the City Art Museum of St. Louis* 16 (January 1931), supplement.

Saint Louis 1947
Forty Masterpieces: A Loan Exhibition of Paintings from American Museums. City Art Museum of Saint Louis, October 6–November 10, 1947. Exh. cat. Saint Louis, 1947.

Saint Paul 1991
Homecoming: The Art Collection of James J. Hill. Saint Paul, James J. Hill House, May 18–September 21, 1991. Exh. cat. by Jane H. Hancock, Sheila Ffolliott, and Thomas O'Sullivan. Saint Paul, Minn., 1991.

Saint-Paul-de-Vence 1973
André Malraux. Saint-Paul-de-Vence, Fondation Maeght, July 13–September 30, 1973. Exh. cat. Saint-Paul-de-Vence, 1973.

Saint Petersburg, Moscow 1975
One Hundred Paintings from The Metropolitan Museum. Saint Petersburg (formerly Leningrad), The Hermitage, May 22–July 27, 1975; Moscow, Pushkin Museum, August 28–November 2. Exh. cat. In Russian. Moscow, 1975.

Saint Petersburg, Moscow 1988
From Delacroix to Matisse: Masterpieces of French Painting from the Nineteenth Century to the Early Twentieth Century from The Metropolitan Museum of New York and The Art Institute of Chicago. Saint Petersburg (formerly Leningrad), The Hermitage, March 15–May 10, 1988; Moscow, Pushkin Museum, June 10–July 30. Exh. cat. In Russian. Saint Petersburg (Leningrad), 1988.

Saint Petersburg, Moscow, Madrid 1970–71
French Painting of the Second Half of the Nineteenth Century and the Beginning of the Twentieth Century: Works by the Impressionists from Museums in France. Saint Petersburg (formerly Leningrad), The Hermitage, December 1, 1970–January 10, 1971; Moscow, Pushkin Museum, January 25–March 1; Madrid, Museo Español de Arte Contemporaneo, April. Exh. cat. In Russian. Moscow, 1971. Spanish ed., *Los Impresionistas franceses.* Madrid, 1971.

Saint Petersburg, The Hermitage 1976
Saint Petersburg (formerly Leningrad), The Hermitage. *Peinture de l'Europe occidentale.* Vol. 1. Saint Petersburg (Leningrad), 1976.

Saint-Victor 1859
Paul de Saint-Victor. "Salon de 1859." *La Presse*, July 2, 1859.

Saint-Victor 1861
Paul de Saint-Victor. "Salon de 1861." *La Presse*, August 2, 1861.

Saint-Victor 1864
Paul de Saint-Victor. "Salon de 1864." *La Presse*, June 26, 1864.

Salerno 1991
Luigi Salerno. *I pittori di vedute in Italia (1580–1830).* Rome, 1991.

Salmon 1956
André Salmon. *Souvenirs sans fin: Deuxième Époque (1908–1920).* 5th ed. Paris, 1956.

Sancerre 1864
Victor Sancerre. "Salon de 1864. Histoire—batailles." *Les Beaux-Arts* 8 (June 1, 1864), pp. 321–23.

San Diego, Williamstown 1988
J.-B.-C. Corot: View of Volterra. San Diego, Timken Art Gallery, May 8–June 26, 1988; Williamstown, Massachusetts, Sterling and Francine Clark Art Institute, July 15–September 11. Exh. cat. by Fronia E. Wissman. San Diego, 1988.

Sandoz 1974
Marc Sandoz. *Théodore Chassériau 1819–1856: Catalogue raisonné des peintures et estampes.* Paris, 1974.

San Francisco 1973
Three Centuries of French Art: Selections from The Norton Simon, Inc. Museum of Art and The Norton Simon Foundation. The Fine Arts Museums of San Francisco, California Palace of the Legion of Honor, opened May 3, 1973. Exh. cat. edited by F. Lanier Graham. San Francisco, 1973.

San Francisco 1974
Three Centuries of French Art: Selections from The Norton Simon, Inc. Museum of Art and The Norton Simon Foundation. The Fine Arts Museums of San Francisco, California Palace of the Legion of Honor, opened October 19, 1974. Exh. cat. Vol. 2. San Francisco, 1975.

San Francisco, Dallas, Minneapolis, Atlanta, Oklahoma City 1981–83
Master Paintings from The Phillips Collection. The Fine Arts Museums of San Francisco, California Palace of the Legion of Honor, July 4–November 1, 1981; Dallas Museum of Fine Arts, November 22, 1981–February 16, 1982; The Minneapolis Institute of Arts, March 14–May 30; Atlanta, High Museum of Art, June 24–September 16; Oklahoma City, Oklahoma Art Center, October 17, 1982–January 9, 1983. Exh. cat. by Eleanor Green and Robert Cafritz. New York, 1981.

San Francisco, Toledo, Cleveland, Boston 1962–63
Barbizon Revisited. The Fine Arts Museums

of San Francisco, California Palace of the Legion of Honor, September 27–November 4, 1962; The Toledo Museum of Art, November 20–December 27; The Cleveland Museum of Art, January 15–February 24, 1963; Boston, Museum of Fine Arts, March 14–April 28. Exh. cat. by Robert L. Herbert. Boston, 1962.

Sarasota 1963
Palmer Family Collections: A Selection of Paintings and Drawings Lent by the Family, by the Estate of Pauline K. Palmer and by The Art Institute of Chicago, Potter Palmer Collection. Sarasota, John and Mable Ringling Museum of Art, February 23–March 24, 1963. Exh. cat. Sarasota, Fla., 1963.

Sarasota, Buffalo, Rochester, Raleigh, Philadelphia, Columbus, Pittsburgh 1966–67
Masterpieces from Montreal: Selected Paintings from the Collection of The Montreal Museum of Fine Arts. Sarasota, Florida, John and Mable Ringling Museum of Art, January 10–February 13, 1966; Buffalo, Albright-Knox Art Gallery, March 15–April 21; Rochester, New York, Rochester Memorial Art Gallery, May 6–June 25; Raleigh, The North Carolina Museum of Art, July 9–August 21; Philadelphia Museum of Art, September 15–October 23; Columbus Gallery of Fine Arts, November 10–December 26; Pittsburgh, Museum of Art, Carnegie Institute, January 24–March 5, 1967. Exh. cat. Montreal, 1965.

Sartor 1909
Marguerite Sartor. *Catalogue historique et descriptif du Musée de Reims: Peintures, toiles peintes, pastels, gouaches, acquarelles & miniatures.* Paris, 1909.

Sartori 1994
Polly Sartori. "Corot's Private World: An Invitation to His Studio." *Christie's International Magazine* (September–October 1994), pp. 17–19.

Schaffhausen 1963
Die Welt des Impressionismus. Schaffhausen, Museum zu Allerheiligen, June 29–September 29, 1963. Exh. cat. Schaffhausen, 1963.

Scharf 1962
Aaron Scharf. "Camille Corot and Landscape Photography." *Gazette des beaux-arts,* 6th ser., 59 (February 1962), pp. 99–102.

Schoelcher 1831
Victor Schoelcher. "Salon de 1831." *L'Artiste* 2 (1831), pp. 1–4.

Schoelcher 1835
Victor Schoelcher. "Salon de 1835." *Revue de Paris,* n.s., 17 (1835), pp. 164–94.

Schoeller and Dieterle 1948
André Schoeller and Jean Dieterle. *Corot: Premier Supplément à "L'Oeuvre de Corot" par A. Robaut et Moreau-Nélaton, Éditions Floury.* Paris, 1948.

Schoeller and Dieterle 1956
André Schoeller and Jean Dieterle. *Corot: Deuxième Supplément à "L'Oeuvre de Corot" par A. Robaut et Moreau-Nélaton, Éditions Floury.* Paris, 1956.

Schwartz and Bok 1989
Gary Schwartz and Marten Jan Bok. *Pieter Saenredam: The Painter and His Time.* New York, 1989.

Seattle 1951
"Masters of Nineteenth Century Painting and Sculpture." Seattle Art Museum, March 7–May 6, 1951.

Selden 1872
Camille Selden. *Revue politique et littéraire,* May 25, 1872, p. 1140.

Selz 1988
Jean Selz. *La Vie et l'oeuvre de Camille Corot.* Paris, 1988.

Sérullaz 1951
Maurice Sérullaz. *Corot.* Paris, 1951.

Sète 1995
Paul Valéry et les arts. Sète, Musée Paul-Valéry, July 20–October 15, 1995. Exh. cat. Paris, 1995.

Shea 1972
Joe Shea. "Death on a Very Special Day." *Village Voice,* June 8, 1972.

Shelburne 1994
La Bacchante à la panthère by Jean-Baptiste Camille Corot. Shelburne Museum, April 24–October 23, 1994. Exh. cat. by Lauren B. Hewes. Shelburne, Vt., 1994.

's Hertogenbosch 1992
Van Boucher tot Boudin: Honderd jaar Franse schilderkunst, 1750–1850, uit de collectie van het Musée des Beaux-Arts te Quimper. 's Hertogenbosch, Noordbrabants Museum, June 27–September 6, 1992. Exh. cat. Ghent, 1992.

Shizuoka, Kobe 1986
Landscape Painting in the East and West: Inaugural Exhibition. Special Presentation from The Metropolitan Museum of Art. Shizuoka Prefectural Museum of Art, April 19–June 1, 1986; Kobe, City Museum of Nanban, June 7–July 15. Exh. cat. Shizuoka, 1986.

Silvestre 1853
Théophile Silvestre. *Histoire des artistes vivants, français et étrangers: Études d'après nature.* Paris, 1853.

Silvestre 1856
Théophile Silvestre. *Histoire des artistes vivants, français et étrangers: Études d'après nature.* Paris, 1856.

Silvestre 1873
Théophile Silvestre. "Salon de 1873." *Le Pays,* 1873.

Silvestre 1878
Théophile Silvestre. *Les Artistes français: Études d'après nature.* Paris, 1878.

Sloane 1951
Joseph C. Sloane. *French Painting between the Past and the Present: Artists, Critics, and Traditions, from 1848 to 1870.* Princeton, 1951.

Smits 1991
Josine M. Eikelenboom Smits. *The Architectural Landscapes of Jean-Baptiste-Camille Corot.* 2 vols. Ph.D. diss., Stanford University, 1991. Microfilm, Ann Arbor, Mich.

Société de Gens de Lettres et d'Artistes 1828
Société de Gens de Lettres et d'Artistes. *Visite au Musée du Louvre, ou guide de l'amateur à l'exposition des ouvrages de peinture, sculpture, gravure, lithographie et architecture des artistes vivans (année 1827–1828).* Paris, 1828.

Southampton, New York 1986
In Support of Liberty: European Paintings at the 1883 Pedestal Fund Art Loan Exhibition. Southampton, The Parrish Art Museum, June 29–September 1, 1986; New York, National Academy of Design, September 18–December 7. Exh. cat. by Maureen C. O'Brien. Southampton, N.Y., 1986.

Springfield 1935
From David to Cézanne: Paintings and Drawings. Springfield Museum of Fine Arts, February 9–March 10, 1935. Exh. cat. Springfield, Mass., 1935.

Stein 1992
Marcia Kay Stein. *The Orpheus and Eurydice Paintings of Camille Corot: Lyrical Reflections of Contemporary Society.* M.A. thesis, Rice University, 1992. Microfilm, Ann Arbor, Mich.

Sterling and Adhémar 1958
Charles Sterling and Hélène Adhémar. *Peintures: École française, XIXe siècle.* Vol. 1. Musée National du Louvre. Paris, 1958.

Sterling and Salinger 1966
Charles Sterling and Margaretta M. Salinger. *French Paintings: A Catalogue of the Collection of The Metropolitan Museum of Art.* Vol. 2, *XIX Century.* New York, 1966.

Stevens 1859
Mathilde Stevens. *Impressions d'une femme au Salon de 1859.* Paris, 1859.

Stjernfelt 1995
Frederik Stjernfelt. "Lille bidrag til plettens teori: Den stirrende urt hos den sene Corot." *Kritik,* no. 115 (1995), pp. 25–29.

Stockholm 1924
"French Paintings." Stockholm, Moderna Museet, 1924.

Stockholm, Oslo 1919

Corotutställning. Stockholm, Nationalmuseum, February 24–March 23, 1919; Oslo, Nasjonalgalleriet, April 12–May 12. Exh. cat. Stockholm, 1919. Norwegian ed., *Corot-Utstilling.* Oslo, 1919.

Stop 1872

Stop. *Le Journal amusant*, May 25, 1872.

Strasbourg, Besançon, Nancy 1947

Les Origines de l'art contemporain: La Peinture française de Manet à Bonnard. Strasbourg; Besançon; Nancy; 1947. Exh. cat. Paris, 1947.

Stuffmann 1993

Margret Stuffmann. "Zwischen der Schule von Barbizon und den Anfängen des Impressionismus: Zur Landschaftsphotographie von Gustave Le Gray"/"Between the Barbizon School and the Beginnings of Impressionism: The Landscape Photography of Gustave Le Gray." In *Pioniere der Landschaftsphotographie, Gustave Le Gray, Carleton E. Watkins: Beispiele aus der Sammlung des J. Paul Getty Museums, Malibu/Pioneers of Landscape Photography, Gustave Le Gray, Carleton E. Watkins: Photographs from the Collection of the J. Paul Getty Museum*, pp. 90–106. Frankfurt am Main, Städtische Galerie, Städelsches Kunstinstitut, September 2–November 7, 1993. Exh. cat. Frankfurt am Main, 1993.

Sutton 1962

[Denys Sutton]. "The Significance of Corot." *Apollo* 77 (September 1962), pp. 507–8.

Sutton 1995

Peter C. Sutton. *The William Appleton Coolidge Collection.* Boston, 1995.

Swane 1930

Leo Swane. *Fransk malerkunst fra David til Courbet.* Copenhagen, 1930.

Swane 1954

Leo Swane. *Etatsråd Wilhelm Hansen og hustru Henny Hansens malerisamling: Katalog over kunstvaerkerne på Ordrupgård.* Copenhagen, 1954.

Sweet 1966

Frederick A. Sweet. "Great Chicago Collectors." *Apollo* 84 (September 1966), pp. 190–207.

Sydney, Melbourne 1980–81

French Painting: The Revolutionary Decades, 1760–1830. Paintings and Drawings from the Louvre and Other French Museums. Sydney, Art Gallery of New South Wales, October 17–November 23, 1980; Melbourne, National Gallery of Victoria, December 17, 1980–February 15, 1981. Exh. cat. by Arlette Sérullaz et al. Sydney, 1980.

Tabarant 1963

Adolphe Tabarant. *La Vie artistique au temps de Baudelaire.* 2nd ed. Paris, 1963.

Taillandier 1967

Yvon Taillandier. *Corot.* Paris, 1967.

Talbot 1978

William S. Talbot. "Some French Landscapes: 1779–1842." *Bulletin of The Cleveland Museum of Art* 65 (March 1978), pp. 75–91.

Tel Aviv 1964

Trésors des musées de Bordeaux. Tel Aviv Museum, January–March 1964. Exh. cat. Tel Aviv, 1964.

Ténint 1841

Wilhelm Ténint. *Album du Salon de 1841: Collection des principaux ouvrages exposés au Louvre.* Paris, 1841.

The Hague 1966

In het licht van Vermeer: Vijf eeuwen schilderkunst. The Hague, Mauritshuis, June 25–September 5, 1966. Exh. cat. The Hague, 1966.

Thienen 1950

F. W. S. van Thienen. *Algemeene kunst Geschiedenis.* Vol. 5. Utrecht, 1950.

Thierray 1859

Jules Thierray. "Salon de 1859." *Le Paris élégant*, no. 13 (July 1, 1859).

Thierray 1861

Jules Thierray. "Salon de 1861." *Le Paris élégant*, no. 14 (July 15, 1861), pp. 5–9.

Thomson 1892

David Croal Thomson. *Corot.* London, 1892.

Thomson 1902

David Croal Thomson. *The Barbizon School of Painters: Corot, Rousseau, Diaz, Millet, Daubigny, Etc.* London, 1902.

Thoré 1838

Théophile Thoré [William Bürger]. "Le Salon de 1838." *Revue de Paris*, n.s., 53 (May 6, 1838), pp. 50–59.

Thoré 1839

T. [Théophile Thoré (William Bürger)]. "Salon de 1839." *Le Constitutionnel*, May 8, 1839, pp. 1–2.

Thoré 1846

Théophile Thoré [William Bürger]. *Le Salon de 1846. Précédé d'une lettre à George Sand.* Paris, 1846.

Thoré 1847

Théophile Thoré [William Bürger]. *Le Salon de 1847. Précédé d'une lettre à Firmin Barrion.* Paris, 1847.

Thoré 1870

Théophile Thoré [William Bürger]. *Salons de W. Bürger, 1861 à 1868.* 2 vols. Paris, 1870.

Thuillier 1974

Jacques Thuillier. *L'opera completa di Poussin.* Milan, 1974.

Tokyo 1982

L'Angélus de Millet: Tendances du réalisme en France, 1848–1870. Tokyo, National Museum of Western Art, April 17–June 13, 1982. Exh. cat. Tokyo, 1982.

Tokyo 1983

"Chefs-d'Oeuvre de l'art français." Tokyo, Fujii Art Museum, 1983.

Tokyo 1991

Portraits du Louvre: Choix d'oeuvres dans les collections du Louvre. Tokyo, National Museum of Western Art, September 18–December 1, 1991. Exh. cat. Tokyo, 1991.

Tokyo, Fukuoka, Kyoto 1985–86

The Impressionist Tradition: Masterpieces from The Art Institute of Chicago. Tokyo, Seibu Museum of Art, October 18–December 17, 1985; Fukuoka Art Museum, January 5–February 2, 1986; Kyoto Municipal Museum of Art, March 4–April 13. Exh. cat. Tokyo, 1985.

Tokyo, Fukuoka, Sapporo, Shizuoka, Chiba, Kawasaki, Osaka 1993

100 Chefs-d'Oeuvre du Musée des Beaux-Arts de Rouen: Le Grand Siècle de la peinture française, d'Ingres à Monet. Tokyo, March 2–28, 1993; Fukuoka, April 28–May 23; Sapporo, June 5–July 11; Shizuoka, July 16–August 22; Chiba, September 15–October 12; Kawasaki, October 16–November 14; Osaka, November 19–December 6. Exh. cat. [Japan], 1993.

Tokyo, Kobe, Sapporo, Hiroshima, Kitakyushu 1980

Millet, Corot and the School of Barbizon. Tokyo, Seibu Museum of Art, March 15–April 14, 1980; Kobe, Hyogo Museum of Modern Art, April 19–May 18; Sapporo, Hokkaido Museum of Modern Art, May 24–June 15; Hiroshima Prefectural Museum of Art, June 21–July 13; Kitakyushu Municipal Museum of Art, July 19–August 10. Exh. cat. Tokyo, 1980.

Tokyo, Kyoto 1961–62

"Art français." Tokyo; Kyoto; 1961–62.

Tokyo, Kyoto, Fukuoka 1970

Jean-François Millet et ses amis—peintres de Barbizon. Tokyo, Seibu Department Store, August 15–September 30, 1970; Kyoto, Municipal Museum, October 4–November 7; Fukuoka, Cultural Center, November 12–December 6. Exh. cat. Tokyo, 1970.

Tokyo, Nara 1983

Impressionism and the Modern Vision: Master Paintings from The Phillips Collection. Tokyo, Takashimaya, August 25–October 4, 1983; Nara Prefectural Museum of Art, October 9–November 13. Exh. cat. [Japan], 1983.

Tokyo, Okayama, Kanazawa, Tokushima, Kumamoto 1982–83
Millet, Corot, Courbet: École de Barbizon. Tokyo; Okayama; Kanazawa; Tokushima; Kumamoto; September 1982–February 1983. Exh. cat. [Japan], 1982.

Tokyo, Osaka, Yokohama 1989–90
J.-B. Camille Corot. Tokyo, Odakyu Grand Gallery, Shinjuku, September 13–October 1, 1989; Osaka, Navio Museum of Art, October 20–November 14; Yokohama, Sogo Museum of Art, January 18–February 25, 1990. Exh. cat. Tokyo, 1989.

Tokyo, Utsunomiya, Kumamoto, Nara, Nagoya 1976–77
Millet, Corot, Courbet, et l'école de Barbizon. Tokyo, Isetan Museum of Art, October 14–November 9, 1976; Utsunomiya, November 20–December 24; Kumamoto, January 5–23, 1977; Nara, January 29–March 13; Nagoya, March 16–27. Exh. cat. Tokyo, 1976.

Tokyo, Yokohama, Toyohashi, Kyoto 1989–90
French Masterpieces from the Ordrupgaard Collection in Copenhagen. Tokyo, Nihonbashi Takashimaya, August 3–29, 1989; Yokohama, Takashimaya, September 7–26; Toyohashi, City Art Museum, October 27–November 26; Kyoto, Takashimaya, December 27, 1989–January 23, 1990. Exh. cat. Tokyo, 1989.

Toledo, Toronto 1946–47
The Spirit of Modern France: An Essay on Painting in Society, 1745–1946. The Toledo Museum of Art, November–December 1946; The Art Gallery of Toronto, January–February 1947. Exh. cat. Toronto, 1946.

Toronto 1938
Catalogue: Paintings of Women from the Fifteenth to the Twentieth Century. The Art Gallery of Toronto, October 14–November 14, 1938. Exh. cat. Toronto, 1938.

Toronto 1940
An Exhibition of Great Paintings in Aid of the Canadian Red Cross and of Small Pictures by Members of the Ontario Society of Artists. The Art Gallery of Toronto, November 15–December 15, 1940. Exh. cat. Toronto, 1940.

Toronto 1949
Catalogue and Guide: An Exhibition of Paintings and Sculpture Arranged by the Canadian National Exhibition Association and The Art Gallery of Toronto. Toronto, August 26–September 10, 1949. Exh. cat. Toronto, 1949.

Toronto 1950
J. B. C. Corot 1796–1875. The Art Gallery of Toronto, January–February 1950. Exh. cat. Toronto, 1950.

Toronto, Ottawa, Montreal 1954
Paintings by European Masters from Public and Private Collections in Toronto, Montreal and Ottawa. The Art Gallery of Toronto, January 15–February 21, 1954; Ottawa, National Gallery of Canada, March 10–April 11; The Montreal Museum of Fine Arts, April 24–May 23. Exh. cat. Ottawa, 1954.

Toulouse 1864
"Exposition de l'Union Artistique de Toulouse." Toulouse, 1864.

Toulouse 1865
Exposition des produits des beaux-arts et de l'industrie à Toulouse. Toulouse, Ancien Couvent des Jacobins, opened June 19, 1865. Exh. cat. Toulouse, 1865.

Towner 1970
Wesley Towner. *The Elegant Auctioneers.* Completed by Stephen Varble. New York, 1970.

Townsend 1913
James B. Townsend. "The McMillin Collection. (First Review.)." *American Art News* 11, no. 13 (January 4, 1913), p. 5.

Trianon 1849
Henry Trianon. *Le Correspondant* 24 (April–September 1849), p. 470.

Ulbach 1860
Louis Ulbach. "L'Orphée de Gluck.—Madame Viardot." *Gazette des beaux-arts* 5 (January 15, 1860), pp. 99–105.

Valenciennes 1800
Pierre-Henri Valenciennes. *Éléments de perspective pratique à l'usage des artistes, suivis de réflexions et conseils à un élève sur la peinture et particulièrement sur le genre du paysage.* Paris, 1800. Reprint ed., Geneva, 1973.

Valentiner 1914
Wilhelm R. Valentiner. *Catalogue of a Collection of Paintings and Some Art Objects: German, French, Spanish and English Paintings and Art Objects.* Vol. 3, *Modern Paintings.* Philadelphia, 1914.

Van Gogh 1958
Vincent van Gogh. *The Complete Letters of Vincent van Gogh.* 3 vols. Greenwich, Conn., 1958.

Van Liere 1980
Eldon N. Van Liere. "Solutions and Dissolutions: The Bather in Nineteenth-Century French Painting." *Arts Magazine* 54, no. 9 (May 1980), pp. 104–23.

Vannes, Brest, Caen 1971–72
Quelques Aspects du paysage français du XIXᵉ siècle: 42 Tableaux du Musée du Louvre. Vannes, Palais des Arts, June 9–September 5, 1971; Musée de Brest, September 24–November 15; Caen, Musée des Beaux-Arts, December 11, 1971–February 13, 1972. Exh. cat. Caen, 1971.

Van Rensselaer 1889a
Marianna Griswold Van Rensselaer. "Corot."

The Century 38 (June 1889), pp. 255–71.

Van Rensselaer 1889b
Marianna Griswold Van Rensselaer. *Six Portraits: Della Robbia, Correggio, Blake, Corot, George Fuller, Winslow Homer.* Boston, 1889.

Varriano 1991
John Varriano. *Rome: A Literary Companion.* London, 1991.

Vauxcelles 1905
Louis Vauxcelles. "La Collection Chéramy." *L'Art et les artistes* 1 (April–September 1905), pp. 124–31.

Venice 1934
Venice, XIX Biennale, 1934. Exh. cat. Venice, 1934.

Venice 1952
Venice, XXVI Biennale, Room XXXI, "J. B. Camille Corot," 1952. Exh. cat. Venice, 1952.

Venturi 1939
Lionello Venturi. *Les Archives de l'impressionnisme: Lettres de Renoir, Monet, Pissarro, Sisley et autres. Mémoires de Paul Durand-Ruel. Documents.* 2 vols. Paris and New York, 1939.

Venturi 1941
Lionello Venturi. *Peintres modernes: Goya, Constable, David, Ingres, Delacroix, Corot, Daumier, Courbet.* Translated by Juliette Bertrand. Paris, 1941.

Venturi 1946
Lionello Venturi. *Painting and Painters: How to Look at a Picture from Giotto to Chagall.* New York, 1946.

Venturi 1947
Lionello Venturi. *Modern Painters: Goya, Constable, David, Ingres, Delacroix, Corot, Daumier, Courbet.* 2 vols. New York and London, 1947.

Vergnaud 1835
A.-D. Vergnaud. *Petit Pamphlet sur quelques tableaux du Salon de 1835 et sur beaucoup de journalistes qui en ont rendu compte.* Paris, 1835.

Vergnet-Ruiz and Laclotte 1962
Jean Vergnet-Ruiz and Michel Laclotte. *Petits et Grands Musées de France: La Peinture française des Primitifs à nos jours.* Paris, 1962.

Vergnet-Ruiz and Laclotte 1972
Jean Vergnet-Ruiz and Michel Laclotte. *Petits et Grands Musées de France: La Peinture française des Primitifs à nos jours.* New ed. Paris, 1972.

Vermot 1845
Henry Vermot. "Salon de 1845. XVI.—Les Paysages." *L'Artiste,* 4th ser., 4 (June 1, 1845), pp. 65–70.

Viardot 1835
L[ouis] V[iardot]. "Salon de 1835." *Le National de 1834,* April 5, 1835.

Viardot 1837
Louis Viardot. "Salon de 1837." *Le Siècle*, April 17, 1837.

Victoria et al. 1973–75
"The Montreal Museum Lends. II: Nineteenth and Twentieth Century Paintings." Art Gallery of Greater Victoria; Calgary, Alberta College of Art; Edmonton, Alberta, Edmonton Art Gallery; Saskatoon, Saskatchewan, Mendel Art Gallery; Regina, Saskatchewan, Norman MacKenzie Art Gallery; Stratford, Ontario, Rothmans Art Gallery; Sherbrooke, Quebec, University of Sherbrooke; Hamilton, Ontario, Art Gallery of Hamilton; Rimouski, Quebec, Musée Régional de Rimouski; Halifax, Dalhousie Art Gallery; Saint John's, Newfoundland, Memorial Art Gallery; Fredericton, New Brunswick, Beaverbrook Art Gallery. Traveling exhibition sponsored by the National Gallery of Canada, Ottawa, July 17, 1973–July 31, 1975.

Vienna 1873
Exposition Universelle de Vienne, 1873. France. Oeuvres d'art et manufactures nationales. Vienna, 1873. Exh. cat. Paris, 1873.

Vienna 1930
"XV. Wechselausstellung im Oberen Belvedere." Vienna, Oberen Belvedere, 1930.

Vienna 1936
Vienna, Secession, 1936.

Vienna 1951
"Europäische Malerei im XIX. Jahrhundert." Vienna, Hofburg, January 9–April 1, 1951.

Vienna, Österreichische Galerie 1924
Vienna, Österreichische Galerie. *Galerie des neunzehnten Jahrhunderts im Oberen Belvedere.* Vienna, 1924.

Vienna, Österreichische Galerie 1937
Vienna, Österreichische Galerie. *Galerie des neunzehnten Jahrhunderts im Oberen Belvedere.* 2nd ed., rev. Vienna, 1937.

Vienna, Österreichische Galerie 1966
Vienna, Österreichische Galerie. *Die neue Galerie des Kunsthistorischen Museums, Wien.* Catalogue by Friderike Klauner, Günther Heinz, and Elisabeth Mahl. Vienna, 1966.

Vienna, Österreichische Galerie 1967
Vienna, Österreichische Galerie. *Katalog der neuen Galerie in der Stallburg.* Edited by Friderike Klauner. Vienna, 1967.

Vienna, Österreichische Galerie 1991
Vienna, Österreichische Galerie. *Französische Kunst in der Österreichischen Galerie in Wien: Sammlungskatalog der Galerie des 19. Jahrhunderts.* Edited by Stephan Koja. Vienna, 1991.

Ville-d'Avray 1987
Corot à Ville-d'Avray. Musée de Ville-d'Avray. December 1987. Exh. cat. Ville-d'Avray, 1987.

Vinding 1948
Ole Vinding. *Syner og virkelighed.* Copenhagen, 1948.

Vinet 1861
Ernest Vinet. "Salon de 1861." *Revue nationale et étrangère* 4 (June 25, 1861), pp. 609–18.

Volpi Orlandini 1976
Marisa Volpi Orlandini. "Camille Corot e 'l'arte nuova'." *Qui. Arte Contemporanea,* no. 16 (March 1976), pp. 22–26.

Waldmann 1910a
Emil Waldmann. "Französische Bilder in amerikanischem Privatbesitz." *Kunst und Künstler* 9 (November 1910), pp. 85–97.

Waldmann 1910b
Emil Waldmann. "Modern French Pictures: Some American Collections." *Burlington Magazine* 17 (April 1910), pp. 62–66.

Waldmann 1938
Emil Waldmann. "Die Sammlung Widener." *Pantheon* 22 (1938), pp. 335–43.

Walker 1976
John Walker. *National Gallery of Art, Washington.* New York, 1976.

Walter 1966
Rodolphe Walter. "Jean-Baptiste Corot et la cathédrale restaurée." *Gazette des beaux-arts,* 6th ser., 67 (April 1966), pp. 217–28.

Walter 1969
Rodolphe Walter. "Critique d'art et vérité: Émile Zola en 1868." *Gazette des beaux-arts,* 6th ser., 73 (April 1969), pp. 225–34.

Walter 1975
Rodolphe Walter. "Camille Corot et Madame Osmond; ou un jeu bien caché." *L'Oeil,* no. 239 (June 1975), pp. 30–37, 84.

Walter 1986
Rodolphe Walter. "Documents Corot conservés dans la famille Robert." *Archives de l'art français,* n.s., 28 (1986), pp. 299–305.

Walters 1884
William T. Walters. *Collection of W. T. Walters, 65 Mt. Vernon Place, Baltimore.* Baltimore, 1884.

Walters 1909
William T. Walters. *The Walters Collection, Baltimore.* Baltimore, 1909.

Waltham 1967
Exchange Exhibition, Exhibition Exchange: From the Collection of the Museum of Art, Rhode Island School of Design, Providence. Waltham, Rose Art Museum, Brandeis University, February 20–March 26, 1967. Exh. cat. Waltham, Mass., and Providence, R.I., 1967.

Washington 1956–57
"Loan Exhibition of Paintings by J. B. C. Corot." Washington, D.C., The Phillips Collection, December 16, 1956–January 17, 1957.

Washington 1968
Paintings from the Albright-Knox Art Gallery, Buffalo, New York. Washington, D.C., National Gallery of Art, May 19–July 21, 1968. Exh. cat. Buffalo, 1968.

Washington 1978
The William A. Clark Collection: An Exhibition Marking the Fiftieth Anniversary of the Installation of the Clark Collection at the Corcoran Gallery of Art, Washington, D.C. Washington, D.C., Corcoran Gallery of Art, April 26–July 16, 1978. Exh. cat. Washington, D.C., 1978.

Washington 1986
"Duncan Phillips: Centennial Exhibition." Washington, D.C., The Phillips Collection, June 14–August 31, 1986.

Washington 1988–89
Places of Delight: The Pastoral Landscape. Washington, D.C., The Phillips Collection and the National Gallery of Art, November 6, 1988–January 22, 1989. Exh. cat. by Robert Cafritz, Lawrence Gowing, and David Rosand. Washington, D.C., 1988.

Washington, Columbus, Evanston, Houston, Tampa, Omaha, Akron 1983–85
La Vie moderne: Nineteenth-Century French Art from the Corcoran Gallery. Washington, D.C., Corcoran Gallery of Art, October 1, 1983–January 8, 1984; Columbus, Georgia, Columbus Museum of Arts and Sciences, January 27–March 18; Evanston, Illinois, Mary and Leigh Block Gallery, Northwestern University, May 18–July 15; Houston, Museum of Fine Arts, August 10–October 7; Tampa, Florida, Tampa Museum, October 28, 1984–January 13, 1985; Omaha, Nebraska, Joslyn Art Museum, February 9–March 31; Akron, Ohio, Akron Art Museum, April 20–June 16. Exh. cat. with a preface by Michael Botwinick, foreword by Edward J. Nygren, and an essay by Lilien F. Robinson. Washington, D.C., 1983.

Washington et al. 1970–72
Nineteenth and Twentieth Century Paintings from the Collection of the Smith College Museum of Art. Washington, D.C., National Gallery of Art, May 16–June 14, 1970; Houston, Museum of Fine Arts, August 2–September 13; Seattle Art Museum, October 7–November 22; Kansas City, Missouri, William Rockhill Nelson Gallery of Art, December 20, 1970–February 1, 1971; Richmond, Virginia Museum of Fine Arts, February 28–April 11; The Toledo Museum of Art, October 3–November 14; Dallas Museum of Fine Arts, December 12, 1971–January 16, 1972; Athens, Georgia

Museum of Art, University of Georgia, February 13–March 26; Utica, New York, Munson-Williams-Proctor Institute, April 23–June 4; The Cleveland Museum of Art, September 10–October 22. Exh. cat. by Mira Matherny Fabian, Michael Wentworth, and Charles Chetham. Northampton, Mass., 1970.

Washington, National Gallery of Art 1948
Washington, D.C., National Gallery of Art. *Paintings and Sculpture from the Widener Collection.* Washington, D.C., 1948.

Washington, National Gallery of Art 1985
Washington, D.C., National Gallery of Art. *European Paintings: An Illustrated Catalogue.* Washington, D.C., 1985.

Washington, Phillips Collection 1952
Washington, D.C., The Phillips Collection. *The Phillips Collection: A Museum of Modern Art and Its Sources. Catalogue.* Washington, D.C., 1952.

Washington, Phillips Collection 1985
Washington, D.C., The Phillips Collection. *The Phillips Collection: A Summary Catalogue.* Washington, D.C., 1985.

Washington, San Francisco 1986
The New Painting: Impressionism, 1874–1886. Washington, D.C., National Gallery of Art, January 17–April 6, 1986; The Fine Arts Museums of San Francisco, M. H. de Young Memorial Museum, April 19–July 6. Exh. cat. by Charles S. Moffett, with Ruth Berson, Barbara Lee Williams, and Fronia E. Wissman. San Francisco, 1986.

Waterville 1952
"Study Exhibition." Colby College, Waterville, Maine, 1952.

Waterville, Manchester 1969
Nineteenth and Twentieth Century Paintings from the Smith College Museum of Art, Northampton, Massachusetts. Waterville, Maine, Colby College Art Museum, July 3–September 21, 1969; Manchester, The Currier Gallery of Art, October 11–November 23. Exh. cat. Introduction by Charles Chetham. Manchester, N.H., 1969.

Watkins 1946
Franklin C. Watkins. "Jean Baptiste Camille Corot." *Magazine of Art* 39 (December 1946), pp. 371–73.

Watt 1936
Alexander Watt. "Notes from Paris." *Apollo* 23 (April 1936), pp. 224–26.

Wehle 1930
Harry B. Wehle. "The Exhibition of the H. O. Havemeyer Collection." *Bulletin of The Metropolitan Museum of Art* 25 (March 1930), pp. 54–76.

Wehle 1938
Harry B. Wehle. "Hagar in the Wilderness by Corot." *Bulletin of The Metropolitan Museum of Art* 33 (November 1938), pp. 246–49.

Weitzenhoffer 1982
Frances Weitzenhoffer. *The Creation of the Havemeyer Collection, 1875–1900.* Ph.D. diss., City University of New York, 1982. Microfilm, Ann Arbor, Mich.

Weitzenhoffer 1986
Frances Weitzenhoffer. *The Havemeyers: Impressionism Comes to America.* New York, 1986.

Wenzel 1979
Carol Rose Wenzel. *The Transformation of French Landscape Painting from Valenciennes to Corot, 1787 to 1827.* Ph.D. diss., University of Pennsylvania, 1979. Microfilm, Ann Arbor, Mich.

Werner 1969
Alfred Werner. "Corot: Serenity and Purity. Benefit at Wildenstein." *Arts Magazine* 44, no. 2 (November 1969), pp. 30–33.

Whitehill 1970
Walter Muir Whitehill. *Museum of Fine Arts, Boston: A Centennial History.* 2 vols. Cambridge, Mass., 1970.

Whiteley 1974
Jon Whiteley. "Homer Abandoned: A French Neo-Classical Theme." In *The Artist and the Writer in France: Essays in Honour of Jean Seznec,* edited by Francis Haskell, Anthony Levi, and Robert Shackleton, pp. 40–51. Oxford, 1974.

Widener 1900
Peter A. B. Widener. *Catalogue of Paintings Forming the Private Collection of P. A. B. Widener, Ashbourne, near Philadelphia.* Vol. 1, *Modern Paintings.* Paris, 1900.

Wildenstein 1974–91
Daniel Wildenstein. *Claude Monet: Biographie et catalogue raisonné.* 5 vols. Lausanne and Paris, 1974–91.

Williamstown 1956
French Paintings of the Nineteenth Century. Williamstown, Sterling and Francine Clark Art Institute, opened May 8, 1956. Exh. cat. Williamstown, Mass., 1956.

Williamstown 1959
Supplement: French Paintings of the Nineteenth Century. Williamstown, Sterling and Francine Clark Art Institute, August 1959. Exh. cat. Williamstown, Mass., 1959.

Williamstown 1981
In the Studio: The Making of Art in Nineteenth-Century France. Williamstown, Sterling and Francine Clark Art Institute, 1981. Exh. cat. by David B. Cass. Williamstown, Mass., 1981.

Williamstown 1984
Alexandre Gabriel Decamps 1803–1860: Exhibition and Catalogue. Williamstown, Sterling and Francine Clark Art Institute, March 2–April 29, 1984. Exh. cat. by David B. Cass and Michael M. Floss. Williamstown, Mass., 1984.

Williamstown, Sterling and Francine Clark Art Institute 1970
Williamstown, Sterling and Francine Clark Art Institute. *List of Paintings, 1970.* Williamstown, Mass., 1970.

Williamstown, Sterling and Francine Clark Art Institute 1972
Williamstown, Sterling and Francine Clark Art Institute. *List of Paintings in the Sterling and Francine Clark Art Institute.* Williamstown, Mass., 1972.

Williamstown, Sterling and Francine Clark Art Institute 1981
Williamstown, Sterling and Francine Clark Art Institute. *Highlights: Sterling and Francine Clark Art Institute.* Preface by John H. Brooks. Williamstown, Mass., 1981.

Williamstown, Sterling and Francine Clark Art Institute 1984
Williamstown, Sterling and Francine Clark Art Institute. *List of Paintings in the Sterling and Francine Clark Art Institute.* Williamstown, Mass., 1984.

Williamstown, Sterling and Francine Clark Art Institute 1992
Williamstown, Sterling and Francine Clark Art Institute. *List of Paintings in the Sterling and Francine Clark Art Institute.* Williamstown, Mass., 1992.

Wilmerding 1972
John Wilmerding. *Winslow Homer.* New York, 1972.

Winnipeg 1954
French Pre-Impressionist Painters of the Nineteenth Century: Paintings, Watercolors, Drawings, Graphics. Winnipeg Art Gallery, April 10–May 9, 1954. Exh. cat. Winnipeg, 1954.

Winterthur 1955
Europäische Meister, 1790–1910. Winterthur, Kunstmuseum, June 12–July 24, 1955. Exh. cat. Winterthur, 1955.

Wissman 1989
Fronia E. Wissman. *Corot's Salon Paintings: Sources from French Classicism to Contemporary Theater Design.* Ph.D. diss., Yale University, 1989. Vol. 1. Microfilm, Ann Arbor, Mich.

Wivel 1993
Mikael Wivel. *Ordrupgaard: Selected Works.* Copenhagen, 1993.

Woodward and Robinson 1985
Carla Mathes Woodward and Franklin W.

Robinson, eds. *A Handbook of the Museum of Art, Rhode Island School of Design.* Providence, 1985.

Worcester 1949
"Portraits of Women, XV–XX Centuries." Worcester, Massachusetts, Worcester Art Museum, 1949.

Yarnall and Gerdts 1986
James L. Yarnall and William H. Gerdts. *The National Museum of American Art's Index to American Art Exhibition Catalogues from the Beginning through the 1876 Centennial Year.* 6 vols. Boston, 1986.

Yokohama, Chiba, Nara 1995
The Real World: Nineteenth-Century European Paintings from the Museum of Fine Arts, Boston. Yokohama, Sogo Museum of Art, April 27–July 24, 1995; Chiba, Sogo Museum of Art, August 4–September 17; Nara, Sogo Museum of Art, September 27–November 5. Exh. cat. Boston, 1994.

Yokohama, Hokkaido, Osaka, Yamaguchi 1991–92
La Peinture française au XIX^ème siècle: Le Musée des Beaux-Arts de Lille. Yokohama; Hokkaido; Osaka; Yamaguchi; 1991–92. Exh. cat. [Japan], 1991.

Young 1986
Mahonri Sharp Young. "The Pedestal." *Apollo* 124 (July 1986), pp. 49–51.

Zahar 1931
Marcel Zahar. "Maîtres du XIX^e siècle." *Formes,* no. 16 (June 1931), pp. 103–4.

Zander 1934
Alleyne Zander. "Individualists. . . . Braque; Matthew Smith; the 'Renoir; Cezanne and Their Contemporaries Exhibitions.' " *Art in Australia,* no. 57 (November 15, 1934), pp. 54–62.

Zervos 1934
C[hristian] Z[ervos]. "Renoir, Cézanne, leurs contemporains & la jeune peinture anglaise." *Cahiers d'art,* nos. 5–8 (1934), pp. 125–36.

Zervos 1951
Christian Zervos. *Pablo Picasso.* Vol. 4. Paris, 1951.

Zimmermann 1985
Antje Zimmermann. "Poesie und Wahrheit in Corots Figurenbildern." *Wallraf-Richartz-Jahrbuch* 46 (1985), pp. 399–409.

Zimmermann 1986
Antje Zimmermann. *Studien zum Figurenbild bei Corot.* Cologne, 1986.

Zola 1991
Émile Zola. *Écrits sur l'art.* Edited by Jean-Pierre Leduc-Adine. Paris, 1991.

Zurich 1933
Französische Maler des XIX. Jahrhunderts. Zurich, Kunsthaus, May 14–August 6, 1933. Exh. cat. Zurich, 1933.

Zurich 1934
Camille Corot 1796–1875. Zurich, Kunsthaus, August 16–October 7, 1934. Exh. cat. Zurich, 1934.

Zurich 1943
Ausländische Kunst in Zürich. Zurich, Kunsthaus, 1943. Exh. cat. Zurich, 1943.

Zurich 1947
Petit Palais: Musée de la ville de Paris. Zurich, Kunsthaus, June 9–August 31, 1947. Exh. cat. Zurich, 1947.

Zurich, Kunsthaus 1959
Zurich, Kunsthaus. *Aus der Sammlung.* Zurich, 1959.

Concordance of Catalogued Works

Robaut 1905 number	Catalogue number	Robaut 1905 number	Catalogue number	Robaut 1905 number	Catalogue number
R 2	1	R 245	40	R 394	73
R 3	2	R 248	48	R 407	60
R 16	3	R 250	49	R 411	81
R 33	4	R 256	46	R 423	80
R 35	5	R 259	31	R 428	79
R 44	6	R 266	33	R 455	84
R 53	21	R 271	68	R 456	93
R 57	18	R 278	35	R 457	83
R 62	19	R 292	39	R 457 bis	82
R 65	7	R 301	53	R 458	85
R 66	8	R 304	54	R 459 bis	72
R 67	9	R 308	57	R 460	114
R 68	10	R 310	55	R 464	90
R 71	11	R 323	56	R 466	89
R 79	15	R 328	67	R 474	66
R 83	13	R 332	36	R 502	91
R 84	12	R 343	69	R 555	38
R 89	16	R 357	59	R 556	97
R 97	20	R 358	58	R 559	110
R 105	17	R 359	94	R 587	50
R 121	24	R 362	61	R 588	52
R 123	25	R 363	63	R 589	87
R 130	26	R 366	62	R 608	92
R 139	23	R 368	64	R 669	96
R 169	22	R 370	51	R 684	112
R 199	27	R 372	75	R 718	111
R 200	29	R 374	76	R 731	109
R 207	32	R 376	78	R 756	42
R 221	37	R 377	77	R 766	113
R 224 bis	45	R 379	65	R 815	101
R 236	43	R 380	70	R 917	102
R 240	44	R 381	74	R 964	100
R 244	41	R 382	71	R 1003	98

Robaut 1905 number	Catalogue number		Robaut 1905 number	Catalogue number		Robaut 1905 number	Catalogue number
R 1009	123		R 1557	134		R 2004	156
R 1040	86		R 1558	136		R 2013	157
R 1044	108		R 1559	137		R 2038	149
R 1046	106		R 1559 bis	135		R 2107	150
R 1054	88		R 1560	139		R 2129	163
R 1061	103		R 1561	138		R 2130	142
R 1063	104		R 1563	141		R 2133	152
R 1065	105		R 1573	153		R 2140	154
R 1097	114		R 1576	143		R 2169	159
R 1099	115		R 1622	120		R 2180	162
R 1108	116		R 1623	125		R 2190	161
R 1136	95		R 1625	126		R 2194	160
R 1276	118		R 1636	127		R 2373	158
R 1277	117		R 1641	147		R 2459 (B)	28
R 1376	119		R 1644	128		S-D 1948* 7	47
R 1402	124		R 1731	132		D-P 1992** 44	155
R 1426	133		R 1797	129		none	14
R 1431	144		R 1798	130		none	30
R 1464	99		R 1805	131		none	34
R 1507	107		R 1906	146			
R 1510	140		R 1943	121			
R 1522	145		R 1995	151		* Schoeller and Dieterle 1948	
R 1532 bis	122		R 2003	148		** Dieterle and Pacitti 1992	

Index of Cited Works

Index of Former Owners

This index lists former owners mentioned in the provenance section of the catalogue entries; present owners are not included. Art dealers and galleries are named among the former owners, but not when a work was with them only on deposit or loan, or when they acted solely as temporary agent or custodian; thus, for example, the auction houses through which many works passed are not listed here as owners.

General Index

Béthune, Corot at, 418
Bethune, Dr. G. A., collection, 404
Beugniet (dealer), 271, 399; collection, 401
Biard, François-Auguste, portrait by Corot, 114
Biarritz, Corot at, 417
Bicknell, Albion, collection, 404
Bida, Alexandre, awards to, 272
Bidauld, Jean-Joseph-Xavier, 11, 40; compared to
 Corot, 23, 78; influence on Corot, 70, 73; works,
 Vue de Subiaco and *Vue d'Avezzano*, 23 n. 102
Bidault, Jean-Joseph-Xavier, 385
Binant, A., 414
Birch's Gallery (Philadelphia), 417
Blanc, Charles: assessment of Corot, 259, 266, 270,
 272; critical of Corot, 262, 272, 374; writings, 183
Blanche, Jacques-Émile, 101; assessment of Corot's
 works, xiv; collection, 92, 406
Blangy-sur-Ternoise, Corot at, 225
Bochet (collector), 401
Bodinier, Guillaume, 21
Boguet, Nicolas-Didier, 11, 39 n. 20; *La Loge Aldo-*
 brandini à Frascati, 39 n. 20
Boilly, Julien, 21, 111
Bois-Guillaume, Corot at, 30–31, 32, 106, 409, 410,
 411; cat. no. 1
Bonheur, Rosa, Corot's opinion of, 413
Bonington, Richard Parkes, 12, 36; influence on
 Corot, 15
Bonvin, François, 314
Bordeaux: city of, 414; Corot in, 417; Corot's work
 shown in, 400; Musée de, 399
Borel, Pierre, 136, 194
Boston, Corot's paintings shown in, 404, 417, 418
Boston Art Club, 418
Bouchaud, Léon-Prudent (collector), 401
Bouché, Alexander, portrait of Corot, 122
Boucher, François: influence on Corot, 280; works,
 Diane sortant du bain (Diana after the Bath), 333, *334*;
 fig. 149
Boudan, Mme, embarrassing evening with, 104
Boudin, Eugène, 36; influenced by Corot, 108
Boulogne, Corot at, 411
Boulogne-sur-Mer, Corot at, 415
Bourberouge, Corot at, 414
Boussaton (dealer), auction sale of (1858), 400–401
Bouyer, Raymond, assessment of Corot, 270, 284,
 375
Bouzemont (collector), 401
Bovy, Antoine: Corot visits, 135, 415; friend of
 Corot, 149
Bovy, Daniel: Corot visits, 135, 245, 415; friend of
 Corot, 149; travels with Corot, 386
Bovy, Octavie. *See* Baron, Octavie
Bovy family, Corot visits, 194
Bovy-Lysberg, Charles, 248, 298
Bracqemond, Félix, 219, 220; reminiscences of, 150
Brame, Hector (dealer), 96, 271, 399, 402
Brandon, Édouard: correspondence with Corot,
 242, 245, 254, 278, 380, 398, 415; friend of
 Corot, 149; imitator of Corot, 392; student of
 Corot, 388
Brandon, Édouard (attributed to), *Bûcherons dans une*
 clairière (R.F. 3779), 392 n. 50
Brandon, Jules, correspondence with Corot, 242
Brascassat, Jacques-Raymond, 21, 42; *Le Colisée vu des*
 jardins Farnèse (*The Coliseum Seen From the Farnese*
 Gardens), 40, 42; fig. 27
Brest, Corot at, 415
Breton, Jules, award to, 272

Breton, Adrien, 361
Breysse (dealer), 271, 348, 399
Briand, Louis: collection, 316; Corot visits, 416
Brittany, Corot in, 32, 149, 220, 250, 410, 412, 413,
 414, 415; cat. no. 112
Brizard: Corot visits, 412, 413; travels with Corot,
 146, 220, 418
Brown collection, 404
Bruce, Hamilton, collection, 403
Brunet, Gilbert, 90
Brunoy, Corot at, 418
Brussels, Corot in, 414
Bruyas, Alfred, collection, 218
Burgundy, Corot in, 98, 411
Burty, Philippe, collection, 406

C

Cabanel, Alexandre: award to, 272; *Naissance de Vénus*,
 301
Cabat, Nicolas-Louis, 266
Cachardy, Charles-Joseph (collector), 401
Cadart, Alphonse, 404, 405, 417
Caen, Corot at, 415
Callias, Hector de: assessment of Corot, 398; writ-
 ings, 281, 288–87
Cals, Adolphe, collection, 406
Cambay, Dr., 271, 402; collection, 399
Camiot, Charles, collection, 104
Camondo, Isaac de, collection, 402
Camondo collection, 401
Camus, copies work of Corot, 389
Camus, Dr., collection, 401, 406
Canada, Corot collections in, 406
Cantrel, Émile, writings, 280
Capri, Corot at, 410
Cardon collection, 403
Carracci, Annibale, 11
Caruelle d'Aligny, Théodore, *see* Aligny, Théodore
 Caruelle d'
Cassatt, Mary, promotion of Corot's work, xiv
Castagnary, Jules: assessment of Corot, 259, 259
 n. 2, 260, 289–90, 373; collection, 319; writings,
 276, 301, 330, 340, 342, 348, 350
Castaignet, Mme: Corot's paintings for, 308–10; cat.
 no. 129, 130; Corot visits, 309, 415
Castel Gandolfo, Corot at, 63, 214, 301, 312
Castellan, Edmond, writings, 261 n. 12, 288
Castelli Romani, Corot at, 63, 146, 197, 199
Castel Sant'Angelo (Rome), Corot's painting of,
 48–50, 385
Cayeax (minister), 411
Cayeux, Corot at, 340
Cazin, Charles, collection, 406
Cézanne, Paul, 11 n. 26; compared to Corot, 166;
 influenced by Corot, xiv
Chailly, painters at, 91, 411
Chamouillet, François-Joseph, 205; collection, 401
Chamouillet, Jules, 205
Chamouillet, Léon, 205, 416
Chamouillet, Octave, 205
Chamouillet, Octavie (née Sennegon), 205; por-
 traits of, 116
Chamouillet family, 414
Champfleury (Jules Husson): assessment of Corot,
 397; decries Salon jury, 145; writings, 211–12,
 227, 392, 412
Chardin, Jean-Baptiste-Siméon: compared to
 Corot, 269; influence on Corot, 314

Charmois, Christophe, 120
Charmois, Claire (née Sennegon): marriage, 120;
 portrait by Corot, 116, 120; cat. no. 50
Charpentier family (Alençon), Corot visits, 414
Chartres, Corot at, 93–96, 411; cat. no. 37; fig. 46
Chassériau, Théodore, decoration for artists' ball
 (ca. 1834), 149, 149 n. 42
Château-Thierry, Corot at, 415, 416
Chauchard, Alfred, collection, 348, 398
Chauvin, Pierre-Athanase, 11, 54; compared to Corot,
 78; *Saint-Pierre de Rome vue du Pincio*, 56 n. 6
Chavet, Victor, 314; *La Dormeuse*, 314
Chaville, Corot at, 24, 33–34; cat. no. 3
Chénier, André, 209
Chennevières, Philippe de, 146, 232; assessment of
 Corot, 141, 231
Chéramy, Paul-Arthur, collection, 202, 402
Chesneau, Ernest, writings, 373–74
Chintreuil, Antoine: copies work of Corot, 389;
 friend of Corot, 271; student of Corot, 150;
 works, 392
Cibot, François-Barthélemy-Michel, 233
Cicéri, Pierre-Luc-Charles, 93, 292–93
Cile (collector), 401
Cincinnati: Corot collections in, 405; Corot's paint-
 ings shown in, 418
Civita Castellana, Corot at, 23, 66, 80, 92, 126, 410;
 cat. no. 23; fig. 44; as source for later works, 156,
 190
Claghorn, James L., collection, 404
Clamecy, Corot at, 411
Clapisson, Léon, collection, 223, 401
Claretie, Jules: collection, 406; recollections of
 Corot, 254; writings, 348, 362
Clark, Kenneth, xiv
Claude Lorrain, 11; compared to Corot, xiv, 80, 186,
 232, 234, 236, 340; influence on Corot, 25, 45, 78,
 145, 148, 183, 186, 210, 220, 293, 301, 312; works,
 199; *La Fête villageoise*, 232; *Marriage of Isaac and*
 Rebecca, 186; *Paysage champêtre (Rustic Landscape)*, 183,
 183; fig. 84; *Vue du Campo Vaccino*, 45, *45*; fig. 31
Claudon, Théodore-François-Charles, collection, 401
Clay, Joseph A., collection, 404
Clément, Charles, writings, 301
Cléophas (dealer), 271, 350, 399, 402; collection, 350
Clérambault, Alexandre: Corot visits, 412, 414;
 friend of Corot, 149; letter from, 115 n. 2; por-
 trait by Corot, 410
Clerc de Landresse, Ernestine, 185, 225
Clermont, Corot at, 415
Clodion, 284
Coats, Archibald, collection, 403
Coats, William A., collection, 404
Cochin, baron Denys, collection, 104, 115
Coignard, Louis, copies work of Corot, 389
Coignet, Léon, 48
Colin, Gustave, 231, 252
Colin, Paul, 383 n. 2
collectors of Corot's work, xiv, 397–407; American,
 271, 298–99, 346, 405; artists, 406–7; eager for
 Corot's latest work, 260, 267, 415; early, 150, 400,
 412; European, 271; flock to his studio, 270–71,
 398; often obscure or unknown, 400; promote
 Corot's work, 150; sizes of their collections,
 398–99
Comairas, Philippe: friend of Corot, 149; travels
 with Corot, 220, 386, 418
Comairas (père), Corot's gift of a painting to, 48,
 220 n. 4

Toutain, Mère, inn of, 36, 37, 109

Tréport, Corot at, 274

Tretiakov, Serge, collection, 403

Trinità dei Monti (Rome), Corot's paintings of, 50–54; cat. nos. 12, 13, 14; figs. 34, 35

Troisgots, Corot at, 104, 411, 415

Trouillebert, Paul-Désiré: imitator of Corot, 392; *La Fontaine des Gabourets*, 392

Trouville, Corot at, 109, 111, 411; fig. 50

Troyes, Corot at, 415

Troyon, Constant, compared to Corot, 106

Turgenev, Ivan, collection, 403

Turner, Joseph Mallord William, 12, 36

Turpin de Crissé, Lancelot-Théodore, 11

Turrettini, Charles, 135

Turrettini, Suzanne, 135; copies Corot's work, 248

Tyrol, Corot in, cat. no. 94

U

unfinished work: Baudelaire's essay on, 51; modern appreciation of, vs. Corot's, 25

Union League Club (Philadelphia), 418

United States: Corot collections in, 404–6; *see also* Boston, Cincinnati, Philadelphia, New York

Unterseen, Corot at, 245

V

Valdrôme, Chevandier de, copies work of Corot, 389

Valenciennes, Pierre-Henri de, 5 n. 5, 11, 15, 17, 21, 22, 27, 68
 compared to Corot, 23, 85
 influence on Corot, xiv, 70, 132, 312
 theories and prescriptions of, 30, 40, 42, 43, 57, 62–63, 64, 68, 76–77, 81, 262
 works, 54, 73, 97, 199, 384, 385; *À la villa Farnèse, l'escalier*, 38; *À la villa Médicis*, 56 n. 1; *Étude de ciel au Quirinal*, 98 n. 2; *Monte Cavo pris de Nemi*, 385 n. 17; *Monte Cavo sous un ciel nuageux*, 385 n. 17; *Ruines romaines (Roman Ruins)*, 38, 38; fig. 23; *Sous-bois, arbres aux branches tortueuses (Undergrowth, Trees with Twisted Branches)*, 215, 215; fig. 95; *Le Toit à l'ombre*, 98 n. 2; *Le Toit au soleil*, 98 n. 2; *Vue de la porte du Peuple à Rome*, 98 n. 2; *Vue de Rocca di Papa, le matin*, 385; *Vue du Colisée (View of the Coliseum)*, 40, 40; fig. 26;

Vue du lac de Nemi et Genzano (View of Lake Nemi and Genzano), 132, 132; fig. 60

Vanderbilt, Cornelius, collection, 405

Vanderbilt, William H., collection, 405

Vatican, Corot's painting from grounds of, 62, 412

vedutists (view painters), 24

Velde, van de, influence on Corot, 111

Venetian Renaissance, influence on Corot, 175

Venice, Corot in, 23, 130–31, 410, 411; cat. no. 56; figs. 57, 58, 59

Ventimiglia, Corot at, 411

Venturi, Lionello, 126; assessment of Corot, 38, 73, 94, 220, 282, 336, 353

Verdier, Dr., collection, 271, 399, 402

Vermeer, Jan: compared to Corot, 192, 220, 316, 320, 353, 362; influence on Corot, 102, 314

Vernet, Claude-Joseph, 9, 11, 42, 48, 199; compared to Corot, 78, 80, 183, 309; influence on Corot, 220, 312

Vernier, Émile, lithograph of Corot's work, 330

Veronese, compared to Corot, 254

Versailles: Corot at, 171; Corot's mother's property in, 5; Palace of, Corot's painting of, 171

Vever, Henri, collection, 287, 399, 406

Vevey, Corot at, 412

Vézelay: Corot at, 190; Corot visits, 412

Viardot, Louis, writings, 156, 159

Viardot, Pauline, 290

Victoria, Queen, collection, 278

Vien, Joseph-Marie, *Ermite endormi*, 380

Vigen, Corot at, fig. 109

Villa Medici (Rome), Corot's painting of fountain of, 54–56; cat. no. 15

Ville-d'Avray: Corot family property at, 8–9, 228, 417; Corot's residence at, 9, 15, 26, 27, 34–35, 86, 146, 228, 301, 410, 412, 413, 414, 415, 416, 417, 418; cat. no. 4, 32, 102, 147, 148, 149; fig. 19, 21, 98; history of the property, 228

Villeneuve-les-Avignon, Corot at, 168; figs. 76, 77

Villers, de, 375

Villers-Cotterêts, Corot at, 412

Vimoutiers, vicinity of, Corot at, 416

Viterbo, Corot at, 410

Vleughels, Nicolas de, 57

Vollon, Antoine, collection, 406

Volterra: Corot at, 183; cat. no. 54; fig. 55; Corot in, 126–27, 147, 411

W

Wagnonville (near Douai), Corot at, 417

Wall collection, 404

Wallet, Paul-Louis-Alexandre, collection, 296

Walter, Rodolphe, 338

Walters, William, 224; collection, 271, 298–99, 403, 404

Warnier-David, Jules, collection, 338, 401

Warren, Mrs. Samuel D., collection, 404

Watteau, Jean-Antoine
 influence on Corot, 280
 works: *L'Indiscret (Indiscreet)*, 190, 191; fig. 87; *A Lady at Her Toilet (La Toilette)*, 278, 280; fig. 123

Weitzenhoffer, Frances, 406

Weyl (dealer), 162, 271, 399, 402

Whistler, James Abbott McNeill: compared to Corot, 375; portrait of Théodore Duret, 406; fig. 177

White, James Forbes, collection, 403

Wigglesworth, Thomas, collection, 404

wigmakers, and Neoclassical painters, 5 n. 5

Williams, I. T., collection, 405

Wilson, Richard, 12 n. 31

Wilstach, W. P., collection, 404

Wissman, Fronia, 182, 280 n. 19, 291 n. 11, 292

Wittel, Gaspar van, 48

Wolf, Albert, collection, 269

Wolfe, Catharine Lorillard, collection, 346, 405

Wolfe, John, collection, 405

Wolff collection, 403

wood, painting on, 55–56

Wright of Derby, Joseph, 48

X

X-radiography, 58, 126, 240, 242, 282, 282, 285, 286, 333, 334; figs. 103, 128, 148

Y

Young, Alexander, collection, 403

Yport, Corot in, 417

Z

Zimmermann, Antje, 314

Zola, Émile, writings on Corot, 260, 266, 342

Zuydcoote, Corot at, 252, 415, 418

Photograph Credits

Aix-en-Provence, photograph by Jean Bernard: cat. no. 94

Boston, Museum of Fine Arts: cat. no. 161

Bruges, photograph by Hugo Maertens: cat. no. 66

Caen, Musée des Beaux-Arts, photograph by Martine Seyve: cat. no. 132

Chicago, The Art Institute of Chicago, © 1994, all rights reserved: cat. nos. 14, 53, 127, 144

Copenhagen, Ordrupgaardsamlingen, photograph by Ole Woldbye: cat. nos. 69, 158

Des Moines, Des Moines Art Center, photograph by Ray Andrews: cat. no. 102

Dijon, photograph by Pascal Tournier: cat. no. 88

Dunkirk, Studio Mallevaey: cat. no. 113

Florence, Bardazzi Fotografia: cat. no. 51

Hamburg, Kunsthalle, Elke Walford Fotowerkstatt: cat. no. 163

Linselles, photograph by Claude Thériez: cat. no. 100

London, photograph courtesy Colnaghi Ltd.: fig. 25

London, photograph courtesy Marlborough Fine Art Ltd.: cat. no. 22

London, Reproduced by courtesy of the Trustees, The National Gallery: fig. 142

Lyons, Studio Basset: cat. no. 138

Montauban, Roumagnac Photographe: fig. 38

Montreal, Montreal Museum of Fine Arts, photograph by Brian Merett: cat. no. 128

Nantes, photograph by Alain Guillard: cat. no. 78

New York, photograph courtesy of Richard L. Feigen & Co.: cat. no. 33

New York, The Metropolitan Museum of Art, The Photograph Studio: cat. nos. 35, 61, 63, 119, 141, 142, 148, figs. 14, 88, 98, 100, 106, 143, 145, 174, 177. Oi-Cheong Lee: cat. nos. 45, 49, 111, 114. Eileen Travell and Katherine Dahab: frontispiece, figs. 2, 67, 68, 116, 172, 173, 175

New York, © 1993 Sotheby's Inc.: fig. 135

New York, Wildenstein & Co.: cat. no. 23

Ottawa, National Gallery of Canada: fig. 107

Paris, Studio Mandin: cat. no. 34

Paris, Réunion des Musées Nationaux: figs. 1, 8, 11, 19, 23, 26, 28, 31, 32, 34, 39, 40, 41, 42, 45, 46, 50, 51, 52, 53, 54, 55, 56, 58, 60, 72, 77, 78, 80, 81, 86, 89, 90, 91, 92, 94, 95, 102, 103, 124, 127, 137, 149, 154, 157, 159, 168, 169, 170, 171. Arnaudet: cat. nos. 6, 8, 28, 55, 112. Ph. Delorme: cat no. 126. P. Y. Le Meur: cat. no. 90. H. Lewandowski: cat. nos. 9, 13, 21, 26, 50, 76, 83, 99, 103, 107, 108, 116, 117, 124, 129, 130, 134, 162, fig. 167. R. G. Ojeda: cat. nos. 31, 37, 42, 48, 54, 87, 126, 149, 156, 159, 160

Paris, © Photothèque des Musées de la Ville de Paris by SPADEM: figs. 160, 161. Pierrain by SPADEM 1996: cat. no. 85

Providence, Museum of Art, Rhode Island School of Design, Museum Works of Art Fund, photograph by Del Bogart: cat. nos. 5, 109

Rotterdam, photograph by Tom Haartsen: fig. 87

Saint Gall, photograph by Stefan Rohner: cat. no. 58

Shelburne, Vermont, photograph by Ken Burris: cat. nos. 118, 151, 153

Vanves, Photographie Giraudon: cat. no. 89, fig. 65

Vienna, Fotostudio Otto: cat. nos. 74, 84

Zurich, photograph courtesy Galerie Nathan: fig. 35

Zurich, Peter Schälchli: cat. no. 143

Photograph by J. Hyde: cat. no. 22